THE ILLUSTRATIONS
IN THE
MANUSCRIPTS OF THE SEPTUAGINT
VOLUME II · OCTATEUCH

THE ILLUSTRATIONS IN

THE MANUSCRIPTS OF THE SEPTUAGINT

FOUNDED BY

ERNEST T. DE WALD · ALBERT M. FRIEND, JR. · KURT WEITZMANN

VOLUME I GENESIS

VOLUME II OCTATEUCH

VOLUME III PSALMS AND ODES

·

PUBLISHED BY THE DEPARTMENT OF

ART AND ARCHAEOLOGY, PRINCETON UNIVERSITY

IN ASSOCIATION WITH

PRINCETON UNIVERSITY PRESS

Pl. LXII.

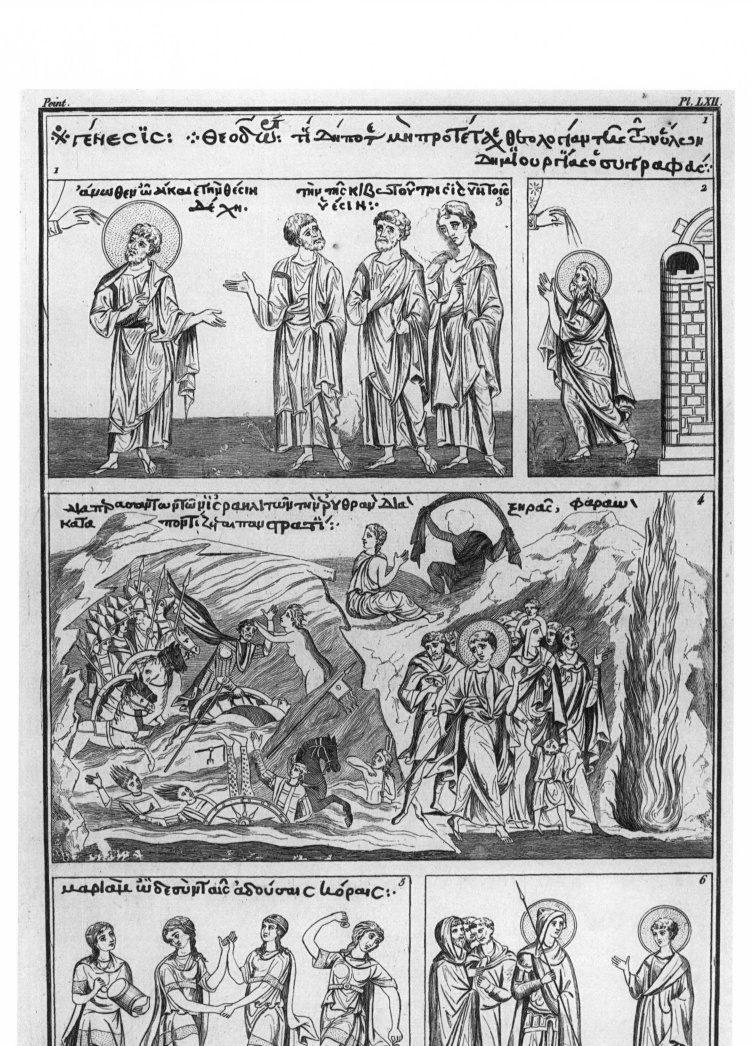

THE BYZANTINE OCTATEUCHS

MOUNT ATHOS, VATOPEDI MONASTERY, CODEX 602
FLORENCE, BIBLIOTECA MEDICEA LAURENZIANA, CODEX PLUTEUS 5.38
ISTANBUL, TOPKAPI SARAYI LIBRARY, CODEX G. I. 8
ROME, BIBLIOTECA APOSTOLICA VATICANA,
CODEX VATICANUS GRAECUS 746
AND CODEX VATICANUS GRAECUS 747
SMYRNA (*OLIM*), EVANGELICAL SCHOOL LIBRARY, CODEX A.1

KURT WEITZMANN AND
MASSIMO BERNABÒ

WITH THE COLLABORATION OF

RITA TARASCONI

TEXT

DEPARTMENT OF ART AND ARCHAEOLOGY

PRINCETON UNIVERSITY

IN ASSOCIATION WITH

PRINCETON UNIVERSITY PRESS

1999

LIBRARY OF CONGRESS CATALOGING-IN-PUBLICATION DATA

WEITZMANN, KURT, 1904–
THE BYZANTINE OCTATEUCHS / KURT WEITZMANN AND MASSIMO BERNABÒ ;
WITH THE COLLABORATION OF RITA TARASCONI.
P. CM. — (THE ILLUSTRATIONS IN THE MANUSCRIPTS OF THE
SEPTUAGINT ; V. 2)
INCLUDES BIBLIOGRAPHICAL REFERENCES AND INDEX.
ISBN 0-691-00722-5 (CL : ALK. PAPER)
I. BIBLE. O.T. OCTATEUCH—ILLUSTRATIONS. 2. ILLUMINATION OF BOOKS AND MANUSCRIPTS,
BYZANTINE. 3. BIBLE. O.T. JOSHUA—ILLUSTRATIONS. 4. MINIATURE PAINTING, MEDIEVAL.
I. BERNABÒ, MASSIMO. II. TARASCONI, RITA. III. TITLE. IV. SERIES.
ND3356.144 VOL. 2 [ND3358.027]
745.6'7487 S—DC21 [745.6'7487] 98-42444

BOOKS PUBLISHED BY THE DEPARTMENT OF ART AND ARCHAEOLOGY ARE PRINTED
ON ACID-FREE PAPER, AND MEET THE PERMANENCE AND DURABILITY GUIDELINES
OF THE COMMITTEE ON PRODUCTION GUIDELINES FOR BOOK LONGEVITY
OF THE COUNCIL ON LIBRARY RESOURCES

SET IN GARAMOND BY IMPRESSIONS BOOK AND JOURNAL SERVICES, INC.

PRINTED IN THE UNITED STATES OF AMERICA
BY CENTENNIAL PRESS

EDITED BY CHRISTOPHER MOSS

PRODUCED BY LAURY A. EGAN

IN MEMORY OF
CHARLES RUFUS MOREY

CONTENTS

CONTENTS

IV. CODICOLOGY, HISTORY, AND STYLE
by Massimo Bernabò

The plates are bound in a separate volume.

PREFACES

MY OCCUPATION with the Octateuchs began in 1932 under the following circumstances. Adolf Goldschmidt, with whom I was working at that time on the corpus of Byzantine ivories, told me that in a meeting at the Prussian Academy Hans Lietzmann had informed him about a seminar he was giving on the recently discovered third-century paintings of the synagogue of Dura Europos in Mesopotamia. Professor Paul Baur of Yale University, one of the excavators and a friend of Lietzmann, had come directly from Dura to Berlin to leave a complete set of photos of these paintings with him. When I heard about this sensational find I asked Lietzmann—though I was no longer a student—whether I could participate in his seminar. Under one condition, Lietzmann told me: that I would read a paper. I gladly accepted and was assigned to study the panel representing the Crossing of the Red Sea. I immediately realized that the iconography of this very elaborate scene had quite a number of details which agreed with the representation of the same subject in the Octateuchs. I had just been on Mount Athos and had seen in the Vatopedi Monastery the Octateuch which had stimulated my interest in this and the related Octateuchs. The relation between the Dura painting and the Byzantine miniatures became the focal point of my paper. This idea fascinated Lietzmann, who had once (with Georg Karo) written an article on the catenae text of the Octateuchs. Ever since, he had hoped that some day an art historian would become interested in doing a thorough study of the Octateuch illustrations. So he asked me whether I would be willing to undertake this task and he promised me the support of the Prussian Academy. Without hesitation I agreed, and I knew that I had embarked on a long-term project.

Lietzmann advised me to get photographs of the miniatures of the Vatican Octateuchs by writing to the prefect of the Vatican Library, Eugène Cardinal Tisserant, and asking for photos of the miniatures of the two key manuscripts, cod. Vat. gr. 746 and cod. Vat. gr. 747. Tisserant answered that in principle he had no objection to having these photos made for me, but that not long ago these manuscripts had been photographed for Princeton University; he advised me to write to Professor Charles Rufus Morey, the chairman of the Department of Art and Archaeology at Princeton, and ask whether he would be willing to let me have a set of prints. Morey answered that he was hesitant to give his

permission because my publication of the Octateuchs would lead to duplication: Princeton had already embarked on the much bigger project of publishing not only the Octateuchs, but all the existing illustrated manuscripts of the Septuagint. Professor Ernest T. De Wald was to publish two Vatican Psalter manuscripts in this series, and Morey himself intended to publish the Octateuchs. But he realized that he was occupied with so many projects, the Antioch excavations being one of them, that he would not find time to work on the Octateuchs in the foreseeable future, and wrote that he would be willing to turn over the Octateuch material to me, provided that I came to Princeton. The letter with this proposal was forwarded to me in 1934 while I was spending a few months at the German Archaeological Institute in Istanbul, where I had started to work on the Octateuch of the Seraglio, a study about which I shall have more to say later. I agreed to come to Princeton, provided that Princeton would pay the expenses. Thus Morey invited me to come to Princeton, and he got a one-year grant from the Institute for Advanced Study.[1]

Before going to Princeton, I was told by the Department of Art and Archaeology that it possessed all the photos of the Octateuch miniatures. This, unfortunately, was not the case. It did possess photos of the miniatures of the two Vatican manuscripts, cod. Vat. gr. 746 and cod. Vat. gr. 747, and of the Florentine Octateuch, but had neither those of the Octateuch in the Vatopedi Monastery on Mount Athos nor those of the one in the Seraglio at Istanbul. In 1934, a few months before going to Princeton, I had made a special trip to Mount Athos expressly to study the Vatopedi manuscript and had taken notes, but I had no camera with me. After I had been in Princeton for only five months, the department made it possible for me to go to Vatopedi again,[2] to engage a photographer to photograph not only the miniatures of the Vatopedi Octateuch, but of all the manuscripts to be included in the Septuagint project, i.e., foremost the Psalter manuscripts and, especially for Albert Mathias Friend Jr., all of the evangelist portraits, which were his special interest. I engaged Anatole von Meibohm, a Russian refugee who lived in Athens, where he worked as a photographer,[3] and we spent three months on Mount Athos photographing not only the Vatopedi Octateuch, but also many other illustrated manuscripts.[4] In the next year, 1936, we again went to Athos to photograph, as far as

[1] [The grant was renewed in the following year; then, in April 1937, the trustees of the Institute appointed Weitzmann as Field Medievalist in the School of Humanistic Studies. Details of the story of the Octateuch project that are given inside square brackets in these notes have been found in the archives of Princeton University, in the Mudd Library, and in the archives of the Institute for Advanced Study, Princeton. Additional material on Weitzmann's first years in Princeton can be found in his memoirs, *Sailing with Byzantium from Europe to America: The Memoirs of an Art Historian* (Munich, 1994).]

[2] [As described by Friend in his report to Panofsky (see note 4), the expedition was the result of the cooperation of the Institute for Advanced Study in Princeton (in which Weitzmann held his position) and the Department of Art and Archaeology of Princeton University. The expenses

of the expedition (travel, photographic equipment, living costs, etc.) were financed by departmental funds.]

[3] [Von Meibohm was a philologist and at that time was connected with the University of Prague. He had been on Athos before the 1935 expedition with Weitzmann.]

[4] [The photos of the Vatopedi Octateuch in Weitzmann's collection in Princeton are dated 1935 or 1939. On 27 January 1936, A. M. Friend sent a report on the 1935 Athos expedition to Erwin Panofsky of the Institute for Advanced Study in Princeton; this report is preserved in the archives of the Institute. "The expedition succeeded beyond our fondest hopes . . . ," says Friend in his report, "in fact we now have more photographic reproductions by far than any of the other expeditions to Athos (Kondakoff, Millet, etc.) obtained." Friend cites the number of manuscripts (277) and number

possible, every illustrated manuscript preserved in its monasteries.

During my two-month visit to Istanbul, when I already had the invitation to come to Princeton in my hand, I spent most of my time studying the Octateuch in the Seraglio. In the eighteenth-century marble kiosk in the innermost courtyard of the Seraglio, the Octateuch, wrapped in yellow silk, was placed before me on a rococo table. The manuscript was in a deplorable state of preservation: it was a bundle of loose gatherings that had no cover. Permission to have all the miniatures photographed was given to Princeton University under the condition that the manuscript would be restored by the best expert in the field at Princeton's expense. Professor Kurt Bittel, then the second director of the German Archaeological Institute in Istanbul and later its director, had excellent relations with the Turkish authorities and was instrumental in securing the permission and making the arrangements for the photographing of the manuscript, as well as engaging the best available expert for such a restoration job. Professor Hugo Ibscher, the famous papyrus restorer in Berlin, not only bound the loose gatherings in three handsome leather covers, but treated the manuscript page by page, adding new pieces of parchment where the edges of the sheets had been damaged by a violet fungus. The Princeton department and I myself owe a special thanks to Professor Bittel for having made possible the excellent photos made for the present publication.

After my arrival in Princeton in 1935 I began writing descriptions of the individual miniatures of all the existing Octateuchs, and it soon became apparent that the underlying text of the Septuagint was in many cases not sufficient for an explanation of their iconography. My previously mentioned study of the Dura synagogue paintings and their connections with the Octateuch miniatures led me to search further for Jewish elements in them; I soon realized that they were quite numerous. I incorporated a fair number of cases of the influence of Jewish sources, but realized that I could not explore this aspect thoroughly and left it to future scholarship to continue research along these lines. In a 1964 article, "Zur Frage des Einflusses jüdischer Bilderquellen auf die Illustration des Alten Testamentes," I demonstrated that Jewish elements also occurred in other recensions, for example, in the Vienna Genesis and the Cotton Genesis, and in the illustrations not only of the Octateuchs, but of other books of the Septuagint, notably the Book of Kings. It was thus apparent that we were dealing with a general phenomenon and not with just an individual case.

The previously mentioned iconographical relationship between the scene of the Crossing of the Red Sea in Dura and the Octateuch miniatures inspired a more thorough investigation of the relationship between the synagogue paintings and the Octateuch miniatures, the result of which was published as a monograph, *The Frescoes of the Dura Synagogue and Christian Art* (1990). The iconographical agreements in many scenes between the Jewish paintings and the Christian miniatures—and not only in the Pentateuch, but also very pronounced in the Book of Kings—led to the conclusion that they harked back to the same archetype, and this meant that there was a close relation between Christian and Jewish art as early as the third century A.D.

Thus the evidence pointed to the existence of extensive cycles of illustrations at least as early as the third century. This idea, I realized, was contrary to the generally accepted theory of Early Christian archaeologists that narrative illustrations as we have them in Bible illustrations did not exist at that early time, but developed only gradually in the fourth century out of the symbolic representations seen in catacomb painting. In order to prove the existence of such narrative illustration at an early period, I investigated this problem on a broad basis in a study entitled *Illustrations in Roll and Codex: A Study of the Origin and Method of Text Illustration* (1947, 2d ed. 1970). In this study I collected the evidence—Megarian bowls and Iliac tablets being the basic sources—that as early as the late Hellenistic and Roman periods there were prolifically illustrated rolls of the Homeric poems and the dramas of Euripides. In order to demonstrate that the illustration of ancient texts was indeed widespread, I wrote a book entitled *Ancient Book Illumination* (1959), in which I treated the various categories of texts that visual evidence showed were illustrated: epic, drama, didactic treatises, scientific treatises of all kinds, etc.

Against this background it became apparent that in order to illustrate the Septuagint Jews and Christians—whoever started first—did not have to invent a new branch of painting, but had before their eyes a very well-developed tradition of accompanying texts with cycles of narrative illustration. In other words, the illustration of the Bible did not begin with a limited number of scenes but rather with fully developed cycles in which a single episode was illustrated in a number of phases. Indeed, as the analogies of the Octateuch scenes will make clear, the archetype was richer than any cycle in the extant codices, and the principles of selection, abbreviation, and condensation were frequently applied. Thus, one should not be surprised to find compositions of biblical scenes that were borrowed from mythological scenes in classical texts. That Byzantine illustrators were indeed familiar with mythological subjects is a topic I discussed in *Greek Mythology in Byzantine Art* (1951).

The earliest manuscript in the present publication is the tenth-century Joshua Rotulus, which raised special problems with regard to the layout of a picture cycle in the form of a rotulus. In a special monograph, *The Joshua Roll: A Work of the Macedonian Renaissance* (1948), intended to be just another preparatory study for the Octateuch publication, I put forward the opinion that the Rotulus scenes were just a selection of pictures lifted from an Octateuch, and that the Rotulus itself was the creation of the Macedonian Renaissance of the tenth century, and that the Octateuch shared many features with the well-known

of photographs taken (2019) by the expedition. Besides the manuscripts of the Old and New Testaments, Friend's list includes musical manuscripts, manuscripts of Gregory of Nazianzos, John of Damascus, and John Kli-

max, as well as manuscripts of the Greek liturgy and medical, botanical, and geographical writings, enamels, metalwork, sculpture, etc.]

Psalter Paris gr. 139, both of which were quite likely products of the same imperial workshop.

After publishing my 1952 article "Die illustration der Septuaginta" (English translation published in 1971 in *Studies in Classical and Byzantine Manuscript Illumination*), in which I discussed the problem of the illustration of the Octateuchs in the context of the illustration of all the books of the Septuagint, and after having written complete descriptions of all the miniatures in the six preserved manuscripts of the Octateuchs, I halted work on their publication in the late 1950s, for two reasons, one external and one internal.[5] In 1956 I had started the expeditions to St. Catherine's Monastery at Mount Sinai and for years to come I concentrated all my energies on that project, publishing the mosaic, the icons, and the illustrated manuscripts. The internal reason had to do with the plan of the corpus, which was decided upon before my arrival in Princeton in 1935, and according to which the first volume was to be the Octateuchs. However, the two earlier illustrated Septuagint manuscripts, the Vienna Genesis and the Cotton Genesis, were not to be included. This was understandable in the case of the Vienna Genesis, which had been published several times in facsimile and had been extensively studied. The Cotton Genesis, however, had never been treated in a monograph. Though only scarred fragments of it now exist, a collation had been made before the fire in 1731, and on this basis I undertook the task of creating a page-by-page reconstruction so that one could get an idea of the full cycle of more than 350 miniatures. Only part of the miniatures could be reconstructed on the basis of the fragments, but the thirteenth-century mosaics in the narthex of San Marco in Venice and copies in later manuscripts aided the reconstruction. The method of this reconstruction was laid out in my article "Observations on the Cotton Genesis Fragments," and after many years of repeated study of the original fragments the final publication appeared in 1986 as volume one of the corpus of illustrated Septuagint manuscripts. By that time, because of my advanced age, I could not finish the task without the help of a collaborator, Professor Herbert L. Kessler.

When a few years ago I finally took up my work on the Octateuchs once again, I realized that I could bring it to completion only with the assistance of a collaborator. After successful collaborations with two of my pupils—with Herbert Kessler on the Cotton Genesis and with George Galavaris on the Sinai manuscripts—I engaged a third pupil of mine, Gary Vikan, to collaborate on the Octateuchs. He had edited the catalogue of the exhibition of Byzantine manuscripts, *Illuminated Greek Manuscripts from American Collections*, which was held in my honor in 1971 by The Art Museum of Princeton University, and had proved himself qualified for a collaborative task. He accepted my offer and began work, but made little progress because his energy was diverted in other directions. The complex work on the Octateuchs, however, required someone with a full commitment to

this one task. Luckily, I found a scholar who was both very competent to do this project and willing to devote his full time to the task of completing it: Massimo Bernabò of the Università di Firenze. Some years ago he had published an Italian translation of my *Illustrations in Roll and Codex* (a reprint of which has recently appeared) a task that had thoroughly acquainted him with my approach. Moreover, he had independently written a few studies on the Octateuchs and, even more important, was willing to take on the task of bringing my descriptions of the miniatures up to date and writing most of the introductory chapters. In a second preface, he will say in his own words what he has done to bring this long delayed publication to a successful conclusion.

For me there remains only one more obligation: to thank those persons and institutions to whom I owe my gratitude for assistance in manifold ways. The first person I must mention is the late Professor Hans Lietzmann of the University of Berlin, who awakened my interest in the Octateuchs and promised me their publication had I stayed in Germany. In Princeton, my deep gratitude goes to the late Professor Charles Rufus Morey, who had originally planned to write the Octateuch volume and then turned it over to me, and to Albert Mathias Friend Jr., who was the *spiritus rector* of the whole enterprise of publishing the illustrated manuscripts of the Septuagint. He managed to get the necessary funds from the Princeton Department of Art and Archaeology to enable me to make the necessary trips to Europe. In the Vatican Library, the prefect Eugène Cardinal Tisserant took a lively interest in my work and kindly gave me permission to work in the library even in the afternoons when it was officially closed. Many sincere thanks go also to the librarians of the Biblioteca Laurenziana in Florence, to the Turkish authorities who enabled me to work in the Seraglio Library in Istanbul, and to the abbot of the Vatopedi Monastery on Mount Athos, whose hospitality I enjoyed during my repeated trips to the Holy Mountain without limitation of time.

Although I spent several decades working on this project, it never would have been completed were it not for the willingness of Professor Massimo Bernabò to pick up the work where I stopped. My thanks are also extended to his wife, Dr. Rita Tarasconi, who collaborated with us and assisted us in many ways. Furthermore, I wish to extend my gratitude to my secretaries, Margaret Rogers Broadwater and Lynda Emery, who not only typed the manuscripts, but also improved them. Last but not least, I wish to thank my wife, Josepha Weitzmann-Fiedler, who during our sixty years of marriage steadily encouraged me in my work and assisted me in countless ways.

Princeton, New Jersey K. W.
November 1991

[5] [On 16 September 1959, Weitzmann wrote to Robert Oppenheimer, the acting director of the Institute for Advanced Study, that "the text of my particular volume on the Octateuchs is almost ready, but for many years I have not found the time to write the introductory chapters since whatever time I could spend on this project has been devoted to the broader issues of the illustration of the Septuagint." On 27 October of that year, Oppenheimer wrote to Weitzmann that the Institute would grant him a yearly fund for a research assistant.]

IN THE FALL of 1988, the Società di Storia della Miniatura Italiana held its third congress in Cortona. Entitled "Il codice miniato: Rapporti tra codice, testo e figurazione," the congress was dedicated to Kurt Weitzmann. Because of his age, Weitzmann declined the invitation to participate and suggested that Herbert Kessler, who was in Rome at the time, give the inaugural lecture in his stead. From then on, through many challenging difficulties, Kessler played the prominent role of discreet *regista*; the publication of the present book owes a great deal to his efforts.

In January 1989, my wife, Dr. Rita Tarasconi, and I visited Professor Weitzmann and his wife, Dr. Josepha Weitzmann-Fiedler, in Sonn-Matt, near Lucerne. The following spring, Weitzmann formally asked me to join him in the project of publishing the Byzantine illuminated Octateuchs. That fall we met in Princeton, and he gave me a draft of the descriptions of the miniatures in the Octateuchs which he had written during the 1930s, 1940s, and 1950s as the first contribution to this project. The draft also contained transcriptions of all of the Greek inscriptions in the miniatures. Revising these descriptions was one of the most demanding tasks before me because of the great number of scholars who had reexamined the Octateuchs in the intervening years; but searching for the sources of the extrabiblical details in the miniatures demanded a similar effort on account of the vast material from pseudepigraphical and Early Christian literature published in the last several decades. It soon became clear that more energy was necessary to bring the project to completion in reasonable time. Thus, Rita Tarasconi was engaged as an assistant in the work.

Financial support from the Dumbarton Oaks Center for Byzantine Studies and a generous grant from the Getty Grant Program made possible my profitable sojourns in Istanbul, Rome, and the Vatopedi Monastery on Mount Athos, allowing me the time to prepare codicological and stylistic descriptions of each Octateuch. In the case of the Laurentian Octateuch, I merely had to check a few minor points, since it had been the subject of my thesis at the Università di Firenze.

The descriptions of the miniatures in chapter 1 were discussed extensively with Weitzmann as they reached preliminary stages of completion. At the time of his death on 7 June 1993, Weitzmann was familiar only with my outlines for chapter 3 and for the codicological and stylistic examination of the manuscripts in chapter 4. Chapters 2 and 3 were originally planned as general introductions reflecting the points of view of the authors of the book. The incomplete state of these sections of the book at the time of Weitzmann's death explains the occasional lack of homogeneity in our two texts. Moreover, the references in Weitzmann's text could not be updated. The history of the study of Octateuch illustration as Weitzmann wrote it for the present book has the value of a historical document left by a prominent scholar of an earlier generation to future research.

With characteristic honesty, Weitzmann always encouraged me to carry on my own lines of research, even when my assumptions challenged his theses; the differences in our contributions, which the reader may encounter in the interpretation both of the iconography of single miniatures and of general phenomena such as the origin of the pictorial cycle and the influence of Jewish writings on it, bear witness to this encouragement. I have always revered Weitzmann as one of the greatest art historians of our time. The methodology I have adopted derives from his *Illustrations in Roll and Codex*, which I translated into Italian in 1972 and which circulated in draft form to the students of the Università di Firenze, encouraged by my professor Professor Maria Grazia Ciardi Dupré Dal Poggetto. Ten years later, in 1983, the first printed edition appeared; it was revised and republished in 1985 and 1991. The iconographical collation of the miniatures of the Octateuchs and the search for their pictorial and literary sources owe a great deal to *Illustrations in Roll and Codex*.

Many people contributed to the preparation of my part of this publication. Father Ephrem, hegumen of the Vatopedi Monastery; Father Lazaros, the librarian; and Fathers Irodotos, Arsenios, and Socrates welcomed me with the greatest kindness and made my stay there serene and fruitful, permitting me to study in their workrooms and cells. Professor Sotiris Kadas of the Byzantine Institute of the University of Thessaloniki helped arrange my sojourn in Vatopedi. Dr. Ahmet Mentes, director of the Topkapı Sarayı Museum in Istanbul, Professor Paul Canart, and Father Leonard Boyle, prefect of the Biblioteca Apostolica Vaticana, and Dr. Anna Lenzuni, director of the Biblioteca Medicea Laurenziana, kindly allowed me to study the Octateuchs preserved in their libraries. Dr. Josepha Weitzmann-Fiedler assisted us in many ways during the five-year enterprise. Dr. Ilse Girona, of the Università di Firenze, revised the English text of my drafts. Dr. Monica Pini, of the Catholic University of Louvain, procured rare bibliographical items I had been unable to find elsewhere. To Professor James H. Charlesworth, of the Princeton Theological Seminary, I owe stimulating ideas on the relationship between pseudepigrapha and miniatures. Professor Sebastian Brock, of the Oriental Institute, Oxford University, kindly resolved my doubts on Syriac writings. Professor Giles Constable, of the Institute for Advanced Study in Princeton, made accessible to me Weitzmann's files in the archive of the Institute. Marion White, formerly the department manager of the Department of Art and Archaeology at Princeton University, was one of the most steadfast supporters of the project, resolving innumerable financial problems. Dr. Christopher Moss worked on this book in the capacity of both managing editor and editor. He edited and improved the text with total commitment and a passion for excellence; we are especially indebted to him for references to modern literature on classical monuments. The index was made by Barbara E. Cohen.

Florence, Italy, M. B.
September 1994

ABBREVIATIONS

A. MANUSCRIPTS

Laurent.	Florence, Biblioteca Medicea Laurenziana, cod. plut. 5.38, Octateuch
Ser.	Istanbul, Topkapı Sarayı Library, cod. G. I. 8, Octateuch
Sm.	Smyrna, Evangelical School Library, cod. A.1, Octateuch
Vat. 746	Rome, Biblioteca Apostolica Vaticana, cod. Vat. gr. 746, Octateuch
Vat. 747	Rome, Biblioteca Apostolica Vaticana, cod. Vat. gr. 747, Octateuch
Vat. Rot.	Rome, Biblioteca Apostolica Vaticana, cod. Palat. gr. 431, Joshua Rotulus
Vtp.	Athos, Vatopedi Monastery, cod. 602, Octateuch

B. BOOKS OF THE BIBLE AND ANCIENT LITERATURE

AdvHaer	Epiphanios, *Adversus haereses* (*Panarion*)	Jn	John
Ant	Josephus, *Antiquitates Judaicae*	Josh	Joshua
ApMos	Apocalypse of Moses (Life of Adam and Eve)	Jub	Jubilees
Bar	Baruch	Judg	Judges
BelJud	Josephus, *Bellum Judaicum*	Kgs	Kings
CAE	The Conflict of Adam and Eve with Satan	LetAris	Letter of Aristeas (*Aristeae epistula*)
CavTr	The Cave of Treasures	Lev	Leviticus
Col	Colossians	*LAB*	Pseudo-Philo, *Liber antiquitatum biblicarum*
CommEx	*Commentarii in Exodum*	LXX	Septuagint
CommGen	*Commentarii in Genesim*	Macc	Maccabees
CommNum	*Commentarii in Numeros*	Mk	Mark
Cor	Corinthians	Mt	Matthew
Dan	Daniel	Num	Numbers
Dem	Aphrahat, *Demonstrationes*	NumR	Numbers Rabbah (Bemidbar Rabbah)
Deut	Deuteronomy	PRE	Pirkê de-Rabbi Eliezer
Eccl	Ecclesiastes	Ps	Psalms
EcclR	Ecclesiastes Rabbah (Qohelet Rabbah)	*QuaestEx*	Theodoret, *Quaestiones in Exodum*
EpBar	Epistle of Barnabas	*QuaestGen*	Theodoret, *Quaestiones in Genesim*
Ex	Exodus	*QuaestJos*	Theodoret, *Quaestiones in Josuam*
ExR	Exodus Rabbah (Šemot Rabbah)	*QuaestJud*	Theodoret, *Quaestiones in Judices*
Ezek	Ezekiel	*QuaestNum*	Theodoret, *Quaestiones in Numeros*
Gal	Galatians	*QuaestPs*	Theodoret, *Quaestiones in Psalmos*
Gen	Genesis	Rev	Revelation
GenR	Genesis Rabbah (Bere'šit Rabbah)	Rom	Romans
Heb	Hebrews	TargN	Targum Neophyti
Hex	*Hexaemeron*	TargOnk	Targum Onkelos
HistEccl	*Historia ecclesiastica*	TargPs-J	Targum Pseudo-Jonathan
HomEx	*Homiliae in Exodum*	Tim	Timothy
HomGen	*In Genesim homiliae*	TJos	Testament of Joseph
HomMt	*In Matthaeum homiliae*	*Vita*	*Vita Adae et Evae*
Isa	Isaiah	Zech	Zechariah
Jer	Jeremiah		

EDITORIAL NOTE

THE GREEK TEXT of the Septuagint is taken from *Septuaginta*, ed. Alfred Rahlfs, 2d ed. (Stuttgart: Deutsche Bibelgesellschaft, 1979). The English translations are those of *The Septuagint with Apocrypha: Greek and English*, ed. Lancelot C. L. Brenton (Peabody, Mass.: Hendrickson, 1986), reprint of *The Septuagint Version of the Old Testament and Apocrypha*, ed. Lancelot C. L. Brenton (London: Bagster and Sons, 1851). For biblical proper names the more familiar forms of the King James Version are used. The numbering of Old Testament passages is that of the Septuagint. The English text of the Peshitta is from *The Holy Bible from Ancient Eastern Manuscripts Containing the Old and New Testaments, Translated from the Peshitta, the Authorized Bible of the Church of the East*, ed. George M. Lamsa, 22d ed. (Nashville: Holman Bible Publishers, 1981). Greek names are for the most part given in strict transliteration, except in cases where an anglicized or latinized form is more familiar. For pseudepigraphic texts we have similarly used Latin titles except for works which are more commonly cited in English.

VOLUME II

OCTATEUCH

INTRODUCTION

SIX ILLUMINATED Byzantine manuscripts of the Octateuch are known, all from the post-iconoclastic period: cod. plut. 5.38 in the Laurentian Library in Florence, from the first half of the eleventh century (hereafter Laurent.); cod. gr. 747 in the Vatican Library from ca. 1070–80 (hereafter Vat. 747); three manuscripts dating from ca. 1150, namely cod. 8 in the Seraglio Library in Istanbul (hereafter Ser.), cod. A.1 once in the Evangelical School Library in Smyrna, but lost in a fire during the Greco-Turkish war in 1922 (hereafter Sm.), and cod. gr. 746 in the Vatican Library (hereafter Vat. 746); and cod. 602 in the Library of the Vatopedi Monastery on Mount Athos, dating from the last decades of the thirteenth century (hereafter Vtp.), a codex of which only the volume containing the books Leviticus to Ruth is preserved.[1]

The manuscripts parallel one another in basic contents (the eight biblical books from Genesis to Ruth in the Greek translation of the Septuagint, accompanied by a catena of commentaries excerpted from the Fathers and two prefaces, one to the catena, one to the Scriptures), format, and cycle of miniatures. The number of miniatures is indubitably high in these manuscripts: for example, Vat. 747 has 367 miniatures, but each miniature may contain several scenes, so that the total number of biblical scenes illustrated exceeds 500: 7 scenes for the Letter of Aristeas, 2 for Theodoret's prologue, approximately 230 for Genesis, 80 for Exodus, 14 for Leviticus, 42 for Numbers, 19 for Deuteronomy, 67 for Joshua, 50 for Judges, and 2 for Ruth. Laurent. is the exception: it has neither a catena nor prefatory writings, and its picture cycle ends with the depiction of Adam and Eve mourning after the Expulsion.

The correspondences among the Octateuchs suggest that all their cycles are witnesses of the same pictorial recension. When this recension originated and how the extant Octateuchs might be placed in a genealogical tree are questions to which scholars have given different answers. Many features indicate that Ser., Sm., and Vat. 746 depend on the same (lost) manuscript of the recension, that Vtp. is certainly a copy of Vat. 746, and that Vat. 747 is the only surviving representative of a different branch of the genealogical tree. But other manuscripts whose miniatures

are connected with the Octateuch recension strongly indicate that the Octateuch cycle existed before the eleventh century, the period in which the oldest Octateuchs, Vat. 747 and Laurent., were produced. These are the tenth-century Joshua Rotulus in the Vatican Library (cod. Palat. gr. 431) and the three extant illustrated copies of the *Christian Topography* (Χριστιανικὴ τοπογραφία) of Kosmas Indikopleustes, the oldest being cod. gr. 699 in the Vatican Library, from the ninth century; the other two copies, one in Florence (Bibl. Laur., cod. plut. 9.28) and one in the Monastery of St. Catherine at Mount Sinai (cod. 1186), date from the eleventh century.

The study of the Octateuchs began in the nineteenth century.[2] The neoclassical appreciation of the classically fashioned scenes in the Joshua Rotulus—which is attested by Winckelmann's mention of personifications in the Rotulus in 1766[3]—led Jean Baptiste Seroux d'Agincourt to reproduce the complete set of its pictures as tiny engravings in 1823.[4] The French scholar also published a plate with details taken from the miniatures of Vat. 746 (which he considered to be a fourteenth-century manuscript), thus acquainting scholars with this Octateuch for the first time.[5] In 1876, Raffaele Garrucci published a complete reproduction of the scenes in the Rotulus in a set of twenty-three high-quality engravings. In the middle of the century, Ferdinand Piper focused on the iconographic features in the miniatures of Vat. 746 that were not connected with the biblical text. He noted the bizarre representation of the serpent mounting a camel while it tempts Eve (figs. 86, 98)—a feature which twentieth-century scholars have considered more extensively—but, unaware of extrabiblical literature, he attributed the representation to the impact of Christian exegetes on the cycle.[6]

Near the end of the century, research on the Octateuchs flourished. In 1876, the Russian scholar Nikodim Kondakov introduced Vat. 747 in his *Istoriia vizantiiskogo iskusstva*[7] (published in French in 1886 as *Histoire de l'art byzantine*)[8] and in 1888 the Finnish scholar Johan Jakob Tikkanen used the Vatican and Laurentian Octateuchs as comparative material in his study of the connections between the miniatures in the Cotton Genesis and the Genesis mosaics in the atrium of San Marco in Venice.[9] In

[1] The following Octateuchs have only ornamental bands at the titles: Florence, Bibl. Laur., cod. Acquisti e Doni 44 (*Catenae Graecae*, vol. 1, *Catena Sinaitica*, ed. Petit, pp. lxxxvii ff.), a manuscript of the eleventh–twelfth century containing the catena on the Pentateuch with the addition of the books Joshua to Ruth; Munich, Bayerische Staatsbibliothek, cod. gr. 9 (*olim* 275; *Catenae Graecae*, vol. 2, *Collectio Coisliniana*, ed. Petit, pp. xxv–xxviii). Paris, Bibl. Nat., cod. gr. 128 (fol. 94v), and its copy, London, Brit. Lib., cod. Burney 34 (fol. 35r), have a drawing of Noah's ark and ornamental bands (ibid., pp. lxxxi, lxxxiii). Basel, Universitätsbibliothek, cod. I (*olim* A. N. III 13; *Catenae Graecae*, vol. 1, *Catena Sinaitica*, ed. Petit, pp. xxvi ff.), a catena on Genesis and Exodus connected with the manuscripts listed above, also has ornamental bands.

[2] The history of the study of the illustrated manuscripts of the Septuagint has recently been discussed by Bernabò, "Studio," pp. 261–99.

[3] J. Winckelmann, *Versuch einer Allegorie, besonders für die Kunst* (Dresden, 1766; repr.: New York and London, 1976), p. 79. For the history of the Rotulus, see *J.-R.*, pp. 85–86 and the literature cited on pp. 87–89.

[4] Seroux D'Agincourt, *Histoire*, vol. 5, pls. 28–30. Jules Labarte's mention of the Joshua Rotulus in his 1864 history of industrial arts (Labarte, *Histoire*, vol. 3, pp. 27–28) depends on Seroux d'Agincourt.

[5] Seroux D'Agincourt, *Histoire*, vol. 5, pl. 62 (reproduced as the frontispiece of the present volume).

[6] Piper, "Bilderkreis," pp. 187–89; Piper, "Denkmäler," p. 478.

[7] N. P. Kondakov, *Istoriia vizantiiskago iskusstva i ikonografii po miniatiuram' grecheskikh rukopisei* (Odessa, 1876).

[8] Idem, *Histoire de l'art byzantin considéré principalement dans les miniatures*, 2 vols. (Paris, 1886 and 1891).

[9] Tikkanen, "Genesi," pp. 212–23, 257–67, 348–63.

1898, Hans Graeven examined the relationship between the Joshua Rotulus and the Vatican Octateuchs.[10] In the following year, the Austrian Byzantinist Josef Strzygowski published his extraordinary study on the then-extant Smyrna codex,[11] including a selection of photographs of sixteen miniatures from the codex and a comparative analysis of the Joshua Rotulus and the other Octateuchs. In 1900–1901, Dimitri Ainalov employed the two Vatican manuscripts in his analysis of the origins of Byzantine art;[12] and in 1916 another Russian scholar, Egor Redin, first introduced the miniatures in the Kosmas manuscripts into the discussion of the Octateuchs.[13]

At the beginning of the twentieth century a new reproduction of the Joshua Rotulus was published by the Vatican Library.[14] The most important advance in the research on the Octateuchs, however, was the nearly complete reproduction of the cycles of miniatures in the Seraglio and Smyrna codices. In 1907, Fedor Uspenskii, the celebrated scholar and director of the Russian Archaeological Institute in Istanbul, published the Octateuch cycle in Ser., along with comparable material from Sm. and Vtp.,[15] and in 1909, Dirk Hesseling reproduced a more comprehensive set of the miniatures in Sm., but with a disappointingly short introduction. It is not known, however, whether the plates printed from the negatives of Sm. that Robert Eisler delivered to Hesseling covered all of the miniatures then extant in the codex.[16] The number of reproductions published from the Octateuch miniatures, as well as direct study of the manuscripts,[17] allowed the Italian art historian Antonio Muñoz to draw, in 1924, the first stemma of the pictorial recension of the Octateuchs and the Joshua Rotulus.[18] Muñoz argued for the existence of an archetypal illustrated biblical roll dating from the fourth century, with the Joshua Rotulus and a second roll, also illustrated and which served as a model for both Vat. 747 and Laurent., being descendants of this archetypal roll:

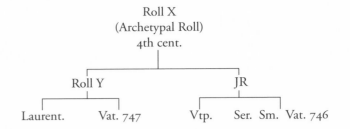

This was the state of Byzantine Octateuch studies in the 1920s, when the present book was first planned, conceived as the second volume of a series entitled "The Illustrations in the Manuscripts of the Septuagint," sponsored by the Department of Art and Archaeology of Princeton University.[19] The project, however, was still to go through a number of lengthy stages before its completion. As Weitzmann himself recounts in his preface to the present book, in April 1934 he was invited by Charles Rufus Morey to join Princeton University in the enterprise and to work on the Octateuchs.[20] Weitzmann and Morey first had to arrange for the restoration of the Seraglio Octateuch at Princeton's expense and, as part of this arrangement, received permission to photograph, study, and publish the manuscript. Weitzmann then established the methodological grounds on which to approach the illustration of medieval texts in *Illustrations in Roll and Codex: A Study of the Origin and Method of Text Illustration*, which came out in 1947.[21] He next treated the related question of the origin and date of the Joshua Rotulus in a monograph that appeared in 1948,[22] in which he proposed that the Rotulus was an original product of the "Macedonian Renaissance"—a concept Weitzmann himself had established in the historiography of Byzantine art[23]—and was based on an Octateuch cycle of the story of Joshua very similar to that in Vat. 747. In his book on the Vatican Rotulus, Weitzmann also vigorously demonstrated, arguing

[10] Graeven, "Rotulo," pp. 221–30.

[11] J. Strzygowski, "Der illustrierte Oktateuch in Smyrna," appendix to Strzygowski, *Sm.*, pp. 113–26.

[12] D. V. Ainalov, "Ellinisticheskie osnovy vizantiiskogo iskusstva," *Zapiski Imperatorskago Russkago Arkheologicheskago Obshchestva*, n.s., 12, *Trudy Otdeleniia arkheologii drevne-klassicheskoi, vizantiiskoi i zapadno-evropeiskoi* 5 (1900–1901) (Eng. transl. published as Ainalov, *Hellenistic Origins*).

[13] E. Redin, *Khristianskaia Topografiia Koz'my Indikoplova po grecheskim i russkim spiskam* (Moscow, 1916).

[14] *Il Rotulo di Giosué* [ed. P. Franchi de' Cavalieri] (Milan, 1905).

[15] F. Uspenskii, *Konstantinopolskii Seral'skii kodeks Vos'mikniziia (L'Octateuque de la Bibliothèque du Sérail à Constantinople)* (*IRAIK* 12) (Sofia, 1907); *Al'bom* (Munich, 1907).

[16] D. C. Hesseling, *Miniatures de l'Octateuque grec de Smyrne: Manuscrit de l'École Évangélique de Smyrne* (Leiden, 1909). For the question of whether Hesseling reproduced all of the miniatures extant in the codex in his time, see p. 338 below.

[17] A. Muñoz, "Nella Biblioteca del Serraglio a Costantinopoli," *Nuova antologia* 130 (1907), pp. 314–20.

[18] Muñoz, "Rotulo," stemma on p. 482.

[19] The project may well have been formally launched on 25 October 1925, the day on which Morey addressed a letter to Mgr. Giovanni Mercati, prefect of the Vatican Library, asking for his collaboration. Morey's original idea involved the "publication of miniatures in manuscripts dating from the earliest periods of manuscript illumination to the year 1200." The letter, now part of the Morey archives, is preserved in the Seeley G. Mudd Library of Princeton University. For the history of the project, see K.

Weitzmann, "Byzantine Art and Scholarship in America," *AJA* 51 (1947), pp. 410–13; Weitzmann's preface to Weitzmann and Kessler, *Cotton Gen.*, p. ix; and Weitzmann's survey in *Byzantium at Princeton*, pp. 16ff. The institutions which originally joined with Morey's department at Princeton in the project were The Pierpont Morgan Library in New York, Harvard University in Cambridge, and the École des Hautes Études in Paris. Gabriel Millet of the École des Hautes Études was invited to participate as the expert on Byzantine art.

[20] This letter, dated 11 April 1934, is also in the Mudd Library in Princeton. In 1935, as may be deduced from another letter, also in the Mudd Library, which Morey sent to Mgr. Eugène Tisserant, the proprefect of the Vatican Library, the following scholars had been engaged for the project: Harold R. Willoughby of the University of Chicago, responsible for New Testament illustrations, Albert M. Friend Jr. of Princeton for portraits of the evangelists, Ernest T. De Wald of Princeton for Old Testament illustrations, and Weitzmann for the Octateuchs.

[21] He specifically applied his method to the codices of the Septuagint in a lecture given that same year for the celebration of Princeton University's bicentennial. The lecture was published in 1953 in German with the title "Die Illustration der Septuaginta" (*MünchJb* 3–4 [1952–53], pp. 96–120); an English translation appeared in 1971 (Weitzmann, "Septuagint").

[22] K. Weitzmann, *The Joshua Roll: A Work of the Macedonian Renaissance* (Princeton, 1948).

[23] Weitzmann was not the true author of the concept of a renaissance of classical art at the time of the Macedonian dynasty in Byzantium, but its affirmation can indisputably be attributed to his writings; see, e.g., Weitzmann, "Character."

against previous scholars, that the version of the cycle preserved in Vat. 747 is by far the best copy of the archetype of the pictorial recension[24] and suggested a stemma of the Octateuch cycle which has been generally accepted:[25]

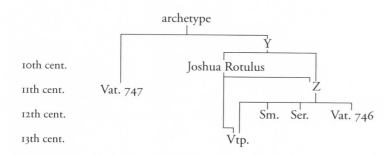

As the project was getting under way, the biblical paintings in the synagogue at Dura Europos were discovered, and their presumed iconographic similarities with medieval art encouraged scholars to explore Early Christian art in search of testimony on lost Jewish figurative models. The connections between the Octateuchs and the Dura paintings were first examined by Weitzmann in 1964,[26] and, more exhaustively, in a monograph of 1990.[27] A number of reappraisals of the paintings and of the Jewish sources of Christian art have appeared since the discovery of the Dura synagogue.[28] In recent years a collection of lectures on the topic delivered at a congress held in Vienna in 1990 has appeared,[29] Rainer Stichel has reviewed the earlier literature and added new material,[30] while Joseph Gutmann[31] and Kurt Schubert[32] have examined the attitudes of Jewish rabbis toward idolatry and reevaluated Jewish traditions in Christian art.

The complete set of miniatures in the Laurentian Octateuch was published in 1978.[33] Recently, the little-known miniatures in Vtp. were also reproduced in two separate publications: in 1973

by Paul Huber[34] and in 1991, in color plates, in the series *The Treasures of Mount Athos*.[35] In 1983, a luxurious facsimile of the Joshua Rotulus edited by Otto Mazal appeared.[36]

In recent decades, research on the Octateuchs has been twofold. On one hand, scholars have associated a growing list of works of art with the Octateuchs, and these works in turn have seemed to point to the existence of a lost Octateuch cycle, possibly composed in the Early Christian or the Middle Byzantine period, and richer than the extant manuscripts in terms of the number of illustrations it contained. The works of art connected with the Octateuchs embrace a multitude of medieval picture cycles, sections of cycles, and single pictures. Even a cursory account of the connections that have been proposed would greatly widen the scope of this study, which is essentially founded on a comparison of the miniatures in the Octateuchs and the search for their sources. Some of these other cycles will be considered here and there in this book and specific references to them will be found in the bibliographies appended to the description of single scenes in chapter 1. It should nevertheless be kept in mind that quite a disparate collection of works has been compared with the Octateuchs,[37] including: the mosaic pavement with Samson scenes at Misis/Mopsuestia (Cilicia),[38] the Bible of Leo Sakellarios (Rome, Bibl. Vat., cod. Reg. gr. 1),[39] the so-called aristocratic Psalters,[40] the Gregory of Nazianzos codex in the Panteleimon Monastery on Mount Athos (cod. 6),[41] the Gregory of Nazianzos codex in the library of the Greek Patriarchate in Jerusalem (cod. Taphou 14),[42] the homiletic manuscript in the Esphigmenou Monastery on Mount Athos (cod. 14),[43] the paintings of the Via Latina catacomb,[44] the frescoes in San Paolo fuori le mura[45] and Santa Maria Antiqua in Rome,[46] the Carolingian Bible in San Paolo fuori le mura,[47] the paintings in Sant'Angelo in Formis,[48] the mosaics in Monreale and Palermo,[49] the Arsenal Bible (Paris, Bibliothèque de l'Arsenal, cod. 5211),[50] the

[24] Weitzmann, *JR*, pp. 31–38, esp. pp. 32–33. But see Lowden, *Octs.*, pp. 74ff.

[25] Weitzmann, *JR*, p. 38; and Weitzmann, "Oct. Ser.," pp. 183–86.

[26] "Zur Frage des Einflusses jüdischer Bilderquellen auf die Illustration des Alten Testamentes," in *Mullus: Festschrift Theodor Klauser* (*JbAChr* Ergänzungsband 1, 1964), pp. 401–15; translated and republished as Weitzmann, "Jewish Sources."

[27] K. Weitzmann and H. Kessler, *The Frescoes of the Dura Synagogue and Christian Art* (DOS 28) (Washington, D.C., 1990).

[28] See especially the essays collected in *No Graven Images* and *The Dura-Europos Synagogue: A Re-evaluation (1932–1972)*, ed. J. Gutmann (Missoula, Mont., 1973).

[29] The contributions appeared in *Kairos*, n.s., 32–33 (1990–91).

[30] Stichel, "Illustration," pp. 93–111.

[31] J. Gutmann, *The Dura Europos Synagogue (1932–1992)* (Atlanta, 1992).

[32] K. Schubert, "Jewish Pictorial Traditions in Early Christian Art," in H. Schreckenberg and K. Schubert, *Jewish Historiography and Iconography in Early Christian and Medieval Christianity* (Assen/Maastricht and Minneapolis, 1992), pp. 141–260.

[33] Bernabò, "Laur. plut. 5.38," pp. 135–57.

[34] P. Huber, *Bild und Botschaft: Byzantinische Miniaturen zum Alten und Neuen Testament* (Zurich, 1973).

[35] Οἱ Θησαυροὶ τοῦ Ἁγίου Ὄρους, vol. 1, Ἐικονογραφημένα χειρόγραφα, pt. 4, Μ. Βατοπεδίου, Μ. Ζωγράφου, Μ. Σταυρονικήτα, Μ. Ξενοφῶντος, ed. P. K. Christou, S. N. Kadas, and A. Kalamartze-Katsaros (Athens, 1991).

[36] *Josua-Rolle: Vollständige Faksimile-Ausgabe im Originalformat des Codex Vaticanus Palatinus Graecus 431 der Biblioteca Apostolica Vaticana: Kommentar*, ed. O. Mazal (Graz, 1983).

[37] A list of cycles related to the Octateuchs is also given by Kötzsche-Breitenbruch, *Via Latina*, p. 29.

[38] Kitzinger, "Samson Floor," pp. 133–44.

[39] Mathews, "Leo Sacellarios," pp. 94–134, esp. pp. 111ff. and passim; and, more recently, P. Canart and S. Dufrenne, "Le Vaticanus Reginensis graecus 1 ou la province à Constantinople," in *Scritture, libri e testi nelle aree provinciali di Bisanzio: Atti del seminario di Erice (18–25 September 1988)*, ed. G. Cavallo, G. De Gregorio, and M. Maniaci (Spoleto, 1991), vol. 2, pp. 631–36.

[40] Weitzmann, "Ps. Vatopedi"; A. Cutler, *The Aristocratic Psalter in Byzantium* (Paris, 1984).

[41] Galavaris, *Gregory Naz.*, pp. 134ff.

[42] Avner, "Septuagint Illustrations," pp. 297–317.

[43] Ibid.

[44] Kötzsche-Breitenbruch, *Via Latina*, pp. 104–5.

[45] Al-Hamdani, "Sources," pp. 14, 17.

[46] Vileisis, "S. Maria Ant.," p. 146.

[47] Gaehde, "Octateuch," pp. 381–82.

[48] De' Maffei, "Sant'Angelo in Formis II," pp. 196–97 notes 6–13, 210ff.

[49] Demus, *Norman Sicily*, pp. 253–55.

[50] Buchthal, *Latin Kingdom*, pp. 60ff.

Hamilton Psalter in Berlin (Kupferstichkabinett, cod. 78.A.9),[51] the Bible of San Isidoro of 960 in León (cod. 2),[52] the Pamplona Bibles (Amiens, Bibliothèque Communale, cod. lat. 108, and Harburg, Oettingen-Wallerstein Collection, cod. 1.2, lat. 4°, 15),[53] the Farfa or Ripoll Bible (Rome, Bibl. Vat., cod. lat. 5729),[54] the Millstatt Genesis (Klagenfurt, Kärtner Landesarchiv, cod. 6/19),[55] the Old Testament in the Pierpont Morgan Library (cod. M. 638),[56] and the Golden Haggadah in the British Library in London (cod. Add. 27210).[57]

On the other hand, new approaches that have emerged in the last decades have undermined the methodological construction and the history of the illustration of the Septuagint outlined by the earlier generation of Byzantinists. Contemporary research focuses on the achievements in Byzantium in the age after the crisis of the seventh and eighth centuries. Early Byzantine art has gone out of fashion, and the dating of an increasing number of Byzantine picture cycles has been moved from the Early to the Middle Byzantine period. The 1982 issue of *Dumbarton Oaks Papers* included two long contributions, by Jeffrey Anderson and John Lowden, that made rough the calm waters of the debate on the origin and later history of the miniature cycle, which had appeared settled in its major points. Anderson published the results of a stylistic and codicological examination of the Seraglio Octateuch. Challenging the argument put forward by Suzy Dufrenne[58] that three separate groups of painters executed the miniatures in the Seraglio manuscript, with painters of each group working on the same miniatures, Anderson connected the production of the Seraglio manuscript to the so-called Kokkinobaphos Master and two painters who preceded this master in the enterprise. Anderson also added new material to support the hypothesis that the patron of the Seraglio manuscript was Isaac Komnenos, a member of the family ruling Byzantium.[59] In this way Anderson tied the twelfth-century edition of the Octateuch to the highest patronage: a Byzantine painter who had been engaged by the imperial family for some of the most beautiful illustrated manuscripts of the period was thus seen as responsible for the execution of the twelfth-century version of the Octateuch cycle. He concluded that the model of Ser., Sm., and Vat. 746 would have been executed around the middle of the eleventh century by the master who worked on the manuscript of pseudo-Oppian's *Cynegetica* now in Venice (Biblioteca Marciana, cod. gr. 479).

In the same issue of *Dumbarton Oaks Papers*, Lowden approached the Vatopedi Octateuch through a basically codicological perspective.[60] Lowden's article was the first of a series of contributions in which he strove both to contest sharply Weitzmann's approach to the Octateuchs and to draw up a new methodological framework for the history of book illumination. In 1992 Lowden reaffirmed his claims in a survey of all the Octateuchs and the Joshua Rotulus which is the most up-to-date and comprehensive study of these manuscripts.[61] In fact, Lowden's book is the most important contribution on the Octateuchs to have appeared in the last several decades. Lowden rejected many of Weitzmann's proposals: he reexamined the question of the origin of the Octateuch archetype and proposed that the archetype was created around 1050–75,[62] assumed the existence of a lost Octateuch from the same period, reconstructed the physical appearance of the lost Smyrna codex, challenged the originality of the Joshua Rotulus and its dependence on an Octateuch, and exhaustively demonstrated that Vtp. is a direct copy of Vat. 746.[63] Lowden,[64] following Otto Kresten,[65] also argued that the Joshua Rotulus was not an original creation of the "Macedonian Renaissance," but an amateur's facsimile (according to Kresten's definition) of a more ancient roll dating from the period of Herakleios. The Joshua cycle in Vat. 747 would then also descend from this roll, whereas the Joshua cycles in Ser., Sm., and Vat. 746 would descend from the Joshua Rotulus.

Before Lowden, Leslie Brubaker in 1976,[66] followed by Tamar Avner in 1980,[67] had advanced the idea that the Octateuch archetype originated in the Middle Byzantine period as a compilation from various sources. Pictures from a Psalter, the Joshua Rotulus, and perhaps an illustrated Genesis would have been incorporated into the newly created Octateuch cycle.[68] Examination of the iconography of the miniatures, however, proves that the material which must hark back to a date earlier than the eleventh century is much more extensive than these scholars claim.[69] The Octateuchs hand down in pictures biblical legends and readings that are otherwise unknown or misunderstood in Middle Byzantine pictorial and literary documents. Byzantine writings cannot be assumed to be the sources of the iconography of a considerable number of miniatures embracing the whole Pentateuch, from Adam and Eve to the disappearance of Moses. The amount of commentary material in these images is so overwhelming that it

[51] Havice, "Hamilton Ps.," pp. 266ff.; Havice, "Marginal Miniatures," pp. 271–72, 279, 307–8.

[52] Williams, "León Bible," pp. 59ff., 70ff., 79, 86, 158ff.

[53] Bucher, *Pamplona Bibles*, p. 99.

[54] Sherman, "Ripoll Bible."

[55] H. Menhardt, "Die Bilder der Millstätter Genesis und ihre Verwandten," in *Festschrift für Rudolf Egger: Beiträge zur älteren europäischen Kulturgeschichte* (Klagenfurt, 1954), vol. 3, pp. 248–371.

[56] Stahl, "Morgan M. 638," pp. 90, 97–99, 231, 240–41, and passim; Stahl, "Old Testament Ill.," pp. 79ff.

[57] Narkiss, *Golden Haggadah*, pp. 66ff.

[58] Dufrenne, "Oct. du Sérail," pp. 247–53.

[59] Anderson, "Seraglio," pp. 83–114; Anderson, "Two Centers," pp. 28–35.

[60] Lowden, "Vtp. Oct.," pp. 116–19; the same article also appeared in *XVI. Internationaler Byzantinisten Kongress, Akten*, vol. 2, pt. 4 (*JÖB* 32, no. 4 [1982]), pp. 197–201.

[61] Lowden, *Octs.*, pp. 105–19.

[62] Ibid., pp. 82–83.

[63] Ibid., pp. 38–42; see also Lowden, "Vtp. Oct.," pp. 116–19.

[64] Lowden, *Octs.*, pp. 117–18, with earlier bibliography.

[65] "Der Josua-Rotulus der Bibliotheca Apostolica Vaticana: Versuch einer neuen Interpretationen," unpublished paper given in Rome, January 1991; and id., "Oktateuch-Probleme: Bemerkungen zu einer Neuerscheinung," *BZ* 84–85 (1991–92), pp. 501–11. See also, by the same author, "Giosué, Rotulo di," in *Enciclopedia dell'arte medievale*, vol. 6 (Rome, 1995), pp. 643–45.

[66] Brubaker, "Reconsideration"; see also Brubaker, "Gregory of Naz.," pp. 374–76, 389–90. Brubaker reviewed Lowden's book in "Life Imitates Art," pp. 203–9.

[67] Avner, "Unknown Genesis Scene," pp. 21–22.

[68] Lowden, *Octs.*, p. 121. See also Brubaker, "Tabernacle Miniatures," pp. 90–92.

[69] For a critique of Brubaker's and Lowden's assumption, see Bernabò, "Studio," pp. 290ff.

transforms the cycle into a visual commentary on the Scriptures which runs down the pages flanking the textual commentary of the catena and is frequently independent from the comments contained in the catena itself.

The miniatures containing details that diverge from the biblical text depend on Early Christian writings and must have originated in that earlier period. Remarkable disagreements with Theodoret's interpretations of the biblical text are encountered in the iconography of the miniatures. (Theodoret's *Quaestiones in Octateuchum* is the main text included in the Octateuchs' catena.) In fact, Theodoret's positions are basically ignored in the miniatures, suggesting that the creation of the miniatures antedates the period around 460, the accepted date of composition of the *Quaestiones*.[70]

Some of the beliefs of contemporary scholars who have worked on the Octateuchs have grown out of a sort of prejudice toward Weitzmann's approaches. In fact, other recent investigations of the miniatures in the manuscripts of the *Christian Topography* of Kosmas have challenged Lowden's interpretation of the Octateuch miniatures that correspond to miniatures in Kosmas. Lowden sees the tabernacle miniatures and the related Creation miniatures in Ser., Sm., and Vat. 746 as dependent on an illustrated manuscript of the *Christian Topography;* he also claims that Vat. 747's rather different illustrations of the same subjects are imprecise copies of the same miniatures in the *Christian Topography*. But, in contrast to these statements, the scholars who have investigated these miniatures in the *Christian Topography*—Herbert Kessler,[71] Elisabeth Revel-Neher,[72] and Wanda Wolska-Conus[73]—have demonstrated that the miniatures in Vat. 747 and in the *Christian Topography* are independent reflections of a tradition, probably Jewish, which originated before the creation of Kosmas's treatise in the sixth century.[74]

When Photios argues against the cosmological fables of the *Christian Topography* in his ninth-century *Bibliotheca*,[75] he men-

tions Kosmas's treatise under the title of *Commentary on the Octateuch* (Χριστιανοῦ Βίβλος ἑρμηνεία εἰς τὴν Ὀκτάτευχον); a few pages on, he describes the *Paraphrasis of the Octateuch* (Μετάφρασις τῆς Ὀκτατεύχου) written by Eudokia, wife of the emperor Theodosios II,[76] Theodoret's commentary on the Octateuch (Ἐξηγήσεις εἰς τὴν Ὀκτάτευκον),[77] and Prokopios's catena on the Octateuch (Ἐξηγητικαὶ σχολαὶ εἴς τε τὴν Ὀκτάτευκον τῶν παλαιῶν γραμμάτων).[78] Photios amply acknowledges the authority of Prokopios's catena and quotes passages from the catena in his *Amphilochia*.[79] One should therefore infer that the collection of biblical books of the Octateuch was widespread in Byzantium during the ninth century, that is, at least two centuries before both of our oldest extant copies and the date proposed by Lowden for the creation of the Octateuch cycle. Moreover, the list of Septuagint manuscripts published by Alfred Rahlfs in 1914 includes more than eighty Octateuchs or catenae on the Octateuch, with examples from pre-iconoclastic times;[80] a fourth-century *Commentary on the Octateuch* by Eusebios of Emesa survives in an Armenian version.[81] Textual criticism has suggested that marginal catenae, like those in the Octateuchs, were written in manuscripts since the late fifth century[82] and the date of origin of the catena compilation must have been the beginning of the sixth century,[83] the same period when Prokopios of Gaza's *Commentary on the Octateuch* (Εἰς τὴν Ὀκτάτευχον ἐξηγήσεις)[84] was compiled.

The extent of the Octateuch cycle (more than 500 miniatures) is typical of Early Christian illustration of the Septuagint. Our best witnesses dating before the crisis of the seventh and eighth centuries, namely the Cotton Genesis and the Vienna Genesis, contain a comparably extended cycle of illustrations. The Octateuchs are not simple creatures.[85] Exploring the cycle as it stands today, we are faced with miniatures of different formats, miniatures with a compositional structure resembling monumental pictures flanking miniatures in the tradition of terse illustrations

[70] *Theodoreti Cyrensis Quaestiones in Octateuchum*, ed. N. Fernández Marcos and A. Sáenz-Badillos (Madrid, 1979), p. xii.

[71] Kessler, "Temple Veil," pp. 53–77.

[72] Revel-Neher, *Arche;* Revel-Neher, "Christian Topography."

[73] Wolska-Conus, "Topographie Chrétienne," pp. 155–91.

[74] For earlier literature on the *Christian Topography*, see Wolska-Conus, *Cosmas;* Mouriki-Charalambous, "Cosmas"; Brubaker, "Tabernacle Miniatures," pp. 73–92; L. Brubaker, "The Relationship of Text and Image in the Byzantine Manuscripts of Cosmas Indicopleustes," *BZ* 70 (1977), pp. 42–57, esp. p. 48 n. 31 and p. 50; Hahn, "Creation." The author of this treatise has recently been identified as Constantine of Antioch: W. Wolska-Conus, "Stéphanos d'Athènes et Stéphanos d'Alexandrie: Essai d'identification et de biographie," *REB* 47 (1989), esp. pp. 28–30.

[75] Photios, *Bibliothèque*, vol. 1, *Codices 1–84*, ed. Henry, pp. 21–22 (cod. 36) and note 1.

[76] Ibid., vol. 2, *Codices 84–185*, pp. 195–96 (cod. 183).

[77] Ibid., vol. 3, *Codices 186–222*, pp. 103–4 (cod. 204).

[78] Ibid., vol. 3, pp. 104–5 (cod. 206).

[79] L. Canfora, "Libri e biblioteche," in *Lo spazio letterario della Grecia antica*, vol. 2, *La ricezione e l'attualizzazione dei testi*, ed. G. Cambiano, L. Canfora, and D. Lanza (Rome, 1995), pp. 29–46, esp. p. 38, note 42.

[80] Rahlfs, *Verzeichnis*, pp. 374–78.

[81] Eusebios of Emesa, *Meknut'iwnk' Ut'amatean Grots' Astuatsashnch'in*, ed. V. Hovhannessian (Venice, 1980).

[82] A. Dain, "La transmission du textes littéraires classiques de Photius à Constantine Porphyrogénète," *DOP* 8 (1954), pp. 45–46; J. Irigoin, *Histoire du texte de Pindare* (Paris, 1952), p. 99 n. 2; A. Turyn, *The Byzantine Manuscript Tradition of the Tragedies of Euripides* (Urbana, 1957), p. 311; N. G. Wilson, "A Chapter in the History of Scholia," *Classical Quarterly* 17 (1967), pp. 244–56 (see pp. 244–47 for a review of earlier literature); id., "Two Notes on Byzantine Scholarship: 1. The Vienna Dioscorides and the History of Scholia," *GRBS* 12 (1971), pp. 557–58; id., *Scholars of Byzantium* (Baltimore, 1983), pp. 33–36; id., "The Relation of Text and Commentary in Greek Books," in *Il libro e il testo: Atti del Convegno internazionale* (Urbino, 20–23 September 1982), ed. C. Questa and R. Raffaelli (Urbino, 1984), pp. 103–10.

[83] R. Devreesse, "Chaînes exégétiques grecques," in *Supplement au Dictionnaire de la Bible de Vigoroux*, vol. 1 (Paris, 1928), cols. 1099, 1105; *Theodoreti Cyrensis Quaestiones in Octateuchum*, ed. Fernández Marcos and Sáenz-Badillos, pp. xi–xii. On the formation of sixth-century repertoires of extracts from the Fathers to be used in theological disputes between Chalcedonians and Monophysites, see A. Cameron, "Disputations, Polemical Literature and the Formation of Opinion in the Early Byzantine Period," in *Dispute, Poems, and Dialogues in the Ancient and Mediaeval Near East: Forms and Types of Literary Debates in Semitic and Related Literature*, ed. G. L. Reinink and H. L. J. Vanstiphout (Leuven, 1991), pp. 101–2

[84] PG 87, col. 21.

[85] Brubaker, "Reconsideration" (unpaged).

of classical texts, scenes that duplicate other scenes, miniatures containing iconographic features that contradict features in other miniatures, details that follow the Septuagint version of the Bible, and details that follow the Peshitta, the Syriac version, or the Targumim, the Aramaic versions.

No Middle Byzantine painter can reasonably be credited with the invention of such rare and bizarre iconographies as the renowned case of the camel-like serpent tempting Eve (nos. 84a–86a), which does not appear in Byzantine sources. A narrative in which Satan mounts a camel before approaching Eve is referred to in the Syriac Cave of Treasures, a retelling of Genesis that originated in the fourth century in the area east of Antioch. But we know that later Syriac Fathers condemned the image of Satan mounting a camel as a deceitful tale of the heretical Henana, who lived in Edessa in the sixth century. The painters of the Middle Byzantine Octateuchs must have treated the pictures in the model they were appointed to reproduce like a scribe confronted with the text he is copying: he strives to transcribe texts and scholia from his model faithfully; even when they have lost any meaning in his eyes, he treats them as relics of a past to be preserved and transmitted. The complexity of the cycle is evident, and the fact that it was assembled from independent preexisting cycles must hence be accepted. A similar case occurs in the Latin cycles of the Carolingian Bibles from Tours: the illustrated frontispieces in these manuscripts were assembled from a variety of Eastern and Western pictorial models.[86] Recent investigation of catena texts of the type contained in the Octateuchs has produced results which mirror this conclusion. Françoise Petit has drawn up the following stemma for the catenae on Genesis and Exodus:[87]

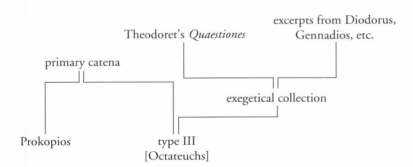

According to Petit, an Antiochene exegetical tradition, originated by Theodoret with additions from other authors of the same school (the "exegetical collection" in the stemma above), was combined with a primary catena composed of short anonymous glosses on toponomy, chronology, geographical terms, and variants of the biblical texts that must have appeared originally as marginal notes in manuscripts of the Scriptures. (Prokopios's early sixth-century commentary depends on this primary catena.) The result was the catena of type III, in the classification of Georg Karo and Hans Lietzmann,[88] which is the catena transmit-

ted by the Octateuchs. The texts assembled in the catena are not later than the first third of the sixth century[89] (which is the supposed *terminus a quo* for the origin of the catena) and the compilers selected the texts with exegetical freedom, including extracts from heretical or Jewish authors. This unconstrained selection of sources should be kept in mind: it is paralleled by an unconstrained selection of iconography in the visual commentary on the Scriptures provided by the picture cycle.

In contrast to the scholars who have suggested an eleventh-century date for the origin of the archetype, the results of the investigation published in the present volume seem to assure that the core of Weitzmann's historical outline of the Octateuch recension is still cogent. We should, however, reconsider Weitzmann's methodological structure in view of the fact that the extant Octateuchs are not only copies, more or less faithful, of an earlier archetype, but new editions with partial reelaborations of the original cycle that reflect the impact of the culture of their own age. We should also reappraise the role played by Jewish sources, both literary and pictorial, in the formation of the Octateuch cycle: this role appears to be more limited than Weitzmann and other authors have suggested. On the other hand, Syriac writings, which inherited and enriched rabbinical exegesis and legends, must instead be credited with a major role in the formation of the Octateuch iconography. Among these works, a lost illustrated version of the Syriac Cave of Treasures apparently provided a number of miniatures that were incorporated into the Octateuchs (this source is labeled the "Syriac Source"). Jewish prototypes may still be confidently presumed for a circumscribed number of images of the life of Moses: what is noteworthy is that most of these images stand out in their figural structure, which resembles that of monumental paintings rather than of miniatures. Thus, the Jewish prototypes connected with the Octateuchs must have originated as pictures in synagogues, rather than in illuminated manuscripts. It is also noteworthy that one of the ancient sources of the cycle (here called the "Main Source") incorporated images with monumental structure, hinting that paintings or mosaics in a Christian building were their ultimate source.

The period when the first illustrated Octateuch (complete with catena, Theodoret's *Quaestiones* with their preface, and the Letter of Aristeas) came into existence must remain hypothetical; however, a date in the Justinianic period may be reasonably proposed for the creation of the first edition of an illustrated Octateuch with its catena. For this edition the "Syriac Source" and the "Main Source" were combined and novel miniatures, such as those accompanying the Letter and the preface to Theodoret's *Quaestiones*, were added; moreover, the cycle of Joshua seems to be a sixth-century invention, with a *terminus post quem* in the late fifth century.

Editions of the illustrated Octateuch with biblical text and commentary transliterated from uncial into minuscule were sponsored in Byzantium in later times: a collation of the cycle

[86] Kessler, *Tours*, pp. 5ff., 139ff.

[87] *Catenae Graecae*, vol. 2, *Catena Coisliniana*, ed. Petit, p. xix; F. Petit, "La tradition de Théodoret de Cyr dans les chaînes sur la Genèse," *Mus* 92 (1979), p. 284.

[88] Karo and Lietzmann, *Catalogus*, p. 14; see also the stemma on p. 11.

[89] R. Devreesse, *Les ancien commentateurs grecs de l'Octateuque et des Rois (fragments tirés des chaînes)* (Vatican City, 1959), pp. vii–viii.

with renowned manuscripts (a Psalter close to the Paris Psalter, the Joshua Rotulus, an illustrated *Christian Topography*, and possibly a *Physiologos*) was probably created between the middle of the tenth century and the middle of the eleventh century. This collated edition may correspond to the eleventh-century manuscript which Anderson and Lowden have hypothesized as the prototype of the cycle. (This work of collation can be recognized in the twelfth-century Octateuch.) Vat. 747 stands out as the edition of the cycle most faithful to the pre-iconoclastic archetype. In contrast, the three Komnenian Octateuchs, Ser., Sm., and Vat. 746, appear to be largely the revised products of patronage connected to the imperial family; these "courtly editions" of the cycle are more attentive to aesthetic values than to the faithfulness of their images to the biblical passages they illustrate. But among these Komnenian Octateuchs, the revision of iconography in Sm. was less extensive than in Ser. and Vat. 746; thus, as Lowden has proposed on codicological grounds, Sm. appears to be the copy closest to the manuscript which served as a model for the Komnenian Octateuchs. The Vtp. edition looks like a "philological edition" of the cycle produced after the collapse of the Latin occupation of Constantinople; it witnesses an effort to restore the cycle employing available old-fashioned manuscripts as both iconographic and stylistic models. Lastly, the "learned edition" of the Laurentian Octateuch represents a case by itself, one that is hardly inserted in the Octateuch pictorial tradition.

The aim of this book is, first of all, to present all of the miniatures in the six Octateuchs with a critical apparatus. The photographs of Vat. 746 and Vat. 747 are Morey's, from the original project; because of their high quality, it was not necessary to replace them with more recent photographs. Those of the Seraglio Octateuch were taken after restoration of the manuscript. The reproductions of the Vatopedi codex are from the Weitzmann collection and were taken during his work at Athos. The photographs of Sm. are from Hesseling's book, except for a number taken by Paul Buberl and preserved in the photo archive of the Österreichische Nationalbibliothek in Vienna. Because of their higher quality, the Buberl photographs, which are published here for the first time, have been used in place of Hesseling's whenever possible, as noted in the captions. The photographs of Laurent. are recent. To facilitate comparative study, the plates reproduce the corresponding miniatures from the various manuscripts side by side, the exception being the anomalous Laurentian codex, the miniatures of which are reproduced at the beginning of the plates.

After the description of the miniatures in chapter 1, the following chapter is a comprehensive survey by Kurt Weitzmann, originally planned as one of the two general introductions to the book, in which he considers the question of the origins of the archetype of the cycle and of its pictorial sources (classical, Jewish, imperial, and Christian). Then follows the chapter originally planned as an introduction by the present writer paralleling that

of Weitzmann. A codicological apparatus with stylistic notes (chapter 4) concludes the volume.

Of the manuscripts involved in the initial project, the Bible of Leo Sakellarios is not included in this book, and, more significantly, the Joshua Rotulus is presented only as reference material. The Rotulus was exhaustively surveyed by Weitzmann in his monograph of 1948, and therefore it was not necessary to describe its miniatures again so minutely, although they have been completely reproduced here. Given recent studies on the Rotulus and the new lavish facsimile edited by Mazal,[90] a codicological description of the Rotulus and a transcription of its biblical excerpts (devoid, however, of any correspondence with the inscriptions in the Octateuchs' miniatures) would have been merely repetitive. Weitzmann added an appendix to his introduction on the question of the origin and date of the Rotulus, in which he essentially reaffirms his previous views.

POSTSCRIPT 1998

Kurt Weitzmann's memoirs, *Sailing with Byzantium from Europe to America*, which appeared posthumously in 1994, conclude with the sentence "it is written in the stars whether or not I will live to see the completed publication [of the Octateuchs]." Weitzmann's hope did not materialize, and I regret that it was not possible to complete the manuscript of the book while he was still alive: the manuscript was submitted in September 1994, one year after Weitzmann's death. Since then, I have had the opportunity to discuss a number of points raised in the book with colleagues, from whom I have received suggestions, criticism, and encouragement and appreciation.[91] It was not possible, however, to incorporate these comments into the present book. Likewise, any publications dealing with the Octateuchs which appeared after the completion of the manuscript have been mentioned only in the bibliography and occasionally in the notes.

Weitzmann's scholarly work represents one of the most important methodological achievements in Byzantine studies of this century, although his methodology, of course, needs to be updated in light of modern research and recent discoveries. However, even in a period in which great methodological constructions such as Weitzmann's seem to be undermined by more empirical approaches to Byzantine art, and attempts to reconstruct lost illuminated manuscripts (one of the main goals of Weitzmann's work) are being abandoned in favor of enquiries limited to the actual evidence of the material handed down to us, we should still consider as a guideline for future research Weitzmann's statement, written in 1975:

> Even when all the surviving illustrated Byzantine manuscripts have been published in documentary fashion, we still will not have a basis broad enough to write an intelli-

[90] *J.-R.*

[91] In particular, I was able to present some of the material in this volume in the form of lectures at the Universities of Groningen, Amsterdam, and Leiden. The conclusions on the genealogy of the Octateuchs and a discussion of other scholars' proposals has been summarized in my article: Bernabò, "Studio." Finally, the Octateuchs and Early Christian biblical

imagery were the subject of my Ph.D. thesis, "Le miniature degli Ottateuchi bizantini: Edizioni illustrate delle Scritture e immaginario cristiano," which I defended in 1996 at the Philosophisch-Historischen Fakultät der Universität Basel with Professors Beat Brenk and Rainer Stichel, to whom I am indebted for their remarks.

gent history of the subject. Actually, any history that confines itself to extant material is a falsification, since the preserved material is only a fraction of what once existed, and its survival is due merely to chance. It must therefore be the aim of the historian to adduce all tangible evidence that will contribute to a broader picture, even at the risk of making occasional mistakes which, however, are less dam-

aging than a history distorted by restricted evidence Here one can learn from the classical archaeologist, who from fragmentary remains proposes reconstructions of temple pediments like those of Aegina, Olympia, the Parthenon, and even Epidaurus, from which so little is left. By a similar method we must reconstruct the fragments of some of our most precious Early Byzantine manuscripts.[92]

[92] "The Study of Byzantine Book Illumination: Past, Present, and Future," in K. Weitzmann, W. C. Loerke, E. Kitzinger, and H. Buchthal,

The Place of Book Illumination in Byzantine Art (Princeton, 1975), p. 12.

I. DESCRIPTION OF THE MINIATURES

1. PARAPHRASE OF THE LETTER OF ARISTEAS

THE SERAGLIO OCTATEUCH alone contains a para-phrase of the Letter of Aristeas, possibly written by Isaac Komnenos. Five spaces left blank in the text column indicate that the paraphrase was meant to be illustrated with a cycle of minia-tures, but none were executed. These spaces break the text of the paraphrase at the following points (the references are to the text edited by Uspenskii in his volume on the Seraglio manuscript):[1]

- fol. 4r = Uspenskii, p. 4, lines 20ff.: letter of Ptolemy II to Eleazar;
- fol. 4v = Uspenskii, p. 4, lines 29ff.: description of the table presented by Ptolemy to Eleazar;
- fol. 5v = Uspenskii, p. 6, lines 26ff.: arrival of the seventy-two Hebrew elders in Alexandria with gifts sent by Eleazar to Ptolemy;
- fol. 7r = Uspenskii, p. 9, lines 19ff.: Ptolemy gives a banquet in honor of the seventy-two elders;

- fol. 8r = Uspenskii, p. 11, lines 19ff.: Ptolemy's gift of silver talents to the seventy-two elders.

These passages correspond precisely to the five episodes (nos. 6–7, 8, 9, 10, 11–12) actually illustrated in the Letter of Aristeas in Ser. as well as in Vat. 747. In other words, a similar selection of episodes was intended to be illustrated in the letter and in its paraphrase. Curiously, the supposed illustration of the temple and its implements which is lost both in Ser. and in Vat. 747 (see the description of the Temple in Jerusalem below, between nos. 8 and 9) is also missing in the paraphrase.[2] The possibility that the paraphrase was created sometime after the Letter of Aristeas in Sm. had been mutilated by the removal of the illustrations of the temple and its implements must be considered.

[1] Uspenskii, pp. 2–14.
[2] Bernabò, "Mecenatismo," p. 19.

2. LETTER OF ARISTEAS

Letter of Aristeas 28–33

DEMETRIOS OF PHALERON DRAWS
UP THE MEMORANDUM

6a. Vat. 747, fol. 2v

The first miniature consists of two scenes, the one at the left rep-resenting Demetrios of Phaleron as he draws up a memorandum stating that the laws of the Jews are lacking in the great library of Alexandria and therefore recommending their translation. The famous librarian, clad in a tunic and chlamys and wearing a tur-ban, sits on a throne and dictates the memorandum to a scribe in front of him. This scribe, dressed in a striped garment and likewise wearing a turban, holds a scroll in one hand and in the other a pen, which he dips into an inkwell carried under his left arm together with a gray container holding two more pens. The scene takes place before a decorative piece of architecture combining elements of a wall with those of a house. The garment and face of Demetrios have been overpainted, and it appears that the foiled arches with rinceau ornament in the spandrels were superimposed on the golden background at the time of restoration.
Located beside Letter of Aristeas 33.

7a. Ser., fol. 11v

Demetrios, clad in a richly embroidered tunic, does not wear a turban but is bareheaded, whereby the illustrator characterizes

him as a Greek. There are no architectural elements and the background is simply painted in blue, but the figural composi-tion is the same as in Vat. 747. Flaked in various spots.
Located beside Letter of Aristeas 33.

Lit.: Kondakov, *Istoriia*, pp. 186–87; Kondakov, *Histoire*, vol. 2, p. 77; Ven-turi, *Storia*, vol. 2, pp. 465–66, fig. 324; Uspenskii, pp. 104–6, figs. 1, 2; Diehl, *Manuel*, vol. 2, p. 619, fig. 295; Menhardt, p. 290; Galavaris, *Grego-ry Naz.*, p. 42; Weitzmann, "Selection," p. 80, fig. 14; Kessler, *Tours*, pp. 92–93; Posner and Ta-Shema, *Hebrew Book*, fig. p. 169; Greenspoon, "Septuagint," fig. p. 34; Anderson, "James the Monk," p. 72; Bernabò, "Mecenatismo," pp. 12ff., pl. II, fig. 1; Iacobini, "Lettera," pp. 79ff., figs. 1, 2; Bernabò, "Teodoreto," pp. 74–75, fig. 8.

Letter of Aristeas 35–40

PTOLEMY SENDS A LETTER TO ELEAZAR

6b. Vat. 747, fol. 2v

In the scene at the right, the Egyptian king Ptolemy II com-mands that a letter be written to Eleazar, the high priest of the Jews, requesting the selection of six elders from each tribe to translate the Jewish laws into Greek. Distinguished by a nimbus and dressed in the loros like a Byzantine emperor, Ptolemy sits on a faldstool while he gives the order to a court official. The latter stands in front of him in a devout posture with crossed arms and wears the typical garment with long sleeves extending over the

hands. The decorative architecture, consisting of elements of a house and a wall, is an extension of the same structure that forms the background of the preceding scene. The figure of the king is overpainted and the crown, which originally had the simpler form of a pearl diadem, has been changed in accordance with the fashion at the time of restoration. The figure of Ptolemy is flaked and the jewel-studded imperial loros is nearly completely destroyed.

Located beside Letter of Aristeas 33.

7b. Ser., fol. 11v

The inscription, written above the preceding scene, reads: ὁ βα(σιλεὺς) πτολεμαῖος κελεύ(ει) ἐπιστολ(ὴν) σταλῆναι πρὸ(ς) τὸν ἐλεάζαρ(ον).

This scene is placed under an arch resting on two marble columns, distinctly separating it from the preceding scene. The figural composition is very close to that in Vat. 747, except that here Ptolemy's nimbus is painted pink and the court official is clad in a short embroidered tunic and wears a cap instead of a turban. Flaked at various spots.

Located beside Letter of Aristeas 33.

Lit.: Venturi, *Storia*, vol. 2, fig. 324; Uspenskii, pp. 104–6, figs. 1, 2; Diehl, *Manuel*, vol. 2, p. 619, fig. 295; Menhardt, p. 290; Weitzmann, "Selection," p. 80, fig. 14; Kessler, *Tours*, pp. 92–93; Anderson, "Seraglio," pp. 86–87, fig. 1; Anderson, "James the Monk," p. 72; Bernabò, "Mecenatismo," pp. 12ff., pl. II, fig. 1; Iacobini, "Lettera," pp. 79ff., figs. 1, 2; Bernabò, "Teodoreto," pp. 74–75, fig. 8.

Letter of Aristeas 57–72

PTOLEMY COMMANDS THE MANUFACTURE OF GIFTS

8. Vat. 747, fol. 3v

The text describes in great detail the gifts King Ptolemy sent to Eleazar, mentioning first the most important object, a huge τράπεζα for the temple in Jerusalem. The illustrator chose the table's manufacture as the subject of his miniature, but the circular table resting on an elaborate base with many niches does not conform to the detailed description in the text. In the foreground a workman sits at a low workbench upon which he hammers a sheet of metal. His assistant, a black-skinned boy, heats a piece of metal over an open fire, fanning the flames at the same time. The text explicitly says that King Ptolemy personally supervised the work, and thus the illustrator has depicted him seated on a throne and giving orders. In a manner which differs from that in the preceding picture, he is not clad in the imperial loros, but wears the chlamys, while on his head rests the same high crown, which the restorer has substituted for the simpler pearl diadem. The background is formed by screenlike architecture suggesting the royal palace. Between two lateral buildings extends a wall decorated with two medallion-heads and a dancing figure in grisaille. A small tempietto, of which the upper story has an open window and golden shutters, stands in front of the central wall. An arbor with nesting birds appears behind the wall and indicates the royal garden. The miniature has been overpainted, and the trefoil arch with the rinceaux in the spandrels seems to be an

addition from the period of restoration. Figures and furniture are partly flaked and the upper part of the assistant is rubbed.

Located beside Letter of Aristeas 56.

Ser., fol. 12v

Blank space for an unexecuted miniature.
Located beside Letter of Aristeas 55.

Lit.: Uspenskii, pp. 106–7, fig. 3; Menhardt, p. 290; Kessler, *Tours,* pp. 92–93; Bernabò, "Mecenatismo," pp. 12ff., fig. 2; Iacobini, "Lettera," pp. 80ff., fig. 7.

Letter of Aristeas, Undetermined Verse

TEMPLE IN JERUSALEM(?)

Vat. 747, one of the two lost folios between fols. 3 and 4

The lost bifolio of Vat. 747 probably contained a miniature, as can be inferred from a comparison with Ser., where unfortunately only a lacuna for an unexecuted miniature exists.

Ser., fol. 13v

The parchment here has been cut out.[1] In this part of Ser., however, the illustrations refer closely to the text alongside their frames, in this case verses 87ff. of the Letter of Aristeas. Here the narrative turns to an accurate description of the temple in Jerusalem (verses 84–86), the altar with its implements, and the sacrifices performed nearby (verses 87–90). Thus we may hypothesize that the lacuna in Ser.—as well as the corresponding miniature in the lost bifolio of Vat. 747—contained an illustration of these subjects.

Located beside Letter of Aristeas 87.

Lit.: Uspenskii, pp. 107–8; *Lettre*, ed. Pelletier, fig. p. 12; Bernabò, "Mecenatismo," pp. 12–13; Iacobini, "Lettera," p. 85, fig. 27.

[1] The recto of fol. 13, with the cut-out parchment, is reproduced in *Lettre*, ed. Pelletier, fig. p. 12. Uspenskii (p. 107) assumed that no miniature had existed here and that there was only a blank space where the parchment was cut out.

Letter of Aristeas 121–127

ELEAZAR GIVES A LETTER TO ARISTEAS AND ANDREAS

9a. Vat. 747, fol. 6r

Aristeas and Andreas, the chief bodyguards who had accompanied Aristeas to Jerusalem, have selected the Hebrew scholars to translate the Jewish laws. The illustrator depicts both emissaries, clad in chlamydes and wearing turbans, standing devotedly before Eleazar and receiving a letter which, according to Letter of Aristeas 173, they will present to King Ptolemy. The high priest sits on a throne and wears a tunic with a broad girdle and a mantle fastened over his breast. A group of dignified Jews, some of the seventy-two scholars who are to depart for Alexandria with

Aristeas and Andreas, stand at a respectful distance. The background consists of fanciful architecture with a wall and two houses pierced by windows and arcades, surmounted by decorative curtains. The miniature was partly overpainted and has flaked again in a few spots. As in the preceding miniatures of this manuscript, a trefoil arcade with rinceaux in the spandrels was added at a later period.

Located beside Letter of Aristeas 172.

Ser., fol. 16v

Blank space for an unexecuted miniature.
Located beside Letter of Aristeas 171.

Lit.: Kondakov, *Istoriia*, pp. 186–87; Kondakov, *Histoire*, vol. 2, p. 77; Uspenskii, pp. 107–8, fig. 4; Menhardt, p. 290; Kessler, *Tours*, pp. 92–93; Bernabò, "Mecenatismo," pp. 13ff., pl. I; Iacobini, "Lettera," pp. 81ff., fig. 13; Bernabò, "Teodoreto," pp. 74–75, fig. 9.

Letter of Aristeas 173–176

Aristeas and Andreas Present the Letter to Ptolemy

9b. Vat. 747, fol. 6r

Upon their arrival in Alexandria, Aristeas and Andreas appear before Ptolemy and each of them delivers a letter, although the text speaks of only one letter. Ptolemy, clad as before in the chlamys and wearing a crown of the period of restoration, sits on a throne, while a bodyguard with a shield and spear stands behind him. The seventy-two translators are received by the king along with the two emissaries; some of them carry in their veiled hands the gifts which have been sent with them. Of the background architecture only a small piece of wall and part of a house decorated with a figure of a dancing girl painted in grisaille are visible. The scene is partly overpainted and somewhat flaked, particularly the heads of Ptolemy and of some of the Jews, and again a trefoil arch has been added over the gold ground.

Located beside Letter of Aristeas 172.

Ser., fol. 16v

Blank space for an unexecuted miniature.
Located beside Letter of Aristeas 171.

Lit.: Uspenskii, p. 108, fig. 4; Menhardt, p. 290; Kessler, *Tours*, pp. 92–93; Bernabò, "Mecenatismo," pp. 13ff., pl. I; Iacobini, "Lettera," pp. 83ff., figs. 13, 16; Bernabò, "Teodoreto," pp. 74–75, fig. 9.

Letter of Aristeas 181–186

Banquet in Honor of the Seventy-Two Elders

10. Vat. 747, fol. 6v

A banquet is given in the royal palace in honor of the seventy-two translators. Ptolemy is distinguished as the only figure lying on a couch, although the text explicitly states that the guests also reclined on couches. Apparently the limited space did not permit the illustrator to show all the participants in the position described in the text, and he was forced to group them around one side of the oval marble table as a dense crowd, with only a few of them seated very close to it. The guests are attended by servants, one of whom puts pieces of bread or cake on the table, while two others are busy filling a pitcher with wine from a great vessel shaped like a samovar. A smaller, wooden table stands between the king and the large marble table, and around it, in addition to Ptolemy, three other distinguished guests have taken their seats. The latter are clad like the other Jews with kerchiefs over their heads, but there is no passage in the text that would account for the separation of this smaller group of Jewish scholars from the rest. It must be observed, however, that the whole miniature and particularly all the heads are much overpainted and it is possible that these three men were originally not characterized as Jews. It seems much more likely that they were either some high officials of the royal court, including Dorotheos, who had charge of the guests, or perhaps some of the philosophers taking part in the discussion, among them Menedemos of Eretria, whom the text mentions by name (LetAris 200–220). Ptolemy, who is clad in a richly embroidered tunic, nimbed with a green halo, and again wears the high crown of the period of restoration, is attended by two servants in long, striped garments. One of them holds in his hand what now looks like a lance but evidently was meant to be a flabellum. Most likely the original artist did depict a flabellum, whose upper part was cut off when the trefoil arch with the rinceaux was added. The considerably overpainted miniature has flaked again in various places, and the heads of the two servants behind Ptolemy are rubbed.

Located beside Letter of Aristeas 187.

Ser., fol. 17r

Blank space for an unexecuted miniature.
Located below Letter of Aristeas 187.

Lit.: Kondakov, *Istoriia*, pp. 186–87; Kondakov, *Histoire*, vol. 2, p. 77; Uspenskii, p. 108, fig. 5; Menhardt, p. 290; Kessler, *Tours*, pp. 92–93; Greenspoon, "Septuagint," fig. p. 37; Bernabò, "Mecenatismo," pp. 13ff., pl. III; Iacobini, "Lettera," pp. 83ff., fig. 20.

Letter of Aristeas 294

Ptolemy Gives Gifts to the Elders

11. Vat. 747, fol. 10v

After days of banqueting, King Ptolemy gave each of the translators three talents of silver in appreciation of the benefit he had derived from his conversations with them. To illustrate this passage the painter used the compositional scheme of the distribution of the *donativum* by the Byzantine emperor to his soldiers. Ptolemy holds a golden vessel of coins to be distributed, although this seems to contradict the text of the Letter of Aristeas, according to which he appointed one of his slaves to deliver the money. The king is accompanied by a bodyguard with a shield and spear, and, as in the first miniature (cf. figs. 6 and 7), he is dressed in

the loros of the Byzantine emperors and once more wears the high crown of the restoration period. The Jewish elders stand before him; the illustrator obviously attempted to depict all of them. Some hold rolls in their covered hands, either to indicate the work they will begin immediately following the welcoming festivities, or in anticipation of the finished work which, after isolation for seventy-two days on the island of Pharos, they will present to Ptolemy before they return to Jerusalem. The miniature has been thoroughly overpainted, notably the faces of the central group of Jews; ornaments have been added on the golden background, and the surface is now flaked again in many spots.

Located beside Letter of Aristeas 293.

12. Ser., fol. 21r

In general the composition agrees with Vat. 747; only details differ slightly. The emperor-king, with a purple nimbus and hold-ing a large golden bowl in his hands, sits on a golden, jewel-studded throne, whose back is surmounted by a statue of a heraldic eagle. The king is accompanied by three court officials instead of his bodyguard. While the illustrator of Vat. 747 organized the crowd of translators more rhythmically and differentiated their postures, the copyist of Ser. lined them up in a monotonous way. He showed each man holding a roll in his hand, emphasizing the assigned task. Slightly flaked in various spots; in several cases the outlines of the figures were redrawn by a later hand.

Located below Letter of Aristeas 294.

Lit.: Kondakov, *Istoriia*, pp. 186–87; Kondakov, *Histoire*, vol. 2, p. 77; Uspenskii, pp. 102, 108, figs. 6, 7; Menhardt, p. 290; Huber, p. 24, figs. C and D, p. 28; Kessler, *Tours*, pp. 92–93; Anderson, "Seraglio," p. 87, fig. 5; Bernabò, "Mecenatismo," p. 13, figs. 3, 4; Iacobini, "Lettera," pp. 83ff., figs. 23, 24; Canfora, *Viaggio di Aristea*, pp. xiii–xiv, 100ff.

3. THEODORETUS AD HYPATIUM[1]

The Letter of Aristeas is followed by Theodoret's preface to his *Quaestiones in Octateuchum*, written in the form of a letter addressed to a certain Hypatios, apparently the same one mentioned in his 113th letter as a presbyter and choir bishop.[2] The text of the preface is arranged to leave two blank lunettes on the parchment folio, where the painter inserted his images.

Theodoret Gives the Letter to a Messenger

13a. Vat. 747, fol. 12r

The illustrator applied a familiar scheme depicting the dispatching of the letter on the one side and its delivery to the addressee on the other. In the scene at the left Theodoret, resembling an ancient portrait of a philosopher or author, sits on a golden throne and hands the letter, in the shape of a roll, to a messenger. The throne stands in front of screenlike architecture with a two-storied, domed building in the center. A curtain is fastened in Hellenistic fashion to the top of the towerlike structure. Slightly flaked in various places.

Located beside the end of the text, on the left side.

14. Ser., fol. 22v

The scene, which is set against a blue background, agrees in all essential points with that of Vat. 747, but the architecture is greatly simplified and the postures and gestures of the figures differ slightly. Badly damaged.

Located at the end of the text, on the left side.

Lit.: Uspenskii, pp. 106, 109, figs. 8, 9/10; Martin, *Heavenly Ladder*, p. 25; Menhardt, pp. 268, 290–92, fig. 3; Galavaris, *Gregory Naz.*, pp. 42, 58 n. 99; Huber, p. 26, figs. E and F, p. 28; Kessler, *Tours*, pp. 92–93; Anderson, "Seraglio," p. 105; Iacobini, "Lettera," pp. 85ff., figs. 25, 26; Bernabò, "Teodoreto," pp. 71ff., figs. 3, 4.

Hypatios Receives the Letter

13b. Vat. 747, fol. 12r

In the scene at the right the messenger steps out of a doorway and delivers the letter to Hypatios, who wears a kerchief over his head and sits on a high-backed golden chair. The scene is placed before screenlike architecture surmounted by a tempietto. As in the previous scene, a curtain is fastened to the top of the structure.

Located beside the end of the text, on the right side.

15. Ser., fol. 22v

Set against a blue background and close to Vat. 747. The architecture is simplified and the gestures and postures of the figures vary slightly: Hypatios, for instance, does not yet hold the letter, but stretches out his hand to receive it. Badly damaged; the heads of Hypatios and the messenger are almost completely destroyed.

Located beside the end of the text, on the right side.

Lit.: Uspenskii, pp. 106, 109, figs. 8, 9/10; Martin, *Heavenly Ladder*, p. 25; Menhardt, pp. 268, 290–92; Galavaris, *Gregory Naz.*, pp. 42, 58 n. 99; Huber, pp. 26, figs. E and F, p. 28; Kessler, *Tours*, pp. 92–93; Anderson, "Seraglio," p. 105; Bernabò, "Teodoreto," pp. 71ff., figs. 3, 5.

[1] PG 80, col. 76.
[2] PG 83, col. 1317.

4. GENESIS

[Genesis 1]

CREATOR AND ANGELS

The first miniature in the Florence and Smyrna Octateuchs is an introductory image to the cycle of Creation. Laurent. depicts a Trinitarian image of God: three rays emanate from his hand and begin the work of creation, an iconography merging elements from diverse biblical prophetic visions.[1] Sm. has a figure of the Creator standing beside a heavenly disk. Both of these miniatures, completely unrelated to each other, are later insertions in the cycle.

1a. Laurent., fol. 1v (upper row, left)

In the first of the five panels into which the full-page miniature of the Florentine manuscript is divided, the illustrator depicted God as the creator of the universe in the midst of the host of angels. On either side of the mandorla are two groups of angels, one above the other and each arranged in a "V" formation headed by an archangel clad in the imperial loros. A fifth group of angels appears at the top, where the frame had to be curved outward to accommodate them. Clad in a white garment with golden highlights, God sits on a golden throne decorated with lions' heads and feet. The light blue mandorla that encloses him is surrounded by seraphim and cherubim and, at the bottom, by four pairs of fire wheels. Three white rays emanate from the hand of the Creator and lead over to the right panel which represents the separation of light and darkness. The miniature is considerably flaked, God's throne and many of the angels' heads being particularly badly damaged, so that larger areas of the golden ground show than originally intended. Heavy flaking runs along the ruling pattern of the folio, which is traced for a two-column manuscript and identical to the following folios with the text.

Lit.: Tikkanen, "Genesi," pp. 222–23; Neuss, *Katalan. Bibelill.*, p. 36; Der Nersessian, *Barl. et Joas.*, p. 114; Tikkanen, *Farbengebung*, pp. 127–28; Garrison, "Creation and Fall," pp. 202–3 n. 5, 208; Bernabò, "Laur. plut. 5.38," pp. 137, 139–40, pl. 1; Lassus, "Création," pp. 91–92, 95–96; De' Maffei, "Unigenito," p. 101, n. 53; Mentré, *Création*, fig. p. 72; *Luoghi memoria scritta*, pl. 21 p. 148.

[1] The vision of Isaiah (Isa 6:1–4) for the six-winged seraphim, the vision of Ezekiel (Ezek 1:1–24) for the cherubim and the fire wheels, and the vision of Daniel (Dan 7:9) for the representation of the Creator as the Ancient of Days clothed in white garments and with long white hair and beard (cf. De' Maffei, "Unigenito," p. 101 n. 54).

[Genesis 1]

CREATOR AND COSMOS

1b. Sm., fol. 2r

God, as the creator of the universe, stands in front of a heavenly sphere set against a golden background and holds a smaller heavenly sphere in his hands. He is represented as the Παλαιὸς τῶν Ἡμερῶν, i.e., the Ancient of Days, with a long beard, curly hair falling over his shoulders, and a nimbus bearing the inscription Ὁ ΩΝ in the bars of the cross. In his right hand he holds a rod with which he accomplishes the creation. The larger of the two spheres,[1] which superficially resemble those in astronomical manuscripts, has at its center the sun, its rays radiating into a second circular zone, while a third zone is filled with stars and a fourth seems to be void of any detail. The smaller sphere is likewise divided into four circles: the innermost presumably contains the earth, a disk with a scalloped frame; the second is partly covered by the crescent of the moon which reaches into the third zone, containing the stars; the fourth circle contains a representation of the zodiac, and traces of the designs of these constellations are still recognizable in a photo taken by Buberl.[2] Four medallions with representations of cherubim are inserted into the third and fourth zones at equal intervals. This introductory miniature in Sm. emerges as a unicum in the whole set of illustrations; evidence suggests it is a later addition or a replacement of a lost folio made during the thirteenth or the sixteenth century.[3]

Located above Genesis 1:1.

Lit.: Strzygowski, *Sm.*, p. 114, pl. 31; Hesseling, fig. 1; Likhachev, *Ikonopisi*, p. 158, fig. 361; Wulff, *Altchr. und Byz. Kunst*, vol. 2, p. 531; Ebersolt, *Min. byz.*, p. 31, pl. 28 no. 1; Neuss, *Katalan. Bibelill.*, p. 36; Der Nersessian, *Barl. et Joas.*, p. 114; Krücke, "Ikonographie," p. 33, fig. 38; Ştefănescu, *Iconographie*, pp. 4–5, pl. 3; Schmidt, *Sechstagewerkes*, pp. 22, 48; Demus, *Norman Sicily*, pp. 253–54; Kitzinger, *Monreale*, p. 129 n. 84; Krücke, "Protestantismus," p. 60; Heimann, "Bury St. Edmunds Psalter," p. 49, pl. 10b; Haussherr, "Bible moralisée," p. 139; Huber, p. 29, fig. p. 29; Bernabò, "Laur. plut. 5.38," pp. 140, 153; Lassus, "Création," pp. 91–97; Weber, *Symbolik*, vol. 1, p. 398; De' Maffei, "Unigenito," p. 105; Anderson, "Seraglio," pp. 93–94; Mentré, *Création*, fig. p. 44; Lowden, "Image of God," pp. 21–22; Lowden, *Octs.*, pp. 18–20, fig. 12.

[1] The sphere with its concentric circles seems to symbolize the firmament, and its arrangement in three zones suggests a Trinitarian idea. Cf. the representation in the mosaics in the atrium in San Marco (Weitzmann, "Genesis Mosaics," pp. 108–9, pl. 108; Weitzmann and Kessler, *Cotton Gen.*, pp. 47–48) or the sixth-century description by John of Gaza of a painting of the cosmos in a Gaza bathhouse (cf. Maguire, *Earth and Ocean*, p. 12).

[2] Strzygowski (*Sm.*, p. 114) particularly mentions the constellations of the scorpion, lion, and centaur.

[3] Cf. Lowden, "Image of God," pp. 21–22 and *Octs.*, pp. 18–20, for the older date and relationship with Western *Bibles moralisées*; Anderson ("Seraglio," pp. 93–95), on the other hand, considers the miniature a restoration probably executed during the sixteenth century on the grounds of a stylistic comparison with the painter of the evangelists in Mount Athos, cod. Koutloumousiou 290, dated 1562. He also concludes that the handwriting of the text and title on fol. 2r must be a later addition.

Genesis 1:1–2

PRIMORDIAL CREATION

For the first image of the cosmos the painter chose to arrange his miniature in horizontal strips, each strip corresponding to a

section of the unformed cosmos. Its apparent simplicity notwithstanding, this representation adopted features from contemporary cosmographic thought and from imagery expressed in other biblical passages: the unformed mass of the heavens, resembling a heap of clouds or smoke, parallels Basil's *Hexaemeron*, after Isaiah 51:6,[1] and Syriac writings.[2] At the same time, the waters above the mountains are not explicitly justified by Genesis 1:2; a clearer reference to them is found in Psalm 103:6,[3] where God employs the abyss as a cloth to cover the earth, so that the waves wash upon the mountains.[4]

Significantly, in the opening miniature of the primordial creation, the Octateuchs avoid any pictorial representation of "the Spirit of God moved over the water" (Gen 1:2), a renowned symbol of the Holy Spirit and a Trinitarian allusion which in other pictorial cycles of Genesis is visualized as a dove above the water.[5] The Trinitarian interpretation is a *topos* among such Christian authors as Clement, Justin, Origen, the Cappadocian Fathers,[6] and Aphrahat, the third- to fourth-century Christian sage living beyond the Roman border in the area under Persian rule.[7] In contrast, the most prestigious Syrian Fathers of the fourth and fifth centuries—John Chrysostom,[8] Ephrem,[9] Theodore of Mopsuestia,[10] and Theodoret[11]—reject the connection between the spirit above the waters and the Holy Spirit, probably in view of heretical ideas circulating among the faithful.[12] For them the spirit is "a wind brooded upon the face of the waters,"[13] or some vital force present inside the waters.[14] Furthermore, the interpretation of the spirit above the waters as the Holy Spirit was used by the Christians in the debate with the Jews.[15] Thus, in avoiding the dove the miniature rejects a specific anti-Jewish accent, and at the same time reveals connections with fourth- and fifth-century Syrian Christianity.[16]

17. Vat. 747, fol. 14v

The illustrator closely followed the text by dividing the picture into three zones. The unformed earth, inscribed γῆ ἀόρατος outside the left border, is depicted as a brown mass with sharp peaks set against a strip of light blue water. The second zone, representing the darkness, is shaped like an arch and painted dark brown, while near the frame a shapeless mass with a rounded outline is placed above the arch. The brown mass above the arch is similar to the same representation in Laurent. (fig. 2). The third zone is occupied by a semicircular heaven containing the blessing hand of God, from which radiate three rays, a Trinitarian symbol.

The miniature is surrounded by the catena on all sides.

18. Ser., fol. 26v

The division into three zones is the same as in Vat. 747, except that the darkness is not arched over the earth but depicted horizontally. The earth zone is enlivened by two caves, similar to Hades' entrances,[17] the one at the right containing a bearded head which is most likely a personification of Hades[18] or a wind, the abyss, Pluto.[19] The three zones are inscribed at the left margin, reading from top to bottom: οὐρανός–γῆ ἀόρατος–σκότος ἐπάνω τῆς ἀβύσσου, the second and the third inscriptions being

erroneously interchanged. The miniature is considerably flaked, torn at the lower left corner, and covered with letters offset from the opposite page.

Located below Genesis 1:2.

19. Sm., fol. 4r (see also text fig. 52)

Close to Ser., but without the caves and the personification of the abyss in the lowest zone.

Located in the catena; the text above is Genesis 1:2.

20. Vat. 746, fol. 19v

The miniature, which is close to Ser. and Sm., includes both caves, one cave at the left, and, at the opposite side, an indefinite black area, without the head depicted in Ser. Above the picture is written οὐρανός, in the middle at the left γῆ ἀόρατος, and at the lower right σκότο(ς) τὸ ἐπάνω τῆς ἀβύσσου. The scribe repeated the mistake found in Vat. 747, interchanging the second and third inscriptions.

Located in the catena.

Lit.: Tikkanen, "Genesi," p. 223; Strzygowski, *Sm.*, p. 114; Ainalov, *Hellenistic Origins*, pp. 46–48, fig. 23; Uspenskii, pp. 109–10, pl. 6 left, fig. 11; Hesseling, fig. 2; De Grüneisen, "Cielo," p. 491, fig. 15 p. 494; Demus, *Norman Sicily*, pp. 253–54; Garrison, "Creation and Fall," pp. 202, 208 n. 4; Henderson, "Sources," p. 12 n. 4; Kessler, "Ivory Plaque," p. 79; Blum, "Cryptic Creation Cycle," p. 215, fig. 4a; Kirigin, *Mano divina*, p. 99; Lassus, "Création," pp. 98–99, fig. p. 98, pl. 2A; Bergman, *Salerno*, p. 15; Sherman, "Ripoll Bible," pp. 3–4, fig. 3; Anderson, "Seraglio," p. 105; Mentré, *Création*, figs. p. 35, pp. 114, 117; Weitzmann and Kessler, *Cotton Gen.*, p. 42; Alexandre, *Commencement*, p. 51, fig. 13; Bernabò, "Esegesi patristica," p. 55, fig. 5; Bernabò, "Studio," pl. 12.

[1] *Hex* 1:8 (*Homélies sur l'Hexaéméron*, ed. Giet, pp. 120–21); Basil describes the sky as smoke or light, a substance neither solid nor thick.
[2] The Syriac Cave of Treasures, 1:11, uses the phrase "thick condensation of clouds" (*Caverne des Trésors*, ed. Ri, vol. 1, pp. 4–5).
[3] "The deep, as it were a garment, is his [i.e., the earth's] covering: the waters shall stand on the hills."
[4] Some Christian Fathers stress that waters and darkness covered the earth and concealed it, as in the miniature. This point is most clearly asserted by Basil, quoting Isa 51:6 (*Hex* 2:1 and 3; *Homélies sur l'Hexaéméron*, ed. Giet, pp. 150–53). See also John Chrysostom, *HomGen* 3:3 and 4:5 (John Chrysostom, *Homilies on Genesis 1–17*, ed. Hill, pp. 41, 54).
[5] E.g., in the Cotton Genesis recension (Weitzmann and Kessler, *Cotton Gen.*, figs. 1, 2).
[6] The many passages of the Christian Fathers identifying the spirit above the waters as the Holy Ghost are too numerous to be enumerated here; for a comprehensive list of early authors, see P. Nautin, "Genèse 1, 1–2, de Justin à Origène," in *In principio: Interprétations des premiers versets de la Genèse* (Paris, 1973), pp. 61–94.
[7] *Dem* bk. 6, 292.24–293.5; cf. R. Murray, *Symbols of Church and Kingdom: A Study in Early Syriac Tradition* (Cambridge, 1975), pp. 143–44; see also pp. 21–22. Aphrahat broadly employs the image of a bird brooding and hovering above the primeval waters as well as above the baptismal waters.
[8] *HomGen* 3:4 (John Chrysostom, *Homilies on Genesis 1–17*, ed. Hill, p. 41).
[9] Kronholm, *Motifs from Genesis*, pp. 43–44.
[10] This position of Theodore is referred to by Iso'dad of Merv, the ninth-century bishop of Hedatta (cf. Jansma, "Early Syrian Fathers," p. 105); see also Severianos of Gabala, *De mundi creatione*, oratio 1 (PG 56, cols. 434–36) and Theodoret, *QuaestGen* 8 (PG 80, col. 89).

[11] *QuaestGen* 8 (PG 80, col. 89). Later, in the sixth century, Prokopios of Gaza, in his collection of interpretations of the Scriptures, refers to diverse views on the subject (PG 87, cols. 45–47).

[12] Kronholm, *Motifs from Genesis*, p. 43.

[13] Cf. Ephrem, *CommGen* 1:7 (Ephraem, *In Genesim et in Exodum commentarii*, ed. Tonneau, p. 7): "After [Moses] had spoken of the darkness which was spread upon the face of the deep, he further said: 'The wind of God brooded upon the face of the waters.' However, although some people . . . understand it as the Holy Spirit, and attribute to it a creative activity on the basis of what is written in this place, the faithful [Christians] do not connect it with Him" (trans. Kronholm, *Motifs from Genesis*, p. 43).

[14] John Chrysostom, *HomGen* 3:4: "What is meant by that part of the text, 'The Spirit of God moved over the water'? It seems to me to mean this, that some life-giving force was present in the waters: it wasn't simply water that was stationary and immobile, but moving and possessed of some vital power" (John Chrysostom, *Homilies on Genesis 1–17*, ed. Hill, p. 41).

[15] For the Jewish views, see, e.g., TargN, TargPs-J, TargOnk, and Fragment-Targums on Gen 1:2 (*Targum Genèse*, ed. Le Déaut, pp. 74–75; *Targum Onqelos to Genesis*, ed. Grossfeld, p. 42; *The Fragment-Targums of the Pentateuch According to Their Extant Sources*, ed. M. L. Klein [Rome, 1980], vol. 2, pp. 3, 90): here the spirit of God is a wind or a spirit of love blowing upon the surface of waters.

[16] The weight of the argument of the spirit above the waters in the Syrian exegesis is considered by L. Van Rompay, "Iso'bar Nun and Iso'dad of Merv: New Data for the Study of the Interdependence of Their Exegetical Works," *OLP* 8 (1977), pp. 231–38.

[17] In Christian thought the waters of the abyss take on the meaning of waters of death, especially in the baptismal liturgy; see P. Lundberg, *La typologie baptismal dans l'ancienne Église* (Leipzig, 1942), pp. 70–71; H. A. Kelly, *The Devil at Baptism: Ritual, Theology, and Drama* (Ithaca, 1985).

[18] This personification often occurs in representations of the Anastasis and the dead saved in Christ; cf., e.g., the marginal illustration to Psalm 12 in the Vatican Psalter, gr. 752, fol. 44v (E. T. De Wald, *Vaticanus Graecus 752* [The Illustrations in the Manuscripts of the Septuagint, vol. 3, Psalms and Odes, pt. 2 (Princeton, 1942)], pl. 19). See also the similar representations of Hades in the Utrecht Psalter, e.g., on fols. 66r and 67r (E. T. De Wald, *The Illustrations of the Utrecht Psalter* [Princeton, 1932], pls. 104, 105). Uspenskii (pp. 109–10) explains the head as the spirit of God upon the waters of Gen 1:2.

[19] Cf. the image of Hades on sarcophagi and in Byzantine miniatures: Weitzmann, *Greek Mythology*, p. 46, figs. 49, 51. It also occurs in marginal Psalters: Corrigan, *Visual Polemics*, pp. 11–12. The caves and head might also recall the Neoplatonic and Christian theme of the cave in which man dwells in darkness before the coming of Christ. See St. Clair, "Narrative and Exegesis," pp. 197–98, with references to Christian writings.

Genesis 1:3–5

Separation of Light from Darkness

Whereas Laurent. displays a terse pictorial translation of the separation of darkness and light, the other Octateuchs introduce two personifications, Nyx (Night) in the darker zone and Orthros (Dawn) in the lighter one.[1] These classically fashioned personifications are connected with the naming of the darkness as night and the light as day by God in verse 5. The Genesis text does not mention the dawn.

1b. Laurent., fol. 1v (upper row, right)

Above the blue-white waters, inscribed ὕδατα and mixed with pieces of incomposite yellow-brown earth, is an area filled with two clouds set against a golden background: the one at the right, inscribed σκότος, is black, while the one at the left, bearing the inscription φῶς, is white. The white cloud originates in the neighboring scene where God sends out the light. Unlike the other Octateuchs, where the waters are depicted distinctly covering the earth, in this miniature, and even more clearly in the following one (fig. 1c), the painter mixed the images of earth and waters together, with a few peaks emerging from the surface of the waves.[2] Somewhat flaked.

21. Vat. 747, fol. 15r

Compared with Laurent., this composition is simplified by the omission of the waters, but at the same time is enriched by the personifications Night and Day placed within the black and white clouds and inscribed outside the picture frame with capital letters: NΎΞ and ʹΗΜΈΡΑ. Nyx, in black-blue grisaille, is represented as a woman in a long garment standing quietly and holding a windblown veil over her head, while Hemera, in light blue grisaille, is personified not as a woman, as one might expect, but as a boy in a short tunic, whose proper identification is most likely Orthros (Dawn). As in the case of Nyx, a veil flutters over the boy's head and twists around his arms, while one of his hands carries a candlelike torch and the other is raised in a gesture of amazement toward the hand of God, the author of creation, which protrudes from the segment of heaven to which the boy looks up.

Located after Genesis 1:5.

22. Ser., fol. 27v

Half the figure of Nyx is cut off by the frame. While νύξ is written in the left margin, traces of the inscription ἡμέρα are visible in the frame at the upper right. Badly flaked at various spots.

23. Sm., fol. 4v

The composition agrees with Vat. 747 in that Nyx is fully visible, and with that of Ser. in that Nyx is striding forward.

24. Vat. 746, fol. 20v

The inscriptions above the miniature read νύξ and ἡμέρα.
Very close to Ser. and Sm. and very rubbed.
Located in the catena; the text above is Genesis 1:5.

Lit.: Kondakov, *Istoriia*, p. 188; Kondakov, *Histoire*, vol. 2, p. 78; Tikkanen, "Genesi," pp. 218, 223; Strzygowski, *Sm.*, pp. 73–74, 114, pl. 32 no. 1; Uspenskii, pp. 110–11, figs. 12, 13; Hesseling, fig. 3; Neuss, *Katalan. Bibelill.*, p. 36; Buchthal, *Paris Ps.*, p. 42; Heimann, "Six Days," p. 272 n. 4; Willoughby, *McCormick Apocalypse*, vol. 1, p. 332; Weitzmann, *JR*, p. 90; Pijoán, *Summa artis*, vol. 7, p. 398, fig. 553; Garrison, "Creation and Fall," p. 208 n. 4; Hempel, "Traditionen," p. 56 n. 15; Sorensen, "Creation," fig. p. 424; Al-Hamdani, "Sources," p. 16; Blum, "Cryptic Creation Cycle," p. 216, fig. 4b; Kirigin, *Mano divina*, p. 99; Bernabò, "Laur. plut. 5.38," p. 140, pl. 1; Lassus, "Création," p. 100, fig. p. 95, pl. 2B; Bergman, *Salerno*, p. 15 n. 21; Anderson, "Seraglio," p. 105; Broderick, "Sarajevo Haggadah," p. 320, fig. 3; Mentré, *Création*, fig. p. 72, fig. p. 113; Weitzmann and Kessler, *Cotton Gen.*, p. 42; *Luoghi memoria scritta*, pl. 21 p. 148.

[1] A similar group, related to the text of the Ode of Isaiah (Isa 26:9) appears in the Paris Psalter recension (text fig. 23). Orthros and Nyx also appear also in the *Physiologos* formerly in the Evangelical School in Smyrna, p. 8 (Strzygowski, *Sm.*, pl. 1); in the latter case the group is unrelated to the text.

[2] Even if the pictorial sequence of the Creation scenes in Laurent. are closely related in a few details to Vat. 747—e.g., on fol. 14v (fig. 17), where similar sharp mountains are depicted, but covered by water—a different imagery may have played an influential role. Cf., e.g., Severianos of Gabala (*De mundi creatione*, oratio 1 [PG 56, col. 441]), who explicitly objected to the notion of waters covering the earth and preventing it from being seen; Severianos recalls the biblical translation of Aquila and concludes that the earth could not be seen because it was still lacking in ornament.

Genesis 1:7–8

Creation of the Firmament and Separation of the Waters

In the following miniatures the images of heaven and the firmament as a vault or dome are taken not from the description of creation in Genesis but rather from Isaiah 40:22; the vault is found in Christian authors, such as the second-century Antiochene Theophilos and the fourth-century Basil,[1] and also in Jewish texts such as the Genesis Rabbah, the rabbinic commentary completed around A.D. 400.[2]

1c. Laurent., fol. 1v (middle row, left)

The firmament, inscribed στερέωμα, forms a light blue arch over the white-blue water, which contains, as does the preceding miniature of this manuscript, circular waves intermingled with pieces of brown uncompounded earth, representing five or six mountain peaks emerging from the sea. A golden zone suggesting the sky separates this mixed mass of water and earth from the firmament, whereas the water above, inscribed ὕδατα, borders directly on the arch and fills its spandrels. The waters are circular cloudlike heaps, resembling the representation in one of the previous miniatures of Vat. 747 (fig. 17).

25. Vat. 747, fol. 15v

The compositional scheme is very close to that of Laurent., except that the firmament, painted light green, forms a border strip and is not separated from the water below by a zone of sky. The lower part of the miniature is very badly flaked.

Located in the catena between Genesis 1:8 and 1:9.

26. Ser., fol. 28r

The main divisions correspond to those in Laurent. and Vat. 747: first a zone of blackish brown earth with an outlined hill[3] and light blue water that are already, to some extent, separated from each other in anticipation of the following verses; then the arch of the firmament painted dark blue, and, finally, above it an upper zone of light blue water. The illustrator added a huge heaven of conventional semicircular shape at the top. The introduction of this second zone of heaven led to a misunderstanding of the origi-

nal scheme, as can be seen from the inscriptions: the upper segment of heaven, which no longer divides the two zones of water, is inscribed at the right margin στερέωμα ἤτοι οὐρανός; and by labeling the whole middle zone ὕδωρ ὑποκάτω τοῦ στερεώματος the scribe apparently mistook the original στερέωμα for another zone of darker colored water. Alongside the lowest strip is written γῆ. Various parts, particularly the upper zone of heaven, are heavily flaked.

Located beside Genesis 1:6.

27. Sm., fol. 5r (see also text fig. 53)

The miniature, which is very close to Ser., is somewhat flaked in the lower portion.

Located in the catena; the text above is Genesis 1:8.

28. Vat. 746, fol. 22r

The composition is very close to Ser. and Sm., but unlike in Ser. the scribe was aware of the original meaning of the various zones. Not explaining the added semicircular segment of sky at all, he inscribed the upper zone of water ὕδωρ–ἄνω τοῦ στερεώματος, the arch of the firmament στερέωμα–ἤτοι οὐρανός, the lower water zone ὕδωρ ὑποκάτω τοῦ στερεώματ(ος), and the earth γῆ.

Located in the catena, between Genesis 1:8 and Genesis 1:9.

Lit.: Tikkanen, "Genesi," p. 223; Ainalov, *Hellenistic Origins*, pp. 47–48, fig. 24; Uspenskii, p. 111; Hesseling, fig. 4; Blum, "Cryptic Creation Cycle," pp. 217–18, fig. 7a; Bernabò, "Laur. plut. 5.38," p. 137, pl. 1; Lassus, "Création," pp. 103–5, 107, drawing p. 102, figs. pp. 95, 101; Hahn, "Creation," p. 37, fig. 9; Bergman, *Salerno*, p. 16; Broderick, "Sarajevo Haggadah," fig. 4; Mentré, *Création*, fig. p. 72, fig. p. 73; Wolska-Conus, "Topographie Chrétienne," p. 167, fig. 7; Bernabò, "Esegesi patristica," p. 55; Lowden, *Octs.*, fig. 1; *Luoghi memoria scritta*, pl. 21 p. 148.

[1] Theophilos, *Ad Autolycum* 2:13 (*Theophilus of Antioch: Ad Autolycum*, ed. and trans. R. M. Grant [Oxford, 1970], p. 48); Basil, *Hex* 3:4 (*Homélies sur l'Hexaéméron*, ed. Giet, pp. 202–5). Notice that Basil imagines the firmament as a concave vault, but with a flat upper surface or roof, different from the representations in the Octateuchs.

[2] GenR 4:5 (*Midrash Rabbah*, ed. H. Freedman and M. Simon, vol. 1, *Genesis*, ed. H. Freedman [London, 1939], p. 30); *Genesis Rabbah*, ed. Neusner, pp. ix–x.

[3] According to Hahn ("Creation," p. 37), the hill as well as the firmament (depicted as a wavy horizontal band) and the upper heaven (depicted as a larger arched band cutting the firmament at its edges) were borrowed from an illustrated copy of the *Christian Topography* of Kosmas Indikopleustes sometime after the creation of the text in the sixth century; these illustrations replaced the original ones in Ser., Sm., and Vat. 746. Hahn's assumption is rejected by Wolska-Conus ("Topographie Chrétienne," p. 167).

Genesis 1:9–10

Separation of the Seas and the Dry Land

1d. Laurent., fol. 1v (right scene, center)

The lower zone of this miniature shows clear separation of the water, inscribed θάλαττα, from the dry land, which is repre-

sented as a chain of mountains with sharp peaks surrounding the sea as if it were a lake. Three small islands are located in the water. The pointed silhouettes of these mountains are comparable to those found in Vat. 747 (fig. 17), where the incomposite earth covered by the waters is represented by three high unadorned peaks. The upper part of the miniature is an exact repetition of the preceding scene in this manuscript: the earth is set against a golden background, above which the sky, now inscribed οὐρανός (following Genesis 1:8, where God calls the firmament "heaven") forms an arch and is at the same time a line of division setting off the upper zone of water, inscribed ὕδατα. This miniature and the two previous ones on the same folio display a feeling for spatial depth which has no parallel in the other four manuscripts, where the illustrations for Genesis 1 are normally flat zones of superimposed elements. Somewhat flaked.

Lit.: Tikkanen, "Genesi," p. 223; Bernabò, "Laur. plut. 5.38," p. 140, pl. 1; Mentré, *Création*, fig. p. 72; Bernabò, "Esegesi patristica," p. 55; *Luoghi memoria scritta*, pl. 21 p. 148.

Genesis 1:9–12

SEPARATION OF THE SEAS AND THE DRY LAND; CREATION OF THE PLANTS

Unlike Laurent., which depicts the separation of the waters from the dry land and the appearance of plants and fruit trees on the earth in two distinct miniatures, the other Octateuchs merge these two scenes into a single composition of unusual shape. (Concerning the firmament as a concave vault, see the introductory comment at Genesis 1:7–8 [nos. 1c, 25–28]). The position of the outlets of the inner sea in the representation of the earth makes it evident that the copyist was inspired by a cartographic representation of the Mediterranean stemming from the same tradition as that of the map in manuscripts of the *Christian Topography* of Kosmas Indikopleustes (text fig. 7).[1] Here, too, the Mediterranean is much simplified and schematized in comparison with the older maps of Ptolemy[2] and has two outlets like the one in Laurent., fol. 2v (see fig. 2): the one at the left marks the Straits of Gibraltar, and the other, at the lower right, indicates the Red Sea or the Nile; both of them flow into the surrounding ocean.

29. Vat. 747, fol. 16r

The inscription, outside the miniature at the upper left, reads: τὸ ὕδωρ τὸ ὑποκάτω τοῦ οὐρανοῦ.

In the upper rectangle on the left, the arched heaven separates two zones of water represented as heaps of clouds. A stream of water falls down from this rectangle to the ocean (inscribed ὠκεανός–ἤτοι ἡ τῶν ὑδάτων μία συναγογή) surrounding the dry earth. The earth is divided in the center by a bizarrely shaped sea with its upper border forming a lunette and with two outlets at the left and bottom. Flowers and trees of a rather uniform character are planted all over the surface of the earth. For a description of the map, see the commentary on the more detailed representation at no. 33.

Located in the catena and beside and below Genesis 1:10.

30. Ser., fol. 29v

In the upper rectangle no semicircular segment of heaven divides the two zones of water, as it does in Vat. 747. The waters form a lake below heaven, from which a stream of water (inscribed τὸ ὕδωρ τὸ ὑποκάτω τοῦ οὐρανοῦ) pours down into the ocean (inscribed ὠκεανός) surrounding the earth. The junction between the heavenly waters and the ocean is more convincing here than in Vat. 747. Unlike Vat. 747, the outline of the earth here resembles a lunette and the inner (Mediterranean) sea is lacking. No definite scientific interest appears in this configuration of the world map, where the intention is to represent the beauty of the created world.[3] The roughly semicircular shape of the earth occurs a second time on fol. 31r (fig. 34);[4] thereafter in Ser., as well as in Sm. and Vat. 746, a rectangular earth surrounded by the ocean supplants the semicircular shape. Heaven and waters are heavily flaked.

Located below and beside Genesis 1:9.

31. Sm., fol. 5v

Very close to Ser., except that the semicircular heaven is placed in the left half of the page and consequently the water flows in the opposite direction to reach the ocean.

Located above and beside Genesis 1:11.

32. Vat. 746, fol. 23r

The inscriptions read: τὸ ὕδωρ τὸ ὑποκάτω τοῦ οὐρανοῦ, ὠκεανός, and ἤτοι ἡ τῶν ὑδάτων συναγωγή.

Very close to Sm. Partly rubbed and flaked.

Located in the catena and below Genesis 1:9.

Lit.: Tikkanen, "Genesi," p. 223; Ainalov, *Hellenistic Origins*, pp. 277–78, fig. 127; De Grüneisen, "Cielo," p. 492, fig. 14 p. 493; Uspenskii, p. 111, fig. 14; Hesseling, fig. 5; Redin, *Koz'my Indikoplova*, p. 117, fig. 94; Blum, "Cryptic Creation Cycle," pp. 217–18, fig. 7b; Bernabò, "Laur. plut. 5.38," pp. 140–43, pl. 6 no. 1, pl. 8 no. 1; Lassus, "Création," pp. 105–8, 144, drawing p. 104, pl. 2D; Mentré, *Création*, fig. p. 74; Wolska-Conus, "Topographie Chrétienne," pp. 167–69, fig. 9; Bernabò, "Esegesi patristica," p. 55.

[1] Cod. Vat. gr. 699, fol. 40v (Stornajolo, *Topografia Cristiana*, pl. 7); Sinai, St. Catherine, cod. 1186, fol. 66v (Weitzmann and Galavaris, *Sinai Greek Mss.*, color pl. 9a, fig. 136). On the relationship among the Octateuchs and the manuscripts of the *Christian Topography*, see Redin, *Koz'my Indikoplova*; Brubaker, "Tabernacle," pp. 73–92; Hahn, "Creation," pp. 105–8; Lowden, *Octs.*, pp. 86ff.; Wolska-Conus, "Topographie Chrétienne," pp. 161–70. The geographic views found in Kosmas were widespread in Byzantium, as proved by the numerous Byzantine manuscripts of the geographical hexameters of Dionysios Periegetes, where we also encounter a description of the world surrounded by the ocean and with gulfs and long rivers recalling the depictions in Laurent. and Vat. 747 (figs. 2, 29, 33, 37, 40) (*Orbis descriptio*, in *Geographi Graeci Minores*, ed. K. Müller, vol. 2 [Paris, 1861], pp. 104–5, vv. 3–11). A similar map is described by the thirteenth-century Syrian writer Bar Hebraeus (Gregory Abū'l-Faraj) in his commentary on Gen 1:9: "the all-embracing gathering of waters, that is, the sea, Oceanus. And from it bays enter into the midst of the habitable (earth), such as the Adriatic Sea" (*Barhebraeus' Scholia*, p. 11).

[2] A comparatively great number of codices of Claudius Ptolemy's *Geography* are known and, although they are not older than the thirteenth century, an archetype from the second century may be hypothesized (Weitzmann, *Ancient Book Ill.*, pp. 128–29, with older bibliography). A relationship

between the Vat. 747 maps of the earth (especially in the following miniatures with the creation of birds, fishes, and terrestrial animals) and Ptolemy has been assumed also by Grabar ("Ciel," pp. 12–13). See also Strzygowski, *Sm.*, p. 74.

[3] A religious rather than a scientific approach to the representation of the terrestrial world may be observed in most of the pictures considered by Maguire, *Earth and Ocean*, pp. 17ff.

[4] A similar roughly semicircular map of the world appears in the manuscripts of the *Christian Topography* preserved in the Biblioteca Medicea Laurenziana, cod. plut. 9.28, fol. 93r, and in the Monastery of St. Catherine at Sinai, cod. gr. 1186, fol. 67r (Wolska-Conus, *Cosmas*, vol. 1, p. 187, and Weitzmann and Galavaris, *Sinai Greek Mss.*, p. 54, fig. 137), but here, according to Wolska-Conus ("Topographie Chrétienne," p. 169, and *Cosmas*, vol. 1, p. 181) the painting is more closely connected to the representation in Vat. 747, fol. 16r (see fig. 29).

Genesis 1:11–12

Creation of the Plants

1e. Laurent., fol. 1v (bottom row)

A range of variegated mountains with craggy peaks is covered with a great variety of flowers, shrubs, and trees, among them apple trees, date palms, and a giant vine on one of the peaks, silhouetted against a golden sky.[1] Such a representation of the created world can hardly be compared with the analogous scenes in Vat. 747, Ser., Sm., and Vat. 746, the only similarity being the representation of the paradisiacal world as an idealized row of trees and bushes. The Laurentian miniature is undoubtedly alien to the generally scientific appearance of the preceding or following miniatures in the picture cycle of the same manuscript.[2] Moreover, the brilliant green and bluish green colors of the mountains are applied uniformly. In the previous scenes, on the contrary, the different tones of the blue and white strokes of the brush give the water a more illusionistic appearance. The central mountain is inscribed ἡ γῆ. Considerably flaked.

Lit.: Tikkanen, "Genesi," p. 223; Bernabò, "Laur. plut. 5.38," p. 140, pl. 1; Mentré, *Création*, fig. p. 72; *Luoghi memoria scritta*, pl. 21 p. 148.

[1] Comparable views of paradisiac landscapes of the created world before the Fall appear in a few pictures dating from the Early Byzantine period, especially floor mosaics (Maguire, *Earth and Ocean*, pp. 17ff., 21–24, figs. 10–12), the best known being the mosaic in the basilica of Doumetios at Nikopolis from the second quarter of the sixth century (Kitzinger, "Nikopolis," pp. 95–108, figs. 18, 19). A similar view occurs in the world map of Kosmas discussed at nos. 29b and 41.

[2] The same shift occurs in the mosaics of San Marco, where the "scientific" sequence is interrupted exactly at the separation of the waters from the dry land, as in Laurent.; similarly, the ornamented earth is a row of trees (Demus, *Mosaics of S. Marco*, vol. 2, pt. 2, pl. 112; see also the preserved watercolor of the Cotton Genesis, where the plants were arranged in two rows: Weitzmann and Kessler, *Cotton Gen.*, pl. 1 no. 1, fig. 7).

Genesis 1:14–18

Creation of the Heavenly Bodies

2. Laurent., fol. 2v

The sky is set against a golden background and formed like an arch resting upon the earth, recalling the dome of a ciborium

over an altar. Painted in light blue, it is densely studded with golden stars and encloses the light blue moon at the left and the red sun at the right, which contain medallion heads facing each other. The earth is planted with flowers and trees, entirely surrounded by the ocean, and cut by an arm of the sea which, as in the miniature of Vat. 747 (fig. 29), is reminiscent of the Mediterranean with one outlet at the left and another at the lower right. Greece, Italy, Anatolia, and the Black Sea are easily recognizable. Another wide gulf, which is probably the Red Sea (also found in Vat. 747 [fig. 33]), cuts the circumference at the lower left.[1] However, unlike in Vat. 747, the earth has a semicircular shape. The sky is almost entirely flaked, and sections of the water and earth are likewise heavily damaged. For a discussion of the map of the earth, see no. 29 above; and for the form of the firmament as a concave vault, see the introduction to Genesis 1:7–8 (nos. 1c, 25–28).

Located in the right column of the text, between Genesis 1:19 and 1:20.

33. Vat. 747, fol. 16v

The compositional scheme is very close to that in Laurent., differing only in that the planted earth has the form of a disk, possibly suggesting the world as a sphere.[2] The disk form of the earth allows a somewhat more distinct rendering of the Mediterranean at its center and permits the sky to rest immediately on the earth without an intermediary zone. The sky is painted a light grayish green, the stars red. The positions of sun and moon, which intersect the frame, are interchanged, with the sun at the left and the moon at the right. In comparison with the previous miniature in the same codex, this map of the Mediterranean Sea is somewhat altered on the eastern side, where Anatolia is a comparatively smaller peninsula extending into the sea and thus forming a broad sheltered bay. The Iberian and Italian peninsulas, Greece, the Sea of Marmara, the Black Sea, Anatolia, the coast of Syria and Palestine, the Red Sea or the Nile, the North African coast with the Gulf of Gabes, and a large protruding Tunisia are all recognizable on the map;[3] a huge unidentified lake or internal sea occupies the central Sahara. Flaked in various spots.

Located below Genesis 1:19.

34. Ser., fol. 31r

The sky, studded with gold and white stars (two of which are considerably brighter than the others), no longer rests upon the earth like a baldachin, as in Laurent. and Vat. 747, but hangs down from above and has the more conventional semicircular shape. The moon and sun, inscribed σελήνη and ἥλιος, intersect the segment of heaven and are filled with busts turning their backs to each other. The solid earth, which is not cut by a body of water, appears as a row of trees and plants on a roughly semicircular island. In the surrounding ocean two heads painted in grisaille appear in the lower corners. These are most likely intended to represent Okeanos and Thalassa. The arrangement of the miniature resembles the Nikopolis mosaic[4] and other related representations of the earth.[5] As in the previous miniature in this manuscript, as well as in Sm. and Vat. 746, scientific attention is supplanted by a less definite view of the created world; consequently, we are led to believe that the painter bor-

rowed this picture from a source different from that of Vat. 747. The miniature lacks a frame, so that the heavenly and earthly zones appear as two separate units.

Located in the catena; the nearest text, Genesis 1:19, is on fol. 30v.

35. Sm., fol. 6r

The sun and moon are placed at different levels, as in Laurent., but otherwise the miniature agrees well with Ser.

36. Vat. 746, fol. 24v

The inscriptions read σελήνη and ἥλιος.

Very close to Ser. and Sm., but with two more distinct rows of trees and with a fig tree in the upper row. A brighter star is visible in the right lower corner of heaven. Considerably rubbed.

Located in the catena; the nearest previous text is Genesis 1:18.

Lit.: Uspenskii, p. 111, figs. 15, 16; Hesseling, fig. 6; Henderson, "Sources," p. 12, pl. 4 no. 3; Schade, *Paradies*, pp. 102–3, pl. 8; Blum, "Cryptic Creation Cycle," pp. 217–19, figs. 7c, 8a, 8b; Bernabò, "Laur. plut. 5.38," pp. 138, 141, 143, pl. 2, pl. 6 no. 2; Wolska-Conus, "Géographie," cols. 188–89; Lassus, "Création," pp. 108–11, 145, drawing p. 110, figs. pp. 106 and 109, pl. 2c; Broderick, "Sarajevo Haggadah," p. 325, fig. 5; Mentré, *Création*, fig. p. 77; Wolska-Conus, "Topographie Chrétienne," pp. 161–70, fig. 6.

[1] Hahn ("Creation," p. 32 n. 14), however, claims that Laurent. must be related to Ser., Sm., and Vat. 746 rather than to Vat. 747. See also Wolska-Conus, "Topographie Chrétienne," p. 167.

[2] The unique representation of the round earth in Vat. 747 was noted by Uspenskii (Uspenskii, p. 111), who also connected the four arms of the inner sea with the four rivers of Eden. Recently, Hahn ("Creation," p. 39) argued that the starry heaven surrounding the earth and the sun and moon in orbit around the earth suggest the spherical form of the world, an assumption rejected by Wolska-Conus ("Topographie Chrétienne," p. 164). Among the fourth-century Fathers, the spherical idea is firmly rejected by the Syriac Theodore of Mopsuestia (*Theodori Mopsuesteni Fragmenta Syriaca e Codicibus Musei Britannici Nitriacis*, ed. E. Sachau [Leipzig, 1869], pp. 7–8) and Severianos of Gabala (*De mundi creatione*, oratio 3 [PG 56, col. 452]).

[3] Cf. Wolska-Conus, "Géographie," col. 188, and "Topographie Chrétienne," pp. 164–65.

[4] Kitzinger, "Nikopolis," p. 92, figs. 18, 19.

[5] See note 1 in the introduction to Genesis 1:9–12 above. A similar image of the earth is found in Psalters in the British Library (Theodore Psalter, cod. Add. 19.352, fol. 174r; Der Nersessian, *Londres Add. 19.352*, fig. 276) and in the Vatican Library (Barberini Psalter, Barb. gr. 372, fol. 219v), discussed by Hahn ("Creation," pp. 31–32, n. 16, fig. 3).

Genesis 1:21

CREATION OF THE BIRDS AND MARINE CREATURES

3a. Laurent., fol. 3r

In principle, the scheme is the same as in the preceding miniature of this manuscript, showing the earth surrounded by the ocean, but the Mediterranean in the center is greatly enlarged to provide sufficient room for the representation of various fishes; vice versa, the earth has shrunk to a mere atoll, meagerly planted with flowers. In the center of each side this atoll is embellished with a golden medallion containing the bust of a wind god represented, alternatively, as a young man wearing a gray himation (left and right) and as an aged, bearded man wearing a red himation (top and bottom), each blowing a horn or flutelike instrument.[1] A considerable number of fish is imprecisely depicted in the sea, among them dolphins, a swordfish, and, in the foreground, a pair of identical sea monsters (the great whales of Genesis 1:21) facing one another. The latter are rendered as dragons with heads like wolves and coiled tails, like the *ketos*, the sea monster of antiquity, mentioned in the *Physiologos*.[2] The huge area of golden sky between earth and heaven is filled with a great many birds in flight. The arch of heaven is studded with stars which do not form an all-over pattern, as usual, but are arranged in groups suggesting constellations. In their midst appears the hand of God, largely flaked, sending down rays into the zone of sky. The sun and moon were represented in the corners of heaven but are now completely flaked, together with other sections of the surface near them, where some writing previously covered with paint has reappeared. The lower part of the miniature is also heavily damaged by flaking and only the gold zone is fairly well preserved.

Located in the left writing column, below Genesis 1:23.

37. Vat. 747, fol. 17r

The cartographic design of the oval, rather than circular earth is essentially the same as in the preceding miniature of this manuscript (fig. 33), and consequently only limited space is available in the narrow arms of the Mediterranean for some small fish. Moreover, there is no intermediary zone of sky between earth and heaven, and thus the birds had to be placed on the earth as well as among the constellations in the arched heaven, as in Laurent. Moreover, Laurent. and Vat. 747 have constellations instead of the all-over pattern of stars found in the other manuscripts and in the preceding miniature in Vat. 747. As is usual in this manuscript, the sun at the left and the moon at the right intersect the frame and face each other. The surface of the earth is very badly flaked. Sketches of animals may still be distinguished, including an elephant in the lower portion.

Located below Genesis 1:23.

38. Ser., fol. 32r

Instead of presenting a cartographic view of the earth, the illustrator has concentrated on the fish and birds, distributing them over two superimposed zones. This arrangement, which also occurs in Sm., is an anomaly compared with the previous and following miniatures in the same codices. A different and poorer variety of fishes (not yet mentioned in the text at this point) is portrayed in the ocean surrounding a rectangular earth filled with differentiated animals in the following Creation of the Terrestrial Animals. In the lower part the artist depicted not only various categories of fishes, such as dolphin, plaice, and swordfish, but also squid, octopus, crab, and various shellfish reminiscent of the aquatic life in ancient floor mosaics, while the

arrangement of the animals in roughly two rows, especially the birds in the upper half, recalls mosaics from the Late Antique and Early Christian periods and biblical pictures with the same subject (text fig. 33).[3] Likewise, in the representation of the birds in the upper zone the illustrator appears to have attempted to copy from his model various types such as heron, raven, quail, and others. The outcome is a rather naive picture, particularly in details of the marine creatures, and a much less accurate rendering of ornithological characteristics than in the corresponding Laurentian illustration. A segment of heaven with the stars in an all-over pattern appears above the earth, the moon at the left and the sun at the right intersecting the segment and facing outward.[4] The miniature is not framed and is somewhat torn around the lower edges.

Located below Genesis 1:23.

39. Sm., fol. 6v

The miniature shows some very slight variations in the detailed rendering of the fish and birds, but as a whole is very close to Ser.

Located below Genesis 1:23.

Vat. 746

Between folios 24 and 25 one leaf containing verses 18–25 is missing and in all probability included a miniature corresponding to those of the other Octateuchs.

Lit.: Uspenskii, pp. 111–12, fig. 17; Hesseling, fig. 7; Benson and Tselos, "Utrecht Ps.," p. 71, fig. 158; De Palol, "Broderie catalane," p. 199, fig. 14; Schade, *Paradies*, pp. 102–3; Mathews, "Leo Sacellarios," p. 113; Bernabò, "Laur. plut. 5.38," pp. 138, 141, pl. 3; Lassus, "Création," pp. 111–14, 145–46, pl. 2E and drawing p. 112; Hahn, "Creation," pp. 32, n. 14, 39–40, fig. 14; Grabar, "Ciel," pp. 12–13, fig. 10; Mentré, *Création*, fig. p. 93; Bernabò, "Adamo," pp. 28–29; Wolska-Conus, "Topographie Chrétienne," p. 167, fig. 8; Büchsel, "Schöpfungsmosaiken," pp. 37–39, fig. 13; Bernabò, "Tre studi," p. 108, fig. 5.

[1] Wind gods blowing horns in medallions appear in the representation of the Creation of the Animals in Ser. and Sm. (figs. 54, 55). Unlike Laurent., however, all four gods are young, nude, and glabrous; moreover, three of the medallions are upside down (for a discussion of this anomaly see below at nos. 41 and 42). In Laurent. the two aged wind gods blow a flutelike instrument, while the other two have horns.

[2] Weitzmann, *SP*, p. 207. A whale portrayed with the same features appeared on page 59 of the *Physiologos* formerly in Smyrna (Strzygowski, *Sm.*, p. 35); a second is in the Laurentian and Sinai copies of the *Christian Topography* of Kosmas, where it is identified as a phocas or seal (Florence, Biblioteca Medicea Laurenziana, cod. plut. 9.28, fol. 269v; Sinai, cod. gr. 1186, fol. 202v; see Hahn, "Creation," p. 34, fig. 6; Weitzmann and Galavaris, *Sinai Greek Mss.*, fig. 181). Four similar whales illustrate Basil, *Hex* 7:6, in the manuscript of the *Sacra Parallela* of John of Damascus in Paris (Bibl. Nat., cod. gr. 923, fol. 247v; Weitzmann, *SP*, fig. 551).

[3] Lassus ("Création," pp. 113–14) observes that this arrangement in two rows is similar to the corresponding scene in the cycle of San Marco in Venice (Demus, *Mosaics of S. Marco*, vol. 2, pt. 1, color pl. 33), but none of the birds and fishes in Ser. or Sm. resembles those in San Marco, which are more accurately drawn (see also Weitzmann, "Genesis Mosaics," p. 110), while the miniatures in Ser. and Sm. recall Late Antique mosaics from Africa. The arrangement in two superimposed rows also occurs in other members of the Cotton Genesis family, such as the ivory paliotto in

Salerno (Kessler, "Ivory Plaque," p. 85, fig. 18), and the Bible of Leo Sakellarios, Rome, Bibl. Vat., cod. Reg. gr. 1, fol. IIr. On the hypothetical relation between the mosaic in San Marco and the Octateuch illustration, see Büchsel, "Schöpfungsmosaiken," pp. 37–39.

[4] The presence of a similar but smaller segment of heaven at the top of the corresponding mosaic of San Marco has been related to Basil, *Hex* 8:7, by Weitzmann and Kessler, *Cotton Gen.*, p. 51.

Genesis 1:24–25

CREATION OF THE TERRESTRIAL ANIMALS

3b. Laurent., fol. 3r

The illustrator filled two-thirds of the narrow panel with verdant land and distributed various species of animals over it, reserving the remaining space for the golden sky and a small segment of heaven from which the hand of God emits life-giving rays toward the earth. Although more than half the earth's surface is flaked, the general arrangement is still recognizable, thanks in part to the preliminary drawing which has reappeared. The animals were arranged in five rows: beginning in the bottom row, one recognizes an elephant at the left, a stag or a deer[1] and a pair of lions at the right (in the middle a long-necked quadruped has almost completely disappeared); the second row has a scaly monster with a long neck coiling backward,[2] a hare, a crouching quadruped (probably a bear), a walking lobster-red unicorn and probably traces of a peacock; the third contains a griffin, a pair of horses (one of them grazing),[3] the remains of an attacking chimera,[4] and above it a light blue, proud horse; the middle of the fourth row is destroyed and only a boar at the left, the tail of a fox in the middle, and a camel at the right remain discernible; the fifth and final row shows, in addition to a squirrel at the right, various kinds of birds: one or two ducks, one or two storks pecking the ground with their red bills, and a cock. These birds are placed among high trees whose tops, silhouetted against the golden sky, contain nests where other birds live; on the first tree at the left may be recognized a heron with its long neck bent backward. It should be noted that some land animals are not in proportion with others, suggesting that the painter did not find all his models in a single source.

Located in the right writing column below Genesis 1:25.

40. Vat. 747, fol. 17r

The cartographic view of the earth with a fish-filled Mediterranean in the center is retained, leaving only limited space on the surrounding land for the depiction of the quadrupeds. Unfortunately the miniature is so thoroughly flaked that only a few traces of the animals are still recognizable: the heads of a lion or a wild boar and an elephant. The earth has a circular form as in the previous miniature, and is thus distinguished from Ser. and Sm.

Located in the catena beside Genesis 1:24.

41. Ser., fol. 32v

The earth is represented as a rectangle with a very schematized Mediterranean Sea in the center adjoining, as usual, the sur-

rounding ocean at the left. While the central arm of water contains only small fishes, larger ones are depicted in the ocean that fills the space between the hippocamp-like sea monsters[5] in the four corners and four medallions in the center of each side. These medallions enclose nude busts of wind gods blowing horns, three of them portrayed upside down in a fashion similar to those that the illustrator of Laurent. depicted in the creation of fishes and birds (cf. fig. 3, left). The newly created quadrupeds inhabiting the earth are a sheep, crouching ox, lion, elephant, and stag below the sea, a hare and leaping fox above it, and a bear in the upper right corner. Another crouching animal resembling a bear was erroneously placed in the right arm of the ocean. The map of the earth in Ser., as well as in Sm., differs greatly from the corresponding representation in Vat. 747, where the earth is circular. The pictures in Ser. and Sm. refer to the same tradition as the map of the earth in the manuscripts of Kosmas Indikopleustes (text fig. 7)[6] and in the previously mentioned sixth-century mosaic in Nikopolis.[7] Finally, some of the animals in Ser., particularly the fox leaping and the gazelle lifting its leg, have been copied from heterogeneous sources, viz., either illustrated manuscripts of the *Physiologos* or, again, of Kosmas (text fig. 9),[8] or an animal catalogue in mosaic pavements.[9] Flaked in a few places.

Located below Genesis 1:26.

42. Sm., fol. 7r

The miniature is very badly flaked, but to judge from what is recognizable it must have been nearly identical to Ser.

Vat. 746

In all probability a corresponding miniature was on the missing leaf, which we assume also contained an illustration of the creation of the fishes and birds.

Lit.: Strzygowski, *Sm.*, p. 114; Uspenskii, p. 112, fig. 18; Hesseling, fig. 8; Muñoz, "Rotulo," p. 477; Wolska-Conus, *Cosmas*, vol. 1, pp. 137–38, fig. 45 p. 230; Bernabò, "Laur. plut. 5.38," pp. 138, 141–2, pl. 3, pl. 8 no. 2; Wolska-Conus, "Géographie," cols. 187–88; Hahn, "Creation," pp. 29–36, 39, figs. 1, 13; Lassus, "Création," pp. 115–16, pl. 2F; Grabar, "Ciel," pp. 12–13; Anderson, "Seraglio," p. 103; Maguire, *Earth and Ocean*, p. 23, fig. 14; Bernabò, "Adamo," p. 28; Wolska-Conus, "Topographie Chrétienne," pp. 161–70, 190, fig. 4.

[1] This quadruped may be identified by comparison with the well-preserved stag in identical posture in the Naming of the Animals on fol. 6r in the same manuscript (fig. 5, top row).

[2] The same monstrous quadruped is pictured in reverse in the Naming of the Animals (fig. 5, top row).

[3] A similar grazing horse may be seen in the Naming of the Animals (fig. 5, top row).

[4] The painter adapted the same model again for the better preserved chimera depicted in the Naming of the Animals near the right edge (fig. 5, top row). A similar model was used by the painter of the Gregory manuscript in Jerusalem, cod. Taphou 14 (fol. 309v), for the group of Bellerophon attacking the chimera. A chimera, a griffin, and an elephant resembling the animals depicted in Laurent. appear in the mosaic pavements of the Great Palace in Constantinople, probably dating from the reign of Herakleios (610–41); see J. Trilling, "The Soul of the Empire: Style and Meaning in the Mosaic Pavement of the Byzantine Imperial Palace in Constantinople," *DOP* 43 (1989), pp. 27–72, esp. pp. 36ff., figs. 1, 23, 26;

Weitzmann, *Greek Mythology*, pp. 24–26, 83, fig. 23; and I. Spatharakis, "The Structure of Book Illumination," in *Bysans och Norden* (Akta för Nordiska forskarkursen i bysantinsk konstvetenskap 1986), ed. E. Piltz (Uppsala, 1989), p. 54.

[5] Sea monsters or whales are not mentioned at this point of LXX, but are in Gen 1:21 (they are correctly depicted in the creation of birds and fishes on fol. 3r in Laurent., fig. 3). Hahn compared these four whales with the illustration of a *ketos* in the Laurentian and Sinai copies of the *Christian Topography* of Kosmas; see note 2 at Genesis 1:21 above.

[6] Wolska-Conus, *Cosmas*, vol. 1, pp. 137–38, and "Géographie," col. 187; Hahn, "Creation," pp. 29–36. The features of the map in Ser., Sm., and the Kosmas manuscripts (Laur. plut. 9.28, fol. 92v; Vat. gr. 699, fol. 40v; Sinai, cod. gr. 1186, fol. 66v) are very similar, with the ocean surrounding the rectangular earth, the inner sea, and the four roundels with the wind gods. Hahn noticed that, for no apparent reason, three of the wind gods are drawn upside down; the anomaly appears in the same miniature in Kosmas, where the word ὠκεανός is inscribed upside down (ibid., p. 35). Hahn concluded that in the prototype of the two Octateuchs the original Creation of the Terrestrial Animals was replaced using the *Christian Topography* as a model. Disagreeing with Hahn, Wolska-Conus (*Cosmas*, vol. 1, pp. 134–37) argued that both the Octateuchs and the Kosmas maps stem from the same geographic tradition but do not depend on each other. For a rectangular map of the earth, see also the Ashburnham Pentateuch, fol. 1v (Gebhardt, *Ashburnham Pentateuch*, p. 11, pl. 2). See also note 2 at Genesis 1:14–18 above.

[7] Kitzinger, "Nikopolis," p. 92, figs. 18, 19.

[8] Hahn, "Creation," pp. 33–35.

[9] Regarding the catalogue of animals appended to the Sinai and Laurentian manuscripts of the *Christian Topography*, Wolska-Conus ("Topographie Chrétienne," pp. 186–91) suggests instead a dependence upon mosaic pavements or wall paintings in Late Antique and Early Christian buildings.

Genesis 1:26–27

CREATION OF MAN

Genesis has double narratives of the creation of man: the first is at verses 26–27 of chapter 1, where God creates man in his own image and likeness, male and female; the second, in two phases, is at verse 7 of chapter 2, where Adam, formed of the dust of the ground, is brought to life by the breath of God. Except for Laurent., where only Genesis 2:7 is illustrated (fig. 4), the Octateuchs illustrate these narratives with two pictures (figs. 43–46, 63–66) that are iconographically very similar. Both of these illustrations correspond to the two phases of the creation of Adam related in Genesis 2:7, namely the forming and the enlivenment of Adam: in the first picture, Adam lies motionless on the ground; in the second, he lifts up his arms and trunk. We cannot disregard the possibility that a lacuna occurred in the model at Genesis 1:26–27 and forced the painter to design a substitute for the lost illustrations by copying the two miniatures of Genesis 2:7.[1] More appealing, however, is the assumption that the painter intentionally employed the same pictures for these related narratives and responded ingeniously and implicitly to the many arguments concerning the double accounts of the creation, such as the "image and likeness" of the created man to his Creator and the creation of man described at two different moments and with different wording in Genesis (1:26–27 and 2:7).[2] The duplicate pair of pictures in the Octateuchs does not imply any discrep-

ancy between the description of God's act of making man at Genesis 1:26–27 and that of forming man out of dust at Genesis 2:7, a view advanced by some of the most prominent early Fathers, such as Origen and Basil. Origen claims that the man made in God's image and likeness at Genesis 1:26–27 cannot be corporeal, and that the corporeal man is the one formed of earth at Genesis 2:7;[3] on the grounds of Psalm 118:73, "Thy hands have made me and fashioned me . . . ," Basil agrees that God's hands made the interior man (the soul) at Genesis 1:26–27 and fashioned the exterior man (the body) out of earth at Genesis 2:7.[4] A striking parallel with the Octateuchs is found in the fourth-century Syrian Father Ephrem: the second chapter of Genesis, he insinuates, simply describes again more abundantly what is narrated briefly in the first chapter, and the part of the creation of Adam omitted in the latter is written in the former.[5]

Although they are related to Genesis 2:7, the two pairs of miniatures are not a literal rendering of the Septuagint: Adam is not physically fashioned by God from the dust of the earth, and the beam of light falling upon Adam's face supplants the life-giving breath God should breathe into his face. In the miniatures no angel receives the command to make man, as Jewish exegesis affirms in order to justify the plural of Genesis 1:26, and the agent of the creation of man is the three rays issuing from God's hand, an iconography which contradicts any claim by Arians and Jews on the dissimilarity of the three persons of the Trinity.[6] No anthropomorphism of the deity is asserted in the miniatures:[7] God does not model man with his hands, like a potter or bronze caster, as in the well-established tradition[8] which has a pictorial counterpart in other illustrated recensions of the Septuagint (text fig. 49).[9]

All of the views which these miniatures attempt to reflect are conveyed authoritatively by John Chrysostom in his eighth homily on Genesis, where he discusses the creation of man and defends the orthodox view against the views of Arius, anthropomorphists, and Jews.[10] A further element suggesting a parallel between John Chrysostom's imagery and the Octateuch miniatures is the pictorial rendering of Adam's shift from a lifeless state to his first animation, which is announced visually by his first movements, his rising from the ground and the stretching of his arms toward the divinity. This depiction impressively evokes the poetic imagery of John Chrysostom's twelfth and thirteenth homilies on Genesis, where he describes the just-formed Adam as a creature unable to use its limbs but endowed with the "breath of life," a vital force; his limbs responded to this force and obeyed his will.[11] Pictorially, the grayish violet, lifeless Adam recalls the lifeless human being lying on the earth in representations of the myth of Prometheus.[12] The elaborate spatial structures of both the Creation of Man and the Enlivenment of Man (figs. 47–50) suggest that both scenes had monumental pictures as their ultimate models.

43. Vat. 747, fol. 18v

Adam is depicted in a rigid attitude, his body painted a grayish violet color to indicate its lifelessness. He lies in the Garden of Eden, which is richly planted with shrubs and trees; several of them are cypresses, their trunks highlighted in gold. This vegetation fills the entire background up to a segment of heaven stud-ded with stars and including the medallion heads of sun and moon facing each other. From this same zone the hand of God emits rays toward Adam's face. Adam's body is severely damaged by flaking.

Located in the catena; the text above is Genesis 1:24.

44. Ser., fol. 35v

Adam, his eyes closed and his skin a natural reddish brown color, lies on the ground among fewer but mightier trees than in Vat. 747. The rays which strike his face emanate directly from the segment of heaven rather than from the hand of God, and the positions of sun and moon are interchanged from those of Vat. 747. The busts in the disks are depicted in frontal view, and a later hand has redrawn the outline of the moon and converted its rays into a cross-nimbus, thus altering the meaning of the bust to that of a youthful Christ Immanuel. Slightly rubbed and flaked.

Located in the catena; the text above is Genesis 1:26.

45. Sm., fol. 8v

Very close to Ser. but Adam's head and his shoulders are slightly raised from the ground. Very damaged by flaking.

46. Vat. 746, fol. 28r

The scene essentially agrees with Ser. and Sm. except that Adam erroneously has the same sand-colored skin as the enlivened figure in the following episode. Considerably flaked; the sun and the moon are almost completely rubbed.

Located in the catena; the text above is Genesis 1:26.

Lit.: Strzygowski, *Sm.*, p. 114, pl. 32 no. 2; De Grüneisen, "Cielo," p. 493; Uspenskii, pp. 112, 159, figs. 19, 20; Hesseling, fig. 9; Benson and Tselos, "Utrecht Ps.," p. 70, fig. 132; Menhardt, p. 295; Schmidt, *Sechstagewerkes*, p. 85; Weitzmann, *RaC*, p. 176; Henderson, "Sources," p. 13, pl. 5 no. 21; Schade, *Paradies*, pp. 103–4, 125–29, pls. 9, 11, 46; Wessel, "Adam und Eva," cols. 43–44; Vzdornov, "Illustraciia," p. 213, fig. 4; Lassus, "Création," pp. 116–18, fig. p. 117; Bernabò, "Laur. plut. 5.38," p. 152; Bergman, *Salerno*, p. 19; Kaiser-Minn, *Erschaffung des Menschen*, drawing 4; Brubaker, "Gregory of Naz.," p. 347; Weitzmann and Kessler, *Cotton Gen.*, p. 42; Bernabò, "Adamo," p. 13; Büchsel, "Schöpfungsmosaiken," pp. 68ff.; Zirpolo, "Ivory Caskets," p. 10.

[1] Schade (*Paradies*, p. 129) argues instead that the image of the Creation of Man in the Octateuchs corresponds to the narrative of Gen 1:26–27, rather than to that of Gen 2:7.

[2] The abstracts from the Fathers on these verses in the catena occupy more than nine folios in Vat. 746 (fols. 25v–29v). An anthology of arguments may be found in Alexandre, *Commencement*, pp. 169–99, and a discussion in Mc. L. Wilson, "The Early History of the Exegesis of Gen. 1.26," *StP* I (1957), pp. 420–37.

[3] Origin, *HomGen* I:13 (PG 12, cols. 155–56); Basil, *Hex* II:3–4. In a Jewish context, this view is found in Philo (cf. Alexandre, *Commencement*, pp. 185–86 and 180).

[4] *Hex* II:3–4 (*Basile de Césarée, Sur l'origine de l'homme*, ed. Smets and Van Esbroeck, pp. 230–34).

[5] Ephrem, *CommGen* 2:1 and 4 (Ephraem, *In Genesim et in Exodum commentarii*, ed. Tonneau, pp. 19, 20).

[6] GenR 8:4–5 and 17:4 (*Genesis Rabbah*, ed. Freedman and Simon, pp. 57–58, 135). The argument on this point between Jewish sages and Christ-

ian Fathers is traditional and is attested in the second century by Justin, *Dialogus cum Tryphone Judaeo* 62 (PG 6, col. 617).

[7] For a criticism of the anthropomorphism deduced from Gen 1:26–27, see John Chrysostom, *HomGen* 8:8, 11 (John Chrysostom, *Homilies on Genesis 1–17*, ed. Hill, pp. 109, 111).

[8] See Basil of Caesarea, *Hex* 11:2–4 and 14 (*Sur l'origine de l'homme*, ed. Smets and Van Esbroeck, pp. 228–35, 266–69), and Epiphanios, *AdvHaer*, haer. 64:18 (PG 41, col. 1100). Both Basil and Epiphanios seem to depend on Jer 18:1–6 and Rom 9:20ff.

[9] E.g., in the Cotton Genesis recension (Weitzmann and Kessler, *Cotton Gen.*, figs. 22–25).

[10] See esp. *HomGen* 8:6–12 (John Chrysostom, *Homilies on Genesis 1–17*, ed. Hill, pp. 107–12).

[11] "This body created in the Lord's design was like an instrument needing someone who can by his own skill and artistry raise a fitting hymn to the Lord through his own limbs, as though by the strings of the lyre. The text says: 'He breathed into him a breath of life, and the human being became alive.' What is the sense of that, 'He breathed a breath of life'? The body made this way, it is saying, he wanted to have a living force and be so directed; this became for the creature a living soul—in other words, full of movement, with the ability to display its own skill through the movement of its limbs" (*HomGen* 13:9 [ibid., p. 173]; see also 12:15 [ibid., pp. 165–66]).

[12] See Kaiser-Minn, *Erschaffung des Menschen*, pls. 22ff.

Genesis 1:26–27 (2:7)

ENLIVENMENT OF MAN

As discussed in the introduction to the previous miniatures (nos. 43–46), this picture is a duplicate of the one illustrating the Enlivenment of Man at Genesis 2:7 (figs. 4b, 63–66b).

47. Vat. 747, fol. 19r

Adam is depicted as in the previous miniature (fig. 43), sitting in the Garden of Eden, but under the influence of the divine rays he has come to life. He sits upright on the ground, drawing up his left leg and extending both arms toward heaven. His skin now has a sandy color. Slightly flaked.

Located in the catena; the text above is Genesis 1:26.

48. Ser., fol. 36v

Adam sits up although his legs are still rigid; his face is struck by rays emanating from the blessing hand of God which emerges from the tripartite heaven. In this miniature, as in the previous illustration in Ser. (fig. 44), the moon has been transformed into a bust of Christ Immanuel by a later restorer.

Located in the catena; the text above is Genesis 1:26.

49. Sm., fol. 9r

Very close to Ser., but the upper part of Adam's body is less erect. Severely damaged by flaking.

Located below Genesis 1:26.

50. Vat. 746, fol. 30r

Very close to Ser. and Sm. The figure of Adam is somewhat closer to Sm. than to Ser.

Located in the catena; the text above is Genesis 1:26.

Lit.: Kondakov, *Istoriia*, p. 188; Kondakov, *Histoire*, vol. 2, p. 78; Venturi, *Storia*, vol. 2, p. 466, fig. 325; Strzygowski, *Sm.*, p. 114, pl. 32 no. 3; De Grüneisen, "Cielo," pp. 457–58, 493, fig. 2 p. 453; Uspenskii, pp. 113, 159, figs. 21, 22; Hesseling, fig. 10; Woodruff, "Physiologus of Bern," p. 241, fig. 27; Schmidt, *Sechstagewerkes*, p. 85; Weitzmann, *RaC*, p. 176; Pijoán, *Summa artis*, vol. 7, p. 398, figs. 554, 555; Henderson, "Sources," p. 12 n. 4; Schade, *Paradies*, pp. 103–4, 125–29, pls. 10, 12; Wessel, "Adam und Eva," cols. 43–44; Bernabò, "Laur. plut. 5.38," p. 152; Lassus, "Création," pp. 117–19, fig. p. 119, drawing p. 120, pl. 3A; Bergman, *Salerno*, pp. 18–19; Anderson, "Seraglio," p. 88, fig. 3; Broderick, "Sarajevo Haggadah," p. 328; Mentré, *Création*, fig. p. 99; Weitzmann and Kessler, *Cotton Gen.*, p. 42; Sed-Rajna, *Hebraic Bible*, p. 12 n. 26; Alexandre, *Commencement*, fig. 14; Bernabò, "Adamo," p. 13; Friedman, "Angelic Creation," p. 89, fig. 17; Büchsel, "Schöpfungsmosaiken," pp. 32, 68ff., fig. 39.

Genesis 1:29

GOD GIVES ADAM PLANTS AND TREES

51. Vat. 747, fol. 19v

Adam walks through the Garden of Eden, where God has given him plants and fruits as food. The whole miniature has been overpainted, the landscape background being made more monotonous and the flowers more ornamental than in the previous miniatures. Large sections of the ground have flaked again.

Located in the catena; the text above is Genesis 1:26.

52. Ser., fol. 37v

Adam walks through the Garden of Eden, which is represented as a dense forest with two apple trees framing the figure in the center. Slightly flaked and stained.

Located in the catena; the text above is Genesis 1:26.

53. Sm., fol. 9v

Very close to Ser. Very flaked.
Located below Genesis 1:26.

54. Vat. 746, fol. 30v

Very close to Ser. and Sm.
Located in the catena; the text above is Genesis 1:26.

Lit.: Uspenskii, p. 113; Hesseling, figs. 9, 11; Menhardt, p. 295, fig. 5; Voss, *Millstätter Gen.*, pp. 69–70 n. 85; Schmidt, *Sechstagewerkes*, p. 85; Schade, *Paradies*, p. 179, pl. 46; Wessel, "Adam und Eva," cols. 43–44; Hutter, "Übermalungen," p. 140; Bernabò, "Laur. plut. 5.38," p. 152; Lassus, "Création," p. 121, pl. 2B; Bernabò, "Adamo," pp. 13, 29 n. 26.

[Genesis 1:28]

ADAM SOVEREIGN OF THE ANIMALS

The picture of Adam and the animals draws on Genesis 1:28, which reads, "And God blessed them, saying, Increase and multi-

ply, and fill the earth and subdue it, and have dominion over the fish of the seas and the flying creatures of heaven and all the cattle and all the earth, and all the reptiles that creep upon the earth." Expressing the sovereignty of man over the savage world, Adam dominates the animal kingdom, sitting in front of a row of wild beasts.[1] The picture, however, is not a literal illustration of Genesis 1:28, but duplicates the illustration for the naming of the animals at Genesis 2:19–20 (figs. 5, 79–82). Fishes and serpents, which are explicitly mentioned in the text, are in fact not pictured in this miniature; moreover, most of the beasts are represented in pairs, especially in Ser., Sm., and Vat. 746, a feature alluding to the naming of the animals at Genesis 2:20, where Adam is the only created being who has no companion. The pictorial sources of the miniature are Christian mosaics, bucolic representations, and, ultimately, zoological treatises; a bucolic representation clearly inspired the figure of Adam sitting as a shepherd.[2] The pair of deer half hidden by the trunk of a tree on the far right, an impossible view,[3] confirms that the scene was composed as a pastiche from distinct representations. It is noteworthy that the Adam-shepherd parallel suggested by this miniature entered Christian imagery.[4] Ephrem, for example, emphasized the similarities between the shepherd Adam and the Good Shepherd of the Gospels (see also the introduction to Genesis 2:19–20).[5]

55. Vat. 747, fol. 19v

The figure of Adam on the left is completely flaked, but the preliminary drawing makes it clear that he was sitting on elevated ground and pointing at the animals in front of him. In the first row an ox, a panther, a camel, and a lion are discernible; behind them is a group of woolly sheep and possibly goats; in the third row are two roes lying on the ground and, concluding the procession, an elephant. The female roe bows her head toward the legs of her companion, in the same loving attitude as the pair of roes in the corresponding miniature in the other Octateuchs, thus hinting at a common model, probably a mosaic pavement and ultimately a zoological treatise. Above the quadrupeds a great variety of birds is visible flying or resting on the high mountain peaks. The whole miniature has been overpainted, and this is particularly pronounced in the sharp brushstrokes of the mountain zone. Large sections have flaked again.
Located below Genesis 1:28.

56. Ser., fol. 37v

This miniature agrees with Vat. 747 in its general layout but differs sharply in detail. Four enormous fruit trees divide the forest into three glades. In the glade at the left a nude Adam sits under an apple tree above a misunderstood stream of water, which in the model was probably the spring of the four rivers of Eden flowing from the Tree of Life. Two dogs drink from the running water.[6] Adam looks at a heraldic eagle, while two doves stand immediately in front of him. In the central glade one can distinguish a horse between a pair of oxen, a lion, and a goat, followed by two foxes and a creature resembling a bear. In the third glade two sheep, a stag, and a deer are recognizable; a pair of wild

boars appears behind the tree at the far right. Numerous birds, which the illustrator made no attempt to differentiate, nest in the trees.
Located below Genesis 1:28.

57. Sm., fol. 9v

Except for some insignificant variations, very close to Ser. Considerably flaked.
Located below Genesis 1:28.

58. Vat. 746, fol. 31r

Very close to Ser. and Sm. and flaked in various places.
Located below Genesis 1:28.

Lit.: *Miniature*, p. 3 n. 10; Uspenskii, p. 113; Hesseling, fig. 12; Troje, ΑΔΑΜ *und* ΖΩΗ, p. 68 n. 2; Wessel, "Adam und Eva," col. 44; Schade, "Tiere," p. 224; Schade, "Adam und Eva," col. 50; Eller and Wolf, *Mosaiken*, fig. 30; Narkiss, *Golden Haggadah*, pp. 66, 71 n. 53; Canivet, "Mosaïque d'Adam," p. 62, n. 52; Muratova, "Iconografia," p. 173, fig. 3; Muratova, "Adam," pl. 5; Mathews, "Leo Sacellarios," p. 111, fig. 7; Bernabò, "Laur. plut. 5.38," p. 152; Lassus, "Création," pp. 121–22, fig. p. 122; Anderson, "Seraglio," p. 106; Konowitz, "Program," pp. 485 and 486 fig. 3; Sed-Rajna, *Hebraic Bible*, p. 12 n. 27; Bernabò, "Adamo," pp. 11–28, figs. 3, 4; Büchsel, "Schöpfungsmosaiken," p. 39; Iacobini, "Lettera," p. 91, fig. 1; Bernabò, "Caverna," pp. 721–22, fig. 12; Sed-Rajna, "Haggadah," p. 419.

[1] On this point, see the introduction to Genesis 2:19–20 (nos. 79–82).
[2] E.g., the *Vergilius Romanus,* cod. Vat. lat. 3867, fol. 6r, illustrating the Third Eclogue, with Menalcas, Damoetas, and Palaemon discussing (Rosenthal, *Vergilius Romanus*, pl. 2).
[3] A similarly unrealistic view of a pair of sheep half covered by a tree trunk is found in the *Vergilius Romanus* (cod. Vat. lat. 3867, fol. 1r; ibid., pl. 1).
[4] A similar Adam, sitting in front of a line of paradisiacal animals, is found in a mosaic in the baptistery of the diakonikon in the basilica of Moses on Mount Nebo, dating from about A.D. 530 (*Byzantinische Mosaiken aus Jordanien*, exh. cat., Schallaburg and elsewhere, September 1986–February 1988 [Vienna, 1986], pl. 2).
[5] *CommGen* 2:9 (Ephraem, *In Genesim et in Exodum commentarii*, ed. Tonneau, p. 23).
[6] On the symbolic meaning of the tree near the spring and the dogs, see Bernabò, "Adamo," p. 15.

Genesis 2:4–6

POND OF EDEN

The cartographic view of the earth is maintained in Vat. 747 but is replaced in the other manuscripts by a forest and a pond in the foreground,[1] recalling the replacements in the previous sequence of the creation of the cosmos. In Ser., Sm., and Vat. 746, aquatic birds and cranes in the pool recall the symbolism of the Fountain of Life in the manuscripts of the Gospels as well as Christian depictions such as the Baptism of Christ with a crane catching an eel in the Jordan (text fig. 31),[2] the Annunciation to the Virgin (text fig. 30),[3] and marshy landscapes with aquatic birds beside seated evangelists.[4] Similar representations of aquatic birds, connected with imperial symbolism, existed in the Baths

of Leo the Wise in Constantinople.[5] Thus, the miniature in Ser., Sm., and Vat. 746 appears to be a later replacement stemming from the impact of New Testament or imperial iconography on the cycle.[6]

59. Vat. 747, fol. 20r

The second chapter opens with a description of the primeval earth preceding the second narrative of Adam's creation. The earth is again represented cartographically, but here it is rectangular rather than round. It is surrounded by the ocean and intersected by the Mediterranean which, as well as the usual outlet to the west, erroneously has two to the south instead of one, i.e., the Nile (cf. figs. 29, 33, and 37). Moreover, besides the large lake occupying the central area of the Sahara, which has been moved westward, a second lake appears in the upper left corner of the map. The earth is densely covered with trees and flowers. The miniature's entire surface is heavily flaked.

Located below Genesis 2:6 and above the catena.

60. Ser., fol. 38v

Unlike in Vat. 747, here fish and birds have already been created: some birds perch in the trees, two ducks and some fish inhabit the pond, and two cranes with short bills stand on its bank, one bowing its neck backward in a characteristic way, the other catching an eel. The realistic postures of these cranes closely resemble those of the storks and herons in the Creation of the Animals in Laurent. (fig. 3, top row) and the heron in Ser. and Sm. (figs. 38 and 39). Moreover, the crane catching an eel contradicts Genesis 1:30, where God gives "every green herb for meat" to the created animals.

Located in the catena; the text above is Genesis 2:6.

61. Sm., fol. 10r

Although the miniature is very badly flaked, it is quite clear from the traces still visible that the composition resembled that in Ser.

Located above the catena.

62. Vat. 746, fol. 32r

Very close to Ser. Slightly flaked in the center.
Located in the catena; the text above is Genesis 2:6.

Lit.: Uspenskii, p. 113; Hesseling, fig. 14; Eller and Wolf, *Mosaiken,* fig. 31; Narkiss, *Golden Haggadah,* pp. 66, 71 n. 53; Bernabò, "Fonti testuali," p. 482, pl. 29 no. 1; Lassus, "Création," p. 123, pl. 3C; Anderson, "Seraglio," p. 106; Roma, *S. Maria di Anglona,* n. 34 pp. 114–15; Bernabò, "Adamo," pp. 13, 29 n. 26; Bernabò, "Esegesi patristica," p. 60, n. 42, fig. 9; Di Domenico, p. 142.

[1] Note that at Gen 2:6, TargN translates "a cloud went up from the earth and watered all the face of the earth" (*Neophyti 1: Targum Palestinense,* vol. 1, *Génesis,* ed. Díez Macho, Eng. trans. by M. McNamara and M. Maher, p. 500; see also *Targum Genèse,* ed. Le Déaut, pp. 84–85) and Targ-Onk: "a cloud would ascend from the earth and water the entire surface of the soil" (*Targum Onqelos to Genesis,* ed. Grossfeld, p. 44); these images are far removed from the Octateuchs. Eusebios of Emesa is well aware of the difference between the Greek and Aramaic versions in a fragmentary passage in PG 86, col. 556.

[2] E.g., in a mosaic on a vault in the inner narthex of the Kariye Camii in Istanbul (Underwood, *Kariye Djami,* vol. 1, pp. 113–14, and vol. 2, pls. 217, 219); the narrative is related to Jn 1:35–42.

[3] E.g., the twelfth-century icon in the Monastery of St. Catherine on Mount Sinai: see K. Weitzmann, "Eine spätkomnenische Verkündigungsikone des Sinai und die zweite byzantinische Welle des 12. Jahrhunderts," in *Festschrift für Herbert von Einem* (Berlin, 1965), pp. 299–312 (repr. in Weitzmann, *Sinai Studies,* pp. 271–87, with annotations on p. 432). On the presence of these aquatic birds, see H. Maguire, *Art and Eloquence in Byzantium* (Princeton, 1981), pp. 44ff.; and id., "The Classical Tradition in the Byzantine Ekphrasis," in *Byzantium and the Classical Tradition,* University of Birmingham Thirteenth Spring Symposium of Byzantine Studies, 1979, ed. M. Mullett and R. Scott (Birmingham, 1981), p. 101.

[4] In the presbyterium in San Vitale in Ravenna, for example, below the feet of Luke, Mark, and Matthew, storks or aquatic birds of the same family are seen in a marsh, while beside the feet of John a pair of ducks swims in a small pond, just as in the Octateuchs. Long-legged birds in streams are represented beneath the evangelists in the Vivian Bible from Tours (fol. 329v; see Kessler, *Tours,* pp. 55–56, figs. 49, 84).

[5] P. Magdalino, "The Bath of Leo the Wise and the 'Macedonian Renaissance' Revisited: Topography, Iconography, Ceremonial, Ideology," *DOP* 42 (1988), p. 108.

[6] For the Fountain of Life and the symbolism of aquatic birds and cranes, see Underwood, "Fountain of Life," pp. 77–78; for a more detailed discussion of the iconography of the Octateuch miniature, see Bernabò, "Esegesi patristica," p. 60.

Genesis 2:7

CREATION AND ENLIVENMENT OF MAN

The following two miniatures duplicate the sequence of the Creation of Man illustrating Genesis 1:26–27, discussed above (nos. 43–50), except for the absence here of the busts of Sun and Moon.[1]

4a, b. Laurent., fol. 4r

In illustrating the first phase of the creation, i.e., the formation of man out of dust, the painter of Laurent. depicted Adam lying lifelessly, comparatively less rigid and anatomically more accurate than in the other Octateuchs. His nude body is classically modelled with strokes of chiaroscuro. The rays, replacing the breathing of life of Genesis 2:7, emanate from God's blessing hand, visible in a segment of star-studded heaven, and strike Adam's closed eyes but have not yet brought him to life. The richly planted garden is set against a golden sky. Placed diagonally in the lower left corner of the upper scene in this two-tiered miniature and painted again in the right part of the lower scene is a small stream originating in Eden. Adam first lies on the left bank of the stream, then, having crossed it, sits on the opposite bank.[2] The small flow of water is what survives from an original illustration of either the pond of Eden (Gen 2:6) or, more probably, of the river flowing out of Eden (Gen 2:10). The four rivers of Eden have been moved by the painter from their proper place in the narrative to the following miniature on fol. 6r (see no. 5e).

In the Enlivement, the second phase of the creation depicted in the lower half of the miniature, Adam sits on the ground with the upper part of his body erect and one leg drawn up. He raises both hands in a gesture of prayer toward the life-giving ray emanating from the blessing hand of God in a segment of star-studded heaven.

Located above Genesis 2:4.

63. Vat. 747, fol. 20v

This manuscript contains an entirely overpainted miniature with only the second phase of the creation sequence and with an iconography different from that in the other Octateuchs. The restorer changed the expression on Adam's face and schematized the bushes and trees, most of them apple trees. Adam sits on a hillock, his legs crossed, and does not take any particular notice of the divine rays descending upon his head from the hand of God which protrudes from a large, bipartite segment of heaven.

Located in the catena; the text above is Genesis 2:7.

64a, b. Ser., fol. 39r

The inscription in the left margin reads: πλάσις ἡ τοῦ ἀδάμ.

In this and the following manuscripts the Creation and Enlivement of Man are combined in one miniature. Adam lies in the foreground, more realistic than in Laurent. and painted in a brownish clay color that emphasizes his lifelessness. In the Enlivement he is painted a natural red-brown color which stresses his animation. Large sections of the miniature, particularly the trees, are badly flaked.

Located in the catena; the text above is Genesis 2:7.

65a, b. Sm., fol. 9v or fol. 10v[3]

Very close to Ser. Badly flaked.
Located above the catena.

66a, b. Vat. 746, fol. 32v

The inscription reads: πλάσις ἡ τοῦ ἀδάμ.

Very close to Ser. and Sm., except that the figure of Adam, partly flaked and rubbed, is painted a grayish green color.

Located in the catena; the text above is Genesis 2:7.

Lit.: Tikkanen, "Genesi," p. 259 n. 4; Schlumberger, *Epopée byz.*, fig. p. 465; Uspenskii, p. 113, fig. 23; Hesseling, fig. 13; Dalton, *Byzantine Art*, p. 464, fig. 276; Troje, ΑΔΑΜ *und* ΖΩΗ, p. 70 n. 3; Muñoz, "Rotulo," p. 476; Schmidt, *Sechstagewerkes*, p. 85; Menhardt, p. 295; Schade, *Paradies*, pp. 103–4, 125–29, pl. 14; Haussig, *History*, p. 398, fig. 23; Hutter, "Über-malungen," pp. 139, 144, fig. 2; Heimann, "Utrecht Psalter," p. 319, fig. 11; Al-Hamdani, "Sources," pp. 23–24, fig. 6b; Bernabò, "Laur. plut. 5.38," pp. 138, 152, pl. 4; Lassus, "Création," pp. 118, 125–27, fig. p. 125; Mathews, "Alt'amar," p. 252; Brubaker, "Gregory of Naz.," p. 347; Bernabò, "Adamo," pp. 13, 29 n. 26; Büchsel, "Schöpfungsmosaiken," pp. 68ff., fig. 40.

[1] For the possible meaning of this absence, see Schade, *Paradies*, p. 103.

[2] The latter suggestion is paralleled by an inscription in the upper margin of the page mentioning Adam, Paradise, and "the river."

[3] Fol. 9v according to Hesseling, p. v; fol. 10v according both to Uspenskii, p. 182, and to the label in the photo taken by Buberl.

Genesis 2:8

INTRODUCTION OF ADAM INTO THE GARDEN OF EDEN

The iconography of this miniature displays no peculiar characteristics and is duplicated by the image of Adam in the Garden of Eden (figs. 75a–78a).

67. Vat. 747, fol. 21r

Adam walks through the Garden of Eden and raises his hands toward the rays which emanate from the blessing hand of God in a segment of heaven and strike his face. The whole miniature has been overpainted and is partly flaked again.

Located in the catena; the text above is Genesis 2:9.

68. Ser., fol. 40r

The inscription in the left margin reads: δέησις ἀδάμ προσ-φέρω(ν) τῷ κ(υρι)ῷ.

Adam stands in the Garden of Eden and looks up at the blessing hand of God protruding from a segment of heaven, as if listening to him. Flaked in various spots.

Located in the catena; the text above is Genesis 2:9.

69. Sm., fol. 11r

The miniature is very badly damaged by flaking, but the few traces still recognizable reveal that the composition was identical to that of Ser.

70. Vat. 746, fol. 34r

The inscription in the left margin reads: δέησϊν ἀδὰμ προσ-φέρει τῷ κ(υρί)ω.

Very close to Ser.
Located in the catena; the text above is Genesis 2:9.

Lit.: Uspenskii, p. 113; Hesseling, fig. 15; Underwood, "Fountain of Life," p. 100; Hutter, "Übermalungen," p. 139; Weitzmann, "Selection," p. 73, fig. 3; Bernabò, "Laur. plut. 5.38," p. 152; Lassus, "Création," p. 127.

Genesis 2:10–14

THE FOUR RIVERS OF EDEN

5e. Laurent., fol. 6r (third and fourth rows)

In this four-tiered miniature the painter divided the story of Adam and Eve before and after the Fall, depicting an undulating horizontal stream from which the four rivers of Paradise, named by the text as Pison, Gihon, Hiddekel, and Euphrates (LXX: Phisom, Geon, Tigris, and Euphrates), descend vertically and separate the scenes which follow below. The ends of three of the streams flow out of the frame. The horizontal stream replaces the rectangle of the ocean of the other Octateuchs. The illustration of the rivers of Paradise should have been located after the cre-

ation of Adam on fol. 4r and before the naming of the animals, i.e., below the breathing of life on fol. 4r or as the first scene of this illuminated page. As a second consequence of this replacement, the painter indicated the removal of Adam and Eve from their earlier paradisiacal existence after their sin by means of the border which is marked by the rivers themselves.

Located below the final lines of chapter 3, which are copied in the upper margin of the folio.

71. Vat. 747, fol. 21v

From a stream of water—probably a representation of the ocean[1]—near the upper frame, the four rivers of Paradise flow upward in a perspective view, framing the Garden of Eden, which is planted with trees, in the center. Most of the surface, particularly the lower half, is heavily flaked.

Located below Genesis 2:14.

72. Ser., fol. 41v

The inscription that runs below the upper frame and ends outside it is mostly flaked, but can be reconstructed by analogy with that of Vat. 746 to read: [πηγὴ ποταμῶν τετρακτὺς] παραδείσου.

The compositional scheme is the same as in Vat. 747. The huge tree in the center of the Garden of Eden is intended to represent the Tree of Knowledge, anticipating the following verses. (Whether this tree was emphasized in the miniature of Vat. 747 as well can no longer be ascertained because of its damaged condition). The miniature in Ser. is also much flaked and torn around the lower edges.

Located in the catena; the nearest text is Genesis 2:14.

73. Sm., fol. 11v

The miniature, which is very close to Ser., is likewise heavily damaged by flaking.

Located below Genesis 2:9.

74. Vat. 746, fol. 35r

The inscription, written outside the frame in the left margin, reads: πηγὴ ποταμῶν τετρακτὺς παραδείσου.

The composition agrees with Ser. and Sm., but the Tree of Knowledge is particularly emphasized by the addition of golden highlights.

Located below Genesis 2:12.

Lit.: Ainalov, *Hellenistic Origins*, p. 277, fig. 128; Uspenskii, p. 113; Stornajolo, *Topografia Cristiana*, p. 17; Hesseling, fig. 16; Pijoán, *Summa artis*, vol. 7, fig. 554; Kitzinger, *Monreale*, p. 62; Lassus, "Création," pp. 127–28.

[1] Uspenskii, p. 113.

Genesis 2:15

ADAM IN THE GARDEN OF EDEN

The image duplicates the previous Adam in the Garden of Eden, nos. 67–70 above.

75a. Vat. 747, fol. 22r

Once more the illustrator depicts Adam's introduction into the Garden of Eden. In the left half of the miniature Adam[1] sits on elevated ground amid trees at the foot of high mountains. The whole miniature has been overpainted and has now partly flaked again.

Located below Genesis 2:18.

76a. Ser., fol. 42r

Adam stands in the Garden, raising one arm and looking up at the sky where, however, neither a segment of heaven nor the divine hand appears. Slightly flaked.

Located in the catena; the nearest text above is Genesis 2:18.

77a. Sm., fol. 12v

Very close to Ser.
Located below Genesis 2:18.

78a. Vat. 746, fol. 36v

Very close to Ser. and Sm. The lower part of the miniature is badly flaked.

Located below Genesis 2:18.

Lit.: Miniature, p. 3 n. 10; Uspenskii, pp. 113–14; Hesseling, fig. 17; Der Nersessian, *Barl. et Joas.*, p. 115; Wessel, "Adam und Eva," col. 44; Hutter, "Übermalungen," p. 140; Bernabò, "Laur. plut. 5.38," p. 152; Iacobini, "Albero della vita," p. 242, fig. 1.

[1] Uspenskii (pp. 113–14) interpreted the figure on the left in the analogous miniature in Ser. (fol. 42r) as Eve, who is present at the event although the account of her creation is given later, at Gen 2:21–22.

Genesis 2:16–17

GOD FORBIDS ADAM TO EAT FROM THE TREE OF KNOWLEDGE

75b. Vat. 747, fol. 22r

In the right half of the miniature Adam looks up to a segment of heaven containing the blessing hand of God and receives the command not to eat from the Tree of Knowledge of Good and Evil. He is shown walking through the Garden of Eden at the foot of high mountains, but the painter did not indicate which of the trees is the Tree of Knowledge. This side of the miniature, like the left half, has been thoroughly overpainted and has flaked again in a few spots.

Located below Genesis 2:18.

76b. Ser., fol. 42r

The inscription, written outside the frame in the left margin, reads: τηρεῖν νόμους δίδωσιν Ἀδὰμ δεσπότης.

Adam stands with crossed arms before the blessing hand of God. The Tree of Knowledge is placed in the center of the minia-

ture, dividing the two scenes, and is distinguished by its size and golden highlights. The trees and plants as well as the figure of Adam are heavily flaked.

Located in the catena; the nearest text above is Genesis 2:18.

77b. Sm., fol. 12v

The miniature, which is very close to Ser., is flaked in various places.

Located below Genesis 2:18.

78b. Vat. 746, fol. 36v

The inscription is written above the right half of the miniature and reads: τηρεῖν νόμους δίδωσιν Ἀδὰμ δεσπότης.

Very close to Ser. and Sm. and equally badly flaked.

Located below Genesis 2:18.

Lit.: Uspenskii, pp. 113–14, fig. 24; Hesseling, fig. 18; Wulff, *Altchr. und Byz. Kunst*, vol. 2, p. 530, fig. 462; Ebersolt, *Min. byz.*, pl. 28 no. 2; Der Nersessian, *Barl. et Joas.*, p. 115; Wessel, "Adam und Eva," col. 44; Schade, "Tiere," p. 224; Hutter, "Übermalungen," p. 140; Bernabò, "Laur. plut. 5.38," p. 152; Iacobini, "Albero della vita," fig. 1.

Genesis 2:19–20

NAMING OF THE ANIMALS

As in the preceding representation (at Genesis 1:28) where God grants Adam dominion over the animals (see nos. 55–58), the first man sits in front of a procession of animals; he is clothed in a transparent veil painted as vertical white striping and brush-strokes. Adam dominates the savage animal kingdom before the Fall and, as a prefiguration of a hermit or a holy man (to quote John Chrysostom),[1] he is dressed in glory and dwells in Eden, talking freely with God. The animals come to Adam as to a shepherd, passing in front of him without any fear (to quote Ephrem), according to their species and varieties; a pack of predators passes by, followed fearlessly by a herd of animals upon which they prey.[2] The veil Adam wears is a pictorial translation of the robe of glory or light found in Jewish texts[3] and popularized by retellings of the biblical narrative such as the Apocalypse of Moses[4] and the Syriac Cave of Treasures;[5] it was renowned among Christian authors, particularly those from Syrian lands, such as Ephrem[6] and John Chrysostom themselves.[7] When Adam appears clothed in Christian monuments, however, he is dressed in garments with a less ethereal appearance than in the Octateuchs, generally weighty white linen,[8] exomis, or skins.[9]

A second striking detail, found only in Vat. 747, is the presence of a brown monkeylike animal and a blue feline with a red tongue in the background of the procession of animals. The first is presumably a portrayal of the devil, and the second looks like a dragon; both of them are spying on Adam. The two creatures have nothing to do with the paradisiac procession of animals in front of Adam referred to in Genesis 1:19, and suggest a borrowing from a story with a livelier narrative. In The Cave of Trea-

sures we read that the devil was seized with envy because of the honor granted to Adam at the naming of the animals;[10] and in Vat. 747 the presence and the attitude of the devil may reflect his feeling of revenge toward Adam. The episode is embellished in a Jewish legend,[11] where the jealous Satan challenges Adam; the winner will be whoever gives the appropriate names to the animals, and he will live in the Garden and till it.[12]

5a. Laurent., fol. 6r (first row)

In a mountainous landscape set against a golden sky, a great variety of animals, both real and fantastic, approach Adam to receive their names. The procession is ordered with the domestic animals leading, the wild beasts following, and the monstrous and evil animals bringing up the rear. Adam sits at the extreme left, as tall as a giant in comparison with the animals and trees,[13] and raises his right hand. With him on the light yellow-green hill is a rabbit between a cat and a doglike creature, a pair of oxen, a goat between two sheep, a camel, and a tiny giraffe. Some birds appear in the upper zone and a bird of prey perches on the very peak of the mountain, while two peacocks fly toward Adam. A bear and a unicorn, a panther and a griffin approach over the second hill, which is painted dark green and framed by two trees. Over the third hill, painted in the same color as the first, an elephant and two horses, one grazing and one rearing, advance together with a stag, a doe, a fox, and two scaly monsters, one of which has a long, involuted neck. These are followed by a serpent, apparently meant to be the same one which will tempt Eve; behind it is the evil chimera of classical antiquity, that fantastic lion with a goat's head upon its back and another head at its tail, well known from the story of Bellerophon. An exact copy of this chimera appears in the Creation of the Animals in the same manuscript (fig. 3b), almost completely flaked.[14] A stork, perched in his nest on the top of a tree, turns his head backward. The figure of Adam and a few of the animals are somewhat flaked.

The miniature occupies almost a full page; only four lines of text, the end of chapter 3, have been copied at the top of the folio.

79a. Vat. 747, fol. 22r

The compositional arrangement is very similar to that of Laurent., with Adam sitting at the extreme left. Adam's body, as well as the stone on which he sits, are profusely veiled with white highlights, the addition of a later repainter.[15] Adam does not raise his arm, as he does in the other Octateuchs. Although the miniature is very badly damaged and many of the animals, which are in a long procession, are no longer identifiable, it is clear that their number and their variety were never as great as in Laurent. Next to Adam are a deer, a scaly equine, an erect snake (similar to that in Laurent.), a cock, the heads of a stag, a giraffe, and a lamb, a pair of snakes, and other quadrupeds. Two silhouettes of birds and one of a calf are sketched in the repainted background together with numerous birds. In the background, between the necks of the stag and the giraffe, is a half-hidden monkeylike brown animal, apparently squint-eyed, with his mouth open and

looking irately at Adam, in the attitude of spying on him. Near the monkey, on the other side of the giraffe's neck, is the blue cat-like head of a dragon, with long ears and yellow almond-shaped eyes. This feline looks upward, opening its eyes wide and sticking out its red tongue.

Located below Genesis 2:22.

80a. Ser., fol. 42v

The inscription in the left margin, as far as it relates to the present scene, reads: θηρῶν πετεινῶν κλῆσις Ἀδάμ ἐνθάδε.

Adam wears a transparent veil depicted as vertical white striping and brushstrokes. The quadrupeds approaching him are more densely grouped and more numerous than in Vat. 747; there is no separation of domestic and wild animals, and the monstrous creatures in Laurent. and Vat. 747 are omitted altogether. A mouse, a lion, a griffin, an ox, and a panther form the front row, while the better-known quadrupeds, such as a sheep, unicorn, horse, elephant, numerous goats, foxes, a stag, a bear, etc., appear in the group behind them. Numerous birds fill the area above them, either flying or standing, although there are no mountains on which they might perch. Slightly flaked.

Located in the catena; the text above is Genesis 2:22.

81a. Sm., fol. 12v

Except for slight variations (e.g., the white horse in the second line of animals in Ser. is transformed in a donkey) the grouping of the animals is essentially the same as in Ser. Adam's transparent veil cannot be recognized with certainty in the existing photograph of the miniature.

Located below Genesis 2:22.

82a. Vat. 746, fol. 37r

Although the center of the scene is almost completely rubbed, the few remaining traces still permit us to deduce that the composition very closely resembled that in Ser. and Sm. Adam is here also clothed with a transparent robe (sleeve and collar are clearly recognizable) with ivory highlights.

Located below Genesis 2:22.

Lit.: Tikkanen, "Genesi," pp. 261–62; *Miniature*, p. 3 n. 10; Uspenskii, pp. 114–15, fig. 24; Hesseling, fig. 18; Wulff, *Altchr. und Byz. Kunst*, vol. 2, p. 530, fig. 462; Ebersolt, *Min. byz.*, p. 31, pl. 28 no. 2; Menhardt, p. 296; De Palol, "Broderie catalane," p. 199, fig. 15; Diringer, *Illuminated Book*, fig. II-9b; Wessel, "Adam und Eva," col. 44; Narkiss, *Golden Haggadah*, pp. 66, 71 n. 53; Hutter, "Übermalungen," p. 140; Bernabò, "Laur. plut. 5.38," pp. 138–39, 152, pl. 5; Bernabò, "Cacciata," fig. 8; Lassus, "Création," pp. 138–39, fig. p. 139, pl. 3D; Broderick, "Garments," pp. 250–54; Mathews, "Leo Sacellarios," p. 111; Thierry, "Alt'amar," pp. 297, 300, fig. 25; Alexandre, *Commencement*, fig. 15; Sed-Rajna, *Hebraic Bible*, pp. 12 nn. 26–27, 13 n. 34; Bernabò, "Adamo," pp. 11–29, figs. 5–7, pl. 1 nos. 1–3; Büchsel, "Schöpfungsmosaiken," p. 74 n. 18; Bernabò, "Esegesi patristica," fig. 8; Bernabò, "Caverna," pp. 721–22, 730–32, 735, figs. 1, 2; Bernabò, "Tradizioni siriache," fig. 3.

[1] *HomMt* 68:3 (PG 58, cols. 643–44), which mentions that the hermits look like Adam who dwelt in that place of beatitudes before the Fall.

[2] Ephrem, *CommGen* 2:9 (Ephraem, *In Genesim et in Exodum commentarii*, ed. Tonneau, p. 23; transl. in Ephrem, *Hymns on Paradise*, ed. Brock, p. 203).

[3] See TargPs-J and TargN (*Targum Genèse*, ed. Le Déaut, p. 31) and GenR 20:12 (*Genesis Rabbah*, ed. Freedman and Simon, p. 171); cf. Brock, "Clothing Metaphors," pp. 11–38, esp. p. 14.

[4] 20:1–2 and 21:5–6 (*OTP*, vol. 2, p. 281).

[5] *Caverne des Trésors*, ed. Ri, vol. 1, pp. 10–11; cf. Brock, "Clothing Metaphors," p. 14.

[6] See his Hymns on Paradise 15:8 and passim (*Éphrem de Nisibe, Hymnes sur le Paradis*, ed. Lavenant and Graffin, p. 190); cf. N. Sed, "Les Hymnes sur le Paradis de Saint Éphrem et les traditions juives," *Mus* 81 (1968), pp. 477–78; Brock, "Clothing Metaphors," p. 15 and the abstracts of Syriac writings in the appendix, pp. 23–28.

[7] *HomGen* 15:4 (PG 53, col. 123); see Jansma, "Early Syrian Fathers," pp. 172–73, where more passages from John Chrysostom are listed.

[8] Cf. Adam among the animals in the mosaic pavement of the Michaelion in Hūarte, dating from 483–485/86, and the two related mosaics with Adam and the animals in the Museum of Hama (probably from that area) and the National Museum of Copenhagen (supposedly from North Syria): P. Canivet and M.-T. Canivet, *Hūarte: Sanctuaire chrétien d'Apamène (IV^e–VI^e s.)*, 2 vols. (Paris, 1987), pp. 207–16, 252ff., 259–60, 274–75, pls. 102–118; see also Canivet, "Mosaïque d'Adam," pp. 56ff.

[9] As in the Theodore Psalter (London, Brit. Lib., cod. Add. 19.352, fol. 6v), where two representations of Adam, among the animals and near a pool, are introduced beside Ps 8:5–8 (Der Nersessian, *Londres Add. 19.352*, fig. 13); similarly, in the Bristol Psalter (London, Brit. Lib., cod. Add. 40731, fol. 16r), beside the same Psalm, Adam is shown clothed among the animals (S. Dufrenne, *L'illustration des Psautiers grecs du Moyen Age: Pantocrator 61, Paris gr. 20, British Museum 40731* [Paris, 1966], fig. 48).

[10] *Caverne des Trésors*, ed. Ri, vol. 1, pp. 8–9.

[11] Ginzberg, *Legends*, vol. 1, pp. 62–64, quoting *Eldad ha-Dani*, ed. Epstein.

[12] The relationship of the miniature in Vat. 747 to such a Jewish legend has been discussed in Bernabò, "Adamo," pp. 25–29. The devil, similarly pictured as a monkey, is hunted by a stag in the Physiologos in Bern (Burgerbibliothek, cod. 318, fol. 17v; *Physiologus Bernensis*, facsimile edition, ed. C. von Steiger and O. Homburger [Basel, 1974], fol. 17v).

[13] The extraordinary size of Adam, which does not occur in other scenes, might reflect a tradition handed down in pseudepigrapha (Apocalypse of Abraham 23:5 [*OTP*, vol. 1, p. 700]) and Midrash Rabbah (GenR 12:6 [*Genesis Rabbah*, ed. Freedman and Simon, pp. 136–37]); cf. Bernabò, "Adamo," p. 30 n. 41.

[14] For a discussion of the iconography of this chimera and its probable ancient model, see note 4 at Genesis 1:24–25.

[15] The restorer apparently misunderstood the transparent veil covering Adam which can be seen in the corresponding scene in Vat. 746 and Sm. Broderick ("Garments," pp. 250–54) first noted these garments in the Octateuchs, recognizing them in Ser. and Vat. 746.

[Genesis 2:21–22]

CREATION OF EVE

Since there was no helpmate for Adam, according to verse 20, "And the Lord God caused a deep sleep to fall upon Adam, and he slept: and he took one of his ribs, and closed up the flesh instead thereof; And the rib, which the Lord God had taken from man, made he a woman, and brought her unto the man" (Gen 2:21–22). The illustration in the Octateuchs does not follow the narrative of the Scripture: no rib is extracted from Adam. Instead

Eve emerges directly from Adam's side, while God performs the act by means of the usual hand emitting rays from heaven. Moreover, the extraction of the rib and the formation of the woman are illustrated in a single depiction, as acts performed by God contemporaneously.[1] The Octateuchs introduced a New Testament typology, widespread since the third century, focusing on the creation of Eve as prefiguring the birth of the Church, which emerged from the chest of the crucified Christ pierced by a lance (Jn 19:34).[2] The simultaneous depiction of the two acts of extracting the rib and forming the woman recalls Syrian imagery: Ephrem and later Syriac commentaries emphasize that God took out and filled up rib and flesh at the same time, "in the twinkling of an eye."[3] Eve arises from the right side of Adam in all the Octateuchs except in Laurent., where she emerges from the left side.[4] The latter peculiarity counters the rule of the right side typical of the Byzantine iconography of Christ on the Cross,[5] where his wounded side is normally the right one.[6] As for the recumbent Adam, the painter apparently adapted a classical model: an Endymion, a Dionysos under the vine, or a reclining shepherd.[7]

5b. Laurent., fol. 6r (second row, left)

While Eve emerges from his left side, Adam lies sleeping on the ground in a counterbalanced position, turned over on his right side with his head turned to the left.[8] Eve stretches out both hands toward God's blessing hand which sends forth life-giving rays from a segment of heaven. Both figures are partly flaked.

79b. Vat. 747, fol. 22r

Although the scene is almost entirely flaked, one can judge from the preliminary drawing underneath that it was very similar to the other Octateuchs. The only preserved area is the upper part with the mountains and a segment of heaven containing the divine hand toward which Eve stretches out her arms. In the heavens a few black undulating lines are traced. This part of the miniature was thoroughly overpainted before flaking again.

Located below Genesis 2:22.

80b. Ser., fol. 42v

The continuation of the inscription in the outer left margin reads: ἐκ πλευρᾶς ὧδε πλάσιν εὔας μοι νόει.

The grouping of Adam and Eve is essentially the same as in Vat. 747, although Adam's posture is less graceful and he appears almost plump. A tree separates the scene from the Naming of the Animals, and Adam sleeps beneath a second, larger tree. Flaked in various places.

Located in the catena; the text above is Genesis 2:22.

81b. Sm., fol. 12v

Very close to Ser. and badly flaked.
Located below Genesis 2:22.

82b. Vat. 746, fol. 37r

Very close to Ser. and Sm. and also severely flaked.
Located below Genesis 2:22.

Lit.: Tikkanen, "Genesi," p. 262; Uspenskii, pp. 114–15, fig. 24; Hesseling, fig. 18; Wulff, *Altchr. und Byz. Kunst*, vol. 2, p. 530, fig. 462; Ebersolt, *Min. byz.*, p. 31, pl. 28 no. 2; Martin, *Heavenly Ladder*, p. 69; Diringer, *Illuminated Book*, fig. II-9b; Der Nersessian, *Aght'amar*, p. 43; Schade, "Adam und Eva," col. 50; Wessel, "Adam und Eva," col. 44; Koshi, *Genesisminiaturen*, p. 7; Al-Hamdani, "Sources," pp. 21–23, fig. 5b; Bernabò, "Laur. plut. 5.38," pp. 138–39, pl. 5; Bernabò, "Cacciata," fig. 8; Lassus, "Création," pp. 129–30, 140, figs. pp. 131, 139, pl. 3D; Bergman, *Salerno*, pp. 20, 43, 46, fig. 57; Brubaker, "Gregory of Naz.," pp. 349, 355; Thierry, "Alt'amar," pp. 297, 300, fig. 25; Havice, "Hamilton Ps.," pp. 128, 267–68; Weitzmann and Kessler, *Cotton Gen.*, p. 54 n. 6; Sed-Rajna, *Hebraic Bible*, pp. 12 n. 26, 13 n. 34; Bernabò, "Adamo," p. 18, figs. 5–7, pl. 1 nos. 1–3; Alexandre, *Commencement*, fig. 15; Bernabò, "Esegesi patristica," pp. 57–60, p. 57 n. 37, fig. 8; Sed-Rajna, "Haggadah," p. 419; Bernabò, "Tradizioni siriache," p. 304, fig. 3; Zirpolo, "Ivory Caskets," p. 10.

[1] In contrast, the Cotton recension depicts the extraction of the rib and the formation of the woman in two separate scenes (Weitzmann and Kessler, *Cotton Gen.*, figs. 33–38).

[2] This prefiguration is one of the most recurrent *topoi* in Christian writers; for a list of authors, see P. T. Ros, "La formación de Eva en los Padres griegos hasta Juan Crisóstomo inclusive," in *Miscellanea Biblica B. Ubach*, ed. R. M. Díaz Carbonell (Monserrat, 1953), pp. 13–15. According to Sed-Rajna, however, the emerging of Eve from the side of Adam is a Jewish element: the Hebrew expression *mi-zal'otaw*, she claims, can be understood to mean either "rib" or "side" (Sed-Rajna, "Haggadah," p. 418). In fact, while the Targumim have only "rib" (cf. *Targum Genèse*, ed. Le Déaut, pp. 88–89), GenR 17:5 (*Genesis Rabbah*, ed. Freedman and Simon, pp. 166–67) relates that R. Samuel b. Nahmani said that God took one of Adam's sides, which gives a different sense than the representation of the emerging of Eve from the side of Adam, as depicted in the Octateuch miniature. The interpretation "side" instead of "rib" seems to be marginal and dubious even in Jewish sources; in contrast, in Christian authors earlier than the Genesis Rabbah we find a more exact and generally accepted parallel between the emerging of Eve from the side of Adam and the origin of the Church from the wounded side of Christ.

[3] The expression is taken from 1 Cor 15:52. Cf. Ephrem, *CommGen* 2:12 (Ephraem, *In Genesim et in Exodum commentarii*, ed. Tonneau, p. 24; transl. in Ephrem, *Hymns on Paradise*, ed. Brock, p. 205: "Once the rib had been extracted in the twinkling of an eye, and God had closed up the flesh in the flicker of an eyelid, and the bare rib had been fashioned with all kinds of adornments and embellishments . . . "); Iso'dad of Merv (*Commentaire d'Iso'dad de Merv*, vol. 1, *Genèse*, ed. Van den Eynde, p. 42), and an anonymous commentary of about the late eighth century (*Diyarbakir 22*, ed. Van Rompay, vol. 2, p. 43).

[4] Eve also emerges from the left side in the cycle of paintings in the Armenian church at Alt'amar (Thierry, "Alt'amar," fig. 3).

[5] G. Millet, *Recherches sur l'iconographie de l'Évangile au XIV^e, XV^e et XVI^e siècles* (Paris, 1960), p. 436; De Grüneisen, *Ste. Marie Ant.*, pp. 325–26.

[6] The difference between the two iconographies of the forming of Eve can be thoroughly assessed by taking into account the exegetical literature, which shows that the standard iconography of the right side in Vat. 747, Ser., Sm., and Vat. 746 appears to be a fruit of the Christian sifting of biblical cycles. The scene in Laurent., on the other hand, stems from a different tradition, namely, the Syriac. Anastasios of Sinai (*Hex*, bk. 9 [PG 89, cols. 993–1004, esp. cols. 1001–2]) emerges as the most resolute champion of a sharp distinction between the side of Adam from which Eve was drawn out, which corresponds to the wounded side of Christ on the Cross from which the Church was born, and the opposite side of Christ, which is the side of the Synagogue (indeed, Anastasios affirms that Gen 2:21 must not be interpreted as the literal birth of Eve, who had already been created

together with Adam at Gen 1:26–27, but as the birth of the Church; ibid., cols. 993–96). The Cave of Treasures 3:12 mentions the left side (*Caverne des Trésors*, ed. Ri, vol. 1, pp. 10–11); see also The Book of the Bee, chap. 14 (*Book of the Bee*, ed. Budge, p. 18).

[7] Also proposed for the figure of Jonah sleeping under the pergola. Cf. E. Dinkler, "Abbreviated Representations," in *Age of Spirituality*, p. 402, fig. 58; Rosenthal, *Vergilius Romanus*, pp. 34–35, figs. 25, 27a; A. Grabar, *Christian Iconography: A Study of Its Origins* (Princeton, 1968), p. 3; and, most recently, Büchsel, "Schöpfungsmosaiken," pp. 53ff.

[8] The sleeping Adam in the *Heavenly Ladder*, cod. Vat. gr. 394, fol. 78r, similarly turns over on his right side (Martin, *Heavenly Ladder*, p. 69, fig. 106).

Genesis 3:1–6

TEMPTATION OF EVE

Skipping over the episode of the introduction of Eve to Adam narrated at Genesis 2:22–25, the pictorial narrative arrives at the first episode of the Fall.

5c. Laurent., fol. 6r (second row, center)

In the second miniature in this row, Eve stands in front of a pink mountain facing the spectator in a pose that reveals a sense of shame extraneous to the Septuagint. She gestures to the erect serpent with her right hand and turns her head toward it[1] while it whispers into her ear. The attitude of Eve suggests that a heterogenous model, possibly a classical type of Aphrodite, in the pose known as *Venus pudica*,[2] has been adapted in this episode. The serpent has lost the goatlike beard and the pointed ears it had in the Naming of the Animals in the miniature in the row above this one. Slightly flaked.

83a. Vat. 747, fol. 22v

The first scene at the extreme left, like the rest of the miniature, has been entirely overpainted, and the original iconography is lost; very large sections have flaked yet again. The repainted Eve is still recognizable approaching the whispering serpent, which has red and violet skin as in the following episode on fol. 24r (fig. 91) and stands erect on its tail without coiling its body. After the flaking of the repainting, only a few traces of the original drawing have reappeared: we can recognize that in the original layout Eve's right arm was painted in a lower position.

Located below Genesis 3:6.

Lit.: Kondakov, *Istoriia*, p. 188; Kondakov, *Histoire*, vol. 2, p. 78; *Miniature*, p. 4 n. 2; Der Nersessian, *Barl. et Joas.*, p. 117; Martin, *Heavenly Ladder*, p. 69; Esche, *Adam und Eva*, pp. 13–14; Diringer, *Illuminated Book*, fig. II-9b; Mouriki-Charalambous, "Cosmas," pp. 18–22, 178; Hutter, "Übermalungen," p. 140; Huber, pp. 38–39; Bernabò, "Laur. plut. 5.38," pp. 139–40, pl. 5; Bernabò, "Cacciata," fig. 8; Bernabò, "Fonti testuali," pp. 471–72; Lassus, "Création," pp. 130–32, 140, fig. p. 139; De' Maffei, "Eva," pp. 32–34; Weitzmann and Kessler, *Cotton Gen.*, p. 42; Roma, *S. Maria di Anglona*, pp. 94, 114 n. 34; Bernabò, "Adamo," fig. 7, pl. 1 no. 3; Zirpolo, "Ivory Caskets," p. 10.

[1] De' Maffei ("Eva," pp. 31–32) related the representation of the erect serpent in Laurent. to a passage of Severianos of Gabala (*De mundi creatione*, oratio 6 [PG 56, col. 495]).

[2] For an Aphrodite type in Byzantine art, see the *Cynegetica* of pseudo-Oppian in Venice, Bibl. Marc., cod. gr. 479, fol. 33r (Weitzmann, *Greek Mythology*, pp. 123–24, fig. 143). Statues of the Knidian Aphrodite, as well as other statues of Aphrodite, are said to have been in Constantinople and elsewhere (Mango, "Antique Statuary," pp. 56, 58, 61, 68), and a nude statue of Aphrodite in the baths of Zeuxippos is described by Christodoros of Koptos (*Epigrammatum Anthologia Palatina*, ed. F. Dübner, vol. 1 [Paris, 1864], p. 25). For comparanda, see M. Bieber, *The Sculpture of the Hellenistic Age*, rev. ed. (New York, 1961), figs. 24–35.

[Genesis 3:1–6]

TEMPTATION OF EVE

The miniature of the Fall in Vat. 747, Ser., Sm., and Vat. 746 is the first of a series of miniatures that group three episodes within a single frame.[1] These miniatures are among the richest in features that expand on the Septuagint narrative; they sometimes even contain details that contradict the iconography of other illustrations in the Octateuchs themselves. (In Vat. 747 the representation of the Fall and the other miniatures of Genesis 3 are considerably repainted.) The narrative of the Fall in Genesis 3:1–6 is illustrated with the three episodes of the Temptation of Eve, Eve Persuading Adam to Eat the Fruit, and Adam Eating the Fruit. In the first, the serpent addressing Eve is bizarrely portrayed as a camel-like animal. This image of the tempter is extraneous to the Septuagint, but it is known both in pseudepigrapha and in rabbinical commentaries.[2] The Cave of Treasures relates that "Satan remained in his envy to Adam and Eve for the favor which the Lord shewed them, and he contrived to enter into the serpent, which was the most beautiful of the animals, and its nature was above the nature of the camel."[3] There is a similar description in the Pirkê de-Rabbi Eliezer, a Jewish text dating to ca. A.D. 832;[4] the earliest mention in a Jewish text, however, is in Genesis Rabbah 19:1, dating from approximately A.D. 400.[5] Notable implicit evidence for the widespread idea of the camel-like appearance of the serpent in the imagery of Syriac Christianity is its firm rejection by later Eastern Christian writers,[6] who attributed the odd image to Henana, the bishop and director of the school of Nisibis at the end of the sixth century.[7] With a very conservative attitude, the painters of Ser., Sm., and Vat. 746 preserved this eccentric version of the cycle.

84a. Ser., fol. 43v

The inscription is written outside the frame in the left margin and, as far as it relates to the present scene, reads: ὄφις γυναικὶ ψηθυρισμὸν προσάγει.

Eve stands under the Tree of Knowledge, looking up at its seductive fruit, and is about to pick a piece. The serpent is very strangely built, with the brown body of a quadruped resembling that of a camel, and feet with split hooves. Nothing in the tree between Eve and the serpent characterizes it as the Tree of Knowledge. Slightly flaked.

Located in the catena; the text above, on fol. 43r, is Genesis 3:6.

85a. Sm., fol. 13r

Very close to Ser. and very extensively flaked.

86a. Vat. 746, fol. 37v

The inscription, written in the left margin, reads: ὄφις γυναικὶ ψηθυρισμὸν προσάγει.

Very close to Ser. and Sm., but the quadruped that the serpent is mounting is lower and blackish brown. Badly flaked, particularly in the lower section.

Located below Genesis 3:2.

Lit.: Piper, "Bilderkreis," pp. 187–89; Piper, "Denkmäler," p. 478; Kondakov, *Istoriia*, p. 188; Kondakov, *Histoire*, vol. 2, p. 78; *Miniature*, p. 4 n. 2; Tikkanen, "Genesi," p. 263 n. 1; Breymann, *Adam und Eva*, pp. 151–52 n. 1; Uspenskii, p. 115, fig. 25; Hesseling, fig. 19; Troje, ΑΔΑΜ *und* ΖΩΗ, p. 68 n. 2; Gerstinger, *Wiener Gen.*, p. 67, fig. 43; Der Nersessian, *Barl. et Joas.*, p. 117; Buberl, *Byz. Hss.*, p. 83; Demus, *Norman Sicily*, p. 332 n. 35; Pijoán, *Summa artis*, vol. 7, fig. 556; Weitzmann, "Septuagint," p. 74, fig. 56; Menhardt, p. 297; Weitzmann, "Oct. Ser.," p. 183; "Wiener Gen.: Resumé," pp. 45–46; Esche, *Adam und Eva*, pp. 13–14, 28, pl. 4; Kretschmar, "Beitrag," p. 301 n. 2; Weitzmann, "Jewish Sources," p. 82; Voss, *Millstätter Gen.*, p. 60; Gutmann, *Images*, fig. 5; Wessel, "Adam und Eva," col. 44; Gutmann, "Ill. Jew. Ms.," p. 40; Schade, *Paradies*, p. 85; Nordström, "Späte Judentum," p. 4; Mouriki-Charalambous, "Cosmas," pp. 18–22, 178; Bucher, *Pamplona Bibles*, p. 134 n. 60; Kelly, "Metamorphoses," p. 303 n. 10; Gaehde, "Turonian Sources," p. 368 n. 35; Huber, p. 39, fig. 38; Weitzmann, "Selection," p. 91, fig. 33; Weitzmann, "Study," p. 52; Mathews, "Leo Sacellarios," p. 116; De' Maffei, "Sant'Angelo in Formis II," pt. 2, p. 197, fig. 7; Bernabò, "Laur. plut. 5.38," pp. 130–32, 140, fig. p. 131, pl. 24 no. 2; Bernabò, "Fonti testuali," pp. 471–72; Gutmann, "Med. Jew. Image," p. 124; Lassus, "Création," pp. 130–32, pl. 3E; Nordström, "Elementi ebraici," p. 974; Weitzmann, *SP*, p. 51; De' Maffei, "Eva," pp. 14–15, 33–34, fig. 1; Bagatti, "Tentazione," p. 223, fig. 11; Thierry, "Alt'amar," p. 306; Bernabò, "Introduzione," p. xxxix n. 112; Schubert, *Jüd. Buchkunst*, pp. 64–65; Weitzmann and Kessler, *Cotton Gen.*, p. 42; Alexandre, *Commencement*, p. 294, fig. 16; Prigent, *Judaïsme*, p. 301; Roma, *S. Maria di Anglona*, pp. 94, 114 n. 34; Bernabò, "Caverna," pp. 717–20, 722, 729–30, figs. 3, 4; Bernabò, "Tradizioni siriache," pp. 306–7, fig. 7; Bernabò, "Studio," pl. 20.

[1] The ample commentaries by the Fathers on such debated biblical events as the Fall occupy the margins around the verses from Genesis 3 which are repeated in a number of consecutive folios in these manuscripts. The painter neglected the possibility of depicting the three episodes of the Fall as separate miniatures distributed over these folios but preferred the extant tripartite arrangement, which he must have found in his model. The same conditions recur with other tripartite miniatures illustrating major events narrated in the first chapters of Genesis.

[2] In GenR 19:1, R. Simeon ben Eleazar affirms that the serpent was like a camel (*Genesis Rabbah*, ed. Freedman and Simon, p. 149).

[3] *Apocrypha Arabica*, ed. Gibson, p. 8.

[4] Weitzmann ("Jewish Sources," p. 82) first related the camel-like appearance of the serpent to the *Pirkê*, a text probably written in Palestine using earlier material (*Pirkê de Rabbi Eliezer [The Chapters of Rabbi Eliezer the Great]*, ed. G. Friedlander [London, 1916], pp. liii–lv; and, more recently, *Los Capítulos de Rabbí Eliezer: Pirkê Rabbí Eliezer: Versión crítica sobre la edición de David Luria, Varsovia 1852*, ed. M. Pérez Fernández [Valencia, 1984], pp. 20–21; in chap. 13 we read that the serpent was a creature whose "appearance was something like that of a camel, and he [i.e., Sammael or Satan] mounted and rode it" (*Pirkê*, ed. Friedlander, p. 92).

[5] "R. Simeon b. Eleazar said: He [the serpent] was like a camel" (*Genesis Rabbah*, ed. Freedman and Simon, p. 149). In other Christian authors, especially Syriac, the serpent tempting Eve is a quadruped, and its punishment is to have its feet cut off. See, e.g., Ephrem, Hymns on Paradise 3:15 (*Éphrem de Nisibe, Hymnes sur le Paradis*, ed. Lavenant and Graffin, p. 59)

and Basil's *De Paradiso*, oratio 3 (PG 30, col. 68). A number of Jewish and Christian sources have been investigated by Nordström, "Elementi ebraici," p. 974, and De' Maffei, "Eva," pp. 13–37.

[6] Iso'dad of Merv (*Commentaire d'Iso'dad de Merv*, vol. 1, *Genèse*, ed. Van den Eynde, pp. 82, 92) was the most resolute opponent of the opinion that the serpent was like a camel; see also Moses bar Cepha, *De Paradiso* (PG 111, cols. 518–19); cf. De' Maffei, "Eva," pp. 24–25.

[7] A. Vööbus, *History of the School of Nisibis* (Louvain, 1965), pp. 235ff.

[Genesis 3:6]

Eve Persuades Adam to Eat the Fruit

Eve addresses Adam, apparently trying to persuade him, a dramatic action not referred to in Genesis, where Eve, after picking and eating the fruit, simply gives it to Adam who eats some of it; Adam is credited with making no objection and no discussion at all occurs between Adam and Eve before Adam also eats the forbidden fruit. This terse account was expanded to include an imagined discussion where Eve exhorts Adam to eat the fruit. Ephrem explicitly states that Eve "took the fruit to her husband and, with many entreaties, got him to eat it—though it is not written that she entreated him."[1] A conversation between Adam and Eve is encountered as early as the first- or second-century Apocalypse of Moses (21:1–4)[2] and is popular in Syrian writings, from The Cave of Treasures[3] to Romanos the Melode.[4]

5d. Laurent., fol. 6r (second row, right)

Eve draws near to Adam, who is standing on the other side of the Tree of Knowledge in the middle of the Garden of Eden. They look at each other and Eve speaks vivaciously. A stork, perched in his nest at the top of a tree, turns his neck to the right. The figures are slightly flaked, and the top of the tree, which was painted over the golden sky, has come off.

83b. Vat. 747, fol. 22v

At the left, a few portions of the foliage of a tree, which apparently had red fruit, may still be distinguished; a section of the serpent coiled around the trunk of the tree is also preserved. Eve approaches Adam from the left. Adam, his right hand placed along his right thigh and covering his abdomen, raises his left hand and moves his leg, turning his body away, apparently refusing to listen to the enticing words of the woman. The whole miniature has been overpainted and is flaked again. A few traces of the original drawing have reappeared, so we know without doubt that the main subject was introduced by the later restorer. The original iconography was very similar to that in Ser., Sm., and Vat. 746 (figs. 84–86), with the figures of Eve and Adam reversed with respect to their positions in the restored version.

Located below Genesis 3:6.

84b. Ser., fol. 43v

The central scene is separated from the lateral ones by trees. In contrast to the preceding miniature, Eve does not bow slightly

but is quite erect as she approaches Adam, who stands opposite her in a rather stiff and somewhat irresolute posture. Slightly flaked.

Located in the catena; the text above, on fol. 43r, is Genesis 3:6.

85b. Sm., fol. 13r

Very close to Ser. and very extensively flaked.

86b. Vat. 746, fol. 37v

Very close to Ser. and Sm. and somewhat flaked.
Located below Genesis 3:2.

Lit.: Tikkanen, "Genesi," p. 263 n. 1; *Miniature*, p. 4 n. 2; Uspenskii, p. 115, fig. 25; Hesseling, fig. 19; Gerstinger, *Wiener Gen.*, p. 67, fig. 43; Der Nersessian, *Barl. et Joas.*, p. 117; Buberl, *Byz. Hss.*, p. 83; Pijoán, *Summa artis*, vol. 7, fig. 556; Weitzmann, "Septuagint," p. 74, fig. 56; Martin, *Heavenly Ladder*, p. 69; Menhardt, p. 297; Esche, *Adam und Eva*, pp. 13–14, 28, pl. 4; Diringer, *Illuminated Book*, fig. II-9b; Gutmann, *Images*, fig. 5; Wessel, "Adam und Eva," col. 44; Mouriki-Charalambous, "Cosmas," pp. 18–22, 178; Weitzmann, "Selection," fig. 33; Hutter, "Übermalungen," p. 140; Huber, fig. p. 38; Mathews, "Leo Sacellarios," p. 116; De' Maffei, "Sant'Angelo in Formis II," pt. 2, p. 197, fig. 7; Eggenberger, "Vergilius Romanus," p. 67 n. 60; Bernabò, "Laur. plut. 5.38," pp. 138–40, pls. 5, 24 no. 2; Bernabò, "Fonti testuali," pp. 471–72; Bernabò, "Cacciata," fig. 8; Lassus, "Création," pp. 130–32, 140, fig. p. 139, pl. 3E; De' Maffei, "Eva," pp. 14–15, 32–34, fig. 1; Bagatti, "Tentazione," p. 223, fig. 11; Bernabò, "Introduzione," p. xxxix n. 112; Alexandre, *Commencement*, fig. 16; Bernabò, "Adamo," fig. 7, pl. 1 no. 3; Bernabò, "Caverna," pp. 722, 732, figs. 3, 4; Bernabò, "Tradizioni siriache," pp. 306–7, fig. 7; Bernabò, "Studio," pp. 281–82, pl. 20.

[1] *CommGen* 2:21 (Ephraem, *In Genesim et in Exodum commentarii*, ed. Tonneau, p. 29; English translation in Ephrem, *Hymns on Paradise*, ed. Brock, p. 213).

[2] *OTP*, vol. 2, p. 281.

[3] In its Arabic version, the Book of the Rolls (*Apocrypha Arabica*, ed. Gibson, p. 9); see also the *Liber Graduum* 21:9 (*PS*, vol. 3, p. 610). Among Syrian writers, see Iso'dad of Merv (*Commentaire d'Isodad de Merv*, vol. 1, *Genèse*, ed. Van den Eynde, p. 88) and a manuscript formerly in Diyarbakir dating from the middle of the eighth century: "Or, il est évident qu'elle ne prit pas et ne lui passa pas le fruit tout simplement, mais (qu')elle rapporta d'abord les paroles du diable, en y ajoutant encore d'autres, par lesquelles elle le persuada de manger, tandis qu'Adam (lui aussi), lui disait quelque chose, et puis mangeait. Mais le prophète a omis ces paroles, parce qu'elles sont connus par le contexte" (*Diyarbakir 22*, ed. Van Rompay, p. 49).

[4] Hymn 1:17–18 (*Romanos le Mélode, Hymnes*, ed. J. Grosdidier de Matons, vol. 1 [Paris, 1964], pp. 87–89). The discussion is also handed down in Armenian texts: see "History of the Creation and Transgression of Adam," in *The Uncanonical Writings of the Old Testament Found in the Armenian Mss. of the Library of St. Lazarus*, 2d ed., ed. J. Issaverdens (Venice, 1934), pp. 45–46.

Genesis 3:6

ADAM EATS THE FRUIT

Eve plucks a fruit from the tree and, at the same time, hands a second (or the same?) fruit to a hesitant Adam who is about to eat a third (or the same?) fruit. Adam eating alone counters the Septuagint, where both Adam and Eve are said to have eaten the fruit at this point in the narrative:[1] "(Eve) having taken of its fruit she ate, and she gave to her husband also with her, and *they* ate" (Gen 3:7). The variation from the Septuagint depicted in the miniature is apparently connected with a tradition found in pseudepigrapha such as The Cave of Treasures[2] and the Apocalypse of Moses 21:5,[3] in the Syriac version of the Bible, the Peshitta,[4] and in the Targumim.[5] Furthermore, in Laurent. the Tree of Knowledge is interpreted as a fig tree, whereas in the other Octateuchs it is an apple tree. The former interpretation is found in pseudepigrapha (e.g., the Life of Adam and Eve) and is the most familiar;[6] one of the earliest occurrences of the latter is found in the Targum of the Canticles, which at 7:8 reads, "the fragrance of the apples of the Garden of Eden."[7]

5f. Laurent., fol. 6r (third row, left)

In the first miniature of the third row the copyist represented the Fall by conflating separate actions into one scene, viz., Eve picking a fruit from the Tree of Knowledge (depicted as a fig tree with its characteristic leaves), Eve handing the fruit to Adam who stands on the other side of the tree, and, finally, Adam pondering what to do. The verdant Garden of Eden is encompassed by a stream of water separating the earth from the golden sky (the stream and the four rivers descending from it have been discussed at no. 5e above); in the scene of the Fall, Adam and Eve have crossed this border. Slightly flaked.

83c. Vat. 747, fol. 22v

In the third episode of the sequence of the Fall, Eve does not pick the fruit from the tree, here intended to be an apple tree, but holds it in her left hand as if she were going to eat it. This change in gesture was quite probably due to the restorer who overpainted the whole miniature. The figure of Eve is comparatively well preserved and shows the style of the later restorer most clearly, while the pose of Adam, who here distinctly eats a piece of red fruit, is confirmed to be original by the drawing which reappeared after the repainting flaked. The remnants of this drawing show that the tree was drawn differently and Adam extended his right arm, instead of bending it, to take the fruit from Eve; thus, the iconography looked like that in Ser., Sm., and Vat. 746.

Located below Genesis 3:6.

84c. Ser., fol. 43v

The inscription referring to the third scene, written in the left margin as a continuation of the previous one, reads: βρῶσιν ἀδὰμ δίδωσιν ἣν εὔα φαγεῖν.

The postures of Adam and Eve are the same as in Laurent., but slightly stiffer, and the Tree of Knowledge, again an apple tree, is emphasized by golden highlights. Slightly flaked.

Located in the catena; the text above, on fol. 43r, is Genesis 3:6.

85c. Sm., fol. 13r

Very close to Ser. and almost completely destroyed.

86c. Vat. 746, fol. 37v

The inscription, written beneath the lower frame, reads: βρῶσιν ἀδὰμ δίδωσιν ἧ(ν) εὖα φαγεῖν.

Very close to Ser. and Sm. The figure of Adam is largely flaked, as are other areas.

Located below Genesis 3:2.

Lit.: Tikkanen, "Genesi," p. 263 n. 1; Uspenskii, p. 115, fig. 25; Hesseling, fig. 19; Gerstinger, *Wiener Gen.*, p. 67, fig. 43; Der Nersessian, *Barl. et Joas.*, p. 117; Buberl, *Byz. Hss.*, p. 83; Pijoán, *Summa artis*, vol. 7, fig. 556; Weitzmann, "Septuagint," p. 74, fig. 56; Martin, *Heavenly Ladder*, p. 69; Menhardt, p. 298; Esche, *Adam und Eva*, pp. 13–14, 28, pl. 4; Diringer, *Illuminated Book*, fig. II-9b; Gutmann, *Images*, fig. 5; Weitzmann, "Jewish Sources," p. 82, fig. 56; Wessel, "Adam und Eva," col. 44; *LCI*, vol. 1, col. 57, fig. 7; Mouriki-Charalambous, "Cosmas," pp. 18–22, 178; Weitzmann, "Selection," fig. 33; Hutter, "Übermalungen," p. 140; Huber, fig. p. 38; Mathews, "Leo Sacellarios," p. 116; De' Maffei, "Sant'Angelo in Formis II," pt. 2, p. 197, fig. 7; Bernabò, "Laur. plut. 5.38," pp. 138–40, pls. 5, 24 no. 2; Bernabò, "Fonti testuali," pp. 471–72; Bernabò, "Cacciata," fig. 8; Lassus, "Création," pp. 130–32, 140, figs. pp. 131, 139, pl. 3E; De' Maffei, "Eva," pp. 14–15, 32–34; Bagatti, "Tentazione," p. 223, fig. 11; Bernabò, "Introduzione," p. xxxix n. 112; Alexandre, *Commencement*, fig. 16; Bernabò, "Adamo," fig. 7; Bernabò, "Caverna," pp. 723, 732–33, figs. 3, 4; Bernabò, "Tradizioni siriache," pp. 306–7, fig. 7; Bernabò, "Studio," pl. 20; Zirpolo, "Ivory Caskets," p. 10.

[1] As reported, e.g., on fol. 22v in Vat. 747: "καὶ ἔφαγον." The singular "he ate" is also found in some Septuagint manuscripts, as opposed to "they ate" of the majority of Septuagint manuscripts and the Samaritan Hebrew (J. W. Wevers, *Text History of the Greek Genesis* [Göttingen, 1974], p. 90). We owe this suggestion to Professor Sebastian Brock.
[2] *Caverne des Trésors*, ed. Ri, vol. 1, pp. 16–17.
[3] *OTP*, vol. 2, p. 281.
[4] "(. . .) she took of the fruit thereof, and did eat, and she also gave to her husband with her; and *he* did eat." See also the passage from the manuscript formerly in Diyarbakir quoted in note 3 at Genesis 3:6 above.
[5] *Targum Genèse*, ed. Le Déaut, pp. 90–91.
[6] ApMos 20:5 (*OTP*, vol. 2, p. 281).
[7] Cf. *The Targum of the Five Megillot: Ruth, Ecclesiastes, Canticles, Lamentations, Esther. Codex Vaticani Urbinati 1*, ed. E. Levine (Jerusalem, 1977), p. 88. We are grateful to Professor Sebastian Brock for this reference. The Tree of Knowledge is also represented as an apple tree in the Vienna Genesis, pict. 1 (Gerstinger, *Vienna Gen.*, pict. 1).

Genesis 3:8

COVERING WITH FIG LEAVES

In all the Octateuchs Adam and Eve hide themselves near or under the Tree of Knowledge from which they have eaten, a detail not specified in the Septuagint—which reads simply "they sewed fig leaves together" (Gen 3:8)—but explicitly mentioned in Genesis Rabbah 15:7 and in Syrian exegeses.[1] The fig tree, against which Adam and Eve had sinned, provides them shelter and covers their shame.

5g. Laurent., fol. 6r (third row, right)

Adam and Eve appear opposite each other beneath a low and leafy fig tree, as if sitting on a knoll, but are actually crouching in midair against the pink background. Their impossible postures

suggest a misunderstanding of the model, where they sat on a knoll, as in the other Octateuchs. Aware of their nakedness, they make a gesture of embarrassment and cover their loins with leafy girdles. As in the preceding scene, the Garden of Eden is encompassed by streams that branch off on the ridge of the mountain and flow down into the picture zone below. The figures of Adam and Eve are both considerably flaked.

87. Vat. 747, fol. 23v

In a mountainous landscape Adam and Eve sit on the top of a hillock (he at the left this time and she at the right) beneath the fig tree from which they have taken leaves to cover their loins. The Tree of Knowledge is rendered here as a fig tree, as in Laurent., whereas in the previous miniature (fig. 83) it was an apple tree. The whole miniature has been overpainted and has partly flaked again, particularly the figure of Eve.

Located in the catena; the text above is Genesis 3:7.

88. Ser., fol. 46r

The inscription, written outside the frame in the left margin, reads: φύλλα συκῆς ἔρραψαν εἰς σκέπην μόνα.

Adam and Eve sit on either side of a small Tree of Knowledge, which is distinctly marked by golden highlights and, as in the previous miniature (fig. 84), is not rendered as either the apple tree or the fig tree of Vat. 747 and Laurent. The hand of God protrudes from a segment of heaven and emanates rays toward Adam's head. This motif, not visible in Laurent. nor in the restored painting in Vat. 747, is connected with verse 8, where God calls Adam and Eve while he is walking in the Garden. Flaked at various spots.

Located in the catena; the text above is Genesis 3:7.

89. Sm., fol. 13v

The composition agrees with that in Ser., except that the rays striking Adam's face emerge directly from the segment of heaven rather than from the hand of God.

Located in the catena; the text above is Genesis 3:7.

90. Vat. 746, fol. 40v

The inscription in the outer (left) margin reads: φύλλα συκῆς ἔρραψαν εἰς σκέπην μόνα.

Very close to Ser. and Sm.

Located in the catena; the text above is Genesis 3:7.

Lit.: Uspenskii, p. 115; Hesseling, fig. 20; Gerstinger, *Wiener Gen.*, p. 69, fig. 44; Buberl, *Byz. Hss.*, p. 83; Wessel, "Adam und Eva," col. 44; Hutter, "Übermalungen," p. 140; Kirigin, *Mano divina*, p. 133 n. 9; Bernabò, "Laur. plut. 5.38," pp. 138–39, pl. 5; Bernabò, "Cacciata," fig. 8; Lassus, "Création," pp. 132, 140, figs. pp. 133, 139; Schwab, "Isaak-Opfer," p. 437; Bernabò, "Adamo," fig. 7; Bernabò, "Esegesi patristica," p. 61, fig. 11; Zirpolo, "Ivory Caskets," pp. 10–11.

[1] *Genesis Rabbah*, ed. Freedman and Simon, p. 124; *The Early Syrian Fathers on Genesis from a Syriac Ms. on the Pentateuch in the Mingana Collection*, ed. A. Levene (London, 1951), p. 78, esp. pp. 155–56.

[Genesis 3]

STORK NOSE-DIVING TO HIS NEST

5h. Laurent., fol. 6r (third row, extreme right)

At the extreme right of the miniature, detached from Adam and Eve, who are hidden under the tree next to one of the streams of Paradise, the painter supplanted the scene of the Creator Addressing Adam and Eve which appears in the other Octateuchs (figs. 91–94) with a picture of a stork against a golden background nose-diving to its nest on the top of a tree; two young storks lift their long orange beaks toward the adult. The picture of the nose-diving stork is presumably an allegory of the return of the Creator and at the same time an allusion to the Annunciation,[1] to the birth of the Virgin,[2] and to redemption.

Lit.: Bernabò, "Esegesi patristica," pp. 60–65, fig. 11; Di Domenico, p. 142.

[1] Cf., e.g., the dove of the Holy Spirit and the nest with two storks on the roof behind the seated Virgin in a twelfth-century icon with the Annunciation, in the Monastery of St. Catherine on Mount Sinai (text fig. 30). See now *Glory of Byzantium*, no. 246.

[2] Cf. the story of Anna's pregnancy in the *Protoevangelium Iacobi* 2:4–4:1 (*Papyrus Bodmer V*, ed. Testuz, pp. 39–43): Anna comes out into the garden of her house and laments because she is not pregnant; then, looking up into a tree and seeing a nest with two birds, she immediately bursts into tears and begs God to let her have a child. An angel, looming out of the heavens, announces the birth of the Virgin to her.

Genesis 3:9–13

DENIAL OF GUILT BY ADAM

91a. Vat. 747, fol. 24r

Adam tries to run away and hide, but at the same time turns his head in the direction of God's voice, where the hand of God protrudes from a segment of heaven and sends rays toward Adam's face. A series of parallel diagonal lines is drawn in the central ray. Holding a huge fig leaf in one hand, Adam points with his other to the figure of Eve, the instigator of the transgression, in the following scene. The whole miniature has been overpainted and has flaked again in a few spots. The original iconography was not preserved, as we learn from comparison with the other manuscripts.

Located below Genesis 3:13.

Lit.: Gerstinger, *Wiener Gen.*, p. 69, fig. 46; Hutter, "Übermalungen," p. 140; De' Maffei, "Eva," p. 33, fig. 10; Weitzmann, *SP*, p. 34; Sed-Rajna, "Haggadah," p. 419.

Genesis 3:14

DENIAL OF GUILT BY EVE

91b. Vat. 747, fol. 24r

Eve also looks up at the divine hand[1] while covering herself with a fig leaf and trying to escape. At the same time she points

to the serpent wound around the trunk of the Tree of Knowledge—here again rendered as an apple tree—as the culprit who deceived her. The winding of the serpent around the tree is an anomaly with regard to the previous miniature of the Fall (fig. 83c), where it stands erect on its tail, as well as with regard to the Septuagint, where the serpent is not said to have climbed the Tree of Knowledge.[2] The whole miniature has been overpainted and has flaked again in a few spots. The original iconography was likely not preserved by the restorer, a factor which might suitably explain both the inconsistency of the miniature with the remnants of the cycle and most of the differences with Ser., Sm., and Vat. 746.

Located below Genesis 3:13.

Lit.: Miniature, p. 4 n. 2; Gerstinger, *Wiener Gen.*, p. 69, fig. 46; Hutter, "Übermalungen," p. 140; De' Maffei, "Eva," p. 33, fig. 10; Weitzmann, *SP*, p. 34.

[1] As in the previous scene, parallel diagonal lines are traced in the central ray.

[2] The climbing of the serpent is reported differently in the pseudepigraphon Apocalypse of Moses 19:3 (*OTP*, vol. 2, p. 279). The iconography of the serpent coiled around the tree presumably stems either from a figure of Herakles in the garden of the Hesperides (Kessler, *Tours*, p. 29, fig. 46, and "Hic Homo Formatur," p. 155, fig. 28; Kaiser-Minn, *Erschaffung der Menschen*, pp. 61ff., pls. 35, 36) or from the legend of Jason and the golden fleece (Mouriki-Charalambous, "Cosmas," pp. 18–22).

Genesis 3:10–20

DENIAL OF GUILT BY ADAM AND EVE, AND CURSE

5i. Laurent., fol. 6r (fourth row, left)

God curses the serpent and Adam and Eve. The serpent, which in the scene of Eve's temptation was represented upright, is now condemned to slither, according to verses 14–15, and advances toward Adam and Eve. Adam, courageously stepping forward, and Eve, who seeks cover behind Adam's back, face God, whose hand appears in a segment of heaven, and hear the curse which predicts their future sorrows and hardships. Adam's and Eve's loins are covered with leafy girdles. Both figures are considerably flaked. At the extreme left the adult stork seen in the previous miniature (fig. 5h) now crouches, alone, in its nest on the top of the tree.

92. Ser., fol. 47r

The inscription, referring to God's summons rather than to his curse, is written above the miniature and reads: κρύψις, ἔλεγχος, κλῆσις ἐκ τοῦ δεσπότου.

Adam and Eve stand in front of a gold-embellished and singularly low tree, whose lower branches cover part of their bodies. Behind them is the Tree of Knowledge, depicted as taller than in the previous miniature (fig. 88). Adam appears in a calm, frontal position with his arms extended, while Eve moves to leave or to hide from God, whose hand issues from a segment of heaven. The couple's motions agree with those of their summoning by God (cf. fig. 91) rather than their curse, but the serpent advanc-

ing on its belly in the foreground makes it quite certain that this is a combination of elements from both episodes. The reptilian serpent distinctly conflicts with its camel-like image in the illustrations of the Fall (figs. 84–86) and of the curse and the mourning (figs. 96, 97), where the serpent descends from the camel-like half of its body. The elaborate spatial structure of the picture in Ser., Sm., and Vat. 746 suggests a monumental image as a model. Slightly flaked and stained.

Located in the catena; the text on fol. 46v is Genesis 3:13.

93. Sm., fol. 15r

Very close to Ser. Flaked at the left; at the right a tear has been sewn together.

94. Vat. 746, fol. 41v

The inscription written above the miniature reads: κρύψις, ἔλεγχος, κλῆσις ἐκ τοῦ δεσπότου.

Very close to Ser. and Sm.

Located below Genesis 3:13.

Lit.: Kondakov, *Istoriia*, p. 188; Kondakov, *Histoire*, vol. 2, p. 78; Uspenskii, p. 115; Hesseling, fig. 21; Gerstinger, *Wiener Gen.*, p. 68, fig. 45; Buberl, *Byz. Hss.*, p. 83; Diringer, *Illuminated Book*, fig. II-9b; Wessel, "Adam und Eva," cols. 44–45; Eller and Wolf, *Mosaiken*, fig. 32; Hutter, "Übermalungen," p. 140; Kirigin, *Mano divina*, p. 133 n. 9; Bernabò, "Laur. plut. 5.38," pp. 138–39, pl. 5; Bernabò, "Cacciata," fig. 8; Lassus, "Création," pp. 133–35, fig. p. 134, pl. 3F; Anderson, "Seraglio," p. 88, fig. 4; Brubaker, "Gregory of Naz.," p. 443 n. 42; Bernabò, "Adamo," fig. 7; Anderson, "James the Monk," p. 80 n. 59; Bernabò, "Caverna," pp. 723, 735, fig. 13; Zirpolo, "Ivory Caskets," p. 10.

Genesis 3:15–16

Cursing of the Serpent

Vat. 747 displays the condemned serpent slithering on the ground, the curse of Adam and Eve, and the mourning of the protoplasts, now clothed in garments of skin. These pictures illustrate, respectively, Genesis 3:14–15, 16–20, and 21. Ser., Sm., and Vat. 746 have tripartite miniatures which contain the condemned serpent separating from its quadruped-like half, a plow with two oxen representing the curse of verses 17–19, and, finally, the mourning of Adam and Eve clothed in the skins of verse 21. The disagreement among the Octateuchs may be ascribed to the restorer of Vat. 747, who overpainted the whole miniature and omitted the references to labor and pain contained in the divine sentence. Had it ever been depicted in the miniature, the restorer of Vat. 747 did not maintain this odd iconography. The *difficilior lectio* of Ser., Sm., and Vat. 746, unrelated to the Genesis text, has to be credited as closer to the original. A lost writing, such as the one underlying the miniature of the Fall (figs. 83–86), was presumably the textual source for the miniature.

95a. Vat. 747, fol. 24v

In the left corner of the miniature the serpent slithers on the ground, while a ray from the segment of heaven in the center strikes its head. The appearance of the serpent is in complete harmony with that of the previous scene (fig. 91). The whole miniature has been overpainted and an ornamental blue stripe with white pattern has been added to the background.[1] Small parts of the surface have flaked again.

Located below Genesis 3:21.

Lit.: Kondakov, *Istoriia*, p. 188; Kondakov, *Histoire*, vol. 2, p. 78; Tikkanen, "Genesi," p. 264; De Grüneisen, "Cielo," pp. 493–95; Wessel, "Adam und Eva," col. 45; Huber, p. 39; Kirigin, *Mano divina*, p. 134; Lassus, "Création," pp. 135–37, figs. pp. 134, 136; Weitzmann, *SP*, pp. 34–35, 50; Bernabò, "Cacciata," p. 277.

[1] At the extreme left of the ornamental row the white pattern resembles an "X" plus two massive "I"s; five more "I"s are painted in the remaining part of the row. These drawings recall the ornamental patterns occasionally painted on walls, such as the very similar ones in the paintings in the church of St. Euphemia in Istanbul, dating from the early Palaiologan period (R. Naumann and H. Belting, *Die Euphemia-Kirche am Hippodrom in Istanbul und ihre Fresken* [Berlin, 1966], scenes 10 and 14, figs. 32b, 33c; see also pp. 161–62). Earlier examples occur in the manuscript of John Chrysostom in Paris, Bibl. Nat., cod. Coislin 79, fols. 1 and 2 (H. Omont, *Miniatures des plus anciens manuscrits grecs de la Bibliothèque National du VI^e au XIV^e siècle* [Paris, 1929], pls. 61, 63). These motifs recur in Vat. 747 in the Expulsion on fol. 25r (fig. 99).

[Genesis 3:15–16]

Cursing of the Serpent

96a. Ser., fol. 47v

In the miniature on fol. 47v, which according to Uspenskii "was completely spoiled," it is still possible to recognize with difficulty the serpent descending from the quadruped he had mounted to persuade Eve (see fig. 84a), and a group of trees in the background.

Located in the catena; the text above is Genesis 3:21.

97a. Sm., fol. 15v

In the left corner the serpent crawls on the ground. The sizable hump of the serpent, which is not caused by a swelling of the ground, the dark shadow under it, and the general correspondence with Vat. 746 (fig. 98) suggest that the original appearance of the serpent's body was covered by the quadruped-like form during an overpainting of the miniature. The reconstruction of the cursed serpent dismounting from a quadruped is again without any textual basis in the Septuagint (cf. the introduction to nos. 84a–86a) and contradicts the illustration of the curse in the previous miniature, where the serpent slithers along the ground (figs. 93–95).

Located above the catena.

98a. Vat. 746, fol. 43r

The inscription, written outside the frame in the left margin, reads: ἔρπειν τ(ὴν) ὄφιν ἱδροῦν τοὺς πρωτοπλάστος.

Very close to Sm. The serpent is here clearly depicted as a hybrid, with the body and the legs of a quadruped, but the illustrator has indicated quite clearly that the serpent is about to dis-

sociate itself from the part of its body that enabled it to walk erectly and that it is now crawling as the result of God's curse. Almost completely flaked.

Located below Genesis 3:21.

Lit.: Piper, "Bilderkreis," p. 187; Tikkanen, "Genesi," pp. 264, 263 n. 1; *Miniature*, p. 4 n. 2; Uspenskii, p. 115; Hesseling, fig. 22; Buberl, *Byz. Hss.*, p. 85; Wessel, "Adam und Eva," col. 45; Crown, "Winchester Ps.," p. 27; Kötzsche-Breitenbruch, *Via Latina*, pl. 3d; Bernabò, "Fonti testuali," p. 472, pl. 25 no. 1; Bernabò, "Cacciata," p. 277; Lassus, "Création," pp. 133–37, fig. p. 136; De' Maffei, "Eva," pp. 27–29, fig. 4; Bernabò, "Caverna," p. 723, fig. 5.

Genesis 3:17–20

CURSING OF ADAM AND EVE

95b. Vat. 747, fol. 24v

In the center of the miniature, which illustrates the curse after the Fall, Adam and Eve stand opposite each other, their arms raised and their abdomens covered by garlands of foliage. The divine hand, pointing downward from a segment of heaven directly above them, emits rays toward their heads; beyond Adam the beam falls to the ground, striking the head of the serpent of the former episode. The whole miniature, which in its actual state illustrates verses 16–19, has been overpainted, and the ornamental blue stripe with a white pattern in the background is an addition. Small parts of the surface have flaked again.

Located below Genesis 3:21.

Lit.: Kondakov, *Istoriia*, p. 188; Kondakov, *Histoire*, vol. 2, p. 78; Tikkanen, "Genesi," p. 264; De Grüneisen, "Cielo," pp. 493–95; Wessel, "Adam und Eva," col. 45; Huber, p. 39; Kirigin, *Mano divina*, p. 134; Kötzsche-Breitenbruch, *Via Latina*, p. 48; Lassus, "Création," pp. 135–37, figs. pp. 134, 136; Weitzmann, *SP*, pp. 34–35, 50; Bernabò, "Cacciata," p. 277.

Genesis 3:17–22

CURSING OF ADAM AND EVE; GOD CLOTHES ADAM AND EVE

96b. Ser., fol. 47v

An almost completely spoiled miniature on fol. 47v contains an illustration similar to those of Sm. and Vat. 746 (figs. 97, 98). It is still possible to recognize the drawing of the oxen and the plow and, on the right, a part of the seated Adam and Eve clothed in the garments of skins God made for them at verse 22.

Located in the catena; the text above is Genesis 3:21.

97b. Sm., fol. 15v

Adam and Eve, clad in shaggy skins, sit disconsolately side by side looking at a team of oxen; a plowshare and a yoke allude to Adam's future hardship in tilling the soil announced in verse 19. A large segment of heaven, without the hand of God, is visible in the center of the composition.

Located above the catena.

98b. Vat. 746, fol. 43r

The inscription, written outside the frame in the left margin, reads: ὁ δεσπότης εἴρηκεν ἐν ἐργασίαις.

The composition is very close to Sm. The figures of Adam and Eve and the team of oxen are heavily rubbed, but the iron plowshare and the yoke with two prongs can be clearly seen.

Located below Genesis 3:21.

Lit.: Tikkanen, "Genesi," pp. 263 n. 1, 264,; Uspenskii, p. 115; Hesseling, fig. 22; Buberl, *Byz. Hss.*, p. 85; Wessel, "Adam und Eva," col. 45; Crown, "Winchester Ps.," p. 27; Kötzsche-Breitenbruch, *Via Latina*, p. 48, pl. 3d; Bernabò, "Fonti testuali," p. 472, pl. 25 no. 1; Bernabò, "Cacciata," p. 277; Lassus, "Création," pp. 133–37, fig. p. 136; De' Maffei, "Eva," pp. 27–29, fig. 4; Anderson, "James the Monk," p. 80 n. 59; Bernabò, "Caverna," p. 723, fig. 5.

Genesis 3:22

GOD CLOTHES ADAM AND EVE

95c. Vat. 747, fol. 24v

In the right corner Adam and Eve sit opposite each other clad in coats of woolly skins. Whereas Adam rests his head on his arm in a gesture of resignation, Eve appears to be very agitated. As usual, the hand of God sends forth rays from a segment of heaven. This part of the miniature has, like the rest, been thoroughly overpainted.

Located below Genesis 3:21.

Lit.: Kondakov, *Istoriia*, p. 188; Kondakov, *Histoire*, vol. 2, p. 78; Tikkanen, "Genesi," p. 264; De Grüneisen, "Cielo," pp. 493–95; Galavaris, *Gregory Naz.*, p. 120; Wessel, "Adam und Eva," col. 45; Huber, p. 39; Kirigin, *Mano divina*, p. 134; Lassus, "Création," pp. 135–37, figs. pp. 134, 136; Weitzmann, *SP*, pp. 34–35, 50; Bernabò, "Cacciata," p. 277.

Genesis 3:24

EXPULSION

The Expulsion of Adam and Eve from the Garden is represented in Vat. 747, Ser., Sm., and Vat. 746 in two distinct episodes contained in a tripartite miniature. Laurent. has only the first of these episodes, in the last row of the large miniature on fol. 6r. The first of these representations of the Expulsion conforms to the narrative of Genesis 3:23–24, since it depicts God himself (or rather his hand) casting Adam and Eve out of the Garden. In the second scene the hand of God is omitted, and an angel pushes the cursed progenitors by their shoulders, following a popular iconography of the Expulsion. No angel participates in the drama narrated in the closing verses of chapter 3 of Genesis, nor is any mention made there of the gate of Eden with one cherub appointed to guard it, as shown between the first and second scenes, nor of the entire third scene of the miniature, the grieving Adam and Eve. All of these features pertain to contemporary Christian imagery: they dramatize the pictorial narrative by means of a vivacious tale of the Fall.

99a. Vat. 747, fol. 25r

In the first scene Adam and Eve, clad in their shaggy skins, are ordered to leave the Garden of Eden by the hand of God that protrudes from a segment of heaven. While still listening, they obey and begin to depart. This first of three scenes has been thoroughly overpainted, like the other scenes. An ornamental blue stripe with a white pattern is painted in the background all along the top of the miniature.[1] Slightly flaked.

Inaccurately located below Genesis 4:2, as in Ser., Sm., and Vat. 746; its proper place would have been at the end of chapter 3.

100a. Ser., fol. 49r

The inscription, written outside the left border of the miniature, reads: γνῶσις γυναικὸς ἐνθάδε τέκνων τόκος. ζωῆς ξύλου τήρησις, to which a later hand added ἡ φλογοτρόπος.

Except for a slight deviation in Eve's grieving gesture (she holds her right hand to her cheek), the composition agrees with Vat. 747. The entire surface is very badly flaked.

Located below Genesis 4:2.

101a. Sm., fol. 16r

Very close to Ser. and likewise badly flaked.
Located below Genesis 4:2.

102a. Vat. 746, fol. 44r

The inscription, written outside the left border, reads: ζωῆς ξύλου τήρησις ἡ φλογοτρόφος.

Very close to Ser. and Sm.
Located below Genesis 4:2.

Lit.: Tikkanen, "Genesi," p. 265; Strzygowski, *Sm.,* p. 114, pl. 33; Venturi, *Storia,* vol. 2, fig. 326; Uspenskii, pp. 115–16, fig. 26; Hesseling, fig. 23; Gerstinger, *Wiener Gen.,* p. 71, fig. 47; Buberl, *Byz. Hss.,* p. 85; Pijoán, *Summa artis,* vol. 7, fig. 557; Menhardt, p. 298; Garrison, "Creation and Fall," p. 208 n. 4; Wessel, "Adam und Eva," col. 45; Kessler, "Hic Homo Formatur," p. 150; Hutter, "Übermalungen," p. 140, fig. 1; Schubert, *Spätantikes Judentum,* p. 17; Kirigin, *Mano divina,* p. 133 n. 9; Kessler, *Tours,* pp. 20–21; Bernabò, "Laur. plut. 5.38," p. 144; Bernabò, "Fonti testuali," pp. 470–71, pl. 24 no. 1; Bernabò, "Cacciata," pp. 274–75, 277, fig. 6; Lassus, "Création," pp. 137–38, fig. p. 138, pl. 3G; Weitzmann, *SP,* p. 35; Anderson, "Seraglio," pp. 88, 106; Brubaker, "Gregory of Naz.," pp. 349, 355; Alexandre, *Commencement,* p. 327; Bernabò, "Adamo," fig. 12; Bernabò, "Caverna," pp. 723–24, fig. 6; Bernabò, "Tradizioni siriache," p. 306, fig. 6; Zirpolo, "Ivory Caskets," p. 11.

[1] The white drawing in this stripe resembles a giant "I." A similar ornamental stripe is also painted in no. 95 in the same manuscript.

[Genesis 3:24]

EXPULSION

The second scene of the Expulsion comprises three elements differing from the Septuagint: the angel expelling Adam and Eve (Genesis indicates God as the performer of the action, whereas in the Apocalypse of Moses 27:1 an angel is responsible);[1] the gate of Eden (known in pseudepigrapha such as The Conflict of Adam and Eve with Satan, a tale of Jewish-Christian origin close to The Cave of Treasures);[2] and, third, the single cherub with the flaming sword, instead of more cherubim and the flaming sword of Genesis 3:24, an additional debt to pseudepigrapha such as The Cave of Treasures and The Conflict of Adam and Eve,[3] as well as to Ephrem.[4] The illustration thus has no extant textual basis; its elements are instead found disseminated in Adam literature, suggesting an origin in that realm.

Finally, in Laurent. Adam and Eve are expelled not clothed in the skins mentioned in Genesis 3:21, but wearing leafy girdles on their loins. This absence of skins at the Expulsion cannot be regarded as a mere mistake by the painter: the skins are also omitted in a number of other Byzantine depictions.[5] The material of these garments is debated in the catena to the Octateuch arranged by Prokopios of Gaza, where the author rejects the view that the skins are allegorical denotations of the perishable bodies or the corporeal mortality of the protoplasts.[6] Such an allegorical interpretation of the skins is maintained by a few Fathers, especially Gregory of Nyssa, who stresses that Adam and Eve were wearing nothing but the fig girdles they made themselves when they were expelled.[7] On the other hand, a literal approach to the material of Adam's and Eve's garments is taken in pseudepigrapha[8] and in Jewish[9] and Christian writings. In the Christian sources, e.g., in John Chrysostom,[10] the skins are identified as sheep's fleece, corresponding to the representation in the miniature, whereas another great Syrian writer, Theodore of Mopsuestia, and his followers describe the clothes as made of tree bark.[11]

5j. Laurent., fol. 6r (fourth row, center)

In the second version of the Expulsion, the only one represented in the Laurentian manuscript, the actual casting out of Adam and Eve is carried out not by God himself, but by an angel who pushes Adam by the shoulders. The angel emerges from the entrance gate to the Garden of Eden, which is guarded by a cherub painted fiery red, like the entire gate, the drapery, and even the angel's face.[12] The cherub virtually melts into the red door. Adam and Eve, wearing only foliage girdles instead of coats of skin, are represented looking back at Paradise with expressions of grief.

99b. Vat. 747, fol. 25r

The composition of this scene, which fills the center of the strip, is essentially the same as in Laurent., but the angel is painted a flesh color and wears blue and violet garments instead of entirely red. Furthermore, in agreement with the text, Adam and Eve are clad in skins. Thoroughly overpainted like the rest of this miniature and now flaked again in various places, particularly the figure of the angel.

Located below Genesis 4:2.

100b. Ser., fol. 49r

The inscription, written above the right half of the upper frame, reads: χώραν διώξις ἥδε τῶν πρωτοπλάστων.

The attitudes are slightly different from Vat. 747—the angel does not step forward so hastily, and Eve holds her arms crossed over her breast and touches her chin—but otherwise the scene agrees with Vat. 747. Large parts of the surface are flaked.

Located below Genesis 4:2.

101b. Sm., fol. 16r

The scene, which, judging from the clumsy faces, must have been overpainted like the rest of the miniature, is very close to Ser. Somewhat flaked.

Located below Genesis 4:2.

102b. Vat. 746, fol. 44r

The inscription, in spite of being completely flaked, can still be read because of the negative traces left on the background: χώραν διώξις . . . τῶν πρωτοπλάστων.

Very close to Ser. and Sm. and somewhat rubbed.

Located below Genesis 4:2.

Lit.: Tikkanen, "Genesi," p. 265; Strzygowski, *Sm.*, p. 114, pl. 33; Venturi, *Storia*, vol. 2, fig. 326; Uspenskii, p. 115, fig. 26; Hesseling, fig. 23; Troje, ΑΔΑΜ und ΖΩΗ, p. 69 n. 2; Gerstinger, *Wiener Gen.*, p. 71, fig. 47; Buberl, *Byz. Hss.*, p. 85; Pijoán, *Summa artis*, vol. 7, fig. 557; Martin, *Heavenly Ladder*, p. 69; Menhardt, pp. 298–99; Diringer, *Illuminated Book*, fig. II-9b; Garrison, "Creation and Fall," p. 208 n. 4; Der Nersessian, *Aght'amar*, p. 43; Wessel, "Adam und Eva," col. 45; Kessler, "Hic Homo Formatur," p. 150; Hutter, "Übermalungen," p. 140, fig. 1; Schubert, *Spätantikes Judentum*, p. 17; Kötzsche-Breitenbruch, *Via Latina*, p. 47; Kessler, *Tours*, pp. 20–21; Bernabò, "Laur. plut. 5.38," pp. 138–39, 144, pl. 5; Bernabò, "Fonti testuali," pp. 470–71, pl. 24 no. 1; Bernabò, "Cacciata," pp. 274–75, 277–78, figs. 6, 8; Lassus, "Création," pp. 137–38, 140, figs. pp. 138, 139, pl. 3G; Weitzmann, *SP*, p. 35; Bergman, *Salerno*, pp. 21, 43, 46, fig. 60; De' Maffei, "Eva," p. 32; Anderson, "Seraglio," pp. 88, 106; Brubaker, "Gregory of Naz.," pp. 349, 355; Alexandre, *Commencement*, pp. 327, 337; Bernabò, "Adamo," pp. 21–22, figs. 7, 12; Anderson, "James the Monk," p. 80 n. 59; Bernabò, "Caverna," pp. 724, 733, fig. 6; Bernabò, "Tradizioni siriache," p. 306, fig. 6.

¹ *OTP*, vol. 2, p. 285. Cf. Brubaker, "Gregory of Naz.," pp. 349, 437 note 14; Kessler, *Tours*, p. 30; and Bernabò, "Septuagint," note 13, with previous literature.

² CAE 2, 4, 9, 12–13, 32 (*Il Combattimento di Adamo*, ed. A. Battista and B. Bagatti [Jerusalem, 1982], pp. 33, 35, 41, 49, 51, 92); the Arabic version cannot be earlier than the eighth–ninth century, but it depends on a text dating from the first centuries of the Christian era (ibid., pp. 27–28). A gate on the way to Paradise is familiar in Christian writings (e.g., John of Damascus, *In Dormitionem B.M.V.* 3:2) and is compared with baptistery gates (Gregory of Nyssa, *Adversus eos qui differunt Baptismum* [PG 46, cols. 417, 421]).

³ *Caverne des Trésors*, ed. Ri, vol. 1, pp. 18–19; *Combattimento*, ed. Battista and Bagatti, p. 35.

⁴ Kronholm, *Motifs from Genesis*, p. 131. The Targumim, on the other hand, explicitly mention two cherubim (*Targum Genèse*, ed. Le Déaut, pp. 98–99).

⁵ See, e.g., the manuscript of Gregory Nazianzenus in Paris, cod. gr. 510, fol. 25v (H. Omont, *Miniatures des plus anciens manuscrits grecs de la Bibliothèque Nationale du VIe au XIVe siècle* [Paris, 1929], pl. 24); the manuscripts

of James of Kokkinobaphos in Paris, Bibl. Nat., cod. gr. 1208, fol. 47r (H. Omont, "Miniatures des homélies sur la Vierge du moine Jacques," *Bulletin de la Société Française de Reproduction de Manuscrits à Peintures* 11 [1927], pl. 5) and in Rome, Bibl. Vat., cod. gr. 1162, fol. 33r (C. Stornajolo, *Miniature delle Omilie di Giacomo Monaco [Cod. Vatic. Gr. 1162] e dell'Evangeliario Greco Urbinate [Cod. Vatic. Urbin. Gr. 2]* [Rome, 1910], pl. 11); and the cycle of Ałt'amar (Thierry, "Ałt'amar," fig. 6), which we have also associated with Laurent. in the emerging of Eve from Adam's left side (see the introduction to [Genesis 2:21–22]).

⁶ Cf. P. F. Beatrice, "Le tuniche di pelle: Antiche letture di Gen 3.21," in *La tradizione dell'Enkrateia*, ed. U. Bianchi (Rome, 1985), pp. 433ff.

⁷ Cf. esp. *In Baptismum Christi* (PG 46, cols. 597–600).

⁸ CAE 10, 29–30 (*Combattimento*, ed. Battista and Bagatti, pp. 45, 88–90).

⁹ GenR 20:12 (*Genesis Rabbah*, ed. Freedman and Simon, p. 171).

¹⁰ *HomGen* 18: " . . . he [the Lord] later arranged for clothes for human beings out of sheep's fleece . . . ;" not much later John Chrysostom again employs the locution "sheep's wool" (John Chrysostom, *Homilies on Genesis 18–45*, ed. Hill, p. 6; PG 53, col. 149). Other Christian Fathers also interpret these skins literally (cf. Bernabò, "Cacciata," p. 277, esp. n. 12).

¹¹ *Fragmenta in Genesim* (PG 66, col. 641); see also R. Devreesse, *Les anciens commentateurs grecs de l'Octateuque et des Rois (fragments tirés des chaînes)* (Vatican City, 1959), pp. 22–23; and the text published by R. M. Tonneau, "Théodore de Mopsueste: Interprétation (du livre) de la Genèse (Vat. Syr. 120, ff. I–IV)," *Mus* 66 (1953), pp. 59–60.

¹² This iconography is connected to a Last Judgment or an Anastasis; see A. D. Kartsonis, *Anastasis: The Making of an Image* (Princeton, 1986), p. 78 and passim.

[Genesis 3–4]

Mourning after the Expulsion

The figures of the grieving Adam and Eve in the last episode of the Expulsion miniature are independent of Genesis, where chapter 3 breaks off at the Expulsion and chapter 4 starts with the intercourse of Adam and Eve and the birth of Cain. The mourning after the Expulsion was, however, a popular episode in the imagery of the first centuries of the Christian era, and appears in both monuments and texts. The Octateuch iconography displays Adam imploring the heavens while Cain unsuccessfully tries to capture his father's attention. Notwithstanding the fact that the story of Adam and Eve after the Expulsion is embellished with various deeds in the Life of Adam and Eve and other pseudepigrapha, no extant source accounts for the Octateuchs' dramatization of the story.¹

5k. Laurent., fol. 6r (fourth row, right)

Adam and Eve, now clad in garments in place of the fig leaves of the preceding scene, sit opposite each other and bemoan the loss of Paradise. The scene is framed on both sides by streams which flow down from the strip above, where they fulfilled a similar function. Both figures are badly flaked.

99c. Vat. 747, fol. 25r

The bearded Adam raises his hands and looks up to heaven without taking any notice of tiny Cain standing in front of him

and touching his knee. Eve sits sorrowfully beside him with her head resting in her right hand; she holds an object, possibly a spindle, in her left hand. The parents are no longer clad in gray skins, but wear tunics colored violet and red. Like the rest of the miniature, this scene has been overpainted and presumably originally included a segment of heaven in the sky to which Adam lifted his hands. The ornamental pattern in the sky is an addition of the restorer. Partly flaked.

Located below Genesis 4:2.

100c. Ser., fol. 49r

The inscription reads: γνῶσις γυναικὸς ἐνθάδ(ε) (τ)έκνων τόκ(ος).

Adam, who looks up to the segment of heaven, is unbearded, and Eve appears to be pregnant, but otherwise the composition agrees with Vat. 747. The figures are very badly flaked, and of little Cain only the face and a small section of garment remain.

Located below Genesis 4:2.

101c. Sm., fol. 16r

Close to Ser., but Eve is not clearly depicted pregnant here. Crudely overpainted.

Located below Genesis 4:2.

102c. Vat. 746, fol. 44r

The inscription, although mostly flaked, can still be read: γνῶσις γυναικὸς ἐνθάδε τέκνων τόκος.

Eve's pregnancy here is more pronounced.

Located below Genesis 4:2.

Lit.: Tikkanen, "Genesi," p. 265; Strzygowski, *Sm.*, pp. 114–15, pl. 33; Venturi, *Storia*, vol. 2, fig. 326; Uspenskii, p. 115, fig. 26; Hesseling, fig. 23; Gerstinger, *Wiener Gen.*, p. 71, fig. 47; Buberl, *Byz. Hss.*, p. 85; Pijoán, *Summa artis*, vol. 7, fig. 557; Diringer, *Illuminated Book*, fig. II-9b; Garrison, "Creation and Fall," p. 208 n. 4; Wessel, "Adam und Eva," col. 45; Hutter, "Übermalungen," p. 140, fig. 1; Schubert, *Spätantikes Judentum*, p. 17; Kötzsche-Breitenbruch, *Via Latina*, p. 49; Bernabò, "Laur. plut. 5.38," pp. 138–39, 144, pl. 5; Bernabò, "Fonti testuali," pp. 470–71, pl. 24 no. 1; Bernabò, "Cacciata," pp. 274–75 n. 10, 277, figs. 6, 8; Lassus, "Création," pp. 137–38, fig. 138, pl. 3G; Bergman, *Salerno*, p. 21, n. 52; Anderson, "Seraglio," pp. 88, 106; Bernabò, "Adamo," figs. 7, 12; Bernabò, "Caverna," p. 724, fig. 6.

[1] The mourning of Adam and Eve is narrated in *Vita* I:I, where they "mourned for seven days, weeping in great sorrow" (*OTP*, vol. 2, p. 258). In the Slavonic *Vita Adamae et Evae* 28:1 they "sat together before the gate of paradise, Adam weeping with his face bent down to the earth, lay on the ground lamenting" (*The Apocrypha and Pseudepigrapha of the Old Testament in English*, vol. 2, *Pseudepigrapha*, ed. R. H. Charles [Oxford, 1913], p. 134).

Genesis 4:2

CAIN AS A TILLER OF THE GROUND

The picture cycle of the Laurenziana manuscript breaks off at the Expulsion on fol. 6r. The cycle in the other Octateuchs continues with a miniature arranged in two superimposed strips with four vignettes of the story of Cain and Abel.[1] The model for Cain

plowing, and for the following figure of Abel as a shepherd, must be sought in bucolic representations.[2]

103a. Vat. 747, fol. 25v

At the foot of high, multicolored mountains with date palms set against a golden sky, Cain, dressed in a tunic, tills the earth with a plowshare drawn by a team of oxen. This last detail is not referred to in the Septuagint, where Cain is only called a tiller of the earth. The miniature has been overpainted and in a few places has flaked again.

Located below Genesis 4:8.

104a. Ser., fol. 50r

The inscription, written above the upper frame and partly damaged, reads: Κάϊν γεωργ(ικὸς) ὁ φθόνων ὑπηρέτης.

Close to Vat. 747, but the mountain has been omitted. Large sections are flaked.

Located in the catena; the text above is Genesis 4:8.

105a. Sm., fol. 16v

Very close to Ser. Flaked in various spots.

106a. Vat. 746, fol. 45r

The inscription, written in the margin to the left of the miniature, reads: Κάϊν γεωργ(ικὸς) ὁ φθόνω(ν) ὑπηρέτης.

Very close to Ser. and Sm. and slightly rubbed and flaked.

Located in the catena; the text above is Genesis 4:8.

Lit.: Piper, "Denkmäler," p. 477; Tikkanen, "Genesi," p. 350; Strzygowski, *Serb. Ps.*, p. 104; Ainalov, *Hellenistic Origins*, p. 10; Uspensky, pp. 116–17, fig. 27; Stornajolo, *Topografia Cristiana*, p. 17; Hesseling, fig. 24; Redin, *Koz'my Indikoplova*, p. 355; Weitzmann, "Martyrion," p. 140; Henderson, "Sources," p. 21 n. 2; Wolska-Conus, *Cosmas*, vol. 1, p. 152 and vol. 2, pp. 116–17 n. 75, 1; Mouriki-Charalambous, "Cosmas," pp. 22–27; Schubert, *Spätantikes Judentum*, p. 18; Kötzsche-Breitenbruch, *Via Latina*, pl. 4e; De' Maffei, "Sant 'Angelo in Formis II," pt. 2, p. 199; Bernabò, "Fonti testuali," pl. 24 no. 2; Ulrich, *Kain und Abel*, pp. 61–64, fig. 82; Anderson, "Seraglio," p. 106; Bernabò, "Introduzione," p. xxxix n. 112; Sed-Rajna, *Hebraic Bible*, p. 12 n. 26; Revel-Neher, *Image of the Jew*, p. 78, figs. 41, 42; Bernabò, "Caverna," p. 724, fig. 7; Bernabò, "Studio," pl. 21.

[1] The miniature would have been appropriately located below Gen 4:2, but the Expulsion miniature was erroneously painted in that place.
[2] Similar plowmen occur in the *Cynegetica* of pseudo-Oppian in Venice, Bibl. Marc., cod. gr. 479, fol. 24v (Furlan, *Codici greci*, fig. 38) and in the Gregory of Nazianzos in Jerusalem, Patr. Lib., cod. Taphou 14, fol. 33r (Galavaris, *Gregory Naz.*, fig. 103).

Genesis 4:2

ABEL AS A KEEPER OF SHEEP

103b. Vat. 747, fol. 25v

A nimbed Abel wearing a shaggy fleece watches his flocks; he stands casually with crossed legs and holds a shepherd's staff. Most of the sheep are grazing, while two goats leaping back to

back turn to look at each other.[1] The miniature has been over-painted and has flaked again in a few places.

Located below Genesis 4:8.

104b. Ser., fol. 50r

Close to Vat. 747, except that the mountains in the background have been omitted and Abel's flock reduced in size. Large sections are flaked, particularly in the lower zone.

Located in the catena; the text above is Genesis 4:8.

105b. Sm., fol. 16v

Very close to Ser. and likewise flaked in various spots.

106b. Vat. 746, fol. 45r

Close to Ser. and Sm. and slightly flaked.
Located in the catena; the text above is Genesis 4:8.

Lit.: Piper, "Denkmäler," p. 477; Tikkanen, "Genesi," p. 350; Ainalov, *Hellenistic Origins*, p. 10; Uspenskii, pp. 116–17, fig. 27; Hesseling, fig. 24; Redin, *Koz'my Indikoplova*, p. 355; Weigand, p. 379; Weitzmann, "Martyrion," p. 140; Henderson, "Sources," p. 21 n. 2; Wolska-Conus, *Cosmas*, vol. 1, p. 152 and vol. 2, pp. 116–17 n. 75,1; Mouriki-Charalambous, "Cosmas," pp. 22–27; Kötzsche-Breitenbruch, *Via Latina*, pl. 4e; De' Maffei, "Sant'Angelo in Formis II," pt. 2, p. 199; Bernabò, "Fonti testuali," pl. 24 no. 2; Ulrich, *Kain und Abel*, pp. 61–64, figs. 82, 86; Anderson, "Seraglio," p. 106; Bernabò, "Introduzione," p. xxxix n. 112; Sed-Rajna, *Hebraic Bible*, p. 12 n. 26; Revel-Neher, *Image of the Jew*, p. 78, figs. 41, 42; Bernabò, "Caverna," p. 724, fig. 7; Bernabò, "Studio," pl. 21.

[1] The scheme of two leaping goats is well known from classical antiquity. The cross-legged figure of the shepherd leaning on his staff is very familiar in ancient bucolic iconography and must be regarded as a standard figure (see Rosenthal, *Vergilius Romanus*, pp. 34–35 and the list in note 2, p. 34; and Weitzmann, *Greek Mythology*, pp. 115–18); to Uspenskii (p. 116) it brought to mind Praxiteles' statuary.

Genesis 4:3–5

SACRIFICES OF CAIN AND ABEL

In Vat. 747 the fire descending from heaven upon Abel's offering is a feature unrelated to the Septuagint's Greek translation, but mentioned in Theodotion's Greek translation.[1] It is popular in pseudepigrapha, such as The Conflict of Adam and Eve with Satan,[2] or The Book of the Bee,[3] a writing dependant on the tradition of The Cave of Treasures; here, a fire burning Abel's offering is introduced as an answer to the question of how God expressed his pleasure with Abel's offering and not with Cain's. The fire is familiar in Jewish texts[4] and Christian exegetes, especially Syrian, such as the third- and fourth-century authors Aphrahat, Ephrem, and John Chrysostom,[5] as well as Alexandrian writers such as Cyril.[6]

103c. Vat. 747, fol. 25v

In the left half of the lower register Cain approaches from the left and Abel from the right. Both men pray to God with veiled hands, while their offerings, some ears of grain and a lamb, are placed before them on the ground. Alternatively, in the other Octateuchs they hold the offerings in their hands.[7] God's hand, protruding from a segment of heaven, sends forth a column of fire that consumes Abel's sacrifice while disregarding Cain's. The scene takes place before high, multicolored mountains with craggy peaks; decorative houses are painted behind them in grisaille. Heavily overpainted.

Located below Genesis 4:8.

104c. Ser., fol. 50r

The brothers hold their sacrifices in their veiled hands, Cain the ears of grain and Abel the lamb. The column of fire is omitted, and the blessing of Abel's offering is indicated simply by the direction of the divine hand. The mountainous background is eliminated entirely. The strip of ground and the brothers' legs and faces are flaked entirely, as well as other parts of the surface to a lesser degree.

Located in the catena; the text above is Genesis 4:8.

105c. Sm., fol. 16v

The scene is very close to Ser. Crudely overpainted.

106c. Vat. 746, fol. 45r

Very close to Ser. and Sm.
Located in the catena; the text above is Genesis 4:8.

Lit.: Piper, "Denkmäler," p. 477; Uspenskii, p. 116, fig. 28; Hesseling, fig. 24; Troje, AΔAM und ZΩH, p. 69 n. 2; Menhardt, p. 299; Hovingh, "Fumée du sacrifice," p. 46 n. 13; Braude, "Cokkel," p. 596, n. 29; Weitzmann, "Jewish Sources," pp. 82–83, fig. 62; Galavaris, *Gregory Naz.*, p. 55; Wessel, "Kain und Abel," cols. 719–20; Revel-Neher, "Iconographie," p. 311; Anderson, "Two Centers," p. 57; Kötzsche-Breitenbruch, *Via Latina*, p. 50, pl. 4e; Bernabò, "Fonti testuali," pp. 472–73, pl. 25 no. 2; Stichel, *Namen Noes*, p. 110; Bergman, *Salerno*, p. 23, fig. 63; Ulrich, *Kain und Abel*, pp. 61–64, figs. 82, 86; Anderson, "Seraglio," p. 106; Prigent, *Judaïsme*, pp. 301–2; Revel-Neher, *Image of the Jew*, p. 78, figs. 41, 42; Bernabò, "Caverna," pp. 724, 734, fig. 7; Bernabò, "Studio," p. 282, pl. 21.

[1] See Origen's *Hexapla* (PG 15, col. 182). Cf. Brock, "Syriac Life of Abel," pp. 486–87.
[2] According to both the edition in *Dictionnaire des apocryphes, ou collection de tous les livres apocryphes relatifs à l'Ancien et au Nouveau Testament*, ed. J.-P. Migne, vol. 1 (Paris, 1856), col. 337, and the one by A. Dillmann (*Das christliche Adambuch des Morgenlandes* [Göttingen, 1853], p. 71).
[3] Chap. 18 (*Book of the Bee*, ed. Budge, p. 26).
[4] A. Scheiber, "La fumée des offrandes de Caïn et d'Abel: Histoire d'une legénde," *REJ* 15/115 (1956), pp. 9–24, esp. p. 11. Weitzmann first indicated the source of the Vat. 747 miniature in haggadic texts ("Jewish Sources," p. 82); the tradition of the fire, however, is not found in most of the earliest Jewish authors, such as Philo and Josephus (see V. Aptowitzer, *Kain und Abel in der Agada* [Vienna and Leipzig, 1922], pp. 41–42), nor in GenR, but it might have likewise existed. Cf. Cyril of Alexandria's knowledge of this detail: R. L. Wilken, *Judaism and the Early Christian Mind: A Study of Cyril of Alexandria's Exegesis and Theology* (New Haven and London, 1971), pp. 58–59.
[5] See Aphrahat, *Dem* 4:2 (*La version arménienne des oeuvres d'Aphraate le Syrien*, ed. G. Lafontaine [Louvain, 1977], p. 35); John Chrysostom, *De inani gloria et de educandis liberis* 39 (*Sur la vaine gloire et l'éducation des enfants*, ed. Malingrey, p. 132); Ephrem, *CommGen* 3:3 (Ephraem, *In Genesim et in Exodum commentarii*, ed. Tonneau, p. 37); cf. S. Brock, "Jewish Traditions in Syriac Sources," *JJS* 30 (1979), p. 225, and Brock, "Syriac Life of Abel," pp. 486–87.

6 Cyril of Alexandria, *Glaphyra in Genesim* 1 (PG 69, col. 36); the passage of Cyril on the fire is reported in the catena of the Octateuchs (e.g., Vat. 746, fol. 45v). Cyril's knowledge of the fire descending upon Abel's offerings, however, quite probably stems from the Haggadah (Wilken, *Judaism and the Early Christian Mind* [as in note 4], pp. 58–59).

7 The offerings on the ground are a rare variant that might be connected to the paraphrasis of the story narrated in a homily of John Chrysostom, where Abel's offerings are raised by a fire to the heavenly altar, while Cain's remained on the ground (*De inani gloria et de educandis liberis* 39; *Sur la vaine gloire et l'éducation des enfants*, ed. Malingrey, p. 132).

Genesis 4:8

SLAYING OF ABEL

The Septuagint does not specify the means by which Cain killed Abel, but in Byzantine art[1] it is usually depicted as stoning. Stoning is commonly reported in Jewish texts: Targum Pseudo-Jonathan translates "and Cain rose against Abel his brother and drove a stone into his forehead."[2] The feature is also common in pseudepigrapha, such as Jubilees and The Cave of Treasures,[3] but is rarely found in Christian exegesis.[4]

103d. Vat. 747, fol. 25v

Cain kills Abel at the foot of a high mountain. While Cain is about to throw a stone and holds another in reserve, Abel has already fallen headfirst to the ground, hit by previous blows and trying in vain to protect his bleeding head. Heavily overpainted.

Located below Genesis 4:8.

104d. Ser., fol. 50r

Whereas the posture of the stone-throwing Cain agrees with Vat. 747, Abel's is entirely different and recalls a sleeping Endymion. He has fallen on his back and leans against a small rise in the ground, apparently too weak to protect his bleeding head with his arms. There is no landscape background. A segment of heaven is represented, but without the hand of God. Considerably flaked, particularly the strip of ground and both brothers' faces.

Located in the catena; the text above is Genesis 4:8.

105d. Sm., fol. 16v

The scene is very close to Ser. and has been overpainted.

106d. Vat. 746, fol. 45r

Very close to Ser. and Sm.
Located in the catena; the text above is Genesis 4:8.

Lit.: Piper, "Denkmäler," p. 477; Tikkanen, "Genesi," pp. 350–51; Uspenskii, p. 116, fig. 28; Hesseling, fig. 24; Troje, AΔAM *und* ZΩH, p. 69 n. 2; Neuss, *Katalan. Bibelill.*, p. 41; Weitzmann, "Martyrion," p. 140; Menhardt, p. 299; Weitzmann, "Jewish Sources," pp. 82–83, fig. 62; Wessel, "Kain und Abel," col. 720; Bucher, *Pamplona Bibles*, p. 138 n. 75; Revel-Neher, "Iconographie," p. 311; Weitzmann, "Study," p. 52; Crown, "Winchester Ps.," p. 28; Kötzsche-Breitenbruch, *Via Latina*, pl. 4e; Kessler,

Tours, p. 30 n. 62; Bernabò, "Fonti testuali," pp. 472–73; pl. 25 no. 2; Weitzmann, *SP*, pp. 35, 50; Bergman, *Salerno*, p. 23; Ulrich, *Kain und Abel*, pp. 61–64, figs. 82, 86; De Angelis, "Simbologia," pp. 1528–29, figs. 1, 2; Anderson, "Seraglio," p. 106; Bernabò, "Introduzione," p. xli n. 115; Weitzmann and Kessler, *Cotton Gen.*, p. 42; Anderson, "James the Monk," pp. 79–80; Revel-Neher, *Image of the Jew*, p. 78, fig. 41; Bernabò, "Caverna," pp. 724, 734, fig. 7; Zirpolo, "Ivory Caskets," p. 11; Bernabò, "Studio," pl. 21.

1 See, for instance, the ivory plaques in Cleveland, St. Petersburg, Lyon, and Pesaro (Goldschmidt and Weitzmann, *Elfenbeinskulpturen*, vol. 1, *Kästen*, pls. 47, 48, 51, 55); the manuscript of James of Kokkinobaphos in Rome, cod. Vat. gr. 1162, fol. 35v (Stornajolo, *Omilie di Giacomo Monaco* [as in note 5, p. 41], pl. 12); and the *Sacra Parallela* in Paris, Bibl. Nat., cod. gr. 923, fol. 355r (Weitzmann, *SP*, fig. 11).

2 G. Vermes, "The Targumic Version of Genesis IV 3–16," *Annual of Leeds University Oriental Society* 3 (1963), pp. 88, 100; cf. *Targum Genèse*, ed. Le Déaut, p. 105; GenR 22:8 (*Genesis Rabbah*, ed. Freedman and Simon, p. 188).

3 Jub 4:31 (*OTP*, vol. 2, p. 64); CavTr 5:29 (*Caverne des Trésors*, ed. Ri, vol. 1, p. 20).

4 E.g., Didymos the Blind, *On Genesis* 126:24–27 (*Didyme l'Aveugle, Sur la Genèse*, ed. Nautin and Doutreleau, vol. 1, p. 297). For additional references, see Bernabò, "Fonti," p. 473. For a discussion of the weapon used by Cain, with earlier literature, see Barb, "Cain's Murder-Weapon," pp. 386–89.

Genesis 4:9–15

CURSING OF CAIN

107a. Vat. 747, fol. 26r

God calls Cain and inquires about Abel's whereabouts. A beam of light from his hand in heaven strikes the face of Cain, who reacts with a frightened gesture, at the same time moving in the opposite direction as if to escape or hide. In the central ray of the beam of light is an inscription which reads: ποῦ Ἄβελ ὁ ἀδελφός σου. The scene, set against a mountain with decorative buildings between its peaks, has been overpainted like the rest of the miniature and is now somewhat flaked again.

Located below Genesis 4:17.

108a. Ser., fol. 50v

The inscription, written outside the frame in the left margin, reads: ἔλεγχος ὧδε πρωτοφονέως Κάϊν.

Cain's pose is similar to that in Vat. 747 but less dramatic, and he does not attempt to escape. There is no landscape, but simply a blue background. The surface is flaked in various places and the offset of letters from the opposite page is visible.

Located below Genesis 4:17.

109a. Sm., fol. 17r

Very close to Ser. and partly flaked.

110a. Vat. 746, fol. 46r

The inscription, written outside the frame to the left, as far as it pertains to this scene, reads: ἔλεγχος ὧδε πρωτοφονέως Κάϊν.

Very close to Ser. and Sm.
Located below Genesis 4:17.

Lit.: Uspenskii, p. 117, fig. 29; Hesseling, fig. 25; Wessel, "Kain und Abel," col. 720; Kirigin, *Mano divina*, p. 135; Weitzmann, *SP*, p. 36; Bergman, *Salerno*, pp. 23–24, fig. 65; Ulrich, *Kain und Abel*, pp. 61–65, fig. 87; Bernabò, "Caverna," p. 724, fig. 8.

[Genesis 4:16]

Affliction of Cain

In the second episode of the tripartite miniature Cain departs, alone and saddened, after being cursed. No sign is visible of God placing the curse on him as related by Genesis 4:15,[1] and the general focus is on his affliction and remorse. These emotions are not explicitly attributed to Cain in the Genesis account, where (verse 16) Cain is told to go out of the presence of God and dwell in the land of Nod. No extant sources correspond to the illustration: the pictorial narrative seems indebted to a lost tale expounding the story of Cain and emphasizing his grief after the first murder.[2]

107b. Vat. 747, fol. 26r

Expressing remorse and grief, Cain goes "out from the presence of the Lord." Both the figure and the mountainous background have been overpainted and are now slightly flaked again.
Located below Genesis 4:17.

108b. Ser., fol. 50v

Cain holds one hand against his cheek, but otherwise the figure agrees with Vat. 747. Somewhat flaked.
Located below Genesis 4:17.

109b. Sm., fol. 17r

Very close to Ser.

110b. Vat. 746, fol. 46r

Very close to Ser. and Sm.
Located below Genesis 4:17.

Lit.: Kondakov, *Istoriia*, pp. 188–89; Kondakov, *Histoire*, vol. 2, pp. 78–79; Uspenskii, p. 117, fig. 29; Hesseling, fig. 25; Wessel, "Kain und Abel," col. 720; Bergman, *Salerno*, pp. 23–24, fig. 65; Sherman, "Ripoll Bible," p. 10, fig. 9; Ulrich, *Kain und Abel*, pp. 61–65, fig. 87; Bernabò, "Caverna," p. 724, fig. 8.

[1] According to GenR 22:12, God "caused leprosy to break out on him," or "made a horn grow out of him" (*Genesis Rabbah*, ed. Freedman and Simon, p. 191). On the early exegesis of the sign of Cain and its depiction in art, see R. Mellinkoff, *The Mark of Cain* (Berkeley, 1981), esp. pp. 14ff.

[2] See, e.g., the narrative of Cain returning home after the murder, with a detailed description of his feelings, and the successive mourning of Eve, Adam, and Cain himself, contained in the Syriac Life of Abel, 15ff. (ed. Brock, "Syriac Life of Abel," pp. 480ff.); cf. also Mellinkoff, *Mark of Cain* (as in note 1 above), pp. 29–32.

Genesis 4:17

Birth of Enoch

The last scene of Cain's story in this miniature narrates the birth of the pious Enoch in the presence of the disconsolate Cain. The atmosphere of sorrow is not required by the text and again, as in the previous episodes in the same frame, the painter probably drew upon tales expanding the Genesis story.[1] The scene of Enoch's birth is repeated in roughly similar fashion for the birth of Samson in Vat. 746 and Vtp. (figs. 1491, 1492), and more lavishly for the birth of Moses in Ser., Sm., and Vat. 746 (figs. 596–598); its iconography belongs to the same tradition as the birth of the Virgin in New Testament cycles.[2]

107c. Vat. 747, fol. 26r

Cain's wife, named Themech (in *LAB* 2:1), or his sister 'Awan (in Jubilees 4:9),[3] has given birth to Enoch. She lies in childbed, apparently still in pain, and with an expression of grief a midwife offers her a vessel of food, while the newborn child lies in a cradle. Cain sits at the foot of the couch resting his head in his hand in a posture of sorrow. The couch stands before the house where the birth is supposed to have taken place, while Cain sits before the door of a smaller building. Overpainted and somewhat flaked again.
Located below Genesis 4:17.

108c. Ser., fol. 50v

The inscription reads: γνῶσις γυναικὸς παιδὸς ἑνὸς αὐτόκος.
The compositional scheme is the same as in Vat. 747, but devoid of architecture and landscape. Considerably flaked all over the surface.
Located below Genesis 4:17.

109c. Sm., fol. 17r

The composition is not as condensed as in Ser. and the midwife is fully visible.

110c. Vat. 746, fol. 46r

The inscription for this scene is written as a continuation of the preceding one in the margin to the left: γνῶσις γυναικὸς παιδὸς ἑνὸς αὐτόκος.
Very close to Ser. and Sm. Badly flaked, particularly in the center, where the head of the midwife is entirely missing.
Located below Genesis 4:17.

Lit.: Uspenskii, p. 117, fig. 30; Hesseling, fig. 25; Menhardt, p. 299; Lafontaine-Dosogne, *Iconographie de l'enfance*, vol. 1, pp. 99 n. 4, 109 n. 1; Ulrich, *Kain und Abel*, pp. 61–65, fig. 87; Anderson, "Seraglio," p. 94, fig. 20; Bernabò, "Caverna," p. 724, fig. 8.

[1] No extant pseudepigrapha, however, may be credited as the textual basis of the miniature. See, however, the previous note and, for further expansions of Abel's story, Brock, "Jewish Traditions," pp. 226–27.

² Lafontaine-Dosogne, *Iconographie de l'enfance*, vol. 1, pp. 89ff.
³ *OTP*, vol. 2, pp. 305 and 61, respectively.

¹ A lost Apocryphon of Lamech appears in the List of Sixty Books, dating from about the sixth to seventh century (PG 1, col. 516, inserted under Clement; *OTP*, vol. 1, p. xxiii).

[Genesis 4]

Lamech and Tubalcain Leave for the Hunt

The following miniature is dedicated to the story of Lamech murdering Cain: at the far left two characters are talking, then follows the killing of Cain, and, finally, Lamech and his wives talking. It is no surprise that most elements of this tripartite miniature, as in the previous ones, do not depend on the Septuagint, but on a different narrative of the first generations after the Fall such as the Syriac Cave of Treasures, even if a few traits still remain unrelated to any known text.¹ The town depicted in the first episode of the miniature is not related to the Septuagint. In Ser., Sm., and Vat. 746, a man inside the town, undoubtedly Lamech, addresses a boy, undoubtedly Tubalcain, who is presumably preparing for the hunt.

111a. Vat. 747, fol. 26v

At the left of the miniature, the painter depicted a city in the conventional way as a crenelated wall. An unusual high secluded tower stands inside the wall, which has a huge door opened onto a flight of steps. Tower, door, and steps are not mentioned in Genesis. Considerably flaked.

Located below Genesis 5:9.

112a. Ser., fol. 52r

The circular wall of the city is surrounded by three mighty towers, the rear one possibly corresponding to the central tower in the miniature of Vat. 747. The door in the front side of the wall is closed here, and behind the crenelations is a man turning with a gesture of speech to a boy, presumably Lamech addressing Tubalcain. Both figures and large parts of the city are badly flaked.

Located in the catena; the text above is Genesis 5:10.

113a. Sm., fol. 17v

Very close to Ser. The boy inside the wall turns to his left in an attitude of departure.

Located below Genesis 5:2.

114a. Vat. 746, fol. 47r

Very close to Ser. and Sm. The departing boy inside the wall here looks upward, resembling the youth in the next episode in the miniature; the man on the right raises his right hand.

Located below Genesis 5:8.

Lit.: Tikkanen, *Genesismosaiken*, fig. 28; Uspenskii, p. 102, fig. 31; Hesseling, fig. 26; Stichel, "Ausserkanon. Elemente," fig. 8; Bernabò, "Fonti testuali," p. 475 n. 40, pl. 26 no. 1; Ulrich, *Kain und Abel*, figs. 84, 85, 88; Lowden, *Octs.*, p. 101, fig. 145; Bernabò, "Teodoreto," fig. 11; Bernabò, "Caverna," p. 725, fig. 9.

[Genesis 4]

Lamech Kills Cain and Tubalcain

The depiction of Lamech killing a man (Cain) and a youth (Tubalcain) is not taken from the Septuagint, where, in a rather obscure passage (Gen 4:23–24), we read only that Lamech declared to his wives, "I killed a man for wounding me, and a young man for striking me. On Cain fell sevenfold vengeance, but on Lamech seventy times sevenfold." This lack of connection was already observed by Kondakov,¹ who associated the miniature with a story, supposedly of Jewish origin, where Lamech kills only Cain.² Cain, old and remorseful, went to the impassable mountains and groves. Lamech was hunting in those groves and because of his blindness was led by a youth who, according to one version of the story, was his son, Tubalcain. The youth heard a noise in the forest and, thinking that a wild animal caused it, aimed Lamech's arrow in that direction. Hearing the moaning of the dying man, Lamech realized that, unwittingly, he had slain Cain; full of grief, he became vexed and clapped his hands violently, unintentionally striking Tubalcain and causing his death. This story is also told in pseudepigrapha, such as The Cave of Treasures,³ where we have already found connections with previous miniatures, and is also known in Christian authors since the third century.⁴ On the contrary, and very strikingly, some of the prominent Christian writers of the fourth and fifth centuries—Basil and the Syrian Ephrem and Theodoret alike—deliberately do not charge Lamech with Cain's death; according to Ephrem, Lamech was a righteous figure of Seth's genealogy, whereas "others" say that Lamech killed Cain and his own son.⁵ This implies that the story was widespread in the region of Syria. The views of these authors are contained in the passages excerpted in the catena of the Octateuch, which therefore contradicts the miniature cycle.⁶

111b. Vat. 747, fol. 26v

Following the legend reported above, the painter of Vat. 747 depicted Lamech in the center of the miniature shooting an arrow aimed by a little boy. The arrow is directed toward a tree which shelters Cain; only Cain's bearded head, pierced by an arrow, is visible. Moreover, Tubalcain, who had directed the arrow, is shown a second time, lying dead on the ground. High mountains with a towered building near their peak form the background. Like the rest of the miniature, the scene has been overpainted and has flaked again considerably.

Located below Genesis 5:9.

112b. Ser., fol. 52r

The compositional scheme is the same as in Vat. 747, but the landscape is omitted and the forest where Cain is hidden resem-

bles a sheaf of wheat. Any trace of Cain is obliterated, and the other figures are also considerably flaked.

Located in the catena; the text above is Genesis 5:10.

113b. Sm., fol. 17v

The scene, which is close to Ser., is partly rubbed and somewhat flaked.

Located below Genesis 5:2.

114b. Vat. 746, fol. 47r

Very close to Ser. and Sm. Lamech's head is rubbed, and other areas are slightly flaked.

Located below Genesis 5:8.

Lit.: Kondakov, *Istoriia*, p. 189; Tikkanen, *Genesismosaiken*, fig. 28; Kondakov, *Histoire*, vol. 2, p. 79; Uspenskii, p. 102, fig. 31; Hesseling, fig. 26; Neuss, *Katalan. Bibelill.*, pp. 42–43; Cockerell, *Illustrations*, p. 15; Réau, *Miniature*, p. 48; Demus, *Norman Sicily*, pp. 253, 333 n. 36; Hempel, "Traditionen," p. 62 n. 54; Hueck, *Kuppelmosaiken*, pp. 23 n. 3, 134; Wessel, "Kain und Abel," col. 720; Stichel, "Ausserkanon. Elemente," pp. 170–71, fig. 8; Bernabò, "Fonti testuali," pp. 473–75, pl. 26 no. 1; Ulrich, *Kain und Abel*, pp. 62–67, figs. 84, 85, 88; De Angelis, "Simbologia," pp. 1529–30, fig. 3; Prigent, *Judaïsme*, pp. 302–3; Lowden, *Octs.*, p. 101, fig. 145; Bernabò, "Teodoreto," p. 76, fig. 11; Bernabò, "Caverna," pp. 725, 734, fig. 9.

[1] Kondakov, *Histoire*, vol. 2, p. 79.
[2] The legend is reported in The Book of Yashar, probably written in Naples during the sixteenth century: *The Book of Yashar*, ed. Noah, pp. 26–31; J. Dan, "When Was the Sepher Hayashar Written?" in *Sefer Dov Sadan* (Tel Aviv, 1977), pp. 105–10 (in Hebrew).
[3] CavTr 8:2-10 (*Caverne des Trésors*, ed. Ri, vol. 1, pp. 26, 28); see also *Livre du combat d'Adam*, in *Dictionnaire des apocryphes, ou collection de tous les livres apocryphes relatifs à l'Ancien et au Nouveau Testament*, ed. J.-P. Migne, vol. 1 (Paris, 1856), col. 344; and the Palaea historica (*Anecdota*, ed. Vasil'ev, pp. 194–95).
[4] Such as Hippolytus (M. Richard, "Un fragment inédit de S. Hippolyte sur Genèse 4:23," in Hippolyte, *Opera Minora* [Turnhout and Leuven, 1976], vol. 1, chap. 15, pp. 396–97, 398; Jerome (*Epistola 36.4 ad Damasum* [PL 22, cols. 454–55]) claims that the story is Jewish. For a list of authors, see Stichel, "Ausserkanon. Elemente," pp. 170–71, and Bernabò, "Fonti testuali," pp. 473–75.
[5] Kronholm, *Motifs from Genesis*, p. 166, esp. n. 39; and *CommGen* 4:2–3 (Ephraem, *In Genesim et in Exodum commentarii*, ed. Tonneau, pp. 41–42).
[6] Cf., e.g., Vat. 746, fol. 47r; these passages are reported in Nikephoros' catena (Σειρά, ed. Nikephoros, vol. 1, col. 118). Ephrem's excerpt is also in R. Devreesse, "Anciens commentateurs grecs de l'Octateuque," *RBibl* 45 (1936), p. 212; for Theodoret, see PG 80, col. 146.

[Genesis 4:24]

Lamech with Adah and Zillah

The demeanor of Lamech addressing his wives Adah and Zillah (LXX: Ada and Sella) hardly corresponds with the imperious order he gives them (Gen 4:24) to listen to his claim that he killed a man by wounding him and a young man with a blow. The bow depicted in Lamech's hands, which forms a pictorial link with the previous illustration of the killing of Cain, is not

required by the Septuagint, nor does the text mention a reply from the wives, as the gesture of address of one of them implies. The picture is evidently indebted to the same unknown tale that underlay the previous episodes.

111c. Vat. 747, fol. 26v

Lamech, a bearded hunter with a bow in his hand, addresses his two wives in a contrite pose. One of the women addresses him, extending her hand in a gesture of speech, while the other, seen mostly from the back, stands in a reserved attitude. The scene, set before a background of high mountains, is thoroughly overpainted and now flaked again in various places.

Located below Genesis 5:9.

112c. Ser., fol. 52r

The inscription reads: φονεὺς λάμεχ πέφυκε καὶ μετὰ νόμον ἔχθιστα τ᾽ἔργα ταῖς γυναιξὶ πως λέγει.

Save for slight differences in the poses and the absence of a landscape background, the composition agrees with Vat. 747.

Located in the catena; the text above is Genesis 5:10.

113c. Sm., fol. 17v

The scene, somewhat rubbed and flaked, is very close to Ser.

Located below Genesis 5:2.

114c. Vat. 746, fol. 47r

The inscription reads: φονεὺς λάμεχ πέφυκε καὶ μετὰ νόμον ἔχθιστα τ᾽ἔργα ταῖς γυναιξὶ πως λέγει.

Very close to Ser. and Sm. The head of the foremost wife and the lower right corner are rubbed and other parts slightly flaked.

Located below Genesis 5:8.

Lit.: Kondakov, *Istoriia*, p. 189; Tikkanen, *Genesismosaiken*, fig. 28; Kondakov, *Histoire*, vol. 2, p. 79; Uspenskii, p. 102, fig. 31; Hesseling, fig. 26; Neuss, *Katalan. Bibelill.*, pp. 42–43; Demus, *Norman Sicily*, pp. 253, 333 n. 36; Hempel, "Traditionen," p. 62 n. 54; Stichel, "Ausserkanon. Elemente," pp. 170–71, fig. 8; Bernabò, "Fonti testuali," pp. 473–75, pl. 26 no. 1; Weitzmann, *SP*, p. 37; Ulrich, *Kain und Abel*, pp. 62–67, figs. 84, 85, 88; Lowden, *Octs.*, p. 101, fig. 145; Bernabò, "Teodoreto," fig. 11; Bernabò, "Caverna," p. 725, fig. 9.

[Genesis 5:24]

Enoch

Of Adam's offspring listed in chapter 5, the painter was only interested in Enoch, the patriarch who "pleased God; and he was not, for God took him away" (Gen 5:24). The verse is expounded in Hebrews 11:5: "By faith Enoch was translated that he should not see death; and was not found because God had translated him." Such a passage, one of the abridged pieces in the Octateuch catena, apparently inspired the illustrator to insert a classical personification of Thanatos (Death) beside Enoch to mark

his having escaped death.[1] The open scroll in the patriarch's hand characterizes him as a writer and corresponds to the ample literary activity attributed to him by the pseudepigrapha, where Enoch is normally portrayed positively as a righteous man, a visionary, a revealer of divine secrets, a companion of angels.[2] Such an evaluation has a counterpart in the passages inscribed on the scroll and along the top of the parallel miniature, referring respectively to Enoch's arrangement of the calendar and to his being credited with the invention of the months and time, a tradition asserted in the Book of Jubilees[3] and found in Christian chronicles.[4] The personifications of the months in the left half of the miniature and the segment of heaven with sun, moon, and stars painted right above the head of Enoch allude to this scientific activity.[5]

No pictorialization of Enoch's translation is given in the Octateuchs:[6] the painter depicted a group of sarcophagi, two of them with their lids removed, an allusion not only to the earthly remnants of the patriarch, which were not found since God had taken him, but also a pictorial hint at the resurrection of the dead.[7] Here again the Octateuchs echo the image of Enoch in pseudepigrapha: a final judgment is a part of the introductory vision of the first book of 1 Enoch (chap. 5) and the nucleus of the second book (chaps. 37ff.).[8]

Sharing the appreciation of the patriarch found in pseudepigraphical literature and miniature alike, the early Fathers focused on Enoch as on a prefiguration of the assumption of the righteous into heaven[9] and of the Resurrection.[10] The Jewish view is quite different. As early as the first century, Josephus denied Enoch's paternity of astronomy and the calendar, a paternity asserted in the miniature, assigning it instead to the descendants of Seth.[11] Moreover, later rabbinic Judaism radically contested the figure of Enoch, mostly because of the use the Christians made of Enoch: in Genesis Rabbah, the commentary generally held to have been completed in about A.D. 400 and providing an authoritative account of Judaism's views,[12] Enoch is labeled as a hypocrite, whose death is implied in Genesis, where the statement that "he was not, for God took him" is said to mean that "he was no more in the world, having died."[13] Evidently, then, the miniature originated in a Christian or a pseudepigraphical cultural milieu.

115. Vat. 747, fol. 27r

Enoch is portrayed holding an open roll bearing an inscription now almost completely lost; he stands in strict frontality at the foot of high mountains with buildings at their peaks. The figure of death wears a red exomis, traces of which are still visible, leaving his right shoulder bare; he probably had a long and dishevelled beard. In the left half is a representation of a group of sarcophagi with their lids closed. Above the sarcophagi are twelve busts personifying the occupations of the twelve months in the conventional types of the Middle Byzantine period.[14] Arranged in two rows of six, the cycle starts in the upper left corner with the figure of a warrior holding a spear (March). Then follow a shepherd carrying a lamb over his shoulder—the ancient *kriophoros* (April)—a nobleman sniffing a flower (May), a farmer with a sickle in his hand to cut hay (June), another farmer with a scythe (July), and a man who drinks eagerly out of a bottle while in the

other hand he holds a fan (August). The lower row depicts a vintner who shoulders a basket of grapes (September), a falconer holding a falcon in his left hand and in his right a stick from which hang three captured birds (October), a sower (November), a hunter holding a hare in his hand (December), a man celebrating the feast of pork-butchering by carrying a plate with a pig's head on it (January), and finally an old man warming his hands over an open fire (February).

Both sections of the miniature are overpainted, and at the right flower ornaments in suspended spandrels have been added to embellish the golden background. Large sections have flaked again, and the figure of Thanatos is almost completely destroyed, while the figure of Enoch and the sarcophagi are very badly damaged.

Located below Genesis 5:31.

116. Ser., fol. 53r

The inscription is almost completely flaked, but from the words still decipherable one can conclude that it was more or less identical to that in Vat. 746, though differently arranged.

The composition is essentially the same as that in Vat. 747, differing only in some details. While in the former Enoch is represented as a dignified patriarch with a long beard, the painter of Ser. rendered him beardless.[15] Thanatos, sitting on a low bench, is represented as a half-naked boy turning his head away in reaction to his realization that Enoch is out of his reach; at the same time he seems to look at and point to the sarcophagi as his sphere of influence. There is no landscape, but in the sky appears a segment of heaven containing stars and the disks of sun and moon, their heads in profile and turned toward the outside. The sarcophagi are represented in a separate miniature grouped somewhat differently from Vat. 747, and two of them are open, with their lids leaning against their bodies. The busts of the months are grouped differently, eight in the upper row and four in the lower. Their types agree with those in Vat. 747, except that the farmer representing July holds a sheaf of grain in his hand instead of a scythe. The miniature is badly flaked, particularly the figure of Thanatos, and the bottom of the picture is entirely torn and stained.

Located below Genesis 5:26.

117. Sm., fol. 18r

The miniature, which is very close to Ser., is rubbed and flaked. The copyist must have used a model much like Ser. in which eight months were in an upper row and four in a lower one; but in order to avoid too great a density in the upper row, he moved the eighth bust of the falconer down to the lower row, thus causing a break in the sequence, with the month of October now placed at the end of the cycle after the month of February.

Located below Genesis 5:27.

118. Vat. 746, fol. 48v

The inscription reads: Ἐνὼχ μυηθεὶς γραμμάτων πρῶτος νόον. ἔφευρε πρῶτος μῆνα, καιρὸν καὶ χρόνον. ἀλήστ(ην)

ἰσχὺν κατὰ θάνατου φέρων. Part of the inscription on the scroll, which alludes to the months, is also decipherable:[16] Ὁ πρῶτος μὴν Μάρτιος δεύ(τε)ρος.

The composition agrees with Ser. and Sm. and follows the latter particularly closely by repeating the same error in the sequence of months, i.e., October being placed after February. On his right wrist Thanatos has a pair of what appear to be square blue wings; nearby, a blue spot resembles a tiny pendant.

Located in the catena, the text on fol. 48r ending with Genesis 5:27.

Lit.: Piper, "Bilderkreis," pp. 186–87; Piper, "Denkmäler," p. 478; Kondakov, *Istoriia*, p. 189; Dobbert, "Triumph," n. 22 pp. 21–22; Strzygowski, "Monatscyclen," p. 32, pls. 1, 2; Kondakov, *Histoire*, vol. 2, p. 79; Strzygowski, "Trapezunt. Bilderhandschrift," pp. 246, 256; Strzygowski, *Sm.*, p. 115, pl. 34; Uspenskii, pp. 102, 119, fig. 32; Stornajolo, *Topografia Cristiana*, p. 17; Hesseling, fig. 27; Redin, *Koz'my Indikoplova*, p. 357, fig. 429; Xyngopoulos, "Βυζ. παράστασις μηνός," p. 181, fig. 2, nos. 2–5; Okunev, "Lesnovo," p. 254; Webster, *Labors*, p. 25; Réau, *Miniature*, p. 48; Weitzmann, *RaC*, p. 198; Demus, *Norman Sicily*, pp. 253, 333 n. 37; Stern, *Calendrier*, pp. 227–31, 248, 251, 258, 261, 297, 367, pl. 43 no. 4; Stern, "Poésies," pp. 171–75, 182–84, figs. 14, 15; Buchthal, *Byz. Gospel Book*, p. 2; Wolska-Conus, *Cosmas*, vol. 1, p. 152 and vol. 2, pp. 124, 126 n. 82; Galavaris, *Gregory Naz.*, pp. 134, 150, 163; Mouriki-Charalambous, "Cosmas," pp. 27–33; Åkerström-Hougen, *Calendar*, p. 135, fig. 87 nos. 1, 2; Bernabò, "Fonti testuali," pp. 475–77, pl. 26 no. 2; Weitzmann, *SP*, p. 37; Fabbri, "Months at Lentini," p. 232; Alexandre, *Commencement*, p. 392 and commentary at fig. 19; Bernabò, "Esegesi patristica," pp. 51–52, fig. 1.

[1] On this iconography of Death, see Dobbert, "Triumph," pp. 21–22, n. 22; and Mouriki-Charalambous, "Cosmas," pp. 31–32.

[2] See D. S. Russell, *The Old Testament Pseudepigrapha: Patriarchs and Prophets in Early Judaism* (London and Philadelphia, 1987), chap. 3, pp. 24–43.

[3] 4:17–18 (*OTP*, vol. 2, p. 62).

[4] W. Adler, *Time Immemorial: Archaic History and Its Sources in Christian Chronography from Julius Africanus to George Syncellus* (Washington, D.C., 1989), p. 87.

[5] A longer excerpt in the catena of the Octateuchs (e.g., Vat. 746, fol. 47v) assigns these inventions to Enoch, but at the same time says that they were responsible for Enoch's condemnation by the Lord: Ἐνὼχ πρῶτος ἔμαθε γράμματα καὶ ἔγραψε τὰ σημεῖα τοῦ οὐρανοῦ καὶ τὰς τροπὰς καὶ τοὺς μῆνας. Πρὸ τούτου κατὰ τὴν Γραφὴν οὐκ ἦν εὐάρεστος τῷ Θεῷ. δῆλοι δὲ ὅτι ἐκ μετανοίας εὐηρέστησαν ("Enoch first learned the letters and wrote the signs of the heaven; and the [heavenly] movements, and the months; because of that, according to the Scriptures, he did not please the Lord; clearly, by means of his repentance, he pleased [the Lord]").

[6] A literal rendering of Enoch translated is seen in cod. Athos, Panteleimon 6, fol. 152r, a codex containing the liturgical homilies of Gregory of Nazianzos (Galavaris, *Gregory Naz.*, fig. 163), whose cycle depends upon an Octateuch; Enoch's iconography, however, probably adapted here the translation of a saint (ibid., p. 134).

[7] Cf., e.g., the Laurentian Gospels, cod. plut. 6.23, fol. 50r, a miniature illustrating the Second Coming of Christ (Mt 27:24–31; T. Velmans, *Le Tétraévangile de la Laurentienne: Florence, Laur. VI.23* [Paris, 1971], fig. 106).

[8] *OTP*, vol. 1, pp. 14–15 and 29ff., respectively.

[9] Cf. Ireneus, *AdvHaer* 5:5:1 (J. Daniélou, "L'ascension d'Henoch," *Irenikon* 28 [1955], p. 265).

[10] E.g., Theodoret, *QuaestGen* 45 (PG 80, col. 145).

[11] *Ant* 1:69; cf. L. Rosso Ubigli, "La fortuna di Enoc nel giudaismo antico: Valenze e problemi," in *Atti del primo seminario di ricerca su "Storia dell'esegesi giudaica e cristiana antica"* (Idice di San Lazzaro, Bologna, 27–29 October 1983) (*Annali di storia dell'esegesi* 1 [1984]), pp. 158–59.

[12] *Genesis Rabbah*, ed. Neusner, pp. ix–x.

[13] GenR 25:1 (*Genesis Rabbah*, ed. Freedman and Simon, p. 205).

[14] Cf. Buchthal, *Byz. Gospel Book*, pp. 2, 10; Åkerström-Hougen, *Calendar*, p. 135.

[15] This and other details closely relate Ser., Sm., and Vat. 746 to the illustrated manuscripts of Kosmas Indikopleustes; cf. Mouriki-Charalambous, "Cosmas," pp. 27–30.

[16] As restored by Stern, "Poésies," p. 172.

Genesis 6:2–3

SONS OF GOD TAKE DAUGHTERS OF MEN AS WIVES

The painters rendered the passage where the sons of God take the daughters of men as wives as a marriage between one of the sons of Seth and one of the daughters of Cain, both identified by the inscription. The association of the Sethites with God's sons and the Cainites with men's daughters is not in the Septuagint but harks back to a long-standing Jewish, and afterward also Christian, debate on the identity of the sons of God.[1] In contrast to later Judaism, in Christian Fathers the interpretation of the "Sons of God" as the offspring of Seth dominates, especially in Syria, thus suggesting a connection of this miniature with Christian views. This interpretation is also found in Theodoret's commentary on Genesis reported in the catena.[2]

119. Vat. 747, fol. 27v

A group of young men stand on one side of the miniature and a group of women on the other; between them a youth firmly grasps the hand of a shy young woman, sealing the bond of matrimony by the *dextrarum junctio*.[3] At the left, Seth with a pink nimbus sits erectly on a rich throne; at the right, the nimbless Cain sits on a simple bench in a slightly stooped attitude, a sign of his guilty conscience, in front of a cella-like house connected with a smaller building in the center by a high wall, with a third building appearing at the extreme left. An uninterrupted row of high mountains rises behind this architectural plane. The miniature has been overpainted, particularly the heads of the group of men on the left, and has flaked again in many places.

Located in the catena; the text above is Genesis 6:2.

120. Ser., fol. 54r

The inscription, partly obliterated, reads: υἱοὺς θ(εο)ῦ νόμιξε τοὺς σὴθ ἐκγόνους [ἐπιρρεπῶς] βλέποντας εἰς θυγατέρας βροτῶν ἐχούσας τὴν γένεσιν ἐκ Κάϊν.

The composition is the same as that in Vat. 747, but most of the figures' gestures are somewhat different, as are the women's garments, especially in the case of the bride, who is clad in a richly embroidered wedding dress. Seth has a golden nimbus, and there is no background. The miniature is badly stained and flaked in many places.

Located in the catena; the text above is Genesis 6:2.

121. Sm., fol. 18v

Very close to Ser. and considerably flaked.

122. Vat. 746, fol. 49r

The inscription, which starts above the frame, reads: υἱοὺς θ(εο)ῦ νόμιξε τοὺς σῆθ ἐκγόνους·ἐπιρρεπῶς βλέποντας εἰς θυγατέρας·βροτῶν ἐχούσας τὴν γένεσιν ἐκ Κάϊν.

Very close to Ser. and Sm., and likewise flaked, especially in the lower left corner.

Located below Genesis 6:2.

Lit.: Kondakov, *Istoriia*, p. 189; Tikkanen, *Genesismosaiken*, p. 125, fig. 108; Kondakov, *Histoire*, vol. 2, p. 79; Uspenskii, p. 119, fig. 33; Hesseling, fig. 28; Diehl, *Peinture byz.*, pp. 93–94, pl. 81 no. 1; Hutter, "Übermalungen," pp. 140–41; Bernabò, "Laur. plut. 5.38," p. 156 n. 48; Walter, "Dextrarum Junctio," pp. 281–82, fig. 10; Bernabò, "Tradizioni siriache," pp. 304–5, fig. 4.

[1] Cf. Brock, "Jewish Traditions," p. 226, and P. S. Alexander, "The Targumim and Early Exegesis of 'Sons of God' in Genesis 6," *JJS* 23 (1972), pp. 60–71; L. R. Wickham, "The Sons of God and the Daughters of Men: Genesis VI.2 in Early Christian Exegesis," *OT* 19 (1974), pp. 135–47.
[2] *QuaestGen* 47 (PG 80, col. 150); cf. Walter, "Dextrarum Junctio," p. 281.
[3] For this iconography in Byzantine art, see Walter, "Dextrarum Junctio," pp. 281–82, and G. Vikan, "Art and Marriage in Early Byzantium," *DOP* 44 (1990), pp. 145–63.

Genesis 6:5

Giants

Extraordinarily large in size, the giants are represented as armed wild men. In Christian texts the giants are described as sturdy, impious, or aged men, of above average build. On the other hand, the pseudepigrapha preserve an expanded narrative, handed down in 1 Enoch 6ff.,[1] where angels saw the "handsome and beautiful daughters" of men, desired them (6:1–2), and took them as wives (7:1); the women became pregnant and gave birth to great giants (7:2), from whom many sins originated. In that period the peoples learned the art of making swords, knives, shields, and breastplates (8:1). Besides this tale told in 1 Enoch, the Jewish tradition[2] considers the giants to be just warriors. These expansions of the Old Testament text fit the miniature more precisely than does the Septuagint text itself.

123. Vat. 747, fol. 28r

The inscription outside the frame in the upper left corner reads: σφαγεῖς γίγαντες τ(ῶν) κακῶν ἐφεύρε(ται).

The painter rendered the giants as a group of wild-looking hairy men of supernatural size. Four are shown in the front row, with one dressed in heavy armor, while the others wear mantles. The first carries sword and spear, and the second a double ax. The attribute in the left hand of the third is no longer recognizable but was most likely another axlike weapon, and the fourth holds a lance. Three more giants are visible in the second row, one of them likewise carrying a lance. All the figures have been overpainted and have flaked again in various spots.

Located in the catena; the text above is Genesis 6:2.

124. Ser., fol. 54v

The inscription reads: σφαγεῖς γίγαντες τῶν κακῶν ἐφεύρεται.

The giants are reduced to five in number, all of them lined up in a single row. They are stockier and clumsier in their proportions, whereby their supernatural size becomes even more pronounced. Moreover, their attitudes and weapons differ somewhat from those of the corresponding types in Vat. 747: the armed warrior at the left rests his weight on his right leg; the second giant holds an ax instead of a lance; the fourth, whose posture is similar to that of the fifth in Vat. 747, carries a lance in his right hand; and the fifth, who has no counterpart in the former miniature, holds a drawn sword like the first. The miniature, which never had a frame, is flaked in various places and torn and stained at the lower left-hand corner.

Located in the catena; the text above is Genesis 6:2.

125. Sm., fol. 19r

The miniature, which is close to Ser., has been cut at the lower edge and is somewhat flaked.

126. Vat. 746, fol. 50r

The inscription reads: φονεῖς γίγαντες τῶν κακῶν ἐφεύρεται.

The miniature has been rubbed, perhaps intentionally by a pious hand, and is close to Ser. and Sm.

Located below Genesis 6:2.

Lit.: Kondakov, *Istoriia*, p. 189; Tikkanen, *Genesismosaiken*, p. 125, fig. 114; Kondakov, *Histoire*, vol. 2, p. 79; Uspenskii, p. 119, fig. 34; Hesseling, fig. 29; Repp, "Riesen," pp. 151–55; Henderson, "Influences," p. 175, pl. 33f; Henderson, "Sources," p. 12 n. 2; Dodwell, "Originalité," p. 321, pl. 2 no. 4; Hutter, "Übermalungen," p. 140; *Old English Hexateuch*, p. 66; Bernabò, "Laur. plut. 5.38," p. 150 n. 40; Bernabò, "Fonti testuali," p. 477, pl. 27 no. 1; Rickert, *Ashburnham Pent.*, pp. 144, 174.

[1] *OTP*, vol. 1, pp. 15ff.
[2] E.g., TargN on Gen 6:4 (*Neophyti 1: Targum Palestinense*, vol. 1, *Génesis*, ed. Díez Macho, Eng. trans. by McNamara and Maher, p. 511).

Genesis 6:10–14

God Orders Noah to Build the Ark

127. Vat. 747, fol. 28v

Noah receives the order to build the ark from the hand of God and at the same time points to his three sons, Shem (LXX: Sem), Ham (LXX: Cham), and Japheth. The scene takes place before Noah's two-storied house and at the foot of a high mountain. The flower ornament painted on the golden background in suspended spandrels is apparently a later addition. Flaked in several spots.

Located below Genesis 6:19.

128. Ser., fol. 56v

The inscription reads: ἄνωθεν ὦ δίκαιε, τὴν θέσιν δέχῃ τὴν τῆς κιβωτοῦ τρισὶ σὺν τοῖς υἱέσιν.

The composition is the same as in Vat. 747, save that the postures and gestures of Noah and his sons are less differentiated and the architecture and landscape are omitted. Slightly flaked.

Located below Genesis 6:19.

129. Sm., fol. 19v (see also text fig. 54)

The miniature, which is very close to Ser., is somewhat flaked and appears to have been overpainted.

Located below Genesis 6:19.

130. Vat. 746, fol. 52r

The inscription reads: ἄνωθεν ὦ δίκαιε, τὴν θέσιν δέχῃ τὴν τῆς κιβωτοῦ τρισὶ σὺν τοῖς υἱέσιν.

Very close to Ser. and Sm. and slightly flaked.

Located below Genesis 6:19.

Lit.: Seroux d'Agincourt, *Histoire*, vol. 3, p. 68, and vol. 5, pl. 62 no. 3 (reproduced in the frontispiece of the present volume); Venturi, *Storia*, vol. 2, fig. 327; Uspenskii, p. 120, fig. 35; Hesseling, fig. 30; Henderson, "Sources," p. 23, pl. 13 no. 2; Kirigin, *Mano divina*, p. 137; Anderson, "Two Centers," p. 83; Crown, "Winchester Ps.," p. 30; Bergman, *Salerno*, p. 24, fig. 70; Rickert, *Ashburnham Pent.*, p. 143; Lowden, *Octs.*, pp. 13, 101, figs. 143, 144; Bernabò, "Studio," pl. 2.

Genesis 6:14–22

BUILDING OF THE ARK

After the directive to Noah, the cycle of the Flood proceeds with the construction of the ark and the calling of the animals to the ark. The next illustration is the first of a sequence of three miniatures (nos. 131–142) with two separate depictions of the ark painted rather schematically with scarce concession to any landscape background. The labors of Noah's sons in constructing the ark are not detailed in Genesis, and their activities here depend instead on representations of carpenters in ancient art.[1]

131a. Vat. 747, fol. 29r

The inscription above the frame reads: ἡ κατασκευὴ τῆς κιβωτοῦ.

Noah sits in the upper left corner on a low bench, holding in one hand a strange tool composed of a sort of great wooden square with an upper axlike metal part, and in the other a plank. Each of his three sons performs a specialized task: the one at the lower left squares a plank which he holds upright, while other planks lie around him in the hilly landscape; the second holds a curved plank over an open fire; and the third drives thick nails into the roof of the ark, which is shaped like a rectangular casket. The scene is heavily flaked in many places.

Located below Genesis 7:9.

132a. Ser., fol. 57v

The inscription written in the left margin reads: ἡ κατασκευὴ τῆς κιβωτοῦ.

Although the miniature is composed in a manner similar to that of the preceding one, the details vary greatly. The landscape is omitted, so that the figures of the upper zone seem to be suspended in midair. Noah is represented standing, not working but giving instructions to his sons. The son before him uses an ax on the curved bow of the ark, which is shaped like a ship rather than a casket, and he turns his head around, eagerly listening to his father's orders. The two sons in the lower zone have been interchanged, and the one at the left holds a plank over a fire, while the other squares a plank lying on the ground. Nearly two-thirds of the surface is flaked, but the traces still left indicate clearly that the composition was more or less identical to that of Vat. 747.

Located below Genesis 7:9.

133a. Sm., fol. 20r

The scene is very close to Ser. and appears to have been largely overpainted, although it is now flaked heavily again.

Located below Genesis 7:9.

134a. Vat. 746, fol. 53v

The inscription is written in the margin to the left and, as far as it relates to the present scene, reads: ἡ κατασκευὴ τῆς κιβωτοῦ.

Very close to Ser. and Sm.

Located below Genesis 7:9.

Lit.: Uspenskii, p. 120, fig. 36; Hesseling, fig. 31; Redin, *Koz'my Indikoplova*, pp. 56–75, fig. 36; Troje, ΑΔΑΜ *und* ΖΩΗ, p. 70 n. 2; Neuss, *Katalan. Bibelill.*, p. 43; Der Nersessian, *Barl. et Joas.*, p. 104; Pijoán, *Summa artis*, vol. 7, p. 401, fig. 561; Menhardt, p. 301; Stern, "Sainte-Constance," p. 179 n. 99; Galavaris, *Gregory Naz.*, p. 135; Buschhausen, "Archemosaiks," p. 68 n. 54; Anderson, "Two Centers," p. 83; Bergman, *Salerno*, p. 25, fig. 70; Rickert, *Ashburnham Pent.*, p. 143, figs. 99, 100.

[1] See J. Weitzmann-Fiedler, "The Ivory of a Carpenter in the Art Museum, Princeton University," in *Ars Auro Prior: Studia Ioanni Białostocki Sexagenario Dicata* (Warsaw, 1981), pp. 105–8.

Genesis 7:7–9

NOAH AND HIS FAMILY AND THE ANIMALS ENTER THE ARK

131b. Vat. 747, fol. 29r

The inscription above the frame reads: ἡ εἰς τὴν κιβωτὸν εἰσέλευσις.

In the right half of the miniature Noah and his family (his three sons, his wife, and his three daughters-in-law) are assembled on the ark and looking over the side. In his left hand Noah holds a thick board, a detail appearing only in this manuscript; its shape, the holes at the visible end, and the way in which it is

held recall features of a semantron, which is struck with a mallet. According to Jewish and Christian tradition,[1] Noah used such an instrument to call the animals together. The lower story of the ark has a door on either side, through each of which one quadruped is disappearing while other animals approach. To the left are two snakes, an ass, a camel, a giraffe, and a rabbitlike creature, and to the right a stag. The scene has been overpainted and is partly flaked again, particularly in the upper zone.

Located below Genesis 7:9.

132b. Ser., fol. 57v

The inscription that ran below the upper zone is completely destroyed except for a few strokes, but it apparently was worded like that in Vat. 747 and read: ἡ εἰς τὴν κιβωτὸν εἰσέλευσις.

The surface of this miniature is severely flaked. Only a few traces are left of Noah and his wife standing next to him, while the figures of his sons and daughters-in-law are comparatively better preserved. In the lower part, which is particularly heavily damaged, not a single trace remains of the animals to which Noah points with his extended arm. Whereas in Sm. and Vat. 746 birds fill the sky around the ark, none seem to have been included in Ser., judging from the remains of the sky, and in this regard the miniature agrees with Vat. 747.

Located below Genesis 7:9.

133b. Sm., fol. 20r

The shape of the ark and the grouping of Noah's family thoroughly agrees with Ser. Compared with Vat. 747, the number of quadrupeds is larger, but reptiles are entirely lacking. Two sheep, a pair of horses, and an ass approach the ark's left entrance, while a lion, an elephant, a unicorn, a griffin, and an ox move toward the right door. Numerous differentiated birds are grouped around the ark: a peacock, a parrot, and a partridge are easily recognizable at the left, and a dove and heraldic eagle at the right. The miniature is somewhat damaged.

Located below Genesis 7:9.

134b. Vat. 746, fol. 53v

The inscription referring to this scene is a continuation of that of the preceding scene and reads: ἡ εἰς τὴν κιβωτὸν εἰσέλευσις.

Very close to Sm. and only slightly flaked.

Located below Genesis 7:9.

Lit.: De Grüneisen, *Ste. Marie Ant.*, p. 354; Uspenskii, p. 120, fig. 36; Hesseling, fig. 31; Der Nersessian, *Barl. et Joas.*, p. 104; Pijoán, *Summa artis*, vol. 7, p. 401, fig. 561; Menhardt, p. 301, fig. 7; Buschhausen, "Archemosaiks," p. 68 n. 54; Stichel, "Ausserkanon. Elemente," p. 171 n. 47, fig. 9; Vileisis, "S. Maria Ant.," pp. 22–23; Weitzmann and Kessler, *Cotton Gen.*, p. 42; Rickert, *Ashburnham Pent.*, p. 143, figs. 99, 100; Prigent, *Judaïsme*, p. 306.

[1] Stichel, "Ausserkanon. Elemente," p. 171, and, on the presence of a semantron in Byzantine cycles of Noah, id., "Jüdische Tradition in christlicher Liturgie: Zur Geschichte des Semantrons," *CahArch* 21 (1971), pp. 213–28.

Genesis 7:11

THE FLOOD

Different events of the flood are depicted in Vat. 747 than in Ser., Sm., and Vat. 746. The former illustrates the beginning of the cataclysm with "the flood-gates of heaven" (Gen 7:11) opened and rain falling down; the latter present the water covering mountains and the wicked sinking.

135a. Vat. 747, fol. 29v

The inscription above the upper frame reads: ὁ κατακλυσμός.

In the left half of the miniature rain is seen pouring down through the open valves of a gate forming the entrance to a segment of heaven. The ark is so completely enveloped by the heavy rain that it appears completely submerged in the water. Slightly flaked.

Located below Genesis 7:23.

Lit.: Muñoz, "Rotulo," p. 477; Gerstinger, *Wiener Gen.*, p. 74; Der Nersessian, *Barl. et Joas.*, p. 104; Vileisis, "S. Maria Ant.," pp. 25, 27; Koshi, *Genesisminiaturen*, p. 32; Werckmeister, "Pain and Death," p. 603 n. 161; Kötzsche-Breitenbruch, *Via Latina*, p. 53, pls. 4d, 4e; Rickert, *Ashburnham Pent.*, p. 144.

Genesis 7:18–23 and 8:4

THE FLOOD AND RAVEN PERCHED ON A CORPSE

The text of the Septuagint gives no cue for the representation of the raven perched on a corpse in Sm. and Vat. 746. According to one legend the raven did not return to the ark because it saw the corpse of a dead man and set about devouring it. This legend is also known in uncanonical writings,[1] in Christian Fathers of the fourth century, such as John Chrysostom,[2] and in later Jewish writings from the eighth century on.[3]

136a. Ser., fol. 58v

Only in this manuscript is the scene treated as an independent framed pictorial unit separate from the following one. In contradistinction to Vat. 747, the earth, the water, and the pouring rain are clearly distinguished from each other, and the ark floats on the rising tide which is about to cover the summit of the highest mountain. Possibly the painter intended to represent a peak of the mountains of Ararat, where the ark came to rest according to Genesis 8:4. Slightly flaked.

Located below Genesis 7:23.

137a. Sm., fol. 20v

Close to Ser., but with the addition of some of the victims of the deluge. A raven is settling on a floating human corpse, a second drowned figure floats head down, while only the heads or

limbs of others are visible. The corpses of a horse, a lion, and birds are also submerged in the water, and near the lower frame the top of a city tower appears as a reminder of what was once a human settlement. Flaked in several places.

Located below Genesis 7:23.

138a. Vat. 746, fol. 54r

The inscription ὁ κατακλυσμός is written above the frame of the next scene.

Very close to Sm. and flaked in various spots.

Located below Genesis 7:23.

Lit.: De Grüneisen, "Cielo," p. 489; Uspenskii, p. 120, fig. 37; Hesseling, fig. 32; De Grüneisen, *Ste. Marie Ant.*, p. 355; Neuss, *Apokalypse*, p. 73, fig. 97; Der Nersessian, *Barl. et Joas.*, p. 104; Buberl, *Byz. Hss.*, p. 87; Pijoán, *Summa artis*, vol. 7, p. 401, fig. 562; Hempel, "Traditionen," p. 56 n. 18; Mouriki-Charalambous, "Cosmas," pp. 36–39; Koshi, *Genesisminiaturen*, pp. 32–33; Werckmeister, "Pain and Death," p. 603 n. 161; Weitzmann, *Ill. Mss. at St. Catherine's Monastery*, p. 19; Stichel, "Ausserkanon. Elemente," p. 171, pl. 10; Kötzsche-Breitenbruch, *Via Latina*, p. 53; Gutmann, "Noah's Raven," pp. 67, 70–71, fig. 6; Vileisis, "S. Maria Ant.," pp. 25, 27; Anderson, "Seraglio," fig. 23; Rickert, *Ashburnham Pent.*, pp. 144, 174, fig. 101.

[1] Such as the Palaea historica (*Anecdota*, ed. Vasil'ev, p. 199).

[2] HomGen 26:8 (PG 53, col. 234): "Perhaps, with the waters subsiding, the bird, being unclean, happened upon corpses of men and beasts and, finding nourishment to its liking, stayed there" (John Chrysostom, *Homilies on Genesis 18–45*, ed. Hill, p. 153).

[3] Such as PRE 23 (*Pirḳê*, ed. Friedlander, p. 168); for a list of authors, see R. Stichel, "Naturwissenschaftliche Kenntnis des Romanos im Noe-Hymnus," *Hermes* 100 (1972), pp. 249–50, and Stichel, "Ausserkanon. Elemente," p. 171; Gutmann, "Noah's Raven," pp. 70–71; Rickert, *Studien*, p. 125.

Genesis 8:6–7

Noah Sends Forth the Raven

135b. Vat. 747, fol. 29v

In the right half of the miniature the flood has subsided and the mountain peaks are again emerging behind the ark. Noah has opened the window and has just released a raven that is going to search for dry land. The surface surrounding the ark is considerably flaked.

Located below Genesis 7:23.

136b. Ser., fol. 58v

The inscription reads: ὁ νῶε προκύπτων ἀπὸ τῆς κιβωτοῦ; a more recent hand has added εἰ παῦσ(εν) ὕδωρ ἄπιθι βλέψον, κόραξ.

No window is represented in the ark and Noah instead leans over the side, still holding the raven which he intends to release. No dry land is yet visible, but a segment of heaven appears in the sky. Slightly flaked.

Located below Genesis 7:23.

137b. Sm., fol. 20v

The miniature is very close to Ser. and is flaked, particularly in the upper zone.

Located below Genesis 7:23.

138b. Vat. 746, fol. 54r

The inscription reads: ὁ νῶε προκύπτων ἀπὸ τῆς κιβωτοῦ.

The miniature, which is very close to Ser. and Sm., is badly torn and flaked in the lower right corner. A sort of square blue window with a handle is painted in the right part of the ark; it is depicted again on fol. 55v (figs. 142a, 142b).

Located below Genesis 7:23.

Lit.: De Grüneisen, "Cielo," p. 489; Uspenskii, p. 120, fig. 38; Hesseling, fig. 32; De Grüneisen, *Ste. Marie Ant.*, p. 355; Neuss, *Apokalypse*, fig. 97; Der Nersessian, *Barl. et Joas.*, p. 104; Buberl, *Byz. Hss.*, p. 87; Pijoán, *Summa artis*, vol. 7, p. 401, fig. 562; Koshi, *Genesisminiaturen*, p. 32; Kötzsche-Breitenbruch, *Via Latina*, pl. 4d; Anderson, "Seraglio," p. 99, fig. 23; Rickert, *Ashburnham Pent.*, fig. 101.

Genesis 8:10–11

Noah Sends Forth the Dove and Return of the Dove

139a. Vat. 747, fol. 30r

As in the preceding scene, Noah appears at the open window of the ark. In his hands he holds a dove which he is about to release. Much of the surface around the ark is flaked.

Located below Genesis 8:14.

140a. Ser., fol. 59v

The inscription is written outside the frame in the left margin and, as far as it pertains to this scene, reads: νῶε πέμπ(ων) τὴν περιστεράν.

In contradistinction to the other Octateuchs, this scene is not joined to the next by a common frame, but is treated as an independent pictorial unit. The composition resembles that of Vat. 747 very closely, except that Noah does not hold the dove. By analogy to the better-preserved copy in Vat. 746, it may be assumed that the dove was depicted flying, and most likely shown twice. Noah and the ark are very badly damaged by flaking, and the water and sky around the ark are almost completely destroyed.

Located below Genesis 8:14.

141a. Sm., fol. 21r

The miniature is very close to Ser. and somewhat damaged and cut at the lower edge.

Located below Genesis 8:14.

142a. Vat. 746, fol. 55v

The inscription in the left margin reads: νῶε πέμπ(ων) τὴν περιστεράν.

Close to Ser. and Sm. but better preserved. One can clearly recognize the dove departing and then returning with an olive branch in its beak, signifying the merging of two different episodes.

Located in the catena; the text above is Genesis 8:15.

Lit.: Uspenskii, p. 121; Hesseling, fig. 33; Muñoz, "Rotulo," p. 477; Der Nersessian, *Barl. et Joas.*, p. 104; Pijoán, *Summa artis*, vol. 7, p. 401, fig. 563; Diringer, *Illuminated Book*, fig. I-16b; Crown, "Winchester Ps.," p. 31; Koshi, *Genesisminiaturen*, p. 32; Bergman, *Salerno*, pp. 26–27; Rickert, *Ashburnham Pent.*, fig. 102.

Genesis 8:13–19

NOAH REMOVES THE COVERING OF THE ARK AND ANIMALS LEAVE THE ARK

139b. Vat. 747, fol. 30r

The ark has settled on dry land, its covering has been removed, and Noah looks at the high mountains behind it. He is joined by his three sons, his wife in the center of the group, and the three daughters-in-law. The scene has been overpainted and is partly flaked again, particularly the face of Noah and the ground around the ark.

Located below Genesis 8:14.

140b. Ser., fol. 59v

The inscription, a continuation of the one accompanying the preceding scene, is written in the left margin and reads: καὶ ἀποκαλύπτων τὴν στέγην.

Noah raises the cover of the ark with his left hand and in his right holds a stick, probably to prop open the cover. Very badly flaked, particularly the ground around the ark.

Located below Genesis 8:14.

141b. Sm., fol. 21r

Whereas Vat. 747 and Ser. illustrate only the opening of the ark described in verse 13, Sm. and Vat. 746 add the content of verse 19, in which all the wild beasts, the cattle, the birds, and the reptiles emerge from the ark. The miniature has been cut at the lower edge and is badly damaged in the lower section, but the details, still recognizable from a few surviving traces, agree with Vat. 746.

Located below Genesis 8:14.

142b. Vat. 746, fol. 55v

The inscription is a continuation of that for the preceding scene and reads: καὶ ἀποκαλύπτων τὴν στέγην.

While Noah opens the cover, as in Ser. and Sm., the animals leave the ark through three openings. A lion emerges from the

one at the right through which two doves have just flown, a horse is leaving through the central door, while an ox, a small quadruped, and two birds are already peacefully resting on the dry ground below. Finally, through the third opening at the left a bear, a sheep, a camel, and a huge bird emerge.

Located in the catena; the text above is Genesis 8:15.

Lit.: Uspenskii, p. 121; Hesseling, fig. 33; De Grüneisen, *Ste. Marie Ant.*, p. 354; Muñoz, "Rotulo," p. 477; Der Nersessian, *Barl. et Joas.*, p. 104 n. 1; Pijoán, *Summa artis*, vol. 7, p. 401, fig. 563; Diringer, *Illuminated Book*, fig. I-16b; Hutter, "Übermalungen," p. 140; Koshi, *Genesisminiaturen*, p. 32; Stichel, "Ausserkanon. Elemente," p. 171 n. 47; Bergman, *Salerno*, p. 27; Rickert, *Ashburnham Pent.*, p. 144, fig. 102; Prigent, *Judaïsme*, p. 306.

[Genesis 8]

NOAH AND HIS SONS DISMANTLE THE ARK

The first scene of the following tripartite miniature has no reference to the text at this point of the narrative. No dismantling of the ark is described in Genesis 8; we may only envision that it happened perhaps before Noah's sacrifice and, hypothetically, in order to employ the wood of the ark as fuel for the fire of the sacrifice. The miniature duplicates the Building of the Ark (figs. 131–134), yet here the activities of Noah and his sons are different, and Noah himself vigorously participates in the job.

143a. Vat. 747, fol. 30v

The inscription above the frame reads: ἐνταῦθα θυσιάξων νῶε δέχεται τὴν ἐντολὴν τῆς τ(ῶν) κρε(ῶν) μεταλήψεως.

Noah and his three sons are occupied dismantling the ark. Two of the sons are tearing apart the wooden planks, while Noah uses a hammer, assisted by his third son, who is portrayed as a seated shepherd dressed in an exomis and holding a stick.

Located below Genesis 9:7.

144a. Ser., fol. 60v

The inscription above the frame reads: ἐνταῦθα θυσιάξων νῶε δέχεται τ(ὴν) ἐντολ(ὴν) τ(ῆ)ς τῶν κρε(ῶν) μεταλ(ήψεως).

The lower edge of the miniature is torn and the remainder is very badly flaked. Enough is still visible to ascertain that the details agreed thoroughly with Sm. and Vat. 746.

Located below Genesis 9:7.

145a. Sm., fol. 21v

Very close to Vat. 747.
Located below Genesis 9:7.

146a. Vat. 746, fol. 57r

The inscription below the picture reads: ἐνταῦθα θυσιάξων νῶε δέχεται τὴν ἐντολὴν τῆς τῶν κρεῶν μεταλήψεως.

Very close to Sm.
Located below Genesis 9:7.

Lit.: Strzygowski, *Sm.*, pp. 74, 115, pl. 35; Uspenskii, p. 121; Hesseling, fig. 34; Bernabò, "Caverna," pp. 725–26, fig. 10.

Genesis 8:20–9:1

SACRIFICE AFTER THE FLOOD

The two following sections of the tripartite miniature, showing the Sacrifice after the Flood, are strictly connected with each other and relate respectively to the consecutive verses Genesis 8:20–22 and 9:1. The covenant between Noah and God will be represented a second time in the following miniature with the Covenant after the Flood (figs. 147–150). The scenographic setting, dominated by the imposing arch of the rainbow in the miniature of the covenant, contrasts strikingly with the simple disposal of characters in the sacrifice, where no elaborate pictorial formula is employed, except for the landscape in Vat. 747. These divergences between two successive miniatures representing a very similar or the same subject suggest that they originated in different artistic milieus.

143b, c. Vat. 747, fol. 30v

Flames on a stone altar consume some slaughtered animals offered by Noah, while God's hand sends down rays toward the altar from a segment of heaven, indicating that the sacrifice pleases God. At one side of the altar Noah and his wife stand with gestures of prayer; at the other side are his three sons but only one of their three wives. God's promise that henceforth "seed and harvest, cold and heat, summer and spring shall not cease by day and night" (Gen 8:22) is illustrated to the right of the sacrifice scene by an oval which includes a representation of the four seasons.[1] Spring is represented at the upper left by a farmer cutting a meadow (cf. June in the series of the months in fig. 115); opposite him is another farmer, this one cutting grain and naked to indicate the heat of summer (cf. July in fig. 115). At the lower left a farmer personifies autumn by tilling the earth with a spade, a type which alongside the sower (cf. fig. 115) is used in other Byzantine sets of months for November. Finally, winter is rendered as an old man clad in a skin and warming his hands over an open fire (cf. February in fig. 115). The three sections of this miniature are held together by a range of high, craggy mountains with interspersed decorative houses painted in grisaille. Slightly flaked in various spots.

Located below Genesis 9:7.

144b, c. Ser., fol. 60v

Very close to Sm. and Vat. 746.
Located below Genesis 9:7.

145b, c. Sm., fol. 21v

Several differences from Vat. 747 may be noticed in the details and, moreover, the landscape is omitted altogether. Noah stands to the left of the central altar with his three daughters-in-law, his wife being omitted. At the right his three sons stand with several quadrupeds, among them a lion and a camel, which of course do not represent the animals to be sacrificed, but merely some of those which have just left the ark. The illustrator changed the order of the four seasons and in two cases chose different types. Spring is represented at the lower left by a youth in a long robe holding a flower in his left hand (cf. May in the series of months in fig. 117); the farmer at the upper right, who is cutting grain in the summer, is clad in a tunic, not naked as in Vat. 747; at the upper left autumn, in agreement with November in fig. 117, is personified by a sower, and winter, as usual, by a man warming himself by a fire. The four personifications selected by the painter correspond with the text of the Septuagint (Gen 8:22), which reads "seed and harvest, cold and heat"; in Vat. 747 the sower is supplanted by a farmer cutting a meadow. The oval enclosing the four seasons is held by the personifications Day and Night, represented as nudes and distinguished only by their color, Day being white and Night black. The miniature is flaked in several spots.

Located below Genesis 9:7.

146b, c. Vat. 746, fol. 57r

The miniature agrees in every respect with Sm. The animals behind Noah's sons are badly rubbed and the personifications of the four seasons are slightly damaged.

Located below Genesis 9:7.

Lit.: Strzygowski, *Sm.*, pp. 74, 115, pl. 35; Uspenskii, p. 121; Hesseling, fig. 34; De Grüneisen, *Ste. Marie Ant.*, p. 356; Demus, *Norman Sicily*, p. 253; Willoughby, *McCormick Apocalypse*, vol. 1, p. 332; Hanfmann, *Season Sarcophagus*, p. 93 n. 387; Stern, "Poésies," p. 175 n. 1, figs. 18, 19; Vileisis, "S. Maria Ant.," pp. 33–34; Bergman, *Salerno*, p. 28; Rickert, *Ashburnham Pent.*, p. 144, figs. 103, 104; Bernabò, "Caverna," p. 726, fig. 10.

[1] Ample commentaries on this mention of seasons are found in John Chrysostom, *HomGen* 27:11 (John Chrysostom, *Homilies on Genesis 18–45*, ed. Hill, p. 171, reported in Σειρά, ed. Nikephoros, vol. 1, col. 154), and in Theodoret's *QuaestGen* (PG 80, col. 95) and *QuaestPs* (PG 80, col. 1463: commentary on Ps 73:16–17). See also Hanfmann, *Season Sarcophagus*, vol. 2, p. 93 n. 387.

Genesis 9:12–14

COVENANT AFTER THE FLOOD

The covenant between God and Noah is represented by a picture arranged with a keen feeling for spatial depth uncommon in the Octateuchs, and most evidently transmitted by the impressionistic landscape in Vat. 747 and by the arrangement of the procession of people on the right, which resembles a group approaching a priest for communion.

147. Vat. 747, fol. 31r

The inscription above the picture reads: ἡ τοῦ τόξου ἐν οὐρανῷ ἀνάδειξις.

God makes a covenant with Noah who stands isolated opposite his family, composed of his sons, wife, and daughters-in-law. They raise their hands in prayer and look up to the blessing hand of God which appears within a segment of heaven. As a sign of the covenant God sets a "bow in the cloud." The illustrator, following an interpretation handed down in Genesis Rabbah 35:2–3,[1] painted the bow as a natural, iridescent rainbow resting upon two ponds of water, i.e., the ocean surrounding the earth (cf. figs. 2, 3, 29–37, 40–42). The rainbow separates the earth, bordered by high mountains, from the waters above the firmament (which are connected with the waters below, i.e., the ocean) filling the lower part of the spandrels, the golden sky above them, and the blue segment of heaven intersected by the rainbow. The segment thus cut off is painted in gold. A house painted in grisaille is visible on the mountains.

Located below Genesis 9:15.

148. Ser., fol. 62r

The inscription above the picture reads: ἡ τοῦ τόξου ἐν οὐρανῷ ἀνάδειξις.

The compositional scheme in general is the same as in Vat. 747, but some of the details differ: the grouping and postures of Noah and his family vary slightly, the mountains are omitted, and the divine hand does not appear in the segment of heaven, whose lower, intersected portion is painted in a darker blue studded with stars; attached to it are the disks of sun and moon, their averted heads in profile. Furthermore, the clouds fill the spandrels entirely without leaving any space for a separate zone of sky. The miniature is heavily flaked, particularly the ground around the figures.

Located below Genesis 9:16.

149. Sm., fol. 22r

Very close to Ser. The segment of heaven is particularly badly flaked.

Located below Genesis 9:15.

150. Vat. 746, fol. 57v

The inscription, written in the left margin, reads: ἡ τοῦ τόξου ἐν οὐρανῷ ἀναδείξις.

Very close to Ser. and Sm.

Located below Genesis 9:15.

Lit.: Kondakov, *Istoriia*, p. 189; Kondakov, *Histoire*, vol. 2, p. 79; De Grüneisen, "Cielo," p. 493; Uspenskii, p. 121, fig. 39; Hesseling, fig. 35; Gerstinger, *Wiener Gen.*, p. 77, fig. 49; Buberl, *Byz. Hss.*, p. 88; Demus, *Norman Sicily*, p. 253; Menhardt, p. 302; Henderson, "Influences," p. 187 n. 44; Henderson, "Sources," p. 14 n. 1; Vileisis, "S. Maria Ant.," pp. 31, 33–34; Bergman, *Salerno*, p. 28; Rickert, *Ashburnham Pent.*, p. 145, fig. 105; Lowden, *Octs.*, p. 13, fig. 179; Bernabò, "Caverna," p. 726, fig. 14.

[1] *Genesis Rabbah*, ed. Freedman and Simon, pp. 282–83.

Genesis 9:20–21

Noah Gets Drunk

151a. Vat. 747, fol. 31v

In the left half of the miniature, Noah sits on a chair at the foot of a high mountain and drinks some of the wine his sons are pressing. Two of the sons, one supporting the other, stand in a vat treading the grapes, while the third, with a spadelike ladle in his hands, is busy stirring the wine flowing from the vat into a large marbled tub. The wine flows through a spout shaped like a lion's head into one of the four big clay vessels in the foreground. The pictorial arrangement is based on a classical representation of putti pressing wine.[1] Partly overpainted and flaked again in various spots.

Located below Genesis 9:24.

152a. Ser., fol. 62v

The inscription is written in the left margin and reads: ἡ τοῦ οἴνου μετάληψις καὶ γύμνωσις νῶε.

The scene differs in several details from that in Vat. 747, although its general compositional scheme is in agreement. This copy is the only one in which, strangely enough, Noah does not drink from a vessel but raises his hands and looks up at the huge vine growing on a tree behind the winepress. While two sons tread the grapes as in Vat. 747, the third holds a vessel with which he seems to be emptying the marble tub and pouring the wine into the five vessels placed in front of it; the tub has no spout. The entire surface of this miniature is very heavily flaked.

Located below Genesis 9:24.

153a. Sm., fol. 22v

Very close to Ser., except that Noah holds a drinking vessel as in Vat. 747. However, he does not hold it firmly, and since the miniature apparently has been much overpainted, the possibility cannot be excluded that this vessel was added by the restorer.

Located below Genesis 9:24.

154a. Vat. 746, fol. 58r

The inscription in the left margin reads: ἡ τοῦ οἴνου μετάληψις καὶ γύμνωσις νῶε.

The scene agrees with Ser. and Sm., but Noah drinks greedily from a big bowl.

Located below Genesis 9:24.

Lit.: Kondakov, *Istoriia*, p. 189; Kondakov, *Histoire*, vol. 2, p. 79; Strzygowski, *Sm.*, p. 116, pl. 36; Uspenskii, p. 121; Hesseling, fig. 36; Gerstinger, *Wiener Gen.*, p. 78, fig. 48; Buberl, *Byz. Hss.*, p. 89; Menhardt, p. 302; Hutter, "Übermalungen," p. 140, fig. 3; Kötzsche-Breitenbruch, *Via Latina*, p. 55, pl. 5d; Bergman, *Salerno*, p. 29; Brubaker, "Gregory of Naz.," pp. 392, 462 n. 168; Korol, *Cimitile*, p. 151 n. 634; Sed-Rajna, *Hebraic Bible*, p. 23 n. 21.

[1] See, e.g., the season sarcophagi investigated by Hanfmann, *Season Sarcophagus*, figs. 31, 45, 52, 66, 148.

Genesis 9:22–23

Ham Informs His Brothers and Shem and Japheth Cover Noah

151b. Vat. 747, fol. 31v

In the right half of the miniature Noah lies drunk and asleep on a couch; the lower part of his tunic is pulled up, exposing his naked legs and penis. At the foot of the couch stand his three sons: Ham is represented hurriedly departing and at the same time turning around to his two brothers, telling them of their father's nakedness. Shem and Japheth turn their backs to Noah and carry a mantle over their shoulders, the himation of Genesis 9:23, with which they are going to cover their father. In the background is Noah's two-storied house where the event is supposed to take place; beyond it emerge high mountains with a decorative house in classical style cradled on its slopes. Most of the scene has been overpainted, particularly the sons' garments and the head of the son on the right; it is flaked again in various spots.

Located below Genesis 9:24.

152b. Ser., fol. 62v

The figural composition is the same as in Vat. 747, but the mountains and house are omitted, Noah's couch is reduced to a mattress, and the sons are represented in calmer postures. Moreover, a slightly later moment in the episode is chosen, in which Shem and Japheth have already covered their father's nakedness with a sleeved tunic, replacing the himation mentioned at Genesis 9:23 and represented in Vat. 747. These details are still recognizable though the whole miniature is very badly flaked and entire sections are completely lost.

Located below Genesis 9:24.

153b. Sm., fol. 22v

The scene is very close to Ser. and was largely overpainted before flaking again.

Located below Genesis 9:24.

154b. Vat. 746, fol. 58r

Very close to Ser. and Sm.
Located below Genesis 9:24.

Lit.: Kondakov, *Istoriia*, p. 189; Kondakov, *Histoire*, vol. 2, p. 79; Strzygowski, *Sm.*, p. 116, pl. 36; Uspenskii, p. 121; Hesseling, fig. 36; Gerstinger, *Wiener Gen.*, p. 78, fig. 48; Buberl, *Byz. Hss.*, p. 89; Demus, *Norman Sicily*, p. 253; Menhardt, pp. 302–3; Hutter, "Übermalungen," pp. 140–42, 144, fig. 3; Koshi, *Genesisminiaturen*, p. 14; Kötzsche-Breitenbruch, *Via Latina*, p. 55, pl. 5d; Weitzmann, *SP*, pp. 38, 50; Bergman, *Salerno*, pp. 29–30; Korol, *Cimitile*, p. 151 n. 634; Weitzmann and Kessler, *Cotton Gen.*, p. 42; Sed-Rajna, *Hebraic Bible*, p. 23 n. 21; Ferrua, *Catacombe sconosciute*, p. 146 n. 9.

Genesis 9:24–27

Noah Blesses Shem and Japheth

155a. Vat. 747, fol. 32r

Aroused from his intoxication, Noah sits on a chair opposite his sons and raises his hand in a gesture of blessing toward Shem and Japheth who stand devotedly and with appreciative gestures before him. Ham, having heard the curse of his son Canaan, hurriedly leaves his father and brothers. For Noah the painter used the usual formula of an ancient philosopher teaching his pupils.[1] The scene, which takes place in the open in front of a high mountain, has been thoroughly overpainted and is flaked again in several spots.

Located below Genesis 10:1.

156. Ser., fol. 64r

At variance with Vat. 747, Ham holds his hand against his cheek as a sign of grief, while this brothers more hurriedly approach their father who holds a scroll in his left hand. The landscape is omitted, but otherwise the scene agrees with Vat. 747. Large sections of the surface, particularly the figure of Ham, are flaked and the ground and Noah's chair are completely destroyed.

Located below Genesis 9:29.

158a. Sm., fol. 23r

This scene, which is very close to Ser., is likewise very badly flaked, and the figure of Ham is almost completely lost.

159a. Vat. 746, fol. 59v

Very close to Ser. and Sm.
Located below Genesis 9:29.

Lit.: Uspenskii, p. 122; Hesseling, fig. 37; Gerstinger, *Wiener Gen.*, p. 78, fig. 50; Buberl, *Byz. Hss.*, p. 89; Weitzmann, *RaC*, pp. 156–57, fig. 146; Hutter, "Übermalungen," p. 140, fig. 6; Revel, "Textes rabbin.," p. 119 n. 1; Anderson, "Seraglio," p. 95, fig. 22.

[1] Weitzmann, *RaC*, pp. 156–57.

Genesis 9:29

Burial of Noah

155b. Vat. 747, fol. 32r

For the representation of Noah's death the illustrator has chosen a conventional burial scheme: two young men, apparently Shem and Japheth, lower their father's corpse, which is wrapped like a mummy, into a sarcophagus while three women watch the scene and weep as a sign of deep mourning. The son holding the feet of the corpse is depicted as if standing in the sarcophagus, as in Vat. 746. Parts of the sky, the mountains, and the ground around the sarcophagus are flaked.

Located below Genesis 10:1.

157. Ser., fol. 64r

Close to Vat. 747, but Noah is being buried in his clothes and is lowered into a marble sarcophagus whose shape is adjusted to the reclining position of the deceased. Two other figures are visible behind the three daughters-in-law, whose grief is far less pronounced than in Vat. 747; they are probably meant to represent Noah's wife and Ham. Flaked in several places.

Located below Genesis 9:29.

158b. Sm., fol. 23r

The scene is very close to Ser., except that the foremost woman turns around to the other mourners. The miniature has been crudely overpainted and is flaked again, particularly in the upper left corner.

159b. Vat. 746, fol. 59v

Only the three daughters-in-law mourn at the foot of the sarcophagus. Both sons stand inside the sarcophagus while they lower the corpse, rather than bending over the rim, but otherwise the scene agrees with Ser. and Sm.

Located below Genesis 9:29.

Lit.: Uspenskii, p. 122; Hesseling, fig. 37; Buberl, *Byz. Hss.*, p. 89; Der Nersessian, *Barl. et Joas.*, p. 173; Hutter, "Übermalungen," pp. 140, 142–44, fig. 6; Anderson, "Seraglio," p. 95, fig. 22.

Genesis 10

DESCENDANTS OF NOAH

Chapter 10 of Genesis enumerates Noah's descendants in three groups, corresponding to his three sons. The illustration in the left part of the miniature offers a novel depiction of the earth colonized by Noah's descendants, represented divided into sections or islands by large interior rivers or arms of the sea. There are five of these sections in Vat. 747, while the other manuscripts reduce them to three, unifying the two lowest sections. This map of the earth has no discernible resemblance to the maps depicted in the miniatures of the Creation (see figs. 29–42): it stems from a different tradition. The illustrator located specific races in the separate sections of the map not according to the list of tribes in chapter 10 of Genesis, but probably based on beliefs and established maps of his time.[1] Notably, this tripartite miniature has no resemblance to the following miniature with the five tribes of Noah's genealogy (figs. 164–167), which avoids any cartographic aim and depicts the races differently with more variegated facial types and dresses.

160a. Vat. 747, fol. 32v

On the upper left island four men are sitting on the ground. The one distinguished by his posture and his beard might be one of Noah's descendants who talks to his tribe and looks back at them, at the same time pointing to the young inhabitants of the

opposite island. On the central island and on the lower left one, the groups are engaged in lively conversation, whereas the last group at the lower right faces the right border. Apparently the illustrator intended them to be looking at the neighboring scene, which represents Nimrod.

Located below Genesis 10:10.

161a. Ser., fol. 64r

The inscription, which was placed outside the frame in the margin and is now partly destroyed, reads: ἡ οἴκησις τῶν [νήσων].

The lower part of the miniature is torn away and the sons of Ham are entirely lost, while only the heads are left of the sons of Cush. The remainder, heavily stained and flaked, agrees essentially with Vat. 747, except for a slightly different arrangement of the figures in each group.

Located below Genesis 10:10.

162a. Sm., fol. 23v

This copy preserves the compositional scheme best, but it is less reliable in the finer details since the whole surface has been very crudely overpainted. The sons of Ham in the lower left corner wear strange pointed hats.

163a. Vat. 746, fol. 60r

The inscription, placed in the outer margin and very faded, reads: ἡ οἴκησις τῶν νήσων.

The miniature is very badly flaked, but enough remains to ascertain that the compositional arrangement agreed closely with Sm.

Located below Genesis 10:10.

Lit.: Uspenskii, p. 122, fig. 40; Hesseling, fig. 38; Bernabò, "Fonti testuali," pl. 27 no. 2; Bernabò, "Caverna," pp. 726–27, fig. 11.

[1] A list of tribes is given in the catena in our manuscripts, in an anonymous passage reported, e.g., in Vat. 746 on fols. 60r–60v. Also, Prokopios of Gaza in his Octateuch catena (PG 87, cols. 308–12) gives a complete register of the tribes stemming from Noah's descendants.

Genesis 10:9

NIMROD THE HUNTER

160b. Vat. 747, fol. 32v

Nimrod (LXX: Nebrod) is rendered as a giant hunter aiming an arrow at a stag high up on a mountain. Considerably flaked.

Located below Genesis 10:10.

161b. Ser., fol. 64r

The inscription reads: ἡ τοῦ νεβρὼδ ἀνάδειξις.

Close to Vat. 747, except that Nimrod carries a quiver over his shoulder. The miniature is partly torn at the bottom and the remainder is stained and very flaked.

Located below Genesis 10:10.

162b. Sm., fol. 23v

Very close to Ser. The miniature has been overpainted and has flaked again.

163b. Vat. 746, fol. 6or

The inscription reads: ἡ τοῦ νεβρῶδ ἀνάδειξις.

Very close to Ser. and Sm. The miniature is badly flaked and the stag is rubbed.

Located below Genesis 10:10.

Lit.: Uspenskii, p. 122, fig. 40; Hesseling, fig. 38; Vzdornov, "Illustraciia," pp. 213–14, fig. 6; Bernabò, "Fonti testuali," pp. 477–78, pl. 27 no. 2; Livesey and Rouse, "Nimrod," p. 237 n. 88; Bernabò, "Caverna," pp. 726, 737, fig. 11.

Genesis 10:11

NIMROD BUILDS A TOWER

Nimrod is building a tower, either the Tower of Babel, from which his kingdom started according to Genesis 10:10,[1] or of one of the cities he founded according to Genesis 10:11. Nimrod was believed to be the mythical founder of some of the greatest towns in Mesopotamia, i.e., Seleukeia/Ktesiphon, Edessa, and Nisibis;[2] related legends might be the source that led the painter to reserve for Nimrod these two scenes in the cycle.

160c. Vat. 747, fol. 32v

Nimrod, building a tower, holds a large stone in his hands and is about to add it to a wall alongside an already finished tower. A landscape of high mountains forms the background.

Located below Genesis 10:10.

161c. Ser., fol. 64r

The inscription, written by a much later hand, reads: θηρῶν διώκτης Νεβρῶδ ὁ πρῶτος γίγας.

Close to Vat. 747, except that the landscape is missing. The lower part of the miniature is torn away and the rest is stained and almost completely flaked, so that only the preliminary drawing reveals the original composition.

Located below Genesis 10:10.

162c. Sm., fol. 23v

Nimrod, instead of carrying a stone in his hands, appears to be touching the wall of the completed tower. However, the omission of the stone may very well be attributable to the later restorer who crudely overpainted the composition. Somewhat flaked.

163c. Vat. 746, fol. 6or

Very close to Ser. Partly flaked.
Located below Genesis 10:10.

Lit.: Uspenskii, p. 122, fig. 40; Hesseling, fig. 38; Bernabò, "Fonti testuali," pp. 477–78, pl. 27 no. 2; Bernabò, "Caverna," pp. 726, 737, fig. 11.

[1] A connection between Nimrod and a tower or the Tower of Babel appears in various Jewish writings; see P. van der Horst, *Essays on the Jewish World of Early Christianity* (Freiburg, 1990), pp. 220–32.

[2] Cf. J. B. Segal, *Edessa: "The Blessed City"* (Oxford, 1970), pp. 1–3; H. Drijvers, "Syriac Christianity and Judaism," in *The Jews among Pagans and Christians in the Roman Empire*, ed. J. Lieu, J. North, and T. Rajak (London and New York, 1992), p. 138. Edessa, Nisibis, and Seleukeia/Ktesiphon were founded by Nimrod according to TargN and TargPs-J on Gen 10:10 (*Targum Genèse*, ed. Le Déaut, pp. 136–37), GenR 37:4 (*Genesis Rabbah*, ed. Freedman and Simon, p. 297), and the Chronicle of Michael the Syrian, bk. 2, chap. 2 (*Chronique de Michel le Syrien, Patriarche Jacobite d'Antioche [1166–1199]*, ed. J.-B. Chabot, vol. 3 [Paris, 1910], p. 20).

Genesis 10

DESCENDANTS OF NOAH

As previously remarked (see the introduction preceding no. 160a), this miniature apparently illustrates the same chapter 10 as the previous one (figs. 160–163), Noah's genealogy after the flood, but it displays a different selection of races. An origin of this miniature in a separate milieu should thus be assumed.

164. Vat. 747, fol. 32v

The inscription outside the margin above the picture reads: οἱ τῶν τοῦ νῶε υἱῶν ἀπόγονοι.

Noah's descendants are shown in five groups standing in front of a mountainous background. The whole miniature is badly flaked, but the following details are still discernible. The first group at the left consists of six people, two of whom wear the chlamys and a third raises a lacerna in his left hand. In the second group two of the five men stand in the foreground: one, a black-skinned man, is clad in a short mantle draped to leave half his chest bare, and the other, a youth, is dressed in a short embroidered tunic. The central group is composed of three youths in short tunics and himations. The two in front, though their eyes meet, turn their backs to each other and point to the flanking groups. The fourth group comprises two soldiers in the front row carrying lances and talking to each other, while the head of a third appears above their shoulders. Beside the left soldier, but now almost entirely destroyed, a black-skinned and half-naked man is discernible, similar to the one at the left in the second grouping. At the extreme left, the fifth group also includes a black-skinned man wearing a kind of turban, and beside him still another figure of the same type, though his skin is dark brown instead of violet-black. Finally, at the extreme right, a fair-skinned youth in a short tunic is visible. The whole miniature was overpainted in the Palaiologan period, and in the process many of the ethnographical details, which, to judge from the other copies, must have been a major concern of the painter of the archetype, were apparently lost, particularly the headdresses. Nevertheless, it is still very obvious that, with the exception of the three youths in the central group, the painter combined representatives of different races in each group. The central group is

apparently meant to represent the homogeneous nation of the Greeks in contrast to the barbarians of the four flanking groups. The black-skinned men can be identified as Ethiopians, and those with dark brown skins as Egyptians, in analogy to many similar figures in illustrations of the Joseph story.

The miniature, which roughly cuts the text in the middle of Genesis 10:24 (apparently without logical explanation), is located below ἐγέννεσεν τὸν Σαλά and above Σαλὰ δὲ ἐγέννεσεν τὸν Ἔβερ. The other Octateuchs break the text at the same words.

165. Ser., fol. 64v

The inscription outside the margin above the picture reads: οἱ τῶν τοῦ νῶε υἱῶν ἀπόγονοι.

Many of the figures agree with Vat. 747, but, with the exception of the central group, their number is reduced, while within each group a unification of types has taken place. Only in the first group at the left are the representatives of two different nations still combined: a soldier wearing a high-crested helmet and holding a sword in his hand is associated with three youths whose caps characterize them as Persians. In the second group three dark-skinned Ethiopians converse among themselves; they are clad in loincloths, wear fillets in their hair, and are armed with lances and swords. The fourth group is entirely different than in Vat. 747: here all three men wear high hats, and one is clad in a garment with long sleeves extending beyond the hands. This sort of costume was worn by high dignitaries of the Byzantine court and thus seems characteristic of rank rather than nationality. In the fifth group three dark-skinned Egyptians wearing turbans are grouped together, one of them armed with a spear and shield.[1] The miniature is flaked in several spots.

Located in the middle of Genesis 10:24, exactly like no. 164.

166. Sm., fol. 24r

The inscription outside the margin above the picture reads: οἱ τῶν τοῦ νῶε υἱῶν ἀπόγονοι.

Very close to Ser. The miniature has been overpainted and is partly flaked again.

167. Vat. 746, fol. 60v

The inscription outside the margin above the picture reads: οἱ τῶν τοῦ νῶε υἱῶν ἀπόγονοι.

Close to Ser. and Sm. Partly flaked; the heads at the left are rubbed away.

Located in the middle of Genesis 10:24, exactly as no. 164.

Lit.: Uspenskii, pp. 122–27, figs. 41, 42; Hesseling, fig. 39; De Grüneisen, *Ste. Marie Ant.*, p. 193, fig. 145; Koukoules, *Vie et civilisation*, vol. 5, pl. 7 no. 3; Garidis, "Représentation," p. 89, fig. 5; Hutter, "Übermalungen," pp. 140, 144, fig. 4; Bernabò, "Laur. plut. 5.38," p. 149 n. 39; *Image du noir*, fig. 65; Mütherich, "Darstellungen," p. 728; Bernabò, "Caverna," p. 727, fig. 15.

[1] Uspenskii, p. 122, advances the following identification of the groups, left to right: Venetians, Arabs from Egypt and Syria, Greeks, nomads from southern Russia (Pechenegs), and Arabs from Asia Minor, Syria, and Palestine.

Genesis 11:3

Manufacture of Bricks for the Tower of Babel

168. Vat. 747, fol. 33r

The miniature is very badly flaked, and at the center and the left the surface is nearly completely destroyed. Nevertheless, it is clear from the remaining traces that the composition essentially agreed with that of the other manuscripts. Two men at the left are piling up bricks in an open fire, and in the foreground a row of bricks, apparently already baked, is pictured. A third man approaches the fire from the right, bringing more unbaked bricks which he has taken from the pile in the lower right corner. The background is formed by a landscape of high mountains. Large areas of the surface are flaked.

Located below Genesis 11:3.

169. Ser., fol. 65r

Close to Vat. 747, except that the bricks are being baked in a regular furnace and behind the two men at the left the head of a third is visible. Moreover, the miniature never included a landscape setting. Major parts of the surface are so completely flaked that little more than the preliminary drawing remains.

Located below Genesis 11:3.

170. Sm., fol. 24r

Very close to Ser. One of the workers is stirring the fire with a stick. This miniature is also partly flaked.

171. Vat. 746, fol. 61r

The inscription reads: ἡ τῶν πλίνθων ἔκκαυσις ὡς ὁρᾷς ἤδε. Very close to Ser. and Sm. Only slightly flaked.

Located below Genesis 11:3.

Lit.: Uspenskii, p. 127; Hesseling, fig. 40.

Genesis 11:8–9

Collapse of the Tower of Babel and Confounding of Languages

The destruction of Babel and the confounding of the languages are represented in the form of a triptych. The central panel shows the wall of Babel collapsing around the still erect tower, while the smaller wing panels contain the confounding of languages, showing four groups of men fleeing at the corners of the miniature, evidently corresponding to the four cardinal points;[1] the men walk away from Babel addressing each other unsuccessfully. The central panel has only a weak tie to the Septuagint, which relates that God, having confounded the tongue of the sons of men, "scattered them thence over the face of all the earth, and they left off building the city and the tower." The pictorial creation must be based on more embellished accounts,

such those in Jubilees 10:26 and other pseudepigrapha, where the tower is actually overthrown by violent winds sent by God.[2] The plural at Genesis 11:7, which in the LXX reads, "Come, and having gone down let *us* there confound their tongue," is interpreted in Jewish texts as an indication that God was accompanied by angels performing the confounding of languages.[3] The Christians took it as a reference to the Trinity: in an anti-Arian exposition of the verse, Ephrem claimed that the Son and the Spirit are here addressed by God with the plural,[4] a statement supported by later authors.[5] The hand of God appearing from the heavens here and the exclusion of any celestial being to whom God's words might have been addressed thus evidently originated in the Christian realm.

172. Vat. 747, fol. 33v

In Vat. 747 the episode of the collapse of the walls takes place before a high mountain and beneath a golden sky upon which a later hand has painted some flower-petal ornaments in the spandrels of a trefoil arch, similar to those in the initial miniatures of this manuscript (figs. 6, 8–11); however, most of this ornamentation has been obliterated. Together with the walls, the scaffolding has fallen, injuring the working bricklayers. Some of them are buried under heaps of stones, one has fallen headfirst, and another, as yet unharmed, turns his head toward the hand of God which appears in the upper left corner in a segment of heaven. At the left side of the tower, a zone of water not mentioned in the LXX is depicted. The depiction of the confounding of languages is distributed over four separate panels on the "wings" of the triptych. To characterize the dispersed nations the painter used ethnographical types similar to the illustration of Genesis 10 (figs. 164–167). In the upper left panel, a black-skinned Ethiopian clad in a loincloth is pointing to his mouth, expressing his inability to make himself understood to another man, clad in a chlamys, who flees in terror carrying a standard in his hand. In the scene below, a fair-skinned youth dressed in a tunic and partly cut off by the frame holds his hand before his mouth while two others draw away from him, one an Ethiopian bearing a lance and the other a fair-skinned youth making a gesture of rejection. In the upper right panel a standard-bearer and a man in an oriental costume turn away from a third man who is trying in vain to talk to them. Finally, in the lower right panel an elderly man stretches his arms toward three black-skinned figures, one holding a standard and another an ax; they stand in calm poses, unconcerned by the older man's attempts to communicate with them. Each of the small panels has its own background of high mountains with decorative buildings painted in grisaille between their peaks. All the panels are more or less damaged by flaking.

Located above Genesis 11:10, at the top of fol. 33v.

173. Ser., fol. 65v

The arrangement of the panels and the grouping of the figures are essentially the same as in Vat. 747, but there are many deviations in the details. Next to the bricklayer who is falling headfirst

is another, half hidden by a plank from the scaffolding, who is about to be hit by a falling stone, and at the right, where in Vat. 747 only a head is visible, one can see a frightened worker climbing over the ruined scaffold and looking up at the sky. In the panel at the upper left the man pointing to his mouth is fair-skinned and the fugitive is characterized as a Persian by his cap and lacerna. In the scene below, the speaker wears a pointed hat and, of the two others, the one making a gesture of repulsion is black-skinned. In the upper right panel the standard-bearer wears the court costume with long sleeves and melon-shaped hat, while his companion, a dark-skinned man, tries to free himself from the grip of the third, who eagerly tries to make himself understood. In the fourth panel an Egyptian wearing a turban is accompanied by a bearded man with a pointed hat who tries to answer the gesticulating man at the left. None of the panels has a background and large parts of the surface are flaked.

Located below Genesis 11:9.

174. Sm., fol. 24v

Very close to Ser.

175. Vat. 746, fol. 61v

Very close to Ser. and Sm. The central panel is somewhat flaked.

Located below Genesis 11:9.

Lit.: Kondakov, *Istoriia*, pp. 187, 190; Kondakov, *Histoire*, vol. 2, pp. 77, 80; Uspenskii, pp. 127–29, fig. 43; Hesseling, fig. 41; Redin, *Koz'my Indikoplova*, p. 92; Katzenellenbogen, "Central Tympanum," p. 147, fig. 12; Demus, *Norman Sicily*, p. 254; Menhardt, p. 303; Buchthal, *Latin Kingdom*, p. 76; Henderson, "Influences," p. 182 n. 36; Garidis, "Représentation," p. 89, fig. 4; Mütherich, "Psalterillustration," p. 172; Anderson, "Two Centers," p. 83; Bernabò, "Laur. plut. 5.38," p. 151 n. 43, p. 156 n. 48; *Image du noir*, fig. 66; Mütherich, "Darstellungen," p. 728; Bergman, *Salerno*, p. 30; Weitzmann and Kessler, *Cotton Gen.*, p. 42.

[1] Cf. GenR 38:10 (*Genesis Rabbah*, ed. Freedman and Simon, p. 309).
[2] *OTP*, vol. 2, p. 77; see also the *Sibylline Oracles*, bk. 3, 101–2 (*OTP*, vol. 1, p. 364).
[3] TargPs-J on Gen 11:8 (*Targum Genèse*, ed. Le Déaut, p. 145). Notwithstanding the plural in the Greek version, note that GenR 38:10 charges the LXX with altering the text and translates the passage with a singular, "Come, I will go down, and there confound their language" (*Genesis Rabbah*, ed. Freedman and Simon, p. 309); see E. Tov, "The Rabbinic Tradition Concerning the 'Alterations' Inserted into the Greek Pentateuch and Their Relation to the Original Text of the LXX," *JSJ* 19 (1984), p. 78.
[4] *CommGen* 8:3 (Ephraem, *In Genesim et in Exodum commentarii*, ed. Tonneau, p. 53); Kronholm, *Motifs from Genesis*, pp. 213–14.
[5] See Prokopios of Gaza, who also interpreted the plural as addressed to the Trinity (*CommGen* [PG 87, col. 312]), not to celestial beings.

[Genesis 11:26]

ABRAM'S FIRST STEPS

The only remark in the text concerning the early life of Abram is the statement that Terah (LXX: Tharrah) begat three sons: Abram, Nahor (LXX: Nachor), and Haran (LXX: Arrhan). No

depiction of the birth of Abram appears in the cycle, although the inscription in Ser. and Vat. 746 refers to the birth. The story of Abram begins with a scene from his earliest childhood, apparently showing his mother talking to him while he takes his first steps. Such infancy scenes, only indirectly suited to the text, are also introduced for the childhood of Isaac (figs. 293, 294) and Moses (figs. 600–602) in Ser., Sm., and Vat. 746. The iconography recalls images of infancy on ancient sarcophagi.[1]

176. Vat. 747, fol. 34r

Abram, distinguished by a nimbus, is shown as a little boy just learning to walk and trying to hold himself up by grasping the knee of his seated mother. High mountains and a decorative piece of architecture form the background.
Located below Genesis 11:26.

177. Ser., fol. 67r

The inscription reads: ἡ τοῦ ἀβραὰμ γέννησις.
Close to Vat. 747, save for some details, for instance, the absence of Abram's nimbus and the landscape. Both figures and ground are considerably flaked.
Located above Genesis 11:27.

178. Sm., fol. 25r

Very close to Ser. Partly flaked.

179. Vat. 746, fol. 63r

The inscription reads: ἡ τοῦ ἀβραὰμ γέννησις.
Very close to Ser. and Sm.
Located above Genesis 11:27.

Lit.: Uspenskii, p. 129; Hesseling, fig. 41a; Bernabò, "Laur. plut. 5.38," p. 153.

[1] Lafontaine-Dosogne, *Iconographie de l'enfance*, vol. 1, pp. 122–24, fig. 70.

Genesis 11:31

ARRIVAL OF TERAH IN HARAN

180. Vat. 747, fol. 34r

The inscription is placed above the frame. It reads: ἡ τοῦ θάρρα πρὸς χαναὰν πανοικὶ μετάβασις.
On his way to Canaan, Terah arrives in Haran (LXX: Charrhan) with his whole family; in the miniature he nears a two-story building symbolizing the city. Alongside Terah, who is the only nimbed figure, walks his wife. Ahead of them walks a youth, looking back and carrying his mantle on a shouldered stick. A larger group of men and women talking among themselves follows Terah; according to the text, in this group are Abram, his wife Sarai, and Lot, Terah's grandson. High mountains form the background. The miniature is flaked in many places.
Located below Genesis 11:31.

181. Ser., fol. 67r

The inscription is placed outside the frame in the margin and is defective at the end. It reads: ἡ τοῦ θάρρα πρὸς χαναὰν [πανοικὶ μετάβασις].
Very close to Vat. 747 save for small details. Instead of high mountains, two trees framing the procession comprise the landscape. The miniature is partly torn and stained at the bottom, and the entire surface is so badly flaked that not a single face is left and large parts of the draperies are destroyed.
Located below Genesis 11:31.

182. Sm., fol. 25v

Very close to Ser. Partly flaked.
Located below Genesis 11:31.

183. Vat. 746, fol. 63r

The inscription reads: ἡ τοῦ θάρρα πρὸς χαρρὰν πανοικὶ μετάβασις. The word χαρρὰν is a later emendation of χαναάν.
Very close to Ser. and Sm.
Located below Genesis 11:31.

Lit.: Uspenskii, p. 129; Hesseling, fig. 42.

Genesis 11:32

DEATH OF TERAH

184a. Vat. 747, fol. 34v

Terah has died, and Abram, nimbed and represented for the first time as a bearded old man, stands behind the couch and looks mournfully at his dead father. High mountains with a decorative piece of architecture in grisaille form the background.
Located below Genesis 12:3.

185a. Ser., fol. 67v

The inscription reads: θάρρα τελευτή.
Abram expresses his grief by holding his hand to his mouth, but otherwise the scene agrees with the one in Vat. 747. There is no background, and the entire surface is very badly flaked.
Located below Genesis 12:3.

186a. Sm., fol. 26r

Very close to Ser.
Located above Genesis 12:4.

187a. Vat. 746, fol. 63v

The inscription reads: θάρρα τελευτή.

Very close to Ser. and Sm. Slightly flaked.
Located below Genesis 12:3.

Lit.: Uspenskii, p. 129; Hesseling, fig. 43.

Genesis 12:1–3

God Orders Abram to Leave Haran

184b. Vat. 747, fol. 34v

In the right half of the miniature Abram, his hands raised in prayer, stands before the blessing hand of God in a segment of heaven bidding him to leave Haran and go to Canaan.
Located below Genesis 12:3.

185b. Ser., fol. 67v

Very close to Vat. 747 but without the landscape background. The figure of Abram is mostly flaked, and the divine hand is completely lost.
Located below Genesis 12:3.

186b. Sm., fol. 26r

Very close to Ser. The segment of sky containing God's hand has been completely rubbed away.
Located above Genesis 12:4.

187b. Vat. 746, fol. 63v

Very close to Ser. and Sm.
Located below Genesis 12:3.

Lit.: Uspenskii, p. 129; Hesseling, fig. 43; Bergman, *Salerno*, p. 32.

Genesis 12:5

Abram's Journey to Canaan

188. Vat. 747, fol. 34v

With his family and belongings Abram journeys to Canaan, accompanied by his wife, Sarai, and a young man (apparently his nephew, Lot) in front of him who turns his head back. The people are followed by a herd of laden camels led by one boy and driven by another. A chain of high mountains with decorative houses painted in grisaille forms the background.
Located below Genesis 12:6.

189. Ser., fol. 68v

The inscription reads: ἡ πρὸς χαναὰν τοῦ αβραὰμ μετάβασις.
Very close to Vat. 747 save for small details and the omission of the landscape. Somewhat flaked.
Located below Genesis 12:6.

190. Sm., fol. 26r

Very close to Ser.

191. Vat. 746, fol. 64r

The inscription reads: ἡ πρὸ(ς) χαναὰν τοῦ αβραὰμ μετάβασις.
The frame around the miniature is omitted, and the heads of Abram and the camels are rubbed.
Located below Genesis 12:6.

Lit.: Uspenskii, p. 129; Hesseling, fig. 44; Lowrie, *Art*, pl. 143a; Anderson, "Seraglio," pp. 87, 89, fig. 6.

Genesis 12:7

God Appears to Abram at Sichem

In the left half of the miniatures is God's first appearance to Abram in Sichem (LXX: Sychem) together with the altar erected by Abram with a fire burning on it. No sacrifice or fire burning on the altar is referred to at this point in Genesis; the sacrifice therefore seems to be an iconographic borrowing from a sacrifice scene such as the burnt offering at Mamre (figs. 212a–215a).

192a. Vat. 747, fol. 34v

The inscription reads: ἡ τοῦ θυσιαστηρίου οἰκοδομή.
Abram, having built the altar in Sichem, prays to heaven, shown as a segment from which golden rays emanate to the flames on the altar. High mountains form the background. Slightly flaked.
Located beside Genesis 12:9.

193a. Ser., fol. 68v

From the segment of heaven the hand of God appears, making a blessing gesture toward Abram symbolic of the promise that the land of Canaan will be given to his seed. In other respects, however, the praying Abram and the flaming altar, still recognizable despite extremely bad flaking, correspond with Vat. 747. The mountains are omitted.
Located below Genesis 12:8.

194a. Sm., fol. 26r

Very close to Ser.

195a. Vat. 746, fol. 64v

The inscription reads: ἡ τοῦ θυσιαστηρίου οἰκοδομή.
Very close to Ser. and Sm.
Located below Genesis 12:8.

Lit.: Uspenskii, p. 129; Hesseling, fig. 45; Lowrie, *Art*, pl. 143b; Koshi, *Genesisminiaturen*, p. 39; Bergman, *Salerno*, p. 33.

Genesis 12:11–13

Abram Instructs Sarai

192b. Vat. 747, fol. 34v

Abram, afraid that the Egyptians may kill him because of his fair wife, suggests to Sarai that she pose as his sister. Abram firmly holds Sarai's arm, a gesture apparently expressing his fear of losing his wife. Behind Sarai is a group of men and women, members of Abram's large family. The high mountains in the background are a continuation of those in the preceding scene and are embellished with a house in grisaille.

Located beside Genesis 12:9.

193b. Ser., fol. 68v

Abram here addresses a group of men; neither Sarai nor any other women are represented. At the right edge of the miniature a fire burns upon an unexplained altar, evidently a misplaced duplicate of the altar in the previous scene (fig. 193a).

Located below Genesis 12:8.

194b. Sm., fol. 26r

Very close to Ser.

195b. Vat. 746, fol. 64v

Very close to Ser. and Sm.
Located below Genesis 12:8.

Lit.: Uspenskii, p. 129; Hesseling, fig. 45; Koshi, *Genesisminiaturen*, p. 39; Weitzmann, *SP*, pp. 38, 48.

Genesis 12:14–15

Arrival of Abram in Egypt

The Septuagint's text corresponds only partially with the episode illustrated in the miniature, where a few details, such as Pharaoh's gesture and the Egyptian pointing to Abram and Sarai in Vat. 747 (fig. 196) or alternatively talking with Abram in Ser., Sm., and Vat. 746 (figs. 197–199), have no convincing reference in the biblical account. A text with a plot more embellished than that in the Septuagint should possibly be assumed as a basis for the illustration. A Syriac verse homily on Abram and Sarai in Egypt, for instance, which dates from the fifth or early sixth century, rewrites the narrative of Abram's arrival in Egypt, adding dramatizing features which provide convincing explanations for the iconography of this miniature.[1] Connections are also found with the Genesis Apocryphon discovered in Qumran Cave 1, 19:24–27, and with Genesis Rabbah 40:1.[2]

196. Vat. 747, fol. 35r

Abram, bowing slightly, addresses his wife as if giving her last-minute instructions. Sarai looks into her husband's eyes and moves toward the Egyptians at the right. Next to her is a dark-skinned Egyptian in a short tunic pointing at the pair; one of Pharaoh's princes, wearing a long patterned garment and a turban, stands beside him with crossed arms. Pharaoh himself, dressed in a striped garment and a particularly tall turban, sits in front of his house and stretches his hand toward Sarai. A landscape of high mountains forms the background.

Located beside Genesis 12:15.

197. Ser., fol. 69r

The inscription, which begins outside the upper frame and continues within it, reads: ἡ εἰς αἴγυπτον τοῦ αβραὰμ κάθοδο(ς) καὶ σάρρας ἀφαίρεσις.

Behind Abram and Sarai are members of their family and a herd of camels, cut off by a tree near the frame. Abram does not speak to his wife but apparently addresses the nearer of the two Egyptians in the center. Although they repeat the poses of the figures in Vat. 747, both are clad in short tunics, and the distinction between the Egyptian commoner and the prince is therefore lost. Pharaoh wears a tunic and himation, pearl-studded purple shoes, and an oriental turban. While the landscape is omitted, the architecture is expanded by the addition of a city surrounded by a crenelated wall and a tower flanking Pharaoh's house. Pharaoh's face is flaked.

Located beside Genesis 12:16.

198. Sm., fol. 26v

Very close to Ser. Slightly flaked at the right.

199. Vat. 746, fol. 65r

As in Ser., the inscription begins above the frame and reads: ἡ εἰς αἴγυπτο(ν) τοῦ αβραὰμ κάθοδος καὶ σάρρας ἀφαίρεσις.

The group at the left is more condensed, but otherwise the scene is close to Ser. and Sm. The miniature is slightly rubbed at the right, and some of the faces are overpainted.

Located beside Genesis 12:16.

Lit.: Kondakov, *Istoriia*, p. 187 n. 2; Kondakov, *Histoire*, vol. 2, p. 77 n. 2; Uspenskii, p. 129; Hesseling, fig. 46; Lowrie, *Art*, p. 213, pl. 143c; Diringer, *Illuminated Book*, fig. 1-17a; *Image du noir*, fig. 72; Weitzmann, *SP*, pp. 38, 48; Bernabò, "Tradizioni siriache," pp. 309–10, fig. 9.

[1] S. P. Brock and S. Hopkins, "A Verse Homily on Abraham and Sarah in Egypt: Syriac Original with Early Arabic Translation," *Mus* 105 (1992), esp. vv. 72–89, pp. 116–18.

[2] Cf. *La Bible: Écrits intertestamentaires*, ed. A. Dupont-Sommer and M. Philonenko (Tours, 1987), p. 390 (see also the text reconstructed by Vermes, *Scripture and Tradition*, pp. 98–99 and n. 4), and *Genesis Rabbah*, ed. Freedman and Simon, p. 329, respectively. In these two texts Pharaoh sends Egyptian princes to inquire whether Abram and Sarai are spies, and a discussion occurs between Abram and the Egyptians.

Genesis 12:18–20

ABRAM AND SARAI BEFORE PHARAOH

200. Vat. 747, fol. 35r

Pharaoh sits in front of his house, which is topped by a little baldachin, and with a gesture expresses his indignation over Abram's pretending that Sarai was his sister. Abram stands in front of him explaining, while Sarai tries to hide behind her husband. At the right, one of Pharaoh's bodyguards is seen transmitting to another the command that Abram and his wife be sent away. Both Egyptians are black-skinned and wear patterned mantles. High mountains interspersed with decorative buildings in grisaille form the background.

Located beside Genesis 12:20.

201. Ser., fol. 69r

The inscription, placed outside the frame in the margin, reads: ἡ τῆς σάρρας ἀντίστρεψις πρὸς ἀβραάμ.

While Pharaoh speaks, Abram does not reply to the accusation but holds his right hand over his breast. Standing at the right is a group of three bodyguards receiving the order to expel Abram, but otherwise the composition very much agrees with Vat. 747. There is no background and the surface is badly flaked, with damage to all of the figures.

Located below Genesis 12:20.

202. Sm., fol. 26v

Very close to Ser. The group of bodyguards is somewhat flaked.

203. Vat. 746, fol. 65r

As in Ser., the inscription is placed in the left margin and reads: ἡ τῆς σάρρας ἀντίστρεψις πρὸς ἀβραάμ.

Very close to Ser. and Sm. Abram's and Sarai's faces are overpainted.

Located below Genesis 12:20.

Lit.: Uspenskii, p. 129; Hesseling, fig. 47; Lowrie, *Art*, p. 273, pl. 143d; Diringer, *Illuminated Book*, fig. I-17a; Weitzmann, *SP*, pp. 38–48; Bergman, *Salerno*, pp. 33–34, fig. 84.

Genesis 13:9–11

SEPARATION OF ABRAM AND LOT

204. Vat. 747, fol. 35r

In the upper panel of the miniature, Abram walks ahead of his large family through a mountainous landscape and looks back at Sarai, who raises her hand as if she has just spoken to him. At the same time he points to his rich herds, comprising two horses, a mare with a suckling colt, sheep, and camels. In the lower panel, Lot, who is distinguished by a nimbus, journeys in the opposite direction from that of Abram in the preceding scene. He is followed by his two daughters and other members of his large family and points to his herds, consisting of a camel, a horse, and some sheep, and to a youth carrying a heavy sack over his shoulder. In the mountains behind this group two buildings appear; at the left a house painted in grisaille which is merely decorative, and in the center a domed tower, perhaps intended to represent Sodom, where Lot is going to settle. The miniature has been repainted, particularly the figures of Abram and his wife, and is flaked again in various spots.

Located beside Genesis 13:9.

205. Ser., fol. 70r

The inscription in the upper panel reads: ἡ τῶν ποιμένων διαμάχη. This phrase alludes to the cause of Abram's and Lot's separation but it is not the basis for the miniature.

Abram is followed only by Sarai, not by any other members of his large family. The mare with its colt is omitted and instead of camels a herd of oxen leads the procession. No mountain landscape is included, and the surface is flaked in several places, particularly the figure of Abram.

The inscription in the lower panel reads: ἐξ ὧν καὶ ὁ τοῦ λὼτ διαχωρισμός.

Compared with Vat. 747, the composition is simplified inasmuch as only the two daughters and the youth carrying the heavy sack remain as representatives of Lot's big family, but the herds are richer, consisting of sheep, two camels, an ox, and a horse. The figure of Lot and the sheep are almost entirely flaked, and other parts of the miniature are also heavily damaged.

Located below Genesis 13:10.

206. Sm., fol. 26v

Very close to Ser. The animals are severely flaked.

207. Vat. 746, fol. 65v

The inscription in the upper panel reads: ἡ τῶν ποιμένων διαμάχη. The inscription in the lower panel reads: ἐξ ὧν καὶ ὁ τοῦ λὼτ διαχωρισμό(ς).

Very close to Ser. and Sm.

Located beside Genesis 13:9.

Lit.: Uspenskii, p. 129; Hesseling, fig. 48; Hutter, "Übermalungen," p. 140; Brenk, *S. Maria Magg.*, p. 62 n. 52; Deckers, *S. Maria Magg.*, p. 34; Weitzmann, *SP*, pp. 39, 48; Oltrogge, *Histoire ancienne*, p. 183 n. 450.

Genesis 13:14–15

GOD'S PROMISES TO ABRAM

208. Vat. 747, fol. 35v

God promises Abram the land around him to the north, south, east, and west. Abram raises his hands in prayer toward a segment of heaven from which the hand of God, now completely flaked, once issued. He stands in front of a lake whose water is

rendered with shading, and at the foot of high mountains in which a house appears at the right. The water seems to be a pictorial rendering of the word θάλασσαν, which in the text means "the western direction," but at the same time implies that, as seen from Palestine, the Mediterranean lies in that direction.

Located beside Genesis 13:14.

209. Ser., fol. 70r

The inscription reads: τρίτος χρηματισμὸ(ς) πρὸς αβραάμ.

The landscape is omitted and only the water remains, though cut off at the left by the frame, thus, in contrast to Vat. 747, resembling not a lake, but more correctly the eastern end of the Mediterranean. All parts of the miniature—the praying Abram, the hand of God in the segment of heaven, and the sea—are nearly completely flaked.

Located beside Genesis 13:15.

210. Sm., fol. 26v or 27r[1]

Very close to Ser. The miniature was cut vertically through the middle and stitched together again.

211. Vat. 746, fol. 66r

Very close to Ser. and Sm. Somewhat flaked.
Located beside Genesis 13:14.

Lit.: Uspenskii, p. 129; Hesseling, fig. 49; Der Nersessian, *Barl. et Joas.*, p. III; Tselos, "Joshua Roll," p. 278, fig. 5; Menhardt, pp. 303–5, fig. 9.

[1] Fol. 26v according to Hesseling, p. vi; fol. 27r according to Uspenskii, p. 183.

Genesis 13:18

Abram Dwells by the Oak of Mamre

212b. Vat. 747, fol. 35v

In the right half of the miniature Abram sits on an elevation in the ground, the very spot where he has decided to dwell. In the background two buildings emerge from behind a mountain ridge. A considerable part of the figure of Abram and parts of the background are flaked. In the text this scene precedes the event represented at the left, and it seems probable that a reversal of position took place in this and the other manuscripts.

Located beside Genesis 14:1.

213b. Ser., fol. 70r

The inscription reads: ἡ πρὸς τὴν δρῦν κατοίκησις.

Instead of a rich landscape, a single tree, the oak of Mamre mentioned in the text, is depicted behind the seated Abram. The lower part of the miniature has been torn off, and the remainder is stained and almost completely flaked.

Located below Genesis 13:18.

214b. Sm., fol. 27r

Very close to Ser.

215b. Vat. 746, fol. 66v

The inscription reads: ἡ πρὸ(ς) τὴν δρῦν κατοίκησις.
Very close to Ser. and Sm. The figure of Abram is flaked and rubbed.

Located beside Genesis 14:1.

Lit.: Uspenskii, p. 129; Hesseling, fig. 50; Bergman, *Salerno*, pp. 34–35.

Genesis 13:18

Sacrifice of Abram at Mamre

212a. Vat. 747, fol. 35v

The left half of the miniature shows Abram's sacrifice of a burnt offering on the altar he has erected at Mamre. The figure of Abram and the ground are partly flaked.

Located beside Genesis 14:1.

213a. Ser., fol. 70r

In this manuscript a lamb is consumed by the fire on the altar. The figure of Abram is severely flaked, and the altar is also almost completely destroyed.

Located below Genesis 13:18.

214a. Sm., fol. 27r

Very close to Ser. The miniature was cut vertically and stitched together again.

215a. Vat. 746, fol. 66v

Very close to Ser. and Sm.
Located beside Genesis 14:1.

Lit.: Uspenskii, p. 129; Hesseling, fig. 50.

Genesis 14:5–6

Battle of the Kings

The next scene illustrates the battle in the valley of Siddim (LXX: "the salt valley"), where four kings fight against five others. The names of the four victorious kings are recorded in the text as: Amraphel, king of Shinar (LXX: Amarphal of Sennaar); Arioch, king of Ellasar; Chedorlaomer (LXX: Chodollogomor), king of Elam; and Tidal (LXX: Thargal), king of nations. These four have defeated the five kings represented as giants, whose names are also given in the text (verses 2 and 8) in the following order: Bera (LXX: Balla), king of Sodom; Birsha (LXX: Barsa),

king of Gomorrah; Shinab, king of Admah (LXX: Sennaar of Adama); Shemeber, king of Zeboiim (LXX: Symobor of Seboim); and Zoar, king of Bela (LXX: Segor of Balac). That the five defeated kings were giants is attested in verse 4 ("[the four kings] cut to pieces the giants . . . ").[1]

The general composition of the battle scene has been borrowed from a model, dating probably from the second–third century, where the cavalrymen overwhelm the enemy infantrymen and their horses tread on the fallen soldiers, as, for instance, in the well-known Ludovisi sarcophagus in the Museo Nazionale Romano in Rome, dating from ca. A.D. 250.[2] Mounted archers were introduced into the Roman army in the third century, especially after A.D. 238, following the Parthians, together with the composite bow like the one used by the foremost horsemen in the Octateuch miniatures.[3]

216. Vat. 747, fol. 35v

Four men on horseback attack from the left, the foremost shooting with a bow. The second and fourth figures pierce with their lances a slain soldier lying under the horses' hooves. The defeated kings, rendered as giants, have been forced to their knees, some of them looking back at the attackers. Two of them carry bows over their shoulders without using them for defense, while one holds a triangular shield. The battle is set against a mountain range with decorative buildings between the peaks. The miniature was thoroughly overpainted in the Palaiologan period, as is particularly evident from the heads of the defeated kings, and later flaked again to a large extent. The group of defeated kings, outnumbering those in the other Octateuchs and contradicting the Septuagint's text, and the triangular shape of the shield, unusual in this manuscript, are also the result of restoration.

Located below Genesis 14:7.

217. Ser., fol. 70v

The number of fleeing kings is here reduced to three, while a fourth man has fallen under the horses' hooves, as in Vat. 747. Since the miniature in Vat. 747 has been entirely overpainted, Ser. must be purer. Two kings carry lances and are half naked, and all three are bleeding from wounds. The foremost rider attacks them with a lowered lance, while the archer in this group is relegated to third place. The miniature is unframed and very heavily flaked.

Located below Genesis 14:2.

218. Sm., fol. 27v

The archer on horseback, shown half naked, has again changed positions and is placed between the first and third riders, but otherwise the composition is close to Ser. The miniature has been overpainted and is now flaked again, particularly in the lower right corner.

219. Vat. 746, fol. 66v

The inscription reads: πε(ρὶ) τῆς ἐν χεβρῶν κατοικ(ήσεως) τοῦ ἀβρὰμ καὶ περὶ τοῦ πολέμου τῶν πέντε βασιλέων.

In grouping the riders the copyist followed Ser. more closely than Sm. The defeated kings are very crudely overpainted, and their attackers are very badly rubbed.

Located below Genesis 14:7.

Lit.: Uspenskii, p. 129; Hesseling, fig. 51; Hutter, "Übermalungen," p. 140; Bernabò, "Laur. plut. 5.38," pp. 149–50, pl. 10 no. 2; De Angelis, "Simbologia," pp. 1530–31, fig. 5.

[1] See also TargPs-J on Gen 14:1, 5, 13, which reads that the four kings, marching upon the five cities, annihilated the descendants of the giants of Gen 6:4 (*Targum Genèse*, ed. Le Déaut, pp. 157ff.).

[2] Cf. Bernabò, "Laur. plut. 5.38," pp. 149–50, where examples from the second century on are considered.

[3] R. Bianchi Bandinelli, *The Hellenistic-Byzantine Miniatures of the Iliad (Ilias Ambrosiana)* (Olten and Lausanne, 1955), pp. 122–26, esp. p. 124, note 1.

Genesis 14:10

DEATH OF THE KINGS OF SODOM AND GOMORRAH

220a. Vat. 747, fol. 36r

Two of the defeated group, the kings of Sodom and Gomorrah, met their deaths by falling into slime-pits. Thus, in the left half of the miniature, at the foot of a high mountain, is a row of three pits into which the two kings have fallen headfirst. The struggling kings' feet are covered by imperial purple, pearl-studded shoes.

Located beside Genesis 14:9.

Ser., fol. 71r

Blank space for an unexecuted miniature.
Located beside Genesis 14:11.

221a. Sm., fol. 27v

Unlike the miniature in Vat. 747 and the text, which explicitly cites only the two kings of Sodom and Gomorrah as victims, the copyist here represented three men falling into pits. The men's legs are bare, without royal raiment. Badly flaked.

222a. Vat. 746, fol. 67r

The copyist has repeated the error of Sm., depicting three men in the pits. Very badly flaked.
Located below Genesis 14:10.

Lit.: Uspenskii, pp. 129–30; Hesseling, fig. 52; Lowden, Review of *Cotton Gen.*, p. 346.

Genesis 14:12

Lot Taken Captive

220b. Vat. 747, fol. 36r

In the right half of the miniature, the victorious kings' horsemen lead the captured Lot away, his hands tied. Lot is nimbed and wears a short tunic. The miniature was overpainted and then flaked again in various places.
Located beside Genesis 14:9.

Ser., fol. 71r

Blank space for an unexecuted miniature.
Located beside Genesis 14:11.

221b. Sm., fol. 27v

The scene is almost completely flaked, but to judge from the few traces of paint remaining, it cannot have varied greatly from Vat. 747.

222b. Vat. 746, fol. 67r

The inscription reads: ἡ τοῦ λὼτ αἰχμαλωσία.
The horsemen lead Lot away by a rope slung around his neck. The miniature is so badly flaked that in several places only the preliminary drawing remains.
Located below Genesis 14:10.

Lit.: Uspenskii, pp. 129–30; Hesseling, fig. 52; Hutter, "Übermalungen," p. 140; Stahl, "Morgan M. 638," p. 115.

Genesis 14:13

Abram Informed of Lot's Capture

223a. Vat. 747, fol. 36r

In the left half of the miniature a messenger hurriedly approaches Abram to report Lot's capture; Abram sits under the oak of Mamre. The miniature has been overpainted and has flaked again.
Located beside Genesis 14:13.

Ser., fol. 71r

Blank space for an unexecuted miniature.
Located beside Genesis 14:14.

224a. Sm., fol. 27v

Abram, framed on either side by a tree, extends his hand as if asking the messenger for more details. The scene has been overpainted and has flaked again.

225a. Vat. 746, fol. 67r

The left half of the picture is almost completely destroyed, but the few traces remaining confirm that in this copy, too, Abram

was shown seated with the messenger standing in front of him. A third tree separates the messenger from the scene at the right, so that Abram sits in a grove rather than under the one oak mentioned in the text.
Located below Genesis 14:13.

Lit.: Uspenskii, pp. 129–30; Hesseling, fig. 53; Hutter, "Übermalungen," p. 140; Stahl, "Morgan M. 638," pp. 113–14.

Genesis 14:14

Abram Arms His Servants

223b. Vat. 747, fol. 36r

Abram addresses a group of his armed servants, ordering them to free Lot from captivity. The scene, which together with the one at the left is placed at the foot of a range of high mountains, has been overpainted and then has partly flaked again.
Located beside Genesis 14:13.

Ser., fol. 71r

Blank space for an unexecuted miniature.
Located beside Genesis 14:14.

224b. Sm., fol. 27v

Close to Vat. 747. The scene has been split vertically, crudely overpainted, and has flaked again.

225b. Vat. 746, fol. 67r

The inscription reads: ἡ τοῦ ἀβραὰμ στρατολογία.
Very close to Sm. The figure of Abram is badly flaked.
Located below Genesis 14:13.

Lit.: Uspenskii, pp. 129–30; Hesseling, fig. 53; Stahl, "Morgan M. 638," pp. 113–14.

Genesis 14:15–16

Abram Smites the Kings

226. Vat. 747, fol. 36r

At the foot of a high mountain, Abram's servants defeat Lot's capturers. The enemy cavalry is in full flight and only one of the retreating riders, an archer, puts up any resistance. Lot has been liberated and lies in proskynesis, touching the feet of Abram, who stands at the extreme left and seems at the same time to direct his servants' attack; in the background, an archer is bending his bow. The miniature has been overpainted and is almost entirely flaked again, so that certain parts, particularly Abram's servants in the left half of the picture, are nearly completely destroyed.
Located beside Genesis 14:21.

Ser., fol. 71v

Blank space for an unexecuted miniature.
Located beside Genesis 14:21.

227. Sm., fol. 28r

Insofar as the very damaged condition of this miniature allows any judgment, the composition is very similar to that in Vat. 747 but shows deviations in details, for example, in the pose of the fleeing horseman who tries to protect himself with a shield. The crude brushstrokes on the face of the foremost rider and on some of the shields indicate that the miniature was overpainted before it flaked again very badly, damaging the whole surface. Only parts of the head and figure of Lot remain.

228. Vat. 746, fol. 67v

The inscription reads: ἡ τοῦ λὼτ ἀνάσωσις.
This copy, which is also still recognizably very close to Sm., is nearly completely flaked. Here as well, restoration of the miniature by a later hand preceded the present damage.
Located below Genesis 14:22.

Lit.: Uspenskii, p. 130; Hesseling, fig. 54; Henderson, "Sources," p. 14, pl. 6 no. 2; De Angelis, "Simbologia," p. 1531, fig. 6.

Genesis 14:17–24

Meeting of Abram and Melchizedek

The story of the meeting of Abram and Melchizedek is narrated in three episodes in the left half of the following miniature: in the foreground the actual meeting of the two patriarchs is depicted, while between the slopes in the background are two condensed episodes from an extrabiblical story of Abram and the hermit Melchizedek. The meeting of Abram and Melchizedek depicted in the foreground was the subject of one of the most controversial issues between Jewish sages and Christian Fathers. Following Hebrews 7:1–4, Christian Fathers such as Clement[1] and John Chrysostom[2] saw in Abram's homage to Melchizedek and in Melchizedek's blessing and gifts of loaves and wine to Abram a prefiguration of Christ and the eucharist, and especially the supremacy of the people of the New Testament over the people of the Old.[3] Notwithstanding that fact, Vat. 747 does not represent the gifts; with no loaves or wine displayed, the scene not only deviates from the Septuagint, but turns into a mere discussion between two patriarchs. Thus, Vat. 747 apparently avoids polemic, mirroring the position of the Targumim[4] and the Christian Fathers such as Ephrem,[5] who do not emphasize the homage at all: to them, Melchizedek is Shem, the son of Noah, become king, whom Abram regards as infinitely more important than himself. Sm. and Vat. 746 also do not render the homage pictorially;[6] in these two manuscripts, however, Melchizedek is dressed as a king, and bread and wine occupy an important position in the space between the two patriarchs.[7]

229a. Vat. 747, fol. 36v

At the foot of a high mountain in the valley of Shaveh (LXX: Saby), the meeting takes place between Melchizedek, the king of Salem, and Abram, both of whom bear the nimbus. Melchizedek, who is dressed as a priest and is followed by two kings wearing crowns, raises his hands in a gesture of blessing toward Abram, who at the head of his family welcomes the king and priest.
Located below Genesis 15:7.

Ser., fol. 72r

Blank space for an unexecuted miniature.
Located below the catena; the text above is Genesis 15:7.

230a. Sm., fol. 28r

In certain details the composition differs from that in Vat. 747. Melchizedek, though clad as a priest, wears the royal crown; Abram is followed, in addition to his family, by soldiers with lances, and between them on the ground lie the loaves and jugs of wine which Melchizedek has offered to Abram. The miniature was crudely overpainted before flaking again.

231a. Vat. 746, fol. 68r

The inscription reads: ἡ δεκά(τη) τοῦ ἀβρὰ(μ) καὶ εὐλογία. It does not agree with the miniature, which represents not Abram's tithe, but the loaves and wine offered by Melchizedek.
Very close to Sm., except that none of the figures behind Abram bear lances.
Located below Genesis 15:5.

Lit.: Kondakov, *Istoriia*, pp. 190–91; Kondakov, *Tablits*, pl. 12 no. 4 (erroneously labeled as Vat. 747 instead of Vat. 746); Kondakov, *Histoire*, vol. 2, pp. 80–81; Uspenskii, p. 130; Hesseling, fig. 55; Wilpert, *Mosaiken und Malereien*, vol. 1, p. 426, fig. 146; Gerstinger, *Wiener Gen.*, p. 80, fig. 52; Buberl, *Byz. Hss.*, p. 91; Woodruff, "Prudentius," p. 72 n. 1; Deckers, *S. Maria Magg.*, pp. 34, 41; Stichel, "Ausserkanon. Elemente," pl. 11a; Bernabò, "Laur. plut. 5.38," p. 148 n. 39; Bernabò, "Fonti testuali," pp. 478–79; Bernabò, "Esegesi patristica," pp. 52–54, figs. 2, 3.

[1] *Stromata* 4:25 (PG 8, cols. 1370–71).
[2] *De Melchisedeco* (PG 56, cols. 261–62).
[3] Cf. M. Simon, *Verus Israel: Étude sur les rélations entre Chrétiens et Juifs dans l'Empire Roman 135–425* (Paris, 1948), pp. 104–11; F. Horton Jr., "Melchizedek Tradition through the First Five Centuries of the Christian Era and in the Epistle to the Hebrews" (Ph.D. diss., Duke University, 1970), chap. 4, pp. 151–219, esp. p. 155; C. Giannotto, *Melchisedek e la sua tipologia: Tradizioni giudaiche, cristiane e gnostiche (sec. II A.C.–sec. III D.C.)* (Brescia, 1984), pp. 155–70, where the figure of Melchizedek is also considered from the point of view of the Christian heresies.
[4] TargN and TargPs-J on Gen 14:18.
[5] *CommGen* 11:2 (Ephraem, *In Genesim et in Exodum commentarii*, ed. Tonneau, pp. 55–56); see also Jerome, *Epistola 73 ad Evangelum presbyterum* (PL 22, cols. 676–81).
[6] Cf. the emphasis on the Christian Melchizedek in the marginal Psalters, such as the Khludov Psalter (Moscow, Historical Museum, cod. 129), fol. 115r; the Pantokrator Psalter, fol. 4v (a flyleaf removed from Athos, Pantokrator cod. 61 and preserved in St. Petersburg, Saltykov-

Shchedrin Lib., cod. gr. 265); and Paris, Bibl. Nat., cod. gr. 20, fol. 25r (cf. Corrigan, *Visual Polemics*, pp. 55ff., figs. 70, 71).

[7] For a more detailed discussion, cf. Bernabò, "Esegesi patristica," pp. 52–54.

[Genesis 14]

ABRAM AND THE HERMIT MELCHIZEDEK

The meeting between Abram and Melchizedek in the mountains is narrated extensively in the Palaea historica,[1] a writing classified together with the *spuria* of Athanasios,[2] and, in an abridged version, in The Cave of Treasures.[3] According to the story, the young Melchizedek climbed Mount Tabor after he refused to take part in a sacrifice which Melchi, his father and king of Salem, had ordered in the temple of the twelve gods. On that mountain he lived the life of a hermit, remaining naked and letting his hair and fingernails grow. After seven years God bade Abram climb Mount Tabor in order to cut Melchizedek's hair and nails, clothe him, and ask for his benediction. This Abram did, and, having completed his task, walked down from Mount Tabor together with Melchizedek, who then anointed him. The introduction of this story into the background of the Octateuch miniature implies a connection with a hermit ambience: Melchizedek himself seems a prefiguration of John the Baptist[4] or the prototype of a hermit dwelling in the mountains, his body covered by shaggy hair and his nails resembling a bird's claws, as vividly described in Syria by Ephrem[5] or John Chrysostom.[6]

229b. Vat. 747, fol. 36v

Standing in the mountains in the background, Abram raises both arms; Melchizedek, in front of him, wears a simple, short-sleeved garment of a brownish green color, under which there is apparently no other clothing, since his extended arms are naked.

Located below Genesis 15:7.

Ser., fol. 72r

Blank space for a miniature not executed.
Located below the catena; the text above is Genesis 15:7.

230b. Sm., fol. 28r

Only the praying Abram remains of the mountain scene. Although the place where one would expect to see Melchizedek is very flaked, it is clear from what is left that he was not represented there. However, it must be emphasized that the miniature is thoroughly overpainted in a crude manner, and it seems more than likely that the restorer did not repaint a figure that originally appeared at this very spot.

231b. Vat. 746, fol. 68r

The inscription reads: ἡ τοῦ μελχίσεδεκ πρὸς ἀβρὰ(μ) φα-νέρω(σις).

Although composed in much the same fashion as the scene in Vat. 747, this scene is rendered much more realistically. In much closer agreement with the text of the apocryphal story, Melchizedek is represented as a naked hermit with an emaciated body and long, tousled hair.[7]

Located below Genesis 15:5.

Lit.: Kondakov, *Istoriia*, pp. 190–91; Kondakov, *Tablits*, pl. 12 no. 4 (erroneously labeled as Vat. 747 instead of Vat. 746); Kondakov, *Histoire*, vol. 2, pp. 80–81; Uspenskii, p. 130; Hesseling, fig. 55; Wilpert, *Mosaiken und Malereien*, vol. 1, p. 426, fig. 146; Troje, ΑΔΑΜ *und* ΖΩΗ, p. 70 n. 2; Muñoz, "Rotulo," pp. 481–82; Gerstinger, *Wiener Gen.*, p. 80, fig. 52; Huber, p. 20; Koshi, *Genesisminiaturen*, p. 41 n. 192; Stichel, "Ausserkanon. Elemente," pp. 171–72, pl. 11a; Bernabò, "Laur. plut. 5.38," p. 148 n. 39; Bernabò, "Fonti testuali," pp. 478–79; Bernabò, "Esegesi patristica," pp. 54–55, fig. 2.

[1] *Anecdota*, ed. Vasil'ev, pp. 209–10; cf. D. Flusser, "Palaea Historica: An Unknown Source of Biblical Legends," in *Studies in the Haggadah and Folk-Literature*, ed. J. Heinemann and D. Noy (Jerusalem, 1971), p. 58.
[2] PG 28, cols. 525–28. Kondakov first indicated this work as the textual basis for the scene (*Histoire*, vol. 2, pp. 80–81).
[3] CavTr 22:12 (*Caverne des Trésors*, ed. Ri, vol. 1, pp. 65, 67).
[4] Cf. Giannotto, *Melchisedek* (as in note 3 in the introduction to Genesis 14:17–24), pp. 155–70.
[5] A. Vööbus, *History of Asceticism in the Syrian Orient*, vol. 2 (Louvain, 1960), pp. 26–27; S. Brock, "Early Syrian Asceticism," *Numen* 20 (1973), pp. 11–12 (repr. in id., *Syriac Perspectives on Late Antiquity* [London, 1984]).
[6] *HomMt* 68:3 (PG 57, cols. 643–44). It is noteworthy that the representation of Melchizedek with long hair, as in Vat. 746, counters the admonitions to monks issued by Rabbula, the bishop of Edessa from 411, which explicitly forbid monks to grow their hair; see A. Vööbus, *Syriac and Arabic Documents Regarding Legislation Relative to Syrian Asceticism* (Stockholm, 1960), p. 28.
[7] As told in PG 28, col. 528; and *Caverne des Trésors*, ed. Ri, vol. 1, p. 15.

Genesis 15:1–5

PROMISE OF POSTERITY TO ABRAM

229c. Vat. 747, fol. 36v

Abram, his arms raised in prayer, stands in a mountainous landscape and hears the promise of posterity from God, whose blessing hand appears in a segment of heaven set against the golden sky.

Located below Genesis 15:7.

Ser., fol. 72r

Blank space for an unexecuted miniature.
Located below the catena; the text above is Genesis 15:7.

230c. Sm., fol. 28r

The segment of heaven is enlarged and embellished by the addition of proleptical moon and stars, which are mentioned in verse 5, which is illustrated in the following miniature (figs. 232–235). The miniature was overpainted and then severely flaked again.

231c. Vat. 746, fol. 68r

The inscription reads: ἡ πρὸς ἀβραὰμ τοῦ κ(υρίο)υ περὶ τῆς γῆς ὑπόσχεσις.

Close to Sm.

Located below Genesis 15:5.

Lit.: Uspenskii, p. 130; Hesseling, fig. 55; Wilpert, *Mosaiken und Malereien*, vol. 1, p. 426, fig. 146; Gerstinger, *Wiener Gen.*, p. 80, fig. 52; Bernabò, "Laur. plut. 5.38," p. 148 n. 39; Bernabò, "Esegesi patristica," figs. 2, 3.

Genesis 15:1–5 or 7–8

PROMISE OF POSTERITY TO ABRAM OR GOD ORDERS ABRAM TO PREPARE A SACRIFICE

The scene is a more or less precise repetition of the preceding miniature depicting the Promise of Posterity to Abram, except in Vat. 747, where the stars in heaven are missing. In Ser., Sm., and Vat. 746 the stars may have been introduced merely as a painter's mistake; in Vat. 747, the stars may have been erroneously omitted or the illustration might have referred to the order God gives to Abram to prepare the sacrifice depicted in the right half of the miniature.

232a. Vat. 747, fol. 37r

In a landscape setting, Abram stands in prayer and faces the divine hand. It would be difficult to relate this scene to a specific verse of Genesis 15 were it not for the fact that the corresponding scenes in the other manuscripts include the stars in heaven referred to in verse 5. The landscape around Abram is flaked in various places.

Located beside Genesis 15:16.

233a. Ser., fol. 74r

The inscription reads: πρόρρη(σις) περὶ τ(ῆ)ς εἰς αἴγυπτ(ον) καθόδου τοῦ λαοῦ.

The inscription refers to a later promise and does not quite fit the miniature. The miniature is unfinished: Abram's head and arms and the segment of heaven are only outlined by preliminary drawing. Within the segment the sun and the moon were sketched, while the stars were supposed to be put in later by brush. The miniature is torn at the lower left corner, heavily stained, and partly flaked.

Located in the catena; the text above is Genesis 15:17.

234a. Sm., fol. 28v

The inscription, partly faded, reads: πρόρρησις περὶ τῆς εἰς αἴγυπτ(ον) καθόδου τοῦ λαοῦ.

Very close to Ser. The miniature was overpainted before flaking again.

235a. Vat. 746, fol. 70r

The inscription, written outside the frame in the left margin, reads: πρόρρησις περὶ τῆς εἰς αἴγυπτον καθόδου τοῦ λαοῦ.

Very close to Ser. and Sm. The stars between the sun and moon are very clearly indicated.

Located below Genesis 16:10; yet note that no. 256 has been erroneously inserted on fol. 69r, below Genesis 15:17, in the proper place of this miniature, no. 235, according both to the succession of the biblical events and to the sequence of the picture cycles in the other Octateuchs.

Lit.: Uspenskii, p. 130, fig. 44; Hesseling, fig. 56; Goodenough, *Symbols*, vol. 9, p. 116 n. 197; Menhardt, p. 305; Koshi, *Genesisminiaturen*, p. 41 n. 192; Dufrenne, "Oct. du Sérail," pp. 248–49, fig. 1; Kessler, "Prophetic Portraits," p. 150; Lowden, *Octs.*, p. 64.

Genesis 15:17

FLAME PASSES BETWEEN THE DIVIDED BEASTS

232b. Vat. 747, fol. 37r

Abram has divided a heifer, a goat, and a ram in half and laid the pieces opposite each other; a flame from heaven passes between the pieces. The illustrator has followed the description very literally by depicting the halves of the three slaughtered animals on either side of a stream of fire pouring down from a segment of heaven. The animals lack heads and tails and have been flayed according to the Jewish ritual for animal sacrifice.[1] Abram gazes at this miracle, holding a dove in one hand and a pigeon in the other, these being the animals he has not divided. High mountains, a continuation of those in the scene at the left, form the background. Slightly flaked.

Located beside Genesis 15:16.

233b. Ser., fol. 74r

The inscription reads: πε(ρὶ) τῶν διχοτομημάτ(ων).

As in the preceding scene in this manuscript, Abram's head and arms and the segment of heaven are unfinished. Whereas in Vat. 747 both halves of each of the three slaughtered animals are shown, this and the following manuscripts depict the three animals undivided, one at the left and two at the right of the column of flames, but otherwise the composition is very similar to Vat. 747.

Located in the catena; the text above is Genesis 15:17.

234b. Sm., fol. 28v

The inscription reads: πε(ρὶ) τ(ῶν) διχοτομημάτ(ων).

Very close to Ser. Crudely overpainted and now flaked once more.

235b. Vat. 746, fol. 70r

The inscription reads: πε(ρὶ) τῶν διχοτομημάτω(ν).
Very close to Ser. and Sm. The figure of Abram is rubbed. Erroneously located below Genesis 16:10; see no. 235a.

Lit.: Uspenskii, p. 130, fig. 44; Hesseling, fig. 56; Nordström, "Water Miracles," p. 82; Dufrenne, "Oct. du Sérail," pp. 248–49, fig. 1; Lowden, *Octs.*, p. 64.

¹ Nordström, "Water Miracles," p. 82.

Genesis 15:18

God's Covenant with Abram

236. Vat. 747, fol. 37v

Once more Abram is represented standing in a landscape holding his hands in a gesture of prayer and looking up to the hand of God which issues from a segment of heaven. He hears God's promise that the land from the river of Egypt to the great river Euphrates will be given to his seed. The painter has illustrated the realization of this promise, the occupation of the country between the two rivers by Abram's descendants. First there is a group of men, the foremost of whom digs with a spade on the shore of the Nile, which flows in a big curve from the upper right to the lower left corner, a maplike projection that contrasts with the mountainous landscape. A second group, led by men on horseback, crosses the river. The groups on both banks, however, are partly overlapped by the river as if they were partly submerged in it. A third group has reached the Euphrates, and two youths stand in the river to draw water, while a young woman with a baby in her arms watches them. Some of the heads have been overpainted, notably that of the foremost horseman, and the surface is flaked in various places.
Located beside Genesis 16:1.

237. Ser., fol. 74v

The partly flaked inscription reads: ἡ πρὸ(ς) ἀβρα(ὰμ τοῦ) κ(υρίο)υ ἐπαγγε(λία) πε(ρὶ) τ(ῆ)ς ἀπὸ ποταμου ἕ(ως) ποτ(ά)-μ(ου) κατασχέσε(ως).
The miniature is unfinished: the heads are only sketched in preliminary drawings, some hands are not outlined at all, and the digging man's spade is not executed, so that in the present state his pose is meaningless. In addition to the omission of the landscape setting, there are some other slight differences between this composition and that in Vat. 747: the horseman who has traversed the river is led by a man who strides through the water, and the group at the right is headed by a youth, who likewise stands in the water holding a bowl in his hand. Strangely enough, in this and some following miniatures Abram has no nimbus; in this respect Sm. and Vat. 746 agree with Ser. In addition to being unfinished, the miniature is flaked in various spots and the writing on the opposite page has left an offset of many letters.
Located beside Genesis 16:1.

238. Sm., fol. 29r

The inscription reads: ἡ πρὸς ἀβραὰμ τοῦ κ(υρίο)υ ἐπαγ-γελ(ία) περὶ τ(ῆ)ς ἀπὸ ποταμοῦ ἕως ποταμοῦ κατασχέσε(ως).
Very close to Ser. The whole surface was overpainted at a later period and in a very rough style.

239. Vat. 746, fol. 70v

The inscription, which is written above the picture, reads: ἡ πρὸ(ς) ἀβραὰμ τοῦ κ(υρίο)υ ἐπαγγελία πε(ρὶ) τῆς ἀπὸ ποτά-μ(οῦ) ἕως ποταμ(οῦ) κατασχέσεως.
Very close to Ser. and Sm. but more condensed. Partly rubbed.
Located beside Genesis 16:12–13, it should have been located in the place of the previous miniature, i.e., below Genesis 16:10 (see no. 235a).

Lit.: Uspenskii, p. 130; Hesseling, fig. 57; Dufrenne, "Oct. du Sérail," pp. 248–49, fig. 2; Bernabò, "Laur. plut. 5.38," p. 154; Anderson, "Seraglio," p. 89, fig. 7; Lowden, *Octs.*, pp. 23, 36, fig. 14.

Genesis 16:3

Sarai Gives Hagar to Abram

240a. Vat. 747, fol. 37v

Sarai grasps the slightly resisting Hagar firmly by the wrist and leads her to her husband, who waits calmly in front of the two-story house he will enter with his wife's maid. Abram and Sarai are both nimbed, in contrast to the other manuscripts, where neither has a halo. The background is composed of high mountains with decorative grisaille buildings between their peaks.
Located beside Genesis 16:12.

241. Ser., fol. 74v

The inscription reads: τὰ κ(α)τ(ὰ) τ(ὴν) ἄγαρ.
Hagar offers less resistance than in Vat. 747, Sarai is seen in frontal view, and Abram points to the open door of his house, encouraging Hagar to follow him. Abram's house to the left is balanced by another at the right, perhaps meant to represent the servants' quarters, but just as possibly invented for purely compositional purposes. As in the previous scenes in this manuscript, the heads and hands are only sketched in preliminary drawings, and the surface is flaked in many places.
Located beside Genesis 16:3. In contrast to the other Octateuchs, the copyist seems erroneously to have left an additional space for a picture, so that the painter was compelled to divide the miniature depicting the story of Hagar and to fill this space with the upper half of the story (the lower half, corresponding to nos. 242a–242d, is painted in its proper place).

243a. Sm., fol. 29v

The inscription reads: τὰ κ(α)τ(ὰ) τ(ὴν) ἄγαρ.

In order to fit the composition into a more elongated format, the size of the figures was considerably reduced and the architecture expanded in width. However, the types of the three figures agree thoroughly with Ser.

244a. Vat. 746, fol. 71r

The inscription, written in the left margin outside the picture frame, reads: τὰ κατὰ τὴν ἄγαρ.

Very close to Ser. and Sm. Slightly flaked.

Located beside Genesis 17:11, it should have been in the place of the previous miniature, i.e., beside Genesis 16:12–13 (see no. 235a).

Lit.: Uspenskii, p. 130; Hesseling, fig. 58; Wilpert, *Mosaiken und Malereien*, vol. 1, p. 382, fig. 123; Menhardt, p. 305; Dufrenne, "Oct. du Sérail," p. 248; Lowden, *Octs.*, pp. 23, 36, fig. 14; Bernabò, "Agar e Ismaele," pp. 217ff., figs. 1–3.

Genesis 16:15

Birth of Ishmael

240b. Vat. 747, fol. 37v

Hagar, sitting on a delivery chair and expressing pain, is assisted by a midwife as she gives birth to Ishmael. Abram's house, where the scene is supposed to take place, is visible behind this group. The miniature was overpainted and then flaked again.

Located beside Genesis 16:12.

242a. Ser., fol. 75r

The inscription reads: ἡ ἰσμαὴλ γένεσ(ις).

The execution of the miniature never went beyond the stage of a frameless preliminary drawing which is partly torn and partly heavily stained. The birth scene is almost completely lost; only Hagar's head and the doorframe above it remain. At the time Uspenskii photographed this miniature, slightly more of it was preserved than today.[1]

Located beside Genesis 17:11.

243b. Sm., fol. 29v

The inscription reads: ἡ ἰσμαὴλ γέννησ(ις).

In the birth scene the midwife is not occupied with the actual delivery of the child, as she is in Vat. 747, but rather sits beside the mother and points to the baby lying on the ground.

244b. Vat. 746, fol. 71r

The inscription, written in the left margin outside the frame, reads: ἡ τοῦ ἰσμαὴλ γενησ(ις).

Very close to Sm. The birth scene is partly rubbed, apparently intentionally, as representations of this subject quite frequently are. The wall of the house and the midwife are almost completely flaked.

Located beside Genesis 17:11, the miniature should have been located in the place of the previous miniature, beside Genesis 16:12–13 (see no. 235a).

Lit.: Uspenskii, pp. 101, 130, fig. 45; Hesseling, fig. 58; Wilpert, *Mosaiken und Malereien*, vol. 1, p. 382, fig. 123; Dufrenne, "Oct. du Sérail," pp. 248–49, fig. 3; Anderson, "Seraglio," p. 89; Lowden, *Octs.*, pp. 23, 36, fig. 15; Bernabò, "Agar e Ismaele," pp. 217ff., figs. 1–3.

[1] Uspenskii, fig. 45.

[Genesis 16:4–14]

Ishmael Addresses Sarai

Hagar's story is narrated in two passages in Genesis: first in 16:1–16, then in 21:9–21, where Abraham finally expels Hagar and the child Ishmael (figs. 295–303). In the Octateuch miniatures connected with Genesis 16, Sarai gives her Egyptian maid Hagar to Abram (Gen 16:1) and, in precisely the next scene in Vat. 747, a female figure is addressed by Ishmael: this woman must be identified as Sarai. Her looking back toward the boy, possibly haughtily before the later overpaintings, may have reflected an offense she suffered, a sentiment implied by the words Sarai addresses to Abram at Genesis 16:5. The Septuagint text, however, cannot persuasively be considered the source of this scene: no specific connection is obvious between the words employed in the Septuagint and the traits emphasized in the illustration.[1]

Ser., Sm., and Vat. 746 replaced the episode of the offended Sarai with a sequence from chapter 21 duplicating the episodes of Hagar's expulsion. This misplacing and duplication of illustrations has the hallmark of a patch in the cycle introduced because of a lacuna or a badly preserved miniature in the model, so that undoubtedly these manuscripts cannot be taken as the correct reading of the cycle. The *difficilior lectio* in Vat. 747 must be the purest reflection of the archetype.

240c. Vat. 747, fol. 37v

Ishmael addresses a female figure at the right who looks back toward the boy. The painter who restored the miniature gave this woman Hagar's traits, but her clothes preclude an identification as Hagar, since Hagar is dressed only in a light tunic in the previous scenes. Moreover, the woman poses as a lady rather than as a servant. This female figure is probably Sarai, who is represented in similar garments in the upper panel. The miniature has been overpainted and then flaked again, so that large sections of the landscape are completely destroyed, especially a tree between Ishmael and Sarai and another in front of her.

Located beside Genesis 16:12.

Lit.: Bernabò, "Agar e Ismaele," pp. 217ff., fig. 1.

[1] Sarai's feelings of sorrow and the wrong she suffered have been extensively considered by Philo (*Quaestiones et solutiones in Genesim et Exodum* 3:22–26; Philo, *Questions and Answers on Genesis*, ed. Marcus, pp. 208–13). Syriac writings (cf. Iso'dad of Merv [*Commentaire d'Iso'dad de Merv*, vol. 1,

Genèse, ed. Van den Eynde, p. 167]) and the Targumim (TargN on Gen 16:5 [*Neophyti 1: Targum Palestinense*, vol. 1, *Génesis*, ed. Díez Macho, p. 534; cf. also *Targum Genèse*, ed. Le Déaut, pp. 174–75]), pay ampler attention to Sarai's feelings and Hagar's arrogance than does the Septuagint. Even in these texts, however, no direct connection may be found with the iconography in Vat. 747.

[Genesis 21:9–20]

Sarah Sees Ishmael Sporting with Isaac; Abraham Sends Hagar and Ishmael Away; An Angel Appears to Hagar

Three events in Hagar's life after the birth of Ishmael are represented at this point in Ser., Sm., and Vat. 746, but they do not follow the account of Hagar's story at Genesis 16:4–12, where the episodes of Hagar's presumed offenses to Sarai, Sarai's revenge, the flight of Hagar, and the angel addressing Hagar with the promise that her seed "shall not be numbered for multitude" are narrated. Instead, the pictures consist of excerpts of three miniatures illustrating Genesis 21:9–20 (figs. 295–303): Sarah Sees Ishmael Sporting with Isaac, Abraham Sends Hagar and Ishmael Away, and An Angel Appears to Hagar (note that at Gen 17:15 God ordered Abraham to call his wife not Sarai, but Sarah).

242b, c, d. Ser., fol. 75r

The surviving parts of the children's bodies in the first episode clearly reveal that the iconography is taken from the opening miniature of the sequence for chapter 21 (Sarah Sees Ishmael Sporting with Isaac, figs. 295–297, Genesis 21:9–10). Abraham Sends Hagar and Ishmael Away (figs. 298–300, Genesis 21:14) is repeated in full, with Abraham slightly pushing Hagar, who carries Ishmael on her arms. From the third scene, in which the angel appears to Hagar in the wilderness (figs. 301–303, Genesis 21:15–20), only Ishmael and the flying angel are taken over, while Hagar is omitted, thereby rendering the angel quite meaningless. In the second and third scenes the figures are preserved down to their knees.
Located beside Genesis 17:11.

243c, d, e. Sm., fol. 29v

Of the two playing children running toward each other, the one on the left, probably Isaac, points to his ear. With this gesture the artist perhaps intended to indicate that Isaac has been struck there by the stronger Ishmael. Hagar, who carries a sack of provisions over her shoulder, is pushed by Abraham with both hands; and in the third episode Ishmael does not carry a bow as he does in the corresponding episode at Genesis 21 (figs. 301–303).

244c, d, e. Vat. 746, fol. 71r

Very close to Sm. The expulsion scene is slightly damaged.
Located beside Genesis 17:11; it should have been located in the place of the previous miniature, beside Genesis 16:12–13 (see no. 235a).

Lit.: Uspenskii, pp. 101, 130, fig. 45; Hesseling, fig. 58; Wilpert, *Mosaiken und Malereien*, vol. 1, p. 382, fig. 123; Dufrenne, "Oct. du Sérail," pp. 248–49, fig. 3; Green, "Marginal Drawings," p. 131; Bernabò, "Fonti testuali," pp. 483–84; Anderson, "Seraglio," p. 89; Lowden, *Octs.*, pp. 23, 36, fig. 15; Bernabò, "Agar e Ismaele," pp. 217ff., figs. 2, 3.

Genesis 17:9–10

God Makes the Covenant of Circumcision with Abraham

245a. Vat. 747, fol. 38r

In the upper zone of the miniature, after God changed Abram's name to Abraham at Genesis 17:5, the patriarch stands against a fantastic landscape with mountain peaks transformed into somewhat unreal architectural structures, painted in grisaille, for decorative purposes. He raises his hands toward the blessing hand of God in a segment of heaven.
Located beside Genesis 17:11.

246a. Ser., fol. 76r

The inscription reads: περὶ τ(ο)ῦ ὀνόματο(ς) αὐτοῦ καὶ τ(ῆ)ς περιτομῆς.
The miniature is unfinished. The heads and extremities of all the figures are only outlined, the garments and the landscape are painted with a first coat, and the hand of God has not yet been delineated. In contrast to the other manuscripts, the praying Abraham stands at the left instead of being superimposed over the following scene.
Located beside Genesis 17:12.

247a. Sm., fol. 29v

The inscription, of which only the beginning is recognizable, reads: περὶ τοῦ ὀνόμ(α)το(ς).
Abraham stands on the crest of the mountain, on which trees grow.

248a. Vat. 746, fol. 73r

Very close to Sm.
Located beside Genesis 18:6, it should have been located in the place of no. 244, beside Genesis 17:11 (see no. 235a).

Lit.: Uspenskii, p. 130; Hesseling, fig. 59; Benson and Tselos, "Utrecht Ps.," p. 70, fig. 128; Der Nersessian, *Barl. et Joas.*, p. 111; Dufrenne, "Oct. du Sérail," pp. 248–49, fig. 4; Bernabò, "Laur. plut. 5.38," p. 153; Lowden, *Octs.*, p. 93, fig. 71.

Genesis 17:11–12 or 23–27

Circumcision of the Men of Abraham's House

This cycle presents the circumcision, which in the text is commanded by God at verses 11–12 and accomplished by Abraham at

verses 23–27 (see figs. 253–256). In the miniature Abraham orders a servant to circumcise his people, while verse 23 says that he performed the action himself.

245b. Vat. 747, fol. 38r

Abraham sits at the left and watches a young man who is about to circumcise the foremost of a large group of youths; the other men either have already been circumcised or are waiting to be. The lower zone of the miniature is even more heavily flaked than the upper, the figure of Abraham being nearly completely destroyed.

Located beside Genesis 17:11.

246b. Ser., fol. 76r

Abraham sits on a chair and raises his hand in a gesture of blessing toward the youths who are being circumcised. More realistic than the scene in Vat. 747, the very moment of circumcision itself is represented here.

Located beside Genesis 17:12.

247b. Sm., fol. 29v

Very close to Ser.

248b. Vat. 746, fol. 73r

Very close to Sm.

Located beside Genesis 18:6, it should have been located in the place of no. 244, beside Genesis 17:11 (see no. 235a).

Lit.: Uspenskii, p. 130; Hesseling, fig. 56; Der Nersessian, *Barl. et Joas.*, p. 111; Dufrenne, "Oct. du Sérail," pp. 248–49, fig. 4; Bernabò, "Laur. plut. 5.38," p. 153; Lowden, *Octs.*, p. 71, fig. 93.

Genesis 17:3–16 or 17–21

ABRAM FALLS ON HIS FACE

In chapter 17 Abram/Abraham falls in proskynesis two times, the first at verse 3, the second at verse 17. According to the first passage, the patriarch—whose name is still Abram—fell in proskynesis upon hearing God's promise that he would be the father of many nations (verses 4–5); according to the second passage, the patriarch—now named Abraham—fell upon his face and laughed when God predicted the birth of a son. The position of the miniature after the previous illustration of the Circumcision of the Men of Abraham's House (Gen 17:11–12) would suggest that the miniature refers to the second proskynesis rather than to the first; but, deviating from the text of the second passage, the patriarch is not laughing in the miniature.

249. Vat. 747, fol. 38v

Abraham lies at the foot of a mountain in proskynesis, looking down at the ground instead of up to the hand of God in heaven.

Abraham's two-story house is seen at the right with its entrance curtain fastened open.

Located beside Genesis 17:17.

Lit.: Muñoz, "Rotulo," p. 477; Weitzmann, *RaC*, 2d ed., p. 258; Galavaris, *Gregory Naz.*, p. 55 n. 93; Huber, p. 21; Weitzmann, *SP*, pp. 39–40, 48; Bernabò, "Genesis Mosaics," p. 107; Lowden, *Octs.*, p. 61, fig. 85.

Genesis 17:4–5

GOD MAKES ABRAHAM A FATHER OF MANY NATIONS

Replacing Abraham in proskynesis in Vat. 747, Ser., Sm., and Vat. 746 have an iconic image with the anthropomorphic Christ, a rare feature in the Octateuchs and evidently a later interpolation; Abraham and Sarai pray to him. The presence of Christ was apparently encouraged by the Christian approach to the text. Verses 4 and 5, where God pronounces Abraham the father of many nations, are connected with a New Testament exegesis, following Romans 4:17, and were employed by the Christians against the Jews: the Christians underscored that Abraham is the father not only of one nation, but of many.[1] Finally, the presence of Sarai is not required by the Septuagint, where Abraham alone is mentioned.

250. Ser., fol. 77r

In a segment of heaven a bust of Christ appears in frontal view blessing Abraham, who stands at the left, and extending the other hand toward Sarai, who approaches from the right. She apparently has just come out of the door of the house at the right, and a second house has been added at the left, probably purely for reasons of symmetry. The bust of Christ and the faces and extremities of Abraham and Sarai are sketched in preliminary drawing; the rest is painted only with an initial coat.

Located beside Genesis 17:17.

251. Sm., fol. 30r or 30v [2]

The inscription reads: ἡ ἐπαγγελ(ία) τέκνου τοῦ ἰσαάκ.
Very close to Ser. Christ's head seems overpainted.

252. Vat. 746, fol. 73r

Very close to Ser. and Sm.

Located beside Genesis 18:12; note that the painter erroneously introduced in the sequence two other scenes, namely no. 260 on fol. 72r and no. 264 on fol. 72v. Thus, the proper place of this miniature should be three spaces before, below Genesis 17:18 (see also no. 235a).

Lit.: Uspenskii, p. 130; Hesseling, fig. 62; Weitzmann, *RaC*, 2d ed., p. 258; Menhardt, p. 306; Weitzmann, "Oct. Ser.," p. 184, figs. 3, 4; Bucher, *Pamplona Bibles*, pp. 134 n. 56 and 138 n. 75; Dufrenne, "Oct. du Sérail," pp. 248–49, fig. 5; Huber, p. 21, fig. C p. 20; Bernabò, "Laur. plut. 5.38," pp. 153 n. 45, 154; Weitzmann, *SP*, pp. 39–40, 48; Weitzmann, "Genesis Mosaics," p. 107; Lowden, *Octs.*, p. 61, fig. 86.

[1] For this interpretation in early Syriac Fathers, see R. Murray, *Symbols of Church and Kingdom: A Study in Early Syriac Tradition* (Cambridge, 1975), pp. 44–45.

[2] Fol. 30v according to Hesseling, p. vii; fol. 30r according to Uspenskii, p. 183.

Genesis 17:18–20

ABRAHAM PLEADS TO GOD FOR ISHMAEL

253a. Vat. 747, fol. 38v

In the left half of the miniature Abraham is seen praying to God on behalf of Ishmael, lifting up his head and hands toward the divine hand in a segment of heaven. Ishmael, according to the text a boy of thirteen, stands behind the patriarch in a devoted attitude with arms crossed. He is partly overlapped by the figure of Abraham in the following scene. High mountains with a building painted in grisaille between two peaks form the background.

Located beside Genesis 17:24.

254a. Ser., fol. 77v

Close to Vat. 747 except that Ishmael holds his arms before his breast instead of crossing them. There is no landscape and the figures are unfinished, the heads and extremities being only sketched and the garments painted only with an initial layer that is flaked in various spots.

Located beside Genesis 17:24.

255a. Sm., fol. 30r or 30v[1]

Very close to Ser.

256a. Vat. 746, fol. 69r

Very close to Ser. and Sm.

Located beside Genesis 15:17, yet properly belonging on fol. 72v beside Genesis 17:23 (see no. 252).

Lit.: Uspenskii, p. 130; Hesseling, fig. 63; Lassus, *Livre des Rois*, p. 88, fig. 124; Dufrenne, "Oct. du Sérail," p. 248; Bernabò, "Laur. plut. 5.38," pp. 151 n. 43, 153; Anderson, "Seraglio," p. 94, fig. 18; Sed-Rajna, *Hebraic Bible*, p. 32 n. 23; De Angelis, "Simbologia," fig. 11; Lowden, *Octs.*, p. 71, fig. 94.

[1] Fol. 30v according to Hesseling, p. vii; fol. 30r according to Uspenskii, p. 183.

Genesis 17:23

ABRAHAM CIRCUMCISES THE MEN OF HIS HOUSE

253b. Vat. 747, fol. 38v

In the right half of the miniature Abraham circumcises the penis of Ishmael who, with an expression of pain, sits on a bench,

surrounded by other youths who represent "every male among the men of Abraham's house." Abraham, depicted in a kneeling position, is without a nimbus. The scene takes place in front of Abraham's house which is surmounted by a little tempietto. The scene is linked to the preceding one by the common landscape setting of high mountains. Slightly flaked.

Located beside Genesis 17:24.

254b. Ser., fol. 77v

Close to Vat. 747 except for small details: Abraham touches the ground with both knees, the youths surrounding Ishmael are differently grouped, and the house behind them is simplified. Heads and extremities are sketched in preliminary drawing, and the rest is painted with an initial layer which has flaked in various places.

Located beside Genesis 17:24.

255b. Sm., fol. 30r or 30v[1]

The inscription reads: πε(ρι)τομ(ῆ) τοῦ ἀβραὰμ καὶ τ(ῶν) οἰκείων αὐτ(ῶν).

Very close to Ser.

256b. Vat. 746, fol. 69r

Very close to Ser. and Sm.

Located beside Genesis 15:17; its proper place is on fol. 72v beside Genesis 17:23 (see no. 252).

Lit.: Uspenskii, p. 130; Hesseling, fig. 63; Lassus, *Livre des Rois*, p. 88, fig. 124; Stahl, "Morgan M. 638," p. 212 n. 393; Dufrenne, "Oct. du Sérail," p. 248; Bernabò, "Laur. plut. 5.38," pp. 151 n. 43, 153; Anderson, "Seraglio," p. 94, fig. 18; Sed-Rajna, *Hebraic Bible*, p. 32 n. 23; De Angelis, "Simbologia," p. 1533, fig. 11; Lowden, *Octs.*, p. 71, fig. 94.

[1] Fol. 30v according to Hesseling, p. vii; fol. 30r according to Uspenskii, p. 183.

Genesis 18:1–2

ABRAHAM MEETS THE ANGELS

In the first of the two illustrations devoted to the story of Abraham's hospitality (figs. 257–260, 261–264), there is no evident Christianization of this renowned episode: the cycle does not focus on the three persons approaching Abraham as a christological allusion. In the second illustration, the Palaiologan overpainting in Vat. 747 does not allow any secure assumptions, yet we might hesitantly note that the table and the objects on it in this codex display Christian traits; in contrast, the squared table with three chalices in Ser., Sm., and Vat. 746 suggests an altar prepared for the eucharist and must be ascribed to a Christian revision of the iconography.[1] The literal rendering of the text in Vat. 747 denotes a reluctance toward any potential prefiguration, suggesting an affinity with a Jewish milieu or with the exegesis of Christian writings related to the Antiochene school.[2]

257. Vat. 747, fol. 39r

Abraham has fallen down in proskynesis before the three men who appear to him near the oak of Mamre. These figures are nimbed, wear fillets in their hair, and hold scepters just like angels, though they have no wings; however, the painting is not finished and behind the shoulder of the left angel are discernible some short horizontal strokes and above them a line cutting the slope of the white mountain range, lines that may be explained as a preliminary sketch of the wings. Moreover, a dark brushstroke between this figure and the central angel may be interpreted as an outline of the left angel's other wing. The "tent" from which Abraham has emerged, as recounted in Genesis 18:1, is represented as a shepherd's *tugurium* consisting of two trees whose tops are bound together.[3] In this way they form a precarious retreat within which a piece of red drapery lies on the ground. High mountains with decorative buildings form the background. Slightly flaked.

Located beside Genesis 18:5.

258. Ser., fol. 78r

The miniature is unfinished: the heads and extremities of all the figures are merely sketched; the garments show only an initial layer of paint to which a later hand has added black lines; and the scepters are still missing from the hands of the three men, who in this instance are clearly characterized as angels by their wings. The composition essentially agrees with that of Vat. 747, except that Abraham is looking at the angels instead of at the ground. The two entwined trees are roughly painted, and the open space between them, and the drapery as well, are eliminated, so that it seems doubtful that the copyist still associated them with a tent.

Located beside Genesis 18:5.

259. Sm., fol. 30r or 30v[4]

The inscription reads: πε(ρὶ) τῆς τῶν ἀγγέλων ξενοδοχ(ίας) τῆς ἐν τῇ δρυι.

Very close to Ser.

260. Vat. 746, fol. 72r

The inscription is placed in the left margin and reads: περὶ τῆς τῶν ἀγγέλων ξενοδοχίας τῆς ἐν τῇ δρυι.

Very close to Ser. and Sm.

Located below Genesis 17:18; its proper place is on fol. 73r beside Genesis 18:6 (see no. 252).

Lit.: Tikkanen, *Genesismosaiken*, fig. 39; Uspenskii, p. 131; Hesseling, fig. 60; Wilpert, *Mosaiken und Malereien*, vol. 1, p. 428, fig. 147; Woodruff, "Prudentius," p. 73 n. 3; Pijoán, *Summa artis*, vol. 7, p. 400, fig. 558; Goodenough, *Symbols*, vol. 10, p. 95 n. 118, fig. 264; Henderson, "Influences," p. 175 n. 20; Wessel, "Abraham," col. 18; Huber, p. 21, fig. A on p. 20; Dufrenne, "Oct. du Sérail," pp. 248–49, fig. 6; Brenk, *S. Maria Magg.*, p. 58 n. 59; Deckers, *S. Maria Magg.*, p. 47; Kötzsche-Breitenbruch, *Via Latina*, p. 58, pls. 7a, 7b; Spatharakis, "Psalter Dionysiou," p. 177, pl. 98b; Bernabò, "Laur. plut. 5.38," p. 154; Weitzmann, *SP*, p. 40; Messerer, "Antike und Byzanz," p. 861, fig. 34; Weber, *Symbolik*, vol. 2, n. 14 p. 65; Anderson, "Seraglio," p. 89.

[1] The iconography of the scene in Ser., Sm., and Vat. 746 has close parallels in the marginal Psalters: the Khludov Psalter (Moscow, Historical Museum, cod. 129, fol. 49v), the Theodore Psalter (London, Brit. Lib., cod. Add. 19.352, fol. 62v), and the Barberini Psalter (Vatican, cod. Barb. gr. 372, fol. 81v); cf. Corrigan, *Visual Polemics*, pp. 53–55, figs. 68, 69, and M. Shchepkina, *Miniatiury Khludovskoi psaltyri* (Moscow, 1977), fol. 49v.

[2] Cf. L. Thunberg, "Early Christian Interpretations of the Three Angels in Gen. 18," *StP* 7 (1966), pp. 560–70.

[3] Cf. E. B. Smith, *The Dome: A Study in the History of Ideas* (Princeton, 1950), pp. 65ff.

[4] Fol. 30r according to Hesseling, p. vii; fol. 30v according both to Uspenskii, p. 183, and to the label in the photo taken by Buberl.

Genesis 18:8–10

HOSPITALITY OF ABRAHAM

In the following representation of Abraham's hospitality the cow crouching down in the foreground, transmitted in Ser., Sm., and Vat. 746, does not appear in the text. This cow must be the mother of the slaughtered calf, according to a tradition found in the Testament of Abraham (6:4–5),[1] which relates that "after the meat was eaten, the calf got up again and exultantly suckled his mother." Moreover, the name of Abraham's wife is now changed from Sarai to Sarah, according to God's command given to Abraham at Genesis 17:15. See also the introduction to nos. 257–260.

261. Vat. 747, fol. 39r

The three men Abraham entertains as guests are grouped around a table, upon which are a great bowl and two smaller cups. One of the men points to the prepared table while turning around to Abraham, who approaches carrying a vessel of milk in his hands. The man at the right raises his hands in a gesture of blessing toward Abraham, and the third in the center, characterized as Christ by the cross in his nimbus, faces the viewer with a blessing gesture. A wall and two flanking houses form the background, to which, at the left, is added a small tempietto out of which Sarah looks down, overhearing the conversation between Abraham and his guests to the effect that she shall bear a son. Suspended from the upper frame and set against a golden background is a decorative drapery fastened in the center to a lion's mask and caught up at the ends. Most of the miniature was thoroughly overpainted by a copyist who made some fundamental changes. As in the preceding miniature of this manuscript (fig. 257), it can be shown that the men were originally depicted as angels with wings. Two wing tips appear above the central wall, proving that the central figure was also originally an angel and not Christ, and that, therefore, the cross in the nimbus must also be a later addition. The architecture, with its lack of structural sense, is typically Palaiologan and an invention of the restorer, with the exception of the one building from which Sarah overhears the conversation. The drapery in the sky must likewise be attributed to the restorer.

Located beside Genesis 18:12.

262. Ser., fol. 78r

Close to Vat. 747, except for Abraham's house, from which Sarah looks down partially hidden by a curtain at the right. In addition there is some variation in details which originally may have been in Vat. 747 before it was repainted: for instance, the oak tree at the left identifying the locality as Mamre; the cow crouching down in front of the table; the table itself, which is square; and the three chalices on the table. This miniature is in the same unfinished state as the preceding ones in this manuscript. The heads and extremities are merely outlined, and the eyes, noses, and mouths were drawn in at a later time by an unskilled hand. The scepters in the angels' hands have not been drawn, and the draperies are painted with only a first layer, to which the same later hand added some rough lines. The left part of the miniature is badly torn and most of the surface is stained.

Located beside Genesis 18:12.

263. Sm., fol. 30r or 30v²

The inscription reads: ἡ ἁγία τρι(άς).

Close to Ser. For reasons of symmetry a second tree was added, whereby the landscape became merely a decorative element instead of indicating a specific locality. The miniature has been overpainted, and the restorer has added a cross to the central angel's nimbus, thereby characterizing him as Christ, just as the restorer of Vat. 747 did.

264. Vat. 746, fol. 72v

Very close to Sm. The face of the central angel is rubbed.

Located beside Genesis 17:23; its proper place is on fol. 73r beside Genesis 18:12 (see no. 252).

Lit.: Kondakov, *Istoriia*, p. 190; Kondakov, *Histoire*, vol. 2, p. 80; Strzygowski, *Serb. Ps.*, p. 86; Uspenskii, p. 131, fig. 46; Hesseling, fig. 61; Wilpert, *Mosaiken und Malereien*, vol. 1, p. 428, fig. 148; Alpatov, "Trinité," p. 158, fig. 10; Morey, *Early Christian Art*, p. 147; Pijoán, *Summa artis*, vol. 7, p. 401, figs. 559, 560; Goodenough, *Symbols*, vol. 10, p. 95 nn. 119–20, figs. 265, 266; Menhardt, p. 306; Martin, *Heavenly Ladder*, p. 44; Weitzmann, "Cotton Gen. Fragments," p. 122 n. 32; Buchthal, *Latin Kingdom*, pp. 72, 80, pl. 151a; Wessel, "Abraham," col. 18; Huber, fig. B, p. 20; Stemberger, "Patriarchenbilder," p. 22; Perler, "Théophanies," p. 282; Stichel, "Ausserkanon. Elemente," p. 180; Dufrenne, "Oct. du Sérail," p. 248; Brenk, *S. Maria Magg.*, p. 60; Deckers, *S. Maria Magg.*, p. 55; Lassus, "Création," p. 141 n. 34; Bernabò, "Laur. plut. 5.38," p. 154; Weber, *Symbolik*, vol. 2, n. 14 p. 65.

¹ *OTP*, vol. 1, p. 885. A similar report is in the Palaea historica (*Anecdota*, ed. Vasil'ev, p. 215). Stichel ("Ausserkanon. Elemente," p. 180) first discovered this tale and connected it with the Octateuch miniature.

² Fol. 30r according to Hesseling, p. vii; fol. 30v according to Uspenskii, p. 183.

Genesis 18:22–23

Abraham Pleads with God on Behalf of Sodom

265. Vat. 747, fol. 39v

Abraham prays to God, asking him to spare the city of Sodom from destruction. He stands in a landscape setting in front of the walled city of Sodom, lifting up his head and hands toward the blessing hand of God which issues from a small segment of heaven. Flaked in various spots.

Located beside Genesis 18:30.

Ser., fol. 79v

Blank space for an unexecuted miniature.
Located beside Genesis 18:29.

266. Sm., fol. 31r

The inscription reads: ἡ τοῦ ἀβραὰμ πρὸ(ς) θ(εὸ)ν δέησις περὶ τῶν σοδόμων.

Close to Vat. 747 except that the city gate of Sodom is open and Abraham, crudely overpainted, is represented approaching the divine hand.

267. Vat. 746, fol. 75r

The inscription reads: ἡ τοῦ ἀβραὰμ πρὸς τὸν θ(εὸ)ν δέησ(ις) περὶ τῶν σοδόμω(ν).
Very close to Sm.
Located beside Genesis 18:30.

Lit.: Seroux d'Agincourt, *Histoire*, vol. 3, p. 68, and vol. 5, pl. 62 no. 2 (reproduced in the frontispiece of the present volume); Uspenskii, pp. 131, 135; Hesseling, fig. 64; Weitzmann, *SP*, p. 40; Bernabò, "Studio," pl. 2.

Genesis 19:1

Lot Meets the Angels

268. Vat. 747, fol. 40r

Lot has just arisen from his chair in front of the city of Sodom and, bowing slightly and extending his hands in a gesture of greeting, he hurries to meet the two angels approaching him. The city of Sodom, situated at the foot of a high mountain, is rendered as a house with lateral annexes and an elaborate staircase that, turning twice, leads up to the entrance. This structure has a typically Palaiologan character and in its present state is a work of the restorer who repainted the whole miniature, which now has flaked again in various spots, damaging the angels in particular.

Located beside Genesis 19:2.

Ser., fol. 79v

Blank space for an unexecuted miniature.
Located beside Genesis 19:1.

269. Sm., fol. 31v

The inscription reads: ἡ τοῦ λὼτ πρὸς τοὺς ἀγγέλους πρόσκλησις.
Lot stands quietly in front of his house, which has a little dome over the entrance door, and raises his right hand in a wel-

coming gesture toward the two approaching angels. The miniature is partly flaked.

Located beside Genesis 19:2.

270. Vat. 746, fol. 75v

The inscription reads: ἡ τοῦ λῶτ πρὸς τοὺς ἀγγέλους πρόσκλησις.

Very close to Sm.

Located beside Genesis 19:2.

Lit.: Uspenskii, pp. 131, 135; Hesseling, fig. 65; Hutter, "Übermalungen," pp. 141, 143, 145–46, fig. 5.

Genesis 19:4–8

Lot's Encounter with the Sodomites

271. Vat. 747, fol. 40r

The Sodomites, armed with spears and battle axes, approach Lot's house to demand the surrender of the two men he is lodging as guests. Lot has come out of his house and argues violently, though in vain, with the determined Sodomites. Lot's house is depicted as a centralized building surmounted by a ciboriumlike structure. This structure, like the one in the preceding miniature in this manuscript, is a creation of the Palaiologan restorer who repainted the figures and landscape, as can be recognized by the heads of the Sodomites, the sharp linear treatment of the mountain peaks, and the ornamental design of the sky.

Located beside Genesis 19:7.

Ser., fol. 80r

Blank space for an unexecuted miniature.
Located beside Genesis 19:6.

272. Sm., fol. 31v

The inscription reads: ἡ τῶν σοδομιτῶν ἀναιδὴς τ(ῶν) ἀγγέλ(ων) ζήτησις.

Close to Vat. 747 but Lot's house is treated much more simply.
Located beside Genesis 19:8.

273. Vat. 746, fol. 76r

The inscription reads: ἡ τῶν σοδομιτῶν ἀναιδὴς τῶν ἀγγέλων ζήτησις.

Lot's two daughters, whom he is willing to surrender to the Sodomites instead of his guests, appear inside the house, behind the parapet of the entrance door. The remainder of the composition is the same as that in Sm.

Located beside Genesis 19:6.

Lit.: Uspenskii, pp. 131, 135; Hesseling, fig. 66; Stern, "Sainte-Constance," p. 177, fig. 17; Henderson, "Influences," p. 190 n. 52; Hutter, "Übermalungen," p. 141; Tsuji, "Nouvelles observations," p. 31; Weitzmann, *SP*, p. 41; Koenen, "Genesis 19,4/11 und 22,3/13," p. 143 n. 141.

Genesis 19:23

Lot and Family Enter Zoar

The story of Lot, from the flight from Sodom to his drunkenness in the cave, has two distinct series of illustrations, one in Vat. 747 and the other in Sm. and Vat. 746. (In Ser. the spaces corresponding to these miniatures were left blank.) Lacunae or spoiled miniatures in the model presumably compelled the painters to reinvent the lost iconographies. In the following miniatures (figs. 277–279) the general design of the pictures is the same but Lot, on the left, and his daughters are entering a cave in Vat. 747 (fig. 277) and a town (Zoar) in Sm. and Vat. 746 (figs. 278, 279). The miniature of Vat. 747 is overpainted and is thus most likely a misreading. But the assumption that the representation of the town of Zoar in Sm. and Vat. 746 is a faithful witness of the original iconography raises the problem that in the cycle the arrival at Zoar follows the destruction of Sodom (figs. 274–276), whereas in the text the arrival at Zoar is described at verse 23, preceding the three deeds represented in the miniature of the destruction of Sodom, i.e., the burning of Sodom (verses 24–25), Lot's wife transformed into a statue (verse 26), and the observing Abraham (verses 27–28). Accordingly, a second hypothesis might be advanced: that the town of Zoar in Sm. and Vat. 746 is an unfaithful restoration replacing the original cave, as seen in Vat. 747 (fig. 277). In fact, Lot's bowing posture is more appropriate to the entering of a cave than a town. Thus, the restorer of Vat. 747 might not have departed from the original iconography.

Ser., fol. 81v

Blank space for an unexecuted miniature.
Located below Genesis 19:29.

278. Sm., fol. 32r

The inscription reads: ἡ ἐν σηγὼρ τοῦ λῶτ δίαξις πρὸς μικρ(όν).

Lot, having fled Sodom with his wife and two daughters, approaches the city of Zoar (LXX: Segor) to seek refuge there. The city is rendered, as usual, as a circular wall enclosing a house, to which a second, smaller ringwall is attached at the left. Flaked in some places.

279. Vat. 746, fol. 77r

The inscription reads: ἡ ἐν σηγὼρ τοῦ λῶτ δίαξις πρὸς μικρόν.

Very close to Sm.

Located beside Genesis 19:22. Note that on fol. 76r the scribe erroneously left an additional space beside Genesis 19:12, which does not correspond to the location of any picture in the other manuscripts; in this space he inserted the scene of the destruction of Sodom (no. 276). Thus, the proper location of this miniature should have been on fol. 77v beside Genesis 19:28, where no. 282 is actually located.

Lit.: Uspenskii, pp. 131, 135; Hesseling, fig. 68; Tsuji, "Nouvelles observations," p. 34; Deckers, "Lot-Sarkophag," pp. 144–45, fig. 16.

Genesis 19:24–28

Destruction of Sodom

The group of people fleeing Sodom in Sm. and Vat. 746 (Vat. 747 was overpainted) has no clear reference in the Septuagint, where we read of Lot, his wife, and his two daughters being exhorted by the angels to escape (Gen 19:15–16). The two additional figures were probably meant to represent the angels themselves, even though one of the angels is also shown flying above the heads of Lot and his daughters; however, one might have expected to see them depicted as angels, as they were previously (cf. fig. 268). An alternative key is the assumption that a Jewish text, *Sefær hayyâshâr* 19:48,[1] lies behind the representation of more than four people fleeing Sodom: according to this source, Lot fled from the town together with his wife, his two daughters, and all who belonged to him.

274. Vat. 747, fol. 40v

Lot hurries away from the place of the disaster; turning to his daughters, he gestures and encourages them to follow him closely. The group is guided by an angel flying above their heads. Lot's wife, meanwhile, has looked back at the burning city and been turned into a pillar of salt (verse 26). From a segment of heaven fire falls upon the city of Sodom, which is so completely consumed by a mass of flames that only the yellowish brown color beneath the conflagration reveals the existence of the city's wall. Abraham appears behind the high mountain (verses 27–28) and looks down at the burning city with an expression of horror, holding his right hand over his mouth in a gesture of grief. Most of the surface was overpainted and has flaked again.

Located beside Genesis 19:22.

Ser., fol. 81r

Blank space for an unexecuted miniature.
Located below Genesis 19:22.

275. Sm., fol. 32r

The inscription reads: ἡ τῶν σοδώμων πυρπόλησις ἡ τοῦ λῶτ ἀποφυγή.

Close to Vat. 747 except for a few details. Two more figures were added to the group of Lot and his two daughters. The landscape is omitted, and the framed bust of Abraham is now suspended in the air. Unlike Vat. 747, the flames have not enveloped the city of Sodom completely, and the wall with its flanking towers and two enclosed houses are still discernible among the flames. The miniature is flaked in various places.

276. Vat. 746, fol. 76r

There was not sufficient space within the frame for the entire inscription, and its beginning was therefore placed partly above

and partly to the left of the miniature. It reads: ἡ τῶν σοδομίτων πυρπόλησις. ἡ τοῦ λῶτ ἀποφυγή.

Very close to Sm. Slightly flaked.

Located beside Genesis 19:12. Note that this space does not correspond to any picture in the other Octateuchs; here the scribe of Vat. 746 erroneously left additional space for a picture, so the following miniatures are dislocated.

Lit.: De Grüneisen, "Cielo," p. 489; Uspenskii, pp. 131, 135; Hesseling, fig. 67; Gerstinger, *Wiener Gen.,* p. 83, fig. 57; Buberl, *Byz. Hss.,* p. 93; Weitzmann, *Greek Mythology,* p. 131 n. 102; Nordström, "Water Miracles," p. 79; Galavaris, *Gregory Naz.,* p. 136; Tsuji, "Nouvelles observations," p. 34; Der Nersessian, *Londres Add. 19.352,* p. 79; Hutter, "Übermalungen," p. 141; Koshi, *Genesisminiaturen,* p. 41; Deckers, "Lot-Sarkophag," p. 136, fig. 17a; Kötzsche-Breitenbruch, *Via Latina,* p. 60, pl. 8d; Weitzmann, *SP,* p. 41; Anderson, "Seraglio," p. 102; Weitzmann and Kessler, *Cotton Gen.,* p. 42; Sed-Rajna, *Hebraic Bible,* p. 33 n. 31; Anderson, "Theodore Psalter," p. 562.

[1] Nordström, "Water Miracles," p. 79. The Vienna Genesis, pict. V (Gerstinger, *Wiener Gen.,* pl. 9) also shows eight people fleeing from the town.

Genesis 19:30

Lot and His Daughters Enter the Cave

It was mentioned above (see the introduction to Genesis 19:23) that in Sm. the composition corresponding to that in Vat. 747 was apparently turned into a representation of verse 23, Lot approaching of the city of Zoar (no. 278). Accordingly, the illustrator depicted Lot and his daughters climbing up into the mountains, as narrated in verse 30, in the following miniature, beside the episode of Lot's daughters getting their father drunk (verses 37–38).

277. Vat. 747, fol. 40v

Closely followed by his two daughters, the slightly stooped Lot is about to enter the low mouth of a cave in the mountains. The figures and the landscape have been thoroughly overpainted and a large section of these have flaked again.

Located beside Genesis 19:28.

Ser., fol. 82r

Blank space for an unexecuted miniature.
Located below Genesis 19:33.

281a. Sm., fol. 32v

Lot and his daughters approach a steep mountain peak against a background of trees.

282a. Vat. 746, fol. 77v

Very close to Sm. Figures and mountain are considerably rubbed.

Located beside Genesis 19:28; its proper place is in the following space, beside Genesis 19:37 (see no. 276).

Lit.: Uspenskii, pp. 131, 135; Hesseling, fig. 69; Gerstinger, *Wiener Gen.*, p. 84, fig. 53; Buberl, *Byz. Hss.*, p. 94.

Genesis 19:33

Lot's Daughters Get Their Father Drunk

280. Vat. 747, fol. 41r

Having decided to get their father drunk, the two daughters offer him wine. Lot sits down and holds a chalice into which one of his daughters pours wine from a jug, while the other stands behind her sister, turning her head in a manner that seems to express displeasure. In agreement with the text, the scene occurs within a cave. All three heads are overpainted, like the rocky peaks and the patterned sky, part of which has flaked again, together with the second daughter's face and other spots.

Located beside Genesis 19:34.

Ser., fol. 82r

Blank space for an unexecuted miniature.
Located below Genesis 19:33.

281b. Sm., fol. 32v

The inscription reads: ἡ ἐν τῷ ὄρει μετὰ τῶν θυγατέρων λὼτ οἴκησις καὶ συνάφεια.

Only one daughter is shown, and she holds the drinking vessel toward which Lot stretches out his hand. She stands in front of the open entrance to the house inside which the scene is supposed to take place, a setting which contradicts the text, where Lot's drunkenness takes place inside a cave. The daughter's face is flaked; Lot's has been overpainted.

282b. Vat. 746, fol. 77v

The inscription reads: ἡ ἐν τῷ ὄρει μετὰ τῶν θυγατέρων λὼτ οἴκησις καὶ συνάφεια.

Very close to Sm. Lot's head is rubbed.

Located beside Genesis 19:28; its proper place is in the following space, beside Genesis 19:37 (see no. 276).

Lit.: Uspenskii, pp. 131, 135; Hesseling, fig. 69; Gerstinger, *Wiener Gen.*, p. 84, figs. 51, 53; Buberl, *Byz. Hss.*, p. 94; Weitzmann, *RaC*, p. 92; Hempel, "Zum Problem," p. 127; Hutter, "Übermalungen," p. 141.

Genesis 19:37–38

Birth of Ben-ammi

283. Vat. 747, fol. 41r

Lot's younger daughter sits in front of a two-story house and gives birth to a child which she names Ben-ammi (LXX:

Amman). The figure of the mother is almost completely flaked with the exception of her lowered face, which shows an expression of great pain. A midwife is squatting in the lower left corner, busy delivering the child. Another child, previously born to the older daughter and named Moab, lies unattended in a cradle. The whole miniature has been overpainted, and large sections of it have flaked again.

Located beside Genesis 20:3.

Ser., fol. 82v

Blank space for an unexecuted miniature.
Located beside Genesis 19:37.

284. Sm., fol. 32v

The inscription reads: ἡ τῶν ἐκ θυγατέρων τοῦ λὼτ παίδων ἀπότεξις τοῦτε μωὰβ καὶ ἀμμάν.

Close to Vat. 747, except that the landscape is omitted entirely and a woman has been added, either Moab's mother or nurse, placing the child in the cradle.

285. Vat. 746, fol. 77v

The inscription reads: ἡ τῶν ἐκ θυγατέρων τοῦ λὼτ παίδων ἀπότεξις τοῦτε μωὰβ καὶ ἀμμάν.

Very close to Sm. Flaked in various places.

Located beside Genesis 19:34; its proper place is in the following space, beside Genesis 19:37.

Lit.: Kondakov, *Istoriia*, p. 191; Kondakov, *Histoire*, vol. 2, p. 81; Uspenskii, pp. 131, 135; Hesseling, fig. 70.

Genesis 20:2

Abraham and Sarah before Abimelech

286a. Vat. 747, fol. 41v

Abraham and Sarah are brought before Abimelech, king of Gerar, who sits in front of his palace in a mountainous landscape setting. One of the king's dark-skinned servants, clad in a tunic which leaves half his chest naked, has seized Sarah by the wrist and is dragging her forcibly to his master. Abraham follows his wife, raising his hand and swearing that the woman is his sister. The miniature has been partly overpainted, particularly the figure of Abraham and Abimelech's head, now adorned by a typically Palaiologan crown.

Located beside Genesis 20:13.

Ser., fol. 84r

Blank space for an unexecuted miniature.
Located beside Genesis 20:13.

287a. Sm., fol. 33r

The inscription, of which only the second half is visible, reads: καὶ σάρρα(ς) ὑποκράτησις.

Very close to Vat. 747 except that Abimelech and his servant wear turbans and Sarah has no nimbus and turns to her husband, who is making a gesture of speech. The miniature has been crudely overpainted.

288a. Vat. 746, fol. 78v

The inscription, written above the miniature, reads: ἡ τοῦ ἀβραὰμ ἐν γεράροις οἴκης καὶ σάρρ(ας) ὑποκράτησις.

Very close to Sm.

Located beside Genesis 19:37; its proper place is in the following space, beside Genesis 20:13 (see no. 276).

Lit.: Uspenskii, p. 135; Hesseling, fig. 71.

Genesis 20:14

Abimelech Interrogates Abraham

286b. Vat. 747, fol. 41v

Seated in part of his palace, which is depicted in the form of a ciborium, Abimelech interrogates Abraham about why he made a false statement about his wife. Abraham sits opposite the king and raises his right hand in a gesture of excuse and defense. Sarah has already been given back; standing behind her husband, she holds him by the arm. The same servant who seized Sarah in the previous miniature now stands beside her with a gesture reassuring her that he will not touch her again. Large sections of the miniature were overpainted and are now flaked again. Abimelech and the ciboriumlike structure are particularly badly flaked, and Abraham's and Sarah's faces as well as parts of the mountainous landscape have suffered much.

Located beside Genesis 20:13.

Ser., fol. 84r

Blank space for an unexecuted miniature.
Located beside Genesis 20:13.

287b. Sm., fol. 33r

The inscription reads: σύντομος ἀπόδοσις.

Although illustrating the same passage, the miniature is conceived differently. Abraham does not face Abimelech but stands at the opposite side of the picture, stretching his hands toward Sarah, who is just returning to him. At the same time one of Abimelech's servants approaches with a flock of sheep and calves as a gift to Abraham from his master. Another servant stands in front of the king with two money bags in his hands containing the thousand pieces of silver that Abimelech, who sits in front of his palace, has ordered him to give to Abraham. Parts of the miniature, particularly the figure of Abimelech, have been overpainted.

288b. Vat. 746, fol. 78v

The inscription accompanying this scene is erroneously placed too high and is written alongside the preceding scene. It reads: καὶ σύντομος ἀπόδοσις.

Very close to Sm.

Located beside Genesis 19:37; its proper place is in the following space, beside Genesis 20:13 (see no. 276).

Lit.: Uspenskii, pp. 131, 135; Hesseling, fig. 71; Henderson, "Sources," p. 15, pl. 6 no. 5.

Genesis 21:2

Birth of Isaac

289b. Vat. 747, fol. 42r

Sarah reclines on her bed, while a midwife is busy bathing the newborn nimbed child in the water in a golden vessel.[1] Behind the couch and in front of a mountain and the golden sky is Abraham's house, inside which Isaac's birth is supposed to have taken place.

Located beside Genesis 21:1.

Ser., fol. 84r

Blank space for an unexecuted miniature.
Located beside Genesis 21:1.

290b. Sm., fol. 33v (see also text fig. 55)

The beginning of the inscription referring to the birth scene reads: ἡ τοῦ ἰσαὰκ ἐκ σάρρας ἀπότεξις.

Sarah points to the foot of her couch where a midwife holds the newborn baby in her arms above the water in a basin and washes him; the midwife sits in frontal view behind the basin.

Located beside Genesis 21:5.

291b. Vat. 746, fol. 79r

The beginning of the inscription reads: ἡ τοῦ ἰσαὰκ ἐκ σάρρας ἀπότεξις.

Very close to Sm.

Located beside Genesis 20:13; its proper place is in the following space, beside Genesis 21:2 (see no. 276).

Lit.: Uspenskii, pp. 131, 135; Hesseling, fig. 72; Menhardt, p. 307; Diringer, *Illuminated Book*, fig. I-17b; Kitzinger, "Hellenistic Heritage," p. 102 n. 27; Bernabò, "Laur. plut. 5.38," p. 151 n. 43; Weitzmann, *SP*, p. 42.

[1] Kitzinger ("Hellenistic Heritage," p. 102 n. 27) considers the iconography of the washing of the newborn child with midwives and a washbasin to be a heritage of imperial art of the Hellenistic age (ibid., pp. 100ff.) incorporated into Old and New Testament cycles. The child is generally held by a midwife above the water level; the variant with the child being washed in the water is supposedly a tenth-century revival (ibid., p. 103).

Genesis 21:4

CIRCUMCISION OF ISAAC

289a. Vat. 747, fol. 42r

In the left half of the miniature and against a backdrop of mountains and a golden sky Abraham circumcises the little Isaac, who, held by a young servant, stretches out his hands toward his father.
Located beside Genesis 21:1.

Ser., fol. 84r

Blank space for an unexecuted miniature.
Located beside Genesis 21:1.

290a. Sm., fol. 33v (see also text fig. 55)

The end of the inscription reads: καὶ περιτομή.
Close to Vat. 747 but the act of circumcision is being performed with less animation.
Located beside Genesis 21:5.

291a. Vat. 746, fol. 79r

The end of the inscription reads: καὶ περιτομή.
Very close to Sm.
Located beside Genesis 20:13; its proper place is in the following space, beside Genesis 21:2 (see no. 276).

Lit.: Tikkanen, *Genesismosaiken*, p. 107, fig. 87; Uspenskii, pp. 131, 135; Hesseling, fig. 72; Menhardt, p. 307; Diringer, *Illuminated Book*, fig. I-17b; Bernabò, "Laur. plut. 5.38," p. 151 n. 43; Weitzmann, *SP*, p. 42.

[Genesis 21:8]

ISAAC'S FIRST STEPS

The story of Abraham watching the first steps of his son Isaac is not recounted by the Septuagint, which reads (Gen 21:8): "the child grew and was weaned, and Abraham made a great feast." Following the text, Vat. 747 illustrates only the feast (fig. 292); Sm. and Vat. 746 add the first steps of the child (figs. 293a, 294a), an episode duplicating the childhood of Abraham in all four Octateuchs (figs. 176–179) and foretelling the child Moses running toward Pharaoh, a scene which appears only in Ser., Sm., and Vat. 746 (figs. 600–602). The iconography of the scene is connected with New Testament infancy scenes and particularly with the cycle of the Virgin (see the introduction to nos. 600–602).

Ser., fol. 84v

Blank space for an unexecuted miniature.
Located beside Genesis 21:7.

293a. Sm., fol. 33v (see also text fig. 55)

In the left corner of the miniature the little Isaac stands with raised arms before his seated father, proudly showing him that he can move freely without support.
Located above Genesis 21:12.

294a. Vat. 746, fol. 79v

A less courageous Isaac seems to be clinging to his father's knee with his right hand. Abraham sits in front of his house.
Located beside Genesis 21:2; its proper place is in the following space, beside Genesis 21:7 (see no. 276).

Lit.: Uspenskii, pp. 131, 135; Hesseling, fig. 73; Weitzmann, *SP*, p. 42.

Genesis 21:8

FEAST FOR ISAAC

292. Vat. 747, fol. 42r

On the day Isaac was weaned, Abraham gave a big feast in his son's honor. The proud father sits on the left side of a well-set table, holding his son on his lap with one hand and with the other encouraging his guests, men of varying ages, to help themselves. The background is formed by a high mountain and two flanking buildings, one of which is Abraham's house, in which the feast is supposed to take place, and the second merely a decorative building invented for reasons of symmetry. Partly overpainted, especially the head of the central figure, and now flaked again in various spots.
Located beside Genesis 21:6.

Ser., fol. 84v

Blank space for an unexecuted miniature.
Located beside Genesis 21:7.

293b. Sm., fol. 33v (see also text fig. 55)

The inscription reads: ἡ τοῦ ἀβραὰμ δοχὴ ἰσαὰκ ἀπογαλάκτισις ἐγένετο.
Very close to Vat. 747, but the mountain background is omitted and only one house is visible, with a curtain at its entrance door.
Located above Genesis 21:12.

294b. Vat. 746, fol. 79v

The inscription reads: ἡ τοῦ ἀβραὰμ δοχὴ ἰσαὰκ ἀπογαλάκτι(σις) ἐγ(ένε)το.
Very close to Sm.
Located beside Genesis 21:2; its proper place is in the following space, beside Genesis 21:7 (see no. 276).

Lit.: Uspenskii, pp. 131, 135; Hesseling, fig. 73; Weitzmann, *SP*, p. 42.

Genesis 21:9–10

SARAH SEES ISHMAEL SPORTING WITH ISAAC

In the series of miniatures concluding the story of Hagar (nos. 295–303), as in the preceding series involving the flight of the pregnant Hagar and the birth of Ishmael (nos. 240–244), we encounter traits not dependant on the Septuagint narrative. Sm. and Vat. 746 (nos. 296, 297) have Ishmael running away and Isaac bleeding, presumably after a quarrel (Vat. 747 has been overpainted and its iconography is probably corrupted). The text of the Septuagint says that Sarah saw the son of Hagar "sporting (παίζοντα) with Isaac her son" (Gen 21:9), but in the Pauline words at Galatians 4:29, Ishmael persecuted Isaac. An anonymous passage in the catena[1] reads that, as Sarah watched, Ishmael hit Isaac while playing.[2] This version goes back to an interpretation of παίζοντα taken in the sense of "striking"; in contrast, the Peshitta has "mocking."[3] The tale of the fight between Ishmael and Isaac, also handed down in Josephus[4] and in Targum Pseudo-Jonathan at Genesis 21:10,[5] is given with further details in Genesis Rabbah 53:11, where R. Eleazar refers to bloodshed: in the miniature Isaac bleeds from his nose.[6] The interpretation of παίζοντα as "striking" is picked up by Syriac writers.[7]

295. Vat. 747, fol. 42r

Greatly excited, Sarah calls her husband's attention to the incident and demands that Ishmael together with his mother, Hagar, be expelled. Ishmael sits on the ground and seems to be trying to snatch a ball-like toy from little Isaac's hands, while Abraham and Sarah arrive just in time to separate the quarreling children. The scene takes place outdoors in front of a high mountain with a decorative building between its peaks. The miniature has been partly overpainted and is now flaked again in various places, notably the faces of Sarah and Ishmael. The original iconography has probably been changed in overpainting.

Located beside Genesis 21:9.

Ser., fol. 84v

Blank space for an unexecuted miniature.
Located beside Genesis 21:9.

296. Sm., fol. 33v (see also text fig. 55)

The inscription reads: ἡ τοῦ ἰσμαὴλ μετὰ ἰσαὰκ παιδιὰ, ἐξ ἧς καὶ ἡ δίωξις.

The figures of Abraham and Sarah agree with Vat. 747, but the quarrel between the two children is depicted differently and much more dramatically. Having beaten the little Isaac, Ishmael runs away when he sees Abraham and Sarah approaching; Isaac, bleeding from the nose and crying, seeks his parents' protection. The miniature has been crudely overpainted, rubbed, and is flaked again in various spots.

297. Vat. 746, fol. 80r

The inscription reads: ἡ τοῦ ἰσμαὴλ μετὰ ἰσαὰκ παιδιὰ, ἐξ ἧς καὶ ἡ δίωξις.

This miniature has also been clumsily overpainted but apparently without notable iconographical innovations. It is very close to Sm.

Located beside Genesis 21:7; its proper place is in the following space, beside Genesis 21:9 (see no. 276).

Lit.: Uspenskii, pp. 131, 135; Hesseling, fig. 74; Wilpert, *Mosaiken und Malereien*, vol. 1, p. 382, fig. 124; Tsuji, "Nouvelles observations," p. 36; Weitzmann, "Study," p. 52, fig. 44; Bernabò, "Fonti testuali," pp. 483–84, pl. 30 no. 2; De Angelis, "Simbologia," pp. 1534–35, fig. 16; De' Maffei, "Eva," pp. 34–35; Weitzmann and Kessler, *Cotton Gen.*, p. 42; Bernabò, "Agar e Ismaele," pp. 217ff., figs. 4, 5.

[1] Cf. Eusebios of Emesa, Diodoros, and Akakios of Caesarea in *Catenae Graecae*, vol. 1, *Catena Sinaitica*, ed. Petit, p. 140, and *Catenae Graecae*, vol. 2, *Collectio Coisliniana*, ed. Petit, pp. 195–96.

[2] Also in the Palaea historica Ishmael hits Isaac (*Anecdota*, ed. Vasil'ev, p. 219). On these and other passages, see Bernabò, "Fonti testuali," pp. 483–84.

[3] I am indebted to Prof. Sebastian Brock for these references.

[4] Here Sarah fears that Ishmael "might do some injury to Isaac" (*Ant* 1:215; *Josephus*, ed. Thackeray, vol. 4, pp. 105–6).

[5] *Targum Genèse*, ed. Le Déaut, p. 209.

[6] R. Eleazar quotes 2 Kgs 2:14 (*Genesis Rabbah*, ed. Freedman and Simon, p. 470).

[7] *Diyarbakir 22*, ed. Van Rompay, vol. 2, p. 110; cf. Jansma, "Early Syrian Fathers," pp. 170–71. A similar explanation is also found in the Palaea historica (*Anecdota*, ed. Vasil'ev, p. 219).

Genesis 21:14

ABRAHAM SENDS HAGAR AND ISHMAEL AWAY

The episode of Abraham casting out Hagar and Ishmael is depicted in much the same way in all the manuscripts. The child is represented as a baby in Hagar's arms, an anomaly in comparison with the preceding scene, where Ishmael is a grown-up boy who stands and runs quite freely. The ambiguous Septuagint text reads either that Abraham put loaves and a skin of water on both Hagar's and Ishmael's shoulders, or that Abraham put loaves, a skin of water, and Ishmael on Hagar's shoulders.[1] Following the Peshitta, Syriac writings claim that the words in the Septuagint verse are misplaced: Abraham put loaves, a skin of water, and Ishmael on Hagar's shoulders, and Hagar carried the child in her arms.[2] (This interpretation coincides with one of the two readings of the Septuagint text.) Genesis Rabbah 53:13[3] interprets that Sarah cast "an evil eye on him (Ishmael), whereupon he was seized with feverish pains"; hence, Hagar had to carry him.

298. Vat. 747, fol. 42v

Abraham hangs a bag of provisions over Hagar's shoulder as she departs for the desert. She carries the little Ishmael in her arms and looks back toward Abraham. High mountains, with a decorative building in the left corner, form the background.

Located beside Genesis 21:13.

Ser., fol. 85r

Blank space for a miniature not executed.
Located beside Genesis 21:17.

299. Sm., fol. 34r

The inscription reads: ἡ τῆς ἄγαρ ἐκδίωξις.

A slightly less emotional moment is represented here: having hung the bag of provisions over Hagar's shoulder, Abraham now pushes the woman away with both hands. The miniature has been clumsily overpainted.

300. Vat. 746, fol. 80r

The inscription reads: ἡ τῆς ἄγαρ σὺν τῷ ἰσμαὴλ ἐκδίωξις.

Less drastically than in Sm., Abraham raises only one hand, and this movement is depicted as a gesture of speech rather than of pushing. Otherwise the composition agrees with Sm.

Located beside Genesis 21:9; its proper place is in the following space, below Genesis 21:9 (see no. 276).

Lit.: Uspenskii, pp. 131, 135; Hesseling, fig. 75; Wilpert, *Mosaiken und Malereien*, vol. 1, p. 382, fig. 125; Bernabò, "Agar e Ismaele," pp. 217ff., figs. 5, 6.

 ¹ *Diyarbakir 22*, ed. Van Rompay, vol. 2, p. 110 n. 11; see also *Catenae Graecae*, vol. 2, *Collectio Coisliniana*, ed. Petit, pp. 196–98.

² *Diyarbakir 22*, ed. Van Rompay, vol. 2, p. 110; see also *Commentaire d'Iso'dad de Merv*, vol. 1, *Genèse*, ed. Van den Eynde, p. 183.

³ *Genesis Rabbah*, ed. Freedman and Simon, p. 472.

Genesis 21:15–20

AN ANGEL APPEARS TO HAGAR

301. Vat. 747, fol. 42v

Facing starvation, Hagar sits on the ground and with an expression of grief rests her head on her hand. In front of her are the empty bag which held provisions that have been eaten and an empty skin that contained water. Ishmael runs away with quiver and bow over his shoulder, thus accomplishing the fate anticipated for him in verse 20, which says that Ishmael grew and became an archer. He looks back at his mother and makes a gesture as if to calm and reassure her that his hunting will supply the food to save them from starvation. High mountains rise behind the scene, with decorative buildings emerging behind the peaks. Flaking in various places.

Located beside Genesis 21:17.

Ser., fol. 85v

Blank space for an unexecuted miniature.
Located beside Genesis 21:17.

302. Sm., fol. 34r

The inscription reads: ἡ ἐν ἐρήμωι πλάν(η) καὶ ὀλιγωρία ἰσμαὴλ καὶ ἀγγέλου ἐπιφοίτησις.

Close to Vat. 747, but with the addition of the angel flying down from heaven and reassuring the sad Hagar that she need not fear because God will make Ishmael a great nation, as re-

counted in verses 17–18. The landscape is simpler, consisting of trees and a few plants. Ishmael's quiver lies on the ground. The miniature has been overpainted.

303. Vat. 746, fol. 80v

The inscription, which is written in the left margin, reads: ἡ ἐν ἐρήμωι πλάνη καὶ ὀλιγωρία ἰσμαὴλ καὶ ἀγγέλου ἐπιφοίτησις.

Very close to Sm.

Located below Genesis 21:15; its proper place is in the following space, below Genesis 21:16 (see no. 276).

Lit.: Uspenskii, pp. 131, 135; Hesseling, fig. 76; Menhardt, p. 307; Green, "Marginal Drawings," p. 131; Bernabò, "Agar e Ismaele," pp. 217ff., figs. 6, 7.

Genesis 21:28–32

COVENANT BETWEEN ABRAHAM AND ABIMELECH

304. Vat. 747, fol. 42v

Abraham and Abimelech make a covenant at Beer-sheba (LXX: the well of the oath). Abimelech is at one side of the well; clad in an imperial chlamys, he extends his right hand in a gesture of assurance toward Abraham, who stands on the other side. Seven ewe lambs which Abraham has presented to Abimelech lie in front of the well. The miniature was partly overpainted and at that time a pearl crown on Abimelech's head was replaced by the higher, three-pronged type of the later period. Most of the figure of Abimelech, the well, the flock, and the landscape are flaked, leaving only the figure of Abraham in fairly good condition.

Located beside Genesis 21:26.

Ser., fol. 86v

Blank space for an unexecuted miniature.
Located beside Genesis 21:32.

305. Sm., fol. 34v

The inscription reads: ὅρκο(ς) ἀβραὰμ πρὸς ἀβιμέλεχ πε(ρὶ) τοῦ φρέατο(ς).

Close to Vat. 747 but Abimelech is dressed differently: he wears a long embroidered tunic and a turban instead of a crown. The miniature has been overpainted.

306. Vat. 746, fol. 81r

The inscription reads: ὅρκος ἀβραὰμ πρὸς ἀβιμελεχ περὶ τοῦ φρέατος.

Very close to Sm. Overpainted and flaked, particularly in the lower left corner.

Located below Genesis 21:16.

Lit.: Uspenskii, pp. 131, 135; Hesseling, fig. 77.

Genesis 22:1–3

GOD ORDERS ABRAHAM TO SACRIFICE ISAAC;
AND ABRAHAM, ISAAC, AND SERVANTS
ON THE WAY TO SACRIFICE

307. Vat. 747, fol. 43r

God tests Abraham by commanding him to sacrifice Isaac. Abraham listens and looks up to the divine hand protruding from a segment of heaven which is set against the golden sky, and at the same time begins to move in the opposite direction to follow his departing servants. At the foot of a high mountain one servant leads an ass laden with split wood for the burnt offering, while the other carries his mantle over a shouldered staff and holds the little, nimbed Isaac by the hand.

Located beside Genesis 22:1.

308. Ser., fol. 87r

The inscription reads: ἡ τοῦ ἀβραὰμ δοκιμὴ ἡ διὰ τὸν ἰσαάκ.

Close to Vat. 747 except that the copyist has forgotten the wood on the ass's back, the second servant does not pay attention to the child (who is following him as quickly as he can), and Abraham is represented in a slightly different and less impassioned posture.

Located beside Genesis 22:2.

309. Sm., fol. 34v

The inscription reads: ἡ τοῦ ἀβραὰμ δοκιμὴ ἡ διὰ τὸν ἰσαάκ.

Very close to Ser. Flaked in various places.

Located below Genesis 22:5.

310. Vat. 746, fol. 81v

The faded inscription reads: ἡ τοῦ ἀβραὰμ δοκιμὴ ἡ διὰ τὸν ἰσαάκ.

The entire surface is severely flaked, but enough remains to recognize that the composition was very close to Ser. and Sm.

Located beside Genesis 21:25; its proper place is in the following space, beside Genesis 22:1 (see no. 276).

Lit.: Uspenskii, p. 131; Hesseling, fig. 78; Buchthal, *Paris Ps.*, p. 67 n. 10; Weitzmann, "Martyrion," p. 142; Weitzmann, *RaC*, p. 141, fig. 126; Weitzmann, *JR*, p. 25 n. 26; Wessel, "Abraham," col. 16; Mouriki-Charalambous, "Cosmas," pp. 44–51; Bucher, *Pamplona Bibles*, p. 150 n. 190; Stahl, "Morgan M. 638," p. 54; Stichel, "Ausserkanon. Elemente," p. 167; Dufrenne, "Oct. du Sérail," p. 249, fig. 8; Weitzmann, *SP*, p. 42; Koenen, "Genesis 19,4/11 und 22,3/13," p. 132 n. 88; Brubaker, *Gregory of Naz.*, p. 385; Sed-Rajna, "Haggadah," p. 419.

Genesis 22:5–6

ABRAHAM AND ISAAC ON THE WAY
TO SACRIFICE

311. Vat. 747, fol. 43r

Abraham and Isaac ascend a slope to the place where the sacrifice is to be made. Isaac carries the bundle of split wood on his shoulders and looks back at his father, who follows him with a knife in his hand. The two servants Abraham has left behind sit on the ground in conversation, while the ass grazes. High mountains and a decorative building painted in grisaille form the background. Slightly flaked.

Located beside Genesis 22:7.

312. Ser., fol. 87v

The inscription reads: ἡ πρὸς τὸ ὄρος ἀνάβασις καὶ τοῦ πυρὸς καὶ τῶν ξύλων ἑτοιμασία.

Close to Vat. 747 but the landscape is omitted here, and all the figures sit or walk on a common groundline. In contrast to Vat. 747, the painter chose to depict the episode in the story before the climbing of the mountain, at the moment when Abraham is just loading the wood onto his son's back and is thus unable to hold a knife. Isaac carries a bowl with fire in his left hand, although, according to the text, it should be carried by his father. The ass, tethered to a peg, looks docilely at the two conversing servants. Slightly stained and flaked.

Located beside Genesis 22:6.

313. Sm., fol. 34v

The inscription reads: ἡ πρὸς τὸ ὄρος ἀνάβασις καὶ τοῦ πυρὸς καὶ τῶν ξύλων ἑτοιμασία.

Very close to Ser. and considerably flaked.

314. Vat. 746, fol. 82r

The inscription reads: ἡ πρὸς τὸ ὄρος ἀνάβασις καὶ τοῦ πυρὸς καὶ τῶν ξύλων ἑτοιμασία.

Very close to Ser. and Sm. and slightly flaked.

Located beside Genesis 22:1; its proper place is in the following space, beside Genesis 22:6 (see no. 276).

Lit.: Uspenskii, p. 132, fig. 47; Stornajolo, *Topografia Cristiana*, p. 17; Hesseling, fig. 79; Buchthal, *Paris Ps.*, p. 67 n. 10; Weitzmann, "Chronicles," p. 89; Weitzmann, *RaC*, p. 142, fig. 127; Wessel, "Abraham," col. 16; Galavaris, *Gregory Naz.*, p. 135 n. 43; Mouriki-Charalambous, "Cosmas," pp. 44–51; Bucher, *Pamplona Bibles*, p. 138 n. 75; Hamann-Mac Lean, *Vizantiiskii Stil'*, fig. p. 405; Stahl, "Morgan M. 638," p. 54; Stichel, "Ausserkanon. Elemente," p. 167; Brubaker, *Gregory of Naz.*, pp. 385–86, 389.

Genesis 22:9–13

SACRIFICE OF ISAAC

Several features in the representation of the Sacrifice of Isaac in the Octateuchs are not explained by the Septuagint and must be sought in other sources. The first feature is the hand of God replacing the angel of verse 11, which already occurs in a painting in the Dura synagogue (text fig. 42)[1] and follows rabbinical tradition also found in pseudepigrapha such as the *Liber antiquitatum biblicarum*,[2] and Christian texts from Syria, where the "voice of The Lord" supplants the angel.[3] The second feature is the ram tied to a tree instead of entangled by its horns in a thicket (verse 13); the tree also occurs in Dura, is reported in the Targumim,[4] and is widely accepted in the Syrian tradition.[5] At Dura, however, it is dubious whether the horns of the ram are caught in the tree or tied to it by means of a rope,[6] whereas in the Octateuchs the ram is manifestly tied to the tree with a long rope,[7] a detail which is again connected with Syriac writings[8] and is found in fourth- to sixth-century Christian monuments.[9] In contrast, in the sixth-century mosaic pavement in the synagogue of Beth Alpha (text fig. 43), the ram is tied with a rope but seems suspended from a branch of the tree.[10] A third incongruity in comparison with the text of the Septuagint is the placement of Isaac beside the altar instead of on top of it,[11] a feature which may be found both in pseudepigrapha[12] and in Christian descriptions of the event, such those by Gregory of Nyssa[13] and Ephrem, the latter stunningly recalling the Octateuch illustration or a similar depiction with his vivid description of the sacrifice.[14] Iconographically, this feature mirrors a classical group from the illustration of the *Telephos* of Euripides (text fig. 21), which may well have been adapted by the painter for Abraham sacrificing his son.[15] The fourth feature is that in the miniature Isaac is a young boy; in contrast, as a rule, in the Jewish tradition Isaac is a thirty-seven-year-old man;[16] but various Christian traditions, such as the Syrian one, make him considerably younger, a child or even a baby.[17] finally, in the Octateuchs—and at Beth Alpha as well—Isaac's hands are tied behind his back, but the Septuagint specifies that Abraham bound Isaac's *feet*. The representation agrees rather with Syriac writings, where we read that "Abraham showed him the bonds and Isaac folded his hands."[18]

315. Vat. 747, fol. 43v

Abraham has bent Isaac's head back and is about to cut his throat when a voice from heaven stops him from harming his son. God's hand protrudes from a segment of heaven set against the golden sky and emits rays toward Abraham's head, which is turned. Isaac, his feet and hands fettered, kneels in front of the altar. Some of the kindling that Isaac had carried leans against the altar, upon which a large fire is already burning. The ram which Abraham will sacrifice instead of his son appears at the left, with a thin blue rope tying its horn to the golden tree in the background. Slightly flaked.

Located beside Genesis 22:12.

316. Ser., fol. 88r

The inscription reads: ἡ τελεία ἀγάπη καὶ ἡ τοῦ κριοῦ ἀντὶ ἰσαὰκ θυσία.

Very close to Vat. 747 but its action is not as passionate and the postures of Abraham and Isaac are somewhat different, both being rendered more frontally. The ram and other parts of the miniature are flaked, while the knife in Abraham's hand is rubbed, apparently intentionally.

Located beside Genesis 22:13.

317. Sm., fol. 35r

The inscription reads: ἡ τελεία ἀγάπη καὶ ἡ τοῦ κριοῦ ἀντὶ ἰσαὰκ θυσία.

Very close to Ser. The knife in Abraham's hand is also rubbed here, again apparently intentionally.

318. Vat. 746, fol. 83r

The inscription reads: ἡ τελεία ἀγάπη καὶ ἡ τοῦ κριοῦ ἀντὶ ἰσαὰκ θυσία.

Very close to Ser. and Sm. Slightly rubbed and flaked.

Located beside Genesis 22:6; its proper place is in the following space, beside Genesis 22:12 (see no. 276).

Lit.: Uspenskii, p. 132; Stornajolo, *Topografia Cristiana*, p. 17; Hesseling, fig. 80; Smith, "Iconography," pp. 168–69; Buchthal, *Paris Ps.*, p. 67 n. 10; Weitzmann, "Chronicles," p. 89; Weitzmann, *RaC*, p. 142, fig. 128; Menhardt, p. 308; Buchthal, *Latin Kingdom*, p. 73; Nordström, "Water Miracles," pp. 82–83; Nordström, "Rabbin. Einflüsse," p. 418; Williams, "León Bible," p. 59; Weitzmann, "Jephthah Panel," p. 350, fig. 15; Wessel, "Abraham," col. 16; Wolska-Conus, *Cosmas*, vol. 1, p. 152; Nikolasch, "Ikonographie des Widders," pp. 208–9, 216; Galavaris, *Gregory Naz.*, p. 135 n. 43; Mouriki-Charalambous, "Cosmas," pp. 44–51; Lassus, *Livre des Rois*, p. 88, fig. 125; Stahl, "Morgan M. 638," p. 52; Kötzsche-Breitenbruch, *Via Latina*, p. 63; Bernabò, "Fonti testuali," pp. 484–85, pl. 31 no. 1; Bergman, *Salerno*, p. 36; De Angelis, "Simbologia," pp. 1533–36, figs. 12, 20; Koenen, "Genesis 19,4/11 und 22,3/13," p. 132 n. 88; Brubaker, *Gregory of Naz.*, pp. 385–86, 389; Gutmann, "Isaac: Variations," p. 122; Anderson, "James the Monk," p. 80 n. 63; Sed-Rajna, "Haggadah," p. 419.

[1] Weitzmann, *Dura*, fig. 3; Kraeling, *Synagogue*, pp. 56–59.

[2] *LAB* 32:4 (*OTP*, vol. 2, p. 346).

[3] Gutmann, "Isaac: Variations," p. 117; the list of Jewish and Christian authors in note 7 on the same page also includes Basil, *Oratio 8 in Abraham* (PG 86, cols. 109–12), yet we were not able to find any reference to a direct role of the Lord in the place of the angel. For the diverse rabbinic positions, see Vermes, *Scripture and Tradition*, chap. 8, "Redemption and Genesis XXII," pp. 193–227, esp. pp. 194–212; and, particularly for Syriac writers, S. Brock, "Genesis 22 in Syriac Tradition," in *Mélanges Dominique Barthélemy: Études bibliques offertes à l'occasion de son 60ᵉ anniversaire*, ed. P. Casett, O. Keel, and A. Schenker (Fribourg and Göttingen, 1981), pp. 1–30, esp. pp. 14–15.

[4] Mouriki-Charalambous, "Cosmas," pp. 44–51; Kraeling, *Synagogue*, p. 57 n. 22; J. Gutmann, "The Illustrated Midrash in the Dura Synagogue Paintings: A New Dimension for the Study of Judaism," *American Academy for Jewish Research Proceedings* 50 (1983), pp. 92–93.

[5] Brock, "Jewish Traditions," pp. 219–20; and id., "Genesis 22" (as in note 3), p. 16.

[6] Kraeling (*Synagogue*, p. 57) does not mention a rope fastening the ram to the tree: its existence in the panel is asserted by H. Typen (*Der Stil der*

Jüdisch-Hellenistischen Homilie [Göttingen, 1955], pp. 31–39), R. Meyer ("Die figurendarstellung in der Kunst des späthellenistischen Judentums," *Judaica* 5 [1949], pp. 29ff., and id., "Betrachtungen zu drei Fresken der Synagoge von Dura-Europos," *ThLz* 74 [1949], cols. 31ff.), and denied by Gutmann ("Isaac: Variations," p. 116, note 3). Cf. Nikolasch, "Ikonographie des Widders," pp. 203–4, 216.

[7] Cf. Bernabò, "Fonti testuali," pp. 484–85.

[8] Brock, "Genesis 22" (as in note 3), p. 17 and n. 81; Brock, "Anonymous Syriac Homily," p. 258. The reference to a Syriac tradition for the ram tied to the tree was suggested by Professor Brock.

[9] Cf. the mosaics in the baptistery in the cathedral at Madaba, dating from the time of Bishop Sergius (575), and in the church of St. George and the church of Massuh at Nebo in Palestine (*Byzantinische Mosaiken aus Jordanien*, exh. cat., Schallaburg and elsewhere, September 1986–February 1988 [Vienna, 1986], p. 241, fig. 38 on p. 242; M. Piccirillo, *Madaba: Le chiese e i mosaici* [Milan, 1989], pp. 31–32, 39 note 23. We owe these references to Dr. Christopher Moss); see also Bagatti, "Sacrificio di Abramo," pp. 294–97, figs. 23–32.

[10] E. L. Sukenik, *The Ancient Synagogue of Beth Alpha* (London, 1932), pp. 40–42, pl. 19; id., *Ancient Synagogues in Palestine and Greece* (London, 1934), pp. 31–36; Nikolasch, "Ikonographie des Widders," pp. 206–7; M. Bregman, "The Depiction of the Ram in the *Aqeda* Mosaic at Beit-Alpha," *Tarbiz* 51 (1982), pp. 306–9; Brock, "Two Syriac Homilies," p. 127.

[11] Versions of the painting that follow the LXX in placing Isaac upon the altar are found in the Dura synagogue (Weitzmann, *Dura*, fig. 3) and in a panel in the bema of the church of St. Catherine's Monastery on Mount Sinai (Weitzmann, "Jephthah Panel," pp. 348–50, fig. 3).

[12] 4 Maccabees, a text that supposedly originated in the Antiochene area or on the coast of Asia Minor, relates (16:20) that "Isaac, seeing his father's hand, with a knife in it, fell down against him, did not flinch" (*OTP*, vol. 2, p. 561).

[13] Gregory of Nyssa describes a painting with the sacrifice of Isaac in *De Deitate filii et Spiritus Sancti* (PG 46, col. 572); see I. S. van Woerden, "The Iconography of the Sacrifice of Abraham," *VChr* 15 (1961), pp. 229–30; English translation in C. Mango, *The Art of the Byzantine Empire 312–1453: Sources and Documents* (Englewood Cliffs, N.J., 1972), p. 34.

[14] Ephrem, *Sermones in Abraham et Isaac* (*Sancti Ephraem Syri Opera Omnia*, vol. 1 [Venice, 1755], p. 273): "Juxta altare procumbebat Isaac, coram patre in genua provolutus, ac manus retro circumactas habens, Abraham interim a tergo cubitorum curvaturam calcante. Deinde una manu comam pueri ad sese retorquens, intuetur ipsum, aspicitque faciem Isaac in eum miserabiliter respiciens, ictumque iam expectantis. Armatam autem gladio habens dexteram, intentat necem, corpus contingit, et iam gutturi acies gladii imminebat, ensamque in sua ipsius adigit viscera" In this minutely described envisioning of the sacrifice, Ephrem actually seems to evoke a picture.

[15] Weitzmann, *RaC*, pp. 174–75, where the sacrifice of Isaac in the Paris Gregory, cod. gr. 510, fol. 174v, is discussed (figs. 173, 175); see also the addenda in the second edition, pp. 256–57, and Weitzmann, "Survival," pp. 58–59, figs. 27, 28. Nordström ("Water Miracles," pp. 82–83) suggested that the way in which Abraham forces Isaac's head backward, sticks the knife into his throat, and pushes Isaac's body with his knees, closely resembles a sacrifice in the Jewish tradition.

[16] GenR 56:8 (*Genesis Rabbah*, ed. Freedman and Simon, p. 497).

[17] Brock, "Genesis 22" (as in note 3), pp. 6–7.

[18] Brock, "Two Syriac Homilies," Memra II, v. 64. Cf. also the more generic expression "[Abraham] bound his son" employed in the Hebrew text, Targumim, Peshitta, and Syriac writings (Brock, "Anonymous Syriac Homily," p. 250).

Genesis 22:15–19

PROMISE OF POSTERITY AND RETURN FROM SACRIFICE

319. Vat. 747, fol. 43v

According to the text, an angel of God promises Abraham posterity. As in the preceding scene, the illustrator does not represent an angel, but rather God's hand in the heavens. Abraham looks up at the hand and turns around to follow Isaac, his two servants, who are conversing with each other, and the ass back to Beer-sheba, which is indicated by the well near the right border. A high mountain range with a decorative building painted in grisaille between the peaks forms the background. As in the illustration of verses 1–3, Abraham is related simultaneously to two consecutive phases of the episode. The miniature has been partially overpainted, particularly the right half with the two servants, and is largely flaked again.

Located beside Genesis 22:17.

320. Ser., fol. 89r

The inscription reads: ὁ χρηματισμὸς ἀβραὰμ καὶ ἡ ἀπὸ τοῦ ὄρους κατάβασις.

Very close to Vat. 747, but while it is more faithful to the text in depicting the half-figure of an angel flying down from heaven, instead of the hand of God, in other respects it is abbreviated: the little Isaac is missing, the ass is omitted, and the landscape is greatly simplified. Slightly flaked.

Located beside Genesis 22:15.

321. Sm., fol. 35r

The inscription reads: ὁ χρηματισμὸς ἀβραὰμ καὶ ἡ ἀπὸ τοῦ ὄρους κ(α)τ(ά)βασ(ις).

Very close to Ser. and overpainted.

Located below Genesis 22:17.

322. Vat. 746, fol. 83v

The inscription reads: ὁ χρηματισμὸς ἀβραὰμ καὶ ἡ ἀπὸ τοῦ ὄρους κατάβασις.

Very close to Ser. and Sm.

Located beside Genesis 22:12; its proper place is in the following space, beside Genesis 22:16 (see no. 276).

Lit.: Uspenskii, p. 132; Hesseling, fig. 81; Buberl, *Byz. Hss.*, p. 95; Buchthal, *Latin Kingdom*, p. 73; Bergman, *Salerno*, p. 37.

Genesis 23:2

DEATH OF SARAH

323a. Vat. 747, fol. 44r

Sarah has died at Hebron and lies with hands crossed on her deathbed in front of Abraham's two-story house, inside which the scene is supposed to take place. Abraham bends down to embrace his wife, while a group of mourners, including one who keens with hair loosened, stands around the foot of the deathbed. A second house at the right gives symmetry to the composition, and a connecting wall separates the scene from the golden sky.

Located beside Genesis 23:9.

324a. Ser., fol. 89v

The inscription reads: ἡ τῆς σάρρας τελευτή.

The scene, which fills the left half of the miniature, is abbreviated in that no mourners are shown at the foot of the deathbed. Abraham, having covered the feet of the deceased with a cloth, contemplates her with an expression of deep sorrow and grief.

Located beside Genesis 23:9.

325a. Sm., fol. 35v

The inscription reads: ἡ τῆς σάρρας τελευτή.
Very close to Ser. and crudely overpainted.
Located below Genesis 23:8.

326a. Vat. 746, fol. 84r

The inscription reads: ἡ τῆς σάρρας τελευτή.
Very close to Ser. and Sm., as is still recognizable despite the very heavy flaking.
Located beside Genesis 22:16; its proper place is in the following space, beside Genesis 23:9 (see no. 276).

Lit.: Uspenskii, p. 132, fig. 48; Hesseling, fig. 82; Gerstinger, *Wiener Gen.*, p. 85, fig. 58; Der Nersessian, *Barl. et Joas.*, pp. 171–72; Buberl, *Byz. Hss.*, p. 95.

Genesis 23:16–19

ABRAHAM PURCHASES A BURIAL PLACE
FROM EPHRON

323b. Vat. 747, fol. 44r

The marble sarcophagus in which Abraham has buried Sarah stands in the cave of Mamre. Standing at the head of the sarcophagus, Abraham addresses Ephron, the Hittite, from whom he has bought the burial ground and who, surrounded by the sons of Heth, stands at the other end of the sarcophagus. The entire surface is considerably flaked.

Located beside Genesis 23:9.

324b. Ser., fol. 89v

In the right half of the miniature Abraham stands in the foreground and speaks with Ephron, who is accompanied by only one of the sons of Heth, with whom he stands behind the sarcophagus. In his hands Ephron holds a money bag containing the four hundred didrachms of silver which Abraham paid him for the burial ground. The portrayal of the locality is less precise than in Vat. 747, since there is no indication of the cave, which is to be imagined in the high mountains rising behind the group.

Located beside Genesis 23:9.

325b. Sm., fol. 35v

Very close to Ser. except that several of Heth's sons stand behind the sarcophagus. Crudely overpainted.

326b. Vat. 746, fol. 84r

Closer to Ser. than to Sm. and severely flaked.
Located beside Genesis 22:16; its proper place is in the following space, beside Genesis 23:9 (see no. 276).

Lit.: Uspenskii, p. 132, fig. 48; Hesseling, fig. 82; Gerstinger, *Wiener Gen.*, p. 85, fig. 58; Benson and Tselos, "Utrecht Ps.," p. 70, fig. 145; Der Nersessian, *Barl. et Joas.*, pp. 171–72; Goodenough, *Symbols*, vol. 9, p. 211 n. 96; Revel, "Textes rabbin.," p. 121 n. 2.

Genesis 24:2–4

ABRAHAM SENDS ELIEZER TO TAKE A WIFE
FOR ISAAC

327. Vat. 747, fol. 44v

Abraham sits in front of his two-story house and asks his servant Eliezer to seek a wife for Isaac, not from the daughters of the Canaanites, but rather in Mesopotamia. He makes him swear to this on his thigh. Thus, in the picture the youthful servant, with a certain reticence, puts his hand on his master's upper thigh. The preparation for the trip to Mesopotamia is denoted by a camel driver who stands with crossed arms in the door of the annex connected by a wall to the main house and looks at a camel which is half cut off by the lateral border. High mountains, set against a golden sky, and a decorative building in the right upper corner form the background.

Located beside Genesis 24:2.

328. Ser., fol. 90v

The inscription reads: ὁ ὀρκισμὸς τοῦ ἀν(θρώπ)ου τοῦ ἐπὶ τῆς οἰκίας ἀβραὰμ διὰ τὴν τοῦ ἰσαὰκ ἀποστολὴν ἕνεκεν τῆς τῆς [sic] γυναικὸς αὐτοῦ.

Abraham does not speak directly to his servant as in Vat. 747, but calls upon God to witness the servant's oath: he looks up and

raises his hand toward a segment of heaven which is studded with stars. There is no architectural or landscape setting, and the camel driver, who holds his camel by the reins, stands devotedly behind the chief servant.

Located beside Genesis 24:3.

329. Sm., fol. 36r

The inscription reads: ὁ ὁρκισμὸς τοῦ ἀν(θρώπ)ου τοῦ ἐπὶ τῆς οἰκίας ἀβραὰμ διὰ τὴν τοῦ ἰσαὰκ ἀποστολ(ὴν) ἕνεκεν τῆς γυναικὸ(ς) αὐτοῦ.

Very close to Ser. and crudely overpainted.

330. Vat. 746, fol. 85r

The inscription reads: ὁ ὁρκισμὸς τοῦ ἀν(θρώπ)ου τοῦ ἐπὶ τῆς οἰκίας ἀβραὰμ διὰ τὴν τοῦ ἰσαὰκ ἀποστολὴν ἕνεκεν τῆς γυναικὸς αὐτοῦ.

Very close to Ser. and Sm. and overpainted rather clumsily.

Located beside Genesis 23:9; its proper place is in the following space, beside Genesis 24:3 (see no. 276).

Lit.: Uspenskii, p. 132, fig. 49; Hesseling, fig. 83; Lassus, "Miniatures byz.," p. 47, fig. 2; Gerstinger, *Wiener Gen.*, p. 88, fig. 61; Buberl, *Byz. Hss.*, p. 96; Menhardt, p. 308; Anderson, "Seraglio," p. 87, fig. 2.

Genesis 24:10

ELIEZER'S JOURNEY

331. Vat. 747, fol. 45r

Abraham's chief servant is on his way to Mesopotamia, accompanied by the camel driver who leads the ten camels laden with baskets full of provisions and gifts. The heads of both figures, turned to look back, and the outline of the mountains have been repainted.

Located beside Genesis 24:8.

332. Ser., fol. 91v

The inscription reads: ἔνθα ἀποσταλεὶς ὁ ἐπὶ τῆς οἰκίας ὁδηγεῖται ὑπὸ θ(εο)ῦ.

In accordance with Abraham's promise (verse 7), "he shall send his angel before thee," the servant and his companion are guided by an angel, depicted as a half-figure who flies over their heads and points the way. Unlike Vat. 747, there is no landscape and both men face forward.

Located beside Genesis 24:8.

333. Sm., fol. 36v

The inscription reads: ἔνθα ἀποσταλεὶς ὁ ἐπὶ τῆς οἰκί(ας) μετὰ ἰσαακ ὁδηγεῖται ὑπ(ὸ) θ(εο)ῦ.

Very close to Ser. and overpainted. A tear has damaged the upper part of the camel driver.

334. Vat. 746, fol. 85v

The inscription reads: ἔνθα ἀποσταλεὶς ὁ ἐπὶ τῆς οἰκίας ἀβραὰμ ὁδηγεῖται ὑπὸ θ(εο)ῦ.

Very close to Ser. and Sm. and somewhat flaked.

Located beside Genesis 24:3; its proper place is in the following space, beside Genesis 24:10 (see no. 276).

Lit.: Uspenskii, p. 132; Hesseling, fig. 84; Gerstinger, *Wiener Gen.*, p. 88, fig. 63.

Genesis 24: 17–19

ELIEZER MEETS REBEKAH AT THE WELL

335. Vat. 747, fol. 45r

Rebekah emerges from behind a well out of which water flows into a trough[1] and gives Abraham's servant a drink from the jug she is holding. Directly behind the servant a camel driver is seen leading his thirsty animals to the trough. The miniature has been overpainted, particularly the heads, the crest of the mountain, and the camels; the restorer added a mane to one camel, but most of this layer has flaked again.

Located beside Genesis 24:10.

336. Ser., fol. 92r

The inscription reads: ἐνταῦθα ποτίζονται ὑπὸ ῥεβέκκας καὶ οἱ ἄν(θρωπ)οι καὶ αἱ κάμηλοι.

Close to Vat. 747.

Located beside Genesis 24:17.

337. Sm., fol. 36v

The inscription reads: ἐνταῦθ(α) ποτίζονται ὑπὸ ῥεβέκκας καὶ οἱ ἄν(θρωπ)οι καὶ αἱ κάμηλοι.

Very close to Ser., overpainted, and slightly rubbed and flaked.

Located below Genesis 24:15.

338. Vat. 746, fol. 86v

The inscription reads: ἐνταῦθα ποτίζονται ὑπὸ ῥεβέκκας καὶ οἱ ἄν(θρωπ)οι καὶ αἱ κάμηλοι.

Very close to Ser. and Sm.

Located beside Genesis 24:10; its proper place is in the following space, beside Genesis 24:17 (see no. 276).

Lit.: Uspenskii, p. 132; Hesseling, fig. 85; Wilpert, *Mosaiken und Malereien*, vol. 1, p. 433, fig. 151; Gerstinger, *Wiener Gen.*, p. 88, fig. 64; Buberl, *Byz. Hss.*, p. 97; Demus, *Norman Sicily*, p. 254; Hempel, "Traditionen," p. 56 n. 19; Kitzinger, *Monreale*, p. 62.

[1] Demus (*Norman Sicily*, p. 254) interpreted the trough in the Octateuchs and in the Vienna Genesis (pict. 13) as a second well which renders literally the Greek text of LXX, where the same well is labeled with two different words (Gen 24:11 and 24:16).

Genesis 24:22

Eliezer Gives Trinkets
to Rebekah

339a. Vat. 747, fol. 45v

In the left half of the miniature, Abraham's servant gives Rebekah two bracelets, having previously given her the golden earrings which she is already wearing. The scene takes place before a high mountain with a decorative building between its peaks. The servant's face is flaked.

Located beside Genesis 24:32.

340a. Ser., fol. 92v

The inscription reads: ἐνταῦθα δίδωσι τῇ ρεβέκκα ὁ ἐπὶ τῆς οἰκίας τὰ κόσμια.

Close to Vat. 747 except that there is no landscape and Rebekah is dressed differently.

Located beside Genesis 24:32.

341a. Sm., fol. 37r

The inscription reads: ἐνταῦθ(α) δίδωσι τῇ ρεβέκκα ὁ ἐπὶ τῆς οἰκίας τὰ κόσμια.

Very close to Ser.

342a. Vat. 746, fol. 87r

The inscription reads: ἐνταῦθα δίδωσι τῇ ρεβέκκα ὁ ἐπὶ τῆς οἰκίας τὰ κόσμια.

Close to Ser. and Sm., except in one detail, the raising of the servant's hand in a gesture of speech, which agrees with Vat. 747.

Located beside Genesis 24:17; its proper place is in the following space, beside Genesis 24:32 (see no. 276).

Lit.: Uspenskii, p. 132; Hesseling, fig. 86; Gerstinger, *Wiener Gen.*, fig. 62; Buberl, *Byz. Hss.*, p. 99; Hempel, "Traditionen," p. 56 n. 19; Mütherich, "Psalterillustration," p. 172.

Genesis 24:28, 32

Rebekah Reports the Meeting

339b. Vat. 747, fol. 45v

After meeting with Abraham's servant, Rebekah immediately runs home and tells the news to "the house of her mother." In verse 28 no member of her family is specifically mentioned as being present in the house, but verse 29, which relates that her brother Laban went out to the well to meet the servant, suggests that the young man sitting in the center of the composition is Laban. He raises his hand in a gesture of astonishment while listening to Rebekah, who accompanies her report with vivid gestures. Instead of being situated in front of the house of Rebekah's

mother, the scene is placed in the open air before the same mountain that forms the background of the scene at the left. At the right in this miniature, Abraham's camels (partly cut off by the lateral border because of lack of space) lie on the ground without their burdens: according to verse 32, Laban has brought Abraham's servant into his house, unloaded the camels, and given the animals straw and provender.

Located beside Genesis 24:32.

340b. Ser., fol. 92v

Rebekah tells her story to two men: the older bearded one in the foreground is apparently her father, Bethuel (LXX: Bathuel), and the younger is again Laban. The scene takes place before her mother's house, thus matching the text better than Vat. 747.

Located beside Genesis 24:32.

341b. Sm., fol. 37r

Very close to Ser.

342b. Vat. 746, fol. 87r

As in the left scene of this miniature, the gestures are somewhat changed here: Bethuel holds his hand open as if he expected Rebekah to hand her gifts over to him. Laban raises his hand in an animated gesture of speech, and Rebekah holds her left hand to her throat.

Located beside Genesis 24:17; its proper place is in the following space, beside Genesis 24:32 (see no. 276).

Lit.: Uspenskii, p. 132; Hesseling, fig. 86; Gerstinger, *Wiener Gen.*, fig. 62; Buberl, *Byz. Hss.*, p. 99; Hempel, "Traditionen," p. 56 n. 19; Mütherich, "Psalterillustration," p. 172.

Genesis 24:49–50

Eliezer Requests Rebekah's Hand

343a. Vat. 747, fol. 46r

In the left half of the miniature, Abraham's servant is shown requesting Rebekah's hand in marriage on behalf of Isaac. According to the text he speaks to her father, Bethuel, and her brother, Laban, but the illustrator has represented only Bethuel, characterized by his white beard, probably due to the realization that consent to Rebekah's marriage had to come primarily from the bride's father. Abraham's servant, approaching respectfully, and Bethuel, sitting in front of his house, express the request and consent with vivid gestures. A high wall and a golden sky form the background. Slightly flaked.

Located beside Genesis 24:49.

344a. Ser., fol. 94r

The inscription reads: ἔνθα προς δεχθέντες οἱ περὶ τὸν ἰσαὰκ, κοινολογοῦνται περὶ τοῦ γάμου.

Close to Vat. 747 but its meaning is altered. Abraham's servant, who is accompanied by the camel driver, has just given a huge golden ring to the man seated in front of the house, who in this case must also be Bethuel, although his beard is dark and shorter than in Vat. 747. The delivery of the gifts is described in verse 53, and this verse is illustrated in the right half of the miniature, where, in agreement with the text, they are being presented to Laban, Rebekah, and Rebekah's mother, but not to Bethuel. Apparently the copyist no longer fully understood the original meaning of the conversation scene and fused it with the scene at the right, making it a part of a larger composition dealing exclusively with the presentation of the gifts.

Located beside Genesis 24:66.

345a. Sm., fol. 37v

The inscription reads: ἔνθ(α) προ(ς) δεχθέντες οἱ πε(ρὶ) τ(ὸν) ἰσαὰκ κοινολογοῦνται πε(ρὶ) τοῦ γάμου.

Very close to Ser.

346a. Vat. 746, fol. 87v

The inscription reads: ἔνθα προσδεχθέντες οἱ περὶ τὸν ἰσαὰκ, κοινολογοῦνται περὶ τοῦ γάμου.

Very close to Ser. and Sm. and very badly flaked.

Located beside Genesis 24:32; its proper place is in the following space, beside Genesis 24:56 (see no. 276).

Lit.: Uspenskii, p. 132, fig. 50; Hesseling, fig. 87; Hempel, "Traditionen," p. 56 n. 19.

Genesis 24:53

ELIEZER GIVES GIFTS TO REBEKAH'S FAMILY

343b. Vat. 747, fol. 46r

Abraham's servant and his camel driver step out of a building, which is crowned by a little tempietto, and pile on the ground raiments which are intended as gifts to Rebekah's family. Of the three persons mentioned in the text as recipients of these gifts, namely Laban, Rebekah, and her mother, only the last is represented, standing in front of her two-story house and characterized by a matronly veil. As in the left-hand scene of the same miniature, a high wall and a golden sky form the background.

Located beside Genesis 24:49.

344b. Ser., fol. 94r

The gifts are here being presented to Rebekah herself, who wears the same dress as in the preceding and following miniatures of this manuscript, and to the youthful, beardless Laban. Rebekah holds a heavy golden ring in her hands while Abraham's servant presents her with another one, and the camel driver lays a

raiment on the ground, where several others have already accumulated. The house belonging to Rebekah's parents is the only remaining indication of background.

Located beside Genesis 24:66.

345b. Sm., fol. 37v

Very close to Ser.

346b. Vat. 746, fol. 87v

Very close to Ser. and Sm. and badly flaked.

Located beside Genesis 24:32; its proper place is in the following space, beside Genesis 24:56 (see no. 276).

Lit.: Uspenskii, pp. 132–33, fig. 50; Hesseling, fig. 87; Hempel, "Traditionen," p. 56 n. 19; Mütherich, "Psalterillustration," p. 172.

Genesis 24:59–61

ELIEZER RETURNS WITH REBEKAH

347. Vat. 747, fol. 46r

On her way to meet Isaac, Rebekah rides on one of Abraham's camels, led by the driver, while the chief servant follows, carrying his mantle over a shouldered staff. The scene is placed before a landscape of high mountains. Rebekah's head and other parts of the surface are flaked.

Located beside Genesis 24:63.

348. Ser., fol. 94r

The inscription reads: ἔνθα λαβόντες τὴν ρεβέκκαν ὑποστρέφουσι χαίροντες.

Close to Vat. 747 but without a landscape and augmented by a man marching alongside the camel driver. Apparently the man is meant to represent Abraham's servant who in Vat. 747 walks behind the camels. Consequently the man placed behind the animals in Ser. should represent Laban bidding farewell to his departing sister, as implied by the first words of verse 59. Flaked in several places.

Located beside Genesis 24:67.

349. Sm., fol. 37v

The inscription reads: ἔνθα λαβόντες τὴν ρεβέκκαν ὑποστρέφουσι χαίροντες.

Very close to Ser., and somewhat rubbed and flaked.

Located below Genesis 24:61.

350. Vat. 746, fol. 88v

The inscription reads: ἔνθα λαβόντες τὴν ρεβέκκαν ὑποστρέφουσι χαίροντες.

Very close to Ser. and Sm. Rebekah's head and the lower left corner are rubbed.

Located beside Genesis 24:56; its proper place is in the following space, beside Genesis 24:65 (see no. 276).

Lit.: Uspenskii, p. 133; Hesseling, fig. 88; Kitzinger, *Monreale*, p. 62; Mütherich, "Psalterillustration," p. 172.

Genesis 25:6

Abraham Gives Gifts to His Concubines' Sons

351a. Vat. 747, fol. 46v

Abraham presents his concubines' sons with gifts and tells them to go to the east of the country. The illustrator has depicted three of the many sons mentioned in the text: the first extends his arms and bows to Abraham respectfully, while the second turns around and speaks to the third. The gifts lying on the ground consist of a bowl, a ring, a vessel with handles (all in gold), and a red raiment. The scene takes place in front of a mountain range.

Located beside Genesis 25:9.

352a. Ser., fol. 94v

The inscription reads: ἔνθα δίδωσι τοῖς ἐκ τῶν παλλακῶν υἱ(οῖς) αὐτοῦ δόματα ὁ ἀβραάμ.

The sons are more closely grouped and much more numerous than in Vat. 747. Abraham gestures as if putting gifts into the open hands of the foremost sons. No such objects are visible, although we would assume that they existed in an earlier model.

Located beside Genesis 25:11.

353a. Sm., fol. 38r

The inscription reads: ἔνθα δίδωσι τ(οῖς) ἐκ τῶν παλλακ(ῶν) υἱ(οῖς) αὐτ(οῦ) δόματα ὁ ἀβραάμ.

Very close to Ser.

354a. Vat. 746, fol. 89r

The inscription, for which the scribe did not find sufficient space within the frame, continues outside the left border. It reads: ἔνθα δίδωσι τοῖς ἐκ τῶν παλλακῶν υἱοῖς αὐτοῦ δόματα ὁ ἀβραάμ.

Very close to Ser. and Sm.

Located beside Genesis 24:65; its proper place is in the following space, beside Genesis 25:9 (see no. 276).

Lit.: Uspenskii, p. 133; Hesseling, fig. 89; *Libro della Bibbia*, pl. 26.

Genesis 25:9–10

Burial of Abraham

351b. Vat. 747, fol. 46v

Abraham's corpse, nimbed and wrapped like a mummy, is lowered into a marble sarcophagus by his sons, Isaac and Ishmael, alongside Sarah's nimbed mummy. The man at the left, who is fully visible and takes the more prominent place at the head of the sarcophagus, is obviously Isaac; consequently the other, partly hidden by the foot of the sarcophagus and wearing a less distinct nimbus, must be Ishmael. The scene takes place within the cave of Mamre in the field of Ephron which Abraham had previously purchased.

Located beside Genesis 25:9.

352b. Ser., fol. 94v

The inscription reads: ἔνθα θανὼν θάπτετ(αι) μετ(ὰ) σάρρας ἐν τῷ διπλῷ μνημείῳ.

Very close to Vat. 747 but simplified by the omission of the cave of Mamre which is so essential to the scene. Moreover, the two corpses are not wrapped, and Abraham is the only figure with a nimbus in this copy. There is no distinction between the sons, who are treated as equals. Leaning against the sarcophagus is its lid, and only in this detail is Ser. more complete than Vat. 747. All the heads and bodies of the figures are flaked.

Located beside Genesis 25:11.

353b. Sm., fol. 38r

The inscription reads: ἔνθα θανὼν θάπτεται μετὰ σάρρας ἐν τῷ διπλῷ μνημείῳ.

Very close to Ser.

354b. Vat. 746, fol. 89r

The inscription reads: ἔνθα θανὸν θάπτετ(αι) μετὰ σάρρας ἐν τῷ διπλῷ μνημείῳ.

Very close to Ser. and Sm.

Located beside Genesis 24:65; its proper place is in the following space, beside Genesis 25:9 (see no. 276).

Lit.: Uspenskii, p. 133; Hesseling, fig. 89; *Libro della Bibbia*, pl. 26.

Genesis 25:21–22

Isaac Entreats God for Posterity

355a. Vat. 747, fol. 46v

Isaac prays that posterity be granted to his wife, and he raises his hands to the hand of God in heaven, set against a golden strip of sky. Rebekah sits before Isaac in a sorrowful attitude, resting her head on her arm. Within the fold of her paenula is a brown area with an undecipherable outlined brown object. Isaac stands

at the foot of the mountain, while Rebekah sits before her house, which has a tile roof and is linked by a wall to the building in the next scene at the right.

Located beside Genesis 25:23.

356a. Ser., fol. 95v

The inscription reads: ἔνθα δέετ(αι) ἰσαὰκ πε(ρὶ) τ(ῆ)ς στερώ(σεως) ρεβέκκας.

In contrast to Vat. 747, any indication of Rebekah's pregnancy is avoided. She is clad in a lacerna and the house behind her is reduced to a mere doorframe, while the landscape and footstool are omitted altogether. Otherwise the composition agrees with Vat. 747. Isaac's face is rubbed, and the figure of Rebekah is slightly damaged.

Located beside Genesis 25:24.

357a. Sm., fol. 38r

The inscription reads: ἔνθα δέεται ἰσαὰκ πε(ρὶ) τῆς στερώσε(ως) ρεβέκκας.

Very close to Ser.

358a. Vat. 746, fol. 89v

The inscription is written outside the frame and reads: ἔνθα δέετ(αι) ἰσαὰκ πε(ρὶ) τῆς στερώσεως ρεβέκκας.

Very close to Ser. and Sm. Both figures are somewhat flaked.

Located beside Genesis 25:9; its proper place is in the following space, below Genesis 25:23 (see no. 276).

Lit.: Uspenskii, p. 133, fig. 51; Hesseling, fig. 90; Menhardt, p. 309; *Libro della Bibbia*, pl. 26; Lassus, *Livre des Rois*, p. 85, fig. 107; Kirigin, *Mano divina*, p. 142; Grape-Albers, *Welt des Arztes*, fig. 188; Bernabò, "Laur. plut. 5.38," pp. 150, 151 n. 41, pl. II no. 1.

Genesis 25:24–26

Birth of Esau and Jacob

355b. Vat. 747, fol. 46v

Rebekah, clad only in a short undergarment, is supposed to be sitting on a delivery chair, which the illustrator forgot to paint. The twins' delivery is depicted with great realism. Rebekah's face and the attitude of her head express pain. Her left hand is clenched, while her right grasps the head of the midwife, who is sitting on the ground and delivering Jacob, the second-born son. As the text describes, Jacob touches the heel of Esau, the first-born, who lies on the ground, already delivered. In agreement with the text, Esau has hairy skin. The scene is set before the house, which in Hellenistic fashion is topped by trees.

Located beside Genesis 25:23.

356b. Ser., fol. 95v

The inscription reads: ἔνθα τίκτει δίδωμα.

Close to Vat. 747 but the pain of birth is less emphasized. Rebekah sits on a throne and the midwife on a low bench. In contrast to Vat. 747, the cubic house with an entrance door is not connected to the building in the left-hand scene; thus the two episodes are more distinctly separated from one another, as one would expect them to have been in the archetype.

Located beside Genesis 25:24.

357b. Sm., fol. 38r

The inscription reads: ἔνθα τίκτει δίδωμα.

Very close to Ser.

358b. Vat. 746, fol. 89v

The inscription reads: ἔνθα τίκτει δίδωμα.

Very close to Ser. and Sm. The scene is very rubbed, apparently intentionally.

Located beside Genesis 25:9; its proper place is in the following space, below Genesis 25:23 (see no. 276).

Lit.: Uspenskii, p. 133, fig. 51; Hesseling, fig. 90; Menhardt, p. 309; Henderson, "Influences," p. 178 n. 32; Lafontaine-Dosogne, *Iconographie de l'enfance*, vol. 1, pp. 84 n. 4, 99 n. 4, 103; *Libro della Bibbia*, pl. 26; Lassus, *Livre des Rois*, p. 85, fig. 107; Grape-Albers, *Welt des Arztes*, p. 83, fig. 188; Bernabò, "Laur. plut. 5.38," pp. 150, 151 n. 41; Dufrenne, *Psautier d'Utrecht*, p. 81 n. 76; Björnberg-Pardo, *Simson*, p. 257.

Genesis 25:29–31

Esau Returns from the Hunt

359a. Vat. 747, fol. 47r

Esau, wearing the puttees of a hunter and carrying a bow and quiver over his shoulder, returns from the field hungry and asks his brother to give him some pottage, vividly underscoring his request by pointing to his mouth. Jacob, barefoot and nimbed, stirs the kettle of boiling soup over an open fire. He turns his head to his brother and raises his left hand in a gesture of speech, telling him that he will comply with the request provided Esau sells him his birthright. The scene takes place before a mountainous landscape and the open door of Isaac's two-story house.

Located beside Genesis 25:32.

360a. Ser., fol. 96r

The inscription reads: ἔνθα ἑψῶν φακὸν ἰακὼβ αἰτεῖται παρὰ ἡσαῦ φαγεῖν.

Close to Vat. 747 except for a few details. Esau is bearded, his hair dishevelled, and instead of demonstrating his desire for food, he raises his right hand in a gesture of speech. Jacob has no nimbus. Moreover, the house is simplified and the landscape is omitted altogether. Both figures are partly flaked.

Located beside Genesis 25:32.

361a. Sm., fol. 38v

The inscription reads: ἔνθα ἐψῶν φακ(ὸν) ἰακὼβ αἰτεῖται παρὰ ἡσαῦ φαγ(εῖν).

Very close to Ser.

Located below Genesis 25:32.

362a. Vat. 746, fol. 90r

The inscription, for which the scribe did not find sufficient space within the frame, is placed outside it at the left. It reads: ἔνθα ἐψῶν φακὸν ἰακὼβ αἰτεῖται παρὰ ἡσαῦ φαγεῖν.

Very close to Ser. and Sm. The whole surface is very badly flaked.

Located below Genesis 25:23; its proper place is two spaces further on, beside Genesis 25:32 (see nos. 276 and 366b).

Lit.: Uspenskii, p. 133, fig. 52; Hesseling, fig. 91; Gerstinger, *Wiener Gen.,* p. 89, fig. 65; Menhardt, p. 309.

Genesis 25:34

Esau Sells His Birthright

359b. Vat. 747, fol. 47r

Jacob offers a bowl of lentil pottage to his tired brother who sits in front of his father's house, having first taken off the quiver and rested it against the entrance door. With one hand Esau takes the bowl, while he stretches the other out in a gesture confirming that he has sold his birthright.

Located beside Genesis 25:32.

360b. Ser., fol. 96r

The inscription reads: ἐνταῦθα φωμοῦ καὶ φακῆς πιπράσκει τὰ πρωτοτόκια ἡσαῦ.

Close to Vat. 747 but slightly different and more elaborate in some details. Behind Jacob, Isaac's house is depicted as an independent architectural unit, and the kettle of soup on the fire is repeated in the lower right corner. Esau has propped both quiver and bow against his chair and the movements of his hands are slightly different, although they express the same emotions as in Vat. 747. The surface is slightly flaked in various spots.

Located beside Genesis 25:32.

361b. Sm., fol. 38v

The inscription reads: ἐνταῦθα ψωμοῦ καὶ φακῆς πιπράσκει τὰ πρωτοτόκια ἡσαῦ.

Very close to Ser.

Located below Genesis 25:32.

362b. Vat. 746, fol. 90r

The inscription starts within the frame and continues beneath the lower border line. It reads: ἐνταῦθα ψωμοῦ καὶ φακῆς πιπράσκει τὰ πρωτοτόκια ἡσαῦ.

Very close to Ser. and Sm. The surface is badly flaked.

Located beside Genesis 25:23; its proper place is two spaces later, beside Genesis 25:32 (see nos. 276 and 366b).

Lit.: Uspenskii, p. 133, fig. 52; Hesseling, fig. 91; Gerstinger, *Wiener Gen.,* p. 89, fig. 65; Menhardt, pp. 309–10.

Genesis 26:7–8

Abimelech Sees Isaac Sporting with Rebekah

The two miniatures illustrating Abimelech's discovery that Rebekah is Isaac's wife and not his sister are reversed: the event depicted in the lower strip precedes the upper one. Since all of the manuscripts contain this error, it must have existed in a very early copy or perhaps in the archetype itself.

363b. Vat. 747, fol. 47v

In the center of the lower scene Isaac and Rebekah, both nimbed, calmly talk to each other. Apparently for the sake of dignity the painter avoided any indication of Isaac "sporting" with his wife as the text describes. Abimelech, the king of the Philistines, dressed like a Byzantine emperor, watches them from the balcony of his palace, its living quarters built over a portico. A group of three men stands at the left, one of them clothed in a long garment and with his arms crossed, while the other two are half naked and dark-skinned. They represent the inhabitants of Gerar who, according to verse 7, questioned Isaac about Rebekah even before Abimelech saw him with his wife. The scene is set before a rich landscape of mountains and grisaille-like houses of purely decorative significance. The faces of Isaac and Rebekah are completely destroyed, but otherwise the surface is only slightly damaged. Abimelech's palace has a porch with horseshoe arches resembling those in Islamic and Early Christian Syrian architecture.[1]

Located beside Genesis 26:17.

364b. Ser., fol. 97v

The inscription is a continuation of the one in the upper frieze (see the next scene).

The scene is arranged much as in Vat. 747 but expanded and somewhat different in details. Isaac and Rebekah, both without nimbi, are aware of being watched by Abimelech and look up at him, respectfully covering their hands as they face him. The king's palace is depicted as a walled city entered by a gate, now closed, in a marbled frame with a kind of porter's lodge above it. Abimelech, wearing a turban instead of a crown, looks out of the window of this lodge, the shutters of which are open. The Philistines who have followed Isaac and Rebekah are more numerous, fully dressed, and some are characterized by their beards as older men. A certain distance behind them a man and woman are hurrying to join the rest of the Philistines; they repeat Isaac and Rebekah physiognomically but are probably merely

genre figures introduced to fill the space in the left of the minia-
ture. All the figures and the architecture are slightly flaked.

Located beside Genesis 26:18.

365b. Sm., fol. 39r

For the inscription, see the next scene.

Very close to Ser., except for the center where a hole has been
patched with a new piece of parchment and then repainted by
the same crude hand that retouched so many miniatures in this
manuscript. On the basis of what was left of the original group
the restorer completed the left-hand figure correctly to resemble
a woman, although he had her turn her head toward the
Philistines instead of looking at Abimelech. The other figure,
which should represent Isaac, is restored incorrectly as a little
boy, revealing that the restorer completely misunderstood the
content of the scene.

366b. Vat. 746, fol. 90v

For the inscription, see the next scene.

Close to Ser. and the original parts of Sm. but there are devia-
tions in small details. Isaac is represented in a short tunic, bare-
foot, and crossing his arms. Moreover, there are some differences
in the Philistines' movements and the hurrying man at the left is
seen from the front and no longer holds his wife by the arm.
Slightly flaked.

Located beside Genesis 25:25; yet the painter confused a blank
space at the bottom of the page after the end of the text with a
space intentionally left blank for a miniature and erroneously
executed a painting there. Consequently, the sequence of minia-
tures has been disrupted a second time (see no. 276) and the
proper place of the present miniature is two spaces further on,
beside Genesis 26:17.

Lit.: Uspenskii, p. 133, fig. 53; Hesseling, fig. 92; Gerstinger, *Wiener Gen.*,
p. 89, fig. 68; Buberl, *Byz. Hss.*, p. 100; Menhardt, p. 310.

[1] Cf. K. A. C. Creswell, *Early Muslim Architecture*, 2d ed. (Oxford,
1969), vol. 1, pt. 1, figs. 105, 173, and pp. 198–201 for the origin of the
horseshoe arch; E. T. De Wald, "The Appearance of the Horseshoe Arch in
Western Europe," *AJA* 26 (1922), pp. 317–19, figs. 1, 2.

Genesis 26:9

ISAAC AND REBEKAH BEFORE ABIMELECH

363a. Vat. 747, fol. 47v

Having watched Isaac and Rebekah from his palace in the first
scene, Abimelech orders the pair to appear before him in the sec-
ond. The central group of Isaac and Rebekah looking at the king
of the Philistines corresponds very closely to the same group in
the first scene, except that Isaac is bowing slightly, thereby
expressing devotion or fear, and Rebekah hides her left hand
under her mantle and thus no longer speaks to her husband, but
simply awaits tensely the outcome of the inquiry. Clad like a

Byzantine emperor, Abimelech sits on a throne before a bal-
dachin and raises his hand in a gesture of speech. His head is
overpainted, and the restorer replaced the original short pearled
crown (cf. the picture below) with a taller one of late Byzantine
type. Two dark-skinned Philistines stand at the left. One, clad in
a long striped garment and with his arms crossed, appears to be a
court official. He turns his head toward a half-naked Philistine,
apparently a commoner, who speaks vehemently, probably re-
porting what he has seen transpiring between Isaac and Rebekah.
The background is formed by a range of high mountains, although
the scene is, of course, to be thought of as taking place within the
palace.

Located beside Genesis 26:17.

364a. Ser., fol. 97v

The inscription reads: ἡ εἰς τὰ γέραρα οἴκησις ἰσαὰκ καὶ
διάλε, and, continuing in the miniature below: ξις ἀβιμέλεχ
περὶ ρεβέκκας.

Close to Vat. 747 but in detail it deviates in many ways and
the landscape is entirely omitted. With veiled hands, Isaac and
Rebekah approach Abimelech, who sits on a faldstool in front of
his houselike palace. Between them stands the court official with
crossed arms who in Vat. 747 was placed behind the couple, and
at the left, instead of one, are three hurrying Philistines with
their arms extended. They, as well as Abimelech and the court
official, wear turbans. Slightly stained and flaked.

Located beside Genesis 26:18.

365a. Sm., fol. 39r

The inscription reads: ἡ εἰς τὰ γέραρα οἴκησις ἰσαὰκ καὶ
διάλεξις, and, continuing in the miniature below: ἀβιμέλεχ
πε(ρὶ) ρ[εβέκκας]. The last word was lost when a new piece of
parchment was inserted to cover a hole.

Very close to Ser.

366a. Vat. 746, fol. 90v

The inscription reads: ἡ εἰς τὰ γέραρα οἴκησις ἰσαὰκ καὶ
διάλεξις, and, continuing in the miniature below: πρὸς ἀβιμέ-
λεχ περὶ ρεβέκκας.

Very close to Ser. and Sm.

Located beside Genesis 25:25; its proper place is two spaces
further on, beside Genesis 26:17 (see no. 366b).

Lit.: Uspenskii, p. 133, fig. 53; Hesseling, fig. 92; Gerstinger, *Wiener Gen.*,
p. 89, fig. 68; Buberl, *Byz. Hss.*, p. 100; Menhardt, p. 310; *Image du noir*,
fig. 68.

Genesis 26:2–4 or 24

APPEARANCE OF GOD TO ISAAC

In the following miniatures, the scenes are once more reversed in
sequence and the representation at the right should precede the

one at the left. Moreover, in contrast to the other manuscripts, where the stars in the heavens and the violet background suggest that the appearance of God is the one referred to at Genesis 26:24, in Vat. 747 the scene might also refer to the appearance at Genesis 26:2–4.

367b. Vat. 747, fol. 48r

Standing at the foot of a high mountain, Isaac prays and looks up at God, whose blessing hand issues from a segment of heaven in the sky. Isaac's face and portions of the background are flaked.

Located beside Genesis 26:31.

Genesis 26:24

APPEARANCE OF GOD TO ISAAC IN THE NIGHT

368b. Ser., fol. 98r

Isaac, clad in a short tunic, stands in prayer before a dark violet background, whereby the painter tried to convey the impression of night. God, with a gesture of blessing, is depicted as a half figure leaning from a segment of heaven. The surface is flaked in many places.

Located beside Genesis 26:31.

369b. Sm., fol. 39v

Very close to Ser.
Located below Genesis 26:31.

370b. Vat. 746, fol. 91v

Very close to Ser. and Sm. The cloud of night is depicted in brown-black, and stars appear in the segment of heaven. The miniature has been overpainted. Slightly flaked and rubbed.

Located beside Genesis 25:32; its proper place is two spaces further on, beside Genesis 26:31 (see no. 366b).

Lit.: Uspenskii, pp. 134, 159, fig. 54; Hesseling, fig. 93; Bernabò, "Laur. plut. 5.38," p. 153 n. 45.

Genesis 26:27–29

MEETING OF ISAAC AND ABIMELECH

367a. Vat. 747, fol. 48r

Isaac and Abimelech make a covenant near the well which, according to the text, has just been dug. Isaac respectfully approaches the Philistine king and, extending his right hand in a gesture of speech, asks him why he has come. At the same time Isaac points with his left hand toward the well, just as Abimelech does with his right, in a gesture sealing their oath. In this way two consecutive actions are expressed simultaneously. Abimelech,

clad as usual in this manuscript as a Byzantine emperor, is surrounded by court officials who, according to verse 26, attend this meeting; they can be identified as Ahuzzath (LXX: Ochozath) and Phichol, commander-in-chief of the army. A mountain, with a house emerging behind the peaks in a purely decorative manner, forms the background. Isaac's and Abimelech's faces are badly flaked, as are portions of the ground.

Located beside Genesis 26:31.

368a. Ser., fol. 98r

The inscription reads: ἔνθα ἐγένοντο ὅρκοι ἀνὰ μεταξὺ ἰσαὰκ καὶ ἀβιμέλεχ.

Instead of pointing to the well, Isaac touches it with a wand, while Abimelech raises his right hand in a gesture of speech instead of joining Isaac in sealing the oath. One of Abimelech's two companions is omitted, and the other, dressed like his master in a short embroidered tunic and wearing a turban, stands under a tree. The whole surface is badly flaked.

Located beside Genesis 26:31.

369a. Sm., fol. 39v

The inscription reads: ἔνθα ἐγένοντο ὅρκοι ἀναμεταξὺ ἰσαὰκ καὶ ἀβιμέλεχ.

Very close to Ser.
Located below Genesis 26:31.

370a. Vat. 746, fol. 91v

The inscription reads: ἔνθα ἐγένοντο ὅρκοι ἀνὰ μεταξὺ ἰσαὰκ καὶ ἀβιμέλεχ.

Very close to Ser. and Sm. The figure of Isaac is partly rubbed.
Located beside Genesis 25:32; its proper place is two spaces further on, beside Genesis 26:31 (see no. 366b).

Lit.: Uspenskii, p. 134, fig. 54; Hesseling, fig. 93.

Genesis 27:1–5

ISAAC SENDS ESAU OUT FOR VENISON

371a. Vat. 747, fol. 48v

The aged and ill Isaac, lying with one leg under the other on his couch, has raised himself up and, with his arm thrust forward toward Esau, asks him for some venison. Although Isaac's head is slightly damaged just below the brows, it is nevertheless clear that, in accordance with verse 1, the illustrator represented his eyes as being closed, and he did so not only here, but also in the following scenes in this manuscript. Esau stands devotedly with crossed arms in front of his father, while at the left Rebekah peers out from behind the curtain of the entrance door to Isaac's house and listens to the conversation. A wall with slit windows and a golden strip form the background.

Located beside Genesis 27:27.

372a. Ser., fol. 99v

The inscription reads: ἀποστολὴ ἠσαῦ εἰς θήραν ἐκ τοῦ ἰσαάκ.

Although the general arrangement is the same as in Vat. 747, each figure is treated somewhat differently. Isaac sits on a chair and Esau, standing in front of him, holds his arms down, the left one being hidden in his mantle. Rebekah, who holds the hem of her mantle before her face, is fully visible in front of the house. All the figures are damaged by flaking.

Located beside Genesis 27:27.

373a. Sm., fol. 40r

The inscription reads: ἀποστολὴ ἠσαῦ εἰς θήραν ἐκ τοῦ ἰσαάκ. Very close to Ser.

Located below Genesis 27:25.

374a. Vat. 746, fol. 92v

The inscription reads: ἀποστολὴ ἠσαῦ εἰς θήραν ἐκ τοῦ ἰσαάκ. Very close to Ser. and Sm.

Located beside Genesis 26:17; its proper place is two spaces further on, below Genesis 27:27 (see no. 366b).

Lit.: Uspenskii, p. 134; Hesseling, fig. 94; Wilpert, *Mosaiken und Malereien*, vol. 1, p. 434, fig. 152; Menhardt, p. 310; Deckers, *S. Maria Magg.*, p. 65; Kötzsche-Breitenbruch, *Via Latina*, pl. 11d; De' Maffei, "Sant'Angelo in Formis II," pt. 2, p. 197, fig. 9.

Genesis 27:5

Esau Leaves for the Hunt

371b. Vat. 747, fol. 48v

Esau, on his way to hunt, leaves his father's house through the entrance door. He is depicted as a hunter with a bow in one hand and quiver in the other. A wall with slit windows forms the same kind of background as in the preceding scene at the left.

Located beside Genesis 27:27.

372b. Ser., fol. 99v

The same type of Esau is placed beneath a tree and all architectural surroundings are omitted. Apparently the illustrator did not want to represent him leaving for the hunt as in Vat. 747 but rather showed the hunt itself, with Esau searching for deer in a forest. The figure of Esau is badly flaked.

Located beside Genesis 27:27.

373b. Sm., fol. 40r

Very close to Ser.
Located below Genesis 27:25.

374b. Vat. 746, fol. 92v

Very close to Ser. and Sm.

Located beside Genesis 26:17; its proper place is two spaces further on, beside Genesis 27:27 (see no. 366b).

Lit.: Uspenskii, p. 134; Hesseling, fig. 94; Wilpert, *Mosaiken und Malereien*, vol. 1, p. 434, fig. 152; Menhardt, p. 310; Deckers, *S. Maria Magg.*, p. 65; Kötzsche-Breitenbruch, *Via Latina*, pl. 11d; De' Maffei, "Sant'Angelo in Formis II," pt. 2, p. 197, fig. 9; Bernabò, "Introduzione," p. xl n. 113.

Genesis 27:17–20

Jacob Offers Venison to Isaac

371c. Vat. 747, fol. 48v

Jacob offers a bowl of meat to his father, placing it on a table, while Isaac, lying on the couch, raises himself up and reaches for the bowl with both hands. Rebekah, who has prepared the meal to deceive Isaac, stands at the right with her right hand raised in a gesture of speech, which means that she has just instructed her favored son on how to act (verses 7–13), while with her left hand she holds her mantle in a gesture of slight embarrassment. All three figures are nimbed. The interior setting is indicated by a raised curtain which hangs on a lion's mask.

Located beside Genesis 27:27.

372c. Ser., fol. 99v

The inscription reads at the right: ρεβέκκα ὑποτιθεμένη τῷ ἰακὼβ κλέψαι τὴν εὐλογίαν, and at the left: ἰακὼβ εὐλογο-υμενο(ς) ὑπὸ ἰσαὰκ ἀπατηθέντο(ς).

Close to Vat. 747, but the naturalistic details are augmented by the skins of the kids with which Rebekah has covered the arms and neck of her favored son (verse 16), and by the loaf of bread on the table which Jacob offers to his father together with the meat. None of the three figures bears a nimbus. The whole surface is badly flaked.

Located beside Genesis 27:27.

373c. Sm., fol. 40r

The inscription at the right reads: ρεβέκκα ὑποτιθεμένη τῷ ἰακὼβ κλέψαι τὴν εὐλογίαν, and at the left: ἰακὼβ εὐλογου-μ(εν)ο(ς) ὑπὸ ἰσαὰκ ἀπατηθέντος.

Very close to Ser. The scene is partly flaked, rubbed, and over-painted.

Located below Genesis 27:25.

374c. Vat. 746, fol. 92v

The inscription at the right reads: ρεβέκκα ὑποτιθεμέ(νη) τῷ ἰακὼ(β) κλέψαι τὴν εὐλογίαν. The left half of the inscription is placed outside the frame and reads: ἰακὼβ εὐλογουμενο(ς) ὑπὸ ἰσαὰκ ἀπατηθέντο(ς).

Very close to Ser. and Sm.

Located beside Genesis 26:17; its proper place is two spaces further on, below Genesis 27:27 (see no. 366b).

Lit.: Uspenskii, p. 134; Hesseling, fig. 94; Wilpert, *Mosaiken und Malereien*, vol. 1, p. 434, fig. 152; Menhardt, p. 310; Brenk, *S. Maria Magg.*, p. 64;

Kötzsche-Breitenbruch, *Via Latina*, p. 65, pl. 11d; De' Maffei, "Sant'Angelo in Formis II," pt. 2, p. 198, fig. 9; Weitzmann, *SP*, pp. 42, 48.

Genesis 27:30–31

ESAU OFFERS VENISON TO ISAAC

375a. Vat. 747, fol. 49r

Esau, still armed with a quiver and bow, offers his father a golden bowl of venison. Isaac is reclining on the couch and apparently has no intention of raising himself up and taking the bowl, nor is a table visible on which to place it. In this way the illustrator distinguishes very clearly the refused meal from the one accepted from Jacob shown in the preceding scene (fig. 371c). A domed building indicates Isaac's house.

Located beside Genesis 27:38.

376a. Ser., fol. 101r

The first line of the inscription is related to this scene and reads: ήσαῦ διάγνωσις τῆς ἀπάτης.

In Ser., Sm., and Vat. 746 the subtle differentiation between the accepted and the refused meals is lost, and compositionally the offering of Esau's venison agrees very closely with the preceding scene (figs. 372c, 373c, 374c) in that Esau places the bowl on the table and Isaac has raised himself up and stretches out his hand to take it. The surface is slightly flaked in various spots.

Located beside Genesis 27:38.

377a. Sm., fol. 40v

The inscription, as far as it relates to this scene, reads: ήσαῦ διάγνωσις τῆς ἀπάτης.

Very close to Ser. Both figures are flaked around the chest.

Located below Genesis 27:38.

378a. Vat. 746, fol. 93r

The inscription reads: ήσαῦ διάγνωσις τῆς ἀπάτης.

Very close to Ser. and Sm.

Located beside Genesis 26:31; its proper place is two spaces further on, beside Genesis 27:38 (see no. 366b).

Lit.: Uspenskii, p. 134, fig. 55; Hesseling, fig. 95; Menhardt, p. 311; Deckers, *S. Maria Magg.*, p. 69.

Genesis 27:41

ESAU PURSUES JACOB

375b. Vat. 747, fol. 49r

The text, which merely mentions Esau's plan to kill his brother, is illustrated with a scene of the actual pursuit. Esau runs after Jacob, who flees and looks back fearfully at his brother. The scene takes place in front of the open door of Isaac's house, and the

painter may well have wanted to suggest that Jacob escaped into the interior of the house. The heads of both brothers are flaked.

Located beside Genesis 27:38.

376b. Ser., fol. 101r

The second half of the inscription, which relates to this scene, reads: καὶ ἀποδυσπέτησις ἐπὶ τῇ τῆς εὐλογίας στερήσει.

The figures agree with Vat. 747, but the architecture is omitted. Both figures are badly flaked.

Located beside Genesis 27:38.

377b. Sm., fol. 40v

The inscription reads: καὶ ἀποδυσπέτησις ἐπὶ τῇ τῆς εὐλογίας στερήσει.

Very close to Ser. Both figures are somewhat flaked.

Located below Genesis 27:38.

378b. Vat. 746, fol. 93r

The inscription reads: καὶ ἀποδυσπέτησις ἐπὶ τῇ τῆς εὐλογίας στερήσει.

Very close to Ser. and Sm. Both figures are somewhat flaked.

Located beside Genesis 26:31; its proper place is two spaces further on, beside Genesis 27:38 (see no. 366b).

Lit.: Uspenskii, p. 134, fig. 55; Hesseling, fig. 95; Menhardt, p. 311; Deckers, *S. Maria Magg.*, p. 69.

Genesis 27:42–45

REBEKAH ADVISES JACOB

379a. Vat. 747, fol. 49v

In the left half of the miniature, Rebekah sits in front of her two-story house and asks Jacob to go to Laban in Mesopotamia until his brother's rage has subsided. Jacob raises his hands as if he were still frightened. Contrary to the previous scenes of this manuscript, Rebekah has no nimbus. Slightly flaked.

Located beside Genesis 27:45.

380a. Ser., fol. 101v

The inscription, although written almost entirely between the figures of the right scene, pertains exclusively to the left scene. It reads: ρεβέκκας ὑποθῆκαι πρὸς ἰακὼβ καὶ ἀποστολὴ εἰς μεσοποταμίαν.

Close to Vat. 747, except that the wall behind Jacob is replaced by two flanking trees. Flaked in various places.

Located beside Genesis 27:43.

381a. Sm., fol. 41r

The inscription reads: ρεβέκκας ὑποθῆκαι πρὸς ἰακὼβ καὶ ἀποστολὴ εἰς μεσοποταμίαν.

Very close to Ser.

382a. Vat. 746, fol. 94v

The inscription starts within the frame, reading ρεβέκκας ὑποθῆκαι πρὸς ἰακὼβ, and continues in the left margin, reading καὶ ἀποστολὴ εἰς μεσοποταμίαν.

Very close to Ser. and Sm. The line of division between the two scenes is of a later date.

Located below Genesis 27:27; its proper place is two spaces further on, beside Genesis 27:43 (see no. 366b).

Lit.: Uspenskii, p. 134, fig. 56; Hesseling, fig. 96; Menhardt, p. 311.

Genesis 27:41

Rebekah Addresses Isaac

379b. Vat. 747, fol. 49v

Rebekah expresses her apprehension that Jacob might take a Canaanite wife and thus induces Isaac to send Jacob to Laban. In the miniature, Rebekah has just stepped out of a house which is topped by a small tempietto and addresses her husband who sits, quietly listening, in front of the entrance of another house.

Located beside Genesis 27:45.

380b. Ser., fol. 101v

The scene is reversed: Isaac sits at the left and his wife stands at the right. Rebekah's gesture of speech is more pronounced than in Vat. 747 and Isaac is also speaking, not merely listening. Flaked in various spots.

Located beside Genesis 27:43.

381b. Sm., fol. 41r

Close to Ser. but the architecture at the right is omitted.

382b. Vat. 746, fol. 94v

Because of the building at the right, the miniature is closer to Ser. than to Sm. A later hand has repeated the beginning of the inscription in crude letters.

Located below Genesis 27:27; its proper place is two spaces further on, beside Genesis 27:43 (see no. 366b).

Lit.: Uspenskii, p. 134, fig. 56; Hesseling, fig. 96; Menhardt, p. 311.

Genesis 28:1–2

Isaac Sends Jacob to Take a Wife

383. Vat. 747, fol. 49v

Isaac asks Jacob to go to Mesopotamia and take a wife from among Laban's daughters. Isaac, with sorrowful eyes, sits on a chair, while his son stands devotedly in front of him with arms crossed. Three buildings fill the whole background in a decorative manner. Slightly flaked.

Located beside Genesis 28:3.

384. Ser., fol. 102r

The inscription reads: ἰσαὰκ εὐλογία πρὸς ἰακὼβ καὶ ἀποστολὴ εἰς λάβαν.

The poses of the figures are slightly changed compared with those in Vat. 747. Isaac makes a gesture of blessing, and Jacob is already moving toward the right in preparation for his departure. Only one house is represented behind Isaac, while part of the background is filled with trees and plants.

Located beside Genesis 28:2.

385. Sm., fol. 41r

The inscription reads: ἰσαὰκ εὐλογία πρὸς ἰακὼβ καὶ ἀποστολὴ εἰς λάβαν.

Very close to Ser. Apparently overpainted.

Located below Genesis 28:2.

386. Vat. 746, fol. 96r

The inscription reads: ἰσαὰκ εὐλογία πρὸ(ς) ἰακὼβ κ(αὶ) ἀποστολὴ εἰς λάβαν.

Very close to Ser. and Sm.

Located beside Genesis 27:38; its proper place is two spaces further on, beside Genesis 28:4 (see no. 366b).

Lit.: Uspenskii, p. 134; Hesseling, fig. 97; Vileisis, "S. Maria Ant.," p. 40.

Genesis 28:9

Esau's Marriage

387. Vat. 747, fol. 49v

Esau takes as his wife Mahalath (LXX: Maeleth), the daughter of Ishmael and the sister of Nebajoth (LXX: Nabeoth). He holds the bride's wrist and raises his other hand in a gesture of speech, proposing to her, while the bride holds the hem of her mantle in a gesture of slight embarrassment. Behind Mahalath stands her sister, Nebajoth; the man at the left with crossed arms is probably a follower of Esau who witnesses the marriage ceremony. Ishmael sits at the right and extends his hand in a manner suggesting his willingness to give his daughter to Esau. His head and Esau's are overpainted, and the sword in Ishmael's hand is probably an addition made by the restorer. The scene, which is supposed to take place in the house of the bride's father, has a mountainous background. The upper part of the miniature particularly is very badly flaked.

Located below Genesis 28:9.

388. Ser., fol. 102r

The inscription is partly obliterated at the left but can easily be reconstructed with the help of Sm. and Vat. 746. It reads: ἠσαῦ λαμβάνων ἐκ τῶν τοῦ ἰσμαὴλ θυγατέρων πρὸς τ(αῖς) γυναιξὶν αὐτοῦ [καὶ ταύτην].

The chief participants in the marriage ceremony, the bridal couple and the father, are the same as in Vat. 747, but Nebajoth

and Esau's follower are omitted. On the other hand, we see a new figure added between Ishmael and Mahalath who, like Esau's follower, crosses his arms. Like Ishmael and his daughter, he wears a turban which obviously characterizes him as a servant of Ishmael. The left part of the miniature is partly torn.

Located beside Genesis 28:10.

389. *Sm., fol. 41r*

The inscription reads: ἠσαῦ λαμβάνων ἐκ τῶν τοῦ ἰσμαὴλ θυγατέρων πρὸς ταῖς γυναιξὶν αὐτ(οῦ) καὶ ταύτ(ην).

Very close to Ser. Flaked in various spots and overpainted.
Located below Genesis 28:6.

390. *Vat. 746, fol. 96v*

The inscription reads: ἠσαῦ λαμβάνων ἐκ τῶν τοῦ ἰσμαὴλ θυγατέρω(ν) πρὸ(ς) ταῖς γυναιξὶν αὐτοῦ καὶ ταύτη(ν).

Very close to Ser. and Sm. All the figures are somewhat flaked.

Located beside Genesis 27:43; its proper place is two spaces further on, beside Genesis 28:10 (see no. 366b).

Lit.: Uspenskii, p. 134; Hesseling, fig. 98; Menhardt, p. 311; Walter, "Dextrarum Junctio," pp. 281–82.

Genesis 28:11–13

Jacob's Dream

Jacob sleeps beneath the ladder, but the angel descending the ladder in Vat. 747 points his finger at the space toward the left, implying that originally Jacob was located to the left of the ladder.[1] It should be emphasized that the angels in Vat. 747 have no wings, an omission found in the Dura Europos depiction of the episode[2] and in the Early Christian custom of representing angels. The figure of the reclining Jacob is borrowed from an Endymion type.[3]

391. *Vat. 747, fol. 50r*

Jacob sleeps on the ground with his head resting on a stone. His body is somewhat raised and turned and his feet are twisted, features by which the painter sought to express restless, dream-filled sleep. Two angels without wings climb up a golden ladder which reaches from the ground to heaven, while between them a third, also without wings, walks down and points his finger toward the left. A bust of God blesses the angels from a segment of heaven set against a golden sky. High mountains form the background.

Located beside Genesis 28:14.

392. *Ser., fol. 102v*

The inscription reads: ἡ τῆς θείας κλίμακος καὶ τῶν ἀγγέλων καθ'ὕπνους ἰακὼβ ὀπτασία.

Close to Vat. 747 but the details vary slightly. Jacob, with his hand resting on a rock, lies in a somewhat more relaxed attitude.

Only two angels are represented, the lowermost of Vat. 747 being eliminated; they are winged, although each angel has only one wing, the other having been forgotten by the copyist. The upper angel, his left hand covered by his mantle, devotedly approaches heaven, which is studded with stars but lacks the figure of God. The mountain landscape is omitted, and all the figures are slightly flaked.

Located beside Genesis 28:14.

393. *Sm., fol. 41v*

The inscription reads: ἡ τῆς θείας κλίμακος καὶ τῶν ἀγγέλων καθ'ὕπνους ἰακὼβ ὀπτασία.

Very close to Ser.

394. *Vat. 746, fol. 97r*

The inscription reads: ἡ τῆς θείας κλίμακος τῶν ἀγγέλω(ν) καθ'ὕπνους ἰακὼβ ὀπτασία.

Close to Ser. and Sm., except that both angels have two wings. Slightly flaked.

Located beside Genesis 28:4; its proper place is two spaces further on, beside Genesis 28:14 (see no. 366b).

Lit.: De Grüneisen, "Cielo," p. 489; Uspenskii, p. 134, fig. 57; Hesseling, fig. 99; Wilpert, *Mosaiken und Malereien*, vol. 1, p. 437, figs. 153, 154; Clemen, *Monumentalmalerei*, p. 129, fig. 96 p. 128; Neuss, *Katalan. Bibelill.*, p. 44; Buchthal, *Paris Ps.*, p. 67 n. 11; Lowrie, *Art*, p. 213, pl. 144; Kraeling, *Synagogue*, p. 72 n. 199; Goodenough, *Symbols*, vol. 10, p. 167 n. 8, fig. 299; Gutmann, "Ashburnham Pent.," p. 72; Martin, *Heavenly Ladder*, pp. 14, 109, fig. 294; Menhardt, p. 311; Galavaris, *Gregory Naz.*, p. 136; Kötzsche-Breitenbruch, *Via Latina*, p. 68, pl. 12e; Al-Hamdani, "Sources," p. 25; Crown, "Winchester Ps.," p. 34; Bernabò, "Laur. plut. 5.38," p. 153 n. 45; Fink, *Bildfrömmigkeit*, p. 54; Vileisis, "S. Maria Ant.," p. 44; Buschhausen, "Via Latina," p. 299; Bergman, *Salerno*, p. 38; Brubaker, "Gregory of Naz.," pp. 389–90; Weitzmann, *Dura*, pp. 18–20, figs. 12, 13; Sed-Rajna, *Hebraic Bible*, p. 53 n. 32; Sed-Rajna, "Haggadah," p. 419.

[1] As seen, e.g., in the Homilies of Gregory Nazianzenus in Paris, Bibl. Nat., cod. gr. 510, fol. 174v (Weitzmann, *Dura*, pp. 18–20, fig. 11).

[2] Cf. Kraeling, *Synagogue*, pp. 72–74; Weitzmann, *Dura*, pp. 17–19.

[3] For ancient examples of this Endymion type, see *LIMC*, vol. 3, pt. 1, pp. 728–42; vol. 3, pt. 2, pp. 551–61.

Genesis 28:18

Jacob Pours Oil on the Stone

395. *Vat. 747, fol. 50r*

Jacob is pouring oil out of a horn over the stone which he has erected as a pillar on the top of a hillock. The scene takes place in a rich mountain landscape with grisaille architecture beyond the peaks.

Located beside Genesis 28:22.

396. *Ser., fol. 103v*

The inscription reads: ἡ τοῦ ἐλαίου πρὸς τὴν ἐκ λίθου στήλην ἄλειψις τοῦ ἰακώβ.

Less consistent with the text than Vat. 747: Jacob puts oil on a hillock instead of a pillar. The landscape is eliminated except for one tree.

Located beside Genesis 28:14.

397. Sm., fol. 41v

The inscription reads: ἡ τοῦ ἐλαίου πρὸς τὴν ἐκ λίθου στήλην ἄλειψις τοῦ ἰακώβ.

Very close to Ser.

Located below Genesis 28:19.

398. Vat. 746, fol. 97v

The inscription reads: ἡ τοῦ ἐλαίου πρὸς τὴν ἐκ λίθων στήλην ἄλειψις τοῦ ἰακώβ.

Very close to Ser. and Sm. Slightly flaked.

Located beside Genesis 28:10; its proper place is two spaces further on, beside Genesis 28:22 (see no. 366b).

Lit.: Uspenskii, p. 134; Hesseling, fig. 100; Lowrie, *Art*, pl. 144b; Menhardt, p. 312; Sed-Rajna, *Hebraic Bible*, p. 53 n. 37; Sed-Rajna, "Haggadah," p. 419.

Genesis 29:10

JACOB ROLLS THE STONE FROM THE WELL

Jacob's meeting with Rachel is represented in two scenes which, however, are combined in one miniature so that Rachel is depicted only once and relates to both scenes at the same time.

399a. Vat. 747, fol. 50v

In the scene at the left, Jacob lifts the stone covering the well, while Laban's flock is already drinking from the trough in front of it. Jacob's action is motivated by the appearance of Rachel, who is seen at the right following her father's flocks. In the center, half hidden by mountain slopes, is one of the shepherds of Haran with whom Jacob was conversing (verses 4–8) before Rachel arrived. High mountains with houses in grisaille form the background.

Located beside Genesis 29:10.

400a. Ser., fol. 104v

The inscription, which relates exclusively to the left scene, reads: ἡ τοῦ λίθου ἐκ τοῦ φρέατος μετακύλισις καὶ τῶν προβάτων πότισις ἡ ἐξ ἰακώβ.

Close to Vat. 747, except that the landscape is very simplified. Slightly flaked.

Located beside Genesis 29:11.

401a. Sm., fol. 42r

The inscription reads: ἡ τοῦ λίθου ἐκ τοῦ φρέατος μετακύλισις καὶ τῶν προβάτων πότισις ἡ ἐξ ἰακώβ.

Very close to Ser., except that Jacob carries a heavy load on one shoulder, perhaps intended as a repetition of the stone being lifted. Since the miniature was apparently grossly overpainted, it may very well be that this second stone, occurring in no other copy, was added by the restorer.

402a. Vat. 746, fol. 98r

The inscription reads: ἡ τοῦ λίθου ἐκ τοῦ φρέατο(ς) μετακύλισις καὶ τῶν προβάτων πότισις ἡ ἐξ ἰακώβ.

Very close to Ser. and Sm. Slightly flaked.

Located beside Genesis 28:14; its proper place is two spaces further on, beside Genesis 29:10 (see no. 366b).

Lit.: Uspenskii, p. 134; Hesseling, fig. 101; Menhardt, p. 312; Stahl, "Morgan M. 638," p. 123, fig. 156; Deckers, *S. Maria Magg.*, p. 76; Stahl, "Old Test. Ill.," p. 84, fig. 81.

Genesis 29:12

MEETING OF JACOB AND RACHEL

399b. Vat. 747, fol. 50v

Jacob, identified by his nimbus, has approached a bareheaded Rachel. Half hidden by a hillock, he raises his hand in a gesture of speech, apparently disclosing his identity; Rachel looks at him and answers with a corresponding gesture of speech. This pose relates her more closely to this second scene, in which Jacob and Rachel become acquainted, than to the preceding scene, of which she is likewise a part.

Located beside Genesis 29:10.

400b. Ser., fol. 104v

Jacob is represented in frontal view, and Rachel wears a sort of bonnet, but otherwise the scene agrees closely with Vat. 747. Slightly flaked.

Located beside Genesis 29:11.

401b. Sm., fol. 42v

Very close to Ser.

Located above Genesis 29:33.

402b. Vat. 746, fol. 98r

Very close to Ser. and Sm. Slightly flaked.

Located beside Genesis 28:14; its proper place is two spaces further on, beside Genesis 29:10 (see no. 366b).

Lit.: Uspenskii, p. 134; Hesseling, fig. 101; Brenk, *S. Maria Magg.*, pp. 65–67; Deckers, *S. Maria Magg.*, p. 76; Stahl, "Morgan M. 638," p. 123, fig. 156; Stahl, "Old Test. Ill.," p. 84, fig. 81.

Genesis 29:13

MEETING OF JACOB AND LABAN

403a. Vat. 747, fol. 51r

Surrounded by high mountains, Jacob and Laban meet, embracing and kissing each other with great affection. Laban is represented with a dark beard and wearing a long garment.

Located beside Genesis 29:31.

404a. Ser., fol. 106r

The inscription, as far as it relates to the left-hand scene, reads: ἡ ἀναγνώρισις λάβαν ἥ τε πρόσπτυξις.

Ser., Sm., and Vat. 746 show Laban followed by his flocks, making it clear that the meeting took place in the open field. The mountainous landscape is greatly reduced. Both figures are somewhat flaked.

Located beside Genesis 29:31.

405a. Sm., fol. 42v

The beginning of the inscription reads: ἡ ἀναγνώρισις λάβαν ἥ τε πρόσπτυξις.

Very close to Ser. Overpainted and flaked.

Located above Genesis 29:33.

406a. Vat. 746, fol. 98v

The inscription reads: ἡ ἀναγνώρισις λάβαν ἥ τε πρόσπτυξις.

Very close to Ser. and Sm.

Located beside Genesis 28:22; its proper place is two spaces further on, beside Genesis 29:31 (see no. 366b).

Lit.: Uspenskii, p. 135; Hesseling, fig. 102; Benson and Tselos, "Utrecht Ps.," p. 71, fig. 152; Brenk, *S. Maria Magg.*, pp. 65–67; Deckers, *S. Maria Magg.*, pp. 78–79.

Genesis 29:15–19

JACOB BETWEEN LEAH AND RACHEL

403b. Vat. 747, fol. 51r

Jacob stands in front of Laban's house between his uncle's two daughters. With a gesture of amazement, Jacob turns to the woman at the left, who holds his full attention; she surely represents Rachel, who seems pleased and very conscious of Jacob's glances. Leah at the right gestures in speech and apparently is vainly trying to attract Jacob's attention. The two sisters wear tunics, with pallas covering their heads.[1]

Located beside Genesis 29:31.

404b. Ser., fol. 106r

The second half of the inscription reads: καὶ ἡ μετὰ χαρᾶς ἰακὼβ ὑποδοχὴ καὶ παράσχεσις τῶν γυναικῶν.

The grouping of the three figures is the same as in Vat. 747, but the expressions of the characters are slightly different, as are the clothes worn by the women, i.e., a tunic, a palla covering the head, and a sort of bonnet. Although in this case, too, Jacob affectionately turns to Rachel at the left, they both look compassionately at Leah, who holds the hem of her mantle before her face in a gesture implying sorrow or weeping. Laban's house is omitted.

Located beside Genesis 29:31.

405b. Sm., fol. 42v

The second half of the inscription reads: καὶ ἡ μετὰ χαρᾶς ἰακὼβ ὑποδοχ(ὴ) καὶ παράσχεσις τῶν γυναικῶν.

Close to Ser. except that Jacob has a short beard.

Located above Genesis 29:33.

406b. Vat. 746, fol. 98v

The part of the inscription that refers to this scene is written in the left margin and reads: καὶ ἡ μετὰ χαρᾶς ἰακὼβ ὑποδοχὴ καὶ παράσχεσις τῶν γυναικῶν.

Very close to Sm.

Located beside Genesis 28:22; its proper place is two spaces further on, beside Genesis 29:31 (see no. 366b).

Lit.: Uspenskii, p. 135; Hesseling, fig. 102; Brenk, *S. Maria Magg.*, pp. 65–67; Deckers, *S. Maria Magg.*, pp. 78–79; Stahl, "Morgan M. 638," p. 125–26.

[1] The difference between Rachel's clothes in this scene and in that of the meeting with Jacob, in both Vat. 747 and in the other Octateuchs (see figs. 399–402), has been noted by Brenk, *S. Maria Magg.*, pp. 66–67.

Genesis 29:32–35

CHILDREN OF JACOB AND LEAH

407. Vat. 747, fol. 51v

Leah presents to her husband the four sons she has borne him. Jacob rests his left hand on the shoulder of the boy at the extreme left, probably Reuben, the firstborn. The other three, then, would be in sequence: Simeon, the second, looking at his older brother, and Levi and Judah, the third and fourth, embracing each other affectionately. On the other hand, the attitude of the two brothers suggests that they are Simeon and Levi, who are mentioned together in various places in the text and are blessed together by Jacob in Genesis 49:5–7. A domed building fills the central background, and a two-story house topped by a drapery is placed at the right.

Located beside Genesis 29:34.

408. Ser., fol. 106v

The inscription reads: εὐχαριστία λείας ἐπὶ τῇ παιδοποιία.

The four boys are aligned in a more monotonous way than in Vat. 747, each of them standing frontally with crossed arms. The bearded Jacob does not touch his eldest son; he looks at Leah, who is turned in profile, and presents her four sons with a vehement gesture. The family group is placed between a hillock at the left and a house at the right.

Located beside Genesis 29:34.

409. Sm., fol. 43r

The inscription reads: εὐχαριστία λεί(ας) ἐπὶ τῇ πολυπαιδία.
Very close to Ser. The miniature has been grossly overpainted.
Located above Genesis 30:4.

410. Vat. 746, fol. 99v

The inscription reads: εὐχαριστεία λείας ἐπὶ τῇ πολυπαιδία.
Very close to Ser. and Sm. Partly flaked.
Located beside Genesis 29:10; its proper place is two spaces further on, beside Genesis 29:35 (see no. 366b).

Lit.: Uspenskii, p. 135, fig. 58; Hesseling, fig. 103; Tsuji, "Nouvelles observations," p. 42.

Genesis 30:3–4

RACHEL GIVES BILHAH TO JACOB

The general layout and the individual figures in Ser., Sm., and Vat. 746 duplicate Jacob between Leah and Rachel (figs. 403b–406b).

411. Vat. 747, fol. 51v

Rachel, grieving that she has not borne Jacob any children, persuades her husband to have a child by her maid, Bilhah (LXX: Balla). Jacob stands in the center in a dignified pose; the woman at the right is apparently Rachel, her gesture of speech corresponding with that of Rachel in the preceding miniature (fig. 407). The figure at the left, then, would be Bilhah, who puts her hand assuringly on Jacob's shoulder, encouraging him to follow her. The scene is placed between a house surmounted by a drapery at the left and a two-story house with an open entrance at the right.

Located beside Genesis 30:4.

412. Ser., fol. 107r

The inscription reads: παροχὴ τῆς παιδίσκης βάλλας ἐκ ραχὴλ καὶ [τεκ]νοποί[ησις].
Close to Vat. 747, but the expressions of the figures have been changed. Rachel at the right holds the hem of her mantle before

her face in a gesture of grief or weeping, while Jacob looks at her with compassion and at the same time turns toward Bilhah. It should be noted that this group is an almost exact repetition of the scene in which Jacob stands between Rachel and Leah (fig. 404), which makes it appear less individualized than the portrayal in Vat. 747. The scene is framed by a hillock at the left and a simple house at the right.

Located beside Genesis 30:4.

413. Sm., fol. 43r

The inscription reads: παροχὴ τῆς παιδίσκης βάλλας ἐκ ραχὴλ καὶ τεκνοποίησις.
Very close to Ser. Apparently the miniature was heavily overpainted.
Located below Genesis 30:5.

414. Vat. 746, fol. 101r

The inscription reads: παροχὴ τῆς παιδίσκης βάλλας ἐκ ραχὴλ καὶ τεκνοποίησις.
Very close to Ser. and Sm.
Located beside Genesis 29:31; its proper place is two spaces further on, beside Genesis 30:4 (see no. 366b).

Lit.: Uspenskii, p. 135, fig. 59; Hesseling, fig. 104; Bernabò, "Agar e Ismaele," pp. 219–20, figs. 8, 9.

Genesis 30:14–15

REUBEN FINDS MANDRAKES

Although mandrakes are actually roots, the painters took the Greek expression μῆλα μανδραγορῶν (Gen 30:14) literally and represented them as apples.[1]

415. Vat. 747, fol. 52r

Reuben runs to his mother with mandrakes in both hands and offers her one of them. Leah reaches for the gift and turns her head to her sister Rachel, who has asked for a share of Reuben's find and stretches out her hands for some of the fruit. Presumably the painter meant them to have been picked from the fruit tree behind Reuben. High mountains with grisaille architecture form the background.

Located beside Genesis 30:18.

416. Ser., fol. 108r

The inscription reads: ἡ τῶν μανδραγόρω(ν) μήλων εὕρεσις.
Reuben holds three mandrakes the shape and color of red apples in his right hand. Both women look at him, wanting the fruit. Except for the fruit tree, there is no landscape. Slightly torn and stained at the lower left corner.

Located beside Genesis 30:18.

417. Sm., fol. 43v

The inscription reads: ἡ τῶν μανδραγόρων μήλ(ων) εὕρεσις.
Very close to Ser.
Located below Genesis 30:18.

418. Vat. 746, fol. 101v

The inscription reads: ἡ τῶν μανδραγόρων μήλων εὕρεσις.
Very close to Ser. and Sm. The border line is omitted.
Located beside Genesis 29:35; its proper place is two spaces further on, beside Genesis 30:17 (see no. 366b).

Lit.: Uspenskii, p. 135; Hesseling, fig. 105; Menhardt, p. 312.

¹ In the pseudepigraphic Testament of Issachar (1:5) the plant brought by Reuben is described as a fragrant fruit which grew in the land of Haran (*OTP*, vol. 2, p. 802). The tradition of the apple is also known by the later writer Bar Hebraeus (Gregory Abū'l-Faraj) (*Barhebraeus' Scholia*, p. 75).

Genesis 30:37

JACOB PREPARES THE RODS

419a. Vat. 747, fol. 53r

At the left, Jacob holds a rod from which, according to the text, he has peeled white strips that produced speckled, streaked, and spotted sheep. This action has the blessing of God, whose hand protrudes from a small segment of heaven set against a golden sky. Part of Jacob's flock grazes in front of him.
Located beside Genesis 31:1.

420a. Ser., fol. 110r

The first part of the inscription, relating to the scene at the left, reads: ἰακὼβ λεπίζων τὰς ῥάβδ(ους).
Close to Vat. 747, except that God's blessing hand and the landscape background are omitted. Somewhat flaked.
Located beside Genesis 31:1.

421a. Sm., fol. 44v

The inscription reads: ἰακὼβ λεπίζων τ(ὰς) ῥάβδους.
Very close to Ser. Partly flaked.
Located above Genesis 31:5.

422a. Vat. 746, fol. 102v

The inscription reads: ἰακὼβ λεπίζων τὰς ῥάβδους.
Very close to Ser. and Sm.
Located beside Genesis 30:4; its proper place is two spaces further on, beside Genesis 31:1 (see no. 366b).

Lit.: Uspenskii, p. 135; Hesseling, fig. 106; Wilpert, *Mosaiken und Malereien*, vol. 1, p. 442, fig. 156; Gerstinger, *Wiener Gen.*, p. 91, fig. 69; Buberl, *Byz. Hss.*, p. 101; Brenk, *S. Maria Magg.*, p. 73; Deckers, *S. Maria Magg.*, pp. 96–97; Sed-Rajna, *Hebraic Bible*, p. 53 n. 44.

Genesis 30:38–39

JACOB LAYS THE RODS IN
THE WATERING TROUGHS

419b. Vat. 747, fol. 53r

In the right-hand scene, Jacob places one of the peeled rods in a golden basin representing the gutter of the watering trough. Two more rods are propped against the rim of the vessel, from which the flock is drinking. In the background two goats are fighting each other, forming a heraldic group.
Located beside Genesis 31:1.

420b. Ser., fol. 110r

The second half of the inscription reads: καὶ ἐν τοῖς ποτιστηρίοις τῶν προβάτων ἐμβάλλων.
Jacob has placed all the rods he has peeled in the basin. Only the heads of the two fighting goats are visible, but the herd is augmented by some cattle and a watchdog.
Located beside Genesis 31:1

421b. Sm., fol. 44v

The inscription reads: καὶ ἐν τ(οῖς) ποτιστηρίοις τῶν προβάτ(ων) ἐμβάλλων.
Very close to Ser. The figure of Jacob and the flock at his feet are badly flaked.
Located above Genesis 31:5.

422b. Vat. 746, fol. 102v

The inscription reads: καὶ ἐν τοῖς ποτιστηρίοις τῶν προβάτω(ν) ἐμβάλλων.
Very close to Ser. and Sm.
Located beside Genesis 30:4; its proper place is two spaces further on, beside Genesis 31:1 (see no. 366b).

Lit.: Uspenskii, p. 135; Hesseling, fig. 106; Wilpert, *Mosaiken und Malereien*, vol. 1, p. 442, fig. 156; Gerstinger, *Wiener Gen.*, p. 91, fig. 69; Buberl, *Byz. Hss.*, p. 101; Brenk, *S. Maria Magg.*, p. 73; Deckers, *S. Maria Magg.*, pp. 96–97; Sed-Rajna, *Hebraic Bible*, p. 53 n. 44.

Genesis 31:3

GOD ORDERS JACOB TO RETURN TO
THE LAND OF HIS FATHERS

423a. Vat. 747, fol. 53v

God's order that Jacob return to the land of his fathers is illustrated in the left-hand scene of this miniature. Jacob, in prayer, looks up to the blessing hand of God issuing from a segment of heaven.
Located beside Genesis 31:13.

Ser., fol. 111r

Blank space for an unexecuted miniature.
Located beside Genesis 31:13.

424a. Sm., fol. 45r

Close to Vat. 747.
Located above the catena.

425a. Vat. 746, fol. 103r

Very close to Sm.
Located beside Genesis 30:17; its proper place is two spaces
further on, beside Genesis 31:13 (see no. 366b).

Lit.: Uspenskii, p. 135; Hesseling, fig. 107; Brenk, *S. Maria Magg.*, p. 73;
Deckers, *S. Maria Magg.*, pp. 98, 101; De' Maffei, "Sant'Angelo in Formis
II," pt. 1, p. 32.

Genesis 31:4–16

Jacob Informs Leah and Rachel about His Return

423b. Vat. 747, fol. 53v

In the right half of the miniature, Jacob talks to Leah and
Rachel, whom he persuades to return with him to the land of his
fathers. One of his wives turns away from him slightly as if she
were not quite prepared to leave, while the other seems to con-
sent eagerly. These expressions have no support in the text.
Located beside Genesis 31:13.

Ser., fol. 111r

Blank space for an unexecuted miniature.
Located beside Genesis 31:13.

424b. Sm., fol. 45r

The inscription reads: ἐνταῦθα ἰακὼβ συμβουλευόμενος
μετὰ τῶν γυναικ(ῶν) περὶ τῆς εἰς τὰ ἴδια ὑποστροφ(ῆ)ς.
Compared with Vat. 747, Rachel and Leah are represented
more monotonously, standing side by side in similar poses and
looking at Jacob. But the scene is more detailed in that some
sheep, goats, and oxen are included, indicating that the meeting
took place in the "plain where the flocks were."
Located above the catena.

425b. Vat. 746, fol. 103r

The inscription reads: ἐνταῦθ(α) ἰακὼβ συμβουλευόμ(εν)ο(ς)
μετὰ τ(ῶν) γυναικῶν πε(ρὶ) τῆς εἰς τὰ ἴδια ὑποστροφῆς.
Very close to Sm.
Located beside Genesis 30:17; its proper place is two spaces
further on, beside Genesis 31:13 (see no. 366b).

Lit.: Uspenskii, p. 135; Hesseling, fig. 107; Galavaris, *Gregory Naz.*, p. 136;
Brenk, *S. Maria Magg.*, p. 73; Deckers, *S. Maria Magg.*, pp. 98, 101;
De' Maffei, "Sant'Angelo in Formis II," pt. 1, p. 32.

Genesis 31:26–35

Laban Reproaches Jacob

426. Vat. 747, fol. 54r

Laban rushes toward Jacob with impassioned gestures, re-
proaching him for having stolen his idols. Jacob faces him in a
dignified manner, refuting the accusation with his left hand and
with his right hand indicating with a gesture of speech that
Laban may kill the person with whom the idols are found. At the
right, Rachel and Leah sit on a camel's packsaddle, and there can
be no doubt that the woman in the foreground, wearing a trou-
bled look and gesturing nervously in protest, is Rachel, whose
feeling of guilt is clearly expressed. According to the Septuagint,
Rachel and Leah were searched independently, each in her own
tent (verses 33–34), and thus this miniature conflates different
episodes. Laban is followed by some of his brothers (see verse 23),
whose heads and busts were entirely overpainted by the Palaiolo-
gan restorer. Laban's face and parts of the ground are slightly
flaked.
Located beside Genesis 31:42.

Ser., fol. 112v

Blank space for an unexecuted miniature.
Located beside Genesis 31:41.

427. Sm., fol. 45v

Only the first part of the inscription relates to this scene. It
reads: ἐνταῦθα κ(α)τ(α)λαμβάνεται φεύγων ὁ ἰακὼβ.
Close to Vat. 747 except for slight changes in the costumes
and the gestures, particularly those of Rachel, which are less
expressive. Furthermore, some of Jacob's cattle and camels,
absent in Vat. 747, are depicted between Laban and Jacob, and
the women are sitting under a tree, although, according to the
text, the inquiry takes place in Rachel's tent (verses 34–35).

428. Vat. 746, fol. 105v

The beginning of the inscription reads: ἐνταῦθα καταλαμ-
βάνεται φεύγων ὁ ἰακὼβ.
Close to Sm. Under Rachel's saddle, the head and arms of
what is supposed to be a stolen idol are visible. Rachel is distin-
guished by a pearl diadem worn underneath her paenula. Jacob's
face is entirely flaked, whereas the other figures and the flocks are
only slightly damaged.
Located beside Genesis 31:1; its proper place is two spaces fur-
ther on, beside Genesis 31:41 (see no. 366b).

Lit.: Uspenskii, p. 135; Hesseling, fig. 108; Gerstinger, *Wiener Gen.*, p. 92,
fig. 70; Buberl, *Byz. Hss.*, p. 103; Hutter, "Übermalungen," p. 141; Weitz-
mann, *SP*, p. 43.

Genesis 31:51–54

COVENANT BETWEEN JACOB AND LABAN

429a. Vat. 747, fol. 54v

In the left half of the miniature Laban and Jacob make a covenant, standing on either side of a pillar that they have erected as witness to their oath. The pillar has the shape of a two-story building with slit windows; a flame burns on its top. Two different features are combined here: the pillar refers to the demarcation of boundaries and to the swearing of the oath described in verses 51–53, and the flame to the offering of a sacrifice mentioned at the beginning of verse 54. The gestures of Laban at the left plainly render the act of swearing, whereas those of Jacob, who raises his hand in prayer before the flame, apply rather to the sacrifice, which has God's approval, as indicated by the rays falling on the flame from a segment of heaven.

Located beside Genesis 32:4.

Ser., fol. 113r

Blank space for an unexecuted miniature.
Located beside Genesis 32:4.

430a. Sm., fol. 46r

The inscription that belongs to this scene has erroneously been placed on the ground of the preceding miniature (fig. 427), where it forms the second part of the inscription, the first half of which is correctly placed. The second part reads: καὶ γίνεται ὅρκο(ς) ἐξ ἀμφοτέρω(ν).

At the left of this miniature, which combines no fewer than three scenes within one frame, we recognize the bearded Laban at the left and the youthful Jacob at the right of the pillar, which is here without a flame. Thus, the copyist confined himself to the illustration of the oath, without making reference to the sacrifice.

431a. Vat. 746, fol. 106r

As in Sm., the inscription relevant to this scene forms a continuation of the one accompanying the preceding miniature (fig. 428). It reads: καὶ γίνεται ὅρκος ἐξ ἀμφοτέρων.

Very close to Sm.

Located beside Genesis 31:13; its proper place is two spaces further on, beside Genesis 32:2 (see no. 366b).

Lit.: Uspenskii, p. 135; Hesseling, fig. 109; De' Maffei, "Sant'Angelo in Formis II," pt. 1, p. 32.

Genesis 31:54

FEAST AFTER THE COVENANT

429b. Vat. 747, fol. 54v

The two parties to the oath feast together: Jacob sits at the left with his two wives, while Laban and his brothers are seated on

the right side of the table. Jacob and Laban are conversing with each other.

Located beside Genesis 32:4.

Ser., fol. 113r

Blank space for an unexecuted miniature.
Located beside Genesis 32:4.

430b. Sm., fol. 46r

The first part of the inscription, relating to the feast, reads: ἐνταῦθα φαγόντες ἀσπάζονται.

Compared with Vat. 747, the scene is abbreviated in that only two men sit between Laban, this time at the left, and Jacob at the right. On the other hand, it is enriched by the addition of a servant boy who offers a cup to Jacob.

431b. Vat. 746, fol. 106r

The inscription reads: ἐνταῦθα φαγόντες ἀσπάζονται.
Very close to Sm. Slightly flaked.
Located beside Genesis 31:13; its proper place is two spaces further on, beside Genesis 32:2 (see no. 366b).

Lit.: Uspenskii, p. 135; Hesseling, fig. 109; Gutmann, "Ashburnham Pent.," p. 72; De' Maffei, "Sant'Angelo in Formis II," pt. 1, p. 32; Bernabò, "Laur. plut. 5.38," p. 156 n. 48.

Genesis 32:1

EMBRACE OF JACOB AND LABAN

Ser., fol. 113r

Since Ser. is always closer to Sm. and Vat. 746 than to Vat. 747, it can justifiably be assumed that the same lacuna which was prepared for the two preceding scenes was also intended to contain the scene of Laban's departure, included in Sm. and Vat. 746 but lacking in Vat. 747.

Located beside Genesis 32:4.

430c. Sm., fol. 46r

The second part of the inscription reads: καὶ διΐστανται.

Laban and Jacob embrace and kiss each other before taking their leave. The copyist has deviated from the text, according to which Laban kissed only his sons and daughters, but the deviation seems to have been done consciously to give greater significance to the departure by showing the heads of the families.

431c. Vat. 746, fol. 106r

The inscription reads: καὶ διΐστανται.
Very close to Sm. The heads are somewhat rubbed.
Located beside Genesis 31:13; its proper place is two spaces further on, beside Genesis 32:2 (see no. 366b).

Lit.: Uspenskii, p. 135; Hesseling, fig. 109.

Genesis 32:2–3

JACOB MEETS THE ANGELS

432a. Vat. 747, fol. 54v

In the left half of the upper strip Jacob is shown bowing deeply to a group of angels, the host of God, at a place called Nahanaim, which the Septuagint translates as "encampments." All the figures are overpainted and partially flaked.

Located beside Genesis 32:21.

Ser., fol. 114r

Blank space for an unexecuted miniature.
Located beside Genesis 32:21.

433a. Sm., fol. 46v

The inscription reads: ἡ τῶν ἀγγέλων τοῦ θ(εο)ῦ ὑπάντησις καὶ ἡ θεία παρεμβολ(ή).

With open arms, Jacob approaches the group of angels moving toward him with gestures of greeting and blessing.

434a. Vat. 746, fol. 108r

The inscription reads: ἡ τ(ῶν) ἀγγέλων τοῦ θ(εο)ῦ ὑπάντησις καὶ ἡ παρεμβολή.

Very close to Sm. Slightly flaked.

Located beside Genesis 31:41; its proper place is two spaces further on, beside Genesis 32:21 (see no. 366b).

Lit.: Uspenskii, p. 135; Hesseling, fig. 110; Gerstinger, *Wiener Gen.*, p. 73, fig. 72; Buberl, *Byz. Hss.*, p. 104; Revel, "Textes rabbin.," p. 122 n. 2; Lassus, *Livre des Rois*, p. 86, figs. 110, 111; Deckers, *S. Maria Magg.*, p. 106.

Genesis 32:4–7

JACOB SENDS MESSENGERS

432b. Vat. 747, fol. 54v

Jacob sends messengers to Esau, and they return with the news that Esau is approaching. Although the text speaks of "messengers" in the plural, only one is depicted in this scene, which fills the right half of the upper strip. The two sections of the episode are combined: Jacob raises his hand in a gesture of speech as if dispatching the messenger, whereas the latter's attitude of approach and his gesture of speech reveal that he has already returned and is making his report. Jacob is overpainted, and both figures and the ground are flaked.

Located beside Genesis 32:21.

Ser., fol. 114r

Blank space for an unexecuted miniature.
Located beside Genesis 32:21.

433b. Sm., fol. 46v

The composition is essentially the same. The messenger carries a bag of provisions on a shouldered staff.

434b. Vat. 746, fol. 108r

Very close to Sm.
Located beside Genesis 31:41; its proper place is two spaces further on, beside Genesis 32:21 (see no. 366b).

Lit.: Uspenskii, p. 135; Hesseling, fig. 110; Gerstinger, *Wiener Gen.*, p. 93, fig. 72; Buberl, *Byz. Hss.*, p. 104; Brenk, *S. Maria Magg.*, p. 74; Lassus, *Livre des Rois*, p. 86, figs. 110, 111; Deckers, *S. Maria Magg.*, p. 107.

Genesis 32:7

JACOB DIVIDES HIS HOUSEHOLD

432c. Vat. 747, fol. 54v

In the miniature's lower strip, a conflation of two scenes occurs; Jacob, the central figure, is related to both. At the left are represented those members of Jacob's family who are supposed to remain behind in the camp. As he leaves, Jacob turns to them, giving them instructions to be followed should he not return. The figure of Jacob is partly overpainted and the whole scene is flaked.

Located beside Genesis 32:21.

Ser., fol. 114r

Blank space for an unexecuted miniature.
Located beside Genesis 32:21.

433c. Sm., fol. 46v

While speaking to the people left behind, Jacob makes no motion suggesting departure, as he does in Vat. 747, and in this way he is more closely related to this first scene of the lower strip.

434c. Vat. 746, fol. 108r

Very close to Sm.
Located beside Genesis 31:41; its proper place is two spaces further on, beside Genesis 32:21 (see no. 366b).

Lit.: Uspenskii, p. 135; Hesseling, fig. 110; Gerstinger, *Wiener Gen.*, p. 93, fig. 72; Buberl, *Byz. Hss.*, p. 104; Lassus, *Livre des Rois*, p. 86, figs. 110, 111.

Genesis 32:20–23

JACOB LEAVES TO MEET ESAU

432d. Vat. 747, fol. 54v

The same Jacob that forms part of the preceding scene is shown leaving for the meeting with Esau, joined by one of his

wives as the only companion of the many mentioned in verse 23. He follows his servants, whom he has sent ahead to deliver some herds to Esau as gifts. The text enumerates three servants who were dispatched at certain intervals, but the illustrator of this manuscript depicted only two of them. The first, followed by his herd, is about to disappear behind the slope of a mountain, and the second has just left Jacob and is driving his herd in front of him. Slightly flaked.

Located beside Genesis 32:21.

Ser., fol. 114r

Blank space for an unexecuted miniature.
Located beside Genesis 32:21.

433d. Sm., fol. 46v

In agreement with the text, all three servants dispatched by Jacob are represented. It should be noted, however, that the third servant, who is without a herd, is depicted in a posture quite similar to that of Jacob's wife in Vat. 747; on the other hand, Jacob's wife is omitted. Thus, it would seem that this is the same type of figure and that the third servant in Sm. is but a transformation of the wife in Vat. 747. The second and third servants' herds, clearly separated in Vat. 747, are here merged into one. The connection with the preceding scene is established only by virtue of the third servant's turned head, and the lack of a second figure of Jacob is more strongly felt than in Vat. 747.

434d. Vat. 746, fol. 108r

Very close to Sm.
Located beside Genesis 31:41; its proper place is two spaces further on, beside Genesis 32:21 (see no. 366b).

Lit.: Uspenskii, p. 135; Hesseling, fig. 110; Gerstinger, *Wiener Gen.*, p. 93, fig. 72; Buberl, *Byz. Hss.*, p. 104; Lassus, *Livre des Rois*, p. 86, figs. 110, 111.

Genesis 32:25–27

Jacob Wrestles with the Angel

435. Vat. 747, fol. 55r

In a mountainous landscape set against a golden sky, Jacob wrestles with the angel. He seizes the angel's right arm, lifting his leg and causing his thigh to be numbed. Flaked in various spots.

Located beside Genesis 32:31.

Ser., fol. 114v

Blank space for an unexecuted miniature.
Located beside Genesis 32:27.

436. Sm., fol. 46v

The inscription reads: ἡ πρὸς ἄγγελον τοῦ ἰακὼβ παλαίστρα.

Jacob touches the angel with only one hand, raising the other in a gesture of speech. This indicates that the illustrator has included the content of verse 27, in which Jacob asks the angel's blessing. The right half of the same miniature contains a scene in which two men embrace and kiss. This can only be interpreted as the meeting between Jacob and Esau, described in the next chapter. The impassioned postures of the two men rushing toward each other agrees particularly well with the scene in Vat. 747 (fig. 438). Since, however, this event is illustrated in the following miniature in Sm. with much more detail (fig. 439) and since it is not mentioned in the text, its repetition can only be explained as an error. This assumption is supported by the fact that Vat. 747 does not include the repetition.

437. Vat. 746, fol. 108v

The inscription reads: ἡ πρὸς ἄγγελον τοῦ ἰακὼβ παλαίστρα.
The scene is very close to Sm. and likewise includes the repetition of Jacob's meeting with Esau. Slightly flaked.
Located beside Genesis 32:2; its proper place is two spaces further on, beside Genesis 32:31 (see no. 366b).

Lit.: Uspenskii, p. 135; Hesseling, fig. 111; De Grüneisen, *Ste. Marie Ant.*, pp. 359–60; Gerstinger, *Wiener Gen.*, p. 95, fig. 73; Buberl, *Byz. Hss.*, pp. 105–6; Menhardt, p. 313; Grivot and Zarnecki, *Gislebertus*, p. 72; Stahl, "Morgan M. 638," p. 134 n. 244; De' Maffei, "Sant'Angelo in Formis II," pt. 1, p. 32; Brubaker, "Gregory of Naz.," pp. 386–87, 389–90; Korol, *Cimitile*, pp. 82–84 nn. 274, 276, 278.

Genesis 33:4

Embrace of Jacob and Esau

438. Vat. 747, fol. 55r

Jacob and Esau embrace and kiss fervently. Behind Jacob at a respectful distance stands his family; among them, his two wives are clearly distinguished. Esau is followed by some of the four hundred men who accompanied him. Both brothers and Esau's men are entirely overpainted, and only Jacob's family is still preserved in its original condition.

Located beside Genesis 33:14.

Ser., fol. 116v

Blank space for an unexecuted miniature.
Located beside Genesis 33:14.

439. Sm., fol. 47r

The inscription reads: ἡ πρὸ(ς) ἠσαῦ δι(ὰ) ὑπαντῆς καταλλαγὴ καὶ ἀσπασμὸς ἀμφοτέρων.
The meeting is depicted as in Vat. 747, but the copyist has expanded Jacob's family and divided it into three groups. Next to Jacob a man stands alone with the flocks and looks back at the second group, which consists exclusively of young men, while the final group is headed by Leah and Rachel. This division of Jacob's

family is essentially in agreement with verse 2 of the same chapter, although the details of the miniature deviate somewhat from it. According to the text, the first group is constituted by the two handmaids and their children, the second by Leah with her children, and the third by Rachel with Joseph.

440. Vat. 746, fol. 109v

The inscription reads: ἡ πρὸ(ς) ἠσαῦ δι(ὰ) ὑπαντῆς καταλλαγὴ κ(αὶ) ἀσπασμὸς ἀμφοτέρων.

Very close to Sm. Slightly flaked.

Located beside Genesis 32:21; its proper place is two spaces further on, beside Genesis 33:10–11 (see no. 366b).

Lit.: Uspenskii, p. 135; Hesseling, fig. 112; Menhardt, p. 313; Hutter, "Übermalungen," pp. 141, 143, 145, fig. 7; Deckers, *S. Maria Magg.*, p. 108; De' Maffei, "Sant'Angelo in Formis II," pt. 1, p. 32; Korol, *Cimitile*, p. 83 n. 278.

Genesis 34:1–2

Shechem Seizes Dinah

In the right half of the miniatures Shechem (LXX: Sychem) grips Dinah's arm in front of the city wall of Shalem (LXX: Salem). Dinah does not appear frightened and does not resist Shechem, who in Sm. and Vat. 746 is clad in an unusual tunic with its left sleeve extending over the arm, a costume often used for dancers in Byzantine art. In the same two manuscripts, inhabitants of the city look down from their buildings to the streets, where a feast is supposed to be held. These details have no close relation with the narrative of Genesis 34:1–2 and appear to be the original *lectio difficilior* of the scene; rather, they aim to express moral concern in the representation of the assault on Jacob's young daughter by a pagan dancer. They must have been introduced from a foreign source related to the Jewish amplifications of the story handed down in Genesis Rabbah 80:5 and Pirkê de-Rabbi Eliezer 38:[1] Dinah visited Shalem during a festival with dancing and singing women and joined the feast in the streets of the city. Then, according to a fragment of Theodotos's *On the Jews*, Shechem fell in love with her and "after seizing her as his own, he carried her off and ravished her."[2]

441b. Vat. 747, fol. 55v

In the right half of the miniature Shechem firmly grips the arm of Dinah. Shechem is clad in a richly embroidered tunic and a chlamys, like a Byzantine prince, implying that his costume is a later replacement. The couple stands in front of the closed city gate of Shalem, which is depicted as a circular wall enclosing a central two-story building. Shechem's head is overpainted.

Located beside Genesis 34:16.

Ser., fol. 117v

Blank space for an unexecuted miniature.
Located beside Genesis 34:16.

442b. Sm., fol. 47v

The inscription reads: καὶ ἡ τῆς δεῖνας ὕβρις.

Shechem stands in the open gate and seizes Dinah by her veil, while she seems to follow him willingly into the city, which is represented as a towered fortress.[3] Two inhabitants of Shalem watch Dinah's abduction through windows in the wall; a couple, visible through one of these windows, is apparently conversing.[4] Shechem is clad in a tunic with the left sleeve extending over his hand, as is common in Byzantine depictions of dancers.

443b. Vat. 746, fol. 110r

The inscription reads: κ(αὶ) ἡ τῆς δίνας ὕβρ(ι)ς.

Very close to Sm., except that the couple conversing in Sm. is replaced here by a third person, with carmine hair, who watches Dinah and Shechem.

Located beside Genesis 32:31; its proper place is two spaces further on, beside Genesis 34:16 (see no. 366b).

Lit.: Uspenskii, p. 135; Hesseling, fig. 113; Nordström, "Water Miracles," p. 79.

[1] See, respectively, *Genesis Rabbah*, ed. Freedman and Simon, pp. 738–39; and *Pirkê*, ed. Friedlander, p. 287. See also Josephus, *Ant* 1:337 (*Josephus*, ed. Thackeray, vol. 4, pp. 160–62) and EcclR 10:8 (M. M. Kasher, *Encyclopedia of Biblical Interpretation: A Millennial Anthology*, [New York, 1959], vol. 4, pp. 174–75).
[2] The fragment is preserved in Alexander Polyhistor's *On the Jews*; excerpts of the latter are likewise known only from Eusebios's *Praeparatio evangelica* (*Eusebii Praeparatio Evangelica*, ed. E. H. Gifford [Oxford, 1903], vol. 3, pt. 1, pp. 427 c/d; now in *OTP*, vol. 2, p. 792).
[3] Shalem is mentioned as a fortress in the tale that Judah tells Joseph in TargN on Gen 44:18 (*Targum Genèse*, ed. Le Déaut, p. 398).
[4] With some hesitation, we might suggest they are Dinah and Shechem themselves.

Genesis 33:18–20 and 34:6–17

Jacob's Sacrifice at Shalem

Ser., fol. 117v

Blank space for an unexecuted miniature.
Located beside Genesis 34:16.

442a. Sm., fol. 47v

The beginning of the inscription, as far as it relates to the left scene, reads: τὰ σίκιμα.

Having arrived before the city of Shalem and pitched a tent, Jacob erected an altar. In the miniature he is seen sacrificing a burnt offering, accompanied by his family and his flocks. The burnt offering is not mentioned at Genesis 33:18.[1] A cypress tree stands behind them at the left. The foremost figure of the group of Jacob's sons, who might be Jacob himself, is apparently watching the two people in front of the city gate of Shalem; his pose, on the other hand, corresponds with that of the man vividly conversing with the prince of Shalem in the same

episode of Vat. 747 (fig. 441a). This is probably a confused conflation of episodes caused by the misunderstanding of a badly preserved model. Some members of Jacob's family have been damaged by flaking.

443a. Vat. 746, fol. 110r

The inscription begins: τὰ σίκιμα.

Very close to Sm.

Located beside Genesis 32:31; its proper place is two spaces further on, beside Genesis 34:16 (see no. 366b).

Lit.: Uspenskii, p. 135; Hesseling, fig. 113; Wilpert, *Mosaiken und Malereien,* vol. I, p. 444, fig. 157; Menhardt, fig. 11; Nordström, "Water Miracles," p. 79.

[1] Nordström, "Water Miracles," p. 79, related the burnt offering with the Targumim; cf. the translations of TargPs-J and TargN given in *Targum Genèse,* ed. Le Déaut, pp. 314–15.

Genesis 34:6–17

SHECHEM ASKS THAT DINAH BE HIS WIFE

441a. Vat. 747, fol. 55v

The scene in the left half of the miniature corresponds in position and essentially also in compositional scheme with the representation of Jacob's sacrifice before Shalem in Sm. and Vat. 746 (figs. 442a and 443a). Jacob and his sons discuss Shechem's request that Dinah be his wife. The foremost figure should be Jacob—or alternatively one of his sons—vividly gesturing in speech with Shechem's father, Hamor (LXX: Emmor), represented as an aged man and erroneously nimbed like a patriarch. Between Hamor and the Israelites, the young Shechem, clad in tunic and chlamys, stands in frontal view listening to the discussion. All the heads in this scene have been overpainted.

Located beside Genesis 34:16.

Lit.: Brenk, *S. Maria Magg.,* p. 75.

Genesis 34:24

CIRCUMCISION OF THE SHECHEMITES

444a. Vat. 747, fol. 56r

One of Jacob's sons circumcises all the male inhabitants of Shalem. In this scene, one of the men, who has just been circumcised, sits on a bench, bleeding and gesturing excitedly. The background is formed by mountains with a house in grisaille visible among the high peaks.

Located beside Genesis 34:25.

Ser., fol. 118v

Blank space for an unexecuted miniature.

Located beside Genesis 35:7.

445a. Sm., fol. 47v or 48r [1]

The first half of the inscription reads: ἡ μετὰ δόλου περιτομ(ὴ) τ(ῶν) σικιμιτῶν.

The composition is essentially the same as in Vat. 747 and is changed only to the extent that several Shechemites are sitting on a long bench and are clad in tunics with one sleeve over their hands.

Located above Genesis 35:8.

446a. Vat. 746, fol. 111v

The inscription reads: ἡ μετὰ δόλου περιτομὴ τῶν σικιμιτῶν.

Very close to Sm.

Located beside Genesis 33:10–11; its proper place is two spaces further on, beside Genesis 35:7 (see no. 366b).

Lit.: Uspenskii, p. 135; Hesseling, fig. 114; Wilpert, *Mosaiken und Malereien,* vol. I, p. 444, fig. 158; De Angelis, "Simbologia," pp. 1533–34, fig. 13.

[1] Fol. 47v according to Hesseling, p. viii; fol. 48r according to Uspenskii, p. 184.

Genesis 34:25

SLAYING OF THE SHECHEMITES

444b. Vat. 747, fol. 56r

Simeon, Levi, and their followers, armed with shields, spears, and swords, attack Shalem and kill all its male inhabitants, shown streaming out of the open city gate. The Shechemites are unarmed; the foremost has already been slain and is bleeding from many wounds. As in the preceding miniature, the walled city encloses a two-story building.

Located beside Genesis 34:25.

Ser., fol. 118v

Blank space for a miniature that was not executed.

Located beside Genesis 35:7.

445b. Sm., fol. 47v or 48r [1]

The second half of the inscription reads: καὶ ὁ ἐξ αὐτῆς ὄλεθρος τούτων.

A group of naively painted, helmeted Israelite soldiers, replacing the armed civilians in Vat. 747, uses lowered lances in their attack on two Shechemites, who are vainly pleading for their lives, while others lie bleeding on the ground, already slain. From atop the towers of the city three weeping women watch the slaughter of their men.

Located above Genesis 35:8.

446b. Vat. 746, fol. 111v

The inscription reads: καὶ ὁ ἐξ αὐτῆς ὄλεθρο(ς) τούτων.

Very close to Sm.

Located beside Genesis 33:10–11; its proper place is two spaces further on, beside Genesis 35:7 (see no. 366b).

Lit.: Uspenskii, p. 135; Hesseling, fig. 114; Wilpert, *Mosaiken und Malereien*, vol. 1, p. 444, fig. 158; De Angelis, "Simbologia," pp. 1533–34, fig. 13.

¹ Fol. 47v according to Hesseling, p. viii; fol. 48r according to Uspenskii, p. 184.

Genesis 35:9–12

God Gives Jacob the Name of Israel

447a. Vat. 747, fol. 56v

In the first of three scenes united within one frame, God gives Jacob the name of Israel. Raising his hands in prayer, Jacob looks up to the blessing hand of God, which sends out rays from a segment of heaven set against a golden sky. Jacob's head has been overpainted.

Located beside Genesis 35:16.

448a. Ser., fol. 119r

The beginning of the inscription reads: εὐχ(ὴ) ἰακὼβ.

Jacob, framed by two trees, is without a nimbus and is clad in a short tunic, as is usual in this manuscript, but otherwise the scene agrees with the one in Vat. 747. Very badly flaked.

Located beside Genesis 35:16.

449a. Sm., fol. 48r or 48v¹

The inscription begins: εὐχὴ ἰακώβ.

Very close to Ser.

450a. Vat. 746, fol. 113r

The beginning of the inscription is placed outside the frame and reads: εὐχὴ ἰακώβ.

Very close to Ser. and Sm.

Located beside Genesis 34:16; its proper place is two spaces further on, beside Genesis 35:16 (see no. 366b).

Lit.: Uspenskii, p. 135; Hesseling, fig. 115; Gerstinger, *Wiener Gen.*, p. 97, fig. 74; Buberl, *Byz. Hss.*, p. 108; Lassus, *Livre des Rois*, fig. 106.

¹ Fol. 48r according to Hesseling, p. viii; fol. 48v according to the label in the photo taken by Buberl.

Genesis 35:16–18

Birth of Benjamin

447b. Vat. 747, fol. 56v

In the central scene, Rachel sits before Jacob's house and gives birth to Benjamin, who has already been delivered and lies on

the ground. The midwife holds Rachel by the shoulder and whispers encouragement, but Rachel no longer hears her. Her head has fallen upon her shoulder, and her closed eyes indicate that she has already expired. As in a previous birth scene (fig. 355), the copyist has forgotten to paint the delivery chair upon which Rachel is supposed to be sitting.¹

Located beside Genesis 35:16.

448b. Ser., fol. 119r

The middle section of the inscription reads: τίκτει ραχήλ.

The scene is nearly completely flaked, but the remaining traces indicate that it is closer to Sm. and Vat. 746 than to Vat. 747.

Located beside Genesis 35:16.

449b. Sm., fol. 48r or 48v²

The inscription reads: τίκτει ραχήλ.

Rachel, her eyes open, is represented as still being in labor, supported under the arm by the midwife, but otherwise the scene agrees with Vat. 747.

450b. Vat. 746, fol. 113r

The inscription reads: τίκτει ραχήλ.

Very close to Ser. and Sm.

Located beside Genesis 34:16; its proper place is two spaces further on, beside Genesis 35:16 (see no. 366b).

Lit.: Uspenskii, p. 135; Hesseling, fig. 115; Gerstinger, *Wiener Gen.*, p. 97, fig. 74; Lassus, *Livre des Rois*, p. 85, fig. 106.

¹ Cf. Lassus, *Livre des Rois*, pp. 33 and 85.
² Fol. 48r according to Hesseling, p. viii; fol. 48v according to the label in the photo taken by Buberl.

Genesis 35:19

Burial of Rachel

447c. Vat. 747, fol. 56v

The third scene of the miniature represents Rachel's burial. The midwife lowers the corpse, wrapped like a mummy, into a sarcophagus which stands in a cave.

Located beside Genesis 35:16.

448c. Ser., fol. 119r

The end of the inscription reads: καὶ θνήσκει.

The scene essentially agrees with the one in Vat. 747. Jacob's house is repeated, emerging behind the mountain.

Located beside Genesis 35:16.

449c. Sm., fol. 48r or 48v

The inscription reads: καὶ θνήσκει.

Very close to Ser.

450c. Vat. 746, fol. 113r

The inscription reads: καὶ θνῄσκει.

Very close to Ser. and Sm.

Located beside Genesis 34:16; its proper place is two spaces further on, beside Genesis 35:16 (see no. 366b).

Lit.: Uspenskii, p. 135; Hesseling, fig. 115; Gerstinger, *Wiener Gen.*, p. 97, fig. 74; Buberl, *Byz. Hss.*, p. 109; Pächt, "Life of Joseph," p. 40; Lassus, *Livre des Rois*, p. 85, fig. 106.

Genesis 35:22–26

Jacob's Children

In the next miniature the scenes are again reversed from the sequence of the narrative: Isaac's death should follow, not precede, Jacob's genealogy. The placement of Jacob's offspring in a second, lower register was presumably necessitated by the merging of the two scenes within a single frame; originally Jacob was in the same register as his offspring and pointed to them. The empty chair in Ser., Sm., and Vat. 746 is a trait unconnected with the Septuagint narrative. The aim was perhaps to indicate that Rachel, Jacob's favorite wife, was dead and therefore unable to sit beside him and contemplate his twelve sons—an explanation, however, which is hypothetical and without textual basis.

451b. Vat. 747, fol. 56v

Jacob's genealogy is distributed over both registers. In the upper strip Jacob sits at the right on a throne, pointing; the meaning of this gesture is unclear. In the lower strip the twelve sons are depicted lined up in a row, starting at the left with the firstborn and ending at the right with little Benjamin. Joseph, next to Benjamin, is distinguished by a nimbus. To avoid monotony, the painter depicted most of the sons talking to each other and gesturing vividly.

Located beside Genesis 35:28.

452b. Ser., fol. 119r

The inscription, beginning in the upper strip at the right, reads: γενεαλογία ἰακώβ; it continues in the lower strip with the names of the sons, which, however, do not follow the same order as their listing in the text. They read, from left to right: ἰσαχ(αρ), ρουβ(ην), συμ(εων), ζαβο(υλων), δαν, νεφ(θαλειμ), γάδ, λευί, ἰουδ(ας), ἀ(ση)ρ, ἰω(σηφ), β(ενιαμειν).

The miniature is almost completely flaked, but its composition, still recognizable from details, is very close to the corresponding miniatures in Sm. and Vat. 746. The miniature is unframed and is stained at the left.

Located beside Genesis 35:28.

453b. Sm., fol. 48v

The inscription begins in the upper strip: γενεαλογία ἰακώβ; and continues in the lower strip: ἰσαχ(αρ), ρουβ(ην), ζαβου-

(λων), συμ(εων), δαν, νεφ(θαλειμ), γαδ, λευι, ιου(δας), ἀσήρ, ιω(σηφ), β(ενιαμειν).

In the upper strip Jacob sits before his house and points to an empty chair in front of him. The copyist has tried to rearrange the sons in smaller, conversing groups but has not succeeded in breaking the monotony to the same degree as did the illustrator of Vat. 747.

Located below Genesis 35:29.

454b. Vat. 746, fol. 114r

The inscription reads: γενεαλογία ἰακώβ; and continues: ἰσαχ(αρ), ρουβ(ην), ζαβου(λων), συμε(ων), δαν, νεφ(θαλειμ), γαδ, λευι, ιουδ(ας), ἀσήρ, ιωσηφ, βένιαμ(ειν).

Very close to Ser. and Sm. The ground in the lower strip is somewhat flaked.

Located beside Genesis 35:7; its proper place is two spaces further on, beside Genesis 36:1 (see no. 366b).

Lit.: Uspenskii, p. 135; Hesseling, fig. 116; Havice, "Hamilton Ps.," pp. 266–67; Havice, "Marginal Miniatures," p. 128.

Genesis 35:29

Burial of Isaac

451a. Vat. 747, fol. 56v

Isaac's burial is represented out of sequence in the left half of the upper strip. Jacob and Esau, the former distinguished by a nimbus, lower their father's corpse, which is wrapped like a mummy, into a sarcophagus which stands in a cave.

Located beside Genesis 35:28.

452a. Ser., fol. 119r

The inscription reads: τελευτὴ ἰσαάκ.

Instead of a cave, a house serves as the background; otherwise, the representation agrees with Vat. 747. The scene is very flaked.

Located beside Genesis 35:28.

453a. Sm., fol. 48v

The inscription reads: τελευτὴ ἰσαάκ.

Very close to Ser.

Located below Genesis 35:29.

454a. Vat. 746, fol. 114r

The inscription reads: τελευτὴ ἰσαάκ.

Very close to Ser. and Sm.

Located beside Genesis 35:7; its proper place is two spaces further on, beside Genesis 36:1 (see no. 366b).

Lit.: Uspenskii, p. 135; Hesseling, fig. 116.

Genesis 36:6

Esau's Departure

455. Vat. 747, fol. 57v

Esau leaves the land of Canaan and his brother, Jacob, taking all of his belongings with him. At the left side of the miniature, Jacob sits before his two-story house and with a gesture bids Esau farewell. Esau drives away his herds, which consist of sheep, a horse, and two camels. Both brothers' heads are overpainted, and the restorer transformed Jacob into an aged, bearded patriarch.

Located beside Genesis 36:27.

456. Ser., fol. 120r

Close to Vat. 747 except for a few details. Esau drives four camels in front of him, but no horse, and at the same time looks back at his brother. The sheep stand with their heads to the left; the painter probably intended to indicate that they were going to stay with Jacob in Canaan. Jacob is represented as youthful and wears a short tunic. The miniature is slightly flaked and somewhat rubbed.

Located beside Genesis 36:26.

457. Sm., fol. 49r

The inscription reads: κατοικία ἰακὼβ ἡ εἰς τὴν γῆν χαναὰν ἐν ᾗ καὶ ὁ π(ατ)ὴρ αὐτοῦ καὶ ὁ πάππος.

Close to Ser., except that Jacob has a short beard, apparently in agreement with the archetype.

Located below Genesis 36:25.

458. Vat. 746, fol. 114v

The inscription reads: κατοικία ἰακὼβ ἡ εἰς τὴν γῆν χαναὰν ἐν ᾗι καὶ ὁ π(ατ)ὴρ αὐτοῦ καὶ ὁ πάππος.

By showing Jacob without a beard, the copyist follows Ser. rather than Sm., but the rest of the miniature agrees with both manuscripts.

Located beside Genesis 35:16; its proper place is two spaces further on, beside Genesis 36:26–27 (see no. 366b).

Lit.: Uspenskii, p. 136; Hesseling, fig. 117; Menhardt, p. 316.

Genesis 36:31–43

Kings of Edom

459. Vat. 747, fol. 57v

From the long list of kings of Edom enumerated in verses 31–43, the painter arbitrarily chose three. Dressed in richly embroidered tunics and wearing pearl-studded purple shoes and pearl crowns like Byzantine emperors, they sit on cushioned faldstools before individual grisaille baldachins and converse with each other.

Located beside Genesis 36:40.

460. Ser., fol. 120v

The postures of the nimbed kings agree with those of Vat. 747, but instead of sitting on faldstools, they are seated on chairs, the middle and the right ones being united to form a bench. The baldachins are shaped differently and painted as real architecture. The frame is omitted and all the figures are badly flaked.

Located beside Genesis 36:40.

461. Sm., fol. 49v

The inscription reads: οἱ ἐν ἐδὼμ βασιλεύσαντες.

Going one step further than in Ser., the copyist has fused all three chairs into one continuous bench; otherwise, the miniature agrees very much with Ser. The figures were overpainted and are partly flaked again.

Located above Genesis 36:43.

462. Vat. 746, fol. 115r

The inscription reads: οἱ ἐν ἐδὼμ βασιλεύσαντες.
Very close to Sm.

Located beside Genesis 36:1; its proper place is two spaces further on, beside Genesis 36:40 (see no. 366b).

Lit.: Uspenskii, p. 136, fig. 60; Hesseling, fig. 118; Menhardt, p. 327; Lowden, *Octs.*, p. 60.

Genesis 37:5–9

Joseph Tells His Dreams to His Brothers

Beginning with this initial episode of the story of Joseph, only sections of the cycle in Vat. 747 coincide with those in Ser., Sm., and Vat. 746. In fact, distinctly different selections of episodes from Joseph's story exist, as well as dissimilar iconographies for the same episode. All of the Octateuchs have the same number of miniatures for the story of Joseph, but the number of individual episodes within each frame varies. The miniatures are located alongside approximately the same passages of Genesis, even when they represent different episodes; in other words, the blank spaces left by the scribes in the columns of text in each manuscript coincide and depend on a model shared by all four Octateuchs. The iconography of the first miniature of Joseph's story in Ser., Sm., and Vat. 746 combines elements from Joseph's two dreams, i.e., the sheaves (Gen 37:5–8) and the sun, moon, and stars paying reverence to Joseph (Gen 37:9); after that, those same manuscripts have Jacob Sends Joseph to His Brothers and Joseph's Brothers See Him Arriving (nos. 468–470). The corresponding sequence in Vat. 747, in the same locations in the text, represents Jacob Sends Joseph to His Brothers (no. 466) and Joseph's Brothers See Him Arriving (no. 467).

463. Ser., fol. 122v

According to the text, Joseph tells his brothers about his first dream and his father and brothers about the second. The illustrator, who combined both events in one scene, chose an open field

as the setting and omitted the figure of the father. Standing in the midst of a flock, Joseph raises both hands in an expression of excitement and describes the dreams to his brothers, who stand grouped at the left with crossed arms, staring at him in hatred. A hill at the right forms the background for eleven small sheaves, which are grouped around a very large one and bow down before it. In a segment of heaven, the sun and moon are represented as medallion-heads looking down at Joseph. The stars visible in the other two copies were forgotten by the copyist. Slightly damaged by flaking and the offset of letters from the opposite page.

Located beside Genesis 37:10.

464. Sm., fol. 49v

The inscription reads: ἰωσὴφ ἀποστελλόμενο(ς) εἰς ἐπιζή-τησιν καὶ ἐπίσκεψιν τῶν ἀδελφ(ῶν) καὶ ἐνυπνιαζόμενος.

Joseph is represented as being much younger than his brothers, but otherwise the composition agrees thoroughly with Ser.

Located below Genesis 37:9.

465. Vat. 746, fol. 115v

The inscription reads: ἰωσὴφ ἀποστελλόμενος εἰς ἐπιζή-τησιν καὶ ἐπίσκεψιν τ(ῶ)ν ἀδελφῶν καὶ ἐνυπνιαζόμεν(ος).

Because Joseph is as tall as his brothers, the miniature is closer to Ser. than to Sm. Flaked in various spots.

Located beside Genesis 36:26–27; its proper place is two spaces further on, beside Genesis 37:9 (see no. 366b).

Lit.: Uspenskii, p. 136; Hesseling, fig. 119; De Grüneisen, *Ste. Marie Ant.*, p. 364; Gerstinger, *Wiener Gen.*, p. 98, fig. 80; Buberl, *Byz. Hss.*, p. 110; Menhardt, p. 316; Vikan, "Life of Joseph," p. 51; Kötzsche-Breitenbruch, *Via Latina*, p. 70; Vikan, "Joseph Iconography," p. 101 n. 20, p. 106; Vileisis, "S. Maria Ant.," pp. 56, 62–63.

Genesis 37:14

JACOB SENDS JOSEPH TO HIS BROTHERS

Benjamin's presence at the farewell is not mentioned in the text. In Jewish legends, however, Benjamin was neither guarding the flocks with his brothers nor present when Joseph was sold, and professes that he had nothing to do with the selling of Joseph.[1] It is thus possible that he remained home with his father, as in the miniature. The location of the miniatures in the text is discussed in the introduction to Genesis 37:5–9. Jacob Sends Joseph to His Brothers in Vat. 747 (no. 467) corresponds to the preceding scene of Joseph Tells His Dreams to His Brothers in the other manuscripts (nos. 463–465);[2] Joseph's Brothers See Him Arriving in Vat. 747 is located approximately in the same position in the text as the miniature combining Jacob Sends Joseph to His Brothers and Joseph's Brothers See Him Arriving in Ser. and Vat. 746 (nos. 468 and 470). This latter location, however, does not correspond to the contents of the miniatures in any of the manuscripts, but does correspond to the story of Joseph's sale to the merchants, who are represented in the very next miniature in all the manuscripts. Thus, the dislocation of miniatures in the column of text must have occurred in an earlier

copy of the Octateuch. Moreover, since the miniature of the three kings of Edom is correctly located beside the list of those kings at Genesis 36:31–43, this earlier copy must have had a blank space for a miniature that was carelessly omitted in the text column during its production, and this omission occurred in the folio containing Genesis 37.

466. Vat. 747, fol. 58r

Jacob, sitting before his house, has sent Joseph to his brothers at Shechem. Already on his way, Joseph marches toward a mountain with his mantle slung around a shouldered staff. Benjamin, who is not mentioned in the text, touches Jacob's knee with a gesture of childish awkwardness. The surface is flaked in various spots.

Located beside Genesis 37:10.

468a. Ser., fol. 124r

This scene, which in Vat. 747 constitutes an independent miniature, is combined with the next scene by a common frame in Ser. and the other Octateuchs. Joseph has not yet departed, but stands before his father and bids him farewell. Jacob is represented in frontal view, turning to Joseph, and little Benjamin seeks support at his father's chair rather than his knee. The house is omitted. The miniature is stained and slightly flaked.

Located beside Genesis 37:29, thus corresponding to the following scene in Vat. 747 (no. 467).

469a. Sm., fol. 50r

Very close to Ser.

470a. Vat. 746, fol. 116r

Very close to Ser. and Sm.

Located beside Genesis 36:40; its proper place is two spaces further on, beside Genesis 37:27 (see no. 366b).

Lit.: Graeven, "Typen," p. 94, fig. 3; Uspenskii, p. 136, fig. 61; Hesseling, fig. 120; De Grüneisen, *Ste. Marie Ant.*, pp. 363–64; Gerstinger, *Wiener Gen.*, p. 100, figs. 77, 85, 88; Buberl, *Byz. Hss.*, p. 113; Buchthal, *Paris Ps.*, p. 67 n. 12; Vikan, "Life of Joseph," pp. 54, 223 n. 27; Vikan, "Joseph Iconography," p. 101, nn. 8, 20, 22, pp. 106–7; Vileisis, "S. Maria Ant.," pp. 63–64; Brubaker, "Gregory of Naz.," pp. 358–59; Friedman, "Vienna Genesis," pp. 66–67, fig. 4; Lowden, *Octs.*, p. 60.

[1] Ginzberg, *Legends*, vol. 2, pp. 30, 110.
[2] To be precise, the location of the miniature in Vat. 747 is not very accurate since it illustrates Gen 37:14 and is located beside Gen 37:10. The location of the corresponding miniature in the other Octateuchs is more accurate, illustrating Gen 37:9 and located beside Gen 37:10.

Genesis 37:17–19

JOSEPH'S BROTHERS SEE HIM ARRIVING

The episode of Joseph coming to his brothers occupies an entire miniature in Vat. 747, while it is combined with Jacob's

farewell in the other codices. As mentioned above (see the introduction to Genesis 37:14), the episode is located in the column of text in the place appropriate to the episodes in the following miniatures (nos. 471–474).

467. Vat. 747, fol. 58v

Joseph approaches his brothers, who are encamped in the mountains, guarding their flocks. One of them points to him with both arms extended, while another, unperturbed, plays the transverse flute. The entire miniature is slightly flaked, except for the golden sky.

Located beside Genesis 37:27.

468b. Ser., fol. 124r

The brothers are grouped and gesture differently than in Vat. 747, but the same flute player appears at the foot of the mountain; he sits upright with crossed legs, and a sheep dog plays at his feet. Joseph is represented in a reticent posture, as if anticipating trouble.

Located beside Genesis 37:29, thus corresponding to the following scene (no. 467) in Vat. 747 (see no. 468a).

469b. Sm., fol. 50r

The inscription reads: ἰωσὴφ ἀνευρὼν τ(οὺ)ς ἀδελφούς.
Very close to Ser.

470b. Vat. 746, fol. 116r

The inscription reads: ἰωσὴφ ἀνευρὼν τοὺς ἀδελφούς.
Very close to Ser. and Sm.

Located beside Genesis 36:40; its proper place is two spaces further on, beside Genesis 37:27 (see no. 366b).

Lit.: Graeven, "Typen," p. 94, fig. 3; Uspenskii, p. 136, fig. 61; Hesseling, fig. 120; De Grüneisen, *Ste. Marie Ant.*, pp. 363–64; Gerstinger, *Wiener Gen.*, p. 100, figs. 77, 86, 88; Buberl, *Byz. Hss.*, p. 113; Buchthal, *Paris Ps.*, p. 67 n. 12; Weitzmann, *JR*, p. 25 no. 26; Levin, "Some Jewish Sources," p. 241; Stahl, "Morgan M. 638," p. 52; Vikan, "Life of Joseph," pp. 54, 57, 223 n. 27; Bernabò, "Laur. plut. 5.38," p. 156 n. 48; Vikan, "Joseph Iconography," p. 102 and nn. 20, 29, p. 107; Brubaker, "Gregory of Naz.," p. 360; Weitzmann and Kessler, *Cotton Gen.*, p. 42; Friedman, "Vienna Genesis," pp. 66–67, fig. 4; Lowden, *Octs.*, p. 60.

Genesis 37:24

JOSEPH THROWN INTO THE PIT

In the first episode of this miniature Joseph is lowered into the pit, addressing or even protesting to his brothers, a detail not reported in the text. The dislocation of miniatures observed in the introduction to Genesis 37:14 continues in this miniature, which occupies a space in the text approximately alongside Genesis 37:34, the very text upon which the next miniature, illustrating the episode of Joseph's coat displayed to Jacob, depends.

471a. Vat. 747, fol. 58v

The left half of the upper strip is occupied by a scene showing the brothers having seized Joseph by the arms and about to lower him into the pit. Slightly flaked.

Located beside Genesis 37:34.

472a. Ser., fol. 124r

Joseph is being seized only by his left arm, while he raises his right hand in a gesture of speech as if he wished to say something to his brothers before being cast into the pit. The number of brothers is reduced to three on either side of Joseph. Slightly flaked.

Located beside Genesis 37:35.

473a. Sm., fol. 50v

The inscription reads: ἰωσὴφ ἐκδυόμενος καὶ εἰς τὸν λάκκον ἐμβαλ [continuing in the lower strip] λόμενος.
Very close to Ser. Joseph's head is flaked.
Located above Genesis 38:1.

474a. Vat. 746, fol. 116v

The inscription reads: ἰωσὴφ ἐκδυόμενος καὶ εἰς τ(ὸν) λάκκο(ν) ἐμβαλλόμ(εν)ο(ς).
Very close to Ser. and Sm.
Located beside Genesis 37:9; its proper place is two spaces further on, beside Genesis 37:34 (see no. 366b).

Lit.: Uspenskii, p. 136, fig. 62; Hesseling, fig. 121; De Grüneisen, *Ste. Marie Ant.*, p. 346; Buchthal, *Paris Ps.*, p. 67 n. 12; Tsuji, "Chaire," p. 51; Koshi, *Genesisminiaturen*, pp. 14–15; Vikan, "Life of Joseph," p. 66; Bernabò, "Laur. plut. 5.38," p. 151 n. 43; Vikan, "Joseph Iconography," p. 102, 107 n. 33; Weitzmann, *SP*, pp. 44, 50; Vileisis, "S. Maria Ant.," p. 68; Brubaker, "Gregory of Naz.," pp. 362–64, 367, 374–75, 382; Mathews, "Philo Judaeus," pp. 36, 38, 42–44, figs. 1, 2; De Angelis, "Simbologia," figs. 17, 18; Weitzmann and Kessler, *Cotton Gen.*, p. 42.

Genesis 37:25

JOSEPH'S BROTHERS FEAST

471b. Vat. 747, fol. 58v

Alongside the preceding scene, the brothers, having rid themselves of Joseph, sit around a table and feast.

Located beside Genesis 37:34.

472c. Ser., fol. 124r

In this and the following manuscripts the scene is misplaced: instead of following the casting into the pit, as in Vat. 747, it is moved down into the lower strip. On the other hand, the scene is more complete, since it includes the arrival of the Midianite merchants. The bust of one of them and the long necks of their camels emerge from behind the mountain slope, while the

brother sitting at the left end of the table looks up and notices their presence. Partly flaked.

Located beside Genesis 37:35.

473c. Sm., fol. 50v

Very close to Ser.
Located above Genesis 38:1.

474c. Vat. 746, fol. 116v

Very close to Ser. and Sm.
Located beside Genesis 37:9; its proper place is two spaces further on, beside Genesis 37:34 (see no. 366b).

Lit.: Uspenskii, p. 136, fig. 63; Hesseling, fig. 121; Buchthal, *Paris Ps.,* p. 67 n. 12; Pächt, "Life of Joseph," p. 39; Vikan, "Life of Joseph," p. 71; Bernabò, "Laur. plut. 5.38," pp. 151 n. 43, 156 n. 48; Havice, "Hamilton Ps.," pp. 274–75; Weitzmann, *SP,* pp. 44, 50; Havice, "Marginal Miniatures," p. 129; Mathews, "Philo Judaeus," pp. 36, 38, 42–44, figs. 1, 2; Brubaker, "Gregory of Naz.," p. 451 n. 88; De Angelis, "Simbologia," figs. 17, 18.

Genesis 37:28

Selling of Joseph to the Midianites

471d. Vat. 747, fol. 58v

In the center of the lower strip, Joseph is shown being sold to the Midianites, who are represented as black men wearing turbans and striped white mantles. While Joseph's right hand is still held by one of his brothers, his left is taken by a Midianite who is already departing. At least two more merchants are partly hidden by the mountain slope.

Located beside Genesis 37:34.

472d. Ser., fol. 124r

In this manuscript and in Sm. the scene of Joseph's sale is conflated with the preceding feast. Two of the brothers have just arisen from the table, and the exchange with the merchants has already been concluded. The foremost brother no longer holds Joseph; instead, he weighs the money in his hand. The Midianites taking Joseph away are restricted in number to two, and they are represented with chestnut-colored skins and wearing loincloths. Partly flaked.

Located beside Genesis 37:35.

473d. Sm., fol. 50v

The inscription reads: καὶ πιπρασκόμενος.
Very close to Ser. The scene is flaked.
Located above Genesis 38:1.

474d. Vat. 746, fol. 116v

The inscription reads: καὶ πιπρασκόμενος.

Very close to Ser. and Sm.
Located beside Genesis 37:9; its proper place is two spaces further on, beside Genesis 37:34 (see no. 366b).

Lit.: Uspenskii, p. 136, fig. 63; Hesseling, fig. 121; Buchthal, *Paris Ps.,* p. 67 n. 12; Vikan, "Life of Joseph," pp. 73–74; Bernabò, "Laur. plut. 5.38," p. 151 n. 43; Vikan, "Joseph Iconography," pp. 102–3; Havice, "Hamilton Ps.," pp. 274–75; Weitzmann, *SP,* pp. 44, 50; Brubaker, "Gregory of Naz.," p. 368; Mathews, "Philo Judaeus," pp. 36, 38, 42–44, fig. 1; De Angelis, "Simbologia," figs. 17, 18.

Genesis 37:28

Midianites Bring Joseph to Egypt

471e. Vat. 747, fol. 58v

On the way to Egypt, Joseph rides on one of the camels being led by the Midianites. Very heavily flaked.
Located beside Genesis 37:34.

472e. Ser., fol. 124r

Each of the two Midianites is shown leading his own camel, but otherwise the scene agrees with the one in Vat. 747.
Located beside Genesis 37:35.

473e. Sm., fol. 50v

Very close to Ser. The scene is quite badly flaked.
Located above Genesis 38:1.

474e. Vat. 746, fol. 116v

Very close to Ser. and Sm.
Located beside Genesis 37:9; its proper place is two spaces further on, beside Genesis 37:34 (see no. 366b).

Lit.: Uspenskii, p. 136, fig. 63; Hesseling, fig. 121; Buchthal, *Paris Ps.,* p. 67 n. 12; Koshi, *Genesisminiaturen,* p. 16; Vikan, "Life of Joseph," p. 76; Vikan, "Joseph Iconography," p. 104; Weitzmann, *SP,* pp. 44, 50; Brubaker, "Gregory of Naz.," p. 369; Mathews, "Philo Judaeus," pp. 36, 38, 42–44, figs. 1, 2; De Angelis, "Simbologia," figs. 17, 18.

Genesis 37:31

Joseph's Brothers Slaughter a Goat

471c. Vat. 747, fol. 58v

The copyist did not find space for the next scene alongside the preceding one, and therefore he placed it in the upper left corner of the lower strip, between the frame and a mountain slope, thus inverting the narrative sequence found in Genesis: in the miniature the killing of the goat (Gen 37:31) precedes Joseph's sale to the Midianite merchants (Gen 37:28). The identical reversal occurs in Philo's *De Josepho* 14,[1] where Joseph's tunic is bloodied

and sent to Jacob before his sale to the merchants. The same inversion occurs in other Joseph picture cycles.[2] One of the brothers is cutting the throat of the kid, and a second, whose head alone appears behind the slope, holds Joseph's coat and is ready to stain it with the goat's blood.

Located beside Genesis 37:34.

472b. Ser., fol. 124r

In this manuscript, Sm., and Vat. 746 this scene is even more misplaced than in Vat. 747: it occupies the right half of the upper strip. On the other hand, the copyists of these latter three manuscripts had more space at their disposal and thus depicted the scene more fully. While a second brother assists in the killing of the goat, all the others stand behind the one who holds the coat.

Located beside Genesis 37:35.

473b. Sm., fol. 50v

Very close to Ser.
Located above Genesis 38:1.

474b. Vat. 746, fol. 116v

Very close to Ser. and Sm.
Located beside Genesis 37:9; its proper place is two spaces further on, beside Genesis 37:34 (see no. 366b).

Lit.: Uspenskii, p. 136, fig. 62; Hesseling, fig. 121; Buchthal, *Paris Ps.,* p. 67 n. 12; Cecchelli, *Cattedra,* p. 126; Pächt, "Life of Joseph," p. 39; Tsuji, "Chaire," p. 51; Vikan, "Life of Joseph," pp. 84, 243 n. 128; Vikan, "Joseph Iconography," pp. 102, 107 n. 39; Weitzmann, *SP,* pp. 44, 50; Brubaker, "Gregory of Naz.," pp. 364, 449 n. 73; Mathews, "Philo Judaeus," pp. 36, 38, 42–44, figs. 1, 2; De Angelis, "Simbologia," p. 1535, figs. 17, 18.

[1] *Philo,* ed. Colson, vol. 6, pp. 148–49; cf. Mathews, "Philo Judaeus," pp. 36, 38.
[2] Vikan, "Joseph Iconography," p. 107 n. 43; Pächt, "Life of Joseph," pp. 38–39, scenes nos. 6 (the staining of the coat) and 8ff. (the brothers banqueting, the merchants arriving, etc.).

Genesis 37:32–33

JACOB SHOWN JOSEPH'S COAT

Vat. 747 here differs further from the other Octateuchs: it has a single illustration, Joseph's coat displayed to Jacob, who tears his hair and beard. Ser., Sm., and Vat. 746 have, in addition, Jacob Puts Sackcloth on His Loins; Jacob's sackcloth is there interpreted as a jacket which covers not only his loins but also his whole back and arms, apparently converting it into a more conventional form not unlike the penitential sakkos of the Byzantine clergy.[1] In all the Octateuchs, the miniature is located in the text of chapter 38, which contains the story of Judah and Tamar depicted in the next miniature, thus confirming that the dislocation of miniatures in the Octateuchs' model continues. This dislocation comes to an end with the next miniature: from there on,

the miniatures correspond to the text surrounding them. Presumably, the painter of the model either found an additional space for a miniature here in chapter 38 or decided to skip one of the miniatures from the unattractive story of Judah and Tamar so as to recuperate the correspondence between the Greek text and the illustrations.

475. Vat. 747, fol. 59r

Joseph's brothers display his blood-stained coat to their father, who sits on a throne, very disturbed and tearing his hair and beard, from which a few brown strands hang.[2] The scene takes place before high mountains with architectural decorations in grisaille between their peaks.

Located beside Genesis 38:8.

476a. Ser., fol. 124v

Jacob rests his head on his hand, a gesture that is less specific than that in Vat. 747, since it is sometimes used to denote meditation as well as mourning. The sons, instead of being condensed into a group, are lined up in a row. Background and frame are lacking, and all the figures are somewhat flaked.

Located beside Genesis 38:8.

477a. Sm., fol. 51r

The inscription reads: ὁ χιτὼν ἰωσὴφ ὑποδεικνυόμ(εν)ο(ς) τῷ π(ατ)ρί.

The composition is essentially the same as in Ser., but there are slight changes in the arrangement of the sons, and one of them has been omitted, reducing their number from eleven to ten.

Located below Genesis 38:10.

478a. Vat. 746, fol. 119r

The inscription reads: ὁ χιτὼν ἰωσὴφ ὑποδεικνυόμ(εν)ο(ς) τῷ π(ατ)ρί.

In this miniature, too, which is close to Ser. and Sm., there are some variations in the grouping of the sons. In agreement with Vat. 747, Jacob here has a nimbus.

Located beside Genesis 37:27; its proper place is two spaces further on, beside Genesis 38:11 (see no. 366b).

Lit.: Tikkanen, *Genesismosaiken,* fig. 44; Uspenskii, p. 136; Hesseling, fig. 122; Buchthal, *Paris Ps.,* p. 67 n. 12; Pächt, "Life of Joseph," p. 39; Koshi, *Genesisminiaturen,* p. 17; Vikan, "Life of Joseph," p. 87; Maguire, "Depiction of Sorrow," p. 129, fig. 4; Bernabò, "Laur. plut. 5.38," pp. 151–52, pl. II no. 2; Weitzmann, *SP,* pp. 45, 48; Brubaker, "Gregory of Naz.," pp. 364, 375, 381; De Angelis, "Simbologia," p. 1535, fig. 19.

[1] Cf. C. Walter, *Art and Ritual of the Byzantine Church* (London, 1982), pp. 16–19. Walter adduces a miniature in the Paris Gregory Nazianzenus as an early representation of a penitential sakkos (Bibl. Nat., cod. gr. 510, fol. 78; ibid., fig. 4; H. Omont, *Les miniatures des plus anciens manuscrits de la Bibliothèque Nationale du VIᵉ au XIVᵉ siècle* [Paris, 1929], pl. 29).
[2] Similar strands hang from the beard of other aged persons in Vat. 747, e.g., the judge in fig. 1432.

Genesis 37:33–35

Jacob Puts Sackcloth on His Loins

476b. Ser., fol. 124v

A group of four sons and one daughter (mentioned in verse 35) tries to comfort Jacob, who sits before them, having just placed a piece of sackcloth around his shoulders (verse 34). The illustration apparently merges two separate episodes. Slightly flaked.

Located beside Genesis 38:8.

477b. Sm., fol. 51r

The inscription reads: θρῆνος ἰακὼβ ἕνεκεν ἰωσήφ.

There are only three sons and one daughter, but otherwise the scene agrees with Ser.

Located below Genesis 38:10.

478b. Vat. 746, fol. 119r

The inscription reads: θρῆνος ἰακὼβ ἕνεκεν ἰωσήφ.

In this miniature two sons and two daughters stand before Jacob.

Located beside Genesis 37:27; its proper place is two spaces further on, beside Genesis 38:11 (see no. 366b).

Lit.: Uspenskii, p. 136; Hesseling, fig. 122; Buchthal, *Paris Ps.*, p. 67 n. 12; Vikan, "Life of Joseph," p. 87; Bernabò, "Laur. plut. 5.38," pp. 151–52, pl. II no. 2; Weitzmann, *SP*, pp. 45, 48; De Angelis, "Simbologia," p. 1535.

Genesis 38:25–26

Judah Gives Three Pledges to Tamar

The Octateuchs illustrate only two episodes from the story of Judah and Tamar, both connected with New Testament exegesis. The first, Judah giving pledges of seal, cord, and staff to Tamar, was interpreted by Ephrem as a prefiguration of the birth of Christ, the person of the Trinity who was to be born through Tamar.[1]

479a. Vat. 747, fol. 59v

In the left half of the miniature, Tamar reveals to her father-in-law, Judah, that she has become pregnant by him. Judah's gestures indicate that he is answering her, admitting his guilt in not having given her his youngest son to be her husband.

Located beside Genesis 38:28.

480a. Ser., fol. 126r

In Tamar's hands are the ring and the signet cord which Judah gave her when he assumed she was a harlot. The ring and cord were added at a later time; her raised hand originally signified a gesture of speech. Judah is dressed in a long garment and is simply listening.

Located beside Genesis 38:28.

481a. Sm., fol. 51v

The beginning of the inscription, as far as it relates to the left scene, reads: τὰ κ(α)τ(ὰ) ρουβεὶν καὶ τὴν νύμφην αὐτοῦ.

Close to Ser. except that in this copy the ring and cord in Tamar's hands are original. However, the object she firmly grasps in her right hand seems not to have been correctly understood, since it resembles a flower.

Located above Genesis 38:28.

482a. Vat. 746, fol. 119v

The inscription reads: τὰ κατὰ ρουβὶν καὶ τὴν νύμφην αὐτοῦ.

Close to Ser. and Sm. Here, as in Ser., the ring and cord are later additions.

Located beside Genesis 37:34; its proper place is two spaces on, beside Genesis 38:28 (see no. 366b).

Lit.: Uspenskii, pp. 136–37, fig. 64; Hesseling, fig. 123; Buberl, *Byz. Hss.*, p. 113; Koukoules, "Ἔθιμα τῶν Βυζαντινῶν," pp. 97–98, fig. 1; Tsuji, "Essai d'identification," pp. 144–45; Bernabò, "Laur. plut. 5.38," pp. 151 n. 41, 155; Weitzmann, *SP*, pp. 45, 48; Ferrua, *Catacombe sconosciute*, p. 146 n. 9; Lowden, *Octs.*, p. 60.

[1] *CommGen* 34:5 (Ephraem, *In Genesim et in Exodum commentarii,* ed. Tonneau, p. 82).

Genesis 38:29–30

Birth of Pharez and Zarah

The second scene from the Judah and Tamar episode, like the first, implies momentous prefigurations. According to Matthew 1, Pharez, Tamar's firstborn twin, was an ancestor of David and, through him, of Christ.

479b. Vat. 747, fol. 59v

Tamar gives birth to twins. Pharez (LXX: Phares), the firstborn, lies on the ground while a kneeling midwife is busy delivering Zarah (LXX: Zara), the second son. The mother sits in front of the house where the scene is supposed to take place, her hands clenched in pain. As is frequently the case in birth scenes (especially in this manuscript: cf. figs. 355, 447), a delivery chair is not used and the woman appears to give birth while standing. An abundant issue of blood is falling to the ground between Tamar's legs. All the figures, particularly the babies, are badly flaked.

Located beside Genesis 38:28.

480b. Ser., fol. 126r

Tamar sits on a cushioned chair, and her expression is less pained than in Vat. 747. The second boy stretches out only one

arm, thus alluding to verse 28, according to which he first put out his hand but then withdrew it again.

Located beside Genesis 38:28.

481b. Sm., fol. 51v

The second part of the inscription reads: καὶ τοὺς τεχθέντας αὐτ(οῦ) παῖδας.

The midwife sits on a low bench, but otherwise the scene agrees thoroughly with Ser.

Located above Genesis 38:28.

482b. Vat. 746, fol. 119v

The inscription reads: καὶ τοὺς τεχθέντας αὐτ(οῦ) παῖδας.

The scene, which is closer to Ser. than to Sm., has been intentionally rubbed in the center.

Located beside Genesis 37:34; its proper place is two spaces further on, beside Genesis 38:28 (see no. 366b).

Lit.: Uspenskii, pp. 136–37, fig. 64; Hesseling, fig. 123; Buberl, *Byz. Hss.*, p. 113; Koukoules, "Ἔθιμα τῶν Βυζαντινῶν," pp. 97–98, fig. 1; Koukoules, *Vie et civilisation*, vol. 4, pl. 1 no. 1; Lafontaine-Dosogne, *Iconographie de l'enfance*, vol. 1, p. 84 n. 4; Bernabò, "Laur. plut. 5.38," pp. 151 n. 41, 155; Weitzmann, *SP*, pp. 45, 48; Ferrua, *Catacombe sconosciute*, p. 146 n. 9; Lowden, *Octs.*, p. 60.

Genesis 39:1

Joseph Brought to Egypt

484a. Ser., fol. 127r

The first half of the inscription reads: ἡ τοῦ ἰωσὴφ εἰς αἴγυπτον ἀπαγωγή.

Joseph is brought to Egypt riding on a camel. This scene, which repeats the illustration for Genesis 37:28 (Figs. 471e–474e), is fused with the one beside it showing Joseph Sold to Potiphar.

Located beside Genesis 39:6.

485a. Sm., fol. 51v

The inscription reads: ἡ τοῦ ἰωσὴφ εἰς αἴγυπτον ἀπαγωγή.

Very close to Ser. A hole in the center of the scene has been repaired.

486a. Vat. 746, fol. 120v

The inscription reads: ἡ τοῦ ἰωσὴφ εἰς αἴγυπτον ἀπαγωγή.

Whereas in the preceding instances Joseph holds the reins himself, here one of the Ishmaelites is leading the camel and Joseph merely holds a stick. This slight alteration underlines the fusion of the two conflated scenes which are united in this miniature.

Located beside Genesis 38:11; its proper place is two spaces further on, beside Genesis 39:6 (see no. 366b).

Lit.: Uspenskii, p. 137, fig. 65; Hesseling, fig. 124; De Grüneisen, *Ste. Marie Ant.*, p. 366; Diehl, *Manuel*, vol. 2, p. 597, fig. 281; Diehl, *Peinture byz.*, p. 94, pl. 81 no. 2; Buberl, *Byz. Hss.*, p. 113; Menhardt, p. 317; Kitzinger, "Story of Joseph," p. 268; Vikan, "Life of Joseph," pp. 92–93; Vileisis, "S. Maria Ant.," pp. 77–78; Anderson, "Seraglio," p. 89; Brubaker, "Gregory of Naz.," p. 452 n. 94; Gauthier-Walter, "Cycle de Joseph," p. 155, fig. 16.

Genesis 39:1

Joseph Sold to Potiphar

483. Vat. 747, fol. 59v

A large group of black-skinned Ishmaelites offers Joseph for sale. Potiphar (LXX: Petephres), a captain of Pharoah's guard, dressed in a rich, gold-embroidered garment and a turban, sits before his house and extends his hand toward the little boy who stands before him with respectfully crossed arms. Potiphar's house, topped by a baldachin, is counterbalanced by a purely decorative building at the left. High mountains with grisaille architecture form the background. The miniature is badly flaked, particularly the face of Potiphar, which is completely destroyed.

Located beside Genesis 39:6.

484b. Ser., fol. 127r

The continuation of the inscription reads: καὶ πρὸς πετεφρὴ πράσις.

As is usual in this manuscript, the number of Ishmaelites is restricted to two. The men lead the camels which belong to the previous scene and are thus related to two scenes simultaneously. Landscape and architecture are omitted entirely.

Located beside Genesis 39:6.

485b. Sm., fol. 51v

The inscription reads: καὶ πρὸς πετεφρὴ πράσις.

Very close to Ser. The scene has been grossly overpainted.

486b. Vat. 746, fol. 120v

The inscription reads: κ(αὶ) πρὸ(ς) πετεφρῆ πράσις.

Very close to Ser. and Sm.

Located beside Genesis 38:11; its proper place is two spaces further on, beside Genesis 39:6 (see no. 366b).

Lit.: Uspenskii, p. 137, fig. 65; Hesseling, fig. 124; De Grüneisen, *Ste. Marie Ant.*, p. 366; Diehl, *Manuel*, vol. 2, p. 597, fig. 281; Diehl, *Peinture byz.*, p. 94, pl. 81 no. 2; Buberl, *Byz. Hss.*, p. 113; Goetz, "Oriental Types," p. 55, fig. A on p. 54; Menhardt, "Bilder," p. 317; Vikan, "Life of Joseph," pp. 92–93; Vikan, "Joseph Iconography," pp. 104, 107 n. 53; Vileisis, "S. Maria Ant.," pp. 77–78; Brubaker, "Gregory of Naz.," pp. 369–70, 455 n. 123; Mathews, "Philo Judaeus," pp. 42–43; *Image du noir*, fig. 70; Anderson, "Seraglio," p. 89; Brubaker, "Gregory of Naz.," pp. 369–70, 455 n. 123; Gauthier-Walter, "Cycle de Joseph," p. 155, fig. 16.

Genesis 39:12

POTIPHAR'S WIFE SEIZES JOSEPH'S GARMENTS

487a. Vat. 747, fol. 60r

Potiphar's wife grasps the fleeing Joseph by the sleeve of his richly embroidered tunic and is about to strip him of it. The scene takes place before a high wall set against a golden sky and against the background of Potiphar's house, where the episode is supposed to have taken place. The woman's face is overpainted, and the figure of Joseph is partly flaked.

Located beside Genesis 39:10.

488a. Ser., fol. 127v

Close to Vat. 747, except that Potiphar's wife holds Joseph by the wrist instead of by the sleeve. Thus, the attempted seduction, which preceded the action of stripping, is represented here. An attempt was made to place the scene in a kind of classical interior, a gable which rests at the left on a column and at the right on a section of wall.

Located beside Genesis 39:10.

489a. Sm., fol. 52r

The beginning of the inscription, relating to the scene at the left, reads: ὁ τῆς αἰγυπτί(ας) πρὸς ἰωσῆφ ἔρως.

Potiphar's wife, her left hand hidden under her paenula, does not hold Joseph by force as in Ser., but rather tries to seduce him by persuasion. The gable rests on two columns. Otherwise the composition agrees with Ser.

Located above Genesis 39:12.

490a. Vat. 746, fol. 121v

The inscription begins: ὁ τῆς αἰγυπτίας πρὸ(ς) ἰωσῆφ ἔρως.
Closer to Ser. and Sm. Slightly flaked.

Located beside Genesis 38:28; its proper place is two spaces further on, beside Genesis 39:11 (see no. 366b).

Lit.: Uspenskii, p. 137, fig. 66; Hesseling, fig. 125; De Grüneisen, *Ste. Marie Ant.*, pp. 369–70; Wilpert, *Mosaiken und Malereien*, vol. 1, p. 62, figs. 17, 18; Gerstinger, *Wiener Gen.*, fig. 93; Buchthal, *Latin Kingdom*, p. 73; Pächt, "Ephraimill.," p. 254; Menhardt, p. 318; Revel, "Textes rabbin.," p. 125 n. 1; Stahl, "Morgan M. 638," p. 60, fig. 70; Crown, "Winchester Ps.," p. 35; Vikan, "Life of Joseph," pp. 101, 108; Bernabò, "Laur. plut. 5.38," p. 154; Vileisis, "S. Maria Ant.," pp. 82, 84; Anderson, "Seraglio," p. 94, fig. 19; Brubaker, "Gregory of Naz.," p. 370; Haussherr, "Bible moralisée," p. 139 n. 90.

Genesis 39:12

JOSEPH'S FLIGHT

At the right of this scene Ser. and Sm., but not Vat. 746, introduce a second figure of Potiphar's wife, more statuesque and ges-

turing in a classical attitude. Probably a later insertion, like the elaborate architectural setting, this second figure of the woman was presumably inspired by the second part of verse 12, which reads that Joseph left his clothes in her hands. Joseph's nakedness is not explicitly mentioned in the text, and it is not necessarily implied by the context, as a result of the woman grabbing his clothes, as other illustrated Joseph cycles show.[1] Thus, the painter's decision here must find support in other literary sources, such as the explicit attestation of Joseph's nakedness in his own account in the Testament of Joseph, one of the Testaments of the Twelve Patriarchs, a Jewish or Christian pseudepigraphon written either at the end of the second century B.C. or in the early second century A.D., possibly in Egypt[2]: "When I saw, therefore, that in her madness she had seized my garment, I shook loose and left it and fled naked."[3]

487b. Vat. 747, fol. 60r

Gesturing in fright, Joseph runs naked out of the house and looks back at the open entrance through which he has just escaped. A continuation of the wall from the preceding scene forms the background. The figure of Joseph is very badly flaked.

Located beside Genesis 39:10.

488b. Ser., fol. 127v

The escaping Joseph is the same as in Vat. 747, but Potiphar's wife is also present. The architecture is badly misunderstood, but is composed of the same elements as in Vat. 747: a wall, forming the background, of which only the cornice remains, and the entrance to the house at the left, partly covered by the imaginary wall.

Located beside Genesis 39:10.

489b. Sm., fol. 52r

The continuation of the inscription reads: καὶ ἡ ἀποτυχ(ία) καὶ ἡ κατηγορία. The second phrase refers to the next scene.

Potiphar's wife has just stripped Joseph and still holds his tunic in her hand. Thus the copyist here illustrates an action that, in the other manuscripts, is represented or at least alluded to in the preceding scene. Otherwise, however, the compositional scheme agrees with Ser.

Located above Genesis 39:12.

490b. Vat. 746, fol. 121v

The inscription reads: καὶ ἡ ἀποτυχία καὶ ἡ κατηγορία.

Both figures agree with Ser., but Joseph's tunic lying on the ground has been added, thus alluding to his stripping. The figure of the woman is slightly flaked.

Located beside Genesis 38:28; its proper place is two spaces further on, beside Genesis 39:11 (see no. 366b).

Lit.: Uspenskii, pp. 102, 137, fig. 66; Hesseling, fig. 125; De Grüneisen, *Ste. Marie Ant.*, pp. 369–70; Wilpert, *Mosaiken und Malereien*, vol. 1, p. 62,

figs. 17, 18; Gerstinger, *Wiener Gen.*, fig. 93; Buchthal, *Latin Kingdom*, p. 73; Menhardt, p. 318; Pächt, "Ephraimill.," p. 254; Revel, "Textes rabbin.," p. 125 n. 1; Lassus, *Livre des Rois*, p. 87, fig. 119; Stahl, "Morgan M. 638," p. 60, fig. 70; Anderson, "Two Centers," pp. 83–84; Vikan, "Life of Joseph," pp. 101, 108, 111–12; Bernabò, "Laur. plut. 5.38," p. 154; Vileisis, "S. Maria Ant.," pp. 82, 84; Anderson, "Seraglio," p. 94, fig. 19.

¹ E.g., the mosaics of San Marco in Venice (Demus, *Mosaics of S. Marco*, vol. 2, pt. 2, pl. 268), the Maximianus cathedra (ibid., fig. 386), or the Vienna Genesis, pict. 31 (Gerstinger, *Vienna Gen.*, pict. 31).
² See *OTP*, vol. 1, pp. 775–78.
³ Testament of Joseph 8:3 (*OTP*, vol. 1, p. 821).

Genesis 39:16–18

POTIPHAR'S WIFE DISPLAYS THE GARMENT TO POTIPHAR

In the upper strip, Potiphar's wife flaunts Joseph's clothes in front of her husband. In contrast to verses 15, 16, and 18, where the woman is said to have left Joseph's clothes beside her, in this very dramatic representation the woman vividly approaches her sitting husband, almost running in Vat. 747, and waves a tunic in the air in front of him.

491a. Vat. 747, fol. 60r

Potiphar's wife shows Joseph's tunic to her husband. While she appears to be in a state of great excitement, Potiphar sits calmly before his house, resting his head on his hand in a gesture of thought. The scene is badly flaked.
Located beside Genesis 39:22.

492a. Ser., fol. 128r

The groundline that separates this miniature from the one below in Vat. 747 is omitted in Ser. and the other manuscripts, and the two superimposed scenes have been fused in such a way that Potiphar's wife, with Joseph's tunic in her hand, stands on the left tower of the prison, while her husband sits on a golden chair on the right tower. Potiphar stretches out his hand as if he were asking for the tunic.
Located beside Genesis 39:22.

493a. Sm., fol. 52v

Very close to Ser.
Located below Genesis 40:1.

494a. Vat. 746, fol. 122v

Very close to Ser. and Sm.
Located beside Genesis 39:6; its proper place is two spaces further on, beside Genesis 39:22 (see no. 366b).

Lit.: Uspenskii, p. 137, fig. 67; Hesseling, fig. 126; Wilpert, *Mosaiken und Malereien*, vol. 1, p. 63, fig. 19; Xyngopoulos, "Ἀνάγλυφον," fig. 5 no. 2; Gerstinger, *Wiener Gen.*, figs. 94, 95; Pächt, "Life of Joseph," p. 40;

Kitzinger, "Hellenistic Heritage," p. 109, fig. 16; Tsuji, "Chaire," p. 50 n. 11; Crown, "Winchester Ps.," p. 36; Vikan, "Life of Joseph," p. 120; Brubaker, "Gregory of Naz.," p. 455 n. 123.

Genesis 40:7–19

JOSEPH INTERPRETS THE DREAMS OF THE BUTLER AND THE BAKER

In the lower strip, Joseph interprets the dreams inside a circular prison, while a guard, not required by the text, sits nearby; in Ser., Sm., and Vat. 746 the guard holds a stick. Especially in these latter three manuscripts, the iconography recalls a marble slab found in the martyrion in Seleukeia (Antioch), and dating from the late fifth or the first half of the sixth century (now in The Art Museum, Princeton University) (text fig. 4),¹ and depicting the three prisoners, part of the seated guard, and a vault without crenelation above the heads of the prisoners, flanked by two pilasters.² In contrast to the marble slab, Vat. 747 omits the guard on the left; moreover, while the slab, Sm., and Vat. 746 depict stone vaulting, Ser. and Vat. 747 agree in transforming the vault of the prison into a crenelated wall, with the front wall omitted and the two side pilasters turned into two towers.

491b. Vat. 747, fol. 60r

The chief butler and the chief baker sit on the floor of the prison and a nimbed Joseph squats between them. Joseph listens to the narration of the dream by the man on the left, who raises his hands toward heaven in a vivid gesture, probably of gratitude; his companion is apparently nervous or alarmed, presumably disappointed by Joseph's response. The prison is depicted as a background wall between two flanking towers, the front wall having been omitted to give a view of the interior. On either side are sections of a mountainous landscape. The whole surface is badly damaged by flaking.
Located beside Genesis 39:22.

492b. Ser., fol. 128r

All three prison inmates sit on chairs with their feet in stocks. Joseph turns toward the prisoner at the left, who raises his arms and therefore can be identified as the chief butler, expressing joy at his imminent release, whereas the chief baker at the right merely extends his right hand as if arguing with Joseph. The captain of the guard sits outside the prison holding a long staff in his hands. The feature of the feet locked in stocks, which does not appear in Vat. 747, is apparently a later replacement.³ Somewhat flaked and rubbed.
Located beside Genesis 39:22.

493b. Sm., fol. 52v

The inscription reads: ἡ τοῦ ἰωσὴφ εἰς τ(ὸ) δεσμωτ(ήριον) κάθειρξις.

Close to Ser., but the prisoners' feet are not locked in stocks, and there are slight deviations in their gestures. Joseph turns more decidedly toward the chief butler, and the pose of the chief baker more explicitly expresses grief. The figure of Joseph is flaked.

Located below Genesis 40:1.

494b. Vat. 746, fol. 122v

The inscription reads: ἡ τοῦ ἰωσὴφ εἰς τὸ δεσμωτήριον κάθειρξις.

Close to Ser. and Sm., except that the chief butler holds his left hand before his breast and the chief baker rests his head in his hand as a sign of grief. The figure of the captain of the guard is badly rubbed.

Located beside Genesis 39:6; its proper place is two spaces further on, beside Genesis 39:22 (see no. 366b).

Lit.: Uspenskii, p. 137, fig. 67; Hesseling, fig. 126; De Grüneisen, *Ste. Marie Ant.*, pp. 369–70, 372; Wilpert, *Mosaiken und Malereien*, vol. 1, p. 63, fig. 19; Gerstinger, *Wiener Gen.*, figs. 94, 95; Weitzmann, "Martyrion," p. 139; Weitzmann, "Septuagint," p. 53, fig. 31; Menhardt, p. 318; Weitzmann, "Oct. Ser.," p. 184; Soteriou, Εἰκόνες, vol. 2, pp. 62–63; "Wiener Gen.: Resumé," pp. 44, 51; Kitzinger, "Hellenistic Heritage," p. 109, fig. 16; Weitzmann, "St. Nicholas Triptych," p. 2; Eschweiler et al., "Inhalt," p. 70; Revel, "Textes rabbin.," p. 127 n. 2; Kötzsche-Breitenbruch, *Via Latina*, p. 28; Vikan, "Life of Joseph," p. 130; Havice, "Hamilton Ps.," p. 272; Al-Hamdani, "Sources," p. 29; Vileisis, "S. Maria Ant.," p. 88; Buschhausen, "Via Latina," p. 299.

[1] *Age of Spirituality*, pp. 465–66, no. 416; *Byzantium at Princeton*, pp. 45–46, no. 7. For a comparison of the marble slab and the Octateuchs, cf. Weitzmann, "Martyrion," p. 139, and Weitzmann, "Septuagint," p. 53.

[2] A close parallel to the representation in the Octateuchs is found in a miniature illustrating Ps 104 in the twelfth-century Psalter cod. Vat. gr. 1927, fol. 191v (cf. De Wald, *Vat. Gr. 1927*, pl. 45). A similar iconography also occurs in the episodes of the three generals sitting in jail from the cycle of St. Nicholas, as depicted in a triptych in the Monastery of St. Catherine on Mount Sinai (Soteriou, Εἰκόνες, vol. 1, pl. 46, and vol. 2, pp. 62–63; Weitzmann, "St. Nicholas Triptych," p. 2, fig. 1).

[3] The same locking of feet is depicted, for example, in the Skylitzes manuscript in Madrid (Bibl. Nac., cod. vitr. 26-2), fol. 186r: A. Grabar and M. Manoussacas, *L'illustration du manuscrit de Skylitzès de la Bibliothèque Nationale de Madrid* (Venice, 1979), fig. 234.

Genesis 40:7–19

Joseph Interprets the Dreams of the Butler and the Baker

The miniature in Ser., Sm., and Vat. 746 has no counterpart in Vat. 747. In the upper strip Joseph interprets the dreams of the chief butler and the chief baker. This picture is a duplicate of the previous miniature (figs. 492b–494b) and differs from it both in the position of the three men, who are standing here instead of sitting, and in the location of the episode, which now takes place in an open, undefined space instead of in the prison as the text would demand (Gen 40:3 and 7). The picture seems to be a late addition to the cycle, designed to accommodate an unsatisfactory model. A similar iconography, with an open-air setting, is found in the Cotton Genesis recension.[1]

496a. Ser., fol. 128v

Joseph approaches the two eunuchs, asking about their dreams. The chief butler raises his hand in a gesture of speech, whereas the chief baker throws up his hands in despair. All the figures, but particularly that of Joseph, are badly flaked.

Located beside Genesis 40:17.

497a. Sm., fol. 52v

The inscription reads: ἰωσὴφ διακρίνων τὰ ὀνείρατα τοῦ ἀρχιοινοχόου καὶ ἀρχισιτοποιοῦ.

Except for slight changes in the gestures and the fact that the eunuchs wear short tunics, the scene is close to Ser.

Located below Genesis 40:14.

498a. Vat. 746, fol. 123r

The inscription reads: ἰωσὴφ διακρίνων τὰ ὀνείρατα τοῦ ἀρχιοινοχόου.

Compared with Ser., the two eunuchs are interchanged, the one facing Joseph throwing up his arms. All three figures wear short tunics.

Located beside Genesis 39:11; its proper place is two spaces further on, beside Genesis 40:11 (see no. 366b).

Lit.: Uspenskii, p. 137; Hesseling, fig. 127; Menhardt, pp. 318–19; Pächt, "Life of Joseph," p. 41; Stahl, "Morgan M. 638," pp. 136–37, fig. 175; Bernabò, "Fonti testuali," pl. 28 no. 2; Lowden, *Octs.*, p. 60.

[1] Weitzmann and Kessler, *Cotton Gen.*, figs. 417, 418.

Genesis 40:13–19

Butler Serves Pharaoh and Baker Hanged

The realization of Joseph's interpretations is pictured in the lower register. The picture is duplicated by the scene in the upper strip of the next miniature, which is depicted in the same way in all the Octateuchs (figs. 499a–502a), except that in the first scene Pharaoh is sitting on a small bench, and in the second he is lying on a bed. See also the introduction to Genesis 40:6–7.

496b. Ser., fol. 128v

The miniature does not depict the content of the dreams as narrated by the eunuchs, but the actual events that followed and conformed to Joseph's interpretation of the dreams. At the left, the chief butler offers a cup to Pharaoh, who sits before a set table. At the right, the chief baker hangs on a cross; his head has been cut off and lies on the ground. Two crows eat the flesh of the naked, bleeding corpse.[1] Flaked in various spots.

Located beside Genesis 40:17.

497b. Sm., fol. 52v

The inscription reads: ὁ φαραὼ ὑπομιμνησκόμεν(ος) πε(ρὶ) τοῦ ἰωσήφ.

Very close to Ser.

Located below Genesis 40:14.

498b. Vat. 746, fol. 123r

The inscription reads: φαραὼ ὑπομιμνησκόμενο(ς) περὶ τοῦ ἰωσήφ.

Very close to Ser. and Sm.

Located beside Genesis 39:11; its proper place is two spaces further on, beside Genesis 40:11 (see no. 366b).

Lit.: Uspenskii, p. 137; Franchi de' Cavalieri, "Furca," p. 84 n. 1; Hesseling, fig. 127; Pächt, "Life of Joseph," p. 41; Koshi, *Genesisminiaturen*, p. 34 n. 159; Weitzmann, "Jewish Sources," p. 89; Bernabò, "Fonti testuali," pp. 479–80, pl. 28 no. 2; Anderson, "Seraglio," pp. 92–93, fig. 11; Weitzmann and Kessler, *Cotton Gen.*, p. 41; Lowden, *Octs.*, p. 60.

[1] For the crucifixion of the baker, see the discussion at nos. 499a–502a below.

[Genesis 40:20]

BUTLER AND BAKER IN FRONT OF PHARAOH

No convincing link to the illustration of Pharaoh addressing two servants, preserved only in Vat. 747, is found in the Septuagint, except for a flimsy reference in Genesis 40:20, where Pharaoh gives a banquet for his servants. Philo, *De Josepho* 98,[1] gives an embellished narrative of the banquet: "While the dignitaries were banqueting and the servants were regaling themselves as at a public feast, the king remembered the eunuchs in the prison and bade them to be brought to him. And, when he saw them, he ratified what had been foreseen in the interpretation of the dreams, by ordering one to be beheaded and impaled, and the other to be restored to his former office." This picture may thus represent Pharaoh's audience with the freed eunuchs and his decision about their fates, and may have originated from a narrative such as Philo's.

495. Vat. 747, fol. 60v

Pharaoh addresses his two eunuchs, who stand in front of him with arms crossed; he pronounces the verdict that the chief butler will be restored to his position and the chief baker hanged. Pharaoh sits on a throne before the wall of the palace, above which emerge three separate buildings connected by balustrades.

Located beside Genesis 40:17.

Lit.: Kötzsche-Breitenbruch, *Via Latina*, p. 29 n. 147; Lowden, *Octs.*, p. 60; Iacobini, "Lettera," p. 80, fig. 4.

[1] *Philo*, ed. Colson, vol. 6, pp. 188–89.

Genesis 40:20–22

BUTLER SERVES PHARAOH AND BAKER HANGED

According to Genesis 40:19, Joseph predicts to the chief baker that "ἀφελεῖ Φαραὼ τὴν κεφαλήν σου ἀπὸ σου, καὶ κρεμάσει σε ἐπὶ ξύλου," that is, "Pharaoh shall take away thy head from off thee, and shall hang thee on a tree"; later, at Genesis 40:22, Pharaoh "τὸν δὲ ἀρχισιτοποιὸν ἐκρέμασεν," that is, "hanged the chief baker." The Greek text does not say explicitly that the baker was to be crucified, as depicted in the miniature; in a somewhat vague pronouncement, it foretells that Pharaoh ordered him beheaded and then hanged.[1] It should be recalled that the scene duplicates nos. 496b–498b in Ser., Sm., and Vat. 746—or vice versa; this fact may indicate that the model was unsatisfactory and that the painter was required to reinvent the scene and turned for a model to the picture illustrating the similar narrative in Genesis 40:13–19. In addition, in the present illustration, the inscription, as we read it in Vat. 746 ("here the chief butler tells Pharaoh about Joseph"), refers not to the episode depicted but to a different event, narrated later in the text at Genesis 41:9–13. This discrepancy between inscription and image indicates confusion in the execution of the miniature and implies that the model depicted such an episode. If this were the case, the illustration must erroneously have preceded Pharaoh's dreams, represented in the lower strip of the miniature (nos. 499b–502b).

499a. Vat. 747, fol. 61r

The chief butler offers a cup to Pharaoh, who lies on a couch beside a table, around which three turbaned court officials are seated. At the right the nude corpse of the decapitated chief baker hangs on a cross; his head lies on the ground. Slightly flaked.

Located beside Genesis 41:12.

500a. Ser., fol. 129r

Close to Vat. 747, except that Pharaoh's guests do not wear turbans and thus any indication of an oriental court is avoided. The two crows picking at the flesh of the chief baker are mentioned in verse 19.

Located beside Genesis 41:11.

501a. Sm., fol. 53r

Very close to Ser.

502a. Vat. 746, fol. 123v

The inscription reads: ἔνθα ὁ ἀρχιοινοχόος διηγεῖται τῷ φαραὼ περὶ ἰωσήφ.

Very close to Ser. and Sm.

Located beside Genesis 39:22; its proper place is two spaces further on, beside Genesis 41:10 (see no. 366b).

Lit.: Hartel and Wickhoff, *Wiener Gen.*, p. 165, fig. 20; Uspenskii, p. 138, fig. 68; Franchi de' Cavalieri, "Furca," p. 84 n. 1; Hesseling, fig. 128; De

Grüneisen, *Ste. Marie Ant.*, pp. 346, 374–75, fig. 303; Gerstinger, *Wiener Gen.*, fig. 100; Buberl, *Byz. Hss.*, p. 117; Koshi, *Genesisminiaturen*, p. 34 n. 159; Stahl, "Morgan M. 638," pp. 136–37, fig. 176; Vikan, "Life of Joseph," pp. 137–38; Bernabò, "Fonti testuali," pp. 479–80; Vileisis, "S. Maria Ant.," pp. 95–96; Brubaker, "Gregory of Naz.," p. 457 n. 136; Vikan, "Pictorial Recensions," p. 4; Weitzmann and Kessler, *Cotton Gen.*, p. 41; De Angelis, "Simbologia," p. 1538, fig. 25.

¹ The procedure of execution by beheading and hanging seems to be asserted in the Targumim. TargN has: "he will crucify you on a cross" (*Targum Genèse*, ed. Le Déaut, p. 366) or "he will hang you on a gibbet" or "the tree" or "gallows" (*Neophyti 1: Targum Palestinense*, vol. 1, *Génesis*, ed. Díez Macho, p. 608 and notes 8 and 9). TargOnk has: "Pharaoh will remove your head from you and hang you on the gallows," specifying the Hebrew "tree" or "wooden pole" (*Targum Onqelos to Genesis*, ed. M. Aberbach and B. Grossfeld [New York, 1982], pp. 134–35 n. 12). Josephus (*Ant* 2:73) seems to mention the crucifixion but not the decapitation: "on the third day he will be crucified" (or "impaled": ἀνασταυρωθέντα) (*Josephus*, ed. Thackeray, vol. 4, p. 198). Cf. also Philo, *De somniis*, bk. 2, 213 (*Philo*, ed. Colson, vol. 5, p. 538; cf. Mathews, "Philo Judaeus," p. 39) and *De Josepho* 96 (*Philo*, ed. Colson, vol. 6, p. 188). On the procedure and the meaning of the Greek terms employed, cf. G. Bertram, *TDNT*, vol. 3, pp. 915–21, and J. Schneider, *TDNT*, vol. 5, pp. 37–41. The hanging of the baker is also represented in the Vienna Genesis, pict. 34, where the baker is hanged on a fork (Gerstinger, *Vienna Gen.*, pict. 34).

Genesis 41:2–3

PHARAOH'S DREAM OF THE LEAN AND THE FAT COWS

Again Vat. 747 differs from the other manuscripts: Ser., Sm., and Vat. 746 depict the lean and the fat cows just emerging from the river, as in verses 2–3; in Vat. 747 (no. 499b) the lean cows are already devouring the fat ones, following verse 4.

500b. Ser., fol. 129r

Pharaoh lies on a couch between two groups of cows, each consisting of only three animals instead of seven, and no clear distinction is visible between the fat and the lean ones. The architectural background is omitted. The left-hand group of cows is somewhat rubbed.
Located beside Genesis 41:11.

501b. Sm., fol. 53r

Very close to Ser.

502b. Vat. 746, fol. 123v

The inscription reads: ἐνταῦθα φαραὼ ἐνυπνιάζεται.
Very close to Ser. and Sm.
Located beside Genesis 39:22; its proper place is two spaces further on, beside Genesis 41:10 (see no. 366b).

Lit.: Hartel and Wickhoff, *Wiener Gen.*, p. 165, fig. 20; Uspenskii, p. 138, fig. 69; Hesseling, fig. 128; De Grüneisen, *Ste. Marie Ant.*, pp. 346, 374–75, fig. 303; Buberl, *Byz. Hss.*, p. 117; Stahl, "Morgan M. 638," pp. 136–37, fig. 176.

Genesis 41:4

PHARAOH'S DREAM OF THE LEAN COWS DEVOURING THE FAT

See the introduction to Genesis 41:2–3.

499b. Vat. 747, fol. 61r

Pharaoh lies on a couch and dreams about the lean and fat cows. This dream is rendered visually by seven lean cows in a row that have already swallowed the heads of the seven fat ones. In the background is Pharaoh's palace with a domed upper story.
Located beside Genesis 41:12.

Lit.: Gerstinger, *Wiener Gen.*, fig. 100; De Angelis, "Simbologia," p. 1538, fig. 25.

Genesis 41:14–24

JOSEPH INTERPRETS PHARAOH'S DREAMS

In the following episode the iconographies of Vat. 747 and Ser., Sm., and Vat. 746 agree.

503. Vat. 747, fol. 61v

Pharaoh sits upon his couch and asks Joseph to interpret his dreams; the youth stands before him with arms reverently crossed. A group of Egyptians, apparently the interpreters who had been unable to explain the dreams, stands at the right. The scene, which should take place in an interior, is set against a mountainous background. The content of Pharaoh's dreams is depicted in a second picture underneath, unlike the preceding miniature (figs. 499b–502b), where the dreams and Pharaoh are aligned on the same groundline. At the left the seven lean cows devour the heads of the seven fat ones, and at the right a row of seven good heads of grain is placed above a row of seven thin heads. The figure of Pharaoh is overpainted and the late Byzantine crown on his head replaces a pearl diadem of the earlier period.
Located beside Genesis 41:33.

504. Ser., fol. 130r

Joseph stands close to Pharaoh and talks to him. The unsuccessful interpreters are distinguished by their headdresses, and the one at the right wears a Persian cap. The cows in the lower strip are reversed, the lean ones being at the left and the fat at the right; they stand with their hooves in the river. The seven heads of grain are not on individual stalks as in Vat. 747, but united in a shrub. Moreover there is only one set of ears: the second was omitted due to lack of space. Slightly flaked and rubbed.
Located beside Genesis 41:25. Note that, in comparison with Vat. 747, the scribe of Ser. left an additional space here, so that the correspondence between the two manuscripts is disrupted,

and the space for the present miniature in Ser. corresponds with that of the following miniature in Vat. 747.

505. Sm., fol. 53r or 53v[1]

The inscription reads: ἐνταῦθα ἰωσὴφ ἐπιλύ(ων) τὸ ἐνύπνιον τὸ τῶν βο(ῶν) καὶ τῶν ἀσταχύ(ων).

Very close to Ser., but less condensed: in the upper strip Joseph is fully visible, as in Vat. 747, and in the lower strip space was found for both sets of seven ears, although no clear distinction is made between the thin and the good. Pharaoh wears a kind of turban instead of a crown, but this deviation is probably due to a later overpainting of the miniature.

506. Vat. 746, fol. 124r

The inscription reads: ἐνταῦθα ἰωσὴφ ἐπιλύω(ν) τὸ ἐνύπνιον τὸ τῶν βοῶν κ(αὶ) τῶν ἀσταχύων.

Very close to Ser. and Sm. The entire surface is considerably flaked.

Located beside Genesis 40:11; its proper place is two spaces further on, beside Genesis 41:33 (see no. 366b).

Lit.: Uspenskii, p. 138, figs. 70, 71; Hesseling, fig. 129; Gerstinger, *Wiener Gen.*, fig. 103; Buberl, *Byz. Hss.*, p. 118; Menhardt, p. 319; Cahn, "Illustrated Josephus," p. 298; Nordström, *Castilian Bible*, p. 68; Koshi, *Genesisminiaturen*, p. 20; Vikan, "Life of Joseph," pp. 139–40; Havice, "Hamilton Ps.," p. 271; Weitzmann, *SP*, p. 46; Havice, "Marginal Miniatures," p. 114; Lowden, *Octs.*, p. 69, figs. 91, 92.

[1] Fol. 53r according to Hesseling, p. ix; fol. 53v according to Uspenskii, p. 184.

Genesis 41:39–41

PHARAOH SETS JOSEPH OVER ALL EGYPT

In this miniature we again encounter divergences among the Octateuchs. Vat. 747 illustrates Pharaoh Sets Joseph over All Egypt, narrated in verses 39–41, followed by Joseph Given a Chariot, narrated in verse 43 (no. 507b). In contrast, Ser., Sm., and Vat. 746 depict first, on the left, Pharaoh Giving Gifts to Joseph, according to verse 42; beside him stands Asenath (LXX: Aseneth), Joseph's Egyptian wife, who is not mentioned in the giving of the gifts at verse 42 and is given to Joseph only later, at verse 45.[1] Then, on the right, follows Joseph Given a Chariot, recounted in verse 43 (nos. 508b–510b), but with an iconography different from that in Vat. 747.

507a. Vat. 747, fol. 61v

In the left half of the miniature Pharaoh tells Joseph that he has decided to set him over all Egypt. Joseph, still barefoot and wearing a short tunic like a prisoner, stands reverently before Pharaoh, who sits on a throne. The architectural background consists of a house and an ornamental back wall. The miniature

is overpainted, and the type of crown on Pharaoh's head has been altered. The figure of Pharaoh is particularly badly flaked.

Located beside Genesis 41:46.

Lit.: Stahl, "Morgan M. 638," p. 140, fig. 140; Vikan, "Life of Joseph," pp. 150, 381; Havice, "Hamilton Ps.," pp. 270, 272–73; Weitzmann, *SP*, p. 46; Riddle, "Triumph," pp. 74–75; Havice, "Marginal Miniatures," pp. 128–29.

[1] Asenath's presence induced Stichel ("Ausserkanon. Elemente," p. 176) to link the miniature not to the Septuagint, but rather to the romance Joseph and Asenath (21:5–6: *OTP*, vol. 2, p. 235), where the gifts are actually given to Joseph while Asenath is beside him. Yet the Joseph and Asenath narrative describes many details that the Octateuch miniature does not include: "And Pharaoh took Joseph and Aseneth and put golden crowns on their heads And Pharaoh set Asenath at Joseph's right side and put his hands on their heads, and his right hand was on Asenath's head"

Genesis 41:(39–)42, 45

PHARAOH GIVES GIFTS AND ASENATH TO JOSEPH

See the introduction to Genesis 41:39–41.

508a. Ser., fol. 130v

Instead of talking to Joseph, Pharaoh gives him a small red box which must contain the ring mentioned as the first of many gifts. Moreover, Joseph is already dressed in the "vestment of fine linen," a richly embroidered long tunic. The necklace of solid gold hangs around his neck and on his head sits a pearl diadem. Beside him stands Asenath, daughter of Potipherah, priest of On (LXX: Petephres, priest of Heliopolis), who has been given to him as his wife. A bodyguard stands behind Pharaoh, but any indication of an architectural background is omitted. All the figures are badly flaked.

Located beside Genesis 41:36, corresponding to the following miniature in Vat. 747 (see no. 504).

509a. Sm., fol. 53v

The inscription reads: ἔνθα φαραὼ ἀποκαθιστῶν ἄρχοντα πάσης αἰγύπτου τὸν ἰωσὴφ παρέχων αὐτῷ καὶ τ(ὴν) ἀσενέθ.

Pharaoh holds the ring in his hand and is about to put it on Joseph's little finger. Otherwise the scene is very close to Ser.

510a. Vat. 746, fol. 125r

The inscription reads: ἔνθα φαραὼ ἀποκαθιστῶν ἄρχοντα πάσης αἰγύπτου τὸν ἰωσὴφ παρέχων αὐτῷ καὶ τὴν ἀσενέθ.

Very close to Sm.

Located beside Genesis 41:10; its proper place is two spaces further on, beside Genesis 41:46 (see no. 366b).

Lit.: Uspenskii, p. 138, fig. 72; Hesseling, fig. 130; Menhardt, p. 320; Stahl, "Morgan M. 638," p. 140; Stichel, "Ausserkanon. Elemente," p. 176; Vikan, "Life of Joseph," pp. 150, 381; Havice, "Hamilton Ps.," pp. 270, 272–73; Weitzmann, *SP*, p. 46; Riddle, "Triumph," pp. 74–75, pl. 6; Brubaker,

"Gregory of Naz.," p. 371; Havice, "Marginal Miniatures," pp. 128–29; Gauthier-Walter, "Joseph," p. 27.

Genesis 41:46

Joseph Given a Chariot

See the introduction to Genesis 41:39–41. Even though the four Octateuchs illustrate the same verse, the iconography in Vat. 747 diverges from that in Ser., Sm., and Vat. 746 in that Joseph's chariot moves in the opposite direction.

507b. Vat. 747, fol. 61v

Wearing a crown and chlamys, Joseph drives the chariot that Pharaoh gave him along with other gifts in verse 43. The background is formed by an elongation of the same wall that appears behind the scene at the left. This portion of the miniature is also overpainted, and Joseph's crown has been modernized. The surface is somewhat flaked.

Located beside Genesis 41:46.

508b. Ser., fol. 130v

Joseph drives the chariot to the left instead of the right; he wears the same rich garment and the same gold necklace as in the preceding scene. Partly flaked.

Located beside Genesis 41:36, corresponding to the following miniature in Vat. 747 (see no. 504).

509b. Sm., fol. 53v

Very close to Ser.

510b. Vat. 746, fol. 125r

Very close to Ser. and Sm.

Located beside Genesis 41:10; its proper place is two spaces further on, beside Genesis 41:46 (see no. 366b).

Lit.: Uspenskii, p. 138, fig. 72; Hesseling, fig. 130; Menhardt, p. 320; Stahl, "Morgan M. 638," p. 140, fig. 179; Vikan, "Life of Joseph," pp. 150, 381; Havice, "Hamilton Ps.," pp. 270, 272–73; Weitzmann, *SP*, p. 50; Riddle, "Triumph," pp. 74–75, pl. 6; Brubaker, "Gregory of Naz.," p. 372; Havice, "Marginal Miniatures," pp. 128–29; Gauthier-Walter, "Joseph," pp. 27, 29.

Genesis 41:56–57

Joseph Sells Grain

511. Vat. 747, fol. 62r

In this and all the following scenes Joseph is dressed like a member of the Byzantine imperial family, wearing a chlamys, pearl crown, and pearl-studded purple shoes. He sits in front of a house and orders the sale of the grain. One of his servants, a light-skinned youth, is filling another youth's sack with grain which he has taken from the huge pile in the foreground. A group of black-skinned Egyptians in short mantles and turbans looks on, gesturing in surprise and awaiting their turn to have their sacks filled. A range of high mountains forms the background. Partly flaked.

Located beside Genesis 41:55.

512. Ser., fol. 131r

Close to Vat. 747 but with slight variations. One of Joseph's servants fills a dark-skinned Egyptian's sack, while a second servant, obviously an overseer, stands behind him making a gesture as if he were computing and showing Joseph the amount of grain being placed in the sack. Some of the Egyptians are clad in short mantles, others in long, striped garments with excessively long sleeves; here and in Sm. and Vat. 746 their skin color is dark brown. The building behind Joseph, with its conical roof, is not an ordinary house, as in Vat. 747; rather it is intended to represent a granary. The miniature is heavily damaged by flaking, but enough remains to show that the composition is very close to Sm.

Located beside Genesis 41:46, corresponding to the following miniature in Vat. 747 (see no. 504).

513. Sm., fol. 54r

The inscription reads: ἐνταῦθα ἰωσὴφ πιπράσκων τὸν σῖτον πρὸς τοὺς αἰγυπτίους.

Very close to Ser.

514. Vat. 746, fol. 126r

The inscription reads: ἐνταῦθα ἰωσὴφ πιπράσκων τὸν σῖτον πρὸ(ς) τοὺς αἰγυπτίους.

Very close to Ser. and Sm. The entire surface is slightly flaked.

Located beside Genesis 41:33; its proper place is two spaces further on, beside Genesis 41:55 (see no. 366b).

Lit.: Uspenskii, p. 138; Hesseling, fig. 131; Menhardt, p. 321; Weitzmann, *SP*, pp. 47–48.

Genesis 42:1–4

Jacob Sends His Sons to Egypt

In the following miniature Ser., Sm., and Vat. 746 show Jacob Sends His Sons to Egypt, an illustration that does not appear in Vat. 747.

516. Ser., fol. 131v

Sitting before his house, Jacob sends his sons to Egypt to buy grain. Ten of his sons stand before him with their arms crossed, listening to his orders; little Benjamin, the eleventh son, who will remain at home, faces his departing older brothers. This episode occupies the entire miniature, in contrast to Sm. and Vat. 746,

where it is depicted in the upper half together with the episode of Joseph's brothers bowing before him.

Located beside Genesis 41:55, corresponding to the following miniature in Vat. 747.

518a. Sm., fol. 54v

The inscription reads: ἔνθα ἀποστέλλοντ(αι) οἱ ἀδελφοὶ ἰω-σὴφ παρὰ τοῦ π(ατ)ρ(ὸ)ς αὐτ(ῶν) εἰς αἴγυπτον.

Very close to Ser., but the miniature has been overpainted. Due to a mistake on the part of the restorer the group of brothers now numbers more than ten.

519a. Vat. 746, fol. 126v

The inscription begins within the frame and continues outside it in the left margin. It reads: ἔνθα ἀποστέλλονται οἱ ἀδε(λφοὶ) ἰωσὴφ παρὰ τοῦ π(ατ)ρ(ὸ)ς αὐτ(ῶν) εἰς αἴγυπτον.

Very close to Ser. and Sm. The miniature is heavily over-painted.

Located beside Genesis 41:46; its proper place is two spaces further on, beside Genesis 42:21 (see no. 366b).

Lit.: Uspenskii, p. 138; Hesseling, fig. 132; Menhardt, p. 321; Vikan, "Life of Joseph," p. 158; Bernabò, "Studio," pl. 10.

Genesis 42:6–7

JOSEPH'S BROTHERS BOW BEFORE HIM

In this scene as well, the iconography in Vat. 747 diverges from that of the other Octateuchs. The former depicts only the episode of the arrival of the brothers; the latter have the same scene in the lower strip, but reversed and with a bodyguard standing by Joseph, replacing the Egyptian officials and the heap of grain in Vat. 747. As pointed out above (see the introduction to Genesis 42:1–4), in the upper strip Ser., Sm., and Vat. 746 add the departing of Joseph's brothers from Jacob, which does not appear in Vat. 747.

515. Vat. 747, fol. 62v

His brothers lie in proskynesis before Joseph, who sits before his house, stretching out his hand in an impassioned gesture expressive of his rough speech to them. A group of Egyptian officials standing behind the heap of grain watch the scene. The background is composed of high mountains with a decorative house painted in grisaille visible between the peaks.

Located beside Genesis 42:21.

517. Ser., fol. 132v

The scene is reversed; Joseph sits at the left, accompanied by a bodyguard rather than his officials. Moreover, the heap of grain is missing.

Located beside Genesis 42:21; the placement of the miniatures in Ser. and Vat. 747 again coincides.

518b. Sm., fol. 54v

The inscription reads: ἔνθα ἐπερωτῶνται περὶ τοῦ π(ατ)ρ(ὸ)ς αὐτῶν. καὶ πε(ρὶ) βενιαμίν.

Very close to Ser. The figure of Joseph has been overpainted and has flaked again.

519b. Vat. 746, fol. 126v

The inscription, placed in the margin, reads: ἐνταῦθα ἐπερωτῶνται πε(ρὶ) τοῦ π(ατ)ρ(ὸ)ς αὐτῶν καὶ πε(ρὶ) βενιαμίν.

Very close to Ser. and Sm. Badly overpainted.

Located beside Genesis 41:46; its proper place is two spaces further on, beside Genesis 42:21 (see no. 366b).

Lit.: Uspenskii, p. 138; Hesseling, fig. 132; Menhardt, p. 321; Vikan, "Life of Joseph," pp. 158, 166; Bernabò, "Studio," pl. 10.

Genesis 42:25

JOSEPH'S BROTHERS SUPPLIED WITH GRAIN

Further differences among the cycles occur here: the miniature of Joseph's Brothers Empty the Sacks before Jacob in Vat. 747 (fig. 520) corresponds to the lower scene in Ser., Sm., and Vat. 746 (figs. 521b–523b), but with important iconographical departures; the latter codices have an additional picture in the upper strip showing Joseph's Brothers Supplied with Grain.

521a. Ser., fol. 133r

Enthroned and flanked by two bodyguards, Joseph orders his brothers' sacks to be filled with grain. Most of the brothers look on as two busy themselves filling a sack; two asses stand by ready to be loaded. The man standing behind this group, gesturing as if in calculation, corresponds to a similar figure in the illustration of Genesis 41:56–57 (figs. 512–514) and can therefore be identified as one of Joseph's officials measuring grain, although he is differentiated from them by his mantle. One of the brothers approaches Joseph with bent knees and covered hands. He might be identified as Simeon, who was retained while the others returned home; otherwise, we must assume that he is a detail from an unknown narrative. Flaked in various spots.

Located beside Genesis 42:35.

522a. Sm., fol. 54v

The inscription reads: ἐνταῦθ(α) λαβόντες σῖτον ὑποστρέφου(σι).

The scene is somewhat condensed. The court official is lacking and the postures of the brothers show slight variations, but otherwise the composition agrees with Ser.

Located below Genesis 42:35.

523a. Vat. 746, fol. 127v

The inscription reads: ἐνταῦθα λαβόντες σῖτον ὑποστρέ-φουσιν.

Particular emphasis is given to the computing official, but otherwise the miniature is close to Ser. and Sm.

Located beside Genesis 41:55; its proper place is two spaces further on, beside Genesis 42:35 (see no. 366b).

Lit.: Strzygowski, *Sm.,* p. 116, pl. 37; Uspenskii, p. 138; Hesseling, fig. 133; Buberl, *Byz. Hss.,* p. 120; Menhardt, p. 322; Pächt, "Life of Joseph," p. 42.

Genesis 42:35–37

Joseph's Brothers Empty the Sacks before Jacob

See the introduction to Genesis 42:24–25. Even though the four Octateuchs illustrate the same episode, the iconography in Vat. 747 has only a general resemblance to that in Ser., Sm., and Vat. 746 in the way the scene is laid out. Many features differ, for example, the number of brothers emptying the sack in the presence of Jacob, and the details of the sacks lying unopened on the ground and of little Benjamin gesturing, which appear only in Vat. 747. Benjamin is presumably connected with verse 34, where Joseph's request to bring Benjamin to Egypt is related to Jacob.

520. Vat. 747, fol. 62v

The foremost brother empties the grain from his sack and, with it, a bundle of money. Other sacks, as yet unopened, sit on the ground. The other brothers and Jacob, sitting on a throne, raise their hands in gestures of surprise. Little Benjamin is visible close to Jacob. Flaked, chiefly along the ruling lines.

Located beside Genesis 42:35.

521b. Ser., fol. 133r

Two of the brothers busily empty one sack; the other, unopened sacks are omitted. The figure behind Jacob represents one of the brothers, but Benjamin is lacking. One of the brothers has separated himself from the group standing in conversation and addresses Jacob with a lively gesture of speech. He can be identified as Reuben, who asks his father to deliver Benjamin into his hands. Flaked in various places.

Located beside Genesis 42:35.

522b. Sm., fol. 54v

The inscription reads: ἐνταῦθ(α) διηγοῦνται τῷ π(ατ)ρὶ περὶ τοῦ ἰωσὴφ καὶ ὅτι ἐπιζητεῖται βενιαμίν.

Benjamin stands behind Jacob together with one of his brothers, while the others are lined up at the right in a rather monotonous manner. In other respects the scene is close to Ser.

Located below Genesis 42:35.

523b. Vat. 746, fol. 127v

The inscription, outside the frame in the margin, reads: ἐνταῦθ(α) διηγοῦνται τῷ π(ατ)ρὶ πε(ρὶ) τοῦ ἰωσὴφ καὶ ὅτι ἐπιζητεῖται βενιαμίν.

The figure of Benjamin is close to that in Sm., but the emphasis is on the speaking Reuben, who without apparent reason is depicted smaller. The vivid gestures of the conversing brothers agree with Ser.

Located beside Genesis 41:55; its proper place is two spaces further on, beside Genesis 42:35 (see no. 366b).

Lit.: Strzygowski, *Sm.,* p. 116, pl. 37; Uspenskii, p. 138; Hesseling, fig. 133; Menhardt, p. 322.

Genesis 43:13–14

Jacob Gives Benjamin to His Sons

Ser., Sm., and Vat. 746 illustrate verses 13–14 and 26 of chapter 43 with three distinct scenes. In contrast, Vat. 747 illustrates verses 19–23, 26–28, and 29 with three distinct scenes.

525a. Ser., fol. 134r

Jacob sits in front of his house and with a gesture of grief sends his sons to Egypt for the second time, handing little Benjamin over to them. The brother taking Benjamin by the hand is apparently Judah, who according to verses 8ff. assumed responsibility for his safety.

Located beside Genesis 43:22.

526a. Sm., fol. 55r

The partly rubbed inscription reads: ἔνθα πάλιν ἀποστέλλονται ἕνεκα σίτου καὶ βενιαμίν.

Very close to Ser.

Located below Genesis 43:21.

527a. Vat. 746, fol. 128v

The inscription reads: ἔνθα πάλιν ἀποστέλλοντ(αι) ἕνεκα σίτου καὶ βενιαμ(ίν).

Very close to Ser. and Sm.

Located beside Genesis 42:21; its proper place is two spaces further on, beside Genesis 43:23 (see no. 366b).

Lit.: Strzygowski, *Sm.,* p. 116, pl. 37; Uspenskii, pp. 138–39, fig. 73; Hesseling, fig. 134; Gerstinger, *Wiener Gen.,* fig. 104; Buberl, *Byz. Hss.,* p. 123; Menhardt, p. 322; Stahl, "Morgan M. 638," pp. 130, 137, 140, fig. 163; Vikan, "Life of Joseph," p. 176; Bernabò, "Laur. plut. 5.38," p. 152, pl. 12 no. 1; Stahl, "Old Test. Ill.," p. 84, fig. 79; Bernabò, "Studio," pl. 10.

Genesis 43:15

Journey of Joseph's Brothers with Benjamin to Egypt

See the introduction to Genesis 43:13–14. Iconographically, the scene echoes Joseph's journey to Egypt with the Midianites (figs. 471–474).

525b. Ser., fol. 134r

On their second journey to Egypt the brothers are shown driving three camels, two of which carry the money bags and other gifts destined for Joseph, while the third bears Benjamin. The group of brothers is fused with the one in the preceding departure scene. The figure of Benjamin is partly flaked.
Located beside Genesis 43:22.

526b. Sm., fol. 55r

Very close to Ser.
Located below Genesis 43:21.

527b. Vat. 746, fol. 128v

Very close to Ser. and Sm.
Located beside Genesis 42:21; its proper place is two spaces further on, beside Genesis 43:23 (see no. 366b).

Lit.: Strzygowski, *Sm.*, p. 116, pl. 37; Uspenskii, pp. 138–39, fig. 73; Hesseling, fig. 134; Buberl, *Byz. Hss.*, p. 123; Koukoules, *Vie et civilisation*, vol. 1, pt. 2, pl. 1 no. 1; Stahl, "Morgan M. 638," fig. 163; Vikan, "Life of Joseph," p. 176; Bernabò, "Laur. plut. 5.38," p. 152, pl. 12 no. 1; Stahl, "Old Test. Ill.," p. 84, fig. 79; Bernabò, "Studio," pl. 10.

Genesis 43:15–17

Joseph's Brothers Bow before Him

See also the introduction to Genesis 43:13–14. The depiction of Joseph's brothers before him (verse 15) and Joseph bidding his steward to bring them into the house and slay a beast to be eaten with them, is transmitted only in Vat. 747. Unlike the text, which relates that Joseph's brothers stood in front of him, the miniature represents them in proskynesis, possibly mirroring the illustration in the strip below (fig. 524c). Ser., Sm., and Vat. 746 have a more ceremonial image which is hardly linked to a definite passage in the text (see the introduction to Genesis 43:26).

524a. Vat. 747, fol. 63r

The brothers have fallen in proskynesis before the enthroned Joseph, who addresses them. Two Egyptian court officials with crossed arms stand between Joseph and his brothers, observing the encounter. A high mountain ridge forms the background. Somewhat flaked.
Located beside Genesis 43:22.

Lit.: Vikan, "Life of Joseph," p. 176; Bernabò, "Laur. plut. 5.38," p. 152.

Genesis 43:19–23

Joseph's Steward Reassures the Brothers

The episode of Joseph's steward reassuring the brothers that they need not be afraid is also transmitted in Vat. 747 alone.

524b. Vat. 747, fol. 63r

Having given the steward of Joseph's household a money bag which he holds in his left hand, the brothers talk with him. The overseer, who wears a peaked helmet, raises his right hand in a gesture of speech. Somewhat flaked.
Located beside Genesis 43:22.

Lit.: Vikan, "Life of Joseph," p. 176; Stahl, "Morgan M. 638," fig. 181; Bernabò, "Laur. plut. 5.38," p. 152.

Genesis 43:26

Joseph's Brothers Present Gifts to Him

Ser., Sm., and Vat. 746 show the brothers carrying gifts in their hands and approaching Joseph. The gifts are inspired by the first half of verse 26 ("and Joseph entered into the house, and they brought him the gift they had in their hands into the house; and they did him reverence . . . "). On the left, Joseph embraces Benjamin, an action not mentioned in the text at this point, but a prolepsis: Joseph has not yet revealed his identity and the embrace of Joseph and Benjamin is described only later, in Genesis 45:14. The representation is patterned after the Magi offering their gifts to the Christ child and seems inspired by court ceremony: disregarding the words of Genesis, Ser., Sm., and Vat. 746 focus on the offering of gifts and on the conciliatory hug between the two brothers. In contrast, Vat. 747 presents the brothers in proskynesis following the second half of verse 26 ("they did him reverence with their faces to the ground"); and, as in verse 29, it shows Joseph pointing at Benjamin, pretending not to know him. In Vat. 747 the brothers carry no gifts to Joseph.

525c. Ser., fol. 134r

The group of brothers approaches Joseph and offers him gifts. The men hold golden pyxides and vessels, and the last carries a money bag. Joseph sits on a throne before his house, accompanied by a bodyguard, and holds Benjamin in his arms and kisses him.
Located beside Genesis 43:22.

526c. Sm., fol. 55r

The inscription is partly rubbed and reads: ἔνθα ἰδὼν ἰωσὴφ τὸν βενιαμίν, καταφιλεῖ αὐτόν.
Very close to Ser., except for slight changes in the arrangement of the brothers.
Located below Genesis 43:21.

527c. Vat. 746, fol. 128v

The inscription reads: ἔνθα ἰδὼν ἰωσὴφ τὸν βενιαμίν, κα-ταφιλεῖ αὐτ(όν).

Very close to Ser. and Sm., except that in this copy, too, the brothers are grouped slightly differently.

Located beside Genesis 42:21; its proper place is two spaces further on, beside Genesis 43:23 (see no. 366b).

Lit.: Strzygowski, *Sm.*, p. 116, pl. 37; Uspenskii, pp. 138–39, fig. 74; Hesseling, fig. 134; Pächt, "Life of Joseph," p. 43; Vikan, "Life of Joseph," pp. 176, 178; Bernabò, "Laur. plut. 5.38," p. 152, pl. 12 no. 1; Stahl, "Old Test. Ill.," p. 84, fig. 79.

Genesis 43:26–29

JOSEPH INTERROGATES HIS BOWING BROTHERS ABOUT BENJAMIN

See the introduction to Genesis 43:26 (nos. 525c–527c).

524c. Vat. 747, fol. 63r

Once again the brothers are represented in proskynesis before Joseph, with the exception of Benjamin, who stands behind them. Joseph points at the boy and, pretending not to know him, asks his brothers whether he is the youngest brother they promised to bring with them. Somewhat flaked.

Located beside Genesis 43:22.

Lit.: Vikan, "Life of Joseph," pp. 176, 178; Stahl, "Morgan M. 638," pp. 140–41, fig. 181; Bernabò, "Laur. plut. 5.38," p. 152.

Genesis 43:30

JOSEPH WEEPING

Of the five episodes depicted in the next miniatures, only Joseph and his brothers at the tables corresponds in all the manuscripts, although even in this scene the iconography in Ser., Sm., and Vat. 746 departs slightly from that in Vat. 747. The first two episodes are illustrated only in Ser., Sm., and Vat. 746.

529a. Ser., fol. 134v

The inscription reads: ἔνθα ἰωσὴφ ἰδὼν τὸν βενιαμὶν καὶ κλαύσας ἐνεκρατεύσατο καὶ.

At the left in the upper strip Joseph stands weeping before a house which represents the chamber into which he retired.

Located beside Genesis 44:1.

530a. Sm., fol. 55v

The inscription reads: ἔνθα ἰωσὴφ ἰδὼν τὸν βενιαμὶν καὶ κλαύσ(ας) ἐνεκρατεύσατο καὶ.

Very close to Ser.

531a. Vat. 746, fol. 129r

The inscription reads: ἔνθα ἰωσὴφ ἰδὼν τὸν βενιαμὶν καὶ κλαύσ(ας) ἐνεκρατεύσατο.

Very close to Ser. and Sm.

Located beside Genesis 42:35; its proper place is two spaces further on, beside Genesis 44:1 (see no. 366b).

Lit.: Uspenskii, p. 139, fig. 75; Hesseling, fig. 135; Menhardt, p. 322; Vikan, "Life of Joseph," p. 185; Anderson, "Seraglio," p. 89.

Genesis 43:31

JOSEPH WASHES HIS HANDS

This episode is found only in Ser., Sm., and Vat. 746; it differs from the Septuagint, where Joseph is described as washing his face rather than his hands. See also the introduction to Genesis 43:30.

529b. Ser., fol. 134v

In the second scene in the upper strip, Joseph washes his hands over a bowl while a servant pours water out of a golden pitcher. Joseph's head is rubbed.

Located beside Genesis 44:1.

530b. Sm., fol. 55v

Very close to Ser.

531b. Vat. 746, fol. 129r

Very close to Ser. and Sm.

Located beside Genesis 42:35; its proper place is two spaces further on, beside Genesis 44:1 (see no. 366b).

Lit.: Uspenskii, p. 139, fig. 75; Hesseling, fig. 135; Menhardt, p. 322; Vikan, "Life of Joseph," p. 185; Anderson, "Seraglio," p. 89.

Genesis 43:32

JOSEPH AND HIS BROTHERS FEAST SEPARATELY

The general layout of this illustration coincides in all of the manuscripts, although differences still occur. In Vat. 747, Joseph eats alone, as he does in verse 32, whereas in Ser., Sm., and Vat. 746 two men sit at his table; they must be two of Joseph's brothers or even Joseph's sons Ephraim and Manasseh.[1] Moreover, the young man standing beside Joseph in Vat. 747 is in front of him in the other manuscripts; the latter also add a third table with the Egyptian, thus representing verse 32 more faithfully. The young man close to Joseph is presumably Benjamin: according to Genesis Rabbah 92:5,[2] Benjamin was told by Joseph to approach him closely and then to sit at his table[3] (the episode is not mentioned in LXX).

528a. Vat. 747, fol. 63v

While his brothers are in a separate group, eating and drinking around a low table, Joseph dines alone; a young man stands near him. The palace in which the feast takes place appears as a domed building with an annex. Flaked in various spots.

Located beside Genesis 44:1.

529c. Ser., fol. 134v

The inscription begins with the word καὶ in the upper strip and continues in the lower: παραθεῖναι τράπεζαν τοῖς τὲ ἀδελφ(οῖς) καὶ τοῖς αἰγυπτίοις παρεκελεύσατο.

The scene is expanded and spread over two strips. In the right half of the upper strip Joseph sits at a table with two guests. A young man approaches from the right. In the lower strip three Egyptians sit at a separate table since, according to the text, they are not permitted to eat with the Hebrews; the brothers are grouped around a third table.

Located beside Genesis 44:1.

530c. Sm., fol. 55v

The inscription reads: παραθεῖναι τράπεζαν τοῖς τὲ ἀδελφοῖς καὶ τοῖς αἰγυπτίοις παρεκελεύσατο.

Very close to Ser.

531c. Vat. 746, fol. 129r

The inscription reads: καὶ παραθεῖναι τράπεζαν τοῖς τὲ ἀδελφοῖς καὶ τοῖς αἰγυπτίοις παρεκελεύσατο.

Very close to Ser. and Sm.

Located beside Genesis 42:35; its proper place is two spaces further on, beside Genesis 44:1 (see no. 366b).

Lit.: Uspenskii, p. 139, figs. 75, 76; Hesseling, fig. 135; Benson and Tselos, "Utrecht Ps.," pp. 65, 70, fig. 54; Menhardt, p. 322; Hempel, "Traditionen," p. 57 n. 21; Gutmann, "Passover Haggadah," p. 17; Vikan, "Life of Joseph," p. 185; Anderson, "Seraglio," p. 89; Sed-Rajna, *Hebraic Bible*, p. 75 n. 66.

[1] Again according to GenR 92:5, Ephraim and Manasseh did eat together with Joseph (*Genesis Rabbah*, ed. Freedman and Simon, p. 852).
[2] Ibid., p. 852.
[3] See Gutmann, "Passover Haggadah," p. 17.

Genesis 44:4

JOSEPH'S STEWARD PURSUES THE BROTHERS

This episode is transmitted only in Vat. 747; in the other Octateuchs the corresponding space in the lower half of the miniature is filled with two of the tables of the banquet given by Joseph at Genesis 43:32 (figs. 529c–531c). The depiction contains two features not fully explained by the Septuagint text: first, the group of horsemen accompanying Joseph's steward does not occur in the Septuagint, which relates that Joseph ordered his steward to pur-

sue his brothers and does not mention other servants, whose presence may merely be inferred; and second, the gesturing of the chief horseman is not mentioned in the Septuagint text. Both of these features are found in expanded narratives of Joseph's story, among them Philo's *De Josepho* 211,[1] a text previously used to explain the otherwise barely decipherable miniature on fol. 60v in the same Vat. 747 (see no. 498). Philo states that "the steward, by order of his master, with a considerable body of servants, appeared in pursuit waving his hands and beckoning them to halt." A second text featuring a group of servants pursuing the brothers is the Ethiopic History of Joseph, where "Joseph said to his minister of food: 'Go, take with you forty strong men and pursue those Hebrew men'"; Joseph's minister then reaches the brothers and calls them from afar, claiming that they stole Joseph's cup.[2] A rich literature on Joseph existed in early times; one of those texts must have been the source of the details in this and other miniatures of the Joseph cycle in the Octateuchs.[3]

528c. Vat. 747, fol. 63v

In the right half of the lower strip a group of horsemen gallops to the left. The men represent the steward of Joseph's house and his followers, sent to pursue the brothers and to bring back the one in whose sack Joseph's silver cup was found. The steward gestures vividly with his right arm.

Located beside Genesis 44:1.

Lit.: Muñoz, "Rotulo," p. 477; Vikan, "Life of Joseph," p. 185.

[1] *Philo*, ed. Colson, vol. 6, pp. 242–43.
[2] E. Isaac, "The Ethiopic History of Joseph," *Journal for the Study of Pseudepigrapha* 6 (1990), p. 90.
[3] Ibid., pp. 39ff.; *OTP*, vol. 2, pp. 469–70, 472–75, for another history of Joseph; and *OTP*, vol. 1, pp. 819–25, for two different recensions of the Testament of Joseph.

Genesis 44:11–12

FINDING THE CUP IN BENJAMIN'S SACK

Like the previous episode, this one exists only in Vat. 747.

528b. Vat. 747, fol. 63v

At the left, one of the brothers empties the sack containing Joseph's silver cup. He must therefore be Benjamin, although the copyist has not differentiated him in the usual way by rendering him smaller. The other brothers look on, and one of them makes a gesture of fear. One would expect to see Joseph's steward and his followers in front of them, demanding that the sacks be opened. Presumably they existed in the model: a conflation evidently took place between the pursuing Egyptians of the preceding scene and the brothers of this one.

Located beside Genesis 44:1.

Lit.: Muñoz, "Rotulo," p. 477; Stahl, "Morgan M. 638," p. 141 n. 263; Vikan, "Life of Joseph," pp. 185, 191, 194.

Genesis 44:14–18

Joseph's Brothers Fall Down before Him

Different passages are illustrated in Vat. 747 and in the other manuscripts, the former choosing only the embrace of Joseph and Benjamin, the others having two distinct episodes from the last phase of the story. The miniature in Vat. 747 is, however, closer to the passage to which it is related than are the pictures in the other codices.

533a. Ser., fol. 136v

Having once more returned to Egypt, the brothers fall on their knees before Joseph, who sits on a throne flanked by two bodyguards. Only Judah stands upright, begging that he may be detained instead of his brother, Benjamin, whom Joseph has decided to keep as his servant, according to verse 17.
Located beside Genesis 45:10.

534a. Sm., fol. 56r

The inscription reads: ἐνταῦθα δέονται τοῦ ἰωσὴφ οἱ ἀδελφοὶ ἀποσταλῆναι καὶ τὸν βενιαμίν.
Very close to Ser.
Located below Genesis 45:10.

535a. Vat. 746, fol. 130r

The inscription reads: ἐνταῦθα δέονται τοῦ ἰωσὴφ οἱ ἀδε(λφοὶ) ἀποσταλῆναι κ(αὶ) τ(ὸν) βενιαμίν.
Very close to Ser. and Sm. Flaked in various places.
Located beside Genesis 43:23; its proper place is two spaces further on, beside Genesis 45:11 (see no. 366b).

Lit.: Uspenskii, p. 139, fig. 77; Hesseling, fig. 136; Menhardt, p. 323; Vikan, "Life of Joseph," p. 204; Anderson, "Seraglio," pp. 89, 92, figs. 8, 9.

Genesis 45:1

Joseph Sends His Men Out of the Room

In this scene, preserved only in Ser., Sm., and Vat. 746, the gesture of Joseph, who rests his hand on Benjamin's shoulder, emphasizes the special love between the two brothers in the conciliatory atmosphere of these events. Nowhere in the text, however, do we find a reason for this gesture, except for a flimsy reference in Genesis 44:17, where Joseph demands that Benjamin remain with him as a servant; it may be a proleptic reference to the ensuing event of Joseph embracing Benjamin in Genesis 45:14. Furthermore, the cowls covering the brothers' heads are a unique attribute, found neither in the previous nor in the following miniatures.

533b. Ser., fol. 136v

Joseph, seated before his house, reveals his identity to his brothers, who face him respectfully with their arms crossed. Joseph has drawn Benjamin near and his hand lies on his shoulder. Before making his identity known he dismisses his bodyguards with a commanding gesture; the guards leave in a hurry.
Located beside Genesis 45:10.

534b. Sm., fol. 56r

The inscription reads: ἔνθα ἀνακαλύπτει τὰ περὶ ἑαυτοῦ τοῖς ἀδελφοῖς καὶ δηλοῖ τῷ π(ατ)ρὶ κατελθεῖν εἰς αἴγυπτον.
Very close to Ser.
Located below Genesis 45:10.

535b. Vat. 746, fol. 130r

The inscription reads: ἔνθα ἀνακαλύπτει πάντα τὰ πε(ρὶ) ἑαυτοῦ τοῖς ἀδε(λφοῖς) καὶ δηλοῖ τῶι π(ατ)ρὶ κατελθεῖ(ν) εἰς αἴγυπτον.
Very close to Ser. and Sm. Flaked in several spots.
Located beside Genesis 43:23; its proper place is two spaces further on, beside Genesis 45:11 (see no. 366b).

Lit.: Uspenskii, p. 139, fig. 78; Hesseling, fig. 136; Menhardt, p. 323; Galavaris, *Gregory Naz.*, p. 136; Stahl, "Morgan M. 638," p. 141 n. 263; Vikan, "Life of Joseph," p. 204; Anderson, "Seraglio," pp. 89, 92, figs. 8, 9.

Genesis 45:14

Joseph Kisses Benjamin

This episode is found only in Vat. 747 and corresponds to figs. 533–535 in the other manuscripts.

532. Vat. 747, fol. 64r

Joseph, sitting on a throne, and Benjamin, standing before him, embrace; according to verse 14, they are supposed to weep on each other's necks. The other brothers look on, expressing their surprise. Rather than embracing Joseph, Benjamin oddly touches his brother's abdomen with his right hand, a detail which remains to be explained. Two houses of different types, one in perspective and the other in frontal view, form the background.
Located beside Genesis 45:10.

Lit.: Stahl, "Morgan M. 638," p. 141, fig. 182; Vikan, "Life of Joseph," p. 204.

Genesis 45:21–24

Joseph Sends His Brothers Away

Not surprisingly, Vat. 747 illustrates an episode different from the one in the other Octateuchs. The latter cut the long proces-

sion of cattle and carts departing from Joseph into two superimposed strips, thus filling the whole space of the miniature by means of an artistic device employed also in figs. 529–531. Vat. 747, instead, omits the departure from Egypt and illustrates immediately the brothers' arrival before Jacob.

537. Ser., fol. 137r

Joseph sends his brothers home to their father with abundant gifts. He sits on a throne and a bodyguard stands behind him; while he is still addressing them, his brothers leave with all the gifts they have received. The long caravan is distributed over two superimposed strips. In the upper register, five brothers leave with two carts drawn by teams of oxen and loaded with gifts and provisions for the journey; in the lower register, the remaining five brothers are shown driving some of the ten asses and the ten mules that the text enumerates. Although the animals laden with gifts for Jacob are clearly separated into two groups, neither group is clearly distinguished as asses or mules.

Located beside Genesis 45:23.

538. Sm., fol. 56v

The inscription reads: ἔνθα λαμβάνουσιν ἐξ αἰγύπτου ἁμάξας καὶ κτήνη δι᾽ὢν ὀφείλουσι πανοικὶ κατελθεῖν οἱ ἀδελφοὶ ἰωσήφ.

Very close to Ser.

539. Vat. 746, fol. 130v

The inscription reads: ἔνθα λαμβάνουσιν ἐξ αἰγύπτου ἁμάξας καὶ κτήνη δι᾽ὢν ὀφείλουσι πανοικὶ κατελθεῖ(ν) οἱ ἀδελφοὶ ἰωσήφ.

Very close to Ser. and Sm. Flaked in various places.

Located beside Genesis 44:1; its proper place is two spaces further on, beside Genesis 45:23 (see no. 366b).

Lit.: Uspenskii, p. 139, figs. 79, 80; Hesseling, fig. 137; Menhardt, p. 324; Eller and Wolf, *Mosaiken*, fig. 33.

Genesis 45:25–27
JOSEPH'S BROTHERS REPORT TO JACOB

See the introduction to Genesis 45:21–24.

536. Vat. 747, fol. 64v

Jacob, sitting before his house, raises his hand in a gesture of amazement as he hears his sons' report; the young men stand in front of him with Benjamin heading the group. The wagon drawn by oxen, in which Jacob is going to travel to Egypt, is visible in the foreground, while in the background, partly hidden by hillocks, a group of camels and a group of horses appear. The latter could be understood as the mules destined as gifts for Jacob,

but camels are not specifically mentioned among the presents brought from Egypt.

Located beside Genesis 45:22.

Lit.: Muñoz, "Rotulo," p. 477; Stahl, "Morgan M. 638," pp. 141–42, fig. 184; Weitzmann, *SP*, pp. 47–48.

Genesis 46:1
JACOB'S JOURNEY TO EGYPT AND SACRIFICE AT BEER-SHEBA

Only the representation of Jacob's sacrifice during the trip to Egypt occurs in all four manuscripts (nos. 541–543); Vat. 747 also illustrates the journey with his sons and camels.

540a. Vat. 747, fol. 64v

Followed by his sons and their families, Jacob, on his way to Egypt, arrives at Beer-sheba (LXX: the well of the oath) and there offers a sacrifice to God. Jacob stands in front of a flaming altar and raises his hands in prayer toward the divine hand. Jacob's sons and their wives follow at a respectful distance and are separated from the patriarch by a well. They, in turn, are followed by a group of camels partly cut off by the left border line.

Located beside Genesis 46:4.

Genesis 46:1
JACOB'S SACRIFICE AT BEER-SHEBA

See the introduction to no. 540a.

541a. Ser., fol. 137r

The scene is very abbreviated in comparison with Vat. 747 (fig. 540a); only Jacob's sacrifice is represented.

Located beside Genesis 46:4.

542a. Sm., fol. 56v

Very close to Ser. The inscription which starts in this miniature and continues in the one below refers to the event illustrated in the latter scene.

543a. Vat. 746, fol. 132r

Very close to Ser. and Sm. Partly flaked. As in Sm. the inscription belongs to the following scene.

Located beside Genesis 45:11. Note that the scribe of Vat. 746 failed to reserve a space corresponding to Genesis 46:4 in the following pages, i.e., the space beside which the analogous miniatures in Vat. 747 and Ser. are executed (figs. 540, 541). He must have become aware of the two spaces mistakenly left before and of the consequent displacement of the illustrations in relation to

the text and decided to reduce the dislocation. Thus, from here on the location of the miniatures in Vat. 746 differs by only one place in comparison with Vat. 747 and Ser.

Lit.: Uspenskii, p. 139, fig. 81; Hesseling, fig. 138; Ljubinković, "Sopoćani," p. 231 n. 53; Kötzsche-Breitenbruch, *Via Latina*, p. 73; De' Maffei, "Sant' Angelo in Formis II," pt. 1, p. 32; Korol, *Cimitile*, pl. 52a.

Genesis 46:2

God Speaks to Jacob in a Dream

Ser., Sm., and Vat. 746 illustrate Jacob's dream with conventional iconography, but they introduce a personification, which is quite an unusual intrusion in the Octateuch cycle. In contrast, Vat. 747 shows the resumption of the journey to Egypt (fig. 540b).

541b. Ser., fol. 137r

God appears to Jacob in a dream and promises him safe passage to Egypt. Jacob lies in a deep sleep on a couch, his head turned away from the hand of God which protrudes from a segment of heaven. In order to illustrate the text's statement that the dream occurred at night, the painter added a boy with a fluttering veil set against a dark cloud, a conflation of elements pertaining to Nyx (Night, a female personification) and Orthros (Dawn). Both of these elements were apparently borrowed from an earlier miniature in the same manuscript (see fig. 22). The figure is mostly rubbed, but, as may be ascertained from Sm. and Vat. 746, the hybrid Nyx looks back at the sleeping Jacob and at the same time is about to leave, indicating the passing of the night.

Located beside Genesis 46:4.

542b. Sm., fol. 56v

The inscription (see no. 542a) reads: ἔνθα προτρέπεται ἰσραὴλ ἀφόβως κατέλθεῖν εἰς αἴγυπτον.

Very close to Ser.

543b. Vat. 746, fol. 132r

The inscription (see no. 543a) reads: ἔνθα προτρέπεται ἰσραὴλ ἀφόβως κατελθεῖν εἰς αἴγυπτον.

Very close to Ser. and Sm. Somewhat flaked.

Located beside Genesis 45:11.

Lit.: Graeven, "Typen," pp. 108–9, fig. 17; Uspenskii, p. 139, fig. 82; Hesseling, fig. 138; Vikan, "Life of Joseph," p. 211; De' Maffei, "Sant'Angelo in Formis II," pt. 1, p. 32; Korol, *Cimitile*, pl. 52a.

Genesis 46:5–6

Resumption of the Journey to Egypt

See the introduction to Genesis 46:2.

540b. Vat. 747, fol. 64v

Jacob travels to Egypt in the wagon sent by Joseph for his journey. In an attitude of repose, Jacob lies on the open cart drawn by a team of oxen. A herd of camels follows, again cut off by the left border line, as in the preceding scene of this manuscript.

Located beside Genesis 46:4.

Lit.: Graeven, "Typen," pp. 108–9, fig. 17; Vikan, "Life of Joseph," p. 211; Kötzsche-Breitenbruch, *Via Latina*, p. 73, pl. 15c; De' Maffei, "Sant'Angelo in Formis II," pt. 1, p. 32; Korol, *Cimitile*, pl. 52a.

Genesis 46:8–27

Jacob's Descendants

Ser., Sm., and Vat. 746 portray Jacob's numerous progeny with a conventional representation of a line of fourteen men (Genesis 46:27 states that "all the souls of the house of Jacob who came with Joseph into Egypt, were seventy-five souls.") In the same place, Vat. 747 has Jacob and Joseph Embracing, which in the other manuscripts occurs instead in the upper strip of the next miniature (nos. 544, 549a, 550a, 551a).

545. Ser., fol. 137v

Of Jacob's progeny, the illustration presents only twelve men, intended to represent the twelve sons of the first generation, and two youths of smaller size, possibly Ephraim and Manasseh, who in some of the later scenes are still depicted as children. The twelve sons are differentiated by various types of costumes, postures, and attitudes, and are subdivided into smaller groups conversing among themselves. Only the sixth figure from the left can be positively recognized: his priestly costume identifies him as Levi. In the text (verse 11) he is named as the third son, and thus it is clear that the order of the miniature does not correspond to that of the Septuagint. The miniature is badly flaked, particularly some of the faces.

Located beside Genesis 46:20.

546. Sm., fol. 57r

The inscription reads: οἱ τοῦ ἰσραὴλ υἱοὶ καὶ οἱ τούτων ἀπόγονοι.

Very close to Ser.

Located below Genesis 46:20.

547. Vat. 746, fol. 132v

The inscription reads: οἱ τοῦ ἰσραὴλ υἱοὶ καὶ οἱ τούτων ἀπόγονοι.

Very close to Sm. and Ser. Slightly flaked.

Located beside Genesis 45:23; its proper place is one space further on, beside Genesis 46:21 (see nos. 366b and 543a).

Lit.: Uspenskii, p. 139; Hesseling, fig. 139.

Genesis 46:29

EMBRACE OF JACOB AND JOSEPH

The Embrace of Jacob and Joseph has basically the same iconography in all the manuscripts, although in Ser., Sm., and Vat. 746 it is combined with another illustration in a lower register. From the order of the miniatures and their location in the text column, it is clear that the embrace in Vat. 747 (no. 544) corresponds to Jacob's Descendants in the miniatures of the other manuscripts (nos. 545–547); and Pharaoh's welcome to the brothers in Vat. 747 (no. 548) corresponds to the embrace and the welcome in the others (nos. 549–551). The text surrounding the miniatures (Gen 47:1ff.) is related to the welcome; thus the embrace, which appears in the upper strip of Ser., Sm., and Vat. 746, must have been moved from its proper place to attach it to the welcome.

544. Vat. 747, fol. 65r

Jacob and Joseph embrace and kiss each other very excitedly. Joseph has just stepped down from his chariot, which is mostly cut off by the right border line, so that only the team of horses is visible. Joseph's brothers stand at the left, expressing their amazement at the event. Set against a golden sky and emerging from behind a mountain ridge is the city of Goshen (LXX: City of Heroes), depicted in the usual way as a circular wall with flanking towers.

Located beside Genesis 46:20.

549a. Ser., fol. 138v

Close to Vat. 747, but at the left the number of brothers has been reduced to two, while a flock of sheep is added, and at the right Joseph's chariot is fully visible. Moreover, any indication of setting is omitted. The surface is flaked in various spots.

Located beside Genesis 47:1.

550a. Sm., fol. 57r or 57v[1]

The inscription reads: ἔνθα συνήντησεν ἰωσὴφ καὶ ἠσπά-σατο τὸν π(ατέ)ρα.

Very close to Ser.

551a. Vat. 746, fol. 133v

The inscription reads: ἔνθα συνήντησεν ἰωσὴφ καὶ ἠσπά-σατο τὸν π(ατέ)ρα.

Very close to Ser. and Sm.

Located beside Genesis 46:21; its proper place is one space further on, beside Genesis 47:1–2 (see nos. 366b and 543a).

Lit.: Uspenskii, p. 139; Hesseling, fig. 140; Vikan, "Life of Joseph," p. 214.

[1] Fol. 57v according both to Hesseling, p. ix, and to the label in the photo taken by Buberl; fol. 57r according to Uspenskii, p. 185.

Genesis 47:2–3

JOSEPH PRESENTS HIS BROTHERS TO PHARAOH

548. Vat. 747, fol. 65r

The text states that Joseph presented only five of his brothers, but a clustered group of six or seven is shown in the illustration. Pharaoh sits on a throne and welcomes them.

Located beside Genesis 47:1.

549b. Ser., fol. 138v

Pharaoh, who has a blue nimbus, sits in a frontal pose on his throne with a bodyguard beside him. Joseph leads the group of five brothers who follow him in single file; Levi, clad in priestly vestments, is the foremost. The entire surface of this miniature is badly flaked.

Located beside Genesis 47:1.

550b. Sm., fol. 57r or 57v[1]

The inscription reads: ἐνταῦθα ἀναγγέλλει φα(ραὼ) τὰ περὶ τῶν ἀδελφῶν.

Very close to Ser., though somewhat condensed.

551b. Vat. 746, fol. 133v

The inscription reads: ἐνταῦθα ἀναγγέλλει φα(ραὼ) τὰ περὶ τ(ῶν) ἀδε(λφῶν).

Very close to Ser. and Sm. Flaked in various places.

Located beside Genesis 46:21; its proper place is one space further on, beside Genesis 47:1–2 (see nos. 366b and 543a).

Lit.: Uspenskii, p. 139; Hesseling, fig. 140; De Grüneisen, *Ste. Marie Ant.,* p. 226, fig. 182; Vikan, "Life of Joseph," p. 214; Kötzsche-Breitenbruch, *Via Latina,* p. 71, n. 453, pl. 14c.

[1] Fol. 57v according both to Hesseling, p. ix, and to the label in the photo taken by Buberl; fol. 57r according to Uspenskii, p. 185.

Genesis 47:10

JACOB BLESSES PHARAOH

Of the two times Jacob blesses Pharaoh, at verses 7 and 10 respectively, only one has been illustrated. Again, the iconography in Vat. 747 differs from that in the other manuscripts.

552. Vat. 747, fol. 65v

Joseph brings his father before Pharaoh, who sits before his two-storied palace and welcomes him. While Jacob approaches with a gesture of blessing, Joseph turns to his brothers. The scene takes place in front of a background of high mountains. Flaked in various places.

Located beside Genesis 47:15.

553. Ser., fol. 139r

The scene is reversed, so that Pharaoh sits at the left of Jacob, and Joseph and his brothers approach from the right. Pharaoh is flanked by two bodyguards, but in contrast to the preceding scene in this manuscript, he is not nimbed. The background is completely eliminated.

Located beside Genesis 47:14.

554. Sm., fol. 57r or 57v¹

The inscription is partly rubbed and reads: ὧδε εἰσάγει ἰωσὴφ τὸν π(ατέ)ρα πρὸς φαραώ.

Very close to Ser. Pharaoh and his bodyguards have been very crudely overpainted.

Located below Genesis 47:22.

555. Vat. 746, fol. 134r

The inscription reads: ὧδε εἰσάγει ἰωσὴφ τὸν π(ατέ)ρα πρὸς φαραώ.

Very close to Ser. and Sm. Flaked in various spots.

Located beside Genesis 47:1–2; its proper place is one space further on, beside Genesis 47:15 (see nos. 366b and 543a).

Lit.: Uspenskii, p. 139, fig. 83; Hesseling, fig. 141; Diehl, *Manuel,* vol. 2, p. 617, fig. 294; Menhardt, p. 325; Goodenough, *Symbols,* vol. 9, p. 84 n. 28, fig. 81; Henderson, "Joshua Cycle," p. 47; Toubert, "Bréviaire d'Oderisius," pp. 255–57, fig. 37; Spatharakis, *Corpus,* fig. 569; Anderson, "Seraglio," pp. 91, 93–94, figs. 12, 17; Sed-Rajna, *Hebraic Bible,* p. 54 n. 59; Lowden, *Octs.,* pp. 17, 60.

¹ Fol. 57v according to both Hesseling, p. ix, and to the label in the photo taken by Buberl; fol. 57r according to Uspenskii, p. 185.

Genesis 47:20–21

Joseph Acquires the Lands of the Egyptians

The location of this miniature approximately beside Genesis 47:20ff. and the inscription in Sm. and Vat. 746 suggest a reference to Joseph's acquisition of all the lands of the Egyptians and the Egyptians being brought into bondage as his servants (verses 20–21). Such an assumption finds support in the gesture of the foremost Egyptian in Vat. 747. The more dramatic iconography in Vat. 747 corresponds closely to the text and can be taken as the original version of the scene. Ser., Sm., and Vat. 746, on the other hand, show a reversed arrangement of the scene and a nonspecific conversation between Joseph and his subjects which might illustrate any of the negotiations described in Genesis 47:15–25. The conventional iconography in Ser., Sm., and Vat. 746 corresponds to the more courtly atmosphere and to the artistic devices already noted in the Joseph cycle in these codices (see, e.g., figs. 525–527, 529–531, 533–535, 537–539, 541–543, 545–547).

556. Vat. 747, fol. 65v

Three black-skinned Egyptians approach Joseph; the foremost bows respectfully while asking for bread. Joseph, enthroned before a baldachin painted in grisaille, extends his arm in an imperious gesture, demanding their cattle and all their land in return. Considerably flaked all over the surface.

Located beside Genesis 47:22.

557. Ser., fol. 139r

Joseph sits at the left flanked by two bodyguards and raises his hand in a gesture of speech rather than in a harsh command. Considerably flaked all over the surface.

Located below Genesis 47:20.

558. Sm., fol. 57v

The partly rubbed inscription reads: ἔνθα λαμβάν[ων ἰωσὴφ τὴν τῶν] αἰγυπτίων [γῆν δίδω]σι σῖτ[ον].

Very close to Ser. The upper portions of the Egyptians are very badly flaked.

559. Vat. 746, fol. 134v

The inscription reads: ἔνθα λαμβάνων ἰωσὴφ τὴν τῶν αἰγυπτίων γῆν δίδωσι σῖτον.

Very close to Ser. and Sm. Slightly flaked.

Located beside Genesis 47:15; yet for the following miniature at the bottom of the same page (no. 563), the painter confused a blank space at the end of the text with a space reserved for a miniature, and erroneously inserted an illustration. The proper place for this miniature is two spaces further on, beside Genesis 47:22 (see nos. 366b and 543a).

Lit.: Uspenskii, p. 140; Hesseling, fig. 142; Weitzmann, *RaC,* p. 156, fig. 147; Menhardt, p. 326; Spatharakis, *Corpus,* fig. 569.

Genesis 47:29–31

Jacob Kisses Joseph's Staff

Shortly before dying, Jacob asked Joseph to swear that he would not bury him in Egypt. At first glance the miniatures differ only in that Jacob leans on a staff in Vat. 747, while in the other manuscripts he lies in bed. Vat. 747 follows Genesis 47:31 closely: "and he [Joseph] swore to him [Jacob]. And Israel did reverence, leaning on the top of his [Joseph's] staff." In the other manuscripts, the detail of Joseph's hand touching Jacob's thigh is taken from the swearing procedure requested of Joseph in verse 29 ("put thy hand under my thigh") and enacted in verse 31; but each painter rendered the gesture in a different way, and none of them apparently understood the meaning of the gesture correctly and so did not illustrate the episode faithfully, with Joseph's hand under his father's thigh: in Ser. Joseph's hand is stretched out above Jacob's leg; in Sm. Joseph touches Jacob's ankle with his

hand; and in Vat. 746 Joseph's hand touches Jacob's thigh. Moreover, in these manuscripts the staff held by Joseph and the touching of Jacob's lips are features not explained by the Genesis text. The layout of the scene in Ser., Sm., and Vat. 746 is that of a conventional dialogue between Joseph and Jacob with the addition of the staff (cf., e.g., figs. 565, 567); it is presumably an unsuccessful revision of the original, more dramatic version of the scene reflected in Vat. 747. The rest of its iconography was fashioned from the inscription in Sm. and Vat. 746, which appropriately reads: "Jacob . . . kisses the top of Joseph's staff."

561. Ser., fol. 140v

Instead of placing his hand under Jacob's thigh as verse 29 would require, Joseph simply stretches his left arm toward Jacob's leg to swear the oath. Jacob, reclining on his bed, touches his lips to the staff which Joseph holds in a hardly realistic manner. In fact, Joseph makes no effort to grasp the staff, which seems pasted to his hand; rather he addresses Jacob with this gesture. A group of brothers not required by the text is pictured at the head of the couch, gesturing in sorrow. At the right is Joseph's house, in which the scene is supposed to take place. Slightly flaked.

Located beside Genesis 48:5.

562. Sm., fol. 58r

The inscription reads: ἐνταῦθα ἀρρωστῶν ἰακὼβ ἐντέλλεται τῷ ἰωσὴφ περὶ πάντ(ων) καὶ ἀσπάζεται τῆς ῥάβδου τὸ ἄκρον.

Very close to Ser., but the fingers of Joseph's left hand touch Jacob's ankle.

Located beside the catena.

563. Vat. 746, fol. 134v

The inscription reads: ἐνταῦθα ἀρρωστ(ῶν) ἰακὼβ ἐντέλλεται τῷ ἰωσὴφ πε(ρὶ) πάντ(ων) καὶ ἀσπάζεται τ(ῆ)ς ῥάβδου τὸ ἄκρ(ον).

Joseph does not hold a staff, as he does in Ser. and Sm., but simply raises his hand in a gesture of speech, promising his father that he will fulfill his wishes. Otherwise the miniature is very close to Ser. and Sm. The painter of Vat. 746 depicted Joseph's fingers touching Jacob's thigh.

Located beside Genesis 47:18; its proper place is two spaces further on, beside Genesis 48:5 (see no. 559).

Lit.: Uspenskii, p. 140, fig. 84; Hesseling, fig. 143; Menhardt, p. 326; Maguire, "Depiction of Sorrow," p. 151 n. 149; Bernabò, "Fonti testuali," pp. 482–83, pl. 29 no. 2; Korol, *Cimitile*, pp. 95 n. 340, 96 nn. 342–44, 98 n. 352, pl. 41d; Lowden, *Octs.*, p. 60; Bernabò, "Tre studi," pp. 108–9, fig. 9.

Genesis 47:31

JACOB BOWS BEFORE JOSEPH

See the introduction to Genesis 47:29–31. The iconography in Vat. 747 follows the Septuagint ("And Israel did reverence, leaning on the top of his staff") and diverges from both the Hebraic text and the tradition in the Targumim, where Jacob bowed upon the bed or summoned his strength and sat up in the bed.[1] Syrian and eastern Christian tradition, following Hebrews 11:21, usually introduces the staff.[2]

560. Vat. 747, fol. 66r

Jacob, whose eyes are closed, has raised himself up on the couch and leans with great effort on a round-knobbed staff, which he grasps with his left hand and is apparently stuck into the ground behind the bed. Joseph stands at the foot of the couch and raises his hand. The background is composed of three buildings: the central one with a dome and the one at the right are merely outlined, whereas the third, at the left, is foreshortened and suggests three-dimensionality.

Located beside Genesis 48:5.

Lit.: Bernabò, "Fonti testuali," pp. 482–83; Lowden, *Octs.*, p. 60; Bernabò, "Tre studi," p. 108, fig. 6; Bernabò, "Studio," pp. 295–96, pl. 22.

[1] See TargOnk on Gen 48:2 (*Targum Onkelos to Genesis*, ed. Aberbach and Grossfeld, p. 155).
[2] E.g., Ephrem, *CommGen* 41:2 (Ephraem, *In Genesim et in Exodum commentarii*, ed. Tonneau, p. 93); Theodoret, *QuaestGen* (PG 80, 214). The Peshitta translates "And Israel bowed himself upon the head of his staff."

Genesis 48:14–15

JACOB BLESSES EPHRAIM AND MANASSEH

The arrangement of the scene recalls a panel in the synagogue at Dura Europos (see text fig. 1).[1] It is questionable, however, whether Jacob crossed his hands in the Dura panel, as he does in the Octateuchs, or simply laid them upon his grandsons' heads.[2]

564. Vat. 747, fol. 66v

Jacob has raised himself up on the couch and places his crossed hands on Ephraim and Manasseh, who are represented as boys of the same size and already clad in imperial chlamydes. Joseph looks on very sympathetically and stretches out his hand toward Jacob as if to encourage him. The background is formed by a central domed building and behind it a high wall which seems to be out of proportion with the building. With the exception of the golden sky, the entire surface of this miniature is flaked.

Located beside Genesis 48:19.

565. Ser., fol. 141v

The children are clearly distinguished from one another by their size: the one under Jacob's right hand is taller and therefore should represent the elder son, Manasseh, although this is contrary to the text, according to which Jacob placed his right hand on the younger Ephraim. Joseph extends both hands in a more emphatic gesture than in Vat. 747. The background setting is confined to one tall house at the left, where the scene is supposed

to take place. The surface is somewhat flaked, and the miniature is not framed.

Located beside Genesis 48:17.

566. Sm., fol. 58v

The inscription reads: ἔνθα ἐπευλογεῖ τοὺς ἐκγόνους ὁ ἰσραὴλ στ(αυ)ροειδ(ῶς).

Very close to Ser.

567. Vat. 746, fol. 135r

The inscription reads: ἔνθα ἐπευλογεῖ τοὺς ἐκγόνους ὁ ἰσραὴλ σταυροειδῶς.

Very close to Ser. and Sm., save that the boys are of the same size.

Located beside Genesis 47:22; its proper place is two spaces further on, beside Genesis 48:18–19 (see no. 559).

Lit.: Uspenskii, p. 140; Hesseling, fig. 144; Wilpert, *Mosaiken und Malereien*, vol. 1, p. 445, fig. 159; Gerstinger, *Wiener Gen.*, fig. 105; Buberl, *Byz. Hss.*, p. 125; Stechow, "Jacob," pp. 193–96; Weitzmann, *RaC*, p. 101; Menhardt, p. 327; Goodenough, *Symbols*, vol. 9, p. 105 n. 129, fig. 91; Weitzmann, "Oct. Ser.," p. 183, fig. 1; Weitzmann, "Narration," p. 90, pl. 36 fig. 17; Weitzmann, "Jewish Sources," p. 77, fig. 57; Bucher, *Pamplona Bibles*, p. 138 n. 75; Stahl, "Morgan M. 638," pp. 46–47; Rosenthal, *Vergilius Romanus*, pp. 27–28, fig. 137; Kötzsche-Breitenbruch, *Via Latina*, p. 76 n. 481, pl. 16d; Chapman, "Jacob Blessing," pp. 37, 41, fig. 7; Korol, *Cimitile*, pp. 95 n. 340, 96 n. 343, 110, 116–17 n. 449, 118–19, 123, pls. 46c, 46d; Gutmann, "Dura Influence," pp. 27–28; Weitzmann, *Dura*, pp. 21–24, figs. 19, 20; Bernabò, "Tre studi," pp. 108–9, fig. 6.

[1] Weitzmann, "Jewish Sources," p. 77, fig. 57, and Weitzmann, *Dura*, pp. 21–24, figs. 19, 20.

[2] Korol, *Cimitile*, pp. 110ff.; Rosenthal, *Vergilius Romanus*, pp. 27–28.

Genesis 48:22

JACOB BEQUEATHS THE CITY OF SHECHEM TO JOSEPH

Before dying, Jacob bequeathed Shalem (LXX: Sicima or Secima: cf. Gen 33:18), the city of the prince Shechem (LXX: Sychem), to Joseph. The Hebraic text reads "I have given to thee one portion (*shechem*) above thy brethren"; in contrast, Targum Pseudo-Jonathan and Targum Neophyti, as in the Septuagint and the miniature, read: "I give you a portion more than your brethren: . . . Shechem which I took . . . from the hands of the Amorites."[1] The two towns represented in Vat. 747 double the one town, Shechem, required by the text, possibly for compositional reasons. Genesis Rabbah 97:6, however, transmits a tradition, attributed to R. Simon, which has the interpretation:[2] "Thou (i.e., Joseph) hast grown between two Shechems[3] [said Jacob to him], yet didst not perpetrate their [evil] deeds; therefore, shall [the town of] Shechem be in thy portion." More faithful to the Septuagint, Ser., Sm., and Vat. 746 depict one town, but introduce the unnecessary figures of Ephraim and Manasseh.

568. Vat. 747, fol. 67r

Jacob lies at ease on his couch, and Joseph stands behind it raising his hand in a gesture of speech. A two-story house, where the scene is supposed to take place, is visible at the left. A smaller house at the right, drawn only in outline, and a wall complete the architectural background. A separate picture below shows two walled cities.

Located beside Genesis 48:22.

569. Ser., fol. 142r

Joseph stands at the foot of Jacob's couch, joined by his two sons, not mentioned at this point in the text; apparently the episode is interpreted as a continuation of the preceding scene. The city of Shechem is represented only once, but more elaborately, with its walls enclosing two houses and embellished by a few cypresses within and outside the walls. Flaked all over the surface.

Located below Genesis 48:22 (and above Genesis 49:1)

570. Sm., fol. 59r

The inscription reads: ἐνταῦθα τὴν πόλιν σίκιμα δίδωσιν ἰακὼβ ἰωσὴφ σίκιμα ἤτοι σαμάρεια.

Very close to Ser.

571. Vat. 746, fol. 136r

The inscription reads: ἐνταῦθα τὴν πόλιν σίκιμα δίδωσι(ν) ἰακὼβ ἰωσὴφ σίκημα ἤτ(οι) σαμάρεια.

Very close to Ser. and Sm. Slightly flaked.

Located beside Genesis 48:5; its proper place is two spaces further on, in the catena, the text above being Genesis 48:22 (see no. 559).

Lit.: Uspenskii, p. 140; Hesseling, fig. 145; Bernabò, "Fonti testuali," p. 483; Korol, *Cimitile*, p. 124 n. 496.

[1] *Neophyti 1: Targum Palestinense*, vol. 1, *Génesis*, ed. Díez Macho, p. 633; *Targum Genèse*, ed. Le Déaut, pp. 430–31. GenR 97:6 has both "portion" and "town of Shechem" (*Genesis Rabbah*, ed. Freedman and Simon, pp. 943–44).

[2] *Genesis Rabbah*, ed. Freedman and Simon, p. 944.

[3] Possibly indicating Pharaoh and Potiphar (ibid., p. 943 n. 4).

Genesis 49:1–28

JACOB PREDICTS HIS SONS' FUTURE

The illustration in Vat. 747 (fig. 572) apparently presents the oldest of the brothers, Reuben, being reproached by Jacob (verses 3–4). In contrast, Jacob's farewell in Ser., Sm., and Vat. 746 is less animated and more conventional (cf., e.g., figs. 561–563, 565–567, 569–571, and 577–579); the scene generically illustrates Jacob's farewell at verses 1–28.

573. *Ser., fol. 142v*

Jacob has gathered his sons around him and gives them his last prophetic blessing. The sons are divided into two groups, one standing at the head and the other at the foot of the couch, while Joseph stands isolated between them in the very center of the composition. Around Jacob are grouped fourteen men instead of the twelve sons required by the text; perhaps the additional two are intended to represent Ephraim and Manasseh. Joseph's face is badly flaked.

Located below Genesis 49:4.

574. *Sm., fol. 59v*

The inscription reads: ἔνθα ἀρρωστῶν ἰ(σρα)ὴλ προλέγει τοῖς υἱοῖς περὶ πάντων.

Very close to Ser.

575. *Vat. 746, fol. 137r*

The inscription reads: ἔνθα ἀρρωστῶν ὁ ἰ(σρα)ὴλ προλέγει τοῖς υἱοῖς περὶ πάντων.

Close to Ser. and Sm. The number of sons and the additional figures remain the same, but six instead of five are grouped at the left, while at the right there are seven instead of eight figures arranged in single file.

Located beside Genesis 48:5; its proper place is two spaces further on, in the catena, the text above being Genesis 48:22 (see no. 559).

Lit.: Uspenskii, p. 140, fig. 85; Hesseling, fig. 146; Buberl, *Byz. Hss.*, p. 127; Goodenough, *Symbols*, vol. 9, pp. 105–6 n. 130, fig. 92; Menhardt, p. 327; Kötzsche-Breitenbruch, *Via Latina*, p. 76 n. 481; Maguire, "Depiction of Sorrow," p. 151 n. 149; Bernabò, "Laur. plut. 5.38," p. 149 n. 39; Weitzmann, *Dura*, pp. 24–25, fig. 27; Bernabò, "Tre studi," pp. 108–9, fig. 10.

Genesis 49:3–4

JACOB REPROACHES REUBEN

See the introduction to Genesis 49:1–28.

572. *Vat. 747, fol. 67v*

Close to Ser. (fig. 573), except that the background is formed by two symmetrical buildings connected by a wall. Jacob knits his brows while addressing his firstborn, Reuben, who, frightened by his words, stares at his father. Joseph also looks at Reuben with an expression of reproach. The miniature is slightly flaked, particularly the right-hand group of sons.

Located beside Genesis 48:22.

Lit.: Stahl, "Morgan M. 638," p. 47 n. 79; Kötzsche-Breitenbruch, *Via Latina*, p. 76 n. 481; Bernabò, "Laur. plut. 5.38," p. 149 n. 39; Korol, *Cimitile*, pp. 115, 124 n. 496, pl. 44f; Weitzmann, *Dura*, pp. 24–25, fig. 26; Bernabò, "Tre studi," pp. 108–9, fig. 7.

Genesis 49:29–32

JACOB REQUESTS BURIAL WITH HIS FATHERS

Ser., Sm. (in the upper strip), and Vat. 746 have an illustration of the miniature that is lacking in Vat. 747. This illustration is conventionally arranged: with minor changes it repeats previous scenes in the same manuscripts (see figs. 561–563, 565–567, 569–571, and 573–575) and even the group of Jacob and Joseph on fol. 67r in Vat. 747 (fig. 568). Pictorially it balances the lower strip with a chiasmus of Jacob dying and a group of mourning people. The contents can be plausibly related to Jacob's final request in verses 29–32 on the grounds of its location in the Greek text beside those verses.

577a. *Ser., fol. 153v*

Jacob expresses to his sons his desire to be buried in the cave at Mamre; his sons stand aside, gesturing excitedly and deeply moved. Only Joseph is near his father. The number of brothers differs in the various manuscripts; here there are nine, not counting Joseph.

Located below Genesis 49:33.

578a. *Sm., fol. 62v*

The inscription reads: ἐνταῦθα τελευτὴ ἰακώβ.

Very close to Ser. Correctly, there are eleven figures in the group of brothers.

579. *Vat. 746, fol. 138v*

The inscription reads: περὶ τῆς τελευτῆς ἰακώβ.

Very close to Ser. and Sm. Here ten brothers are grouped together at the right. Jacob's head is rubbed.

Located in the catena, the text above being Genesis 48:22; its proper place is two spaces further on, beside Genesis 49:33–50:1 (see no. 559).

Lit.: Uspenskii, p. 140, fig. 86; Hesseling, fig. 147; Buberl, *Byz. Hss.*, p. 126; Menhardt, p. 328; Maguire, "Depiction of Sorrow," p. 155 n. 173; Bernabò, "Tre studi," pp. 108–9, fig. 11.

Genesis 50:1

JOSEPH KISSES JACOB

The episode is pictured with one iconography in Vat. 747 and a different one in Ser., Sm., and Vat. 746.

576. *Vat. 747, fol. 70v*

Joseph embraces and kisses his father; his brothers, divided into two groups as before, look on with expressions of mourning.

At the left, a woman—perhaps Asenath, Joseph's wife[1]—places her hands on the upper end of the couch. The background is composed of a domed building in the center with two little baldachins painted in grisaille on its lateral annexes, all three set against a high back wall and a golden sky.

Located beside Genesis 50:1.

577b. Ser., fol. 153v

The composition is reversed, Jacob lying with his head to the right. Manasseh, who is weeping, and Ephraim stand close to Joseph. The number of mourning brothers is reduced to three and neither a woman nor any architectural background is included, as they are in Vat. 747. The head of the brother at the extreme left is rubbed.

Located below Genesis 49:33.

578b. Sm., fol. 62v

Very close to Ser.

580. Vat. 746, fol. 139v

The inscription reads: περὶ τῆς τελευτῆς ἰακώβ.

Very close to Ser. and Sm. Manasseh's head is rubbed and the three brothers are partly flaked.

Located below Genesis 49:4 and the catena. The scribe of Vat. 746 divided the episodes, which are arranged in two superimposed strips in Ser. (nos. 577a, 577b) and Sm. (nos. 578a, 578b), into two separate miniatures (nos. 579 and 580); by these means he reduced the dislocation of the miniatures in Vat. 746 compared to the other manuscripts. Thus, the proper place of no. 579 would now be only one space farther on, beside Genesis 49:33–50:1 (see also no. 559).

Lit.: Uspenskii, p. 140, fig. 87; Hesseling, fig. 147; Gerstinger, *Wiener Gen.*, figs. 107, 108; Buberl, *Byz. Hss.*, p. 128; Menhardt, p. 328; Maguire, "Depiction of Sorrow," pp. 155 n. 173, 161–64, fig. 75; Bernabò, "Laur. plut. 5.38," p. 149 n. 39; Bernabò, "Tre studi," pp. 108–9, fig. 8.

[1] According to a Jewish tale, Asenath came with the women of Egypt to weep and mourn over Jacob when she heard of his death (Ginzberg, *Legends*, vol. 2, p. 149).

Genesis 50:2

JOSEPH ORDERS THE EMBALMING OF JACOB

Again there are iconographic differences in the following miniatures. Deviating from the text, Ser., Sm., and Vat. 746 show Jacob's corpse not wrapped in bandages and being lowered into a sepulcher. The composition in these manuscripts appears to be borrowed from a conventional entombment scene such as Joseph's entombment in figs. 591c, 593b, and 594c, or those in figs. 155, 157–159, or 1420–1422.

581b. Vat. 747, fol. 71r

In the right half of the upper miniature, Joseph sits on a throne before a wall and orders two young men to embalm his father.

Located beside Genesis 50:2–3.

582a. Ser., fol. 154r

Enthroned on a faldstool, Joseph orders a group of four dark-skinned Egyptians wearing turbans to embalm his father.

Located beside Genesis 50:2.

583a. Sm., fol. 63r

The inscription reads: ἐνταῦ(θα) πενθοῦσι τ(ὸν) ἰακὼβ οἱ αἰγύπτιοι.

Very close to Ser.

584a. Vat. 746, fol. 149r

The inscription reads: ἐνταῦθα πενθοῦσι τὸν ἰακὼβ οἱ αἰγύπτιοι.

Very close to Ser. and Sm. Considerably flaked.

Located beside Genesis 49:33–50:1; its proper place is one space further on, beside Genesis 50:2 (see no. 580). As in nos. 579 and 580, however, the scribe of Vat. 746 divided this scene into two separate miniatures (nos. 584a/584b and 585); in Ser. (nos. 582a–582c) and Sm. (nos. 583a–583c) it is arranged in two superimposed strips. The dislocation of the miniatures in Vat. 746 is thus eliminated.

Lit.: Uspenskii, p. 140, fig. 88; Hesseling, fig. 148; Buberl, "Problem," p. 46, fig. 21; Buberl, *Byz. Hss.*, p. 128; Stahl, "Morgan M. 638," p. 134, fig. 171; Sed-Rajna, *Hebraic Bible*, p. 55 nn. 63, 69.

Genesis 50:2

EMBALMING OF JACOB

581a. Vat. 747, fol. 71r

At the left two men carry out Joseph's order and embalm Jacob's corpse, which is still lying on the couch and already wrapped in winding sheets. In the background the house where the scene is supposed to take place and a wall are visible.

Located beside Genesis 50:2–3.

582b. Ser., fol. 154r

The act of embalming is no longer understood by this copyist, and the two Egyptians are merely lowering Jacob's corpse, wrapped in a shroud, into a sarcophagus. There can hardly be any doubt that the version in Vat. 747 is closer to the archetype.

Located beside Genesis 50:2.

583b. Sm., fol. 63r

Very close to Ser.

584b. Vat. 746, fol. 149r

Very close to Ser. and Sm. Considerably rubbed.
Located beside Genesis 49:33–50:1.

Lit.: Uspenskii, p. 140, fig. 88; Hesseling, fig. 148; Buberl, "Problem," p. 46, fig. 21; Buberl, *Byz. Hss.*, p. 128.

Genesis 50:4–6

JOSEPH ASKS PHARAOH TO HAVE JACOB BURIED IN CANAAN

Insignificant differences appear in the iconographical layout of the following episode: unlike Vat. 747, the other manuscripts do not include the Egyptian prince on the left, do not show Joseph bowing, and replace the official beside Pharaoh with a group of turbaned Egyptians.

581c. Vat. 747, fol. 71r

Pharaoh, sitting on a throne, gives Joseph permission to bury his father in Canaan. Joseph, bowing respectfully and making an imploring gesture, stands between two court officials clad in chlamydes. These are two of Pharaoh's princes whom Joseph had previously asked to intercede on his behalf with Pharaoh regarding his father's burial. A house topped with drapery stands behind Joseph, and another building with two stories is cut off by the left border.
Located beside Genesis 50:2–3.

582c. Ser., fol. 154r

In the center of the composition a group of five dark-skinned princes wearing turbans pleads with Pharaoh on Joseph's behalf; one member of the group turns toward Joseph, who remains at a respectful distance. Pharaoh sits in frontal position on his throne, wearing a turban instead of the imperial crown, and with a nimbus.
Located beside Genesis 50:2.

583c. Sm., fol. 63r

The inscription reads: ἐνταῦθ(α) αἰτεῖται ἰωσὴφ ἀνελθ(εῖν) ἐν γῆ χαναάν.
Very close to Ser.

585. Vat. 746, fol. 149v

The inscription reads: ἐνταῦθα αἰτεῖται ἰωσὴφ ἀνελθεῖν ἐν γῆ χαναάν.
Very close to Ser. and Sm. Flaked in various places; Joseph's head is almost completely destroyed.
Located beside Genesis 50:2.

Lit.: Uspenskii, p. 140, fig. 89; Hesseling, fig. 148; Buberl, *Byz. Hss.*, p. 128.

Genesis 50:7–9

JOSEPH ON THE WAY TO CANAAN

The scene is missing in Vat. 747 and is preserved only in the upper strip of the miniature in Ser., Sm., and Vat. 746.

587a. Ser., fol. 154v

Large sections of this miniature are so completely flaked that the scene would hardly be understandable were it not preserved in the other copies. The remaining traces agree in detail with Sm.
Located beside Genesis 50:12.

588a. Sm., fol. 63v

The inscription reads: ὁ ἰωσήφ ἄγων τὸ σῶμα τοῦ π(ατ)ρ(ό)ς.
The funeral procession to Jacob's burial place in Canaan is led by a group of five of Joseph's brothers who carry Jacob's coffin on their shoulders. Joseph, standing on a quadriga driven by a charioteer, immediately follows the coffin and is followed in turn by one of Pharaoh's servants driving a biga and by a large group of soldiers, the foremost holding a standard.

589a. Vat. 746, fol. 150r

The inscription reads: ἰωσὴφ ἄγων τὸ σῶμα τοῦ π(ατ)ρ(ό)ς.
Very close to Sm. The surface of the miniature, particularly the left half, is badly flaked.
Located beside Genesis 50:11.

Lit.: Uspenskii, p. 140; Hesseling, fig. 149; Menhardt, p. 328.

Genesis 50:10–13

BURIAL OF JACOB

Ser., Sm., and Vat. 746 have two scenes superimposed one above the other, while Vat. 747 preserves only the burial of Jacob, and this is reversed in comparison with the other manuscripts. Moreover, Vat. 747 emphasizes the atmosphere of the scene with more realistic and dramatic features.

586. Vat. 747, fol. 71v

Joseph and one of his brothers lower Jacob's corpse, which is wrapped like mummy, into a marble sarcophagus while the other brothers, with gestures of mourning, bend over it. At the same time Joseph holds his nose with his left hand against the smell of the corpse, a familiar feature in illustrations of the raising of Lazarus. The burial takes place in the cave of Mamre below the peak of a mountain.
Located beside Genesis 50:11.

587b. Ser., fol. 154v

The composition is almost completely flaked; judging from the few traces left there can be no doubt that it was close to Sm.

Located beside Genesis 50:12.

588b. Sm., fol. 63v

The inscription reads: καὶ θάπτων.

The brothers in the cave have already buried Jacob and are shown lowering the lid of the sarcophagus. Joseph does not appear to be among them. A group of Egyptians gesturing in mourning stand separated from this scene by the river Jordan that crosses the miniature diagonally.

589b. Vat. 746, fol. 150r

The inscription reads: καὶ θάπτων.
Very close to Sm. Flaked over the entire surface.
Located beside Genesis 50:11.

Lit.: Uspenskii, p. 140; Hesseling, fig. 149; Maguire, "Depiction of Sorrow," pp. 129, 151, fig. 6.

Genesis 50:16–17

Joseph's Brothers Beg Forgiveness

Ser., Sm., and Vat. 746 close the cycle with three distinct episodes; in contrast, Vat. 747 has the unique scene of Joseph's death (fig. 590), the iconography of which differs from the corresponding scene in the other codices (nos. 591b–594b). Moreover, whereas Vat. 747 portrays Joseph as an aged, bearded man, Ser., Sm., and Vat. 746 picture him as a young prince.

591a. Ser., fol. 155r

Following Jacob's burial, Joseph's brothers are afraid that Joseph may take revenge for all the evil they did to him and so they come to ask his forgiveness. Some of them kneel while others draw near, all of them imploring him with their gestures; the foremost respectfully covers his hands with his mantle. Joseph sits before a baldachin and holds his right hand to his chin in a gesture expressing thoughtfulness. Somewhat flaked.

Located beside Genesis 50:22.

592. Sm., fol. 63v

The inscription reads: ἀξίωσις τῶν ἀδελφῶν ἰωσὴφ μετὰ τὸν τοῦ π(ατ)ρ(ὸ)ς θάνατον.

Very close to Ser. The figure of Joseph is badly flaked. Unlike in Ser. and Vat. 746, where this scene occupies the upper half of a two-part miniature, here it is a separate illustration, possibly to remedy a dislocation in the miniatures in the spaces left by the scribe, as occurs in Vat. 746 more than once.

594a. Vat. 746, fol. 150v

The inscription reads: ἀξίωσις τῶν ἀδελφῶν ἰωσὴφ μετὰ τὸν τοῦ π(ατ)ρ(ὸ)ς θάνατον.

Close to Ser. and Sm., except that the foremost brother does not cover his hands with his mantle.

Located beside Genesis 50:24.

Lit.: Uspenskii, pp. 140–41, fig. 90; Hesseling, fig. 150; Menhardt, p. 329; Stahl, "Morgan M. 638," p. 132, fig. 169.

Genesis 50:24–26

Joseph Asks His Brothers to Carry His Bones Out of Egypt and Death of Joseph

See the introduction to Genesis 50:16–17.

591b. Ser., fol. 155r

In the left half of the lower miniature the brothers are massed together in a single group, mourning Joseph, who lies dying in his bed. Joseph's eyes are still open; this last feature suggests that the illustration also relates to verses 24–25, in which Joseph makes his brothers swear to him that they will not bury him in Egypt, but take his bones to the land of his fathers. Slightly flaked.

Located beside Genesis 50:22.

593a. Sm., fol. 63v

The inscription reads: θάνατο(ς) ἰωσήφ.
Very close to Ser.

594b. Vat. 746, fol. 150v

The inscription reads: θάνατος ἰωσήφ.
Very close to Ser. and Sm.
Located beside Genesis 50:24.

Lit.: Uspenskii, p. 140, fig. 91; Hesseling, fig. 151; Menhardt, p. 329; Stahl, "Morgan M. 638," fig. 176.

Genesis 50:26

Death of Joseph

See the introduction to Genesis 50:16–17.

590. Vat. 747, fol. 71v

Joseph lies on a couch, and his eyes reveal that he has died. His mourning brothers stand behind the couch in two groups, except for one who, singled out and placed in the center of the composition, bends over the couch just as Joseph did when his father died (cf. fig. 576). The figure's gesture is not referred to in the Septuagint; most likely this brother is intended to represent Benjamin, who was particularly honored by Joseph on many occa-

sions. The symmetrically arranged architectural setting is placed against a golden sky, with a domed building in the center and two houses on either side, all three connected by a wall. The whole surface is very badly flaked.

Located beside Genesis 50:24.

Genesis 50:26

Burial of Joseph

591c. Ser., fol. 155r

Two of the brothers lower Joseph's corpse, fully dressed in his imperial garment, into a marble sarcophagus, while the other brothers look on mournfully.

Located beside Genesis 50:22.

593b. Sm., fol. 63v

The inscription, a continuation of the one at the left, reads: καὶ ταφή.

Very close to Ser. Partly flaked.

594c. Vat. 746, fol. 150v

The inscription reads: καὶ ταφή.
Very close to Ser. and Sm.
Located beside Genesis 50:24.

Lit.: Uspenskii, p. 140, fig. 91; Hesseling, fig. 151; Menhardt, p. 329; Stahl, "Morgan M. 638," p. 133, fig. 169.

5. EXODUS

Exodus 1:15–16

Pharaoh Orders the Killing of the Male Newborn Children of the Hebrews

The divergences between Vat. 747 and the other manuscripts, which are particularly evident from the beginning of the Joseph cycle, continue in the Exodus cycle. Whereas Vat. 747 illustrates Pharaoh's order to kill all male Hebrew newborn children, Ser., Sm., and Vat. 746 introduce a rather conventional picture with the birth and washing of Moses; in fact, the composition resembles very closely a Birth of the Virgin or John the Baptist (text fig. 24).[1] This iconographical borrowing from a New Testament episode is justified by the parallelism between the story of the birth and infancy of Moses and that of the Messiah.[2] All of the illustrations occur in the text column approximately beside Exodus 1:17ff., where the story of the midwives before Pharaoh is narrated, suggesting that the illustration in Vat. 747 is the original version in the cycle and that Ser., Sm., and Vat. 746 replaced that illustration with the Birth of Moses.

595. Vat. 747, fol. 72r

Pharaoh orders two Hebrew midwives to kill all Hebrew male newborn children. He sits on a throne before his palace, which consists of two roofed houses and a connecting wall with a small story above, from which a drapery spreads in typical Hellenistic manner. The two midwives, whom the text names as Shiphrah and Puah (LXX: Sepphora and Phua), bow respectfully before Pharaoh, while at the left, at a respectful distance, two court officials with crossed arms observe the audience. The miniature is very badly flaked, and all the heads as well as large parts of the background are destroyed.

Located beside Exodus 1:17.

Lit.: Weitzmann, *RaC*, 2d ed., pp. 254, 258; Weitzmann, "Septuagint," p. 73, fig. 55; Weitzmann, "Oct. Ser.," pp. 184–85, fig. 5; Weitzmann, "Jewish Sources," p. 78; Gaehde, "Octateuch," p. 353 n. 12; Schubert, *Spätantikes Judentum*, p. 71; Weitzmann, "Study," p. 52, fig. 43; Kötzsche-Breitenbruch, *Via Latina*, p. 29 n. 147; Schubert, "Egyptian Bondage," pp. 30–31; Chasson, "Tuscan Bible," p. 161; Schubert, *Jüd. Buchkunst*, pp. 64–65; Prigent, *Judaïsme*, pp. 259, 306; Weitzmann, *Dura*, pp. 27–28, fig. 31; Lowden, *Octs.*, pp. 61, 74, 85, fig. 79.

[1] Cf. Weitzmann, *Castelseprio*, pp. 37, 54–56; Lafontaine-Dosogne, *Iconographie de l'enfance*, vol. 1, pp. 99–100; and V. Juhel, "Le bain de l'Enfant-Jésus: Des origines à la fin du douzième siècle," *CahArch* 39 (1991), pp. 111–32.
[2] Cf. R. E. Brown, *The Birth of the Messiah: A Commentary on the Infancy Narratives in Matthew and Luke* (Garden City, N.Y., 1977), passim, where many analogies are considered.

Exodus 2:2

Birth of Moses

596. Ser., fol. 156r

Two midwives holding golden vessels in their hands approach Moses' mother, Jochebed, who lies on a couch; a third midwife, with her sleeves tucked up, washes the nimbed newborn child in a golden basin. A golden pitcher stands on the ground. The background consists of two houses with a connecting wall; the painter has misunderstood the architecture's relationship to the scene, depicting the first two midwives standing behind the wall.

Located below Exodus 1:17.

597. Sm., fol. 64r

The inscription reads: ἡ τοῦ μωσέως γέννησις.

The mother holds her left hand over her knee instead of at her breast, and the midwife washing the child is assisted by another who pours water from a pitcher into the basin and carries a towel; otherwise the composition agrees with Ser. The midwife washing the baby is flaked; all the other faces have apparently been overpainted.

598. Vat. 746, fol. 152r

The inscription reads: ἡ τοῦ μωσέως γέννησις.

The mother's attitude resembles that in Sm., whereas the placement of the pitcher on the ground is in agreement with Ser. The mother's head is rubbed, Moses' head is completely flaked, and slight damage is discernible to various areas of the surface.

Located beside Exodus 1:17.

Lit.: Uspenskii, p. 141, fig. 92; Hesseling, fig. 152; Der Nersessian, *Barl. et Joas.*, pp. 173–74; Koukoules, "Ἔθιμα τῶν Βυζαντινῶν," p. 104, fig. 5; Pijoán, *Summa artis*, vol. 7, fig. 564; Koukoules, *Vie et civilisation*, vol. 4, pl. 1 no. 4; Weitzmann, *RaC*, 2d ed., pp. 254, 258; Weitzmann, "Septuagint," p. 73 n. 55; Weitzmann, "Oct. Ser.," pp. 184–85, fig. 6; Goodenough, *Symbols*, vol. 9, p. 198 n. 4, fig. 174; Kitzinger, "Hellenistic Heritage," p. 102 n. 27; Lafontaine-Dosogne, *Iconographie de l'enfance*, vol. 1, pp. 99 n. 4, 100 n. 3; Ettlinger, *Sistine Chapel*, p. 57 n. 4; Eller and Wolf, *Mosaiken*, fig. 34; Gaehde, "Octateuch," p. 353 n. 13; Weitzmann, "Study," p. 24; Kötzsche-Breitenbruch, *Via Latina*, p. 29 n. 147; Schubert, "Egyptian Bondage," pp. 30–31; Chasson, "Tuscan Bible," p. 161; Schubert, *Jüd. Buchkunst*, p. 64; Demus, *Mosaics of S. Marco*, vol. 2, pt. 1, p. 171; Prigent, *Judaïsme*, pp. 259, 306; Weitzmann, *Dura*, pp. 27–28; Lowden, *Octs.*, pp. 61, 74, 85, figs. 80–82.

Exodus 2:3–5

MOSES' RESCUE

The divergences between Vat. 747 and the other manuscripts are fairly consistent here, as only the cradle and the gesture of the standing woman, Thermuthis, are similar in all the manuscripts. Vat. 747 shows Miriam hidden between two peaks and a woman near the bank either placing the ark in a pond or retrieving it. The pond supplants the Nile reed-bed mentioned at Exodus 2:3 and 2:5. If the woman is placing the ark, she is to be identified as Jochebed (Ex 2:3); if she is rescuing it, she is to be identified as one of the handmaids ordered by Thermuthis to retrieve it (Ex 2:5).[1] The rock from which the woman leans separates her actions from Thermuthis at the right, who points at the ark; consequently, the woman must be identified as Jochebed putting the cradle into the mud by the river, rather than as one of the handmaids complying with Thermuthis's order to rescue it. Apparently, Pharaoh's daughter herself is striving to recover the cradle with her outstretched hand. The picture traces its origin to a peculiar tradition of Moses' rescue, where Thermuthis does not send her *handmaid*, but stretches out her *hand* to recover the cradle, following an alternative interpretation of the ambiguous

Hebrew term *'mth*.[2] This tradition is handed down by Targum Pseudo-Jonathan,[3] by a group of rabbis,[4] and in a few Jewish writings.[5] Ser., Sm., and Vat. 746 show a maid hastening to the ark with her arms outstretched, and Miriam spying on the events from behind some reeds. In this picture and in the next one in the lower strip, Thermuthis has acquired an unexpected nimbus, perhaps mistakenly copied from the model used for her figure; as a result, Thermuthis is identified as a holy precursor.[6] In this group of Octateuchs the scene of the rescue closely follows Exodus 2:5, "having seen the ark in the ooze, she (Thermuthis) sent her maid, and took it up." Thermuthis has seen the cradle and is having her handmaid retrieve it.[7]

Finally, the locations of the miniatures in the text columns approximately beside Exodus 2:8ff. complicates the question, since this text does not correspond to any of the events pictured, but rather narrates the calling of Moses' mother to suckle the babe.[8]

599. Vat. 747, fol. 72v

While Miriam, hidden between two peaks, gazes from a distance, Thermuthis stands on the bank of the Nile on the right; having seen the chest with the baby, she stretches out her right arm. A female figure emerges from behind a rock laying down the chest into the stream with both her hands (or retrieving it from the stream). The chest is depicted as a rectangular cradle.[9] Thermuthis is distinguished by a piece of sumptuously embroidered cloth worn over her garment and resembling the imperial loros of Byzantine empresses. The whole surface is badly flaked.

Located beside Exodus 2:9.

600a. Ser., fol. 157v

Pharaoh's daughter is represented in a pose similar to that in Vat. 747, but her arm, which in Vat. 747 is resolutely outstretched, loses its emphasis here. The princess is also dressed differently than in Vat. 747, wearing a mantle with a clasp in front, the imperial pearl crown, and a nimbus. She notices the ark floating in a pool and orders the maid standing behind her with arms extended to fetch it. Both women have apparently just stepped out of the house with its entrance open. Moses' sister sits on the bank in an attitude of sorrow, concealing herself behind some reeds. In the background two arcaded houses are connected by a drapery hanging from their roofs.

Located beside Exodus 2:8.

601a. Sm., fol. 64v

The inscription reads: ἡ ἐν θήκῃ μωσέως εὕρεσις.
Very close to Ser. Partly rubbed, flaked, and overpainted.

602a. Vat. 746, fol. 153r

The inscription reads: ἡ ἐν θήκῃ μωσέως εὕρεσις.
Very close to Ser. and Sm.
Located beside Exodus 2:8.

Lit.: Uspenskii, p. 141, fig. 93; Hesseling, fig. 153; Wilpert, *Mosaiken und Malereien*, vol. 1, p. 446, fig. 160; Wodtke, "Dura," p. 59; Millet, "Introduction," p. xviii; Goodenough, *Symbols*, vol. 9, p. 198 n. 4, fig. 175; Buchthal, *Latin Kingdom*, p. 58 n. 2; Weitzmann, "Jewish Sources," fig. 63; Eller and Wolf, *Mosaiken*, fig. 35; Narkiss, *Golden Haggadah*, pp. 67, 73 n. 72; Gaehde, "Octateuch," p. 353, fig. 65; Schubert, *Spätantikes Judentum*, pp. 71–72; Brenk, *S. Maria Magg.*, p. 78 n. 97; Weitzmann, "Selection," p. 90, fig. 32; Weitzmann, "Study," pp. 49–50, fig. 41; Kötzsche-Breitenbruch, *Via Latina*, p. 78, n. 494, pl. 17c; Schubert, "Errettung des Moses," p. 67 n. 31; Gutmann, "Med. Jew. Image," p. 132 n. 8; Weitzmann, *SP*, p. 248; Demus, *Mosaics of S. Marco*, vol. 2, pt. 1, pp. 171–72; Gutmann, "Josephus," p. 435; Sed-Rajna, *Hebraic Bible*, p. 92 n. 14; Prigent, *Judaïsme*, p. 305; Weitzmann, *Dura*, pp. 29–31, figs. 35, 36; Schubert, "Auffindung," pp. 287, 292 n. 11.

[1] Similar figures bending over on the river bank are found at Dura (text fig. 40) and in the Menologion of Basil II in the Vatican Library, cod. gr. 1613, p. 13 (discussed and reproduced in Weitzmann, *Dura*, pp. 28–29, figs. 29, 33), both scenes representing Jochebed putting the ark into the Nile, and in the Carolingian Bible of San Paolo fuori le mura in Rome, fol. 20v (text fig. 5), representing the maid (ibid., fig. 34; Gaehde, "Octateuch," pp. 352ff., fig. 64). The names Jochebed and Thermuthis do not appear in the Septuagint, but are given in *LAB* 9:12 (*OTP*, vol. 2, p. 316) and Josephus, *Ant* 11:224 (*Josephus*, ed. Thackeray, vol. 4, p. 260), respectively.

[2] Cf. *Targum Onkelos to Exodus*, ed. Drazin, pp. 47–48 n. 4, and *Targum Onqelos to Exodus*, ed. Grossfeld, p. 5. The most extreme pictorial version of the rescue by Thermuthis is found at Dura, where Thermuthis immerses herself in the flowing water to grasp the cradle (Weitzmann, *Dura*, fig. 30; Kraeling, *Synagogue*, pp. 176–77, 353–54; Schubert, "Errettung des Moses," pp. 59–68), but the source of this depiction seems to have been an image of the local deity Anahita (Goodenough, *Symbols*, vol. 1, pp. 198–226; J. Neusner, "Judaism at Dura-Europos," *History of Religions* 4 [1964], pp. 87–89).

[3] "Elle vit la corbeille au milieu des papyrus; elle étendit le bras et la prit et sur-le-champ elle fut guérie de l'éruption" (*Targum Exode et Lévitique*, ed. Le Déaut, pp. 21, 23).

[4] ExR 1:23 (*Exodus Rabbah*, ed. Freedman and Simon, pp. 28–29), where a debate among rabbis is reported.

[5] PRE 48 (*Pirkê*, ed. Friedlander, pp. 378–79); Ezekiel the Tragedian, *Exagoge*, v. 21 (*OTP*, vol. 2, p. 809); Sotah 12a–12b (*Babylonian Talmud*, ed. Epstein, vol. 3, pp. 62–63); in fact, like Midrash Rabbah, Sotah reports the rescue both by Thermuthis and by the handmaid.

[6] A possible link with the New Testament is the cradle she points at, which was regarded as a symbol of the future Church; cf. Cyril of Alexandria, *Glaphyra in Exodum* 1:5 (PG 69, col. 397), a passage reported in Prokopios's catena to the Octateuch (PG 87, cols. 515–16; *Catenae Graecae*, vol. 1, *Catena Sinaitica*, ed. Petit, pp. 279–80).

[7] The same account is found in TargOnk, "She (Thermuthis) saw the basket in the river and sent her slave girl to fetch it" (*Targum Onkelos to Exodus*, ed. Drazin, p. 46); TargN, "And she saw the basket within the meadow and sent her maidservant to fetch it" (*Neophyti 1: Targum Palestinense*, vol. 2, *Éxodo*, ed. Díez Macho, p. 409); Peshitta at Ex 2:5; Jub 47:5 (*OTP*, vol. 2, p. 138); *LAB* 9:5 (ibid., p. 316); in a group of rabbis quoted in ExR 1:23 (*Exodus Rabbah*, ed. Freedman and Simon, pp. 28–29); and in Philo, *De vita Mosis* 1:14 (*Philo*, ed. Colson, vol. 6, pp. 282–83). Alternatively, Josephus, *Ant* 2:224 (*Josephus*, ed. Thackeray, vol. 4, p. 261) has "she sent off some swimmers with orders to bring that cot to her."

[8] This episode is depicted in the paintings of the Dura synagogue (Weitzmann, *Dura*, p. 31, fig. 30) and in the Carolingian Bible in S. Paolo fuori le mura in Rome (ibid., fig. 34; Gaehde, "Octateuch," fig. 64).

[9] Cf. *Ant* 2:220, where Moses is placed in "a basket of papyrus reeds, fashioned in the form of a cradle" (*Josephus*, ed. Thackeray, vol. 4, p. 259; quoted by Gutmann, "Josephus," p. 435).

[Exodus 2]

THERMUTHIS PRESENTS MOSES TO PHARAOH

This scene is neither mentioned in the Septuagint nor depicted in Vat. 747. The inspiration for the scene in Ser., Sm., and Vat. 746 probably came from popular anecdotes on the infancy of Moses, illustrated in the pictorial tradition handed down to us[1] and narrated, e.g., in Josephus's *Jewish Antiquities*.[2] Josephus, however, who was interested in other miraculous events of Moses' infancy, does not mention Moses running toward Pharaoh, but says that Thermuthis "brought Moses to her father and showed him to him," and then "laid the babe in her father's arm."[3] Thus, the core of the iconography of this illustration depends on an infancy cycle such as that of the Virgin, and in particular on a representation of either the Presentation of the Virgin in the Temple (text fig. 26) or the First Steps of the Virgin,[4] as depicted in the mosaics in the Kariye Camii in Istanbul (text fig. 32).[5] The nimbi that both Thermuthis and Pharaoh unexpectedly receive might have originally been in the models for those figures, for example, the Virgin and the priest, and erroneously maintained in the Octateuch scene.

600b. Ser., fol. 157v

Thermuthis, wishing to present Moses to Pharaoh, lets the boy run toward her father, while two women, possibly Moses' mother and sister, watch with great emotion and tension. Pharaoh sits on a throne before a baldachin, extending his right hand toward the child who approaches with open arms, guided gently by the daughter. Not only does Moses have a nimbus, but so do the monarch and his daughter. The heads of these two are rubbed, perhaps intentionally.

Located beside Exodus 2:8.

601b. Sm., fol. 64v

The inscription reads: ἡ εἰς φαραὼ εἰσαγωγή.

Very close to Ser. Pharaoh and his bodyguards are badly flaked.

602b. Vat. 746, fol. 153r

The inscription reads: ἡ πρὸς φαραὼ εἰσαγωγή.

Very close to Ser. and Sm.

Located beside Exodus 2:8.

Lit.: Uspenskii, p. 141, fig. 94; Hesseling, fig. 153; Wilpert, *Mosaiken und Malereien*, vol. 1, p. 446, fig. 160; Weitzmann, "Jewish Sources," pp. 83–84, 90, 93, fig. 63; Lafontaine-Dosogne, *Iconographie de l'enfance*, vol. 1, p. 150 n. 4; Eller and Wolf, *Mosaiken*, fig. 35; Weitzmann, "Study," p. 28, fig. 22; Weitzmann, "Selection," p. 90, fig. 32; Kötzsche-Breitenbruch, *Via Latina*, pl. 17c; Weitzmann, *SP*, p. 248; Sed-Rajna, *Hebraic Bible*, p. 92 n. 23; Gutmann, "Testing," p. 107; Prigent, *Judaïsme*, p. 305.

[1] Pictorial examples of this episode are found in the mosaics of San Marco in Venice (Demus, *Mosaics of S. Marco*, vol. 2, pt. 2, pl. 314) and on an icon with Moses Receiving the Law and a cycle of his life in the Monastery of St. Catherine on Mount Sinai (Gutmann, "Testing of

Moses," fig. 2; Mouriki, "Moses Cycle," p. 542, fig. 2); but the iconography of these works is unrelated to the Octateuchs.

2 *Ant* 2:228–237 (*Josephus*, ed. Thackeray, vol. 4, pp. 262–68).
3 *Ant* 2:232 (*Josephus*, ed. Thackeray, vol. 4, pp. 264–65).
4 Lafontaine-Dosogne, *Iconographie de l'enfance*, vol. 1, pp. 122–24.
5 Underwood, *Kariye Djami*, vol. 2, pls. 104, 105.

Exodus 2:12

Moses Slays the Egyptian

Without giving further details, the Septuagint relates only that Moses struck the Egyptian who had beaten the Hebrew. The group of Moses and the Egyptian is based on a classical depiction of a fighting warrior, like Theseus,[1] for instance, or Herakles swinging a club in one of his deeds.[2] The parallel between Moses and Herakles was known in the Jewish ambience since Philo, and is witnessed by the paintings in the synagogue of Dura Europos, where Moses' rod is replaced by a knobby club,[3] as it is in the Octateuchs.

603. Vat. 747, fol. 73r

Moses, in an impassioned attitude and holding a club in his hand, slays the Egyptian. The Egyptian has fallen to the ground and is trying in vain to protect himself with his raised arm. The lower part of his body is hidden under a mound of sand, beneath which Moses will bury him hastily after killing him. Meanwhile, the frightened Hebrew tries to escape behind a hillock. High mountains form the background. The Hebrew's head and other spots are badly flaked.

Located beside Exodus 2:13.

604. Ser., fol. 158r

Moses' attitude is very similar to that in Vat. 747, but the other two figures are depicted somewhat differently. The Egyptian's body is fully visible and covered only loosely by sand. He is bleeding from the head, but makes no effort to protect himself against Moses' club. The Hebrew quietly watches the slaying and, while with one hand he gesticulates in surprise, he extends the other toward Moses in a gesture of address. The heads of the Egyptian and the Hebrew are rubbed.

Located beside Exodus 2:12.

605. Sm., fol. 65r or 65v[4]

The inscription reads: ἡ τοῦ αἰγυπτίου πάταξις καὶ ἐν τῇ ἄμμω κ(α)τ(ά)κρυψις.

Very close to Ser. Moses is slightly flaked and his head as well as the Hebrew seem to have been overpainted.

606. Vat. 746, fol. 154r

The inscription reads: ἡ τοῦ αἰγυπτίου πάταξις καὶ ἐν τῇ ἄμμω κατάκρυψις.

Although the entire surface of the miniature is badly flaked, enough remains to ascertain that all three figures agree completely with Ser. and Sm.

Located beside Exodus 2:13.

Lit.: Uspenskii, p. 141, fig. 95; Hesseling, fig. 154; Weitzmann, "Martyrion," p. 140; Ettlinger, *Sistine Chapel*, pp. 50–51, pl. 37e; Eller and Wolf, *Mosaiken*, fig. 36; Gaehde, "Octateuch," p. 353 nn. 12, 13; Anderson, "Two Centers," pp. 84–85, pl. 41; Spatharakis, *Corpus*, fig. 570; Weitzmann, *SP*, p. 53; Demus, *Mosaics of S. Marco*, vol. 2, pt. 1, p. 174.

1 The scheme is a very common one for ancient representations of Theseus; a number of them have been published by W. Daszewski, *Nea Paphos*, vol. 2, *La mosaïque de Thésée* (Warsaw, 1977), pp. 46–51, pls. 4, 11, 13, 14, 16–18, 20, 21, 23c, 24, 27, 28. See, in addition, the Roman mosaic from Salzburg (now in the Kunsthistorisches Museum, Vienna) with Theseus battling the Minotaur (*LIMC*, vol. 7, pt. 2, p. 622, no. 256). We are indebted to Dr. Christopher Moss for these references.
2 A similar iconography is found in the San Marco mosaics (Demus, *Mosaics of S. Marco*, vol. 2, pt. 2, pl. 319). Classical examples of the type of Herakles with his club raised over his head have been published by R. Vollkommer, *Herakles in the Art of Classical Greece* (Oxford, 1988), figs. 14, 21, 32, 36–38 (we are indebted to Chistopher Moss for this reference). It may be pointed out, however, that the Septuagint employs the word πατάξας (Ex 2:12: "πατάξας τὸν Αἰγύπτιον"); the same verb recurs at Exodus 17:16 ("καὶ πατάξεις τὴν πέτραν") when Moses strikes the rock at Rephidim; and there Moses does strike the rock with a stick.
3 See, e.g., the panel with the Crossing of the Red Sea (Weitzmann, *Dura*, figs. 48, 49); cf. Goodenough, *Symbols*, vol. 10, pp. 119–25; Neusner, "Judaism at Dura-Europos" (as in note 2 in the introduction to Exodus 2:3–5), pp. 89–91.
4 Fol. 65v according to Hesseling, p. x; fol. 65r according to Uspenskii, p. 185.

Exodus 2:16–17

Moses Rescues Jethro's Daughters

Moses rushing to aid the daughters of Jethro (LXX: Jothor) is represented, as in nos. 603–606, as a Theseus-Herakles figure, threatening the shepherds with his knobby club. Exodus 2:17, "and Moses rose up and rescued them," does not specify how Moses saved the women from the shepherds; thus, the pictorial identification of Moses with one of the Greek heroes is a part of the cycle's own imagery (see also the introduction to Exodus 2:12).

607a. Vat. 747, fol. 73r

Moses stands behind the well and swings his club at the shepherds who have come to chase away the daughters of Jethro. The shepherds, who are represented escaping behind the crest of a hillock, are almost completely destroyed by flaking. Although assisted by Moses, Jethro's daughters were nevertheless unable to drive their flocks to the watering place, and so in the picture Jethro's flocks drink from a trough near the well, followed by a group of women whose number should be seven according to the Septuagint. Moses and the daughters are flaked, although less badly than the shepherds, and large parts of the background are completely destroyed.

Located beside Exodus 2:22.

608a. Ser., fol. 159r

Close to Vat. 747. Moses is placed prominently in the center, and the shepherds fleeing in haste are fully visible, driving away their flocks. Jethro's daughters, reduced to two in number, stand at the left, and while one of them watches Moses' amazing performance the other pours water from the well bucket into the trough. Very badly damaged; certain details can be recognized only by comparison with the better-preserved compositions in Sm. and Vat. 746.

Located beside Exodus 2:20.

609a. Sm., fol. 65r or 65v¹

The inscription reads: ἡ τῶν ποιμένων δίωξις.

Very close to Ser. Jethro's daughters are badly flaked and the larger part of the miniature seems to have been overpainted.

610a. Vat. 746, fol. 154v

Because of spatial limitations within the frame, the inscription had to be placed outside, at the left; it reads: ἡ τῶν ποιμένον δίωξις.

Very close to Ser. and Sm.

Located beside Exodus 2:19.

Lit.: Uspenskii, p. 141; Hesseling, fig. 155; Ettlinger, *Sistine Chapel*, p. 51 n. 1, pl. 38a; Demus, *Mosaics of S. Marco*, vol. 2, pt. 1, p. 174; Sed-Rajna, *Hebraic Bible*, p. 93 nn. 36, 38.

¹ Fol. 65v according to Hesseling, p. x; fol. 65r according to Uspenskii, p. 185.

Exodus 2:20–21

MOSES EATS WITH JETHRO'S FAMILY

607b. Vat. 747, fol. 73r

Moses is received in the house of Jethro, or Renel (LXX: Raguel), as he is also called at verse 18. He sits at the left end of the dining table, while Jethro sits at the right; between them are two of Jethro's seven daughters who have joined them for the meal. One of them turns her head toward her father and the other looks at Moses. Presumably this latter daughter is meant to represent Zipporah (LXX: Sepphora), who is given to Moses as his wife. The composition is framed by two houses, in the interior of which the meeting is supposed to take place. All the figures and the background are badly flaked.

Located beside Exodus 2:22.

608b. Ser., fol. 159r

Compared with Vat. 747, the composition is reversed. It shows Moses at the right, nimbed and seated on a rich throne, and Jethro at the left. The miniature is nearly completely destroyed, but the remaining traces make it clear that in its details the scene agreed with Sm. and Vat. 746.

Located beside Exodus 2:20.

609b. Sm., fol. 65r or 65v¹

The inscription reads: ἡ πρὸς ἰοθὸρ εἰσέλευσις.

Close to Ser. Jethro is represented gesturing in speech, apparently telling Moses that he is giving him one of his daughters in marriage. The bride, Zipporah, who sits next to Moses, is distinguished by a garment more richly decorated than her sister's and by her joyfully raised hand. The settings on the table are painted in great detail; it is even clear that the main course was chicken.

610b. Vat. 746, fol. 154v

The inscription, again placed outside the frame, reads: ἡ πρὸ(ς) ἰοθὸρ εἰσέλευσις.

Very close to Ser. and Sm.

Located beside Exodus 2:19.

Lit.: Uspenskii, p. 141; Hesseling, fig. 155; Lassus, *Livre des Rois*, p. 87, fig. 120; Demus, *Mosaics of S. Marco*, vol. 2, pt. 1, pp. 174–75, 179; Sed-Rajna, *Hebraic Bible*, p. 93 n. 40.

¹ Fol. 65v according to Hesseling, p. x; fol. 65r according to Uspenskii, p. 185.

Exodus 3:1–2

MOSES LOOKS AT THE BURNING BUSH

In the upper strip of Sm. and Vat. 746 Moses arrives with his flock and looks at the burning bush in astonishment. Vat. 747 does not depict this episode, but shifts directly to Moses loosening his sandal (fig. 611).

Ser., fol. 160r

The painter filled the space provided for the burning bush with a repetition of the illustration of the miracle of the serpent described in Exodus 4:3 (fig. 615).

Located beside Exodus 3:1.

612a. Sm., fol. 66r

The inscription reads: ἡ τῆς β(ά)τ(ου) ἄφλεκτος κατάκαυσις.

Moses, followed by his flock, stands opposite the burning bush and a segment of heaven above it. His right hand is raised and his left is lowered in a very clumsy way. The miniature has been crudely overpainted.

613a. Vat. 746, fol. 157r

The inscription reads: ἡ τῆς βάτου ἄφλεκτος κατάκαυσις.

Very close to Sm., except that Moses points at the bush with his left hand and raises his right to his chin in a gesture of astonishment.

Located below Exodus 3:6.

Lit.: Uspenskii, p. 141; Hesseling, fig. 156; Goodenough, "Christian and Jewish Art," pp. 415–17, fig. p. 417; Weitzmann, "Ps. Vatopedi," p. 47,

fig. 18; Nordström, "Jewish Legends," pp. 491–93; Weitzmann and Ševčenko, "Moses Cross," p. 386, n. 9, fig. 5; Cahn, "Souvigny Bible," p. 95, fig. 58; Mouriki-Charalambous, "Cosmas," p. 59; Deckers, *S. Maria Magg.*, p. 141; Anderson, "Seraglio," p. 98; Demus, *Mosaics of S. Marco*, vol. 2, pt. 1, p. 175; Aliprantis, *Moses*, p. 19, fig. 13; Sed-Rajna, *Hebraic Bible*, p. 93 n. 49; Weitzmann, *Dura*, pp. 35–38, fig. 44; Lowden, *Octs.*, pp. 70–71, fig. 97.

Exodus 3:2–6

Moses Loosens His Sandal

Sm. and Vat. 746 represent Moses gazing at the angel while loosening his sandal, a feature that contradicts the statement in verse 6, "Moses turned away his face, for he was afraid to gaze at God." At the same time they erroneously replace God addressing Moses (verse 4) with the angel,[1] suggested by verse 2, where the angel appears in the bush. Vat. 747 has an accurate representation, with a God-fearing Moses turning his face away from God's hand in heaven, as in verse 6; but the tongue of fire falling from heaven is not a literal rendering of the text, and the miniature does not include the angel. Angels, however, are said to be flaming fire both elsewhere in the Bible[2] and in Jewish lore.[3] The unique depiction of the fire burning the bush in Vat. 747 seems to be a pictorial rendering of Exodus Rabbah 2:5, which says, "the fire was from both sides of the bush and upwards, just as the heart is placed between the upper part of both sides of a man."[4] The iconography of the picture in Sm. and Vat. 746 is indebted to a widespread tradition of representations of the burning bush with Moses gazing at God.[5] Vat. 747, on the other hand, has a much more sacred atmosphere, appropriate to theophany, achieved through the expressionistic style of its painting and its focus on the most symbolic features of the event selected for the miniature.

611. Vat. 747, fol. 74r

High on Mount Horeb Moses loosens his right sandal[6] and turns his head away from God's hand in heaven. A huge column of fire falls from this segment of heaven, setting fire to the bush. A golden sky rises above the high mountain range, which is painted bluish white with pink peaks. Large sections of the ground are flaked.

Located in the catena; the text above is Exodus 3:6.

Ser., fol. 161v

The painter filled the space provided for the loosening of the sandals with a repetition of the meeting between Moses and Jethro described in Exodus 4:18 (fig. 616).

Located beside Exodus 3:1.

612b. Sm., fol. 66r

The inscription reads: ἡ τοῦ ὑποδήματο(ς) λύσις.
An angel flies from heaven toward Moses who is loosening his sandal and gazing at the angel.

613b. Vat. 746, fol. 157r

The inscription reads: ἡ τοῦ ὑποδήματος λύσις.
Very close to Sm.
Located below Exodus 3:6.

Lit.: Tikkanen, *Genesismosaiken*, fig. 52; Uspenskii, pp. 141–42; Hesseling, fig. 156; Weitzmann, "Martyrion," p. 137; Goodenough, "Christian and Jewish Art," pp. 415–17, fig. p. 417; Weitzmann, "Ps. Vatopedi," pp. 33, 43, fig. 18; Buchthal, *Latin Kingdom*, p. 58 n. 3; Nordström, "Jewish Legends," pp. 491–93; Weitzmann and Ševčenko, "Moses Cross," p. 386, n. 9, fig. 5; Cahn, "Souvigny Bible," p. 95, fig. 58; Mouriki-Charalambous, "Cosmas," p. 59; Stahl, "Morgan M. 638," pp. 196–97; Gaehde, "Octateuch," p. 353 n. 15; Der Nersessian, "Parekklesion," p. 336; Crown, "Winchester Ps.," p. 46; Chasson, "Tuscan Bible," p. 170; Bergman, *Salerno*, p. 40, fig. 93; Jeremias, *S. Sabina*, pp. 23–24; Anderson, "Seraglio," p. 98; Demus, *Mosaics of S. Marco*, vol. 2, pt. 1, p. 175; Gutmann, "Josephus," p. 438; Aliprantis, *Moses*, p. 19, fig. 13; Sed-Rajna, *Hebraic Bible*, p. 93 n. 49; Weitzmann, *Dura*, pp. 35–38, figs. 44, 45; Lowden, *Octs.*, pp. 70–71, fig. 97.

[1] According to an ancient Jewish literary tradition, the angel, and not God, approached Moses from the burning bush; see Memar Marqah 1:1, 2 (*Memar Marqah: The Teaching of Marqah*, ed. MacDonald, vol. 2, pp. 3, 4). Eusebios of Caesarea supported the idea that God himself, and not one of his angels, appeared to Moses (*HistEccl* 1:2 [PG 20, col. 59]).

[2] As in Ps 104:4: "(the Lord) who makes his angels spirits, and his ministers a flaming fire."

[3] E.g., PRE 4 (*Pirḳê*, ed. Friedlander, pp. 21–22; cf. Alexander, "Targumim," p. 68).

[4] *Exodus Rabbah*, ed. Freedman and Simon, p. 53.

[5] A similar iconography, but with Moses correctly gazing toward the hand of God instead of the misplaced angel in Sm. and Vat. 746, is found in the mosaic of the triumphal arch in the church of St. Catherine's monastery at Mount Sinai (G. H. Forsyth and K. Weitzmann, *The Monastery of Saint Catherine at Mount Sinai: The Church and Fortress of Justinian* [Ann Arbor, Mich., 1973], pl. 182), on the lipsanotheca in the Museo Cristiano in Brescia (H. Giess, "Die Gestalt des Sandalenlösers in der mittelalterlichen Kunst," in *Miscellanea Bibliothecae Hertzianae zu Ehren von Leo Bruhns, Franz Graf Wolff Metternich, Ludwig Schudt* [Munich, 1961], pp. 48ff., fig. 24), and in the mosaics of San Marco in Venice (Demus, *Mosaics of S. Marco*, vol. 2, pt. 2, pl. 329).

[6] The Septuagint text has "λῦσαι τὸ ὑπόδημα ἐκ τῶν ποδῶν σου" (e.g., Vat. 747, fol. 74r). The loosening of only one sandal, while the second one has not already been taken off and put on the ground, is a feature possibly connected with a specific Jewish heritage. Whereas the Masoretic text and Peshitta report the plural "sandals," TargOnk, TargPs-J, and other Hebrew texts have the singular ("loosen your sandal from your foot": see *Targum Onqelos to Exodus*, ed. Grossfeld, p. 7, esp. n. 5). In the Dura Europos synagogue (text fig. 41) and the Kosmas manuscripts both sandals are depicted lying on the ground, and, corresponding with the illustration, the inscription in the Kosmas miniature (Sinai, cod. 1186, fol. 101v; Weitzmann and Galavaris, *Sinai Greek Mss.*, fig. 163) has the plural ὑποδήματα. In the mosaic at the monastery of St. Catherine the loosening of both sandals is clearly shown (cf. Weitzmann, *Dura*, figs. 41–43).

Exodus 4:3–6

Moses' Rod Transformed into a Serpent and His Arm Become Leprous

Moses looks at the two miracles performed by God, namely, the rod transformed into a serpent (verse 3) and his arm turned leprous and white as snow (verse 6) and then restored to flesh

(verse 7). The illustration shifts the contents of verse 4, where Moses stretches out his arm and holds the serpent's tail to have the rod restored. In a realistic and impressive sequence, lost in the other manuscripts, Vat. 747 displays the progression of the miracle of the serpent in three successive phases. Instead of putting his hand to his bosom (verses 6 and 7), Moses holds it over his upper right arm.

614a. Vat. 747, fol. 76v

Standing at the foot of the mountain, Moses looks up at the hand of God in heaven. At his feet lies a brown rod, the upper part of which has been turned into three serpent heads, thus either representing the progression of the miracle in successive stages, or improperly duplicating the miracle of the rod transformed into a serpent swallowing the Egyptian serpents before Pharaoh (fig. 640). Moses extends his right arm, which is white, and grasps it with his left hand, his left arm passing over his upper right arm.

Located beside Exodus 4:18.

615. Ser., fol. 160r
617a. Ser., fol. 167r

Erroneously depicted twice, the miracle involving the serpent is identical in both cases. Unlike in Vat. 747, Moses here extends his arms toward heaven, in which the entire right arm of God appears. Furthermore, the rod terminates in only one serpent instead of three. The surface of the second scene is partly flaked and shows the impression of letters from the opposite page.

Located beside Exodus 3:1 (no. 615) and beside Exodus 4:14 (no. 617a).

618a. Sm., fol. 68r

The inscription, which is related only to the second miracle, reads: ἡ τῆς δεξι(ᾶς) μωσέως χιονώδης λεύκανσις.

Very close to Ser.

619a. Vat. 746, fol. 162v

The inscription reads: ἡ τῆς δεξιᾶς μωσέως χιονώδης λεύκανσις.

Very close to Ser. and Sm. The serpent is largely flaked.

Located beside Exodus 4:16.

Lit.: Uspenskii, pp. 141, 142, fig. 97; Hesseling, p. i, fig. 157; Eller and Wolf, *Mosaiken*, fig. 37; Der Nersessian, "Parekklesion," p. 337; Kirigin, *Mano divina*, p. 147; Bergman, *Salerno*, p. 41, fig. 96; Anderson, "Seraglio," pp. 98–99, figs. 26, 28; Aliprantis, *Moses*, p. 19, fig. 68; Sed-Rajna, *Hebraic Bible*, p. 93 n. 54; Anderson, "James the Monk," p. 84, fig. 12; Lowden, *Octs.*, pp. 17–18, 23, 70–71, figs. 95, 96.

Exodus 4:18

Moses' Farewell to Jethro

Ser., Sm., and Vat. 746 depict a conventional farewell between Moses and Jethro; in contrast, the corresponding miniature in

the lower strip of Vat. 747 displays a divergent version in which two scenes are conflated. It is striking that the gesture of Moses in Ser., Sm., and Vat. 746, placing his right hand over his upper left arm, does not have much to do with a farewell or welcoming pose, as seen, e.g., in figs. 269, 270, 427, 428, 433, 434, or 735–737 in the same manuscripts.[1] Rather, it mirrors in reverse Moses' gesture in the illustration in the upper strip in Vat. 747 (fig. 614a), but no corresponding illustration exists in Ser., Sm., or Vat. 746. It is tempting to assume that Moses' farewell pose here was taken from a figure of Moses with his arm transformed that was in the model of Ser., Sm., and Vat. 746 but was not copied in those manuscripts. Notice, finally, that Moses' rod is again represented as Herakles' club (see the introductions to Exodus 2:12 and 2:16–17).

614b. Vat. 747, fol. 76v

Moses grasps a broad club, which is larger at the lower end, while bidding farewell to his father-in-law and simultaneously journeying to Egypt, as a part of the next scene in the right half of the same picture (no. 614c).

Located beside Exodus 4:19.

616. Ser., fol. 161v
617b. Ser., fol. 167r

Once more as the result of a mistake, the farewell scene is represented twice, one miniature being a precise copy of the other. The scene itself is an isolated iconographic unit, and Moses' march to Egypt, with which it is combined in Vat. 747, is not illustrated in Ser., Sm., or Vat. 746. Jethro, who in Vat. 747 extends his right hand in a gesture of speech, in Ser. uses his left hand for that purpose, while blessing his departing son-in-law with his right hand. Jethro is nimbed and stands before his house. Moses stands in a somewhat baffling pose, perhaps one of respect, holding one arm before his breast and the other in a gesture of speech; presumably he is asking Jethro to let him take his leave. The surface of the second scene is partly flaked and shows the impression of letters from the opposite page.

Located in the catena below Exodus 3:6 (no. 616) and beside Exodus 4:16 (no. 617b).

618b. Sm., fol. 68r

The inscription reads: ἡ πρὸς ἰοθὸρ ἀποχαιρέτισ(ι)ς.

Very close to Ser.

619b. Vat. 746, fol. 162v

The inscription reads: ἡ πρὸς ἰοθὸρ ἀποχαιρέτισις.

Very close to Ser. and Sm. House and ground are slightly flaked.

Located beside Exodus 4:16.

Lit.: Tikkanen, "Genesi," p. 267 n. 2; Uspenskii, p. 142, figs. 96, 98; Hesseling, fig. 157; Deckers, *S. Maria Magg.*, pp. 144–45; Anderson, "Seraglio," pp. 98–99, figs. 27, 28; Sed-Rajna, *Hebraic Bible*, p. 93 n. 54; Anderson, "James the Monk," p. 84, fig. 12; Lowden, *Octs.*, pp. 17–18, 23, 70–71, figs. 95, 96.

[1] A possible similarity can be found in the attitude of the same Jethro in Vat. 747 (fig. 734).

Exodus 4:20

JOURNEY OF MOSES TO EGYPT

The episode of the journey of Moses' family to Egypt occurs in Vat. 747 alone: the other manuscripts fill the whole of the miniature with the farewell scene between Jethro and Moses. Exodus 4:20 says that "Moses took his wife and his children, and mounted them on the beasts, and returned to Egypt; and Moses took the rod which he had from God in his hand." In Vat. 747 the scene is arranged with the older child on a donkey and Zipporah and her younger child, suckling at her breast, on a second donkey. The group of Zipporah and the babe seems to be borrowed from a group of the Virgin and child on the journey to Egypt.[1]

614c. Vat. 747, fol. 76v

Moses and his family journey at the foot of two high mountains. Zipporah, who carries a nursing infant at her breast, is represented on horseback, while a half-grown boy, Gershom, the firstborn son, is riding on a second horse so close to his mother that she can put her left arm around him. Moses walks behind, carrying the rod God gave him. He looks back at his father-in-law, who belongs to the preceding scene.

Located beside Exodus 4:19.

Lit.: Tikkanen, "Genesi," p. 267 n. 2.

[1] This corresponds to the parallel in Christian authors between Zipporah and Mary (see note 2 in the introduction to nos. 620b–623b).

Exodus 4:24

ANGEL MENACES MOSES

This debated and somewhat obscure story is narrated in Exodus 4:24, where an angel confronts Moses and tries to kill him.[1] According to the Septuagint, Zipporah, "having taken a stone, cut off the foreskin of her son and fell at his (i.e., the angel's) feet . . . "; thus Moses is saved and the angel departs from him. In Ser., Sm., and Vat. 746 the angel only advances toward Moses with his right arm raised and without any obvious gesture of threat; he looks like a messenger conveying a command from God, while Moses displays acquiescence. The version in Vat. 747 depicts the angel menacing Moses and barring the way to Egypt with his statuelike presence, while Moses flees in fright; this scene clearly originated in a period and a milieu where the weight of this Exodus event had a profound impact. The less dramatic version in the other Octateuchs evidently reappraises this emphasis; consciously or not, it parallels the Christian Fathers, who tend to minimize the Jewish emphasis on the child's circumcision as the means of Moses' salvation from death by the angel: the angel did not intend to kill Moses, but only to send Zipporah away, or, alternatively, to terrify Moses. Passages from these Christian Fathers are included in the Octateuch catena.[2]

620a. Vat. 747, fol. 77v

Standing in a majestic pose and clad in a chlamys, an angel directs a lance toward Moses, who is frightened and tries to escape while looking back at the angel. The angel's face and parts of the ground are badly flaked.

Located in the catena; the text above is Exodus 4:26.

621a. Ser., fol. 170v

The angel, clad in a himation, approaches hurriedly, holding the lance merely as a conventional attribute and gesturing in speech with his left hand, while Moses listens quietly with his hands raised and his head devoutly bowed. A house at the right represents the inn which the text mentions as the meeting place.

Located in the catena, the text below being Exodus 4:27.

622a. Sm., fol. 69r or 69v[3]

The inscription reads: ὁ ἄγγελο(ς) συναντῶν τῷ μωυσῇ μετὰ τῆς ρομφαί(ας).

Very close to Ser. The angel holds a lance instead of the sword mentioned in the inscription.[4]

According to Uspenskii, this miniature was on fol. 69v.[5]

623a. Vat. 746, fol. 165r

The inscription reads: ὁ ἄγγελος συναντῶν τῷ μωυσῇ μετὰ τῆς ρομφαίας.

Very close to Ser. and Sm. Figures and ground are badly flaked.

Located below Exodus 4:26.

Lit.: Uspenskii, p. 142, fig. 99; Hesseling, p. i, fig. 158; Ettlinger, *Sistine Chapel*, p. 59.

[1] For a history of the contention about this episode in the Jewish sphere, see Vermes, *Scripture and Tradition*, chap. 7, "Circumcision and Exodus IV 24–26," pp. 178–92.

[2] See, e.g., Vat. 746, fols. 164v and 165r, or Vat. 747, fols. 77v and 78r; cf. Σειρά, ed. Nikephoros, vol. 1, cols. 610–14, with excerpts from Cyril, John Chrysostom, Theodoret (*QuaestEx* 14 [PG 80, cols. 241–44]), and other Fathers.

[3] Fol. 69r according to Hesseling, p. x; fol. 69v according to Uspenskii, pp. 142 and 185.

[4] Hesseling, p. i. A sword is also mentioned by Isidore in a passage from an epistle reported in the Octateuchs in Nicephoros's catena (see note 2 above), and by Theodoret in *QuaestEx* 14 (PG 80, cols. 241–44).

[5] Uspenskii, p. 142.

[Exodus 4:25]

ZIPPORAH SHOWS THE ANGEL HER SON'S BLOOD

In the left half of the lower strip of all four manuscripts, Zipporah shows the angel the blood of her circumcised son. The Septuagint does not mention this act, but only that Zipporah circumcised her son and then fell at the feet of the angel. An elaborated version of the story must have been the source of the illustration. In Targum Onkelos on Exodus 4:25 Zipporah addresses the angel, asking him to spare Moses because of the cir-

cumcision: "Whereupon Zipporah took a flint and circumcised the foreskin of her son and she approached in front of him saying: 'On account of this circumcision blood, let my husband be given [back] to us.'"[1] In this text, however, Zipporah neither bows in front of the angel nor touches his feet.[2]

620b. Vat. 747, fol. 77v

Having circumcised one of her sons, Zipporah draws attention to the deed. Alongside the circumcised son sits another child, the second of Zipporah's children. The woman turns around and, looking with some fright at the angel of the next scene at the right, points resolutely to the blood falling from her son's abdomen.

Located in the catena; the text above is Exodus 4:26.

621b. Ser., fol. 170v

In this and the following manuscripts both the children, who are erroneously represented as being about the same age, have been circumcised. Only one child sits on the bench, while the other, who should be seated on the same bench, is actually suspended in midair. Zipporah extends her left arm toward the angel.

Located in the catena, the text below being Exodus 4:27.

622b. Sm., fol. 69r or 69v[3]

The inscription reads: ἐνταῦθα περιτέμνει σεπφώρα τ(ὸν) υ(ἰὸν) αὐτῆς λίθῳ.

Very close to Ser.

623b. Vat. 746, fol. 165r

The inscription reads: ἐνταῦθα περιτέμνει σεπφώρα τὸν υἰὸν αὐτῆς λίθῳ.

Very close to Ser. and Sm. All the figures and the ground are badly damaged; yet we may recognize that here, unlike in Ser., only one of the children has been circumcised (as related in LXX).

Located below Exodus 4:26.

Lit.: Uspenskii, p. 142, fig. 100; Hesseling, p. ii, fig. 158; Ettlinger, *Sistine Chapel*, pl. 40b.

[1] *Targum Onqelos to Exodus*, ed. Grossfeld, pp. 11–12; cf. also Vermes, *Scripture and Tradition*, p. 181.

[2] Christian authors saw Zipporah as a prefiguration of Mary, with the blood of her son anticipating Christ's death; cf. Cyril's passage excerpted in the Octateuch catena (see note 2 of the introduction to Exodus 4:24).

[3] Fol. 69r according to Hesseling, p. x; fol. 69v according to Uspenskii, pp. 142 and 185.

Exodus 4:25–26

Zipporah Touches the Angel's Feet

Zipporah touching one of the angel's feet does not belong to the Septuagint narrative, where she only falls at the angel's feet;

the act is instead connected with the Hebrew text, where Zipporah "touched his legs with it (the severed foreskin)"[1] and with rabbis' sayings, where Zipporah either brings the cut foreskin to the feet of the angel or (more generally) bows and only touches his feet.[2] Christian writers, like Ephrem, also know this version.[3] The Octateuch cycle emphasizes the figure of Zipporah in this and the previous scene.

620c. Vat. 747, fol. 77v

Zipporah is depicted in proskynesis before the angel, who stands in a majestic pose clad in a chlamys and holding a lance in his hand. Both figures are very badly flaked.

Located in the catena; the text above is Exodus 4:26.

621c. Ser., fol. 170v

Slightly more erect than in Vat. 747, Zipporah touches the angel's foot with one hand and raises the other in a gesture of speech. The angel is shown moving away from Zipporah, thus illustrating verse 26, which describes his departure. In the text, however, the angel departs from "him" and this can only refer to Moses. The motif of departure, taken from verse 26, therefore makes the picture somewhat incongruous with the text.

Located in the catena, the text below being Exodus 4:27.

622c. Sm., fol. 69r or 69v[4]

Very close to Ser.

623c. Vat. 746, fol. 165r

Very close to Ser. and Sm. Both figures are very badly flaked. Located below Exodus 4:26.

Lit.: Uspenskii, p. 142; Hesseling, p. ii, fig. 158; Ettlinger, *Sistine Chapel*, p. 59, pl. 40b.

[1] Cf. Vermes, *Scripture and Tradition*, p. 178.

[2] ExR 5:8 (*Exodus Rabbah*, ed. Freedman and Simon, p. 85); cf. Vermes, *Scripture and Tradition*, pp. 179–80, 186–90.

[3] CommEx 4:4 (Ephraem, *In Genesim et in Exodum commentarii*, ed. Tonneau, p. 113): "Mulier autem . . . *cepit silicem et* tremens in conspectu angeli *circumcidit filium suum; et reliquit eum* sanguine conspersum *et tenuit pedes angeli dicens*"

[4] Fol. 69r according to Hesseling, p. x; fol. 69v according to Uspenskii, pp. 142 and 185.

Exodus 4:27

God Addresses Moses

624a. Vat. 747, fol. 78r

Although according to the text God asks Aaron to meet Moses, the illustrator represents Moses receiving the order. The man's beardlessness distinguishes him from Aaron, and he raises his hands and looks up to the sky, where no hand of God is represented. Portions of the ground are flaked.

Located beside Exodus 4:28.

625a. Ser., fol. 170v

Moses looks up at the divine hand in a segment of heaven which, like the figure itself, is partly flaked.

Located beside Exodus 4:28.

626a. Sm., fol. 70r

Very close to Ser. Moses' head is flaked.

627a. Vat. 746, fol. 166r

Very close to Ser. and Sm.
Located beside Exodus 4:28.

Lit.: Uspenskii, p. 142; Hesseling, fig. 159; Stahl, "Morgan M. 638," fig. 167; Deckers, *S. Maria Magg.*, p. 145.

Exodus 4:27

Embrace of Moses and Aaron

624b. Vat. 747, fol. 78r

Moses and Aaron embrace and kiss each other. In this and all the following miniatures of this manuscript Aaron is represented nimbed and with white hair and a white beard.

Located beside Exodus 4:28.

625b. Ser., fol. 170v

Close to Vat. 747 except that Aaron has black hair and a short black beard but no nimbus (this is true not only of this and the following scenes in Ser., but likewise of Sm. and Vat. 746). The meeting takes place in a forest at the foot of a mountain.

Located beside Exodus 4:28.

626b. Sm., fol. 70r

The inscription reads: ἔνθα συναντᾶ μωυσῆς ἀαρών.
Very close to Ser.

627b. Vat. 746, fol. 166r

The inscription reads: ἔνθα συναντᾶ μωυσῆς ἀαρών.
Very close to Ser. and Sm.
Located beside Exodus 4:28.

Lit.: Uspenskii, p. 142; Hesseling, fig. 159; Stahl, "Morgan M. 638," fig. 167; Deckers, *S. Maria Magg.*, p. 145.

Exodus 4:29–31

Moses and Aaron Face the Elders

624c. Vat. 747, fol. 78r

Moses and Aaron together face the elders of the Israelites. Whereas the text describes Aaron as the one who talks and per-

forms the miracles, Vat. 747 places Moses in front and lets him address the people. The elders, framed by two mountain peaks, gesture in astonishment and, following the text, bow devotedly to their leaders. Portions of the surface are flaked.

Located beside Exodus 4:28.

625c. Ser., fol. 170v

The miniature is almost completely destroyed by flaking, but enough details are still recognizable to show the deviations from Vat. 747. Unlike Vat. 747, Ser., Sm., and Vat. 746 show the metamorphosed serpent on the ground, although the text does not specifically mention the serpent, speaking only of the miracles in general. Moreover, both leaders raise their right hands.

Located beside Exodus 4:28.

626c. Sm., fol. 70r

The inscription reads: μωυσῆς καὶ ἀαρ(ὼν) ἀναγγέλλοντ(ες) τῷ λαῷ τὰ παρὰ τοῦ θ(εο)ῦ λαληθέντα αὐτοῖς.
Very close to Ser.

627c. Vat. 746, fol. 166r

The inscription reads: μωυσῆς καὶ ἀαρὼν ἀναγγέλλοντες τῷ λαῷ τὰ παρὰ τοῦ θ(εο)ῦ λαληθέντα αὐτοῖς.
Very close to Ser. and Sm.
Located beside Exodus 4:28.

Lit.: Uspenskii, p. 142; Hesseling, fig. 159; Stahl, "Morgan M. 638," p. 133, fig. 167; Deckers, *S. Maria Magg.*, p. 145.

Exodus 5:1–5

Moses and Aaron Ask Pharaoh to Let the People Go

628. Vat. 747, fol. 78r

Moses and Aaron approach Pharaoh asking him to let their people go back to the wilderness to hold a feast. Pharaoh, with a bodyguard at his side, is enthroned before a baldachin and wears the costume of a Byzantine emperor. His head is overpainted, and the restorer has changed the earlier type of pearl crown, which Pharaoh usually wears in this manuscript, into a later type of taller form. All parts of the miniature are badly flaked, save for the upper golden strip of sky.

Located beside the catena and Exodus 5:4.

629. Ser., fol. 171r

Although the text describes both Moses and Aaron talking to Pharaoh, here Moses alone speaks with his arm extended. Aaron, on the other hand, stands in a respectful pose, crossing both arms over his breast. Pharaoh, who sits on a lyre-back throne, holds a drawn sword in his lap and is flanked by three bodyguards. All the figures are slightly flaked.

Located in the catena; the text above is Exodus 5:4.

630. Sm., fol. 70r

The inscription reads: μωυσῆς καὶ ἀαρὼν διαλεγόμενοι τῷ φαραώ.

Very close to Ser. The faces in the left group are partly flaked.

631. Vat. 746, fol. 166v

The inscription reads: μωυσῆς καὶ ἀαρὼν διαλεγόμενοι τῷ φαραώ.

Very close to Ser. and Sm. All the heads are more or less flaked.

Located beside the catena and Exodus 5:4.

Lit.: Uspenskii, p. 142, fig. 101; Hesseling, fig. 160; Ettlinger, *Sistine Chapel*, pl. 40a; Buchthal, *Historia Troiana*, p. 26 n. 1; Brenk, *S. Maria Magg.*, p. 83; Deckers, *S. Maria Magg.*, pp. 145, 148.

Exodus 5:12

Israelites Collect Stubble

632. Vat. 747, fol. 78v

As one of the increasing hardships imposed on the Israelites, they are forced to collect stubble instead of straw. In the foreground an Israelite workman in a short tunic carries on his shoulder a wicker basket, which he is going to empty onto a pile of already collected stubble. With an emphatic gesture of command, an Egyptian taskmaster spurs him to hasten. A second group with another taskmaster is placed on the ridge of a mountain; the taskmaster is again distinguished from the worker by his long garments: he inspects the second Israelite's basket, probably to make sure that only stubble and not straw had been collected.

Located beside Exodus 5:10.

633. Ser., fol. 171v

Close to Vat. 747, except that the Israelite offering his basket for inspection is omitted: only the basket itself in the taskmaster's hand now remains. However, the omitted figure has been replaced by two others: one is a mere repetition of the basket-bearer in the lower row, and the other is just emptying his basket and is still holding it on his shoulder. Because the mountain landscape is eliminated, all the figures in the upper row are suspended in midair, thereby losing their spatial relationship to the group on the ground. The miniature is unframed.

Located beside Exodus 5:6.

634. Sm., fol. 70v

The inscription reads: οἱ ἰσραηλῖται περὶ τὴν συλλο(γὴν) τῶν ἀχύρ(ων) κ(α)τ(α)ναγκαζόμενοι.

Close to Ser., except that the Israelite in the middle of the upper row, instead of holding his basket on his shoulder, has placed it so that the taskmaster can inspect it in the same way he does the other basket in front of him.

635. Vat. 746, fol. 167r

The inscription reads: οἱ ἰσραηλῖται περὶ τὴν συλλογὴ(ν) τ(ῶν) ἀχύρων καταναγκαζόμενοι.

Very close to Sm.

Located beside Exodus 5:11.

Lit.: Uspenskii, pp. 142–43, fig. 102; Hesseling, fig. 161; Neuss, *Katalan. Bibelill.*, p. 46; Eller and Wolf, *Mosaiken*, fig. 38; Schubert, "Egyptian Bondage," pp. 36–37 nn. 24–25, fig. 9.

Exodus 5:14

Egyptians Beat the Israelites

636a. Vat. 747, fol. 79v

A group of dark-skinned Egyptians wearing patterned mantles and turbans beats the officers of the Israelites with sticks because they have failed to deliver the prescribed amount of bricks. These officers, dressed like Israelite elders with hoods, gesture in fear as they try to escape their pursuers. The miniature is flaked in various spots.

Located beside Exodus 7:5.

637a. Ser., fol. 174v

Close to Vat. 747. Slightly flaked.

Located beside Exodus 7:6.

638a. Sm., fol. 71v

The inscription reads: οἱ ἰσραηλῖται μαστιγούμενοι π(αρὰ) τῶν αἰγυπτίων διὰ τ(ὰ)ς πλίνθους.

Close to Ser., save that the group of Egyptians numbers six instead of five.

639a. Vat. 746, fol. 169v

The inscription is written outside the frame in the left margin: οἱ ἰσραηλῖται μαστιγούμενοι παρὰ τῶν αἰγυπτίων διὰ τὰς πλινθίας.

Very close to Sm.

Located beside Exodus 7:8.

Lit.: Uspenskii, p. 143, fig. 103; Hesseling, fig. 162.

Exodus 5:15–18

Israelites Complain to Pharaoh

636b. Vat. 747, fol. 79v

The Israelite officers approach Pharaoh and complain about their treatment. Pharaoh, in the dress of a Byzantine emperor, sits before a structure in the form of a ciborium, with a body-

guard standing behind him. Considerably flaked in various places, particularly the heads.

Located beside Exodus 7:5.

637b. Ser., fol. 174v

The ciboriumlike structure is replaced by a small house representing Pharaoh's palace. A second, similar house is added at the right purely for reasons of symmetry, but the figural composition essentially agrees with Vat. 747. Pharaoh is raised to prominence by a nimbus.

Located beside Exodus 7:6.

638b. Sm., fol. 71v

The inscription reads: καὶ πρὸς φαραὼ εἰσερχόμενοι καὶ καταβοῶντες.

The purely decorative building at the right is not included in this copy, which otherwise is close to Ser.

639b. Vat. 746, fol. 169v

The inscription is written in the left margin as a continuation of that for the preceding scene. It reads: καὶ πρὸς φαραὼ εἰσερχόμ(εν)οι καὶ καταβοῶντες.

Very close to Sm.

Located beside Exodus 7:8.

Lit.: Uspenskii, p. 143, fig. 104; Hesseling, fig. 162.

Exodus 7:10–12

Miracle of the Rod

In Vat. 747, two Egyptians, a bearded white man and a bearded black man, clad in exomeis confront Moses and Aaron. They replace three categories named in verse 11: wise men, sorcerers, and magicians. Ser., Sm., and Vat. 746 actually have three men, but not with attributes corresponding to the text. A white and a black man recur repeatedly, with insignificant variations in their garments, in most of the miracles performed by Moses and Aaron (see figs. 648, 664, 668, 672, 676). The two Egyptians should be identified as Jannes and Jambres, a well-known pair in the Jewish tradition, in pseudepigrapha,[1] and in Christian, pagan, and other sources.[2] Moses is portrayed as an unbearded young man, in contrast to verse 7, which states that he was eighty-three years old when he faced Pharaoh.

640. Vat. 747, fol. 80r

The bearded Aaron and the youthful Moses, both nimbed, approach Pharaoh from the left. Pharaoh sits enthroned in the center of the miniature and makes a gesture of astonishment while a bodyguard stands behind him, unconcerned with the proceedings. Moses points to the miracle taking place before

Pharaoh's footstool where one serpent, transformed from his rod, swallows other serpents transformed from the rods of the Egyptians who stand on the other side of Pharaoh's throne. At the right, the two Egyptian magicians raise their hands in gestures of embarrassment; their faces express fright. Slightly flaked.

Located beside Exodus 7:11.

641. Ser., fol. 175r

The compositional scheme is the same as in Vat. 747, but the details differ. Pharaoh is flanked by two bodyguards, one on either side. Aaron is youthful like Moses and without a nimbus, and while Moses' serpent swallows only two other serpents instead of three, there are three Egyptians: the oldest holds his hand to his mouth in a gesture of embarrassment; the second, very young, gestures in astonishment; and the third, a bearded man in strict profile, holds his hand before his breast. All three are dressed like Greek philosophers instead of being represented as dark-skinned and half-naked Africans.

Located beside Exodus 7:11.

642. Sm., fol. 72r [3]

The inscription reads: πε(ρὶ) τ(ῆ)ς ῥάβδου μωυσέος τῆς εἰς ὄφιν μετακληθείσης.

The composition is very close to Ser. but somewhat condensed.

Located below Exodus 7:10.

643. Vat. 746, fol. 170r

The inscription reads: πε(ρὶ) τ(ῆ)ς ῥάβδου μωυσέως τῆς εἰς ὄφιν μετακλη θείσ(ης).

Very heavily damaged by flaking; the composition is very close to Ser. and Sm. The second Egyptian, who raises his hand toward heaven, agrees with the Ser., and the third Egyptian in three-quarter view with Sm. Moses has no nimbus.

Located beside Exodus 7:11.

Lit.: Uspenskii, p. 143, fig. 105; Hesseling, fig. 163; Goodenough, *Symbols*, vol. 9, p. 84 n. 27, fig. 80; Williams, "León Bible," p. 61; Gaehde, "Octateuch," p. 354, fig. 67; Kessler, *Tours*, p. 128; Al-Hamdani, "Sources," p. 32, fig. 11b; Havice, "Hamilton Ps.," p. 275; Havice, "Marginal Miniatures," p. 130; St. Clair, "Narrative and Exegesis," p. 195, fig. 2.

[1] Among the pseudepigrapha, see the extant fragments from the Book of Jannes and Jambres (*OTP*, vol. 2, pp. 427–42).

[2] Ibid., pp. 427–28. Their names are also reported in 2 Tim 3:8. In the Palaea historica (*Anecdota*, ed. Vasil'ev, p. 231) Jannes and Jambres are explicitly mentioned in connection with the rods transformed into serpents and the following episodes. See also their treatment in the marginal Psalters (Corrigan, *Visual Polemics*, pp. 28–29).

[3] Of the two photos taken by Buberl of this miniature, one has a label indicating fol. 72r, the other indicating fol. 71v; the latter is probably a mistake.

Exodus 7:17–20

PLAGUE OF WATER CHANGED INTO BLOOD

Notwithstanding the fact that the Septuagint says that Aaron, not Moses, performed the first three miracles—rivers transformed into blood, frogs, and lice—the first two miracles in the Octateuchs are performed by Moses with a thin stick which replaces the Herakles-like club depicted in his previous deeds (figs. 616–619, 620–623). In Jewish tradition it is strongly asserted that Aaron performed these miracles: Moses, having found his salvation in the flow of the Nile, could not have struck the waters with his stick.[1] The variation of Moses represented as the unique performer of wonders, and his ensuing preeminence over Aaron, is not surprising, however, and has literary support in both Jewish[2] and Christian writers.[3] The compositional scheme of Moses performing the miracle with his stick, an eschatological symbol of the Messiah,[4] has a counterpart in Early Christian representations of the Miracle in Cana or the Raising of Lazarus,[5] where Christ frequently performs the miracles holding a stick in his hand.[6] The visual message conveyed seems to be that, just as Christ transformed water into wine at Cana, so Moses transformed water into blood. The Vat. 747 miniature is a muddle of features from the Plague of Water and the Plague of Frogs (fig. 648); similar mistakes occur in the second, third, and fourth plagues (figs. 648, 652, 656).

644. Vat. 747, fol. 80v

Before the eyes of Pharaoh and his servants, Moses, with Aaron standing behind him, turns the water of the river to red blood at the spot where he touches it with a thin brown stick. Pharaoh approaches from the left, standing between a bodyguard, whose shield is decorated with pseudo-kufic lettering, and a youthful Egyptian who raises both hands in fear and amazement. The frogs jumping out of the water belong to the second plague (see no. 648). Slightly flaked.

Located beside Exodus 7:22.

645. Ser., fol. 176v

Close to Vat. 747, except for the absence of the misplaced frogs. Pharaoh is accompanied by a second bodyguard and by a second Egyptian, who, like the first, gestures in astonishment and fright. The stream is here a small pool into which the polluting blood flows from a vessel, referring to the fact that, according to verse 19, even the water kept in vessels of stone or wood was turned into blood. Unlike the preceding miniature of this manuscript (fig. 641), Aaron is now bearded, but there is no homogeneity on this point: in the following scenes of this manuscript, and in Sm. and Vat. 746 alike, Aaron is sometimes depicted as bearded, sometimes youthful.

Located beside Exodus 7:21.

646. Sm., fol. 72v

The inscription reads: πε(ρὶ) τοῦ ὕδατ(ος) τοῦ πο(ταμοῦ) τοῦ μεταποιηθ(έν)τ(ος) εἰς αἷμα.

The two amazed Egyptians are represented barefoot and dipping their toes into the polluted water. The vase is omitted and the composition is somewhat condensed, but otherwise the scene agrees with the one in Ser.

Located below Exodus 7:21.

647. Vat. 746, fol. 171v

The inscription reads: περὶ τοῦ ὕδατο(ς) τοῦ ποταμοῦ τοῦ μεταποιηθέντος εἰς αἷμα.

In the freer arrangement of the figures and the inclusion of the vase the miniature agrees with Ser., while in showing the Egyptians barefoot it is close to Sm. The painter drew the soldier at the left with an abnormal neck and forgot his left leg.

Located beside Exodus 7:21.

Lit.: Uspenskii, p. 143, fig. 106; Hesseling, fig. 164; Williams, "León Bible," p. 61; Lassus, *Livre des Rois*, pp. 85, 95, fig. 109; Maguire, "Depiction of Sorrow," p. 159 n. 204; Al-Hamdani, "Sources," p. 32, fig. 11b; De Angelis, "Simbologia," p. 1538, figs. 26, 27.

[1] TargPs-J (*Targum Exode et Lévitique*, ed. Le Déaut, p. 59) and ExR 10:4 (*Exodus Rabbah*, ed. Freedman and Simon, pp. 134, 127): "R. Tanhum said: God said to Moses: 'The water which protected thee when thou wert cast into the Nile shall not be smitten by thee'; hence and Aaron stretched out his hand."

[2] See, e.g., Artapanos, quoted by Eusebios (*Praeparatio evangelica* 9, 27:27–33: *OTP*, vol. 2, pp. 901–2). See also Ginzberg, *Legends*, vol. 2, p. 330.

[3] E.g., Epiphanios, *AdvHaer*, bk. 2, 1, haer. 64 (PG 41, col. 1192). On the contrary, Prokopios of Gaza follows the Septuagint literally (*CommEx* [PG 87, cols. 545–46]).

[4] According to legends, Moses' stick is the rod God created on the first Sabbath eve, which was delivered to Adam, passed to Enoch, Noah, etc., and lastly belonging to Moses and then to Aaron; it flowers in Numbers 17:8 (see figs. 941–945). The story of the rod is narrated in PRE 40 (*Pirkê*, ed. Friedlander, pp. 312–13) and more profusely in the entire chapter 30 of The Book of the Bee (*Book of the Bee*, ed. Budge, pp. 50–65). On the rod in Early Christian art, see A. St. Clair, "The Basilewsky Pyxis: Typology and Topography in the Exodus Tradition," *CahArch* 32 (1984), pp. 22–23, and Kaiser-Minn, *Erschaffung des Menschen*, pp. 75ff. On Moses as a prefiguration of Christ, see J. Daniélou, *Sacramentum futuri: Études sur les origines de la typologie biblique* (Paris, 1950), pt. 4, chap. 2, pp. 131–51.

[5] This correspondence may not be limited to the pictorial realm, but perhaps involves a typological meaning of Moses as a prefiguration of Christ (on this subject, see the works cited in the previous note).

[6] Pictorial parallels include the Miracle at the Wedding in Cana or the Multiplication of Loaves on the wooden doors of S. Sabina in Rome or in the Via Latina catacomb (cubiculum O, arcosolium: Ferrua, *Catacombe sconosciute*, fig. 145), where Christ employs a stick to transform the water into wine, a feature not mentioned in the text of the Gospels. In the Via Latina catacomb the correspondence between Christ and Moses is stressed by the merging of features from the respective narratives of the Raising of Lazarus, the Receiving of the Law, and the Column of Fire in cubicula C and O (ibid., figs. 67, 137).

Exodus 8:2–7

PLAGUE OF FROGS

648. Vat. 747, fol. 81r

The composition recalls that of the first plague scene (fig. 644). The frogs, wrongly represented in the former plague,

are lacking here, and Moses, with Aaron standing behind him, should dip his stick into a pool instead of touching the soil. The astonished Pharaoh, followed by a bodyguard, gazes toward Moses. At the right, one Egyptian magician meaninglessly points at Moses' stick, and a second points instead at the heavens (in Ser. he points at a frog in a tree), where there is a swarm of lice pertaining to the third plague and wrongly duplicated here.[1]

Located beside Exodus 8:7.

649. Ser., fol. 178r

Unlike Vat. 747, Ser. correctly represents the second plague with Moses dipping a rod into the water, while the youthful Aaron, with a scroll in his hand, stands modestly behind him. Some frogs swim in the water while others climb up a fig tree. Pharaoh excitedly turns to Moses and stretches out his hands, which are hidden under his chlamys. Two Egyptians stand at a respectful distance and point to the frogs in the water and in the tree. Slightly flaked.

Located beside Exodus 8:7.

650. Sm., fol. 73r

The inscription reads: πε(ρὶ) τ(ῶν) ἐξενεχθέντων βατράχων.
Close to Ser. but the two Egyptians, instead of Aaron, hold scrolls in their hands like Greek philosophers.

651. Vat. 746, fol. 173r

The inscription reads: πε(ρὶ) τῶν ἐξενεχθέντων βατράχων.
Very close to Ser. and Sm.
Located beside Exodus 8:7.

Lit.: Uspenskii, p. 143, fig. 107; Hesseling, fig. 165; Pijoán, *Summa artis*, vol. 7, p. 402, fig. 565.

[1] Notwithstanding the fact that they are clothed as wise Egyptian elders instead of dressed in the usual exomeis, these two pointing figures should be identified again as Jannes and Jambres (see the introduction to Exodus 7:10–12).

[Exodus 8:16–19]

PLAGUE OF LICE

The design of the next miniature, in which Moses and Aaron face Pharaoh and one of his bodyguards, duplicates the Plague of the Murrain of Cattle (figs. 660–663); it has no relation to the text, which records no discussion between Moses and Pharaoh.

652. Vat. 747, fol. 81v

Moses, with Aaron standing behind him, addresses Pharaoh, who is accompanied by one bodyguard. A swarm of lice is flying in the sky.

Located beside Exodus 8:15.

653. Ser., fol. 178v

Close to Vat. 747, except that the copyist forgot to paint the lice. Slightly flaked.

Located beside Exodus 8:14.

654. Sm., fol. 73v

The inscription reads: πε(ρὶ) τ(ῆ)ς τῶν σκνιπῶν ἀναδόσεως.
Very close to Ser. and more complete in that the lice are shown flying through the air.

655. Vat. 746, fol. 173v

The inscription reads: πε(ρὶ) τῆς τῶν σκνιπῶν ἀναδόσεως.
Very close to Ser. and Sm.
Located beside Exodus 8:14.

Lit.: Uspenskii, p. 143; Hesseling, fig. 166; Weitzmann, *Dura*, p. 40, fig. 53.

Exodus 8:20–24

PLAGUE OF DOG FLIES

656. Vat. 747, fol. 82r

Three Egyptians flee from a walled city; one of them is clad in a short tunic and the other two in patterned mantles that leave part of their black breasts bare. In a very realistic manner the young, white-skinned man in a tunic shows the scars all over his body where he has been stung by the insects. A marbled free-standing column at the foot of a high mountain (as in figs. 429a–431a, 1346–1349, 1360–1363, 1399–1401) represents the demarcation of the boundary set by God to preserve his people from the dog flies, a visual rendering of the term διαστολή employed in verse 19. Slightly damaged by flaking.

Located beside Exodus 8:28.

657. Ser., fol. 179v

Very close to Vat. 747. By depicting the dog flies over the city, however, the artist fully explains the attitude of the fleeing Egyptians. The number of men is increased to four and all of them are light-skinned; they are clad in short tunics. The city is slightly different from the one in Vat. 747: one flanking tower is cut off by the frame while two houses are enclosed within its walls. Flaked in various spots.

Located beside Exodus 8:28.

658. Sm., fol. 74r

The inscription reads: πε(ρὶ) τῆς κυνομυί(ας).
Very close to Ser.

659. Vat. 746, fol. 174r

The inscription reads: περὶ τῆς κυνομυίας.
Very close to Ser. and Sm.
Located beside Exodus 8:27.

Lit.: Uspenskii, p. 143, fig. 108; Hesseling, fig. 167; Du Mesnil du Buisson, *Doura-Europos*, p. 31; Tsuji, "Passage," p. 63 n. 24; *Image du noir*, fig. 71; Weitzmann, *Dura*, p. 40, figs. 52, 53.

Exodus 9:1–6

Plague of the Murrain of Cattle

660. Vat. 747, fol. 82r

In the representation of the fifth plague, Moses, accompanied as usual by Aaron, addresses Pharaoh, who stands opposite him and points with his right hand to where the dying animals lie on the ground. There is a groundline beneath the feet of Pharaoh and the bodyguard beside him, but this line does not continue beneath the feet of Moses and Aaron. It thus appears that the copyist intended to divide the picture into two strips but then abandoned the idea. Verse 3 mentions horses, asses, camels, oxen, and sheep among the victims of the plague, but the copyist simplified the depiction of the cattle: at the left he showed a goat, a sheep, and another goat behind it, and at the right an ox lies on the ground, while a fifth animal, under Pharaoh's feet, is too badly flaked to permit identification. The miniature is heavily flaked in several places.

Located beside Exodus 9:6.

661. Ser., fol. 180r

The separation into two distinct zones only attempted in Vat. 747 is accomplished here: the conversation scene, which is enlarged by the addition of a second bodyguard, forms a miniature on its own, while the animals are painted outside the frame and without a background setting, thus losing all spatial relationship to the scene above. The number of animals is reduced by the omission of the ox at the extreme right.

Located beside Exodus 9:5.

662. Sm., fol. 74r

The inscription is largely rubbed and only the beginning remains: πε(ρὶ) τῆς [τῶν κτηνῶν τελευτῆς].

In the reproduction in Hesseling the miniature was cut around its border line, but it can be surmised that, like Ser., the animals were depicted beneath the lower frame. Most of the heads have been overpainted.

663. Vat. 746, fol. 175r

The inscription reads: πε(ρὶ) τῆς τῶν κτηνῶν τελευτῆς.
Very close to Ser. and Sm. but very badly flaked.
Located beside Exodus 9:5.

Lit.: Uspenskii, p. 143, fig. 109; Hesseling, fig. 168.

Exodus 9:10–11

Plague of Boils

664. Vat. 747, fol. 82v

Instead of tossing ashes to bring on the sixth plague, the boils which break out on man and beast alike, Moses and Aaron raise their hands toward Pharaoh. No effect of the plague is visible. Pharaoh stands in the center with one of his bodyguards; at the right two black-skinned Egyptian sorcerers, Jannes and Jambres, look on with gestures of amazement and fear. According to Exodus 9:11, the two sorcerers should not be present because of their sores.[1] This miniature is a conventional episode of competition between Moses and Aaron on one side, and Jannes and Jambres on the other, rather than a precise rendering of the sixth plague, as already observed in the introduction to [Exodus 8:16–19].

Located beside Exodus 9:14.

665. Ser., fol. 180v

Moses and Aaron hold aspergilla not evoked by the text,[2] with which they toss ashes from the furnace toward heaven, represented as a blue segment studded with stars above their heads. Pharaoh is flanked by two bodyguards, and Moses, Aaron, and the two sorcerers hold scrolls in their hands; otherwise, the composition is close to Vat. 747.

Located beside Exodus 9:13.

666. Sm., fol. 74r or 74v[3]

The inscription reads: πε(ρὶ) τ(ῆ)ς αἰθάλης καὶ τ(ῶν) φλυκτίδω(ν).
Very close to Ser.

667. Vat. 746, fol. 175v

The inscription reads: πε(ρὶ) τῆς αἰθάλης καὶ τῶν φλυκτίδων.
Very close to Ser. and Sm., as is still recognizable in spite of serious damage by large-scale flaking.
Located beside Exodus 9:14.

Lit.: Uspenskii, p. 143; Hesseling, fig. 169; *Image du noir*, fig. 69.

[1] Their presence might be inferred. In the Book of Jannes and Jambres, Jannes is reported to be present at the miracle and opposing Moses and Aaron (*OTP*, vol. 2, p. 438).

[2] In Jewish legend Moses and Aaron hold the ashes in their hands and do not use aspergilla (Ginzberg, *Legends*, vol. 2, p. 354).

[3] Fol. 74v according to both Hesseling, p. x, and Uspenskii, p. 185; fol. 74r according to a label in the photo taken by Buberl.

Exodus 9:23

Plague of Hail

668. Vat. 747, fol. 83r

In the illustration of the seventh plague, as in the preceding scene, Pharaoh stands between Moses and Aaron and the two sorcerers, Jannes and Jambres, but this time the painter omitted the bodyguard. From a segment of heaven set against a golden strip of sky hail falls down to earth, but only on the Egyptians in the right half of the picture, who raise their hands in fright.

Located beside Exodus 9:31.

669. Ser., fol. 181v

Pharaoh is accompanied by two bodyguards, but otherwise the composition is close to Vat. 747 except for small deviations in the spatial relationship of the two Egyptian sorcerers and the attitude of Pharaoh, who points at the hail rather than expressing fear.

Located beside Exodus 9:31.

670. Sm., fol. 75r

The inscription reads: πε(ρὶ) τ(ῆ)ς κατενεχθείσης χαλάζης.
Very close to Ser.

671. Vat. 746, fol. 176v

The inscription reads: πε(ρὶ) τῆς κατενεχθείσης χαλάζης.
Very close to Ser. and Sm. but rubbed and very heavily flaked.
Located beside Exodus 9:31.

Lit.: Uspenskii, p. 143, fig. 110; Hesseling, fig. 170; Pijoán, *Summa artis*, vol. 7, p. 402, fig. 567; Eller and Wolf, *Mosaiken*, fig. 39; Galavaris, *Gregory Naz.*, p. 68 n. 126; Weitzmann, *Dura*, pp. 40–41, fig. 54.

Exodus 10:13–15

Plague of Locusts

672. Vat. 747, fol. 83r

The compositional scheme for the representation of the eighth plague is rather conventional and essentially the same as that of the two preceding scenes: Pharaoh stands in the center, accompanied by a bodyguard. The two sorcerers Jannes and Jambres, here clothed in exomeis of skin and visibly frightened, stand at the right, and Moses and Aaron at the left. Only the swarm of locusts over their heads gives specificity to this scene. Large parts of the ground and the figures are flaked.

Located beside Exodus 10:6.

673. Ser., fol. 182r

Except for the usual addition of a second bodyguard and small differences in the attitudes of the figures, the composition is very similar to that in Vat. 747. There are fewer locusts, but they are larger and depicted with greater realism.

Located beside Exodus 10:7.

674. Sm., fol. 75r

The inscription reads: πε(ρὶ) τῆς τῶν ἀκρίδων ἀναδόσεως.
Very close to Ser.

675. Vat. 746, fol. 177r

The inscription reads: περὶ τῆς τῶν ἀκρίδων ἀναδόσεως.
Very close to Ser. and Sm. but negligently executed. Both legs of the bodyguard at the left were forgotten, and the man at the right lacks one leg. Slightly flaked.
Located beside Exodus 10:8.

Lit.: Uspenskii, p. 144, fig. 111; Hesseling, fig. 171; Wilpert, *Mosaiken und Malereien*, vol. 1, p. 384, fig. 126; Eller and Wolf, *Mosaiken*, fig. 40.

Exodus 10:22

Plague of Darkness

676. Vat. 747, fol. 83v

The plague of darkness, the ninth in the series, shows Pharaoh and the two Egyptian sorcerers, Jannes and Jambres, enveloped in a black cloud, and Moses and Aaron standing outside it in broad daylight. Moses turns to speak to Aaron, and Pharaoh addresses the fleeing Egyptians; as a result, these two groups appear quite unconnected except for Moses' pointing hand. Slightly flaked.

Located beside Exodus 10:16.

677. Ser., fol. 183v

The black cloud envelops only the two frightened sorcerers, whereas Pharaoh, accompanied by his two bodyguards, watches the spectacle in amazement. Moses' and Aaron's positions are interchanged: Moses, who lifts his hand in order to invoke the miracle, stands at the left, and Aaron stands between him and Pharaoh. Moses' head is rubbed, and the Egyptian at the right is slightly damaged.

Located beside Exodus 10:23.

678. Sm., fol. 75v

The inscription reads: πε(ρὶ) τοῦ ψηλαφητ(οῦ) σκότους.
Very close to Ser.

679. Vat. 746, fol. 178r

The inscription reads: πε(ρὶ) τοῦ ψηλαφητοῦ σκότους.
Very close to Ser. and Sm. Pharaoh's head is rubbed.
Located beside Exodus 10:21.

Lit.: Uspenskii, p. 144, fig. 112; Hesseling, fig. 172.

Exodus 11:2–3

EGYPTIANS GIVE JEWELS TO ISRAELITES

680a. Vat. 747, fol. 84r

According to the text, God tells Moses that his people will go to their Egyptian neighbors and request gold and silver objects and raiments from them. The illustration depicts not the giving of this command, but rather its execution. A crowd of Egyptians, men and women, is coming out of the huge entrance door of a drapery-crowned building to deliver gifts to the Israelites. The foremost Egyptian, black-skinned and dressed only in a patterned mantle, offers an object which, to judge from the manner in which it is held, may perhaps be a jug. None looks too willing to surrender his property. The group of Israelites likewise consists of men and women, and their leader has already accepted a gift and holds what looks like a money bag in his hands. Further gifts are arranged on the ground; among them a huge vessel with handles is recognizable. Some of these objects as well as other sections of the miniature are badly flaked.

Located beside Exodus 11:7.

681a. Ser., fol. 184r

Close to Vat. 747, but the details differ. The foremost Egyptian holds a cloth in one hand and a golden vessel in the other, and the two men next to him carry golden bracelets. However, no objects are visible on the ground, and the Israelites, who stand respectfully at a distance, make no move to take the gifts. The architectural setting is changed into a small, tile-roofed house.

Located beside Exodus 11:8.

682a. Sm., fol. 76r

The inscription reads: πε(ρὶ) τῶν χρυσ(ῶν) καὶ ἀργυρῶν σκευ(ῶν) τῶν ἐξ αἰγυπτίων λαμβανομένων.

Very close to Ser. A window has been added to the house, and a woman watches from the window.

683a. Vat. 746, fol. 179r

The inscription reads: πε(ρὶ) τῶν χρυσῶν καὶ ἀργυρῶν σκευῶν τῶ(ν) ἐξ αἰγυπτίων λαμβανομέ(νων).

Very close to Ser. and Sm. and somewhat flaked.

Located beside Exodus 11:7.

Lit.: Uspenskii, p. 144, fig. 113; Hesseling, fig. 173.

Exodus 11:5 or 12:29

PREDICTION OF THE PLAGUE OF THE FIRSTBORN

680b. Vat. 747, fol. 84r

The lower illustration refers both to the prediction of the tenth plague (Ex 11:5), in which all firstborn of man and beast die, and

to its fulfillment (Ex 12:29). Only the cattle are shown dying. In the illustration of the accomplishment of the tenth plague (figs. 688–691), on the other hand, only the Egyptians' babies are shown dying. In a lower strip which is joined by a common frame with the preceding scene, animals of various species lie prostrate on the ground, but the entire surface of the miniature is so badly flaked that details are no longer recognizable.

Located beside Exodus 11:8.

681b. Ser., fol. 184r

Among the prostrate dying animals sheep, goats, oxen, horses, asses, and camels can be distinguished. Slightly flaked.

Located beside Exodus 11:8.

682b. Sm., fol. 76r

The grouping of the animals is very close to Ser.

683b. Vat. 746, fol. 179r

Very close to Ser. and Sm. but partly flaked and rubbed.

Located beside Exodus 11:7.

Lit.: Uspenskii, p. 144, fig. 114; Hesseling, fig. 173.

Exodus 12:1–311

GOD INSTITUTES THE PASSOVER

The scenes in the miniature below read from right to left.

684c. Vat. 747, fol. 86v

According to the text, God gives Moses and Aaron detailed instructions about the institution of the Passover, but in the right corner of the upper strip only Moses stands with a gesture of prayer before the hand of God in heaven, listening to his commands.

Located beside Exodus 12:25.

685c. Ser., fol. 190r

The pose of the praying Moses is slightly different.

Located beside Exodus 12:26.

686c. Sm., fol. 78v

Very close to Ser.

687c. Vat. 746, fol. 185r

Very close to Ser. and Sm.

Located beside Exodus 12:25.

Lit.: Uspenskii, p. 144; Hesseling, fig. 174; De Angelis, "Simbologia," fig. 21; Revel-Neher, *Image of the Jew*, fig. 33.

Exodus 12:21–22

Passover

The Passover sacrifice is minutely illustrated in four consecutive scenes, which, amazingly, must be read right to left. The illustration exhibits a genuine and meticulous concern for the ritual. The ceremony is accurately depicted in details such as the Jewish *tallit*,[1] worn by the Israelite killing the lamb, and the bundle of hyssop leaves plunged directly into the blood of the sacrificed lamb, as described at Exodus 12:22.[2] In Ser., Sm., and Vat. 746 a sort of cross has been marked with the lamb's blood on the door, countering the instructions of the text to mark lintel and sideposts. This choice is manifestly a Christian interpolation.[3]

684b, a, e, d. Vat. 747, fol. 86v

In the middle of the upper strip, an Israelite wearing a hood kneels on the lamb, preparing to kill it with a knife; then, at the left, he cuts the lamb's throat, from which blood spurts. Below at the right—as we can interpret from the better preserved miniatures in the other Octateuchs—he dips a bunch of hyssop into the blood of the dead lamb which lies at the foot of some steps leading to a door. To the left, he paints the left part of the lintel and the side posts of a door with the blood of the sacrificed lamb. The head of the second figure is overpainted, and large sections of the ground in both strips are very badly flaked.

Located beside Exodus 12:25.

685b, a, e, d. Ser., fol. 190r

Close to Vat. 747, except that both phases in the upper strip represent the cutting of the lamb's throat and thus the distinction between the preparation for the killing and the actual slaughter is eliminated. The bundle of hyssop leaves is here clearly plunged into the blood of the lamb. In both of the lower scenes the Israelite has painted the lintel with two strokes of blood and the area of conjunction between the valves of the door with a third stroke, roughly in the form of a cross.

Located beside Exodus 12:26.

686b, a, e, d. Sm., fol. 78v

Starting in the upper level and continuing in the lower, the inscription reads: ἔνθα σφάξαντες τὸν ἀμν(ὸν) λαμβάνουσι τὸ αἷμα καὶ χρίουσι τὰς φλίας.

Very close to Ser.

687b, a, e, d. Vat. 746, fol. 185r (see also text fig. 59)

Starting in the upper level and continuing in the lower, the inscription reads: ἔνθα σφάξαντες τὸν ἀμνὸν λαμβάνουσι τὸ αἷμα καὶ χρίουσι τὰς φλίας.

Very close to Ser. and Sm.

Located beside Exodus 12:25.

Lit.: Uspenskii, p. 144; Hesseling, fig. 174; De Angelis, "Simbologia," p. 1536, fig. 21; Revel-Neher, *Image of the Jew*, p. 74, fig. 33.

[1] Cf. Revel-Neher, *Image of the Jew*, pp. 72ff.; and C. O. Nordström, *The Duke of Alba's Castilian Bible* (Uppsala, 1964), pp. 86ff.

[2] Note that Targum Onkelos (*Targum Onqelos to Exodus*, ed. Grossfeld, pp. 32–33) renders the Hebrew term *saf* (LXX: "by the door") with the expression "in a basin," a ceremonial object absent from the Octateuchs, and that Mekilta, Tractate Pisha 6:11 (*Mekilta de-Rabbi Ishmael*, ed. Lauterbach, vol. 1, pp. 44, 84) specifies "to scoop out a hole near the threshold" over which the slaughter occurred.

[3] Cf. as early a writer as Cyprian of Carthage, *Testimonia adversus Judaeos*, bk. 2, 22 (PL 4, col. 745).

Exodus 12:29–30

Plague of the Death of the Firstborn

688. Vat. 747, fol. 87r

The smiting of all the firstborn children in Egypt is illustrated in two superimposed strips, separating Pharaoh's child from those of the common people. The royal child, clad in a richly embroidered tunic, lies on a large bed with his feet covered; Pharaoh approaches, drying his tears with the hem of his mantle. He is accompanied by the two wise men or magicians seen in the former miniatures: one of them runs his fingers through his beard as a sign of grief; the other turns away and weeps. In the lower strip three dead children are depicted, two of them attended by their mourning fathers.

Located beside Exodus 12:34.

689. Ser., fol. 190v

Close to Vat. 747, except that the legs of the dying children are not covered and the attitudes of most of the figures are different, notably that of Pharaoh. Pharaoh moves his right hand toward his chin in a gesture usually denoting thoughtfulness rather than grief, while pushing away the two men with the other as if asking them to leave the room. A little house at the left indicates the palace in which the scene is supposed to take place. The figure of Pharaoh is rubbed and slightly damaged by flaking and the offset of letters from the opposite page.

Located beside Exodus 12:33.

690. Sm., fol. 79r

Starting in the upper level and continuing in the lower, the inscription reads: ὄλεθρο(ς) τῶν πρωτοτόκων, πάντων.

Very close to Ser.

691. Vat. 746, fol. 185v

Starting in the upper level and continuing in the lower, the inscription reads: ὄλεθρος τῶν πρωτοτόκων πάντων.

Very close to Ser. and Sm.

Located beside Exodus 12:33.

Lit.: Uspenskii, p. 144, figs. 115, 116; Hesseling, fig. 175; Williams, "León Bible," pp. 62–63, 160.

Exodus 12:37–42

Israelites Leave Egypt

692. Vat. 747, fol. 87r

A crowd of Israelites on the march, with Moses in the center, illustrates the exodus from Egypt. The group is headed by two women, one with a baby clinging to her garment, the other carrying a baby on her shoulder and holding in her hand one of the golden vessels given to the Israelites by the Egyptians before their departure. Moses is followed by Aaron who, strikingly, has no nimbus and is nearly hidden by Moses and two women, one of whom carries a huge golden dish of unleavened dough on her shoulders (cf. verse 34). A flock of sheep, which the Israelites took with them when they left, brings up the rear. The fact that the exodus took place at night is indicated by the personification Nyx emerging from behind the mountain range with a veil over her head and enveloped in a black cloud set against the golden sky. Large parts of the figures as well as the background are badly flaked.

Located beside Exodus 12:40.

693. Ser., fol. 191r

The width of the composition is extended in a friezelike manner which permits a more complete rendering of some figures than in Vat. 747. This is particularly true of Aaron, who seems to address Moses while the latter turns to him, pointing with one hand in the direction of the still distant goal and holding a scroll in the other. A bearded man in profile is added to the group, raising his hands in prayer to the hand of God in heaven; the hand, not evoked by the text, directs its rays not toward this man, but toward Moses. A bearded man leads the child in the foreground by the hand,[1] and a woman behind him carries one of the golden dishes of unleavened dough. The hindmost woman carries a baby on her shoulder and a golden vessel in her hand, like the woman in the forefront. Goats and oxen are added to the flock of sheep. Flaked in various places.

Located beside Exodus 12:40.

694. Sm., fol. 79r or 79v[2]

The inscription reads: χρῆσις ἀργυρίου καὶ χρυσίου καὶ ἀποφυγή.

Very close to Ser.

695. Vat. 746, fol. 186r

The inscription reads: χρῆσις ἀργυρίου καὶ χρυσίου καὶ ἀποφυγή.

Very close to Ser. and Sm. and somewhat flaked.

Located beside Exodus 12:40.

Lit.: Uspenskii, p. 144, fig. 117; Hesseling, fig. 176; Wilpert, *Mosaiken und Malereien*, vol. 1, p. 456, fig. 166; Millet, "Introduction," pp. xii–xiii; De Wald, *Vat. Gr. 1927*, p. 44; Lowrie, *Art*, pl. 144c; Weitzmann, *JR*, p. 90; Weitzmann, *Greek Mythology*, p. 131; Williams, "León Bible," p. 63; Ettlinger, *Sistine Chapel*, p. 51, pl. 37d; Der Nersessian, *Londres Add. 19.352*, p. 102; Belting, "Byz. Art," p. 19, fig. 25; Weitzmann, *Dura*, p. 42, fig. 58.

[1] The motif of the child led by the hand may be related to Ex 13:8 (see Weitzmann, *Dura*, p. 58).

[2] Fol. 79v according to Hesseling, p. xi; fol. 79r according to both Uspenskii, p. 186, and to the label in the photo taken by Buberl.

Exodus 13:17–22

Israelites Carry the Bones of Joseph

In the following sequence illustrating the exodus from Egypt and triumph over Pharaoh (figs. 696–699, 700–703, 704–707), the pillar of fire regularly precedes the marching Israelites, except in figs. 692–695, which are related to Exodus 12:37–42: actually, the pillar of fire, together with its mate, the pillar of cloud, is mentioned as leading the Israelites later, in Exodus 13:21. The pillar of fire appears as a tall flame,[1] except in the episode of the drowning of the Egyptians (figs. 704–707) where the flames wrap around a sort of obelisk. The pillar of cloud is not depicted as a column, but as a zone of darker color; in most cases the personification Nyx is inserted in this zone (figs. 692–695, 700–703).[2] This dark zone resembles the roundish dark area in the miniatures accompanying Psalms 104:39 in the marginal Psalters.[3] While the text of Exodus explicitly mentions pillars or columns ("στύλος πυρός" and "στύλος νεφέλης," respectively), Psalm 104 does not use the word pillar, but says that God "spread a cloud for a covering to them (the Israelites), and a fire to give them light by night." Finally, Paul's statement at 1 Corinthians 10:1–2[4] recalls the prominent meaning of the cloud for the Christian message of salvation: in Christian exegesis the cloud is normally interpreted as the Holy Ghost.[5]

This miniature, illustrating Exodus 13:17–22, wrongly follows the miniature with the Egyptians pursuing the Israelites (Ex 14:9) and the Arrival at the Red Sea (Ex 14:16–21) (figs. 696–699), instead of preceding it.[6]

700. Vat. 747, fol. 88v

The foremost group of marching Israelites is headed by a man extending his arms in amazement toward the guiding pillar of fire sent by God in Exodus 13:21. Moses walks between Aaron, who is distinguished by a nimbus, and a woman who ought to be Miriam. In the center men carry on their shoulders the gold-colored coffin containing Joseph's bones which, according to Exodus 13:19, Moses took with him. In the group at the rear a woman carries a baby in her arms, and another holds a little child by the hand. In the upper left corner the personification Nyx appears in a darker zone of cloud, painted in grisaille and holding a billowing veil over her head. The dark horizontal band hanging over the Israelites is probably intended to represent the cloud that hides them from the Egyptians. Partly flaked.

Located below Exodus 14:11.

701. Ser., fol. 195v

Close to Vat. 747 except for a few details. A bearded man takes the place of Miriam and, like Moses, he raises his hand in a gesture of astonishment. Aaron is not distinguished by a nimbus. The central group is condensed: the coffin containing Joseph's bones, painted in brown with golden highlights, is shortened and carried by two men walking side by side. Some of the figures that were included in the central group in Vat. 747 have been placed in the last group, where a man holds a baby on his arm and in front of him, unlike Vat. 747, a woman looks backward and carries a baby on her shoulder. A segment of heaven, representing the protective dark cloud, is suspended over the heads of the Israelites. The figure of Nyx in Vat. 747 is replaced here by the personification Dawn, a nimbed young man walking up the mountain slope with a long lighted torch in his hand. This figure closely corresponds to the male figure in the division of light and darkness in Genesis 1:3–5 (figs. 21–24). Dawn may possibly be a mistake or a misunderstanding; alternatively, it might have been inspired by verse 24, where, during the morning watch, God looks down on the Egyptian camp. The miniature is partly rubbed, particularly in the center.

Located below Exodus 14:11.

702. Sm., fol. 80v

The inscription reads: οἱ ἰσραηλῖται φεύγοντες αἴγυπτον πανοικὶ ἐπιφερόμενοι καὶ τὰ τοῦ ἰωσὴφ ὀστᾶ.

Close to Ser. The miniature was torn in two and sewn together again, and the surface is flaked in various places.

Located below Exodus 14:11.

703. Vat. 746, fol. 190r

Because of the lack of space within the frame, the inscription was written in the left margin. It reads: οἱ ἰσραηλῖται φεύγοντες αἴγυπτον πανοικὶ ἐπιφερόμενοι καὶ τὰ τοῦ ἰωσὴφ ὀστᾶ.

Very close to Ser. and Sm.

Located below Exodus 14:11.

Lit.: Strzygowski, *Sm.*, p. 116, pl. 39; Uspenskii, p. 145, fig. 120; Hesseling, fig. 178; Goodenough, "Christian and Jewish Art," p. 412; Weitzmann, *RaC*, pp. 107, 164, 249 (2d ed.); Weitzmann, *JR*, p. 90; Weitzmann, *Greek Mythology*, p. 131; Der Nersessian, *Londres Add. 19.352*, p. 102; Stahl, "Morgan M. 638," pp. 96–97; Belting, "Byz. Art," p. 19, fig. 26; Cutler, "Marginal Ps.," p. 57 n. 72; Maguire, "Depiction of Sorrow," p. 159 n. 204; Aliprantis, *Moses*, p. 63; Weitzmann, *Dura*, p. 47, fig. 67; Lowden, *Octs.*, p. 81, figs. 114, 115.

[1] In early images both the pillar of fire and the pillar of cloud are proper columns, as in the paintings of the Dura Europos synagogue, the *Christian Topography* of Kosmas Indikopleustes, and the marginal Psalters (see Weitzmann, *Dura*, figs. 48, 56, 57, and pp. 41–42 for a discussion of the subject).

[2] It should be noted, however, that a dark stripe in the topmost section of the miniature is also seen in events which do not occur during the night (see, e.g., the dance of Miriam in fig. 708). A deep blue segment hangs over the Israelites in the related miniature of Kosmas, and an irregular band is depicted in the background in the Exodus panel at Dura (see Kraeling, *Synagogue*, p. 75, and the literature cited in note 1 above).

[3] E.g., in the Theodore Psalter in London, Brit. Lib., cod. Add. 19.352, fol. 142r (Der Nersessian, *Londres Add. 19.352*, fig. 228), the Baltimore Psalter, Walters Art Gallery, cod. W733, fol. 77r (color plates in A. Cutler and J. W. Nesbitt, *L'arte bizantina e il suo pubblico* [Torino, 1986], figs. pp. 345 and 346), the Psalter Pantocrator, cod. 61, fol. 151v (S. Dufrenne, *L'illustration des Psautiers grecs du Moyen Age: Pantocrator 61, Paris grec 20, British Museum 40731* [Paris, 1966], pl. 23), and the Psalter in Paris, Bibl. Nat., cod. gr. 20, fol. 15r (ibid., pl. 39). On the other hand, these manuscripts depict the fire leading the Israelites as a column with a fire burning on its top.

[4] "Brethren, I would not that you should be ignorant how that all our fathers were under the cloud, and all passed through the sea; and were all baptized unto Moses in the cloud and in the sea."

[5] See, e.g., Gregory of Nyssa, *De vita Mosis* (PG 44, col. 361), and Origen, *HomEx* 5 (PG 12, col. 326); cf. J. Daniélou, *Sacramentum futuri: Études sur les origines de la typologie biblique* (Paris, 1950), pp. 152ff.

[6] Lowden, *Octs.*, p. 81.

Exodus 14:9

EGYPTIANS PURSUE THE ISRAELITES

696a. Vat. 747, fol. 88r

Standing majestically on a quadriga seen in frontal view, Pharaoh leads the pursuing Egyptians. The painter was not capable of rendering the horses in the same view as the chariot, and depicted them dashing toward the right, so that they do not seem properly connected with the vehicle. Pharaoh points with his right hand toward the standard-bearer who follows him on a biga and heads the troop of mounted black-skinned horsemen. Flaked in various spots.

Located beside Exodus 13:15.

697a. Ser., fol. 194r

Not only Pharaoh, resplendent in golden armor, but also the standard-bearer stand on quadrigas; both have their own charioteers driving the teams. The horsemen are not specifically characterized as Egyptians by the color of their skin, as they are in Vat. 747.

Located beside Exodus 13:15.

698a. Sm., fol. 80r

The inscription, which continues in the lower strip, reads: καταδίωξις φαραὼ κατὰ μωσέως καὶ ἰσραηλιτῶν.

Very close to Ser.

699a. Vat. 746, fol. 189r

The inscription, likewise distributed over two strips, reads: καταδίωξις φαραὼ κατὰ μωσέως καὶ ἰσραηλιτῶν.

Very close to Ser. and Sm.

Located beside Exodus 13:15.

Lit.: Strzygowski, *Sm.*, p. 116, fig. 3, pl. 38; Uspenskii, pp. 144–45, fig. 118; Hesseling, fig. 177; Millet, "Introduction," pp. xii–xiii; Lowrie, *Art*, pl. 145a; Williams, "León Bible," p. 63; Eller and Wolf, *Mosaiken*, fig. 41; Der

Nersessian, *Londres Add. 19.352*, p. 102; Weitzmann, "Ode Pictures," pp. 69–70; Wolska-Conus, "Topographie Chrétienne," fig. 14; Weitzmann, *Dura*, figs. 65, 66; Lowden, *Octs.*, p. 81, figs. 112, 113; Bernabò, "Teodoreto," fig. 12.

Exodus 14:16–21

Arrival at the Red Sea

The Red Sea, which the Israelites are about to cross, is divided into a number of strips; the original version of the miniature must have depicted twelve strips, providing each tribe of Israel with its own path.[1] Such a division is unknown in the Septuagint text and depends upon Jewish legends, familiar also to Christians.[2] Strikingly, Theodoret, the author of the catena on the Octateuch that constitutes the core of the abstracts in our manuscripts, definitely denies that the sea was divided into twelve sections.[3] The pillar of fire is depicted at the rear of the marching Israelites in Vat. 747; in the other manuscripts the pillar of cloud is also depicted. In fact, in Exodus 14:19 the angel of God that went before the Israelites and the pillar of cloud—the pillar of fire is not explicitly mentioned—moved to the rear of the Israelites. In the Octateuchs the angel of God seems to have been identified with and pictorially rendered as the pillar of fire,[4] as in the episode of the burning bush in Vat. 747 (see fig. 611 and introduction to Exodus 3:2–6).

696b. Vat. 747, fol. 88r

Marching ahead of the Israelites, Moses has reached the Red Sea and in order to divide its waters, according to Exodus 14:16, he lifts his rod, here represented as an astoundingly long black stick, swelling at both the ends. Moses touches this rod to the ragged shoreline that rises like a wall in front of him. Moses' head and that of the first Israelite are repainted, as is the rod, whose original position is recognizable by the upper portion of its outline which still appears through the later layer of paint: the rod was originally shorter and Moses held it almost vertically at his side with his left hand. The sea is pictured vertically in an elongated form and is divided into strips, which are more accurately painted in the other Octateuchs. The pillar of fire is at the rear of the crowd, whereas in the other Octateuchs the shady zone of the cloud is also painted near the left frame of the miniature. The group of marching Israelites is so heavily flaked that certain details, e.g., the child being carried on the shoulders of the hindmost woman, are hardly recognizable. Large sections of the background are severely damaged as well.

Located beside Exodus 13:15.

697b. Ser., fol. 194r

Holding a long, thin rod, Moses stretches out his left hand and dips his foot into the sea, which is divided into strips. The group of Israelites shows different types: one man in the center holds a baby in front of him while he marches; another at the rear looks back and expresses his amazement at the pillar of fire

which is sufficiently removed from the lateral border to allow a representation of the dark cloud behind it, making the Israelites invisible to the pursuing Egyptians.

Located beside 13:15.

698b. Sm., fol. 80r

Very close to Ser.

699b. Vat. 746, fol. 189r

Very close to Ser. and Sm.
Located beside Exodus 13:15.

Lit.: Strzygowski, *Sm.*, p. 116, fig. 3, pl. 38; Uspenskii, p. 144, fig. 119; Hesseling, fig. 177; Millet, "Introduction," pp. xii–xiii; Lowrie, *Art*, pl. 145a; Nordström, "Water Miracles," p. 95 n. 1; Williams, "León Bible," pp. 63–64; Eller and Wolf, *Mosaiken*, fig. 41; Der Nersessian, *Londres Add. 19.352*, p. 102; Weitzmann, "Ode Pictures," pp. 69–70; Wolska-Conus, "Topographie Chrétienne," p. 178, fig. 14; Weitzmann, *Dura*, p. 46, figs. 65, 66; Lowden, *Octs.*, p. 81, figs. 112, 113; Bernabò, "Teodoreto," p. 77, fig. 12.

[1] The division of water into strips is similar but more clearly depicted in miniatures of Kosmas Indikopleustes, as in Sinai, cod. 1186, fols. 73r and 74r (text fig. 34; Weitzmann and Galavaris, *Sinai Greek Mss.*, figs. 141, 143, color pl. 10a).

[2] See, e.g., TargPs-J (*Targum Exode et Lévitique*, ed. Le Déaut, pp. 115–17), Mekilta, Tractate Beshallah 5 (*Mekilta de-Rabbi Ishmael*, ed. Lauterbach, vol. 1, pp. 222–24), Athanasios (reported in Bar Hebraeus [Gregory Abū'l-Faraj] [*Barhebraeus' Scholia*, p. 121]), Epiphanios (*AdvHaer*, bk. 2, 1, haer. 64 [PG 41, col. 1192]), and Origen (*HomEx* 5 [PG 12, col. 330], also quoting Ps 135:13). Cf. Nordström, "Water Miracles," pp. 95–96, fig. 7; Stichel, "Bemerkungen," p. 389; and Weitzmann, *Dura*, p. 47.

[3] *QuaestEx* (PG 80, cols. 255–56); cf. Bernabò, "Teodoreto," pp. 77–78.

[4] Angels are identified with flaming fire in Jewish lore. Origen, in contrast, stresses that the column of clouds formed a wall behind the Israelites to protect them from the Egyptians, while the column of fire was not moved to the rear (*HomEx* 5 [PG 12, col. 329]). In PRE 42 (*Pirkê*, ed. Friedlander, p. 329), the angel Michael made himself "a wall of fire" between the Israelites and Egyptian army.

Exodus 14:27–30

The Egyptians Drown

The Septuagint relates at Exodus 14:26–27 that Moses closed the sea by stretching out his hand over the waters; no mention is made of the rod represented in the miniature. The attitude of Moses here is mirrored in the following miracle at Marah (figs. 712a–715a), where a wooden switch to sweeten the waters is actually mentioned by the text; the same pose is repeated, although less closely, at the Smiting of the Rock (Ex 17:6; figs. 720, 721, 724). In the Bible, however, the *virga* is a widespread symbol of the Messiah,[1] who according to Deuteronomy 18:18 will be a new Moses, a concept Judaism hands down to Christianity:[2] by means of his rod, a type of the Cross of Christ, Moses drives back the Red Sea and sweetens the waters at Marah to save his people.[3]

The unique accumulation of personifications in Ser., Sm., and Vat. 746—Depth, Desert, Red Sea, and Night (in Vat. 747 only

Night is pictured)—has a counterpart in the miniature illustrating the first Ode of Moses in the Paris Psalter (Bibl. Nat., cod. gr. 139, fol. 419v) (text fig. 22) and related manuscripts,[4] and may be explained as an influence stemming from a manuscript of this group on the Octateuchs.[5]

704. Vat. 747, fol. 89v

After the Israelites have reached the other shore, Moses turns back his head, lowers his right arm and dips his cylindrical brown rod into the Red Sea, represented as a lake surrounded by mountains. Trying in vain to rein in his team of horses, Pharaoh still stands on his chariot which is sinking gradually; around him some of the soldiers struggle with the waves, while others are already floating as dead bodies on the surface. The main troop of cavalry, led by an officer on a chariot, races over the water and is still fully visible, but the horses are rearing up as they feel the water giving way under them. As in the preceding miniature the Israelites are guided by the pillar of fire, represented as a tall column shaft from which flames erupt. The personification Nyx, a seminude woman reclining on a mountain slope and holding a billowing veil over her head, emerges just above the Israelites. The sky, as often in this manuscript, is painted in gold. Large sections of the surface are flaked.

Located below Exodus 15:1.

705. Ser., fol. 197v

Moses has an attitude slightly different from that in Vat. 747, his rod is more elongated, and he is not the last of the Israelites: he is followed by a man with a sack over his shoulder. A man marches at the head of the group with his hands raised in amazement toward the pillar of fire, to which Moses also extends his left hand. Pharaoh has a nimbus painted in green.[6] Two of the soldiers try to reach the shore by swimming, and the standard-bearer, half submerged, still hails the doomed Pharaoh. Nyx steps up the mountain as in the preceding miniature of Ser., Sm., and Vat. 746 (figs. 701–703). Unlike in Vat. 747, three more personifications appear. They are not inscribed, but their original meaning can be learned from a comparison with the related composition in the Paris Psalter (fol. 419v), where the nude man emerging in front of Pharaoh to draw down his crowned head is inscribed Bythos (Depth), the nude woman with oars over her shoulder who seems to be frightened by the disturbance in her domain is inscribed Erythra Thalassa (Red Sea), and the youthful figure sitting with crossed legs on the ground is inscribed Eremos (Desert).

Located below Exodus 14:29.

706. Sm., fol. 81v

The inscription reads: διαπερασάντων ισραηλιτ(ῶν) τὴν ἐρυθρὰν διὰ ξηρᾶς, φαραὼ καταποντίζεται παυστρατί.

Very close to Ser. The personification Nyx is completely rubbed.

Located below Exodus 15:1.

707. Vat. 746, fol. 192v

The inscription reads: διαπερασάντων τῶν ισραηλιτῶν τὴν ἐρυθρὰν διὰ ξηρᾶς, φαραὼ καταποντίζεται παυστρατί.

Very close to Ser. and Sm. The head of Nyx is rubbed.

Located below Exodus 14:31.

Lit.: Seroux d'Agincourt, *Histoire*, vol. 3, p. 68, and vol. 5, pl. 62 no. 4 (reproduced in the frontispiece of the present volume); Kondakov, *Istoriia*, p. 192; Kondakov, *Histoire*, vol. 2, p. 82; Strzygowski, *Sm.*, p. 116, pl. 39; Uspenskii, pp. 103, 145–46, fig. 121; Hesseling, fig. 179; Diehl, *Manuel*, vol. 2, p. 617, fig. 293; Wilpert, *Mosaiken und Malereien*, vol. 1, p. 454, fig. 165; Neuss, *Katalan. Bibelill.*, p. 47; Cockerell, *Illustrations*, p. 15; Lassus, "Quelques représentations," pp. 168–76, fig. 1; Benson and Tselos, "Utrecht Ps.," pp. 65, 70, fig. 57; Buchthal, *Par. Gr. 139*, pp. 21–22; Millet, "Introduction," p. xv; Der Nersessian, *Barl. et Joas.*, pp. 106, 121; Buchthal, *Paris Ps.*, pp. 31–33, fig. 64; Willoughby, *McCormick Apocalypse*, vol. 1, p. 518; De Wald, *Vat. Gr. 1927*, p. 44; Morey, *Early Christian Art*, pp. 69, 73, 270, fig. 63; Pijoán, *Summa artis*, vol. 7, p. 402, figs. 568, 570; Krautheimer-Hess, "Porta dei Mesi," p. 169, fig. 7; Lowrie, *Art*, pl. 145c; Weitzmann, "Ps. Vatopedi," pp. 36–37, 48, fig. 23; Weitzmann, *JR*, p. 90; Weitzmann, *Greek Mythology*, p. 131; Weitzmann, "Oct. Ser.," p. 185, figs. 7, 8; Goodenough, *Symbols*, vol. 10, pp. 106 n. 6, 117, 118 n. 75, fig. 267; Byvanck, "Psautier de Paris," p. 37, fig. 2; Buchthal, *Latin Kingdom*, p. 58 n. 4; Williams, "León Bible," p. 65; Popovich, "Personifications," pp. 20–21; Schade, *Paradies*, p. 166; Eller and Wolf, *Mosaiken*, fig. 42; Wessel, "Durchzug," col. 3; *LCI*, vol. 3, col. 307, fig. 1; Der Nersessian, *Londres Add. 19.352*, p. 102 and n. 11; Buchthal, *Historia Troiana*, p. 37 n. 1; Tsuji, "Passage," p. 63 n. 24; Robb, *Art*, pp. 48–51, fig. 16; Gaehde, "Octateuch," p. 355, figs. 68, 69; Spatharakis, "Psalter Dionysiou," p. 177, pl. 98b; Weitzmann, "Ode Pictures," pp. 69–71; Kötzsche-Breitenbruch, *Via Latina*, pp. 30 n. 157, 83, pls. 19f, 19g; Cutler and Weyl Carr, "Ps. Benaki," p. 284; Cutler, "Aristocratic Ps.," pp. 251–52; Deckers, *S. Maria Magg.*, p. 171; Weitzmann, *SP*, p. 54; Jeremias, *S. Sabina*, p. 31; Anderson, "Seraglio," p. 102; Demus, *Mosaics of S. Marco*, vol. 2, pt. 1, p. 176; Narkiss, "Pharaoh," p. 8, fig. 2; Sed-Rajna, *Hebraic Bible*, p. 94 n. 69; Weitzmann, *Dura*, pp. 41–42, 48–49, figs. 69, 70; Lowden, *Octs.*, pp. 96–98, figs. 133–136; Bernabò, "Studio," pl. 2.

[1] For an exhaustive discussion of this topic, see M. Dulaey, "'Virga virtutis tuae, virga oris tuae': Le bâton du Christ dans le Christianisme ancien," in *Quaeritur inventus colitur: Miscellanea in onore di Padre Umberto Maria Fasola* (Vatican City, 1989), pp. 235–45, quoting Ps 44:7, Ps 23:4, and Isa 10:5.

[2] Ibid., esp. pp. 238–42.

[3] Cyril of Jerusalem, *Catechesis 13, De Christo crucifixo et sepulto* 19 (PG 33, cols. 795–98); cf. G. T. Armstrong, "The Cross in the Old Testament According to Athanasius, Cyril of Jerusalem and the Cappadocian Fathers," in *Theologia Crucis, Signum Crucis: Festschrift für Erich Dinkler zum 70. Geburtstag*, ed. C. Andresen and G. Klein (Tübingen, 1979), pp. 19ff., esp. 23–24, and appendix; P. Lundberg, *La typologie baptismal dans l'ancienne Église* (Leipzig, 1942), pp. 185–86.

[4] Buchthal, *Paris Psalter*, pp. 30ff.

[5] Weitzmann, "Ps. Vatopedi," p. 48.

[6] The unexpected halo has been related to a Jewish legend by Narkiss, "Pharaoh," p. 8.

Exodus 15:20

MIRIAM'S DANCE

708. Vat. 747, fol. 90v

Miriam (LXX: Mariam), the prophetess sister of Aaron, stands at the left in a quiet pose and beats a drum, exciting the

girls in front of her to a wild, ecstatic dance. The central pair of girls throw their heads, arms, and one of their legs backward, and interlace their little fingers, thus resembling a well-known type of raving maenad.¹ The dependence on a classical model is also visible in the right dancer of this pair—her drapery leaves one of her breasts free of clothing.² A third dancer, also a classical maenad type, whirls around with cymbals in her hands.³ Slightly flaked.

Located beside Exodus 15:19.

709. Ser., fol. 200r

Close to Vat. 747, but all four women are dressed in heavy garments with broad golden borders and jeweled girdles. The motions of the dancers are calmer, ecstatic frenzy replaced by a choruslike dance in which their bodies hardly move and their feet do not leave the ground. The central dancers look at Miriam as they clasp hands. The head of one of them is completely rubbed.

Located beside Exodus 15:20.

710. Sm., fol. 82v

The inscription reads: μαριὰμ ὧδε σὺν ταῖς ἀδούσαις κόραις. Very close to Ser.

711. Vat. 746, fol. 194v

The inscription reads: μαριὰμ ὧδε σὺν ταῖς ἀδούσαις κόραις. Very close to Ser. and Sm.

Located beside Exodus 15:19.

Lit.: Seroux d'Agincourt, *Histoire*, vol. 3, p. 68, and vol. 5, pl. 62 no. 5 (reproduced in the frontispiece of the present volume); Kondakov, *Istoriia*, p. 192; Kondakov, *Tablits*, pl. 12 no. 5; Kondakov, *Histoire*, vol. 2, p. 82; Toesca, "Cimeli biz.," p. 41 n. 1; Uspenskii, p. 146, fig. 122; Hesseling, fig. 180; Koukoules, "Συμβολή," fig. p. 35; Koukoules, "Χορός," fig. 5; Pijoán, *Summa artis*, vol. 7, figs. 569, 571; Lowrie, *Art*, pl. 145b; Koukoules, *Vie et civilisation*, vol. 5, pl. 4 no. 4; Williams, "León Bible," p. 66; Weitzmann, "Classical in Byz. Art," p. 168, fig. 147; Der Nersessian, *Londres Add. 19.352*, p. 102 n. 11; Lassus, *Livre des Rois*, p. 87, fig. 122; Stahl, "Morgan M. 638," p. 92, fig. 119; Cutler, "Spencer Ps.," p. 144 n. 57; Anderson, "Two Centers," pp. 83, 85, pl. 41b; Cutler and Weyl Carr, "Ps. Benaki," p. 284; Weitzmann, "Ode Pictures," pp. 69–70; Cutler, "Aristocratic Ps.," pp. 251–52; Demus, *Mosaics of S. Marco*, vol. 2, pt. 1, p. 176; Hutter, "Bild der Frau," p. 167, fig. 9; Sed-Rajna, *Hebraic Bible*, p. 147 n. 3; Iacobini, "Lettera," p. 81, fig. 17; Bernabò, "Studio," pl. 2.

¹ Cf. F. Matz, *Die Dionysischen Sarkophage*, pt. 1, *Die Typen der Figuren* (Berlin, 1968), types 25, 32, and 34 (for this reference and the one in note 3 below we are indebted to Dr. Christopher Moss); and Weitzmann, "Classical in Byz. Art," p. 168.
² An illustration of the dancing Miriam more closely following the Septuagint text is encountered in the marginal Psalters, where it is connected with the first Ode of Moses in Ex 15:1–9: see the Psalter Pantokrator 61, fol. 206r (Dufrenne, *Psautiers grecs*, pl. 29); the Theodore Psalter, London, Brit. Lib., cod. Add. 19.352, fol. 192v (Der Nersessian, *Londres Add. 19.352*, fig. 302); and the Khludov Psalter, Moscow, Historical Museum, cod. 129, fol. 148v (M. Shchepkina, *Miniatiury Khludovskoi psaltyri* [Moscow, 1977], fol. 148v).
³ Cf. Matz, *Die Dionysischen Sarkophage*, pt. 1, *Die Typen der Figuren* (as in note 1), type 8.

Exodus 15:23–25
MIRACLE AT MARAH

Rather than throwing the piece of wood God showed him into the waters in order to sweeten them, Moses simply dips the tree into the water or points it at the water, thus following the iconographical scheme of the episodes of the drowning of the Egyptians in the Red Sea (figs. 704–707) and the smiting of the rock that follows (figs. 720–721, 724). Moses' attitude of fleeing does not conform to the text and parallels his pose closing the waters in the miniature of the drowning.¹ Christian pictorial counterparts are found in representations of Christ performing miracles with his *virga* in early sarcophagus friezes and catacomb paintings, especially in water miracles; thus, the scene is to be regarded as a type of baptism.² Moreover, in Ser., Sm., and Vat. 746, the piece of wood cast by Moses into the water cannot be distinguished from the rod with which he performed wonders in previous episodes.

712a. Vat. 747, fol. 91r

At Marah (LXX: Merrha) Moses uses a tree to sweeten one of the three pools of bitter water. This tree is pictured as a short, flat stick with a concavity in its outline. Moses is accompanied by Aaron and a crowd of Israelites, one of whom dips water from the upper pool with a pitcher. Another crowd of Israelites stands on the other side of the water murmuring against Moses; one of the men points to his dry lips demonstrating his thirst. Meanwhile, two Israelites have already knelt down to drink some of the water. Slightly flaked.

Located below Exodus 16:1.

713a. Ser., fol. 201r

Although essentially the same as in Vat. 747, the composition differs in some details. Aaron stands to Moses' left, and to his right is a walking woman carrying a baby on her shoulder. Moses holds a stick which is shorter and thinner than the tree in Vat. 747. There are only two pools in the mountainous landscape, and the two Israelites quenching their thirst bend over the water and use their hands to cup it, instead of lapping it up directly. The flat roofs of a group of buildings appear above the mountain.

Located below Exodus 16:1.

714a. Sm., fol. 83r

The inscription reads: ἔνθα τὸ μερρᾶς ὕδωρ γλυκαίνεται. Very close to Ser.

715a. Vat. 746, fol. 196r

The inscription reads: ἔνθα τὸ μερρᾶς ὕδωρ γλυκαίνεται. Close to Ser. and Sm. but Moses' stick here is black, longer, and enlarged at the lower end. Very heavily damaged by flaking. Located below Exodus 16:1.

Lit.: De Grüneisen, "Cielo," p. 495; Uspenskii, p. 146, fig. 123; Hesseling, fig. 181; De Grüneisen, *Ste. Marie Ant.*, fig. 187; Neuss, *Katalan. Bibelill.*, p. 47; Der Nersessian, *Barl. et Joas.*, p. 112; Weitzmann, *Greek Mythology*, p. 131; Wolska-Conus, *Cosmas*, vol. 1, pp. 145 n. 3, 146; Mouriki-Charalambous, "Cosmas," pp. 64–65, 68–69; Buchthal, *Historia Troiana*, p. 37 n. 1; Belting, *Beneventan. Buchmalerei*, p. 163 n. 23; Brenk, *S. Maria Magg.*, p. 90 n. 143; Stahl, "Morgan M. 638," pp. 146–47, fig. 189; Anderson, "Seraglio," p. 99, fig. 31; Weitzmann, *SP*, p. 54; Weitzmann, *Dura*, pp. 48, 65.

[1] These correspondences have been noted by Anderson ("Seraglio," p. 99), who claims that the attitude of Moses was adapted for the illustration of the smiting of the rock.

[2] Among other episodes symbolizing the Baptism are the Flood, the Crossing of the Red Sea, the Waters of Marah, the Smiting of the Rock, and the Wedding at Cana; see the introduction to Exodus 14:27–30, notes 1–3. For the *virga*, see also the introduction to Exodus 7:17–20, esp. notes 4–6.

Exodus 15:27

Miracle at Elim

712b. Vat. 747, fol. 91r

On their march through the desert the Israelites reach Elim (LXX: Ailim), which is described as a place with twelve fountains and seventy palm trees. Because the strip of ground did not provide enough room, the painter placed some of the fountains on the slope of a mountain rising along the lateral border. He depicted only five of the seventy palm trees, which have a sort of red, rice-grain heart above the trunk. The group of Israelites with Moses in the preceding scene is also related to this one, especially in Ser., Sm., and Vat. 746.

Located below Exodus 16:1.

713b. Ser., fol. 201r

In contrast to Vat. 747, some of the fountains are grouped alongside the lateral border and others above the trees. Seven palm trees are lined up, each one representing ten.

Located below Exodus 16:1.

714b. Sm., fol. 83r

The inscription reads: ὧδε τὰ ὀστελέχ(η) τ(ῶν) φοινίκων καὶ αἱ δώδεκα πηγαί.

Very close to Ser.

715b. Vat. 746, fol. 196r

The inscription reads: ὧδε τὰ ὀστελέχη τ(ῶν) φοινίκω(ν) καὶ αἱ δώδεκα πηγαί.

Very close to Ser. and Sm. Partly flaked.

Located below Exodus 16:1.

Lit.: De Grüneisen, "Cielo," p. 495; Uspenskii, pp. 102, 146, fig. 123; Hesseling, fig. 181; De Grüneisen, *Ste. Marie Ant.*, fig. 187; Redin, *Koz'my Indikoplova*, p. 205; Nordström, "Jewish Legends," p. 503; Nordström,

"Water Miracles," pp. 93 n. 1, 106; Williams, "León Bible," p. 66; Wolska-Conus, *Cosmas*, vol. 1, pp. 145 n. 3, 146; Mouriki-Charalambous, "Cosmas," pp. 64–65, 68–69; Stahl, "Morgan M. 638," fig. 189; Anderson, "Seraglio," fig. 31; Wolska-Conus, "Topographie Chrétienne," p. 176.

Exodus 16:13

Miracle of the Quails

The Septuagint provides no explanation for the quails descending into the open mouths of the Israelites, but a tentative connection might be advanced by a Christian reading of the miracle: the food from heaven is a eucharistic type and, especially the manna represented in the lower half of the miniature, symbolizes Jesus, the bread of life, following John 6:31ff.[1] Pictorially, the miniature recalls that of the Israelites eating quails (Num 11:32–33; figs. 904, 906, 908, 909).

716a. Vat. 747, fol. 92r

Quails descend from a segment of heaven directly into the open mouths of four Israelites who lie in various positions on the ground, one of them depicted from behind.

Located beside Exodus 16:15.

717a. Ser., fol. 203r

The number of Israelites is increased to six. All the men sit in more upright attitudes on elevations of the ground at the foot of a high mountain. The segment of heaven is omitted, and the quails fly toward the Israelites' mouths without actually entering them.

Located beside Exodus 16:15.

718a. Sm., fol. 84r

The inscription reads: ὀρτυγομήτρας ἐνταῦθα μετάληψις.

Very close to Ser.

719a. Vat. 746, fol. 198r

The inscription, written in the left margin, reads: ὀρτυγομήτρας ἐνταῦθα μετάληψις.

Very close to Ser. and Sm. but flaked in various places.

Located beside Exodus 16:16.

Lit.: Uspenskii, p. 146, fig. 124; Hesseling, fig. 182; Wilpert, *Mosaiken und Malereien*, vol. 1, p. 457, fig. 167; Redin, *Koz'my Indikoplova*, p. 225; Der Nersessian, *Barl. et Joas.*, pp. 118–19; Morey, *Early Christian Art*, pp. 148, 151; Pijoán, *Summa artis*, vol. 7, fig. 566; Goodenough, *Symbols*, vol. 10, p. 106 n. 9, fig. 269; Wolska-Conus, *Cosmas*, vol. 1, pp. 145 n. 3, 146; Mütherich, "Psalterillustration," p. 171; Mouriki-Charalambous, "Cosmas," pp. 73–78, 79–80, 182; Stahl, "Morgan M. 638," fig. 187; Deckers, *S. Maria Magg.*, pp. 145, 178; Anderson, "Seraglio," pp. 91–92, 94–95, 99, figs. 14–16; Demus, *Mosaics of S. Marco*, vol. 2, pt. 1, p. 176; Wolska-Conus, "Topographie Chrétienne," p. 175; Anderson, *New York Lectionary*, p. 92, fig. 63.

[1] Cf., e.g., John Chrysostom's *In Joannem*, homil. 46 (PG 59, cols. 257–62), and *In epistulam 2 ad Corinthios*, homil. 11 (PG 61, cols. 473–80).

Exodus 16:17

ISRAELITES GATHER MANNA

The gathering of manna is rendered in essentially the same way in all the Octateuchs, with Israelites hurrying toward the white grains resembling coriander seeds (Ex 16:31) that fall from a segment of heaven. Exodus 16:14 relates that the manna appeared in the morning on the surface of the ground when the layer of dew had lifted, and Exodus 16:4 cites the manna sleeting down from heaven as one of God's promises.

716b. Vat. 747, fol. 92r

The manna, rendered as small white spots, thus faithfully following verse 31, pours down from a segment of heaven; four Israelites, two on either side, hurriedly converge to gather the manna.

Located beside Exodus 16:15.

717b. Ser., fol. 203r

The composition, close to Vat. 747, is augmented by a second segment of heaven in the upper right corner with the hand of God.

Located beside Exodus 16:15.

718b. Sm., fol. 84r

The inscription reads: ἡ τοῦ μάννα συλλογή.

Very close to Ser.

719b. Vat. 746, fol. 198r

The inscription, written in the left margin, reads: ἡ τοῦ μάννα συλλογή.

Very close to Ser. and Sm.

Located beside Exodus 16:16.

Lit.: Uspenskii, p. 146, fig. 125; Hesseling, fig. 182; Wilpert, *Mosaiken und Malereien*, vol. 1, p. 457, fig. 167; Redin, *Koz'my Indikoplova*, p. 223; Der Nersessian, *Barl. et Joas.*, pp. 118–19; Morey, *Early Christian Art*, pp. 148, 151; Pijoán, *Summa artis*, vol. 7, fig. 566; Goodenough, *Symbols*, vol. 10, p. 106 n. 9, fig. 269; Wolska-Conus, *Cosmas*, vol. 1, pp. 145 nn. 1 and 3, 146; Mütherich, "Psalterillustration," p. 171; *LCI*, vol. 3, col. 151, fig. 1; Mouriki-Charalambous, "Cosmas," pp. 73–78; Stahl, "Morgan M. 638," p. 146, fig. 187; Deckers, *S. Maria Magg.*, p. 178; Weitzmann, *SP*, p. 55; Anderson, "Seraglio," pp. 91–92, 94–95, 99, figs. 14–16; Demus, *Mosaics of S. Marco*, vol. 2, pt. 1, p. 176; Wolska-Conus, "Topographie Chrétienne," p. 175; Anderson, *New York Lectionary*, p. 92, fig. 63.

Exodus 16:33–34

AARON PRESERVES MANNA

Sm. illustrates this episode with a composition different from that in Vat. 747 and Ser. This scene and the next one, Moses smiting the rock at Horeb, which is depicted in the lower half of the same miniatures in Vat. 747 and Ser. (nos. 720b, 721b), were

probably unsatisfactory or lacking in the model of Sm.; the painter replaced both of them with newly invented scenes and added a third scene (fig. 723), not found in any other manuscript. The copyist of Vat. 746 must have used the same defective model, but he filled the pictorial lacuna with only one newly invented scene, illustrating Exodus 18:9 (fig. 725), which is likewise not found in any other copy. The shape of the vessel where Aaron preserves manna is the same as that of the stamnos depicted on the table inside the tabernacle in fig. 762 (the stamnos appears only in Vat. 747) and again on the table in figs. 812–814.

720a. Vat. 747, fol. 93r

Moses commands Aaron to preserve some of the gathered manna as a reminder for future generations. The Israelites advance through the desert with Aaron, who walks ahead of them filling a huge brown jug. He is followed by Moses, who turns around to a group of men and women as if asking them to gather the manna for this very purpose, but a half-grown boy carrying a heavy basket on his shoulders is the only one who actively responds to the request. Added as a pure genre motif, another, still smaller boy takes his first steps and grips Moses' mantle. Slightly flaked.

Located beside Exodus 16:29.

721a. Ser., fol. 205v

Close to Vat. 747, except for small and insignificant deviations: the larger group of Israelites is composed of only men, the boy behind them carries the manna in a vessel instead of a basket, and the smaller boy, a little older here, is able to walk without assistance.

Located beside Exodus 16:32.

722. Sm., fol. 85r (see also text fig. 56)

The inscription reads: ἡ ἀπόθεσις τοῦ μάννα ἐν τῇ χρυσῇ στάμνῳ.

Moses looks at Aaron, in the center, who is clothed in full priestly attire and takes the manna that the Israelites have collected in their robes to place in a huge golden jug.

Lit.: Uspenskii, p. 146, fig. 126; Hesseling, fig. 183; Neuss, *Katalan. Bibelill.*, p. 47; Muñoz, "Rotulo," p. 476; Goodenough, *Symbols*, vol. 10, p. 16 n. 79, fig. 241; Anderson, "Seraglio," p. 99, figs. 29, 32; Wolska-Conus, "Topographie Chrétienne," pp. 175–76; Lowden, *Octs.*, pp. 73–74, figs. 102, 104, 105.

Exodus 17:3–4

MOSES PRAYS TO GOD

See the introduction to Exodus 16:33–34. The scene, probably newly invented by the painter, repeats the conventional scheme of a patriarch praying to the hand of God in the heaven.

723. Sm., fol. 85r

The inscription reads: δέησις μωυσέ(ως) πρὸ(ς) κ(ύριο)ν.

At the foot of the mountain Moses prays to God's blessing hand in heaven and asks for help against the agitated Israelites who stand behind him complaining of thirst and, with vivid gestures, threatening to stone him.

Lit.: Uspenskii, p. 146; Hesseling, fig. 183; Muñoz, "Rotulo," p. 476; Deckers, *S. Maria Magg.*, p. 180; Anderson, "Seraglio," p. 99, fig. 30; Lowden, *Octs.*, pp. 73–74, fig. 104.

Exodus 17:6

SMITING THE ROCK AT HOREB

Vat. 747 and Ser. have the smiting of the rock at Exodus 17:6 in the lower half of the miniature. Ser. apparently copied the figures, landscape, and buildings from the miracle at Marah represented four folios earlier in the same manuscript (fig. 713);[1] the pillar of fire at the left, not evoked by the text at this point, was borrowed from one of the preceding scenes of Exodus. Sm. may have possibly adapted Moses dipping his rod into the pool from the story of the golden calf (figs. 794–797).[2] In the apparently corrupted reading in Vat. 747, Moses dips his rod in the water, thus confirming the parallel noted above between the iconography of Moses' water miracle and Christ's miracles (see the introduction to Exodus 14:27–30).

720b. Vat. 747, fol. 93r

Instead of smiting the rock, as he does in verse 6, Moses dips his rod, here a very long, thin stick, into a small pool of water; Moses' attitude recalls that in the scene with the closing of the Red Sea (fig. 704). The Israelites approach the pool, eager to quench their thirst. One of them is already drinking from his cupped palm; another grasps a sort of black ring with one hand, and a second ring floats on the surface of the pool. Another crowd of Israelites stands behind Moses. The man with the white beard next to Moses is apparently Aaron, although he is not nimbed. He and the other Israelites are about to depart while Moses is still occupied performing the miracle. The uppermost strip of the tripartite sky is painted in gold. Slightly flaked.

Located beside Exodus 16:29.

721b. Ser., fol. 205v

Close to Vat. 747, but, as in the text, Moses causes a spring to emerge from the rock with his rod rather than dipping the rod into a pool, which is depicted at the base of the rock. Moses himself as well as the crowd behind him are already departing while the miracle is being performed. Aaron is replaced by a woman with a child on her shoulder, and the Israelite at the left, who in Vat. 747 draws water, is replaced by a figure that repeats the drinking man in the foreground. Above the ridge of a high mountain, house roofs emerge. Behind the group at the left is once again the pillar of fire which constantly guided the Israelites

since their departure from Egypt. Rubbed and flaked in a few places.

Located beside Exodus 16:32.

724. Sm., fol. 85v

The inscription reads: ἡ ἐν χωρὴβ πάταξις τ(ῆ)ς πέτρ(ας).

Moses touches the top of the rock with his rod and causes a spring to gush forth and flow down to the plain, where it forms a broad stream. The hand of God issuing from a segment of heaven emits rays toward Moses' head and blesses the prophet. An older Israelite kneels over the rock, eager to drink directly from the spring, while others stand farther away with their feet in the stream. One of them is busy drawing water with a vessel, while another has already filled his pitcher and offers a drink to the excited group of older men, one of whom greedily holds a cup to his lips.

Lit.: Uspenskii, p. 146, fig. 127; Hesseling, fig. 184; Muñoz, "Rotulo," p. 476; Buchthal, *Paris Ps.*, p. 67 n. 14; Williams, "León Bible," p. 66; Mütherich, "Psalterillustration," pp. 170–71; Belting, *Beneventan. Buchmalerei*, p. 163 n. 23; Deckers, *S. Maria Magg.*, p. 188; Mouriki-Charalambous, "Cosmas," p. 83; Anderson, "Seraglio," p. 99, fig. 32; Demus, *Mosaics of S. Marco*, vol. 2, pt. 1, p. 177; Weitzmann, *Dura*, pp. 51 n. 19, 65, fig. 94; Lowden, *Octs.*, pp. 73–75, figs. 102, 105.

[1] Anderson, "Seraglio," p. 99.
[2] Ibid.

Exodus 17:9

MOSES ADDRESSES JOSHUA

See the introduction to Exodus 16:33–34. Vat. 746 replaces the scene of the smiting of the rock represented in the other manuscripts (figs. 720, 721, 724) with a conventional figure of Moses addressing Joshua, following Exodus 17:9.

725. Vat. 746, fol. 201v

Moses addresses Joshua, who is nimbed and dressed in full armor, and orders him to raise an army with which to fight the Amalekites. A group of Israelites conversing among themselves witnesses Moses' command.

Located below Exodus 17:9.

Lit.: Seroux d'Agincourt, *Histoire*, vol. 3, p. 68, and vol. 5, pl. 62 no. 6 (reproduced in the frontispiece of the present volume); Muñoz, "Rotulo," p. 476; Deckers, *S. Maria Magg.*, pp. 194–95; Anderson, "Seraglio," p. 99; Bernabò, "Studio," pl. 2.

Exodus 17:12–13

BATTLE AGAINST AMALEK

In the course of the battle against Amalek, Aaron and Hur (LXX: Or) supported the hands of Moses, who sat on a stone, in

order to have the Israelites prevail. The Octateuchs show Moses standing up instead of sitting down on the stone. Vat. 747 especially emphasizes Moses stretching out his arms as a Christian *orans*, forming an impressive cross over the battlefield where the Israelites are defeating the enemy army. The pictorial emphasis on the sign of the cross giving the victory to Israel is indicative of the ambience where the miniature finds its roots: in fact, the victorious Moses with upheld hands became a type of the cross among Christians very early on. Following the Epistle of Barnabas (12:2), in the Church Fathers' exegesis this episode is one of the most renowned parallels between Exodus and the New Testament.[1] Moreover, Vat. 747 is the only manuscript which shows Aaron and Hur supporting the hands of Moses by grasping his wrists, thus following the text; in contrast, Ser., Sm., and Vat. 746 show the two men supporting Moses' hands by grasping his upper arms and elbows. Notwithstanding the fact that Moses ordered Joshua to lead the assault against Amalek (verse 9) and afterward Joshua is again mentioned as victor over Amalek (verse 13), none of the warriors can be identified as Joshua.[2]

726. Vat. 747, fol. 94r

Moses stands on the ridge of a mountain with extended arms and with his hands supported by the nimbed Aaron and Hur; below, the battle between the Israelites and the Amalekites rages. The Israelites, dressed in tunics, attack from the left, and although they have already slain some of their heavily armed enemies, the outcome of the battle has not yet been decided and the Amalekites are counterattacking savagely. Flaked in various spots.

Located beside Exodus 17:14.

727. Ser., fol. 207v

The miniature is expanded in width, permitting the illustrator to represent larger armies attacking not only with spears, as in Vat. 747, but also with swords, and to increase the number of slain and wounded Amalekites in the center of the battlefield. Moses' supporters, both with nimbi, are distinguished by their age, the one with the white beard apparently being Aaron and the younger man with a dark beard being Hur; they support Moses's arms by grasping his elbows. Beyond the first ridge rise other mountains with high peaks, which form the foil for Moses and his two assistants. Slightly flaked.

Located beside Exodus 18:14.

728. Sm., fol. 86r

The inscription reads: μωυσῆς τῇ χειρῶν ἐκτάσει κ(α)τ(α)-πολεμῶν τ(ὸν) ἀμαλήκ.

Very close to Ser. Aaron's head is flaked.

729. Vat. 746, fol. 202v

Because of lack of space within the frame, the inscription was written outside it at the upper left corner. It reads: μωυσῆς τῇ ἐκτάσει τῶν χειρ(ῶν) καταπολεμ(ῶν) τ(ὸν) ἀμαλήκ.

Very close to Ser. and Sm. and somewhat flaked.
Located beside Exodus 17:13.

Lit.: Uspenskii, pp. 146–47, fig. 128; Hesseling, fig. 185; Wilpert, *Mosaiken und Malereien*, vol. 1, p. 459, fig. 168; Neuss, *Katalan. Bibelill.*, p. 47; Buchthal, *Paris Ps.*, p. 67 n. 13; Morey, *Mediaeval Art*, p. 157, fig. p. 157; Morey, *Early Christian Art*, pp. 148, 151, 286, fig. 160; Buchthal, *Latin Kingdom*, p. 59; Williams, "León Bible," p. 67; Schapiro, *Words*, p. 22 n. 34; Gaehde, "Octateuch," p. 373; Brenk, *S. Maria Magg.*, p. 91; Deckers, *S. Maria Magg.*, pp. 198–99; Anderson, "Seraglio," p. 99; De Angelis, "Simbologia," pp. 1531–32, fig. 7; Sed-Rajna, *Hebraic Bible*, p. 95 n. 75; Bernabò, "Tradizioni siriache," p. 304, fig. 1.

[1] In the Epistle of Barnabas, nothing is said about Moses sitting down on a stone, paralleling the miniature (PG 2, col. 761). For a discussion of this prefiguration and a list of early authors, see J. Daniélou, *Sacramentum futuri: Études sur les origines de la typologie biblique* (Paris, 1950), pp. 145–46.

[2] Both Jews and Christians emphasized Joshua's role. Jewish legends focus on Joshua's appointment as the successor of Moses as a reward after his victory against Amalek. ExR 26:3 (*Exodus Rabbah*, ed. Freedman and Simon, pp. 319–20) speculates that Moses wanted to train Joshua for the battle because Joshua was to bring Israel into the Land; see also Mekilta de-Rabbi Ishmael, Tractate Amalek 1 (*Mekilta*, ed. Lauterbach, vol. 2, p. 140). Among Christians, Justin remarked that the victory against the Amalekites was gained by Joshua, the leader prefiguring Jesus (*Dialogus cum Tryphone Judaeo* [PG 6, col. 731]).

Exodus 18:5–7

MEETING OF MOSES AND JETHRO

In the meeting of Moses and Jethro, Ser., Sm., and Vat. 746 introduce at the right a genre scene depicting two men driving an ass on which a woman is riding. This scene represents the arrival of Zipporah, Moses' wife, with her two children. In this way the miniature merges Moses kissing Jethro (verse 7) with the coming of Zipporah to meet Moses (verse 5), skipping the intermediate episode of Moses prostrating himself before Jethro (verse 7).

730a. Vat. 747, fol. 94v

Jethro (LXX: Jothor) and Moses, his son-in-law, embrace and kiss each other. Three men, one older and two younger, stand behind Jethro, all of them nimbed like Jethro; behind Moses are a saddled ass and a boy who reverently crosses his arms. It would have been more appropriate to show Jethro and Moses reversed, with the boy and the ass following the arriving Jethro. According to the text, Jethro brought Zipporah (LXX: Sepphora), his daughter and Moses' wife, and her two sons, Gershom (LXX: Gersam) and Eliezer, with him. Thus, the little boy would represent one of Zipporah's sons, and the aged bearded man on the left would probably be Aaron.

Located beside Exodus 18:14.

731a. Ser., fol. 208v

Unlike in Vat. 747, Moses approaches from the left and Jethro from the right. Jethro, who is not nimbed, is followed by Zipporah riding an ass driven by two boys armed with rods, evidently

intended to represent her sons, Gershom and Eliezer. The walled city with a flanking tower cut off by the right lateral border can only be intended to represent the town of Midian, the city in which Jethro was priest. Two young men stand behind Moses.

Located beside Exodus 17:19.

732a. Sm., fol. 86v

The inscription reads: ὁ τοῦ μωυσεός πενθερὸς καὶ ἡ γυνὴ καὶ τὰ τέκνα.

Close to Ser.

Located below Exodus 18:13.

733a. Vat. 746, fol. 204r

The inscription reads: ὁ τοῦ μωυσέως πενθερὸς καὶ ἡ γυνὴ καὶ τὰ τέκνα.

Very close to Ser. and Sm.

Located above Exodus 18:13.

Lit.: Uspenskii, p. 147, fig. 129; Hesseling, fig. 186; Williams, "León Bible," p. 107 n. 41; Galavaris, *Gregory Naz.*, p. 56 n. 95.

Exodus 18:12

MOSES AND JETHRO FEAST

730b. Vat. 747, fol. 94v

Moses, Aaron, Jethro, and Zipporah feast around a table. The scene is supposed to take place within one of the two houses connected by a high wall that together form the background. Slightly flaked.

Located beside Exodus 18:14.

731b. Ser., fol. 208v

Three Israelite elders replace Zipporah sitting at the table in Vat. 747, one of them dressed in a cowl and the two others wearing richly embroidered tunics. There is no architecture in the background.

Located beside Exodus 17:19.

732b. Sm., fol. 86v

The inscription reads: ἐνταῦθα ἀριστοποιούμενοι οἱ αὐτοί.

Very close to Ser.

Located below Exodus 18:13.

733b. Vat. 746, fol. 204r

The inscription reads: ἐνταῦθα ἀριστοποιούμενοι οἱ αὐτοί.

Very close to Ser. and Sm.

Located above Exodus 18:13.

Lit.: Uspenskii, p. 147, fig. 130; Hesseling, fig. 186; Xyngopoulos, "Ἀνάγλυφον," fig. 5 no. 3.

Exodus 18:24

JETHRO'S FAREWELL TO MOSES

734a. Vat. 747, fol. 95r

In the left half of the upper strip Moses and Jethro respectfully bow to each other, while the former gives the latter assurance that he will listen to his counsel.

Located beside Exodus 19:7.

735a. Ser., fol. 209v

Close to Vat. 747 except that Jethro, turning around, is about to leave Moses, and his figure should thus be connected with the scene on the right.

Located beside Exodus 19:7.

736a. Sm., fol. 87r

Very close to Ser.

737a. Vat. 746, fol. 205r

Very close to Ser. and Sm. The ground is heavily flaked.

Located beside Exodus 19:7.

Lit.: Uspenskii, p. 147, fig. 131; Hesseling, fig. 187; Weitzmann, "Ps. Vatopedi," p. 35, fig. 21; Weitzmann, *SP*, p. 55; Anderson, "Seraglio," p. 90, fig. 10; Aliprantis, *Moses*, fig. 102.

Exodus 18:27

JETHRO RIDES HOME

734b. Vat. 747, fol. 95r

In the right half of the upper strip, Jethro rides home on his ass. Partly flaked.

Located beside Exodus 19:7.

735b. Ser., fol. 209v

Close to Vat. 747, except that while riding home, Jethro looks back in the direction of Moses.

Located beside Exodus 19:7.

736b. Sm., fol. 87r

The inscription reads: ἀποστολὴ ἰοθὸρ πρὸς τὰ οἰκεῖα.

Very close to Ser.

737b. Vat. 746, fol. 205r

The inscription reads: ἀποστολὴ ἰοθὸρ πρὸς τὰ οἰκεῖα.

Close to Ser. and Sm. The ground is badly flaked.

Located beside Exodus 19:7.

Lit.: Uspenskii, p. 147, fig. 131; Hesseling, fig. 187; Weitzmann, "Ps. Vatopedi," p. 35, fig. 21; Anderson, "Seraglio," p. 90, fig. 10; Aliprantis, *Moses*, fig. 102.

Exodus 19:7–8

MOSES ADDRESSES THE ISRAELITES

Ser., Sm., and Vat. 746 separate the episodes of Moses addressing the Israelites, following Exodus 19:7–8 (nos. 735c–737c), and God announcing the theophany on Sinai, following Exodus 19:9–13 (nos. 735d–737d). In Vat. 747 (no. 734c) Joshua replaces Moses addressing the Israelites, thus unifying the two episodes. Joshua is not mentioned in the text and has not appeared before: he stands out as a copy of the figure in Moses Descends from Sinai in the same manuscript (fig. 803). An unsatisfactory model may have caused the divergences among the manuscripts and the inappropriate iconography.

735c. Ser., fol. 209v

In the left half of the lower strip Moses addresses the Israelites while holding a scroll in one hand and gesturing in speech with the other.
Located beside Exodus 19:7.

736c. Sm., fol. 87r

Very close to Ser. Several faces are flaked.

737c. Vat. 746, fol. 205r

Very close to Ser. and Sm. The ground is mostly flaked.
Located beside Exodus 19:7.

Lit.: Uspenskii, p. 147, fig. 132; Hesseling, fig. 187; Weitzmann, "Ps. Vatopedi," p. 35, fig. 21; Williams, "León Bible," p. 107 n. 41; Kirigin, *Mano divina*, p. 148; Anderson, "Seraglio," p. 90, n. 52, fig. 10; Aliprantis, *Moses*, fig. 102.

Exodus 19:9–13

GOD ANNOUNCES THE THEOPHANY ON SINAI

See the introduction to Exodus 19:7–8.

734c. Vat. 747, fol. 95r

Moses rushes to the foot of Mount Sinai and once more approaches God, who announces his coming in a thick cloud. Moses' raised hands are covered by his mantle, and he looks up to God's blessing hand in the heavens. On the left, a group of Israelites looks suspicious or frightened. Joshua, standing apart from the rest of the Israelites, grasps a lance. He dares to look up to the divine hand, but he, too, shrinks from it. Flaked in various places.
Located beside Exodus 19:7.

735d. Ser., fol. 209v

Close to Vat. 747, save for the fact that the left half of the strip forms a separate illustration.
Located beside Exodus 19:7.

736d. Sm., fol. 87r

The inscription, beginning in the upper half, reads: καὶ μωυσῆ πρὸς τὸ ὄρο(ς) ἀνάβασις.
Very close to Ser.

737d. Vat. 746, fol. 205r

The inscription, arranged as in Sm., reads: καὶ μωυσέως πρὸς τὸ ὄρος ἀνάβασις.
Very close to Ser. and Sm. The ground is mostly flaked.
Located beside Exodus 19:7.

Lit.: Uspenskii, p. 147, fig. 132; Hesseling, fig. 187; Weitzmann, "Ps. Vatopedi," p. 35, fig. 21; Galavaris, *Gregory Naz.*, p. 137; Anderson, "Seraglio," p. 90, n. 52, fig. 10; Aliprantis, *Moses*, fig. 102.

Exodus 19:16

THEOPHANY ON SINAI

The general arrangement, in particular three of the terrified Israelites, is paralleled by images of the Metamorphosis.[1] Notwithstanding the fact that the three heads in the clouds in Ser., Sm., and Vat. 746 recall the vision of Ezekiel (Ezek 37:1–10) or the Apocalypse, from a formal point of view they are apparently derived from heads of ancient wind gods.[2]

738. Vat. 747, fol. 98r

From a segment of heaven a beam of bright light flashes,[3] and two trumpets (instead of the one mentioned in the text)[4] are directed toward Mount Sinai, which is shrouded in a dark cloud. At the foot of the mountain are some amazed and trembling Israelites in varying postures: one has fallen on his face; two others, trying to protect themselves, are forced to their knees; and a fourth, with a gesture of terror, tries to escape. A large section of the mountain and parts of the figures are flaked.
Located beside Exodus 20:18.

739. Ser., fol. 217r

A stream of fire passes through the low clouds to hit the peaks of Mount Sinai. At the left a sounding trumpet protrudes from the clouds, and at the right lightning in the form of rays descends upon the frightened Israelites. In addition to the four Israelites of Vat. 747, a fifth stands upright, covering his face with his hands. The clouds are covered with the offset of letters from the opposite page. Three heads painted in grisaille appear in the clouds: at the left a human head, and at the right those of a bull and a lion.
Located beside Exodus 20:18.

740. Sm., fol. 90r

The inscription reads: αἰ βρονταὶ καὶ αἰ τ(ῆς) σάλπιγγος φοναὶ καὶ ὁ ἐξ οὐρανοῦ ἦχος.

Very close to Ser. The human and bull's heads are only faintly indicated and that of the lion not at all, but the head and the neck of an eagle are recognizable near the right lateral border at the spot where the right-hand flash of lightning emerges from the clouds.

741. Vat. 746, fol. 212v

The inscription reads: αἰ βρονταὶ καὶ αἰ τῆς σάλπιγγος (and continuing below the miniature) φοναὶ καὶ ὁ ἐξ οὐρανοῦ ἦχος.

In this copy the heads of the human, bull, and lion are very distinct, whereas only one eye and the beak of the eagle are discernible.

Located beside Exodus 20:19.

Lit.: Uspenskii, p. 147, fig. 133; Hesseling, fig. 188; Eller and Wolf, *Mosaiken*, fig. 43; Dinkler-von Schubert, *Schrein*, p. 24, fig. 50; Schade, *Paradies*, p. 102, pl. 7; Maguire, "Depiction of Sorrow," p. 159 n. 204; Anderson, "Seraglio," pp. 102–3 n. 122, fig. 33; De Angelis, "Simbologia," p. 1539, fig. 31.

[1] Such as the apse mosaic in the Monastery of St. Catherine on Mount Sinai (Forsyth and Weitzmann, *Sinai Church and Fortress* [as in note 5 of the introduction to Exodus 3:2–6 above], pls. 103, 110, 111, 114).

[2] Anderson ("Seraglio," p. 102) surmises a parallel with illustrations of animals in the manuscript of pseudo-Oppian's *Cynegetica* in Venice, Bibl. Marc., cod. gr. 479, fol. 11r. Schade (*Paradies*, p. 102) quotes Jewish writings for the head of the bull; regarding literary sources, see also Ginzberg, *Legends*, vol. 2, p. 182, and vol. 3, p. 122, and Mekilta de-Rabbi Ishmael, Tractate Bahadesh 4 (*Mekilta de-Rabbi Ishmael*, ed. Lauterbach, vol. 2, p. 221), where a roaring lion as a figure of God is introduced in the discussion of the storm on Sinai.

[3] De Angelis ("Simbologia," p. 1539) interprets the red of the sky as blood instead of fire, referring to Haggadah on Ex 24:7–9.

[4] The plural occurs in pseudo-Philo's *LAB* 11:4 (*OTP*, vol. 2, p. 318).

Exodus 24:4–6

Moses Prays to God

See the introduction to Exodus 24:7 and 10 below. Astonishingly, the cycle has no illustration for the Giving of the Law, and chapters 20–21 are completely ignored.

742a. Vat. 747, fol. 103v

In the left half of the miniature Moses stands on a hillock before a burning altar and prays to God's hand. Somewhat flaked.

Located below Exodus 24:11.

743a. Ser., fol. 229v

Close to Vat. 747. Slightly flaked.
Located beside Exodus 24:10.

744a. Sm., fol. 95v

The inscription reads: α θυσιαστήριον.
Very close to Ser.

745a. Vat. 746, fol. 226v

The inscription reads: θυσιαστήριον.
Very close to Ser. and Sm.
Located below Exodus 24:7.

Lit.: Uspenskii, p. 147, fig. 134; Hesseling, fig. 189; Sed-Rajna, *Hebraic Bible*, p. 96 n. 91; Weitzmann, *Dura*, fig. 76.

Exodus 24:7 and 10

Canonization of the Law

Having skipped the Giving of the Law in chapters 20–21, the cycle gives no emphasis to the Canonization of the Law by the consent of the assembly of Israel: the weight of the event and the covenant with Israel in biblical history are overshadowed and almost neglected. The complex prelude, the ceremony described in verses 4–6 (Moses taking the blood of the sacrificed young calves and pouring half of it into bowls, and half on the altar of twelve stones) and the sprinkling of the blood on the people in verse 8, are not represented: the left-hand half of the miniature is limited to a generic scene of God addressing Moses while a fire burns on an altar. Likewise, in the next scene, the painter was content to show Moses displaying an open scroll to the Israelites, after verse 7. This scroll, representing "the book of the covenant" which Moses read "in the ears of his people," is a widespread iconography in representations of the Receiving of the Law.[1]

742b. Vat. 747, fol. 103v

Moses has just come down from the summit and emerges from behind the mountainside holding in his hand an open scroll from which he reads God's commandments to his people. The Israelites stand in two groups at the foot of the mountain, attentively listening to Moses' message. Somewhat flaked.

Located below Exodus 24:11.

743b. Ser., fol. 229v

Close to Vat. 747, except for the varying types of the Israelites. A pair of footprints referring to God's feet (mentioned in verse 10) is visible on the ground between the two groups, and beneath them was something resembling sapphire slabs; here the miniature follows the Septuagint closely.[2]

Slightly flaked.
Located beside Exodus 24:10.

744b. Sm., fol. 95v

The inscription reads: μωυσῆς μυσταγωγούμενος καὶ τῷ λαῷ ὑπαγορεύων, τὰ μυσταγωγηθέντα.
Very close to Ser.

745b. Vat. 746, fol. 226v

The inscription reads: μωυσῆς μυστα(γω)γούμενος καὶ τῶι λαῶι ὑπαγορεύων τὰ μυσταγωγηθέντα.

Very close to Ser. and Sm.

Located below Exodus 24:7.

Lit.: Uspenskii, p. 147, fig. 134; Hesseling, fig. 189; Mouriki-Charalambous, "Cosmas," p. 59; Sed-Rajna, *Hebraic Bible*, p. 96 n. 91; Weitzmann, *Dura*, p. 53, fig. 76.

[1] For a possible connection with Jewish lore, see Ginzberg, *Legends*, vol. 3, p. 119, quoted by G. Vikan in *Age of Spirituality*, p. 469.

[2] Likewise the Hebrew, which has "his feet." TargPs-J (*Targum Exode et Lévitique*, ed. Le Déaut, vol. 2, p. 201) and TargN (ibid., p. 200) translate "beneath the footstool of his feet"; TargOnk (*Targum Onqelos, Exodus*, ed. Grossfeld, p. 72) has "beneath the throne of his Glory" (see also ibid., p. 72 n. 7).

Exodus 24:13–16

God Addresses Moses

746a. Vat. 747, fol. 105r

Before Moses and Joshua ascend the mountain, they instruct the elders of the Israelites as to how to conduct affairs during their absence. In the miniature Joshua does not ascend the mountain, but speaks to the elders, among whom the two next to him are identifiable as Hur and Aaron. In the meantime, Moses has gone to the mountain where he prays, as usual, to the hand of God in heaven. Large sections of the sky are flaked.

Located in the catena; the text above is Exodus 25:9.

747a. Ser., fol. 233r

Joshua and the elders watch Moses, who faces God's hand more frontally and with crossed arms, listening to his commandments. Slightly rubbed in two places.

Located below Exodus 25:9.

748a. Sm., fol. 97r

The inscription reads: μωυσῆς ἐντελλόμενος πε(ρὶ) τῶν ἀπαρχῶν.

Very close to Ser.

749a. Vat. 746, fol. 229r

The inscription starts within the frame and continues in the left margin. It reads: μωυσῆς ἐντελλόμενο(ς) περὶ τῶν ἀπαρχ(ῶν).

Very close to Ser. and Sm., though more condensed. Moreover, the miniature was overpainted, in the course of which the hand of God and the spear in Joshua's hand were lost.

Located below Exodus 25:9.

Lit.: Uspenskii, p. 147, fig. 135; Hesseling, fig. 190.

Exodus 25:2–4

Moses Commands the Israelites to Bring Offerings for the Sanctuary

746b. Vat. 747, fol. 105r

The painter depicted the realization of God's command to Moses that the Israelites bring him offerings with which to build a sanctuary. Moses sits on an elevation of the ground, with Joshua standing at his side, while he receives the offerings of his people. The foremost elder is laying some metal objects at Moses' feet, while the others look on. Large sections of the ground are flaked.

Located in the catena; the text above is Exodus 25:9.

747b. Ser., fol. 233r

Close to Vat. 747, except for a few details. The foremost Israelite has already laid down his offerings of four small objects resembling fruit and a fleece, and now he stands before Moses, bowing deeply with a gesture of devotion. The Israelite next to him carries more fruitlike objects in his arms, which are covered by his mantle.

Located below Exodus 25:9.

748b. Sm., fol. 97r

The inscription reads: ὁ λαὸ(ς) προ(σ)φέροντες τὰ κελευσθέντ(α).

Very close to Ser.

749b. Vat. 746, fol. 229r

The inscription reads: ὁ λαὸς προσφέροντες τὰ κελευσθέντα.

Very close to Ser. and Sm. Overpainted.

Located below Exodus 25:9.

Lit.: Uspenskii, p. 147, fig. 136; Hesseling, fig. 190.

Exodus 25:10–20

Ark of the Covenant

In the illustration of the Ark of the Covenant the Octateuchs do not conform with the Septuagint in at least three details. first, the door is double-paneled, while the text gives no description of the ark's doors;[1] second, the lid has a rounded form which, likewise, is not called for by the text and is an apparent misunderstanding of the correct form of the ark with a flat lid;[2] and third, two figures are introduced at the sides of the ark, presumably intended to be Aaron and either Moses or one of Aaron's sons. In Ser., Sm., and Vat. 746, the miniature is apparently indebted to the corresponding illustration in Kosmas's *Christian Topography* (text fig. 35), as are other miniatures in this section of the Exodus cycle.[3]

750. Vat. 747, fol. 106r

The Ark of the Covenant is represented as a brown wooden case with a double door crowned by an arch where the mercy seat (τὸ ἱλαστήριον) should be. The whole surface is not gilded as the text would require; only parts are outlined in gold. The two golden cherubs that are supposed to frame the two sides of the mercy seat are suspended in midair. Two nimbed priests flank the ark, each resting one hand on it. The priests wear full-length blue tunics with yellow hems; brown and green chitons, respectively, with golden hems; diadems of pearls with round protuberances (misunderstandings of Jewish *tefillin*);[4] bands encircling their hips; and shoulder mantles with their patches decorated with twelve gemstones. All these garments are reproduced separately in Vat. 747 on fol. 108v (fig. 770) and are discussed below.

Located beside Exodus 25:20.

751. Ser., fol. 234v

Close to Vat. 747, except for small variations in detail. The ark, which rests on four lion's paws, is decorated with an undulating line not called for in the text and recalling the more precise image in figs. 755–757. The double door and mercy seat are painted in solid gold, whereas the cherubim are only partly gilded. The priests hold scepters, which have no basis in the text. The younger and unbearded one at the right in Vat. 747 is replaced here by a bearded figure, and the attire of both priests shows some variations, in particular the bands fastening the tunics close to their chests[5] and what should be two *tefillin* on their heads.[6]

Located beside Exodus 25:20.

752. Sm., fol. 98r

The inscription reads: τὸ ἱλαστήριον, τὰ χερυβὶμ καὶ οἱ ἱερεῖς.

Very close to Ser.

753. Vat. 746, fol. 231r

The inscription reads: τὸ ἱλαστήριον, τὰ χερυβὶμ καὶ οἱ ἱερ(εῖς).

Very close to Ser. and Sm. The whole miniature and particularly the figures of the priests have been crudely overpainted.

Located in the catena; the text above is Exodus 25:20.

Lit.: Uspenskii, p. 148, fig. 137; Stornajolo, *Topografia Cristiana*, p. 17 n. 26; Hesseling, fig. 191; Redin, *Koz'my Indikoplova*, p. 262; Willoughby, *McCormick Apocalypse*, vol. 1, p. 496; Goodenough, *Symbols*, vol. 10, p. 16 n. 79; Nordström, "Water Miracles," pp. 84–86; Wolska-Conus, *Cosmas*, vol. 1, p. 144 n. 1; Mouriki-Charalambous, "Cosmas," pp. 93–101; Lassus, *Livre des Rois*, p. 86, fig. 113; Revel-Neher, "*Cohen gadol*," p. 59, fig. 8; Brubaker, "Tabernacle," pp. 85–88, fig. 6; Deckers, *S. Maria Magg.*, p. 212; Broderick, "Sarajevo Haggadah," p. 323, fig. 7; Weitzmann, *Dura*, pp. 57, 60–61, fig. 87; Revel-Neher, "Christian Topography," p. 87, fig. 13; Bernabò, "Mecenatismo," p. 15, fig. 6; Revel-Neher, *Image of the Jew*, p. 64, fig. 14; Lowden, *Octs.*, pp. 87–88, figs. 121, 122.

[1] A door with two simple panels appears in the Consecration of the Tabernacle in the Synagogue at Dura Europos (Weitzmann, *Dura*, fig. 80), in an illustration of Kosmas's *Christian Topography*, Sinai, cod. 1186, fol. 82r (Weitzmann and Galavaris, *Sinai Greek Mss.*, fig. 149), and in other archaeological evidence (cf. Hachlili, *Ancient Jewish Art*, pp. 272–80); these representations seemingly depend on a Jewish model (Revel-Neher, "Christian Topography," pp. 82ff.).

[2] Revel-Neher, "Cosmas," pp. 80ff. A similar form of the ark is found at Dura Europos (Weitzmann, *Dura*, p. 57, fig. 80). See also the symbolism of the Christian liturgy as expounded in Germanos of Constantinople, *Hist-Eccl* 5 (*On the Divine Liturgy*, ed. P. Meyendorff [Crestwood, N.Y., 1984], p. 58).

[3] Cf., e.g., Sinai, cod. 1186, fol. 82r (text fig. 35; Weitzmann and Galavaris, *Sinai Greek Mss.*, pp. 56–57, fig. 149), where the priests are identified as Zacharias and Abias.

[4] Cf. Revel-Neher, *Image of the Jew*, pp. 55ff., esp. p. 64; and Brubaker, "Tabernacle," pp. 87–88 n. 49, for a possible connection with Christian exegesis.

[5] This band is reported in the priestly attire described by E. Schürer, *The History of the Jewish People in the Age of Jesus Christ (175 B.C.–A.D. 135)*, rev. ed., ed. G. Vermes, F. Millar, and M. Black, vol. 2 (Edinburgh, 1979), p. 294.

[6] Cf. Revel-Neher, *Image of the Jew*, p. 64.

Exodus 25:23–27

SHEWBREAD TABLE

In Vat. 747 the shewbread table has a rectangular shape, the length double the width, according to Exodus 25:23. In the other manuscripts the table is square and alludes to the form of the earth, with the wavy line signifying the ocean and the outer border the paradise beyond the ocean. This representation, which does not conform to the Septuagint, is probably a borrowing from the tradition found in the illustrated copies of the *Christian Topography* of Kosmas Indikopleustes (text fig. 36).[1]

754. Vat. 747, fol. 106r

The table for the shewbread is seen from above as a rectangle painted completely in gold with a broad blue border studded with diamonds and pearls, described as "a border of an hand breadth" (verse 25). Attached to the corners are four hooks meant to represent the rings into which the staves were inserted. Severely damaged by flaking.

Located beside Exodus 25:29.

755. Ser., fol. 235v

The solid gold center of the table, which has an almost square shape, is surrounded by two smaller borders on colored ground, the inner one decorated with a zigzag pattern and the outer one with wavy lines and four tiny circles

Located beside Exodus 25:29.

756. Sm., fol. 98r or 98v[2]

Very close to Ser. The parchment has been torn in two and then sewn together again.

757. Vat. 746, fol. 232r

The inscription reads: ἡ χρυσῆ τράπεζα.
Very close to Ser. and Sm.
Located below Exodus 25:28.

Lit.: Uspenskii, p. 148; Hesseling, fig. 192; Wolska-Conus, *Cosmas*, vol. 1, p. 144 n. 2; Mouriki-Charalambous, "Cosmas," pp. 104–6; Brubaker, "Tabernacle," pp. 82–83, fig. 4; Hahn, "Creation," pp. 38–39, n. 33, figs. 11, 12; Kühnel, "Temple and Tabernacle," p. 163, fig. 10; Kühnel, *Jerusalem*, p. 154, fig. 122; Iacobini, "Lettera," p. 80, fig. 8.

¹ See, e.g., Sinai, cod. 1186, fol. 81r (text fig. 36; Weitzmann and Galavaris, *Sinai Greek Mss.*, fig. 148); cf. Mouriki-Charalambous, "Cosmas," pp. 104–6; Hahn, "Creation," pp. 38–39; Brubaker, "Tabernacle," pp. 82–83. The four small circles may correspond to the medallions with the four winds in the map of Kosmas (Hahn, "Creation," p. 38).
² Fol. 98r according to Hesseling, p. xi; fol. 98v according to Uspenskii, p. 186.

Exodus 25:31–32

MENORAH

The Octateuchs transmit dissimilar representations of the menorah, the seven-branched candelabrum. All the menorahs depicted in the manuscripts have a three-legged base and a crossbar at the top, a feature found especially in the Syro-Palestinian region, with the earliest examples appearing toward the end of the third century.[1] The form of the branches differs significantly, however: Vat. 747 presents a more geometric form, basically composed of roundish knobs,[2] while the other manuscripts favor a floral design. These shapes stem from different pictorial traditions, for which there is rich archaeological evidence.[3] Moreover, in Ser., Sm., and Vat. 746, the branches composed of alternating lilies and knobs are related to later representations, the closest one seeming to be the menorah in the *Christian Topography* of Kosmas Indikopleustes (text fig. 36).[4] Thus it seems that the iconography of the menorah in Ser., Sm., and Vat. 746 was taken from the tradition handed down in the illustrated Kosmas manuscripts. Finally, Ser., Sm., and Vat. 746 also represent one of the curtains of the tabernacle on either side of the menorah (see nos. 759b–761b below).

758. Vat. 747, fol. 106v

The seven branches of the golden menorah are composed of oval and round elements alternating with disks, and are connected at the top by a crossbar with trefoils bearing burning lamps; the base is three-legged.
Located beside Exodus 25:36.

759a. Ser., fol. 236r

The seven flames and lamps have been transformed into golden lily-shaped ornaments. The branches are composed of alternating lilies and round balls. Dots all over the candlestick represent pearls.
Located beside Exodus 25:37.

760a. Sm., fol. 98v or 99v⁵

The inscription reads: περὶ τῶν λύχνων.
Very close to Ser.

761a. Vat. 746, fol. 233r

The inscription, including the number of a textual paragraph, reads: πε(ρὶ) τῶν λύχνων.
Very close to Ser. and Sm.
Located below Exodus 25:36.

Lit.: Uspenskii, p. 148; Stornajolo, *Topografia Cristiana*, p. 17 n. 26; Hesseling, fig. 193; Redin, *Koz'my Indikoplova*, p. 260; Wolska-Conus, *Cosmas*, vol. 1, p. 144 n. 3; Galavaris, *Gregory Naz.*, p. 137; Mouriki-Charalambous, "Cosmas," pp. 107–10; Der Nersessian, "Parekklesion," p. 339; Brubaker, "Tabernacle," pp. 82, 84–85; Weitzmann, *Dura*, p. 58, fig. 88.

¹ Hachlili, *Ancient Jewish Art*, pp. 236–56, esp. p. 253; V. A. Klagsbald, "The Menorah as Symbol: Its Meaning and Origin in Early Jewish Art," *JA* 12–13 (1986–87), pp. 129–32, esp. pp. 130–32 for the original meaning of the bar and its suggested connection with Zechariah's vision (Zech 3–4).
² As found, e.g., in a mosaic from Tirath Zvi (Hachlili, *Ancient Jewish Art*, pl. 55).
³ In addition to the evidence provided by Hachlili and Klagsbald (see note 1 above), comparisons may be found in Goodenough, *Symbols*, vol. 3, figs. 440, 615, 639, 877.
⁴ Sinai, cod. 1186, fol. 81r (Weitzmann and Galavaris, *Sinai Greek Mss.*, fig. 148); here the shape is more clearly delineated with roundels and lilies, and the seven burning lamps at the top are replaced by birds. See also the menorah in Beth Sh'an, reproduced in Hachlili, *Ancient Jewish Art*, fig. 18, p. 269. For the appearance of the menorah in the Octateuchs and the Jewish tradition, see also Mouriki-Charalambous, "Cosmas," pp. 107–10.
⁵ Fol. 98v according to Hesseling, p. xi; fol. 99v according to Uspenskii, p. 186.

Exodus 26:1–6

TABERNACLE CURTAINS

759b. Ser., fol. 236r

Of the ten curtains described in detail in the text, only two are depicted, one on either side of the candlestick. Whereas the text gives their colors as blue, purple, and scarlet, and says that they are decorated with cherubim, here both are blue and decorated with golden stars. Both curtains have a golden border. Attached to the inner edge of the right-hand one is a row of loops (ἀγκύλαι), and to that of the left a row of rings (κρίκοι), so that the curtains may be joined. Partly flaked.
Located beside Exodus 25:37.

760b. Sm., fol. 98v or 99v¹

Alongside the curtain at the left runs the inscription: κρίκοι; alongside the curtain at the right the word ἀγκύλαι is written.
Very similar to Ser.

761b. Vat. 746, fol. 233r

As in Sm., the words κρίκοι and ἀγκύλαι are written alongside the two curtains.

Very close to Ser. and Sm.

Located below Exodus 25:36.

Lit.: Uspenskii, p. 148; Hesseling, fig. 193; Brubaker, "Tabernacle," p. 81.

[1] Fol. 98v according to Hesseling, p. xi; fol. 99v according to Uspenskii, p. 186.

Exodus 26:15–35

Tabernacle

In Vat. 747 the golden jar (stamnos) of manna occupies the place where, according to Exodus 26:35, the shewbread table should be. The stamnos is not explicitly listed among the sacred objects to be kept inside the tabernacle, but it is traditionally housed there. This tradition is authoritatively witnessed among the Christians by the exhaustive description of the tabernacle in Hebrews 9:4,[1] where the "golden pot that had manna, and Aaron's rod that budded" are located on the table inside the Holy of Holies. To Christians the table prefigures the altar "upon which the manna, which was Christ, descended from heaven."[2] The other Octateuchs follow the Septuagint in representing the menorah and the shewbread table, in conformance with the tradition found in the illustrated manuscripts of Kosmas Indikopleustes (text fig. 37); moreover, the precinct fence of the tabernacle in these Octateuchs assumes the arrowlike forms also found in Kosmas.[3]

762. Vat. 747, fol. 107v

The tabernacle (ἡ σκηνή) is rendered as a precinct with a golden frame to which the veil covering its sides is fastened by large rings. Contrary to the text, the veil is not painted in blue, purple, and scarlet and decorated with cherubim, but rather is solid gold with an indistinct blue pattern. The interior of the structure is divided by a double line into two sections: in the left part is the Ark of the Covenant, represented as a framed, golden rectangle; in the right section are the golden menorah and next to it the stamnos of manna, on the supposed north and south sides of the tabernacle respectively. The stamnos of manna is depicted as a golden vessel with two handles. Because of lack of space the menorah is depicted in a horizontal position and with only one flame. Slightly flaked.

Located beside Exodus 26:29.

763. Ser., fol. 238r

The shape of the tabernacle is the same as in Vat. 747, but it is rendered without the veil; the sides are painted in two horizontal strips, the upper gold, the lower blue. A fence is placed around it. At the very spot where Vat. 747 shows the vase of manna, Ser. has

a golden rectangle with little roundels on it, apparently the table with the shewbread.

Located beside Exodus 26:29.

764. Sm., fol. 99v or 100r[4]

The inscription reads: ἡ σκηνὴ ἡ τράπεζα καὶ ἡ λυχνία.

Very close to Ser.

765. Vat. 746, fol. 235r

The inscription reads: ἡ σκηνὴ ἡ τράπεζα καὶ ἡ λυχνία.

Very close to Ser. and Sm.

Located beside Exodus 26:30.

Lit.: Uspenskii, p. 148, fig. 138; Stornajolo, *Topografia Cristiana*, p. 17 n. 26; Hesseling, fig. 194; Redin, *Koz'my Indikoplova*, p. 260; Wolska-Conus, *Cosmas*, vol. 1, p. 143 n. 2; Mouriki-Charalambous, "Cosmas," pp. 115–16, 122–25; Brubaker, "Tabernacle," pp. 76–81, fig. 1; Deckers, *S. Maria Magg.*, p. 211; Revel-Neher, *Arche*, p. 182 n. 389; Weitzmann, *Dura*, p. 67, fig. 96; Wolska-Conus, "Topographie Chrétienne," p. 184; Lowden, *Octs.*, pp. 88–89, figs. 124, 125.

[1] The passage is reported in the catena. Cf. Mouriki-Charalambous, "Cosmas," pp. 122, 125; Brubaker, "Tabernacle," pp. 76–79.

[2] Germanos of Constantinople, *HistEccl* 4 (*On the Divine Liturgy*, ed. Meyendorff, pp. 58–59).

[3] See the literature cited in note 1 above.

[4] Fol. 99v according to Hesseling, p. xi; fol. 100r according to Uspenskii, p. 186.

Exodus 27:4–9

Brazen Grate

766. Vat. 747, fol. 108r

A grill with flames underneath it represents "the brazen grate with network" which, according to the text, "shall extend to the middle of the altar." The miniature is framed by a broad border studded with jewels and pearls, similar to the one surrounding the table for the shewbread (fig. 754); actually, it represents the fencing of the court with a double colonnade shown in cartographic view.

Located beside Exodus 27:18.

767. Ser., fol. 239v

The brazen grate is the same as in Vat. 747, but the outer frame clearly represents the enclosure of the court. Each of the four sides shows a row of pillars, projected on the ground and painted in light blue with bands at their tops and bases. They are set against a darker blue ground suggesting curtains extending from pillar to pillar. At the right the pillars are somewhat pushed together toward the corners, leaving a larger area open at the center which marks the entrance to the court.

Located beside Exodus 27:18.

768. Sm., fol. 100r or 100v [1]

The inscription reads: ἡ ἐσχάρα.

Very close to Ser. but there is no indication of an entrance to the court at the right side of the enclosure.

Located beside Exodus 27:18.

769. Vat. 746, fol. 236v

The inscription reads: ἡ ἐσχάρα.
Very close to Ser. and Sm.
Located beside Exodus 27:18.

Lit.: Uspenskii, p. 148; Hesseling, fig. 195; Nordström, "Temple," p. 72; Williams, "León Bible," pp. 73–74; Mouriki-Charalambous, "Cosmas," p. 132; Williams, "Castilian Tradition," p. 75; Brubaker, "Tabernacle," p. 90; Lowden, *Octs.*, pp. 89–90, figs. 127, 128.

[1] Fol. 100r according to Hesseling, p. xi; fol. 100v according to Uspenskii, p. 186.

Exodus 27:9–11

COURTYARD CURTAINS

The miniature with the courtyard curtains is missing at this point in Vat. 747; it appears in the text below a later passage, Exodus 28:7. In its place Vat. 747 shows four squares enclosing the priestly garments of Aaron (fig. 770), illustrating the very text passage to which they are physically related. Thus the picture in Vat. 747 is presumably the miniature originally designed for this position, and which in the other manuscripts was replaced by a representation of the curtains, probably influenced by the *Christian Topography* of Kosmas (text fig. 38).[1]

771. Ser., fol. 241v

The miniature depicts four of the curtains to be hung between the pillars enclosing the court. They are decorated with a checkered pattern, the first and second painted in blue and red, the third and fourth in yellowish brown and olive green. The first and third curtains have a denser pattern than the second and fourth. All four are framed in gold. Loops and rings (ἀγκύλαι and κρίκοι) are fastened to their inner edges, as in the curtains described and illustrated in the preceding chapter (cf. figs. 759–761).

Located above Exodus 28:7.

772. Sm., fol. 100v

Above the four squares, near the inner edges, the words for loops and rings are written twice: κρίκκοι—ἀγκύλαι—κρίκκοι—ἀγκύλαι.

Like Ser., the first and third curtains have a pattern denser than that of the second and fourth.

Located below Exodus 28:5.

773. Vat. 746, fol. 237v

The four inscriptions run alongside the curtains: κρίκοι—ἀγκύλαι—κρίκοι—ἀγκύλαι.

Very close to Ser. and Sm. The patterns of all four curtains are painted in red and steel blue, and they are framed in yellowish brown.

Located below Exodus 28:5.

Lit.: Uspenskii, p. 148; Stornajolo, *Topografia Cristiana*, p. 17; Hesseling, fig. 196; Wolska-Conus, *Cosmas*, vol. 1, p. 144 n. 3; Mouriki-Charalambous, "Cosmas," p. 116; Brubaker, "Tabernacle," pp. 81–82, 90; Lowden, *Octs.*, p. 81, fig. 84.

[1] Brubaker, "Tabernacle," pp. 81–82.

Exodus 28:6–42

PRIESTLY CLOTHES

Only Vat. 747 illustrates Aaron's priestly garments (see the introduction to Exodus 27:9–11). Many of the elements of these garments do not conform with the text of the Septuagint, and the sandals in the last square are not mentioned at all; indeed, Jewish priests probably officiated barefoot.[1] It is evident, however, that these are not misunderstandings by the painter; rather, the picture seems to reflect a different tradition of priestly garments, presumably widespread in the area where this miniature originated. This tradition also departs from the evidence provided by the Dura Europos synagogue, where the priestly garments worn by Aaron in the panel with the Consecration of the Tabernacle (text fig. 3)[2] correspond only partially with Vat. 747.

770. Vat. 747, fol. 108v

Chapter 28 describes the priestly garments worn by Aaron and his sons, and Vat. 747 illustrates most of them, enclosed in four squares. In the sequence from left to right, the first and second garments are interchanged, so that the description starts with the second square. It shows a shoulder mantle, the ephod (the ἐπωμίς of Exodus 28:6–14 in the Septuagint), painted in red with two shoulder pieces of gold affixed to it, each having six colored stones. Partly covered by this mantle is an object painted in blue-green with a large golden rectangle in the center, representing in a very simplified form the "breastplate of judgment" (λογεῖον τῶν κρίσεων) to be worn by Aaron whenever he enters the holy place (verses 15–30). The plate has two short stripelike segments at the lower corners to fix it to the mantle, corresponding to the circlets of pure gold (verses 24–25 and 13–14). The pattern of twelve stones, four rows of three stones each (verses 17–21), interwoven with the breastplate is missing,[3] as are the two emerald stones engraved with the names of the Israelite tribes to be put on the shoulder pieces (verses 9–12). The golden shoulder pieces affixed to the mantle, each with six stones, have no clear connection with the text; they probably replace the twelve missing stones of the breastplate.

The first square contains the "full-length tunic (ὑποδύτης ποδήρης) all in blue" with "a fringe round about the opening" (verses 27–30). A broad golden panel runs down the middle and along the hem, where a row of little bells is attached. The tunic is covered by a sort of blue jacket, which has no correspondence with the text.

An oval plate of pure gold (πέταλον χρυσοῦν καθαρόν), which is worn in front of the miter, fills the third square (verse 32). Instead of the engraved inscription "Holiness of God," it is decorated with a red stone and nine pearls, and is attached to a red piece of cloth serving to tie it around the miter.

The last square contains the golden bonnet (κίδαρις), represented with the shape of a Persian headdress (verse 35). Its crown is adorned with rows of pearls and on the top is the same golden plate depicted in the preceding square. Below are two golden sandals with long bands used as wrappings for the legs.

Located below Exodus 28:5.

Lit.: Brubaker, "Tabernacle," p. 90; Weitzmann, *Dura*, p. 59, fig. 90; Lowden, *Octs.*, p. 61, fig. 83.

[1] Cf. Schürer, *History of the Jewish People* (as in note 5, no. 751 above), vol. 2, p. 294; cf. the Rabbula Gospels (Florence, Bibl. Laur., cod. plut. 1.56, fol. 3v), where Aaron is barefoot (*Rabbula Gospels*, ed. Cecchelli, Furlani, and Salmi, fol. 3v).
[2] For a minute description of these garments, cf. Weitzmann, *Dura*, pp. 59–61.
[3] A more complete representation of the breastplate with the four rows of stone is found, e.g., in the *Christian Topography* of Kosmas, Sinai, cod. 1186, fol. 84r (Weitzmann and Galavaris, *Sinai Greek Mss.*, fig. 151).

Exodus 28:43

AARON AT THE SANCTUARY

The Exodus sanctuary has been transformed into a Christian altar with a ciborium. The old covenant sanctuary prefigures the Christian Church and the divine liturgy, and its liturgical objects correspond to the Christian ones.[1]

774. Vat. 747, fol. 110r

Aaron ministers in front of the altar of the sanctuary, the θυσιαστήριον τοῦ ἀγίου. Some of the raiments previously described and illustrated have been altered slightly. The two shoulder pieces on the mantle are larger and painted in green, apparently to suggest the color of emeralds, and inscribed with the names of the tribes. These are written by a later hand, however, and since there was no space for all twelve, only the names of Leah's five sons were included, four on the more visible shoulder piece and the fifth on the farther one. The names read: ρουβὴν, συμεών, λευὶ, ιούδας, ισάχαρ, and ζαβουλών. The breastplate is hidden under the mantle and Aaron does not wear the miter, i.e., the κίδαρις, illustrated in the preceding miniature, but rather the imperial Byzantine pearl diadem.

This representation of the sanctuary was inspired by the interior of a Christian church: the altar stands under a marbled ciborium, separated from the rest of the building by a marble transenna and "royal doors" before the altar. Behind the ciborium is a flight of marble steps suggesting the rows of seats for the presbyters running around the interior wall of an apse. The golden patena and chalice in Aaron's hands suggest that he is officiating at a Christian service. The background, however, does not suggest an interior setting but rather is painted in the colors

of the sky, and the uppermost strip is gold. Flaked in various spots.

Located beside Exodus 28:33.

775. Ser., fol. 244v

Aaron wears a cube-shaped object on his head, replacing the pearl diadem with Jewish *tefillin*,[2] and holds a golden hemispherical vessel instead of the patena and chalice; his mantle does not have the shoulder pieces. In the sanctuary the Christian element is emphasized even more strongly by the cross on the ciborium and a codex with a jeweled cover on the altar table occupying the place of a lectionary in the Christian service. One wing of the royal door is open.

Located below Exodus 28:33.

776. Sm., fol. 102r

The inscription reads: ὁ ἱερεὺς ἀαρὼν ἐνδεδυμένο(ς) τὴν ἱερατικὴν στολὴν μετὰ τῆς ἐπωμίδος καὶ τοῦ δήλου, τὰ τ(ῶν) ἀγίων ἄγια.

Very close to Ser., save that the marble incrustation of the transenna is richer and at the top of the stairs the bishop's seat is clearly indicated.

777. Vat. 746, fol. 241r

The inscription reads: ὁ ἱερεὺς ἀαρὼν ἐνδεδυμένο(ς) τὴν ἱερατικὴν στολὴν μ(ε)τ(ὰ) τῆς ἐπωμίδος καὶ τοῦ δήλου, τὰ τ(ῶν) ἀγίων ἄγια.

Close to Ser. and Sm.; in the details of the decoration of the sanctuary it is closer to the former.

Located below Exodus 28:33.

Lit.: Uspenskii, p. 148, fig. 139; Stornajolo, *Topografia Cristiana*, p. 17 n. 26; Hesseling, fig. 197; Goodenough, *Symbols*, vol. 10, p. 16 n. 79; Mouriki-Charalambous, "Cosmas," p. 137; Lassus, *Livre des Rois*, p. 86, fig. 112; Gaehde, "Octateuch," pp. 360–61, fig. 72; Revel-Neher, "*Cohen gadol*," p. 56, fig. 7; Brubaker, "Tabernacle," p. 80, fig. 2; Kessler, "Temple Veil," pp. 56ff., fig. 5; Revel-Neher, *Image of the Jew*, p. 65, fig. 17.

[1] In the commentary of Germanos of Constantinople (*HistEccl* 5), the ciborium "represents the place where Christ was crucified" and "similarly corresponds to the ark of covenant of the Lord in which, it is written, is His Holy of Holies and His holy place" (*On the Divine Liturgy*, ed. Meyendorff, p. 58). For a discussion of the iconography of the ark and Christian liturgy, see Mathews, "Leo Sacellarios," pp. 103ff.
[2] Cf. Revel-Neher, *Image of the Jew*, pp. 55ff., esp. p. 65.

Exodus 29:4–5

MOSES ORDAINS AARON AND HIS SONS AS PRIESTS

In Ser., Sm., and Vat. 746 the tabernacle in this miniature (figs. 778–781) and in the following one (figs. 783–785) closely resembles the tabernacle depicted in the manuscripts of the *Christian Topography* of Kosmas Indikopleustes (text fig. 37).

778. Vat. 747, fol. 111r

Moses hands Aaron one of the vestments, apparently the shoulder mantle, which is to be worn over the gold-embroidered tunic. The sons, not nimbed, are dressed like their father and wear the same imperial crowns; in addition they hold scepters. The scene takes place before the tabernacle, which is represented in the same fashion as in the illustration for chapter 26 (fig. 762), but its character as a tent is more emphasized in that it is fastened to the ground with four pegs. Slightly flaked.

Located beside Exodus 29:1.

779. Ser., fol. 246r

In contrast to Vat. 747, Aaron already wears the shoulder mantle over the tunic, so that it is unclear which vestment Moses is handing him. All three priests wear the *tefillin* on their heads[1] instead of the pearled crown, and the sons are also nimbed. Instead of the whole tabernacle, only one of the checkered curtains is shown, but the manner in which this curtain is pegged to the ground makes it quite obvious that it stands for the whole tabernacle. The scene takes place in a courtyard like that in the miniature of the brazen grate (figs. 766–769), enclosed by a row of pillars projected on the ground and with blue curtains extending between them, forming an ornamental frame.

780. Sm., fol. 103r

The inscription reads: ἡ σκηνὴ τοῦ μαρτυρίου καὶ οἱ ἱερεῖς ἐνδυόμενοι ὑπὸ μωυσέος.

Written on three sides of the tabernacle are the capital letters Λ, Υ, and Η. These letters are distributed so that they resemble indications of the cardinal points.

Located below Exodus 29:1.

781. Vat. 746, fol. 242v

The inscription reads: ἡ σκηνὴ τοῦ μαρτυρίου καὶ οἱ ἱερεῖς ἐνδυμένοι ὑπὸ μωυσέος. It is quite clear from the manner in which the writer added a breathing mark and a crossbar to the capital Λ, turning it into an alpha, and incorporated it into the inscription that he was not aware of the meaning of the three capital letters.

Very close to Ser. and Sm. Rubbed in the lower left corner.

Located beside Exodus 31:2.

Lit.: Uspenskii, p. 148, fig. 140; Hesseling, figs. 198, 199; Wolska-Conus, *Cosmas*, vol. 1, p. 144 n. 4; Mouriki-Charalambous, "Cosmas," pp. 132–34; Brubaker, "Tabernacle," p. 90; Mentré, *Création*, fig. p. 142; Weitzmann, *Dura*, pp. 56, 66, fig. 82; Wolska-Conus, "Topographie Chrétienne," p. 186; Kessler, "Temple Veil," pp. 60ff., fig. 13; Lowden, *Octs.*, pp. 89–90, figs. 129, 130; Revel-Neher, *Image of the Jew*, p. 65, color pl. 8.

[1] Cf. Revel-Neher, *Image of the Jew*, pp. 55ff., esp. p. 65.

Exodus 29:18–23

Sacrificing a Ram and the Bread

See the introduction to Exodus 29:4–5.

782. Vat. 747, fol. 112v

According to the text, Moses instructs Aaron and his sons on how they should perform the sacrifice of a ram on the altar and set a cake from the basket of unleavened bread before God. Aaron and his sons are omitted from the miniature and Moses alone is portrayed with the offerings: a ram being consumed by flames on an altar and a wicker basket filled with bread. As in the preceding miniature, the scene takes place in front of the pegged tabernacle. Slightly flaked.

Located beside Exodus 29:38.

783. Ser., fol. 249r

Close to Vat. 747, except that, as in the preceding miniature of this manuscript, the tabernacle is represented by one of its checkered curtains, and rows of pillars both enclose the court and form a frame.

Located beside Exodus 29:38.

784. Sm., fol. 104v

The inscription reads: ἡ τοῦ μαρτυρίου σκηνὴ—ὁ μωυσῆς—τὸ κακοῦν καὶ οἱ ἄρτοι—ὁ βωμός.

Close to Ser. As in the preceding miniature of this manuscript (fig. 780), the three capital letters Λ, Υ, and Η are written on three sides of the tabernacle. The basket of unleavened bread appears to be suspended above the ground.

785. Vat. 746, fol. 244v

The inscription reads: ἡ τοῦ μαρτυρίου σκην(ὴ)—ὁ μωυσ(ῆς)—τὸ κακοῦν καὶ οἱ ἄρτοι—ὁ βωμός.

Very close to Ser. and Sm., particularly to the latter in that the basket is suspended in the air.

Located beside Exodus 29:38.

Lit.: Uspenskii, p. 148; Hesseling, fig. 199; Wolska-Conus, *Cosmas*, vol. 1, p. 144 n. 4; Mouriki-Charalambous, "Cosmas," p. 133; Brubaker, "Tabernacle," p. 90; Mentré, *Création*, fig. p. 142; Weitzmann, *Dura*, pp. 56, 58–59, 66, fig. 83; Wolska-Conus, "Topographie Chrétienne," p. 186; Kessler, "Temple Veil," p. 63; Lowden, *Octs.*, pp. 89–90, figs. 131, 132.

Exodus 30:17–19

Laver

The miniature depicts a marble fountain instead of the brazen laver with a brazen base where Aaron and his sons are to wash their hands and feet with water. As in the case of the priestly clothes (fig. 770), the painters seem to depart from the text consciously and reflect a local ritual.

786a. Vat. 747, fol. 114r

In a marble fountain with a broad basin mounted on a pedestal, water splashes from a golden pinecone at the top of a colonnette. Neither Aaron nor his sons wash their hands in the

basin, as called for by verse 19, but rather two ordinary Israelite youths do so. Flaked in various places.

Located beside Exodus 31:2.

787a. Ser., fol. 251v

In addition to the golden pinecone, water also splashes from the heads of two serpents coiled around the central colonnette.

Located beside Exodus 31:2.

788a. Sm., fol. 106r

The fountain is simpler than in Ser. and without the two serpents.

789a. Vat. 746, fol. 246v

Very close to Sm.
Located beside Exodus 31:3.

Lit.: Lambakis, "Ἀνακοινώσεις," pp. 53–54, fig. 12; Uspenskii, p. 148, fig. 140; Hesseling, fig. 200; *ODB*, vol. 3, fig. on p. 1628.

Exodus 31:1–11

Bezaleel and Aholiab Make Liturgical Objects

786b. Vat. 747, fol. 114r

Moses calls Bezaleel (LXX: Beseleel) of the tribe of Judah and Aholiab (LXX: Eliab) of the tribe of Dan to manufacture the tabernacle, all its furniture, the candlestick, the altar, all the priestly vestments, the anointing oil, and the incense. In the miniature Bezaleel sits at a workbench over a sheet on which are spread numerous tools. A cauldron stands on an open fire behind him and a second cauldron is on an iron support in front of the table. He is perhaps working on one of the metal objects for the tabernacle, while Aholiab is pounding a huge pestle in a golden mortar, apparently preparing the incense. Flaked in various spots.

Located beside Exodus 31:2.

787b. Ser., fol. 251v

Close to Vat. 747, except for a few details. Bezaleel works with some sort of instrument on a slab of colored marble. Only the iron support remains of the second cauldron, and additional tools are being heated there in the fire. The mortar is painted like colored marble, and the contents of the workshop are augmented by a wicker basket containing more tools. Partly rubbed.

Located beside Exodus 31:2.

788b. Sm., fol. 106r

The inscription reads: βεσελεὴλ κατασκευάζων τὴν τῶν θυμιαμάτων σύνθεσιν.

Very close to Ser.

789b. Vat. 746, fol. 246v

The inscription reads: βεσελεὴλ κατασκευάζων τὴν τῶν θυμιαμάτων σύνθεσιν.

Very close to Ser. and Sm. Bezaleel's head is rubbed.
Located beside Exodus 31:3.

Lit.: Lambakis, "Ἀνακοινώσεις," pp. 53–54, fig. 12; Uspenskii, p. 148, fig. 141; Hesseling, fig. 200; Weitzmann, *SP*, p. 56.

Exodus 31:18

Giving of the Law

See the introduction to Exodus 32:3–4.

790a. Vat. 747, fol. 114v

In the left half of the miniature Moses ascends the steep slope of Mount Sinai and with veiled hands receives one stone tablet, instead of the two called for by the text; the tablet is proffered by the hand of God from a segment of heaven set against a golden strip of sky. The tablet is outlined in blue and contains a golden letter or an indefinite sketch. At the foot of the mountain, partly hidden by a hillock in the foreground, a group of Israelites converses while awaiting Moses' return. Slightly flaked.

Located beside Exodus 31:18.

791a. Ser., fol. 252r

Close to Vat. 747, except that the group of waiting Israelites is enlarged by the addition of two men in reclining posture, with their backs turned to each other, lying on the same hillock that partly covers the rest of the group. Slightly flaked.

Located beside Exodus 31:18.

792a. Sm., fol. 106v

As in Vat. 747, the two reclining Israelites are missing from the foreground. Parts of the mountain are flaked.

793a. Vat. 746, fol. 247r (see also text fig. 60)

The inscription reads: ὁ μωυσῆς δεχόμ(εν)ο(ς) τὰς πλάκ(ας) ἐκ χειρὸς θ(εο)ῦ.

Close to Ser. and Sm. The whole group of waiting Israelites is encamped in the foreground.

Located below Exodus 31:17.

Lit.: Tikkanen, *Genesismosaiken*, fig. 57; Uspenskii, p. 148, fig. 142; Hesseling, fig. 201; Buchthal, *Par. Gr. 139*, pp. 26, 44–46, 58 n. 166; Buchthal, *Paris Ps.*, p. 37 n. 5; Weitzmann, *RaC*, p. 170, fig. 165; Weitzmann, "Ps. Vatopedi," p. 34, fig. 20; Buchthal, *Latin Kingdom*, p. 58 n. 5; Weitzmann and Ševčenko, "Moses Cross," p. 387, fig. 6; Ettlinger, *Sistine Chapel*, p. 51; Mouriki-Charalambous, "Cosmas," pp. 89–90; Gaehde, "Turonian Sources," pp. 372–73, fig. 72; Stahl, "Morgan M. 638," pp. 93–94, fig. 121; Kessler, *Tours*, pp. 61, 68, fig. 91; Bergman, *Salerno*, p. 42, fig. 97; Kessler, "Pentateuch," pp. 20–23; Aliprantis, *Moses*, p. 34, figs. 100, 104; Weitzmann, *Dura*, pp. 53–54, fig. 77; Fiaccadori, "Regno di 'Aksum," pp. 172–73, figs. 10, 11.

Exodus 32:3–4

ISRAELITES GIVE AARON GOLDEN EARRINGS

The sequence of scenes is interrupted at this point. In the text the scene of the golden calf follows immediately after the Giving of the Law which fills the left half of the preceding miniature, but the painter let this latter scene be followed by Moses Destroys the Tablets, which is related to a later passage (Ex 32:17–19). In each case this change in position may have been made intentionally by the illustrator to group together two scenes that form a pair because of their content: the journey to and return from Mount Sinai, and the manufacture and destruction of the golden calf.

794a. Vat. 747, fol. 115v

Aaron complies with his people's wishes that he make an image for them and asks them to bring him their golden earrings. In the miniature a group of Israelites throws rings into a large fire to be melted down, while Aaron stands on the other side of the flames making encouraging gestures. At the same time, the completed golden calf proleptically appears on a marble column, being worshipped by some of the Israelites who have turned away from the others. Partly flaked.
Located below Exodus 32:28.

795a. Ser., fol. 254v

Close to Vat. 747. Aaron is represented as more youthful and with a nimbus, and the Israelite next to the flames throws a golden pitcher into the fire and simultaneously turns around to the molten image, thus connecting more closely the two consecutive phases of the creation of the golden image. Slightly flaked.
Located below Exodus 32:27.

796a. Sm., fol. 107v

The inscription reads: ἡ μοσχοποιία.
Very close to Ser.

797a. Vat. 746, fol. 249v

The inscription reads: ἡ μοσχοποιία.
The miniature is nearly completely rubbed, but from the few remaining traces it may be ascertained that the composition was very close to Ser. and Sm.
Located below Exodus 32:28.

Lit.: Lambakis, "Ἀνακοινώσεις," p. 54, fig. 13; Uspenskii, pp. 148–49, fig. 144; Hesseling, fig. 202; Buchthal, *Latin Kingdom*, p. 58; Williams, "León Bible," pp. 68–69, fig. 98; Ettlinger, *Sistine Chapel*, pp. 51 n. 2, 52, pl. d.

Exodus 32:17–19

MOSES DESTROYS THE TABLETS

See the introduction to Exodus 32:3–4.

790b. Vat. 747, fol. 114v

Returning from Mount Sinai, Moses is approached by Joshua who tells him about the noise in the camp. Meanwhile Moses must have seen the golden calf, although it is not represented in the miniature, for he destroys the tablets in his hands and throws the blue pieces angrily to the ground.
Located beside Exodus 31:18.

791b. Ser., fol. 252r

Close to Vat. 747, except that two phases of the destruction of the tablets are depicted simultaneously: on the one hand, Moses is about to break the tablets in his hands, and on the other, the broken pieces already fall to the ground.
Located beside Exodus 31:18.

792b. Sm., fol. 106v

The inscription reads: ἡ συντριβὴ τῶν πλακῶν.
Very close to Ser.

793b. Vat. 746, fol. 247r (see also text fig. 60)

The inscription reads: ἡ συντριβὴ τῶν πλάκων.
Very close to Ser. and Sm.
Located below Exodus 31:17.

Lit.: Tikkanen, *Genesismosaiken*, fig. 57; Uspenskii, p. 148, fig. 143; Hesseling, fig. 201; Weitzmann, *RaC*, p. 170, fig. 165; Weitzmann, "Ps. Vatopedi," fig. 20; Stahl, "Morgan M. 638," pp. 93–94, fig. 121; Aliprantis, *Moses*, p. 34, figs. 100, 104; Sed-Rajna, *Hebraic Bible*, p. 96 n. 92; Weitzmann, *Dura*, fig. 77.

Exodus 32:20

MOSES BURNS THE GOLDEN CALF

See the introduction to Exodus 32:3–4.

794b. Vat. 747, fol. 115v

The angry Moses points with his left hand to the flames into which he has thrown part of the golden calf. He has ground other parts of the image into powder and scattered it on the water, and he now touches the gold-dusted surface of the water with his staff, forcing the Israelites to drink from it. One man kneels down in order to drink from the pool directly, another holds a pitcher to his mouth, and the rest of the group stands awaiting their turn to obey Moses' command. Flaked in various places.
Located below Exodus 32:28.

795b. Ser., fol. 254v

Except for slight differences in the attitudes of the Israelites who are about to drink from the dust-covered water, the composition is close to that in Vat. 747. Slightly flaked.
Located below Exodus 32:27.

796b. Sm., fol. 107v

The inscription reads: ἡ διὰ τῆς τέφρ(ας) τῶν χρυσ(ῶν) σκευῶν ἐκ μωυσέος ἀποκατάστασις.

Very close to Ser.

797b. Vat. 746, fol. 249v

The inscription reads: ἡ διὰ τῆς τέφρας τ(ῶν) χρυσ(ῶν) σκευῶν ἐκ μωυσέος ἀποκατάστασις.

Very close to Ser. and Sm. The figure of Moses and the pool are mostly rubbed.

Located below Exodus 32:28.

Lit.: Lambakis, "Ἀνακοινώσεις," p. 54, fig. 13; Uspenskii, pp. 148–49, fig. 144; Hesseling, fig. 202; Williams, "León Bible," pp. 68–69, fig. 98; Anderson, "Seraglio," p. 99.

Exodus 32:21–22

Moses Reproaches Aaron

The next two scenes are transmitted in Vat. 747 alone.

798a. Vat. 747, fol. 116r

In the left half of the miniature Moses sits on a mound and reproaches Aaron, who stands before him in a respectful posture and tries to defend his casting the golden calf. Behind Moses stands Joshua, who is not explicitly mentioned in this text passage. Partly flaked.

Located below Exodus 33:7.

Lit.: Muñoz, "Rotulo," p. 477; De Angelis, "Simbologia," fig. 28; Lowden, *Octs.*, p. 75.

Exodus 32:28

Slaying of the Idolaters

798b. Vat. 747, fol. 116r

In the right half of the miniature a group of Levites slays the Israelites who have sinned against God. The text states that they kill "their brothers and neighbors and those that are nearest to them" with a sword, but the illustrator used the conventional scheme of piercing fleeing enemies in the back with a lance. The miniature has been overpainted in several places, particularly the heads, and large sections of the surface have flaked again.

Located below Exodus 33:7.

Lit.: Muñoz, "Rotulo," p. 477; Williams, "León Bible," pp. 69–70; Ettlinger, *Sistine Chapel*, p. 52, pl. 38c; Weitzmann, *SP*, p. 56; De Angelis, "Simbologia," p. 1538, fig. 28.

Exodus 34:4–7

Second Giving of the Law

799. Vat. 747, fol. 117r

Moses has gone up to Mount Sinai with the second set of stone tablets he has hewn. While he holds up the tablets, he turns his head away from the blessing hand of God in a segment of heaven set against a strip of golden sky, thus following God's order not to try to see his face (Ex 33:20). Mount Sinai is represented as a steep mountain, the slope of which partly conceals the figure of Moses, and below its peak is a hole in the rock where, according to Exodus 33:22, God put Moses while he passed by. Large sections of the surface are flaked.

Located beside Exodus 34:1.

800. Ser., fol. 257r

Close to Vat. 747.
Located beside Exodus 34:3.

801. Sm., fol. 109r

The inscription reads: μωυσῆς δεχόμενος ἐκ θ(εο)ῦ τ(ὰς) πλάκ(ας).
Very close to Ser.

802. Vat. 746, fol. 251v

The inscription reads: μωυσῆς δεχόμενο(ς) ἐκ θ(εο)ῦ τὰς πλάκας.
Very close to Ser. and Sm.
Located below Exodus 33:23.

Lit.: Piper, "Bilderkreis," p. 184; Tikkanen, *Genesismosaiken*, fig. 58; Uspenskii, p. 149; Stornajolo, *Topografia Cristiana*, p. 17; Hesseling, fig. 203; Der Nersessian, *Barl. et Joas.*, p. 139; Pijoán, *Summa artis*, vol. 7, p. 402, fig. 572; Schweinfurth, *Byzantin. Form*, fig. 50b; Martin, *Heavenly Ladder*, p. 26; Williams, "León Bible," p. 70; Ettlinger, *Sistine Chapel*, p. 51; Eller and Wolf, *Mosaiken*, fig. 46; Rice, *Byz. Art*, fig. 344; Mellinkoff, "Round-topped Tablets," p. 29 n. 8; Weber, *Symbolik*, vol. 1, pp. 152, 153, fig. 68; Aliprantis, *Moses*, pp. 68, 80, fig. 98; Weitzmann, *Dura*, p. 53, fig. 78.

Exodus 34:29–30

Moses Descends from Sinai

803. Vat. 747, fol. 118v

Moses descends from Mount Sinai holding the tablets inscribed with the Ten Commandments under his arm, turning his head toward the blessing hand of God in the segment of heaven set against a strip of golden sky. Beams of light radiate from Moses' head, so bright that the waiting Israelites are frightened and dare not approach him. Aaron stands at the foot of the mountain and has turned away, covering his face with his mantle. Behind him stands Joshua, not specifically mentioned here

by the text, who does dare to look up at Moses. A group of four Israelite elders kneels at the lower right corner; their varying poses and gestures range from momentary surprise to expressions of fear and the desire to hide. The cave depicted in the mountain represents the cleft of the rock in which God put Moses while he was passing by (Ex 33:22). Large sections of the mountain are flaked.

Located beside Exodus 35:1.

804. *Ser., fol. 258v*

Close to Vat. 747 but the painter emphasizes Moses' unapproachableness more strongly. The rays around his head are more powerful, and none of the four elders, two of whom are standing, nor even Joshua, dares to look at Moses. They all cover their faces with either their hands or their mantles. Mountain and figures are flaked in various spots.

Located beside Exodus 34:29.

805. *Sm., fol. 110v*

The inscription reads: κάτεισιν ἐκ τοῦ ὄρους μωυσῆς δεδο-ξασμέ(νον) ἔχ(ων) τὸν πρ(όσωπον).

Very close to Ser.

Located below Exodus 35:1.

806. *Vat. 746, fol. 254v*

The inscription reads: κάτεισι(ν) ἐκ τοῦ ὄρους μωυσῆς δεδο-ξασμέ(νον) ἔχων τὸ(ν) πρόσωπ(ον).

Very close to Ser. and Sm.

Located below Exodus 34:35.

Lit.: Uspenskii, p. 149, fig. 145; Hesseling, fig. 204; Ettlinger, *Sistine Chapel,* p. 51, pl. 38e; Vzdornov, "Illustraciia," p. 214, fig. 8; Mouriki-Charalambous, "Cosmas," p. 89; Mellinkoff, *Horned Moses,* p. 6, fig. 7; Heimann, review of Mellinkoff, p. 286; Kötzsche-Breitenbruch, *Via Latina,* p. 88; Aliprantis, *Moses,* pp. 68, 80, fig. 99; Fiaccadori, "Regno di 'Aksum," pp. 172–73, figs. 8, 9; Fiaccadori, "Prototipi," p. 69, figs. 2, 3.

Exodus 35:35

Bezaleel Makes Curtains for the Sanctuary

807a. *Vat. 747, fol. 120v*

Although the text names Bezaleel and Aholiab as the makers of all furniture, vestments, etc., for the sanctuary, the painter depicted only Bezaleel, as the more important of the two. He is bending over a table and working on a piece of purple-colored embroidery mounted in a wooden frame. Flaked in various places.

Located beside Exodus 36:32.

808a. *Ser., fol. 261r*

Close to Vat. 747. Table and chair are shaped differently.
Located beside Exodus 36:32.

809. *Sm., fol. 112v*

The inscription reads: βεσελεὴλ κ(α)τ(α)σκευάζων τὰ ἔπι-πλα καὶ τὰ λοιπὰ τ(ῶν) θείων σκευῶν.

Very close to Ser.

811a. *Vat. 746, fol. 257r*

The inscription reads: βεσελεὴλ κατασκευάζων τὰ ἔπιπλα καὶ τὰ λοιπὰ τῶν θείων σκευῶν.

Very close to Ser. and Sm. Slightly flaked.

Located beside Exodus 36:32.

Lit.: Uspenskii, p. 149, fig. 146; Hesseling, fig. 205; Goodenough, *Symbols,* vol. 10, p. 16 n. 79; Rice, *Byzantines,* pl. 50; Laiou, "Role of Women," p. 245 n. 61; Kessler, "Temple Veil," pp. 56ff., fig. 8.

Exodus 36:9–37:3

Curtains and Clothes for the Sanctuary

807b. *Vat. 747, fol. 120v*

Of all the objects created by Bezaleel and Aholiab, the miniature selects the woven and embroidered ones and repeats them with only slight changes as they were represented previously in chapter 28 (fig. 770). The red garment with a golden border in the center of the lower row represents the shoulder mantle (ἐπωμίδα), but it is simplified and without the two shoulder pieces. At the right is the blue tunic (ὑποδύτη ποδήρη) with golden borders and the row of little bells at its hem. At the left is the plate of pure gold (πέταλον χρυσοῦν καθαρόν) with four pearls and the red ribbons by which it is to be fastened around the miter. Above it, the miter itself (κιδάρις) is somewhat different in shape from the bonnet depicted in fig. 770 and is adorned with a white and a red stone. Hanging from the upper frame[1] is the veil (καταπέτασμα) with a broad golden border and decorated with simple ornaments instead of cherubim, as required by the text. Flaked in various spots.

Located beside Exodus 36:32.

808b. *Ser., fol. 261r*

Close to Vat. 747, but the miter has a cubic top, the two emeralds are clearly visible on the shoulder mantle, the tunic is laced across the breast, and the veil has a pattern of rosettes.

Located beside Exodus 36:32.

810. *Sm., fol. 112v*

Very close to Ser.

811b. *Vat. 746, fol. 257r*

Very close to Ser. and Sm.

Located beside Exodus 36:32.

Lit.: Uspenskii, p. 149, fig. 146; Hesseling, fig. 206; Goodenough, *Symbols*, vol. 10, p. 16 n. 79; Henderson, "Joshua Cycle," p. 50; Mouriki-Charalambous, "Cosmas," p. 138; Brubaker, "Tabernacle," p. 90; Weitzmann, *Dura*, p. 57, fig. 85; Kessler, "Temple Veil," pp. 56ff., fig. 8.

[1] Apparently it has lost the lintel of the entrance gate on which the curtain should hang.

Exodus 38:9–12

Table with Liturgical Vessels

Vat. 747

Between fols. 120 and 121 one leaf is cut out which contained the passage Exodus 37:6–38:20 and apparently also a miniature corresponding to those in the other manuscripts.

812. Ser., fol. 262v

Various sacrificial vessels, which in the text are named as τρυβλία, θυΐσκας, κυάθους, and σπονδεῖα, are placed on a table covered with a red cloth bordered in gold. A jeweled golden bowl stands at the left and in it is a blue chalice with handles, next to it is a golden vessel in the shape of an amphora, followed by a blue ewer and finally a jewel-studded paten with a strangely shaped, square chalice on it. The curtain over the table, unwarranted by the text,[1] is lifted and held by a hand in the middle and by two golden hooks in the shape of snakes at the sides.

Located beside Exodus 38:11.

813. Sm., fol. 113v

The inscription reads: κατασκευὴ τοῦ ἱεροῦ καὶ τῶν σκευῶν. Very close to Ser.

Located above Exodus 38:9.

814. Vat. 746, fol. 257v

The inscription reads: κατασκευὴ τοῦ ἱεροῦ καὶ τῶν σκευῶν. Very close to Ser. and Sm.

Located beside Exodus 38:5.

Lit.: Uspenskii, p. 149, fig. 147; Hesseling, fig. 207; Goodenough, *Symbols*, vol. 10, p. 18 n. 96, fig. 245; Weitzmann, *Dura*, pp. 63 n. 8, 57, fig. 86; Kessler, "Temple Veil," pp. 56ff., fig. 7; Iacobini, "Lettera," p. 80, fig. 9.

[1] The curtain may well reflect a use in the synagogue, where, as a rule, a curtain hung in front of the Torah ark; cf. J. Gutmann, "The History of the Ark," *ZAW* 83 (1971), p. 22.

Exodus 40:38

Fire above the Sanctuary

815. Vat. 747, fol. 122v

The text says that a cloud enveloped the tabernacle by day and fire was upon it by night. The miniature depicts the latter circumstance, showing fire falling on the tabernacle from a segment of heaven. The tabernacle (σκηνή) is represented not as a tent as in some previous scenes (cf. figs. 778, 782), but as a Christian altar under a ciborium, a combination which in other instances is used to illustrate the altar of the sanctuary (θυσιαστήριον τοῦ ἁγίου) (cf. fig. 774).

Located beside Exodus 40:38.

816. Ser., fol. 265r

Close to Vat. 747. The altar is covered with a plain purple cloth with golden borders, the dome and columns of the ciborium are made of different colored marbles, and in the segment of heaven a row of stars appears.

Located beside Exodus 40:35.

817. Sm., fol. 115v

The inscription reads: ἡ δόξα κ(υρίο)υ σκιάζουσα τὸ ἱλ(α)στήριον.

Very close to Ser.

818. Vat. 746, fol. 260r

The inscription reads: ἡ δόξα κ(υρίο)υ σκιάζουσα τὸ ἱλαστήριον.

Very close to Ser. and Sm. Flaked in various places.

Located beside Exodus 40:36.

Lit.: Uspenskii, p. 149; Hesseling, fig. 208; Deckers, *S. Maria Magg.*, p. 215.

6. LEVITICUS

The cycle preserved in the Vatopedi Octateuch begins with Leviticus, the headpiece of which is reproduced as text fig. 61.

Leviticus 1:11, 3:12–13, 4:22–24, 4:27–29, 5:6, 5:18, or 5:25; and 1:5, 3:1–2, or 4:4

Sacrificing Goats or Calves

Using the same iconography, Vat. 747 represents a goat being sacrificed and the other Octateuchs a calf "by the doors of the tabernacle of witness." The offering of goats or calves is prescribed at various points of chapters 1–5, but only in the descriptions in chapter 5 is it a priest who performs the sacrifice. In these cases a goat is sacrificed, as in the illustration of Vat. 747, where the executioner is dressed like the sons of Aaron in the preceding miniatures (see fig. 778). According to this hypothesis, however,

the illustration should have been located after the following miniature, Offering Turtledoves or Pigeons, which is described at Leviticus 5:7–9 (nos. 824–828). The illustration in Vat. 747 seems to be the original: the painter intended to summarize the sacrifices prescribed in chapters 1–5 in one miniature.

819a. Vat. 747, fol. 125v

A man wearing an imperial crown kneels on the goat's back, holding it by the horns as he cuts its throat.[1] Aaron stands beside him and, instead of sprinkling the altar with blood, points to the tabernacle which, as in the last miniature of Exodus and throughout Leviticus and Numbers, is represented as a Christian altar and ciborium. The spatial relationship between these two elements is incorrectly understood: the altar stands in front of the ciborium instead of underneath it. A silk cloth with a medallion pattern enclosing jeweled crosses regularly covers the altar in this manuscript. The two Israelites at the right might be those offering the sacrifice. Aaron and the executioner are slightly flaked.

Located beside Leviticus 4:3.

820a. Ser., fol. 269v

The sacrifice of the calf is carried out by a man dressed in the clothes of an ordinary Israelite who kneels on the animal's back, holding it by the head and cutting its throat. Aaron stands beside him sprinkling the altar with blood. On the right, five Israelites, mostly elderly men, converse among themselves. The altar correctly stands under the domed ciborium, and its cover is painted red with a simplified lily pattern.

Located beside Leviticus 4:2.

821a. Sm., fol. 118v

The inscription, continuing in the lower strip, reads: περὶ τῶν προσφερομένω(ν) θυσιῶν ὑπὸ τοῦ ἱερέ(ως) πε(ρὶ) ἁμαρτιῶν.

Very close to Ser. but Aaron's nimbus is omitted.

822a. Vat. 746, fol. 265v

The inscription, which continues in the lower strip, reads: περὶ τῶν προσφερομένων θυσιῶν ὑπὸ τοῦ ἱερέως περὶ ἁμαρτιῶν.

Very close to Ser. and Sm. and like the latter represents the chief priest without a nimbus. Slightly flaked.

Located beside Leviticus 4:10.

823a. Vtp., fol. 9v

The inscription, continuing in the lower strip, reads: [περὶ τῶν προσφερο]μένω(ν) θυσιῶν ὑπὸ τοῦ ἱερέως περὶ ἁμαρτιῶ(ν).

Very close to Sm. and Vat. 746. The miniature is considerably flaked, particularly the ciborium.

Located beside Leviticus 4:9.

Lit.: Uspenskii, p. 150, fig. 148; Hesseling, fig. 209; Buchthal, *Latin Kingdom,* p. 59; Nordström, "Water Miracles," pp. 81–82; Huber, fig. 1; Weitzmann, *Dura,* p. 59, fig. 89; Θησαυροί, p. 254, fig. 47.

[1] For the connection of this iconography with Jewish ritual, see Nordström, "Water Miracles," pp. 81–82; and Weitzmann, *Dura,* p. 59.

Leviticus 1:12–13, 3:14–16, 4:26, 4:31, 5:6, 5:18, or 5:25; and 1:7–9, 3:3–5, 4:12

Burning the Offering

In the following representation we cannot be certain which description of sacrifice in the text is referred to. Portions of the goat are burned on the fire in all the passages listed for the preceding scene except in Leviticus 4:26, where only the fat of the victim is burned. Furthermore, the priest pointing to the sky is not required by the text: the painter may have been inspired by ritual.

819b. Vat. 747, fol. 125v

Certain portions of the goat are being burned on a brazen altar in front of which stands Aaron together with one of his sons, who is pointing to the sky, and an Israelite in a devout posture.

Located beside Leviticus 4:3.

820b. Ser., fol. 269v

Three men stand in front of the brazen altar on which the head and other parts of the calf are being burned. Aaron, the foremost figure, holds a piece of cloth for which we can offer no explanation. Behind him stands one of his sons pointing to heaven, but the copyist has deprived him, as well as Aaron, of any priestly distinctions, and both of them look like ordinary Israelites. They differ from the youthful Israelite who stands respectfully at the right only in their hoods and beards. Somewhat rubbed.

Located beside Leviticus 4:2.

821b. Sm., fol. 118v

Very close to Ser.

822b. Vat. 746, fol. 265v

Very close to Ser. and Sm. and somewhat flaked.
Located beside Leviticus 4:10.

823b. Vtp., fol. 9v

Very close to Ser., Sm., and Vat. 746 and heavily flaked all over the surface.

Located beside Leviticus 4:9.

Lit.: Uspenskii, p. 150, fig. 149; Hesseling, fig. 209; Huber, fig. 1; Weitzmann, *Dura,* p. 59, fig. 89; Θησαυροί, p. 254, fig. 47.

Leviticus 5:7–9

Offering Turtledoves or Pigeons

After the miniature illustrating the sacrifice of a goat or calf (figs. 819–823) and summarizing the first four chapters of Leviticus, no further interest is displayed in the ceremonies described in chapter 5. Only one particular example of sacrifice is depicted: if the sinner "cannot afford a sheep, he shall bring for his sin which he has sinned, two turtledoves or two young pigeons to God" (Lev 5:7). The other cases considered in chapter 5 as well as in chapters 6 and 7 are wholly ignored.

Vat. 747

Between fols. 125 and 126 is a lacuna covering the text of Leviticus 4:34–5:2. In all probability the lost section contained a miniature similar to that in the other Octateuchs.

824. Ser., fol. 272r

Two doves are depicted on one side and two pigeons on the other side of what looks like a chessboard painted with blue and red squares. Previously this checkered pattern was used to render either the curtains of the tabernacle (figs. 771–773) or the tabernacle itself (figs. 780, 781, 783–785), but in this instance, where the text prescribes that some of the blood of the doves be sprinkled on the side of the altar and the remainder dropped at its base, it represents instead the cover of the altar, which stands for the altar itself. Slightly flaked.

Located beside Leviticus 5:15.

825. Sm., fol. 120v

Very close to Ser.

826. Vat. 746, fol. 267r
827. Vat. 746, fol. 268v

Close to Ser., except that the chessboard has a rectangular shape and is more densely patterned. Rubbed in various places.

The copyist inserted the miniature prematurely in the text beside Leviticus 4:26 (fig. 826) and, after realizing his error, obliterated it and inserted it above Leviticus 5:15 (fig. 827).

828. Vtp., fol. 12v

Close to Ser., Sm., and Vat. 746, but with larger squares on the chessboard. Somewhat flaked and rubbed.

Located beside Leviticus 5:11.

Lit.: Uspenskii, p. 150; Stornajolo, *Topografia Cristiana*, p. 17; Hesseling, fig. 210; Huber, fig. 2; Anderson, "Seraglio," p. 97; Θησαυροί, pp. 254–55, fig. 48; Lowden, *Octs.*, p. 70.

Leviticus 8:6–7

Ordination of Aaron and His Sons

Neglecting the prescriptions given in chapters 6 and 7, the cycle illustrates only a part of the rite of ordination in chapter 7. Chapter 8 is almost completely ignored in the cycle.

829. Vat. 747, fol. 129r

Moses holds a vestment which he is giving to Aaron as part of the ordination ceremony. Aaron is already dressed in a chiton and tunic (the ὑποδύτη), so the garment in Moses' hand can only be the shoulder mantle (the ἐπωμίς). At the same time, Moses turns in the other direction to wash Aaron's sons. From a golden amphora he pours water over the heads of the two sons, who are naked except for loincloths.

Located beside Leviticus 7:38.

830. Ser., fol. 275v

Close to Vat. 747. Aaron wears a miter instead of a pearled crown and no nimbus, and the garment in his and Moses' hands is characterized as the shoulder mantle by a clasp attached to the border, representing one of the two emeralds (cf. fig. 808). Flaked in various spots.

Located beside Leviticus 8:6.

831. Sm., fol. 123r

The inscription reads: πε(ρὶ) τῆς στολῆς τοῦ ἱερέως ἀαρὼν καὶ τῆς δι'ὕδατος ἐκπλύσεως.

Very close to Ser.

832. Vat. 746, fol. 267v
833. Vat. 746, fol. 271v

The inscription, in no. 833 (fol. 271v), reads: περὶ τῆς στολῆς τοῦ ἱερέως ἀαρὼν καὶ τῆς δι'ὕδατο(ς) ἐκπλύσεως.

As in the preceding case, the scene was first placed in the text prematurely, then rubbed out and repeated later on. Very close to Ser. and Sm. and slightly rubbed.

Located beside Leviticus 4:30 (no. 832) and below Leviticus 8:1 (no. 833).

834. Vtp., fol. 20v

The inscription reads: πε(ρὶ) τ(ῆς) στολῆς τοῦ ἱερέως καὶ τ(ῆ)ς τοῦ ὕδ(α)το(ς) ἐμπλήσε(ως).

Close to Ser., Sm., and Vat. 746. Moses is represented in a more hieratic, frontal posture. Very heavily flaked; the heads of all the figures are nearly completely destroyed.

Located beside Leviticus 7:38.

Lit.: Uspenskii, p. 150, fig. 150; Hesseling, fig. 211; Huber, fig. 3; Gaehde, "Octateuch," p. 360 n. 13; Chasson, "Tuscan Bible," p. 174; Anderson, "Seraglio," p. 97; Lowden, "Vtp. Oct.," p. 118, figs. 7, 8; Lowden, *Octs.*, pp. 70, figs. 25, 26.

Leviticus 10:1–2

Aaron's Sons Devoured by Fire from the Tabernacle

From chapter 10 the cycle illustrates the most narrative passage in verses 1–3, where two of Aaron's sons, Nadab and Abihu (LXX: Abiud), make an offering not commanded by God by putting fire and incense in a censer; for this offense they themselves are consumed by fire that came from God. Afterward, Moses explains their sin to Aaron. The rules enumerated in the rest of the chapter were of no interest to the illustrator.

835a. Vat. 747, fol. 131v

One of Aaron's sons approaches the tabernacle with a burning bowl in his hands; another fire burns on a brazier in front of the altar. The other son flees before a threatening ray of fire emanating from the hand of God underneath the dome of the ciborium. Flaked in various places.
Located beside Leviticus 10:10.

836a. Ser., fol. 278v

Close to Vat. 747. The hand of God is placed outside the ciborium dome, and rays of fire are directed against both sons. Only the son with the flaming bowl wears a mantle, which is reminiscent of the priestly shoulder mantle. The other son, who walks away rather than runs, is clad in a short tunic like an ordinary Israelite. The ciborium dome is slightly rubbed.
Located beside Leviticus 10:10.

837a. Sm., fol. 125v

The inscription reads: περὶ τῶν ξένω πυρὶ θυμιασάντ(ων) καὶ θείω κατακαυθέντ(ων).
Very close to Ser. The hand of God is placed lower and the altar is shortened.

838a. Vat. 746, fol. 275r

The inscription reads: περὶ τῶν ξένω πυρὶ θυμιασάντων καὶ θείω κατακαυθέντων.
Close to Ser. and Sm. The hand of God is placed near the edge of the ciborium; one of the four supporting columns, which should overlap the altar, is placed behind it.
Located beside Leviticus 10:10.

839a. Vtp., fol. 22v

The inscription reads: περὶ τῶν ξένω πυρὶ θυμιασάντων κ(αὶ) θείω κατακαυθέντω(ν).
Both details mentioned in the description of Vat. 746 occur in this copy as well, thus proving the miniature's direct dependence on that cycle. Flaked in various spots.
Located beside Leviticus 10:6.

Lit.: Uspenskii, p. 150, fig. 151; Hesseling, fig. 212; Buchthal, *Latin Kingdom*, p. 59; Huber, fig. 3; Θησαυροί, p. 255, fig. 49.

Leviticus 10:3

Moses Explains the Sons' Offense to Aaron

See the introduction to Leviticus 10:1–2.

835b. Vat. 747, fol. 131v

Moses speaks to the approaching Aaron about his sons' offense; the father also raises his hand in a gesture of speech as if to offer a reply. The background is slightly flaked.
Located beside Leviticus 10:10.

836b. Ser., fol. 278v

Moses talks more excitedly, with both hands raised, and Aaron wears neither priestly vestments nor a nimbus.
Located beside Leviticus 10:10.

837b. Sm., fol. 125v

The inscription reads: διάλεξις μωυσεῖ μετὰ ἀαρών.
Very close to Ser.

838b. Vat. 746, fol. 275r

The inscription reads: διάλεξις μωυσεῖ μετὰ ἀαρών.
Very close to Ser. and Sm.
Located beside Leviticus 10:10.

839b. Vtp., fol. 22v

The inscription reads: διάλεξις μωυσεῖ μετὰ ἀαρών.
Very close to Ser., Sm., and Vat. 746. Both figures are partly flaked.
Located beside Leviticus 10:6.

Lit.: Uspenskii, p. 150, fig. 152; Hesseling, fig. 212; Huber, fig. 4; Θησαυροί, p. 255, fig. 49.

Leviticus 11:1–8, 13–19

Clean and Unclean Animals

The animals represented in the miniature do not correspond completely to the Septuagint text; the painter shows no obligation to observe the biblical ordinances concerning the eating of clean and unclean meats. Illustrated zoological treatises probably served as the pictorial source of a number of the animals depicted. For instance, the ostrich added by the painter of Vtp. is the twin of one represented on the page with the bird catalogue in Dionysios of Philadelphia's *Ornithiaka* in the Dioskorides manuscript in Vienna (Nationalbibliothek, cod. med. gr. 1, fol. 483v).[1]

840. Vat. 747, fol. 133v

Moses faces the hand of God in heaven. Grouped around him are birds and quadrupeds; the two other categories of unclean animals, aquatic animals and reptiles, are omitted. While the Bible mentions only four species of unclean quadrupeds—camel, rabbit, hare, and swine—many more are represented here, but the rabbit and the hare are omitted. From left to right are a lion, a camel, a boar, a spotted doglike animal, a calf(?), a fox, and a giraffe, half concealed by a hill. In contrast, the text enumerates about twenty birds, but only six are depicted, among them a huge heraldic eagle, a swallow flying downward, and an owl. Flaked in various spots.

Located beside Leviticus 12:1.

841. Ser., fol. 282r

The hilly landscape is omitted, so that Moses appears to be suspended in midair, and the quadrupeds and birds are more numerous. On the ground one recognizes a lion, a bear, a giraffe, a boar, and an ox (which does not belong with the unclean animals), as well as a jackal-like quadruped, a fox, a rabbit, and, suspended above them, a camel. The following birds are grouped around the heraldic eagle: a parrot, a hoopoe, and an owl at the right, and at the left and below, a raven and other birds, all of which the copyist tried to depict with ornithological exactness. Flaked in various places.

Located beside Leviticus 11:47.

Sm.

The corresponding miniature certainly appeared on the folio now missing between fols. 125 and 128.

Vat. 746

A lacuna which included Leviticus 11:44–13:1 falls between fols. 279 and 280; it surely contained the miniature which Vat. 747 and Ser. possess at the end of chapter 11.

842. Vtp., fol. 28v

The inscription is almost completely rubbed and illegible.

The format of the miniature is extended in width, so that Moses at the left and the camel at the right could be placed on the ground, unlike the illustration in Ser. Space was also provided for additional animals such as the elephant, ostrich, and hedgehog in the center, and other quadrupeds on the ground. The entire surface of the miniature is considerably flaked.

Located beside Leviticus 11:47.

Lit.: Uspenskii, pp. 150–51, fig. 153; Millet, "Octateuque," p. 74; Wulff, *Altchr. und Byz. Kunst,* vol. 2, p. 530, fig. 461; Réau, *Miniature,* p. 48; Demus, *Norman Sicily,* p. 332 n. 34; Kauffman, "Bury Bible," p. 68, pl. 28d; Huber, fig. 5; Θησαυροί, p. 255, fig. 50; Iacobini, "Lettera," pp. 91ff., figs. 31, 32.

> [1] *Codex Vindobonensis med. Gr. 1 der Österreichischen Nationalbibliothek,* 2 vols. (Graz, 1965 and 1970), fol. 483v.

Leviticus 13:38–39

God Gives Directions Concerning Lepers

Again unattracted by representations of the examples of sin or disease described in Leviticus, the cycle skips chapter 12 with its rules concerning sacrifices related to births. The next miniature, connected with chapter 13, illustrates the directives concerning leprosy, whereby a man or woman afflicted with the disease must appear before Aaron or one of his sons so that they may judge whether the person is clean or unclean.

843. Vat. 747, fol. 135v

Aaron stands in front of the tabernacle, which is depicted as an altar under a ciborium, with a flight of marble steps and the bishop's seat behind it and the transenna in front of it. The leper, his skin covered with sores, is placed in a second strip below. Clad only in a loincloth, the leper raises his head and hands toward Aaron, thereby establishing contact between the lower and upper strips. The fact that the leper's skin is crowded with countless sores reveals that the illustration was inspired by the case of a leper described in verses 38ff. instead of the previous case, where single sores are examined. Flaked in various spots.

Located beside Leviticus 13:44.

844. Ser., fol. 285r

The dividing line between the two strips is omitted, and Aaron and the tabernacle are suspended at different levels. Aaron wears the miter instead of the pearl crown and the imperial chlamys instead of the shoulder mantle with two shoulder pieces.

Located beside Leviticus 13:42.

845. Sm., fol. 128r

The inscription reads: ἡ τοῦ λεπροῦ ἐκδίωξις ἡ ἀπ(ὸ) τοῦ ἱεροῦ.

Very close to Ser.

846. Vat. 746, fol. 272r
847. Vat. 746, fol. 281r

The inscription reads: ἡ τοῦ λεπροῦ ἐκδίωξις ἡ ἀπὸ τοῦ ἱεροῦ.

The miniature was first painted too early in the text, then obliterated and repeated in the proper place. Very close to Ser. and Sm.

Located beside Leviticus 8:13 (no. 846) and below Leviticus 13:41 (no. 847).

848. Vtp., fol. 34v

The inscription reads: ἡ τοῦ λεπροῦ ἐκδίωξις ἡ ἀπὸ τοῦ ἱεροῦ.

Very close to Ser., Sm., and Vat. 746. Aaron stands on the same groundline as the leper. Large parts of the leper are flaked.

Located below Leviticus 13:41, exactly as in Vat. 746; note that both the manuscripts break the text at the same verse, which is unrelated to the illustration.

Lit.: Uspenskii, p. 151, fig. 154; Hesseling, fig. 213; Mathews, *Early Churches*, fig. 96; Huber, fig. 6; Gaehde, "Octateuch," pp. 362 n. 56, 364; De' Maffei, "Eva," p. 29, fig. 5; Anderson, "Seraglio," p. 97; Θησαυροί, p. 255, fig. 51; Revel-Neher, "Hypothetical Models," p. 408, fig. 2.

Leviticus 14:4–6

THE CLEANSED LEPER'S OFFERING

The cycle selected only one case from chapter 14, the purification of the healed leper in the first verses. The other examples considered subsequently are ignored.

849. Vat. 747, fol. 136v

Clad in a short tunic, the healed leper brings Aaron two birds as an offering; the one to be killed is already lying dead on the ground, while the living one to be dipped into the blood of the slain is still held in the offerer's hand. Bunches of hyssop are depicted on the ground, in accordance with verse 4; the cedar wood and the scarlet cloth, which the same verse instructs the leper to bring to be purified, are omitted. The tabernacle is suspended far above in the background.
Located beside Leviticus 14:5.

850. Ser., fol. 287v

The healed leper holds two birds in his hand, and a slain bird lies on the ground. This can hardly mean that he is offering three birds, but rather that the sacrifice is represented in two successive stages: first, the bringing of the two birds, and then the slaughter of one. Scarlet cloth, cedar wood, and hyssop are omitted.
Located beside Leviticus 14:4.

851. Sm., fol. 129v

The inscription reads: ἡ τοῦ λεπροῦ κάθαρσις καὶ ἡ διὰ τῶν ὀρνίθων θυσία.
Very close to Ser.

852. Vat. 746, fol. 273v
853. Vat. 746, fol. 283r

The inscription reads: ἡ τοῦ λεπροῦ κάθαρσις καὶ διὰ τῶν ὀρνίθ(ων) θυσία.
This is the last of the four instances in which a miniature was at first painted too early in the text, then rubbed out and repeated later in the proper place. Very close to Ser.
Located beside Leviticus 9:3 (no. 852) and below Leviticus 14:4 (no. 853).

854. Vtp., fol. 37r

The inscription reads: ἡ τοῦ λεπροῦ κάθαρσις κ(αὶ) διὰ τῶ(ν) ὀρνίθων θυσία.

Very close to the three preceding copies. Both figures are very badly flaked.
Located below Leviticus 14:4.

Lit.: Uspenskii, p. 151, fig. 155; Hesseling, fig. 214; Millet, "Octateuque," p. 75; De Grüneisen, *Ste. Marie Ant.*, p. 226, fig. 183 p. 229; Huber, fig. 7; Gaehde, "Octateuch," p. 364; Anderson, "Seraglio," pp. 95, 97, 99, fig. 24; De Angelis, "Simbologia," p. 1536, fig. 22; Revel-Neher, *Image of the Jew*, pp. 64–65, fig. 15; Lowden, *Octs.*, pp. 84–85, figs. 106, 107.

Leviticus 15:1–2

GOD GIVES DIRECTIONS FOR THE ISSUE OF BLOOD

In chapter 15 God gives Moses and Aaron detailed directions concerning the treatment of a man or woman afflicted with an issue of blood from the flesh. A conventional representation of God talking to Moses appears here instead of any specific representation of these directions.

855. Vat. 747, fol. 139r

Moses stands on a slope, his hands raised toward the blessing hand of God in a segment of heaven set against a golden strip of sky. Aaron stands at the left side, facing the viewer.
Located beside Leviticus 15:29.

856. Ser., fol. 292v

Close to Vat. 747. Moses stands on a hillock; Aaron, unnimbed, holds a scroll in his hand.
Located beside Leviticus 16:1.

857. Sm., fol. 132r

The inscription reads: νόμος δίδοται μωσεῖ περὶ τοῦ γονορροιοῦς.
Very close to Ser.

858. Vat. 746, fol. 289v

The inscription reads: νόμος δίδοται μωσ(εῖ) πε(ρὶ) τοῦ γονορρυοῦς.
Very close to Ser. and Sm.
Located below Leviticus 15:32.

859. Vtp., fol. 47v

The inscription reads: νόμο(ς) δίδωται μωσῆ πε(ρὶ) τοῦ γονορρυοῦς.
The position of Moses' legs and the draping of his garments have been changed. The figure of Aaron has been cut out, and the ground behind Moses is heavily stained.
Located above Leviticus 15:33.

Lit.: Uspenskii, p. 151; Hesseling, fig. 215; Buchthal, *Latin Kingdom*, p. 59 n. 6; Huber, fig. 8; Θησαυροί, p. 255, fig. 52.

Leviticus 16:10

SCAPEGOAT SENT INTO THE WILDERNESS

860. Vat. 747, fol. 141r

Aaron sends the scapegoat to be sacrificed into the wilderness. Emerging from the precinct of the altar through the royal doors and brandishing a whip, he drives away the goat.

Located beside Leviticus 17:1.

861. Ser., fol. 295v

Close to Vat. 747. Aaron shoulders the whip and is less agitated. Heavily flaked all over the surface.

Located beside Leviticus 17:1.

862. Sm., fol. 134r

The inscription reads: ἀποπεμπόμενο(ς) παρὰ τοῦ ἱερέ(ως) εἰς τ(ὴ)ν ἔρημον ὁ ἀποπομπαῖος τρᾶγος.

Very close to Ser.

863. Vat. 746, fol. 292v

The inscription reads: ἀποπεμπόμ(εν)ο(ς) παρὰ τοῦ ἱερέως εἰς τὴν ἔρημον ὁ ἀποπομπαῖος τρᾶγο(ς).

Very close to Ser. and Sm. Overpainted.

Located beside Leviticus 17:1.

864. Vtp., fol. 52r

The inscription, written at a later period in gold letters, reads: ἀποπεμπόμενος παρὰ τοῦ ἱερέως εἰς τ(ὴ)ν ἔρημον ὁ ἀποπομπαῖος τρᾶγος.

Close to Ser., Sm., and Vat. 746. The decorative elements have been increased, particularly in the ciborium. The miniature is set against a monochromatic, bluish green background of a later date. Parts of Aaron's garment are flaked.

Located beside Leviticus 17:1.

Lit.: Uspenskii, p. 151; Hesseling, fig. 216; Huber, fig. 9; Θησαυροί, p. 256, fig. 53.

Leviticus 20:27

STONING ENCHANTERS AND MEN OR WOMEN WITH A DIVINING SPIRIT

The rules concerning blood (chapter 17), sexual relations (chapter 18), the various cases covered in chapter 19, and illicit sexual intercourse (chapter 20:8–21) are overlooked by the cycle, which continues with the stoning of enchanters and men or women with a divining spirit. The representation is rather conventional; its scheme is also used, e.g., in figs. 926–930.

865. Vat. 747, fol. 144v

A group of Israelites throws stones at a youth. The victim has fallen to the ground and tries to raise himself up while simultaneously attempting to protect his head, which is already bleeding, against further stones.

Located beside Leviticus 21:1.

866. Ser., fol. 302r

The number of executioners is reduced to two and their victim is represented as a bearded man. The executioners throw stones with gestures that closely correspond to Vat. 747 but not to Sm., Vat. 746, or Vtp. Slightly rubbed and stained.

Located beside Leviticus 21:1.

867. Sm., fol. 137v

The inscription reads: ἁλοὺς ἐγγαστρίμυθο(ς) καὶ ἐπαοιδὸς λιθοβολεῖται.

The attitude of the executioners differs from that of the preceding copies, whereas the victim is closer to Ser. than to Vat. 747.

868. Vat. 746, fol. 298v

The inscription reads: ἁλοὺς ἐγγαστρίμυθος καὶ ἐπαοιδὸ(ς) λιθοβολεῖται.

Close to Sm. Crudely overpainted and partly rubbed again.

Located below Leviticus 20:27.

869. Vtp., fol. 63r

The inscription reads: ἁλοὺς ἐγγαστρίμυθος καὶ ἐπαοιδὸς λιθοβολεῖται.

Closest to Vat. 746. Heavily flaked and stained. The realism of the scene is somewhat mitigated by the omission of the blood from the culprit's head.

Located below Leviticus 20:27.

Lit.: Uspenskii, p. 151, fig. 156; Hesseling, fig. 217; Huber, fig. 107; De Angelis, "Simbologia," p. 1538, fig. 29; Θησαυροί, p. 256, fig. 54.

Leviticus 23:17 or 24:5–6

OFFERING LOAVES

The contents of chapters 21 and 22, mostly concerning priests and sacrificial victims, are omitted; the cycle continues with one illustration for chapter 23 or 24. The rather unspecific scene might be related to the offering of two loaves to be made on the fiftieth day following the wave offering, as prescribed in Leviticus 23:17; the table is more probably inspired by the golden table where twelve identical loaves, in two rows of six, must be placed according to the ritual described in Leviticus 24:5–6. It is noteworthy that the cycle, by devoting this single illustration to chap-

ters 23 and 24, exhibits very scant interest in the consecration of the Sabbath (Lev 23:3ff.), Passover, the feast of the unleavened bread (Lev 23:5ff.), and the other main Hebrew feasts prescribed in Leviticus 23:15–44.

870. Vat. 747, fol. 146v

A young Israelite brings three loaves on a dish which he sets down on a table, while Aaron, standing in front of the tabernacle, which has been transformed into a Christian altar with a ciborium, receives the gift with extended hands.

Located beside Leviticus 23:17.

871. Ser., fol. 305v

The offerer holds a golden bowl filled with small, rounded, cakelike loaves. Some of the loaves have already been placed on the table and Aaron is taking one of them while speaking to the offerer. Slightly flaked.

Located beside Leviticus 23:16.

872. Sm., fol. 139v

The inscription reads: ἡ τῆς πεντηκοστῆς δι’ἄρτων θυσία.
Very close to Ser.

873. Vat. 746, fol. 302r

The inscription reads: ἡ τῆς πεντηκοστῆς δι’ἄρτων θυσία.
Close to Ser. and Sm. The whole miniature has been very crudely overpainted.

Located below Leviticus 23:15.

874. Vtp., fol. 70r

The inscription reads: ἡ τῆς πεντηκοστ(ῆς) δι’ἄρτων θυσία.
Very close to Vat. 746. Slightly flaked.

Located below Leviticus 23:14.

Lit.: Uspenskii, p. 151, fig. 157; Hesseling, fig. 218; Huber, fig. 11; Θησαυροί, p. 256, fig. 55.

Leviticus 24:23

STONING THE BLASPHEMER

The last miniature of Leviticus is again a stoning: the man who has cursed God is brought out of the camp and stoned. The section of the cycle devoted to Leviticus thus concludes with a final conventional execution of a sinner, confirming the very meager attention it pays to some of the most sacred Hebrew precepts; chapters 25–27, in fact, have no illustrations.

Vat. 747

The text breaks off at Leviticus 23:27 and resumes at Numbers 3:13. This extensive lacuna probably contained only one miniature illustrating the end of chapter 24.

875. Ser., fol. 309r

The culprit, both hands fettered, is dragged out of a doorway by one of the Israelites, while others throw stones at him. He has already been hit several times, and his head is bleeding heavily; his executioners hold more stones in reserve in their mantles. The blessing hand of God in heaven is directed toward the executioners, encouraging them in their task. The miniature is partly rubbed and stained.

Located beside Leviticus 25:8.

876. Sm., fol. 141r

The inscription, which does not refer to a man cursing God, but rather to one who kills his fellow man (verse 21), is badly damaged and reads: φονεὺς εὑρεθεὶς οὗτος λιθοβολεῖται.

The miniature was not only overpainted, but in the process of restoration was considerably changed. The left half, with the fettered culprit before the doorway, was most likely retained from the original composition, whereas the right half must have been so completely destroyed that the restorer replaced it with an entirely new group, copying the illustration of a similar event from Numbers 15:35–36 on fol. 162v (fig. 928). The Israelites turn their backs on the fettered man at the left, whom the restorer, apparently no longer understanding his original significance, has shown tied to a tree.

Located beside Leviticus 25:7.

877. Vat. 746, fol. 305r

The inscription reads: φονεὺς εὑρεθεὶς οὗτο(ς) λιθοβολεῖται.
Very close to Ser. Overpainted and slightly rubbed at the center.

Located above Leviticus 25:8.

878. Vtp., fol. 77v

The inscription reads: φονεὺς εὑρεθεὶς οὗτος λιθοβολίται.
Close to Ser. and Vat. 746. A walled city stands behind the condemned, and the number of executioners has been increased. Large sections of the surface are flaked.

Located below Leviticus 24:23.

Lit.: Venturi, *Storia*, vol. 2, p. 466, fig. 328; Uspenskii, p. 151, fig. 158; Hesseling, p. ii, fig. 219; Huber, fig. 12; Kirigin, *Mano divina*, p. 149; Lowden, *Octs.*, p. 17.

7. NUMBERS

Numbers 5:2–4

LEPERS SENT OUT OF THE CAMP

As in the Leviticus cycle, the illustrations in Numbers betray scant interest in the rules God gave the Israelites. Accordingly, neither the census decreed by God at Numbers 1:2ff., nor the special status granted to the Levites at Numbers 3, nor any other prescriptions were given attention in the planning of the cycle. The first illustration we encounter concerns a disease, namely leprosy, mentioned in chapter 5, where God commands that every leper and every person having an issue of blood be sent out of the camp.

879. Vat. 747, fol. 154v

Moses sits on a chair and raises his hand in a gesture of command toward two lepers who are leaving but at the same time turn around with frightened gestures. The background, with the exception of the upper golden strip, is slightly flaked.

Located beside Numbers 5:1.

880. Ser., fol. 324v

There are several deviations from Vat. 747: the lepers are a sizeable group, Moses sits before two buildings surmounted respectively by a small upper story and a tempietto, and between him and the lepers appears a young Israelite who listens intently to Moses' order and at the same time executes it by pushing the lepers away. This youth, dressed in a short tunic, is represented in exactly the same posture as the leper next to Moses in Vat. 747, and one figure must therefore be a transformation of the other.

Located in the catena; the text above is Numbers 5:8.

881. Sm., fol. 150r

The inscription reads: πε(ρὶ) τ(ῶν) λεπρῶν τ(ῶν) ἐκβαλλο-μένων ἐκ τ(ῆ)ς παρεμβολῆς.

Very close to Ser.

882. Vat. 746, fol. 318r

The inscription reads: περὶ τῶν λεπρῶν τῶν ἐκβαλλομένων ἐκ τῆς παρεμβολῆς.

Close to Ser. and Sm. Slightly flaked.

Located below Numbers 4:49 (and above Numbers 5:1).

883. Vtp., fol. 108r

This copy deviates in several respects from Ser., Sm., and Vat. 746: the hindmost leper turns around as if he were not willing to leave and had something to say to Moses; the young Israelite in the center wears a mantle over his tunic; and the architecture is completely changed. A portal with columns is seen in frontal view, inorganically connected with a building at its left which is flanked by a free-standing column. The background, painted in pink, violet, and gray, is of a later date.

Located above Numbers 5:3.

Lit.: Uspenskii, p. 152, figs. 159, 306; Hesseling, fig. 220; Huber, fig. 13; Θησαυροί, p. 256, fig. 56.

Numbers 5:24 or 26

TRIAL OF BITTER WATER

The woman charged with adultery is not bareheaded and with loosened hair, as required by Numbers 5:18, and on the whole the picture gives an imprecise representation of the test of the bitter water as prescribed in Numbers 5:18–28 and, more meticulously, in haggadic writings.[1] The painter seems not to have had any knowledge of the Jewish procedure nor any curiosity about it. The iconography appears instead to be an offspring of Mary's trial of the water as described in apocryphal Gospels[2] and commonly represented in Byzantine art.[3]

884. Vat. 747, fol. 155v

A priest offers the woman the bitter water that causes the curse. The priest, who with his nimbus is apparently meant to represent Aaron, stands behind the closed royal doors and holds a golden vessel from which one woman is about to drink, while another, standing aside, looks at her.

Located beside Numbers 6:2.

885. Ser., fol. 326v

Close to Vat. 747. Slightly flaked.

Located beside Numbers 6:2.

886. Sm., fol. 151v

The inscription reads: τὸ τῆς ἐλέγξεως ὕδωρ.

Very close to Ser.

887. Vat. 746, fol. 320r

The inscription reads: τὸ τῆς ἐλέγξεως ὕδωρ.

Very close to Ser. and Sm. The priest—most likely as the result of a later restoration—holds an open bowl instead of an amphora-like vessel with handles. Slightly flaked.

Located below Numbers 6:1.

888. Vtp., fol. 112r

The inscription, written in red and barely visible against the brown ground, reads: τὸ τῆς ἐλέγξεως ὕδωρ.

The composition is expanded, and behind the woman being tried three more stand awaiting their turns. At a later time the background was colored in a monochromatic brown.

Located beside Numbers 6:1.

Lit.: Uspenskii, p. 152, fig. 160; Hesseling, fig. 221; Babić, "Fresques," p. 322, fig. 20; Lafontaine-Dosogne, *Iconographie de l'enfance*, vol. 1, p. 36 n. 3; Huber, fig. 14; Θησαυροί, pp. 256–57, fig. 57; Bernabò, "Tradizioni siriache," p. 305, fig. 5.

¹ The procedure is debated by rabbis in Sotah 8a–b, a Jewish treatise contained in Mishna, Tosefta, and Talmud (*Babylonian Talmud*, ed. Epstein, vol. 3, pp. vii, 34–36).

² *Protoevangelium Iacobi* 16:2 (*Papyrus Bodmer V*, ed. Testuz, pp. 96–97); *Ps.-Matthaei Evangelium* 12:2–4 (*Evangelia Apocrypha*, ed. K. von Tischendorf, 2d ed. [Leipzig, 1876], pp. 73–75).

³ See Weitzmann, *Castelseprio*, pp. 48–50.

Numbers 6:10–15

OFFERING AFTER A VOW

In Vat. 747 the Israelite incorrectly brings to Aaron only two of the offerings mentioned in the text: a ram (verse 14) and a bowl containing unleavened bread (verse 15); in the other manuscripts a ram and a pair of turtledoves or pigeons (verse 10) are offered. These birds must be sacrificed as a sin offering when the person who has taken the vow of separation has been defiled by coming into contact with anyone who has suddenly died. This miniature is the only illustration devoted to chapter 6.

889. Vat. 747, fol. 156v

The priest sits on a chair and extends his hand to receive the gifts of the ram and the bowl with the unleavened bread brought by a young man. The tabernacle, in front of which the scene is supposed to take place, is depicted in a small size and suspended far above in the background. Flaked in various spots.

Located beside Numbers 6:23.

890. Ser., fol. 329r

Close to Vat. 747 but the offerer holds a pair of turtledoves or young pigeons in his hands (verse 10). Flaked in various places.

Located beside Numbers 6:21.

891. Sm., fol. 152v

The inscription reads: περὶ τοῦ τῇ ἑβδόμῃ ἡμέρᾳ ξυρηθέντος καὶ θυσίαν τῇ μετὰ ταῦτα προσαγαγόντος.

Very close to Ser.

892. Vat. 746, fol. 322v

The inscription reads: περὶ τοῦ τῇ ἑβδόμῃ ἡμέρᾳ ξυρισθέντος καὶ θυσίαν τῇ μετὰ ταῦτα προσαγαγόντο(ς).

Very close to Ser. and Sm.

Located below Numbers 6:24.

893. Vtp., fol. 116r

The inscription reads: πε(ρὶ) τοῦ τῇ ἑβδόμῃ ἡμέ(ρᾳ) ξηρισθέντο(ς) καὶ θυσίαν τῇ μετὰ ταῦτα προσαγαγόντο(ς).

Very close to Ser., Sm., and Vat. 746. Flaked in various spots. Located beside Numbers 6:24.

Lit.: Uspenskii, p. 152; Hesseling, fig. 222; Huber, fig. 15; Θησαυροί, p. 257, fig. 58.

Numbers 7:89–8:4

MOSES AND AARON BEFORE THE TABERNACLE

The only miniature in chapter 7 illustrates Moses going into the tabernacle, where God asked him to tell Aaron to set up the seven-branched candlestick.

894. Vat. 747, fol. 158v

Moses and Aaron, conversing together, stand alongside the wooden Ark of the Covenant with its semicircular top indicating the mercy seat. Two golden cherubim, which are supposed to cover the mercy seat's two sides (cf. figs. 750–753), are depicted in suspension and flanking a ciboriumlike structure representing the tabernacle. The cherubim have silhouettes of a man's and a lion's head and a man's and a calf's head, respectively. The seven-branched golden candlestick is visible opposite Moses and Aaron, the trefoils along its top connected by a bar. The ark is flanked by a goat and a lamb, two of the many sacrificial animals which, according to the preceding verses of chapter 7, were offered by the princes of the Israelites. Flaked in several places.

Located beside Numbers 8:2.

895. Ser., fol. 333r

Close to Vat. 747. A few details vary: the shape of the ciborium, the decoration of the ark and candlestick, and Aaron's costume (a chlamys). The blessing hand of God is represented in heaven. The cherubim have more details, with eyes on their wings and extended hands. There are two birds probably meant to represent additional sacrificial animals, although the text mentions only quadrupeds in this connection. The form of the tabernacle is slightly different from that in the illustration of Exodus 25:20 (figs. 751–753), where a wavy line is painted in the frame around the doors.

Located above Numbers 8:2.

896. Sm., fol. 154v

The inscription reads: ὁ χρηματισμὸ(ς) κ(υρίο)υ ἐκ μέσου λαοῦ—τὰ χερουβίμ—ἡ λυχνία—ἡ κιβωτό(ς).

Very close to Ser.

897. Vat. 746, fol. 325v

The inscription reads: ὁ χρηματισμὸς κ(υρίο)υ ἐκ μέσου λαοῦ—τὰ χερουβίμ—ἡ λυχνία—ἡ κιβωτός.

Very close to Ser. and Sm.

Located below Numbers 7:89.

898. Vtp., fol. 122r

The inscription, written in red and hardly recognizable, reads: ὁ χρηματισμὸς κ(υρίο)υ ἐκ μέσου λαοῦ—τὰ χερουβίμ—ἡ λυχνία—ἡ κιβωτό(ς).

Close to Ser., Sm., and Vat. 746. The candlestick holds seven burning candles. The bluish gray coloring of the background, through which a pink ground is discernible, and the inscription are of a later date.

Located beside Numbers 8:2.

Lit.: Uspenskii, p. 152, fig. 161; Stornajolo, *Topografia Cristiana*, p. 17; Hesseling, fig. 223; Goodenough, *Symbols*, vol. 10, p. 12 n. 53, fig. 240; Wolska-Conus, *Cosmas*, vol. 1, p. 144 n. 1; Galavaris, *Gregory Naz.*, p. 137; Huber, fig. 16; Brubaker, "Tabernacle," p. 86, fig. 7; Weitzmann, *Dura*, pp. 57–58, 61–62, figs. 91, 92; Θησαυροί, p. 257, fig. 59.

Numbers 10:1–28

Cloud Lifted from the Tabernacle and Departure from Sinai

The cycle skips the consecration of the Levites that occupies the remainder of chapter 8 and the rules for Passover dictated in chapter 9. Vat. 747 is the only manuscript depicting the departure of the Israelites from their encampment on Mount Sinai, when the cloud was lifted from the tabernacle.

899. Vat. 747, fol. 160v

A bluish gray cloud extends downward from a segment of heaven, lightly touching the peak of the steep mountain instead of enveloping it, thus indicating suitable weather for the departure. The Israelites' journey is represented in such a way that the transport of the Ark of the Covenant occupies a central rectangular panel around which twelve squares are arranged, one reserved for each of the twelve tribes. Four youths carry the ark on two staves, each of which is put through two rings on either side of the ark (cf. Ex 25:12–16); two more Israelites hold the top of the ark; and Moses and Aaron lead the procession, turning their heads to make sure the ark follows them. Each of the squares contains three soldiers armed with a spear and shield, except for the four squares at the corners, where the third soldier is replaced by an Israelite blowing a trumpet. According to the text, only two silver trumpets were made, following Moses' orders, for the purpose of announcing the removal of the camp. The representation of four instruments may reflect an attempt at symmetry or at marking the cardinal points; it also has a textual justification in that four alarms were sounded at the depar-

ture. Parts of the miniature, particularly the central panel, are somewhat flaked.

Located below Numbers 10:29.

Lit.: Stornajolo, *Topografia Cristiana*, p. 17 n. 26; Mouriki-Charalambous, "Cosmas," pp. 144–48; Revel-Neher, *Arche*, p. 171 n. 345; Weitzmann, *Dura*, pp. 44–45, 61, fig. 61; Lowden, *Octs.*, p. 75, fig. 110.

Numbers 10:33

Tribes March and Carry the Ark

The passage in chapter 10 which mentions the departure from Mount Sinai is illustrated by a miniature akin to the preceding one in Vat. 747 but considerably simplified.

900. Vat. 747, fol. 162r

In the central panel the ark is carried by only four youths, omitting the two Israelites holding the mercy seat in the previous miniature. Furthermore, each tribe is represented by only one soldier, and of these only the two marching on the same level as the central procession are rendered full-length, while those in the upper and lower registers are reduced to half figures. Slightly flaked.

Located beside Numbers 11:25.

Ser., fol. 339r

The miniature on fol. 339r has been cut out. The miniature was located in the catena, the text below being Numbers 11:25.

901. Sm., fol. 158r

The inscription reads: χωρεῖ τὸ πν(εῦμ)α τοῦ θ(εο)ῦ πρὸ(ς) ἀξίους.

Close to Vat. 747. The dividing line between the central panel and that at the right is omitted; thus, one of the representatives of the twelve tribes here seems to be leading the procession, walking ahead of Moses and Aaron.

902. Vat. 746, fol. 331r

The inscription reads: χωρεῖ τὸ πν(εῦμ)α τοῦ θ(εο)ῦ πρὸ(ς) ἀξίους.

Very close to Sm. All the figures are more or less flaked.

Located beside Numbers 11:25.

903. Vtp., fol. 132r

The inscription, for which there was no room within the central panel, is written below the miniature. It reads: χωρεῖ τὸ πνεῦ(μα) τοῦ θ(εο)ῦ πρὸ(ς) ἀξίους.

Very close to Ser., Sm., and Vat. 746, and somewhat rubbed, flaked, and stained.

Located beside Numbers 11:25.

Lit.: Strzygowski, *Sm.*, pp. 116–17, pl. 40 no. 1; Uspenskii, p. 152, fig. 307; Stornajolo, *Topografia Cristiana*, p. 17; Hesseling, fig. 224; Weitzmann, *RaC*, p. 164; Roth, "Jewish Antecedents," p. 38 n. 5; Goodenough, *Symbols*, vol. 10, p. 12 n. 52, fig. 235; Wolska-Conus, *Cosmas*, vol. 1, p. 145 n. 2; Mouriki-Charalambous, "Cosmas," pp. 144–48; Huber, fig. 17; Lassus, *Livre des Rois*, p. 86, fig. 114; Revel-Neher, *Arche*, p. 171 n. 345; Kühnel, "Temple and Tabernacle," pp. 162–63; Kühnel, *Jerusalem*, p. 154, figs. 120, 121; Weitzmann, *Dura*, pp. 44–45, fig. 62; Θησαυροί, p. 257, fig. 60.

Numbers 11:26

Eldad and Medad Prophesy

904b. Vat. 747, fol. 162r

In the lower left miniature Eldad and Medad (LXX: Modad) are represented prophesying in the camp. They stand in the center of the composition, and each addresses a group of Israelites who seem to be cautious or even hesitant and are turning aside. Slightly flaked.

Located below Numbers 11:35.

905b. Ser., fol. 339v

The two prophets are more youthful than in Vat. 747 and are dressed in short embroidered tunics and chlamydes; and the two groups of Israelites, who listen more willingly, are somewhat larger.

Located below Numbers 11:34.

907b. Sm., fol. 158r

The inscription reads: ἐλδὰδ προφήτ(ης) καὶ μωδὰδ θάμβο(ς) μέγα.

Very close to Ser.

909b. Vat. 746, fol. 332r

The inscription reads: ἐλδὰδ προφήτης καὶ μωδὰδ θάμβος μέγα.

Very close to Ser. and Sm.

Located below Numbers 11:28.

910. Vtp., fol. 133v

The inscription reads: ἐλδὰδ προφήτ(ης) καὶ μωδὰδ θάμβος μέ(γα).

There seem to be more women among the listening Israelites than in the other copies, with which the miniature otherwise agrees. Considerably flaked.

Located above Numbers 11:34.

Lit.: Uspenskii, pp. 152–53, fig. 163; Hesseling, fig. 225; "Eldad and Medad," fig. col. 575; Huber, fig. 18; Θησαυροί, p. 258, fig. 61.

Numbers 11:27–28

Moses Told about Eldad and Medad

904a. Vat. 747, fol. 162r

A boy runs up to Moses, who is seated on a high-backed chair, and reports that Eldad and Medad are prophesying. Joshua is also present; according to the text, he becomes agitated and advises Moses to forbid Eldad and Medad from prophesying, but in the miniature he stands silent and motionless behind Moses' chair. The surface is flaked in various places, except for the uppermost golden strip of sky.

Located below Numbers 11:35.

905a. Ser., fol. 339v

Close to Vat. 747. Joshua is shown without a shield and holds his spear in the other hand.

Located below Numbers 11:34.

907a. Sm., fol. 158r

The inscription reads: πάντες προφῆται σοὶ δὲ τούτων οὐ μέλλει.

Very close to Ser.

909a. Vat. 746, fol. 332r

The inscription reads: πάντες προφῆται σοὶ δὲ τούτων οὐ μέλλει.

Very close to Ser. and Sm.

Located below Numbers 11:28.

911a. Vtp., fol. 134r

The inscription reads: πάντες προφῆται σοὶ δὲ τούτων οὐ μέλλει.

Very close to Ser., Sm., and Vat. 746.

Located above Numbers 12:1.

Lit.: Uspenskii, p. 153, fig. 162; Hesseling, fig. 225; "Eldad and Medad," fig. col. 575; Huber, fig. 19; Weitzmann, *SP*, pp. 58–59, 61; Θησαυροί, p. 258, fig. 62.

Numbers 11:31–33

Israelites Eat Quails

904c. Vat. 747, fol. 162r

A covey of quails flies down from a segment of heaven straight into the open mouths of the Israelites, who are lying at the foot of a mountain, swallowing the indigestible birds. Two of the Israelites have already become sick and, with an expression of suffering, turn their heads away.[1]

Located below Numbers 11:35.

906. Ser., fol. 340r

The consequences of eating the birds are rendered very graphically: one Israelite has had diarrhea and another is vomiting. God's hand from a segment of heaven indicates that he is smiting the people with this plague. Flaked in various spots and slightly stained.

Located beside Numbers 11:34.

908. Sm., fol. 158r

The inscription reads: πικρ(ᾶς) τελευτῆς πρόξενος λαιμαργία.

Very close to Ser. and somewhat rubbed.

909c. Vat. 746, fol. 332r

The inscription reads: πικρᾶς τελευτῆς πρόξενος λαιμαργία.
Very close to Ser. and Sm.
Located below Numbers 11:28.

911b. Vtp., fol. 134r

The inscription reads: πικρᾶς τελευτ(ῆς) πρόξενος λαιμαργία.

Very close to Ser., Sm., and Vat. 746. Heavily flaked in some places.

Located above Numbers 12:1.

Lit.: Uspenskii, p. 153, fig. 164; Hesseling, fig. 226; Huber, fig. 19; Kirigin, *Mano divina*, p. 149; Θησαυροί, p. 258, fig. 62.

¹ In verse 33, the quail meat was still between the teeth of the Israelites when God punished them.

Numbers 12:11–14

Miriam Becomes Leprous

912a. Vat. 747, fol. 163r

In front of the altar and ciborium, Moses addresses Aaron and Miriam, both of whom he has summoned to the tabernacle to rebuke them for speaking against him. In contradiction to the text, Miriam has not contracted leprosy as punishment. The background is flaked in various spots.

Located below Numbers 13:21.

913. Ser., fol. 342r

Miriam's face, arms, and hands are covered with sores. Aaron, who is not nimbed, beseeches Moses to relieve the girl of the plague, while Moses asks God to heal Miriam.

Located below Numbers 13:19.

915a. Sm., fol. 159r

The inscription reads: τῆς μαρίας λέπρωσις ἐκ γλωσσαλγίας.

Very close to Ser. Aaron is not speaking but raises his hand in surprise.

916a. Vat. 746, fol. 334r

The inscription reads: τῆς μαρίας λέπρωσις ἐκ γλωσσαλγίας.

Closer to Ser. than to Sm.
Located below Numbers 13:22.

917. Vtp., fol. 136r

The inscription reads: τῆς μαρίας λέπρωσις ἐκ γλωσαλγίας.

In general, close to Ser. and Vat. 746 but differs in detail. Despite the gesture of prayer, Moses seems to be speaking not to God but to Aaron who, as in Vat. 747, is nimbed. Marble transennae have been added before the altar, the ornament of the ciborium has been enriched, and the shape of the ciborium is different.

Located above Numbers 12:8.

Lit.: Uspenskii, p. 153, fig. 165; Hesseling, fig. 227; Weitzmann, *RaC*, pp. 98–99, 247 (2d ed.), fig. 84; Kirigin, *Mano divina*, p. 150; Huber, fig. 20; Lowden, "Vtp. Oct.," pp. 120–21, figs. 15, 16; Lowden, "Production," p. 198; Lauxtermann, *Byzantine Epigram*, pp. 67–68; Θησαυροί, p. 258, fig. 63; Lowden, *Octs.*, pp. 28, 47–48, figs. 45, 46.

Numbers 13:17–20

Moses Sends Spies to Canaan

912b. Vat. 747, fol. 163r

Moses, sitting on a mound, sends out spies to explore the land of Canaan. The number of spies is less than twelve, although the text specifies one from each tribe. The spies are dressed in short tunics and armed like soldiers with spears and shields. Flaked in various spots.

Located below Numbers 13:21.

914. Ser., fol. 342r

The spies, numbering ten, vary greatly in age, and while most of them wear short tunics, one of them has his hem tucked up, another is clad in an exomis, and a third has his tunic swagged over the breast. Moses' tunic is painted in solid gold.

Located below Numbers 13:19.

915b. Sm., fol. 159r

The inscription reads: μωσῆς προπέμπει γῆς σκοπήσαι τὴν θέσιν.

Close to Ser. There are eleven spies here.

916b. Vat. 746, fol. 354r

The inscription reads: μωσῆς προπέμπει γῆς σκοπήσαι τὴν θέσιν.

The group of spies agrees in number with Sm., but the individual types are in many respects closer to Ser.

Located below Numbers 13:22.

918. Vtp., fol. 137r

The group of spies is considerably different: the men all advance on the same level and overlap each other more, giving the impression that they are assembled in full number. The three foremost soldiers wear helmets with flamelike crests, and the hindmost is seen from the back. The miniature is flaked, rubbed, and stained in several places.

Located beside Numbers 13:2.

Lit.: Uspenskii, p. 153; Hesseling, fig. 227; Weitzmann, *RaC*, pp. 98–99, 247 (2d ed.), fig. 84; Huber, fig. 201; Gaehde, "Octateuch," pp. 368–69, fig. 83; Lowden, "Vtp. Oct.," pp. 120–21, fig. 16; Lowden, "Production," p. 198; Θησαυροί, p. 258, fig. 64; Lowden, *Octs.*, pp. 28, 47–48, fig. 45.

Numbers 13:23

Spies Return with Fruits

919a. Vat. 747, fol. 165r

From the "valley of the cluster" where they have collected samples of various fruits, the spies return to the camp. The left half of the miniature contains the procession, headed by two Israelites carrying on their shoulders a staff from which a single, huge cluster of grapes is suspended. The others carry pomegranates and figs, but these fruits are either hidden by the veils covering the spies' hands or are not clearly distinguished, as in the case of the Israelite who directly follows the bearers of the cluster. The ground is very badly flaked.

Located below Numbers 15:3.

920a. Ser., fol. 345v

The group of Israelites following the two bearing the grapes is more expanded and the attributes are shown in great detail: two of the men hold figs and a third carries two pomegranates.

Located below Numbers 14:38.

921a. Sm., fol. 161r

Very close to Ser.

Vat. 746

Fol. 337, which in all probability contained a miniature corresponding to those in Vat. 747, Ser., and Sm., was cut out at an early date and replaced by a parchment leaf on which the text, but not the miniature, was restored.

Vtp.

This manuscript never included the corresponding miniature. This confirms that when this copy was made, Vat. 746, which served as its direct model, had already lost the above-mentioned folio with its miniature. The copyist was well aware of the textual lacuna in Vat. 746 and left the recto of fol. 144 empty with the intention of eventually filling in the missing passage of the text and the corresponding miniature from another model, but this was never done.

Lit.: Uspenskii, p. 153, fig. 166; Hesseling, fig. 228; Huber, fig. 22; Deckers, *S. Maria Magg.*, pp. 205–6; Lowden, "Vtp. Oct.," p. 117; Lowden, *Octs.*, p. 47.

Numbers 14:29–35

Carcasses of the Murmurers

919b. Vat. 747, fol. 165r

Angry about the returning spies' grumbling, God predicts that, with the exception of Joshua and Caleb, the adult Israelites would be excluded from the Promised Land, their carcasses will fall in the wilderness, and their children will be shepherds in the wilderness for forty years before being allowed to enter. In the right half of the miniature the illustrator depicted the realization of this prediction by means of a heap of skulls and bones set against a mountainous background. Heavily flaked.

Located below Numbers 15:3.

920b. Ser., fol. 345v

Choosing to render gradual decomposition, the illustrator has represented some intact corpses, a torso and some limbs, and skulls and bones. The mountainous background is eliminated, so that the various elements appear to be suspended.

Located below Numbers 14:38.

921b. Sm., fol. 161r

The inscription reads: τὰ κῶλα πίπτει τῶν ἀπειθ(ῶν) ἐνθάδε. Very close to Ser.

Vat. 746

The original folio containing this scene has been replaced.

Vtp.

See the remark on the preceding scene.

Lit.: Uspenskii, p. 153; Hesseling, fig. 228; Huber, fig. 22; Lowden, "Vtp. Oct.," p. 117.

Numbers 14:44

ARK ON THE HILLTOP

922a. Vat. 747, fol. 165v

The wooden Ark of the Covenant is placed on a hillock, its mercy seat reaching into a golden strip of sky. It is flanked by Moses on one side who addresses Joshua on the other. Joshua is not explicitly mentioned in the text, but his presence even when not required by the text has occurred previously (figs. 803–806) and may in this case be explained by the illustrator's desire to introduce him proleptically as Moses' successor and the future keeper and protector of the ark. Slightly flaked.

Located beside Numbers 15:3.

923. Ser., fol. 345v

Close to Vat. 747, but the ark is painted gold and its legs are shown. Slightly rubbed and flaked.

Located below Numbers 14:45.

925a. Sm., fol. 161v

The inscription reads: τρόπ(ους) προφαίνει θυσι(ῶν) μωσ(ῆ)ς μέγας.

Very close to Ser.

Located beside Numbers 15:4.

Vat. 746

In all probability the corresponding miniature was on the verso of fol. 337, which was cut out and replaced by a page containing the text but no illustration.

Vtp.

The miniature must have already been lost in Vat. 746 at the time the copyist of Vtp. used it as model (see the remarks under Numbers 13:23).

Lit.: Uspenskii, p. 153, fig. 167; Hesseling, fig. 229; Huber, fig. 23; Lowden, "Vtp. Oct.," p. 117; Revel-Neher, "Christian Topography," p. 87, fig. 16; Lowden, *Octs.*, p. 81, fig. 118.

Numbers 14:45

AMALEKITES AND CANAANITES
SMITE THE ISRAELITES

922b. Vat. 747, fol. 165v

The Israelites are defeated by the Amalekites and Canaanites (LXX: Chananites) at Hormah (LXX: Herman). The enemy army, headed by the cavalry, attacks the Israelite foot soldiers with spears and bows. The Israelites flee, looking back at their pursuers with frightened expressions and leaving behind two of

their wounded who have been pierced and have fallen to the ground.

Located beside Numbers 15:3.

924. Ser., fol. 345v

Close to Vat. 747, but both the advancing and the fleeing army are reduced in number, and some of the types differ: the pursuing archer is replaced by a horseman spurring on the foot soldiers following him. Only one of the two slain Israelites has fallen to the ground, while the other is trying to rise and protect himself against the next onslaught. Furthermore, a separate group of combatants, lacking in Vat. 747, is visible between the two lines. Here an enemy foot soldier is about to decapitate an Israelite who has been forced to his knees and pleads in vain for his life. Flaked in various places.

Located below Numbers 14:45.

925b. Sm., fol. 161v (see also text fig. 57)

The inscription reads: τραχηλιῶντα λαὸν ἐκτέμνει ξίφος.

Very close to Ser.

Located beside Numbers 15:4.

Vat. 746

The corresponding miniature has been lost, together with the preceding one.

Vtp.

A corresponding miniature never existed in this manuscript (see the remarks under the preceding miniature and on the illustration of Numbers 13:23).

Lit.: Uspenskii, pp. 153–54; Hesseling, fig. 229; Huber, fig. 23; Lassus, *Livre des Rois*, p. 88, fig. 123; Lowden, "Vtp. Oct.," p. 117; Lowden, *Octs.*, p. 81, fig. 118.

Numbers 15:35–36

STONING THE SINNER

Again, the cycle ignores the rules decreed by God to the Israelites, in this case the sacrifices listed at Numbers 15:1–31, and illustrates only the stoning of a sinner with the conventional iconography also found in Leviticus (see nos. 865–869).

926. Vat. 747, fol. 166v

The man who disobeyed the ordinances concerning the sabbath and gathered sticks on that day is put to death by Moses' order. Four Israelites are executing the sentence and stoning the culprit, whose heavily bleeding head has already been hit. Having fallen to the ground, the victim now tries in vain to protect himself against further blows. Moses stands at the side with a commanding gesture, and Joshua, who, as in some previous

instances, is not explicitly mentioned in the text (cf. nos. 804–807, 922a), stands behind him.

Located beside Numbers 15:38.

927. Ser., fol. 347v

Close to Vat. 747, except for the left half, where Moses not only directs the execution, but also looks up at the blessing hand of God issuing from a segment of heaven. Joshua holds a spear in his right hand, and Aaron appears in frontal view between him and Moses. Aaron's presence is justified by verse 33, according to which the culprit was brought before Moses and Aaron for trial. The right group has been badly scratched, perhaps intentionally by a pious reader expressing wrath.

Located beside Numbers 15:38.

928. Sm., fol. 162r or 162v[1]

The inscription reads: ποινὴν ἀπειθῶν τήνδ᾽ὑπέσχε τῷ νόμ(ῳ).

Very close to Ser.

929. Vat. 746, fol. 339r

The inscription reads: ποινὴν δ᾽ἀπειθῶν τήνδ᾽ὑπέσχε τῶι νόμωι.

Very close to Ser. and Sm.

Located below Numbers 15:40.

930. Vtp., fol. 146v

The inscription reads: ποινὴν δ᾽ἀπειθῶν τήνδ᾽ὑπέσχε τῷ νόμῳ.

Very close to Ser., Sm., and Vat. 746. The ground and parts of the figures are badly flaked.

Located above Numbers 15:39.

Lit.: Uspenskii, p. 154; Hesseling, fig. 230; Huber, fig. 24; Θησαυροί, p. 259, fig. 65.

[1] Fol. 162v according both to Hesseling, p. xiii, and Uspenskii, p. 187; fol. 162r according to the label in the photo taken by Buberl.

Numbers 16:32–34

Earth Swallows Korah and His Followers

931. Vat. 747, fol. 167v

In punishment for their rebellion against Moses, a sudden cleavage in the earth swallows Dethan (LXX: Dathan), Abiram (LXX: Abiron), and Korah (LXX: Core) with all the men, animals, and houses belonging to them. Moses, with a commanding gesture, stands on a hill accompanied by a group of elders looking alarmed by Moses' wrath and the catastrophe. Flaked in various spots.

Located beside Numbers 17:1.

932. Ser., fol. 349v

The rebels are divided into two groups: in the upper group two men are visible behind two corpses, a tent, a sheep, and an ox, and they hold up their arms as if trying to protect themselves against the rays that are directed toward them by the divine hand issuing from a segment of heaven. They are most likely intended to represent Dethan and Abiram, whereas the old man in the center of the lower group, surrounded by a woman and young men, can probably be identified as Korah. This second group is accompanied by an ass, a horse, and the same two tumbling buildings, a cella and a domed tower, which occur, though distributed differently, in Vat. 747. There is no hill: Moses, holding a scroll in his hand, and the elders of Israel stand on the ground-line. One of the elders is weeping, a second pleads with Moses, and the foremost in the center gestures vividly in surprise and astonishment. Slightly flaked and rubbed.

Located beside Numbers 16:33.

933. Sm., fol. 163v

The inscription reads: δαθὰν, ἀβειρὼν ζῶντας ἡ γῆ λαμβάνει.

Very close to Ser. and probably overpainted in part, as is particularly noticeable in the elders' faces.

Located beside Numbers 17:3.

934. Vat. 746, fol. 340v

The inscription reads: δαθὰν, ἀβειρὼν ζῶντ(ας) ἡ γῆ λαμβάνει.

The rebels are more deeply submerged, and the two groups are more or less fused into one. Flaked in several places.

Located below Numbers 17:3.

935. Vtp., fol. 150r

The inscription reads: δαθὰν, ἀβειρὼν ζῶντ(ας) ἡ γῆ λαμβάνει.

Very close to Vat. 746. Flaked in various spots and heavily stained in the area around Moses.

Located above Numbers 16:34.

Lit.: Strzygowski, *Sm.*, p. 117, pl. 40 no. 2; Uspenskii, pp. 103–4, 154, fig. 168; Hesseling, fig. 231; De Grüneisen, *Ste. Marie Ant.*, p. 226, fig. 177; Weitzmann, "Constantinop. Book Ill.," p. 327, fig. 317; Buchthal, *Latin Kingdom*, p. 59; Ettlinger, *Sistine Chapel*, p. 53, pl. 41a; Cahn, "Josephus," pp. 298–99; Huber, fig. 25; Gaehde, "Octateuch," pp. 369–70, fig. 85; Weitzmann, *SP*, pp. 59, 61; Lowden, "Vtp. Oct.," p. 120, figs. 13, 14; Weyl Carr, *Byz. Illum.*, p. 92; Vikan, "Edible Icons," pp. 47–49, fig. 1; Θησαυροί, p. 259, fig. 66; Lowden, *Octs.*, pp. 16, 62–64, figs. 34–39.

Numbers 16:42–49

God Addresses Moses and Aaron and Smites the Israelites

936. Vat. 747, fol. 168r

When the congregation rebelled against Moses and Aaron and ran to the Tabernacle of Witness, a cloud covered the tabernacle

and God appeared to Moses and Aaron and told them to separate themselves from the congregation, which he would destroy. In the miniature, fire rather than a cloud is seen falling from a segment of heaven and enveloping the tabernacle, which consists of a ciborium with an altar in front of it. At the same time, God's hand is directed toward Moses, who looks up. Aaron stands beside Moses and holds the pyxis and censer with which he will stop the plague. A group of stricken Israelites lies below the tabernacle; some of the men are sick and others already dead. The miniature is flaked in various places and all the heads have been overpainted.

Located beside Numbers 17:12.

937. *Ser., fol. 351r*

Close to Vat. 747. Aaron is without a nimbus and censer, and the attitudes of the dying Israelites differ. The tabernacle itself is replaced by a representation of its courtlike enclosure which is rendered in the usual way (cf. figs. 767ff., 780ff.) as a quadrangle of pillars projected on the ground, with blue curtains stretching between them.

Located beside Numbers 17:15.

938. *Sm., fol. 164r*

The inscription, written outside the frame at the left, reads: προσευχὴ μωυσῆ καὶ ἀαρ(ὼν) περὶ τοῦ λαοῦ.

Very close to Ser.

939. *Vat. 746, fol. 341v*

The inscription, written outside the frame at the right, reads: προσευχ(ὴ) μωυσῆ καὶ ἀαρὼν περὶ τοῦ λαοῦ.

Very close to Ser. and Sm.

Located beside Numbers 17:12.

940. *Vtp., fol. 151v*

The inscription reads: προσευχ(ὴ) μωυσῆ καὶ ἀαρὼν περὶ τοῦ λαοῦ.

Very close to Ser., Sm., and Vat. 746 and flaked in various spots.

Located beside Numbers 17:11.

Lit.: Uspenskii, p. 154, fig. 169; Stornajolo, *Topografia Cristiana*, p. 17; Hesseling, fig. 232; De Grüneisen, *Ste. Marie Ant.*, p. 226, fig. 181; Wolska-Conus, *Cosmas*, vol. 1, p. 144 n. 4; Huber, fig. 26; Θησαυροί, p. 259, fig. 67; Lowden, *Octs.*, fig. 34.

Numbers 17:7–14

ROD OF AARON FLOWERS

941. *Vat. 747, fol. 168v*

Twelve rods, one for each tribe, lean against the tabernacle. The one belonging to Aaron has brought forth buds and blos-

soms. Moses and Aaron stand in front of the tabernacle and look at this miraculous transformation with gestures of amazement. Flaked in various spots.

Located beside Numbers 17:27.

942. *Ser., fol. 351v*

The altar stands underneath the ciborium and is partly concealed by the golden royal doors and a marble transenna. The twelve rods, instead of leaning against the tabernacle, are represented standing alongside it without any visible support. Aaron is not looking at his rod, as in Vat. 747, but rather turns to Moses with a gesture of speech, and both of them hold scrolls in their hands.

Located beside Numbers 17:28.

943. *Sm., fol. 164v*

The inscription reads: αἱ τῆς τοῦ ἀαρ(ὼν) ῥάβδου βλαστήσ-(εις).

Very close to Ser.

944. *Vat. 746, fol. 342v*

The inscription reads: αἱ τῆς τοῦ ἀαρὼν ῥάβδου βλαστήσεις.

Close to Ser. and Sm., but one detail was misunderstood by the painter: the transenna next to the royal doors is transformed into a piece of architecture that is completely out of scale and is decorated with a slit window.

Located beside Numbers 17:28.

945. *Vtp., fol. 153v*

The inscription reads: αἱ τῆς τοῦ ἀαρὼν ῥάβδου βλαστήσεις.

The painter, copying directly from Vat. 746, repeated the mistake involving the transenna. Flaked in various places.

Located below Numbers 17:28.

Lit.: Uspenskii, p. 154, fig. 170; Hesseling, fig. 233; Redin, *Koz'my Indikoplova*, p. 297, fig. 325; Lowrie, *Art*, p. 213, pl. 145d; Lafontaine-Dosogne, *Iconographie de l'enfance*, vol. 1, pp. 171 n. 1, 175 n. 2; Galavaris, *Gregory Naz.*, p. 137; Huber, fig. 27; Θησαυροί, p. 259, fig. 68; Revel-Neher, *Image of the Jew*, pp. 64–65, fig. 16.

Numbers 18:12–17

OFFERING FIRSTFRUITS

The next miniature is the sole illustration dedicated to the prescriptions in chapter 18. The rules decreed in chapter 19 are entirely ignored, and the cycle continues with chapter 20.

946. *Vat. 747, fol. 170r*

As prescribed in the text, the Israelites bring the firstfruits as offerings to Moses. A bearded young Israelite clad as the high priest is apparently to be identified as a proleptic Eleazar (cf. no.

962a). One Israelite holds a sheep and another a goat, and the two drive a calf before them. A third Israelite carries a bag over his shoulder, probably containing the firstfruits of grain mentioned in verse 12. The tabernacle to which these offerings are being brought is represented in small scale high above the ground, as if it were suspended in midair.

Located beside Numbers 19:2.

947. Ser., fol. 354r

Close to Vat. 747 but certain details are changed. Instead of Aaron, another Levite faces the offerers. The calf is omitted, and a third Israelite follows holding a cylindrical vessel probably containing oil, wine, or grain (verse 12), while a fourth is shown carrying a dove, a creature not explicitly listed among the animals prescribed in chapter 18. The tabernacle includes the royal doors alongside the altar table and underneath the ciborium.

Located beside Numbers 19:1.

948. Sm., fol. 166r

The inscription reads: ὁ λαὸς προσφέροντες τὰς θυσίας διὰ τῶν λευιτῶν τῷ κ(υρί)ῳ.

Very close to Ser., but without the royal doors in the tabernacle.

949. Vat. 746, fol. 345r

The inscription reads: ὁ λαὸς προσφέροντες τὰς θυσίας διὰ τῶν λευιτῶν τῷ κ(υρί)ῳ.

Very close to Sm.

Located above Numbers 18:31.

950. Vtp., fol. 158v

The inscription reads: ὁ λαὸς προσφέροντες τὰς θυσίας διὰ τῶν λευιτῶν τῷ κ(υρί)ῳ.

Very close to Sm. and Vat. 746.

Located above Numbers 19:2.

Lit.: Uspenskii, p. 154, fig. 171; Hesseling, fig. 234; Lowrie, *Art*, pl. 145e; Huber, fig. 28; Θησαυροί, p. 260, fig. 69.

Numbers 20:1

Burial of Miriam

951. Vat. 747, fol. 171r

Miriam died in Kadesh in the desert of Zim (LXX: Sin). Two Israelites are laying her corpse, which is wrapped like a mummy, in a marble sarcophagus, while Moses, Aaron, and some other Israelites behind them look on with expressions of grief. Parts of the ground are flaked.

Located beside Numbers 20:2.

952. Ser., fol. 356v

Close to Vat. 747. Miriam's corpse is wrapped in a shroud, and the large group of mourners, excluding Moses and Aaron, consists exclusively of Israelite elders.

Located beside Numbers 20:2.

953. Sm., fol. 167r

The inscription reads: ΤΕΛΕΥΤῊ ΜΑΡΙΆΜ.

Very close to Ser.

Located above Numbers 20:3.

954. Vat. 746, fol. 347r

The inscription reads: τελευτὴ μαριάμ.

Very close to Ser. and Sm., but as in Vat. 747, Miriam's corpse is wrapped like a mummy.

Located beside Numbers 20:1.

955. Vtp., fol. 162r

The inscription reads: τελευτὴ μαριάμ.

Close to Vat. 746; here, too, Miriam's corpse is in mummylike wrappings. The miniature is somewhat rubbed and flaked.

Located below Numbers 19:22.

Lit.: Uspenskii, p. 154; Hesseling, fig. 235; Lowrie, *Art*, pl. 146a; Huber, fig. 29; Θησαυροί, p. 260, fig. 70; Lowden, *Octs.*, fig. 119.

Numbers 20:11

Smiting of the Rock at Kadesh

956a. Vat. 747, fol. 171v

Instead of smiting the rock, as described in verse 11, Moses gently touches it with his rod. Water is already flowing down to where the animals—a flock of sheep at the left, and two oxen and a camel at the right—drink from it. Slightly flaked.

Located beside Numbers 20:14.

957. Ser., fol. 357r

Close to Vat. 747. The hand of God blesses Moses from heaven. Three Israelites emerge from behind the hill and with gestures of astonishment observe the miracle instead of hastening to quench their thirst, as one might expect from the text and in analogy with other miniatures of similar content (cf. figs. 712–715, 720, 721, 724). A goat has been added to the flock of sheep and the oxen are more numerous, while the camel is omitted. Slightly flaked and stained.

Located beside Numbers 20:11.

958. Sm., fol. 167v

The inscription reads: ἡ ἐκ τῆς πέτ(ρας) διὰ τῆς ῥάβδου μω-υσέο(ς) τοῦ ὕδατο(ς) ἔκβλυσις.

Very close to Ser.

959. Vat. 746, fol. 348r

The inscription reads: ἡ ἐκ τῆς πέτρας διὰ τῆς ῥάβδου μω-υσέω(ς) τοῦ ὕδατο(ς) ἔκβλυσις.

Very close to Ser. and Sm.

Located beside Numbers 20:14.

960. Vtp., fol. 163r

The inscription reads: ἡ ἐκ τῆς πέτρ(ας) διὰ τῆς ῥάβδου μω-υσέως τοῦ ὕδατο(ς) ἔκβλυσις.

Very close to Ser., Sm., and Vat. 746 and flaked in a few spots.

Located beside Numbers 20:11.

Lit.: Uspenskii, p. 154, fig. 172; Hesseling, fig. 236; Lowrie, *Art*, pl. 146b; Lafontaine-Dosogne, *Iconographie de l'enfance*, vol. 1, p. 95 n. 78; Mouriki-Charalambous, "Cosmas," p. 83; Huber, fig. 30; Wolska-Conus, "Topographie Chrétienne," p. 177; Weitzmann, *Dura*, p. 65; Büchsel, "Schöpfungsmosaiken," p. 37, fig. 11; Θησαυροί, p. 260, fig. 71.

Numbers 20:14–19

Moses' Messengers before the King of Edom

In the same place where the preceding miniatures in Ser., Sm., Vat. 746, and Vtp. show the three Israelites watching the miracle of the spring (figs. 957–960), Vat. 747 has the messengers sent by Moses to the king of Edom, asking permission for the Israelites to pass through his realm. One of the two scenes is evidently a misunderstanding of the original iconography.

956b. Vat. 747, fol. 171v

Two messengers beg the king's consent; the king is clad like a Byzantine emperor and raises his hand in refusal. He is accompanied by a bodyguard, portrayed as an aged man closely resembling Aaron, with a long white beard; the king himself looks like Eleazar. All the figures in this scene are partly hidden by the crest of the hill.

Located beside Numbers 20:14

Numbers 20:28

Burial of Aaron

961a. Vat. 747, fol. 172r

Aaron's corpse, wrapped like a mummy, lies in an open sarcophagus, and the only allusion to the fact that Aaron's death took place at the summit of Mount Hor is a small, jutting rock in the foreground. Eleazar, who has just been dressed in his father's priestly vestments, and Moses stand mournfully at the foot of the sarcophagus. Slightly flaked.

Located beside Numbers 20:26.

962a. Ser., fol. 358r

Close to Vat. 747 but details differ. Aaron is clad in a shroud, the sarcophagus is not situated at the peak but at the foot of Mount Hor, and Eleazar is conversing with Moses instead of mournfully looking at his deceased father. Ground, sarcophagus, and figures are all flaked in various spots.

Located beside Numbers 20:29.

963a. Sm., fol. 168r

The inscription, which continues in the lower strip, reads: ἡ τοῦ ἀαρ(ὼν) τελευτὴ, καὶ ἡ τῶν υἱῶν αὐτοῦ ἀνάδειξις.

Very close to Ser.

964a. Vat. 746, fol. 349r

The inscription, which ends in the lower strip, reads: ἡ ἀαρὼν τελευτὴ, καὶ ἡ τ(ῶν) υἱῶν αὐτοῦ ἀνάδειξις.

Close to Ser. and Sm., but Aaron's corpse with its mummylike wrappings agrees with the depiction in Vat. 747.

Located beside Numbers 20:29.

965a. Vtp., fol. 165v

The inscription, extending over both strips, reads: ἡ ἀαρὼν τελευτὴ, καὶ ἡ τ(ῶν) υἱῶν αὐτοῦ ἀνάδειξις.

Depends most closely on Vat. 746. Slightly flaked.

Located below Numbers 20:29.

Lit.: Uspenskii, pp. 154–55, fig. 308; Hesseling, fig. 237; Huber, fig. 31; Θησαυροί, p. 260, fig. 72.

Numbers 20:29

Ordination of Eleazar

961b. Vat. 747, fol. 172r

After Moses and Eleazar descended from Mount Hor, all the congregation mourned Aaron for thirty days. A group of Israelites of varying ages stands at the right, bowing their heads in an expression of grief, but Moses and Eleazar do not seem to be taking part in the general mourning. Moses approaches Eleazar and talks to him, while Eleazar faces the viewer in a dignified frontal pose. Apparently the painter intended to depict the investiture of Eleazar, although this would have meant an interruption in the sequence of scenes, since Eleazar's ordination took place shortly before Aaron's death.

Located beside Numbers 20:26.

962b. Ser., fol. 358r

Moses and Aaron converse; the distinctive treatment of this group in Vat. 747 has given way to a more conventional scheme. The mourning Israelites are also less differentiated in their gestures, and all of them are clad in short tunics. Flaked in various spots.

Located beside Numbers 20:29.

963b. Sm., fol. 168r

Very close to Ser.

964b. Vat. 746, fol. 349r

Very close to Ser. and Sm.
Located beside Numbers 20:29.

965b. Vtp., fol. 165v

Very close to Ser., Sm., and Vat. 746 and flaked in several places.

Located below Numbers 20:29.

Lit.: Uspenskii, pp. 154–55, fig. 308; Hesseling, fig. 237; Chasson, "Tuscan Bible," pp. 180–81; Huber, fig. 31; Θησαυροί, p. 260, fig. 72.

Numbers 21:6–9

Brazen Serpent

The episode of the brazen serpent set upon a standard or a pole was taken by Christian writers,[1] following John 3:14–15, as a type of Cross and salvation: as Moses exalted the serpent in the desert, so it is necessary to exalt the Son of man. Wishing to invalidate the Christian views, the rabbis embraced a different meaning, translating the expression as "by a miracle," rather than "upon a standard," thus signifying that Moses threw the serpent into the air, where it hung miraculously suspended between heaven and earth.[2] The representation in the miniature is entirely foreign to the rabbis' explanation[3] and adheres to the Septuagint:[4] Moses raises a pole with the brazen serpent as its horizontal arm by means of a rope, so that serpent and pole form a rough cross.[5]

966. Vat. 747, fol. 172v

Moses, represented larger than life size, with great vigor hoists the brazen serpent on a pole, so that the group of Israelites who have been bitten by snakes and stand on a hill can look at this sign and be saved. One of the men points to the brazen serpent, while another who has been bitten in the leg lifts the afflicted limb toward the saving sign. Piled up at the foot of the hill are the corpses of those Israelites who have already succumbed to the many two-horned snakes that surround them and are apparently still attacking. Flaked in various spots.

Located beside Numbers 21:9.

967. Ser., fol. 359r

Close to Vat. 747, except that only three men constitute the group on the hill of those ultimately to be saved. Two of them expose their bitten legs to the brazen serpent, which in this and the following manuscripts is painted in gold, while the third prays to it. The deceased in the foreground lie facing in two directions, and one of them is still sitting upright, although his closed eyes seem to indicate that he too is dead. Slightly flaked and stained.

Located beside Numbers 21:8.

968. Sm., fol. 168v

The inscription reads: ὁ χαλκοῦς ὄφις ὁ ὑπὸ μωυσέος.
Very close to Ser. and somewhat rubbed.

969. Vat. 746, fol. 349v

The inscription reads: ὁ χαλκοῦς ὄφις ὁ ὑπὸ μωυσέος.
Very close to Ser. and Sm.
Located beside Numbers 21:10.

970. Vtp., fol. 166v

The inscription reads: ὁ χαλκοῦς ὄφις ὁ ὑπὸ μωυσέος.
Very close to Ser., Sm., and Vat. 746 and flaked in various spots, particularly the faces.
Located below Numbers 21:7.

Lit.: Uspenskii, p. 155, fig. 173; Hesseling, fig. 238; Wulff, *Altchr. und Byz. Kunst*, Nachtrag, p. 70, fig. 544; Galavaris, *Gregory Naz.*, p. 137; Huber, fig. 32; Maguire, "Depiction of Sorrow," pp. 137, 173, fig. 23; Kresten, "Hinrichtung," p. 122, n. 36, fig. 12; Θησαυροί, pp. 260–61, fig. 73; Bernabò, "Tradizioni siriache," p. 304, fig. 2; Revel-Neher, "Christian Topography," p. 93.

[1] EpBar 12 (PG 2, col. 761); Justin, *Dialogus cum Tryphone Judaeo* (PG 6, col. 699). Among later authors, see Aphrahat, *Dem* 12:8 (*PS*, vol. 1, col. 523); Cyril of Jerusalem, *Catechesis 13, De Christo crucifixo et sepulto* 20 (PG 33, col. 797); and Theodoret, *QuaestNum* 38 (PG 80, cols. 288–89). A list of authors appears in G. T. Armstrong, "The Cross in the Old Testament According to Athanasius, Cyril of Jerusalem and the Cappadocian Fathers," in *Theologia Crucis, Signum Crucis: Festschrift für Erich Dinkler zum 70. Geburtstag*, ed. C. Andresen and G. Klein (Tübingen, 1979), appendix (see also pp. 19ff., 24–25, 28).

[2] T. W. Manson, "The Argument of Prophecy," *JThS* 46 (1945), pp. 130–32.

[3] Among Jewish writings, cf. the expansion reported in TargPs-J and TargN (*Targum Nombres*, ed. Le Déaut, p. 193), whereas TargOnk states that "Moses made a copper serpent and placed it on a standard" (*The Targum Onqelos to Numbers*, ed. Grossfeld, p. 126). NumR 19 reads, "Moses made a serpent of brass, and set it up by a miracle," which is interpreted, "he cast it into the air and it stayed there" (*Numbers Rabbah*, p. 772).

[4] Cf. Revel-Neher, "Christian Topography," p. 93.

[5] This christological meaning is confirmed by a miniature in the Homilies of Gregory Nazianzenus, Paris, Bibl. Nat., cod. Coislin 239, fol. 18r (Galavaris, *Gregory Naz.*, p. 137, fig. 190), where the Octateuch composition is replicated, although abridged, reversed, and slightly different, to illustrate a passage in Gregory's second homily on Easter, in which the author compares the brazen serpent with the Crucifixion (Oratio 45, *In sanctum Pascha* 22 [PG 36, col. 653]). In fact, Gregory points to the brazen

serpent not as a type, but as an antitype, of Christ. An iconic representation of the episode with an explicit allusion to the Cross is found in the manuscript of the Gospels in Paris, Bibl. Nat., cod. gr. 74, fol. 171r (*Évangiles avec peintures byzantines du XIᵉ siècle: Reproduction des 361 miniatures du manuscrit grec 74 de la Bibliothèque Nationale*, ed. H. Omont [Paris, n.d.], pl. 148).

Numbers 21:23–25

ISRAELITES SMITE SIHON

971. Vat. 747, fol. 173r

The Israelites defeat the Amorites and slay their king, Sihon (LXX: Seon), who had refused them peaceful passage through his land. Moses stands behind the battle line and urges on his soldiers who are attacking the enemy cavalry. With his lance the foremost Israelite has pierced the king himself, who has fallen headfirst from his stumbling horse. On this point the illustrator deviates slightly from the text, which states that the king was smitten with the edge of the sword. One of the Israelites, armed with a sword, attacks the only enemy horseman who offers any resistance at all, while the rest of the cavalry flees, leaving behind their king and one more victim on the battlefield. Behind the slope of a mountain a walled city with flanking towers and a closed city gate is visible, in all probability meant to represent the city of Jahaz (LXX: Jassa), where the battle takes place. Flaked in various spots.

Located beside Numbers 21:32.

972. Ser., fol. 360v

Close to Vat. 747. Moses stands quietly as a spectator behind the battle line, while the army is urged on by a soldier leading the frontal attack. The Israelites are armed exclusively with lances, and none of them carries a sword or shield. Enemy horsemen and foot soldiers counterattack, none of them having yet turned to flight; the nimbed enemy king, who wears a pearl diadem and purple shoes, falls from his horse and is the only casualty so far. In the upper right corner, as in Vat. 747, a walled city appears, but it is no longer related spatially to the lower zone since the mountain is reduced to a mere groundline. The city is approached by Israelites who apparently encounter no resistance and simply take possession of it. This action indicates that, unlike Vat. 747, the scene does not depict the city of Jahaz where the battle took place, but rather one of the cities that the Israelites occupied after the Amorites' defeat, most probably the city of Heshbon (LXX: Esebon), which was the capital of King Sihon. Badly flaked, particularly in the lower part of the miniature.

Located beside Numbers 21:32.

973. Sm., fol. 169r

The inscription reads: καταπολεμούμενος ὁ σηὼν βασιλεύς. Very close to Ser.

974. Vat. 746, fol. 351r

The inscription reads: καταπολεμούμενο(ς) ὁ σηὼν βασι-(λεύς).
Very close to Ser. and Sm.
Located beside Numbers 21:32.

975. Vtp., fol. 169r

The inscription reads: καταπολεμούμενος ὁ σιὼν βασιλεύς.
Close to Ser., Sm., and Vat. 746. Flaked in various places.
Located beside Numbers 21:32.

Lit.: Uspenskii, p. 155, fig. 174; Hesseling, fig. 239; *Mönchsland Athos*, p. 182, fig. 102; Huber, fig. 33; Θησαυροί, p. 261, fig. 74; Lowden, *Octs.*, pp. 29, 49, figs. 2–5.

Numbers 21:33–35

ISRAELITES SMITE OG

976. Vat. 747, fol. 173r

The defeat of Og, the king of Bashan (LXX: Basan), is represented in a scheme similar to that of the battle with King Sihon in the preceding scene, except that the position of the armies is reversed. The Israelites, as usual bareheaded and only lightly armed with spears, attack from the right and pursue the enemy cavalry, which no longer resists but turns to the left in full flight. While one horseman falls from his horse, the king himself has already been captured and is being brought by an Israelite in heavy armor to Moses, who stands behind the battle line. The location of the battle is indicated by the city of Edrei (LXX: Edrain), which is situated on a mountain slope and represented in the usual manner as a circular wall with flanking towers and a huge city gate. A foot soldier, representative of King Og's reserve forces, emerges from it but will arrive on the battlefield too late to avert complete defeat. The entire surface is very badly flaked.

Located beside Numbers 21:34.

977. Ser., fol. 360v

As in their portrayals of the defeat of the Amorites, Ser. and the other Octateuchs show the enemy offering fierce resistance, and although several horsemen have been thrown from their horses, none of those still in their saddles has abandoned the fight. The background is entirely omitted, so that the city of Edrei, out of which two soldiers—rather than one—make a sortie, seems to be suspended and spatially unrelated to the battle scene in the foreground. The captured king, with a blue nimbus, fettered hands, and dressed like a Byzantine emperor, is led before Moses, who stands in front of a huge reserve army of Israelites. Slightly flaked.

Located beside Numbers 21:33.

978. Sm., fol. 169r

The inscription, which is to be understood as a continuation of that for the preceding picture, reads: ὡσαύτως καὶ ὁ ὤγ ὑπὸ τῶν ἰσραηλιτῶν.

Very close to Ser.

979. Vat. 746, fol. 351r

The inscription reads: ὡσαύτως καὶ ὁ ὤγ ὑπὸ τῶν ἰσραηλιτῶν.
Very close to Ser. and Sm.
Located beside Numbers 21:33.

980. Vtp., fol. 169r

The inscription reads: ὡσαύτ(ως) καὶ ὁ ὤγ ὑπὸ τῶν ἰσρα-ηλιτ(ῶν).

Close to Ser., Sm., and Vat. 746. A fleeing horseman in the foreground, seen from behind, rides a horse which is drawn in skillful foreshortening. The two enemy foot soldiers outside the city gate and the foremost fighting Israelite hold swords which, however, are sheathed and therefore of little avail in the struggle. Stained and flaked in various spots.

Located beside Numbers 21:33.

Lit.: Uspenskii, p. 155, fig. 175; Hesseling, fig. 239; *Mönchsland Athos*, p. 182, fig. 102; Huber, fig. 34; Θησαυροί, p. 261, fig. 74; Lowden, *Octs.*, pp. 29, 49, figs. 2–5.

Numbers 22:15–21

MESSENGERS SENT TO BALAAM

981. Vat. 747, fol. 173v

Princes of Balak, king of Moab, are sent as messengers to Balaam to ask him to come with them and curse the Israelites who are threatening to invade their country. Having refused a first offer, Balaam consents when they present themselves a second time, and saddles up his ass. In the miniature, two youthful soldiers who substitute for Balak's princes[1] are striding toward Balaam. One of them carries shield and spear, and the second points toward Balaam, an elderly man who sits on a mound in a mountainous landscape. In the center, the saddled ass stands waiting to carry Balaam to Balak. Flaked in various places.

Located beside Numbers 21:11.

982. Ser., fol. 362r

Close to Vat. 747 but certain details are altered. The landscape is omitted, and the messengers, no longer advancing, are already engaged in conversation and pleading with Balaam, who sits on a chair in front of his house.

Located beside Numbers 22:6.

983. Sm., fol. 169v

The inscription reads: προσκαλούμενο(ς) βαλαάμ, ὑπὸ βαλάκ.
Very close to Ser. Balaam and the ass are somewhat flaked.

984. Vat. 746, fol. 352r

The inscription reads: προσκαλούμενος βαλαάμ, ὑπὸ βαλάκ.
Very close to Ser. and Sm. Balaam's head and the ass are badly rubbed.

Located beside Numbers 22:12.

985. Vtp., fol. 171r

The inscription reads: προ(ς) καλούμ(ενος) βαλαάμ, ὑπὸ βαλάκ.

The figural composition is close to Ser., Sm., and Vat. 746. The house is replaced by a fanciful niche, typical of the taste of the late Byzantine period. The ass has been cut out, and the rest of the miniature is considerably stained.

Located below Numbers 22:10.

Lit.: Uspenskii, p. 155, fig. 176; Hesseling, fig. 240; Huber, fig. 35; Θησαυροί, p. 261, fig. 75.

[1] In the condensed report in pseudo-Philo's *Liber antiquitatum biblicarum* 18:7 (*OTP*, vol. 2, p. 325), Balak simply sent "other men," who are not designated princes, to Balaam; in TargN on Num 22:15 more numerous and eminent messengers are sent (*Targum Nombres*, ed. Le Déaut, p. 210).

Numbers 22:30–31

BALAAM AND THE ANGEL

Following Numbers 22:25, the ass Balaam rides should be falling down beneath him, instead of standing up, while she speaks to him. Such a departure from the narrative is witnessed in early writings: in *De vita Mosis*, e.g., Philo does not say that the ass sank down, rather that it retreated and "again swerved to the right and left and floundered hither and thither unable to keep still, as though heady with wine or drink."[1] The Palaea historica, too, ignores the stumbling of the ass.[2]

986. Vat. 747, fol. 174v

Balaam, riding on the ass, perceives the angel who stands in his way holding a drawn sword in his hand; the old man shades his eyes against the rays emanating from the hand of God in heaven set against a golden strip of sky. The ass, who noticed the angel first and therefore balked, turns its head and speaks to Balaam, reproaching him for having hit it three times. Flaked in various spots.

Located beside Numbers 22:35.

987. Ser., fol. 364r

Close to Vat. 747 but a bust of Christ replaces the hand of God in heaven. Flaked in various places.

Located beside Numbers 22:35.

988. Sm., fol. 170v

The inscription reads: ὁ βαλαὰμ διαλεγόμενο(ς) τῇ ὄνω ἐπι-φανέντος ἀγγέλου.

Very close to Ser.

989. Vat. 746, fol. 354r

The inscription reads: βαλαὰμ διαλεγόμ(εν)ο(ς) τῇ ὄνω ἐπι-φανέντος ἀγγέλου.

Very close to Ser. and Sm.

Located beside Numbers 22:36.

990. Vtp., fol. 175r

The inscription reads: ὁ βαλαὰμ διαλεγόμ(εν)ο(ς) τῇ ὄνω ἐπιφανέντος ἀγγέλου.

Balaam and the angel, who is inscribed ὁ ἀρχ(άγγελος) μιχ(αήλ), are represented with more dramatic gestures, and the ass is balking even more violently than in Vat. 747.[3] On the other hand, the motif of the animal speaking to its master is dropped, since it does not turn its head as in the previous copies. The bearded bust of Christ is inscribed IC XC, and no rays emanate from the segment of heaven. Flaked and heavily stained.

Located below Numbers 22:34.

Lit.: Uspenskii, pp. 155, 159, figs. 177, 309; Hesseling, fig. 241; Millet, "Octateuque," pp. 74–75; Hyslop, "Reliquary," p. 338; Der Nersessian, *Barl. et Joas.*, p. 140; *Mönchsland Athos*, p. 182, fig. 103; Buchthal, *Latin Kingdom*, p. 59; Huber, pp. 21, 26, figs. D, E, F, 36; Gaehde, "Octateuch," p. 368, fig. 81; Kötzsche-Breitenbruch, *Via Latina*, p. 84, pl. 20e; Lowden, "Production," p. 200; Lowden, "Vtp. Oct.," p. 124, figs. 22, 23; Aliprantis, *Moses*, pp. 53–54, fig. 133; Θησαυροί, pp. 261–62, fig. 76; Lowden, *Octs.*, pp. 48–49, figs. 47, 48.

[1] *De vita Mosis* I:270 (*Philo*, ed. Colson, vol. 6, pp. 414–15 and note b on p. 415).

[2] *Anecdota*, ed. Vasil'ev, p. 253.

[3] For the relationship of this miniature to monumental painting, see Lowden, *Octs.*, pp. 48–49.

Numbers 23:1–6

Balaam's First Prophecy

In the illustration of Balaam's first prophecy near the pillars of Baal, all the manuscripts except Vat. 747 depict an angel which is not mentioned in the Septuagint but is present in the rabbinical tradition.[1]

991. Vat. 747, fol. 175r

The prophet Balaam stands to the right and King Balak, dressed like a Byzantine emperor, to the left of the seven altars on which burnt offerings have been sacrificed. The altars, apparently built of brick, stand in two rows of three, with the seventh above the others, on the slope of a steep mountain. Large parts of the ground and the sky are flaked.

Located below Numbers 23:12.

992. Ser., fol. 365v

Generally close to Vat. 747. However, Balaam turns to an angel standing behind him and conveys the words which "God put into the mouth of Balaam" (verses 4–5). On the other side, Balak, distinguished by a blue nimbus, is accompanied by one of the princes of Moab who are mentioned in verse 6. The mountain is omitted, so that only three large altars in the shape of colonnettes stand on the ground, while the remaining four are suspended and their forms vary.[2] According to the text, one calf and one ram were sacrificed on each of the seven altars; but, while Vat. 747 does not show any sacrificial animals at all, the illustrator of Ser. depicted a single ram in the foreground with the knife that was used to cut its throat beside it. The presence of God is symbolized by a segment of heaven, although the usual protruding hand is lacking.

Located beside Numbers 23:13.

993. Sm., fol. 171r

The inscription reads: ὁ βαλαὰκ προτρεπόμενος διὰ θυσιῶν τῷ βαλαὰμ καταρά(σα)σθαι τὸν ἰ(σρα)ήλ.

Close to Ser.

994. Vat. 746, fol. 355v

The inscription reads: βαλὰκ προτρεπόμενο(ς) διὰ θυσιῶν τῷ βαλαὰμ καταράσασθαι τὸν ἰσραήλ.

Close to Ser. and Sm. By mistake the number of altars has been reduced from seven to six.

Located beside Numbers 13:12.

995. Vtp., fol. 178r

The inscription reads: βαλαὰκ προτρεπόμενο(ς) διὰ θυσιῶν τῷ βαλαὰμ καταράσασθαι τ(ὸν) ἰ(σρα)ήλ.

Vtp. reveals its direct dependence on Vat. 746 by repeating the mistake in the number of altars. The pearl diadem on Balak's head has been omitted. The faces of the angel and of the Moabite prince and a small section in the lower left corner are flaked.

Located below Numbers 23:13.

Lit.: Uspenskii, p. 155, fig. 178; Hesseling, fig. 242; Nordström, "Water Miracles," p. 80; Nordström, "Rabbinica," pp. 35–37, figs. pp. 37 and 39; Huber, fig. 37; Gaehde, "Octateuch," p. 368, fig. 82; Nordström, "Elementi

ebraici," pp. 976–77; De Angelis, "Simbologia," pp. 1536–37, fig. 23; Prigent, *Judaïsme*, pp. 306–7; Θησαυροί, pp. 262, fig. 77.

[1] NumR 20:18 (*Numbers Rabbah*, ed. Freedman and Simon, p. 806); see also Ginzberg, *Legends*, vol. 3, p. 372; Nordström, "Water Miracles," p. 80; and Nordström, "Rabbinica," pp. 35–37.

[2] Nordström ("Water Miracles," p. 80) connected these differences in the depiction of the altars with a Jewish tradition, according to which they were built by various holy men from Adam to Moses.

Numbers 23:14–18

Balaam's Second Prophecy

996. Vat. 747, fol. 175v

Balaam's second prophecy is made from the top of Pisgah in the field of Zophim (LXX: "from the top of the hewn rock in the high place of the field"), and consequently the illustrator portrayed Balaam, Balak, and between them two of the princes of Moab standing on the top of a mountain, or rather somewhat behind it, so that their feet are hidden. Sacrifices on seven altars also preceded this prophecy and thus again seven brick altars are shown burning on the slope, four of them in a lower row and three in the upper row. Balaam points to the plain where the blessed Israelites look up to the group on the mountain. The heads of Balaam, Balak, and the Moabites between them are overpainted, and large sections of the mountain and the background are flaked.

Located beside Numbers 23:24.

997. Ser., fol. 366v

Close to Vat. 747. The nimbed Balak stands in front of Balaam, and both of the men point to a group of Israelite elders, who are shown standing and gesturing as if engaged in conversation with the two men on the mountain. The princes of the Moabites and the seven altars are omitted altogether, but God's hand in heaven is added, indicating the divine inspiration of Balaam's prophecy. Parts of the mountain are flaked.

Located beside Numbers 23:25.

998. Sm., fol. 171v

The inscription reads: ἔτι προτρεπόμενος ὁ βαλὰκ καταρά(σα)σθαι τὸν ἰ(σρα)ήλ.

Very close to Ser. Considerably overpainted.

999. Vat. 746, fol. 356v

The inscription reads: ἔτι προτρεπόμενος ὁ βαλὰκ τῷ βαλαὰμ καταράσασθαι τὸν ἰσραήλ.

Very close to Ser. and Sm. By mistake, the figure of the prophet has been changed into that of a youth wearing a short embroidered tunic. The illustrator may have thought of this youth as one of the princes of the Moabites, but if so, Balaam, the principal figure in the whole scene, is missing.

Located beside Numbers 23:24.

1000. Vtp., fol. 179v

The inscription reads: ἔτι προτρεπόμενος ὁ βαλὰκ τῷ˜βαλαὰκ˜καταράσασθαι τὸν ἰ(σρα)ήλ.

The close dependence upon Vat. 746 is again revealed by the repetition of the error whereby Balaam was changed into a youth in a tunic. The mountain is slightly flaked.

Located below Numbers 23:23.

Lit.: Uspenskii, p. 156, fig. 179; Hesseling, fig. 243; Huber, fig. 38; Θησαυροί, p. 262, fig. 78.

Numbers 23:28–30

Balaam's Third Prophecy

1001a. Vat. 747, fol. 176r

Balaam's third prophecy concerning the blessing of Israel is made in the wilderness on the summit of Peor (LXX: Phogor), and once more only after burnt offerings have been sacrificed on seven altars. This time the altars are built like columns on the mountain located at the center of the composition and are arranged in a single line. Balaam stands at the left, both hands raised in prayer, while King Balak is seen at the right, making a gesture of embarrassment and accompanied by two of the princes of Moab. Slightly flaked.

Located beside Numbers 24:10.

1002a. Ser., fol. 368r

Close to Vat. 747. Balaam raises only one hand. Balak does not appear embarrassed but extends his hand toward Balaam, and only one of the princes is present, holding a spear as bodyguards usually do.

Located beside Numbers 24:10.

1003a. Sm., fol. 172r

The inscription reads: εὐχὴ βαλαὰμ, τοῦ βαλὰκ θυμὸς μέγας.

Very close to Ser. The prince of Moab behind Balak does not hold a lance.

1004. Vat. 746, fol. 357r

Very close to Sm.

Located beside Numbers 24:3. The other Octateuchs depict within the same frame two scenes that in Vat. 746 are separated and located in places that do not correspond with the other Octateuchs.

1006. Vtp., fol. 181v

Very close to Sm. and Vat. 746 and considerably flaked, especially the faces and the mountain.

Located below Numbers 24:3. Like Vat. 746, the two consecutive episodes are separated (figs. 1006 and 1007).

Lit.: Uspenskii, p. 156, fig. 180; Hesseling, fig. 244; Nordström, "Water Miracles," p. 80; Nordström, "Rabbinica," pp. 35–37, fig. p. 38; Huber, fig. 39; Gaehde, "Octateuch," p. 368 n. 81.

Numbers 24:2–8

Exodus from Egypt

1001b. Vat. 747, fol. 176r

In his third prophecy Balaam alludes to the exodus of the Israelites from Egypt, and the illustrator, responding to this allusion, depicted the Israelites on this journey. The men are shown as soldiers and are divided into three groups, the foremost headed by Moses and Aaron.

Located beside Numbers 24:10.

1002b. Ser., fol. 368r

The Israelite soldiers, numbering nine, follow Moses and Aaron in single file instead of in groups. Slightly flaked.

Located beside Numbers 24:10.

1003b. Sm., fol. 172r

Close to Ser. The second soldier from the left has been omitted.

1005. Vat. 746, fol. 357v

Close to Sm. The group of soldiers is more condensed.
Located beside Numbers 24:5.

1007. Vtp., fol. 182v

Closest to Vat. 746. The number of soldiers is again reduced to seven. Heavily stained and somewhat flaked, particularly the figure of Aaron.

Located below Numbers 24:7.

Lit.: Uspenskii, p. 156, fig. 181; Hesseling, fig. 244; Huber, fig. 40; Θησαυροί, p. 262, fig. 79.

Numbers 24:15–19

Balaam's Fourth Prophecy

1008. Vat. 747, fol. 176v

In the course of his fourth prophecy Balaam predicts that, among other successes, the Israelites will take possession of the cities Edom and Seir (LXX: Esau). In the miniature Balaam stands in a mountainous landscape and indicates to Balak two walled cities, one above the other and each situated at the foot of a mountain. Behind the upper city, which is probably meant to represent Edom, a group of soldiers emerges as if eager to defend it, whereas a corresponding group of soldiers before the lower

city, i.e., Seir, appears to be quietly awaiting the approach of the enemy. The entire surface of the miniature is flaked.

Located beside Numbers 24:24.

1009. Ser., fol. 369v

The landscape is omitted entirely, so that the upper city appears to be suspended, and Balaam and Balak, who are conversing, are placed at ground level. A civilian stands before the upper city, wearing a turban and raising his hand as if noticing Balaam and Balak, whereas the corresponding Seirite is an unarmed soldier who lays his hand over his breast as if making a solemn assertion. The walled cities are somewhat distorted: the city gate of the upper one, for example, is situated in the tower, while the flanking tower of the lower city is assimilated into the wall, etc. Slightly flaked.

Located beside Numbers 24:24.

1010. Sm., fol. 172v

The inscription reads: ἀμφοῖν προεῖπε βαλαὰμ τὰς ἐκβάσεις. Very close to Ser.

1011. Vat. 746, fol. 358v

The inscription reads: ἀμφοῖν προεῖπε βαλαὰμ τὰς ἐκβάσεις. Very close to Ser. and Sm.

Located beside Numbers 24:23.

1012. Vtp., fol. 185r

The inscription, in which Balak is erroneously mentioned in place of Balaam, reads: ἀμφοῖν προεῖπε βαλαὰκ τὰς ἐκβάσεις.

The painter has tried to correct some of the distortions of the walled cities and, unlike Ser., Sm., and Vat. 746, where only the Edomite addresses Balaam and Balak, he has showed the Seirite also approaching them in a very direct manner. Both these figures are partly flaked, and the whole miniature is heavily stained.

Located beside Numbers 24:21.

Lit.: Uspenskii, p. 156, fig. 182; Hesseling, fig. 245; Havice, "Hamilton Ps.," p. 278; Huber, fig. 29; Havice, "Marginal Miniatures," p. 132; Θησαυροί, pp. 262–63, fig. 80.

Numbers 25:7–8

Phinehas Slays Zimri and Cozbi

The cycle ignores the story of the daughters of Moab, who seduced the Israelites and convinced them to adore Baalpeor. Skipping the Israelites' idolatry, the cycle continues with the climactic scene of Zimri's prohibited sexual intercourse with the Midianite Cozbi, where Phinehas, the son of Eleazar, faithful to God, rises up from among the Israelites and thrusts both of them through with a spear.

1013a. Vat. 747, fol. 178v

Zimri (LXX: Zambri), the Simeonite, and Cozbi (LXX: Chasbi), the Midianite woman, are represented lying in an embrace on a bed; being guilty of miscegenation, they are transfixed with a spear by the wrathful Phinehas (LXX: Phinees). At the left stand Moses and another Israelite, bearded and nimbed, most probably Eleazar although he is not clad in priestly vestments. Flaked in various spots.

Located beside Numbers 27:3.

1014a. Ser., fol. 373v

Close to Vat. 747. Neither Phinehas nor the man behind Moses is nimbed. The latter is youthful and therefore represents just an ordinary Israelite. Considerably flaked.

Located beside Numbers 27:3.

1015a. Sm., fol. 174r or 174v¹

The inscription reads: ζῆλος φινεὲς καὶ φόνος δεινὸς λάγνων.

The whole miniature has been clumsily overpainted, especially the central part, which seems to have been thoroughly rubbed and then restored by an artist who, with no knowledge of the content, replaced the couple with a bearded old man with a nimbus, resembling the dying Jacob in fig. 574.²

1016a. Vat. 746, fol. 359v

The inscription reads: ζῆλος φινεὲς κ(αὶ) φόνο(ς) δεινὸ(ς) λάγνων.

A pious reader, apparently offended by the realism of the scene, has thoroughly rubbed out the couple on the couch.

Located beside Numbers 25:8.

1017a. Vtp., fol. 186v

The inscription reads: ζῆλος φινεὲς καὶ φόνος δειν(ὸς) λαγν(ῶν).

Very close to Ser. Phinehas, as in Vat. 747, has a reddish nimbus. Flaked in various spots.

Located below Numbers 25:7.

Lit.: Uspenskii, p. 156, figs. 183, 185; Hesseling, fig. 246; Muñoz, "Rotulo," p. 477; Weitzmann, *Greek Mythology*, p. 22, n. 33, fig. 19; Nordström, "Water Miracles," pp. 80–81; Nordström, "Rabbinica," pp. 44–47, fig. 45; Bucher, *Pamplona Bibles*, pp. 93, 138 n. 74; Huber, fig. 42; Stichel, "Ausserkanon. Elemente," p. 177 n. 74; Kötzsche-Breitenbruch, *Via Latina*, p. 86; Havice, "Hamilton Ps.," pp. 277–78; Weitzmann, *SP*, pp. 60, 61; Cutler, "Aristocratic Ps.," p. 234 n. 12; Havice, "Marginal Miniatures," p. 131; Θησαυροί, p. 263, fig. 81.

[1] Fol. 174v according to Hesseling, p. xiii; fol. 174r according to Uspenskii, p. 187.
[2] Kötzsche-Breitenbruch, *Via Latina*, p. 86.

Numbers 25:16–18

ISRAELITES SMITE THE MIDIANITES

1013b. Vat. 747, fol. 178v

While in the text God orders Moses to smite the Midianites, here we see the realization of this command.[1] A group of youthful Israelites, armed with spears and swords, is attacking the Midianites who are already thoroughly defeated and bleeding heavily from their wounds, either lying prostrate or trying to raise themselves up from the ground in a vain attempt to protect themselves against the furious onslaught. Heavily flaked.

Located beside Numbers 27:3.

1014b. Ser., fol. 373v

Close to Vat. 747. Within the group of attackers as well as that of the defeated, the attitudes vary considerably, and among the Israelites a bearded old man in a long garment takes part in the defeat of the Midianites. Flaked in various spots, particularly the faces.

Located beside Numbers 27:3.

1015b. Sm., fol. 174r or 174v²

Very close to Ser.

1016b. Vat. 746, fol. 359v

Very close to Ser. and Sm.
Located beside Numbers 25:8.

1017b. Vtp., fol. 186v

Very close to Ser., Sm., and Vat. 746. Very badly flaked, particularly the group of Israelites.
Located below Numbers 25:7.

Lit.: Uspenskii, p. 156, figs. 184, 186; Hesseling, fig. 246; Nordström, "Water Miracles," pp. 80–81; Nordström, "Rabbinica," pp. 44–47; Huber, fig. 42; Havice, "Hamilton Ps.," pp. 277–78; Θησαυροί, p. 263, fig. 81.

[1] In contrast, Nordström ("Water Miracles," pp. 80–81; "Rabbinica," pp. 44–47) suggested that the illustration depicts young Israelites who, imitating Phinehas, slew people guilty of miscegenation; he points to an external source such as Philo's *De vita Mosis* I:303 (*Philo*, ed. Colson, vol. 6, p. 432) or Josephus, *Ant* 4:154 (*Josephus*, ed. Thackeray, vol. 4, pp. 548–50).
[2] Fol. 174v according to Hesseling, p. xiii; fol. 174r according to Uspenskii, p. 187.

Numbers 27:22–23

JOSHUA PROCLAIMED MOSES' SUCCESSOR

The Septuagint relates that in the proclamation of Joshua as successor of Moses, the prophet alone placed his hands on

Joshua; the cycle, in contrast to the text, also introduces Eleazar into the scene, apparently to convey more emphasis to the event. The setting and iconography derive from a depiction of the coronation of an imperial prince. This is especially clear in Vat. 747, where both Joshua and Eleazar wear imperial diadems and garments.

1018. Vat. 747, fol. 179r

Moses proclaims Joshua his successor in the presence of Eleazar, the priest. Joshua, dressed in an imperial chlamys and holding a spear, stands in the center of the miniature and faces the viewer. Eleazar, with a scepter in his hand and nimbed like the others, approaches from the right and Moses from the left; both lay their right hands upon Joshua's crowned head. Parts of the ground are flaked.

Located beside Numbers 27:16.

1019. Ser., fol. 374r

Close to Vat. 747. Joshua does not wear a crown nor does he carry a spear; Eleazar does not hold a scepter and his head is covered by a miter instead of a pearl crown. A hand of God sends out rays toward Moses' head.

Located beside Numbers 27:16.

1020. Sm., fol. 175r

The inscription reads: μωσῆς ἰησοῦν δημαγωγὸν δεικνύει.
Very close to Ser.

1021. Vat. 746, fol. 362v

The inscription reads: μωσῆς ἰησοῦν δημαγωγὸν δεικνύει.
Very close to Ser. and Sm. Moses' tunic is painted gold.
Located beside Numbers 27:18.

1022. Vtp., fol. 194r

The inscription reads: μωσῆς ἰησοῦν δημαγωγὸν δεικνύει.
Like Vat. 746, Moses' tunic is painted gold.
Located below Numbers 27:17.

Lit.: Uspenskii, p. 156, fig. 187; Hesseling, fig. 247; Buchthal, *Latin Kingdom*, p. 59 n. 8; Huber, fig. 43; Kirigin, *Mano divina*, p. 150; Chasson, "Tuscan Bible," p. 178; Θησαυροί, p. 263, fig. 82.

Numbers 30:2–3

Taking a Vow

The Hebrew sacrifices and major feasts described in chapters 28 and 29 are ignored in the cycle, which resumes with this miniature related to chapter 30. This chapter contains the statutes concerning the taking of a vow and the swearing of an oath. The iconography is rather conventional, repeating that of illustrations already encountered both in Leviticus (see figs. 843–848, 849–854, 870–874) and in Numbers (see figs. 889–893).

1023. Vat. 747, fol. 181v

Moses is represented speaking to a young man who raises his hands as if taking a vow. The scene takes place near the altar of the sanctuary, which appears at small scale high above the figures and without any spatial relationship to them. The altar table has a sumptuous cover and stands in front of the abbreviated ciborium instead of underneath it.

Located beside Numbers 30:2.

1024. Ser., fol. 378v

The man making the vow is bearded. The altar table and ciborium are related to each other more correctly, although the tabernacle as a whole is suspended in the air, as in Vat. 747.

Located beside Numbers 30:3.

1025. Sm., fol. 177v

The inscription reads: εὐχῆς τρόπους δείκνυσι μωσ(ῆ)ς εὐθέτως.
Very close to Ser.

1026. Vat. 746, fol. 365v

The inscription reads: εὐχῆς τρόπους δείκνυσι μωσῆς εὐθέτως.
Close to Ser. and Sm. The man making the vow is youthful, as in Vat. 747.
Located beside Numbers 30:4.

1027. Vtp., fol. 202r

The inscription reads: εὐχ(ῆς) τρόπ(ους) δείκνυσι μωσ(ῆς) εὐθέτ(ως).
Very close to Ser. and Sm. and particularly to Vat. 746, with which the beardlessness of the man agrees. The right half of the miniature is somewhat stained.
Located above Numbers 30:3.

Lit.: Uspenskii, p. 156, fig. 188; Hesseling, fig. 248; Huber, fig. 44; Θησαυροί, p. 263, fig. 83.

Numbers 31:19–24

Israelites Wash Their Clothes

1028. Vat. 747, fol. 183r

Moses has given the order that all Israelites who fought the Midianites shall purify themselves (verses 19–20), and Eleazar

has ordered them to wash their clothes (verses 23–24). The picture illustrates the washing of the clothes, but instead of Eleazar, it is Moses who oversees the purification of the Israelites. The miniature is divided into two separate registers: Moses stands in the upper one and points down to the action in the lower, where three young men stand in a stream which flows through a mountainous landscape and wash their clothes. Moses stands in front of the altar of the sanctuary where, as in the preceding miniature of this manuscript, the altar table is covered with a sumptuous cover and placed outside the ciborium instead of beneath it. Flaked in various spots.

Located beside Numbers 31:27.

1029. Ser., fol. 381r

The ground and dividing line between the two strips are omitted, so that Moses is more closely connected with the action in the lower zone. This connection, however, is spatially unconvincing, and Moses and the altar of the sanctuary seem suspended in midair. Of the three men, two of whom are bearded, only one washes what looks like a piece of cloth, while the others stand on the bank and wring out furs. As in the preceding miniature of this manuscript, the spatial relationship of the altar table and ciborium is more correct.

Located beside Numbers 31:26.

1030. Sm., fol. 179r

The inscription reads: σκευῶν κάθαρσις ἐντολαῖς τοῦ μωσέως. Very close to Ser.

1031. Vat. 746, fol. 367v

The inscription reads: σκευῶν κάθαρσις ἐντολαῖς τοῦ μωσέως. Close to Ser. and Sm. Moses stands higher up and the altar of the sanctuary is lowered.

Located beside Numbers 31:28.

1032. Vtp., fol. 206v

The inscription reads: σκευῶν κάθαρσις ἐντολαῖς τοῦ μωσέως.

Close to Vat. 746, with which the painting of Moses' tunic completely in gold agrees.

Located above Numbers 31:23.

Lit.: Uspenskii, pp. 156–57, fig. 189; Hesseling, fig. 249; Huber, fig. 45; Θησαυροί, pp. 263–64, fig. 84.

Numbers 32:32–33

DISTRIBUTION OF TERRITORIES ON THE EASTERN BANK OF THE JORDAN

1033. Vat. 747, fol. 184v

Moses has given the Gadites, the Reubenites, and the half-tribe of Manasseh living space on the eastern bank of the Jordan.

A group of Israelites, headed by Moses and Joshua who converse with one another, emerges from behind the ragged western bank of the river, which has its source below the peak of a steep mountain. Meanwhile the Reubenites and Gadites cross the Jordan; one of them has already reached the opposite bank and assists the foremost of those still wading through the water to step ashore. All of them have tucked up their tunics, and one carries his child on his shoulders. The cattle are crossing upstream and the flocks of sheep downstream. Flaked in various places.

Located beside Numbers 32:33.

1034. Ser., fol. 384r

Close to Vat. 747 but the spatial concept has been entirely changed. The landscape is omitted, thus isolating the river, which has no source but flows in a cartographic fashion diagonally across the surface of the miniature. Moses and Joshua have changed places, and the latter is dressed in full armor but wears no helmet; he holds a spear, but the Israelites behind him bear lances. Most of the Reubenites and Gadites with some of their flocks have already reached the eastern bank and are waiting for the stragglers who wade through the river in single file, followed by the rest of the flocks.

Located beside Numbers 32:33.

1035. Sm., fol. 180v

The inscription reads: φυλαὶ περῶσαι τ(ὸν) ποταμὸν αἱ δέκα. Very close to Ser.

1036. Vat. 746, fol. 369v

The inscription reads: φυλαὶ περῶσαι τ(ὸν) ποταμὸν αἱ δέκα. Very close to Ser. and Sm.
Located beside Numbers 32:33.

1037. Vtp., fol. 211v

The inscription reads: φυλαὶ περῶσαι τὸν ποταμὸν αἱ δέκα. Very close to Ser., Sm., and Vat. 746. Slightly flaked. Located beside Numbers 32:33.

Lit.: Uspenskii, p. 157, fig. 190; Hesseling, fig. 250; Huber, fig. 46; Θησαυροί, p. 264, fig. 85.

Numbers 33:52

MOSES AND JOSHUA DESTROY THE IMAGES

As he did for the illustration of Deuteronomy 7:5 (figs. 1054–1058), the painter chose a text passage related to a destruction of images. At verse 52 Moses bids the Israelites to destroy their enemies' images; the painter emphasizes the importance of the deed by representing Moses himself destroying the pagan statues. At the same time he introduces Joshua, the leader who will succeed Moses, as his companion in the task of destruction.

1038. Vat. 747, fol. 186r

Both Moses and Joshua swing clubs to smash the pagan statues mounted on two marble columns. One column standing on a vaulted substructure provides the platform for two images: one statue, still upright, is of a seminude youth with a spear and shield, and the other, entirely nude, is tumbling or rather diving, as if he were a living being trying to get down from the pedestal of his own volition. The same diving attitude also characterizes the third image on the column in the foreground. Slightly flaked.

Located beside Numbers 33:50.

1039. Ser., fol. 386r

The figures of Moses and Joshua are close to those in Vat. 747, but the building on which the upper column rests is more complex and both columns are thicker, providing a broader platform for more numerous images. The upper column supported no fewer than four statues: two nude images are already diving headfirst; the third, clad in a loincloth, is about to plunge; and the fourth, still intact, resembles the statue of an emperor clad in a chlamys and extending his arm in an oratorical gesture. The column in the foreground held two images: one, a seminude youth, falls on his back and in a strangely animated way throws his arms backward, while the other is already totally smashed and its pieces are shown falling to the ground. Slightly flaked.

Located beside Numbers 33:50.

1040. Sm., fol. 182r

The inscription reads: ἐνταῦθα συντρίβουσι(ν) εἴδωλα πλάνης. Very close to Ser.

1041. Vat. 746, fol. 371r

The inscription reads: ἐνταῦθα συντρίβουσιν εἴδωλα πλάνης. Very close to Ser. and Sm.
Located beside Numbers 33:52.

1042. Vtp., fol. 215r

The inscription reads: ἐνταῦθα συντρίβουσιν εἴδωλα πλάνης. Very close to Ser., Sm., and Vat. 746. Slightly stained.
Located below Numbers 33:52.

Lit.: Uspenskii, p. 157, figs. 191, 310; Hesseling, fig. 251; Lassus, *Livre des Rois*, p. 87, fig. 118; Huber, fig. 47; Θησαυροί, p. 264, fig. 86.

Numbers 34:13–18

MEASURING THE LAND

1043. Vat. 747, fol. 186v

Moses issues the rules governing the hereditary allotment of the land of Canaan to the nine tribes and the half tribe remaining on the western bank of the Jordan. He gives orders to two young men who, with a measuring cord in their hands, are surveying a plot of land at the foot of a mountain. Moses heads a group of Israelites, among whom Joshua is recognizable; but Eleazar the priest, who according to the text was, together with Joshua, in charge of the distribution, is missing. The ground is flaked in various places.

Located beside Numbers 34:17.

1044. Ser., fol. 387r

A single distinguished person stands between Moses and Joshua, replacing the crowd shown in Vat. 747. This man is nimbed and dressed in a richly decorated costume, and although he does not wear a priest's miter, he can only represent Eleazar, who is designated by the text as the supervisor of the distribution, together with Joshua. The kneeling Israelite, one of the two engaged in the surveying, turns his head to Moses as if awaiting specific directions, while the other holds not only the cord, but also a surveyor's rod. The group at the left is somewhat flaked. The two women at the right should be identified as two of Zelophehad's (LXX: Salpaad) five daughters, whose inheritance is considered in chapter 36. In the illustration of Joshua 17:3–4 (figs. 1337–1341), where the same story is repeated, all five daughters are represented.

Located beside Numbers 34:17.

1045. Sm., fol. 182v

The inscription reads: σχοινισμὸς ὧδε, μέτρα γῆς, κλήρων δόσις.
Close to Ser. The figure of Eleazar is almost obscured by those of Moses and Joshua.
Located above Numbers 34:20.

1046. Vat. 746, fol. 372r

The inscription reads: σχοινισμὸς ὧδε, μέτρα γῆς, κλήρων δόσις.
Very close to Ser. and Sm.
Located beside Numbers 34:17.

1047. Vtp., fol. 216v

The inscription reads: σχοινισμὸς ὧδε, μέτρα γ(ῆ)ς, κλήρων δῶσις.
Very close to Ser., Sm., and Vat. 746. Joshua's mantle and the faces of all the figures are almost completely destroyed by flaking.
Located below Numbers 34:17.

Lit.: Uspenskii, p. 157, fig. 192; Hesseling, fig. 252; Huber, fig. 48.

The final chapters of Numbers (35–36) and the opening chapters of Deuteronomy (1–3) have no miniatures. The cycle of illustrations resumes with a miniature illustrating Deuteronomy 4:1–40.

8. DEUTERONOMY

Deuteronomy 4:1–40

MOSES' EXHORTATION TO THE ISRAELITES

The first three chapters of Deuteronomy review events after the exodus from Egypt; in the fourth, Moses admonishes and warns his people to keep God's commandments. The painters did not depict a particular verse of chapter 4, but rather gave paramount importance to this picture by representing Moses as an enthroned Christ with an open Gospel book. Vat. 747 also inserted the figure of Joshua, thus stressing Moses' successor, who is not mentioned in the fourth chapter.[1]

1048a. Vat. 747, fol. 148r

Moses sits on a golden throne in a strongly hieratic frontal view, holding the open book of commandments in one hand and blessing with the other. A group of elders stands to the right, and to the left is Joshua in full armor and a youthful Israelite in a short tunic, who turns around to a third Israelite wearing a long garment. Moses' head and other parts of the surface are somewhat flaked.

Located beside Deuteronomy 4:41.

1049a. Ser., fol. 401r

Close to Vat. 747; Moses holds a scroll instead of a book and his head is slightly turned toward the group at the left, which is not led by Joshua, but consists of a larger group of ordinary people, all of whom wear short tunics. The left half of the miniature is badly flaked and heavily stained.

Located beside Deuteronomy 4:42.

1050a. Sm., fol. 190r

The inscription reads: μωσῆς λαοῖς δίδωσι τοὺς θείους νόμους.

Very close to Ser. The tunics of two of the Israelites in the left group are decorated with clavi over the shoulder and segments over the knees.

1051a. Vat. 746, fol. 382r

The inscription reads: μωσῆς λαοῖς δίδωσι τοὺς θείους νόμους.

Very close to Ser. and Sm. The figure of Moses is mostly rubbed and the figures at the left are slightly flaked.

Located beside Deuteronomy 4:40.

1052. Vtp., fol. 237v

The inscription reads: μωσῆς λαοῖς δίδωσι τοὺς θείους νόμους.

Close to Ser., Sm., and Vat. 746.

Located beside Deuteronomy 4:40.

Lit.: Uspenskii, p. 157, fig. 193; Hesseling, fig. 253; Wilpert, *Mosaiken und Malereien*, vol. 1, p. 453, fig. 164; Weitzmann, "Martyrion," p. 142; Ettlinger, *Sistine Chapel*, p. 52, pl. 38b; Kauffman, "Bury Bible," p. 66, pl. 28a; Huber, fig. 49; Lassus, *Livre des Rois*, p. 87, fig. 121; Brenk, *S. Maria Magg.*, p. 84; Θησαυροί, p. 264, fig. 87.

[1] Joshua's presence during the speech, which according to Deut 1:1 Moses delivered in the wilderness, is accounted for by Deut 1:38 and further by Deut 3:28.

Deuteronomy 4:41–43

CITIES OF REFUGE

1048b. Vat. 747, fol. 148r

To represent the cities offering refuge to any man who unwittingly killed his neighbor, three walled cities with flanking towers and central gates are lined up side by side. The names of the cities were Bezer, Ramoth, and Golan (LXX: Bosor, Ramoth, and Ganlon).

Located beside Deuteronomy 4:41.

1049b. Ser., fol. 401r

Close to Vat. 747. All three walls enclose cypress trees and the two outer ones also surround houses. At the left the miniature is heavily flaked.

Located beside Deuteronomy 4:42.

1050b. Sm., fol. 190r

The inscription, a continuation of the one in the picture above, reads: καὶ τοῖς φονευταῖς ἀφορίζει τ(ὰς) πόλεις.

Very close to Ser.

1051b. Vat. 746, fol. 382r

The inscription reads: καὶ τοῖς φονευταῖς ἀφορίζει τὰς πόλεις.

Very close to Ser. and Sm.

Located beside Deuteronomy 4:40.

1053. Vtp., fol. 237v

The inscription reads: καὶ τοῖς φονευταῖς ἀφορίζει τὰς πόλεις.

Close to Ser., Sm., and Vat. 746. The three cities form a separate pictorial unit of their own. The cypress trees are omitted. The gate of the central city is flaked.

Located beside Deuteronomy 4:42.

Lit.: Uspenskii, p. 157, fig. 194; Hesseling, fig. 253; Wilpert, *Mosaiken und Malereien*, vol. 1, p. 453, fig. 164; Huber, fig. 50; Lassus, *Livre des Rois*, p. 87, fig. 121; Θησαυροί, p. 264, fig. 87.

Deuteronomy 7:5

Destroying the Images

After skipping chapters 5 and 6 of Deuteronomy, where the decalogue and other commandments are given, the cycle strikingly focuses again on the destruction of images which Moses orders at Deuteronomy 7:5. The illustration is akin to that for Numbers 33:52 (figs. 1038–1042). The same prohibition of images was given at Sinai in Exodus 34:13 but is not illustrated in that place.

1054. Vat. 747, fol. 150v

Moses exhorts his people to destroy the altars of their enemies, break down their images, cut down their groves, and burn their graven images. A group of elderly Israelites approaches from behind a mountain ridge and uses torches to set fire to the grove. A marble column in the center of the grove bears the statue of a seminude god holding a bow, probably an Apollo; the figure stretches its left arm downward and a piece of cloth hangs along its left side. The gray-green color of the idol suggests bronze. Giving the order, Moses stands at the left near the peak of a mountain and partly hidden by it. Part of the ground is flaked.

Located beside Deuteronomy 5:1.

1055. Ser., fol. 406v

Close to Vat. 747. The group of Israelites is larger, and the image, painted in a yellow-brown that might suggest either bronze or gold, represents a nude god in a contrapposto posture extending his right hand.

Located beside Deuteronomy 7:7.

1056. Sm., fol. 192v

The inscription reads: ἄλση θεόπτης ἐμπιπρᾶ καὶ τ(ὴν) πλάνην.
Very close to Ser.

1057. Vat. 746, fol. 386v

The inscription reads: ἄλση θεόπτης ἐμπιπρᾶ καὶ τὴν πλάνην.
Close to Ser. and Sm.
Located beside Deuteronomy 7:7.

1058. Vtp., fol. 246v

The inscription reads: ἄλση θεόπτης ἐμπιπρᾶ καὶ τ(ὴν) πλάνην.
Very close to Ser., Sm., and Vat. 746.
Located beside Deuteronomy 7:5.

Lit.: Uspenskii, pp. 157–58, figs. 195, 196; Hesseling, fig. 254; Huber, fig. 51; Θησαυροί, pp. 264–65, fig. 88.

Deuteronomy 12:1

Moses Addresses the Israelites

After skipping chapters 8–11, where new prescriptions are given and the covenant with Israel is renewed, the cycle resumes with chapter 12. This is illustrated with two miniatures; the first has the conventional iconography of Moses addressing his people, which is not specifically related to the chapter.

1059. Vat. 747, fol. 192r

Moses sits on a throne and addresses a group of Israelites consisting of elderly and young men alike. The ground and the face of Moses are partly flaked, and all the heads in the group of Israelites are overpainted.

Located beside Deuteronomy 12:12.

1060. Ser., fol. 415v

Close to Vat. 747; however, the Israelites wear long robes and hold their hands in receptive rather than responding gestures.

Located beside Deuteronomy 12:13.

1061. Sm., fol. 196r

The inscription reads: πρόσχεις θέων ἄριστα τοῖς γεγραμμέν(οις).
Very close to Ser.

1062. Vat. 746, fol. 394r

The inscription reads: πρόσχεις θέων ἄριστα τοῖς γεγραμμένοις.
Very close to Ser. and Sm.
Located beside Deuteronomy 12:13.

1063. Vtp., fol. 256v

The inscription reads: πρόσχεις θέων ἄριστα τοῖς γεγραμμένοις.
Very close to Ser., Sm., and Vat. 746. The miniature is slightly flaked and heavily stained, making the inscription difficult to read.
Located beside Deuteronomy 12:11.

Lit.: Uspenskii, p. 158, fig. 197; Hesseling, fig. 255; Henderson, "Joshua Cycle," p. 47; Galavaris, *Gregory Naz.*, p. 27 n. 36; Huber, fig. 52; Deckers, *S. Maria Magg.*, pp. 223–24; Spatharakis, *Corpus*, fig. 571; Θησαυροί, p. 265, fig. 89.

Deuteronomy 12:27

Offering a Goat

The second miniature of chapter 12 also has a conventional iconography, this one of a sacrifice and altar (see, e.g., figs. 819–823, 843–848, 849–854).

1064. Vat. 747, fol. 193r

One of Moses' prescriptions in chapter 12 concerns the offering of flesh sacrifices on the altar and the pouring of their blood at the foot of the altar. These ordinances are executed in the miniature by two nimbed Levites characterized by priestly garb with wide golden borders and pearl diadems. One of them cuts the throat of a goat and collects the blood in a vessel, while the second pours the blood onto the marble steps leading to a marble screen with the royal doors which, in the manner of Byzantine churches, separates the altar from the congregation. The altar itself, covered with a sumptuous cover bearing a pattern of large circles, is placed before the ciborium instead of beneath its dome.

Located beside Deuteronomy 12:30.

1065. Ser., fol. 417r

The sacrifice is not performed by Levites but by common Israelites in short tunics. The screen with the royal doors is omitted, but the spatial relationship between the ciborium and the altar, which is covered with a simpler altar cloth, is better understood.

Located beside Deuteronomy 12:30.

1066. Sm., fol. 197r

The inscription reads: τῶν θυμάτων αἵματα πρὸς βάσιν κένου. Very close to Ser.

1067. Vat. 746, fol. 395v

The inscription reads: τῶν θυμάτων αἵματα πρὸς βάσιν κένου. Very close to Ser. and Sm.
Located beside Deuteronomy 12:30.

1068. Vtp., fol. 258v

The inscription reads: τῶν θυμάτων αἵματα πρὸς βάσιν κένου. Close to Ser., Sm., and Vat. 746.
Located beside Deuteronomy 12:30.

Lit.: Uspenskii, p. 158, fig. 198; Hesseling, fig. 256; Nordström, "Water Miracles," pp. 81–82; Huber, fig. 53; De Angelis, "Simbologia," p. 1537, fig. 24; Θησαυροί, p. 265, fig. 90.

Deuteronomy 14:9–18

Clean and Unclean Animals

After skipping chapter 13, dealing with the seductions of foreign deities, the cycle starts again at chapter 14, which is concerned largely with Moses' ordinances governing the clean and unclean meats of quadrupeds, aquatic animals, and birds. However, the miniature that accompanies these passages illustrates only the latter two categories.

1069. Vat. 747, fol. 194v

A young Israelite holds a fish which clearly has the fins and scales required by the text for edible aquatic animals, and a second Israelite cuts the throat of a clean edible bird. Whereas none of the unclean aquatic animals is depicted, the painter took great pains to represent at least seventeen of the twenty forbidden genera of birds enumerated in the text. A few of them are so reduced in size that their genus is hardly recognizable, but there seems to be no doubt that the first illustrator of this scene took pains to represent the birds with ornithological accuracy. The eagle in strong heraldic posture, the owl, the hoopoe, and others are still clearly distinguishable. Very probably this accuracy is due to the influence of an illustrated scientific treatise on birds. The entire surface of the miniature is slightly flaked.

Located beside Deuteronomy 14:24.

1070. Ser., fol. 420r

The representations of the unclean birds vary considerably from those in Vat. 747. Although there are only fifteen birds, and the owl, for instance, is missing, on the whole the accuracy of their portrayal is emphasized even more than in Vat. 747. Instead of being placed against a mountainous background, they are isolated units without spatial relationship to each other, as is typical of scientific treatises. The miniature is very damaged. The lower part of the man holding the fish is torn away, and the rest of the figure is badly flaked.

Located below Deuteronomy 14:22.

1071. Sm., fol. 198v

The inscription reads: ζώων πετεινῶν ἐκλογὴ πέλει τάδε. Very close to Ser.

1072. Vat. 746, fol. 398v

The inscription reads: ζώων πετεινῶν ἐκλογὴ πέλει τάδε. Very close to Ser. and Sm.
Located beside Deuteronomy 14:24.

1073. Vtp., fol. 263v

The inscription reads: ζώων πετεινῶν ἐκλογὴ πέλει τάδε. Very close to Ser., Sm., and Vat. 746.
Located beside Deuteronomy 14:23.

Lit.: Uspenskii, p. 158, fig. 199; Hesseling, fig. 257; Huber, fig. 54; Θησαυροί, p. 265, fig. 91.

Deuteronomy 16:2–15

Passover Offerings and Feast of Tabernacles

Skipping chapter 15, where more prescriptions are given, the cycle begins again in chapter 16, which is primarily concerned

with the three great feasts: the Passover, the Feast of Weeks, and the Feast of Tabernacles. The miniature depicts features of only the first and last. No particular devotion to or emphasis on these major Hebrew feasts is shown, the iconography being rather conventional. In Vat. 747 the representation of the tabernacle as a tent (LXX: σκηνή) is very similar to that of Joshua 19:51 (LXX: σκηνὴ τοῦ μαρτυρίου) (figs. 1372–1375); it does not correspond to the more elaborate representations in Exodus (LXX: σκηνὴ τοῦ μαρτυρίου) (figs. 762–765, 774–777).

1074. Vat. 747, fol. 196r

Two sheep, a goat, and an ox represent the animals to be sacrificed on Passover, and the pitched tent in the background, the σκηνή, refers, of course, to the Feast of Tabernacles. At the left, a young Israelite in a short tunic points to the animals and the tent, and turns to a group of followers, including a woman (related to verse 14), as if explaining the ordinances concerning the feasts to them. The tabernacle is represented by the tent in the background. The surface is flaked in various spots.

Located beside Deuteronomy 16:18.

1075. Ser., fol. 423v

Close to Vat. 747 but the tent is omitted. In its place is a representation of those items that are to be gathered after the Feast of Tabernacles: a wicker basket of grapes and a wine jug in front of the animals, and a pile of threshed grain behind them. The group of Israelites is reduced to two youthful men who face not only the offerings, but also the hand of God issuing from a segment of heaven and with its gesture imparting blessing to the ordinances.

Located beside Deuteronomy 16:18.

1076. Sm., fol. 200r

The inscription reads: σκηνῶν ἑορτὴ προσφοραί τε θυμάτων. Very close to Ser.

1077. Vat. 746, fol. 401r

The inscription reads: σκηνῶν ἑορτὴ προσφοραί τε θυμάτων. Very close to Ser. and Sm.

Located beside Deuteronomy 16:18.

1078. Vtp., fol. 268r

The inscription reads: σκηνῶν ἑορτὴ προσφοραὶ τε θυμάτων.

Close to Ser., Sm., and Vat. 746. The pile of threshed grain is omitted.

Located beside Deuteronomy 16:18.

Lit.: Uspenskii, p. 158, fig. 200; Hesseling, fig. 258; De Grüneisen, *Ste. Marie Ant.*, p. 226, fig. 179; Huber, fig. 55; Θησαυροί, p. 265, fig. 92.

Deuteronomy 18:15

MOSES ANNOUNCES THE COMING OF A PROPHET

The rules decreed in chapter 17 are entirely ignored in the cycle, which starts again at chapter 18. This passage was probably selected on account of its importance for Christians: in his speech to the people in Acts 3:22–23, Peter refers to Moses' prediction that a prophet will be raised up among the Israelites as an allusion to the coming of Christ.[1]

1079. Vat. 747, fol. 198v

Moses holds in one hand an open scroll, on which the words μωσ(ῆς) προφάσκει χ(ριστὸ)ν ἐλθεῖν ἐν τάχει are written, and points with the other toward a segment of heaven in which the bust of the youthful Christ Immanuel is visible. A group of elderly Israelites stands opposite Moses, looking up at Christ. The two foremost of these wear hoods, the Jewish *tallitot*.[2]

Located beside Deuteronomy 20:1.

1080. Ser., fol. 428v

Close to Vat. 747. The figure of Christ is depicted against a star-studded semicircular zone. Lines are provided on the scroll in Moses' hand for an inscription that was never executed. Various spots are flaked, particularly the heads of the Israelite elders.

Located beside Deuteronomy 20:1.

1081. Sm., fol. 202v

The inscription reads: μωσῆς προφάσκει χ(ριστὸ)ν ἐλθεῖν ἐν τάχ(ει).

Close to Ser. On the background, in addition to the explanatory inscription, is Moses' name in capital letters, Ὁ ΠΡΟΦ(ήτης) ΜΩΥΣ(ῆ)C, and the text inscribed on the open scroll is a variant of verse 15, reading: προφή(την) ὑμῖν ἀναστή(σει) κ(ύριο)ς ὁ θε(ὸ)ς ἐκ τῶν ἀδελφῶν ὡς ἐμέ.

1082. Vat. 746, fol. 405r

The inscription reads: μωσῆς προφάσκει χ(ριστὸ)ν ἐλθεῖν ἐν τάχ(ει).

Close to Sm. Christ's garment and Moses' tunic are painted completely in gold, whereas in the preceding examples they were only highlighted with gold. Moses' name is written in minuscule μωυσῆς, although the scribe had begun to write in majuscule Ὁ ΠΡΟΦ(ήτης). The text on the open scroll reads: προφή(την) ὑμῖν ἀναστή(σει) κ(ύριο)ς ὁ θε(ὸ)ς ἐκ τ(ῶν) ἀδελφῶν ὡς ἐμέ. All the figures and the ground are badly damaged.

Located beside Deuteronomy 20:1.

1083. Vtp., fol. 273v

The inscription reads: μωσῆς προφάσκει χ(ριστὸ)ν ἐλθεῖν ἐν τάχει.

Close to Vat. 746 in that Christ's garment and Moses' tunic are depicted in solid gold. The group of Israelites is enlarged. The

inscription on the open scroll reads: προφή(την) ὑμῖν ἀναστή-(σει) κ(ύριο)ς ὁ θε(ὸ)ς ἐκ τῶν ἀδελφῶν σου ὡς ἐμέ; but Moses' name is omitted. Moses' mantle, parts of the Israelites' garments, and portions of the star-studded heaven are flaked.

Located below Deuteronomy 20:1.

Lit.: Uspenskii, pp. 158–60, figs. 201, 202; Hesseling, fig. 259; Huber, pp. 22–23, figs. G, H, I, 56; De' Maffei, "Eva," p. 29, fig. 6; Cutler, "Aristocratic Ps.: State of Research," p. 251 n. 99; Weyl Carr, "Gospel Frontispieces," p. 9 n. 63; Θησαυροί, p. 265, fig. 93; Revel-Neher, *Image of the Jew*, p. 74, fig. 34; Lowden, "Vtp. Oct.," p. 118, fig. 10; Lowden, *Octs.*, fig. 28.

[1] This image has a parallel in the marginal Psalters, where in Ps 90 Moses points at or bows before an icon of Christ; see the Khludov Psalter, fol. 90v (Moscow, Historical Museum, cod. 129; M. Shchepkina, *Miniatiury Khludovskoi psaltyri*, [Moscow, 1977], fol. 90v), and Athos, Pantokrator, cod. 61, fol. 128r (Corrigan, *Visual Polemics*, p. 72, figs. 84, 85).

[2] See Revel-Neher, *Image of the Jew*, pp. 72ff.

Deuteronomy 21:3–4

SLAYING A HEIFER

1084. Vat. 747, fol. 199v

As atonement for an unsolved murder, Moses prescribes that the city which is next to the site of the crime shall slay a heifer in a valley. In accordance with this ordinance, the painter depicted two Israelites on a mountain, one grasping a heifer by its hind leg and the other holding it by its tail over a cavernous valley. The heifer's head has already been cut off and lies at the bottom of the valley. The surface of the miniature is flaked in various places.

Located beside Deuteronomy 21:13.

1085. Ser., fol. 432r

Only one of the Israelites holds the heifer by the leg and tail, while the other, wielding a knife, has just slain it.

Located beside Deuteronomy 21:15.

1086. Sm., fol. 203v

The inscription reads: ριπτοῦσιν οὗτοι τὴν δάμαλιν ἐς χάος. Close to Ser.

1087. Vat. 746, fol. 408r

The inscription reads: ριπτοῦσιν οὗτοι τὴν δάμαλιν ἐς χάος. Close to Ser. and Sm.

Located beside Deuteronomy 21:15.

1088. Vtp., fol. 278r

The inscription reads: ριπτοῦσιν οὗτοι τὴν δάμαλιν ἐς χάος. Close to Ser., Sm., and Vat. 746. The heifer is nearly completely flaked, while the remainder of the surface is damaged to a lesser degree.

Located beside Deuteronomy 21:15.

Lit.: Uspenskii, p. 160, fig. 203; Hesseling, fig. 260; Huber, fig. 57; De Angelis, "Simbologia," pp. 1538–39, fig. 30; Θησαυροί, p. 266, fig. 94.

Deuteronomy 22:23–24

STONING THE ADULTERERS

The stoning is depicted with conventional iconography, as frequently found in Leviticus and Numbers (see figs. 865–869, 875–878, 926–930). The case is that of a betrothed woman found with another man within a city: both are stoned before the city gate.

1089. Vat. 747, fol. 202r

Two young Israelites stand on a hillock and cast stones upon a couple who have already fallen to the ground, bleeding from previously inflicted wounds. With raised arms, the man and woman try in vain to defend themselves against further blows. The surface is slightly flaked in various spots.

Located beside Deuteronomy 24:1.

1090. Ser., fol. 439v

Close to Vat. 747; however, the group of Israelites throwing stones is larger and stands on the same level as the victims. Whereas the posture of the guilty man agrees with Vat. 747, the woman, lying on the ground in a position of repose, tries to protect herself merely by pulling her kerchief over her breast, perhaps a more graceful attitude, but less appropriate under the circumstances.

Located beside Deuteronomy 24:1.

1091. Sm., fol. 206r

The inscription reads: λίθους ἐφεῦρον μισθὸν ἀκολασίας. Close to Ser.

1092. Vat. 746, fol. 414r

The inscription reads: λίθους ἐφεῦρον μισθ(ὸν) ἀκολασίας. Close to Ser. and Sm. Located beside Deuteronomy 24:1.

1093. Vtp., fol. 293r

The inscription reads: λίθους ἐφεῦρον μισθὸν ἀκολασίας. Close to Ser., Sm., and Vat. 746. The pose of the woman, who in the previous copies leans on her left arm concealed by her kerchief, is no longer understood. Slightly flaked.

Located below Deuteronomy 24:1.

Lit.: Uspenskii, p. 160, fig. 204; Hesseling, fig. 261; Huber, fig. 58; Θησαυροί, p. 266, fig. 95; Lowden, *Octs.*, p. 81, fig. 116

Deuteronomy 24:1–2

EATING GRAPES AND PICKING
KERNELS OF GRAIN

The illustration does not occur in Vat. 746 or Vtp.

1094. Vat. 747, fol. 203r

According to Moses' ordinance an Israelite may eat grapes in a neighbor's vineyard but not collect them in a vessel, and similarly he may pick kernels of grain in his neighbor's field but not cut them with a sickle. The painter first illustrates the breaking of the rule by showing a woman cutting grapes with a knife and collecting them in a wicker basket, and then compliance with it by showing another woman picking kernels of grain with her hands. The scene takes place at the foot of a steep mountain. The vine is badly flaked, and so are other areas of the surface, though to a lesser degree.

Located beside Deuteronomy 25:9.

1095. Ser., fol. 441v

The first woman plucks grapes with her hands and the second stands between two sheaves of grain she has already collected. The mountain is omitted.

Located beside Deuteronomy 25:7.

1096. Sm., fol. 207r

The inscription reads: πτωχαῖς ἐφεῖται συλλέγειν σου τὰς ῥάγας.

Close to Ser. The grain is collected in a vessel instead of in sheaves.

Lit.: Uspenskii, p. 160, fig. 205; Hesseling, fig. 262; Huber, fig. 59; Lowden, *Octs.*, p. 81, fig. 117.

Deuteronomy 29:9–11

MOSES ADDRESSES THE ISRAELITES

Chapters 24–28 are skipped entirely; the rules and the promulgation of the Law contained in this section of Deuteronomy did not attract the painter's interest. The cycle resumes in chapter 29 with a conventional figure of Moses addressing the Israelites: Moses tells them that this is the day on which they will stand before God to enter into the covenant with him.

1097. Vat. 747, fol. 207v

Holding a scroll in one hand, Moses gestures with the other while addressing a group of Israelites that does not include the women, children, and strangers mentioned in the text, but only some elderly men. God's presence is indicated by his hand sending out rays from heaven toward Moses. The ground is badly flaked, whereas the figures are less damaged.

Located beside Deuteronomy 29:13.

1098. Ser., fol. 451v

Close to Vat. 747, but Moses looks up at and points with his right hand toward heaven instead of speaking to the Israelites, who are grouped somewhat differently. No divine hand issues from the star-studded heaven, but only rays which are painted red and descend on Moses and the Israelites alike.

Located beside Deuteronomy 29:13.

1099. Sm., fol. 211v

The inscription reads: νῦν μυσταγωγεῖ μωσῆς ἰσραηλίτας.
Very close to Ser.

1100. Vat. 746, fol. 423r

The inscription reads: νῦν μυσταγωγεῖ μωσῆς ἰσραηλίτας.
Very close to Ser. and Sm.
Located beside Deuteronomy 29:13.

1101. Vtp., fol. 312v

The inscription reads: νῦν μυσταγωγεῖ μωσῆς ἰ(σρα)ηλίτας.
Close to Vat. 746 in that Moses' tunic is painted completely in gold. As in previous instances, the number of Israelites is enlarged, whereas in heaven not only the hand of God, but even the stars and rays are omitted. The face of one Israelite is badly flaked.

Located beside Deuteronomy 29:13.

Lit.: Uspenskii, p. 160, fig. 206; Hesseling, fig. 263; Huber, fig. 60; Θησαυροί, p. 266, fig. 96; Lowden, *Octs.*, pp. 46, 56, figs. 40–44.

Deuteronomy 31:24–25

MOSES WRITES THE LAW

1102a. Vat. 747, fol. 210r

Moses is represented seated and writing the words of the Law on a scroll in his lap. A Levite stands in front of him, crowned and in priestly costume, and extends his hand to receive the scroll which he holds in his other hand, so that two successive stages in the handing over of the Law are represented simultaneously. The ground is partly flaked.

Located beside Deuteronomy 31:24.

1103a. Ser., fol. 456r

The Levite's place is taken by Joshua. Clad in golden armor, he extends his right hand in a gesture of speech toward Moses. The figure of Joshua is somewhat rubbed.

Located beside Deuteronomy 31:24.

1104a. Sm., fol. 214r

The inscription, which is somewhat rubbed, reads: μωσῆς ἰησοῦν ἐντολαῖς θείαις στέφει.

Very close to Ser. Moses writes on a tablet instead of a scroll. This may, however, be the result of a later restoration, since the inscription leaves sufficient space for the scroll hanging over Moses' arm.

Located below Deuteronomy 31:23.

1105a. Vat. 746, fol. 427r

The inscription reads: μωσῆς ἰησοῦν ἐντολαῖς θείαις στέφει. Very close to Ser. and Sm.

Located beside Deuteronomy 31:25.

Vtp.

Between fols. 317 and 318 one folio is cut out which contained the passage Deuteronomy 31:25–32:5 and apparently also a miniature corresponding to those in the other manuscripts.

Lit.: Uspenskii, pp. 160–61, fig. 207; Hesseling, fig. 264; Nordström, "Water Miracles," p. 85, fig. 1; Huber, fig. 61; Revel-Neher, "Hypothetical Models," p. 407, fig. 1.

Deuteronomy 31:26

SCROLL WITH MOSES' LAW DEPOSITED IN THE ARK

1102b. Vat. 747, fol. 210r

A Levite deposits the scroll with the words of the Law in the Ark of the Covenant, which is built like a cupboard with one valve of its double door standing open. The scroll is also shown a second time in the Levite's hand. Figure, ark, and background are partly flaked.

Located beside Deuteronomy 31:24.

1103b. Ser., fol. 456r

Close to Vat. 747 but the Levite wears neither crown nor nimbus, and his left hand, hidden under his lacerna, does not hold a scroll. Furthermore, the ark, painted solidly in gold, is shaped somewhat differently. The ground is partly flaked.

Located beside Deuteronomy 31:24.

1104b. Sm., fol. 214r

The inscription is somewhat rubbed and reads: δέξαι κιβωτὲ τὸν νόμον τοῦ κ(υρίο)υ.

Very close to Ser. Perhaps due to the restorer's error the pattern of the closed valve is repeated in the interior of the cupboard.

Located below Deuteronomy 31:23.

1105b. Vat. 746, fol. 427r

The inscription reads: δέξαι κιβωτὲ τὸν νόμον τοῦ κ(υρίο)υ. Very close to Ser. and Sm.

Located beside Deuteronomy 31:25.

Vtp.

Between fols. 317 and 318 one folio is cut out which contained the passage Deuteronomy 31:25–32:5 and apparently also a miniature corresponding to those in the other manuscripts.

Lit.: Uspenskii, pp. 160–61, fig. 208; Hesseling, fig. 264; Nordström, "Water Miracles," pp. 86–87, fig. 1; Huber, fig. 61.

Deuteronomy 31:30–32:43

MOSES SINGS HIS SONG TO THE ISRAELITES

1106a. Vat. 747, fol. 212v

Seated in a frontal position atop a mountain with an open book on his knee, Moses addresses a group of Israelite elders who stand in front of him in reverential attitudes. Figures and background are somewhat flaked.

Located below Deuteronomy 32:52.

1107. Ser., fol. 463v

Close to Vat. 747. The scale of the figures is larger, thus reducing the free space. All the figures are badly flaked and the lower left corner is stained.

Located below Deuteronomy 32:47.

1109a. Sm., fol. 216v

The inscription reads: ᾠδῆς ἄκουσον ἰ(σρα)ὴλ τῆς δευτέρ(ας). Very close to Ser.

1110a. Vat. 746, fol. 432v

The inscription reads: ᾠδῆς ἄκουσον ἰ(σρα)ὴλ τῆς δευτέρας. Very close to Ser. and Sm.

Located below Deuteronomy 32:50.

1111a. Vtp., fol. 328r

The inscription reads: ᾠδῆς ἄκουσον ἰ(σρα)ὴλ τῆς δευτέρας.

Close to Ser., Sm., and particularly to Vat. 746 as far as the grouping of the Israelites is concerned. The beginning of the ode is written on the book of the Law: π(ρό)σεχε, οὐ(ρα)νέ, κ(αὶ) λαλήσω, κ(αὶ) ἀκουέτω γῆ.

Located beside Deuteronomy 33:11.

Lit.: Uspenskii, p. 161, figs. 209, 211; Hesseling, fig. 265; Weitzmann, *RaC*, pp. 131–32, fig. 112; Henderson, "Joshua Cycle," p. 47; Huber, fig. 62; Havice, "Marginal Miniatures," p. 118 n. 175; Θησαυροί, p. 266, fig. 97.

Deuteronomy 32:44

MOSES TEACHES HIS SONG TO JOSHUA
AND THE ISRAELITES

1106b. Vat. 747, fol. 212v

The second half of verse 44 repeats the teaching of the ode to the Israelites, but this time specifically mentions Joshua among the listeners. The painter has therefore placed a figure of Joshua between Moses and the group of Israelites: Joshua extends his hand toward the elders, at the same time turning his head toward Moses, who touches his shoulder. This time Moses delivers the ode in a standing position and does not hold the book of the Law. The figures and ground are somewhat flaked.

Located below Deuteronomy 32:52.

1108. Ser., fol. 463v

Close to Vat. 747, but Moses holds his hand more upright, Joshua is without a helmet, and the group of elders is larger. The whole surface of the miniature is badly flaked and the lower right corner is stained.

Located below Deuteronomy 32:47.

1109b. Sm., fol. 216v

The inscription reads: ἄνειμι καὶ γὰρ εἰς ὄρος τὸ τοῦ τέλους. Very close to Ser.

1110b. Vat. 746, fol. 432v

The inscription reads: ἄνειμι καὶ γὰρ εἰς ὄρος τὸ τοῦ τέλους. Very close to Ser. and Sm. The heads of the elders are badly rubbed.

Located below Deuteronomy 32:50.

1111b. Vtp., fol. 328r

The inscription reads: ἄνειμι καὶ γὰρ εἰς ὄρος τὸ τοῦ τέλους. Very close to Ser., Sm., and Vat. 746. Some of the Israelites' garments are slightly flaked.

Located below Deuteronomy 33:11.

Lit.: Uspenskii, p. 161, figs. 210, 212; Hesseling, fig. 265; Weitzmann, *RaC*, pp. 131–32, fig. 112; Huber, fig. 62; Weitzmann, "Ode Pictures," p. 71; Havice, "Marginal Miniatures," p. 118 n. 175; Θησαυροί, p. 266, fig. 97.

Deuteronomy 34:1–4

MOSES SHOWN THE PROMISED LAND

1112. Vat. 747, fol. 214v

Moses is allowed to see the Promised Land from the top of Pisgah (LXX: Phasga) in the mountain of Nebo. Half hidden by the peak of the mountain, Moses looks down at three walled cities below and a fourth one which emerges from behind a second, smaller mountain. This single city is apparently Jericho, while the other three are probably not to be thought of as specific cities, because the text mentions only two—Gilead and Zoar (LXX: Galaad and Segor)—in addition to Jericho; rather, they are symbols for the dwelling places of the tribes of Dan, Naphtali, Ephraim, Manasseh, and Judah. In the upper right corner God's hand is seen sending out rays toward Moses from a segment of heaven. The surface is flaked in various spots.

Located beside Deuteronomy 34:1.

1113. Ser., fol. 470r

The composition is reversed, with the half figure of Moses visible on the mountain at the right and God's hand at the left. The Promised Land is represented as a rich plain inhabited by birds and planted with trees, which, however, are not depicted as the palm trees one might expect to see in the country around Jericho, and as the text specifies. A stream of water flows across the foreground, either representing the River Jordan, which Moses was not allowed to cross, as sentenced at Deuteronomy 3:27, or illustrating the phrase that Moses could see "all the land of Judah unto the utmost sea." Iconographically, however, the depiction is taken from an aquatic landscape as seen in Annunciation scenes and elsewhere (text fig. 30).[1]

Located beside Deuteronomy 34:3.

1114. Sm., fol. 218v

Very close to Ser. The miniature has apparently been overpainted.

1115. Vat. 746, fol. 437r

The inscription reads: ὄρους προκύψας γῆς θέασαι τὴν θέσιν. Very close to Ser. and Sm. Flaked all over the surface.
Located beside Deuteronomy 34:1.

1116. Vtp., fol. 333v

The inscription reads: ὄρους προκύψας γῆς θέασαι τὴν θέσιν. Very close to Ser., Sm., and Vat. 746. Flaked in various spots.
Located beside Deuteronomy 34:1.

Lit.: Uspenskii, p. 161, fig. 213; Hesseling, fig. 266; Redin, *Koz'my Indikoplova*, p. 325, fig. 376; Weitzmann, *JR*, p. 91, fig. 92; Ettlinger, *Sistine Chapel*, p. 52, pl. 39a; Gaehde, "Octateuch," pp. 372–73; Huber, fig. 63; Brenk, *S. Maria Magg.*, p. 95; Deckers, *S. Maria Magg.*, p. 225; Lowden, "Vtp. Oct.," fig. 12; Sed-Rajna, *Hebraic Bible*, p. 96 n. 97; Θησαυροί, p. 266, fig. 98; Lowden, *Octs.*, p. 115, figs. 30, 176.

[1] Weitzmann, "Spätkomnenische Verkündigungsikone des Sinai"; Mouriki, "Moses Cycle," p. 538. See also the references in the introduction to Genesis 2:4–6 (nos. 59–62).

[Deuteronomy 34]

MOSES AND THE ANGEL WALK TOWARD THE MOUNTAIN

The following scene has no direct connection with Deuteronomy 34:5–6, which tells that Moses died in the land of Moab, and that no one knows the place where he was buried. Diverse literary accounts expanded the story of the last hours of Moses, searching for a key to the riddle of the unknown place of his burial and challenging the reality of his death. These accounts are found in both Jewish and Christian writings—the most renowned being Jude 9—and in pseudepigrapha;[1] they transmit the famed tale of the battle between the angel and the devil over Moses' corpse,[2] a version of Moses' disappearance popular in Christian times.[3] The cycle neither treats the details of these legends nor does it follow Deuteronomy. In the first miniature, Moses walks behind an angel either carelessly (Vat. 747, fig. 1117a) or in worry (Ser., Sm., Vat. 746, and Vtp.; figs. 1118a– 1121a); in the second, Moses, hidden among peaks, looks at the angel fearlessly (in Vat. 747) or weeping (in the other manuscripts); in addition, a flying angel addresses God in an attitude of questioning or apology. The pictorial narrative in the Octateuchs, apparently merely an epitome of a more expanded narrative, is enlivened by traits that adhere to a different vision of Moses' end, which is discussed below in the introduction to nos. 1117c–1121c.[4]

1117a. Vat. 747, fol. 215r

Moses walks toward a steep mountain, either Mount Nebo, which he has been ordered to ascend (verse 49), or the remote and unknown place of his burial. He raises his hand to God's hand in a small segment of heaven set against a golden strip of the tripartite sky. Youthful to the very end, Moses resolutely follows an angel who carries a scepter; with his free hand he points in the direction of the mountain while turning his head back. Small spots of the surface are flaked.

Located below Deuteronomy 34:12.

1118a. Ser., fol. 471v

Close to Vat. 747 but the angel holds an orb with a cross in addition to the scepter, and the hand of God is replaced by a beam of light. Here, and more obviously in Sm., Vat. 746, and Vtp., Moses' frowning eyes express sorrow. The whole background is filled with a mountain range, and thus Mount Nebo is not indicated distinctly. Slightly flaked.

Located after the end of the catena of Deuteronomy and before the first of Theodoret's *Quaestiones in Josuam*.

1119a. Sm., fol. 219r or 219v[5]

Very close to Ser.

1120a. Vat. 746, fol. 438r

Very close to Ser. and Sm.
Located beside Deuteronomy 34:12.

1121a. Vtp., fol. 335v

Close to Ser., Sm., and Vat. 746. The rays in the heavenly segment and the angel's scepter are omitted.

Located beside Deuteronomy 34:12.

Lit.: Tikkanen, *Genesismosaiken*, fig. 56; Uspenskii, p. 161, fig. 214; Hesseling, fig. 267; Redin, *Koz'my Indikoplova*, p. 325, fig. 375; Neuss, *Katalan. Bibelill.*, p. 49; Lowrie, *Art*, pl. 146c; Weitzmann, *JR*, pp. 91–92, figs. 93, 94; Tselos, "Joshua Roll," p. 278; Weitzmann, "Constantinop. Lectionary," p. 368 n. 45; Buchthal, *Latin Kingdom*, p. 59 n. 7; Williams, "León Bible," p. 79; Ettlinger, *Sistine Chapel*, p. 52, pl. 39c; Huber, fig. 64; Gaehde, "Octateuch," pp. 372–73, fig. 89; Brenk, *S. Maria Magg.*, p. 95; Deckers, *S. Maria Magg.*, p. 225; Heimann, "Moses-Darstellungen," pp. 5–6, fig. 4; Demus, *Mosaics of S. Marco*, vol. 2, pt. 1, p. 179; Lowden, *Octs.*, p. 115, fig. 177.

[1] See J. H. Charlesworth, *The Old Testament Pseudepigrapha and the New Testament: Prolegomena for the Study of Christian Origins* (Cambridge, 1985), pp. 75–77.

[2] Among these pseudepigrapha are the Testament of Moses, a text of Palestinian origin commonly dated to the beginning of the first century A.D., and the supposedly rewritten edition known as the Assumption of Moses. Cf. R. J. Bauckham, "Excursus: The Background and Source of Jude 9," in *Jude, 2 Peter* (Waco, Texas, 1983), pp. 65–76, esp. p. 67 for the date of composition of the Testament of Moses, and pp. 72–73 for the reconstructed final section of this text. The lost archetype of the different versions of the end of Moses in these texts may be reconstructed as follows: after Moses had dismissed Joshua and died, a contest arose between Michael, the angel sent by God to remove Moses' corpse and bury it, and the devil, who wanted to bring his corpse to the Israelites and provoke them to worship Moses as a god. In this dispute the devil affirmed he would not permit Moses to be buried because he was a murderer, since he had struck a man in Egypt to defend a Hebrew (Ex 2:12); but Michael rebuked Satan and delivered Moses' corpse from his power.

[3] Ibid., pp. 67–74, where the extant evidence and the variants are collected and examined.

[4] Gaehde, "Octateuch," pp. 372–73, examined a group of representations of the disappearance of Moses. In addition to the monuments he considered, the conflict among the devil and angels over Moses' body is depicted on an icon in the Monastery of St. Catherine at Mount Sinai (see Mouriki, "Moses Cycle"). To the texts cited in note 2 above, we can add Philo, *Moses* 2:291 (*Philo*, ed. Colson, vol. 6, p. 594), and the vast collection of details concerning Moses' disappearance assembled by Ginzberg (*Legends*, vol. 3, pp. 439–79, and vol. 6, notes 946f.).

[5] Fol. 219v according to Hesseling, p. xiv; fol. 219r according to Uspenskii, pp. 161, 188.

[Deuteronomy 34]

ANGEL APPOINTED TO TAKE MOSES' SOUL

In the second episode of his disappearance, Moses stands hidden in a deep ravine between two towering mountains, visibly mourning except in Vat. 747, where he turns his glance toward the flying angel on the right. The angel stretches out his arms in a gesture apparently of perplexity, apology, or appeal to the heavens for instructions. None of these elements belongs to Deuteronomy. Moses mourning the approach of his inevitable death is a complex topic in Jewish writings.[1] Striking parallels are encountered in Sotah;[2] in Memar Marqah or Book of Wonder,[3] a Samaritan text dating from the fourth century;[4] in Petirot

Moshe, a Midrash dating from earlier than the seventh century;[5] and in the cognate Chronicles of Jerahmeel.[6] Certain features were also known to the second-century Christian writer Clement of Alexandria.[7] These expansions of Moses' story relate that the prophet refused to die and prayed to avoid his fate. God appointed his angels to fly down to earth and bring back Moses' soul, but unsuccessfully; one of the angels searched for Moses until he reached the mountains and the valleys which told him that God had concealed Moses.[8]

Traits in the miniatures thus manifestly hark back to a similar tradition of Moses' disappearance: Moses mourning in the ravine may be connected with his attempts to escape death, and the angel addressing the heavens might be identified as Gabriel refusing to take Moses' soul.

1117c. Vat. 747, fol. 215r

A flying angel, represented as only a half figure in contrast to the previous miniature, spreads its arms in a gesture of apology or seeking instructions.
Located below Deuteronomy 34:12.

1118c. Ser., fol. 471v

The angel is here addressing the segment of heaven, giving a report or asking for instructions.
Located after the end of the catena of Deuteronomy and before the first of Theodoret's *Quaestiones in Josuam*.

1119c. Sm., fol. 219r or 219v[9]

Very close to Ser.

1120c. Vat. 746, fol. 438r

Very close to Ser. and Sm.
Located beside Deuteronomy 34:12.

1121c. Vtp., fol. 335v

Very close to Ser., Sm., and Vat. 746.
Located beside Deuteronomy 34:12.

Lit.: Uspenskii, p. 161, fig. 215; Hesseling, fig. 267; Redin, *Koz'my Indikoplova*, p. 325, fig. 375; Lowrie, *Art*, pl. 146c; Weitzmann, *JR*, p. 91, figs. 93, 94; Williams, "León Bible," p. 95; Weitzmann, "Crusader Icons," p. 191; Huber, fig. 64; Gaehde, "Octateuch," pp. 372–73; Brenk, *S. Maria Magg.*, p. 95; Deckers, *S. Maria Magg.*, p. 225; Chasson, "Tuscan Bible," p. 181; Demus, *Mosaics of S. Marco*, vol. 2, pt. 1, p. 179; Lowden, *Octs.*, p. 115, fig. 177.

[1] In addition to the literature mentioned in the previous notes, see Josephus, *Ant* 4:323–331 (*Josephus*, ed. Thackeray, vol. 4, pp. 630–34), which specifically mentions a ravine as the place where Moses disappeared, although no angel attends Moses' departure. These earlier traditions are also known in a later writing, Michael Glykas's *Annales* (PG 158, cols. 304–5).
[2] Sotah 13b–14a (see the translation in *The Jewish Encyclopedia*, vol. 9 [New York and London, 1905], p. 53). Cf. J. Neusner, *The Mishnah: A New*

Translation (New Haven, 1988), p. 449; *The Tosefta Translated from the Hebrew, Third Division, Nashim (The Order of Women)*, ed. J. Neusner (New York, 1979), pp. 163–64; *Babylonian Talmud*, ed. Epstein, vol. 3, pp. 70–72.
[3] 5:3 (*Memar Marqah: The Teaching of Marqah*, ed. MacDonald, vol. 2, pp. 206–7).
[4] J. D. Purvis, "Samaritan Traditions on the Death of Moses," in *Studies on the Testament of Moses*, ed. G. W. E. Nickelsburg Jr. (Cambridge, Mass., 1973), pp. 94–99.
[5] For a French translation, see "La mort de Moïse," in *Légendes juives apocryphes sur la vie de Moïse*, ed. M. Abraham (Paris, 1925), pp. 93–113.
[6] *Chronicles of Jerahmeel*, ed. Gaster, 50–52, pp. 133–49.
[7] For instance, the angels descending from heaven to take Moses' soul (*Stromata*, bk. 6, chap. 15 [PG 9, cols. 356–57]).
[8] Chronicle of Jerahmeel 50:5, 9–14 (*Chronicles of Jerahmeel*, ed. Gaster, pp. 135–40).
[9] Fol. 219v according to Hesseling, p. xiv; fol. 219r according to Uspenskii, pp. 161, 188.

[Deuteronomy 34]

Moses Mourns

1117b. Vat. 747, fol. 215r

A bust of Moses appears between two mountain peaks, looking toward the angel of the next scene. Slightly flaked.
Located below Deuteronomy 34:12.

1118b. Ser., fol. 471v

Moses weeps and turns his head in the opposite direction.
Located after the end of the catena of Deuteronomy and before the first of Theodoret's *Quaestiones in Josuam*.

1119b. Sm., fol. 219r or 219v[1]

Very close to Ser.

1120b. Vat. 746, fol. 438r

Very close to Ser. and Sm.
Located beside Deuteronomy 34:12.

1121b. Vtp., fol. 335v

Very close to Ser., Sm., and Vat. 746. The miniature is badly damaged, most of the mountain and Moses' face being almost completely flaked.
Located beside Deuteronomy 34:12.

Lit.: Uspenskii, p. 161, fig. 215; Hesseling, fig. 267; Redin, *Koz'my Indikoplova*, p. 325, fig. 375; Lowrie, *Art*, pl. 146c; Weitzmann, *JR*, p. 91, figs. 93, 94; Williams, "León Bible," p. 95; Weitzmann, "Crusader Icons," p. 191; Huber, fig. 64; Gaehde, "Octateuch," pp. 372–73; Brenk, *S. Maria Magg.*, p. 95; Deckers, *S. Maria Magg.*, p. 225; Chasson, "Tuscan Bible," p. 181; Demus, *Mosaics of S. Marco*, vol. 2, pt. 1, p. 179; Lowden, *Octs.*, p. 115, fig. 177.

[1] Fol. 219v according to Hesseling, p. xiv; fol. 219r according to Uspenskii, pp. 161 and 188.

9. JOSHUA

Joshua 1:1–9

Joshua Appointed as Moses' Successor

1122a. Vat. 747, fol. 215v

Wearing armor highlighted in gold and a decorated helmet, the new leader raises both hands in prayer toward God's hand in heaven, now mostly flaked. One group of armed and arguing Israelites, consisting of elderly and youthful men, stands behind Joshua, while another group, in front of the hero, is shown already departing. The second group is a representation of God's order to march, although the actual departure does not take place until after Joshua has spoken to his followers, which is represented in the next scene.

Located below Joshua 1:2.

1123a. Ser., fol. 472r

Joshua, in a gold suit of armor and with a blue nimbus, holds a lance in one hand; the left-hand group of Israelites is arranged somewhat differently from that in Vat. 747, and the right-hand group, in front of Joshua, is just about to turn to leave and begin their march. A rich landscape setting, consisting of two mountains and a tree at the right, is included behind Joshua.

Located below Joshua 1:2.

1124a. Sm., fol. 219v

Very close to Ser.

1125a. Vat. 746, fol. 439r

The miniature is slightly narrower, and consequently the right-hand group of Israelites is abbreviated and partly hidden by the tree.

Located above Joshua 1:3.

1126a. Vtp., fol. 337r

Close to Vat. 746. Joshua does not wear a helmet and is already on the march, while at the same time he still talks with God. On the other hand, the Israelites who follow him do wear helmets—some of them very elaborate—and full armor, and they too are represented marching. It is justifiable to assume that these alterations in the costumes as well as the change from inactivity to motion is due to the direct influence of the first scene of the Vatican Rotulus which, together with the following five scenes, is now lost. The color of the background in this and the following miniatures of this manuscript is yellowish brown, which may be understood as a substitute for gold rather than a depiction of the sky.

Located beside Joshua 1:3.

Lit.: RG, p. 17, pls. 50 no. 1, A no. 1; Uspenskii, p. 161, fig. 216; Hesseling, fig. 268; Lowrie, *Art*, pl. 146d; Weitzmann, *JR*, pp. 92–93, 106–7, fig. 95;

Buchthal, *Latin Kingdom*, p. 59 n. 10; Henderson, "Joshua Cycle," p. 47; Huber, fig. 65; Gaehde, "Octateuch," pp. 377, 380, fig. 95; Deckers, *S. Maria Magg.*, p. 227; Kirigin, *Mano divina*, p. 151; Corrie, "Conradin Bible," p. 176, fig. 112.

Joshua 1:10–18

Joshua Commands the Officers

1122b. Vat. 747, fol. 215v

With a lance in his hand Joshua stands in a dignified stance; behind him is a group of Israelites. The foremost soldier in the second group raises his hand in a gesture assuring Joshua that the Israelites are willing to obey his command. All the soldiers wear tunics and are armed only with shields and spears, while Joshua alone is dressed in heavy armor.

Located below Joshua 1:2.

1123b. Ser., fol. 472r

Although the general arrangement is like that in Vat. 747, there are differences in detail: Joshua raises his hand in a gesture of speech toward the soldiers, whose gestures assure him of their obedience; the soldiers behind Joshua wear the same heavy armor as their leader. finally, the painter depicted a mountain and a conventional walled city, presumably meant to be the city of Shittim mentioned in Joshua 2:1.

Located below Joshua 1:2.

1124b. Sm., fol. 219v

Close to Ser. The left-hand group of Israelites is arranged slightly differently.

1125b. Vat. 746, fol. 439r

The grouping of the soldiers at the left is more like Ser. than Sm. The walled city at the right partly overlaps the second group of soldiers, thus giving the effect that the men are emerging from behind the city.

Located above Joshua 1:3.

1126b. Vtp., fol. 337r

From Vat. 746 the painter took over the spatial relationship of Joshua's followers to the city. The city is more elaborate in its detail but in a purely decorative way, with the towers inorganically placed inside instead of outside the wall. All the heads and large areas of the mountain are flaked.

Located beside Joshua 1:3.

Lit.: RG, p. 17, pls. 50 no. 1, A no. 1; Uspenskii, p. 161, fig. 217; Hesseling, fig. 268; Lowrie, *Art*, pl. 146d; Weitzmann, *JR*, pp. 93, 105, fig. 96; Huber, fig. 65; Gaehde, "Octateuch," pp. 377, 380; Deckers, *S. Maria Magg.*, p. 227; Anderson, "Seraglio," p. 90.

Joshua 2:1

Joshua Sends Spies to Jericho

1127. Vat. 747, fol. 216v

Joshua, enthroned and flanked by a group of Israelite soldiers armed with spears and shields, sends out spies to explore the land around Jericho. The two spies, holding spears as their only weapons, depart while turning their heads around to Joshua, who is still talking to them. Parts of the ground are flaked.

Located beside Joshua 2:1.

1128. Ser., fol. 474v

Close to Vat. 747 but Joshua does not wear a helmet, and the scene is enriched by the addition of several landscape features: a high mountain, a tree, and beneath the tree two cubic altars, one placed above the other in a purely decorative way.

Located beside Joshua 2:1.

1129. Sm., fol. 220v

Close to Ser.
Located beside Joshua 2:1.

1130. Vat. 746, fol. 441r

Close to Ser. and Sm.
Located beside Joshua 1:18.

1131. Vtp., fol. 340v

Some of the soldiers behind Joshua wear helmets and heavy armor instead of simple tunics. Joshua sits on a golden chair similar to the one in Vat. 747, which is painted in yellow-brown to simulate gold, whereas in Ser., Sm., and Vat. 746 a marble cube serves as Joshua's seat. The entire surface of the miniature is badly damaged.

Located beside Joshua 2:1.

Lit.: RG, p. 17, pl. A no. 2; Uspenskii, p. 162, fig. 218; Hesseling, fig. 269; Lowrie, *Art*, p. 213, pl. 146e; Weitzmann, *JR*, pp. 93–94, 105, fig. 97; Kollwitz, "Josuazyklus," p. 106, pl. 11b; Henderson, "Joshua Cycle," p. 48; Huber, fig. 66; Brenk, *S. Maria Magg.*, p. 97; Deckers, *S. Maria Magg.*, p. 230; Weitzmann, *SP*, p. 63; Anderson, "Seraglio," pp. 94–95, fig. 21; Θησαυροί, p. 267, fig. 99.

Joshua 2:1

Rahab Greets the Spies

1132. Vat. 747, fol. 216v

The two spies, coming down from the mountains, approach Jericho, a walled city with flanking towers enclosing several houses. Anticipating hiding the spies, the harlot Rahab comes out of the city and greets them, extending her right hand while

with her left she holds the hem of her veil in a gesture of embarrassment.

Located below Joshua 2:1.

1133. Ser., fol. 474v

Close to Vat. 747 but more condensed. Rahab's gestures and dress are slightly altered. In addition to a cypress tree, there is only one house within the city wall, and this is obviously meant to represent the harlot's residence. The mountains are depicted only as a foil, one peak circumscribing the spies and the other the harlot, and are not as spatially integrated with the scene as they are in Vat. 747.

Located beside Joshua 2:1.

1134. Sm., fol. 220v

Close to Ser. The lower edge of the folio is trimmed, cutting off the feet of the spies and of the harlot.

1135. Vat. 746, fol. 441r

Close to Sm.
Located below Joshua 2:2.

1136. Vtp., fol. 340v

Although large sections of the miniature are flaked, including the upper part of the harlot, the mountain surrounding her, and much of the spies, enough is left to make it clear that the painter closely followed Vat. 746. As usual he elaborated the walled city in a decorative manner, replacing the cypress tree with a tower with a conical roof.

Located above Joshua 2:1.

Lit.: RG, p. 17, pl. A no. 2; Uspenskii, p. 162, fig. 219; Hesseling, fig. 269; Lowrie, *Art*, p. 213, pl. 146e; Weitzmann, *JR*, p. 94; Buchthal, *Latin Kingdom*, pp. 59 n. 10, 60; Stern, "Quelques problèmes," p. 102; Kollwitz, "Josuazyklus," p. 106; Henderson, "Joshua Cycle," p. 48; Huber, fig. 66; Deckers, *S. Maria Magg.*, p. 230; Anderson, "Seraglio," pp. 94–95, fig. 21; Θησαυροί, p. 267, fig. 99.

Joshua 2:3

The King's Soldiers Address Rahab

The miniature illustrates the episode of the soldiers sent by the king of Jericho to Rahab in order to have the spies handed over. The soldiers, however, are erroneously depicted with the appearance and the attitude of the spies in the previous scene.

1137. Vat. 747, fol. 217r

The two soldiers stand before the city of Jericho and speak with Rahab, who leans over the crenelated wall. With a striking gesture, the woman points to the door of her house which can be

seen in the center. Two golden bushes are distributed over the background.

Located beside Joshua 2:7.

1138. Ser., fol. 475r

The inviting gesture that Rahab exhibits in Vat. 747 is replaced by a gesture of speech. Due to lack of space the scene is condensed, which resulted in the cutting off of the right edge of the city with its flanking tower.

Located beside Joshua 2:7.

1139. Sm., fol. 221r

Part of the city tower remains visible at the right border; otherwise the miniature is almost identical with that in Ser.

1140. Vat. 746, fol. 441v

Close to Ser. and Sm.
Located beside Joshua 2:9.

1141. Vtp., fol. 341v

The wall and towers of the city are again enriched by ornamental designs. The background is painted an indistinct yellow-gray; but by placing two bushes near the spies' heads, the painter apparently intended to convey the impression that the city was located at the foot of a precipitous mountain. The heads of the spies, parts of their tunics, the inside of the city wall, and the city gate are flaked.

Located beside Joshua 2:9.

Lit.: RG, p. 17, pl. B no. 1; Uspenskii, p. 162, fig. 220; Hesseling, fig. 270; Lowrie, *Art*, p. 213, pl. 147a; Weitzmann, *JR*, p. 94; Kollwitz, "Josuazyklus," p. 106; Henderson, "Joshua Cycle," p. 48; Huber, fig. 67; Deckers, *S. Maria Magg.*, p. 230; Weitzmann, *SP*, p. 63; Θησαυροί, p. 267, fig. 100.

Joshua 2:4–6

SOLDIERS DEMAND THE SPIES' SURRENDER

1142a. Vat. 747, fol. 217v

At the left of the miniature, two messengers of the king of Jericho approach Rahab before the wall of Jericho and demand that the spies surrender. The foremost messenger raises his hand in a gesture of speech; Rahab reciprocates, lying to them and saying that the spies have left the city. In addition to spears, the messengers carry shields, attributes that distinguish them from the spies. The latter appear at half-length, looking down from the wall before the harlot's house, where they are supposed to be hidden.

Located beside Joshua 2:24.

1143a. Ser., fol. 476r

Close to Vat. 747, except that both messengers are talking to Rahab and the city is more elaborate. The wall is flanked in the usual way by two towers and is interrupted by the city gate, while

above it several houses are visible. Precisely which one represents the harlot's residence is not certain.

Located beside Joshua 3:1.

1144a. Sm., fol. 221v

Very close to Ser. The harlot's clumsy head, drawn in straight profile, seems to be the result of a later restoration.

Located beside Joshua 3:2.

1145a. Vat. 746, fol. 442r

Very close to Sm. and Ser.
Located beside Joshua 3:1.

1146a. Vtp., fol. 343r

Close to Ser., Sm., and Vat. 746.
Located beside Joshua 2:24.

Lit.: Piper, "Bilderkreis," p. 184; *RG*, p. 18, pl. B no. 2; Uspenskii, p. 162, figs. 221, 222; Hesseling, fig. 271; Lowrie, *Art*, p. 213, pl. 147b; Weitzmann, *JR*, p. 94; Kollwitz, "Josuazyklus," p. 106, pl. 11c; Henderson, "Joshua Cycle," p. 48; Mütherich, "Psalterillustration," p. 172, fig. 35; Huber, fig. 68; Brenk, *S. Maria Magg.*, p. 99; Deckers, *S. Maria Magg.*, pp. 231, 237; Weitzmann, *SP*, p. 63; Θησαυροί, p. 267, fig. 101.

Joshua 2:15

SPIES FLEE RAHAB'S HOUSE

1142b. Vat. 747, fol. 217v

At the right, Rahab lets the spies down through the window of her house, which is merged with a section of the city wall into a unified structure that is clearly separated from the wall in the left scene. Rahab holds a rope with both hands and lets down both spies simultaneously.

Located beside Joshua 2:24.

1143b. Ser., fol. 476r

A denticulated ornament distinguishes the harlot's house from the city wall more clearly than in Vat. 747. Rahab holds the rope with only one hand, while with the other she touches her chin in a thoughtful gesture, and she lets down only one spy; the other spy, already on the ground, is helping his comrade to get safely to his feet.

Located beside Joshua 3:1.

1144b. Sm., fol. 221v

Close to Ser.
Located beside Joshua 3:2.

1145b. Vat. 746, fol. 442r

Close to Ser. and Sm.
Located beside Joshua 3:1.

1146b. Vtp., fol. 343r

Close to Ser., Sm., and Vat. 746. The architectural setting is enriched, though without clarifying the locality. All that remains of Rahab's house is the window, and this is set in a high wall that terminates in a crenelated ringwall with towers.

Located beside Joshua 2:24.

Lit.: Piper, "Bilderkreis," p. 184; *RG*, p. 18, pl. B no. 2; Uspenskii, p. 162, figs. 221, 222; Hesseling, fig. 271; Lowrie, *Art*, p. 213, pl. 147b; Weitzmann, *JR*, p. 94; Kollwitz, "Josuazyklus," p. 106, pl. 11c; Henderson, "Joshua Cycle," p. 48; Mütherich, "Psalterillustration," p. 172, fig. 35; Huber, fig. 68; Brenk, *S. Maria Magg.*, p. 99; Deckers, *S. Maria Magg.*, pp. 231, 237; Weitzmann, *SP*, p. 63; Θησαυροί, p. 267, fig. 101.

Joshua 2:22

PURSUING OF THE SPIES

1147. Vat. 747, fol. 217v

In a mountainous landscape, the two Israelite spies disappear at the left behind the slope of a high mountain, while in the right foreground the king of Jericho's two messengers, having missed the spies, ride in full gallop away from them. The shields slung over the horsemen's backs identify them as the same men who spoke to Rahab in the preceding miniature (fig. 1142a). In the lower right corner a monument is visible; unrelated to the text and resembling a classical stele, its semicircular top is decorated with a relief bust, and the white-blue grisaille imitates marble. All four mountains and the monument are almost completely flaked.

Located below Joshua 3:2.

1148. Vat. Rot., sheet I

The two spies converse as they climb the mountainside where a beardless, half-nude personification lies. The two messengers gallop away from Jericho. On the right, a soldier is apparently searching for the spies inside a precinct wall enclosing a tree. The soldier seems to replace the relief monument in Vat. 747: his shield corresponds to the frame of the stele, and the precinct wall corresponds to the lower part of the stele.

1149. Ser., fol. 476r

The scene is condensed, and consequently the Israelite spies are marching on the same groundline where the horses of the messengers are galloping. Thus the spatial relationship, which particularly in Vat. 747 so clearly represented the bypassing of the spies, is now obscured. In both figural groups, that of the conversing spies and that of the shieldless horsemen, Ser. follows the Rotulus, whereas in the monument it follows Vat. 747. Parts of the miniature, particularly the figure of the spy at the left, are flaked.

Located beside Joshua 3:3.

1150. Sm., fol. 221v

Very close to Ser.

1151. Vat. 746, fol. 442r

Close to Ser. and Sm.
Located beside Joshua 3:2.

1152. Vtp., fol. 343r

Although the spies are depicted on the same ground level as the messengers, as in Ser., Sm., and Vat. 746, their attitude of ascending the hill and the way in which both carry their spears over their shoulders are copied from the Vatican Rotulus, as is the group of houses. However, the most direct dependence on the Rotulus is evident in the soldier with his shield replacing the stele. The painter of Vtp. apparently misunderstood the division of the sections of the Rotulus and erroneously depicted the soldier in the next miniature (fig. 1158). The foremost horseman wears a strange hood. The mountain is flaked in various spots.

Located beside Joshua 3:1.

Lit.: Piper, "Bilderkreis," p. 184; Garrucci, *Storia*, p. 98; Graeven, "Rotulo," p. 228; Strzygowski, *Sm.*, pp. 118ff.; *RG*, pp. 12, 19, pl. B no. 2; Uspenskii, p. 162, figs. 223, 224; Hesseling, fig. 271; Millet, "Octateuque," pp. 76–77; Alpatov, "Rapport," p. 303 n. 4; Lowrie, *Art*, p. 213, pl. 147b; Weitzmann, *JR*, pp. 8–9, 55, figs. 2–4; Tselos, "Joshua Roll," pp. 277–78, figs. 8, 9; Henderson, "Joshua Cycle," p. 49; Mütherich, "Psalterillustration," p. 172, fig. 35; Huber, fig. 69; Deckers, *S. Maria Magg.*, pp. 231, 237; J.-R., pp. 53–54; Θησαυροί, p. 267, fig. 101.

Lit. on Vat. Rot.: Seroux d'Agincourt, *Histoire,* vol. 3, p. 35, and vol. 5, pl. 28 no. 2; Piper, "Bilderkreis," pp. 151, 184; Garrucci, *Storia,* pl. 157 nos. 1, 2 left; Bayet, *Art byzantin*, p. 72; Graeven, "Rotulo," p. 228; RG, p. 19, pl. 1; Millet, "Octateuque," pp. 76–77; Alpatov, "Rapport," p. 303 n. 4; Buchthal, *Paris Ps.*, fig. 97; Artelt, *Dialogdarstellung*, pp. 38–39; Weitzmann, JR, pp. 8–9, 52, 54, 63–64, 69, 76, figs. 1, 57; Tselos, "Joshua Roll," pp. 277–78, fig. 7; Henderson, "Joshua Cycle," p. 49; Deckers, *S. Maria Magg.*, pp. 231, 237; J.-R., pp. 29, 31, 34, 46, 53–54, 66ff.; Bernabò, "Studio," pl. 6.

Joshua 3:9–14

JOSHUA LEADS HIS ARMY

1153. Vat. 747, fol. 218r

Joshua marches at the head of his army and points in the direction of the Jordan; the river, however, is not included in the picture. At the same time Joshua turns his head toward his men, telling them of the miracle that will take place. The Israelites are divided into two groups, both comprised of soldiers with shields and spears. Some soldiers in each group look backward, presumably to the place where they had lodged for three days before their departure. Joshua is the only one clad in heavy golden armor and a helmet, and by representing him more than a head taller than the others the painter has stressed his prominence. Large areas of the ground are flaked.

Located beside Joshua 3:7.

1154. Vat. Rot., sheet I

Joshua marches ahead of two groups of Israelites. Some are characterized as soldiers, clad in steel-blue coats of mail and wearing helmets in addition to carrying shields and spears; the others represent civilians carrying shoulder bags.

1155. Ser., fol. 476v

As in the Rotulus, the upper group of Israelites is composed of civilians, although their shoulder bags are missing, and the lower group comprises soldiers wearing helmets; Joshua, however, is bareheaded. The soldier next to Joshua is distinguished from the others by his heavy armor; this also agrees with the Rotulus. Close to Vat. 747, on the other hand, are the strong spatial separation of the two groups of Israelites, and the facts that the warriors wear simple tunics instead of coats of mail, and that two of them carry their shields clumsily under their right arms. In contrast to Vat. 747 and the Rotulus, where Joshua points forward, here he holds his right arm up.

Located beside Joshua 3:9.

1156. Sm., fol. 222r

Close to Ser.
Located above Joshua 3:10.

1157. Vat. 746, fol. 442v

Very close to Ser. and Sm.
Located beside Joshua 3:9.

1158. Vtp., fol. 344r

Very close to the Rotulus. At least one of the two hindmost warriors carrying his shield over his left shoulder resembles a figure in the Rotulus, while the other warrior of the same type is partly overlapped by the monument belonging to the previous scene (fig. 1152). As in the other Octateuchs, the Israelite civilians do not carry shoulder bags and the bearded man in their midst turns his head back. Joshua, the soldiers, and the civilians alike are very badly flaked; their faces in particular are badly damaged or entirely destroyed.

Located above Joshua 3:9.

Lit.: Strzygowski, *Sm.*, pp. 118ff.; *RG*, p. 20, pl. B no. 3; Uspenskii, pp. 103, 162, fig. 225; Hesseling, fig. 273; Alpatov, "Rapport," pp. 304 n. 6, 305 n. 2; Lowden, *Octs.*, pp. 109–10, fig. 157.

Lit. on Vat. Rot.: Seroux d'Agincourt, *Histoire*, vol. 3, p. 35, and vol. 5, pl. 28 no. 2; Garrucci, *Storia*, pl. 157 no. 2; *RG*, p. 20, pl. 1; Alpatov, "Rapport," pp. 304 n. 6, 305 n. 2; Buchthal, *Paris Ps.*, p. 63, fig. 97; Weitzmann, *JR*, pp. 9, 13, fig. 1; Tselos, "Joshua Roll," p. 277, fig. 7; Morey, "Castelseprio," pp. 177–79, 189, fig. 7; Kraeling, *Synagogue*, p. 80 n. 235; *J.-R.*, pp. 29, 31, 34, 46, 54, 66ff.; Lowden, *Octs.*, pp. 109–10, fig. 156; Bernabò, "Studio," pl. 6.

Joshua 3:14–16

THE ARK'S ARRIVAL AT THE JORDAN

The representation of the ark in the following miniatures is completely different from that found in the miniatures of Exodus (figs. 750–753) and Numbers (figs. 894–903, 922a–925a). The form of the ark here contradicts the Septuagint text (Ex 37:3–5)[1] in not being carried by means of poles of acacia passing through golden rings (cf. figs. 900–903).[2]

1159. Vat. 747, fol. 218r

Four priests carry the Ark of the Covenant on their shoulders. The shape of the ark is that of a huge reliquary, painted light brown with golden highlights and mounted on a board of the same color. The lid is covered by a cloth. In agreement with the text, one of the priests dips his foot into the Jordan, which has its source at the top of a hill and develops into a river filling the whole foreground. The background, usually painted in two strips of different shades of blue, is here augmented by a third strip at the top, painted gold.

Located beside Joshua 3:7.

1160. Vat. Rot., sheet II

Half of the ark is covered with a dark violet covering held in place by rows of nails; the edge of the board upon which the shrine rests is jewel-studded, and the front side of the shrine is decorated with a Deesis. Any indication of water is omitted, and the priests seem to be carrying the ark toward a mountain slope instead of the bank of the Jordan.

1161. Ser., fol. 477r

The Deesis decorating the ark's front side is very distinct. The river is similar to that in Vat. 747 but has the form of a ribbon, with both banks visible. The hill from which the water comes forth is omitted.

Located beside Joshua 3:15.

1162. Sm., fol. 222v

Close to Ser. but truncated at the bottom so that the priests stand with their feet in the river. The ark is simplified, and its front is not decorated. As can be seen most clearly in the heads of the two foremost priests, the miniature must have been restored at a later period; the restorer must have added the ornamental border, which occurs nowhere else in this manuscript. One question must be raised, i.e., whether this restoration resulted in the shortening of the miniature, leaving open the possibility that the pictorial area was originally larger at the bottom.

1163. Vat. 746, fol. 443r

Close to Ser. The foremost priest dips his foot into the water, as in Vat. 747, and in this respect Vat. 746 follows the text more precisely than Ser.

Located beside Joshua 3:15.

1164. Vtp., fol. 344v

The four priests walk just above the groundline, thus following the Rotulus; but the small blue strip over the green ground indicates the river which is present in the other Octateuchs. All the figures are somewhat flaked.

Located beside Joshua 3:15.

Lit.: Strzygowski, *Sm.*, pp. 118ff.; *Miniature*, p. 7 n. 1; *RG*, p. 21, pl. B no. 4; Uspenskii, p. 162; Hesseling, fig. 272; Weitzmann, *JR*, pp. 9–10, 47, figs. 6, 7; Tselos, "Joshua Roll," pp. 281–82, fig. 15; Eller and Wolf, *Mosaiken*, fig. 45; Henderson, "Joshua Cycle," p. 49; *LCI*, vol. 1, col. 554, fig. 1; Huber, fig. 71; Lassus, *Livre des Rois*, pp. 86–87, figs. 115, 116; Demus, "Kariye Djami," p. 158, fig. 58; Spatharakis, "Psalter Dionysiou," p. 177, pl. 99c; Der Nersessian, "Parekklesion," pp. 338–39; Mathews, "Leo Sacellarios," p. 107; Spain, "Relics Ivory," p. 301; Revel-Neher, "Christian Topography," p. 87, fig. 15; Θησαυροί, p. 267, fig. 102; Kessler, "Temple Veil," pp. 56ff., fig. 5; Lowden, *Octs.*, pp. 109–10, figs. 158, 159.

Lit. on Vat. Rot.: Seroux d'Agincourt, *Histoire*, vol. 3, pp. 35–36, and vol. 5, pl. 28 nos. 2–3; Garrucci, *Storia*, pl. 157 no. 3; Uvarov, *Album*, pl. 4; *RG*, p. 21, pl. 2; Avery, "Alexandrian Style," pp. 145–46, fig. 42; Weitzmann, *JR*, pp. 9–10, 39, 47, 52–53, figs. 5, 48; Tselos, "Joshua Roll," p. 281, fig. 15; Dufrenne, "Illustration 'historique,'" p. 92 n. 13; Henderson, "Joshua Cycle," p. 49; *Pittura e pittori*, p. 115, fig. 104; Revel-Neher, "*Cohen gadol*," p. 50, fig. 1; Revel-Neher, "Iconographie," p. 314; Deckers, *S. Maria Magg.*, p. 234; Spain, "Relics Ivory," p. 301; *J.-R.*, pp. 29, 31, 34, 46–47, 54–55, 68ff.; Bernabò, "Studio," pl. 6.

¹ See Williams, "León Bible," pp. 80–81.

² A similar form of the ark is found in the Bible of Leo Sakellarios in the Vatican Library, cod. Reg. gr. 1, fol. 85v, where it has a rounded lid and is carried on the shoulders of eight priests without wooden poles. This form might reflect the influence of Christian liturgy (see Mathews, "Leo Sacellarios," pp. 103ff.).

Joshua 3:17

The Ark Pauses in the Midst of the Jordan

See the introduction to no. 1166.

1165a. Vat. 747, fol. 219r

The four priests carry the Ark of the Covenant in a manner very similar to that in the preceding scene (fig. 1159), but the indication of place is distinctly different. By representing one pool of water at the right and a second at the left, the painter conveys the impression that the priests are standing in the middle of the Jordan.

Located beside Joshua 4:9.

1168a. Ser., fol. 477v

A river god sits on a little hill in front of the priests carrying the ark and raises his hand as if greeting the procession. Although he is represented upright and in profile, small details such as his crossed legs exposing the sole of one foot reveal that the river god is a distorted translation of the river god in the Rotulus. Water pours forth from a vase, flows down into the scene below, turns at the lower right corner, and stops before a pile of stones, on the other side of which a second stream of water occupies the lower left corner. The painter thus tried to convey the impression that the two superimposed scenes take place in the same locality, the middle of the dry bed of the Jordan. Also similar to the Rotulus are the two pools of water in the corners of the miniature. A group of Israelites in festive garments walks behind the ark, corresponding to the marching group in the Rotulus.

Located beside Joshua 4:9.

1169a. Sm., fol. 223r

Close to Ser.

Located above Joshua 4:11.

1170a. Vat. 746, fol. 443v

Close to Ser. and Sm. The ark is rubbed.

Located beside Joshua 4:9.

1171a. Vtp., fol. 345v

Close to the other Octateuchs. The river god is represented in the same reclining position as in the Rotulus. Forced to eliminate the vase because of lack of space, the painter placed the stream itself like a cornucopia in the god's hand, the same hand which in the Rotulus holds a reed. The painter replaced the Deesis group on the ark's front side with a medallion bust of a holy image, most probably the Virgin, who is connected with the ark in both Christian thought¹ and depictions. The figures of several priests and Israelite elders are very badly flaked.

Located beside Joshua 4:9.

Lit.: Strzygowski, *Sm.*, pp. 118ff.; *RG*, p. 21, pl. C no. 1; Uspenskii, pp. 162–63, figs. 226, 228; Hesseling, fig. 274; Millet, "Octateuque," pp. 77–79, figs. 2, 3; Alpatov, "Rapport," pp. 305 n. 3, 310 n. 1; Weitzmann, *RaC*, p. 191, figs. 194, 195; Weitzmann, *JR*, pp. 10–12, 47–48, figs. 8, 11, 12; Tselos, "Joshua Roll," pp. 281–82, figs. 16–18; Williams, "León Bible," pp. 80–81; Kollwitz, "Josuazyklus," pp. 106, 109; Henderson, "Joshua Cycle," pp. 40–47; Mouriki-Charalambous, "Cosmas," pp. 150–54; Huber, fig. 72; Gaehde, "Octateuch," p. 377, fig. 97; Stahl, "Morgan M. 638," p. 244 n. 438; Brenk, *S. Maria Magg.*, p. 96; Der Nersessian, "Parekklesion," pp. 338–39, fig. 15; Spain, "Relics Ivory," p. 301; *J.-R.*, pp. 54–56; Θησαυροί, pp. 267–68, fig. 103; Lowden, *Octs.*, pp. 13, 108–9, figs. 147–150; Revel-Neher, "Hypothetical Models," p. 408, fig. 3.

¹ For a parallel between the ark and the Virgin, see Prokopios of Gaza's *Commentarii in Exodum* 25:2 (PG 87, cols. 635–36), following Paul's Heb 9:4.

Joshua 3:17 and 4:8

The Ark Pauses in the Midst of the Jordan; Laying Down of the Twelve Stones

In contrast to the Octateuchs, the Rotulus adds a group of Israelites behind the priests who carry the ark; these men are busy with the twelve stones that God ordered be taken out of the middle of the Jordan (Josh 4:1–3) and that the Israelites in verse 8 pick up and carry to their camp, where they put them down. The attitude of the Israelites here, however, is that of laying down stones, not that of lifting them up,[1] so they must illustrate the laying down of the stones in verse 8, an episode Vat. 747 depicts as a separate scene (fig. 1165b).

1166a, b. Vat. Rot., sheet II

As in Vat. 747 (see no. 1165a), the carrying of the ark is a repetition of the preceding scene (fig. 1160). A river god lies with legs crossed on elevated ground above the scene. The priests are followed by two groups of Israelites; some emerge from behind the mountain, and others lay down the stones they have been carrying on their shoulders.

Lit.: Seroux d'Agincourt, *Histoire*, vol. 3, p. 38, and vol. 5, pl. 29 no. 1; Piper, *Mythologie*, vol. 2, p. 506; Piper, "Bilderkreis," p. 151; Garrucci, *Storia*, pl. 158 nos. 1 right, 2 left; Uvarov, *Album*, pp. 90–93, pl. 4; Strzygowski, *Sm.*, pp. 120ff.; *RG*, p. 21, pl. 2; Millet, "Octateuque," pp. 77–79, fig. 1; Avery, "Alexandrian Style," pp. 145–46, fig. 42; Alpatov, "Rapport," p. 305 n. 3; Weitzmann, "Pariser Psalter," p. 184 n. 1; Buchthal, *Par. Gr. 139*, p. 24; Buchthal, *Paris Ps.*, p. 37; Weitzmann, *JR*, pp. 11–12, 47, 52–53, 56, 69–70, 80, figs. 5, 85; Tselos, "Joshua Roll," p. 282, figs. 6, 14; Morey, "Castelseprio," pp. 177–79, 189, fig. 7; Dufrenne, "Illustration 'historique,'" p. 92 n. 13; Kollwitz, "Josuazyklus," p. 106, pl. 11a; Henderson, "Joshua Cycle," pp. 40–47; Mouriki-Charalambous, "Cosmas," pp. 150–54; Gaehde, "Octateuch," p. 377, fig. 96; Stahl, "Morgan M. 638," p. 244 n. 438; Brenk, *S. Maria Magg.*, p. 96; Deckers, *S. Maria Magg.*, p. 234; *J.-R.*, pp. 29, 31–32, 34, 46–47, 54–56, 66ff.; Lowden, *Octs.*, pp. 108–9, fig. 146; Bernabò, "Studio," pl. 1.

[1] *RG*, p. 21; Weitzmann, *JR*, p. 11; and, for a different view, Henderson, "Joshua Cycle," pp. 40–47.

Joshua 4:8 and 9

Laying Down of the Twelve Stones

See the introduction to no. 1166. In Vat. 747, the depiction of the Jordan in the lower left corner makes it clear that the Israelites carrying the stones have just left the river bed and that the illustration refers to Joshua 4:8 (the Israelites laying down the stones in the camp), not to Joshua 4:9 (Joshua setting up twelve stones in the midst of the Jordan). The depiction of the Israelites amid two streams of water in Ser., Sm., and Vat. 746, on the other hand, ties the illustration to verse 9; but, in contrast to the illustration, verse 9 requires Joshua himself instead of the stone-carriers to set up the stones. The iconographical inconsistency suggests that Ser., Sm., and Vat. 746 transmit a corrupted version of the scene.[1]

1165b. Vat. 747, fol. 219r

Having brought the stones from the bed of the Jordan into their camp, the elect of the twelve tribes pile them up. One Israelite has just laid his stone on the top of the pile, a second holds a stone in his hands, and a third still carries a stone on his shoulder. Represented like a ribbon that crosses the lower left corner, the Jordan covers the feet of the hindmost carriers. Joshua, in full armor and surrounded by a group of Israelite soldiers, watches the event and extends his right arm as if giving directions.

Located beside Joshua 4:9.

1168b. Ser., fol. 477v

Close to Vat. 747. Joshua is bareheaded; the soldiers behind him hold lances instead of shields; the middle stone-carrier is facing left and lets his stone slide down from his shoulder, thus resembling one of the carriers of the preceding scene in the Joshua Rotulus (fig. 1166);[2] and the group at the left is augmented by some additional Israelites, who similarly wear tunics but carry lances. In contrast to Vat. 747, the Jordan is represented as a stream of water flowing down from the upper register and emerging again at the left side. The left-hand group of Israelites is somewhat rubbed.

Located beside Joshua 4:9.

1169b. Sm., fol. 223r

Very close to Ser.
Located above Joshua 4:11.

1170b. Vat. 746, fol. 443v

Very close to Ser. and Sm.
Located beside Joshua 4:9.

Lit.: Strzygowski, *Sm.*, pp. 118ff.; *RG*, p. 21, pl. C no. 1; Uspenskii, pp. 162–63, fig. 227; Hesseling, fig. 274; Millet, "Octateuque," pp. 77–79, fig. 2; Alpatov, "Rapport," pp. 305 n. 3, 310 n. 1; Weitzmann, *RaC*, p. 191, fig. 194; Weitzmann, *JR*, pp. 12–14, figs. 10, 11; Tselos, "Joshua Roll," pp. 282–84, figs. 17, 30; Williams, "León Bible," pp. 80–81; Henderson, "Sources," p. 12 n. 2; Kollwitz, "Josuazyklus," pp. 106, 109; Henderson, "Joshua Cycle," pp. 40–47; Mouriki-Charalambous, "Cosmas," pp. 150–54; Gaehde, "Octateuch," p. 377, fig. 97; Der Nersessian, "Parekklesion," pp. 338–39; Brenk, *S. Maria Magg.*, p. 96; *J.-R.*, pp. 56–57; Lowden, *Octs.*, pp. 13, 108–9, figs. 147–150.

[1] For a different view, see Henderson, "Joshua Cycle," pp. 40–47; and *J.-R.*, p. 56.
[2] For a different view, see Henderson, "Joshua Cycle," pp. 40–47.

Joshua 4:8 and 12–13

Israelites Carry the Stones and Armed Israelites Cross the Jordan

The Rotulus replaced the Laying Down of the Stones in Vat. 747, Ser., Sm., and Vat. 746 (nos. 1165b, 1168b–1170b) with the

Israelites carrying the stones, led by Joshua. The group of soldiers depicted ahead of the Israelites connects the illustration to verses 12–13, where the children of Reuben and Gad and the half-tribe of Manasseh pass armed over the Jordan. Verses 12–13, however, do not mention Joshua as personally leading his people across the river.

1167. Vat. Rot., sheets II and III

The Israelites carry the stones on their shoulders; a second armed group, led by Joshua, marches at the right.

Lit.: Seroux d'Agincourt, *Histoire*, vol. 3, p. 36, and vol. 5, pl. 28 no. 4; Piper, *Mythologie*, vol. 2, p. 506; *RG*, p. 22, pls. 2, 3; Millet, "Octateuque," pp. 77–79, fig. 1; Wörmann, *Geschichte*, vol. 3, pp. 67–68, fig. 47; Avery, "Alexandrian Style," pp. 145–46, fig. 42; Alpatov, "Rapport," p. 305 n. 3; Weitzmann, *RaC*, p. 191, fig. 193; Weitzmann, *JR*, pp. 13–14, 48, figs. 5, 9; Tselos, "Joshua Roll," p. 282, fig. 19; Morey, "Castelseprio," pp. 177–79, 189, fig. 7; Kraeling, *Synagogue*, p. 80 n. 235; Buchthal, *Latin Kingdom*, p. 59 n. 10; Kollwitz, "Josuazyklus," p. 106, pl. 11a; Henderson, "Joshua Cycle," pp. 40–47; Mouriki-Charalambous, "Cosmas," pp. 150–54; Gaehde, "Octateuch," p. 377, fig. 96; Stahl, "Morgan M. 638," p. 244 n. 438; Brenk, *S. Maria Magg.*, p. 96; Deckers, *S. Maria Magg.*, p. 234; Weitzmann, "Selection," pp. 73–74, fig. 4; Corrie, "Conradin Bible," pp. 176–77, fig. 111; *J.-R.*, pp. 29, 32, 34, 47, 56–57, 66ff.; Lowden, *Octs.*, pp. 108–9, fig. 146.

Joshua 4:9 and 12–13

Israelites Carry the Twelve Stones; Laying Down of the Twelve Stones; Armed Israelites Cross the Jordan

1171b, c, d. Vtp., fol. 345v

The painter combined the version of Ser., Sm., and Vat. 746 (figs. 1168b–1170b) with that of the Rotulus (fig. 1167). From the latter he took the marching Joshua and the combined groups of stone-carriers and heavily armored soldiers, although the latter are reduced to a single man seen from the back and turning his head around. On the other hand, the tradition of Ser., Sm., and Vat. 746 is recognizable in the group of Israelites standing at the right behind Joshua, but the men have been deprived of their weapons and their meaning is no longer clear. The stone pile and the stream of water flowing down from the upper miniature also agree with Ser., Sm., and Vat. 746, but the painter connected this stream with the pool of water at the left, underneath the stone pile, thus obliterating the concept of the two dammed banks of the Jordan. In the marching group, the stone-carrier at the extreme left, who lets his stone slide from his shoulder, corresponds to the one in the Octateuchs who stands in the middle of the group; but now, placed as he is behind the marching carriers, he is completely separated from the place where he is supposed to lay down his stone. The surface is badly flaked in various spots.

Located beside Joshua 4:9.

Lit.: Strzygowski, *Sm.*, pp. 118ff.; Uspenskii, p. 163, fig. 229; Millet, "Octateuque," pp. 77–79, fig. 3; Alpatov, "Rapport," p. 305 n. 3; Weitzmann, *RaC*, p. 191, fig. 195; Weitzmann, *JR*, pp. 13–14, fig. 12; Tselos, "Joshua Roll," p. 282, fig. 18; Henderson, "Sources," p. 12 n. 2; Henderson, "Joshua

Cycle," pp. 40–47; Mouriki-Charalambous, "Cosmas," pp. 150–54; Huber, fig. 72; Stahl, "Morgan M. 638," p. 244 n. 438; Gaehde, "Octateuch," p. 377; Brenk, *S. Maria Magg.*, p. 96; Der Nersessian, "Parekklesion," p. 338, fig. 15; *J.-R.*, pp. 56–57; Θησαυροί, pp. 267–68, fig. 103.

Joshua 4:20–24

Joshua Piles Twelve Stones at Gilgal

1172. Vat. 747, fol. 219v

After the Israelites encamped in Gilgal (LXX: Galgala), Joshua, in heavy armor and wearing a helmet, builds an altar with the twelve stones taken from the Jordan. A group of Israelite soldiers stands at a respectful distance, separated from their leader and partly hidden by two mountains. The soldiers hold spears and are clad in simple tunics.

Located beside Joshua 5:1.

1173. Vat. Rot., sheet III

Close to Vat. 747 but with some differences. Joshua is bareheaded, and the Israelites are divided into two groups, with the soldiers in full armor preceding the civilians. In addition, the end of the mountain slope, which partly covers the Israelites, is transformed into a structure of three terraced cubes. On the mountain lies a youthful personification of Gilgal.

1174. Ser., fol. 478v

The bareheaded Joshua, the fully armed soldiers directly behind their leader, and the personification of Gilgal on the mountain are close to the Rotulus. However, the soldiers are not followed by civilians, and in this respect the miniature agrees with the one in Vat. 747. The cubes are isolated from the mountain, reduced to two, and changed from marble to brick.

Located beside Joshua 5:1.

1175. Sm., fol. 223v

Very close to Ser.

1176. Vat. 746, fol. 444r

Very close to Ser. and Sm. The figure of Joshua is partly rubbed.

Located beside Joshua 5:2.

1177. Vtp., fol. 347r

The personification of Gilgal, which is better understood than in Ser., Sm., and Vat. 746, and the tree beside him reveal renewed use of the Rotulus by this painter. On the other hand, the group behind Joshua, consisting exclusively of armed soldiers, and the brick cubes at the left agree with the other Octateuchs. The slit windows in the smaller of the two cubes indicate that the painter thought of them as actual buildings. Some of the soldiers have

elaborate crests on their helmets, which are typical of the decorative enrichments made by this painter. Large parts of the miniature are flaked, particularly the group of soldiers.

Located beside Joshua 5:1.

Lit.: Strzygowski, *Sm.*, pp. 118ff.; *RG*, p. 22, pl. C no. 2; Uspenskii, pp. 103, 163, figs. 230, 311; Hesseling, fig. 275; Huber, fig. 73; Deckers, *S. Maria Magg.*, p. 235; *J.-R.*, p. 57; Θησαυροί, p. 268, fig. 104; Lowden, *Octs.*, pp. 108–9, figs. 151–155.

Lit. on Vat. Rot.: Seroux d'Agincourt, *Histoire*, vol. 3, p. 36, and vol. 5, pl. 28 no. 5; Garrucci, *Storia*, pl. 158 no. 2; *RG*, p. 22, pls. 3, 3a; Wörmann, *Geschichte*, vol. 3, pp. 67–68, fig. 47; Berstl, *Raumproblem*, pp. 18–20, pl. 6; Neuss, *Kunst d. Alten Christen*, p. 115, fig. 165; Köves, *Formation*, pp. 48–49, fig. 4; Weitzmann, *JR*, pp. 14, 58–59, 70–71, figs. 9, 75; Kraeling, *Synagogue*, p. 80 n. 235; Weitzmann, "Character," pp. 206–7, fig. 188; Kollwitz, "Josuazyklus," p. 106; Deckers, *S. Maria Magg.*, p. 235; *J.-R.*, pp. 29, 32, 34, 47, 57, 66ff.; Lowden, *Octs.*, pp. 108–9, fig. 146.

Joshua 5:3

Circumcision of the Israelites

1178. Vat. 747, fol. 220r

Heeding God's command at verse 2, Joshua sits on a chair with a red cushion and rests his feet on a red footstool. Instead of circumcising his people, as he does in verse 3, Joshua raises his hand in a gesture of speech and addresses a group of Israelites in front of him who have just been circumcised. They lift the hems of their tunics with one hand and hold the other to their faces in an expression of great pain. Behind Joshua, who wears a helmet, stands another group of Israelites holding spears, apparently representing those who have already been circumcised. A mountain peak rises behind the group of circumcised men. The surface is flaked in various spots.

Located beside Joshua 5:11.

1179. Vat. Rot., sheet III

Joshua sits on the lowest of three cubic rocks that form the end of a mountain slope. He is bareheaded, surrounded by a large group of fully armed soldiers, and faced by the youths who have just been circumcised. Their expressions of pain are realistically accompanied by the depiction of dripping blood. At the top lies a mountain god, a personification of the "Hill of the Foreskins."

1180. Ser., fol. 480r

Close to the Rotulus. The surface is flaked in various spots.
Located beside Joshua 5:7.

1181. Sm., fol. 224r

Very close to Ser.

1182. Vat. 746, fol. 445v

Very close to Ser. and Sm.
Located beside Joshua 5:12.

1183. Vtp., fol. 349v

Some details again reveal a close dependence on the Rotulus, for example, the more restrained movement of Joshua's right hand and the expression of the circumcised Israelites in the front row. Joshua sits on a rock but rests his feet on a golden footstool, as in Vat. 747. The mountain god leans back against the rocks and, with his arm thus freed, points in the direction of Joshua. A golden cornucopia is placed in his left arm, and the treatment of the body seems to indicate that the painter wanted it to be understood as female. Not a single figure is undamaged by flaking and all the heads are completely destroyed.

Located beside Joshua 5:12.

Lit.: Strzygowski, *Sm.*, pp. 118ff.; *RG*, p. 23, pl. C no. 3; Uspenskii, p. 163, fig. 231; Hesseling, fig. 276; Alpatov, "Rapport," p. 304 n. 2; Weitzmann, *JR*, p. 56; Weitzmann, "Character," pp. 213–14, figs. 196, 197; Huber, fig. 74; De Angelis, "Simbologia," p. 1534, fig. 15.

Lit. on Vat. Rot.: Seroux d'Agincourt, *Histoire*, vol. 3, p. 36, and vol. 5, pl. 28 no. 6; Garrucci, *Storia*, pl. 158 no. 2; *RG*, p. 22, pls. 3, 3a; Wörmann, *Geschichte*, vol. 3, pp. 67–68, fig. 47; Berstl, *Raumproblem*, pp. 18–20, pl. 6; Alpatov, "Rapport," p. 304 n. 2; Weitzmann, *JR*, pp. 14, 56, 70, figs. 9, 58, 75; Weitzmann, "Character," pp. 207, 213, fig. 188; Henderson, "Joshua Cycle," p. 50; Weitzmann, "Selection," pp. 73–74, fig. 4; De Angelis, "Simbologia," p. 1534, fig. 14; *J.-R.*, pp. 29, 32, 35, 47, 56; Bernabò, "Studio," pl. 1.

Joshua 5:13–14

Joshua and the Archangel Michael

1184a. Vat. 747, fol. 220r

At the left of the miniature, Joshua stands with a lance in his left hand and, raising his right arm, asks the angel his identity. Like Joshua, the angel ("the chief captain of the host of the Lord," namely, the archangel Michael)[1] is dressed in heavy armor and a chlamys, but unlike him wears jewel-studded imperial purple shoes and his head is bare. In his right hand he holds the sword prescribed by the text and in the left its sheath. The figure of Joshua is repeated at the angel's feet in the posture of proskynesis. The surface is flaked in various spots and the heads are particularly damaged.

Located beside Joshua 6:1.

1185. Vat. Rot., sheet IV

Close to Vat. 747. Instead of approaching the angel, Joshua stands still. The inscription identifies the angel, who is adorned with a diadem, as Michael. The scene takes place before the walled city of Jericho. A personification of the city of Jericho sits at the right.[2]

1188. Ser., fol. 480v

Joshua is close to Vat. 747, whereas the inclusion of the city of Jericho agrees with the Rotulus. Unlike both Vat. 747 and the Rotulus, Joshua holds a drawn sword in one hand and a sheath in the other, giving the impression that he is threatening the angel.

Located below Joshua 5:14.

1190a. Sm., fol. 224r or 224v³

Very close to Ser. The figures of the angel and the kneeling Joshua are badly flaked.

Located below Joshua 6:1.

1191a. Vat. 746, fol. 446r

Very close to Ser. and Sm. The angel's wings, the head of the kneeling Joshua, and the drawn sword of the standing hero are rubbed.

Located below Joshua 6:1.

1192. Vtp., fol. 350v

Joshua stands quietly before the angel, as in the Rotulus, but in all other respects the painter followed the tradition of Ser., Sm., and Vat. 746. However, deviating from all these examples, the angel, inscribed ὁ ἀρχ(άγγελος) Μιχ(αήλ), is depicted in a hieratic frontal view looking at the viewer. Instead of the imperial purple shoes, he wears the same kind of footgear as the leader of the Israelites. The right arm of the kneeling Joshua is covered by his chlamys, and a sword is attached to his left side. In addition to the sword, both figures of Joshua are shown carrying a huge shield fastened around his neck with a strap. The painter's decorative sense is apparent in the increased ornamentalization of the armor and especially in the elaborate treatment of the helmet crest.

Located below Joshua 5:13.

Lit.: Strzygowski, *Sm.*, pp. 118ff.; *RG*, p. 23, pl. C no. 4; Uspenskii, p. 163, fig. 232; Hesseling, fig. 277; Ebersolt, *Min. byz.*, p. 32, pl. 29 no. 2; Weitzmann, *JR*, pp. 14, 62, fig. 14; Tselos, "Joshua Roll," fig. 21; Williams, "León Bible," p. 82; Kollwitz, "Josuazyklus," pp. 106, 108–9, pl. 12b; Henderson, "Joshua Cycle," pp. 50–51; Galavaris, *Gregory Naz.*, p. 137; Gualdi, "Marin Sanudo," p. 176; Huber, fig. 75; Brenk, *S. Maria Magg.*, p. 99; Deckers, *S. Maria Magg.*, pp. 241–42; Cutler, *Transfigurations*, p. 95; Lazarev, *Vizantiiskoe*, fig. p. 46; *J.-R.*, p. 57; Θησαυροί, p. 268, fig. 105; Bernabò, "Studio," pls. 13–15.

Lit. on Vat. Rot.: Seroux d'Agincourt, *Histoire*, vol. 3, p. 36, and vol. 5, pl. 28 no. 7; Piper, "Bilderkreis," p. 151; Kondakov, *Istoriia*, p. 59; Kondakov, *Tablits*, pl. 2 no. 3; Kondakov, *Histoire*, vol. 1, p. 100, fig. p. 99; Pérate, review of Kondakov, p. 251; Garrucci, *Storia*, nos. 1, 2; Uvarov, *Album*, pl. 5; Alpatov, "Zametki," fig. 10; Hartel and Wickhoff, *Wiener Gen.*, pl. C; Graeven, "Rotulo," p. 225; Graeven, "Typen," pp. 101–3; Strzygowski, *Sm.*, p. 120; Wickhoff, *Roman Art*, pp. 184–86, fig. 77; Ainalov, *Hellenistic Origins*, pp. 134, 160–61, fig. 65; Venturi, *Storia*, vol. 1, fig. 151; Richter and Taylor, *Golden Age*, pp. 227–28, 284–85, pl. 27 no. 1; *RG*, p. 23, pl. 4; *Menologio*, p. 4; Dalton, *Byzantine Art*, fig. 271; Hieber, *Miniaturen*, fig. 3; Morey, "Sources," p. 40, fig. 21; Kövès, *Formation*, pp. 47–48, fig. 3; Diehl, *Art chrétien primitif*, p. 28, pl. 25; Morey, "Notes," p. 50, fig. 54; Weitzmann, "Pariser Psalter," p. 183 n. 3; Woodruff, "Pruden-

tius," p. 73; Bréhier, "Icônes," p. 158; Diehl, *Peinture byz.*, pl. 69 no. 2; Buchthal, *Paris Ps.*, pp. 30, 61ff., fig. 97; Artelt, *Dialogdarstellung*, p. 38; Lugt, "Man and Angel," p. 271, fig. 4; Ștefănescu, *Iconographie*, pl. 34b; Morey, "Byzantine Renaissance," p. 146, pl. 2a1; Morey, *Mediaeval Art*, pp. 50–51, fig. 43; Keck, "Iconography of Joshua," p. 271; Morey, "Castelseprio," p. 189, fig. 9; Morey, *Early Christian Art*, pp. 69, 148–49, 192, 270, fig. 58; Buchthal, "Gandhara Sculpture," p. 162, fig. 34; Bognetti et al., *Castelseprio*, pl. 86a; Weitzmann, *JR*, pp. 14, 62, 66–67, figs. 13, 67; Cecchelli, *S. Maria Magg.*, p. 181; Buchthal, *Latin Kingdom*, p. 59 n. 10; Diringer, *Illuminated Book*, fig. I-15; Dohrn, *Tyche*, pp. 46, 51 n. 117, pl. 48 no. 3; Williams, "León Bible," p. 82; Kollwitz, "Josuazyklus," pp. 106, 108–9; Jenkins and Kitzinger, "Cross," p. 248, pl. 7; Lazarev, *Storia*, fig. 105; Henderson, "Joshua Cycle," pp. 50–51; *Libro della Bibbia*, p. 17, fig. 16; Robb, *Art*, pp. 51–52, fig. 17; Brenk, *S. Maria Magg.*, p. 99; Deckers, *S. Maria Magg.*, pp. 241–42; Cutler, *Transfigurations*, p. 95, fig. 80; Kitzinger, "Hellenistic Heritage Reconsidered," p. 659, fig. 2; *J.-R.*, pp. 29–30, 32, 35, 48, 57–58, 66ff.; Connor, "Joshua Fresco," p. 58; Galavaris, "Ζω-γραφική," p. 344, fig. 12; Bernabò, "Studio," pl. 7.

[1] The identification of the angel as the archangel Michael, attested by the inscription in the Joshua Rotulus, is typical for Byzantium and is also found in Early Christian commentaries, e.g., Origen, *Selecta in Jesum Nave* (PG 12, col. 821) and Theodoret, *QuaestJos* (PG 80, col. 468). Cf. Connor, "Joshua Fresco," pp. 57–58; and *J.-R.*, pp. 57–58.

[2] The model for the representation of this personification was classical, quite close to the Ariadne in a Roman mosaic found in Salzburg, now in Vienna (Weitzmann, *JR*, pp. 66–67, fig. 68); the mosaic in Salzburg has also been published in W. Jobst, *Römische Mosaiken in Salzburg* [Vienna, 1982], pl. 55, and *LIMC*, vol. 3, pt. 2, p. 732, no. 91; for these references we are indebted to Dr. Christopher Moss).

[3] Fol. 224v according to Hesseling, p. xiv; fol. 224r according to Strzygowski, *Sm.*, p. 118, Uspenskii, p. 188, and the label in the photo taken by Buberl.

Joshua 6:21–24

FALL OF JERICHO

1184b. Vat. 747, fol. 220r

The walls of Jericho fall by themselves when the Israelites encompass the city for the seventh time on the seventh day of the siege. Four priests carry the Ark of the Covenant covered by a draped cloth. Complying with the sequence prescribed by the text, seven priests walk ahead of the ark and blow trumpets, while the warriors follow behind it. The latter are represented as a group of youths in short tunics, the foremost holding a spear and shield which are hardly recognizable due to flaking. Above the priests' heads the city of Jericho is depicted, its towers already collapsing. By showing the trumpets raised, the painter has made it very clear that their blowing caused the destruction. The ground is partly flaked, and the heads of the youthful soldiers are repainted.

Located beside Joshua 6:1

1186. Vat. Rot., sheets IV and V
1187. Vat. Rot., sheets V and VI

The four priests march with the ark in the center, preceded by the seven priests blowing trumpets as in Vat. 747; but the group of Israelites following the ark is made up of civilians carrying

shoulder bags and holding staffs in their hands. The ark has the same shape and ornamentation, including the Deesis on the front, as in previous instances in the Rotulus. The priests hold their trumpets horizontally since the city of Jericho is not above their heads, as it is in Vat. 747. High up in the picture, Joshua encourages the fighting soldiers, part of whom are attacking the enemy with spears and swords. The men of Jericho are being completely defeated: two Israelites have entered the inner city, the walls and towers of which are collapsing, and they set fire to the city with torches. Below the wall, a personification of Jericho sits mournfully on the bare ground.[1] According to verse 21, Jericho was not destroyed by fire, as the painter leads the spectator to believe, but "by the edge of the sword." It is only in verse 24, i.e., after messengers were sent out by Joshua, as depicted in the next scene, that the burning of Jericho is mentioned. No burning of the city, however, is represented in the Octateuchs, and apparently the painter borrowed the burning scene and the figure of Joshua himself from the subsequent representation of the conquest of the city of Ai (figs. 1232, 1234–1237), which is described at Joshua 8:24 and 28.[2]

1189. Ser., fol. 480v

Close to the Rotulus. Here too civilians, not soldiers, march behind the ark. The painter made the mistake of showing them also blowing trumpets, although according to the text this activity was restricted to the priests. The attitudes in which these trumpets are held, however, particularly by the Israelite at the extreme left, coincide with those of the staffs in the Rotulus and hence the trumpets must be simply misunderstood staffs.

Located beside Joshua 5:14.

1190b. Sm., fol. 224r or 224v[3]

Very close to Ser. The trumpet of the foremost priest is omitted, but his raised hand indicates that it held the trumpet high, like the corresponding figure in Ser. Most of the figures are flaked, and the priests' heads in particular show the rough style of the later restorer.

1191b. Vat. 746, fol. 446r

Very close to Ser. and Sm.
Located below Joshua 6:1.

1193. Vtp., fol. 351r
1194. Vtp., fol. 353r

The miniature showing the procession (fig. 1193) has all the simplifications and alterations that Ser., Sm., and Vat. 746 display when compared with the Rotulus, i.e., the reduced number of priests with trumpets, the carrying of trumpets by the people following the ark, the single cube as scenery, and so on. On the other hand, the conquest of Jericho, which is represented in a second, separate miniature (fig. 1194), depends exclusively on the Rotulus, although the painter did make some alterations. First, because of the physical separation of this scene from the proces-

sion, he repeated the group of priests with trumpets standing behind the figure of the commanding Joshua to remind the viewer anew of the primary cause of the city's destruction. At the same time, the painter must have questioned Joshua's unusual elevation above the ground and therefore added a cube—transformed into a building with slit windows—as a pedestal for the hero to stand on. Thus he used in a new and more concrete manner the motif which in the Rotulus always serves as a device to create depth in spatial relationships. The battle scene is somewhat condensed, and the group of Israelites approaching the battleground is omitted. The city is simplified by the elimination of all the houses within the ringwall. The most direct dependence on the Rotulus is found in the cutting off of the city personification who sits in the lower left corner of the next miniature (fig. 1203a). This line of division coincides with a cut in the Rotulus, where two sheets of parchment were sewn together. The first of these two miniatures is very badly damaged, all the heads being completely flaked, as are large parts of the priests, the foremost Israelite civilian, and the cube.

Located beside Joshua 6:2 and 6:21 respectively.

Lit.: Strzygowski, *Sm.*, pp. 118ff.; Graeven, "Typen," p. 103; *RG*, p. 24, pl. C no. 4; Uspenskii, p. 163, figs. 233, 312; Hesseling, fig. 277; Alpatov, "Rapport," p. 303 n. 1; Morey, *Early Christian Art*, p. 149; Goodenough, *Symbols*, vol. 10, p. 18 n. 90, fig. 244; Weitzmann, *JR*, pp. 14–17, 48, 107, figs. 14, 17, 18, 21; Tselos, "Joshua Roll," pp. 285ff., fig. 21; Williams, "León Bible," pp. 82–83, 111–12 n. 84; Kollwitz, "Josuazyklus," p. 107, pl. 12b; Cahn, "Souvigny Bible," pp. 95–96, 99; Henderson, "Joshua Cycle," p. 51; Buchthal, *Historia Troiana*, p. 37 n. 1; Huber, figs. 76, 77; Gaehde, "Octateuch," p. 378; Brenk, *S. Maria Magg.*, p. 101; Der Nersessian, "Parekklesion," pp. 338–39 n. 213; Deckers, *S. Maria Magg.*, p. 245; Spain, "Relics Ivory," p. 301; Lowden, "Production," p. 199; Lowden, "Vtp. Oct.," pp. 122–23, figs. 20a, 20b; *J.-R.*, pp. 58–59; Revel-Neher, *Arche*, p. 174 n. 358; Θησαυροί, pp. 268–69, fig. 106; Lowden, *Octs.*, p. 52, fig. 59; Bernabò, "Studio," pls. 14, 15.

Lit. on Vat. Rot.: Winckelmann, *Versuch einer Allegorie*, p. 79; Seroux d'Agincourt, *Histoire*, vol. 3, p. 36, and vol. 5, pl. 28 no. 8; Labarte, *Histoire*, p. 28; Garrucci, *Storia*, pl. 159 no. 2; Kondakov, *Istoriia*, p. 58; Kondakov, *Tablits*, pl. 2 no. 4; Kondakov, *Histoire*, vol. 1, pp. 97–98; Strzygowski, *Sm.*, p. 120; Graeven, "Typen," p. 103; Richter and Taylor, *Golden Age*, pp. 236–37, pl. 27 no. 2; *RG*, p. 24, pls. 4, 5; Alpatov, "Rapport," p. 303 n. 1; Lietzmann, "Datierung," p. 182; Gasiorowski, *Malarstwo Minjaturowe*, p. 18, fig. 3; Weitzmann, *JR*, pp. 15–17, 48–49, 58, 67, 80, 107, figs. 13, 16, 69; Tselos, "Joshua Roll," pp. 285ff., fig. 22; Cecchelli, *S. Maria Magg.*, p. 181; Buchthal, *Latin Kingdom*, pp. 59 n. 10, 60; Williams, "León Bible," pp. 82–83, 111–12 n. 84; Dufrenne, "Illustration 'historique,'" p. 92 n. 13; Kollwitz, "Josuazyklus," pp. 106–7; Cahn, "Souvigny Bible," pp. 95–96, 99; Lazarev, *Storia*, fig. 106; Henderson, "Joshua Cycle," p. 51; Buchthal, *Historia Troiana*, p. 37 n. 1; Kitzinger, "Samson Floor," pp. 141–42, fig. 6; Gaehde, "Octateuch," p. 378; Stahl, "Morgan M. 638," p. 88; Demus, "Kariye Djami," p. 158, fig. 57; Brenk, *S. Maria Magg.*, p. 101; Deckers, *S. Maria Magg.*, p. 245; De' Maffei, "Sant'Angelo in Formis II," pt. 1, p. 40; Lowden, "Production," p. 199; Lowden, "Vtp. Oct.," pp. 122–23, figs. 19, 21; *J.-R.*, pp. 30, 32, 35, 48, 58–59, 66ff.; Revel-Neher, *Arche*, pp. 173–74, fig. 81; Lowden, *Octs.*, p. 52, fig. 58; Revel-Neher, "Hypothetical Models," p. 408, fig. 4; Bernabò, "Studio," pl. 7.

[1] Like the previous personification of Jericho in the episode of Joshua and the angel (fig. 1185), this female personification of the town also depends upon a classical model, such as the woman in the wall painting of Ares and Aphrodite in the House of M. Lucretius Fronto at Pompeii (Weitzmann, *JR*, p. 67, fig. 70; R. Ling, *Roman Painting* [Cambridge, 1991], colorpl. IXA).

[2] Williams ("León Bible," pp. 83, 111–12 n. 84) asserts that the archetype contained an illustration of the burning of the town, based on the fact that the San Isidoro Bible preserves a representation of the burning of Jericho (fol. 91r).

[3] Fol. 224v according to Hesseling, p. xiv; fol. 224r according to Strzygowski, *Sm.*, p. 118, to Uspenskii, p. 188, and to the label in the photo taken by Buberl.

Joshua 6:22

Joshua Commands the Spies to Save Rahab

Twice after the destruction of Jericho Joshua dispatches spies: first (Josh 6:22) he orders the same spies who had previously explored Jericho to save Rahab, her family, and her house; second (Josh 7:2), he sends out spies from Jericho to Ai to scout the country around that city. This picture is apparently connected with the former event, because in the following picture (fig. 1196) Joshua addresses a woman, presumably Rahab. The painter, however, depicted three spies, instead of the two the text specifies; this mistake might be the result of a conflation of two consecutive groups of spies, as seen in the Rotulus and in the other Octateuchs (figs. 1196–1203a). The miniature is placed alongside Joshua 6:22ff., which also suggests a connection with the episode of the sending of the spies to Rahab (Josh 6:22–23), rather than with the following dispatching of spies to Ai (Josh 7:2).[1]

1195. Vat. 747, fol. 221r

In a mountainous landscape, Joshua sits in full armor on a cushioned throne with his feet resting on a pearl-studded footstool. Behind him and partly hidden by a small hill stands a group of bareheaded Israelite soldiers with shields and lances; in front of him the spies are about to leave on their mission, looking back as if still listening to Joshua's order. The painter forgot to paint the spears that they hold in the next scene (fig. 1196).

Located beside Joshua 6:22.

Lit.: Strzygowski, *Sm.*, pp. 118ff.; *RG*, p. 25, pl. 50 no. 2; Muñoz, "Rotulo," p. 479; Alpatov, "Rapport," pp. 303 n. 1, 304 n. 1; Benson and Tselos, "Utrecht Ps.," p. 70, fig. 131; Weitzmann, *JR*, pp. 17–18, 49, 54, 61, 107–8, fig. 20; Tselos, "Joshua Roll," p. 280, fig. 10; Morey, "Castelseprio," pp. 178–79, fig. 6; Henderson, "Joshua Cycle," pp. 51–52; *J.-R.*, p. 59.

[1] For a different view, cf. Henderson, "Joshua Cycle," pp. 51–52.

Joshua 6:23

Rahab before Joshua

1196a. Vat. 747, fol. 221r

The spies have returned from their mission with Rahab, whose life they have saved. As in the preceding scene, three spies instead of two are erroneously represented. Joshua, seated on a throne at the foot of a precipitous mountain, is surrounded by Israelite soldiers, while the spies approach from the left. Accord-

ing to the text they brought Rahab and her whole family, but here only the harlot appears, her head covered with a veil, bowing slightly before Joshua and raising both her hands in a gesture of supplication.[1] The surface is flaked in various spots.

Located beside Joshua 6:23.

Lit.: Strzygowski, *Sm.*, pp. 118ff.; *RG*, p. 26, pl. 50 no. 2; Muñoz, "Rotulo," p. 479; Weitzmann, *JR*, pp. 17, 49, 55, fig. 20; Tselos, "Joshua Roll," pp. 279–80, fig. 10; Nordström, "Water Miracles," pp. 83–84 n. 8; Kollwitz, "Josuazyklus," p. 107; Henderson, "Joshua Cycle," pp. 51–52; *J.-R.*, p. 59.

[1] Rahab's gesture, not in LXX, may seem expected, but the fuller account of the meeting found in Josephus (*Ant* 5:15), relates that Joshua acknowledged his gratitude to the harlot and assured her compensation for the protection provided to the Israelite spies (*Josephus*, ed. Thackeray and Marcus, vol. 5, p. 14, quoted by Nordström, "Water Miracles," pp. 83–84 n. 8).

Joshua 7:2

Joshua Sends Spies to Ai

See the introduction to no. 1195. The depiction of the city Ai in the Rotulus, in contrast to that in Vat. 747, shows that the Rotulus painter intended to illustrate not the sending of the spies to Rahab, but rather the second mission to explore the country around the city of Ai, and in agreement with this change the scribe wrote verse 2 and the beginning of verse 3 of chapter 7 underneath the scene. Ser., Sm., Vat. 746, and Vtp. follow the Rotulus, but the location of the miniature in the text is alongside Joshua 6:22, corresponding to Joshua Commands the Spies to Save Rahab, as in Vat. 747 (no. 1195), thus suggesting a subject originally close to that in Vat. 747.

1197a, b. Vat. Rot., sheet VI

The Rotulus depicts the spies twice: first departing armed with lances and looking back at Joshua, and then on the march. The motion of the first two spies, Joshua enthroned in front of Jericho, and the Israelite army behind him agree with Joshua Commands the Spies to Save Rahab in Vat. 747 (fig. 1195). Ai is depicted as a conventional Hellenistic walled city set between the central mountain and the tree among rocks at the right; its personification sits on the peak of the mountain.[1]

1199a, b. Ser., fol. 482v

Close to the Rotulus. However, the second spy from the left no longer holds a lance and his raised hands now give the false impression of vivid gestures of speech. The landscape and architectural settings are greatly reduced; the central mountain and the personification are entirely omitted. Joshua has a green nimbus.

Located beside Joshua 6:22.

1201a, b. Sm., fol. 225r

Close to Ser., even in the omission of the second spy's lance.

1202a, b. Vat. 746, fol. 447v

Very close to Ser. and Sm. The figure of the second spy from the right is rubbed, as is the architecture behind him.

Located beside Joshua 6:22.

1203a, b. Vtp., fol. 353v

Close to the Rotulus. The city of Ai is fully represented with numerous towers and houses; due to lack of space the painter omitted the central mountain, but he retained the city personification and placed it on the right flanking tower. Besides omitting her nimbus, the painter misunderstood his model in two respects: the girdle of her chiton is taken as a division line between the lower and the upper garment, and her cornucopia has become an unrolled scroll. Of the city of Jericho, only Rahab's house and a small section of wall adjoining it are retained. Particularly close to the Rotulus is the second spy from the left, who is correctly portrayed carrying his lance over his shoulder. But the painter also made a number of changes of his own: he depicted Joshua wearing a dress helmet and sitting on a golden throne with a high semicircular back, and he let the hero's feet rest on a kidney-shaped cushion on top of the footstool; instead of gesturing in speech with his right hand, Joshua uses his left, while with his right he toys with the knob of the chair in a very affected manner. The painter's love of decorative embellishment led him to dress the first spy in rich armor and a helmet and to depict his windblown mantle in a very unnaturalistic way. The personification in the lower left corner belongs to the preceding scene (fig. 1194). Small spots in the city and elsewhere are flaked.

Located beside Joshua 6:22.

Lit.: Strzygowski, *Sm.,* pp. 118ff.; Kondakov, *Pamiatniki,* p. 284, fig. 98; *RG,* p. 25, pl. C no. 5; Uspenskii, p. 163, fig. 234; Hesseling, fig. 278; Muñoz, "Rotulo," p. 478; Alpatov, "Rapport," pp. 303 n. 1, 304 n. 1, 314 n. 3; Gerstinger, *Griech. Buchmalerei,* fig. 5; Weitzmann, "Constantinop. Book Ill.," pp. 328–29, fig. 318; Weitzmann, *JR,* pp. 17–18, fig. 21; Morey, "Castelseprio," pp. 178–79, fig. 8; Weitzmann, *Bibliotheken des Athos,* pp. 21–22, fig. p. 23; Kollwitz, "Josuazyklus," p. 107; Lazarev, *Storia,* p. 347 n. 51, fig. 411; Henderson, "Joshua Cycle," pp. 51–52; Huber, fig. 78; Weitzmann, *SP,* p. 64; Lowden, "Production," p. 199; Lowden, "Vtp. Oct.," pp. 122–23, figs. 17, 18; *J.-R.,* p. 59; Θησαυροί, p. 269, fig. 107; Lowden, *Octs.,* pp. 28, 51, figs. 53, 54.

Lit. on Vat. Rot.: Winckelmann, *Versuch einer Allegorie,* p. 79; Seroux d'Agincourt, *Histoire,* vol. 3, p. 36, and vol. 5, pl. 28 no. 9; Garrucci, *Storia,* pls. 160 nos. 1 and 2, 161 no. 1; Kondakov, *Istoriia,* p. 58; Kondakov, *Histoire,* vol. 1, pp. 98–99, fig. p. 98; Uvarov, *Album,* pl. 1 no. 1; Beissel, *Vatican. Miniaturen,* pp. 7–8, pl. 4; Schultze, *Archäologie,* p. 192; Schultze, *Itala-Miniaturen,* fig. p. 36; Strzygowski, *Sm.,* p. 120; *RG,* pls. 6, 6a; Hieber, *Miniaturen,* fig. 2; Muñoz, "Rotulo," p. 477; Alpatov, "Rapport," p. 303 n. 1, 304 n. 1, 314; Gerstinger, *Griech. Buchmalerei,* fig. 4; Künstle, *Ikonographie,* vol. 1, pp. 301–2, fig. 122; Artelt, *Dialogdarstellung,* pp. 39–40; Pijoán, *Summa artis,* vol. 7, p. 164, fig. 256; Lazarev, *Istoriia,* pl. 20; Weitzmann, *JR,* pp. 17–18, 45, 49, 54, 56, 58, 61–62, 64, 67–68, 107–8, figs. 19, 54, 71; Tselos, "Joshua Roll," p. 280, fig. 11; Morey, "Castelseprio," pp. 178–79, 188, fig. 3; Diringer, *Illuminated Book,* fig. I-16a; Kollwitz, "Josuazyklus," p. 107; Henderson, "Joshua Cycle," pp. 51–52; Ehrensperger-Katz, "Villes fortifiées," pp. 7–10, fig. 13; Kitzinger, "Samson Floor," pp. 141–42, fig. 6; Mango, "Storia dell'arte," p. 280, fig. 54; Low-

den, "Production," p. 199; Lowden, "Vtp. Oct.," pp. 122–23, fig. 19; *J.-R.,* pp. 30, 32, 35, 48–49, 59, 67ff.; Lowden, *Octs.,* p. 51, fig. 55.

[1] Weitzmann, *JR,* pp. 67–68, suggests as a model a female figure in a painting in the Tomb of the Nasonii (ibid., fig. 72; B. Andreae, *Studien zur römischen Grabkunst* [Heidelberg, 1963], pl. 55).

Joshua 7:3

Return of the Spies

In correspondence with the preceding scene (fig. 1197), the Rotulus illustrates the return of the spies who had explored the country around Ai, instead of Rahab before Joshua, as in Vat. 747 (fig. 1196a).

1198a. Vat. Rot., sheet VII

The composition agrees very much with Rahab before Joshua in Vat. 747 (fig. 1196a), the only alteration being the omission of the figure of Rahab. The excerpt of Joshua 7:3 underneath the picture corresponds to the content of the illustration.

1200a. Ser., fol. 482v

Close to the Rotulus. All the soldiers behind Joshua are shown in frontal view. On the other hand, this miniature, as well as the corresponding ones in the other Octateuchs, are placed alongside the text narrating the Rahab episode, which is the scene actually illustrated in Vat. 747.

Located beside Joshua 6:22.

1201c. Sm., fol. 225r

Very close to Ser.

1202c. Vat. 746, fol. 447v

Very close to Ser. and Sm.

Located beside Joshua 6:22.

1203c. Vtp., fol. 353v

The group of soldiers behind Joshua depends upon the Rotulus; the house and wall behind Joshua are additions. The artist's decorative inclination is apparent in the rich design of Joshua's golden throne. Parts of the architecture and of the figures are flaked.

Located beside Joshua 6:22.

Lit.: Strzygowski, *Sm.,* pp. 118ff.; *RG,* p. 26, pl. C no. 5; Uspenskii, p. 163, fig. 235; Hesseling, fig. 278; Muñoz, "Rotulo," pp. 478–79; Gerstinger, *Griech. Buchmalerei,* fig. 5; Lazarev, *Istoriia,* pl. 18; Weitzmann, *JR,* pp. 17–18, fig. 21; Weitzmann, *Bibliotheken des Athos,* pp. 21–22, fig. p. 23; Hänsel, "Miniaturmalerei," pp. 133–34 n. 1; Lazarev, *Storia,* p. 347 n. 51, fig. 411; Henderson, "Joshua Cycle," pp. 51–52; Huber, fig. 78; Lowden,

"Production," p. 199; Lowden, "Vtp. Oct.," pp. 122–23, figs. 17, 18; Θη-σαυροί, p. 269, fig. 107; Lowden, *Octs.*, p. 51, figs. 53, 54.

Lit. on Vat. Rot.: Seroux d'Agincourt, *Histoire*, vol. 3, p. 36, and vol. 5, pl. 28 no. 10; Garrucci, *Storia*, pl. 161 nos. 1, 2; *RG*, pl. 7; Muñoz, "Rotulo," p. 478; Buchthal, *Paris Ps.*, p. 61, fig. 98; Weitzmann, *JR*, pp. 17–18, 49, 54, fig. 22; Tselos, "Joshua Roll," p. 277, fig. 3; Morey, "Castelseprio," pp. 178–79, fig. 5; Henderson, "Joshua Cycle," pp. 51–52; Brenk, *S. Maria Magg.*, p. 103; *Quinto centenario*, pl. 27; Engemann, "'Corna' Gestus," p. 495, pl. 4b; Lowden, "Production," p. 199; Lowden, "Vtp. Oct.," pp. 122–23; *J.-R.*, pp. 30, 32, 35, 49, 59, 73ff.; Narkiss, "Main Plane," p. 440, fig. 13; Lowden, *Octs.*, pp. 111–12, fig. 160.

Joshua 7:4

Three Thousand Israelites March Against Ai

1196b. Vat. 747, fol. 221r

A group of soldiers in heavy armor but without helmets marches toward the right.[1]

Located beside Joshua 6:23.

1198b. Vat. Rot., sheet VII

Close to Vat. 747. However, the group of soldiers on the march is headed by a leader who turns his head back and extends his right arm in an encouraging gesture. A cube and a group of buildings enrich the landscape.

1200b. Ser., fol. 482v

Close to the Rotulus. The leader of the soldiers is pictured frontally, so that his holding of the shield with his right arm instead of his left is somewhat awkward. The cube has shrunk and become deformed.

Located beside Joshua 6:22.

1201d. Sm., fol. 225r

Very close to Ser.

1202d. Vat. 746, fol. 447v

Very close to Ser. and Sm.

Located beside Joshua 6:22.

1203d. Vtp., fol. 353v

Both the direct dependence on the Rotulus and the painter's artistic capability are witnessed by the miniature's convincing portrayal of the leading soldier from the back. The scene is attached to the preceding one so closely that the dividing cube is almost hidden between the two groups of soldiers. The tree above it shows the direct influence of the Rotulus. On the other hand, the group of cubes at the right is reduced to a single one pressed so far into the corner that it has lost any spatial relation-

ship to the rest of the landscape, but at the same time it gains a different spatial function by overlapping the leader's leg. The tree and other small spots are flaked.

Located beside Joshua 6:22.

Lit.: Strzygowski, *Sm.*, pp. 118ff.; *RG*, p. 26, pls. 50 no. 2, C no. 5; Uspenskii, p. 163, fig. 235; Hesseling, fig. 278; Muñoz, "Rotulo," pp. 478–79; Gerstinger, *Griech. Buchmalerei*, fig. 5; Lazarev, *Istoriia*, pl. 18; Weitzmann, *JR*, pp. 17–18, figs. 20, 21; Tselos, "Joshua Roll," p. 279, fig. 10; Weitzmann, *Bibliotheken des Athos*, pp. 21–22, fig. p. 23; Hänsel, "Miniaturmalerei," pp. 133–34 n. 1; Lazarev, *Storia*, p. 347 n. 51, fig. 411; Henderson, "Joshua Cycle," pp. 51–52; Huber, fig. 78; Lowden, "Production," p. 199; Lowden, "Vtp. Oct.," pp. 122–23, figs. 17, 18; *J.-R.*, p. 59; Θησαυροί, p. 269, fig. 107; Lowden, *Octs.*, p. 51, figs. 53, 54.

Lit. on Vat. Rot.: Seroux d'Agincourt, *Histoire*, vol. 3, p. 36, and vol. 5, pl. 28 no. 10; Garrucci, *Storia*, pl. 161 nos. 1, 2; *RG*, pl. 7; Weitzmann, *JR*, pp. 54, 59, figs. 22, 59; Tselos, "Joshua Roll," p. 279; Morey, "Castelseprio," pp. 178–79, fig. 5; Kollwitz, "Josuazyklus," p. 107; *Quinto centenario*, p. 64, pl. 28; Lowden, "Production," p. 199; Lowden, "Vtp. Oct.," pp. 122–23, fig. 19; *J.-R.*, pp. 30, 32, 35, 49, 59; Narkiss, "Main Plane," p. 440, fig. 13; Lowden, *Octs.*, pp. 111–12, fig. 160.

[1] Mazal (*J.-R.*, p. 59) suggests the identification of the foremost soldier as Jair, the son of Manasseh, who in the corresponding illustration in the Joshua Rotulus seems to be presented as the leader of the expedition to Ai. According to a Jewish legend, Jair was killed in the defeat at Ai (Ginzberg, *Legends*, vol. 4, p. 8).

Joshua 7:4–5

Defeat of the Israelites at Ai

1204a. Vat. 747, fol. 221v

Between two steep mountains, the cavalry of Ai attacks the Israelite infantry with lowered lances; their adversaries fall back under the fierce onslaught. Two Israelites, bleeding and mortally wounded, lie on the ground. On the mountain at the right the city of Ai is rendered as a simplified walled city with no houses visible within its limits.

Located beside Joshua 6:26.

1205. Vat. Rot., sheets VII and VIII

Both armies are composed of infantrymen armed with swords and spears. Ai is depicted as a walled city with several houses within its precinct. In the center of the scene, a classical personification of Ai[1] sits on a mountain and holds a cornucopia with its right hand. Cubic structures, such as an altar with one of its crowning volutes still preserved and half submerged, are employed as filling motifs.

1207. Ser., fol. 483r

The painter copied the composition of the Rotulus but simplified it. The city personification is omitted. The altar at the left has been retained, but its volute is misunderstood still further. The scene ends at the left in the very place where the tree cuts

through the Israelite army in the Rotulus; thus it happened that not only Ser., but also Sm., Vat. 746, and Vtp. erroneously took the rear of the army, beyond the tree, over into the preceding picture (figs. 1200–1203). This cut is easily explained by the use of the Vatican Rotulus as a model, since in it the tree provides the only possible straight vertical division line between these two interlocked, adjoining scenes.

Located beside Joshua 6:26.

1209a. Sm., fol. 225v

Close to Ser. but including the city personification of the Rotulus. The personification has lost its elegant pose.

1210a. Vat. 746, fol. 448r

Very close to Sm. The personification holds the cornucopia in its left hand and points with its right to the retreating Israelites, thus avoiding twisting its body.

Located beside Joshua 6:26.

1211a. Vtp., fol. 354v

Copied directly from the Rotulus. The scene is condensed so that the retreating Israelites are placed above their wounded instead of on the same groundline. In order to partially fill the vacuum in the lower left corner the wounded soldier at the extreme left is given a huge shield. Though the left section of the city wall is interrupted by a gate like the one in the Rotulus, the painter depicted an even larger, open gate at the right and let one of the jambs overlap a leg of the hindmost soldier, so as to give the impression that the men of Ai were just breaking out of the city. With this feature the painter apparently wanted to portray the phrase "they pursued them from the gate" (Josh 7:5). Large parts of the mountain, the city, and the figures, particularly their faces, are flaked.

Located beside Joshua 6:26.

Lit.: Graeven, "Rotulo," pp. 226–28, pls. 4a, 5a; *RG*, p. 26, pl. D no. 1; Strzygowski, *Sm.*, pp. 118ff.; Uspenskii, p. 163, figs. 236, 313; Hesseling, fig. 279; Millet, "Octateuque," pp. 75–76; Weitzmann, *JR*, pp. 19, 57, 61, figs. 24, 25; Tselos, "Joshua Roll," p. 279; Hänsel, "Miniaturmalerei," pp. 133–34 n. 1; Kollwitz, "Josuazyklus," p. 107; Henderson, "Joshua Cycle," p. 53; Huber, fig. 79; *J.-R.*, p. 60; Θησαυροί, pp. 269–70, fig. 108; Lowden, *Octs.*, pp. 28, 111, figs. 163, 164.

Lit. on Vat. Rot.: Winckelmann, *Versuch einer Allegorie*, p. 79; Seroux d'Agincourt, *Histoire*, vol. 3, p. 36, and vol. 5, pl. 28 no. 11; Garrucci, *Storia*, pls. 161 no. 2, 162 no. 1; Graeven, "Rotulo," pp. 224–25, pl. 1; *RG*, p. 26, pls. 7, 8; Millet, "Octateuque," pp. 75–76; Pijoán, *Summa artis*, vol. 7, p. 164, fig. 254; Weitzmann, *JR*, pp. 19, 58–59, 61, 68, 76, 79, 81, figs. 22, 23, 73; Tselos, "Joshua Roll," p. 279; Kollwitz, "Josuazyklus," p. 107; Henderson, "Joshua Cycle," p. 53; Brenk, *S. Maria Magg.*, p. 103; *J.-R.*, pp. 30, 32, 35, 49, 60; Narkiss, "Main Plane," p. 440, fig. 13; Lowden, *Octs.*, pp. 111–12, fig. 160.

¹ Weitzmann (*JR*, p. 68) suggests a parallel with a female figure in a painting in the Tomb of the Nasonii (ibid., fig. 74; B. Andreae, *Studien zur römischen Grabkunst* [Heidelberg, 1963], pl. 58:2).

Joshua 7:6–15

Joshua and the Elders Pray to God

1204b. Vat. 747, fol. 221v

Having ascended halfway up a mountain, Joshua bends one knee and raises his hands toward heaven in a gesture of supplication. There was presumably once a hand of God in the segment of heaven, now flaked, from which rays emanated in the direction of Joshua's face. Even in this situation Joshua wears a helmet. The elders, five in a row and one isolated in the foreground, kneel at a certain distance behind their leader and join in his prayer. Departing from verse 6, Joshua is represented neither rending his clothes nor sprinkling ashes; rather than a realistic translation of the text, the painter chose an imperial iconography for the miniature.

Located beside Joshua 6:26.

1206a. Vat. Rot., sheet VIII

Close to Vat. 747. Joshua, however, is bareheaded, and the elders number seven altogether; five of them are represented in a row with the additional two in front of the others. The hand of God to which Joshua prays appears above the heads of the soldiers in the next scene. A city emerges behind the slope of the mountain; its towers are higher than usual and are decorated with windows.

1208a. Ser., fol. 483r

The position of Joshua on the mountain, the grouping of the elders, and their comparatively more erect poses agree with Vat. 747, while Joshua's bare head conforms to the Rotulus. The number of elders is reduced to five.

Located beside Joshua 6:26.

1209b. Sm., fol. 225v

Very close to Ser. The number of elders is further reduced to four.

1210b. Vat. 746, fol. 448r

This miniature in general follows Ser. and Sm. The elders, though here again numbering seven, are no longer lined up in formation but are crowded together without order.

Located beside Joshua 6:26.

1211b. Vtp., fol. 354v

The grouping of the seven elders and the position of Joshua, whose right leg is overlapped by one of the elders, agree most closely with Vat. 746; contrary to the norm, no direct influence of the Rotulus is recognizable in this instance. The figures of the elders are nearly completely flaked, but their outlines are still visible, thus permitting the sure identification of their positions and attitudes. The figure of Joshua is also flaked in various spots.

Located beside Joshua 6:26.

Lit.: Graeven, "Rotulo," pp. 226–28, pls. 4a, 5a; Strzygowski, *Sm.*, pp. 118ff.; *RG*, p. 27, pl. D no. 1; Uspenskii, p. 163, figs. 237, 313; Hesseling, fig. 279; Alpatov, "Rapport," pp. 304 n. 5, 305 nn. 1, 3; Weitzmann, *JR*, pp. 19, 55, figs. 27, 29; Schapiro, "Place," p. 164, fig. 2a; Tselos, "Joshua Roll," p. 279; Huber, fig. 79; Henderson, "Joshua Cycle," pp. 53–54; Cutler, *Transfigurations*, pp. 66–67; Θησαυροί, pp. 269–70, fig. 108; Lowden, *Octs.*, pp. 28, 111, figs. 163, 164.

Lit. on Vat. Rot.: Seroux d'Agincourt, *Histoire*, vol. 3, p. 36, and vol. 5, pl. 28 nos. 12, 13; Garrucci, *Storia*, pl. 162 nos. 1, 2; Kondakov, *Istoriia*, p. 58; Kondakov, *Histoire*, vol. 1, fig. p. 98; *RG*, p. 27; Venturi, *Storia*, vol. 1, fig. 148; Alpatov, "Rapport," pp. 304 n. 5, 305 nn. 1, 3; Weitzmann, *JR*, pp. 19, 56, 64, figs. 23, 26; Henderson, "Joshua Cycle," pp. 53–54; Stahl, "Morgan M. 638," p. 132, fig. 165; Cutler, *Transfigurations*, pp. 66–67, fig. 52; Kirigin, *Mano divina*, p. 151; *J.-R.*, pp. 30, 32, 35, 49, 60, 67ff.; Narkiss, "Main Plane," p. 440, fig. 13.

Joshua 7:18–21

TRIAL OF ACHAN

1204c. Vat. 747, fol. 221v

The trial of Achan (LXX: Achar) is joined by the frame and the mountainous landscape to the scene of Joshua's prayer. A group of Israelites in short tunics, the foremost resting his shield on the ground while the others seem to be unarmed, bring Achan before Joshua, who is clad in full armor, wears a helmet, and sits on a faldstool. In one hand the leader of the Israelites holds a lance, while the other is raised in a gesture of speech toward Achan, who stands with arms crossed before the judge, awaiting his verdict.

Located beside Joshua 6:26.

1206b. Vat. Rot., sheets VIII and IX

Close to Vat. 747. Joshua is bareheaded and sits on a massive chair; behind him is a group of heavily armed Israelite soldiers. The Israelites facing Joshua are divided into two groups, one consisting of Achan and two soldiers, the second of civilians, who are probably meant to represent the tribe of Judah or, more specifically, the family of the Zarhites from among whom Achan was pointed out as the guilty one, according to verse 17. Holding a spear, Achan raises his right hand in a gesture of speech; according to verse 20, he is making his confession.[1] The scribe was well aware that the painter had included the content of verse 20 in his scene, and thus he wrote both verses 19 and 20 beneath it.

1208b. Ser., fol. 483r

Close to the Rotulus. However, due to an error in dividing the Rotulus scenes, the men of the tribe of Judah have been placed at the beginning of the following scene, where they now senselessly face the lateral border (cf. figs. 1214–1217). Achan is not speaking to Joshua but holds a spear, with his right arm crossing his body. The group of Israelites in the next miniature (fig. 1214) is badly damaged by flaking.

Located beside Joshua 6:26.

1209c. Sm., fol. 225v

Close to Ser. Achan, however, crosses his arms and carries no lance, thus following the version in Vat. 747. The whole scene, as is recognizable even in the reproduction, was crudely overpainted at a later period. This is apparent particularly in the group of Israelite civilians in the next miniature (fig. 1215).

1210c. Vat. 746, fol. 448r

Very close to the Rotulus: Achan gestures in speech and also holds a lance. The heads of the Israelites taken over into the next miniature (fig. 1216) and parts of the mountain behind them are badly flaked.

Located beside Joshua 6:26.

1211c. Vtp., fol. 354v

Close to the Rotulus and Vat. 746. The central figure in the group of Israelite civilians (fig. 1217) depends directly on Vat. 746. Joshua's more restrained pose and his splendid golden throne are additions by the painter of Vtp. All the heads are nearly completely flaked, and other parts of the bodies and large areas of the mountain are likewise severely damaged.

Located beside Joshua 6:26.

Lit.: Graeven, "Rotulo," pp. 225–28, pls. 4, 5; Strzygowski, *Sm.*, pp. 118ff.; *RG*, p. 27, pl. D no. 1; Schapiro, "Place," p. 164, fig. 2a; Uspenskii, p. 163, figs. 237, 313; Hesseling, fig. 279; Weitzmann, *JR*, pp. 19–20, 55, 108, figs. 27, 29, 30; Tselos, "Joshua Roll," pp. 278–79; Williams, "León Bible," p. 84; Lazarev, *Storia*, fig. 104; Henderson, "Joshua Cycle," p. 55; Huber, figs. 79, 80; *J.-R.*, pp. 60–61; Θησαυροί, pp. 269–70, fig. 108; Lowden, *Octs.*, pp. 28, 111, figs. 163, 164.

Lit. on Vat. Rot.: Seroux d'Agincourt, *Histoire*, vol. 3, p. 36, and vol. 5, pl. 28 nos. 12, 13; Garrucci, *Storia*, pl. 162 nos. 1, 2; Strzygowski, *Sm.*, pp. 120–21; *RG*, p. 27, pls. 8, 9; Lazarev, *Istoriia*, pl. 18; Weitzmann, *JR*, pp. 19–20, 108, figs. 23, 26; Tselos, "Joshua Roll," p. 279; Schapiro, "Place," p. 164, fig. 3; Williams, "León Bible," p. 84; Henderson, "Joshua Cycle," p. 55; *J.-R.*, pp. 30, 32–33, 35, 49–50, 60–61, 70ff.; Narkiss, "Main Plane," p. 440, fig. 13; Lowden, *Octs.*, pp. 111–12, fig. 160.

[1] A different interpretation of Achan's pose and a connection with a Jewish legend (Ginzberg, *Legends*, vol. 4, pp. 8–9) have been advanced by Mazal (*J.-R.*, pp. 60–61).

Joshua 7:24

ACHAN TAKEN AWAY

Achan is represented alone, whereas the text also mentions his sons and daughters: in contrast, in the Stoning of Achan (figs. 1218–1223) he is joined by members of his family.

1212. Vat. 747, fol. 222r

After Achan is condemned to death, two armed soldiers drag him away by the hair; his arms are fettered behind his back. The scene takes place before steep mountains. The head of the foremost soldier and other spots of the surface are flaked.

Located beside Joshua 7:11.

1213. Vat. Rot., sheet IX

Close to Vat. 747, except that Achan is not fettered and two soldiers drag him away by his hair and his left arm. The background has a Pompeian-style flat-roofed house with a tower, a section of a low wall, and trees.

1214. Ser., fol. 484r

Although the picture is very flaked, the remaining traces indicate that it is close to the Rotulus. Only the high mountain in the background reveals the influence of the version represented by Vat. 747.

Located beside Joshua 7:13.

1215. Sm., fol. 226r[1]

Very close to Ser. The whole miniature has apparently been heavily overpainted.

1216. Vat. 746, fol. 449r

Very close to Ser. and Sm. Achan's head seems intentionally rubbed by a pious hand.

Located beside Joshua 7:13.

1217. Vtp., fol. 356v

Close to the other Octateuchs; small details such as the sword at the side of the soldier at the right reflect the influence of the Rotulus. All three figures as well as the mountains are heavily flaked.

Located beside Joshua 7:14.

Lit.: Strzygowski, *Sm.*, pp. 118ff.; *RG*, p. 28, pl. D no. 2; Uspenskii, pp. 163–64; Hesseling, fig. 284; Weitzmann, *JR*, p. 20; Schapiro, "Place," p. 164, fig. 2b; Huber, fig. 80; *J.-R.*, p. 61; Demus, *Mosaics of S. Marco*, vol. 2, pt. 1, p. 182; Θησαυροί, p. 270, fig. 109; Lowden, *Octs.*, pp. 111–12, figs. 165, 166.

Lit. on Vat. Rot.: Seroux d'Agincourt, *Histoire*, vol. 3, p. 36, and vol. 5, pl. 28 no. 13; Garrucci, *Storia*, pls. 162 no. 2, 163 no. 1; Strzygowski, *Sm.*, p. 121; *RG*, p. 28, pl. 9; Lietzmann, "Datierung," p. 183; Morey, *Mediaeval Art*, pp. 50–51, fig. 17; Weitzmann, *JR*, pp. 20, 62, 77–78, figs. 26, 63; Schapiro, "Place," p. 164, fig. 3; Kollwitz, "Josuazyklus," p. 107; Lazarev, *Storia*, fig. 104; *J.-R.*, pp. 30, 33, 35, 50, 61; Lowden, *Octs.*, pp. 111–12, fig. 160.

[1] Note that fols. 226 and 227 are in reverse order (cf. Strzygowski, *Sm.*, p. 117; Lowden, *Octs.*, pp. 62–63), and this fact may have induced a mistake in Uspenskii's indication of the folios on which the corresponding miniatures were located (see Uspenskii, p. 188).

Joshua 7:25

STONING OF ACHAN

In this miniature the poses of both the executioners and the stoned figure of Achan closely recall previous episodes of stoning (cf. figs. 926–930, 1089–1093). Achan is executed together with a group of his male relatives, thus departing from the text of the Septuagint, in which no other members of Achan's family are cited. A rabbi's comment explicitly states, "And all Israel stoned him with stones; him alone";[1] but a different Jewish tradition relates that Achan's sons and daughters were also put to death "because they were cognizant of the matter, and did not report it."[2]

1218a. Vat. 747, fol. 222v

A group of Israelites stands on a mountain slope and throws stones upon Achan and his family, who lie in a ditch. Achan, already hit, tries to rise again and protect himself with his right arm, but his executioners, depicted as civilians in short tunics, continue their persecution, throwing stones with their right hands and holding some in reserve in their left hands. One of Achan's companions has been killed and has fallen down headfirst, while only the heads of some others are visible, their faces wearing expressions of terror. The group in the ditch is flaked in various spots.

Located beside Joshua 7:26.

1219a. Vat. Rot., sheet IX

The scene is enlarged by the addition of a second group of executioners on the opposite slope. Moreover, unlike Vat. 747, the men on the left bend backward in order to put more force behind their throws. No fewer than four members of Achan's family are depicted already fallen down headfirst. High above the mountain peak is the reclining youthful personification of the locality where the execution took place, the valley of Achor.

1220a. Ser., fol. 485r

The climbing posture of the executioners and the fact that only one group of them is represented agree with Vat. 747, but most of the details correspond to the Rotulus, namely, the grouping of the four dead members of Achan's clan two by two, the swords in the hands of the executioners, the tree in front of them, and finally the personification. In order to justify the latter's posture, a high mountain is added, and the youth finds support by leaning on its crest. The surface is partially flaked and stained.

Located beside Joshua 7:26.

1221a. Sm., fol. 227v

Very close to Ser.

1222a. Vat. 746, fol. 449v

Very close to Ser. and Sm.
Located beside Joshua 8:1.

1223a. Vtp., fol. 357v

Very close to Ser., Sm., and Vat. 746. Achan grasps his bleeding head, and the personification is replaced by a different one

facing in the opposite direction. The new figure, which cannot be explained as a transformation of the mountain god in the Rotulus, is draped in a garment that covers most of the body from the breast down to the feet, and he sits very erect on a rock on the slope. The upper, nude part of the figure is very badly flaked, but it appears that the painter intended to represent a female. He may very well have changed the sex intentionally to indicate that the locality, Ἀχὼρ according to verse 24, is a valley, i.e., φάραγγα, a feminine term. Most of the background and parts of the figures are badly flaked.

Located beside Joshua 7:26.

Lit.: Strzygowski, *Sm.*, pp. 118ff.; *RG*, p. 28, pl. D no. 3; Uspenskii, p. 164, fig. 238; Hesseling, fig. 285; Weitzmann, *JR*, p. 20, fig. 28; Henderson, "Joshua Cycle," pp. 54–55; Huber, fig. 81; Kirigin, *Mano divina*, p. 152 n. 47; *J.-R.*, p. 61; Θησαυροί, p. 270, fig. 110; Lowden, *Octs.*, p. 111, figs. 167, 168.

Lit. on Vat. Rot.: Seroux d'Agincourt, *Histoire*, vol. 3, p. 36, and vol. 5, pl. 28 no. 13; Piper, *Mythologie*, vol. 2, p. 506; Garrucci, *Storia*, pl. 163 no. 1; Graeven, "Antike Vorlagen," pp. 11–12, fig. p. 12; Graeven, "Rotulo," p. 223, pl. 2a; *RG*, p. 28, pl. 9; Morey, *Mediaeval Art*, pp. 50–51, fig. 17; Weitzmann, *JR*, p. 20, fig. 26; Tselos, "Joshua Roll," p. 277, fig. 1; Beckwith, *Veroli Casket*, p. 3, fig. 1; Williams, "León Bible," p. 84; Kollwitz, "Josuazyklus," p. 107; Simon, "Nonnos," p. 296, fig. 12; Lazarev, *Storia*, fig. 104; Henderson, "Joshua Cycle," pp. 54–55; Lazarev, *Vizantiiskoe*, fig. p. 48; *J.-R.*, pp. 30, 33, 35, 50, 61, 70.

 [1] NumR 23:6 (*Numbers Rabbah*, ed. Freedman and Simon, p. 870).
 [2] PRE 38 (*Pirkê*, ed. Friedlander, p. 296).

Joshua 8:1–3

GOD PROMISES JOSHUA THE CAPTURE OF AI AND SOLDIERS ON THE MARCH

1218b. Vat. 747, fol. 222v

God's order to send out the army to conquer the city of Ai and the execution of this order are united with the stoning of Achan by a common frame and the same mountainous terrain. Joshua stands between two mountain peaks and raises his hands in prayer toward a double segment of heaven from which the hand of God emerges. Below, the thirty thousand soldiers that Joshua sent out are shown on the march, clad in heavy armor but with bare heads. They are led by a commander who marches with an energetic stride and turns his head as if spurring the soldiers to hasten. All the figures are slightly damaged.

Located beside Joshua 7:26.

1219b. Vat. Rot., sheet X

Joshua's pose is more devout. To the left of the mountain peak appears a piece of Pompeian architecture and near Joshua are two cubelike buildings. The group of marching soldiers, wearing heavy armor and helmets, is here commanded by Joshua himself—thus departing from the text—who is represented in the same posture as the leading officer in Vat. 747. In front of this second Joshua stands a classical altar and a column with an overhanging conical roof crowned by a pinecone.

1220b. Ser., fol. 485r

The painter clearly followed the Rotulus by repeating Joshua as the leader of the marching Israelites. However, he omitted the Pompeian architecture in the mountains and the altar in front of Joshua. The same mountain ridge surrounds both scenes. As in previous instances, the painter had trouble depicting a figure from the back, and the hindmost soldier thus becomes an unfortunate mixture of front and back views. The cubelike houses of the Rotulus are replaced by the top of a marbled column with a capital and entablature.

Located beside Joshua 7:26.

1221b. Sm., fol. 227v

Close to Ser.

1222b. Vat. 746, fol. 449v

Close to Ser. and Sm. The praying Joshua stands on the column, using it as a pedestal.

Located beside Joshua 8:1.

1223b. Vtp., fol. 357v

Joshua's position on the column manifestly follows Vat. 746. The direct dependence on Vat. 746 is further demonstrated by a detail as minute as the scalloped outline of the marching Joshua's shield. However, the artist, of greater talent than the one who executed his model, again corrects the posture of the hindmost soldier and paints him in a convincing back view without using the corresponding type from the Rotulus as model, but depicting a new type who rests his shield on the ground. By improving this soldier's pose, however, he somewhat obscured the original meaning of the whole scene as that of troops on the march. Characteristic of the painter's Palaiologan style is the modernization of the Hellenistic helmet into a kind of medieval pot helmet. The lower part of the miniature, the peak of the mountain, the hand of God, and most of the faces are heavily flaked.

Located beside Joshua 7:26.

Lit.: Strzygowski, *Sm.*, pp. 118ff.; *RG*, p. 28, pl. D no. 3; Uspenskii, p. 164, fig. 239; Hesseling, fig. 285; Weitzmann, *JR*, pp. 21, 108, fig. 28; Kollwitz, "Josuazyklus," p. 107; Huber, fig. 81; *J.-R.*, pp. 61–62; Θησαυροί, p. 270, fig. 110; Lowden, *Octs.*, figs. 168, 169.

Lit. on Vat. Rot.: Seroux d'Agincourt, *Histoire*, vol. 3, p. 36, and vol. 5, pl. 28 no. 14; Garrucci, *Storia*, pl. 163 nos. 1, 2; *RG*, p. 28, pl. 10; Morey, "Notes," pp. 36, 49, fig. 44; Benson and Tselos, "Utrecht Ps.," pp. 58, 61, fig. 112; Weitzmann, *JR*, pp. 21, 54, 56–57, 59–60, 63, 77, 81, 108, fig. 31; Kollwitz, "Josuazyklus," p. 107; *J.-R.*, pp. 30, 33, 35, 50, 61–62, 67ff.

Joshua 8:15–19

CAPTURE OF AI

An illustration of the conquest of Ai requires a representation of three armies: first, that of the Israelites under the leadership of Joshua which pretends to flee and intentionally gives ground to the

enemy (verse 15); second, that composed of the men of Ai who break out of their city to pursue the fleeing Israelites (verses 16–17); and third, the second army of Israelites which emerges from ambush and conquers the city, destroying it by fire (verse 19).

1224a. Vat. 747, fol. 223r

The content of the miniature is much obscured by the omission of the enemy army in the center of the composition. Apparently this was due to lack of space, since the illustrator combined the battle scene with the next one in a single frieze, its width limited by the dimension of the page. At the left, the bareheaded Israelites approach the city. Some are still marching while the vanguard has reached its objective and is torching the city of Ai, situated between two mountain slopes. A short distance away, the other Israelite army is shown turning to flight while some of its soldiers look back. This latter motif, of course, lost its meaning when the group of pursuing enemies was dropped. One would expect to see Joshua in this second group of Israelites, as in the more precise scenes in the Rotulus and the other Octateuchs. A personification painted in gray-blue grisaille sits on the right-hand mountain slope; it is clearly characterized as Nyx by the billowing veil over her head. The personification is well motivated by the text, which explicitly states no fewer than three times (Josh 8:3, 9, and 13) that the preparations for the battle were made during the night. Part of the ground, particularly in front of the fleeing Israelites, is flaked.

Located below Joshua 8:29.

1225a. Vat. Rot., sheet X

The illustrator of the Rotulus also felt compelled to limit the picture area for this and the following battle scene. The figures are reduced in size and the two compositions are superimposed. In the upper portion of the miniature, the Israelites are seen coming forward from behind a mountain slope. The three foremost soldiers set fire to the walled city with torches held in one hand, while in the other they carry their shields. Meanwhile, the men of Ai break out of the gate with lowered lances to pursue the first Israelite army. The hindmost soldier, covering the retreat, is Joshua himself, with nimbus and chlamys. Tied to Joshua's spear is a pennant, a feature that represents the giving of the signal for the second army to come out of ambush. A personification of Ai, an adaptation of a classical model,[1] sits on a rock on the mountain in a thoughtful pose and holding a cornucopia. The personification occupies exactly the same place as Nyx in Vat. 747, thus suggesting that it replaces Nyx, which is more connected with the text. A cubic structure is attached to the walled city.

1226. Ser., fol. 486v

Close to the Rotulus. However, all three armies are abbreviated and condensed in such a way that some soldiers of the left-hand army of Israelites instead of storming the city are now on the heels of the pursuing men of Ai, whom they erroneously attack with lowered lances. The fleeing Israelites are likewise so close to the pursuing men of Ai that Joshua, as the hindmost,

would inevitably have been pierced by the lances of the pursuers were the spatial relationship taken literally. The encompassing wall of the city with its towers is omitted and only three houses enveloped in flames remain within. The city personification, who, like Joshua, has a blue nimbus, is fully dressed, and its gesture of thoughtfulness is replaced by what might be considered one of surprise; instead of a mural crown, it wears a pearl-studded imperial crown. The surface is slightly flaked.

Located below Joshua 8:29.

1228a. Sm., fol. 226r or 226v[2]

Close to Ser., but the three torch-bearers are more spread out and hold only a torch in one hand and a shield in the other, as in the Rotulus. The three houses are not yet enveloped in flames and the personification, half hidden, emerges from behind the mountain.

1229a. Vat. 746, fol. 450v

Close to Ser. in that the city personification is fully visible, and to Sm. in that the torch-bearers carry shields, although their number is reduced from three to two, as in Ser.

Located below Joshua 8:29.

1230. Vtp., fol. 359v

The painter followed Vat. 746 most closely, particularly for the group of torch-bearers, but he changed and enriched his model in several ways. The foremost soldier of Ai, for instance, attacks Joshua with his lance held up in an attitude that does not occur in any of the other miniatures. The city personification balances the cornucopia in the air, holding its tip. The group of three houses is augmented at the left by a fourth house and a tower. Moreover, the painter must have realized that showing the Israelite army attacking the men of Ai from the left did not make sense, and thus he separated the two groups with a mountain peak and let the Israelites hold their lances upright. The whole surface of the miniature is flaked, but fortunately the figures are less affected than the ground, the mountain, and the architecture.

Located beside Joshua 8:25.

Lit.: Strzygowski, *Sm.*, pp. 118ff.; *RG*, p. 29, pls. D no. 4, 50 no. 3; Uspenskii, p. 164, fig. 241; Hesseling, fig. 280; De Wald, "Fragment," p. 150, fig. 15; Weitzmann, *RaC*, pp. 171–72, fig. 166; Weitzmann, *JR*, pp. 21–22, 57, 69, fig. 32; Tselos, "Joshua Roll," pp. 286ff., figs. 23, 24; Kollwitz, "Josuazyklus," p. 107; Huber, fig. 82; *J.-R.*, p. 62; Θησαυροί, p. 270, fig. 111; Lowden, *Octs.*, p. 62, figs. 87, 88.

Lit. on Vat. Rot.: Winckelmann, *Versuch einer Allegorie*, p. 79; Seroux d'Agincourt, *Histoire*, vol. 3, p. 36, and vol. 5, pl. 28 no. 14; Garrucci, *Storia*, pls. 163 no. 2, 164 no. 1; *RG*, p. 29, pl. 10; Morey, "Notes," pp. 36, 49, fig. 44; Lietzmann, "Datierung," pp. 181–82, pl. 13; Weitzmann, *RaC*, pp. 171–72, fig. 167; Weitzmann, *JR*, pp. 21–22, 68–69, fig. 31; Tselos, "Joshua Roll," pp. 286ff., fig. 22; Cecchelli, *S. Maria Magg.*, p. 182; Kollwitz, "Josuazyklus," p. 107; De Angelis, "Simbologia," p. 1533, fig. 10; *J.-R.*, pp. 30, 33, 35, 50, 62, 70ff.

[1] Weitzmann, *JR*, pp. 68–69.
[2] Fol. 226v according to Hesseling, p. xv, and Uspenskii, p. 188; fol. 226r according to Strzygowski, *Sm.*, p. 118.

Joshua 8:21–22

DEFEAT OF THE MEN OF AI

1224b. Vat. 747, fol. 223r

Joshua drives the army of bareheaded Israelites into battle against the men of Ai, who are characterized by their helmets. Most of the warriors on both sides fight with lances, except one of the Israelites who wields a sword and one of the men of Ai who fights with a bow. A number of men have already been killed and have fallen headlong to the ground. Joshua, holding a spear and shield, takes a hasty step forward and extends his right arm in an emphatic gesture of encouragement, while behind him another group of Israelite soldiers stands in quiet posture. The figure of Joshua, originally clad in shining golden armor, has been overpainted by a later hand and is now dressed in a tunic and a mantle with soft, indistinct folds. The surface is flaked in several places.

Located below Joshua 8:29.

1225b. Vat. Rot., sheet X

The battle is no longer raging as in Vat. 747, but rather the men of Ai, completely defeated, are being annihilated and are unable to offer any resistance. In agreement with the text, the Israelites attack them from both sides in a pincer movement. The Israelites who had previously been in ambush and had then burned the city, emerge from behind a mountain slope and attack from the left, the foremost soldier just driving his lance into the back of the fallen enemy. At the same time the other Israelites, who pretended to flee, have turned back and the foremost soldier pierces a second enemy soldier through the neck. Other men of Ai have apparently been wounded already and have fallen to their knees. Two encounters take place behind the front line. Joshua, surrounded by soldiers, raises his right arm in a gesture of encouragement.

1227. Ser., fol. 486v

Close to the Rotulus. However, the two Israelite armies are drawn so close together that they seem to threaten and fight each other with their raised swords. The lances on both sides are directed only against the defeated men of Ai on the ground: the accumulation of helmets depicted behind these three men creates the effect of a whole defeated army. A mountain peak encompasses each of the two fighting armies. The paint has flaked off in small spots all over the surface.

Located below Joshua 8:29.

1228b. Sm., fol. 226r or 226v[1]

Not quite as condensed as in Ser. The two individual fighting groups between the main battle and the commanding Joshua are similar to those in the Rotulus, but they are drawn so close together that the Israelites seem to fight each other and not the doomed victims. One of the victims, the figure lying on the ground, was copied, while the other, held by his hair, was omit-

ted. In the battle scene proper a row of spears is visible above the heads of the defeated men of Ai. This clearly indicates that the painter no longer understood the subtle point of the pincerlike movement and so showed the two Israelite armies fighting each other. A mountain ridge, a continuation of that in the left-hand battle scene, fills the entire background.

1229b. Vat. 746, fol. 450v

Close to Sm. Here too the impression is created that the two Israelite armies are fighting each other, but the soldiers at the left do not direct their lowered spears against those at the right. One of the two individual fighting groups behind the line is preserved, although the Israelite here is not concerned with his adversary on the ground, but is treated as a straggler from the main force.

Located below Joshua 8:29.

1231. Vtp., fol. 360r

The painter follows Vat. 746 most closely, as is apparent particularly in the representation of the single straggler behind the battlefront and of the crawling victim at his feet. In contrast, however, the foremost soldier in the army at the left does not strike in the usual manner, holding his sword over his head, but rather thrusts it into the thigh of his adversary, an Israelite from the second army. Some spearpoints are also directed against this second army, and thus it is clear that again the painter misunderstood the true relationship of the armies to each other and turned the left-hand army of Israelites into the men of Ai. The surface is badly flaked in various spots.

Located above Joshua 8:27.

Lit.: Strzygowski, *Sm.,* pp. 118ff.; *RG,* p. 29, pl. D no. 4; Uspenskii, p. 164, fig. 240; Hesseling, fig. 280; Weitzmann, *RaC,* p. 171, fig. 166; Weitzmann, *JR,* pp. 21–22, fig. 32; Tselos, "Joshua Roll," pp. 286ff., figs. 23, 24; Kollwitz, "Josuazyklus," p. 107; Huber, fig. 83; Θησαυροί, p. 270, fig. 112; Lowden, *Octs.,* p. 62, figs. 87, 88.

Lit. on Vat. Rot.: Seroux d'Agincourt, *Histoire,* vol. 3, p. 36, and vol. 5, pl. 28 no. 14; Garrucci, *Storia,* pls. 163 no. 2, 164 no. 1; *RG,* p. 29, pl. 10; Morey, "Notes," pp. 36, 49, fig. 44; Lietzmann, "Datierung," pp. 181–82, pl. 13; Weitzmann, *JR,* pp. 21–22, fig. 31; Tselos, "Joshua Roll," pp. 277, 286ff., figs. 4, 22; Cecchelli, *S. Maria Magg.,* p. 182; Kollwitz, "Josuazyklus," p. 107; De Angelis, "Simbologia," p. 1533, fig. 10.

[1] Fol. 226v according to Hesseling, p. xv, and Uspenskii, p. 188; fol. 226r according to Strzygowski, *Sm.,* p. 118.

Joshua 8:23

KING OF AI BROUGHT BEFORE JOSHUA

The scene of the capture of the king of Ai follows the destruction of the city described in Joshua 8:24–28 and illustrated in figs. 1232–1237. In the text, on the contrary, the king is brought to Joshua before the order to burn the city is given. This change in sequence occurs in all the Octateuchs and thus must have been a feature of either the archetype of the cycle or of an early copy.

1238a. Vat. 747, fol. 223v

The victorious Israelite army has returned to Joshua, and one of the soldiers drags the captured king of Ai before him, holding his fettered victim by the shoulder and hair. The king is clad in a long robe with a collar, and his royal rank is shown by the pearl-studded crown of the Byzantine emperors he wears on his head. Joshua sits enthroned on a faldstool, holding a spear in one hand and extending the other toward the prisoner with an expression of surprise. Behind him stand some more Israelite warriors, whose heads have been overpainted. The figure of Joshua is also partly overpainted, particularly the face with its pathetic look and the crude spear.

Located above Joshua 9:1.

1239a. Vat. Rot., sheet XI

Close to Vat. 747 but there are slight changes. While all the soldiers wear helmets, Joshua is bareheaded; he sits on a chair, holding a lance and raising his hand in a gesture of speech. The king is likewise bareheaded and wears a splendidly decorated tunic. The scene is encompassed by a steep mountain with a Pompeian house to the left of its summit. Joshua's bodyguard is partly overlapped by a steep mountain slope which separates this scene from the two preceding battles.

1240a. Ser., fol. 487r

Close to the Rotulus but with some changes. The king's head is held by two Israelite soldiers instead of one. The foremost soldier does not face Joshua as in both preceding instances, but is more interested in the captured king. Joshua sits more erectly on a cylindrical marble seat.

Located below Joshua 9:2.

1241a. Sm., fol. 226v

Close to Ser., but because the text cut deeply into the picture area, the whole composition had to be condensed and the group of soldiers in front of Joshua was reduced to nearly half its original size.

1242a. Vat. 746, fol. 451r

Very close to Ser. The heads of Joshua, the soldiers behind him, and the lower part of the captured king are badly flaked.

Located beside Joshua 9:2.

1243a. Vtp., fol. 360v

The miniature agrees with those of Ser. and Vat. 746 in the introduction of a second warrior holding the captured king by the hair, but the prisoner seen from the back and the lance leaning against Joshua's shoulder were taken from the Rotulus. The hindmost soldier, who holds the prisoner with his left hand, raises his right as if he intends to strike him. The foremost soldier, moreover, raises his hand toward Joshua in a gesture of

speech, perhaps reporting the victory or announcing the king's capture. The leader of the Jews sits on a pearl-studded throne of solid gold, and the soldier's armor is modernized. The miniature is very badly flaked, particularly the right-hand group of soldiers with the prisoner, and practically the entire background is destroyed.

Located above Joshua 9:1.

Lit.: Strzygowski, *Sm.*, pp. 118ff.; *RG*, p. 30, pls. E no. 1, M no. 1; Uspenskii, p. 164, fig. 244; Hesseling, fig. 282; Weitzmann, *JR*, pp. 24, 83, figs. 35, 36, 88; Tselos, "Joshua Roll," pp. 288ff., figs. 28, 29; Morey, "Castelseprio," pp. 177–79, fig. 2; Huber, fig. 85; Kresten, "Hinrichtung," figs. 5–8; Θησαυροί, p. 271, fig. 113; Lowden, *Octs.*, p. 62, figs. 89, 90.

Lit. on Vat. Rot.: Seroux d'Agincourt, *Histoire*, vol. 3, p. 36, and vol. 5, pl. 28 no. 15; Garrucci, *Storia*, pl. 164 nos. 1, 2; *RG*, p. 30, pls. 11, 11a; Morey, "Notes," pp. 16, 47–48, fig. 17; Kömstedt, *Vormittelalterl. Malerei*, pp. 36–37, figs. 114, 117; Weitzmann, *Byzantin. Buchmalerei*, p. 45, fig. 301; Cecchelli, *Cattedra*, fig. p. 127; Morey, *Early Christian Art*, pp. 69–70, 72, 270, fig. 59; Lazarev, *Istoriia*, fig. 100; Weitzmann, *JR*, pp. 24, 63, 83, figs. 34, 89; Tselos, "Joshua Roll," pp. 287ff., fig. 25; Morey, "Castelseprio," pp. 177–79, fig. 1; Volbach and Lafontaine-Dosogne, *Byzanz*, p. 1845, pl. 55; *J.-R.*, pp. 30, 33, 35, 51, 63, 67ff.; Kresten, "Hinrichtung," fig. 1.

Joshua 8:24

Slaying of the Men of Ai

1232a. Vat. 747, fol. 223v

The killing of the inhabitants of Ai "with the edge of the sword" should be represented in the left half of a friezelike miniature which is clearly divided by a mountain peak to accommodate two separate episodes. Instead, a single prisoner is being brought before Joshua and is about to be decapitated. With his bodyguard behind him, Joshua stands and faces the army that brought the prisoner. Nearly all the heads are overpainted, showing the wide-open eyes and the loose hair that are the trademarks of the restorer; and Joshua's nimbus, which is otherwise gold in this manuscript, is repainted in blue. However, the depiction of Joshua wearing a helmet while the soldiers are bareheaded is a feature preserved from the original. Parts of the ground and sky are flaked.

Located above Joshua 9:1.

1233b. Vat. Rot., sheet XI

Whereas Vat. 747 correctly represents an inhabitant of Ai, the Rotulus replaces the captive with the king of Ai, repeated in mirror image from the king with his captor from the scene below (fig. 1239). A group of Israelite soldiers is introduced, and some of the men are represented in postures of attack, a feature with no meaning in the context of the leading away of the captured king.

1234a. Ser., fol. 487r

Joshua stands between the two Israelite armies as in Vat. 747, but instead of a single prisoner being killed, two more are shown

lying on the ground in anticipation of meeting the same fate as their slain comrade. Around them lie the lances that they have thrown away.

Located above Joshua 9:1.

1235a. Sm., fol. 226v

Very close to Ser.
Located below Joshua 9:1.

1236a. Vat. 746, fol. 451r

Close to Ser. and Sm.
Located beside Joshua 9:2.

1237a. Vtp., fol. 360v

The painter follows the version of Ser., Sm., and Vat. 746. The Israelite who kills the foremost prisoner is depicted standing instead of kneeling, but his height is not increased correspondingly and thus he appears to be a dwarf compared with the rest of the army. His right arm is held across his breast in a gesture suggesting that he is drawing his sword from its sheath, following Joshua's order to kill the captive. All three captured soldiers of Ai are bleeding heavily from wounds on their breast or shoulder. The victim at the extreme right has been pierced by the lance of the hindmost Israelite, who also holds a sword horizontally in his left hand. The attitudes of most of the Israelite soldiers are somewhat changed, especially the one in front of Joshua who holds a shield and a lance to which a pennant with a cross is attached.

Located beside Joshua 9:1.

Lit.: Strzygowski, *Sm.*, pp. 118ff.; *RG*, p. 30, pl. D. no. 5; Uspenskii, p. 164, fig. 243; Hesseling, fig. 281; Alpatov, "Rapport," p. 305 n. 1; Weitzmann, *JR*, pp. 22–24, 57, fig. 33; Tselos, "Joshua Roll," pp. 287ff., figs. 26, 27; Huber, p. 38, fig. 84; *J.-R.*, pp. 62–63; Θησαυροί, p. 271, fig. 113; Lowden, *Octs.*, p. 62, figs. 89, 90.

Lit. on Vat. Rot.: Seroux d'Agincourt, *Histoire*, vol. 3, p. 36, and vol. 5, pl. 28 no. 15; Garrucci, *Storia*, pl. 164 nos. 1, 2; *RG*, p. 30, pls. 11, 11a; Alpatov, "Rapport," p. 305 n. 1; Weitzmann, *JR*, pp. 23–24, fig. 34; Morey, *Early Christian Art*, pp. 69, 270, fig. 59; *J.-R.*, pp. 30, 33, 35, 50, 62–63, 70f.; Kresten, "Hinrichtung," fig. 13.

Joshua 8:28

Ai Set Afire

1232b. Vat. 747, fol. 223v

Two Israelite soldiers set the walled city on fire with torches, at the same time protecting themselves with their shields against two soldiers of Ai who defend their city with a spear and bow from above the crenelations of the wall. The bulk of the Israelite army emerges from behind the steep mountain which separates this scene from the preceding one, ready to storm the city with lowered lances. The surface is slightly flaked.

Located above Joshua 9:1.

1233a. Vat. Rot., sheet XI

The Rotulus used the illustration of the burning of Ai for the burning of Jericho (fig. 1187). This explains its omission in the present context. However, a residue of the original composition, as it is preserved in Vat. 747, remained more or less in its original place, namely, the group of attacking Israelites. Isolated attacking soldiers without the object of their assault make little sense, and so the painter combined them with the dragging away of the king of Ai as if they were accompanying him to the place of his execution.

1234b. Ser., fol. 487r

The original composition of the burning of the city of Ai has been abbreviated by the omission of the group of attacking Israelites. The torches in the raised hands of two soldiers approaching the city were omitted, so that not only their gestures, but also the content of the whole scene has become obscure. The attempt to give a new meaning to the gesture of the soldier on the left by having him hold the jamb of a door is unfortunate. In his lowered right hand this same soldier holds a lowered lance and thus in addition to burning he assumes the function of attacking the city, a task which in Vat. 747 is assigned to a whole army following him. The wall, a tower, and a house are already tumbling down, but no defenders are visible within the beleaguered city. The mountain which in Vat. 747 divides this scene from the preceding one is dropped, apparently with the intention of combining the burning of the city and the killing of the captives into a simultaneous and coherent event.

Located above Joshua 9:1.

1235b. Sm., fol. 226v

Very close to Ser. and with the same misunderstandings. The soldier on the left holds his lance more upright.

Located below Joshua 9:1.

1236b. Vat. 746, fol. 451r

Closer to Ser. than to Sm.
Located beside Joshua 9:2.

1237b. Vtp., fol. 360v

Close to Ser., Sm., and Vat. 746. More in agreement with their original function, the two soldiers hold torches in either hand in the same manner as the Israelites in the Rotulus who set fire to the city of Jericho (fig. 1187). The city of Ai is slightly changed, and a tower and a house tumble down outside it instead of inside. The surface is badly flaked.

Located beside Joshua 9:1.

Lit.: Strzygowski, *Sm.*, pp. 118ff.; *RG*, p. 30, pl. D no. 5; Uspenskii, p. 164, figs. 242, 243; Hesseling, fig. 281; Weitzmann, *JR*, pp. 23, 108, fig. 33; Tselos, "Joshua Roll," pp. 287ff., figs. 26, 27; Morey, "Castelseprio," pp. 177–79, fig. 4; Huber, fig. 84; Θησαυροί, p. 271, fig. 113; Lowden, *Octs.*, p. 62, figs. 89, 90.

Lit. on Vat. Rot.: Seroux d'Agincourt, *Histoire,* vol. 3, p. 36, and vol. 5, pl. 28 no. 15; Garrucci, *Storia,* pl. 164 nos. 1, 2; *RG,* p. 30, pls. 11, 11a; Weitzmann, *JR,* pp. 23, 108, fig. 34; Morey, *Early Christian Art,* pp. 69, 270, fig. 59.

Joshua 8:29

HANGING OF THE KING OF AI

Both the execution of the king of Ai in this miniature ("and he [Joshua] hanged the king of Ai on a gallows") and that of the five kings at Joshua 10:26 (figs. 1283–1287: "And Joshua slew them, and hanged them on five trees") follow the prescriptions decreed in Deuteronomy 21:22–23 ("and he [the sinner] be put to death, and ye hang him on a tree"). In both cases, the condemned kings hang on a *furca,* a fork-shaped stake. In the Octateuchs, but not in the Rotulus, the executioner of the king of Ai climbs a ladder in order to hammer a stick behind the king's neck. The condemned's arms are tied behind his back, implying that he was actually executed by hanging on the *furca,* and was not hanged when already dead.[1] In contrast, in the execution of the five kings, only Vat. 747 (fig. 1283) depicts the condemned men with their arms tied; in the Rotulus and the other Octateuchs (figs. 1284–1287) the condemneds' arms dangle down untied, suggesting the corpses of men previously executed, thus precisely following the description of the event in Joshua 10:26, where Joshua is said to slay them before hanging.[2] The Greek expression for "hanging" used in Deuteronomy 21 (κρέμαμαι ἐπὶ ξύλου) is also found in the execution of Pharaoh's chief baker (Gen 40:19; figs. 496–502); but there the execution is interpreted differently, and the condemned man is crucified.[3] The use of the fork as a means of execution seems to have replaced the cross toward the last quarter of the fifth century, a period which should be taken as a *terminus post quem* for the creation of the iconography of the execution in the Book of Joshua.[4]

1238b. Vat. 747, fol. 223v

The king of Ai, with his arms fettered behind his back, hangs on a fork-shaped stake. An executioner has climbed up on a ladder leaning against the stake and with a hammer is wedging what looks like a stick with a curved end between the fork and the king's head so as to squeeze the neck in a tight triangle. Parts of the ground are flaked.

Located beside Joshua 9:2.

1239b. Vat. Rot., sheet XI

The king is suspended on the *furca* in the same way as in Vat. 747. Unlike all the Octateuchs, however, the executioner stands on the ground in a pose which at first appears incomprehensible:[5] he was probably intended to be pulling the cross-stick behind the king's neck with a rope, which the painter erroneously omitted.[6]

1240b. Ser., fol. 487r

Close to Vat. 747. Only the manner of wedging the stick is slightly different in the various copies: in Ser. the executioner holds the stick with one hand as if he were driving it horizontally through his victim's eye.

Located below Joshua 9:2.

1241b. Sm., fol. 226v

Close to Ser. Here, however, blood drips gruesomely from the victim's eye.

1242b. Vat. 746, fol. 451r

Close to Ser. and Sm. The executioner is apparently wedging the stick behind the victim's neck.

Located beside Joshua 9:2.

1243b. Vtp., fol. 360v

In spite of the miniature's very bad condition, we can still recognize that the executioner used his left hand to hold not the ladder, but the stick. As in Vat. 747, the executioner is not driving the stick through the victim's head, but hammering it behind the king's neck from above; but while in Vat. 747 the stick is still above the head, in Vtp. it is in its final position. The upper part of the victim's body and the background are nearly completely flaked, and the figure of the executioner is also partly damaged.

Located beside Joshua 9:1.

Lit.: Strzygowski, *Sm.,* pp. 118ff.; *RG,* p. 30, pls. E no. 1, M no. 1; Uspenskii, p. 164, fig. 244; Franchi de' Cavalieri, "Furca," pp. 90, 100–101; Hesseling, fig. 282; Weitzmann, *JR,* pp. 24–25, 109, figs. 35, 36; Tselos, "Joshua Roll," pp. 288ff., figs. 28, 29; Kollwitz, "Josuazyklus," p. 108; Huber, fig. 85; *J.-R.,* p. 63; Kresten, "Hinrichtung," pp. 114ff., figs. 5–8; Θησαυροί, p. 271, fig. 113; Lowden, *Octs.,* p. 62, figs. 89, 90.

Lit. on Vat. Rot.: Seroux d'Agincourt, *Histoire,* vol. 3, p. 36, and vol. 5, pl. 28 no. 15; Garrucci, *Storia,* pl. 164 nos. 1, 2; Strzygowski, *Sm.,* pp. 120–22, 126; *RG,* pp. 30, 109, pls. 11, 11a; Franchi de' Cavalieri, "Furca," pp. 90, 100–101; Morey, "Notes," pp. 16, 47–48, fig. 17; Kömstedt, *Vormittelalterl. Malerei,* pp. 36–37, fig. 114; Weitzmann, *Byzantin. Buchmalerei,* p. 45, fig. 301; Cecchelli, *Cattedra,* fig. p. 127; Morey, *Early Christian Art,* pp. 69–70, 72, 270, fig. 59; Lazarev, *Istoriia,* fig. 100; Weitzmann, *JR,* pp. 24–25, 40–41, 56, figs. 34, 50; Tselos, "Joshua Roll," pp. 288ff., fig. 25; Morey, "Castelseprio," pp. 177–79, fig. 1; Kollwitz, "Josuazyklus," p. 108; Volbach and Lafontaine-Dosogne, *Byzanz,* p. 1845, pl. 55; Schapiro, *Words,* p. 28 n. 59; *J.-R.,* pp. 30, 33, 35, 51, 63, 67ff.; Kresten, "Hinrichtung," pp. 111ff., fig. 1; Speck, "Tod an der Furca," pp. 349–50; Lowden, *Octs.,* fig. 172; Speck, "Quelle," pp. 84–85; Dinkler-von Schubert, "Nomen ipsum crucis absit," p. 136, pl. 1.

[1] The same type of execution is shown in the Vienna Genesis, pict. 34 (Gerstinger, *Wiener Gen.,* pict. 34).

[2] A similar representation of a hanging on the fork with the arms of two condemned men dangling down untied may be seen in the miniature illustrating Ps 82:12 in cod. Vat. gr. 1927, fol. 153r, a Psalter from the first half of the twelfth century (De Wald, *Vat. Gr. 1927,* pl. 35).

[3] Cf. *TDNT,* vol. 3, pp. 915–21, esp. p. 917; and vol. 5, pp. 37–41.

[4] Franchi de' Cavalieri, "Furca," pp. 90, 114; Morey, "Notes," p. 47.

[5] The suggestion of the editor of the Vatican facsimile (*RG*, p. 30) that the executioner was originally holding a ladder cannot be accepted. Cf. Kresten, "Hinrichtung," pp. 111ff.

[6] Or possibly to raise the sentenced king above the stake on a rope. Both procedures are depicted with more clarity in two miniatures in the manuscript of the chronicle of John Skylitzes in Madrid (Bibl. Nac., cod. vitr. 26–2) on fol. 41r, showing the Arabs executing the Byzantine strategos Krateros (here the same Greek terms as in the Septuagint are used to describe the execution; cf. *Ioannis Scylitzae synopsis historiarum*, editio princeps, ed. J. Thurn [Berlin and New York, 1973], p. 45, lines 27–28), and fol. 135r, the execution of Prince Volosodes (cf. A. Grabar and M. Manoussacas, *L'illustration du manuscrit de Skylitzès de la Bibliothèque Nationale de Madrid* [Venice, 1979], fig. 165, colorpl. 28). See also Kresten, "Hinrichtung," pp. 111ff.; Speck, "Tod an der Furca," pp. 349–50; and Speck, "Quelle" pp. 83–85, where the execution is exhaustively discussed.

Joshua 8:30–31

JOSHUA PRAYS TO GOD ON MOUNT EBAL

1244. Vat. 747, fol. 223v

Clad in full armor and wearing a helmet, Joshua stands with his hands raised in front of an altar on which an offering is burning. The altar has the form of a pillar with a base and a molding at its top. Such a shape is contrary to the text, which explicitly states that the altar was "of uneven stones on which iron had not been lifted up," but the artist apparently preferred to use a more conventional form. Behind Joshua stands the Israelite army partly hidden by a steep mountain, except for one soldier who is fully visible in the foreground. Large parts of the sky and the ground are flaked, as are small spots on the figures.

Located beside Joshua 9:2.

1245. Vat. Rot., sheet XI

Bareheaded and bowing slightly, Joshua looks up at God's hand, a feature not in conformity with the text. All the soldiers are overlapped by a precipitous slope. A slit window added to the pillarlike altar confuses the altar's original form and meaning. The youthful personification of Mount Ebal lies in a leisurely attitude high above the scene. Alongside the altar is the usual scene-dividing structure formed of cubes, and above it is a circular building with slit windows and an overhanging conical roof crowned by a pinecone.

1246. Ser., fol. 487v

Joshua stands upright, his chlamys falling down his back, and the soldiers behind him stand partly in the foreground and partly overlapped by a mountain slope. In all these features Ser. follows the same tradition as Vat. 747, although the grouping of the soldiers behind Joshua is slightly different. The bareheaded Joshua and the warriors with helmets depend upon the Rotulus. Furthermore, the altar is built of bricks instead of stones and includes not one but two slit windows and an additional round opening through all of which flames from the burnt offering are

escaping. The circular building is transformed into a regular marble column surmounted by a conical tile roof. The mountain god is completely misunderstood, reduced to a bust and holding a lance in his hand. Thus, probably unwittingly, the painter creates the impression that Joshua is praying to a martial god.

Located beside Joshua 9:2.

1247. Sm., fol. 226v

Very close to Ser. As can be seen even in the reproduction, the miniature, and in particular Joshua's head, has been crudely overpainted.

1248. Vat. 746, fol. 451r

Close to Ser. and Sm. The figures of the soldiers are partly flaked and rubbed.

Located beside Joshua 9:2.

1249. Vtp., fol. 361r

Close to Ser., Sm., and Vat. 746. However, the personification and the columnar monument are entirely dropped and the pillarlike altar is replaced by an altar table housed within a small semicircular temple at the right.[1] The structure, comprising two terraced stories with slit windows, rises above a wall in the form of a horseshoe. A large flame bursts forth from the top of this temple, while more flames escape through the slits. The background and the architecture are very badly damaged by flaking, while the human figures are comparatively well preserved.

Located beside Joshua 9:2.

Lit.: Strzygowski, *Sm.*, pp. 118ff.; *RG*, p. 31, pl. E no. 2; Uspenskii, pp. 164–66, fig. 245; Hesseling, fig. 283; Weitzmann, *JR*, p. 25; Buchthal, *Historia Troiana*, pp. 26, 51 n. 1; Huber, fig. 86; Θησαυροί, p. 271, fig. 114; Lowden, *Octs.*, pp. 62, 111, figs. 89, 90, 161, 162.

Lit. on Vat. Rot.: Seroux d'Agincourt, *Histoire*, vol. 3, pp. 36–37, and vol. 5, pl. 28 no. 16; Piper, *Mythologie*, vol. 2, pp. 477–78; Piper, "Bilderkreis," p. 151; Garrucci, *Storia*, pl. 164 no. 2; Kondakov, *Istoriia*, p. 58; Kondakov, *Tablits*, pl. 2 no. 1; Kondakov, *Histoire*, vol. 1, pp. 96–98; Uvarov, *Album*, pl. 1 no. 3; Graeven, "Rotulo," p. 224, pl. 3a; *RG*, p. 31, pls. 11, 11a; Uspenskii, pp. 165–66; Morey, "Notes," pp. 16, 47–48, fig. 17; Kömstedt, *Vormittelalterl. Malerei*, pp. 36–37, fig. 115; Benson and Tselos, "Utrecht Ps.," p. 58, fig. 81; Morey, "Byzantine Renaissance," p. 158, pl. 8; Morey, *Early Christian Art*, pp. 69–70, 72, 270, fig. 59; Lazarev, *Istoriia*, fig. 100; Bognetti et al., *Castelseprio*, pl. 86b; Weitzmann, *JR*, pp. 25, 60, 70, 77, 81, figs. 34, 61; Buchthal, *Historia Troiana*, p. 26; Volbach and Lafontaine-Dosogne, *Byzanz*, p. 1845, pl. 55; *J.-R.*, pp. 30, 33, 35–36, 51, 63, 67ff.

[1] Cf. Buchthal, *Historia Troiana*, pp. 26, 51 n. 1.

Joshua 9:3–5

GIBEONITES ON THEIR MARCH TO JOSHUA

1250. Vat. 747, fol. 224r

Four youthful inhabitants of Gibeon (LXX: Gabaon) are depicted on their way to the camp at Gilgal in order to deceive

Joshua. They are clad in short tunics, and the foremost carries a mantle slung around his breast, holding its end in his left hand. Apparently he is meant to be their leader, since he is the only one not carrying a burden; pointing in the direction of a mountain, he looks back at the other three figures as if encouraging his tired companions to continue their journey. With the aid of a rope, the man next to him carries a sack over his shoulder, probably containing the provisions of dry and moldy bread. The third man has a staff with an oval object wound around it; from the other manuscripts (cf. figs. 1252–1255) it can be understood as his mantle. He looks back at the fourth Gibeonite who carries a wine skin. Thus all the attributes mentioned in the text are faithfully depicted.

Located beside Joshua 9:16.

1251. Vat. Rot., sheet XI

The youthful Gibeonites have shrunk to half their normal size and their number is reduced from four to two. One of them walks with the aid of a staff, while the other carries his staff over his shoulder. Both are burdened with sacks around their necks, the only one of the attributes, described in the text with such care, to be depicted here.

1252. Ser., fol. 488r

Close to Vat. 747 but certain details are altered. The first Gibeonite holds a piece of garment in his hand and over the same arm another ragged object, which from the parallel illustrations can be interpreted as worn-out shoes. The second holds a sack over his right shoulder which, in contrast to Vat. 747, is apparently empty. The third carries what originally was meant to be a mantle over his staff, but presumably is misunderstood here as a loaf of dry bread, and with his left hand he grasps at his aching leg. In full agreement with Vat. 747, the fourth is unbearded and carries a wine skin. The great realism of this scene is emphasized by such details as the worn puttees from which toes and sometimes even an entire foot protrude. The mountain in front of the four men is planted with trees. The ground is slightly flaked in the center.

Located beside Joshua 9:15.

1253. Sm., fol. 228r

Very close to Ser. However, the attribute slung over the arm of the first Gibeonite is more clearly characterized as a pair of shoes. Faces and drapery show the marks of a later restorer.

1254. Vat. 746, fol. 452r

Close to Ser. and Sm.
Located beside Joshua 9:16.

1255. Vtp., fol. 362v

The miniature is very badly flaked, but enough remains to ascertain that all four men agree thoroughly with Ser., Sm., and

Vat. 746. The figure of the foremost Gibeonite, for instance, is almost devoid of paint, but the preliminary drawing is visible, revealing his original attitude.

Located beside Joshua 9:17.

Lit.: Strzygowski, *Sm.*, pp. 118ff.; *RG*, p. 31, pl. E no. 3; Uspenskii, p. 166, fig. 246; Hesseling, fig. 286; Weitzmann, *JR*, pp. 25–27, 109, figs. 38, 39; Kollwitz, "Josuazyklus," p. 107; Huber, fig. 87; Weitzmann, "Classical Mode," p. 73; *J.-R.*, pp. 63–64; Lowden, *Octs.*, p. 114, fig. 173.

Lit. on Vat. Rot.: Seroux d'Agincourt, *Histoire*, vol. 3, pp. 36–37, and vol. 5, pl. 28 no. 16; Garrucci, *Storia*, pl. 164 no. 2; Graeven, "Rotulo," p. 229, pl. 7a; *RG*, p. 31, pls. 11, 11a; Artelt, *Dialogdarstellung*, p. 40; Morey, *Early Christian Art*, pp. 70, 72, fig. 59; Weitzmann, *JR*, pp. 26, 109, fig. 34; *J.-R.*, pp. 31, 33, 36, 51, 63–64, 67ff.

Joshua 9:6–13

Gibeonites before Joshua

1256. Vat. 747, fol. 224r

The four Gibeonites approach Joshua in devout attitudes, prominently displaying their attributes as proof of their long journey. With a deep bow, the first one offers dried and moldy loaves in his kerchief-covered hands. The second holds an oval object, which in the preceding scene was interpreted as a mantle; this attribute, however, resembles a huge loaf of bread and its yellow-brown color supports this identification. This would then be a repetition of the attribute carried by the first man, and thus it seems that the painter himself became uncertain about its original meaning. The third Gibeonite is burdened with the heavy wine skin, and the fourth, in agreement with the foremost figure of the preceding scene (fig. 1250), has no attribute at all. Joshua, in full armor and flanked by his bareheaded bodyguard, is represented enthroned, with a lance in his left hand and extending his right toward the emissaries in an inviting gesture. The miniature is flaked in various places.

Located beside Joshua 9:22.

1257. Vat. Rot., sheets XII and XIII

As in the preceding scene of the Rotulus, the number of Gibeonites is reduced to two, but while in the former they at least carry sacks around their necks, in this scene they do not carry a single object. The emissaries bow respectfully and merely extend their hands in a gesture of supplication; the hands of the emissary in the foreground are covered by his mantle. The group of soldiers is considerably larger than in the other manuscripts. On the mountain is the nude personification of Mount Ebal with a cornucopia.

1258. Ser., fol. 488v

Close to Vat. 747, although the distribution of the attributes is somewhat different. As in the preceding miniature of this manuscript (fig. 1253), the first Gibeonite displays a piece of garment and his shoes, and the second an oval object, which in this instance is undoubtedly not a mantle but a loaf of bread. The

mantle, which could not be omitted, is allocated to the third man, who carries it over his shouldered staff. Only the youthful fourth man, heavily burdened with the wine skin, agrees completely with Vat. 747 as far as his attribute is concerned. The group comprising Joshua and his bodyguard is chiefly dependent on the Rotulus. The surface of the miniature is slightly flaked in various spots.

Located beside Joshua 9:22.

1259. Sm., fol. 228r or 228v[1]

Close to Ser. but the first Gibeonite seems to hold an oval object and the second a basket. However, the whole scene was apparently very crudely overpainted, as can be seen clearly in Joshua's head; thus the change in attributes is probably due to a misunderstanding on the part of the restorer.

1260. Vat. 746, fol. 452r

This miniature is also overpainted, particularly the figures of the Gibeonites, but the restorer apparently remained faithful to the original model, since every detail is in close agreement with the well-preserved miniature of Ser.

Located beside Joshua 9:22.

1261. Vtp., fol. 363r

The figures of the four Gibeonites are almost completely flaked, but again the preliminary drawing provides sufficient evidence that the posture and attribute of each agree thoroughly with Ser. and Vat. 746. On the other hand, renewed influence from the Rotulus may be seen in Joshua's gesture of speech, which has a parallel only there and in none of the other Octateuchs. The bodyguard behind Joshua agrees generally with Vat. 747, but the painter of Vtp., on his own initiative, enlarged the group by one soldier, who stands in front of Joshua and holds his sword high in a strange manner, its hilt touching the upper border line. The painter forgot to place a lance in the left hand of Joshua, who sits on a solid gold, jewel-studded throne.

Located beside Joshua 9:21.

Lit.: Strzygowski, *Sm.*, pp. 118ff.; *RG*, p. 31, pl. E no. 4; Uspenskii, p. 166, fig. 247; Hesseling, fig. 287; Alpatov, "Rapport," p. 304 n. 3; Weitzmann, *RaC*, pp. 172–73, fig. 169; Weitzmann, *JR*, pp. 26–27, 109, figs. 39, 40; Weitzmann, "Septuagint," p. 67; Kollwitz, "Josuazyklus," p. 107; Huber, fig. 88; Weitzmann, "Classical Mode," p. 73; *J.-R.*, p. 64; Θησαυροί, p. 271, fig. 115; Lowden, *Octs.*, pp. 17, 114, fig. 174.

Lit. on Vat. Rot.: Seroux d'Agincourt, *Histoire*, vol. 3, p. 37, and vol. 5, pl. 28 no. 17; Garrucci, *Storia*, pls. 164 no. 2, 165; Kondakov, *Istoriia*, p. 58; Kondakov, *Tablits*, pl. 2 no. 2; Kondakov, *Histoire*, vol. 1, pp. 97–98; Graeven, "Antike Vorlagen," pp. 4–7, fig. p. 7; Graeven, "Rotulo," pp. 229–30, pl. 7a; Graeven, "Typen," p. 97, fig. 6; Lowrie, *Monuments*, p. 333, fig. 145; Venturi, *Storia*, vol. 1, fig. 150; *RG*, p. 32, pls. 11, 11a, 12; Alpatov, "Rapport," p. 304 n. 3; Kömstedt, *Vormittelalterl. Malerei*, pp. 36–37, fig. 116; Artelt, *Dialogdarstellung*, p. 40; Lowrie, *Art*, p. 210, pl. 147c; Weitzmann, *RaC*, pp. 172–73, fig. 171; Lazarev, *Istoriia*, pl. 19; Weitzmann, *JR*, pp. 26, 55–56, 70, 109, fig. 37; Schapiro, "Place," p. 164, fig. 4a; Weitzmann, "Septuagint," p. 67; Rice, *Beginnings*, pp. 100–101, fig. 15b; Beckwith, *Veroli Casket*, p. 3, fig. 3; Kollwitz, "Josuazyklus," p. 107;

Lassus, *Early Christian World*, p. 81, fig. 54; Volbach and Lafontaine-Dosogne, *Byzanz*, p. 1845, pl. 55; Havice, "Hamilton Ps.," p. 268; Weitzmann, "Classical Mode," p. 73, fig. 7; *J.-R.*, pp. 31, 33, 36, 51, 64; Lowden, *Octs.*, p. 114, fig. 172.

[1] Fol. 228v according to Hesseling, p. xv; fol. 228r according to Strzygowski, *Sm.*, p. 118, and Uspenskii, p. 188.

Joshua 10:6

GIBEONITES SUPPLICATE JOSHUA FOR HELP

1262. Vat. 747, fol. 224v

Two Gibeonites kneel before Joshua and raise their folded hands in supplication, asking for help against the kings of the Amorites. Joshua sits on a faldstool in frontal view, with a lance in his left hand and his right extended toward the emissaries in a gesture that seems to communicate that their request has been granted. As usual, a bareheaded bodyguard stands behind the Israelite leader. A steep mountain rises behind the Gibeonites. The surface is slightly damaged.

Located beside Joshua 10:1.

1263. Vat. Rot., sheet XII

The two Gibeonites kneel in front of Joshua almost in proskynesis; one of them has his hands covered by his mantle, as in the preceding scene (fig. 1257). Joshua is bareheaded and sits on a solid marble throne.

1264. Ser., fol. 489r

The figures of Joshua and the two Gibeonites agree with the Rotulus, whereas the group of soldiers is closer to Vat. 747. The soldiers are flaked in various spots.

Located beside Joshua 10:1.

1265. Sm., fol. 288v

Very close to Ser.

1266. Vat. 746, fol. 452v

Close to Ser. and Sm.
Located beside Joshua 10:1.

1267. Vtp., fol. 364r

In the group of soldiers behind Joshua the painter tried to depict at least the foremost from the back, but did not succeed very well, and the result is a mixture of frontal and back views. Joshua sits on a solid gold, jewel-studded throne. The background is completely flaked and the two Gibeonites are very badly damaged, but enough of them is left to ascertain that they approached Joshua with their hands covered by their mantles.

Located beside Joshua 10:1.

Lit.: Strzygowski, *Sm.*, pp. 118ff.; *RG*, p. 32, pl. E no. 5; Uspenskii, p. 167, fig. 248; Hesseling, fig. 288; Weitzmann, *RaC*, pp. 172–73, fig. 170; Weitzmann, *JR*, pp. 26–27, 109, fig. 41; Kollwitz, "Josuazyklus," p. 107; Henderson, "Joshua Cycle," pp. 55–56; Huber, fig. 89; Havice, "Marginal Miniatures," p. 133 n. 261; Weitzmann, "Classical Mode," p. 73; *J.-R.*, p. 64; Θησαυροί, p. 271, fig. 116; Lowden, *Octs.*, p. 114, fig. 175.

Lit. on Vat. Rot.: Seroux d'Agincourt, *Histoire*, vol. 3, p. 37, and vol. 5, pl. 28 no. 18; Garrucci, *Storia*, pls. 164 no. 2, 165; Graeven, "Antike Vorlagen," pp. 4–7, fig. p. 7; Graeven, "Rotulo," pp. 229–30, pl. 7a; Graeven, "Typen," p. 97, fig. 6; Lowrie, *Monuments*, p. 333, fig. 145; *RG*, p. 32, pl. 12; Kömstedt, *Vormittelalterl. Malerei*, pp. 36–37, fig. 116; Artelt, *Dialogdarstellung*, p. 40; Lowrie, *Art*, p. 210, pl. 147; Weitzmann, *RaC*, pp. 171–72, fig. 171; Lazarev, *Istoriia*, pl. 19; Schapiro, "Place," p. 164, fig. 4a; Weitzmann, *JR*, pp. 26, 55, 109, fig. 37; Rice, *Beginnings*, pp. 100–101, fig. 15b; Kollwitz, "Josuazyklus," p. 107; Lassus, *Early Christian World*, p. 81, fig. 54; Henderson, "Joshua Cycle," pp. 55–56; Weitzmann, "Classical Mode," p. 73, fig. 7; *J.-R.*, pp. 31, 33, 36, 51, 64, 70f.; Lowden, *Octs.*, p. 114, fig. 172.

Joshua 10:10–13

Defeat of the Amorites

1268. Vat. 747, fol. 225r

The great cavalry battle of the Israelites against the Amorites is subdivided into two engagements: in the first, the enemy is being defeated by Israelite horsemen, and in the second a storm of hailstones assists in the annihilation. From left to right: first, two squadrons of Israelites armed with bows and lances attack and kill a group of three Amorites. The first victim has been pierced in the back with a lance and falls over his horse, the second struggles to remain in the saddle, and the third, mortally wounded, crawls along on the ground while his horse lies dead on its back. In the meantime another part of the Israelite cavalry with lances lowered pursues the fleeing Amorites, who are also being hit by hailstones coming from a segment of heaven. Three more dead Amorites lie on the ground between the attacking and fleeing horsemen: the first, bleeding heavily, on his back, the second on his wounded horse, and the third on his shield. The center of the composition is occupied by a larger than life-size figure of Joshua. High up on the mountain above the battlefield, he strides forward with a wide step; fully equipped with shield and lance, he turns his head and extends his arm toward the sun and the moon, which he orders to stand still over Gibeon and the valley of Ajalon. The sun is depicted as a face seen frontally without bundles of rays; the moon is nearly destroyed. Sun and moon are united in a segment of heaven. The locality is indicated by the city of Gibeon, which is shown as a mere ringwall with a gate but with no houses inside. The entire surface of the miniature is flaked in spots, except for the uppermost strip of sky, which, except for the two segments of heaven, is painted solidly in gold.

Located beside Joshua 10:13.

1269. Vat. Rot., sheet XIII

Close to Vat. 747 but with many differences in detail. Cavalry troops are employed by both sides only in pursuit, whereas the actual battle is fought by infantry, and a great realism and sense of drama are apparent in all of the combat groups. Joshua is close to Vat. 747: he wears a helmet with a high crest and stretches his hand toward the sun and the moon, placed separately on either side of the city of Gibeon. No faces are painted in the sun and moon disks. The city of Gibeon, a number of buildings enclosed within its towered walls, is situated on the slope of a mountain which belongs to the previous scene (fig. 1263). Below it, the personification of the city sits on a stone seat, wearing a mural crown on her nimbed head and holding a long scepter in one hand.[1]

1270. Ser., fol. 490r

Close to the Rotulus in many details. In the infantry battle, two combat groups are similar to those in the Rotulus: one consists of the Israelite raising his sword to decapitate his helpless adversary, and the other of the Israelite piercing a kneeling enemy with raised hand. However, in the first group the defeated Amorite does not touch the Israelite's leg in a gesture of supplication, as he does in the Rotulus, but rather leans with both arms on another prostrate victim; in the second group the enemy is seen from the front instead of the back, and he is being transfixed by a lance from above. In front of these two combat groups is a third in which an Israelite pierces a prostrate enemy through the back with a lowered lance. This group does not exist in the Rotulus, but it may very well have been excerpted from a model like Vat. 747, where a rider is depicted in the same place piercing his prostrate enemy through the back in a very similar fashion. As for the rest, the slain Amorites occupy the entire foreground up to the right border line and are represented in various positions, most of which have no exact parallel. In the scene of pursuit, the Israelite horsemen are in contact with their enemies, just as in the Rotulus, but they have not yet succeeded in throwing a single enemy out of his saddle, although some of them, particularly the foremost rider holding his hands crossed behind his back, seem at least to have been hit. Apparently due to lack of space, the Amorite cavalry is cut in half by the border line. Moreover, the hailstorm, and consequently the motif of shields used as protection against it, are both completely omitted. The position of Joshua and the heads of sun and moon are as in Vat. 747. The walled city of Gibeon with its various buildings is again closer to the Rotulus, but this time it appears on the other slope of the mountain, which properly belongs to the scene. The city personification is reduced in size, greatly simplified, and quite clumsy compared with the one in the Rotulus. She sits on the ground without a scepter and holds her knee with her right hand in a meaningless gesture. The crown is badly placed on her head, which is no longer nimbed.

Located beside Joshua 10:12.

Sm., fol. 229r

According to Uspenskii[2] a miniature with Joshua defeating the Amorites "very weakly depicted" existed on fol. 229r. Hesseling does not reproduce this miniature.

1271. Vat. 746, fol. 453r

Very close to Ser. The Israelite soldier at the extreme left does not pierce the enemy directly before him, but rather, with a lance of exaggerated length transfixes the soldier who lies between two shields beneath Joshua. A second soldier, standing behind the one wielding a sword, transfixes the foremost victim crawling on the ground. The surface is slightly flaked in a few places.

Located beside Joshua 10:12.

1272. Vtp., fol. 365r

The surface of this miniature is heavily stained, badly flaked, and, having been overpainted, has now flaked again. As a result of this damage certain details are obscured and unrecognizable; the lower part of the miniature particularly is nearly completely obliterated. However, the few traces still visible there leave no doubt that the painter followed the same version as Ser. and Vat. 746. Vtp. is more exact than Ser. and Vat. 746 in the depiction of the hailstones.

Located below Joshua 10:12.

Lit.: Strzygowski, *Sm.*, pp. 118ff.; *RG*, p. 33, pl. E no. 6; Uspenskii, pp. 102, 167, figs. 249, 250; Wulff, *Altchr. und Byz. Kunst*, vol. 2, p. 531, fig. 463; Wilpert, *Mosaiken und Malereien*, vol. 1, p. 468, fig. 170; Ebersolt, *Min. byz.*, p. 32, pl. 29 no. 3; Benson and Tselos, "Utrecht Ps.," pp. 66, 70, fig. 102; Weitzmann, *JR*, p. 27, fig. 43; Schapiro, "Place," p. 164, fig. 5; Nordström, "Jewish Legends," pp. 493–95, pl. 2; Kollwitz, "Josuazyklus," pp. 107–8; Eller and Wolf, *Mosaiken*, fig. 47; Henderson, "Joshua Cycle," pp. 56–57; Haussig, *History*, p. 412, fig. 72; Huber, fig. 90; Gaehde, "Octateuch," p. 379; Brenk, *S. Maria Magg.*, p. 103; Deckers, *S. Maria Magg.*, pp. 260, 262–63; De Angelis, "Simbologia," pp. 1532–33, fig. 8; *J.-R.*, pp. 64–65; Θησαυροί, pp. 271–72, fig. 117.

Lit. on Vat. Rot.: Seroux d'Agincourt, *Histoire*, vol. 3, p. 37, and vol. 5, pl. 28 no. 19; Piper, *Mythologie*, vol. 2, pp. 477–78; Piper, "Bilderkreis," p. 151; Bond and Thompson, *Facsimiles*, vol. 1, pl. 108; Garrucci, *Storia*, pls. 165 no. 2, 166 no. 1; Pératé, *Archéologie chrétienne*, pp. 274–75, fig. 176; Uvarov, *Album*, pl. 1 no. 3; Krücke, *Nimbus*, pp. 93, 112–13, pl. 7 no. 2; Michel, *Histoire*, p. 219, fig. 121; *RG*, p. 33, pls. 12, 13, 13a; Dalton, *East Christian Art*, pp. 305–6, pl. 55 no. 1; Lietzmann, "Datierung," p. 183; Kömstedt, *Vormittelalterl. Malerei*, pp. 36–37, fig. 117; Benson and Tselos, "Utrecht Ps.," pp. 58, 69, fig. 103; Weitzmann, *JR*, pp. 27, 57–58, 65–66, 78–79, figs. 42–65; Schapiro, "Place," p. 164, fig. 4b; Keck, "Iconography of Joshua," pp. 270–71, fig. 2; Tselos, "Joshua Roll," p. 277, fig. 2; Cecchelli, *S. Maria Magg.*, p. 187; Dohrn, *Tyche*, pl. 48, no. 3; Mango, "Antique Statuary," p. 72, fig. 8; Weitzmann, "Character," pp. 206–7, fig. 189; Kollwitz, "Josuazyklus," pp. 107–8; Lassus, *Early Christian World*, p. 81, fig. 54; Henderson, "Joshua Cycle," pp. 56–57; Haussig, *History*, p. 412; Gaehde, "Octateuch," p. 379; Brenk, *S. Maria Magg.*, p. 103, 106; Kitzinger, "Role," p. 138, fig. 29; Deckers, *S. Maria Magg.*, pp. 260, 262–63; Weitzmann, "Classical Mode," p. 73, fig. 7; Trnek, "Vier Elemente," p. 38, fig. 23; *J.-R.*, pp. 31, 33–34, 36, 51–52, 64–65; Hutter, "Bild der Frau," p. 166, fig. 5.

[1] The figure reproduces a well-known antique type, such as the Tyche of Antioch by Eutychides of Sikyon (M. Bieber, *The Sculpture of the Hellenistic Age*, rev. ed. [New York, 1961], p. 40, fig. 102; Dohrn, *Tyche*, pls. 1–48, figs. 1–2; cf. Ainalov, *Hellenistic Origins*, p. 134) or the Io watched by Argos ascribed to the Attic painter Nikias (cf. Weitzmann, *JR*, pp. 65–66, 78–79, fig. 66, and "Character," pp. 206–7, fig. 161); the painting is now reproduced in R. Ling, *Roman Painting* [Cambridge, 1991], fig. 133). We are indebted to Christopher Moss for the references to recent literature.

[2] Uspenskii, p. 167.

Joshua 10:16–18

JOSHUA TOLD ABOUT THE FLIGHT OF THE FIVE KINGS

1273. Vat. 747, fol. 225r

Two bareheaded soldiers hastily approach Joshua to deliver a message to him. In full armor and surrounded by his army, the Israelite leader sits on a faldstool and extends his arm toward them, receiving their message. One of the messengers raises his arm in a gesture of speech, while the other points back toward the mountain cave of Makkedah (LXX: Makeda), leaving no doubt as to the nature of the exciting news they report. Inside the cave are the five fleeing kings of the Amorites on galloping horses, three riding in the first row and two, armed with lances, in the second. They are clad in tunics and wear pearl diadems as royal insignia. The surface is flaked in various spots, and the heads of the three foremost kings, who appear to have been anxiously looking back, are destroyed.

Located beside Joshua 10:16.

1274. Vat. Rot., sheet XIII

In the Rotulus the painter has cut the scene into two parts, superimposed them, and reduced the size of the figures in the upper scene to approximately half that of those in the lower. Compared with Vat. 747, most of the figures have been slightly changed. Joshua, bareheaded, raises his right hand in a gesture of speech instead of mere acceptance. This indicates that the painter wanted to include the contents of verse 18, where Joshua gives the order to seal the mouth of the cave with large stones. All the soldiers wear helmets; those behind Joshua hold shields and spears. The cave is placed at the top of a mountain between two craggy rocks. The five kings are clad in richly embroidered royal tunics but wear no crowns. On the mountain is the youthful personification of the cave. The scene is separated from the preceding one at the left by the usual altarlike cube.

1275. Ser., fol. 490r

The miniatures of Ser., Vat. 746, and Vtp., all closely related to one another, merge elements from Vat. 747 and the Rotulus. Some small details can be traced back to the tradition of Vat. 747, for instance, all the kings look ahead and wear pearl crowns, and the messengers are bareheaded. On the other hand, the influence of the Rotulus is apparent in details such as Joshua's bare head, his gesture of speech, and the second messenger raising his hand toward Joshua instead of pointing to the cave. Embedded in the mountains is a piece of architecture of rather indistinct form which has no parallel either in Vat. 747 or in the Rotulus.

Located beside Joshua 10:14.

Sm.

Hesseling does not reproduce this miniature. However, it is not certain that it was actually lost, as Uspenskii mentions that

the previous miniature with Joshua defeating the Amorites, supposedly on the same folio, and missing in Hesseling, did exist, although in a very bad condition (see above, between nos. 1270 and 1271).

1276. Vat. 746, fol. 453r

Very close to Ser. However, the group of soldiers behind Joshua is more fully visible, and only one of the messengers carries a shield. The mountain above the cave is rubbed, and the heads of Joshua and one king are flaked.

Located below Joshua 10:17.

1277. Vtp., fol. 365v

The same insignificant alterations that distinguish Vat. 746 from Ser. also exist in this miniature, once more providing proof that Vtp. is directly dependent upon Vat. 746. The changes that the painter made independently follow the usual pattern: the armor is fancier, a fluttering mantle has been added to one of the messengers, and Joshua sits on a golden, jewel-studded throne. The architecture is expanded to two houses. The miniature is only very slightly damaged at the left border and in Joshua's face.

Located below Joshua 10:16.

Lit.: Strzygowski, *Sm.*, pp. 118ff.; *RG*, p. 34, pls. E no. 7, M no. 2; Uspenskii, p. 167, fig. 251; Wilpert, *Mosaiken und Malereien*, vol. 1, p. 469, fig. 171; Alpatov, "Rapport," p. 304 n. 4; Woodruff, "Prudentius," p. 71; Benson and Tselos, "Utrecht Ps.," p. 71, fig. 180; Weitzmann, *JR*, pp. 27–28, 83, fig. 44; Huber, fig. 91; Deckers, *S. Maria Magg.*, p. 259; *J.-R.*, p. 65; Θησαυροί, p. 272, fig. 118.

Lit. on Vat. Rot.: Seroux d'Agincourt, *Histoire*, vol. 3, p. 37, and vol. 5, pl. 28 no. 20; Garrucci, *Storia*, pl. 166 nos. 1, 2; Graeven, "Antike Vorlagen," pp. 8–9, fig. 9; Graeven, "Rotulo," p. 227, pl. 6a; *RG*, p. 34, pls. 13, 13a; Alpatov, "Rapport," p. 304 n. 4; Artelt, *Dialogdarstellung*, p. 40; Pijoán, *Summa artis*, vol. 7, p. 164, fig. 255; Lowrie, *Art*, pp. 211, 334, figs. 146, 148a; Weitzmann, *JR*, pp. 27–28, 70, 83, fig. 42; Schapiro, "Place," p. 164, fig. 4b; Keck, "Iconography of Joshua," p. 271; Deckers, *S. Maria Magg.*, p. 259; *J.-R.*, pp. 31, 34, 36, 52, 65, 67ff.

Joshua 10:23–25

FIVE KINGS PUT TO DEATH

1278. Vat. 747, fol. 225v

Joshua, depicted on a larger scale than the other figures, sits triumphantly on a throne in frontal view as he orders the Israelites to put their feet on the necks of the downcast kings of the Amorites. His mantle is thrown around his left shoulder and slung over his right leg. With an imposing gesture he rests his left hand on his upper thigh and holds his lance majestically in his right hand. Three bodyguards stand around him. Joshua's head is slightly turned toward the huge army of Israelites that has assembled. Four soldiers in the front row, differentiated by their postures and the manner in which they hold their spears and shields, put their feet on the necks and backs of the five fettered kings who lie on their stomachs on the ground. The captives' hands are fettered

behind their backs, and they wear long tunics and pearl crowns. The soldier at the extreme left tramples two kings at the same time, and two soldiers in the second row step with one foot on victims. Originally there should have been at least five soldiers in the front row. In order to increase the hieratic impression given by the figure of Joshua, the section of background around his head is painted in gold, while the rest of the strip above the heads of the assembled soldiers is dark blue. Joshua's face is completely gone, and further damage is visible at the lower left corner.

Located beside Joshua 10:25.

1279. Vat. Rot., sheets XIV and XV

Joshua is represented in the same posture as in Vat. 747, but his prominence is achieved not so much by supernatural size as by his being seated on an especially high cushion, the placement of a double footstool under his feet, and the enlargement of his helmet's crest. The scene is widely separated from the preceding one by a cubic altar. An essential part of the army stands at the left. The nucleus of the army is assembled at the right. Five soldiers stand in the front row, each with one foot on the ground and the other on the neck of a fallen king. The kings wear diadems instead of crowns; richly decorated tunics with collars, clavi, and broad borders at the hem; and purple shoes. The five soldiers transfix the backs of their victims with their lances and streams of blood flow from their wounds. This is an illustration of the beginning of verse 26, which merely states that Joshua killed the kings. However, in the text this remark refers to their hanging, which is represented in the next scene, and there is no hint that the kings were pierced by lances or killed by other means. The execution of the captured kings is enlarged by the representation of another phase of the same episode at the right, in which five soldiers in single file drag the five fettered kings by their hair in the direction of the assembled Israelites.

1280. Ser., fol. 491r

Very close to the Rotulus. The entire left-hand group of Israelite soldiers and the cubic structure with flanking tree are badly flaked, while the rest of the picture is less damaged.

Located beside Joshua 10:25.

Sm.

Hesseling does not reproduce this miniature. However, it is not certain that it was actually lost, since Uspenskii mentions that the previous miniature with Joshua defeating the Amorites, supposedly on the same folio and also missing in Hesseling, did exist, although in very bad condition (see above, between nos. 1270 and 1271).

1281. Vat. 746, fol. 453v

Very close to Ser. but more condensed. The left-hand group of soldiers is considerably reduced in number, and the soldier at the extreme right who in Ser. treads on the legs of the fifth king is dropped. The fettered kings look as if they have been able to raise

the upper part of their bodies. The heads of Joshua and the soldier next to him are rubbed.

Located beside Joshua 10:24.

1282. Vtp., fol. 366r

The scene agrees in every respect with Vat. 746, upon which it is directly dependent. The group of soldiers at the left is even more reduced, the torsos of the fettered kings are even more erect, and the soldier at the extreme right holds a similar shield of enormous size with a scalloped outline. Other alterations, such as the more elaborate armor and helmets and Joshua's jewel-studded golden throne, are attributable to the painter of this manuscript. The miniature is badly damaged: the figures of the kings are partly flaked, the heads of two are completely destroyed, and many of the feet of the Israelite soldiers are obliterated. Further serious damage is visible near the left- and right-hand borders, while the center is comparatively better preserved.

Located below Joshua 10:23.

Lit.: Strzygowski, *Sm.*, pp. 118ff.; *RG*, p. 34, pl. F no. 1; Uspenskii, p. 167, fig. 252; Weitzmann, *JR*, p. 28; Huber, fig. 92; Stahl, "Morgan M. 638," pp. 77–79; Brenk, *S. Maria Magg.*, p. 107; Deckers, *S. Maria Magg.*, pp. 260, 265; *J.-R.*, p. 65; Θησαυροί, p. 272, fig. 118; Lowden, *Octs.*, pp. 112–13, figs. 170, 171.

Lit. on Vat. Rot.: Seroux d'Agincourt, *Histoire*, vol. 3, p. 37, and vol. 5, pl. 28 no. 21; Garrucci, *Storia*, pls. 166 no. 2, 167 nos. 1, 2; *RG*, p. 34, pls. 14, 15; Weitzmann, *JR*, pp. 28, 54, 58, 83–84, pls. 45, 46; Schapiro, "Place," p. 175, fig. 8; Cecchelli, *S. Maria Magg.*, p. 188; Henderson, "Joshua Cycle," p. 57; Deckers, *S. Maria Magg.*, pp. 260, 265; Stahl, "Morgan M. 638," pp. 77–79, fig. 88; Lazarev, *Vizantiiskoe*, fig. p. 50; *J.-R.*, pp. 31, 34, 36, 52, 65, 67ff.; Djurić, "Novi Isys Navin," p. 14 n. 77; Cutler, "Joshua Roll," fig. p. 1076; Lowden, *Octs.*, pp. 112–13, fig. 169.

Joshua 10:26

HANGING OF THE FIVE KINGS

Like the king of Ai, the five kings are hanged on the *furca*, a detail discussed in the introduction to nos. 1238b–1243b.

1283a. Vat. 747, fol. 225v

In the left half of the miniature the five kings with their arms fettered behind their backs are seen hanging high up on fork-shaped stakes which are lined up in a row. Their crowned heads are wedged through the forks, the ends of which are tied together to prevent the heads from slipping out. A high mountain with two peaks forms the background. Large parts of the ground are completely destroyed, and the figures of the kings are slightly flaked, particularly their heads.

Located beside Joshua 10:33.

1284a. Vat. Rot., sheet XV

The painter organized the stakes in two rows of two, with the fifth centered at the right. The result was a reduction of the

figures to a little more than half their normal size. The heads have lost their diadems, and they are held in the forks by sticks wedged behind their necks, just as in the hanging of the king of Ai (cf. fig. 1239). Moreover, in contrast to Vat. 747, the arms of the kings are no longer fettered, but dangle loosely. In this point the artist is thoroughly consistent with the preceding scene, where the kings are already being killed with lances, so that, according to the artist's interpretation, only their corpses were hanged.

1285a. Ser., fol. 491r

The illustrators of Ser., Vat. 746, and Vtp. merge features from the Rotulus and Vat. 747. The arrangement of the stakes in a single row and, consequently, the normal size of the kings, as well as the depiction of all five kings in three-quarter back view, follow Vat. 747. On the other hand, the dangling arms and the absence of the kings' crowns are like details in the Rotulus. Their royal rank is still recognizable, however, by their tunics and particularly by their pearl-studded purple shoes. The surface is slightly flaked in various spots.

Located beside Joshua 10:27.

Sm.

Hesseling does not reproduce this miniature. However, it is not certain that it was actually lost, as Uspenskii mentions that the previous miniature with Joshua defeating the Amorites, supposedly on the same folio and also missing in Hesseling, did exist, although in very bad condition (see above, between nos. 1270 and 1271).

1286a. Vat. 746, fol. 454r

Close to Ser. but crudely overpainted.
Located beside Joshua 10:37.

1287a. Vtp., fol. 367r

The scene agrees with Ser. and Vat. 746 in all essential details. The figures as well as the ground are partly flaked.

Located beside Joshua 10:28.

Lit.: Piper, "Bilderkreis," p. 185; Strzygowski, *Sm.*, pp. 118ff.; *RG*, p. 35, pl. F no. 2; Uspenskii, pp. 167–68, fig. 253; Franchi de' Cavalieri, "Furca," pp. 90, 92, 100–101; Weitzmann, *JR*, p. 29, fig. 47; Williams, "León Bible," p. 85; Huber, fig. 93; Henderson, "Joshua Cycle," p. 57; Stahl, "Morgan M. 638," pp. 88–89, fig. 113; Havice, "Hamilton Ps.," pp. 268–69; Havice, "Marginal Miniatures," p. 133 n. 256; *J.-R.*, p. 66; Kresten, "Hinrichtung," pp. 114, 116 n. 18, figs. 3, 4; Θησαυροί, p. 272, fig. 120.

Lit. on Vat. Rot.: Seroux d'Agincourt, *Histoire*, vol. 3, p. 37, and vol. 5, pl. 28 no. 21; Piper, "Bilderkreis," pp. 151, 185; Garrucci, *Storia*, pl. 167 no. 2; Strzygowski, *Sm.*, pp. 120, 126; *RG*, p. 35, pl. 15; Franchi de' Cavalieri, "Furca," pp. 90, 92, 100–101; Weitzmann, *JR*, pp. 29, 54, 56, fig. 46; Williams, "León Bible," p. 85; Henderson, "Joshua Cycle," p. 57; Stahl, "Morgan M. 638," pp. 88–89; Havice, "Hamilton Ps.," pp. 268–69; Havice, "Marginal Miniatures," p. 133 n. 257; *J.-R.*, pp. 31, 34, 52, 66; Kresten, "Hinrichtung," pp. 114, 116 n. 18, fig. 2.

Joshua 10:27

STONING OF THE FIVE KINGS

1283b. Vat. 747, fol. 225v

The stoning of the five kings of the Amorites is depicted next to the hanging. Four bareheaded Israelites hurl large rocks onto the corpses that lie already buried under a pile of stones at the bottom of the cave of Makkedah. The soldiers holding the stones over their heads are grouped symmetrically, one pair on either side of a hillock above the cave; those at the left are partly hidden by the slope which belongs to the previous scene. The interior of the cave is so badly flaked that only the upper part of one corpse at the extreme right can be clearly distinguished among the stones. The soldiers and the background are also partly flaked.

Located beside Joshua 10:33.

1284b. Vat. Rot., sheet XV

All that remains of this scene, which marks the end of the Rotulus as it is preserved today, is one soldier at the extreme left who carries a large stone on his left shoulder. This type is not found in the corresponding scene of Vat. 747.

1285b. Ser., fol. 491r

The symmetrical arrangement of the four stone-throwers is similar to that in Vat. 747, but there are differences in detail: all the soldiers wear helmets, and the one at the extreme left still carries his stone on his shoulder. In these two points the painter followed the tradition of the Rotulus. The five kings, lying head down in the cave, are clad in long tunics, and their hands are fettered behind their backs. Both features are inconsistent with the previous scene, where the kings wear short tunics and their arms hang free. The latter feature confirms that the dangling arms in the previous scene of Ser. (fig. 1285a) are a departure from the tradition of Vat. 747, made under the influence of the Rotulus. A hail of stones is visible around and on the corpses. On top of the mountain a half-nude youth sits with his legs crossed and a mantle slung around his hips; this personification of the cave of Makkedah must have been taken over from the lost picture of the Rotulus, which probably included a personification similar to that in fig. 1274. In Ser. he sits upright and points his right index finger at his mouth.

Located beside Joshua 10:27.

Sm.

One folio between fols. 228 and 229 was cut out. Surely it contained this same scene on its verso.

1286b. Vat. 746, fol. 454r

The left-hand group of stone-throwers consists of three soldiers, two casting stones as in Vat. 747 and the third still carrying his stone on his shoulder as in the Rotulus and Ser. At variance with both previous versions is the second soldier from the right, who likewise holds the stone on his shoulder instead of hurling it. The cave is so densely filled with stones that three kings emerge from them only as busts, and only the backs of the heads of the other two are visible. The personification of the cave is represented in the same posture as in Ser., except that he holds his hand underneath his chin.

Located beside Joshua 10:37.

1287b. Vtp., fol. 367r

The painter followed Vat. 746 in depicting five stone-throwers instead of four. The personification is changed into a figure whose legs are completely covered by a mantle and who holds its head in both hands in an expression of horror. Every reminiscence of a mountain god is lost, and it even looks as if the painter wanted the figure to be understood as female. The inner cave is totally destroyed, and no details are discernible except for a single king's head. The soldiers and the personification are also flaked in various spots.

Located beside Joshua 10:28.

Lit.: Strzygowski, *Sm.*, pp. 118ff.; *RG*, p. 35, pl. F no. 2; Uspenskii, p. 167, fig. 253; Weitzmann, *JR*, p. 29, fig. 47; Huber, fig. 93; *J.-R.*, p. 66; Kresten, "Hinrichtung," figs. 3, 4; Θησαυροί, p. 272, fig. 120.

Lit. on Vat. Rot.: Seroux d'Agincourt, *Histoire*, vol. 3, p. 37, and vol. 5, pl. 28 no. 21; Garrucci, *Storia*, pl. 167 no. 2; *RG*, p. 35, pl. 15; Weitzmann, *JR*, p. 29, fig. 46; *J.-R.*, pp. 31, 34, 36, 52, 66–68; Kresten, "Hinrichtung," fig. 2.

Joshua 10:33 or 42

ISRAELITES DEFEAT ENEMIES

Various realms are enumerated in the text as having been conquered and their kings slain (verses 28–41); these deeds are then summed up in a general statement in verse 42. The miniature is a conventional battle scene, with Joshua inciting his victorious army against the fleeing enemy; no detail helps to determine which battle is illustrated.

1288. Vat. 747, fol. 226r

A group of bareheaded Israelites attack with spears and swords, killing a few victims on the ground and pursuing the fleeing enemies, one of whom tries to protect himself with his shield. Joshua, holding a spear and shield in his left hand, is depicted larger than life, extending his right hand in a gesture of encouraging his troops. The entire surface of the miniature is damaged by flaking.

Located beside Joshua 11:1.

1289. Ser., fol. 492r

Close to Vat. 747. However, the fleeing enemy's rear guard tries to defend itself with spears. Joshua, who is represented at normal size, holds only a spear in his left hand and raises his right

in a gesture of speech. A high mountain range envelops the whole scene. The surface of the miniature is badly flaked.

Located beside Joshua 11:1.

1290. Sm., fol. 229r

Close to Ser. The miniature was apparently clumsily overpainted, as is particularly noticeable in the shape of the helmets, the doughy outline of the rocky mountains, and other details.

1291. Vat. 746, fol. 454v

Close to Ser. and Sm. Crudely overpainted. The group of fleeing enemies is slightly flaked.

Located beside Joshua 11:1.

1292. Vtp., fol. 368r

Close to Ser., Sm., and Vat. 746. No mountainous background is included.

Located beside Joshua 11:1.

Lit.: RG, p. 37, pl. F no. 3; Uspenskii, p. 168; Hesseling, fig. 289; Weitzmann, *JR*, pp. 94–95, figs. 98, 99; Tselos, "Joshua Roll," p. 280, fig. 13; Huber, fig. 94; De Angelis, "Simbologia," p. 1533, fig. 9; Θησαυροί, pp. 272–73, fig. 121.

Joshua 11:4–5

KINGS OF CANAAN COME OUT TO FIGHT

1293b. Vat. 747, fol. 226r

In a condensed miniature containing four scenes within its frame, the assembly of enemy kings with their horses and chariots at the waters of Merom (LXX: Maron) is represented in the right half of the upper frieze. The approaching army emerges from behind a mountain ridge. The leader, who is distinguished by his royal pearl crown, can in all probability be identified as Jabin, the king of Hazor. Standing on a chariot drawn by two horses, he holds a lance in one hand and extends the other in the direction in which a troop of cavalry behind him is to follow. A standard-bearer on horseback, seen in frontal view, rides ahead of the king and seems to have reached the height of the mountain pass. The heads of the herald and the king are partly flaked.

Located beside Joshua 11:6.

1294b. Ser., fol. 492v

All that remains of the composition in Vat. 747 is the king on his biga, who now wears a helmet instead of a crown and has thus lost his royal distinction. The two superimposed rows of scenes in Vat. 747 have been reduced to one: the biga from the upper row has been placed on the same level as the battle scene of the lower row, and follows instead of precedes it, thus appearing to be part of the battle itself. At the same time, discrepancies

remain: the horses are represented advancing slowly and the king leans on his spear instead of attacking or defending himself against the assault of the Israelites.

Located beside Joshua 11:6.

1296b. Sm., fol. 229r or 229v[1]

The king on the biga is so close to the defending army that he merges with it.

1299b. Vat. 746, fol. 455r

Close to Ser. The king on the biga remains relatively separated from the battle scene.

Located beside Joshua 11:6.

1301b. Vtp., fol. 369r

This painter represented the horses drawing the biga in full gallop, a feature which, to judge from his general faithfulness to the Rotulus, most likely existed there. Although the king is depicted at a very small size, his higher rank is made clear by the crest on his helmet. The horses are somewhat flaked.

Located above Joshua 11:6.

Lit.: RG, p. 37, pl. F no. 5; Uspenskii, p. 168, figs. 254, 255; Hesseling, fig. 290; Weitzmann, *JR*, figs. 101, 102; Huber, fig. 96; Demus, *Mosaics of S. Marco*, vol. 2, pt. 1, p. 179; Θησαυροί, p. 273, fig. 123; Lowden, *Octs.*, p. 115, fig. 178.

[1] Fol. 229r according to Hesseling, p. xv; fol. 229v according to Uspenskii, p. 188.

Joshua 11:6

GOD INCITES JOSHUA

1293a. Vat. 747, fol. 226r

God's command to Joshua to destroy his enemies is represented in the upper left-hand corner of the miniature. The Israelite leader, wearing armor and a helmet and partly hidden by the slope of a mountain, raises his hands in a gesture of prayer. A segment of heaven in the upper strip of sky probably contained the hand of God.

Located beside Joshua 11:6.

1294c. Ser., fol. 492v

Joshua is represented in the same attitude as in Vat. 747 but at full size and bareheaded. A little tree stands in front of him. As in the case of King Jabin's chariot in the preceding scene, the praying Joshua finds his place in a single frieze instead of in the upper of two superimposed rows. In this case the result was a disruption of the sequence, since God's command should, of course, precede the battle scene.

Located beside Joshua 11:6.

1296c. Sm., fol. 229r or 229v¹

Close to Ser.

1299c. Vat. 746, fol. 455r

Close to Ser. and Sm.
Located beside Joshua 11:6.

1301c. Vtp., fol. 369r

While in Ser., Sm., and Vat. 746 Joshua is stepping forward, the painter of Vtp. represented him from the back, standing with his feet together. However, it may be noticed that the turn of his head and the gesture of his hands do not quite match this view. Instead of a chlamys fastened over the right shoulder, Joshua wears his mantle slung around the upper part of his body and taken over his arms.
Located above Joshua 11:6.

Lit.: RG, p. 37, pl. F no. 5; Uspenskii, p. 168, figs. 254, 255; Hesseling, fig. 290; Weitzmann, *JR*, figs. 101, 102; Huber, fig. 96; Kirigin, *Mano divina*, pp. 151–52; Crooy, *Émaux*, p. 53, fig. 36; Demus, *Mosaics of S. Marco*, vol. 2, pt. 1, p. 179; Θησαυροί, p. 273, fig. 123; Lowden, *Octs.*, p. 115, fig. 178.

¹ Fol. 229r according to Hesseling, p. xv; fol. 229v according to Uspenskii, p. 188.

Joshua 11:7–8

DEFEAT OF THE KINGS OF CANAAN

1293c. Vat. 747, fol. 226r

In the lower frieze, a group of bareheaded Israelite soldiers with lowered lances pursues the beaten enemy. The men are urged on by Joshua, who steps hurriedly forward, holding a spear and shield in his left hand and extending his right hand in a gesture of encouragement. The enemy cavalry is in full flight; due to lack of space, the forequarters of the horses are cut off by the lateral frame. The two armies are somewhat separated by another scene illustrating the next phase of the episode, which is preserved in the other Octateuchs as a separate miniature within its own frame. In the model of Vat. 747, this intermediary scene was perhaps represented directly beneath the battle scene; as the result of condensation, it has been pushed upward in the Vatican copy and placed between the pursuing Israelites and their fleeing enemies. Joshua's head and other spots are flaked.
Located beside Joshua 11:6.

1294a. Ser., fol. 492v

Close to Vat. 747, but the enemy army consists of infantrymen, and most of them are still withstanding the onslaught: only one soldier has turned to flee. As usual in this and the following manuscripts, both armies wear helmets and Joshua is bareheaded. At the bottom of the scene is a stream representing the waters of Merom, an indication of the locality that is lacking in Vat. 747. A mountain range encompasses the whole scene.
Located beside Joshua 11:6.

1296a. Sm., fol. 229r or 229v¹

Close to Ser. but the enemy army is more numerous, and at least half of it is in flight.

1299a. Vat. 746, fol. 455r

Closer to Ser. than to Sm. in that only one enemy has turned to flee. By allowing the foot of the foremost defender to be cut off by a slope, the artist tried to create the impression that the enemy army had appeared from behind the mountain. The surface is flaked in various spots.
Located beside Joshua 11:6.

1301a. Vtp., fol. 369r

The artist changed the attitude of the foremost enemy soldier, depicting him pushing his lance downward. This alteration may have been caused by the painter's desire to show this man using his weapon correctly with his right hand instead of his left, as in the preceding examples. Otherwise the composition agrees in particular with Vat. 746 except that the armor is more elaborate.
Located above Joshua 11:6.

Lit.: RG, p. 37, pl. F no. 5; Uspenskii, p. 168, figs. 254, 255; Hesseling, fig. 290; Weitzmann, *JR*, figs. 101, 102; Huber, fig. 96; Demus, *Mosaics of S. Marco*, vol. 2, pt. 1, p. 179; Θησαυροί, p. 273, fig. 123; Lowden, *Octs.*, p. 115, fig. 178.

¹ Fol. 229r according to Hesseling, p. xv; fol. 229v according to Uspenskii, p. 188.

Joshua 11:9

BURNING OF THE CHARIOTS

1293d. Vat. 747, fol. 226r

Between the attacking Israelites and the fleeing enemy cavalry is a biga, from which a slain soldier is tumbling backward. An Israelite behind it holds a sword in his raised hand and is about to smite the horses, not the tumbling soldier, thus illustrating verse 9, which describes the hamstringing of the enemy's horses. Compared with the corresponding scene in the following Octateuchs, this scene is abbreviated, since it does include the burning of the chariots.
Located beside Joshua 11:6.

1295. Ser., fol. 492v

An Israelite like those in Vat. 747, but clad in a short tunic instead of heavy armor, has raised his sword, not against the two horses drawing the biga, but against a group of three additional horses represented behind them. A second Israelite holds two torches and sets the chariot on fire. The chariot in particular, as well as other spots of the miniature, are flaked.
Located beside Joshua 11:7.

1297. Sm., fol. 229r or 229v¹

Close to Ser. The Israelite more explicitly holds the horse by its tail and is about to cut the sinews of its hind legs.

1298. Vat. 746, fol. 455r

As in Sm., the Israelite with the sword holds the horse by its tail. The surface is slightly flaked. The miniature is placed to the left of the battle scene (fig. 1299) instead of underneath it, and thus appears to precede the battle scene, even though it represents a later phase of the episode.

Located beside Joshua 11:6.

1300. Vtp., fol. 368v

As in Vat. 746, the miniature is misplaced and precedes the battle scene, even to the extent of being located on the preceding page. The feature of seizing the horse's tail also follows Vat. 746 closely. The foreground, together with the feet of the two Israelites, is completely destroyed, and the upper part of the miniature, especially the figure of the aggressor, is also badly damaged by flaking.

Located beside Joshua 11:6.

Lit.: RG, p. 37, pl. F no. 4; Uspenskii, p. 168, fig. 314; Hesseling, fig. 291; Lefebvre de Noëttes, "Système," p. 189, figs. 5, 7; Weitzmann, *JR*, pp. 95–96, figs. 100, 101; Huber, fig. 95; Θησαυροί, p. 273, fig. 122; Lowden, *Octs.*, p. 115, fig. 178.

¹ Fol. 229r according to Hesseling, p. xv; fol. 229v according to Uspenskii, p. 188.

Joshua 11:12

Beheading of Kings

1302a. Vat. 747, fol. 226v

While the text speaks of "all the kings whom Joshua smote with the edge of the sword," the painter arbitrarily chose three for his illustration. Two of them have already been decapitated: the head of the one on the left, mostly flaked, can be discerned at a certain distance from the body, and the head of the right-hand king, lying face upward in a pool of blood, remains close to the victim's breast. The king in the middle, bowing deeply, is about to be decapitated by an Israelite soldier who has already raised his sword. The kings, hands fettered behind their backs, wear short tunics with collars, pearl crowns, and pearl-studded, purple shoes. In all probability one of them is supposed to be Jabin, the king of Hazor, whose decapitation is described in verse 10, but there is no way of ascertaining which of the three is to be identified with him. A second Israelite, holding a shield and spear and also bareheaded, stands alongside the executioner and stretches out his hand toward Joshua, who sits in frontal view and responds with a similar gesture of his left hand. The Israelite leader, seated on a faldstool high up on a hill, rests his right hand on his lance in a gesture expressing grandeur, and, as usual in this

manuscript, is represented larger than the other figures. The entire surface of the miniature is slightly flaked.

Located beside Joshua 11:3.

1303a. Ser., fol. 493r

The general layout of the composition is the same as in Vat. 747, and the figure type of Joshua also agrees well, except that he sits on a golden throne instead of a faldstool; the scene is placed before a range of high mountains instead of being separated from the second scene by a single peak. There are several deviations in the representation of the kings' execution. The king whose head has been cut off is not fettered, the bowing one in the middle is seen in frontal view, and the third is unfettered like the first and is still alive. The two Israelite soldiers are also slightly changed: the painter gave a sheath instead of a shield to one, and to the other a sword in the left hand and a lance in the right, thus eliminating the gesture which in Vat. 747 connected him with Joshua. The kings are draped in long tunics with broad borders at the hem, and the soldiers wear helmets.

Located beside Joshua 11:20.

1304a. Sm., fol. 229v

Close to Ser. However, the foremost king's hands are fettered, but this motif, which occurs in no other manuscript, may have been added by the restorer, who crudely overpainted the whole surface, as is particularly clear upon examination of the faces.

1305a. Vat. 746, fol. 455v

Close to Sm. Although just as overpainted as Sm. with broad and crude brushstrokes, the details of the composition are well preserved in comparison.

Located beside Joshua 11:20.

1306a. Vtp., fol. 370r

Joshua is different from the figure in the other Octateuchs: he is bareheaded and holds the lance in his left hand, while his right, which is extended toward the kings, crosses his body. The Israelite soldier at the right places his foot on the victim's shoulder and transfixes him with his lance, a motif that may well have been adapted from the scene of the killing of the kings of the Amorites (figs. 1278–1282). However, the wrong end of the lance is thrust into the bleeding wound in the king's breast, and this error clearly reveals that this motif is not original. The same soldier holds a shield in his left hand instead of a sword. As is typical in this manuscript, the armor is elaborate, the crowns of the kings are of a late type, and Joshua sits on a solid gold, jewel-studded throne.

Located beside Joshua 11:20.

Lit.: Graeven, "Typen," pp. 106–7, fig. 15; *RG*, p. 37, pl. G no. 1; Uspenskii, p. 168, fig. 256; Hesseling, fig. 292; Weitzmann, *JR*, pp. 96–97, fig. 103; Lazarev, *Storia*, fig. 413; Lassus, *Livre des Rois*, p. 88, fig. 126; Huber, fig. 97; Demus, *Mosaics of S. Marco*, vol. 2, pt. 1, p. 179; Θησαυροί, p. 273, fig. 124.

Joshua 11:13

Hazor Set Afire

1302b. Vat. 747, fol. 226v

A mountain peak separates the burning of the city of Hazor from the preceding scene, with which it is united by a common frame. Behind the slope and partly hidden by it are three bareheaded Israelite soldiers who torch a tower and the gate of the city. The city is cut by the frame, so that part of the gate and a second flanking tower at the right are lost.

Located beside Joshua 11:13.

1303b. Ser., fol. 493r

The dividing mountain is omitted, and consequently the three Israelites are fully visible. Moreover, the feet of the third soldier are overlapped by the hindmost king of the preceding scene, so that the strong separation into two different scenes, so emphasized in Vat. 747, is almost wholly obliterated. The city is represented in more detail, with buildings inside and two flanking towers; the towers are incorrectly placed within the circular wall. The soldiers try to reach over the crenelations with their torches to set the buildings inside on fire.

Located beside Joshua 11:20.

1304b. Sm., fol. 229v

Close to Ser. Crudely overpainted.

1305b. Vat. 746, fol. 455v

More condensed than in Ser. but the soldiers overlap each other in a friezelike arrangement. Overpainted.

Located beside Joshua 11:20.

1306b. Vtp., fol. 370r

Close to Vat. 746 in the more spatially convincing grouping of the three soldiers. The painter enriched the representation of the city by adding towers and moved it away from the lateral frame. Nevertheless, the depiction of the rear wall as a quarter circle instead of a semicircle clearly reveals that the model was only half a walled city cut by a frame, as in Vat. 746.

Located beside Joshua 11:20.

Lit.: Graeven, "Typen," pp. 106–7, fig. 15; *RG*, p. 37, pl. G no. 1; Uspenskii, p. 168, fig. 256; Hesseling, fig. 292; Weitzmann, *JR*, pp. 96–97, fig. 103; Weitzmann, *Greek Mythology*, p. 118; Lazarev, *Storia*, fig. 413; Lassus, *Livre des Rois*, p. 88, fig. 126; Huber, fig. 97; Demus, *Mosaics of S. Marco*, vol. 2, pt. 1, p. 179; Θησαυροί, p. 273, fig. 124.

Joshua 12:1–24

Israelites Defeat Kings

1307. Vat. 747, fol. 227r

Joshua speaks to two groups of Israelites, one consisting of soldiers, the other of civilians. In full armor and wearing a helmet, Joshua sits on a faldstool, leaning on his spear and extending his right hand in a gesture of conversation. In front of him stands a group of bareheaded soldiers leaning on their shields, and, separated from them, a group of civilians clad in short tunics and with their arms crossed in an attitude of devotion. These civilians seem mistakenly to replace the kings defeated by the Israelites listed in chapter 12 and represented in the other Octateuchs. Parts of the background and small spots on the heads of the soldiers are flaked.

Located beside Joshua 13:1.

1308. Ser., fol. 494v

Close to Vat. 747, but Joshua sits on a golden throne, and in front of him stand the soldiers and a group of four captured kings, whose hands are fettered behind their backs. They are dressed in long embroidered tunics and wear pearl-studded purple shoes and imperial crowns. All the figures are slightly flaked.

Located beside Joshua 13:1.

1309. Sm., fol. 230r

Close to Ser.

1310. Vat. 746, fol. 456r

Close to Ser. and Sm.
Located beside Joshua 13:1.

1311. Vtp., fol. 372r

The figure of Joshua in frontal view is replaced by one in profile, and his head is bare. Joshua's head and spots of the ground are flaked.

Located beside Joshua 13:1.

Lit.: *RG*, p. 37, pl. G no. 2; Uspenskii, p. 168, fig. 257; Hesseling, fig. 293; Weitzmann, *JR*, pp. 97–98, figs. 104, 105; Huber, fig. 98; Θησαυροί, p. 273, fig. 125.

Joshua 14:6

Caleb Addresses Joshua

Skipping chapter 13, where the text relates the first division of the land among the tribes, the cycle proceeds with the episode of Caleb in chapter 14. In the last part of the cycle of Vat. 747, the young Joshua, represented with a black beard, is replaced by a visibly older leader with a longer white beard, thus conforming to the statement in Joshua 13:1, "And Joshua was old and very advanced in years. . . ."

1312. Vat. 747, fol. 228r

Caleb, who asks that Hebron be given to him as an inheritance, stands before Joshua with arms raised and head bowed. The leader of the Israelites sits on a throne in profile and with legs crossed, holding a lance in one hand and extending the other in a gesture of speech, although no reply by Joshua to the old man's request is reported in the text. The ground is partly flaked.

Located beside Joshua 14:6.

1313. Ser., fol. 496r

Joshua sits on a golden throne with his legs uncrossed and makes a gesture of speech that resembles blessing. Caleb wears a turban.

Located beside Joshua 14:6.

1314. Sm., fol. 231r

Close to Ser. Crudely overpainted.

1315. Vat. 746, fol. 457r

The type of Caleb is the same, but the figure of Joshua is the type that appears in the next scene (figs. 1317–1319). He sits majestically in frontal view, leaning on his spear and with his right arm akimbo. The miniature is roughly overpainted.

Located beside Joshua 14:6.

1316. Vtp., fol. 374r

Joshua's upper body is represented in frontal view, thus revealing dependence on Vat. 746, whereas his lower body is taken from a profile model. Caleb raises only one arm in a more distinct gesture of speech, the other being hidden under his paenula. Joshua sits in front of a fantastic building whose upper half forms a giant white cross behind his head. The building has a symmetrical loggia on either side and is crowned with drapery tied around a pinecone. Joshua's face and parts of his figure are flaked.

Located beside Joshua 14:6.

Lit.: RG, p. 37, pl. G no. 3; Uspenskii, p. 168, fig. 258; Hesseling, fig. 294; Weitzmann, *JR*, fig. 106; Huber, fig. 99; Lowden, "Vtp. Oct.," p. 122; Demus, *Mosaics of S. Marco*, vol. 2, pt. 1, p. 180; Θησαυροί, pp. 273–74, fig. 126; Lowden, *Octs.*, p. 49, figs. 56, 57.

Joshua 14:13

CALEB KNEELS BEFORE JOSHUA

1317. Vat. 747, fol. 228r

Having obtained Hebron as an inheritance, Caleb falls down in proskynesis before Joshua. His extended hands are covered by his mantle in an expression of deep reverence. Joshua, sitting frontally on a throne in a majestic posture with one arm akimbo, raises his left hand toward the old man in a gesture of speech. A

steep mountain rises behind Caleb. Large parts of the ground are flaked.

Located beside Joshua 14:11.

1318. Ser., fol. 496v

The composition shows only slight differences from that in Vat. 747. Joshua holds a spear in his raised hand, a gesture that eliminates the element of active response to Caleb's request. The old man is represented wearing a turban, and there is no mountain behind him. Both figures are damaged by flaking.

Located beside Joshua 14:12.

1319. Sm., fol. 231r

Close to Ser.

1320. Vat. 746, fol. 457v

Seen in profile, Joshua raises his hand in a gesture of speech and is thus identical to the type of the preceding miniature in Vat. 747, Ser., and Sm. (figs. 1312–1314). As already mentioned, these two Joshua types were exchanged by the painter of Vat. 746, who furthermore showed Joshua bearded in both instances. The miniature is overpainted with broad brushstrokes, and Caleb's face is rubbed.

Located beside Joshua 14:12.

1321. Vtp., fol. 375r

The painter reveals his direct dependence upon Vat. 746 by also depicting Joshua in profile and bearded. Caleb kneels in a more erect posture and closer to Joshua's throne.

Located beside Joshua 14:12.

Lit.: RG, pl. 38, pl. G no. 4; Uspenskii, p. 168; Hesseling, fig. 295; Huber, fig. 100; Θησαυροί, p. 274, fig. 127.

Joshua 15:16–17

CAPTURE OF KIRJATH-SEPHER

1322. Vat. 747, fol. 228v

A group of bareheaded Israelite soldiers storms the city of Kirjath-sepher (LXX: "city of letters"). The first soldier entering the gate of the walled city is Othniel (LXX: Gothoniel), who obtained Caleb's daughter Achsah (LXX: Ascha) in marriage for this exploit. The enemy soldiers abandon the city and flee in haste. At the left, a large Joshua armed with shield and spear drives the Israelites into battle with a gesture of encouragement; he replaces Caleb who, according to the text, was the instigator of the battle. The entire surface of the miniature is damaged by flaking.

Located beside Joshua 15:13.

1323. Ser., fol. 497v

Close to Vat. 747, but Joshua does not wear a shield, and Othniel has already pushed his head through the gate of the city,

inside which two houses are visible. As usual, the Israelites wear helmets and their enemies are bareheaded. The surface is flaked in various spots.

Located beside Joshua 15:14.

1324. Sm., fol. 231v

Close to Ser. Along the left side of the frame is a pen drawing of a roaring lion.

1325. Vat. 746, fol. 458v

Close to Ser. and Sm. Very crudely overpainted.
Located beside Joshua 15:15.

1326. Vtp., fol. 376v

The painter follows the same tradition as the three preceding examples but adds a few new features. The group of attackers is increased by the head of a warrior looking back at Joshua, another head is inserted between the two fleeing soldiers, and the interior of the city is enriched by additional architectural details.

Located beside Joshua 15:16.

Lit.: RG, p. 38, pl. G no. 5; Uspenskii, p. 169, fig. 259; Hesseling, fig. 296; Huber, fig. 101; Gaehde, "Octateuch," pp. 378 n. 135, 380; Θησαυροί, p. 274, fig. 128.

Joshua 15:18–19

Achsah Asks Caleb for a Field

1327. Vat. 747, fol. 229r

Riding on a white ass, Achsah asks her father, who is bareheaded, to give her a place with springs of water. She wears a paenula and raises her right hand in a gesture of speech. Caleb, standing before his daughter, extends his hand in a similar gesture showing that Achsah's request has been granted.

Located beside Joshua 15:21.

1328. Ser., fol. 497v

Achsah, riding on a gray ass, holds her right hand before her breast in an attitude more passive than that in Vat. 747. Caleb is represented as a much older man, as he actually was according to the text, and his head is covered by a turban. The lower left corner of the miniature is torn and stained, and both figures as well as the ass are flaked in various spots.

Located beside Joshua 15:19.

1329. Sm., fol. 232r

Close to Ser.

1330. Vat. 746, fol. 458v

Close to Ser. and Sm.
Located beside Joshua 15:21.

1331. Vtp., fol. 377r

Close to Ser., Sm., and Vat. 746.
Located beside Joshua 15:19.

Lit.: RG, p. 38, pl. G no. 6; Uspenskii, p. 169, figs. 260, 261; Hesseling, fig. 297; Buchthal, *Historia Troiana*, p. 34, pl. 33c; Huber, fig. 101; Θησαυροί, p. 274, fig. 129.

Joshua 16:10

Pharaoh Captures Gezer

1332. Vat. 747, fol. 229v

The Egyptian army, consisting of both cavalry and infantry, takes Gezer (LXX: Gazer). The cavalry attacks the enemy; only one enemy soldier is left outside the wall, already wounded by a lance and crawling on the ground. In the model this victim surely was only one of a larger group of defeated Canaanites. Meanwhile, two foot soldiers set fire to the walled city, which is defended from behind its crenelations by one soldier. Pharaoh rides behind the attacking Egyptians, crowned like a Byzantine emperor and in the attitude of an equestrian statue. Behind him and also on horseback is his standard-bearer, seen in frontal view and wearing strange protruding headgear. The whole scene is condensed, and Pharaoh's horse at the left as well as the walled city at the right are cut by the lateral border lines. The surface is flaked in various spots, and the city gate is completely destroyed.

Located beside Joshua 16:8.

1333. Ser., fol. 499r

Close to Vat. 747 but less abbreviated. At least two defeated Canaanites crawl beneath the hooves of the Egyptian horses, and two Canaanites try to defend the city with a spear and a bow. The assault is made by a group of Egyptian foot soldiers, most of whom are armed with lance and bow, while only one holds a torch. The soldier entering the city gate (to judge from his chain mail, he is a Canaanite who seeks refuge in the city) is not required by the text and is apparently an adaptation from the conquest of the city of Kirjath-sepher, where Othniel enters the enemy city in a similar manner (figs. 1322–1326). Pharaoh, distinguished by a green nimbus, is clad in golden armor and a fluttering purple chlamys, and his standard-bearer wears an ordinary helmet and holds a shield. Along the left border the miniature is torn and stained, while the surface as a whole is only slightly flaked.

Located beside Joshua 17:1.

1334. Sm., fol. 232v or 233r [1]

Close to Ser.
Located below Joshua 16:10.

1335. Vat. 746, fol. 459r

The miniature has been crudely overpainted without changing its general composition. Only details such as the collar of the

herald may be attributed to the restorer. Alongside the left border line half of the figure of Pharaoh is completely destroyed and stained, and the remainder is badly flaked.

Located beside Joshua 17:2.

1336. Vtp., fol. 379r

The Egyptian cavalry and infantry are merged into a single compositional unit. Only one horseman in the foreground remains clearly recognizable, and one can no longer be sure whether the two soldiers above his head are meant to be horsemen or foot soldiers. The man on horseback facing Pharaoh holds an ordinary lance instead of a standard, so that his original function is now obscured. This time with a golden nimbus, Pharaoh holds his lance slightly lowered. The city wall is depicted in its entirety, and the number of its towers is increased. At the left a whole strip of the miniature has flaked off, including a part of Pharaoh's chlamys and one of his horse's legs. Otherwise, the miniature shows only slight damage caused by stains and cracks.

Located beside Joshua 17:1.

Lit.: RG, p. 38, pl. G no. 7; Uspenskii, p. 169, fig. 262; Hesseling, fig. 298; Buchthal, *Historia Troiana*, p. 34, pl. 33c; Huber, fig. 103; Gaehde, "Octateuch," pp. 377–78; Θησαυροί, p. 274, fig. 130.

¹ Fol. 233r according to Hesseling, p. xv; fol. 232v according both to Uspenskii, p. 188, and to the label in the photo taken by Buberl.

Joshua 17:3–4

Joshua Gives an Inheritance to Zelophehad's Daughters

1337. Vat. 747, fol. 230r

The five daughters of Zelophehad (LXX: Salpaad), a descendent of Manasseh, ask Joshua for an inheritance. Joshua orders two young men to survey the land for the daughters with a measuring cord, thus demonstrating his consent to their request. Eleazar stands close behind the Israelite leader; according to the text, the daughters of Zelophehad made the request not only to Joshua, but also to the priest Eleazar and the Israelite princes. The miniature has been overpainted by a restorer who no longer understood the scene's content and thus made some mistakes. The heads especially are restored, as indicated by the wavy outlines of the surveyor's hair, as well as those of the head of Eleazar and the first person in the group at the right. The five figures in this group originally represented the five daughters, as becomes clear not only from a comparison with the other manuscripts (figs. 1338–1341), where the postures of the first and second daughter in particular agree very much with those of the corresponding figures in this miniature, but also from remnants of the original design such as the woman's paenula which covers the forehead of the central figure.¹ The restorer retouched all five heads and gave them beards, probably mistaking them for the

Israelite princes. The armor of the surveyor with the gesticulating hand is also overpainted, and it seems probable that originally he was clad only in a tunic like his companion. The type of Joshua holding a spear in his left hand and raising his right is apparently unchanged, although his head lacks the usual distinction as the result of overpainting. The surface is flaked in several spots, notably in the face of Eleazar.

Located below Joshua 17:6.

1338. Ser., fol. 499v

Close to Vat. 747 but the types are slightly different. The two surveyors are represented as bearded men with turbans and long tunics. Moreover, the one on the left holds a surveyor's rod in addition to the cord, and the one on the right, who turns his head, wears a paenula over his tunic. Instead of giving the order to the surveyors, the bareheaded Joshua holds the spear in his right hand. Eleazar is represented in the same posture as in Vat. 747 but is more fully visible, so that his right hand can be seen, making what must be interpreted as a mediating gesture between Zelophehad's daughter and Joshua. The foremost daughter, Mahlah (LXX: Maala), extends both hands imploringly toward Eleazar; the second, Noah (LXX: Nua), turns to her sister Hoglah (LXX: Egla), who weeps, perhaps anticipating a negative decision; and Milcah and Tirzah (LXX: Melcha and Thersa), the fourth and fifth daughters, converse with each other. Most of the figures are slightly flaked.

Located below Joshua 17:6.

1339. Sm., fol. 233r

Very close to Ser.
Located below Joshua 17:6.

1340. Vat. 746, fol. 459v

Close to Ser. and Sm., except that the three groups are more compressed. The figures, particularly those of the surveyors, have been overpainted.

Located beside Joshua 17:7.

1341. Vtp., fol. 379v

Close to Vat. 746 in the comparatively compressed arrangement of the groups. The surveyor on the left has lost his rod and again holds only the cord in both hands. The second daughter from the right, whose head is nearly completely hidden in Vat. 746, wears a patterned kerchief which is not part of the paenula. The miniature is partly stained.

Located beside Joshua 17:6.

Lit.: RG, p. 38, pl. H no. 1; Uspenskii, p. 169, fig. 263; Hesseling, fig. 299; Eller and Wolf, *Mosaiken*, fig. 48; Huber, fig. 105; Θησαυροί, pp. 274–75, fig. 131; Lowden, *Octs.*, pp. 36–37, figs. 16–20.

¹ When older men wear a kerchief, it covers only the back of the head, as seen, e.g., in fig. 1380.

Joshua 17:17–18

Ephraim and Manasseh Cut Down Trees

1342. Vat. 747, fol. 230r

Joshua commands the men of Ephraim and Manasseh to cut down trees to increase their living space. Two lumbermen, one partly hidden by a mountain slope, swing their axes to fell the trees. Painted in light blue similar to grisaille, the trees are hardly discernible, and only the one in front of the left-hand lumberman is fully visible; the tree before the second figure is mostly destroyed by flaking. Two other youths, one of them clad in armor, are working opposite each other at the foot of a steep mountain, clearing the land by setting the underbrush on fire with torches. The heads were overpainted, but this later layer has also flaked again in part, together with other areas of the original paint.

Located beside Joshua 17:18.

Ser., fol. 500r

Blank space for an unexecuted miniature.
Located beside Joshua 17:18.

1343. Sm., fol. 233r or 233v[1]

Close to Vat. 747 but the method of clearing is depicted somewhat differently. The two lumbermen, facing each other, use a kind of machete or pruning knife to cut the branches rather than the trunks of the trees. At the right only one of the youths actually sets the underbrush on fire, while the other merely assists by holding a vessel with an open fire in his hands. All the workers wear short tunics and high puttees, and, except for the one at the extreme left, they are bearded.

1344. Vat. 746, fol. 460r

Very close to Sm.
Located beside Joshua 17:18.

1345. Vtp., fol. 380r

Close to Sm. and Vat. 746. All the workers wear ornamented stockings instead of puttees, and the tunic worn by the man at the left is embroidered. Some of the workmen's legs and the tunic of the right-hand workman are flaked.

Located beside Joshua 17:16.

Lit.: RG, p. 38, pl. H no. 2; Uspenskii, p. 171, figs. 264, 265; Hesseling, fig. 300; Crooy, *Émaux*, p. 53, fig. 36; Huber, fig. 106; Θησαυροί, p. 275, fig. 132.

[1] Fol. 233v according to Hesseling, p. xv; fol. 233r according to Uspenskii, pp. 171, 188.

Joshua 18:5–7

Joshua Allots Land to the Tribes

1346. Vat. 747, fol. 230v

After the Israelites have assembled at Shiloh (LXX: Selo), Joshua begins allotting land to the remaining seven tribes. Clad in full armor, he sits frontally on the throne, leans on a spear, and commands that the country be surveyed. Three young Israelites are busy erecting a landmark in the form of a marble column. This may refer to verse 5 and represent the demarcation between the house of Judah to the south and the house of Joseph to the north, thus denoting the chief division of the land west of the Jordan; or it may simply represent more generally the imminent demarcation of frontiers among the seven tribes. Beside the column, the River Jordan flows down vertically in cartographic fashion, describing a curve on the ground and turning to the lower right-hand corner. This feature clearly indicates that the country still to be distributed lies on the same side as Joshua's camp at Shiloh, i.e., on the western bank of the river. On the opposite bank two Israelites can be seen piling up huge square blocks of marble. Recapitulating chapters 14–17, verse 7 reminds the reader that the country east of the Jordan has already been allotted to the sons of Gad, Reuben, and the half-tribe of Manasseh; therefore the two men must be representatives of the tribes of Gad and Reuben who are busily erecting what might be taken as a city wall in their newly inherited country. The miniature is cracked and slightly flaked.

Located beside Joshua 18:7.

Ser., fol. 500v

Blank space for an unexecuted miniature.
Located beside Joshua 18:7.

1347. Sm., fol. 233v

Close to Vat. 747 but Joshua is without a helmet. Except for the man trying to carry a column on his shoulder, the Israelites are bearded, and the two masons pile up smaller stones in greater quantity.

1348. Vat. 746, fol. 460r

Close to Sm. However, in contrast to the two preceding copies, where the River Jordan emanates from the empty background, the stream is cut by the upper frame, implying that its spring is beyond the limits of the picture. Most of the figures are clumsily overpainted.

Located beside Joshua 18:7.

1349. Vtp., fol. 381r

Close to Vat. 746, as indicated by the similar design of the River Jordan. The whole surface is heavily stained and slightly flaked.

Located beside Joshua 18:8.

Lit.: RG, p. 38, pl. H no. 3; Uspenskii, p. 171, fig. 266; Hesseling, fig. 301; Koukoules, *Vie et civilization*, vol. 5, pl. 7 no. 1; Huber, fig. 107; Θησαυροί, p. 275, fig. 133.

Joshua 18:10

Casting of Lots at Shiloh

1350a. Vat. 747, fol. 231r

The casting of lots, which, according to the text, was supposed to be done by Joshua himself, is performed in the miniature by a young Israelite acting at Joshua's command. At the left of a frieze-like composition combining several scenes, Joshua is represented bearded, clad in full armor and helmet, and leaning on his spear. He extends his right hand toward the ground, upon which a young Israelite throws his lots. Shaped like dice, the lots are being carried in a ballot bowl, from which the Israelite takes them one by one and drops them. The figure of Joshua and parts of the ground are badly damaged.

Located below Joshua 19:16.

Ser., fol. 502r

Blank space for an unexecuted miniature.
Located below Joshua 19:16.

1351a. Sm., fol. 234r

The inscription reads: κλῆρο(ς) μερίζει πᾶσι τὴν κατοικίαν.
Close to Vat. 747. Joshua is beardless and without a helmet. A border line separates this scene from the neighboring one in the same frieze, thus making it clear to the viewer that it is to be considered as a pictorial unit on its own.

Located below Joshua 19:23, thus corresponding to the following miniature in the other manuscripts; the scribe probably omitted a space blank for a miniature.

1352a. Vat. 746, fol. 461r

The inscription reads: κλῆρο(ς) μερίζει πᾶσι τὴν κατοικίαν.
Close to Sm., but the young Israelite has a pointed beard.
Located below Joshua 19:16.

1353. Vtp., fol. 383r

The inscription reads: κλῆρο(ς) μερίζει πᾶσι τ(ὴν) κατοικίαν.

The scene is an independent pictorial unit. Joshua is bearded as in Vat. 747, and so is the young Israelite, whose pointed beard is like that in Vat. 746.

Located beside Joshua 19:13.

Lit.: RG, p. 38, pl. H no. 4; Uspenskii, pp. 171–72, fig. 267; Hesseling, fig. 302; Koukoules, *Vie et civilization*, vol. 5, pl. 7 no. 2; Huber, fig. 108; Θησαυροί, p. 275, fig. 134.

Joshua 18:11

Departure of a Tribe

The distribution of land among the seven remaining tribes, as described in the second half of chapter 18 and throughout chapter 19, is represented in six phases. From this one might conclude that each scene is intended to be connected with one of the tribes. However, with the exception of the tribe of Dan, the last of the seven, which had to conquer the city of Leshem (figs. 1368–1371) in order to occupy its allotted territory, the Septuagint's narration of the measuring and distribution of land is very monotonous, and no anecdotal feature is reported for any of the first six tribes which might have inspired the artist. Therefore he had to use his imagination and, without any help from the text, depicted the process of distribution in the following six scenes: the departure to the area to be measured; the march to that place; the actual measuring; the quarrel over a demarcation line; the erection of a landmark; and finally the building of cities and the plowing of a field within the firmly established boundaries. Although each of these six scenes is meant to be related to the story of a specific tribe, as is particularly evident in the physical relationship between scenes 4–6 and the text (figs. 1356–1367), taken together they represent a process of distribution which might have repeated itself for the land settlement of each individual tribe, and thus each scene has a specific as well as a general meaning.

In both Vatican manuscripts and in Sm. the miniature which depicts several steps in the surveying of land is attached to verse 16 of chapter 19, i.e., to the end of the distribution of land to the tribe of Zebulon, which is the third in the sequence. Thus, the stories of the first three tribes had to be condensed into this comparatively extended frieze.

1350b. Vat. 747, fol. 231r

The first scene is that of departure. A soldier who leans on his spear while his shield rests on the ground raises his hand toward a young Israelite who turns his head in an expression of bidding the soldier farewell. The departing man must be understood as a representative of the tribe of Benjamin, whose inheritance is the first to be described (Josh 19:11–28).

Located below Joshua 19:16.

Ser., fol. 502r

Blank space for an unexecuted miniature.
Located below Joshua 19:16.

1351b. Sm., fol. 234r

The first half of the inscription related to this scene reads: ἄπεισιν οὗτοι.

The scenes related to the first and second tribes are combined within border lines. The first episode represents a man of the tribe of Benjamin who, instead of being sent off by a soldier, is

followed by three other members of his tribe. He looks straight ahead and holds a measuring cord in his hand.

Located below Joshua 19:23 (see no. 1351a).

1352b. Vat. 746, fol. 461r

The inscription reads: ἄπεισιν οὗτοι.
Close to Sm.
Located below Joshua 19:16.

1354a. Vtp., fol. 383r

The inscription reads: ἄπεισι(ν) οὗτοι.
The first and second distributions constitute a separate miniature. In general, the painter followed the composition of Sm. and Vat. 746, changing it only in a minor detail, letting two men look backward instead of just one.
Located beside Joshua 19:15.

Lit.: RG, p. 38, pl. H no. 4; Uspenskii, pp. 171–72, fig. 267; Hesseling, fig. 302; Koukoules, *Vie et civilization*, vol. 5, pl. 7 no. 2; Huber, fig. 108; Θησαυροί, p. 275, fig. 134.

Joshua 19:1

Tribe on the March

1350c. Vat. 747, fol. 231r

Next to the scene of departure, a young Israelite is seen on the march. According to the program outlined in connection with the preceding scene, he can be interpreted as a member of the tribe of Simeon, whose inheritance is described at Joshua 9:1–9.
Located below Joshua 19:16.

Ser., fol. 502r

Blank space for an unexecuted miniature.
Located below Joshua 19:16.

1351c. Sm., fol. 234r

The inscription, a continuation of the one related to the preceding scene, reads: καὶ μερίζουσι χθόνα.
The Simeonite on the march holds a measuring cord in his hand and turns his head to the group of Benjamites with whom he is united within a common frame. In contrast to Vat. 747, the Simeonite is bearded.
Located below Joshua 19:23 (see no. 1351a).

1352c. Vat. 746, fol. 461r

The inscription reads: καὶ μερίζουσι χθόνα.
Close to Sm. Slightly flaked.
Located below Joshua 19:16.

1354b. Vtp., fol. 383r

The inscription reads: κ(αὶ) μερίζουσι χθόνα.

The figure type is the same as in Sm. and Vat. 746, but the measuring cord in his hand is omitted. Apparently, the painter no longer understood that he was dealing with a figure that originally constituted a separate phase, and it now appears as if the man were leading the group of four Benjamites to the place to be surveyed.
Located beside Joshua 19:15.

Lit.: RG, p. 38, pl. H no. 4; Uspenskii, pp. 171–72, fig. 267; Hesseling, fig. 302; Koukoules, *Vie et civilization*, vol. 5, pl. 7 no. 2; Huber, fig. 108; Θησαυροί, p. 275, fig. 134.

Joshua 19:10

Measuring of the Land

1350d. Vat. 747, fol. 231r

In the last scene of the extended frieze two Israelites are occupied with the actual measurement of the land. Each holds one end of the cord, which is stretched out over the flowery ground. Since the third lot came up for the children of Zebulon (LXX: Zabulon), the two Israelites must be understood as members of this tribe. This supposition is supported by the location of the miniature at the end of the very passage that describes the inheritance of Zebulon (Josh 19:10–16). Slightly flaked.
Located below Joshua 19:16.

Ser., fol. 502r

Blank space for an unexecuted miniature.
Located below Joshua 19:16.

1351d. Sm., fol. 234r

The inscription reads: σχοῖνο(ς) ταθεὶς ἔλυσ(εν) ἄμφω τ(ὰς) ἔρεις.
The composition, which is separated from the preceding one by a border line, is close to Vat. 747, except that the two men hold the cord further away from the viewer. The contention alluded to in the inscription is still in the verbal stage, expressed by the gesticulation of the free hands.
Located below Joshua 19:23 (see no. 1351a).

1352d. Vat. 746, fol. 461r

The inscription reads: σχοῖνος ταθεὶς ἔλυσεν ἄμφω τὰς ἔρεις.
Close to Sm.
Located below Joshua 19:16.

1355. Vtp., fol. 383r

The inscription reads: σχοῖνος ταθεὶς ἔλυσεν ἄμφω τὰς ἔρεις.
The scene, which constitutes a miniature on its own, is close to Sm. and Vat. 746, deviating from them only in that the Israelite on the left holds the cord with both hands. Both figures are somewhat flaked.
Located beside Joshua 19:17.

Lit.: RG, p. 38, pl. H no. 4; Uspenskii, pp. 171–72, fig. 267; Hesseling, fig. 302; Koukoules, *Vie et civilization*, vol. 5, pl. 7 no. 2; Henderson, "Joshua Cycle," p. 59; Huber, fig. 109; Θησαυροί, pp. 275–76, fig. 134.

[Joshua 19:17]

Quarrel between Israelites

The following miniature is attached to Joshua 19:22 and therefore near the end of the passage dealing with the inheritance of the children of Issachar (Josh 19:17–23). Consequently, the two Israelites must be meant to represent members of that tribe, notwithstanding that no quarrel is mentioned here in the text.

1356. Vat. 747, fol. 231r

Two Israelites are depicted fighting with each other, obviously over the establishment of a boundary. While one seizes his opponent by the hair, the other pushes back his adversary's head and is about to slap him in the face. Both heads have been overpainted, and parts of the ground are flaked.
Located beside Joshua 19:22.

Ser., fol. 502r

Blank space for an unexecuted miniature.
Located beside Joshua 19:23.

1357. Sm., fol. 234r

The inscription reads: μάτην με τύπτεις ζημιῶν ἐφωράθ(η)ς.
The Israelite at the left has seized his opponent's tunic near the breast, but the rest of the actions resemble those in Vat. 747. The measuring cord lies on the ground as an indication of the cause of the fight.

1358. Vat. 746, fol. 461r

The inscription reads: μάτην με τύπτεις ζημιῶν ἐφωράθης.
Close to Sm. Flaked in the lower right corner.
Located beside Joshua 19:24.

1359. Vtp., fol. 383v

The inscription reads: μάτην με τύπτεις ζημι(ῶν) ἐφωράθης.
The postures of the two disputants are similar to those in Sm. and Vat. 746, but their actions vary somewhat. The Israelite at the left seizes his opponent by the beard, while the one at the right extends his arms as if to strip the tunic from his adversary's shoulders.
Located beside Joshua 19:31.

Lit.: RG, p. 38, pl. H no. 5; Uspenskii, p. 173, fig. 268; Hesseling, fig. 303; Koukoules, *Vie et civilization*, vol. 3, pl. 8 no. 3; Huber, fig. 110; Θησαυροί, p. 276, fig. 135.

Joshua 19:24

Erection of a Landmark

1360. Vat. 747, fol. 231v

The fifth episode illustrates the erection of a landmark. One Israelite is digging, while another carries a marble column on his left shoulder and waits until the digging is finished so that he may lower his burden and place it in the hole. The next tribe to receive its inheritance is that of Asher (Josh 19:24–31), and thus the two Israelites may be interpreted as members of this tribe. The miniature, however, is attached to verses 32–33, which record the inheritance of Naphtali. The ground is badly flaked.
Located beside Joshua 19:33.

Ser., fol. 502v

Blank space for an unexecuted miniature.
Located beside Joshua 19:33.

1361. Sm., fol. 234v

The inscription reads: ἀλγῶ τ(ὸν) ὦμον σύ δ'ὀρύττειν οὐ θέλεις.
The second Israelite carries the column on his right shoulder, but otherwise the composition agrees very well with Vat. 747.

1362. Vat. 746, fol. 461v

The inscription reads: ἀλγῶ τὸν ὦμον σύ δ'ὀρύττειν οὐ θέλεις.
Close to Sm.
Located beside Joshua 19:34.

1363. Vtp., fol. 384r

The inscription reads: ἀλγῶ τὸν ὦμ(ον) σὺ δ'ὀρύττ(ειν) οὐ θέλεις.
Close to Sm. and Vat. 746.
Located beside Joshua 19:33.

Lit.: RG, p. 38, pl. H no. 6; Uspenskii, p. 173, figs. 269, 315; Hesseling, fig. 304; Huber, fig. 111; Θησαυροί, p. 276, fig. 136.

Joshua 19:32

Plowing of a Field

1364. Vat. 747, fol. 231v

The final colonization of the land within the firmly established boundaries is illustrated by a youthful Israelite plowing his field. The man holds onto the handle of the plow with his left hand; a staff to drive the team of oxen is in his right. The left half of the miniature is occupied by two of the many walled cities which each tribe built within its territory. The inscription

in the corresponding miniatures of the other Octateuchs (figs. 1365–1367) makes it clear that the Israelite is meant to represent a member of the tribe of Naphtali, whose inheritance is recorded in verses 32–39, although in this case as in the preceding one, the miniature has been placed too far down in the text, in the passage dealing with the inheritance of Dan (verses 40ff.). The River Jordan marks the eastern frontier of the settlement of Naphtali; but contrary to the illustration for Joshua 18:5–7 (figs. 1346–1349), it has no cartographic significance, and the erection of the cities and the plowing cannot be interpreted as taking place on opposite banks of the river since, according to the text, all the land belonging to the tribe of Naphtali was situated on the western bank of the Jordan. The ground of the miniature is badly flaked.

Located beside Joshua 19:42.

Ser., fol. 503r

Blank space for an unexecuted miniature.
Located beside Joshua 19:40.

1365. Sm., fol. 234v

The inscription reads: πόλεις—ποταμό(ς)—νεφθαλεὶμ κατοικία.

Close to Vat. 747. The Israelite, who has a pointed beard, holds onto the handle of the plow with his right hand and the oxen's reins with his left. The two walled cities are fused into a single architectural unit with one tower in the center related to both.

Located below Joshua 19:40.

1366. Vat. 746, fol. 461v

The inscription reads: πόλεις—ποταμός—νεφθαλεὶμ κατοικία.

Close to Sm. The handle of the plow and the reins are not clearly distinguished by the painter.

Located beside Joshua 19:45.

1367. Vtp., fol. 384r

The inscription reads: πόλεις—ποταμό(ς)—νεφθαλεὶμ κατοικία.

Close to Sm. and Vat. 746. The Israelite is youthful, wears a broad-brimmed hat, and with his left hand holds a staff instead of reins. The walled cities are more elaborate in detail, while the river is omitted entirely. Since the painter, however, took over the word ποταμός from his model, the omission of the river must be due either to lack of space or to negligence.

Located beside Joshua 19:40.

Lit.: RG, p. 38, pl. I no. 1; Uspenskii, p. 173, figs. 270, 316; Hesseling, fig. 305; Millet, "Octateuque," pp. 75–76; Koukoules, *Vie et civilization*, vol. 5, pl. 8 no. 1; Huber, fig. 112; Θησαυροί, p. 276, fig. 137.

Joshua 19:48

DAN CAPTURES LESHEM

1368. Vat. 747, fol. 231v

A group of bareheaded soldiers from the tribe of Dan storms the city of Leshem (LXX: Lachis) with lowered lances and enters it through a wide gap in the circular wall alongside the closed gate. The strip of ground is nearly completely flaked, revealing the preliminary drawing of the soldiers' legs. The remainder of the surface, including the city and the soldiers, is also badly damaged by flaking.

Located beside Joshua 19:48.

Ser., fol. 503r

Blank space for an unexecuted miniature.
Located beside Joshua 19:48.

1369. Sm., fol. 234v

The inscription reads: τοῦ δὰν φυλή δε τοὺς ἐναντίους τρέπει.
Three soldiers, seen in frontal view and wearing helmets, storm through the breach in the wall in single file. In contrast to Vat. 747, they hold their lowered lances in their left hands.

Located below Joshua 19:47.

1370. Vat. 746, fol. 461v

The inscription reads: τοῦ δὰν φυλὴ δε τοὺς ἐναντίους τρέπει.
Close to Sm. The figures have been overpainted with little skill.

Located beside Joshua 19:48.

1371. Vtp., fol. 384v

Only two of the three soldiers attack with lowered lances, holding their weapons in their right instead of their left hands, as they do in Sm. and Vat. 746. The foremost soldier's lance crosses his body in a manner one might expect from a weapon held in the left hand; apparently the painter tried to change the model, Vat. 746, without seeing the full implications of his alteration. The hindmost soldier, not yet taking part in the assault, approaches with his lance over his shoulder; he wears a cap instead of a helmet. The city is a very deformed structure without the closed gate but nevertheless shows the breach through which the soldiers are about to enter. Slightly flaked.

Located beside Joshua 19:47

Lit.: RG, p. 38, pl. I no. 2; Uspenskii, p. 174, fig. 271; Hesseling, fig. 306; Huber, fig. 113; Θησαυροί, p. 276, fig. 138.

Joshua 19:49–50

Joshua's Residence

1372a. Vat. 747, fol. 232r

The last inheritance to be distributed was the city of Timnath-serah (LXX: Thamnasarach) on Mount Ephraim, which was given to Joshua as his residence. Differentiating Joshua's domicile from those in which entire tribes resided, the painter depicted a house, not a walled city. It is a simple cella with annexes and a second story above the roof. House and ground are flaked.
Located beside Joshua 19:51.

Ser., fol. 503v

Blank space for an unexecuted miniature.
Located beside Joshua 20:1.

1373a. Sm., fol. 235r

In his desire to make Joshua's residence look like a palace, the painter put a colonnaded substructure underneath the house itself, which was further enriched by the addition of a domed rotunda.

1374a. Vat. 746, fol. 462r

Close to Sm.
Located beside Joshua 19:51.

1375a. Vtp., fol. 385r

Close to Sm. and Vat. 746. The front of the house is flaked and its roof rubbed.
Located beside Joshua 19:51.

Lit.: RG, p. 38, pl. J no. 3; Uspenskii, p. 174, fig. 272; Hesseling, fig. 307; Huber, fig. 114; Θησαυροί, p. 276, fig. 139.

Joshua 19:51

Tabernacle

Beside Joshua's residence on the right is the Tabernacle of the Covenant, near the doors of which Joshua himself had cast lots to divide the land among the tribes of Israel (Josh 18:10ff.). The tabernacle is depicted as a tent, a form entirely different from the tabernacle in the Exodus miniatures (figs. 762–765, 778–781) but similar to that in Deuteronomy 16:2–15 in Vat. 747 (fig. 1074).

1372b. Vat. 747, fol. 232r

The tabernacle is depicted as a tent with pegged cords at the four corners and supported by a pole in the center. The top of the tent is embroidered.
Located beside Joshua 19:51.

Ser., fol. 503v

Blank space for an unexecuted miniature.
Located beside Joshua 20:1.

1373b. Sm., fol. 235r

Misunderstanding the structure of the tent, the painter has replaced the four pegged cords with poles like the central one.

1374b. Vat. 746, fol. 462r

Close to Sm.
Located beside Joshua 19:51.

1375b. Vtp., fol. 385r

Close to Vat. 746. The painter decorated the tent with two gilded, jewel-studded bands. The tent is slightly flaked and the ground rubbed.
Located beside Joshua 19:51.

Lit.: RG, p. 38, pl. J no. 3; Uspenskii, p. 174, fig. 272; Stornajolo, *Topografia Cristiana*, p. 17; Hesseling, fig. 307; Huber, fig. 114; Θησαυροί, p. 276, fig. 139.

Joshua 20:3

Trial in a City of Refuge

1376. Vat. 747, fol. 232r

In chapter 20, God commands Joshua to build cities of refuge, where a man who has unwittingly killed another may be protected against the avenger and be brought before the congregation for judgment. Instead of depicting God's command to Joshua, the illustrator portrayed a scene of a trial as it might have taken place after the cities were built. At the left, three Israelite judges sit on a cushioned bench in front of an architectural element in the form of a ciborium and try the case of a murderer. Two of the judges argue with each other, while the third listens to the defense of the murderer, who stands before him and raises both hands in a gesture of supplication. A second Israelite, holding the defendant by the shoulder, is either a court servant who has brought him before the council or perhaps the avenger, who tries to seize him. The slain victim lies on the ground. All three men at the right are youthful and clad in short tunics. Their heads have been overpainted, and this restoration may account for the victim's open eyes, which were originally probably closed. Parts of the ground are flaked.
Located beside Joshua 20:9.

Ser., fol. 504r

Blank space for an unexecuted miniature.
Located beside Joshua 20:9.

1377. Sm., fol. 235r

Very much like Vat. 747 but with slight alterations. The ciboriumlike structure is omitted, and the judges, apparently in deviation from the archetype, are depicted as youthful, two without any beard at all and the third with a short dark beard. The slayer holds his arms respectfully crossed instead of gesturing in supplication.

1378. Vat. 746, fol. 463r

Very close to Sm.

Located beside Joshua 21:11. The misplacing of the miniature in comparison with Vat. 747 and Ser. was probably caused by the scribe, who did not leave a blank space approximately around Joshua 20:9; the miniature now corresponds to the following one in Vat. 747 and Ser.

1379. Vtp., fol. 387v

Very close to Sm. and Vat. 746.

Located beside Joshua 21:7. For the misplacing of the miniature in the text, which corresponds to the misplacement in Vat. 746, see no. 1378; the miniature now corresponds to the following one in Vat. 747 and Ser.

Lit.: RG, p. 38, pl. J no. 4; Uspenskii, p. 174, fig. 273; Hesseling, fig. 308; Huber, fig. 115; Θησαυροί, p. 276, fig. 140.

Joshua 21:1–3

Levites Ask for Cities

1380. Vat. 747, fol. 232v

The Levites ask Joshua, Eleazar the priest, and the heads of the Israelite tribes to allot them the cities promised to them by Moses. In the illustration of this event, a group of elderly Levites with white beards and wearing long tunics, paenulae, and headgear, approach only Joshua: Eleazar and the heads of the tribes have been omitted by the painter. Joshua, who from this point on is depicted as an old man with a white beard, wears heavy armor, holds a lance, and extends his hand in a gesture of speech, meaning that he is granting the Levites' request. Of the many cities given to the Levites enumerated in chapter 21, only five are represented, and these in the usual way as circular walls with flanking towers. Two cities stand at the foot of the mountain, one halfway up the slope, and two more near the peak and partly hidden by it. Parts of the ground are flaked, and the figures are slightly damaged.

Located beside Joshua 21:12.

Ser., fol. 505v

Blank space for an unexecuted miniature.
Located beside Joshua 21:4.

1381. Sm., fol. 235v

Like Vat. 747. However, Joshua is youthful and bareheaded, and only three Levites are visible, the middle and the right-hand one having been grossly overpainted. It may well be that the group of Levites was originally more numerous and was reduced by the restorer. The cities, reduced from five to four, are grouped in two pairs, one above the other. The mountain has been abandoned, and thus any spatial relationship between the cities is eliminated. Each city has lost one of its flanking towers but is enriched by the addition of a house within its walls.

1382. Vat. 746, fol. 465r

Close to Sm. This miniature was also overpainted, but the group of Levites remains as numerous as it had been in the original. In contrast to Vat. 747, the Levites are youthful and have either no beards at all or short dark ones.

Located beside Joshua 22:11 (see no. 1378).

1383. Vtp., fol. 392r

Close to Vat. 746. In this and the following miniature of Vtp. Joshua has a short dark beard—not a white one as in Vat. 747—which still characterizes him as a youthful hero (cf. figs. 1387, 1395, 1398, and 1401). Only the paenula of the foremost Levite is slightly flaked.

Located beside Joshua 22:11 (see no. 1379).

Lit.: RG, p. 38, pl. J no. 5; Uspenskii, p. 174, fig. 274; Hesseling, fig. 309; Huber, fig. 116; Θησαυροί, pp. 276–77, fig. 141.

Joshua 11:7–8

Joshua Allots Land to Manasseh

1384. Vat. 747, fol. 234r

Represented larger than the other figures and seen in frontal view, Joshua sits on a faldstool and leans majestically on his lance while he sends out the tribe of Manasseh to its allotted territory. The members of the tribe that are fully visible are elders wearing paenulae and kerchiefs, but a row of lance tips above their heads suggests that soldiers stand behind them. The man next to Joshua raises his hand toward the leader in a gesture of speech. Joshua, depicted as an old man with a long beard, in full armor, and wearing a helmet, does not respond, but holds his hand before his breast, although the text would require a gesture of blessing instead. The actual departure is illustrated by one man who has turned in the opposite direction, driving pairs of asses, oxen, and sheep before him. Of the various riches enumerated in the text, the cattle is the only item represented by the painter. The entire surface of the miniature is slightly flaked.

Located beside Joshua 22:11.

Ser., fol. 507v

Blank space for an unexecuted miniature.
Located beside Joshua 22:11.

1385. Sm., fol. 237r

The composition shows only unessential differences from that in Vat. 747: Joshua is represented as youthful, of larger than normal size, and seated on a throne; the tribe of Manasseh is restricted to civilians; and the third pair of animals resembles swine rather than sheep. Flaked in various spots.

1386. Vat. 746, fol. 466r

Very close to Sm.
Located beside Joshua 23:1 (see no. 1378).

1387. Vtp., fol. 394r

Turned in profile, Joshua sits on a completely gold, jewel-studded throne. The asses have been changed to horses and, because of a condensation of the composition, the departing man overlaps part of the cattle. Otherwise the scene agrees with Sm. and Vat. 746. Flaked in various places.
Located beside Joshua 23:1 (see no. 1379).

Lit.: RG, p. 38, pl. J no. 6; Uspenskii, p. 174, fig. 275; Hesseling, fig. 310; Huber, fig. 117; Johnstone, "Pallio," p. 106, fig. 5; Θησαυροί, p. 277, fig. 142.

Joshua 22:13–16

Altar Erected in Gilead

1388. Vat. 747, fol. 235r

A delegation of ten Israelite chiefs headed by Phinehas, the son of Eleazar, is sent to the sons of Reuben, Gad, and the half-tribe of Manasseh to reproach them for having turned away from God by building an altar in Gilead (LXX: Galaad). The River Jordan flows down from the peak of a high mountain, crossing the picture and dividing the land into two halves. On its eastern bank, i.e., in the right half of the miniature, members of the tribes of Reuben, Gad, and Manasseh have crossed the Jordan and set up an altar and worship before it. Joshua, depicted as in the previous miniature (fig. 1384), points with his right hand at the river, and is followed by a group of men, the older of whom are clad in long tunics, the younger men in short ones. The painter fused the concept of an altar with that of a landmark and painted a marble column, its base partly overlapped by the water of the Jordan, and its top crowned with the fire of a burning altar. On the left, i.e., geographically speaking the west bank of the Jordan, is the delegation of Israelites depicted as a group of elderly men headed by a bearded soldier who leans on his lance and points in the direction of the altar. Undoubtedly the painter intended the leader to represent Joshua, although the text does

not mention him, but rather Phinehas, son of the priest Eleazar. Phinehas would have to be represented in priestly attire, as indeed he is in another miniature in the Octateuchs (figs. 1013–1017). The sky and river are partly flaked.
Located beside Joshua 23:1.

Ser., fol. 509r

Blank space for an unexecuted miniature.
Located beside Joshua 23:1.

1389. Sm., fol. 238r

Close to Vat. 747, except that Joshua is not represented. Phinehas is not represented either, since no one individual in the group of delegates can be identified as Eleazar's son with any certainty. All the sons of Reuben, Gad, and Manasseh are clad in short tunics, although they are of varying ages, just as in Vat. 747. The miniature has been overpainted, as is particularly clear from the heads of the delegates.
Located below Joshua 22:34.

1390. Vat. 746, fol. 466v

Close to Sm. All the figures are slightly flaked.
Located beside Joshua 24:1 (see no. 1378).

1391. Vtp., fol. 395v

The painter clearly followed Vat. 746 as far as the number of delegates is concerned,. The children of Reuben, Gad, and Manasseh stand partly in the water and partly on the western bank of the river: the clear geographical line of division between the two actions taking place on opposite banks has become obscured.
Located beside Joshua 24:1 (see no. 1379).

Lit.: RG, p. 38, pl. K no. 1; Uspenskii, p. 174, fig. 276; Hesseling, fig. 311; Huber, fig. 118; Θησαυροί, p. 277, fig. 143.

Joshua 24:1–2

Joshua's Last Address to the Israelites

1392. Vat. 747, fol. 235v

Shortly before his death, Joshua gives his last instructions to the elders, judges, officers, and all the people of Israel. Seated in profile on a faldstool and holding a spear, the aged Israelite leader addresses a large crowd standing before him. The elders in the forefront have white beards, wear long tunics, and have kerchiefs over their heads; the common people wear short tunics. The figure of Joshua and parts of the background are badly flaked, the group of Israelites to a lesser degree. All the heads in the right half of the group have been overpainted.
Located beside Joshua 24:1.

Ser., fol. 511r

Blank space for an unexecuted miniature.
Located beside Joshua 24:2.

1393. Sm., fol. 238v

Close to Vat. 747. The gestures, and with them the meaning of the scene, have been changed. Joshua holds his right hand near his hip and does not do the talking; the foremost elder does, extending his right hand in a gesture of speech. Thus, the painter apparently intended to represent verse 21, in which, after Joshua finishes his speech, the Israelites assure him that they will serve God. The Israelites are not grouped in depth as in Vat. 747, but more or less in single file. The elders and judges are more numerous than the common people, of whom only two men remain, engaged in an ardent dispute.

1394. Vat. 746, fol. 467v

Very close to Sm.
Located beside Joshua 24:25 (see no. 1378).

1395. Vtp., fol. 398r

Close to Sm. and Vat. 746, with which the group of Israelites and certain features of Joshua agree thoroughly, e.g., his lack of a helmet and his relative youthfulness. The Israelite at the extreme right is rubbed so completely that the rubbing appears intentional, though for no clear reason.
Located beside Joshua 24:25 (see no. 1379).

Lit.: RG, p. 38, pl. K no. 2; Uspenskii, p. 174, fig. 277; Hesseling, fig. 312; Williams, "León Bible," p. 85; Huber, fig. 119; Stahl, "Morgan M. 638," p. 87; Johnstone, "Pallio," p. 106, fig. 6; Θησαυροί, p. 277, fig. 144.

Joshua 24:24

Israelites' Promises to Joshua

1396. Vat. 747, fol. 236r

The Israelites promise Joshua to obey the voice of God. They consist of only the four elders, the foremost of whom approaches their enthroned leader in an impassioned posture and with his open arms expressing his sincere willingness. The aged Joshua sits in frontal view with one arm akimbo and the other hand majestically holding a spear. Parts of the miniature, particularly the ground, are flaked.
Located beside Joshua 24:25.

Ser., fol. 511r

Blank space for an unexecuted miniature.
Located beside Joshua 24:24.

Sm.

Between fols. 238 and 239 one folio was missing which surely contained not only this but also the following three scenes illustrating verses 25–26, and 33.

1397. Vat. 746, fol. 467v

The crowd consists of four men in postures very similar to those in Vat. 747, but only the two in the middle are characterized as elders; the outer two wear short tunics like ordinary people. The figures of the youthful Joshua and the speaker in the crowd are slightly rubbed.
Located beside Joshua 24:31 (see no. 1378).

1398. Vtp., fol. 398v

The characterization of the four standing Israelites agrees with Vat. 746, while Joshua, seated on a jewel-studded, golden throne, is changed from frontal into more profile view; he raises his right hand in a gesture of speech. All the figures are slightly flaked.
Located beside Joshua 24:32 (see no. 1379).

Lit.: RG, p. 38, pls. K no. 3, M no. 3; Uspenskii, p. 174, fig. 317; Williams, "León Bible," p. 85; Huber, fig. 120; Stahl, "Morgan M. 638," p. 87, fig. 106; Θησαυροί, p. 277, fig. 145.

Joshua 24:25–26

Joshua Hands a Scroll to the Israelites

1399. Vat. 747, fol. 236v

Joshua hands the people of Israel a sealed scroll on which a law and an ordinance are written. The aged leader sits on a faldstool and leans majestically on his lance, while the foremost man in the group of elders takes the scroll in a devout attitude. Two of the elders face a marble column at the right which represents the great stone erected by Joshua as witness to the covenant. All the figures, but particularly that of Joshua, are flaked, and so is part of the ground.
Located beside Joshua 24:30.

Ser., fol. 511v

Blank space for an unexecuted miniature.
Located beside Joshua 24:30.

Sm.

The miniature, together with the preceding one, was on a folio that is now lost.

1400. Vat. 746, fol. 468r

A group of ordinary people in short tunics, not the elders, receive the scroll from the hand of the youthful Joshua, who sits

in frontal view on a marble seat. The column is lacking, but in its place is a hillock with a tree. The painter probably intended these to represent the unhewn rocks (the "big stone") and the oak under which the stone was set up. The miniature has been overpainted.

Located beside Joshua 24:32 (see no. 1378).

1401. Vtp., fol. 398v

As in the previous examples in this manuscript, the painter preferred a profile pose for Joshua, who sits as usual on a jewel-studded, golden throne. Otherwise, the painter followed Vat. 746 in depicting the Israelites as ordinary people and the stone monument as a hillock. The whole surface of the miniature is somewhat flaked.

Located beside Joshua 24:33 (see no. 1379).

Lit.: RG, p. 38, pl. K no. 4; Uspenskii, p. 174, fig. 317; Huber, fig. 121; Θησαυροί, p. 277, fig. 145.

Joshua 24:32

BURIAL OF JOSEPH'S BONES

1402. Vat. 747, fol. 236v

Two Israelites, one youthful and one elderly, lower the lid of the marble sarcophagus which holds the bones of Joseph: in the interior a skeleton can be discerned. A group of elders in mourning attitudes stands at the foot of the sarcophagus. Slightly flaked all over the surface.

Located beside Joshua 24:32.

Ser., fol. 512r

Blank space for an unexecuted miniature.
Located beside Joshua 24:33.

Sm.

The miniature, together with the two preceding ones, was on a folio that is now lost.

1403. Vat. 746, fol. 468r

Close to Vat. 747. The men covering the sarcophagus and the mourners are younger men wearing short tunics. The garments have been overpainted.

Located beside Joshua 24:33 (see no. 1378).

1404. Vtp., fol. 399r

Very close to Vat. 746.
Located beside Joshua 24:33 (see no. 1379).

Lit.: RG, p. 38, pl. K no. 5; Huber, fig. 122; Θησαυροί, p. 278, fig. 146.

Joshua 24:33

BURIAL OF ELEAZAR

1405. Vat. 747, fol. 236v

Two Israelites lower Eleazar's mummy, which erroneously wears an imperial crown and thus resembles Joshua, into a marble sarcophagus. A group of mourning Israelites stands at its foot, and at its head is a gravedigger with a spade over his shoulder. The spade is incongruous for burial in a sarcophagus and appropriate for a burial in an open grave. Since the corresponding scenes in Vat. 746 and Vtp. do show burial in an open grave, the sarcophagus is certainly a later addition. The composition was probably conceived originally as Joshua's burial. The entire surface of the miniature is flaked.

Located beside Joshua 24:33.

Ser., fol. 512v

Blank space for an unexecuted miniature.
Located beside Joshua 24:33.

Sm.

The miniature was the last of the four which decorated the folio now cut out between fols. 238 and 239.

1406. Vat. 746, fol. 468r

Two Israelites, one of whom stands in the open grave, lower Joseph's mummy into the freshly dug grave. A third Israelite with a spade over his shoulder holds a shroud, although at least the upper part of the mummy is already enveloped in a richly patterned shroud. Most of the garments have been overpainted.

Located at the beginning of the catena of Judges, below the title Κρίται (see no. 1378).

1407. Vtp., fol. 399r

Close to Sm. In order to make the act of digging the grave more explicit, the artist painted a hoe and fork lying on the ground. They are presumably meant to represent the implements that were used by the two men who now hold the mummy. The surface is flaked in various spots.

Located beside Joshua 24:33. By placing the last two miniatures very close to each other, the painter corrected the shift of one space that had previously occurred (see no. 1379).

Lit.: RG, p. 39, pl. K no. 6; Buchthal, *Latin Kingdom*, p. 59; Huber, fig. 123; Stahl, "Morgan M. 638," p. 89; Θησαυροί, p. 278, fig. 147.

10. JUDGES

Judges 1:1–3

GOD SPEAKS TO JUDAH AND SIMEON

Vat. 747

One folio is missing between fols. 236 and 237; it contained the beginning of the Book of Judges up to verse 24 of chapter 1 and most likely also the three miniatures which in the other manuscripts illustrate verses 1–3, 8, and 13–15.

Ser., fol. 513v

Blank space for an unexecuted miniature.
Located beside Judges 1:14.

1408. Sm., fol. 239r

Clad in tunics, two youthful, short-bearded Israelites pray to the hand of God in heaven (curiously, the left hand). Three bundles of rays radiate from the hand. The text speaks generally of the children of Israel inquiring of God and receiving the order to fight the Canaanites. Since only two figures are portrayed, it seems likely that the painter wanted one of them to be understood as Judah, to whom God gives his reply, and the other as his brother, Simeon. The depiction of the latter with the same praying gesture as the former can only be understood as the painter's convention and his desire for a symmetrical and hieratic composition at the beginning of the Book of Judges. According to the text, Judah, not God, ordered Simeon to follow him into battle against the Canaanites. Below the lower frame the headpiece of Judges is partially visible.

1409. Vat. 746, fol. 469r

The composition is the same. The bush-studded ground is partly flaked and rubbed.
Located beside Judges 1:15.

1410. Vtp., fol. 401v

The same composition, but lacking the rays radiating from the hand of God, the shoulder pieces of the tunics, and the bushes on the ground.
Located above Judges 1:14.

Lit.: Uspenskii, p. 175, fig. 278; Hesseling, fig. 313; Huber, fig. 124; Kirigin, *Mano divina*, p. 152 n. 48; Θησαυροί, p. 278, fig. 148.

Judges 1:8

CAPTURE OF JERUSALEM

The setting on fire of Jerusalem and the smiting of the enemies "with the edge of the sword" are shown following verse 8. The burning of the town precludes identifying the scene as the capture of Kirjath-sepher (Judg 1:11–12; LXX: Cariathsepher), an episode which the next scene of Caleb addressing Achsah and Othniel (LXX: Gothoniel) would suggest: according to the Septuagint, Othniel took Kirjath-sepher, and, as a reward for the capture of the town, Caleb gave him his daughter Achsah as a wife.

Vat. 747

The miniature, together with the preceding one, was on a folio that is now lost.

Ser., fol. 513v

Blank space for an unexecuted miniature.
Located beside Judges 1:15.

1411. Sm., fol. 239v

With spears, bow, and sword a group of Israelites at the left attack a group of their enemies, apparently the Jebusites who are mentioned in Judges 1:21 as inhabiting Jerusalem at that time. Some of the Jebusites are being pierced by lances and others have been decapitated, while one group still defends itself before the walls of Jerusalem. The Israelites are dressed like Roman soldiers, while the Jebusites wear two different kinds of oriental scale armor and two types of helmets, one round and the other pointed. At the right three Israelites torch the walled city of Jerusalem, which is defended by two Jebusites from the crenelations of the wall. The great differentiation in the movements of these three Israelites is noteworthy: one rushes toward the city, the second turns the corner of the wall, and the third, seen from the back, attacks the central gate. At the same time, the awkward attitudes of their shields, with which they try to defend themselves, reveal the painter's shortcomings. The walled city is somewhat misunderstood in that the Israelite turning the corner disregards the tower at the left, which he should have circled.

1413a. Vat. 746, fol. 469v

In the battle scene at the left the painter has enlarged both groups of combatants by multiplying the helmets.
Located beside Judges 1:16.

1414a. Vtp., fol. 402r

The foremost Israelite soldier holds a lance, while in the preceding miniatures he swings a sword. With this change the close relationship to the text, which requires a sword for the smiting of the enemies, is weakened. In the lower center of the composition the defending Jebusites and the attacking Israelite underneath are partly flaked.
Located beside Judges 1:16.

Lit.: Uspenskii, p. 175, fig. 279; Hesseling, fig. 314; Diehl, *Manuel*, vol. 2, p. 597, fig. 280; Diehl, *Peinture byz.*, p. 94, pl. 81 no. 1; Huber, fig. 125; Θησαυροί, p. 278, fig. 149; Lowden, *Octs.*, p. 69, figs. 98, 100, 101.

Judges 1:13–15

CALEB PROMISES A FIELD TO ACHSAH

Vat. 747

This miniature, together with the two preceding ones, was on a folio that is now lost.

Ser., fol. 513v

Blank space for an unexecuted miniature.
Located below Judges 1:15.

1412. Sm., fol. 239v

Caleb's daughter Achsah and Othniel, to whom Achsah was given as a reward for the capture of the city of Kirjath-sepher, stand before Caleb. Othniel stares intently at Achsah and extends his left hand toward her in a gesture of speech, apparently urging his wife to ask her father for a field. Achsah complies and speaks to her father, who, as his extended right arm reveals, consents to her request. He promises her "the ransom of the upper springs and the ransom of the low springs." This gift is interpreted as an abundantly watered habitat represented by a building, with a dome-shaped tower, surrounded by luxuriant vegetation.

1413b. Vat. 746, fol. 469v

Because it is joined to the preceding battle scene, the composition is very condensed. Caleb's throne overlaps the figure of Achsah, Othniel stands closer to his wife, the size of the building is greatly reduced, and most of the vegetation is placed above the architecture instead of beside it. The figure of Caleb is partly flaked.
Located beside Judges 1:16.

1414b. Vtp., fol. 402r

Very close to Vat. 746.
Located beside Judges 1:16.

Lit.: Uspenskii, p. 175, fig. 280; Hesseling, fig. 315; Diehl, *Manuel*, vol. 2, p. 597, fig. 280; Diehl, *Peinture byz.*, p. 94, pl. 81 no. 1; Huber, fig. 125; Θησαυροί, p. 278, fig. 149; Lowden, *Octs.*, p. 69, figs. 99, 100, 101.

Judges 2:1–2

ANGEL REPROACHES THE ISRAELITES FOR IDOLATRY

Skipping the remainder of chapter 1, where more conquests of towns are narrated, the cycle focuses on an episode of idolatry:

the angel of God speaks to a group of Israelite elders, remonstrating with them for not having kept their part of the covenant, according to which they should have driven out the inhabitants of the conquered cities instead of making a league with them, and should have destroyed their graven images.

1415. Vat. 747, fol. 237v

While speaking to the elders, the angel points to a walled city, most likely meant to be Bethel, which the Israelites have left intact. In front of the central gate of the semicircular, crenelated wall flanked by three towers, two soldiers are asleep; the painter apparently wanted to convey that the army had neglected its tasks. Two other soldiers emerge from behind the city. The graven images, visible inside the wall, are conceived as symbols of Roman worship. In the center, on a pedestal and painted in a gray color simulating metal, is an equestrian statue holding a spear, most likely representing a Roman emperor. This statue is enclosed by a baldachin with a crowning Nike as an acroterion, and on either side of the baldachin a column serves as a pedestal for the nude figure of a god or hero holding a spear. The blue background studded with golden bushes is partly flaked, and the angel's head has been overpainted.
Located beside Judges 2:6.

Ser., fol. 516v

Blank space for an unexecuted miniature.
Located beside Judges 2:6.

1416. Sm., fol. 240v

Two of the Israelite elders extend their arms in gestures of speech toward the angel, although the text does not mention their reply. The angel is about to depart. The group of soldiers alongside the city is increased in number, and the men are more heavily armed. The two soldiers before the gate are conversing, not sleeping as in Vat. 747. The wall of the city is square in plan and is flanked by four towers; its crenelations are replaced by decorative palmettes. The decorative element is further apparent in that the two gods or heroes on the columns are replaced by figures of Nike holding a wreath, and by the doubling of the Nike on the baldachin. These figures, as well as the equestrian statue, are painted in white, producing the effect of a grisaille.

1417. Vat. 746, fol. 471v

Very close to Sm.
Located beside Judges 2:6.

1418. Vtp., fol. 405v

The upper right-hand tower has been absorbed into the wall. The Nike belonging on the right-hand column has erroneously been painted on top of the wall. While parts of the figures and the city are flaked, the equestrian statue seems to have been rubbed intentionally.
Located below Judges 2:5.

Lit.: Uspenskii, p. 175, fig. 318; Hesseling, fig. 316; Huber, fig. 126; Lassus, *Livre des Rois*, p. 87, fig. 117; Θησαυροί, p. 250, fig. 278.

Judges 2:8–9

BURIAL OF JOSHUA

1419. Vat. 747, fol. 237v

Two youthful Israelites lay the corpse of Joshua, whose head stands out against a golden nimbus, in a marble sarcophagus. Joshua, an old man with a white beard, is wrapped like a mummy and draped in a shroud adorned with a geometric pattern. The shape of the sarcophagus is distorted to accommodate the slightly raised head of the corpse. The lid, drawn as if it were half buried in the ground, lies in front of the sarcophagus. At the left stands a group of mourning Israelite elders. The men, who show their grief in expressive gestures, are depicted bareheaded and with disheveled hair. The paint is flaked in many places.
 Located beside Judges 2:10.

Ser., fol. 516v

Blank space for an unexecuted miniature.
Located beside Judges 2:8.

1420. Sm., fol. 240v

The two Israelites burying Joshua's corpse are here elders with long beards. Joshua, with a short dark beard, is represented incorrectly as being more youthful; in fact, the text states that he was 110 years old when he died. All the elders in the group of mourners wear caps, thus losing the expressive effect achieved by their disheveled hair in Vat. 747.

1421. Vat. 746, fol. 471v

The front right corner of the sarcophagus is cut off. Joshua's nimbus is light blue instead of gold.
 Located beside Judges 2:10.

1422. Vtp., fol. 406r

The dependence on Vat. 746 is apparent in the repetition of the same slight irregularity in the shape of the sarcophagus. The garments of the two undertakers, the face of Joshua, and parts of the sarcophagus are badly flaked.
 Located beside Judges 2:7.

Lit.: Uspenskii, p. 175; Hesseling, fig. 317; Huber, fig. 127; Weitzmann, *SP*, p. 71; Θησαυροί, p. 278, fig. 151.

Judges 3:20–24

EHUD SLAYS EGLON

The cycle ignores the stories of the Israelites following the gods of the nations around them and serving Baal and Ashtaroth (LXX: Baal and the Astartes; Judg 2:12ff.), of God's consequent wrath against Israel (Judg 2:20ff.), the story of Othniel the judge (Judg 3:9ff.), and of the invasion of Eglon the king of Moab (LXX: Eglom, King of Moob; Judg 3:12ff.). The illustrations continue in the next miniature with Ehud's (LXX: Aod) murder of Eglon. Here, however, Ehud holds the sword in his right hand instead of his left, in disagreement with the text (Judg 3:21).[1]

1423. Vat. 747, fol. 239r

The center of the composition is occupied by Eglon's palace, a structure whose rich details are unique in the miniature cycle. An open loggia runs along the long side between the front with its entrance and the back of the palace; both front and back are seen in frontal view. The horseshoe arches of the loggia recall Islamic architecture or Early Christian architecture in Syria.[2] The building is topped by a domed tower and enhanced by an annex supporting a richly planted terrace surrounded by a railing. A high staircase flanked by banisters leads to a court that is fenced with a marble rail interrupted in the center by a grillwork door. The murder, which the text describes as taking place inside the summer parlor of the palace, is depicted above the rail with neither a groundline nor any sense of proportion or spatial relationship to the architecture. King Eglon is about to rise from his throne as Ehud, standing in front of him, pierces his belly with a sword. Eglon wears a golden mantle and pearl-studded purple shoes like a Byzantine emperor. A group of young men wearing high pointed hats stands in front of the closed entrance door; they obviously represent Eglon's bodyguards, whom he has sent away in order to be alone with Ehud. They are gesticulating excitedly as if discussing the king's whereabouts, thus following verse 24. The background, partly flaked, is composed of three strips in light blue, dark blue, and gold.
 Located beside Judges 3:24.

Ser., fol. 519r

Blank space for an unexecuted miniature.
Located beside Judges 3:24.

1424. Sm., fol. 242r

The palace differs from that in Vat. 747 in small details, such as the banisters and railings of the court. The annex of the building is augmented by a fountain, its water emanating from a lion's mouth, emptying into a basin, and flowing from there through the court. King Eglon has a nimbus that was most likely colored crimson, as it is in Vat. 746 and Vtp. He wears a tunic richly decorated with clavi and orbiculi, a chlamys, and the typical pearl crown of the Byzantine emperors. Ehud, this time bearded, pierces the king's belly using his left hand, while the sheath hangs at his right side. In these respects Sm. is more precise in its interpretation of the text than Vat. 747. The bodyguards are clad in long, bordered garments and wear fur caps instead of pointed hats.

1425. Vat. 746, fol. 473v

The picture area is proportionately lower than the preceding example so that the roof of the tower and the trees penetrate the upper frame. Otherwise the painter followed the Sm. miniature very closely, except that the bodyguard closest to the entrance door, instead of being represented merely as a head in profile, is more visible and extends one arm toward the palace.

Located beside Judges 3:24.

1426. Vtp., fol. 409r

The close dependence on Vat. 746 is apparent in details such as the identical rendering of the bodyguard facing the palace.

Located above Judges 3:20.

Lit.: Uspenskii, p. 175, fig. 281; Hesseling, fig. 318; Diehl, *Manuel*, vol. 1, p. 426, fig. 197; Diehl, *Peinture byz.*, p. 94, pl. 81 no. 2; Lazarev, *Storia*, fig. 412; Huber, fig. 128; Weitzmann, *SP*, p. 71; De Angelis, "Simbologia," p. 1530, fig. 4; Θησαυροί, p. 279, fig. 152.

[1] Ehud's left hand is not mentioned in Josephus's *Jewish Antiquities* 5:191–93; but, in contrast to the miniature, Josephus says that the king was smitten in his heart, not in his belly, and that he was standing (*Josephus*, ed. Thackeray and Marcus, vol. 5, pp. 86–88).

[2] Cf. the references at Genesis 26:7–8.

Judges 4:4–6

Deborah Addresses Barak

1427a. Vat. 747, fol. 240r

Deborah (LXX: Debbora) the prophetess sits on the ground under two palm trees and extends her right arm in a gesture of speech toward Barak (LXX: Barac), whom she summons to fight on Mount Tabor against Sisera (LXX: Sisara), captain of the host of King Jabin. A group of Israelites stands in front of her arguing heatedly; Barak has stepped forward out of this group to tell Deborah that he is willing to go, provided she joins him. Golden bushes are placed over the blue background, which is partly flaked.

Located beside Judges 4:24.

Ser., fol. 521v

Blank space for an unexecuted miniature.
Located beside Judges 5:1.

1428a. Sm., fol. 243r

In accordance with the text, only one of the trees is characterized as a palm tree. Barak and the elders lack the lively gestures they exhibit in Vat. 747.

1429a. Vat. 746, fol. 475r

Close to Sm. except that Deborah sits higher on a mound. Barak's head is badly flaked.

Located beside Judges 4:23.

1430. Vtp., fol. 410v

Close to Vat. 746 but Deborah sits higher on a benchlike elevation. Her face is badly flaked.

Located below Judges 4:6.

Lit.: Uspenskii, p. 175, fig. 282; Hesseling, fig. 319; Neuss, *Katalan. Bibelill.*, p. 51; Huber, fig. 129; Weitzmann, *SP*, p. 65; Lowden, "Vtp. Oct.," pp. 121–22; Θησαυροί, p. 279, fig. 153.

Judges 4:17–19

Sisera Arrives at Jael's Tent

1427b. Vat. 747, fol. 240r

In the left half of the lower frieze two successive actions are combined into one scene: first, the meeting between the fleeing Sisera and Jael before Jael's tent (Judg 4:17–18), and second, Jael offering a cup to the fugitive (Judg 4:19), an act which took place after they had entered the tent and she covered him with a mantle. Sisera, clad in a short tunic and carrying his shield, spear, and sword, runs toward the right; frightened, he turns his head back in the direction where he presumes his pursuers to be. Jael, hurrying in the other direction, carries a bag in the shape of a skin (the ἀσκός of the Septuagint) under her left arm, while in her right she holds a cup filled with milk taken from the bag. Her dwelling is not represented as a tent, i.e., a σκηνή, but as a conventional king's house topped by a domed tower found repeatedly in this manuscript.

Located beside Judges 4:24.

Ser., fol. 521v

Blank space for an unexecuted miniature.
Located beside Judges 5:1.

1428b. Sm., fol. 243r

Close to Vat. 747. However, Sisera holds the spear in his right hand and the sword in his left while stepping forward with his left leg. The house has lost its domed tower.

1429b. Vat. 746, fol. 475r

Both figures are badly flaked, but enough remains of them to show the close connection with Sm.

Located beside Judges 4:23.

1431a. Vtp., fol. 412r

Sisera, walking rather than running, has a short beard, and Jael carries a very small bag which is completely flaked.

Located beside Judges 4:18.

Lit.: Uspenskii, p. 175, fig. 283; Hesseling, fig. 319; Huber, fig. 130; Weitzmann, *SP*, p. 65; Lowden, "Vtp. Oct.," pp. 121–22; Θησαυροί, p. 279, fig. 154.

Judges 4:21

JAEL SLAYS SISERA

1427c. Vat. 747, fol. 240r

In the right half of the lower frieze Sisera, this time wearing full armor instead of merely a tunic, lies asleep on his right side after having laid aside his shield and his helmet (drawn too small). Jael kneels above his head, holding in her right hand a hammer and in her left a tent peg which she is driving through Sisera's temple. The house at the left may be related not only to the preceding scene, but also to this one, a reminder to the viewer that this event is also supposed to take place within its walls.

Located beside Judges 4:24.

Ser., fol. 521v

Blank space for an unexecuted miniature.
Located beside Judges 5:1.

1428c. Sm., fol. 243r

While the posture of the sleeping Sisera is much clumsier than in Vat. 747, the painter was more careful to display all of Sisera's weapons, i.e., his sword and lance in addition to his shield and helmet.

1429c. Vat. 746, fol. 475r

Pious hands have intentionally rubbed the head of the treacherous Jael and also that of the victim, whose head was represented bleeding heavily.

Located beside Judges 4:23.

1431b. Vtp., fol. 412r

Here a pious hand has done a more thorough job than in Vat. 746 and entirely rubbed off the figure of Jael. Not being as exact in the interpretation of the text as the other manuscripts, Vtp. depicts the tent peg driven by Jael through Sisera's neck rather than his temple. Moreover, the illustrator has omitted Sisera's helmet, perhaps because he no longer understood the shape of the overturned helmet in Vat. 746.

Located beside Judges 4:18.

Lit.: Uspenskii, p. 175, fig. 283; Hesseling, fig. 319; Huber, fig. 130; Lowden, "Vtp. Oct.," pp. 121–22; Θησαυροί, p. 279, fig. 154.

Judges 6:3–4

MIDIANITES AND AMALEKITES CUT THE ISRAELITES' GRAIN

The whole of chapter 5 is occupied by the song of Deborah, which is not illustrated in the cycle.

1432a. Vat. 747, fol. 241r

Three men with their tunics tucked up and with sickles in their hands busily cut the grain which the Israelites had sown for themselves. They have stuck their spears into the ground behind them while they work. The three men are presumably representatives of the three hostile tribes, i.e., the Midianites, the Amalekites, and the "children of the east." A group of Israelites mournfully watches the plundering of their fields, and the foremost, a youthful man in a long tunic, dries his tears with a piece of cloth.

Located beside Judges 6:8.

Ser., fol. 523v

Blank space for an unexecuted miniature.
Located beside Judges 6:8.

1433a. Sm., fol. 244r

One of the Israelite elders, instead of a youth as in Vat. 747, faces the three reapers. The change seems to be the result of a unification of this group of Israelites with that of the next scene, in which a group of elders faces the prophet.

Located above Judges 6:9.

1434a. Vat. 746, fol. 477r

Close to Sm.
Located beside Judges 6:8.

1435a. Vtp., fol. 415v

The reapers are more closely drawn together, so that the right arm of the hindmost is omitted.

Located beside Judges 6:4.

Lit.: Uspenskii, p. 176, fig. 284; Hesseling, fig. 320; Huber, fig. 131; Θησαυροί, p. 279, fig. 155.

Judges 6:8

PROPHET REPROACHES THE ISRAELITES

1432b. Vat. 747, fol. 241r

The unnamed prophet sent by God to remonstrate with the Israelites for their sinfulness is represented larger than the other figures, in an expressive attitude and holding an unfolded scroll in his hands. This scroll was redrawn at a later period and an inscription added in an undecipherable script. The iconography of the figure recalls that of prophets displaying their scrolls in the wall paintings of churches. The prophet faces a group of mourning Israelite elders who are clad in long tunics and mantles and have their heads covered. This group of elders is fused with the group of youthful Israelites in the preceding scene.

Located beside Judges 6:8.

Ser., fol. 523v

Blank space for an unexecuted miniature.
Located beside Judges 6:8.

1433b. Sm., fol. 244r

The elders' gestures are slightly different from those in Vat. 747.
Located above Judges 6:9.

1434b. Vat. 746, fol. 477r

Close to Sm.
Located beside Judges 6:8.

1435b. Vtp., fol. 415v

The scroll reveals a partly rubbed inscription which is taken from verse 8 and reads: ΤΑΔΕ ΛΕΓΕΙ Κ(ΥΡΙΟ)С Ο Θ(ΕΟ)С ΙСΡΑΗΛ ΕΓΩ ΕΙΜΙ ОС ΑΝΗ(ΓΑΓΟΝ ΥΜΑС Ε)Κ ΓΗС ΑΙΓΥΠΤΟΥ.
Located beside Judges 6:4.

Lit.: Uspenskii, p. 176, fig. 284; Hesseling, fig. 320; Huber, fig. 131; Θη-σαυροί, p. 279, fig. 155.

Judges 6:21

SACRIFICE OF GIDEON

1436. Vat. 747, fol. 241v

Standing at the left, Gideon spreads his hands in a gesture of astonishment at the miracle being performed before his eyes by an angel of God. With the tip of his rod, the angel touches the goat kid which lies in an iron pot and is being consumed by a column of fire. Departing from the text, this fire emanates not from a rock but from a segment of heaven. Before Gideon stands a wicker basket containing the unleavened loaves. Both Gideon and the angel have gold nimbi. The background is partly flaked.
Located beside Judges 6:33.

Ser., fol. 525r

Blank space for an unexecuted miniature.
Located beside Judges 6:23.

1437. Sm., fol. 244v

The fiery column emanates from the top of a rocky hill, and in this respect the miniature follows the text more precisely than Vat. 747. Sm. is less accurate, however, in that the iron pot contains the same unleavened loaves as the wicker basket, instead of the goat kid. Moreover, a fire burning underneath the pot seems to annul in part the effect of the miracle. The angel is represented in an attitude of hurried approach, in contrast to his quiet and dignified posture in Vat. 747.

1438. Vat. 746, fol. 478r

Very close to Sm. With his rod the angel touches the wicker basket instead of the iron pot, but this does not depart from the text, according to which both were touched. Gideon's nimbus is green, as it perhaps also was in Sm., while the angel's nimbus, in imitation of gold, is painted yellow-brown.
Located beside Judges 6:21.

1439. Vtp., fol. 417r

Departing from the Septuagint, the angel touches the rock instead of the meat or the loaves with the tip of his rod. This change took place while the painter was actually at work: he first painted the rod touching the wicker basket, as in Vat. 746, then overpainted it without completely effacing all traces. The painter may have been induced to make this change by consulting the accompanying catena, in which Theodoret mentions that the angel smote the rock, not the meat or loaves,[1] as well as by a reminiscence of the iconographic motif of Moses smiting the rock. The figure of Gideon, who has a golden nimbus as in Vat. 747, is partly flaked.
Located beside Judges 6:21.

Lit.: Uspenskii, p. 176, fig. 285; Hesseling, fig. 321; Huber, fig. 132; Θη-σαυροί, pp. 279–80, fig. 156; Bakirtzis, Τσουκαλολάγηνα, p. 33, pl. 34a.

[1] *QuaestJud* 13 (PG 80, col. 501).

Judges 6:36–40

GIDEON WRINGS THE FLEECE

Having skipped the destruction of the altar of Baal (Judg 6:25ff.), the cycle continues with the episode of the fleece.

1440. Vat. 747, fol. 242r

Gideon is represented bending over and wringing the wool fleece over a bowl shaped like a large chalice. In the upper left-hand corner the hand of God appears between tiered segments of heaven, sending out rays in the direction of Gideon's head and reminding the viewer of Gideon's invoking of God before or after he wrung the fleece.
Located beside Judges 6:39.

Ser., fol. 526r

Blank space for an unexecuted miniature.
Located beside Judges 6:39.

Sm.

Between fols. 244 and 245 one folio is missing which surely contained the corresponding miniature.

1441. Vat. 746, fol. 478v

Gideon, this time with a light blue nimbus, is walking. The bowl is adorned with a pair of handles.

Located beside Judges 7:1.

1442. Vtp., fol. 418v

The miniature agrees with Vat. 746 except that Gideon has a golden nimbus, as in Vat. 747, and the rays from the hand of God are not directed toward the blessed Gideon, but toward the fleece, thus lending special emphasis to the object of the miracle.

Located beside Judges 6:36.

Lit.: Uspenskii, p. 176, fig. 319; Huber, fig. 133; Kirigin, *Mano divina*, p. 198 n. 21; Taylor, "Prophetic Scenes," p. 414; Θησαυροί, p. 280, fig. 157.

Judges 7:24

Gideon Addresses the Men of Ephraim

After the episode of the fleece, the cycle skips the stories of the three hundred soldiers fighting against the army of Midian (Judg 7:1–8), the dream of the enemy soldier (Judg 7:13–15), and the successful assault of Gideon's soldiers (Judg 7:16–23).

1443a. Vat. 747, fol. 243r

In the left half of the miniature, Gideon is represented slightly larger than the other men. Instead of sending out messengers to the men of Ephraim, as a literal interpretation of the text would require, he addresses the men of Ephraim directly, sending them into battle against the Midianites. The two foremost soldiers hold shields, and those at the rear carry spears.

Located beside Judges 8:1.

Ser., fol. 528r

Blank space for an unexecuted miniature.
Located beside Judges 8:1.

Lit.: Buchthal, *Latin Kingdom*, p. 60 n. 3; Lowden, *Octs.*, pp. 56–57, fig. 49.

Judges 7:25

Defeat of the Midianites

1443b. Vat. 747, fol. 243r

In the right half of the miniature the men of Ephraim are seen overcoming the Midianites with swords and spears. Three enemies lie slain and bleeding on the ground; others have turned to flight. While the Israelites fight bareheaded, their enemies wear helmets.

Located beside Judges 8:1.

Lit.: Buchthal, *Latin Kingdom*, p. 60 n. 3; Lowden, *Octs.*, pp. 56–57, fig. 49.

Judges 7:25

Defeat of the Midianites and the Heads of Oreb and Zeeb Brought to Gideon

Ser., fol. 528r

Blank space for an unexecuted miniature.
Located beside Judges 8:1.

1444. Sm., fol. 245r

The men of Ephraim, wearing helmets, are piercing two of their enemies who lie dead on the ground, their heads covered by their shields. Two other enemies are just falling forward, while the rest of the army flees, the hindmost man turning around and raising his hand in a gesture of fear. Some of the Midianites are clad in simple tunics and others in chain mail, but all of them wear high, pointed helmets. To the left of the battle scene Gideon, surrounded by a group of Israelites, is shown receiving the heads of the two slain Midianite princes Oreb and Zeeb from the hands of two victorious soldiers. This scene occupies the same place as the sending out of the men of Ephraim in Vat. 747, and looks like a transformation of the latter. In fact, the narration is reversed in Sm. and incorrectly proceeds from left to right. Moreover, among the youthful warriors in short tunics and armed with spears, there is one man clad in a long tunic like an elder of the Israelites; illogically, he also holds a spear. Finally, the white-bearded head of an old man, undoubtedly belonging to another of the elders, is visible between this figure and Gideon. Thus soldiers and elders, usually clearly distinguished in separate groups, are intermingled, and for this reason Gideon's entire retinue, which does not exist in Vat. 747, must be a later addition.

1445. Vat. 746, fol. 480v

Close to Sm. While the number of soldiers in both armies is greater than in Sm., the group around Gideon is more condensed, so that the head of the white-bearded elder is omitted.

Located beside Judges 7:25.

1446. Vtp., fol. 421v

In order to connect the two scenes of this miniature even more closely to one another, the painter, who followed Vat. 746 in most details, wrote the names ΣΉΒ and ΩΡΉΒ on the shields of the two foremost enemy casualties. In the other manuscripts, there is no indication that these two victims are meant to represent the two princes of the Midianites. Furthermore, the painter added the River Jordan between the two scenes, flowing as a narrow band from the top to the bottom of the miniature. In doing so, he relied most closely on the text, which states that the heads were brought to Gideon "from beyond the Jordan." The pointed helmets of the Midianites are elongated in a manneristic fashion.

Located beside Judges 7:25.

Lit.: Uspenskii, p. 176, fig. 286; Hesseling, fig. 322; Buchthal, *Latin Kingdom,* p. 60 n. 3; Huber, fig. 134; Lowden, "Vtp. Oct.," pp. 124–25, figs. 25, 26; Lowden, "Production," p. 197; Walter, "Three Notes," p. 273, fig. 10; Θησαυροί, p. 280, fig. 158; Lowden, *Octs.,* pp. 50, 56–57, figs. 50–52.

Judges 8:20–21

Gideon Beheads the Enemy Kings

The second successful assault of Gideon, the flight of the kings, and the events in Succoth (Judg 8:4–20) are ignored in the cycle, which continues with the beheading of the enemy kings.

1447a. Vat. 747, fol. 243v

The scene at the left illustrates Gideon executing Zebah and Zalmunna (LXX: Zebee and Salmana), the two kings of the Midianites. With their hands fettered behind their backs, the two prisoners lean forward, prepared for their execution. They are stripped of all royal attributes and only a broad golden border on their long tunics remains to indicate their high rank. Gideon is represented in the typical attitude of an executioner, with his drawn sword raised in one hand and its sheath held in the other. The hilt and large areas of the background are flaked.
Located beside Judges 8:27.

Ser., fol. 529v

Blank space for an unexecuted miniature.
Located beside Judges 8:26.

1448a. Sm., fol. 245v

Neither the motions of the condemned kings, who appear to be attempting escape rather than awaiting decapitation, nor the attitude of Gideon are as expressive as in Vat. 747. The kings wear pearl crowns like those of Byzantine emperors, and they, as well as Gideon, are clad in short tunics. Behind Gideon stands a young man in a long garment and mantle, apparently Jether, Gideon's firstborn son, who is mentioned in verse 20 as having refused to slay the captives.

1449a. Vat. 746, fol. 481v

Agrees in all essential details with Sm.
Located beside Judges 8:27.

1450a. Vtp., fol. 423v

Because of lack of space the figure of Jether is partly cut off by the frame. Otherwise close to Vat. 746.
Located beside Judges 8:23.

Lit.: Uspenskii, p. 176, fig. 287; Hesseling, fig. 323; Huber, fig. 135; Θησαυροί, p. 280, fig. 159; Lowden, *Octs.,* pp. 13, 76–77, 85–86, figs. 6–8.

Judges 8:22–25

Gideon Asks for Earrings

The giving of the earrings in verse 25 is not illustrated in Vat. 747. Its picture, which illustrates only verses 22–24, shows the men of Israel asking Gideon to be their ruler, an offer Gideon declines. In verse 24 Gideon makes the request that every man give him an earring out of his spoils, and in verse 25 the Hebrew text reads that the men of Israel spread out a garment, and every man threw an earring onto it. In contrast, the Septuagint has "and he [Gideon] opened his garment, and each man cast therein an earring of his spoils." The miniatures in the Octateuchs conform neither to the Hebrew text nor to the Septuagint.

1447b. Vat. 747, fol. 243v

Gideon and the elders of Israel face each other in quiet dispute, all raising their left hands in a gesture of speech.
Located beside Judges 8:27.

Ser., fol. 529v

Blank space for an unexecuted miniature.
Located beside Judges 8:26.

1448b. Sm., fol. 245v

While Gideon gestures in speech, the Israelites give him the golden earrings from their spoils. Conforming to this passage, the three foremost Israelites hold golden rings in their right hands. However, Gideon does not collect them in his opened himation, as the text would suggest. The Israelites, as usual, are shown without mantles and wearing turbans.

1449b. Vat. 746, fol. 481v

By making four faces visible in the front row of Israelites the illustrator has given the group a somewhat enlarged appearance.
Located beside Judges 8:27.

1450b. Vtp., fol. 423v

Very close to Vat. 746.
Located beside Judges 8:23.

Lit.: Uspenskii, p. 176, fig. 287; Hesseling, fig. 323; Huber, fig. 135; Θησαυροί, p. 280, fig. 159; Lowden, *Octs.,* pp. 76–77, 85–86, figs. 7, 8.

Judges 8:32

Burial of Gideon

1451. Vat. 747, fol. 243v

Two young Israelites deposit Gideon's corpse, wrapped like a mummy, in a marble sarcophagus before which a group of

Israelite elders are mourning. The front end of the sarcophagus is partly overlapped by elevations of ground, suggesting that the sepulchre is situated in the mountains.

Located beside Judges 8:32.

Ser., fol. 530r

Blank space for an unexecuted miniature.
Located beside Judges 8:32.

1452. Sm., fol. 245v

The group of mourners is considerably enlarged and consists entirely of younger men. The painter of this miniature, and for that matter also those of Vat. 746 and Vtp., probably wanted the men to be understood as Gideon's seventy sons mentioned in verse 30. The upper part of the mummy is wrapped in a patterned shroud. The miniature is cut at the lower edge through the mourners' feet, the lower part of the sarcophagus, and its lid.

1453. Vat. 746, fol. 482r

Gideon's sons are grouped in a somewhat different manner from that in Sm. The sarcophagus stands on level ground.

Located beside Judges 8:32.

1454. Vtp., fol. 424v

The grouping of Gideon's sons is closer to Vat. 746 than to Sm. Located beside Judges 8:32.

Lit.: Uspenskii, p. 176, fig. 288; Hesseling, fig. 324; Huber, fig. 136; Maguire, "Depiction of Sorrow," p. 151 n. 149; Θησαυροί, pp. 280–81, fig. 160; Lowden, *Octs.*, pp. 13, 76–77, 85–86, fig. 7.

Judges 9:51–52

ABIMELECH SETS THE TOWN OF
THEBEZ AFIRE

After the death of Gideon, the Israelites worshipped Baal as their god (Judg 8:33); then follows the story of Abimelech, son of Jerubbaal (LXX: Jerobaal), in chapter 9. The cycle skips Israel's new idolatry and from the story of Abimelech selects only the assault on Thebez and Abimelech's death in the battle.

1455a. Vat. 747, fol. 245r

Two soldiers from Abimelech's army put firebrands to the city walls instead of to the gate of the tower within the town, as reported in the text. One of the soldiers is supposed to be Abimelech, who according to verse 52, "drew near the door of the tower to burn it with fire." Portions of paint are flaked all over the surface.

Located beside Judges 9:55.

Ser., fol. 533r

Blank space for an unexecuted miniature.
Located beside Judges 9:54.

1456a. Sm., fol. 247r

Sm., Vat. 746, and Vtp., unlike Vat. 747, correctly represent the tower of Thebez burned by two men, who are clad in long tunics instead of armor.

1457a. Vat. 746, fol. 484v

Very close to Sm. and crudely overpainted by a later hand using thick outlines and hardly any highlights.

Located beside Judges 9:55.

1458a. Vtp., fol. 428v

Very close to Sm. and Vat. 746.
Located beside Judges 9:53.

Lit.: Uspenskii, p. 176, fig. 289; Hesseling, fig. 325; Vzdornov, "Illustraciia," p. 214, fig. 10; Huber, fig. 137; Weitzmann, *SP*, p. 67; Θησαυροί, p. 281, fig. 161.

Judges 9:53–54

ABIMELECH HIT BY A STONE AND
KILLED BY HIS ARMOR-BEARER

1455b. Vat. 747, fol. 245r

A woman stands on the roof of the tower holding the millstone she is going to drop on Abimelech as the latter approaches the tower. Simultaneously, a millstone has already hit Abimelech's head, representing the next moment in the episode. At the same time, the armor-bearer standing on the other side of the tower pierces his master with a lance. In this detail all the manuscripts depart from the text, according to which Abimelech asks to be killed by the sword, which here the armor-bearer carries at his side and does not use. Portions of the paint are flaked all over the surface.

Located beside Judges 9:55.

Ser., fol. 533r

Blank space for an unexecuted miniature.
Located beside Judges 9:54.

1456b. Sm., fol. 247r

Abimelech's death takes place in front of a larger tower. The armor-bearer is clad in a short tunic and carries no arms except a lance. The second millstone has broken to pieces on Abimelech's head.

1457b. Vat. 746, fol. 484v

Close to Sm. Crudely overpainted by a later hand that used thick outlines and hardly any highlights.

Located beside Judges 9:55.

1458b. Vtp., fol. 428v

The heads of all the participants are badly damaged and flaked, and the central part of the miniature is badly affected by stains caused by humidity. Underneath the central figure, outside the frame, the name ἀβιμέλεχ was written by a late hand.

Located beside Judges 9:53.

Lit.: Uspenskii, p. 176, fig. 289; Hesseling, fig. 325; Vzdornov, "Illustraciia," p. 214, fig. 10; Huber, fig. 137; Weitzmann, *SP*, p. 67; Θησαυροί, p. 281, fig. 161.

Judges 10:9–15

Israelites Pray to God to Save Them from the Ammonites

1459. Vat. 747, fol. 245v

Two symmetrically arranged groups of Israelites pray to a segment of heaven with rays emanating in the direction of both groups. The tricolor background (light blue, dark blue, gold) and parts of the ground are flaked, and some of the heads have been restored. This is particularly apparent in the head with the rolling eyes in the center of the group at the left. The foremost figure at the right has a nimbus, the outline of which has been crudely redrawn. The text gives no hint as to who this Israelite might be, and it is possible that the entire nimbus is an addition made by the restorer, who may have thought mistakenly that this Israelite was Jephthah. Both figures, with their black beards, actually look alike.

Located beside Judges 10:9.

Ser., fol. 533v

Blank space for an unexecuted miniature.
Located beside Judges 10:7.

1460. Sm., fol. 247v

The composition is the same as in Vat. 747, but in Sm., as well as in Vat. 746 and Vtp., the group at the left is composed exclusively of youthful men holding spears. This indicates that the painters wanted them to be understood as the hostile Ammonites who had crossed the Jordan to attack the Israelites. Consequently they painted a band of water at the bottom of the miniature and let the rays, emanating this time from the hand of God in a double segment of heaven, be directed exclusively toward the right-hand group. Since the Ammonite soldiers are clad in short tunics instead of the armor that the Israelites' enemies normally wear, and since they carry no weapons other than spears, it seems very

likely that this is merely a group of Israelites converted into Ammonites. Therefore Vat. 747 represents the more original version of this scene. In addition, the depiction of the Ammonites not in attitudes of battle but standing quietly, raising their hands in gestures of speech, seems to speak in favor of this assumption. The figures of the Israelites have been restored with heavy outlines and in a manner which largely eliminates the highlights.

Located below Judges 9:52.

1461. Vat. 746, fol. 485r

Close to Sm.
Located beside Judges 10:9.

1462. Vtp., fol. 429v

Close to Sm. and Vat. 746. The painter's ornamental sense is apparent in the elongated hems of two mantles, drawn in zigzags.

Located beside Judges 10:9.

Lit.: Uspenskii, pp. 176–77, fig. 290; Hesseling, fig. 326; Huber, fig. 138; Θησαυροί, p. 281, fig. 162.

Judges 11:12

Jephthah Sends Messengers to the King of Ammon

1463. Vat. 747, fol. 246r

Jephthah (LXX: Jephthae) sends out two messengers to the king of Ammon. One of the messengers, leaning on his shield, is still listening intently to Jephthah; the other has already taken up his shield and slung it over his shoulder while turning to leave. Parts of the background are flaked.

Located beside Judges 11:13.

Ser., fol. 535r

Blank space for an unexecuted miniature.
Located beside Judges 11:11.

1464. Sm., fol. 248v

Both messengers, holding only spears, are represented in more conventional postures than those in Vat. 747. Jephthah holds a scroll in his left hand.

1465. Vat. 746, fol. 485v

Close to Sm. Its placement in the text, however, is different: while the miniature in Vat. 747 is attached correctly to verses 13ff., in Vat. 746 it accompanies verses 9ff., where the text speaks of a mission consisting of the elders of Gilead (LXX: Galaad) sent to Jephthah. Perhaps the painter thought this was the event

illustrated. The upper bodies of the messengers are badly damaged.

Located beside Judges 11:9.

1466. Vtp., fol. 430v

The messengers' tunics are not tucked up as in Sm. and Vat. 746, and Jephthah leans forward, lending more emphasis to his message. A heavy violet stain surrounds the figure of Jephthah, which has been labeled below the frame by a later hand. This picture also is placed beside verse 8 instead of verses 12–13.

Located beside Judges 11:8.

Lit.: Uspenskii, p. 177, fig. 320; Hesseling, fig. 327; Weitzmann, "Jephthah Panel," p. 348; Huber, fig. 139; Θησαυροί, p. 281, fig. 163.

Judges 11:14–27

Jephthah Sends Messengers to the Ammonites a Second Time

1467. Vat. 747, fol. 246v

Varying from the preceding miniature, Jephthah[1] is represented seated while he sends out the messengers a second time to the king of Ammon. He extends his hand in a gesture of speech toward the two youthful messengers who are armed with spears and shields and receive their orders very attentively.

Located beside Judges 11:27.

Ser., fol. 536r

Blank space for an unexecuted miniature.
Located beside Judges 11:27.

1468. Sm., fol. 248v

In Sm., as well as in Vat. 746 and Vtp., the composition is changed. Dressed like a Byzantine emperor in a somewhat misunderstood chlamys, purple shoes, and a pearl crown, the king of Ammon is shown enthroned in an attitude similar to that of Jephthah in Vat. 747. He addresses the two messengers, who this time are soldiers clad not merely in tunics as in the preceding scene of this same manuscript (fig. 1463) but in full armor. At the right, Jephthah sends out the messengers, so that two actions are combined in one scene. To strengthen the connection between these two actions, the messengers are represented marching from Jephthah toward the king of Ammon, and the one at the right turns his head back. The king, like Jephthah, has a nimbus the color of which was probably the same light blue as in Vat. 746.

Located below Judges 11:27.

1469. Vat. 746, fol. 486v

Close to Ser.
Located beside Judges 11:27.

1470. Vtp., fol. 432r

Close to Sm. and Vat. 746. The king of Ammon wears a later type of crown, and the nimbi of the king and Jephthah are gold.

Located beside Judges 11:27.

Lit.: Uspenskii, p. 177, fig. 291; Hesseling, fig. 328; Weitzmann, "Jephthah Panel," p. 348; Huber, fig. 140; Θησαυροί, p. 281, fig. 164; Lowden, *Octs.*, p. 77, figs. 9–11.

[1] Lowden (*Octs.*, p. 77) identifies this figure as the king of Ammon and asserts that the miniature in Vat. 747 has been truncated at the right, where the figure of Jephthah ought to have been painted; the other manuscripts would hence preserve the original version of the scene with Jephthah on the right and the king seated. The seated figure in Vat. 747, however, has the features not of the king, but of Jephthah, which correspond to the iconography of the figure in other miniatures (see, e.g., fig. 1463); furthermore, the narrative in Sm. and Vat. 746 moves incorrectly from right to left, and the general appearance of the miniature seems to be a pastiche assembled from iconographic pieces found in the cycle.

Judges 11:30–31

Jephthah's Vow

1471. Vat. 747, fol. 246v

Approaching a mountain slope, Jephthah prays to God's hand sending forth rays toward his head from a segment of heaven. The high mountain occupies the right half of the miniature. Parts of the surface are flaked.

Located beside Judges 11:32.

Ser., fol. 536r

Blank space for an unexecuted miniature.
Located beside Judges 11:31.

1472. Sm., fol. 248v

In contradistinction to Vat. 747, Jephthah stands still in an attitude of prayer.

Located above Judges 11:33.

1473. Vat. 746, fol. 487r

Very close to Sm. However, Jephthah's nimbus is green instead of blue. The surface is partly flaked and is rubbed around Jephthah's head.

Located beside Judges 11:33.

1474. Vtp., fol. 433r

Jephthah's head is turned in strict profile and set against a golden nimbus. The ground is heavily stained.

Located beside Judges 11:33.

Lit.: Uspenskii, p. 177, fig. 292; Hesseling, fig. 329; Weitzmann, "Jephthah Panel," p. 348; Huber, fig. 141; Kirigin, *Mano divina*, p. 198 n. 20; Θησαυροί, pp. 281–82, fig. 165; Lowden, *Octs.*, p. 77, fig. 9.

Judges 11:32–33

DEFEAT OF THE AMMONITES

1475. Vat. 747, fol. 246v

Seated frontally on a cushioned throne and with a bodyguard standing behind him, Jephthah faces and points to a group of Israelites whom he has sent into battle against the Ammonites. The bareheaded Israelites fight with swords and spears against their enemies, most of whom have been killed and lie prostrate on the ground. Only one enemy soldier is seen fleeing into the mountains, where five of the twenty cities destroyed by the Israelites are represented. These cities are reduced to simple ring-walls and aligned in three rows; but they are also situated on a mountain and are thus spatially related to each other. The surface is partly flaked.

Located beside Judges 11:34.

Ser., fol. 537r

Blank space for an unexecuted miniature.
Located beside Judges 11:39.

1476. Sm., fol. 248v

Jephthah's bodyguard, holding a shield, is more fully visible. The Israelites wear helmets and attack with spears only, while the fleeing enemy is represented by an entire army instead of a single soldier. The number of cities has been reduced from five to four, but each city is more elaborate in that it has a tower alongside the wall. On the other hand, the mountain is eliminated and thus the spatial relationship between the cities is lost.

Located below Judges 11:33.

1477. Vat. 746, fol. 487r

Close to Sm. Partly flaked.
Located beside Judges 11:35.

1478. Vtp., fol. 433r

Vtp. follows Vat. 746 in one small point, namely that only two pairs of legs of the attacking Israelites are visible, while Sm. shows three pairs. Probably due to mere negligence, the spears in the hands of the fleeing Ammonites are omitted. The group of the fighting Israelites is very much rubbed.

Located beside Judges 11:35.

Lit.: Uspenskii, p. 177, fig. 293; Hesseling, fig. 330; Weitzmann, "Jephthah Panel," p. 348; Huber, fig. 142; Θησαυροί, pp. 281–82, fig. 166; Lowden, *Octs.*, p. 57, figs. 60–63.

Judges 11:34

JEPHTHAH WELCOMED BY HIS DAUGHTER

From this point through the story of Manoah and Samson, the cycle in Vat. 747 diverges from that in the other manuscripts. Sometimes it depicts different events in the stories; at other times it depicts the same events but with different iconography. The corresponding miniatures are missing both in Sm. and Ser.: fourteen blank spaces are left in Ser. for unexecuted miniatures; Hesseling did not reproduce any miniatures in Sm. corresponding to the other manuscripts and, furthermore, none of the scholars who surveyed the manuscript before its destruction reported any blank spaces for unexecuted miniatures. In the next group of miniatures (figs. 1479–1481), Vat. 746 and Vtp. illustrate a moment of Jephthah meeting his daughter that differs from the one in Vat. 747, which, in turn, adds the mourning of the girl, missing in the other codices.

Ser., fol. 537v

Blank space for an unexecuted miniature.
Located beside Judges 12:3.

1480. Vat. 746, fol. 488r

Jephthah, at the head of his victorious army, is represented in a striding attitude, implying that he has just returned from the battle. He stretches out his hand to greet his daughter Seila,[1] who has come out of her father's house and plays the cymbals in welcome. The figures of Jephthah and his daughter, and the lower part of the fully visible soldier have been overpainted by a crude hand.

Located beside Judges 12:1.

1481. Vtp., fol. 434v

Close to Vat. 746, save for little details, e.g., the omission of the spears from the soldiers' hands. The ground of the picture is heavily stained.

Located beside Judges 12:1.

Lit.: Uspenskii, p. 177, fig. 321; Weitzmann, "Jephthah Panel," p. 348; Huber, fig. 143; Θησαυροί, p. 282, fig. 167.

[1] *LAB* 40:1, *OTP*, vol. 2, p. 353.

Judges 11:35–36

JEPHTHAH WELCOMED BY HIS DAUGHTER
AND MOURNING WOMEN

See the introduction to Judges 11:34. The scene represents the moment immediately following the one illustrated in Vat. 746 and Vtp. The veil worn by Jephthah's daughter is usually an attribute only of matrons, even though the text particularly stresses the girl's virginity. The veil may perhaps be understood as an allusion to her future sacrifice, just as Iphigenia in classical art wears a veil before her sacrifice at Aulis. Furthermore, the Septu-

agint does not mention that anyone joined Jephthah's daughter in welcoming her father—the companions are mentioned only later in verse 37.[1] Finally, Jephthah should rend his garments, but in the illustration he is only crying.

1479a. Vat. 747, fol. 247r

Jephthah covers his face with the hem of his mantle, weeping. The foremost of the soldiers, who leans on his shield, raises his right hand in a gesture of compassion for the unhappy father. The daughter faces her father quietly, raising her right hand in a gesture of speech relating to verses 36ff. Over her head she wears a veil, of which she holds the hem in her left hand. Jephthah's daughter is followed by a group of maidens, one of whom is playing a drum. The center of the scene has been damaged by a large drop of wax.
Located beside Judges 11:36.

Lit.: Weitzmann, "Jephthah Panel," p. 348; Stahl, "Morgan M. 638," fig. 191.

[1] Nordström ("Water Miracles," p. 84 n. 8) suggested that the source of the miniature might have been expansions of the story like those found in the Chronicles of Jerahmeel 59:2 (*Chronicles of Jerahmeel*, ed. Gaster, p. 177: "all the virgins and women came forth with timbrels and dances to meet him"), and *LAB* 40 (*OTP*, vol. 2, p. 353: "And Jephthah returned in peace, and women came out to meet him in song and dance").

Judges 11:38

MOURNING OF JEPHTHAH'S DAUGHTER

The cycle skips the crude climax of the Jephthah story, the sacrifice of the daughter, and is satisfied to show a vision of the mournful girl sitting in a mountainous landscape.

1479b. Vat. 747, fol. 247r

Separated from the preceding scene only by a mountain, Jephthah's daughter sits beneath the peak in a mournful attitude with loosened hair. Facing her, sitting on the peak of a second mountain, are her companions who similarly gesture in grief.
Located beside Judges 11:36.

Lit.: Weitzmann, "Jephthah Panel," p. 348; Stahl, "Morgan M. 638," p. 149, fig. 191.

Judges 12:4–5

GILEADITES DEFEAT THE EPHRAIMITES

Vat. 747 and Vat. 746 depict different episodes (no miniature is preserved at this point in the other Octateuchs): the former manuscript shows the final struggle of the Israelites led by Jephthah (fig. 1482), whereas the latter introduces Jephthah's entombment (fig. 1483). In Vat. 746 the illustration is placed closer to the related text.

1482. Vat. 747, fol. 247v

Jephthah, accompanied by a bodyguard, gestures encouragingly and points to the men of Gilead who are fighting the Ephraimites with spears and swords in a mountainous landscape. Some of the enemies have been hit in the back and are falling forward to the ground, while others are hastening to escape. As an indication of the "fords of the Jordan," a band of water flows along the bottom of the miniature.
Located beside Judges 12:8.

Lit.: Weitzmann, "Jephthah Panel," p. 348; Lowden, *Octs.*, p. 58, fig. 68.

Judges 12:7

BURIAL OF JEPHTHAH

Ser., fol. 538r

Blank space for an unexecuted miniature.
Located beside Judges 12:8.

1483. Vat. 746, fol. 488v

Two young men lay Jephthah's corpse, wrapped like a mummy and with its upper part draped in a patterned shroud, into a marble sarcophagus. The lid leans against the side of the sarcophagus near the deceased's feet; three elderly men, gesturing in mourning, bend over the head.
Located beside Judges 12:7.

Vtp.

This miniature was probably on the leaf that has been cut out between fols. 434 and 435.

Lit.: Weitzmann, *Greek Mythology*, p. 29, fig. 31; Weitzmann, "Jephthah Panel," p. 388; Lowden, *Octs.*, p. 58, fig. 69.

Judges 13:3–5

ANGEL PROMISES A SON TO MANOAH'S WIFE

1484a. Vat. 747, fol. 247v

In the left half of the miniature, an angel stands in front of Manoah's wife in a quiet attitude and gestures in speech, promising the woman the birth of a son. The woman, clad in matronly attire, devoutly bows her head.
Located beside Judges 13:4.

Ser., fol. 538v

Blank space for an unexecuted miniature.
Located beside Judges 13:4.

1485. Vat. 746, fol. 488v

In this manuscript the scene forms a miniature by itself. The angel is represented in a more dramatic attitude of approach, and at the right a house with an open door is visible. In both features, the scene resembles an Annunciation to the Virgin. Manoah's wife, who raises both hands in astonishment, is clad in a festive two-colored garment.

Located beside Judges 13:3.

Vtp.

This miniature was probably on the leaf that has been cut out between fols. 434 and 435.

Lit.: Stahl, "Morgan M. 638," p. 204 n. 370; Björnberg-Pardo, *Simson,* pp. 148, 152, 192ff., 256–57, figs. 31, 45.

Judges 13:6–7

MANOAH'S WIFE COMMUNICATES THE PROMISE TO HER HUSBAND

Vat. 747 and Vat. 746 present different iconography for the episode of Manoah meeting his wife.

1484b. Vat. 747, fol. 247v

In the right half of the miniature, Manoah's wife faces her husband and tells him about her encounter with the angel. Both figures are represented gesturing in conversation. The woman's face and parts of the background are flaked.

Located beside Judges 13:4.

Ser., fol. 538v

Blank space for an unexecuted miniature.
Located beside Judges 13:8.

1486. Vat. 746, fol. 489r

The figures of Manoah and his wife are reversed: the husband stands at the left and his wife at the right. The gestures of speech differ from those used by the painter of Vat. 747. Two houses and a connecting wall form a rich foil.

Located beside Judges 13:4.

Vtp.

Most probably this miniature, too, was on the leaf that was cut out between fols. 434 and 435.

Lit.: Stahl, "Morgan M. 638," p. 204 n. 370; Björnberg-Pardo, *Simson,* pp. 148, 152, 192ff., figs. 31, 46.

Judges 13:11–14

MEETING OF THE ANGEL WITH MANOAH AND HIS WIFE

In the final group of miniatures illustrating the story of Manoah, Vat. 746 and Vtp. again show a selection of episodes different from that in Vat. 747 (Ser. and Sm. have no miniatures): the two former manuscripts illustrate the second meeting with the angel (figs. 1488 and 1489), whereas the latter has the sacrifice described at Judges 13:19–20 (fig. 1487). Again, the miniatures in Vat. 746 and Vtp. conform closely to the text beside which they are placed. The iconography in Vat. 746 and Vtp. is conventional; in contrast, Vat. 747 preserves a genuinely intense representation.

Ser., fol. 539r

Blank space for an unexecuted miniature.
Located beside Judges 13:11.

1488. Vat. 746, fol. 489r

The composition in which the angel speaks to Manoah's wife a second time is similar to that illustrating verses 3–5 (fig. 1485), but is expanded by the addition of Manoah, who walks behind his wife. The latter turns her head to her husband and raises her hand toward the angel; she is thus connected to both figures at the same time. The landscape setting is furnished by trees that stand between the figures and frame them.

Located beside Judges 13:11.

1489. Vtp., fol. 435v

Very close to Vat. 746. However, through negligence the painter has omitted the staff from the angel's hand. The miniature is heavily stained, making some of the trees hardly recognizable.

Located beside Judges 13:10.

Lit.: Uspenskii, p. 177; Huber, fig. 144; Stahl, "Morgan M. 638," p. 204; Björnberg-Pardo, *Simson,* pp. 153, 157, 192ff., figs. 47, 62; Θησαυροί, p. 282, fig. 168; Lowden, *Octs.,* p. 58, fig. 71.

Judges 13:19–20

MANOAH'S SACRIFICE

See the introduction to Judges 13:11–14.

1487. Vat. 747, fol. 248r

On the summit of one of the hills forming the landscape, Manoah's offering is represented as a goat kid being consumed by fire. The angel, depicted as a half-figure, flies away extending his hands toward the blessing hand of God which is visible in a segment of heaven. Looking at the flying angel, Manoah retreats

and raises his hands in astonishment, while his wife is more composed. Parts of the background, with the typical golden bushes, and portions of the landscape are flaked.

Located beside Judges 13:11.

Lit.: Stahl, "Morgan M. 638," p. 204; Björnberg-Pardo, *Simson*, pp. 148, 192ff., fig. 32; Lowden, *Octs.*, p. 58, fig. 70.

Judges 13:24

Birth of Samson

The cycles diverge again: Vat. 746 and Vtp. have a conventional birth scene, while Vat. 747 has an introductory miniature to the story of Samson (fig. 1490), which may tentatively be connected to a specific passage in the text.

Ser., fol. 539v

Blank space for an unexecuted miniature.
Located beside Judges 13:20.

1491. Vat. 746, fol. 490r

Manoah's wife, sitting up in childbed, is being served by a midwife; a second midwife attends the newborn Samson. Two houses with a connecting wall form a decorative foil. All the figures have been crudely overpainted.

Located beside Judges 13:24.

1492. Vtp., fol. 436v

Very close to Vat. 746. The mother's bed is somewhat shortened, allowing the first midwife to be more fully visible. With the exception of the heads, the whole picture was painted with a broad brush, producing a mellow effect. This peculiarity occurs only in this and the following miniature (fig. 1495); it is most likely the result of later overpainting.

Located beside Judges 13:24.

Lit.: Uspenskii, p. 177; Huber, fig. 145; Kötzsche-Breitenbruch, *Via Latina*, p. 29 n. 147; Björnberg-Pardo, *Simson*, pp. 153, 157, 192ff., 257–58, figs. 48, 63; Θησαυροί, p. 282, fig. 169; Lowden, *Octs.*, p. 58, fig. 73.

[Judges 13:24]

Samson and His Parents

1490. Vat. 747, fol. 248r

Instead of the birth proper, this manuscript shows Samson already grown up, perhaps illustrating the second half of verse 24. Indicating his blessing by God, Samson is nimbed, not only in this scene but in all those that follow; this contrasts with Vat. 746 and Vtp., which consistently depict him without a nimbus. Manoah, approaching from the right, and his wife, standing at

the left, gesture in astonishment while looking at their blessed son. Large parts of the ground are flaked.

Located beside Judges 13:24.

Lit.: Kötzsche-Breitenbruch, *Via Latina*, p. 29 n. 147; Björnberg-Pardo, *Simson*, pp. 148, 192ff., fig. 33; Lowden, *Octs.*, p. 58, fig. 72.

Judges 14:1

Meeting of Samson and the Philistine Girl

The meeting of Samson and the Philistine girl is depicted in two rather divergent iconographies, one in Vat. 747, the other in Vat. 746 and Vtp. The former clearly displays a more genuine interest in coloring the narrative vividly. The scribe of Ser. omitted a blank space here for the miniature.

1493a. Vat. 747, fol. 248v

In the left half of the miniature a Philistine girl is approached by Samson. Both hold the hems of their mantles with gestures of slight embarrassment. Conventional golden bushes are distributed over the background where a representation of the city of Timnath might be expected (LXX: Thamnatha). Most of the ground is flaked.

Located beside Judges 14:5.

1494a. Vat. 746, fol. 490v

Samson and the Philistine girl are represented in postures different from those in Vat. 747; the two figures also do not wear mantles, and thus the painter lost the expressive motif of their holding the mantles' hems. Moreover, the city of Timnath appears as a ringwall with a tower and gate, depicted behind the woman; a straight wall fills the rest of the miniature for no purpose other than pure decoration.

Located beside Judges 14:1.

1495a. Vtp., fol. 437r

Close to Vat. 746.
Located beside Judges 14:1.

Lit.: Uspenskii, p. 177, fig. 294; Weitzmann, "Mythological Representations," fig. 25; Huber, fig. 146; Weitzmann, "Study," fig. 46; Kenfield, "Alexandrian Samson," pp. 186–88, fig. 5; Kötzsche-Breitenbruch, *Via Latina*, p. 91, pl. 23b; Björnberg-Pardo, *Simson*, pp. 148, 153, 157, 192ff., figs. 34, 49, 64; Θησαυροί, p. 282, fig. 170.

Judges 14:2

Samson Reports the Meeting to His Parents

Vat. 747 moves directly to Samson fighting the lion, depicted in the right half of the miniature (see no. 1493b below); in contrast, Vat. 746 and Vtp. introduce Samson talking with his par-

ents, as recounted in Judges 14:2. See also the introduction to Judges 14:1.

1494b. Vat. 746, fol. 490v

Samson stands before his parents, asking their permission to take the Philistine girl as his wife. The parents sit side by side on a cushioned bench in front of their house, which is situated within the precinct of a low wall. The mother turns toward her husband as if appealing to him to decide the matter. The surface is flaked in various spots.

Located beside Judges 14:1.

1495b. Vtp., fol. 437r

Very close to Vat. 746.
Located beside Judges 14:1.

Lit.: Uspenskii, p. 177, fig. 295; Huber, fig. 147; Kenfield, "Alexandrian Samson," pp. 186–88, fig. 5; Björnberg-Pardo, *Simson*, pp. 153, 157, 192ff., figs. 49, 64; Θησαυροί, p. 282, fig. 170.

Judges 14:5

Samson Leads His Parents to Timnath

The scene is missing in Vat. 747.

Ser., fol. 540v

Blank space for an unexecuted miniature.
Located beside Judges 14:6.

1497a. Vat. 746, fol. 490v

Samson walks ahead of his parents and points to the city of Timnath, the tower and gate of which are fully visible, while part of the ringwall is cut by the right-hand frame. Samson and his mother turn their heads toward Manoah and look at him intently as if still awaiting his consent to Samson's marriage. Manoah's extended arm, however, makes it quite clear to the viewer that he is agreeing. Most of the faces and other parts of the surface are flaked.

Located beside Judges 14:5.

1498a. Vtp., fol. 437v

Close to Vat. 746 except for small details, particularly in the rendering of the city: the gate is smaller and does not fill all the wall space. In the tympanum above the gate, which in Vat. 746 is decorated by a conch, is the bust of a nimbed figure probably intended to represent Christ Pantokrator, thus turning Timnath into a Christian city. The background is partly stained.

Located beside Judges 14:4.

Lit.: Uspenskii, p. 177; Stern, "Layrac," p. 96, fig. 29; Huber, fig. 147; Stahl, "Morgan M. 638," pp. 204–5, fig. 243; Kötzsche-Breitenbruch, *Via Latina*,

p. 91, pl. 23d; Björnberg-Pardo, *Simson*, pp. 153, 157–60, 192ff., figs. 50, 65; Θησαυροί, pp. 282–83, fig. 171.

Judges 14:6

Samson Slays the Lion

The method by which Samson kills the lion is not in agreement with the Septuagint, where Samson is said to crush the lion "as he would have crushed a kid of the goats." In the illustration Samson instead strangles the lion by pressing the beast's head under his armpit, thus suggesting that the iconography was borrowed from a scene of Herakles fighting the Nemean lion, as known in a third-century fragmentary papyrus from Oxyrhynchos (text fig. 20).[1]

1493b. Vat. 747, fol. 248v

Samson strangles the lion by squeezing its neck under his left arm. There is no indication of the locality and the conventional golden bushes cannot, of course, be understood as a formula for the vineyard of Timnath. The ground is partly flaked.

Located beside Judges 14:5.

Ser., fol. 540v

Blank space for an unexecuted miniature.
Located beside Judges 14:6.

1497b. Vat. 746, fol. 490v

The manner of killing the lion is the same as in Vat. 747, except that Samson strangles the lion under his right arm instead of his left. The fight takes place in front of a vine, indicative of the "vineyards of Timnath."

Located beside Judges 14:5.

1498b. Vtp., fol. 437v

Vtp. uses a different scheme for the struggle. Seen in frontal view, Samson tears open the lion's jaw; the animal sits on its hindquarters. This scheme, which the painter exchanged for that of strangling, also goes back to an older tradition and is apparently not contemporary with the Vtp. manuscript. Alongside the fighting group a vine representing the vineyards of Timnath decoratively fills the ground.

Located beside Judges 14:4.

Lit.: Uspenskii, p. 177; Weitzmann, "Martyrion," p. 137; Stern, "Layrac," p. 96, fig. 29; Huber, fig. 147; Weitzmann, "Study," p. 55, fig. 46; Kötzsche-Breitenbruch, *Via Latina*, pp. 90–91, pl. 23b, 23d; Chasson, "Tuscan Bible," p. 190; Björnberg-Pardo, *Simson*, pp. 148, 153, 160, 192ff., 258–62, figs. 34, 50, 65; Weitzmann, *Greek Mythology*, 2d ed., p. xiv; Faccadori, "Costantino," p. 130; Θησαυροί, pp. 282–83, fig. 171.

[1] London, Egypt Exploration Society, pap. gr. Oxy. 2331. Herakles killing the Nemean lion in this manner is found in Diodorus Siculus (*Bibliotheca historica*, bk. 4, 11:3–4); see Weitzmann, "Mythological Represen-

tations," p. 58, fig. 26, and *Age of Spirituality*, pp. 228–29, no. 229. Herakles is associated with Samson both in pre-Christian times and in Christian authors such as Eusebios and Augustine (Björnberg-Pardo, *Simson*, pp. 258ff.; M. Simon, *Hércule et le Christianisme* [Paris, 1955], pp. 171–73). The vividly detailed description of the deed found in Josephus's *Jewish Antiquities* 5:287 (*Josephus*, ed. Thackeray and Marcus, vol. 5, pp. 130–31, quoted by Björnberg-Pardo, *Simson*, p. 260) agrees better with the representation in the Octateuchs: "[Samson] encountered the lion and, unarmed as he was, grappled with it, strangled it with his hands, and flung the beast into the coppice on the border of the road."

Judges 14:8

SAMSON TAKES THE HONEY

The episode of the honeycomb is represented in Vat. 747 as well as in Vat. 746 and Vtp. The two iconographies, however, are radically different.

1496a. Vat. 747, fol. 248v

In the left half of the miniature, the lion's carcass lies on its back and Samson bends over it, holding in his right hand the honeycomb that he has taken out of the lion's mouth. The whole surface is badly flaked.
Located beside Judges 14:10.

Ser., fol. 541r

Blank space for an unexecuted miniature.
Located beside Judges 14:9.

1500a. Vat. 746, fol. 491r

Standing upright, Samson uses his right hand to remove the honeycomb from the lion's mouth, while with his left he is already eating some of it. Thus two successive actions are represented simultaneously. The lion, which lies on its paws, is not depicted as a realistic carcass, as it is in Vat. 747. On the other hand, the miniature again represents the vine indicative of the locality of Timnath, which is missing in Vat. 747. The surface is slightly flaked in various spots.
Located beside Judges 14:10.

1501a. Vtp., fol. 438v

Very close to Vat. 746 but the painter no longer conveys the motif of eating the honeycomb, and Samson simply touches his cheek with his left hand. At the same time, the realism of the scene is increased by the addition of a large swarm of bees around the lion's mouth.
Located beside Judges 14:10.

Lit.: Uspenskii, p. 177; Eller and Wolf, *Mosaiken*, fig. 49; Huber, fig. 148; Stahl, "Morgan M. 638," pp. 206–7; Kenfield, "Alexandrian Samson," p. 188; Kötzsche-Breitenbruch, *Via Latina*, pp. 90–91, pls. 23c, 23e; Björnberg-Pardo, *Simson*, pp. 149, 153, 160, 192ff., figs. 35, 51, 66; Θησαυροί, p. 283, fig. 172.

Judges 14:9

SAMSON OFFERS HONEY TO HIS PARENTS

The next episode appears only in Vat. 747; the other manuscripts move to the feast at Judges 14:10.

1496b. Vat. 747, fol. 248v

Samson holds a honeycomb in his left hand and offers it to his parents, who stand in front of him. His father extends one hand to take the gift and with the other gestures in astonishment, while his mother stands behind her husband in an attitude suggesting timidity. Parts of the background are flaked.
Located beside Judges 14:10.

Lit.: Kötzsche-Breitenbruch, *Via Latina*, p. 91, pl. 23c; Björnberg-Pardo, *Simson*, pp. 148, 192ff., fig. 35.

Judges 14:10–11

SAMSON MAKES A FEAST

The manuscripts also differ in their portrayals of the next event, the feast with the Philistine's and Samson's families and friends: the depiction in Vat. 747 is colorfully detailed and refers only to verse 10; the miniatures of Vat. 746 and Vtp. are rather conventional and add the friends mentioned in verse 11.

1499. Vat. 747, fol. 249r

The group seated around a table includes Samson in the center, turning his head toward his bride sitting beside him, and at the left Samson's father and a woman looking at him who cannot be anyone but Samson's mother, although the text does not explicitly mention her here. A servant, who has apparently taken a drink from the samovar standing on the ground behind him, holds a cup in one hand and a napkin in the other. A building frames the scene on either side, suggesting that it is supposed to take place in an interior. Some of the heads have been overpainted, particularly those of the bride and the mother, and it is more than likely that the crown, which has a late Byzantine shape, was added only at the time of restoration. Simultaneously, the shape of the mother's veil was changed, as becomes clear if one compares it with one she wears in one of the previous pictures (e.g., fig. 1490).
Located beside Judges 14:17.

Ser., fol. 541r

Blank space for an unexecuted miniature.
Located beside Judges 14:9.

1500b. Vat. 746, fol. 491r

Samson, recognizable by his disheveled hair, and his bride sit at the left of the table. Samson's father has taken the seat at the

extreme right, and between him and Samson are three young men who can only be interpreted as representatives of the thirty Philistines who, according to the text, attended the celebration as guests.

Located beside Judges 14:10.

1501b. Vtp., fol. 438v

Close to Vat. 746. Parts of the drapery hanging from the table are flaked.

Located beside Judges 14:10.

Lit.: Uspenskii, p. 177; Eller and Wolf, *Mosaiken*, fig. 49; Huber, fig. 148; Kötzsche-Breitenbruch, *Via Latina*, p. 91, pl. 23e; Björnberg-Pardo, *Simson*, pp. 149, 153, 160, 192ff., figs. 36, 51, 66; Θησαυροί, p. 283, fig. 172.

Judges 14:16

SAMSON REVEALS THE RIDDLE TO HIS WIFE

Both episodes in the next miniature are missing in Vat. 747, whose cycle continues with the smiting of the men from Ashkelon (no. 1504). The scribe of Ser. omitted a blank space here for the miniature.

1502a. Vat. 746, fol. 491v

Samson and his wife face each other, and each raises one hand in a gesture of speech; the wife shows her disapproval of Samson's keeping the secret of the riddle, and he expounds his revelation of the riddle.

Located beside Judges 14:18.

1503a. Vtp., fol. 439r

Identical to Vat. 746 except that Samson's wife wears a two-colored wedding garment.

Located beside Judges 14:17.

Lit.: Uspenskii, p. 177, fig. 296; Huber, fig. 149; Stahl, "Morgan M. 638," p. 249, fig. 207; Weitzmann, *SP*, p. 68; Björnberg-Pardo, *Simson*, pp. 153, 160, 192ff., figs. 53, 67; Θησαυροί, p. 283, fig. 173.

Judges 14:17

SAMSON'S WIFE REVEALS THE RIDDLE TO THE PHILISTINES

The episode is missing in Vat. 747.

1502b. Vat. 746, fol. 491v

Samson's wife addresses a group of her countrymen and repeats the riddle to them. The foremost Philistine raises his hand as if to answer her, though the Septuagint text does not report any reply.

Located beside Judges 14:18.

1503b. Vtp., fol. 439r

Very close to Vat. 746.
Located beside Judges 14:17.

Lit.: Uspenskii, p. 177, fig. 297; Huber, fig. 149; Stahl, "Morgan M. 638," p. 249, fig. 207; Björnberg-Pardo, *Simson*, pp. 153, 160, 192ff., figs. 53, 67; Θησαυροί, p. 283, fig. 173.

Judges 14:18

PHILISTINES EXPLAIN THE RIDDLE TO SAMSON

This episode is missing in Vat. 747. The scribe of Ser. omitted a blank space here for the miniature.

1505a. Vat. 746, fol. 492r

A group of Philistines stands in front of the angry Samson and explains the riddle to him. The surface of the miniature is flaked in various spots.

Located beside Judges 14:19.

1506a. Vtp., fol. 439v

Very close to Vat. 746. The miniature is flaked in various places.

Located beside Judges 14:20.

Lit.: Uspenskii, p. 178; Huber, fig. 150; Björnberg-Pardo, *Simson*, pp. 153–56, 160, 192ff., figs. 53, 68; Θησαυροί, p. 283, fig. 174; Lowden, *Octs.*, p. 59, fig. 78.

Judges 14:19

SAMSON SMITES THIRTY MEN FROM ASHKELON

In the next miniatures two different versions of the episode of Samson smiting the men from Ashkelon (LXX: Ascalon) are depicted: Vat. 747 shows Samson walking away as the men lie on the ground, presumably dead, notwithstanding the fact that the text does not explicitly mention that they were slain. In contrast, Vat. 746 and Vtp. show Samson smiting the men who lie alive on the ground. Moreover, whereas the Septuagint reads, "Samson went down to Ascalon and destroyed of the inhabitants thirty men," in the Octateuchs the episode takes place outside Ashkelon.[1]

1504. Vat. 747, fol. 249r

Samson has smitten thirty men from Ashkelon and deprived them of their garments. At the right and on the slope of a mountain the smitten men lie in various positions, completely naked and apparently dead. At the left Samson is represented leaving the scene of battle, carrying the garments bundled together like a bag on his shoulders. The surface is flaked in various spots.

Located beside Judges 14:19.

1505b. Vat. 746, fol. 492r

Samson stands in front of the defeated men of Ashkelon and gestures threateningly with one hand, while with the other he grasps one of the garments which he has taken from them. Nevertheless, all the men of Ashkelon are still fully dressed. The surface, particularly that of the ground, is flaked.

Located beside Judges 14:19.

1506b. Vtp., fol. 439v

Very close to Vat. 746. Flaked in various spots.
Located beside Judges 14:20.

Lit.: Uspenskii, p. 178; Huber, fig. 150; Björnberg-Pardo, *Simson,* pp. 149, 153–56, 160, 192ff., figs. 36, 53, 68; Θησαυροί, p. 283, fig. 174; Lowden, *Octs.,* p. 59, figs. 77, 78.

[1] The choice of this setting for the action recalls the narrative in Josephus's *Jewish Antiquities* 5:294 (*Josephus,* ed. Thackeray and Marcus, vol. 5, pp. 132–33), which, more precisely than the Septuagint, asserts that Samson despoiled "certain Ascalonites who encountered him on the road."

Judges 14:19

Samson Hands the Raiments to the Philistines

The episode is lacking in the cycle of Vat. 747, which jumps to Samson offering the kid to his father-in-law.

1505c. Vat. 746, fol. 492r

Samson gives the raiments as a reward to those Philistines who have answered the riddle. The two parties hold the raiments at the same time. Slightly flaked.

Located beside Judges 14:19.

1506c. Vtp., fol. 439v

Very close to Vat. 746. Partly flaked.
Located beside Judges 14:20.

Lit.: Uspenskii, p. 178; Huber, fig. 150; Björnberg-Pardo, *Simson,* pp. 149, 153–56, 160, 192ff., figs. 36, 68; Θησαυροί, p. 283, fig. 174; Lowden, *Octs.,* p. 59, fig. 78.

Judges 15:1–2

Samson Offers a Kid to His Father-in-Law

The next episode is represented in Vat. 747 with a completely different iconography than in Vat. 746 and Vtp. The latter manuscripts, furthermore, use an iconography that does not conform to the text, introducing a crowd of people and a woman who is presumably Samson's wife.

1507. Vat. 747, fol. 249r

Samson, who carries a goat kid in his right hand and is about to take it to his wife, meets his father-in-law, who, the text relates, refuses to let him see her because in the meantime he has given her to one of Samson's friends. However, in the miniature the father-in-law approaches his own house and clearly makes an inviting gesture with his right hand, pointing to the entrance door. This situation, then, can only illustrate verse 2, in which he asks Samson to take his second and younger daughter instead. Large parts of the ground, the sky, and the entrance door are flaked.

Located beside Judges 15:3.

Ser., fol. 542v

Blank space for an unexecuted miniature.
Located beside Judges 15:5.

1509a. Vat. 746, fol. 492r

Samson holds the kid with both hands and offers it to a whole crowd of Philistines, although, according to the Septuagint, he meets only his wife's father. Apparently the foremost man in the crowd, who gestures in refusal with both hands, represents Samson's father-in-law. Next to him stands a woman, presumably Samson's wife, whom, according to the text, he would not be allowed to see. Slightly flaked.

Located beside Judges 15:4.

1510. Vtp., fol. 439v

The composition is identical to that in Vat. 746. The figure of Samson's father-in-law is completely flaked, and all of the heads as well as parts of the other figures, particularly the two-colored festive garment worn by Samson's wife, are very badly damaged.

Located beside Judges 15:3.

Lit.: Uspenskii, p. 178; Huber, fig. 151; Björnberg-Pardo, *Simson,* pp. 149, 156, 160, 192ff., figs. 36, 54, 69; Lowden, *Octs.,* p. 59, fig. 76.

Judges 15:4–5

Samson Puts Firebrands between Foxes' Tails

1508. Vat. 747, fol. 249v

Samson fastens a flaming torch to the tails of two foxes, which he has tied together. Several other pairs of foxes carry flaming torches in a similar manner through a field of grain, setting it on fire. The miniature is partly flaked.

Located beside Judges 15:6.

Ser., fol. 542v

Blank space for an unexecuted miniature.
Located beside Judges 15:5.

1509b. Vat. 746, fol. 492r

The action is the same as in Vat. 747, but because of the miniature's different format as well as the more decorative inclinations of the painter, the pairs of foxes are placed around the figure of Samson and distributed over a field of grain that completely fills the picture area to the upper frame. The surface is partly flaked.

Located beside Judges 15:4.

1511. Vtp., fol. 440r

Very close to Vat. 746.
Located beside Judges 15:4.

Lit.: Uspenskii, p. 178; Weitzmann, *Bibliotheken des Athos*, pp. 24–26, fig. 2; Huber, fig. 152; Stahl, "Morgan M. 638," p. 205 n. 374; Kenfield, "Alexandrian Samson," pp. 189–90, fig. 7; Kötzsche-Breitenbruch, *Via Latina*, p. 92, pls. 24b, 24c; De' Maffei, "Sant'Angelo in Formis II," pt. 2, p. 199; Weitzmann, *SP*, p. 68; Björnberg-Pardo, *Simson*, pp. 149, 160, 192ff., figs. 37, 70; Θησαυροί, p. 284, fig. 175; Lowden, *Octs.*, pp. 58–59, figs. 74, 75.

Judges 15:6

PHILISTINES SET THE HOUSE OF SAMSON'S FATHER-IN-LAW ON FIRE

The two episodes of the Philistines burning Samson's wife and her father, and Samson bound with cords (nos. 1512b, 1513b) do not appear in Vat. 747. The scribe of Ser. omitted a blank space here for the miniature.

1512a. Vat. 746, fol. 492v

Three Philistines hold flaming torches, one in each hand, and set fire to the house of Samson's father-in-law. The house is a cella with a gathered-up curtain hanging in the entrance door. Slightly flaked all over the surface.

Located beside Judges 15:6.

1513a. Vtp., fol. 440r

The scene is very similar to that in Vat. 746 and equally flaked in various places.

Located beside Judges 15:6.

Lit.: Uspenskii, p. 178; Huber, fig. 153; Björnberg-Pardo, *Simson*, pp. 156, 160, 192ff., figs. 55, 71; Θησαυροί, p. 284, fig. 176; Lowden, *Octs.*, p. 59, fig. 75.

Judges 15:13

SAMSON FETTERED WITH CORDS

See the introduction to Judges 15:6.

1512b. Vat. 746, fol. 492v

Samson sits on the rock of Etam (see verse 11) and, without offering resistance, allows his hands to be fettered with ropes by two groups of men of Judah. Most of the figures are damaged by flaking.

Located beside Judges 15:6.

1513b. Vtp., fol. 440r

Close to Vat. 746. However, the foremost figures in both groups of men of Judah step behind the rock, so that spatially the scene has more depth and gives the impression that the men have come up from behind to fetter Samson.

Located beside Judges 15:6.

Lit.: Uspenskii, p. 178; Huber, fig. 153; Björnberg-Pardo, *Simson*, pp. 156, 160, 192ff., figs. 55, 71; Θησαυροί, p. 284, fig. 176; Lowden, *Octs.*, p. 59, fig. 75.

Judges 15:14

SAMSON SURRENDERED TO THE PHILISTINES

The episode is not represented in Vat. 747.

Ser., fol. 543r

Blank space for an unexecuted miniature.
Located beside Judges 15:14.

1515a. Vat. 746, fol. 493r

A group of men from Judah surrender the fettered Samson to a group of Philistines. Since the men in both groups are clad in simple tunics, it is difficult to decide which of them represent which group. Most of the figures in the left-hand group, presumably the Philistines, are badly flaked.

Located beside Judges 15:16.

1516a. Vtp., fol. 441r

Very close to Vat. 746.
Located beside Judges 15:16.

Lit.: Uspenskii, p. 178; Huber, fig. 154; Stahl, "Morgan M. 638," p. 206 n. 375, figs. 193, 194; Kötzsche-Breitenbruch, *Via Latina*, pl. 25c; Björnberg-Pardo, *Simson*, pp. 156, 161, 192ff., figs. 56, 72; Θησαυροί, p. 284, fig. 177.

Judges 15:15

SAMSON SLAYS THE PHILISTINES WITH THE JAWBONE

In the next episode one iconography is again used for the event in Vat. 747, and another in Vat. 746 and Vtp.

1514. Vat. 747, fol. 250r

Samson, a head taller than his enemies, holds the jawbone of an ass in his right hand and with it attacks a group of Philistine soldiers. Three of his enemies lie on the ground already slain, one tries to defend himself, and the others take flight. The Philistines wear heavy armor and carry shields and spears, in contrast to Samson, who is clad in a tunic and chlamys. The hill on which Samson stands and parts of the background are flaked.

Located beside Judges 15:17.

Ser., fol. 543r

Blank space for an unexecuted miniature.
Located beside Judges 15:14.

1515b. Vat. 746, fol. 493r

Samson holds the jawbone in a less energetic manner, and the Philistines are depicted as civilians clad in tunics, not as soldiers, and they do not try to defend themselves. The two foremost men are about to fall to their knees, and the others are simply retreating before the hammering blows of the jawbone. The entire scene lacks the vigorous action which is so characteristic of Vat. 747. Flaked in various spots.

Located beside Judges 15:16.

1516b. Vtp., fol. 441r

Very close to Vat. 746.
Located beside Judges 15:16.

Lit.: Uspenskii, p. 178; Huber, fig. 154; Stahl, "Morgan M. 638," pp. 150–52, figs. 193, 194; Kenfield, "Alexandrian Samson," pp. 190–91, fig. 9; Kötzsche-Breitenbruch, *Via Latina*, p. 93, pls. 25b, 25c; *Age of Spirituality*, p. 472; Weitzmann, *SP*, p. 68; Björnberg-Pardo, *Simson*, pp. 149, 156, 161, 192ff., 263–64, figs. 38, 56, 72; Θησαυροί, p. 284, fig. 177.

Judges 15:19

Samson Drinks from the Jawbone

The next four episodes in Vat. 746 and Vtp., three of them included in the following miniature (nos. 1517a–1517c, 1518a–1518c) and the fourth occupying the left half of the succeeding miniature (nos. 1520a, 1521a), do not appear in the cycle of Vat. 747, which skips to the deed of the gate of Gaza. The depiction in Vat. 746 contradicts verse 17, which says that Samson cast the jawbone out of his hand, and then (verse 19) that God opened a hollow place in the jawbone and let water come out of it; the newborn fountain was called "the well of the invoker."[1] Probably unsatisfied by the representation in Vat. 746, the painter of Vtp. returned to the text of the Septuagint and chose to represent the jawbone cast on the ground, as recounted in verse 17.

Ser., fol. 543v

Blank space for an unexecuted miniature.
Located beside Judges 15:19.

1517a. Vat. 746, fol. 493r

Sitting on a rock, Samson drinks out of the jawbone of the ass, which he grasps and raises with his left hand.
Located beside Judges 16:1.

1518a. Vtp., fol. 441v

Samson bends and cups his hands to drink water which he has apparently fetched from "the well of the invoker." The jawbone, from which the water should spring according to verse 19, lies on the ground.
Located beside Judges 15:20.

Lit.: Uspenskii, p. 178; Huber, fig. 155; Stahl, "Morgan M. 638," p. 153, fig. 153; Björnberg-Pardo, *Simson*, pp. 156, 161, 192ff., 264, figs. 57, 73; Θησαυροί, p. 284, fig. 178.

[1] Cf. Björnberg-Pardo, *Simson*, p. 200.

Judges 16:1

Samson Approaches Gaza

See the introduction to Judges 15:19.

Ser., fol. 543v

Blank space for an unexecuted miniature.
Located beside Judges 15:19.

1517b. Vat. 746, fol. 493r

Samson approaches the city gate of Gaza, which in this instance is located in the tower instead of the wall, as is usual. Flaked in various spots.
Located beside Judges 16:1.

1518b. Vtp., fol. 441v

Very close to Vat. 746.
Located beside Judges 15:20.

Lit.: Uspenskii, p. 178; Huber, fig. 155; Björnberg-Pardo, *Simson*, pp. 156, 161, 192ff., figs. 57, 73; Θησαυροί, p. 284, fig. 178.

Judges 16:1

Samson Meets the Harlot

See the introduction to Judges 15:19.

Ser., fol. 543v

Blank space for an unexecuted miniature.
Located beside Judges 15:19.

1517c. Vat. 746, fol. 493r

Samson meets the harlot and speaks with her. The woman makes a gesture of restraint, as if she is not immediately willing to follow Samson's suggestion. The painter has placed the meeting in front of the wall of Gaza, although it is supposed to have taken place within the city. The surface is flaked in various spots.

Located beside Judges 16:1.

1518c. Vtp., fol. 441v

The composition is very close to Vat. 746 except that within the wall the painter depicted a house which is apparently intended to represent the harlot's house.

Located beside Judges 15:20.

Lit.: Uspenskii, p. 178; Huber, fig. 155; Björnberg-Pardo, *Simson*, pp. 156, 161, 192ff., figs. 57, 73; Θησαυροί, p. 284, fig. 178.

Judges 16:2

SAMSON LIES WITH THE HARLOT

Ser., fol. 544r

Blank space for an unexecuted miniature.
Located beside Judges 16:4.

1520a. Vat. 746, fol. 493v

As in the preceding miniature, the painter depicted the scene, which is supposed to take place within Gaza, in front of the city; in addition he showed the harlot's house once within the wall, and a second time outside the city. Samson and the harlot are shown lying side by side on a couch which is, of course, supposed to stand in the interior of her house. At the left is the group of armed Gazites who guard the closed gate of the city, behind which they believe they have trapped Samson, so that they will be able to capture him the next morning. The spatial relationship between the Gazites on the one hand, and Samson and the harlot on the other, is of course obscured by the extraction of the couch scene from its proper surroundings.

Located beside Judges 16:2.

1521a. Vtp., fol. 442r

Close to Vat. 746. Slightly flaked in various spots.
Located beside Judges 16:2.

Lit.: Uspenskii, p. 178, fig. 298; Huber, fig. 156; Weitzmann, *SP*, p. 69; Björnberg-Pardo, *Simson*, pp. 156, 161, 192ff., figs. 58, 74; Θησαυροί, p. 284, fig. 179.

Judges 16:3

SAMSON CARRIES THE GATE OF GAZA

The next episode is missing in Vat. 746 and Vtp., which preferred to illustrate the second part of the same verse 3 (nos. 1520b, 1521b).

1519. Vat. 747, fol. 250r

Having torn the iron-studded gate out of the city wall of Gaza, Samson carries it, together with its marble frame, on his shoulders. In the ringwall at the left one perceives the big gap which has resulted.

Located beside Judges 16:1.

Lit.: Weitzmann, "Martyrion," p. 137; Stahl, "Morgan M. 638," p. 205 n. 374; Weitzmann, *SP*, p. 69; Björnberg-Pardo, *Simson*, pp. 149, 192ff., fig. 39.

Judges 16:3

SAMSON LAYS THE GATE ON THE TOP OF A MOUNTAIN

See the previous introduction.

Ser., fol. 544r

Blank space for an unexecuted miniature.
Located beside Judges 16:4.

1520b. Vat. 746, fol. 493v

Samson deposits the gate of Gaza on a mountain before Hebron. The gate is represented intact, just as it appeared in its original place in the wall (cf. fig. 1520a), i.e., it has kept not only its marble frame but also the three marble steps and the crowning conch.

Located beside Judges 16:2.

1521b. Vtp., fol. 442r

Very close to Vat. 746. The gate is largely flaked.
Located beside Judges 16:2.

Lit.: Uspenskii, p. 178, fig. 299; Huber, fig. 156; Stahl, "Morgan M. 638," p. 205 n. 374; Weitzmann, *SP*, p. 69; Björnberg-Pardo, *Simson*, pp. 156, 161, 192ff., figs. 58, 74; Θησαυροί, pp. 284–85, fig. 179.

Judges 16:9 or 16:12

SAMSON BREAKS THE CORDS

In turn, Vat. 747 now represents more numerous events of the story than Vat. 746 and Vtp., which skip to the betrayal of Samson (nos. 1525a, 1526a). The iconography of this scene may refer either to the first breaking of cords at Judges 16:9 or to the second at Judges 16:12.

1522. Vat. 747, fol. 250r

Samson, in a kneeling position, has broken the cords with which Delilah bound him in order to surrender him to the Philistines. The ends of the seven cords are visible over his fore-

arms. A group of Philistine soldiers, armed with shields and spears, had been lying in wait behind a mountain, although the text explicitly states that the action took place in a chamber, and now, as they see Samson freed, they hastily take flight. Delilah stands at the right, raising her hand in astonishment at Samson's miraculous strength. Parts of the mountain and the background are flaked.

Located beside Judges 16:5.

Lit.: Weitzmann, "Samson and Delilah," p. 9, fig. 2; Björnberg-Pardo, *Simson*, pp. 149, 192ff., fig. 40.

Judges 16:14

SAMSON PULLS AWAY HIS HAIR AND
THE PIN OUT OF THE WALL

See the previous introduction.

1523. Vat. 747, fol. 250v

Samson exerts all his strength to pull away from the wall of a house to which Delilah has fastened seven locks of his hair with a pin. To represent this deed more explicitly, the painter has depicted the hero's long hair extending out horizontally in seven long strands. Delilah stands in front of the house with a gesture of astonishment, and at the right the Philistine soldiers, just as in the previous scene, lie in ambush behind a steep mountain instead of inside the house. They seem to be already retreating, having observed Samson's feat. A large part of the mountain is flaked, and the faces of all the figures are damaged.

Located beside Judges 16:16.

Lit.: Björnberg-Pardo, *Simson*, pp. 149, 192ff., fig. 41.

Judges 16:18

BETRAYAL OF SAMSON

The next episode does not appear in Vat. 747. The scribe of Ser. omitted a blank space here for the miniature.

1525a. Vat. 746, fol. 494v

Delilah reveals the secret of Samson's strength to the chiefs of the Philistines. The hindmost Philistine holds a big money bag, the reward for Delilah's betrayal. Almost the entire figure of Delilah and parts of the wall that serves as a foil are flaked.

Located beside Judges 16:19.

1526a. Vtp., fol. 443v

Close to Vat. 746.
Located beside Judges 16:19.

Lit.: Uspenskii, p. 178, fig. 300; Huber, fig. 157; Björnberg-Pardo, *Simson*, pp. 156, 161, 192ff., figs. 59, 75; Θησαυροί, p. 285, fig. 180.

Judges 16:19

CUTTING OF SAMSON'S HAIR

The Octateuchs transmit two different iconographies of the episode of the cutting of Samson's hair: in Vat. 747, the hero is depicted reversed in comparison with the other manuscripts and the soldiers advancing from the right side are added.

1524. Vat. 747, fol. 250v

Samson lies on the ground with his head resting in the lap of Delilah, who sits on a cushion with her legs drawn up. A young man beside her cuts the sleeping hero's hair while the Philistine soldiers, now displaying great confidence, emerge from their ambush to subdue Samson after he has lost his strength. Again, as in previous scenes in this manuscript, the hiding place is a steep mountain instead of an interior. Most of the mountain and parts of the figures are flaked.

Located beside Judges 16:19.

1525b. Vat. 746, fol. 494v

Half sitting, the sleeping Samson leans against Delilah, who sits on a throne. A young Philistine, approaching from the left, bends over Samson and cuts his hair. As an indication of the setting, a house is represented at the right and a wall with an entrance door at the left. The entire surface of the miniature is badly flaked.

Located beside Judges 16:19.

1526b. Vtp., fol. 443v

Close to Vat. 746. However, the painter's peculiar decorative sense is apparent in details like the footstool, which is shaped like a conch, repeating a form that also serves as an ornament above the door lintel.

Located beside Judges 16:19.

Lit.: Uspenskii, p. 178, fig. 301; Buchthal, *Latin Kingdom*, p. 60 n. 1; Huber, fig. 157; Stahl, "Morgan M. 638," p. 206 n. 377, fig. 246; Weitzmann, *SP*, p. 69; Björnberg-Pardo, *Simson*, pp. 149–52, 156, 161, 192ff., figs. 42, 59, 75; Θησαυροί, p. 285, fig. 180.

Judges 16:21

BLINDING OF SAMSON

In this scene, too, Vat. 747 presents an iconography different from that in Vat. 746 and Vtp.: the latter manuscripts reverse Samson and show the soldier hammering a nail into his eyes instead of putting them out.

1527a. Vat. 747, fol. 251r

Samson lies on the ground, held down by four kneeling Philistines, while a fifth is either putting out or piercing his eyes

with a peg. A house on either side lends balance to the composition. The background is partly flaked.

Located beside Judges 16:22.

Ser., fol. 546r

Blank space for an unexecuted miniature.
Located beside Judges 16:30.

1528. Vat. 746, fol. 494v

With his arms fettered behind his back and reversed from Vat. 747, Samson is held by five Philistines who do not kneel on the ground as in Vat. 747, but bend over their victim so that they seem to be holding the body above the ground. Countering verse 21, which states that Samson's eyes were put out, a sixth Philistine drives a nail through Samson's eyes with a hammer. Other Philistines, watching this cruel spectacle, are grouped on either side. The entire surface of the miniature is very badly flaked.

Located beside Judges 16:22.

1529. Vtp., fol. 444r

Close to Vat. 746. The faces of Samson and his tormenter, as well as other spots, are flaked.
Located beside Judges 16:21.

Lit.: Uspenskii, p. 178; Huber, fig. 158; Stahl, "Morgan M. 638," p. 206 n. 377, fig. 247; Weitzmann, *SP*, p. 70; Björnberg-Pardo, *Simson*, pp. 156–57, 161, 192ff., figs. 43, 60, 76; Sed-Rajna, *Hebraic Bible*, p. 133 n. 15; Θησαυροί, p. 285, fig. 181; *ODB*, vol. 2, fig. p. 865.

Judges 16:21

SAMSON AT THE MILL

The episode is missing in the other manuscripts.

1527b. Vat. 747, fol. 251r

The blinded hero is bound by his neck and belly to two horizontal bars which are connected to a rotating pole. By turning this pole in a circle, Samson puts into motion a millstone to grind grain. Parts of the surface are flaked.

Located beside Judges 16:22.

Lit.: Björnberg-Pardo, *Simson*, pp. 152, 192ff., fig. 43; *ODB*, vol. 2, p. 865.

Judges 16:29–30

SAMSON PERISHES WITH THE PHILISTINES

The iconographies of Samson causing the palace to collapse onto the Philistines correspond only in the representation of Samson embracing two columns, one with each hand; this fea-

ture, though, is explicitly mentioned in verse 29. The other details in the miniature of Vat. 747 differ markedly from those in Vat. 746 and Vtp.

1530. Vat. 747, fol. 251r

Samson embraces the two marble columns upon which the palace rests. The edges of a massive architrave forming the platform for a row of houses crumble, bringing down the buildings at the corners together with one of their inhabitants, while loose stones are threatening to fall and others have already killed two men on the ground. The central section of the row of houses, however, has not yet been affected by the disaster and two couples, conversing with each other, apparently are still unconcerned. The surface is flaked in various spots.

Located beside Judges 16:31.

Ser., fol. 546v

Blank space for an unexecuted miniature.
Located beside Judges 16:31.

1531. Vat. 746, fol. 495r

To some degree the composition is conceived more naturalistically than that in Vat. 747: the palace rests on the ground and the two marble columns which are part of it are on the same level. Samson has actually moved at least one of the columns from its base and the destruction of the palace is nearly complete: houses, towers, and sections of wall are tumbling around and burying a number of Philistines in the debris, so that only their heads and in some cases their hands, gesturing in desperation, protrude. The Philistine to the right of Samson falls down head first, and the one to his left, having escaped, seems to be appealing to Samson for his life. The entire surface of the miniature is badly flaked.

Located beside Judges 16:31.

1532. Vtp., fol. 445r

Close to Vat. 746.
Located beside Judges 16:30.

Lit.: Uspenskii, p. 178; Buchthal, *Latin Kingdom*, p. 60, fig. 149a; Huber, fig. 159; Weitzmann, *SP*, p. 70; Björnberg-Pardo, *Simson*, pp. 152, 157, 161, 192ff., figs. 44, 61, 77; Lowden, "Octateuch," fig. p. 1510; Θησαυροί, p. 285, fig. 182.

Judges 16:31

BURIAL OF SAMSON

The next three miniatures in Vat. 747, which complete the cycle for the Book of Judges, do not occur in the other manuscripts.

1533. Vat. 747, fol. 251r

Two Israelites lower the corpse of Samson, in mummylike wrappings, into a marble sarcophagus whose shape is adapted to the slightly raised head of the deceased. Partly flaked.

Located beside Judges 16:31.

Lit.: Lowden, "Octateuch," fig. p. 1510.

Judges 18:15

Danites Arrive at Micah's House

From the story of Micah's (LXX: Michaias) idolatry, Vat. 747, the only manuscript containing scenes related to the final chapters of Judges, has an illustration of the Danites arriving at Micah's house. The cycle ignores the making of the graven image and the molten image and the arrival of the Levite in chapter 17 (verses 4 and 7ff., respectively) and most of the events in chapter 18: after the Levite joined the Danites with the stolen images, the ephod, and the teraphim (verse 18), Micah protests (verses 22ff.). Later, the Danites conquer Laish (LXX: Laisa) and kill its inhabitants (verses 27ff.). See also the previous introduction.

1534. Vat. 747, fol. 252r

The Danite soldiers, who have come to Micah's house, meet a Levite who had served as Micah's priest and ask him to become their priest. The Levite is nimbed, clad in an imperial chlamys, and has a white beard in contradiction to the text, which explicitly calls him a young man. The heavily armed Danites stand alongside a walled city with a closed gate, although the text speaks only of Micah's house, not of a city.

Located beside Judges 18:17.

Judges 18:16–26

Danites Enter Micah's House

The Danites, with the Levite at their head, enter Micah's house. The episode does not conform to the text, which reads that the Danites stole "the carved image, the ephod, and the teraphim, and the molten image"; only afterward did the Levite choose to join the Danites and Micah cried out to the Danites to regain the stolen objects. Finally, the Danites come to Laish, conquer it, and kill all its inhabitants.

1535. Vat. 747, fol. 252v

Two of the heavily armed Danite soldiers turn their heads back toward the left, where Micah stands with his family. Micah's quiet posture clearly reveals that he is not taking any steps to prevent the Danites from robbing him of the image, ephod, and teraphim which, according to the text, they should have taken with them. None of the disputed objects is represented in the hands of either the Levite or the Danites, suggesting that the

painter intended to represent the Levite himself entering the house to remove the sacred objects.

Located beside Judges 19:1.

Judges 19:28

Levite Carries the Corpse of His Concubine

Of the story of the Levite and his concubine, the Octateuchs picture only the Levite carrying the corpse of the woman on the ass; the cruelest events are overlooked.[1]

1536. Vat. 747, fol. 253v

The Levite from Mount Ephraim is driving an ass, on the back of which he has tied his dead concubine, wrapped in winding sheets, on top of a mattress. The surface is flaked in various spots.

Located beside Judges 19:29.

Ser., fol. 552r

Blank space for an unexecuted miniature.
Located beside Judges 19:28.

1537. Sm., fol. 255r

Close to Vat. 747, but the Levite wears a turban and the concubine is not wrapped in winding sheets, but rather is dressed in a long garment, with her hands crossed over her lap and her feet covered.

1538. Vat. 746, fol. 499r

Very close to Sm.
Located beside Judges 19:29.

1539. Vtp., fol. 451r

Very close to Vat. 746.
Located beside Judges 19:29.

Lit.: Uspenskii, p. 178, fig. 302; Hesseling, fig. 331; Weitzmann, "Jewish Sources," p. 87; Huber, fig. 160; Weitzmann, *SP*, p. 71; Avner, "Septuagint Illustrations," pp. 299–301, 303, 310, pl. 25; Θησαυροί, p. 285, fig. 183; Lowden, *Octs.*, p. 57, figs. 64–67.

[1] A detailed cycle of illustrations of this story occurs in the homiletic manuscript Athos, Esphigmenou, cod. 14 (Avner, "Septuagint Illustrations," pp. 297–317).

Judges 20:37–40

Capture of Gibeah

1540a. Vat. 747, fol. 255r

One group of heavily armed Israelites represents the victorious army which has just conquered the Benjamites in the open field (verse 35), while another group which has been lying in wait sets

fire to the city of Gibeah (LXX: Gabaa), thus giving the agreed-upon signal to the former group.

Located beside Judges 21:3.

Ser., fol. 555v

Blank space for an unexecuted miniature.
Located beside Judges 20:26.

1541a. Sm., fol. 257r

Both groups of Israelite soldiers are reduced in number; the sword-bearer of the left group in Vat. 747 has been omitted, and only two of the torchbearers are left in the second group. On the other hand, within the city of Gibeah a Benjamite is visible above the crenelations of the wall with a spear, trying to defend the city against the two attackers.

1542a. Vat. 746, fol. 501v

Very close to Sm. The miniature has been overpainted with a crude, broad brush.
Located beside Judges 21:3.

1543. Vtp., fol. 455v

Close to Vat. 746. Slightly flaked and stained.
Located beside Judges 21:1.

Lit.: Uspenskii, p. 178, fig. 303; Hesseling, fig. 332; Huber, fig. 161; Avner, "Septuagint Illustrations," pp. 299–301, 306, pl. 26; Θησαυροί, pp. 285–86, fig. 184.

Judges 20:44–45

DEFEAT OF BENJAMIN

1540b. Vat. 747, fol. 255r

The Israelites, heavily armed with spears and swords, are shown fiercely attacking the Benjamites, two of whom lie dead

on the ground, while the rest of the army hastily takes flight. Parts of the surface are flaked.

Located beside Judges 21:3.

Ser., fol. 555v

Blank space for an unexecuted miniature.
Located beside Judges 20:26.

1541b. Sm., fol. 257r

Compared with Vat. 747, the attackers as well as the fleeing Benjamites show far less vigor and motion, and particularly the latter make no attempt to defend themselves or to hasten away. Again, as in the previous scene, the soldiers wear only tunics instead of heavy armor. On the other hand, the number of slain enemies is considerably larger, and they are depicted in a more realistic way, with blood dripping from their wounds.

1542b. Vat. 746, fol. 501v

Close to Sm. However, the Israelite soldier in the middle of the group holds a sword, and in this respect the painter conforms to the version represented in Vat. 747. The miniature has been damaged by flaking and rubbing.
Located beside Judges 21:3.

1544. Vtp., fol. 456r

Close to Vat. 746 in every detail.
Located beside Judges 21:4.

Lit.: Uspenskii, pp. 178–79, fig. 304; Hesseling, fig. 332; Huber, fig. 162; Avner, "Septuagint Illustrations," pp. 299–301, 306, pl. 26; Θησαυροί, p. 286, fig. 185.

11. RUTH

Ruth 2:8

RUTH GATHERS GRAIN

For the story of Ruth, the Octateuchs transmit a cycle composed of only two miniatures.

1545. Vat. 747, fol. 256v

Boaz (LXX: Booz) encourages Ruth to glean in his fields. Ruth is busy picking grain while Boaz, draped in a chlamys, extends his arm toward her in a gesture of speech.

Located beside Ruth 2:3.

Ser., fol. 562v

Blank space for an unexecuted miniature.
Located beside Ruth 2:5.

1546. Sm., fol. 258v

Close to Vat. 747, except for slight changes in the costumes, such as the kerchiefs covering the heads of Ruth and Boaz.
Located below Ruth 2:2.

1547. Vat. 746, fol. 504v

The figure of Ruth agrees with Sm.; Boaz, who is bareheaded and wears a chlamys, resembles instead the dignified figure in Vat. 747.

Located beside Ruth 2:2.

1548. Vtp., fol. 460v

Very close to Vat. 746.
Located beside Ruth 2:2.

Lit.: Uspenskii, p. 179, fig. 305; Hesseling, fig. 333; Neuss, *Katalan. Bibelill.*, p. 76; Huber, fig. 163; Stahl, "Morgan M. 638," p. 211; Chasson, "Tuscan Bible," p. 193; Sed-Rajna, *Hebraic Bible*, p. 147 n. 8; Θησαυροί, p. 286, fig. 186; Levi D'Ancona, "Libro di Ruth," p. 4, fig. 6.

Ruth 3:14

RUTH AND BOAZ SLEEP ON THE GROUND

1549. Vat. 747, fol. 258r

In a mountainous landscape Boaz and Ruth lie on the ground in attitudes of sleep, arranged symmetrically so that their feet touch. The loose brushstrokes beneath the figures are supposed to indicate heaps of grain on which they are resting. The typical golden bushes are visible in the background.

Located beside Ruth 3:14.

Ser., fol. 564r

Blank space for an unexecuted miniature.
Located below and above Ruth 3:15.

1550. Sm., fol. 260r

The inscription reads: βοόζ τε καὶ ῾ρούθ, τῆς ἀληθείας τύποι, ἀνδρὸς μ(ὲν) οὗτο(ς), ὃσθε ἀνθρώπ(ων) πλε τῆς ἐξ ἐθν(ῶν) αὖτη δε πιστῆς συζύγου.

Close to Vat. 747, but Boaz's head is turned toward Ruth and Ruth's position is more upright and not quite as relaxed.

1551. Vat. 746, fol. 507v

Close to Sm. The heads of both figures are badly damaged.
Located beside Ruth 3:14.

1552. Vtp., fol. 465r

Close to Vat. 746, but Boaz is depicted in a more erect position.
Located beside Ruth 3:14.

Lit.: Uspenskii, p. 179, fig. 322; Hesseling, fig. 334; Millet, "Octateuque," p. 74; Neuss, *Katalan. Bibelill.*, p. 76; Huber, fig. 164; Chasson, "Tuscan Bible," p. 193; Sed-Rajna, *Hebraic Bible*, p. 147 n. 8; Θησαυροί, p. 286, fig. 187; Levi D'Ancona, "Libro di Ruth," p. 6, fig. 9.

II. THE ORIGIN
OF THE ILLUSTRATIONS
OF THE OCTATEUCHS

1. ORIGIN OF THE ARCHETYPE

THE EXTENSIVE miniature cycle of the Octateuchs represents a distinct recension within the illustrated manuscripts of the Septuagint. The origin of the recension can be traced back as far as the third century A.D., specifically to about the middle of the century, when the panels of the Dura Europos synagogue were painted. These, as far as our knowledge goes, are the earliest reflections of the Octateuch cycles. In a recent study I pointed out numerous examples of close connections between the Octateuch miniatures and the Dura paintings, leading to the assumption of a common archetype.[1] Here I should like to mention only three of those examples from different books of the Octateuch.

(1) Jacob Blesses Ephraim and Manasseh, from Genesis 48:13–20 (figs. 564–567, text fig. 1).[2] The three decisive iconographic elements in which the miniature and the Dura painting agree are: (a) Jacob lying on a *kline*, following Genesis 48:2; (b) Ephraim and Manasseh standing frontally before the *kline*; and (c) Joseph approaching from the right. In other recensions the composition is quite different: the Vienna Genesis shows Jacob seated, while in the Cotton Genesis, as reflected in the Millstatt Genesis, a codex belonging to the same recension as the Cotton Genesis, he stands.[3]

(2) The most extensive and complex Dura panel is that with the Crossing of the Red Sea (text fig. 2),[4] in which a considerable number of narrative scenes are conflated and in many cases much abbreviated. Quite a number of very specific elements agree with the Octateuch miniatures, allowing us to establish a common recension, for example: (a) the plague-ridden city with its open gate, which has its parallel in the miniature depicting the Plague of Dog Flies in Vat. 747 (fig. 656);[5] (b) the two pillars, of fire and cloud, which are rendered as architectural columns with bases and capitals in both the Dura panel and the miniature; and (c) the non-biblical element of the small child held by the hand in the group of departing Israelites (cf. figs. 700–703) and the Dura painting.

(3) The third instance is a motif in a picture illustrating Numbers 10:1–10. The complex panel representing the tabernacle (text fig. 3)[6] depicts four trumpet-blowers where the biblical text (Num 10:2) mentions only two silver trumpets. Vat. 747, which in many cases is the best witness to the archetype (fig. 899), also has four.[7]

These three examples are all from the Pentateuch; no pictures from the other three books of the Octateuch—Joshua, Judges, and Ruth—are included in the program of the Dura synagogue decoration and, to the extent that the preserved parts of the walls permit a judgment, most likely never were. The Pentateuch as a biblical unit is deeply rooted in the Jewish tradition. If we are correct that the Octateuch illustrations and the Dura paintings reflect the same pictorial recension of the Bible, then we may ask whether the archetype of the Octateuch was in fact only a Pentateuch and whether the other three biblical books were not added at some later time. In the Early Christian tradition, however, the Octateuch seems to have been more popular than the Pentateuch. According to Rahlfs' list of Old Testament manuscripts,[8] there are no fewer than ten Octateuch manuscripts in more or less complete condition up to the end of the tenth and the beginning of the eleventh century, the earliest being Leiden, cod. Voss. grec. 8, from the fourth or fifth century. Still, this leaves a gap of about two hundred years between the earliest preserved Octateuchs and the illustrated archetype that we assume existed at the time the Dura paintings were executed, around the middle of the third century A.D. At the same time, Rahlfs knows of only two Greek manuscripts of the Pentateuch up to the tenth century, both of them fragmentary and therefore problematical. Thus, on the grounds of the preserved manuscripts it must remain speculative whether the illustrated archetype was a Pentateuch, to which the other three books were added, or an Octateuch. The only argument favoring the former assumption, though this is not conclusive, is the basing of the Octateuch illustration on the Jewish tradition and its connection with the Dura paintings.

Aside from the textual argument, an iconographic investigation of the miniatures suggests that the illustrations of the Book of Joshua (and that would mean also Judges and Ruth) were added to an illustrated Pentateuch at some later time. The Ark of the Covenant is depicted as an upright cabinet with a double-valve door throughout the Pentateuch, while in the Book of Joshua it is depicted in a completely different manner, as a horizontal shrine with a gabled roof similar to later reliquary shrines, a resemblance which is not merely formal. In the Book of Joshua the front side of the shrine shows a three-figure group that resembles a Deesis, and clearly was understood as such by the painter

[1] Weitzmann, *Dura*, pp. 17ff.

[2] Ibid., pp. 21ff., figs. 18–24.

[3] Ibid., figs. 22–24.

[4] Ibid., figs. 48, 49.

[5] Ibid., p. 47, fig. 58.

[6] Ibid., p. 61, fig. 80.

[7] Ibid., p. 61, fig. 61.

[8] Rahlfs, *Verzeichnis*, pp. 374ff.

of Vtp. (fig. 1171). This supports the idea that the replacing of the cabinetlike tabernacle with the shrine was the intentional alteration of a Jewish element into a Christian one.

The iconography of the execution of prisoners is a second case of fundamental disagreement between the cycles of the Pentateuch and the Book of Joshua in the Octateuchs. In the Genesis miniature of Butler Serves Pharaoh and Baker Hanged (figs. 499–502) the chief of the bakers, condemned to death, is depicted crucified in a manner resembling Christ on the Cross, and it is not unlikely that a representation of Christ on the Cross served as its model. In the Book of Joshua, on the other hand, the king of Ai is condemned to death by hanging on the *furca*, the gabled cross (figs. 1238–1243). These two traditions are irreconcilable and clearly indicate different traditions, the crucifixion being a case of Christian influence in the Octateuch pictorial cycle.

The connections with the Dura paintings raise the question of where the archetype of the Pentateuch originated. The closest cultural center from which the Mesopotamian painters could have gotten their models was Antioch, from which the desert road led east to Dura.[9] Antioch was a center where flourishing Christian and Jewish communities coexisted harmoniously in the third century, and where illustrated Septuagint manuscripts would likely have been available to representatives of both religions. Thus, it seems to be not a mere accident that the earliest known Octateuch scene came to light in the excavations of Antioch. The incised marble relief dating from the fifth or sixth century (text fig. 4),[10] found in the ruins of a martyrion in Seleukeia near Antioch and now in The Art Museum of Princeton University, depicts Joseph in prison, seated within a vaulted structure and explaining the dreams of the baker and the butler, with the captain of the guard seated at the extreme left. This precise scene is depicted in a manner so similar in all essential features in the twelfth-century Octateuchs (figs. 492–494) that there can hardly be any doubt that both representations hark back to the same archetype. This becomes all the more obvious if we compare the prison scene with that of the corresponding illustration in the other Genesis recensions.

In the Vienna Genesis[11] the prison is depicted as an open precinct into which one looks in a kind of bird's-eye view. The Vienna Genesis belongs to a recension clearly different from that of the Octateuchs. If Gerstinger is right that Antioch was the place of its origin, then we are faced with the possibility that two different recensions existed in the same place. The Vienna Genesis, however, may have been executed in another important center, perhaps Jerusalem or Caesarea. Certainly the last word has not yet been said about the places of origin of the various recensions, but the strongest evidence, the close affinity of the Octa-

teuch miniature with the marble plaque excavated at Antioch, supports the localization of the Octateuch recension in Antioch. It must be made very clear, however, that we are discussing here only the first *illustrated* exemplar of the Octateuch and that our proposal for localization in Antioch is restricted to it. The text is surely older than its first illustration, and there may have been quite a considerable interval of time between the origin of the text and its first illustrated version. Nor did they both necessarily originate in the same place. In other words, while we argue for Antioch as the place of origin of the first illustrated Octateuch, this leaves open the question of the location of the origin of the textual archetype, which might well have been very different. Solving this problem must be left to the textual critics and is not our concern.

A third Genesis recension is represented by the Cotton Genesis miniatures, for which we have proposed Egypt—either Alexandria or perhaps Antinoë—as the place of origin. Here the prison in the scene of Joseph explaining the dreams of the baker and the butler is located in a colonnaded chamber, a setting entirely different from those of the two other recensions.[12]

Despite the fact that all of the existing Octateuchs are products of Constantinople, that city cannot have been the place where the first illustrated archetype originated, since the connection with the Dura paintings indicates a period before the foundation of the Eastern capital. When the illustrated Octateuch became known in Constantinople is not certain, but in all likelihood it was in the pre-iconoclastic period. The enormous enterprise of collecting and copying books in the time of Justinian, the period of the models that were copied in the tenth century in the luxurious volumes of the so-called Niketas Bible,[13] might well have included the production of Octateuch manuscripts. This, however, remains speculative.

Whether the archetype was a Pentateuch or an Octateuch, it had no catenae alongside the Bible text. If Georg Zuntz is correct that catenae were not written alongside the basic text before around the year 800,[14] then we must visualize an archetype of the Pentateuch/Octateuch with a wide single-column text comparable to the Vienna or the Cotton Genesis. This realization has a bearing on the physical appearance of the miniatures: the narrowing of the writing column of the Bible text because of the addition of the catenae led to a reduction of the width of the miniatures, and this reduction took a variety of forms. We encounter here basically the same problem faced by the thirteenth-century mosaicists of San Marco in Venice when they used the Cotton Genesis as a model for the decoration of the narthex. In describing this process I have worked out a series of principles,[15] most of which also apply to the case of the extant Octateuchs and their relation to the postulated archetype.

[9] See note 1 above.

[10] Weitzmann, "Martyrion," pp. 138–39, no. 390, pl. 20; Weitzmann, *Studies*, p. 53, fig. 32; *Age of Spirituality*, pp. 465–66, no. 416; *Byzantium at Princeton*, 45–46, no. 7, with additional bibliography.

[11] Gerstinger, *Wiener Gen.*, pp. 103–4; *Atlas*, p. 33 (pict. 17).

[12] On the place of origin, see Weitzmann and Kessler, *Cotton Gen.*, p. 30; for the Joseph scene, ibid., p. 110, figs. 415, 416.

[13] Belting and Cavallo, *Bibel des Niketas*.

[14] G. Zuntz, "Die Aristophanes-Scholien der Papyri," *Byz* 14 (1939), p. 582; see the remarks of Weitzmann, *RaC*, 1st ed. (1947), p. 120, note 29; 2d ed. (1970), p. 250, addendum to p. 120. For a more recent discussion of the catenae, see N. G. Wilson, "The Relation of Text and Commentary in Greek Books," in *Il libro e il testo: Atti del convegno internazionale* (Urbino, 20–23 September 1982), ed. C. Questa and R. Raffaelli (Urbino, 1984), pp. 103–10.

[15] Weitzmann, "Genesis Mosaics," pp. 105–42, 253–58.

The first of these principles is that of selectivity. There are clear indications that the archetype had more scenes than occur in any one copy of the Octateuchs. The best evidence for this is provided by the above-mentioned marble plaque from Antioch with Joseph in prison (text fig. 4). In the upper right corner a remnant of a second vaulted prison is visible, indicating that there was a subsequent scene of the story of Joseph which most likely depicted Joseph being brought out of the prison. One might even speculate that yet another prison scene preceded at the left. Moreover, it can be shown that occasionally an Octateuch, usually Vat. 747, selects from the archetype a scene not contained in any of the other copies. One example of this is the illustration from Genesis 46 depicting Jacob traveling on a cart to Egypt (fig. 540), an image not contained in any other Octateuch. This scene may have been eliminated in the other Octateuchs because of its secondary importance: it does not contribute any essential action.

A second example which points to a considerably richer pictorial cycle in the archetype is in Exodus. The scene of the discovery of the child Moses in the Nile is depicted differently in Vat. 747 (fig. 599), where Pharaoh's daughter orders the fetching of the child, and in Vat. 746 (fig. 602), which shows the preceding phase of the episode, when Pharaoh's daughter notices the ark floating in the Nile. We can conclude that the archetype had both of these pictures and that each copyist made a different choice. In fact, we have proof of this assumption in a Carolingian miniature in the Bible of Charles the Bald in San Paolo fuori le mura in Rome (text fig. 5). Its Moses picture was indeed derived from the same archetype as the Octateuchs, as has been proved by Joachim Gaehde[16] and confirmed in my book on the Dura synagogue.[17] Here one finds not only the scene of the fetching but three additional scenes: the exposure of the ark in the Nile, Pharaoh's daughter calling Miriam to find a nurse for the child, and the handing over of Moses to Jochebed. All four scenes are lined up in one wide striplike composition, and we can well imagine that this complex and very coherent presentation reflects a miniature of the archetype of the Octateuchs in a one-column Bible text, such as that of the Vienna Genesis or the Cotton Genesis, where one also finds sequences of several phases of one episode in miniatures of wide format.

It is notable that the principle of selectivity is applied especially in those sections where a very popular story is most densely illustrated, so that the omission of a few scenes would not seriously impede the narrative flow. This is true particularly of the story of Joseph, which possessed a special attraction for the Bible illustrators.

A third example is the Samson story in the Book of Judges, which likewise enjoyed considerable popularity. Thus one verse, for instance, Judges 13:24, can have two scenes: the Birth of Samson, which is depicted in Vat. 746 and Vtp. (figs. 1491, 1492), and Samson and His Parents in Vat. 747 (fig. 1490). There is every reason to believe that both of these scenes existed in the archetype and that the various copyists made different choices. Yet, as we shall see later (section 3 below) the birth scene surely does not

appear in its original form, while the scene in Vat. 747 seems to be original.

In another episode the point is not that one or the other phase of an episode is illustrated, but that Vat. 747 has an additional scene not found in any of the other Octateuchs. All of the manuscripts have an illustration of Samson taking a honeycomb out of the mouth of a lion (Judg 14:9; figs. 1496, 1500, 1501), but Vat. 747 adds the subsequent phase of the episode, where Samson hands the honeycomb over to his parents. This scene, belonging to the cycle of the archetype, is of secondary importance and for this reason was omitted from the other Octateuchs.

Condensation is another device for reducing the picture area. In Vat. 747 the scene of Potiphar's wife showing Joseph's garment to her husband and the scene of Joseph in prison are two separate, superimposed pictures (fig. 491). In Vat. 746 the two pictures are condensed into one by the elimination of the ground of the first scene and the placement of Potiphar and his wife in the spandrels above the prison vault (fig. 494). In other miniatures, transplantation of compositional elements was employed in order to achieve condensation. In the scene of Jacob's Dream all of the Octateuchs place Jacob at the right, underneath the ladder (figs. 391–394). But note that the descending angel at the bottom in Vat. 746 and the second angel from below in Vat. 747 (fig. 391) point a finger to the left. This can only mean that in the archetype the sleeping Jacob was to the left of the foot of the ladder instead of underneath it. Jacob is indeed depicted in this place in the manuscript with the homilies of Gregory of Nazianzus now in Paris, Bibliothèque Nationale, cod. gr. 510 (text fig. 6),[18] which obviously reflects the original composition. The reason for the transplantation may well have been the change in width of the writing column. The picture of the Paris Gregory would fit nicely into a text with one wide column, while the pictures in the Octateuchs had to fit a narrower writing column because of the catena.

Another principle is that of additions beyond the requirements of the text. Here it must be stated that most of these additions, which are not based on the biblical text, were not invented by the first illustrators of the Octateuchs. They were taken over from other, mostly classical, texts and will be treated later. Conflation, the fusion of two originally separate subsequent scenes into one, is yet another frequent space-saving device, and was already common in classical art, as I have demonstrated in *Illustrations in Roll and Codex*.[19] This device of combining two actions into one may also be termed the *simultaneous method*. An example of this occurs in the Octateuchs in the illustration of Genesis 8:20–22 (figs. 143–146), where Noah makes a sacrifice after the flood. At the right stand Noah's three sons, who are not mentioned at the end of chapter 8, but at the beginning of chapter 9, which says that the Lord blessed Noah and his sons. So the hand of God in heaven relates to two actions: the acceptance of Noah's sacrifice and the blessing of Noah (who does not appear a second time) and his sons.

In cycles of narrative illustrations the action normally flows in one direction, usually from left to right. On occasion this flow is interrupted by a centralized composition. This principle of cen-

[16] Gaehde, "Octateuch," pp. 352ff., pl. 27.
[17] Weitzmann, *Dura*, p. 29, fig. 34.

[18] Ibid., p. 17, figs. 11–13.
[19] Weitzmann, *RaC*, pp. 24ff., figs. 18, 19.

tralization is used to place special emphasis on a scene and give it a hieratic effect. A striking example of this is the illustration of Genesis 17:4–5, where God makes Abraham a father of many nations, in the twelfth-century Octateuchs (figs. 250–252); here the Lord appears in heaven as a bust of Christ stretching out his hands to the standing Abraham at the left and Sarah at the right. This centralized composition was adapted from monumental art, apparently from an apse composition in a Christian church, where this compositional scheme is most common. That the scheme is indeed a later introduction in the cycle becomes quite apparent if we compare it with the corresponding scene in Vat.

747 (fig. 249), where Abraham lies in proskynesis on the ground before the Lord, who appears as the usual hand reaching out of heaven.

If one takes into account the variety of compositional changes that occurred in the process of copying, it becomes quite obvious that a considerable number of scenes are at least one step removed from the archetype, sometimes perhaps even more. In all of these cases we have to admit that we are far from having a clear picture of what the archetype looked like, how many more scenes it had, and whether the composition has retained its essential features or has undergone minor or major changes.

2. CLASSICAL SOURCES

The relation of the extensive narrative picture cycles to the basic text of the Septuagint is on the whole very close, and the first illustrators succeeded in transforming the text into simple, clear compositions in which the human figures act convincingly, with simple gestures, and in uncomplicated poses. Yet there are numerous elements for which the biblical text is not a sufficient basis to explain the iconography of the miniatures. In the following pages I shall try to demonstrate that these additional elements were not invented by the first Octateuch illustrators but were in most cases taken over from nonbiblical miniatures. It must be realized that the third century A.D., when the archetype must have existed (as proved by the parallels in the Dura paintings), was a flourishing period of codex or roll illustration. An exhaustive history of ancient book illustration has not yet been written. In a series of lectures on this topic published more than thirty years ago,[20] I pointed out the great variety of texts illustrated in classical antiquity. One must assume that the illustrators of the Octateuchs who were able to produce such luxurious manuscripts, with hundreds of pictures, had access to a rich library with a great variety of illustrated texts which provided them with models of all kinds.

In the creation scenes at the beginning of the Octateuch picture cycle we find a considerable number of details for which the Bible text could not have been the sole inspiration.

(1) GEOGRAPHY. Where Genesis 1:9–10 speaks of the creation of earth and water, the illustrator of Vat. 747 (fig. 29) depicts a map showing a basin of water whose form reflects—vaguely but nevertheless recognizably—the shape of the Mediterranean. The illustrator must have known geographical maps, which in all likelihood were based on maps in Claudius Ptolemy's *Geographica*.[21] The original map's character is still recognizable only in Vat. 747, while in the twelfth-century Octateuchs (figs. 30–32) this distinctiveness is lost. This would by no means be the only case where an ancient map was used in a Christian manu-

script. One also finds a map of the Mediterranean in the illustration of the *Christian Topography* of Kosmas Indikopleustes, as seen in the eleventh-century copy in the library of the Monastery of St. Catherine at Sinai, cod. 1186, fol. 66v (text fig. 7).[22] The maplike representation of the earth, framed by the ocean, is repeated in the next miniature, which illustrates Genesis 1:24–25, the creation of the quadrupeds. One will notice that in the midst of each arm of the ocean there is a medallion with the bust of a trumpet-blowing wind god. These are part of a Ptolemy map and also occur in the same position in the Sinai Kosmas—one more proof that both hark back to the same model.

(2) BOTANY. In the next two verses, Genesis 1:11–12, God creates plants and trees. The above-mentioned miniature showing the map also depicts plants on the earth, but they are of a rather generic nature. A more distinct rendering of trees of different shapes appears in the scene of Adam in the Garden of Eden (Gen 1:29–30, figs. 55–58). In the miniature of the Sinai Kosmas manuscript discussed above (text fig. 7), the trees of the Garden of Eden are depicted, apparently based on the same model, in a miniature attached to the map of the earth that does not represent the creation of plants but the Garden of Eden and, as a space-saving device, is turned ninety degrees.

For this miniature the illustrator quite likely had a dendrological treatise available from which he could copy individual trees. The most popular botanical treatise on which a medieval artist could rely was the first-century *De materia medica* of Dioskorides, the most frequently copied botanical text. Book 4 of this monumental compendium is entirely devoted to trees. This book is included among others in the tenth-century Dioskorides manuscript in the Morgan Library in New York, cod. M652.[23]

(3) ZOOLOGY. In Genesis 1:21 God creates all the creatures that live in the water as well as birds. Accordingly, the Octateuchs (figs. 37–39) illustrate fish and sea monsters in a lower zone and birds walking on the ground and flying through the air above.

[20] Weitzmann, *Ancient Book Ill.*

[21] Ibid., pp. 128ff., 156; see *Claudii Ptolomaei Geographiae Codex Urbinas Graecus 82*, ed. J. Fischer (Codices e Vaticanis Selecti 18), 2 vols. (Leiden and Leipzig, 1932).

[22] Weitzmann and Galavaris, *Sinai Greek Mss.*, p. 154, fig. 136, color pl. IXa.

[23] *Pedanii Dioscuridis Anazarbaei De Materia Medica Libri VII, Accedunt Nicandri et Eutecnii Opuscula Medica: Codex Constantinopolitanus Saeculo X . . . nunc inter Thesauros Pierpont Morgan Bibliothecae Asservatus*, 4 vols. (Paris, 1935); *Age of Spirituality*, pp. 207–8, no. 181. For botanical illustration in general, see Weitzmann, *Ancient Book Ill.*, pp. 11ff.

For both categories of animal the illustrators depicted creatures more specific than could be explained by the Bible text. Noticeable among the creatures in the water is the sea monster of the type known as a *ketos*. In his *Hexaemeron* Basil deals extensively with God's creations and describes the *ketos* in great detail. Basil's text was illustrated, as is demonstrated by the fair number of animal pictures accompanying quotations from Basil in the *Sacra Parallela* of John of Damascus as preserved in the ninth-century manuscript in Paris, Bibliothèque Nationale, cod. gr. 923. Variants of this fabulous sea creature are depicted in great detail no fewer than four times in this manuscript (text fig. 8).[24] In the next miniature in the Octateuchs, showing the creation of the quadrupeds (fig. 41), the *ketos* is repeated four times in the corners of the ocean surrounding the earth, precisely as often as it is depicted in the passage in Basil mentioned above. Yet an illustrated Basil manuscript could not have been the source of the Octateuch archetype because, as we have argued above, it reaches back into a period preceding Basil. However, many details in the *Sacra Parallela* miniatures from Basil's *Hexaemeron* cannot be explained by Basil's text, but only by the source on which Basil relied. This source, we feel quite certain, was the treatise *De natura animalium* of Aelian. Thus it seems more than likely that the painter of the Octateuch archetype and the first illustrator of Basil's *Hexaemeron* had a common source, namely, an illustrated Aelian manuscript. The *ketos*, of course, also existed in other illustrated treatises in the classical period, such as the *Physiologos*, which was very popular, and this may be considered as still another possible source for the Octateuch miniature.[25] Yet what speaks in favor of Aelian is that there the *ketos* was repeated four times, as it is in the Octateuch miniature.

This animal book, although popular in antiquity, may not have been the only source for the numerous types of fish in the Octateuch miniature. Another source, though this is only a possibility and not as cogent as Aelian, may have been Book 2 of Dioskorides' *De materia medica*, entitled "On living things," which contains several fish, each in a little pond. Since the Dioskorides manuscript was quite likely used as a source for the depictions of trees, as mentioned above, this popular compendium may also have been used for other creation scenes of the Octateuch. There were also cooking treatises with representations of a variety of fishes. The best-known of these books in antiquity was the *De re coquinaria* of Apicius, who lived in the time of Tiberius. Edward Brandt[26] has quoted a passage which makes it quite clear that this book contained illustrations. No illustrated copy survives, but reflections of it have been recognized in Roman floor mosaics in Malaga; these depict not only a variety of fish, but also cooking implements.[27]

One would correspondingly expect that the various birds illustrated in the upper part of Laurent. (fig. 3) were copied from specialized ornithological treatises. One such treatise is preserved, appended to the famous Anicia Juliana manuscript of Dioskorides in Vienna (Nationalbibliothek, cod. med. gr. 1), which lists a certain Dionysios of Philadelphia, who lived around the year 200, as author.[28] In this treatise each bird is carefully and correctly illustrated motionless and in profile. A close connection between the Octateuchs and the Vienna bird treatise is suggested by the similarities of the ostrich in Vtp., illustrating Leviticus 11:46–47 (fig. 842), with the picture on fol. 483v in the Vienna manuscript.[29] Yet this is not the typical type of bird in the Octateuch pictures, which depict birds either flying or standing on the ground in a distinctive manner. One finds the same characteristics, however, in the few bird pictures in the *Sacra Parallela* accompanying passages from Basil's *Hexaemeron*, once again taken from an illustrated Aelian manuscript. Thus we may surmise that the models for the Octateuch picture were also taken from an illustrated Basil, though it cannot be proved that this particular treatise was their ultimate source.

In Genesis 1:24, which relates the creation of cattle and living creatures of all kinds, meaning essentially the quadrupeds, the illustrator depicts very few quadrupeds on a piece of earth surrounded by an ocean, among them an ox (not standing as would be the case in a scientific treatise such as Dioskorides, but resting peacefully as in a bucolic miniature), a lion, an elephant, and a gazelle scratching its ear with its hind leg. This charming feature also occurs in the miniature depicting a gazelle under palm trees in the Sinai Kosmas, cod. 1186, fol. 146r (text fig. 9),[30] another demonstration that the Octateuchs and the Kosmas manuscripts relied on the same classical models. A considerable number of quadrupeds are also depicted in the scene of the Naming of the Animals, repeated in Genesis 1:29–30 (figs. 55–58) and Genesis 2:19–20 (figs. 79–82), with such fidelity that the first illustration of the Octateuch archetype must have relied on models such as zoological treatises that described each animal in great detail. There are two types of animal illustrations, although a sharp line cannot be drawn between them: one was scientific, such as Dioskorides and quite likely also Aelian, while the other emphasized fabulous animal stories like those described and depicted in the *Physiologos*. The Octateuch painters apparently preferred the scientific type of illustration found in Dioskorides or Aelian, although there is insufficient evidence as far as Aelian is concerned, since among the few passages taken over into Basil's *Hexaemeron* only an illustration of an ox exists.[31]

It almost comes as a surprise that in the final action of creation, the creation of men, the first illustrators of the Octateuch, who had made such ample use of scientific treatises such as Ptolemy's *Geography* as well as various botanical and zoological treatises, apparently did not use classical models like those used

[24] Weitzmann, *SP*, p. 207, fig. 551.

[25] Physiologos: Strzygowski, *Sm.*, p. 25, no. 21; Weitzmann, *Ancient Book Ill.*, p. 17, note 51.

[26] E. Brandt, "Untersuchungen zum römischen Kochbuch," *Philologus*, suppl. 19 (1929), p. 126; see also B. Flower and E. Alföldi, *The Roman Cookery Book: A Critical Translation of the Art of Cooking by Apicius* (London, 1958), p. 14.

[27] J. M. Blázquez, *Mosaicos romanos de Cordoba, Jaen y Malaga* (Madrid, 1981), no. 4, pp. 3–6, no. 55, pls. 62–66.

[28] Weitzmann, *Ancient Book Ill.*, pp. 16, 18 (with further bibliography).

[29] Reproduced in Weitzmann, *Ancient Book Ill.*, fig. 18, and in the facsimile edition: Dioscurides, *Codex Vindobonensis Med. Gr. 1 der Österreichischen Nationalbibliothek* (Graz, 1965), fol. 483v.

[30] Weitzmann and Galavaris, *Sinai Greek Mss.*, pp. 60–61, fig. 172.

[31] Weitzmann, *SP*, fig. 566.

by the illustrators of the Cotton Genesis, who relied on illustrations of the creation of man by Prometheus as models.[32]

(4) ASTRONOMY AND CALENDARS. The creation of the sun and moon, described in Genesis 1:16, is shown with the personified heads of Sol and Luna (figs. 33–36 and elsewhere) in the tradition of classical art. This is such a common feature, not only in classical art but also in Christian art, that there is no need to point to a specific astronomical treatise as the source of each example. A fundamentally different case is the Enoch miniature (figs. 115–118), where a representation of the twelve months is not specifically mentioned in the text but is justified by a tradition that considered Enoch to be an astronomer and the inventor of the calendar. The months are personified by busts holding appropriate attributes. Such personifications of the months occur primarily in calendar manuscripts. Though only one such manuscript, the Filocalus calendar of the year 354, has survived, and even that only in a Carolingian copy,[33] it no doubt reflects a type of illustrated manuscript that must have been quite popular in antiquity and later. In the Filocalus calendar each month is represented by a standing figure holding an appropriate attribute in his hand, just as in the Octateuch miniature, where they are reduced to busts as a space-saving device. Months in bust form also occur in ancient floor mosaics, and the Octateuch painter may have even seen this reduced form in his model.

Such personifications of the months, however, whether standing or in bust form, are merely reduced versions of representations of the labors of the months. In Genesis 8:20–22 (figs. 143–146) the four seasons are depicted next to Noah's sacrifice, in accordance with verse 22, in a fashion clearly dependent on an illustrated calendar. The scenes appear in an oval divided into four sections and are arranged clockwise following the course of the year, beginning at the upper left. As a comparison we may cite a miniature in a Byzantine calendar, a late Byzantine typikon manuscript dated 1346 in the Vatopedi Monastery on Mount Athos, cod. 1199. The manuscript, which contains miniatures of the twelve months, was published for the first time by Josef Strzygowski, with line drawings,[34] and more recently in the series Οἱ Θησαυροὶ τοῦ Ἁγίου Ὄρους.[35] The upper left quadrant of the oval in the Vat. 746 miniature (fig. 146) depicts a man leaning forward and holding a squarish object. In the corresponding miniature of the Vatopedi typikon illustrating the month of September (i.e., fall), on fol. 44v, a man stands in front of a plant and picks grapes which he collects in a basket (text fig. 10).[36] I believe that in the obviously abbreviated Octateuch miniature the man holds the basket of harvested grapes in his hands. The upper right quadrant of the Octateuch miniature depicts a man pruning a tree with a sickle. This corresponds to the miniature of

December (i.e., late fall) in the Vatopedi typikon, fol. 89v (text fig. 11),[37] which shows a very similar type of pruning figure. The third quadrant, at the lower right, shows a seated old man warming his bare legs at a fire, corresponding to the figure in the miniature in the Vatopedi typikon for the month of February (i.e., winter), fol. 134v (text fig. 12).[38] There was no space in the Octateuch picture for the man in front of him, apparently offering food. Finally, the fourth section contains a frontal standing youth holding up a bunch of flowers in his left hand, obviously an illustration of spring, which in the Vatopedi typikon (fol. 177v) is also rendered as a frontal standing youth, representing the month of May; but in this more sumptuous depiction he holds the flowers he has collected in a piece of cloth rather than just in a bunch held in his hand (text fig. 13).[39]

The Octateuch painters also used calendar pictures in other contexts. Genesis 9:20–21 relates that Noah planted a vineyard and got drunk; next to the wine-drinking Noah, the Octateuchs (figs. 151–154) have a wine-making scene with three youths standing in a vat and trampling the grapes. The biblical text does not call for the depiction of this occupation, which must have been copied from a calendar picture for the month of September, and from a richer model than that used for the season miniature discussed above. Scenes of vintage as a seasonal occupation occur, among other examples in classical art, in the season sarcophagus in the Dumbarton Oaks Collection in Washington, D.C., the so-called Barberini sarcophagus, where the wine-making scene is likewise based on a calendar picture.[40]

At the point where Genesis 4 describes Cain as a "tiller of the ground," without indicating in what manner the ground is tilled, the Octateuchs depict him behind an ox-drawn plow (figs. 103–106). For this particular motif the model was also apparently a calendar picture. In the previously mentioned typikon calendar of Vatopedi, the month of November (fol. 76v, text fig. 14)[41] is depicted as a man tilling the ground in precisely the same manner as in the Octateuchs; once more a calendar picture was the source of the Octateuch illustration.

(5) MEDICINE. The Octateuch painter also consulted an illustrated medical treatise for some, but not all, birth scenes. Rebekah, giving birth to Esau and Jacob (Gen 25:24–26), sits up high in a frontal position, while a midwife, who sits on the ground in Vat. 747 but on a chair in the other Octateuchs, removes Jacob from the womb (figs. 355–358); Esau already lies on the ground. A model for such a realistic rendering of a birth scene can be found in a thirteenth-century medical compendium in the National Library of Vienna, cod. 93, where a woman gives birth in precisely the same position (text fig. 15),[42] with four midwives attending the delivery. The reduced Octateuch scene shows

[32] Weitzmann and Kessler, *Cotton Gen.*, pp. 52–53, figs. 24, 25; Weitzmann, *RaC*, pp. 177ff., figs. 177–82.

[33] H. Stern, *Le Calendrier de 354: Étude sur son text et ses illustrations* (Paris, 1953); M. Salzman, *On Roman Time: The Codex-Calendar of 354 and the Rhythms of Urban Life in Late Antiquity* (Berkeley, 1990).

[34] Strzygowski, "Trapezunt. Bilderhandschrift," pp. 241–63.

[35] Θησαυροί, pp. 322–24, figs. 315–324, with all reproductions in color.

[36] Strzygowski, "Trapezunt. Bilderhandschrift," p. 247; Θησαυροί, fig. 313.

[37] Strzygowski, "Trapezunt. Bilderhandschrift," p. 250; Θησαυροί, fig. 316.

[38] Strzygowski, "Trapezunt. Bilderhandschrift," p. 250; Θησαυροί, fig. 318.

[39] Strzygowski, "Trapezunt. Bilderhandschrift," p. 255; Θησαυροί, fig. 321.

[40] Hanfmann, *Season Sarcophagus*, p. 38, no. 82; J. Weitzmann-Fiedler, "Some Observations on the Theme of the Milking Shepherd," in *Byzantine East, Latin West*, p. 105.

[41] Strzygowski, "Trapezunt. Bilderhandschrift," p. 249; Θησαυροί, fig. 315.

[42] *Medicina Antiqua: Libri Quattuor Medicinae, Codex Vindobonensis 93 der Österreichischen Nationalbibliothek* (Graz, 1972), fol. 102r, vol. 1, p. 69; and Grape-Albers, *Welt des Arztes*, p. 82, fig. 184. The parallel with the Octateuchs is discussed here, and the scene of Vat. gr. 747 is reproduced (fig. 189).

only one midwife, and Rebekah puts her hand on the midwife's head, a very realistic feature. This quite scientific birth scene was repeated in the Octateuchs for the depiction of Tamar giving birth to Pharez and Zarah (Gen 38:29–30, figs. 479–482). It should be pointed out that an adaptation from a medical treatise in a Bible manuscript is quite a common feature in ancient and medieval manuscript illumination. For instance, precisely the same type of birth scene used in the Octateuchs also occurs in the Ashburnham Pentateuch (Paris, Bibliothèque Nationale, cod. nouv. acq. lat. 2334, fol. 22v),[43] a seventh-century manuscript which belongs to a different recension. This scheme for birth scenes was not the only one used by the Octateuch painter. In other cases, as we shall see later (section 3 below), a scheme from New Testament illustration was adapted.

(6) Occupational Treatises. In Genesis 6:10–14, where the Lord orders Noah to build an ark and gives specific instructions on its measurements, a representation of the Lord and Noah (figs. 127–130) was all that was needed to depict the Bible passage. Yet all the Octateuchs show an additional scene (figs. 131–134) where the actual building of the ark is depicted in considerable detail, with carpenters at work on the ship. Representations of such an activity could be found in what must have been a handbook on carpentry, of which we see a reflection in a gold glass dated around 300 (text fig. 16).[44] The gold glass shows three scenes of carpenters working on ship planks on either side of the frontal standing shipbuilder Daedalus. That such scenes illustrating professional occupations existed in manuscripts is proved by the miniature of carpenters at work in the eleventh-century encyclopedia of Hrabanus Maurus in Montecassino, cod. 132.[45]

The illustrators of the Octateuchs, moreover, were not the only ones to make use of a specialized treatise on shipbuilding for the representation of the building of Noah's ark. In the fifth-century Cotton Genesis manuscript the miniature with the building of the ark showed more carpenters at work than does the Octateuch miniature,[46] as we know from the corresponding mosaic in San Marco in Venice. Moreover, in the San Marco mosaic the carpenters are of somewhat different types and are actually more closely related to those in the gold glass mentioned above than to the Octateuchs. The illustrators of the Cotton Genesis thus may have had another, though similar, model at their disposal.

While the Octateuch miniature shows a simpler rendering of the building of the ark, it is enriched by a scene depicting the dismantling of the ark (figs. 143–146), an event not mentioned in the Bible text. Moreover, the carpenters are working not on a casketlike ark as one would expect, but on a slender ship, a detail which proves that the scene was not invented to illustrate the Bible text, but was taken, as I suggest, from the same shipbuilding treatise as the scene of the building of the ark. The entire

miniature to which this scene belongs is composed like a triptych, with the main subject, the sacrifice of Noah, the only part based on the Bible text, forming the center, while the wings—the dismantling of the ark at the left and the representation of the seasons (see section 2 above) at the right—are subjects taken over from other sources.

(7) Hunting. At Genesis 25:29, where the Bible text describes Esau as a hunter, he is depicted in accordance with the text simply as a man shouldering a bow (figs. 359–362), which did not require the use of a specific model. However, the Octateuchs depict Nimrod, who is described as a mighty hunter in Genesis 10:9, in the act of shooting a stag with an arrow (figs. 160–163), an action not called for by the text. Here the painter depended on a model which was not difficult for him to find in the repertory of specialized treatises on hunting. In fact, the richly illustrated *Cynegetica* of pseudo-Oppian, dating from the period around 200, exists in an eleventh-century copy in Venice (Biblioteca Marciana, cod. gr. 479) which contains hunting scenes showing almost every animal that was hunted, including, of course, a stag (text fig. 17).[47] It is from a model of this kind that the Octateuch painter took his inspiration.

(8) Bucolic Literature. Bucolic imagery pervaded classical as well as Early Christian art on a large scale, and must have had its root in illustrated bucolic texts, although none has survived in its original context. Yet, where a classical text like pseudo-Oppian's *Cynegetica* depicts a shepherd, inscribed Βούκολος (text fig. 18),[48] the image is surely taken over from a bucolic treatise. He stands frontally with his legs crossed and leans on a staff, precisely the same pose as that of Abel (figs. 103–106), who is thus depicted as a bucolic shepherd next to the plowing Cain. I also attribute the figure of Cain to a classical model, specifically a calendar picture, although it must be admitted that he could also have been derived from another classical model, since this type of a man plowing with an ox-drawn plow occurs also in the *Cynegetica* manuscript in Venice.[49]

(9) Mythography. When the Octateuch painters wanted to draw on classical mythology for models, they had available such illustrated handbooks as that of pseudo-Nonnos, which exists in several copies attached to the homilies of Gregory of Nazianzos. I have suggested that this treatise was based on an older classical source, the *Bibliotheke* of Apollodorus.[50] To illustrate Numbers 33:52, where the destruction "of all their pictures and all their molten images" is mentioned, the Octateuch painters depict idols in the form of statues falling from a high column and a high pedestal (figs. 1038–1042). They employ the same formula of a nude statue on a tall column in illustrations of Deuteronomy 7:5, "you shall destroy their altars and burn their graven images" (figs. 1054–1058). This is precisely the manner in

[43] Gebhardt, *Ashburnham Pentateuch*, p. 15, pl. VIII; Grape-Albers, *Welt des Arztes*, p. 81, fig. 187.

[44] C. R. Morey, *The Gold-Glass Collection of the Vatican Library* (Vatican City, 1959), p. 23, cat. 96, pl. XVI; Grape-Albers, *Welt des Arztes*, p. 177, fig. 362; J. Weitzmann-Fiedler, "The Ivory of a Carpenter in the Art Museum, Princeton University," in *Ars Auro Prior: Studia Ioanni Białostocki Sextagenario Dicata* (Warsaw, 1981), p. 105, fig. 3.

[45] A. M. Amelli, *Miniature sacre e profane dell'anno 1023 illustranti l'enciclopedia medioevale di Rabano Mauro* (Montecassino, 1896), pl. XCV, lib.

XIV, cap. 25, De officinis; Grape-Albers, *Welt des Arztes*, p. 177, fig. 361.

[46] Weitzmann, "Genesis Mosaics," pp. 119ff., figs. 144–150; Weitzmann and Kessler, *Cotton Gen.*, p. 63, fig. 106.

[47] Weitzmann, *Ancient Book Ill.*, p. 16, figs. 31–33; Furlan, *Codici greci*, p. 23, fig. 6.

[48] Weitzmann, *Greek Mythology*, p. 116, fig. 132, pp. 78 and passim; Furlan, *Codici greci*, p. 35, fig. 34b.

[49] Furlan, *Codici greci*, p. 38, fig. 38.

[50] Weitzmann, *Greek Mythology*, pp. 78, 81f., 85, 194f.

which statues of gods were placed on columns in classical antiquity, as can be seen in numerous miniatures in the pseudo-Nonnos text (text fig. 19).[51] It must therefore have been from such a model, whether it was a pseudo-Nonnos manuscript, the *Bibliotheke* of Apollodorus, or some similar handbook of Greek mythology, that the Octateuch painters drew their inspiration. Another striking example is the depiction of the chimera, which in Laurent. is included in the scene of the Naming of the Animals (fig. 5). In classical art this monster is frequently depicted being killed by Bellerophon. In the manuscript tradition we can once again point to the representations in several pseudo-Nonnos texts,[52] which, like the other mythological representation mentioned above, I believe, go back to an illustrated *Bibliotheke* of Apollodorus.

In another kind of adaptation of scenes from classical mythology the artist did not use an ancient motif in its original meaning, but merely copied a compositional scheme of classical art and adapted it to a biblical scene. This can be demonstrated by two examples. In the illustration of Judges 14:5–6, Samson kills the lion by strangling it, pressing the lion's neck under his armpit (fig. 1493). This is precisely the manner in which Herakles killed the Nemean lion, which is explicitly described by Diodorus Siculus IV.2.3–4 and can be seen in a drawing in a third-century papyrus from Oxyrhynchos (text fig. 20).[53] There can thus be no doubt that here the Octateuch painter was inspired by a scene of Herakles killing the Nemean lion.

The second example of the adaptation of a classical model is the specific rendering of Isaac's sacrifice. In the Octateuch miniatures (figs. 315–318) we see Abraham trying to kill Isaac, who kneels in front of the altar. This is in obvious disagreement with the Bible text (Gen 22:9–13), according to which Isaac should be shown quite submissive upon the altar, just as he is represented in an encaustic painting on marble of about the seventh century in the apse of the church at Mount Sinai.[54] The deviation of the Octateuch painter from the Bible text can be explained most readily as an adaptation of the compositional scheme from a scene of classical mythology, specifically, the attempted murder of the boy Orestes by Telephos, which is represented in very much the same manner on an Etruscan urn in Florence (text fig. 21).[55] The two schemes agree not only compositionally but also in their meaning: the killing of both Isaac and the boy Orestes was prevented and the victim saved. The Telephos scene is based on the Euripidean drama *Telephos*. One should not be surprised to find an illustrated Euripides manuscript among the sources of the Octateuch painters. The *Cynegetica* manuscript in Venice discussed above contains quite a number of illustrations from Euripidean dramas such as *Aegeus*, *Peliades*, and others. Further-

more, in tenth-century ivories one finds representations from *Iphigenia at Aulis* and other dramas of Euripides.[56]

(10) PERSONIFICATIONS. A special category of Octateuch illustrations with classical sources is personifications, which are not tied to specific scenes but are rather attached to many different subjects. In the vast Octateuch miniature cycle there are long stretches where no personifications occur, but where they do appear they are quite numerous. The influence of two of the great masterpieces of the Macedonian Renaissance from the middle of the tenth century can explain practically all of these personifications.[57] One of these is the Vatican Joshua Rotulus, which is incorporated in the present volume. In a study devoted to the Rotulus I dealt with the problem of the inserted personifications and traced their classical models, and there is no need to repeat that detailed description.[58] What interests us here is the fact that in the Octateuchs personifications are restricted to the first half of the Book of Joshua, in other words, to that part covered by the Rotulus, which never contained the entire Book of Joshua. In the Octateuchs—and this is significant—no personifications appear in the miniatures illustrating the second half of the Book of Joshua.

The second masterpiece that had an impact on the Octateuch miniatures is, as mentioned above, the well-known Paris Psalter (Bibliothèque Nationale, cod. gr. 139), which is almost crowded with personifications, for which I attempted to determine the classical models in an early study.[59] The Paris Psalter miniature depicting the Egyptians drowning in the Red Sea (Ex 14:27–28, text fig. 22) is replete with no fewer than four personifications: the bust of Nyx (Night) with a veil over her head in the upper left corner, Eremos (Desert) seated on the ground below, Bythos (Depth) pulling Pharaoh down from the chariot, and Erythra Thalassa (the Red Sea) shouldering a rudder at the lower right. Every one of these four personifications is represented in the corresponding miniature of Ser., Sm., and Vat. 746 (figs. 705–707) and in the same place. In spite of the slight variations of pose and gesture, the Octateuch painters undoubtedly used the Paris Psalter miniature as a model. What is significant is that every miniature in the Psalter has one or several personifications, while they are an exception in the Octateuchs, where the rest of the Book of Exodus is barren of personifications.

There is yet another case in which the influence of the Paris Psalter on an Octateuch miniature can be demonstrated. Where Genesis 1:3–5 relates the separation of light from darkness (figs. 21–24), the Octateuch painters depicted Night as the personification Nyx, a woman with a veil over her head standing in front of a dark background. But for Day (Hemera), they did not depict a female figure as one would expect, but a boy holding a

[51] Ibid., p. 65, fig. 77.

[52] Ibid., p. 25, figs. 23–25.

[53] K. Weitzmann, "Papyrus Oxyrh. 2231: Verses on the Labours of Herakles," in *The Oxyrhynchus Papyri*, pt. 22 (London, 1954), p. 85, no. 233, pl. XI; Weitzmann, "Survival," p. 58, figs. 25, 26 (repr. in Weitzmann, *Classical Heritage*); *Age of Spirituality*, pp. 228–29, no. 205.

[54] G. Forsyth and K. Weitzmann, *The Monastery of Saint Catherine at Mount Sinai: The Church and Fortress of Justinian* (Ann Arbor, Mich., 1973), pp. 16–17, pl. 130.

[55] Museo archeologico, inv. 5747/73; Weitzmann, "Survival," p. 59,

fig. 28 (reproduced from H. von Brünn and G. Körte, *I rilievi delle urne etrusche*, vol. 1 [Rome, 1870], pl. 28:6); see now F.-H. Pairault, *Recherches sur quelques séries d'urnes de Volterra à répresentations mythologiques* (Rome, 1972), pp. 247–48, pl. 133b.

[56] K. Weitzmann, "Euripides Scenes in Byzantine Art," *Hesperia* 18 (1949), pp. 159–210.

[57] Weitzmann, "Character," pp. 176ff.

[58] Weitzmann, *JR*, pp. 64ff.

[59] Weitzmann, "Pariser Psalter," pp. 178ff. (repr. with annotations in Weitzmann, *Psalters and Gospels*).

torch. According to the iconographic tradition of classical art, he represents Dawn (Orthros), and he appears similarly in a miniature in the Paris Psalter (text fig. 23). In this miniature the figure of Orthros is a literal illustration of Isaiah 26:9: "With my soul have I desired thee in the night; yea, with my spirit within me will I seek thee early." So the two personifications Nyx and Orthros were created for the Isaiah picture and were taken over by the Octateuch painter into the creation picture, where the figure of Dawn does not quite fit the Bible text, which requires the personification of Day. The Paris Psalter must have already been a famous manuscript in its time, and its pictures were often copied literally or adapted. Thus, we find the Isaiah between Nyx and Orthros copied precisely in the prophet book Vat. gr. 755[60] and adapted in the Smyrna *Physiologos* in the miniature of the nycticorax.[61]

One can only speculate when and under what circumstances the various elements from classical sources were taken over into the Octateuch cycle. Some may already have entered the archetype, but this must remain hypothetical. The only fixed point is the adaptations from the Paris Psalter of the middle of the tenth century. This suggests a long, drawn-out process, so that theoretically the classical elements could have entered the Octateuch picture cycle at any time between its origin and the extant copies of the Octateuch.

While the impact of the Macedonian Renaissance is seen most clearly in the adaptation of personifications and of figure types from classical mythology for biblical figures, it may be pointed out in passing that the impact of classical models also appears in the landscapes of the backgrounds. These are not confined to the section which shows the impact of the Joshua Rotulus, but also occur in some scenes of the Book of Genesis.

It must be emphasized that the use of so many sources from very different types of manuscripts is not exceptional: it was a common practice to take miniatures over from one text into another, a practice that was employed chiefly in luxurious manuscripts produced in the leading scriptoria of capital cities, where the illustrators must have had easy access to rich libraries that had many illustrated books among their treasures. Few miniatures of the rich cycle of the marginal Psalters, such as the Khludov Psalter in Moscow, for example, actually illustrate Psalter passages literally: the majority are scenes taken over from various books of the Old and New Testaments and from other sources such as the Lives of Saints, Kosmas Indikopleustes, the *Physiologos*, and others. Another example is the well-known Gregory of Nazianzos manuscript in Paris, Bibliothèque Nationale, cod. gr. 510, where the artists were quite capable of inventing scenes like those illustrating episodes from the life of St. Basil. When painting scenes for which models were available, however, they often simply copied them, and the number of what we have called "migrated miniatures" outweighs those invented specifically for the text. Among the migrated miniatures are not only those from the Old and New Testaments and the Lives of Saints, but even scenes from historical chronicles such as those of Theodoret, Sozomenos, and Malalas.[62] Both manuscripts, the Khludov Psalter and the Paris Gregory, are apparently the products of leading Constantinopolitan scriptoria.

3. CHRISTIAN SOURCES

The Octateuch painters adapted Christian elements far less frequently than classical ones. These are essentially of three types. In the first type a complete iconographic and compositional scheme is adapted. Where Exodus 2:2 mentions that the daughter of Levi conceived and bore a son (without giving his name, although Moses is meant), for example, the twelfth-century Octateuchs depict an elaborate birth scene (figs. 596–598), with the woman lying on a couch and attended by two midwives serving her food and a third washing the newborn child. This elaborate composition was not invented for this Exodus passage but was taken over from a representation of the birth of the Virgin. A good example of this scene, which agrees in all details with the Octateuch picture, can be seen in the Menologion of Basil II, now in the Vatican Library, cod. gr. 1613 (text fig. 24),[63] where it illustrates the Virgin's birthday, September 8. It is significant that Vat. 747 does not contain this birth scene, but has an illustration of the preceding passage, Exodus 1:15–16, in which Pharaoh gives the order to the Hebrew midwives to kill all Jewish male offspring (fig. 595). The archetype quite likely had both scenes, and the christological type of birth scene replaced the older realistic type found in medical treatises (text fig. 15). We have no way of knowing when this

substitution occurred, but I suspect that it was in the Middle Byzantine period, perhaps at about the same time the borrowings from the Paris Psalter were made (see section 2 above and text figs. 22 and 23).

A second very similar case is the representation of the birth of Samson (figs. 1491, 1492) illustrating Judges 13:24: "Then the woman gave birth to a son and named him Samson; and the child grew up and the Lord blessed him." The twelfth-century Octateuchs again depict an adaptation of a Christian birth scheme of the later Byzantine period, with the woman in bed and two midwives bringing food, but instead of being washed the newborn child lies in a cradle. As mentioned above, Vat. 747, however, represents not the birth of Samson, but the second half of the verse (fig. 1490), and shows the grown-up Samson standing between his parents. As in the case of the birth of Moses, the richer archetype may well have had both scenes: the birth scene of the older type that was replaced by a Christian type, and the scene of the bringing up of Samson.

A third case in which the Christian birth formula was adapted is the birth of Isaac (Gen 21:2), though it is depicted in a slightly reduced form, omitting the midwives who serve food, but in-

[60] Vat. gr. 755, fol. 107r; Lowden, *Prophet Books*, fig. 35.
[61] Evangelical School, cod. B. 8, fol. 4v; Strzygowski, *Sm.*, p. 14.

[62] Weitzmann, "Chronicles," pp. 87–134.
[63] *Menologio*, pl. p. 22.

cluding the bathing of the child (figs. 289–291). It is noteworthy that in this case alone the otherwise conservative illustration of Vat. 747 adapts the Christian scheme. It should be pointed out that the elaborate Christianized birth schema is applied only to the great Old Testament heroes Isaac, Moses, and Samson, and that the old-fashioned schema with the birth-chair is employed for the birth of figures of lesser importance.

In the second type of Christianization, a Christian detail is introduced in a miniature. One example occurs in the representations of God. As a rule, in the Octateuchs God is depicted as a hand reaching out of a segment of sky. In this respect the Octateuchs are in agreement with the Jewish tradition known through the Dura synagogue paintings. There are a few exceptions, however, where the Octateuch painters replaced the hand with a bust of Christ. In the illustration of Genesis 17:4–5 (figs. 250–252), where God makes Abraham a father of many nations, the twelfth-century Octateuch painters depicted Abraham and Sarah facing each other and raising their hands toward a bust of Christ in heaven at the center of the composition. This scheme reflects a monumental composition like that of the two sixth-century apse mosaics in the basilica of Euphrasius in Poreč (Parenzo) (text fig. 25),[64] in which a centered bust of Christ in heaven stretches out his arms with a gesture of speech directed toward the two protagonists. It should be noted that Vat. 747 (fig. 249) illustrates verses 3–16 or 17–21, where Abraham falls on his face. As in the previous cases, the image in Vat. 747 may well preserve the archetypal scene, while the others could be replacements.

In a second example, where God blesses Isaac (Gen 26:24), a bust of Christ leans forward out of a segment of sky to bless Isaac, who stands before him and almost spontaneously touches his head (figs. 367–370). Here one hardly needs to look for a model, and it is very possible that in this case the Octateuch painter created the close contact between the two figures.

A very common feature of Christianized Old Testament scenes, one which is not confined to the Octateuchs or to miniature painting in general, occurs in the depiction of the central angel in the Hospitality of Abraham (figs. 261–264) with a cross nimbus, suggesting a figure of Christ.

Where Pharaoh orders the chief of the bakers to be hanged (Gen 40:22), all the Octateuch miniatures (figs. 499–502) depict him not hanged, but crucified in the same manner as Christ. This, of course, does not imply the identification of the chief of the bakers with Christ, but perhaps with one of the two thieves, or it may be only the adaptation of a common type of execution.

Another example of Christianization is the decoration of the front of the reliquary shrinelike tabernacle with a Deesis representation (see section 1 above).

The third element of Christianization has to do with architectural setting. In Exodus 28:43, where Aaron is asked to approach the altar to minister in the holy place, the Octateuch painters represent the altar under a ciborium and with a chancel railing with a royal door in front of it (figs. 774–777); to the right they depict a presbyter bench with several steps. This setting is precisely that of the apse of a Christian church, as seen, for example, in the miniature of the Presentation of the Virgin in the Temple in the Menologion of Basil II (text fig. 26).[65] In another miniature of the Menologion of Basil II, this one depicting the feast of the chains of St. Peter,[66] the architectural setting is more precise and is even closer to the Octateuch scenes, but nevertheless I believe that the model used by the Octateuch painters was a scene of the Presentation of the Virgin in the Temple, not only because it is a much more familiar scene, but because the Octateuch painters had already used another scene of the Virgin cycle, her birth, as a model.

The same explicit setting of a church apse occurs a second time in a scene illustrating Leviticus 13:38–39 (figs. 843–848), where Aaron faces an altar with an altar cloth beneath a ciborium which is visible through the opened royal doors; once again one sees a high-stepped presbyter bench at the right. There are quite a number of representations of the Christian altar table under a ciborium and there is no need to enumerate them here. Suffice it to mention the instances (figs. 815–818) where the altar cloth is marked by a very pronounced cross decoration. Furthermore, it may be pointed out that the ciborium occurs in different forms, some with a small cupola on a cubic base (figs. 819–821), others with a small pyramid atop a cubic base (figs. 870–874). It is not likely that the illuminators were inspired by actual architecture, but, as in all preceding cases, depended on a manuscript tradition. In fact, a group of tenth-century Constantinopolitan Gospel books—one of the outstanding examples being Paris, Bibliothèque Nationale, cod. gr. 70—shows at the front of each Gospel a golden ciborium (text figs. 27a–27c), each of a different form and with precisely the same variants as the Octateuch ciboria.[67] This Gospel book has evangelist pictures that are closely related in style to the Paris Psalter, indicating that here again the Octateuch painters drew the various forms of the ciborium from a model from the Macedonian Renaissance.

4. IMPERIAL SOURCES

In any iconographic transmission the stable factor is the compositional layout, the placement of the figures and their relation to each other, while the changeable elements are their dress and to some extent their attributes.[68] This point can be demonstrated in the Octateuch illustrations with the figures of Pharaoh and Joseph. In Vat. 747, where Pharaoh addresses the midwives

[64] M. Gautier-van Berchem and E. Clouzot, *Mosaïques chrétiennes du IVme au Xme siècle* (Geneva, 1924), p. 181, figs. 231, 232; M. Prelog, *The Basilica of Euphrasius in Poreč* (Monumenta Artis Croatiae, 4) (Zagreb, 1986), p. 22, pls. 15, 16.

[65] *Menologio*, pl. p. 198.

[66] Ibid., pl. p. 324.

[67] Weitzmann, *Byzantin. Buchmalerei*, p. 14, pl. XII, figs. 79–82.

[68] See Weitzmann, *RaC*, pp. 157–60, on the influence of fashion on the process of copying.

(fig. 595), he is dressed like a Byzantine emperor in the imperial chlamys with tablion and wears a pearl diadem. Although the miniature is damaged, there can be no doubt about the pearl diadem, since it occurs in every scene where Pharaoh is represented, as, e.g., in the scene depicting Moses and Aaron asking Pharaoh to let the Israelites go (Ex 5:1–5; figs. 628–631). In this last scene he is flanked by bodyguards and sits under a baldachin, following a convention of the Byzantine period so common that no parallel need be cited. But since the imperial regalia, including the pearl diadem, originated only in the Constantinian era and the archetype of the Octateuchs reaches back at least as far as the third century, the date of the Dura synagogue paintings, the image of the emperor with a pearl diadem could not have existed in the archetype. At Dura, Pharaoh appears in the same scene dressed in an oriental costume with Persian trousers. In all probability this does not represent the archetype either, but rather an adjustment to the taste of the Mesopotamian painters.[69] What Pharaoh looked like in the archetype can only be surmised. He was most likely rendered in Graeco-Roman dress as a Roman emperor of the pre-Constantinian period.

This imperialization affects not only the figure of Pharaoh, but also Pharaoh's daughter. In the scene where she sees the ark in the Nile, as well as in the subsequent scene where she presents the boy Moses to Pharaoh (figs. 600–602), she too wears a pearl crown and imperial robes. We have previously pointed out (see section 1 above) that the first of these two scenes also occurs in the Exodus picture of the San Paolo Bible (text fig. 5) and that this miniature is based on a Byzantine Octateuch of our recension.[70] In the Carolingian miniature Pharaoh's daughter is not rendered in imperial garments but wears a simple long robe and a veil over her head; this most likely reflects the archetype. We cannot, of course, guess the date of the Octateuch model used by the Carolingian painters, so we do not know when the imperialization of the Octateuch images took place. It must be mentioned that in the Carolingian miniature under discussion Pharaoh, who occupies a dominant place in the center of the composition,

is dressed like an emperor in a chlamys and wears a simple diadem. But this figure is a special case, since we are dealing here with a portrait of the emperor Charles the Bald in the guise of Pharaoh. Therefore it cannot be concluded that the Octateuch already had a crowned Pharaoh at that date.

Another figure to be imperialized is Joseph after he is made ruler in Egypt (Gen 41:40). This is especially pronounced in Vat. 747, where the scene of Jacob blessing Ephraim and Manasseh (fig. 564) shows Joseph wearing a pearl diadem and the imperial chlamys with tablion. In the very similar composition in Dura, Joseph is depicted in Persian trousers and a rather simple tunic of the type also worn by Ephraim and Manasseh.[71] Surely such imperial elements in the Octateuch miniatures were not in the archetype, nor in all likelihood does the Dura painters' orientalized versions of these garments reflect the archetype. As in the case of Pharaoh, it is likely that Joseph was depicted in dress conforming with the Graeco-Roman tradition. It is worth noting that in the twelfth-century Octateuchs Joseph is clad in a short tunic and chlamys (figs. 565–567), and thus looks less imperial than he does in Vat. 747. Furthermore, Ephraim and Mannasseh do not wear imperial dress at all, as they do in Vat. 747, but simple short tunics. In these respects the twelfth-century Octateuchs apparently reflect the archetype more closely, and one begins to realize that these changes in the Octateuchs took place in the Middle Byzantine period. Thus it appears that the imperialization reflects a rather late phase in the history of the Octateuch illustration.

An example of an imperial compositional scheme that was adapted for purely formal reasons can be seen in the miniature showing Pharaoh on a quadriga in frontal pose in pursuit of the Israelites (figs. 696–699). This is the composition used in classical art for the apotheosis of a ruler, a scheme ultimately derived from that of Helios on his quadriga. Obviously the illustrator did not have the apotheosis of Pharaoh in mind, but adopted the motif solely for artistic reasons.

5. JEWISH ELEMENTS

The Jewish elements form a category by themselves because we are dealing here with biblical scenes based on versions different from the Septuagint. Such reinterpretations of the Septuagint text turn out to be so numerous that not all of them can be mentioned in this chapter. So I will confine myself to pointing out a few examples and leave it to Massimo Bernabò to deal more thoroughly with this subject in his discussion of the formation of the cycle (see chapter 3, section 7).

One particularly striking example of an image based on an extrabiblical source, which I believe to be a Jewish writing, is the scene of the temptation of Eve by the serpent which has mounted a camel (figs. 83–86).[72] This distinctive feature is described in the Pirḳê de Rabbi Eliezer, a medieval text surely

based on an older tradition. Two more examples occur in the story of Cain and Abel. In the scene of the sacrifice (figs. 103–106) God sends down a column of fire from heaven to consume Abel's sacrifice, a feature which is not mentioned in the Bible, but which occurs in haggadic writings.[73] The scene following that of the sacrifice, in which Cain kills Abel, must be derived from the same Jewish source. The biblical text simply says that Cain "slew" Abel but it does not say how. In the Octateuch miniatures Cain pelts Abel with stones, another feature taken directly from haggadic writing.[74]

In another case we can point out a miniature that is not a substitute for a biblical scene but the depiction of an event not grounded in the Bible text at all: the scene of Pharaoh's daughter

[69] Weitzmann, *Dura*, p. 28, figs. 29, 31.

[70] Ibid., p. 29, fig. 34.

[71] Ibid., p. 21, figs. 18, 19.

[72] Weitzmann, "Jewish Sources," p. 82, fig. 56.

[73] Ibid., p. 83, fig. 62.

[74] Ibid.

leading the boy Moses to her father, who receives him with open arms (figs. 600–602).[75] The story of the child Moses being brought to Pharaoh by his daughter Thermuthis is told by Flavius Josephus in his *Jewish Antiquities*, and the Octateuch miniatures can be explained only by Josephus's text, even though their details do not follow it closely. A depiction of this story in a form more closely related to Josephus's narrative occurs in a cycle of Moses scenes framing an icon at Mount Sinai depicting Moses receiving the Tablets of the Law (text fig. 28).[76] On the Sinai icon the episode is elaborated in two successive scenes: in the first Moses sits in the lap of Pharaoh, as related in Josephus, but instead of snatching the crown from Pharaoh's head he pulls Pharaoh's beard; in the second scene Pharaoh's daughter leads the child Moses toward Pharaoh. The Octateuch miniatures contract these two compositions into one and place the child Moses in the center running toward Pharaoh. This compositional scheme is clearly derived from the New Testament scene of the Presentation of the Virgin in the Temple as seen in the miniature of the Menologion of Basil II (text fig. 26). It is hardly surprising to see a New Testament compositional scheme used for this Moses scene, since in the preceding miniature of Moses' birth a New Testament scheme was clearly used. That illustrated copies of

Josephus's *Jewish Antiquities* and *Jewish Wars* existed can be proved by the *Sacra Parallela* in Paris, Bibliothèque Nationale, cod. gr. 923, where scenes from both texts accompany text excerpts from Josephus.[77]

Not only biblical narrative scenes, but also details of temple implements such as the menorah, the form of the Ark of the Covenant, and the priestly vestments (figs. 758–761, 750–753, 770, 807–811) are rooted in the Jewish tradition, as can be seen by comparing them with depictions of the same objects in the Dura synagogue.[78]

Narrative scenes such as those mentioned above—like all narrative scenes wherever they are found—were made explicitly for their texts and are best explained by them. In my opinion this means that not only scenes like those drawn from the text of Josephus, for which we have proof, but also those based on the Pirkê de Rabbi Eliezer (or rather the older model on which the Pirkê is based) had illustrations, and that such miniatures migrated from these sources into the Septuagint text. But whatever the channels through which the illustrations based on Jewish legends reached the Octateuch painters, one gets the impression that the texts containing illustrations of Jewish legends must have been numerous and widespread.

6. CONCLUSION

Our analysis of the Octateuch miniatures has showed that the first illustrated archetype had more scenes than the medieval copies, and that many of its images were more elaborate and were reduced to fit the narrower columns of the catenae texts. Such an ambitious project, involving hundreds and hundreds of pictures, can only have been undertaken in one of the leading scriptoria of a capital city. For the reasons stated above we assume that this capital was Antioch. Here there must have been a scriptorium with a group of highly trained miniature-painters with access to many illustrated books, including a variety of illustrated classical as well as Jewish texts. The latter I presume to have been largely Jewish texts written in Greek, such as the Septuagint itself. One such text was quite assuredly the *Jewish Antiquities* of Flavius Josephus. Moreover, I believe that there were illustrated extrabiblical texts written in Greek whose miniatures migrated into the Septuagint cycles. In an inspiring study, Carl Kraeling showed how in the second and third centuries Jews and Christians not only lived together harmoniously but had close personal contact.[79] The illustrated Septuagint could have originated in such an environment and could have been used equally by the Christians and by the hellenized Jews of the period.

Having distinguished several groups of pictorial elements which enriched the illustrated archetype, we must deal with the

question of when they were adapted and integrated. I have repeatedly pointed out the close connection between the Dura synagogue paintings and the miniatures of the Octateuchs, and, assuming a common archetype, it seems more than likely that the elements from Jewish legends found in both existed in the illustrated archetype of the Octateuchs and were conceived as an integral part of it.

The classical elements, however, do not form a unified group. Some of them, like the adaptation of a classical model for the scene of the Sacrifice of Isaac, may well have been employed by the painters of the archetype, while some of the personifications, such as those in the depiction of the Egyptians Drowned in the Red Sea and the Separation of Light from Darkness, were surely added under the influence of the Paris Psalter, i.e., not before the tenth century. In other words, classical elements could have been adapted at any time between the creation of the illustrated archetype and the existing copies.

The Christian elements could likewise have been adapted at various times, though quite likely not as early as the illustrated archetype. For the bust of Christ in heaven we pointed out the parallel of the sixth-century mosaic in Poreč, while the birth scenes taking over the scheme of the Birth of the Virgin or of Christ were surely based on Middle Byzantine miniatures. Thus

[75] Ibid., p. 83, fig. 63.

[76] Weitzmann, "Study," p. 24, figs. 20, 21a, 21b. [A more detailed discussion of the Moses scenes on this Sinai icon may be found in Mouriki, "Moses Cycle," esp. pp. 532–33, who asserts that the second scene represents the trial of Moses with the burning coal, and that the glowing coal itself is visible.]

[77] Weitzmann, *SP*, pp. 36–37 and passim.

[78] Weitzmann, *Dura*, pp. 55ff., figs. 85, 87, 88, 90.

[79] C. H. Kraeling, *The Jewish Community at Antioch* (New Haven, 1932).

we see that the Christian elements entered the illustrated Octateuch at various times. Though they were quite surely not in the archetype, produced when Jewish impact was strong, they could have been integrated at almost any time thereafter.

Finally, the imperial elements were also certainly not in the illustrated archetype. It is likely that they were adapted when the imperial scriptorium of Constantinople began to produce luxurious manuscripts on a large scale. Although it cannot be proved, it is likely that this was in the time of Justinian, when, as we know, luxurious manuscripts were widely produced. Among the products of this time are the famous Dioskorides manuscript in Vienna and the model of the set of Bible miniatures known as the Niketas Bible, known to us through splendid tenth-century copies with miniatures that still betray their models of the Justinianic period.

One comes to realize that the copying of the illustrated Octateuchs underwent a morphological process, and that in each copy some changes were made. Over the course of the centuries the changes accumulated so considerably that it becomes impossible to get a clear picture of the archetype. One can perceive it only at a distance, as if through a veil.

7. ADDENDUM: THE CASE OF THE JOSHUA ROTULUS

Finally, a few remarks must be made concerning the inclusion of the Joshua Rotulus in a volume devoted to the Octateuchs. To begin with, the Joshua Rotulus was never a part of an Octateuch in the form of a scroll, as some scholars have assumed. It was not even a part of a complete Book of Joshua and never contained more than about half of it (chapters 1 to 12, to be precise). The original extent of the Rotulus can be determined by its impact on the Octateuchs, especially Vtp. Thus, six scenes are missing at the beginning of the Joshua Rotulus plus perhaps the last two scenes of Deuteronomy illustrating Moses at Mount Nebo, looking before his death into the Promised Land which Joshua is about to conquer. At the end, the last scenes of the conquest are lost. With the beginning of chapter 13 the panoramic landscape, perhaps the most outstanding and characteristic feature of the Joshua Rotulus, suddenly stops and the simple narrative illustrations confine themselves to the essential figures set before a plain background. The panoramic landscape also occurs in the Octateuchs in the scenes of chapters 1 to 12 of the Book of Joshua, and particularly clearly in the miniatures of Vtp., whose painter obviously used the Vatican Rotulus as a model. It is clear that the illustrator of the Joshua Rotulus had a clearly defined program confining him to the episodes dealing with the conquest of the Promised Land halfway through the Book of Joshua, and that he had no interest in the scenes of the distribution of the country and the events which followed it.[80]

In some iconographic details the Joshua Rotulus shows the influence of the triumphal columns in Rome and Constantinople. In my study of the Rotulus I attempted to demonstrate that certain features of the ancient columns, e.g., the Arcadius column in Constantinople, had been adapted for iconographic purposes to elaborate the triumphal idea.[81] This undeniable relation between the ancient columns and the Joshua Rotulus led Wickhoff, in his well-known book on the Vienna Genesis, to claim that the Rotulus was actually a copy of a model from the classical period in the form of a scroll, and that Old Testament illustration existed in the Early Christian period as rolls with friezes in what he called the *continuous method*. In my opinion, however, there is a basic difference between the friezes of the triumphal columns and that of the Joshua Rotulus. On a column there is a continuous flow of actions over long stretches with very few interruptions, while in the Joshua Rotulus the episodes are clearly separated units that agree with the episodes of the miniatures in the Octateuchs. Thus it is clear that the scenes in the Rotulus are, so to speak, lifted from an Octateuch model. The scenes are enlarged but are still narrow enough to fit a writing column above a much reduced text. Continuity is achieved through the addition of a panoramic landscape taken from classical landscape paintings like those seen in Pompeian wall paintings, inserted, as already mentioned, by the Rotulus painter and then copied from the Rotulus into the twelfth- and thirteenth-century Octateuchs, especially Vtp.

Yet the panoramic landscape is not the only inserted element in the Joshua Rotulus. These additions, consisting of trees, slopes, cubes and altars, the tower of the sacred grove, the city and the rustic villa, and, last but not least, a series of personifications, are described in detail in my study of the Rotulus.[82] All these additions are derived from models of the classical period and are typical of what has become known as the Macedonian Renaissance.[83] Such classical elements also appear in other contemporary manuscripts, such as the Paris Psalter, which, as we have seen (see section 2 above), was also used by the Octateuch painters as the model for the scene of the Separation of Light from Darkness (figs. 21–24), and even more explicitly in the depiction of the Egyptians Drown (figs. 704–707), from which a whole accumulation of personifications was copied very literally.

Considering that the Joshua Rotulus is an excerpt from an earlier Octateuch, what did this Octateuch look like? I have repeatedly pointed out that many scenes in all the preserved Octateuchs appear to be condensed, and that earlier Octateuchs without catenae could have allotted more space in a wider column for the miniatures. Pertinent examples include Jacob's Dream (figs. 391–394) compared with a miniature in the Paris Gregory, cod. gr. 510 (text fig. 6), and the infancy of Moses (figs. 600–602) compared with a miniature in the San Paolo Bible (text fig. 5). There are also indications that the Octateuch model of the Joshua Rotulus had wider miniatures than those in the pre-

[80] Weitzmann, *JR*, chap. 6, "The Original Extent of the Joshua Rotulus," pp. 89ff.

[81] Ibid., chap. 7, "The Triumphal Idea in the Joshua Roll," pp. 100ff.

[82] Ibid., chap. 4, "The Problem of the Continuous Frieze and the Inserted Motifs," pp. 51ff.

[83] Weitzmann, "Character," note 100.

served manuscripts. To cite an example, in one Joshua Rotulus illustration (fig. 1197) Joshua sends out two messengers who then are repeated on the march. This obviously reflects the archetype of the Octateuch, on which the roll is based. In later extant Octateuchs, however, the two actions are fused to save space, forming a single solid group of four figures (figs. 1199, 1201–1203). This example may suffice, but when one looks at the Joshua Rotulus from this point of view, one can easily find other examples of greater spaciousness in the Rotulus than in the Octateuch miniatures.

If, then, the Rotulus is an ad hoc creation of the tenth-century Macedonian Renaissance based on an Octateuch in which the illustrations of the Book of Joshua essentially did not differ from those of the other books of the Octateuch, where did the artist of the Vatican Rotulus find his inspiration for an illustrated scroll? There are no parallels anywhere in the Greek or Latin tradition, and to all appearances the Vatican scroll is a hapax in Mediterranean book illustration of the period. Still, there are no creations *ex nihilo*!

The country in which the method of illustrating scrolls was very frequent and widespread is China, particularly as demonstrated by sacred texts of the Tang period. A good example is the Inga-Kyō Sutra of the Nara period, i.e., the middle of the eighth century (text fig. 29)[84] in which the scenes, such as those in the episode of Prince Siddharta's renunciation of the world, are ren-

dered in distinct and clearly defined units lined up in a frieze and separated from each other by hills, plants, and other landscape props. This method of illustration is so similar to that of the Joshua Rotulus that I am inclined to believe that a Chinese scroll served as its model. Such an influence is hardly surprising considering that Constantinople under the Macedonian emperors of the tenth century was an international civilization with far-reaching trade connections. We know, in fact, that Chinese silks were available in Constantinople, and that by the tenth century paper, a Chinese invention, had reached the Mediterranean countries. Last but not least, it should be remembered that one of the most popular romances in the Byzantine world, of which several copies with rich miniature cycles exist, was that of *Barlaam and Joasaph*.[85] The central theme of this text is the renunciation of the world, which is precisely the theme of the above-mentioned Inga-Kyō Sutra. It has been noted by literary historians that this Byzantine story is unthinkable without the strong influence of a picture cycle illustrating the "Life of Buddha."

Finally, it is worth noting that while the miniatures in the Octateuchs are painted in gouache, the Joshua Rotulus is painted exclusively in lightly colored wash drawing. To be sure, this technique also exists elsewhere in Byzantine book illumination,[86] yet it does not seem improbable that the Joshua Rotulus painter chose to use the wash-drawing technique under the influence of a Chinese scroll.

[84] K. Weitzmann, "The Art of Ancient and Medieval Book Illumination," *Studia Artium Orientalis et Occidentalis* I (1982), pp. 1–13.

[85] Der Nersessian, *Barl. et Joas.*

[86] K. Weitzmann, "A Fourteenth-Century Greek Gospel Book with Washdrawings," in *Essais en l'honneur de Jean Porcher* (*GBA* 62 [1963]), p. 91.

III. FORMATION AND DEVELOPMENT
OF THE CYCLE

1. THE COMPLEXITY OF THE CYCLE

THE TEXTS of the Letter of Aristeas,[1] Theodoret's *Quaestiones in Octateuchum*,[2] the catena on the Octateuch,[3] and the Septuagint text itself[4] in the several Octateuch manuscripts correspond to one another in nine-tenths of their contents[5] and establish the fact that the Octateuchs are descendants of the same sources, a fact that Kurt Weitzmann has discussed extensively in chapter 2. The description and analysis of the miniatures in chapter 1 confirm that the picture cycles transmitted through the Octateuchs can also confidently be included in one genealogical stemma, as previous researchers have argued (see Introduction). Most of the miniatures have basically the same iconography in all the manuscripts and are inserted into the Greek text in predetermined positions beside the same verses, even when they do not illustrate those verses. Sentences are sometimes abruptly cut short to leave space for a miniature, with the interruptions occurring after the same word in each manuscript (see, e.g., nos. 164–167).

Scholars agree that Ser., Sm., and Vat. 746 (as well as Vtp., Vat. 746's apographon) form an iconographic group cognate to Vat. 747: the three Komnenian Octateuchs diverge from Vat. 747 iconographically in individual miniatures and in two sections of the cycle, namely, the story of Joseph and the episodes between chapters 11 and 18 of the Book of Judges. Nevertheless, even in these cases the number of miniatures and their locations within the Greek text agree in each manuscript.[6]

Analysis of the miniatures has also revealed the complexity and heterogeneity of the cycle as preserved in the extant copies of the Octateuch. Illustrated cycles that originated in the Middle Byzantine period display, as a rule, a general homogeneity in the arrangement of scenes within individual miniatures.[7] In the Octateuchs, in contrast, miniatures with one scene alternate with miniatures with two or three scenes in a single row or in superimposed rows. Sometimes two illustrations of the same event or the same character are presented with different iconographies: a half-figure of Christ may substitute for God's hand in heaven (figs. 250–252, 1079–1083); Moses is at times depicted swinging a knobby club, like Herakles (figs. 603–610), but he also is shown carrying a delicate magician's wand as he performs miracles and leads his people (e.g., figs. 644–651, 696–699, or 704–707); the Tabernacle of the Covenant is sometimes a simple tent, as in Joshua (figs. 1372–1375), but at other times it is an elaborate structure, as in Exodus (figs. 762–769, 778–785) and Numbers (figs. 937–940); similarly, the ark is drawn in different shapes in Exodus (figs. 750–753), Numbers (figs. 894–903, 922, 923, 925), and Joshua (figs. 1159–1164, 1184–1192). Children are born to women who stand or sit in austere delivery chairs in most miniatures of Genesis (figs. 240, 243, 244, 283–285, 355–358, 447–450, 479–482); but occasionally elsewhere in Genesis itself (figs. 107–110, 289–291), as well as in Exodus (figs. 596–598) and Judges (figs. 1491, 1492), they are washed in basins and placed in cradles, sometimes with attending maidservants. Identical textual expressions may be pictorially translated into different sets of images: "κρέμαμαι ἐπὶ ξύλου" (literally, "hang on a tree") is understood as a crucifixion in Genesis (figs. 496–502) but as a hanging on a fork in Joshua (figs. 1238–1243, 1283–1287). Illustrations in the same manuscript can even convey discordant details: the serpent tempting Eve, for example, is depicted both as a reptile (figs. 92–95) and with the legs and body of a young camel (figs. 84–86, 96–98).

[1] "Letter," ed. Thackeray, p. 535; *Lettre*, ed. Pelletier, p. 21.

[2] Theodoret, *Quaestiones in Octateuchum*, ed. Fernández Marcos and Sáenz-Badillos, pp. xx, xxv.

[3] Karo and Lietzmann, *Catalogus*, p. 11; Devreesse, "Chaînes," col. 1101; *Catenae Graecae*, vol. 2, *Collectio Coisliniana*, ed. Petit, pp. xciv–xcvi, cix–cx, cxiii.

[4] J. W. Wevers, *Text History of the Greek Genesis* (Göttingen, 1974), pp. 82–100.

[5] Devreesse, "Chaînes," col. 1101; on the Septuagint text of the Octateuchs, see J. W. Wevers, *Text History of the Greek Genesis* (Göttingen, 1974), pp. 50–66, nos. 57 (Vat. 747) and 73 (Vat. 746). Wevers inserts the Octateuch into the "Catena Group," a subgroup belonging to the "O Recension" of Septuagint manuscripts, and considers the "Catena Group" not a proper recension of the Greek Bible, but rather a late mixed text popular among writers of catena texts.

[6] Ser. has fourteen spaces left in the text for unexecuted miniatures, Vat. 746 has nineteen miniatures covering the text from Judg 11 to Judg 16, and Vat. 747 also has nineteen miniatures for Judg 11 to Judg 16 and two more for Judg 19. It is not known whether Sm. had any miniatures covering Judg 11–18. To this complicated state of the cycles in the Octateuchs, it must be added that the locations of the miniatures of the two sections of Judges in Vat. 747, Ser., and Vat. 746 correspond only in part, and that this partial correspondence may be accidental.

[7] See, e.g., the case of the Skylitzes Matritensis: in this manuscript, probably a copy of a late-eleventh-century Constantinopolitan manuscript executed in Palermo, all of the surviving 564 miniatures (save a dozen harking back to a preexisting cycle on the life of the emperor Basil I) contain one or more scenes flanking each other and arranged in a single row; cf. A. Grabar and M. Manoussacas, *L'illustration du manuscrit de Skylitzès de la Bibliothèque Nationale de Madrid* (Venice, 1979), pp. 131ff., esp. pp. 153–54. The authors advanced a date for the manuscript in the second half of the thirteenth century, but an earlier date, approximately around 1150, is now generally accepted; cf. N. G. Wilson, "The Madrid Skylitzes," *Scrittura e civiltà* 2 (1978), pp. 209–19; G. Cavallo, "Scritture italo-greche librarie e documentarie," in *Bisanzio e l'Italia: Raccolta di studi in memoria di Agostino Pertusi* (Milan, 1982); I. Ševčenko, "The Madrid Manuscript of the Chronicle of Skylitzes in the Light of Its New Dating," in *Byzanz und der Westen: Studien zur Kunst der europäischen Mittelalters*, ed. I. Hutter (Vienna, 1984), pp. 117–30.

Iconographic revisions and the combining of miniatures of different origins have certainly marked the pictorial history of the Octateuchs. The manuscripts present us with complicated problems, some of which may have a chronological dimension: the cycle appears to have grown over time by accretion, so that now we see iconographies of different periods. Comparisons of the pictorial readings in the Octateuchs with those in related works make it possible to recognize later contributions to the cycle and to focus on the original core of the illustrations.

2. MINIATURES, CATENA, AND BYZANTINE SOURCES

The addition of the catena to the biblical text cannot have been responsible for substantial changes in the physical relationship between the Octateuch text and its miniatures (see the discussion of Laurent. in section 14 below). Nor have the extracts in the catena had any relevant impact on the cycle in terms of iconography.[8] Some of the exegetical views on Scripture contained in Theodoret's *Quaestiones in Octateuchum*, the text transcribed in the catena which accompanies the Septuagint Genesis to Ruth, are merely ignored in the miniatures. In his "Quaestio ii in Genesim," on the existence of angels,[9] for example, Theodoret states that the angels were indeed created, even though Moses does not mention them in the story of the Creation; but his view did not affect the pictorial cycle, which does not contain the creation of the angels and in which angels play no role until the Expulsion. In his "Quaestio lxxii in Genesim"[10] Theodoret has no explanation for Isaac bleeding (figs. 295–297) nor for Ishmael carried in Hagar's arms (figs. 298–300). In Jacob Bows before Joseph (fig. 560), Jacob grasps the staff upon which he leans in front of Joseph with his left hand; in contrast, Theodoret ("Quaestio cix in Genesim"[11]) states that Jacob used his right hand. Regarding the crossing of the Red Sea, Theodoret affirms that the sea was not divided into twelve paths, one for each tribe of Israel, as others claim;[12] but the Octateuchs (figs. 696–699) show a number of stripes in the sea.[13] Finally, the Octateuchs depict the blind Lamech accidentally killing Cain (figs. 111–114); Theodoret, on the other hand, asserts that Lamech was not the murderer of Cain.[14] The apparatus of illuminations in the Octateuchs was thus evidently created independently of the catena, since the views of the paramount catenist, Theodoret, are ignored and even contradicted by the story told in the miniatures. Theodoret's *Quaestiones* were presumably unknown at the time of the formation of the picture cycle; in other words, the formation of the cycle must date from a period earlier than the accepted date of composition of the *Quaestiones*, about 460.[15]

Byzantine literary and pictorial sources likewise have no convincing parallels to unusual iconographies in the miniatures (see sections 3, 4, and 6 below). For example, the *Chronicle* of George Synkellos, written in Constantinople under the patriarch Tarasios (784–806), used as a source a manuscript containing a collection of extracts from ancient historians (e.g., Panodoros and Ammianus) expanding on the biblical narrative; in contrast, the sources on which the Octateuch miniatures depend are almost totally unknown.[16] Diagnostic cases are provided by scenes in the Pentateuch books, such as the temptation of Eve and the story of Lamech in Genesis, and the disappearance of Moses in Deuteronomy. This last episode, as represented in the Octateuchs, has no counterpart in Byzantine images, in which angels usually attend Moses' corpse.[17] The metamorphosis of Satan into a camel-like serpent which persuades Eve to eat the fruit (figs. 84–86) is a *unicum* in Byzantium: in other Byzantine images of the serpent the iconographic departures from the Genesis text are confined to the addition of feet, a beard, or a horn on its forehead.[18] Even the Kokkinobaphos Master, the painter involved in the production of the twelfth-century Octateuchs, depicted the serpent climbing the tree and with only the extrabiblical attributes of a horn and short beard in the two copies of the Homilies of James the Monk he was engaged to illustrate (Paris, Bibl. Nat., cod. gr. 1208, fol. 47r; Rome, Bibl. Vat., cod. gr. 1162, fol. 35r).[19]

[8] For a different view, see Brubaker, "Tabernacle Miniatures," pp. 78ff.; cf. also Weitzmann, "Selection," pp. 91–92. On the formation of catenae, see P. Gray, "The Select Fathers: Canonizing the Patristic Past," *StP* 23 (1989), pp. 21–36.

[9] PG 80, cols. 77–80.

[10] PG 80, cols. 179–82.

[11] PG 80, col. 214.

[12] *QuaestEx* 25 (PG 80, col. 256).

[13] Stripes are more clearly depicted in the cognate miniatures of the water miracles of Moses in the manuscripts of the *Christian Topography* of Kosmas Indikopleustes, for instance, the miniatures in Sinai, cod. 1186, fols. 74r (text fig. 34) and 73r (Weitzmann and Galavaris, *Sinai Greek Mss.*, figs. 141, 143, and colorplate 10a).

[14] *QuaestGen* 44 (PG 87, cols. 257–60).

[15] Theodoret, *Quaestiones in Octateuchum*, ed. Fernández Marcos and Sáenz-Badillos, p. xii. However, the differences between excerpts by the authors of the catena and miniatures is not confined to Theodoret. The example of the Lamech miniature is instructive on this point: in fact, excerpts given under the names of other illustrious Church Fathers, namely Ephrem (*CommGen* 4:3; Ephraem, *In Genesim et in Exodum commentarii*, ed. Tonneau, p. 42) and Basil (reported in Σειρά, ed. Nikephoros, vol. 1, col. 118), openly disagree with the view that Lamech was responsible for the murder of Cain.

[16] W. Adler, *Time Immemorial: Archaic History and Its Sources in Christian Chronography from Julius Africanus to George Syncellus* (Washington, D.C., 1989), pp. 165ff.

[17] See, e.g., the Menologion of Basil II (cod. Vat. gr. 1613, p. 13), from around 985 (*Il Menologio di Basilio II [cod. vat. gr. 1613]* [Turin, 1907], p. 13). Cf. Gaehde, "Octateuch," pp. 372–73; and Mouriki, "Moses Cycle."

[18] See De' Maffei, "Eva," pp. 33–34.

[19] H. Omont, "Miniatures des homélies sur la Vierge du moine Jacques," *Bulletin de la Société française de reproduction de manuscrits à peintures* 11 (1927), pl. 5; C. Stornajolo, *Miniature delle Omilie di Giacomo Monaco (Cod. Vatic. Gr. 1162) e dell'Evangeliario Greco Urbinate (Cod. Vatic. Urbin. Gr. 2)* (Rome, 1910).

No details of the legend of Lamech killing Cain are known to Prokopios of Gaza;[20] but John Malalas, also writing in the sixth century, affirms that Cain died under the ruined walls of his house.[21] The ninth-century chronicler George Hamartolos admits the existence of a story of Lamech killing Cain, but he himself does not give any details;[22] in the history of the world up to 1057 written by George Kedrenos, Lamech is credited with the murder of two brothers of Enoch.[23] No Byzantine writers mention the killing of Tubalcain by Lamech, as depicted in the miniatures. Only in the course of the twelfth century does a synthesis of the story appear in the mosaics in Monreale and in the chronicle of Michael Glykas.[24] The Octateuch miniatures thus stand out as the earliest and most complete surviving witnesses of the story of Lamech in Byzantium.

The date 460 stands as a landmark in the search for the sources of the cycle. Additional evidence leading back to the period of the cycle's origin is provided by internal evidence in individual miniatures (see section 3 below) and by their ties to Early Christian literature. The iconographic content of the miniatures which did not originate in the Septuagint text is massive and turned the cycle into a pictorial commentary on the Scriptures independent of the written commentary assembled in the catena. This material is not at all homogeneous: as sketched in chapter 1 and in the following sections, it stems, interestingly, from diverse cultural milieus and is generally found in fourth-century literature from Syria.

3. THE SEPTUAGINT GROUP OF MINIATURES

("MAIN SOURCE")

Except for the miniatures of the "Syriac Source," the miniatures in the Octateuchs normally have one or two scenes within each frame, either in one register or in superimposed registers; in the latter cases they form roughly square compositions. These compositional arrangements must have a codicological history different from that of the tripartite rectangular miniatures of the "Syriac Source." Like the "Syriac Source" (see section 4 below), these miniatures, especially in Genesis and Exodus, transmit an abundance of detail that embellishes or alters the biblical narrative and focuses on Christian themes in the Old Testament; in general Christian exegesis of Syrian authors predominates over that of authors from other areas (see section 6 below). This group of miniatures derives from the Greek text of the Septuagint (henceforth it will be labeled the "Main Source").

In the miniatures of the "Main Source" there are no cases of iconographic duplicates or contradicting details within the group (these are encountered only in miniatures of the "Syriac Source"). However, the "Main Source" is far from being homogeneous: from its creation it must have merged material from diverse picture sources. The majority of its scenes exhibits a narrative vein and a terse character recalling illustrations of classical texts. On the other hand, a number of its miniatures have elaborate compositional structures, scenographic settings, landscapes, and/or combinations of elements from successive events in the narrative (see, e.g., the double representation of the Creation and Enlivenment of Man, figs. 43–46, 47–50, 64–66; the Denial of Guilt by Adam and Eve, and the Curse, figs. 92–94; and the Covenant

after the Flood, figs. 147–150). These characteristics pertain to monumental paintings or mosaics rather than to illustrations in manuscripts. The Christian themes related to fourth-century Syriac authors contained in these miniatures (see section 6 below) suggest that their ultimate model was a cycle from that period in a Christian building in Syria. The "Main Source" also has a few illustrations derived from Jewish models (examined in section 7 below) for which monumental images must likewise be assumed as sources.

A diagnostic example of the connection with the Septuagint version in miniatures of the "Main Source" is found in Genesis 48:22, where the Septuagint translates, "And I give to thee [i.e., Joseph] Sicima, a select portion above thy brethren, which I took out of the hand of the Amorites with my sword and bow." Closely following the Hebrew,[25] the Syriac text has: "Moreover I have given to you one portion of the land more than your brothers. . . ." The corresponding miniature in the Octateuchs (figs. 568–571), with its representation of a walled town in the lower register,[26] adheres to the Septuagint. In Vat. 747, the representation of the Pond of Eden as a lake (fig. 59) and of Jacob bowing before Joseph (fig. 560) follow both the Septuagint and the Peshitta, not the Hebrew text nor the Targumim (the Aramaic translations of the Hebrew Bible); both of the latter have, respectively, a cloud watering the surface of the earth at Genesis 2:6[27] and Jacob bowing upon the bed or summoning his strength to sit up in the bed at Genesis 47:31.[28] In Exodus, the Israelites arrive at the Red Sea unarmed (figs. 696–699), as they do in Exo-

[20] *CommGen* (PG 87, cols. 255–56).

[21] PG 97, cols. 65–67.

[22] PG 110, cols. 49–50.

[23] PG 121, cols. 39–40.

[24] PG 148, cols. 235–36. For the Monreale mosaic, see E. Kitzinger, *I mosaici del periodo normanno in Sicilia*, vol. 5, *Il duomo di Monreale: I mosaici delle navate* (Palermo, 1996), figs. 67–70.

[25] TargN adheres to the Hebrew, whereas TargPs-J follows the Septuagint (*Targum Genèse*, ed. Le Déaut, pp. 430–31).

[26] Vat. 747 erroneously represents two towns.

[27] See the references in note 1 of the introduction preceding nos. 59–62 in chapter 1.

[28] See the references in note 1 of the introduction preceding no. 560 in chapter 1.

dus 13:18 in the Septuagint; the Peshitta and the Hebrew coincide in relating that the Israelites were armed when they left Egypt.[29] In the story of Ishmael sporting with Isaac, the depiction of Isaac wounded by Ishmael is connected with a reading of the Septuagint term παίζοντα (Gen 21:9) as "striking," whereas the Peshitta says that Ishmael was "mocking" Isaac. Similarly, the depiction of Ishmael as a baby in Hagar's arms in the following episode (figs. 298–300) is connected either with the Peshitta or with a particular reading of the Septuagint text which was widespread in Syria.[30]

The iconographic examination of the cycle in chapter 1 has shown that extrabiblical details abound in the miniatures of the "Main Source." Further research would surely augment the number of these cases, which have been identified particularly in Genesis and Exodus. Sometimes (for example, in the episode of Ishmael addressing Sarai in Vat. 747, fig. 240) the cycle preserves expansions of the biblical story unknown in other surviving written or pictorial documents; in the sequence of episodes illustrating the story of Moses' disappearance (figs. 1117–1121), only a few elements have a connection with Jewish writings.

Four miniatures of the "Main Source" have chronological implications. First, the menorah with a horizontal bar depicted in Exodus (figs. 758–761) and Numbers (figs. 894–898) is considered to be of Syro-Palestinian origin and to have first appeared at the end of the third century.[31] Second, the general composition of the Battle of the Kings (figs. 216–219) harks back to a third-century scheme; in particular, warriors on horseback with composite bows, like those in the miniature, were introduced from Parthia especially after A.D. 238.[32] Third, the execution of the Pharaoh's chief baker by crucifixion (figs. 496–502) hints at a *terminus ante quem* in the last quarter of the fifth century, approximately coinciding with the date of A.D. 460 furnished by Theodoret's *Quaestiones*. Execution by crucifixion was abolished as a death penalty by Constantine I and was replaced by hanging by fork; in fact, this substitution was not made until the last quarter of the fifth century.[33] Fourth, excavation of the martyrion at Seleukeia near Antioch uncovered a marble relief representing Joseph in Prison (now in The Art Museum, Princeton University; text fig. 4).[34] Dating from the late fifth or the first half of the sixth century, this relief displays an iconography similar to the corresponding scene in the Octateuchs (figs. 491–494)[35] and sug-

gests the existence of a Genesis cycle related to the Octateuch at that date in the Syrian metropolis.

The miniatures of the "Main Source" form a learned collection of pictures commenting on the biblical text and resembling the collections of exegetical extracts well attested in both Syriac and Greek sources.[36] The chronological elements noted above strongly suggest that the invention of these miniatures occurred between the end of the third century and the late fifth century. If the interpretation of an anti-Origenist and anti-Arian emphasis in the double sequence of the Creation of Man is correct (see chapter 1, introductions preceding nos. 43–46, and nos. 4a, 64a–66a), then the "Main Source" was involved in fourth-century debates, providing further evidence that it was created in that period. The employment of Jewish pictorial models for a few miniatures (see section 7 below) and the debt to Jewish literary tradition reflect the historical relationship between the Christian and Jewish communities in the fourth century;[37] the origin of the "Main Source" must hence antedate the final break between Church and Synagogue which occurred at the turn of the century.

The "Main Source" must also have originated in a place where cultural exchanges flourished between the Jewish and the Christian communities. This was true of many towns of fourth-century Syria and northern Mesopotamia, as recent investigations have revealed. A similar panorama is to be seen in Antioch,[38] Edessa,[39] and Nisibis.[40] In Edessa, Jews and Christians frequented the same streets and marketplaces, exchanged ideas, and received the same education; at Nisibis the Christian school was founded following the model of the local Jewish school;[41] and in Antioch, Christians and Jews attended each other's religious rites.[42] The major issues of Christian exegesis reflected in the miniatures of the "Main Source" also derive from eastern Church Fathers such as Ephrem, rather than from the Antiochene Fathers; moreover, the example of Ishmael carried by Hagar also suggests that peculiar readings of the Septuagint connected with the Syriac version of the Bible are witnessed in the "Main Source." However, the links between the "Main Source" and the Septuagint, rather than the Peshitta, presuppose that the "Main Source" originated in a scholarly center of western Syria where the Septuagint was predominant. The continuous exchange of ideas between Antioch and eastern Syria makes the area between Antioch and Edessa a

[29] Cf. U. Schubert, *Spätantikes Judentum und frühchristliche Kunst* (Vienna, 1974), pp. 29, 51, and passim.

[30] See the references in the introduction preceding nos. 298–300 in chapter 1.

[31] Hachlili, *Ancient Jewish Art*, pp. 236–56, esp. p. 253.

[32] R. Bianchi Bandinelli, *The Hellenistic-Byzantine Miniatures of the Iliad (Ilias Ambrosiana)* (Olten and Lausanne, 1955), pp. 122–26, esp. 124, note 1; Bernabò, "Laur. plut. 5.38," pp. 149–50.

[33] Franchi de' Cavalieri, "Furca"; Morey, "Notes," p. 47; E. Dinkler-von Schubert, "Nomen ipsum crucis absit (Cicero, Pro Rabirio, 5,16): Zur Abschaffung der Kreuzigungsstrafe in der Spätantike," *JbAChr* 35 (1992), pp. 135–46 (repr. in *Gymnasium* 102 [1995], pp. 225–41).

[34] *Age of Spirituality*, pp. 465–66, no. 416; *Byzantium at Princeton*, pp. 45–46, no. 7.

[35] Weitzmann, "Martyrion," p. 139; Weitzmann, "Septuagint," p. 53.

[36] Adler, *Time Immemorial* (as in note 16), pp. 166f., mentions Moses

bar Cepha and Iso'dad of Merv.

[37] Cf. J. Neusner, *Judaism and Christianity in the Age of Constantine: History, Messiah, Israel, and the Initial Confrontation* (Chicago, 1987), esp. pp. 141–42.

[38] W. A. Meeks and R. L. Wilken, *Jews and Christians in Antioch in the First Four Centuries of the Common Era* (Missoula, Mont., 1978), pp. 13–24; R. L. Wilken, *John Chrysostom and the Jews: Rhetoric and Reality in the Late Fourth Century* (Berkeley, 1983), pp. 66–79.

[39] H. J. W. Drijvers, "Jews and Christians at Edessa," *JJS* 36 (1985), pp. 88–102; id., "Syrian Christianity and Judaism," in *The Jews among Pagans and Christians in the Roman Empire*, ed. J. Lieu, J. North, and T. Rajak (London and New York, 1992), p. 128.

[40] P. Murray, *Symbols of Church and Kingdom: A Study of Early Syriac Tradition* (Cambridge, 1975), p. 18.

[41] Ibid.

[42] Wilken, *John Chrysostom and the Jews* (as in note 38), pp. 71–72.

single cultural and completely bilingual unit, in which all Christian writings were known both in Greek and in Syriac translations.[43] But the towns of eastern Syria and northern Mesopotamia, such as Edessa and Nisibis, adopted the Peshitta, not the Septuagint. Antioch, the metropolis of western Syria, therefore remains the strongest candidate, and this is also supported by the finding of the slab with Joseph in Prison in the martyrion of Seleukeia.

4. A CYCLE OF ADAM, EVE, AND THE PATRIARCHS INCORPORATED IN THE OCTATEUCHS ("SYRIAC SOURCE")

Besides the case of the serpent depicted both as a reptile (figs. 84–86) and as a camel-like creature (figs. 92–94, 96–98) discussed above, discrepant images occur elsewhere in the Genesis cycle.[44] In the same Adam and Eve sequence, a naked, seated Adam names the animals or receives their tribute as if he were the animals' king (figs. 56–58), whereas in a successive miniature (figs. 80–82), a seated Adam again names the animals, but this time he is veiled in a "robe of glory." The sober scene of the Sacrifice after the Flood (figs. 143–146) contrasts with the Covenant after the Flood (figs. 147–150) in which the sacrifice takes place under a spectacular rainbow. A representation of the Descendants of Noah is given in figs. 164–167 and again in figs. 160–163, where five different peoples are shown moving to the five large territories into which the earth has been divided; this image of the earth, moreover, has nothing in common with the maps in the Creation sequence (e.g., figs. 29–42).

Two sets of miniatures were presumably combined in the Genesis cycle, leading to some incongruities or even contradictions in the newly produced cycle. The miniatures with the camel-like tempter, the Sacrifice after the Flood, and the Descendants of Noah (figs. 160–163) have the same rectangular structure, contain more than one episode (generally three), and are depicted in a style typical of early book illustration, the so-called "papyrus style."[45] Moreover, these miniatures not only record details that embellish the Septuagint text of Genesis (the camel-like tempter and the "robe of glory"), but also present whole episodes that are not mentioned in Genesis, such as Eve Persuades Adam to Eat the Fruit (figs. 84–86, the scene in the center).

On the grounds of these peculiarities, a number of miniatures in the Octateuchs can be singled out which constitute a coherent parallel to Genesis.[46] The narrative may have originally begun with the prohibition of eating from the Tree of Knowledge and Adam's domination of the animals, and ended with the story of

Nimrod. Most of the references to this narrative are found in texts from Syria, particularly in The Cave of Treasures, a retelling of the biblical story originally written in Syriac and incorporating earlier midrashic traditions.

This group of miniatures constitutes an independent source for the Octateuch cycle, and is henceforth labeled the "Syriac Source," from its connection with the Syriac literature. The "Syriac Source" resembles an illustrated popular novel expanding on biblical stories from Adam to Nimrod, and crowded with fantastic animals, such as camel-like serpents (figs. 84–86), blue felines, and monkeylike creatures (fig. 79), that recall manifestations of demons in the Lives of monks and saints. Adam is the sovereign of all these demoniacal beings and of all the created beasts as well (fig. 79). He dominates them just as a holy man or hermit, reliving the conditions of Adam in Paradise, dominates the wild animals and the wilderness around him.[47] In the "Syriac Source" most of the scenes illustrate the fate of evil characters. Eve and Cain play leading roles in the primeval story of humanity; less attention is given to Adam and Abel. Cain is present in seven scenes; the story of Lamech, which is related to the story of Cain, is told in three other episodes; and the fate of Lamech, destined to kill Cain and his own son unwittingly, resembles the fate of characters in classical dramas.

A number of elements and whole episodes in the "Syriac Source" have no extant textual references, even in The Cave of Treasures. Among these are the serpent shedding his camel-like body (figs. 96–98) and Lamech and Tubalcain leaving for the hunt (figs. 111–114). Evidently the "Syriac Source" narrated a story of Adam, Eve, and the Patriarchs more extensive than known versions of The Cave of Treasures and the other Adamitic literature. Furthermore, mentions of Adam *alone* eating the fruit (cf. figs. 84–86, right) and of the *lone* cherub guarding the gate of Eden in the miniature with the Expulsion (cf. figs. 99–102) are

[43] H. J. W. Drijvers, "Early Forms of Antiochene Christology," in *After Chalcedon: Studies in Theology and Church History Offered to Professor Albert Van Roey for His Seventieth Birthday*, ed. C. Laga, J. A. Munitiz, and L. Van Rompay (Leuven, 1985), p. 113; id., "Syrian Christianity and Judaism" (as in note 39), pp. 124–26.

[44] A more detailed discussion on the topic of this section is found in Bernabò, "Caverna," pp. 720ff.

[45] Cf. Weitzmann, *RaC*, pp. 52–53 and passim.

[46] The story seems to consist of the following scenes: Adam in the Garden of Eden, God Forbids Adam to Eat from the Tree of Knowledge (figs. 75–78; the first scene in the miniature duplicates the Introduction of Adam into the Garden of Eden, figs. 67–70); Naming of the Animals, Satan and a Companion Spy on Adam, Creation of Eve (figs. 79–82); Temptation of Eve (by a camel-like serpent), Eve Persuades Adam to Eat the Fruit, Adam

(alone) Eats the Fruit (figs. 84–86); Curse of the Serpent (with the damned serpent shedding the camel-like half of its body), God Clothes Adam and Eve (figs. 95–98); Expulsion (performed by a angel, while a single cherub guards the gate of Eden), Mourning after the Expulsion (with the child Cain approaching his parents, figs. 99–102); Curse of Cain, Affliction of Cain, Birth of Enoch (figs. 107–110); Lamech and Tubalcain Leave for the Hunt, Lamech Kills Cain and Tubalcain, Lamech with Adah and Zillah (figs. 111–114); Noah and His Sons Dismantle the Ark, Sacrifice after the Flood (figs. 143–146); Descendants of Noah, Nimrod the Hunter, Nimrod Builds a Tower (figs. 160–163). Other scenes were probably once part of this group, such as the episodes of Abel (figs. 103–106), now arranged in a miniature with superimposed registers.

[47] Cf. S. Brock, "Early Syrian Asceticism," *Numen* 20 (1973), p. 12 (repr. in id., *Syriac Perspectives on Late Antiquity* [London, 1984]).

not only found in the Peshitta[48] and in other writings from Syria, but they contrast with the Septuagint text itself, which has, respectively, that both Adam and Eve ate (Gen 3:7, "ἔφαγον") the fruit, and that more cherubim (Gen 3:24, "τὰ χερουβιμ") were appointed to guard the gate of Eden.

In other words, the miniatures derived from the "Syriac Source" were not originally designed for the Septuagint but rather reflect the tradition of Scripture in Syria and were apparently invented for a manuscript containing a more colorful narrative of the Genesis episodes, close to The Cave of Treasures. Retellings of biblical stories were widespread at the eve of the Christian era and in Early Christian times. More than eighty titles of pseudepigrapha and cognate writings are known from this period (including The Cave of Treasures),[49] and lists of extracanonical books are found in authors from the sixth century on. An apocryphon on Lamech, for example, which probably expanded the story of the character as narrated in Genesis, might have been a counterpart to the elements of the story of Lamech in the Octateuch miniatures that have no extant textual basis. A similar case of a lost pseudepigraphon used as a model for Septuagint illustrations has been argued for the Cotton Genesis recension:[50] an illustrated manuscript of the Life of Adam and Eve—the text has survived in a Latin and a Greek version, both possibly dating from around A.D. 400[51]—was the probable source of its Adam and Eve scenes.

The Cave of Treasures is attributed to the school of Ephrem. In its present form, it was redacted by a Nestorian at the beginning of the sixth century, but its origin dates to the third or fourth century and has been placed in Edessa or Nisibis, in northern Mesopotamia.[52] The contents of the miniatures in the

"Syriac Source," which is so closely tied to the Syriac tradition, surprisingly do not always conform to the views of the school of Ephrem. As already observed (note 15 above), an excerpt attributed to Ephrem in the catena rejects the view that Lamech killed Cain, as depicted in the "Syriac Source." In addition, Ephrem thinks of the Tree of Knowledge as a fig tree,[53] but in the miniatures it is an apple tree; and concerning the appearance of the tempter, Ephrem's *Commentary on the Book of Genesis* (2:18) explains that Satan was not allowed to come to Adam and Eve in any form other than that of a serpent.[54] The appearance of the tempter as a camel is also rejected by later Eastern Fathers[55] and attributed to Henana, the heretical bishop who directed the School of Nisibis between approximately 510 and 569.[56]

Thus, a manuscript from the region east of Antioch, illustrated with a cycle of mostly tripartite miniatures, was available when the Octateuch cycle was produced. Theodoret's rejection of Lamech as the murderer of Cain (see section 2 above), as illustrated in the "Syriac Source," may suggest a date of before A.D. 460 for this manuscript; an early origin is also supported by the familiarity of fourth-century authors, such as Ephrem and Basil, with Lamech's legend (both Ephrem and Basil reject the view that Cain was killed by Lamech[57]). The date of the creation of this manuscript also comes close to the supposed date of origin of The Cave of Treasures. Edessa[58] and Nisibis[59] were both renowned cultural centers and possible places for the production of this manuscript; Edessa, in particular, was the most prominent center for the copying of Syriac manuscripts and the greatest marketplace for purchasing them.[60] Unfortunately, the scanty archaeological finds do not provide further evidence to substantiate this hypothesis.[61]

[48] Whether the Peshitta had a Jewish or Christian origin is still disputed. For a Christian origin, see, e.g., Drijvers, "Syrian Christianity and Judaism" (as in note 39), pp. 140–41; for a Jewish origin, M. Weitzman, "From Judaism to Christianity: The Syriac Version of the Hebrew Bible," in *The Jews among Pagans and Christians in the Roman Empire*, ed. J. Lieu, J. North, and T. Rajak (London and New York, 1992), pp. 147–50.

[49] J. H. Charlesworth, *The Pseudepigrapha and Modern Research, with a Supplement* (Ann Arbor, Mich., 1981); and *OTP*, vol. 1 or 2, pp. xxiff.

[50] Weitzmann and Kessler, *Cotton Gen.*, pp. 42–43.

[51] *OTP*, vol. 2, p. 252; for a date between 50 B.C. and A.D. 100 and an Egyptian origin, see *La vie grecque d'Adam et Eve*, ed. D. A. Bertrand (Paris, 1987), pp. 29ff.

[52] *Caverne des Trésors*, ed. Ri, vol. 1, pp. xvii–xviii, xxii–xxiii.

[53] *De Paradiso* 2:10 (Ephrem, *Hymns on Paradise*, ed. S. Brock [Crestwood, N.Y., 1990], p. 164).

[54] "Nor did any of the huge and renowned animals, such as Behemoth or Leviathan, come; nor did any of the other animals, or any of the ritually clean cattle, lest some excuse might be found by the transgressors of the commandment. Instead a mere serpent was allowed to come to them, which, even if it was astute, was nevertheless utterly despised and despicable" (trans. in Ephrem, *Hymns on Paradise*, ed. Brock, p. 209).

[55] See Iso'dad of Merv (bishop of Hedatta, near Mosul, in 852), *Commentaire d'Iso'dad de Merv sur l'Ancien Testament*, vol. 1, *Genèse*, ed. C. van den Eynde (Louvain, 1955), p. 82; Moses bar Cepha (bishop of Mosul, flourished about the middle of the tenth century), *Commentaria de Paradiso* 27 (PG 111, cols. 518–19); and Theodoros bar Koni (bishop of Mosul in the eighth century), *Livre des Scolies (recension de Séert)*, vol. 1, *Mimrè I–V*,

ed. R. Hespel and R. Draguet (Louvain, 1981), mimrâ 2:79, p. 107. Cf. also De' Maffei, "Eva," pp. 24–25.

[56] A. Vööbus, *History of the School of Nisibis* (Louvain, 1965), pp. 235ff.; W. S. McCullough, *A Short History of Syriac Christianity to the Rise of Islam* (Chico, Calif., 1982), pp. 155–57.

[57] See note 15 above.

[58] J. B. Segal, *Edessa: "The Blessed City"* (Oxford, 1970); McCullough, *Short History* (as in note 56), pp. 21ff.; Drijvers, "Syrian Christianity and Judaism" (as in note 39), pp. 124–46.

[59] Vööbus, *School of Nisibis* (as in note 56); Murray, *Symbols of Church and Kingdom* (as in note 40), pp. 9ff.; McCullough, *Short History* (as in note 56), pp. 119, 127ff.

[60] M. Mundell Mango, "The Production of Syriac Manuscripts, 400–700 A.D.," in *Scritture, libri e testi nelle aree provinciali di Bisanzio: Atti del seminario di Erice* (18–25 September 1988), ed. G. Cavallo, G. De Gregorio, and M. Maniaci (Spoleto, 1991), pp. 161–79; ead., "Patrons and Scribes Indicated in Syriac Manuscripts, 411 to 800 A.D.," in *XVI. Internationaler Byzantinistenkongress, Akten* vol. 2, pt. 4 (*JÖB* 32, pt. 4 [1982]), pp. 4–5.

[61] Cf. J. Leroy, "Mosaïques funeraires d'Edesse," *Syria* 34 (1957), pp. 306–42; J. B. Segal, "New Mosaics from Edessa," *Archaeology* 12 (1959), pp. 150ff.; J. Leroy, "Nouvelles découvertes archéologiques relatives à Edesse," *Syria* 38 (1961), pp. 159–69; Segal, *Blessed City* (as in note 58); K. Parlasca, "Neues zu den Mosaiken von Edessa und Seleukeia am Euphrat," in *III Colloquio internazionale sul mosaico antico* (Ravenna, 6–10 September 1980), ed. R. Farioli Campanati (Ravenna, 1983), pp. 227ff.; M. Armitt, *The Edessa Mosaic* (Adelaide, Australia, 1987).

5. THE LETTER OF ARISTEAS, THE PROLOGUE OF THEODORET, AND THE FIRST ILLUSTRATED EDITION OF THE OCTATEUCH

The group of seven episodes illustrating the Letter of Aristeas (figs. 6–12) must be regarded as a later addition to the cycle; these miniatures are preserved exclusively in Vat. 747 and Ser. The relationship of text to image in the miniatures of the Letter is freer than for those of the "Syriac Source" and the "Main Source." The illustration in the Letter of the liturgical objects ordered by Ptolemy for the Temple of Jerusalem (fig. 8) ignores both the text of the Letter (LetAris 57–71) and the description of the corresponding objects at Exodus 25:23–25 and 37:10ff., which the Exodus illustration follows closely (figs. 754–757). Similarly, the painter of the Letter did not consider the relevant miniatures in Exodus when he depicted the clothes of the great priest (cf. fig. 9 with figs. 750–753, 770).

Indeed, the painter of the Letter felt no need to adhere closely to the text or to be consistent with the rest of the cycle. The cycle he painted disregards many of the narrative episodes in the Letter, and it ignores the important events intended to legitimate the translation made by the seventy-two elders in Alexandria, the apparent reason why the Letter was conceived.[62] In fact, the cycle simply omits the selection of the seventy-two sages in Jerusalem, the fabulous and divinely inspired way they accomplished their task on the island of Pharos, the reading of the translation before the assembly of Alexandrian Jewry, the general consent it won, and the curse pronounced against anybody who introduced any changes in the translation itself.

The cycle of the Letter was clearly intended not to legitimate the translation of the Septuagint but rather to honor the person who offered his patronage for an illustrated edition of the Octateuch which would have the Letter at its head.[63] King Ptolemy, who patronized the translation of the Scriptures from Hebrew into Greek, may have been chosen as a prototype for the Byzantine patron of this edition: the king purchases treasures for his library (figs. 6, 7), receives messengers (fig. 9), commissions magnificent gifts from his craftsmen (fig. 8), and gives opulent banquets where he distributes his gifts like a Roman emperor bestowing a *donativum* to his worthy followers (figs. 11, 12).

The failure of the painter to focus on the events intended to legitimate the Greek translation of the Scriptures eliminates any possibility of dating the creation of the pictorial sequence of the Letter to an early period, when Jews and then Christians claimed that the Letter was proof of the divine inspiration of the Septuagint translation.[64] In other words, the creation of the Letter's miniatures cannot be assigned to a Jewish sphere, nor to a Christian one, before the fifth century,[65] when Christians were still resolutely defending the Septuagint from Jewish arguments against its divine authority. Not until the period of Justinian I was the quarrel settled: in Justinian's Novella 146 of the year 553, an edict on the use of the translation of the Septuagint in synagogues, no traces of the former debate on the legitimacy of the Septuagint translation can be found.[66] Thus, the *terminus post quem* for the invention of the Letter's cycle may be confidently placed in the age of Justinian.

The two miniatures accompanying the *Quaestiones in Octateuchum*, Theodoret Gives the Letter to a Messenger and Hypatios Receives the Letter (figs. 13–15), are again found only in Vat. 747 and Ser.[67] The text itself provides no real justification for the contents of the miniatures: the existence of a letter which the messenger receives and delivers to Hypatios is only implied in the Prologue, which contains no narrative elements. Theodoret merely thanks Hypatios for urging him to put into writing a commentary to the Scriptures. The messenger, the delivery of the letter, and the attitudes of Theodoret and Hypatios were entirely invented by the painter.

Thus, the situation resembles that of the cycle of the Letter of Aristeas: the illustrations actually elaborate on the text, with the aim of producing a sumptuous pictorial prologue to the catena on the Octateuch. Similar iconographic patterns are employed for the illustrations of both texts: the pair Theodoret/Hypatios parallels the pair Ptolemy/Demetrios of Phaleron in the first miniature of the Letter and by the chiasmus of the great priest Eleazar and Ptolemy receiving his returning messengers (fig. 9).[68] This iconographic affinity with the miniatures of the Letter of Aristeas leads to the assumption that both groups of miniatures were invented for the same edition of the Octateuch.

The negligent treatment of Jewish cult objects and religious history exhibited in the Letter has a counterpart in the illustrations of the Tabernacle of Testimony and the Ark of the Covenant in the Book of Joshua. In fact, the tabernacle in the miniature illustrating Joshua 19:51 (figs. 1372–1375) is represented as a tent pegged with cords and supported by a central pole; this

[62] On the Letter of Aristeas, see now Canfora, *Viaggio di Aristea.*

[63] Bernabò, "Mecenatismo," pp. 15ff.

[64] A discussion of the historical fortune of the Letter can be found in M. Müller, "Hebraica sive Graeca Veritas? The Jewish Bible at the Time of the New Testament and the Christian Bible," *Scandinavian Journal of the Old Testament* 1 (1989), pp. 58–66; and id., "Graeca sive Hebraica Veritas? The Defense of the Septuagint in the Early Church," ibid., pp. 104–10. See also G. Dorival, M. Harl, and O. Munnich, *La Bible grecque des Septante: Du judaïsme hellénistique au christianisme ancien* (Paris, 1988), pp. 47–49; and S. Jellicoe, *The Septuagint and Modern Studies*, 2d ed. (Winona Lake, Ind., 1989), pp. 41–47.

[65] A more exhaustive discussion of date and milieu of origin of the cycle of the Letter can be found in Bernabò, "Mecenatismo," pp. 16ff.

[66] English translation in P. E. Kahle, *The Cairo Geniza*, 2d ed. (Oxford, 1959), pp. 315–17.

[67] Iacobini, "Lettera," pp. 85–86; Bernabò, "Teodoreto," pp. 69–80.

[68] The introduction of a pair formed by the author of a text and a companion mentioned in the same text is not, of course, a creation unique to the Octateuch, and its painter may well have found inspiration elsewhere, e.g., in illustrations of sovereigns exchanging letters by means of messengers or ambassadors.

representation bears no correspondence to the elaborate structure of the tabernacle depicted in Exodus (figs. 762–765, 778–781), which conforms to the biblical text. The form of the ark carried by priests at the arrival at the Jordan (Josh 3:14–16, figs. 1159–1164) resembles a huge reliquary, possibly reflecting the influence of Christian liturgy; this form diverges from the structure depicted in Exodus (figs. 750–753) and Numbers (figs. 894–903) and from the Septuagint description as well.[69] Also in the Book of Joshua, the executions of the king of Ai (figs. 1238–1243) and the five kings of the Amorites (figs. 1283–1287) are depicted as hangings on fork-shaped stakes. As mentioned above, execution by fork was not introduced until the last quarter of the fifth century, and pictorial sources attest hanging by fork from the sixth century.[70] Thus, the miniatures of the Book of Joshua might be a later addition to the cycle, invented for the same edition of the Octateuch as the miniatures of the Letter of Aristeas and the Prologue of Theodoret. It should be added that Doula Mouriki's investigation of the biblical miniatures in the *Christian Topography* of Kosmas Indikopleustes demonstrated that a Pentateuch, not an Octateuch cycle, which belonged to the same iconographic tradition as the extant Octateuchs, was available to the painter who invented the cycle of Kosmas in approximately A.D. 540;[71] in other words, images for Joshua, Judges, and Ruth may not yet have been connected with the Pentateuch to form an Octateuch cycle at that date.

As summarized in the introduction, the catena in the Octateuchs, belonging to the group which scholars have labeled Type C or Type III, is the result of two different traditions: one is composed of a main text constituted by Theodoret's *Quaestiones* around which excerpts from other Antiochene Fathers revolve;

the other is a proper catena tradition whose formation occurred in a different way. The two seem have been combined to form the extant catenae during the sixth century, a date which coincides with the chronological data furnished by the miniatures. This coincidence of dates lends greater validity to the conjecture that the cycles of the Letter and the *Quaestiones* were invented for an edition of the illustrated catena on the Octateuch sometime in the sixth century. A second coincidence between the apparatus of the excerpted texts and images is their similar appreciation of preexisting traditions: the textual commentary of the catena and the pictorial commentary of the cycle are freely assembled from both orthodox and heretical sources.

Unfortunately, the name of the patron of this edition of the Octateuch, which might be called the "Imperial Edition," is unknown. The learned center in which this assembled edition of the illustrated Octateuch was produced is also not known: in contrast to the "Main Source" and the "Syriac Source," no particular features have emerged that hint at a Syriac origin.[72] As mere speculation, the sixth-century metropolis of Constantinople might be held as the natural place of origin for the "Imperial Edition." Although the name and date of the patron remain purely speculative, we can hazard a guess that the sovereign depicted in the cycle of the Letter is a portrait of the patron. In Ser. his features are rather undefined, but in Vat. 747 they are accurately drawn and resemble those of various emperors, including Justinian himself.[73] Justinian, as the promulgator of the Novella on the primacy of the Septuagint translation, is a plausible candidate; at the same time, he was a celebrated patron of luxurious books, including the edition of the Bible which served as a model for the volumes of the Niketas Bible.[74]

6. CHRISTIAN THEMES

The thought of the early Church Fathers influenced departures from a literal rendering of the biblical text in a number of miniatures. New Testament parallels or typological meanings must also have determined the choice of episodes for illustration. A list of miniatures with Christian themes includes:

the Primordial Creation (figs. 17–20), in which there is no depiction of "the Spirit of God moved over the water" of Genesis

1:2, an absence explained by the influence of the views of the Syriac Church Fathers;

the double sequence of the Creation and Enlivement of Man (figs. 43–46, 47–50, 64–66), a duplicated iconography which has connections with Ephrem's and John Chrysostom's imagery and contrasts with the arguments of both Arius and Origen;

the Creation of Eve (figs. 79–82), with Eve emerging from the side of Adam, instead of being fashioned from one of his ribs by

[69] Revel-Neher, "Christian Topography," p. 78; Mathews, "Leo Sacellarios," pp. 103ff.

[70] See the execution of the Pharaoh's baker in the Vienna Genesis, pict. 34 (Gerstinger, *Wiener Gen.,* pict. 34); cf. Kresten, "Hinrichtung," pp. 113–29.

[71] Mouriki-Charalambous, "Cosmas," pp. 150–54, esp. p. 153.

[72] Notably, whereas the marble slab with Joseph in Prison excavated in the martyrion of Seleukeia is iconographically related to the Octateuchs and suggests a tie between the cycle and the Syriac metropolis, two other slabs found in the martyrion with scenes from the story of Samson (Samson and the Lion and Samson Carrying the Gates of Gaza) depart from the Octateuch iconography. The creator of the reliefs seemingly did not have available an Octateuch cycle like that transmitted through the extant manuscripts (cf. Weitzmann, "Martyrion," pp. 137–38, figs. 371, 372, where

iconographic ties with the Octateuchs are proposed instead).

[73] The portraits of Michael VII Doukas (1071–78) in a codex with the homilies of John Chrysostom in Paris (Bibl. Nat., cod. Coislin 79, fols. 1r or 2bis r, 1v or 2bis v, 2r [text fig. 39], 2v) also remarkably resemble that of Ptolemy in Vat. 747. Michael reigned in the years when Vat. 747 was executed. In the Paris codex the features of Michael were adjusted somewhat to resemble those of his successor, the aged Nikephoros III Botaneiates (1078–81), to whom the manuscript was newly dedicated (see Spatharakis, *Portrait,* pp. 107–18, figs. 69–73). The resemblance between Michael VII and Ptolemy, however, might be explained merely by the dedication of Vat. 747 to this emperor.

[74] Belting and Cavallo, *Bibel des Niketas;* see also J. Lowden, "An Alternative Interpretation of the Manuscripts of Niketas," *Byz* 53 (1983), pp. 559–74.

God's hand "in the twinkling of an eye," according to Syriac imagery;

Enoch (figs. 115–118) represented in a configuration echoing views expounded by Paul and early Church Fathers;

the Sons of God Take Daughters of Men as Wives (figs. 119–122), a diagnostic case in which the interpretation of the "sons of God" as the offspring of Seth dominates in Christian authors, especially in Syria, in opposition to Jewish views;

the Collapse of the Tower of Babel and Confounding of Languages (figs. 172–175), with God alone performing the destruction of Babel;

the Meeting of Abram and Melchizedek (figs. 229–231), a scene dedicated to Melchizedek's hermitage which seems to be a visual response to the proliferation of hermits in Syria, with his disheveled appearance conforming to literary descriptions of Syriac hermits with unkempt hair;

the Sacrifice of Isaac (figs. 315–318), with Isaac depicted as a young boy placed beside the altar with his hands—not his feet—tied behind his back and the ram tied to the tree with a rope, following Syriac writings and Early Christian iconography;

the Battle against Amalek (figs. 726–729), with the Christian typology of the imposing cross formed by Moses' outstretched arms;

the Brazen Serpent (figs. 966–970), with the typology of the cross formed by the pole and the serpent;

and Moses Announces the Coming of a Prophet (figs. 1079–1083), with the prophet depicted as Christ.

In contrast to the abundance of Christian themes, the main Hebrew feasts described in Leviticus 23 and 24 and in Numbers 28 and 29 (the Unleavened Bread, the Weeks, the Day of Atonement, the New Year, the Tabernacles, and the Trumpets) are ignored, as are the sacrifices, rituals, and rules prescribed in other sections of the Mosaic books. Episodes of paramount importance for the Jews, such as the canonization of the Law with its complex ceremony (figs. 742–745), receive no emphasis at all. The catalogue of unclean animals given at Leviticus 11 does not correspond to the animals depicted in figs. 840–842. Only rare miniatures with standard iconographies of sacrifices and punishments are encountered in the Octateuchs, and these miniatures are generally connected to Christian imagery. The Trial of the Bitter Water (figs. 884–888) was presumably introduced because of its connection with the story of the Virgin; the offering of unleavened bread and turtledoves or pigeons (figs. 889–893, 824–828) recalls Joseph's offering at the Temple; the miniatures with directions for leprosy and issues of blood in Leviticus and Numbers (figs. 843–848, 849–854, 855–859, 879–883) recall Christ's miracles; the scenes of stoning may have been intended as references to episodes of Christian martyrdom; and a parallel between the heavenly fire that slays Aaron's sons in Leviticus 10:1–2 (figs. 835–839) and the fire which brought a halt to the rebuilding of the Temple in Jerusalem is employed by John Chrysostom in one of his homilies *Adversus Judaeos.*[75]

7. JEWISH TRADITIONS

The number of details in the Octateuch miniatures that can be ascribed to Jewish writings, and that do not appear in extant Christian writings, is not large. The illustration of the Rescue of Moses in Vat. 747 (fig. 599), probably the original illustration of the cycle, is an example of a connection with a Targum. Here, Pharaoh's daughter stretches out her arm to recover the ark with Moses, instead of sending one of her maidens to recover it, as specified in Exodus 2:5 (in both the Septuagint and the Peshitta). In Targum Pseudo-Jonathan[76] and in other Jewish writings the debated original Hebrew expression is translated differently, as "she [i.e., Pharaoh's daughter] stretched out her arm and took it." Vat. 747 adheres to this version. The painting in the Dura Europos synagogue (text fig. 40) presents a variant of the Jewish iconography: Pharaoh's daughter enters the water of the Nile and takes Moses up in her arms.[77]

Another connection with the Targumim is found in the episode of Moses Loosens His Sandal, again in Vat. 747 (fig. 611), where Moses loosens just one of his sandals, thus presumably fol-

lowing Targum Onkelos and Targum Pseudo-Jonathan on Exodus 3:5, as well as a number of other Hebrew manuscripts. In the Dura synagogue depiction (text fig. 41), both sandals are loosened and abandoned on the ground. Moreover, in Vat. 747 the replacement of the angel indicated in the text by the flaming fire embracing and burning the bush also seems to be connected with Jewish writings. The Herakles-like Moses brandishing a knobby club in Moses Slays the Egyptian (figs. 603–606) and duplicated in Moses Rescues Jethro's Daughters (figs. 607–610) is also found at Dura Europos (text fig. 2).[78] Other similar cases of connections with Jewish writings are the episode of Zipporah Shows the Angel Her Son's Blood (figs. 620–623), the representation of the giants of Genesis 6:4 as warriors (figs. 123–126), and the miniature of the Passover (figs. 684–687), where the phases of the ceremony are accurately depicted and the Israelite killing the lamb wears a *tallit.* The miniature of the Passover, moreover, presents us with a rare case of an illustration sequence that reads from right to left, like Hebrew, Aramaic, or Syriac.

[75] 5:7; John Chrysostom, *Discourses against Judaizing Christians*, ed. P. W. Harkins (Washington, D.C., 1977), pp. 138–39; Meeks and Wilken, *Jews and Christians in Antioch* (as in note 38), p. 31.

[76] *Targum Exode et Lévitique*, ed. Le Déaut, p. 21.

[77] Cf. J. Neusner, "Judaism at Dura-Europos," *History of Religions* 4 (1964), pp. 87–89; Weitzmann, *Dura*, pp. 28ff.

[78] Cf. Weitzmann, *Dura*, pp. 42–43, figs. 48, 49.

Additional evidence comes from pictorial sources. The representation of the tabernacle with the Ark of the Covenant and its liturgical objects (figs. 750–769, 812–814) corresponds in both general iconography and individual details with the depiction in Dura (text fig. 3,[79] although the menorah has no horizontal bar), with archaeological finds, and with miniatures in the manuscripts of Kosmas Indikopleustes. These images can be traced to Jewish cartographic representations of the tabernacle. These images probably circulated from the third century on (perhaps in Jewish manuscripts, as has been argued) and were independently copied in the Octateuchs as well as in other cycles, such as that of Kosmas.[80]

Miniatures such as the Passover (figs. 684–687) and Zipporah Shows the Angel Her Son's Blood (figs. 620–623) display the genuine structure of manuscript illustrations, with concise pictures that represent single moments with separate scenes. In contrast, the miniatures with the episodes of Moses Slays the Egyptian in the four Octateuchs (figs. 603–606) and the Rescue of Moses and Moses Loosens His Sandal in Vat. 747 (figs. 599, 611) combine all the significant details from successive points in the story into a single picture. The Rescue of Moses and Moses Loosens His Sandal have a similar dogmatic emphasis which is rare in the cycle as a whole. This approach to the narration corresponds to an arrangement typical of mosaics, wall paintings, and manuscripts with selected miniatures rather than to a manuscript with a cycle illustrating every event of its contents. (Similar monumental characteristics have also been encountered in another group of miniatures of the "Main Source" containing Christian themes; see section 6 above.)

Were the pictorial models for the miniatures of the tabernacle and the chief events in Moses' early life mosaics or wall paintings in a synagogue? Were they contained in a Jewish manuscript in which only the most meaningful passages were illustrated? Fig-ural paintings in synagogues of the third through the sixth century must be considered the rule rather than the exception.[81] However, iconographic comparisons with the synagogue of Dura, which is the most extended testimony of early Jewish art discovered to date, show that substantial divergences exist between the Octateuch miniatures of the episodes of the Rescue of Moses and the burning bush, on the one hand, and the corresponding panels at Dura, on the other. These divergences challenge the direct dependence of the Octateuchs on Dura that a few scholars have posited.[82] This question must be left to future research; here, however, it may be noted that the unarmed Israelites leaving Egypt in the Exodus miniatures (see, e.g., figs. 696–699)—at Dura the Israelites are armed[83]—and the representation of the Priestly Clothes (fig. 770)[84] are additional instances of divergence between Dura and the Octateuchs; the Sacrifice of Isaac in the Octateuchs corresponds more closely to Christian Syriac texts, sixth-century mosaics in Palestinian churches, and even the mosaic floor in the sixth-century synagogue at Beth Alpha (text fig. 43), than to Dura (text fig. 42).[85]

In contrast to the abundance of Christian themes in the miniatures, the number of scenes that must be traced back to Jewish models is small; a Jewish origin of the core of the cycle should be consequently excluded. The connections with the Septuagint detected in significant cases (see section 3 above) confirm that the cycle did not originate in a Jewish sphere. The Jews abandoned the Septuagint after the completion of the Greek version by Aquila around A.D. 130 because of the unfaithfulness of the Septuagint translation in a few passages and the contemporary adoption of that version by the Christians.[86] A Jewish origin of the cycle would imply a date before that time, but such an early date is not defensible on the grounds of the elements studied so far in the cycle and related material.

8. BYZANTINE EDITIONS OF THE CYCLE

Vat. 747 and Laurent., the most ancient editions of the cycle, date from the eleventh century. The Laurent. cycle ends with the Expulsion of Adam and Eve and its pertinence to the same iconographic family as the other Octateuchs is not so evident (see section 14 below). The intensely dramatic vein that pervades the scenes in Vat. 747 must be ascribed to the eleventh-century painter who was charged with executing the miniatures; this painter was more attentive than his twelfth-century colleagues in reproducing unusual iconographic details copied from its model.[87] The production of an Octateuch manuscript such as Vat. 747, which contains Septuagint text, catena, Letter of Aristeas, and a set of more than five hundred illustrated biblical

[79] Weitzmann, *Dura*, fig. 180.

[80] Kessler, "Temple Veil," pp. 60–63; Revel-Neher, "Christian Topography," pp. 87ff.; Wolska-Conus, "Topographie Chrétienne," pp. 155ff.

[81] K. Schubert, "Jewish Pictorial Traditions in Early Christian Art," in H. Schreckenberg and K. Schubert, *Jewish Historiography and Iconography in Early and Medieval Christianity* (Assen and Minneapolis, 1992), p. 158.

[82] Cf. Weitzmann, *Dura*, pp. 26–38.

[83] Cf. Kraeling, *Synagogue*, p. 81 n. 237.

[84] See the introduction preceding no. 770 in chapter I.

[85] See the introduction preceding nos. 315–318 in chapter I; cf. Bernabò, "Tradizioni siriache," pp. 309–11.

[86] Dorival, Harl, and Munnich, *Bible grecque des Septante* (as in note 64), pp. 122–25.

[87] Vat. 747 introduces stylized architecture into the landscapes of a number of Genesis miniatures which recalls the classical architecture depicted in the landscapes of the Joshua Roll. The buildings are sometimes classical villas with porches, set against a background of mountainous slopes; they never have any connection with the biblical narrative pictured in the foreground and reflect only a taste for ornamentation (e.g., figs. 103, 107, 115, 143, 147, 151, 200, 208, 212, 220). They sometimes take the form of towers (figs. 232, 240) or of fragments of classical architecture, such as a door with a tympanum or a column with a huge capital (fig. 245). In the other Octateuchs, they are rare (e.g., figs. 600–602, 713–715, 721), and the miniatures in which they are found do not correspond in subject with those in Vat. 747.

episodes, was presumably fostered by lavish and learned patronage during the course of the eleventh century. However, cycles with an analogous number of images are constantly encountered in post-iconoclastic Byzantine biblical texts (e.g., the Paris Homilies of Gregory of Nazianzos, cod. gr. 510; the so-called marginal Psalters; the Vatican copy of the Book of Kings, cod. Vat. gr. 333; the Laurentian Gospels cod. plut. 6.23; and the Paris Gospels, cod. gr. 74) and classical texts alike (e.g., pseudo-Oppian's *Cynegetica* in Venice, Bibl. Marc., cod. gr. 479).

Notwithstanding that this is an extraordinary number, the extant Byzantine editions of the Octateuch presumably have abbreviated versions of the original set of illustrations. The Octateuch cycle, as it appears in all the extant catena manuscripts, includes miniatures that must originally have been conceived as separate units, for instance, the two scenes of Finding the Cup in Benjamin's Sack and Joseph's Steward Pursues the Brothers (fig. 528, lower register). In other cases, scenes were possibly dropped or lost entirely in the process of copying: of the Judah and Tamar story, only two episodes are preserved (figs. 479–482); in Exodus, the paramount episode of the Crossing of the Red Sea is absent and the cycle shifts from the arrival at the Red Sea (figs. 696–699) to the drowning of the Egyptians (figs. 704–707). For Judges the cycle is drastically abridged: the Sacrifice of the Daughter of Jephthah is missing, and the story of the Levite has only the Levite Carries the Corpse of His Concubine (figs. 1536–1539) and two episodes of battle against the Benjamites (figs. 1540–1544); whole chapters in Judges are also skipped.[88] For Ruth, we find only Ruth Gathers Grain (figs. 1545–1548) and Ruth and Boaz Sleep on the Ground (figs. 1549–1552). The painters may have made omissions in copying the cycle, but the possibility also must be considered that the extant Byzantine cycle was deliberately abbreviated because of the imposing number of episodes it contained.

Weitzmann argued that Vat. 747 is the least corrupted witness of the whole Octateuch recension.[89] Except for a limited number of scenes—essentially the scenes restored during the Palaiologan period—Vat. 747 appears to be the most conservative edition of the illustrated catena on the Octateuch which was probably assembled in the sixth century. Inconsistencies in the twelfth-century Octateuchs that will be discussed below (section 10)

confirm Weitzmann's view that these Octateuchs preserve a revised edition of the cycle.

In cases where the iconography in Vat. 747 deviates from the Septuagint text, such as the tongue of fire replacing the angel in the episode of the Burning Bush (fig. 611), connections with Early Christian writings or Jewish traditions explain the deviations. Expansions of the biblical narrative that are unknown in extant literary or pictorial sources have been suggested in other cases where Vat. 747 deviates from the text, for example, the scene of Ishmael Addresses Sarai (fig. 240c). In this scene, a woman, presumably Sarai/Sarah, is approached by a child, presumably Ishmael; in its place the other Octateuchs (figs. 242–244) include, proleptically, Sarah Sees Ishmael Sporting with Isaac, and Abraham Sends Hagar and Ishmael Away, thus duplicating the miniatures found a few folios later in the manuscripts (figs. 295–300). Generally, the cases of deviation from the text encountered in Vat. 747 appear as the *difficilior lectio* among the extant versions.

As Weitzmann has convincingly demonstrated,[90] the Joshua Rotulus dates from around the middle of the tenth century. The Rotulus has lost its initial and final sections: the existing fifteen sheets cover chapters 2–10 of the Book of Joshua. Its cycle is closely connected with the Octateuchs, but it has more elaborate miniatures than the extant codices. The insertion of classically-fashioned villas, architectural elements and landscapes, and numerous personifications of towns and river and mountain gods distinguishes the iconography of the Rotulus cycle from that of the Octateuchs. Weitzmann has connected the classical insertions in the Rotulus and the Hellenistic style of its images to the tenth-century "Macedonian Renaissance," the Rotulus itself being one of the most outstanding products of this classical revival. More recently the originality of the Rotulus has been challenged: Kresten,[91] followed by Lowden,[92] has claimed that the Rotulus is a faithful tenth-century copy of an earlier, pre-iconoclastic roll, whose production was commissioned to obtain an antiquarian facsimile of a roll which must have been a renowned manuscript, and was possibly damaged. Whatever the degree of originality of the Joshua Rotulus, its cycle proves that the Octateuch cycle (or at least the section of the cycle corresponding to the original extent of the Rotulus) existed during the tenth century.

9. A BYZANTINE COLLATION OF THE CYCLE

A further indication of the existence of the cycle in a period before the earliest extant codices comes from the investigation of the miniatures in Ser., Sm., and Vat. 746. These manuscripts contain an edition of the cycle which constitutes a branch of the genealogical tree parallel to that of Vat. 747. Lowden[93] stated that another Octateuch, codicologically related to Vat. 747, was the common model of the three twelfth-century Octateuchs, since

none of the three codices can be confidently identified as the model for the other two—a view that Weitzmann had already advanced years before on the basis of his investigation of the Joshua miniatures.[94] In fact, the cycles in Ser., Sm., and Vat. 746 each contain some iconographic defects when compared with the cycles in the other two codices. According to Lowden, the manuscript which served as a model dates from about 1050–75.

[88] Cf. Avner, "Septuagint Illustrations."

[89] See Introduction, note 24.

[90] Weitzmann, *JR*, pp. 39–50.

[91] Kresten, "Hinrichtung"; Kresten, "Oktateuch-Probleme," pp. 501–11.

[92] Lowden, *Octs.*, pp. 105ff.

[93] Ibid., pp. 62–65, 73–75, 83.

[94] Weitzmann, *JR*, pp. 30–38.

Differing from Lowden, Anderson suggested that stylistic elements in the three Octateuchs appear to be reflections of the style of the master who executed the miniatures of pseudo-Oppian's *Cynegetica* in Venice and proposed that the model of the twelfth-century Octateuchs was a manuscript by this master dating from the middle of the eleventh century.[95]

A revision unquestionably affected the edition of the cycle known through the three twelfth-century Octateuchs. This revision was twofold: on one side, a learned collation of the cycle with cognate cycles in various illuminated codices whose contents were connected with the Octateuch, a procedure based on a selection of manuscripts from a well-stocked library, which is paralleled by the scholarly appearance of the codices and the catena text; on the other side, a reinvention of iconographies, freely reassembling groups or single figures copied from available pictorial material, with no rigid constraints and with only superficial regard for the literary value of the Septuagint text (see section 10 below).

The Joshua Rotulus was one of the manuscripts that served as models for this collation of the cycle. The appearance of personifications and gods, as well as misunderstandings in the placement of groups of figures from one miniature to the next encountered in the miniatures of Joshua in Ser., Sm., and Vat. 746 (see chapter I), are due to the use of the Rotulus as a model for the three Octateuchs. The borrowing of iconographies from the Rotulus also resulted in erroneous divisions in the miniatures. For example, the group of Israelites in Achan Taken Away (figs. 1214–1216) is misplaced: it should have been depicted close to the right edge in the Trial of Achan (figs. 1208–1210). The availability of the Rotulus for improving the iconography of the cycle turned out to be a failure stylistically: in most of the miniatures of Joshua in the twelfth-century Octateuchs the figures are naively drawn and the stylistic level is disappointingly low. This weakness must thus presumably be ascribed to the author of the pictures in the manuscript derived from the Rotulus which was used, in turn, as a model by the painters of the twelfth-century Octateuchs.

A second manuscript which played a role in this collation was an illustrated Psalter close to the Paris Psalter (text fig. 22), from which the personifications Bythos (the Depths), Eremos (the Desert), and Erythra Thalassa (the Red Sea) in the miniature of the Egyptians Drown in Ser., Sm., and Vat. 746 (figs. 705–707) were imported—these figures are absent in Vat. 747 (fig. 704).[96] A third manuscript which served as a source for the collation was an illustrated codex of the *Christian Topography* of Kosmas Indikopleustes, the oldest extant copy of which is the ninth-century cod. gr. 699 in the Vatican Library. Significantly, around

the middle of the ninth century the *Christian Topography* of Kosmas appears in the *Bibliotheca* of Photios with the title of *Commentary on the Octateuch*.[97] Finally, an illustrated *Physiologos* may have provided images of the quadrupeds (especially the fox and the gazelle) depicted on the rectangle of the earth in the scene of the Creation of the Terrestrial Animals (figs. 41, 42).

The depictions of the ark, the tabernacle, the shewbread table, and the liturgical implements in Ser., Sm., and Vat. 746 (figs. 751–753, 755–757, 759–761, 763–765, 771–773, 779–781, 783–785) diverge from the corresponding images in Vat. 747. Scholars agree that an illustrated Kosmas Indikopleustes (text figs. 7, 9, 35–38) provided the models for the above depictions and for the map of the world and other details in the sequence of miniatures illustrating the creation of the world (figs. 26–28, 30–32, 41, 42) in the twelfth-century Octateuchs.[98] (The cycle of Kosmas depends, in turn, on the iconographic tradition of Vat. 747 for a number of biblical and cartographic images; see section 3 above.) According to the Exodus narrative, the structure of the ark and the tabernacle corresponds with the structure of the created world; thus, the learned personality who presumably directed the collation of the Octateuch cycle ordered the revision of the representations of the world in the beginning miniatures of Genesis. In fact, the maps in Ser., Sm., and Vat. 746 diverge from the maps in Vat. 747 in that they rely on Kosmas's cartography: the earth surrounded by the ocean, as seen in the Creation of the Terrestrial Animals (figs. 41, 42), with swimming fishes and medallions enclosing wind gods, is a faithful copy from a *Christian Topography*. Also the fishes in the ocean and the quadrupeds on the earth seem to be borrowings from other Kosmas treatises.[99] The cartographic revision of the Octateuch cycle also affected other illustrations in the Creation of the World: the impact of Kosmas must also be responsible for the divergences between the Creation of the Birds and the Marine Creatures in Vat. 747 and the twelfth-century manuscripts (figs. 37–39).[100]

The date at which the collation of the Octateuch cycle with the Joshua Rotulus, a Psalter, an illustrated Kosmas, and perhaps a *Physiologos* was carried out must remain hypothetical. The collated edition may correspond with the codex that Lowden and Anderson have proposed as the lost model of Ser., Sm., and Vat. 746, and which they suggest was produced around 1050–75 or around the middle of the eleventh century, respectively. But the possibility that this mid-eleventh-century codex might also be a later copy of the collated edition cannot be disregarded (with its *terminus post quem* placed in the middle of the tenth century, which is the approximate date of execution of both the Joshua Rotulus and the Paris Psalter).

[95] Anderson, "Seraglio," pp. 101–2.

[96] Buchthal, *Paris Psalter*, pp. 30ff.; Weitzmann, "Ps. Vatopedi," p. 48.

[97] Photios, *Bibliothèque*, vol. 1, *Codices 1–84*, ed. Henry, pp. 21–22 (cod. 36). For the date of the *Bibliotheca*, see W. T. Treadgold, *The Nature of the Bibliotheca of Photius* (Washington, D.C., 1980), p. 36; and, more recently, L. Canfora, "Libri e biblioteche," in *Lo spazio letterario della Grecia antica*, vol. 2, *La ricezione e l'attualizzazione dei testi*, ed. G. Cambiano, L. Canfora, and D. Lanza (Rome, 1995), pp. 29–46.

[98] Cf. Redin, *Koz'my Indikoplova*; Brubaker, "Tabernacle Miniatures," pp. 73ff.; Hahn, "Creation," pp. 29ff.; Wolska-Conus, "Topographie Chré-

tienne," pp. 155ff.; Kessler, "Temple Veil," pp. 53ff.; Revel-Neher, "Christian Topography," pp. 78ff.

[99] Hahn, "Creation," pp. 33–35; see the literature cited in the notes to nos. 3b and 41 in chapter 1.

[100] The arrangement in two superimposed rows (Vat. 747 has a different iconography) may have been suggested by representations of the same event in a Genesis cycle like that in the tenth-century Bible of Leo Sakellarios, fol. IIr (text fig. 33) (*Bibel des Leo Patricius: Wiedergabe des Originals von Reg. grec. IA zur Facsimileausgabe von Reg. grec. IB*, ed. S. Dufrenne and P. Canart [Zurich, 1989]; cf. Mathews, "Leo Sacellarios," pp. 111ff.).

10. THE KOMNENIAN REVISION OF THE CYCLE

As anticipated in the previous section, a second revision of the cycle, with free reinvention of iconographies, influenced the twelfth-century Octateuchs, especially in the sections illustrating the story of Joseph, the first chapters of Exodus, and Judges 11–18. Details of these miniatures in the twelfth-century codices are sometimes not consistent iconographically with other details in the rest of the cycle, and New Testament themes not found in Vat. 747 are also introduced.

Elements inconsistent with the rest of the cycle are found in Joseph Interprets the Dreams of the Butler and Baker in Ser., Sm., and Vat. 746 (figs. 496–498), which duplicates and contradicts details in a previous miniature illustrating the same episode (figs. 492–494). The scene depicted below Joseph Interprets the Dreams, Butler Serves Pharaoh and Baker Hanged, is a mere duplication in abbreviated form of the same episode represented in the following miniature of the manuscripts (figs. 500–502). Ephraim and Manasseh are not required by the text in Jacob Bequeaths the City of Shechem to Joseph (figs. 569–571): the two brothers are mistakenly duplicated from the previous episode of Jacob Blesses Ephraim and Manasseh (figs. 565–567) and do not appear in the corresponding illustration in Vat. 747 (fig. 568). In the Embalming of Jacob the standard iconography portrays the dead patriarch entombed, not embalmed by the Egyptian servants of Joseph as in the text (figs. 582–584; cf. Vat. 747, fig. 581). Single miniatures and whole sequences of miniatures are erroneously depicted twice in Ser. and Vat. 746, a feature which implies a negligent and hasty execution of the codices. For example, the scenes of Moses' Rod Transformed into a Serpent and His Arm Become Leprous and of Moses' Farewell to Jethro are duplicated in Ser. (figs. 615–617). In Vat. 746, the painter depicted Offering Turtledoves or Pigeons (figs. 826, 827) and the Ordination of Aaron and His Sons (figs. 832, 833) in erroneous locations, then rubbed out the two scenes and depicted them again in their proper locations.

Artistic conventions and imprecise links to the text predominate in the miniatures of the story of Joseph. Only trivial details distinguish the episodes of the last hours of Jacob's life (e.g., figs. 561–563, 569–571, 573–575, 577–579); as a rule, groups of figures are repeated unimaginatively in contrast with the more expressive and individually characterized miniatures in Vat. 747 (figs. 560, 568, 572, 576). The same conventions and imprecisions are found in the subsequent gatherings of Exodus and in a few miniatures in Genesis. In the miniature representing the Pond of Eden (figs. 59–62), Vat. 747 has a map of the created earth which is in keeping with the text and with the previous images of the Creation in Vat. 747 as well as in Ser., Sm., and Vat. 746; these latter manuscripts, however, introduce a depiction of a lake with aquatic birds extraneous to the text and reflecting New Testament imagery and imperial symbolism (cf. text figs. 30, 31). A New Testament cycle also provided the model for these three manu-

scripts' representation of the River Jordan in Moses Shown the Promised Land (figs. 1113–1115) and of the group of the child Moses running from Pharaoh's daughter to Pharaoh (figs. 600–602; cf. text figs. 26, 32); this episode of Moses' infancy is not found in the text and Vat. 747 ignores it. Similarly, Vat. 747 opens the cycle of Exodus with Pharaoh Orders the Killing of the Male Firstborn Children of the Hebrews (fig. 595), a scene which follows the Septuagint text (Ex 1:15–16); the other manuscripts replace this scene with a representation of the birth of Moses elaborated like the birth of the Virgin with a sumptuous architectural apparatus, golden vessels, washing basins, and servants, for which the terse account in the Septuagint (Ex 2:2) provides no basis. It is noteworthy, though, that the number and locations of these revised miniatures in Ser., Sm., and Vat. 746 coincide with the corresponding miniatures in Vat. 747.

Judges 11–18 is illustrated by means of two different cycles in the Octateuchs.[101] The two cycles either select different verses to be illustrated or illustrate the same verses with different iconographies. In Vat. 747, Samson carries the gates of Gaza upon his shoulders (fig. 1519), whereas in Vat. 746, he puts them down on the top of a hill (fig. 1520). The composition of Samson Offers a Kid to His Father-in-Law (Judg 5:1) is reversed in Vat. 747 and in Vat. 746 (figs. 1507, 1509), and the same reversal occurs, for example, in the Cutting of Samson's Hair (figs. 1524, 1525) and the Blinding of Samson (figs. 1527, 1528). Vat. 746 and Vat. 747 thus doubtlessly hand down two different cycles of Judges.

The impression is that the cycle preserved by the twelfth-century Octateuchs underwent extensive revision[102] in the Komnenian age and that ready-made iconographies were repeated because of the great number of miniatures the painter was called on to invent. Aesthetic values prevail over iconographic accuracy in the revised miniatures: a courtly, "gothic" atmosphere with elegant details and gentle attitudes of figures replaces the dramatism of the scenes in Vat. 747. If approximately the same date is accepted for the execution of Ser., Sm. and Vat. 746, these three manuscripts may represent the extant testimony of a renewed interest in illustrated editions of the Octateuch under the Komnenian dynasty during the second quarter of the twelfth century.

Was the miniature cycle in the model of Ser., Sm., and Vat. 746 damaged, defective, or partially illegible so as to require an enterprising reintegration of its cycle with newly invented miniatures? Or rather, was the patron of the new edition of the Octateuch dissatisfied with this model and eager to elaborate it with novel iconographies, conforming more to his own aesthetic and courtly taste? Whatever the reasons for the revision of the cycle, the Komnenian edition of the Octateuch presents us with a creative treatment of images which mirrors the artistic attitude evident in the miniatures in the two twelfth-century copies of the Homilies on the Virgin by James of Kokkinobaphos, in Rome

[101] Cf. Lowden, *Octs.*, pp. 57–59.
[102] The list of revised miniatures includes scene nos. 242b, 242c, 243c, 243d–244c, 244d, 463–465, 476–478, 488b–490b, 496b–498b, the re-

maining illustrations of the Joseph cycle from 519 to 594 (the end of Genesis), nos. 612, 613, 616, 617b–619b, 621a–623a, 1480, 1483, 1486, 1488, and the cycle of Samson, nos. 1491–1531.

(Bibl. Vat., cod. gr. 1162) and Paris (Bibl. Nat., cod. gr. 1208).[103] According to recent scholarship, the atelier of the so-called Kokkinobaphos Master was engaged in the production of the twelfth-century Octateuchs. Thus, the reinvented iconographies of the twelfth-century edition of the Octateuch must belong to the Komnenian period, not to an earlier model.

However, the enterprise of the Komnenian revision presents us with further puzzles. The fact that the miniatures illustrating the story of Joseph and the beginning of Exodus in Ser., Sm., and Vat. 746 coincide in number and location in the Greek text with those in Vat. 747 makes us postulate a defective state of the cycle in the manuscript which served as a model for the Komnenian Octateuchs. The iconography of some miniatures in Ser., Sm., and Vat. 746 still correspond partially or completely with those in Vat. 747 (see, e.g., the miniatures of Jacob Bequeaths the City of Shechem to Joseph, figs. 568–571, and Jacob Blesses Ephraim and Manasseh, figs. 564–567), and thus the reinvention of iconography did not affect the entire section of Joseph and the beginning of Exodus.

In contrast, the divergence of the Komnenian Octateuchs from Vat. 747 is nearly complete in the miniatures for Judges 11–18, hinting that illustrations for this section of Judges were absent in the model and that the entire cycle was an invention of the Komnenian edition. Of the three Komnenian Octateuchs only Vat. 746 contains images for Judges 11–18; Ser. has blank spaces for unexecuted miniatures (the locations of these spaces correspond with the miniatures in Vat. 746 and approximately with the miniatures in Vat. 747); and Sm. had no miniatures or blank spaces, according to the reports of the scholars who surveyed the codex before its destruction.[104] In Sm. the cycle resumes with the scene of the Levite Carrying the Corpse of His Concubine (Judg 19:28, fig. 1537); the coincidence of iconography and locations of miniatures between Vat. 747 and the other Octateuchs also resumes with this scene.

It is noteworthy that the locations of the illustrations do not correspond closely to the Greek text in Vat. 747: the Gileadites Defeat the Ephraimites is at Judges 12:4–5 in the text, but the miniature (fig. 1482) is depicted beside Judges 12:8; Manoah's Sacrifice (fig. 1487) is narrated at Judges 13:19–20, but the illustration is located beside Judges 13:11. Differently from Vat. 747, the corresponding miniatures in Vat. 746 illustrate the text beside which they are located: next to Judges 12:8, Vat. 746 has the Burial of Jephthah (fig. 1483) mentioned at Judges 12:7; and beside Judges 13:11, the Meeting of the Angel with Manoah and His Wife (fig. 1488) narrated at Judges 13:11ff. As Lowden has argued, mostly on codicological grounds,[105] Sm. appears to be a more slavish copy of the model of the twelfth-century Octateuchs in which only the Joseph cycle and a few miniatures of Exodus were reinvented. In this model, the cycle illustrating Judges 11–18 must have presented only blank spaces, located approximately beside the verses in the Greek text where we find miniatures in Vat. 747. Sm. did not restore the lacunous cycle of Judges in the model, but copied the text alone; on the other hand, Vat. 746 and Ser. planned to restore the model's cycle completely, and Vat. 746 invented new scenes for Judges that correspond to the verses beside the lacunae in the model.

But since Sm. was not the model of both Ser. and Vat. 746 in the other sections of the Octateuch cycle, and, conversely, the lacunous state of Ser. and the corrupted state of Vat. 746 preclude their having been the model of Sm., no hypothetical stemma of the three Octateuchs with a "vertical" transmission of the cycle from one manuscript to another can be drawn.[106] A more satisfactory explanation of the puzzling relations among the Komnenian Octateuchs lies in the assumption of a "horizontal" transmission of the cycle; a contamination among the codices must be hypothesized. This assumption entails a consequence on our understanding of the procedures of production of the twelfth-century Octateuchs by the group of the Kokkinobaphos Master and his associates: when the production of one of the Komnenian codices was undertaken, both the earlier defective Octateuch that served as a model for most of the cycle and a copy with the revised cycle of Joseph must have been available to the group of painters who worked on the miniatures.

11. THE PARAPHRASE OF THE LETTER OF ARISTEAS

Ser. opens with the paraphrase of the Letter of Aristeas ascribed to Isaac Komnenos, a text that exists in this manuscript alone. The aim of this paraphrase was to render less obscure the story of the translation of the Hebrew Bible into Greek; nevertheless, the paraphrase, which closely follows the Letter, is itself rather obscure. The passages of the paraphrase next to the blank spaces left for miniatures indicate which episodes of the narrative had been selected for illustration: they are the same as those selected for the Letter. Just as the text was a mere imitation of the Letter,

so its miniatures were to have illustrated the same episodes as the Letter, except that originally the Letter had six illustrations and the paraphrase was to have had five. The sixth scene (for which a blank space was not reserved in the paraphrase) was to have been the Temple in Jerusalem, that is, precisely the scene that was cut out of Ser. and is missing in Vat. 747. Thus, when the enterprise of the paraphrase was planned, the model was an edition of the Letter with illustrations, or at least with blank spaces left for illustrations; in this edition, the illustration of the Temple, lost

[103] Anderson, "James the Monk," pp. 78ff.
[104] Cf. the codicological description of the codex in chapter 4; see also Lowden, *Octs.*, pp. 59–60.
[105] Lowden, *Octs.*, pp. 62ff.

[106] The terminology is borrowed from L. D. Reynolds and N. G. Wilson, *Scribes and Scholars: A Guide to the Transmission of Greek and Latin Literature*, 3d ed. (Oxford, 1991), pp. 214–15.

in Ser. and Vat. 747, was presumably missing, an intriguing coincidence which makes doubtful the original pertinence of

the paraphrase to Ser., as a few scholars have suggested on paleographical grounds.[107]

12. THE VATOPEDI OCTATEUCH

Vtp. is an apographon of Vat. 746.[108] The manuscript may be assigned on paleographical and stylistic evidence to the last third of the thirteenth century. The contents of its twelfth-century model were left unchanged by the scribe; unmodified as well are the number of miniatures constituting the cycle and their locations in the Septuagint text, which, as a rule, Vtp. copies faithfully from Vat. 746.[109] The Vtp. painter was only partially content with the miniatures in his model: he labored to introduce contemporary elements of style and iconography into armor and helmets, for instance (e.g., figs. 1192, 1194), thrones and architectural settings (e.g., figs. 1203, 1249, 1316), and manneristic, bulging garments and voluminous figures typical of the Palaiologan period (e.g., figs. 935, 990, 1083, 1164, 1398, 1418, 1481).[110]

In contrast to Ser., Sm., and Vat. 746, the Vtp. painter did not introduce significant substitutions into the cycle, nor did he strive to enrich the iconographic legacy he was handling by incorporating elements from foreign sources (with the exception of the ostrich picture on fol. 28v [fig. 842], which he borrowed from an ornithological treatise such as Dionysos of Philadelphia's

Ornithiaka). The source he did use extensively was the Joshua Rotulus.[111] In addition to the details from the Rotulus, which he found indirectly in Vat. 746, the Vtp. painter went back to the Rotulus itself to collate the miniatures of Vat. 746 with their source.[112] Evidently, this manuscript of the period of the Macedonian dynasty was readily available to him.

The Vtp. painter sketched novel elements from the Rotulus, or redrew others more faithfully (e.g., the soldiers seen from the back in fig. 1203).[113] His reverence for the Rotulus was so great that he sometimes borrowed from its iconography uncritically, e.g., in the Fall of Jericho (fig. 1194) he interpreted the cut between two sheets of parchment in the Rotulus as a division between successive scenes (figs. 1194, 1203)—a type of misunderstanding that had in other cases befallen the painter of Vat. 746 (see section 9 above)—consequently corrupting the cycle with new errors.[114] The Vtp. edition of the Octateuch seems to be a philological restoration of the cycle made with ancient, renowned manuscripts still extant in Constantinople after the Palaiologan reconquest of the capital from the Latins in 1261.[115]

13. PALAIOLOGAN RESTORATIONS

A number of miniatures in the Octateuchs were restored in the Palaiologan period or later; individual interventions are noted singly in the descriptions given in chapter 1. Sometimes the restoration work involved simply new layers of pigment which did not affect the iconographic value of the compositions; at other times the original iconography was lost. In Sm., the restoration work reveals the hand of an ungifted painter (e.g., fig. 876): the details obscured by repaintings can normally be recovered by

means of comparisons with twin manuscripts (e.g., figs. 162, 230). No date can be confidently advanced for these repaintings. A major modification in Sm. was the introduction of a representation of the Creator embracing the created globe at the beginning of the text (fig. 16). This image does not cover any earlier depiction and has been connected to the dedication of the codex in 1259 to a church of St. Nikon in Sparta.[116]

[107] See *Lettre*, ed. Pelletier, p. 11 (where a thirteenth-century date for both paraphrase and Letter is proposed); Kresten, "Oktateuch-Probleme," pp. 508–10.

[108] Lowden, "Vtp. Oct.," pp. 116–18; Lowden, *Octs.*, pp. 38–43.

[109] Instances in which Vtp. relocates miniatures (in comparison with their position in Vat. 746) in order to have them nearer to the corresponding text are examined by Lowden, *Octs.*, pp. 46ff.

[110] At the same time, the painter occasionally emended iconographies by resorting to the Church Fathers' commentaries written in the margins of the Septuagint text, for instance, the Sacrifice of Gideon (fig. 1439); see also Lowden, *Octs.*, pp. 45–53.

[111] For the use of miniatures of the period of the Macedonian dynasty as models for manuscripts contemporary to Vtp., see Buchthal and Belting, *Patronage*, pp. 18–20.

[112] Cf. Weitzmann, *JR*, pp. 36–37.

[113] The considerable dependence of Vtp. on the Joshua Rotulus is discussed in the description of the individual miniatures in chapter 1.

[114] A miniature in the Hamilton Psalter in Berlin (Kupferstichkabinett, cod. 78.A.9), a manuscript ascribed to a Cypriot atelier active around 1300

(Havice, "Marginal Miniatures," pp. 85–88), provides a second testimony to the use of the cycle of the Joshua Rotulus in the Palaiologan period. The iconography of the five kings hanging on gallows in the Berlin manuscript (fol. 228r), an illustration referring to Ps 134:10–11, doubtlessly reveals its derivation from the depiction of the Hanging of the Five Kings (fig. 1284) in the Rotulus (ibid., p. 133 and n. 257; Havice, "Hamilton Ps.," pp. 268–69).

[115] For the use of ancient models during the early Palaiologan period, cf., for example, the case of the Paris Psalter (Bibl. Nat., cod. gr. 139) which served as a model for the Psalters cod. Palat. gr. 381 in the Vatican Library, cod. Taphou 51 in the Library of the Greek Patriarchate in Jerusalem, and cod. 38 in the Monastery of St. Catherine at Mount Sinai; cf. K. Weitzmann, "Eine Pariser-Psalter-Kopie des 13. Jahrhundert auf dem Sinai," *JÖBG* 6 (1957), pp. 125–43; O. Demus, "Die Entstehung des Paläologenstils in der Malerei," in *Berichte zum XI. Internationaler Byzantinisten Kongress* (Munich, 1958), p. 17; H. Belting, "Das Palatina-Psalter des 13. Jahrhunderts," *JÖB* 21 (1972), pp. 17–38; Belting, *Illuminierte Buch*.

[116] See the codicological description of the codex in chapter 4.

Numerous repaintings are encountered in the Genesis cycle in Vat. 747. These restorations have been cogently assigned to the last decade of the thirteenth or the beginning of the fourteenth century on the grounds of their correspondence with the mosaics of the Kariye Camii in Istanbul and other works.[117] The extent of these repaintings seems to exceed previous estimates. In comparison to the restorer who worked on Sm., Vat. 747's painter was faced with a more complex enterprise, and some of the compositions were probably no longer legible. Here and there, he merely had to restore colors and redraw insignificant details (e.g., Adam's beard and the gestures of the expelled couple in fig. 99); elsewhere, he introduced Palaiologan architectural settings (figs. 268, 271) and ornaments (fig. 286). In strips of heaven (figs. 95, 99) the painter added an ornamental row of white vertical segments common in the painted architecture of his age. In other cases he changed minor attributes, such as the rod carried by Moses when he arrives at the shore of the Red Sea (fig. 696).

The unreliability of the Vat. 747 repaintings in terms of their faithfulness to the original emerges in the Adam and Eve sequence, the part of the manuscript, that is, in which the miniatures were presumably seriously damaged and perhaps illegible. Here the restorer was forced to reinvent iconographies; he did not rely on a second available Octateuch while repainting the Vat. 747 miniatures. The second Creation of Man (fig. 63), most of the miniature with the Fall (fig. 83), the Denial of Guilt (fig. 91), and the successive Curses of Adam, Eve, and the Serpent (fig. 95) are inventions of the Palaiologan painter; these scenes therefore cannot be taken into account in a search for the archetypal cycle of the Octateuch. Because the restored pigment has also flaked, the underlying original drawing which outlined the figures in the Fall is clearly visible; the original iconography appears very close to the one seen in the other manuscripts (figs. 84–86).

14. THE LAURENTIAN OCTATEUCH

Like the Vatican Rotulus, the Laurentian codex is a *hapax*. Laurent. is not a catena manuscript: it contains only the text of the Septuagint, from Genesis to Ruth, and its illustration cycle closes with the Mourning after the Expulsion (fig. 5).[118] The dimensions of the codex are smaller than those of the other Octateuchs, but this difference in size cannot be held responsible for the changes in the arrangement of the miniatures; in fact, the difference is equal to the size of the area of parchment on which the catena text is written in the other Octateuchs: in other words, if the catena were cut away from all around the margins of Vat. 747, Ser., or Vat. 746, the physical appearance of these codices would be fairly close to that of Laurent.

The painter of Laurent. elaborated the iconography of his scenes by drawing on a variety of classical motifs. An Aphrodite of the *Venus pudica* type lends her modest pose to Eve addressed by the serpent (fig. 5, second row). The anthology of birds flying in the sky on fol. 3r (fig. 3) is one of the most accurate and diverse in Byzantine art, comparable to that found in the *Ornithiaka* in the Vienna codex of Dioskorides (Nationalbibliothek, cod. med. gr. 1); these birds were certainly copied from an ornithological treatise. In contrast, the rather undetailed fish swimming in the sea depicted in the lower half of the miniature suggest that an ichthyological treatise was not available to the Laurent. painter. But again, the terrestrial and mythological animals on the same fol. 3r and in the Naming of the Animals on fol. 6r (fig. 5, top row) derive from illustrations in a zoological manuscript or a mythological handbook, or from a catalogue of animals like that

found in the pavement mosaic in the Great Palace of Constantinople.

In addition to classical motifs, the painter added other elements to expand and elaborate the narrative of the Fall. For example, he depicted Eve vivaciously coaxing Adam to eat the fruit (fig. 5, second row), a scene that is quite different from the more passive reconstructions found in the other Octateuchs (figs. 84–86). He alone chose to have Eve emerge from the left rather than the right side of Adam (fig. 5, second row), which is an exegetical refinement. He substituted the episodes of the Denial of Guilt by Adam and Eve with a tiny representation of a stork or crane nose-diving from the sky to its nest where its offspring are crying (fig. 5, third row on the far right), thus alluding to the birth of the Virgin, the Annunciation, and the coming of the Savior, who would redeem Adam and Eve from their sin. He also depicted the expelled couple nude (fig. 5, bottom row), instead of clothed in skin garments as the text requires, which is another instance of a deliberate reference to the Church Fathers' exegeses.

The script, written in two columns in gold ink, is the most beautiful of the Octateuchs. The production of the codex was surely financed by a wealthy patron, perhaps one familiar with Christian exegeses and with a vast knowledge of classical culture. The outcome was a manuscript not closely related to the other Octateuchs; its cycle hardly contributes to reconstructing the stemma of the Octateuchs, and its pertinence to the Octateuch iconographic family can barely be accepted.

[117] Hutter, "Übermalungen," pp. 139–47; a list of restored miniatures is given on pp. 141–42.

[118] Both Lowden (*Octs.*, pp. 2, 84) and Iacobini ("Lettera di Aristea,"

p. 92 n. 7) erroneously assert that the cycle ends on fol. 4r with the Creation of Adam.

15. GENERAL STEMMA

A tentative stemma of the editions of the illustrated Octateuch may be proposed here. This stemma summarizes the discussion of the formation and development of the cycle in the above sec-

tions and largely resembles that of the catena on the Octateuch which Petit has drawn (see introduction, page 6 above).

IV. CODICOLOGY, HISTORY, AND STYLE

1. FLORENCE, BIBLIOTECA MEDICEA LAURENZIANA, CODEX PLUTEUS 5.38

THE OCTATEUCH in the Laurentian Library in Florence is a single volume consisting of 342 parchment folios with 13 paper folios added to the beginning and end of the codex (fols. vii+342+vi). Its red leather binding (30 × 22 cm) is engraved with a rinceau of leaves running along the margins and a lozenge-shaped design in the middle. The binding was made for the public opening of the library, on 11 June 1571, and dates from about 1565–70.[1] On the front cover of the binding, in a metal medallion, the words "Biblia βίβλια" are inscribed. The spine is a nineteenth-century restoration. A sheet of paper has been glued to the inside of each of the covers.[2]

The folios measure 29 × 22 cm. The size of the writing area is 23 × 16 cm. The text, written in sepia ink, is arranged in two columns of 31 to 34 lines each. Each line has 14 to 18 letters, and each letter is normally 0.1 to 0.2 cm high, with a maximum height of 0.7 cm. The space between the two columns measures 2 cm, while the margins between the columns and the edges of the parchment measure 2 cm at the top, 4 cm at the bottom, 3.5 cm on the outside, and 2 cm on the inside.

The writing, which hangs from the lines of the ruling pattern, is an eleventh-century Greek minuscule with accents and breathing marks added. Word endings and conjunctions are often abbreviated. The *nomina sacra*, on the other hand, are always abbreviated and indicated by a superscribed line. Initial letters, in gold, are larger and set in the margin outside the writing column. The initial letters of the books of the Octateuch are 2.2 to 3.5 cm high and are ornamented with a scrolled rinceau of leaves. The initial letters of the chapters are 1.0 to 2.5 cm high and have no ornamentation. On fol. 2r there is an ornamental headpiece for the Book of Genesis.

The volume has been trimmed and restored. In a few places the parchment is stained and has small holes. In the upper outside corners are stains caused by dampness which have effaced some of the titles and chapter numbers. The damaged corners of fols. 41–63 and 96–325 have been restored, and part of the Greek text has been rewritten in different ink.[3]

The codex contains the Septuagint text of Genesis to Ruth: fols. 2r–68v, Genesis; fols. 69r–123v, Exodus; fols. 124r–165v, Leviticus; fols. 165v–222v, Numbers; fols. 223r–271v, Deuteronomy; fols. 272r–304v, Joshua; fols. 305r–337v, Judges; fols. 338r–342r, Ruth.

Fol. 1v has a full-page miniature illustrating the first days of the Creation (fig. 1). Frames divide the miniature into five scenes arranged in three rows. Four successive miniatures are inserted in the text (on fols. 2v, 3r, 4r) (figs. 2–4), while a final, large miniature, arranged in four strips of different heights, occupies the whole of fol. 6r, except for two lines of text at the top (fig. 5).

The manuscript is numbered with Arabic numerals in the top outer corners. On a few folios, traces of older Arabic numerals can be seen in the lower right-hand corner. The upper corner numerals were written before the codex was trimmed and do not correspond to the lower ones: fol. 4, however, is the same in the two series, but fol. 299 above is marked 300 below; fol. 334 above is marked 335 below; and fol. 338 above is marked 339 below, and so on to the end of the codex. An examination of the gatherings indicates that none of the folios is missing. The numbering of the folios in Bandini's description, written in 1764, does not entirely correspond to what we have at present; for example, in Bandini's catalogue the incipit of the Book of Joshua is on fol. 269, whereas with the modern numbering it is on fol. 272r; Bandini reports that the Book of Judges begins on fol. 302, but it now begins on fol. 305r; and the Book of Ruth, for Bandini, begins on fol. 335, but with the modern numbering it begins on fol. 338r.[4]

The chapters are numbered in gold in the margins of the text. In addition, at the beginning of each book the total number of the folios of the book is written in Greek by a later hand; this number coincides with the number of folios still in each book of the Bible. In the top and bottom margins of the first folio of each book a summary of its contents is written in gold.

One fine feature of the manuscript is the decorative treatment of the final verses of some of the books: the last lines of Exodus (fol. 123v), Leviticus (fol. 165v), Numbers (fol. 222v), Joshua (fol. 304v), and Ruth (fol. 342r) are arranged in figure patterns.

Fol. 1r contains a fifteenth-century list of the Latin titles of the eight books. The codex has three different signatures: N 400, N 318, and N 38 (the first two are crossed out with a line). The signature 318 is repeated on fols. 2r and 342v. Fol. 342v, which is badly damaged, contains a prayer, a list of months, and a note in a fourteenth-century Greek minuscule; the note mentions an unknown reader whose name was John.

At present, the codex is composed of 13 added folios (at the beginning, i–iii paper and iv–vii vellum; at the end, 343–345

[1] According to Bandini, Cosimo I had all the codices in the *plutei* rebound for the opening of the library (A. M. Bandini, *Dei Principi e Progressi della Real Biblioteca Mediceo Laurenziana [Ms. Laur. Acquisti e Doni, 142]*, ed. R. Pintaudi, M. Tesi, and A. Fantoni [Florence, 1990], p. 69); see also *La Biblioteca Medicea-Laurenziana nel secolo della sua apertura al pubblico (11 giugno 1571)* [Florence, 1971], p. 7.

[2] On the paper sheet glued to the inside of the front cover, in the lower left-hand corner, a few block letters are inscribed: B, N, N can be read.

[3] Sepia ink was used on fols. 76–97 and fols. 106–111; a darker ink on fols. 29–75 and fols. 111–270. The rewriting and restoration did not occur simultaneously: on fols. 253 and 237 the piece of parchment used to restore the upper corner covers the rewritten text, whereas on fol. 243 the text was rewritten on the added triangle of parchment.

[4] A. M. Bandini, *Catalogus Codicum Manuscriptorum Bibliothecae Mediceae Laurentianae*, vol. 1, *Varia Continens Opera Graecorum Patrum* (Florence, 1764; reprint Leipzig, 1961), pp. 69–70.

vellum and 346–348 paper), 1 single leaf, 1 binion, 2 ternions, 40 quaternions, and 2 incomplete quinions. The gatherings are arranged as follows:

fols. i–vii (added folios); 1–2 (single leaf); 3–6 (binion); 7–15 (incomplete quinion: fol. 7 was added to the quaternion 8–15); 16–23 (quaternion); 24–31 (quaternion); 32–39 (quaternion); 40–47 (quaternion); 48–55 (quaternion); 56–63 (quaternion); 64–71 (quaternion); 72–79 (quaternion); 80–87 (quaternion); 88–95 (quaternion); 96–103 (quaternion); 104–111 (quaternion); 112–119 (quaternion); 120–127 (quaternion); 128–135 (quaternion); 136–143 (quaternion); 144–151 (quaternion); 152–159 (quaternion); 160–167 (quaternion); 168–175 (quaternion); 176–183 (quaternion); 184–191 (quaternion); 192–199 (quaternion); 200–207 (quaternion); 208–215 (quaternion); 216–223 (quaternion); 224–231 (quaternion); 232–239 (quaternion); 240–247 (quaternion); 248–255 (quaternion); 256–263 (quaternion); 264–271 (quaternion); 272–279 (quaternion); 280–287 (quaternion); 288–295 (quaternion); 296–303 (quaternion); 304–311 (quaternion); 312–319 (quaternion); 320–327 (quaternion); 328–336 (incomplete quinion: fol. 336 was added to the quaternion 328–335); 337–342 (ternion); 343–348 (added folios).

During a restoration, a leaf was glued onto fol. 1r. This leaf bears a horn-shaped watermark, a design used in Florence between 1398 and 1427.[5] The Laurentian manuscripts plut. 5.38 and plut. 10.8 (a Book of Prophets) were used to complete the edition of the Septuagint commissioned by Pope Sixtus V and published in 1586.[6]

All the illuminations in the manuscript were executed by the same painter, who drew landscape, vegetation, and animals with extraordinary care. The landscapes are composed of rows of hills whose peaks are diversely colored in yellowish brown, green, and pink. As a rule, the painter avoided black outlines when modeling figures. Lines are used to separate human figures from the background, or outlines are suggested through the use of tiny patches of color. Color is applied impressionistically (see color fig. 1); the use of brownish watercolor tones for flesh creates naturalistic tones of light and shade on Adam and Eve's naked bodies. This technique endows the figures with a corporeality enhanced by their natural poses. The figures' classical manner is also evident in the use of ancient models for Eve tempted by the serpent and the sleeping Adam in the Creation of Eve (fig. 5).[7]

The painter was trained in the art of the Macedonian period, and his figures are indebted to those depicted in illuminated manuscripts produced in the last phase of the reign of Basil II (976–1025), such as the Gospels in Paris, Bibl. Nat., cod. gr. 64 (text fig. 44).[8] The minute depiction of plants and animals in Laurent. likewise has its parallel in the vignettes above the arcades of the canon tables in the Paris Gospels and in the Gospel Lectionary in Parma, Biblioteca Palatina, cod. Palat. 6, a codex that probably dates from the end of the eleventh century.[9] The impressionistic colors of Laurent. may be found in other Constantinopolitan luxury codices produced ca. 1000, such as the lectionary in the Monastery of St. Catherine at Mount Sinai, cod. 204. The absence of the linear quality common in the art of the second half of the eleventh century prevents any proposal of a date for Laurent. later than the middle of the century.

2. ROME, BIBLIOTECA APOSTOLICA VATICANA,
CODEX VATICANUS GRAECUS 747

The Octateuch Vat. gr. 747 (*olim* 479)[10] is a one-volume codex of 260 numbered parchment folios and 2 unnumbered sheets of paper without watermarks, one added to the beginning and one to the end of the codex. An inscribed gold geometric pattern runs all along the border of the brown leather binding, which measures 38 × 28 cm. Delicate floral ornaments are engraved on the spine. At the top of the spine is a label with the inscription "Vat. gr. 747" and the coats of arms of Pope Pius IX and the prefect of the Vatican Library, Angelo Mai.[11]

The parchment is fairly well preserved except for a few holes, stains caused by dampness, and seams. The margins have been trimmed. The folios measure circa 36.0 × 27.5 cm; the size of the writing area is 29.5 × 21.0 cm (Letter of Aristeas) or 33.0 × 23.0 cm (Septuagint). The text is arranged in one column except for the epilogues on fols. 259r and 260v, which are in two columns. The ink is dark sepia, but initial letters, titles, marginal notes, the names of authors in the catena, and chapter numbers are in carmine. Different ruling patterns are used in the manuscript.[12] The Septuagint text is written alternately either above or below the ruled lines and has 39 to 47 written lines; the Letter of Aristeas has 48 lines, and the catena 72 to 77. On the average, the Letter, the Septuagint, and the catena have, respectively, 65, 65, and 115 letters per line, while the letters are, respectively, 0.1 to 0.5 cm, 0.1 to 0.6 cm, and 0.1 to 0.3 cm high. In the Letter, the margins between the writing area and the edges of the parchment are 1.5 to 2 cm at the top, 4.5 cm at the bottom, 4 to 4.5 cm on the

[5] C. M. Briquet, *Les filigranes: Dictionnaire historique des marques du papier des leur apparition vers 1282 jusqu'en 1600* (Paris and Geneva, 1907), vol. 2, nos. 7676, 7690; V. Mošin and A. Traljić, *Filigranes des XIIIᵉ et XIVᵉ siècles* (Zagreb, 1957), vol. 1, no. 5019.

[6] P. Batiffol, *La Vatican de Paul III à Paul V d'après des documents nouveaux* (Paris, 1890), pp. 90–91.

[7] See chapter 3, section 14.

[8] Lazarev, *Storia*, figs. 139–42; Ebersolt, *Min. byz.*, pls. 42, 43.

[9] Lazarev, *Storia*, figs. 240–244; A. Cutler and J. W. Nesbitt, *L'arte bizantina e il suo pubblico* (Turin, 1986), pp. 171–75.

[10] Devreesse, *Vat. Cod. Manuscripti*, p. 263.

[11] Ibid., p. 263.

[12] Lowden, *Octs.*, p. 12 and appendix 2, p. 130.

outside, and 2.5 to 3.2 cm on the inside; in the Octateuch, they are (in the same order) 1.5 to 2 cm, 1.5 to 2.5 cm, 1.5 to 2.5 cm, and 3.5 to 4.5 cm.

The manuscript was written by one hand in an eleventh-century Greek minuscule,[13] with accents and breathing marks added. Word endings, conjunctions, and articles are often abbreviated; the *nomina sacra* are always abbreviated and indicated by a superscribed line. The initial letters, in carmine, are larger and placed in the margin outside the writing area. They have no ornamentation. The title of each book is in carmine uncials.

The Octateuch Vat. gr. 747 contains the Letter of Aristeas, fols. 1r–11v; Theodoret of Cyrrhus, *Theodoretus ad Hypatium* (*In loca difficilia scripturae sacrae quaestiones selectae, praefatio*),[14] namely, the preface of Theodoret to his *Quaestiones in Octateuchum*, fol. 12r (fol. 12v has been left blank); Genesis and catena on Genesis, fols. 13r–71v; Exodus and catena on Exodus, fols. 72r–122v; Leviticus and catena on Leviticus, fols. 123r–146v (fols. 147r and 147v are blank; the ruling pattern and parchment are different); Numbers and catena on Numbers, fols. 152r–186v; Deuteronomy and catena on Deuteronomy, fols. 187r–191v, 148r–151v, 192r–215r; Joshua and catena on Joshua, fols. 215v–236v; Judges and catena on Judges, fols. 237r–255v; Ruth and catena on Ruth, fols. 256r–259r; Joseppus Christianus, *Libellus memorialis in Vetus et Novum Testamentum*, chapter 122: "On the Translations of the Scriptures from Hebrew into Greek," fols. 259r–260r;[15] Joseppus Christianus, *Libellus memorialis in Vetus et Novum Testamentum*, chapter 124: "On the Seven Exiles of the Hebrews,"[16] fol. 260r; *epilogus:* "On the Obscurity of the Scriptures," fols. 260r–260v;[17] *epilogus:* "On the Ten Names of God," fol. 260v.[18]

Vat. gr. 747 has the following lacunae: Letter of Aristeas 59–107 (a folio is missing between fols. 3 and 4); Exodus 37:6–38:20 (a folio is missing between fols. 120 and 121); Leviticus 4:34–5:21 (a folio is missing between fols. 126 and 127); Leviticus 23:27–Numbers 3:13 (there is a lacuna between fols. 147 and 152); Numbers 34:29–Deuteronomy 1:3 (there is a lacuna between fols. 186 and 187); Deuteronomy 9:2–12:13 (a folio is missing before fol. 192); and Judges 1:1–24 (a folio is missing between fols. 236 and 237).

The manuscript has 367 miniatures.

The folios are numbered in Arabic in the upper right-hand corner. The quires were originally numbered both at the beginning and end; due to trimming, this numbering is preserved in only a few cases (e.g., fols. 21r and 138v).

On fol. 71v, the total number of *stichoi* in Genesis is given (that is, 4308), and on fol. 122v, those of Exodus (4400). Geometric headpieces (text fig. 45) are placed at the beginning of each book; at the ends of various books and chapters, the text is arranged in ornamental patterns.

The manuscript is composed of 2 added sheets of paper, 2 single leaves (fols. 190 and 191) bound with incomplete quaternions, 1 ternion, and 33 quaternions. The gatherings are arranged as follows:

fols. 1–6 (incomplete quaternion); 7–12 (ternion); 13–20 (quaternion); 21–28 (quaternion); 29–36 (quaternion); 37–44 (quaternion); 45–52 (quaternion); 53–60 (quaternion); 61–68 (quaternion); 69–76 (quaternion); 77–84 (quaternion); 85–92 (quaternion); 93–100 (quaternion); 101–108 (quaternion); 109–116 (quaternion); 117–123 (incomplete quaternion); 124–130 (incomplete quaternion); 131–138 (quaternion); 139–146 (quaternion); 147–151 (incomplete quaternion: the outer binion is missing; fol. 147, which is blank, has been added); 152–159 (quaternion); 160–167 (quaternion); 168–175 (quaternion); 176–183 (quaternion); 184–190 (incomplete quaternion: the central bifolio is missing; fol. 190 added); 191–198 (incomplete quaternion with fol. 191 added); 199–206 (quaternion); 207–214 (quaternion); 215–222 (quaternion); 223–230 (quaternion); 231–237 (incomplete quaternion); 238–245 (quaternion); 246–253 (quaternion); 254–260 (incomplete quaternion).

Fols. 148–151, bound together with fol. 147, are misplaced: they contain Deuteronomy 4:41–9:2 and should have been placed after fol. 191. Furthermore, a lacuna occurs in the text of Deuteronomy from 9:2 to 12:3, corresponding to the end of fol. 151v and the beginning of fol. 192r.

Since 1481, the manuscript has been in the inventory of the Vatican Library, together with Vat. gr. 746.[19] Possibly in the fifteenth century, Vat. 747 and Vat. 746 were consulted for the preparation of the frescoes of biblical scenes in the lower rows of the Sistine Chapel, providing details especially for the Moses cycle.[20] They were used again as a consequence of the collapse of a section of the interior surface of the dome of the Baptistry of San Giovanni in Florence in 1819, and the subsequent need to restore the destroyed mosaics. The first restoration was completed by Luigi Ademollo in 1823. A second restoration was planned in 1898, and in 1906 Arturo Viligiardi drew on the two Vatican Octateuchs to prepare three cartoons—Lamech Killing Cain, The Lord Commanding Noah to Build the Ark, and The Building of the Ark—for replacements of the lost mosaics.[21]

Miniatures in different books of the Octateuch reveal identical drawing and coloring techniques, suggesting that one painter

[13] "Letter," ed. Thackeray, p. 504; Rahlfs, *Verzeichnis*, p. 255; Devreesse, *Vat. Cod. Manuscripti*, 263; *Lettre*, ed. Pelletier, p. 8; *Catenae Graecae*, vol. 2, *Collectio Coisliniana*, ed. Petit, p. xcv.

[14] PG 80, col. 76.

[15] PG 106, cols. 125–26, n. 45. See also Athanasios of Alexandria (*Dubia: Synopsis Sacrae Scripturae; PG 28, cols. 433–36) and Theodoret of Cyrrhus (*Ioann. Garnerii Auctarium ad Opera Theodoreti, ad Tomum Primum*, PG 84, cols. 28–32). See also Karo and Lietzmann, *Catalogus*, p. 10, *epilogus* no. 1.

[16] PG 106, col. 128; Karo and Lietzmann, *Catalogus*, p. 10, *epilogus* no. 2.

[17] Karo and Lietzmann, *Catalogus*, p. 10, *epilogus* no. 3.

[18] Karo and Lietzmann, *Catalogus*, p. 10, *epilogus* no. 4.

[19] Devreesse, *Fonds grec*, pp. 82, 122, 178, and passim.

[20] Ettlinger, *Sistine Chapel*, p. 50 and passim.

[21] Cf. L. Ponticelli, "I restauri ai mosaici del Battistero di Firenze," *Commentari* 1 (1950), pp. 187–89, and 2 (1951), pp. 52–53. For the figure of Moses in the scene of God Commanding Noah, for example, the restorer drew on details from both manuscripts. A connection between the Vatican Octateuchs and the Florentine mosaics was noticed by Hueck, *Kuppelmosaiken*, pp. 23, 134. The dependence of the cartoons on the miniatures has recently been asserted by Lowden, *Octs.*, p. 101.

was responsible for the whole cycle. The painter limited black outlines to a few traces marking parts of limbs or borders of clothing; the figures are shaped in broad spatial planes with areas of color applied in a purely impressionistic manner (color figs. 3, 5, 8, 10, 16, 18). Bodies always display corporeal volume and an organic quality, and contrasting areas of light and shading stress their plasticity. The figures move freely in space and assume dynamic, contorted poses. In a few miniatures in Genesis, the painter depicted a background of fantastic mountainous landscape drawn in rough outline and painted in variegated colors with an impressionistic technique; here and there, buildings and single architectural units are set among the peaks (figs. 245, 415, 515), alternating at times with landscape elements (fig. 245). This representation of landscape derives from the Hellenistic tradition and can be found in Early Christian miniatures, for example, in the sixth-century Vienna Genesis (Vienna, Österreichische Nationalbibliothek, cod. theol. gr. 31),[22] a codex which comes from the Syrian region.[23] In the rest of the cycle, the painter rendered landscapes in a more naturalistic fashion (e.g., fig. 1212) or filled the background with three bands of color, normally blue and gold; on the gold band, tree trunks may float in the air (e.g., figs. 423, 455, 614, 790, 1069, 1074, 1079).

Expressiveness is a constant in the style of Vat. 747, which echoes Syrian art of the sixth and seventh centuries.[24] A wide range of expressions and feelings is rendered dramatically in Vat. 747: rage or reproach (Jacob in fig. 572), sorrow (Rachel in fig. 447, Jacob in fig. 475), amazement (Jacob in fig. 536, Manoah's wife in fig. 1487), tension and concentration in conversations or glances (the messengers in fig. 9, Rachel and Leah in fig. 415), intense spirituality (Moses in figs. 611 and 799, Noah and his family in fig. 147), violence (fig. 865), reverence (Abraham in fig. 249), and dynamism and excitement (Potiphar's wife in fig. 491, the dancers in fig. 708).

The plasticity, classical models, and vivid gestures of Vat. 747's figures correspond to the style of Constantinopolitan manuscripts of the 1070s.[25] These stylistic elements suggest in particular an affinity of Vat. 747's painter to the workshop that executed the miniatures in the Psalter cod. 48 in St. Catherine's Monastery on Mount Sinai, from the year 1074.[26] In the Sinai Psalter, the figures of Christ confronting adversaries (fol. 39r) (text fig. 47), the man pulling a thorn from his foot (fol. 34v), and Samuel anointing David (fol. 28r) find parallels in miniatures of Vat. 747, for instance, the prophet and the mourning Israelites in the Prophet Reproaches the Israelites (fig. 1432).[27]

Stylistic correspondences may be found in other manuscripts dating from the 1070s, such as the Gospels in the Public Library of St. Petersburg, cod. gr. 72 (A.D. 1071);[28] the Praxapostolos and Apocalypse in the Gorgii Biblioteka in Moscow, cod. 2280 (Constantinople, A.D. 1072);[29] the Gospels in the Nationalbibliothek in Vienna, cod. theol. gr. 154 (ca. 1070–80);[30] the Gospels in the National Library in Athens, cod. gr. 57 (attributed to the third quarter of the eleventh century);[31] and the Homilies of John Chrysostom in Paris, Bibliothèque Nationale, cod. Coislin 79. In the manuscript in Athens, the evangelists Matthew (fol. 15v, text fig. 48) and John (fol. 265r) closely resemble figures in Vat. 747, such as Eleazar (fig. 9), Theodoret and Hypatios (fig. 13), and sitting patriarchs such as Jacob sending Joseph to his brothers (fig. 466). The portrait of Michael VII Doukas (ruled 1071–78), in the Paris Chrysostom (fol. 2r, text fig. 39), has features recalling those of Ptolemy in Vat. 747;[32] and the compositional scheme of the monk Sabas approaching the emperor (fol. 1r, text fig. 49) mirrors the neighboring scenes of Demetrios of Phaleron Draws Up the Memorandum and Ptolemy Sends a Letter to Eleazar (fig. 6).[33] At the same time, the modeling, shading, and physiognomy of Sabas and Michael VII correspond to those of Demetrios and Ptolemy in Vat. 747. Michael VII Doukas, the emperor origi-

[22] For instance, pict. 45 (Gerstinger, *Wiener Gen.*, pict. 45). Similarities with the Vienna Genesis were noticed by Kondakov (*Histoire*, vol. 2, p. 77). Tikkanen (*Farbengebung*, pp. 119–20) stressed the Hellenistic character of the landscapes, which recently Lowden (*Octs.*, p. 94) has again connected to the Vienna Genesis.

[23] Fillwitz, "Wiener Genesis," pp. 44–46; H. Hunger and O. Kresten, *Katalog der griechischen Handschriften der österreichischen Nationalbibliothek*, vol. 3, pt. 1, *Codices theologici 1–100* (Vienna, 1976), pp. 52–55; G. Cavallo, "La circolazione libraria nell'età di Giustiniano," in *L'imperatore Giustiniano: Storia e mito*, ed. G. G. Archi (Milan, 1978), note 189 on pp. 228–29 and the preliminary note on p. 201.

[24] See, for instance, the Communion of Apostles on fols. 3v and 4r and the group of people in the Raising of Lazarus on fol. 1r in the Gospels in the cathedral of Rossano Calabro, dating from the sixth to the early seventh century (*Codex Purpureus Rossanensis, Commentarium*, ed. G. Cavallo, W. C. Loerke, and J. Gribomont [Rome and Graz, 1987]; for the dating see Cavallo, p. 7, and Loerke, pp. 165–66; M. Rotili, *Il codice purpureo di Rossano* [Cava dei Tirreni, 1980]); and the silver patens of Riha and Stuma (dating from A.D. 575–78), discovered near Mastume, north of Apamea (see *Age of Spirituality*, pp. 611–12, no. 547, colorpl. XVI, fig. 82; M. Mundell Mango, "Where Was Beth Zagba?" in *Okeanos: Essays Presented to Ihor Ševčenko* [Harvard Ukrainian Studies 7], ed. C. Mango and O. Pritsak [Cambridge, Mass., 1983], pp. 421, 424; ead., *Silver from Early Byzantium: The Kaper Koraon and Related Treasures* [Baltimore, 1986], pp. 159–70).

[25] Cf. Kresten, "Oktateuch-probleme," p. 506 n. 25.

[26] Weitzmann and Galavaris, *Sinai Greek Mss.*, pp. 83–87, figs. 232–68. For a different view, stressing the stylistic analogies between Vat. 747 and Vat. gr. 394 (and related codices such as the Gospels in Paris, Bibl. Nat., cod. gr. 74, and the Theodore Psalter in London, Brit. Lib., cod. Add. 19.352), see Lowden, *Octs.*, p. 14.

[27] The painter of the Sinai Psalter, however, uses more detailed drawing for the human figures than does Vat. 747.

[28] Spatharakis, *Corpus*, figs. 133, 134; Lazarev, *Istoriia*, 2d ed., figs. 215–20.

[29] Spatharakis, *Corpus*, pp. 29–30, figs. 166–68.

[30] Gerstinger, *Griech. Buchmalerei*, pls. 12, 14a; P. Buberl and H. Gerstinger, *Die byzantinischen Handschriften*, vol. 2, *Die Handschriften des X.–XVIII. Jahrhunderts* (Die illuminierte Handschriften und Inkunabeln der Nationalbibliothek in Wien, pt. 4, no. 4) (Leipzig, 1938), pl. 8 nos. 1, 2, pl. 9 nos. 1, 2; Lazarev, *Istoriia*, figs. 196–201.

[31] P. Buberl, *Die Miniaturenhandschriften der Nationalbibliothek in Athen* (Vienna, 1917), pp. 9–12, pls. 9–12, figs. 19–28; A. Delatte, *Les manuscrits à miniatures et à ornements des bibliothèques d'Athènes* (Liége, 1926), pp. 8–11, pls. 2–4; A. Marava-Chatzinikolaou and C. Toufexi-Paschou, *Catalogue of the Illuminated Byzantine Manuscripts of the National Library of Greece*, vol. 1, *Manuscripts of New Testament Texts, Tenth–Twelfth Century* (Athens, 1978), pp. 108–17, figs. 216–19.

[32] Spatharakis, *Portrait*, pp. 107–8, figs. 69–73.

[33] Cf. Iacobini, "Lettera," p. 80.

nally portrayed in the Paris Chrysostom[34] also commissioned the Moscow Praxapostolos and Apocalypse codex;[35] hence Ptolemy in Vat. 747 might actually represent Michael VII Doukas, and the execution of Vat. 747 might be connected with an imperial milieu and dated between 1071 and 1078.[36]

Restoration work, in some cases extensive or total, affected a few miniatures in Genesis (see the description of individual miniatures in chapter 1). This restoration was executed by a Palaiologan hand, probably in the 1290s.[37]

3. ISTANBUL, TOPKAPI SARAYI LIBRARY, CODEX G. I. 8

The Seraglio Octateuch is preserved in the library of the Seraglio Museum and is marked G. I. 8 (Gayri Islâmi 8). At present, it is a three-volume codex of 570 numbered parchment folios and 6 added paper folios, one at the beginning and one at the end of each volume. The paper folios were added in this century when the manuscript was restored and have no numbering; they each have a watermark with the initials AHF (A is superscribed) or, alternatively, a baroque coat of arms with a crown on the top and three stars in the center.

One unbound parchment bifolio, heavily damaged, with various holes and with its outer margins lost, precedes the text; the first folio is marked 1 in pencil in the middle; the second folio has no visible numbering. Both of them show traces of Greek letters. At the end of the manuscript a single, unbound parchment leaf, seriously damaged, is numbered 570 in pencil; it too shows traces of Greek letters and the faint outline of a geometric design.

The three volumes have identical black leather bindings (measuring 44.5 × 32.5 cm), somewhat damaged at the spines.

Until the late 1930s, the manuscript lay unrestored and did not have the black leather binding: the loose gatherings were wrapped in yellow silk cloth and only the wooden back cover survived.[38] The state of the manuscript before restoration can be seen in the photographs published by Uspenskii (text fig. 50).

In the 1930s, Princeton University planned to photograph the manuscript for a corpus of illustrations of the Old and New Testaments in Greek manuscripts. After joining Morey in this project, Weitzmann went to Istanbul to do the photographic work. There, the Seraglio Library gave its approval on the condition that the manuscript be restored and photographed at Princeton University's expense.[39] Morey strove to raise the money necessary for the restoration, approximately one thousand dollars, a sum

which appeared huge indeed to Morey himself.[40] Finally, it was agreed that Hugo Ibscher from Berlin, a well-known papyrus restorer, be sent to Istanbul. In 1939 Ibscher restored the manuscript page by page and had it bound in the modern, black leather bindings.

On almost every page the top and bottom margins have been restored. Small holes and stains caused by dampness are visible everywhere. On a few folios (146, 548, 554, 555, 556, 561) strips of parchment have been cut off below the last horizontal line of the ruling pattern.

The folios measure 42 × 31 cm. The size of the writing area is approximately 34 × 23 cm. The text, arranged in one column, is written in sepia ink, but the paraphrase of the Letter of Aristeas is in darker sepia ink. The ruling pattern has either 52 or 53 lines.[41] The paraphrase is written after each two lines of text (26 written lines per page), whereas the Letter of Aristeas has 53 written lines, and the catena on the Octateuch varies greatly, depending upon the text of each page: a page with only the Septuagint text has 35 or 36 written lines, but a page combining Septuagint and catena has 52 or 53 written lines.

Normally, each line has 43 (paraphrase), 55 (Letter of Aristeas), 45 (Septuagint), or 50 (catena) letters. Single letters in the respective texts are 0.4 to 1.0 cm, 0.2 to 0.5 cm, 0.3 to 0.8 cm, and 0.2 to 0.8 cm high. The margins between the writing area and the edges of the parchment are approximately 3.5 cm at the top, 4.5 cm at the bottom, 4.5 cm on the outside, and 3.0 cm on the inside.

The manuscript was written by a "scholarly hand" in a twelfth-century Greek minuscule with accents and breathing marks added.[42] The script of the paraphrase is larger and roundish and was written by a hand different from that of the Letter and the

[34] H. Omont, *Miniatures des plus anciens manuscrits grecs de la Bibliothèque Nationale du VIᵉ au XIVᵉ siècle* (Paris, 1929), pp. 32–34, pls. LXI–LXIV bis; Spatharakis, *Portrait*, pp. 107–8; Spatharakis, *Corpus*, figs. 173, 174; Lazarev, *Storia*, pp. 189–90.

[35] Spatharakis, *Corpus*, p. 30.

[36] A similar date, around A.D. 1075, is proposed by Lowden, *Octs.*, p. 14.

[37] Hutter, "Übermalungen," pp. 139ff., esp. p. 146.

[38] Deissmann, *Serai*, p. 46, assumes that the front cover had precious ornamentation and may have been taken away or stolen on account of its value (p. 52).

[39] Dr. Arid Müfid, of the Seraglio Library, wrote in a letter dated 20 June 1935, "le codex étant fort endommagé par l'humidité, toute manipulation serait impossible avant une restauration complète." Müfid signed the letter as Directeur-Adjoint of the Musées des Antiquités d'Istanbul; the letter is preserved in the Morey archives of the Seeley G. Mudd Library at Princeton University.

[40] In a letter to Weitzmann dated 16 November 1936, now in the Mudd Library in Princeton, Morey writes: "We are endeavoring to raise the money for the restoration of the Saray manuscript since it seems that they will not do anything unless they can hold us up for the $1000 for the restoration. This is the most expensive piece of research that I ever heard of, and it is made worse by the fact that the photographing will have to be done *before*, not after the restoration. If I were you I would worry no more about it, but ask Meibohm if he would be willing to go to Constantinople at some date, perhaps next term, to make the photographs if we succeed in arriving at a satisfactory arrangment."

[41] On the ruling pattern of Ser. and the utilization in other codices of ruled parchment folios possibly prepared for Ser., see Anderson, "Twelfth-Century Instance," pp. 207–16; Lowden, *Octs.*, p. 22 and appendix 2, p. 131.

[42] For an analysis of the handwriting, see Anderson, "Seraglio," pp. 95–96; and Weyl Carr, *Byz. Illum.*, pp. 135–36.

Septuagint.[43] Word endings, conjunctions, and articles are often abbreviated; the *nomina sacra* are always abbreviated and indicated by a superscribed line. Initial letters are in carmine ink (none of the initial letters in the paraphrase, except in the title, are given prominence); they are larger and located in the margin outside the writing area. They have no ornamentation. Their heights are 1.0 to 2.0 cm (Letter), 0.8 to 1.9 cm (Septuagint), and 0.4 to 1.2 cm (catena). The title of each book is in carmine uncials. Along the margins of the Letter and the Octateuch, one or more later hands have added notes and amendments to the text.

The three present volumes of the manuscript contain, respectively, fols. 1–190, 191–379, and 380–570. None of the leaves is missing from the manuscript. Ser. contains the paraphrase of the Letter of Aristeas ascribed to Isaac Komnenos, fols. 3r–9v; the Letter of Aristeas, fols. 10r–22r;[44] Theodoret of Cyrrhus, *Theodoretus ad Hypatium* (*In loca difficilia scripturae sacrae quaestiones selectae, praefatio*), fol. 22v;[45] Genesis and catena on Genesis, fols. 23r–155r; Exodus and catena on Exodus, fols. 155v–265r; Leviticus and catena on Leviticus, fols. 265v–315v; Numbers, fols. 316r–390r and catena on Numbers, fols. 316r–390v; catena on Deuteronomy, fols. 391r–471v; Deuteronomy, fols. 391v–471r; Theodoret of Cyrrhus, *Quaestiones in Josuam*, fols. 471v–472r;[46] Joshua and catena on Joshua, fols. 472r–512r; Judges and catena on Judges, fols. 512v–559r; Ruth and catena on Ruth, fols. 559v–566v; Joseppus Christianus, *Libellus memorialis in Vetus et Novum Testamentum*, chapter 122: "On the Translations of the Scriptures from Hebrew into Greek," fols. 566v–568r;[47] Joseppus Christianus, *Libellus memorialis in Vetus et Novum Testamentum*, chapter 124: "On the Seven Exiles of the Hebrews," fols. 568r–568v;[48] *epilogus:* "On the Obscurity of the Scriptures," fol. 569r;[49] *epilogus:* "On the Ten Names of God," fols. 569r–569v.[50]

The manuscript has 352 miniatures; 2 other miniatures (fols. 13v and 339r) have been cut out; 89 blank spaces were left for miniatures that were never executed: namely, all the miniatures intended for the paraphrase on fols. 4r, 4v, 5v, 7r, and 8r; the miniatures on fols. 12v, 16v, and 17r in the Letter of Aristeas; and the miniatures on fols. 71r–86v, 111r–118v, and 500r–564r in the Octateuch (see chap. 1).

The manuscript has two sets of corresponding numbering in Arabic in the top margin; one is written in ink, one in pencil.

The ink numbering breaks off at 569; the pencil numbering stops at 570 (the back parchment flyleaf). However, on fol. 569v a possibly later hand has written in Greek minuscule that the total number of folios is 568.[51]

The chapters are numbered along the margins in carmine ink. On fol. 155r, the total number of the *stichoi* of Genesis (that is, 4308) is recorded; on fol. 265r, the number of those of Exodus (3400); and on fol. 315v, those of Leviticus (2700). The last lines of the Letter of Aristeas (fol. 22r), *Theodoretus ad Hypatium* (fol. 22v), Numbers (fol. 390v), and Joshua (fol. 512r) are arranged in the form of a cross.

At the bottom of fol. 1r, in blue pencil, there is an inscription: "Nummer 8." A small sheet of paper is glued to the middle of fol. 2v with an inscription in dark ink: "N. 8 Mss grec parchemin XIII siècle. Chaîne des Pères sur l'ancien Testament avec un très grand nombre de miniatures." An Arabic inscription follows. A second Arabic inscription is glued to fol. 3r. On the first paper leaf, each volume gives, in Turkish, the number of the manuscript (that is, 8), the number of the volume itself (I, II, or III), the number of folios, and the total number of miniatures contained in the volume.

At the beginning of the manuscript (fol. 3r) the title of the paraphrase, written in carmine uncials, reads:[52] Τὸ τῆς παλαιᾶς προοιμί(ον) ὅπ(ερ) ὁ [Ἀριστέας] / πρὸς τὸν Φιλοκράτ(ην) ἐκτέθεικ(εν) μακ[ρη/γόρια] καὶ ἀσαφείᾳ ὁ δὲ πορφυρογ(έννετος) / [κὺρ Ἰσαάκιος] καὶ υἱὸς τοῦ μεγάλ(ου) β(ασιλέως) κ(ὺρ) Ἀλεξί(ου) / Κομνην(οῦ) εἰς συντομί(αν) μετερ(ρ)ύθμι/σε καὶ σαφήνει(αν) ("The Preface to the Old [Testament], Lengthy and Obscure, Which Aristeas Set before Philokrates, Kyr Isaac, Born in the Purple and Son of the Great Emperor Kyr Alexios Komnenos, Reduced to a Shorter and More Lucid Version").[53] None of the folios of the paraphrase is missing; on fol. 9v (line 14), we read that the paraphrase itself consists of seven folios, thus confirming that the text is complete.

In 1905, Fedor Uspenskii[54] first restored the title of the Paraphrase. Two years later, he published the manuscript, including the paraphrase, with a Russian translation in a monographic issue of the bulletin of the Russian Archaeological Institute in Constantinople,[55] with a supplement containing an album of photographs of the miniatures.[56] Uspenskii claimed that the key name Ἰσαάκιος could be read in the title of the paraphrase.[57] In

[43] The differences in handwriting between the paraphrase and the rest of the codex have been stressed by Anderson, "Seraglio," p. 84 (following Uspenskii, p. 1) and Lowden, *Octs.*, p. 25.

[44] Uspenskii (p. 1) and Deissmann (*Serai*, p. 47) give different numberings of the paraphrase and the Letter of Aristeas, namely, fols. 1r–7v and 8r–22r, respectively. It is possible that bifolio 1–2, presently unbound, was bound in the codex when they described it.

[45] PG 80, col. 76. Hypatios is certainly the presbyter named in Theodoret's Letter 113 (PG 83, col. 1317).

[46] PG 80, col. 457.

[47] PG 106, cols. 125–26 n. 45; Karo and Lietzmann, *Catalogus*, p. 10, *epilogus* no. 1. See also note 13 above.

[48] PG 106, col. 128; Karo and Lietzmann, *Catalogus*, p. 10, *epilogus* no. 2.

[49] Karo and Lietzmann, *Catalogus*, p. 10, *epilogus* no. 3.

[50] Ibid., *epilogus* no. 4.

[51] Καὶ ὁμοῦ τὰ ὅλα φύλ(λ)α φξη. Uspenskii (p. 244) also gives the total

number of folios as 568.

[52] The letters of the inscription that are presently illegible and have been restored after Uspenskii (p. 1) are given in square brackets; cf. Anderson, "Seraglio," p. 84 n. 10.

[53] English translation by Anderson, "Seraglio," p. 84.

[54] Uspenskii, "'Η Βιβλιοθήκη τοῦ ἐν Κωνσταντινουπόλει Σεραγίου καὶ ἡ ἐν αὐτῇ εἰκονογραφημένη Ὀκτάτευχος," Παναθήναια 5 (30 April 1905), p. 52; and Uspenskii, "Lettre," p. 21.

[55] Uspenskii, pp. 2–14.

[56] The photographs were taken by N. K. Kluge (Uspenskii, p. 101). For the previous history of Ser., see Uspenskii, chap. 5, pp. 230–51; E. Jacobs, *Untersuchungen zur Geschichte der Bibliothek im Serai zu Konstantinopel* (Heidelberg, 1919); Deissmann, *Serai*, pp. 13–21, 49–56.

[57] Uspenskii, p. 1; Uspenskii, "Lettre," pp. 21–22. See also Anderson, "Seraglio," p. 84 n. 10. Uspenskii could also make out the first letters of the second and third lines, here restored according to his reading.

1933, Adolf Deissmann maintained that this title could still be read; and he confirmed in particular the existence of the name of its author, Isaac, now hardly legible;[58] at present, in fact, only the initial I of Ἰσαάκιος can be made out. Isaac is described in the title as "πορφυρογέννετος," whereas in other documents and in Theodoros Prodromos's poems he is addressed as "kaisar" or "sebastokrator";[59] and in the typikon of the Monastery of the Theotokos Kosmosoteira which he wrote beginning in 1152, he himself uses the title "sebastokrator."[60]

The manuscript is composed of 6 added sheets of paper, 1 unbound bifolio at the beginning, 2 binions, 3 ternions, 68 quaternions, and 1 final, unbound, single leaf. The gatherings are arranged as follows:

Volume 1: fols. 1–2 (unbound bifolio); 3–6 (binion); 7–9 (incomplete binion: a leaf is missing between 9 and 10); 10–17 (quaternion); 18–22 (incomplete ternion: a leaf is missing between 22 and 23); 23–30; (quaternion); 31–38 (quaternion); 39–46 (quaternion); 47–54 (quaternion); 55–62 (quaternion); 63–70 (quaternion); 71–78 (quaternion); 79–86 (quaternion); 87–94 (quaternion); 95–102 (quaternion); 103–110 (quaternion); 111–118 (quaternion); 119–126 (quaternion); 127–134 (quaternion); 135–142 (quaternion); 143–150 (quaternion); 151–158 (quaternion); 159–166 (quaternion); 167–174 (quaternion); 175–182 (quaternion); 183–190 (quaternion).

Volume 2: fols. 191–198 (quaternion); 199–206 (quaternion); 207–214 (quaternion); 215–222 (quaternion); 223–230 (quaternion); 231–238 (quaternion); 239–246 (quaternion); 247–253 (incomplete quaternion: a leaf is missing between 251 and 252, but there are no lacunae in the text); 254–261 (quaternion); 262–269 (quaternion); 270–277 (quaternion); 278–285 (quaternion); 286–293

(quaternion); 294–301 (quaternion); 302–309 (quaternion); 310–317 (quaternion); 318–325 (quaternion); 326–333 (quaternion); 334–341 (quaternion); 342–349 (quaternion); 350–355 (ternion); 356–363 (quaternion); 364–371 (quaternion); 372–379 (quaternion).

Volume 3: fols. 380–387 (quaternion); 388–395 (quaternion); 396–403 (quaternion); 404–411 (quaternion); 412–419 (quaternion); 420–427 (quaternion); 428–435 (quaternion); 436–443 (quaternion); 444–451 (quaternion); 452–459 (quaternion); 460–467 (quaternion); 468–475 (quaternion); 476–483 (quaternion); 484–491 (quaternion); 492–499 (quaternion); 500–507 (quaternion); 508–515 (quaternion); 516–523 (quaternion); 524–531 (quaternion); 532–539 (quaternion); 540–547 (quaternion); 548–555 (quaternion); 556–563 (quaternion); 564–569 (ternion); 570 (unbound single leaf).

Uspenskii[61] suggested that the handwriting of the paraphrase might be that of Isaac Komnenos himself. However, we have no conclusive evidence that Isaac wrote the seven folios of his paraphrase in Ser.,[62] and there is no proof that the paraphrase and the rest of the manuscript are contemporary; writings that were originally separate may have been bound together to form the present codex.[63]

The incomplete state of Ser. has led scholars to more precise hypotheses regarding the date of the manuscript. Isaac Komnenos, a learned man,[64] was born in 1093, the sixth child of Emperor Alexios I and Irene Doukaina.[65] His eldest brother, Emperor John II, banished him from Constantinople in 1122. Isaac was later permitted to return to the capital, but was then imprisoned by his brother John and released in 1143, after the accession of Manuel to the imperial throne. In 1152, he wrote the typikon[66] of the Monastery of the Theotokos Kosmosoteira which he founded in Bera (Pher-

[58] Deissmann, *Serai*, p. 47.

[59] Theodoros Prodromos, *Historische Gedichte*, ed. W. O. Hörandner (Vienna, 1974), poems 40–42, pp. 391–98, where he is addressed as "porphyrogennetos" and "sebastokrator" (poem 42, p. 396) or only "porphyrogennetos" (poem 40, p. 391). In the fourteenth-century inscription in the Deesis mosaic in the Kariye Camii, he again bears only the title "porphyrogennetos"; on the mosaic and its inscription, see P. A. Underwood, "The Deesis Mosaic in the Kahrie Cami at Istanbul," in *Late Classical and Medievaeval Studies in Honor of Albert Mathias Friend, Jr.*, ed. K. Weitzmann (Princeton, 1955), pp. 254, 258, fig. A on p. 257. In the typikon of the nunnery of the Theotokos Kecharitomene (1118), founded by his mother Irene Doukaina, Isaac bears the titles "porphyrogennetos" and "kaisar" (PG 127, col. 1091); cf. P. Gautier, "Le typikon de Theotokos Kécharitôménè," *REB* 43 [1985], pp. 5–165.

[60] L. Petit, "Typikon du monastère de la Kosmosotira près d'Ænos (1152)," *IRAIK* 13 (1908), p. 19; Uspenskii, p. 30 n. 1. The title "sebastokrator" had been created not long before by Alexios Komnenos for his elder brother, Isaac: Anne Comnéne, *Alexiade (Règne de l'Empereur Alexis I Comnène 1081–1118)*, ed. B. Leib, vol. 1 (Paris, 1937), p. 113 (= 3:4); cf. R. Guilland, *Recherches sur les institutions byzantines* (Berlin, 1967), vol. 2, pp. 1, 30–31.

[61] Uspenskii, p. 1.

[62] See Deissmann, *Serai*, p. 49 (esp. n. 2).

[63] See Anderson's analysis of the paraphrase and his comparison of it with the rest of the codex in "Two Centers," p. 31, and "Seraglio," pp. 84–85. Pelletier (*Lettre*, p. 11) attributes the writing of both the paraphrase and the Letter of Aristeas to the second half of the thirteenth century; he

claims, moreover, that they cannot be contemporary and that the paraphrase dates from a slightly earlier period. Cf. Lowden, *Octs.*, pp. 24–26.

[64] On the learning of Isaac, see Theodoros Prodromos, poem 42, ll. 9–12 (*Historische Gedichte* [as in note 59], pp. 396–98). Isaac Komnenos's life and literary works have been examined by Uspenskii, pp. 18–32. For a brief outline with a critical approach to Uspenskii's arguments, see Deissmann, *Serai*, pp. 48–49; for further information on his life and literary works, see O. Jurewicz, *Andronikos I. Komnenos* (Amsterdam, 1970), pp. 28–35; for the most recent literature, see Anderson, "Seraglio," p. 86. Isaac is portrayed as a donor at the Virgin's right in the Deesis mosaic in the inner narthex of the Kariye Camii (Underwood, "Deesis Mosaic" [as in note 59], pp. 257–58). The fourteenth-century portrait we have today may be a copy of an earlier portrait icon of Isaac aged not more than thirty, probably executed shortly before 1120, when he still intended to be buried in the narthex of the church. Isaac was also responsible for the architectural restoration of the Kariye Camii in 1120 (R. G. Ousterhout, *The Architecture of the Kariye Camii in Istanbul* [Washington, D. C., 1987], pp. 12, 21).

[65] For a list of the children of Alexios I Komnenos and their birthdays, see A. Kazhdan, "Die Liste der Kinder des Kaisers Alexios I. in einer Moskauer Handschrift (ПЧТ 53/147)," in *Beiträge zur alten Geschichte und deren Nachleben: Festschrift für Franz Altheim zum 6.10.1968*, ed. R. Stiehl and E. Stier, vol. 2 (Berlin, 1969), pp. 233–37; P. Schreiner, "Eine unbekannte Beschreibung der Pammakaristoskirche (Fethiye Camii) und weitere Texte zur Topographie Konstantinopels," *DOP* 25 (1971), p. 248; id., *Die byzantinischen Kleinchroniken* (Vienna, 1975), p. 55.

[66] Published by Petit, "Typikon" (as in note 60), pp. 17–77.

rai), in western Thrace.[67] Because Isaac Komnenos was in Constantinople from 1136 to 1139 and from 1143 to 1152, work on Ser. was possibly in progress either when Isaac had to leave Constantinople in 1139 or at the time of his death, which occurred in or after 1152.[68]

The miniatures in Ser., Sm., and Vat. 746 display considerable stylistic similarities. Ser. is the finest of the three manuscripts. Its style is connected with the hand of the so-called Kokkinobaphos Master, the Constantinopolitan painter who executed (and is named after) the two illuminated manuscripts of the Homilies of James of Kokkinobaphos[69] now in Paris (Bibl. Nat., cod. gr. 1208) and Rome (Bibl. Vat., cod. Vat. gr. 1162). Similarities can easily be recognized in Jacob Sends His Sons to Egypt in Ser. (fig. 516) and the episode of Joseph Interrogates the Virgin about Her Pregnancy in the Vatican copy of the Homilies (fol. 170r, text fig. 51).[70]

Anderson[71] has convincingly proposed that two collaborators

of the Kokkinobaphos Master executed the approximately one hundred miniatures up to the Birth of Pharez on fol. 126 (fig. 480), while the Kokkinobaphos Master himself worked on the remaining miniatures, from Joseph Brought to Egypt, on fol. 127r (fig. 484), to Joshua Gives an Inheritance to Zelophehad's Daughters, on fol. 499v (fig. 1338).[72] Collaborators also seem to have joined the Kokkinobaphos Master in this second section of the cycle. Unquestionably, a drop in quality is noticeable in the Book of Joshua. Here the typical style of the Kokkinobaphos Master, still clear in the miniature with the disappearance of Moses (fig. 1118), is transformed into a generic twelfth-century style: carefully designed compositions turn into stereotyped, monotonous ones in which figures are naively drawn, stiff, flattened into rigid drapery or armor, two-dimensional, and inexpressive.[73] This drop in quality can also be seen in the corresponding miniatures of the Book of Joshua in Sm. and Vat. 746.[74]

4. SMYRNA (*OLIM*), EVANGELICAL SCHOOL LIBRARY, CODEX A.1

The Octateuch once in the library of the Evangelical School in Smyrna (text figs. 52–57) was destroyed by fire in September 1922, in the course of a battle for occupancy of the town during the Greco-Turkish War.[75] Fortunately, in 1907 Uspenskii had published a few photos of the manuscript in his study of Ser.; in 1909, Hesseling's album appeared with 334 photos of the miniatures taken by Robert Eisler;[76] another set of photos, now in the photo archive of the Österreichische Nationalbibliothek in Vienna, was taken by the Austrian byzantinist Paul Buberl. We also have a description prepared by Papadopoulos-Kerameus and

published in 1877 in his catalogue of manuscripts in the school's library;[77] here we learn that the manuscript was a one-volume codex of 261 parchment folios containing the catena on the Octateuch. Yet Hesseling[78] and all the other scholars who studied the manuscript before the fire—namely Strzygowski in 1899,[79] Uspenskii in 1907,[80] and Rahlfs in 1914[81]—give a total of 262 folios. We know from Strzygowski,[82] who provides the most complete codicological description of the Octateuch, that it measured 37 × 30 cm, that it had a modern, brown leather binding, that the text was arranged in one column, and that initial letters

[67] Uspenskii (pp. 20–22), Petit ("Typikon" [as in note 60], p. 19) and Underwood (*Kariye Djami*, vol. 1, *Historical Introduction and Description of the Mosaics and Frescoes*, p. 12) identified the monastery founded by Isaac with the present-day Monastery of the Skalotis. The church, its architecture, and its paintings have been exhaustively studied by S. Sinos, *Die Klosterkirche der Kosmosoteira in Bera (Vira)* (Munich, 1985); cf. also *Glory of Byzantium*, pp. 40–41. Uspenskii's hypothesis that a manuscript Isaac presented to the Kosmosoteira monastery and mentioned in the typikon may be identified as the Seraglio Octateuch (Uspenskii, p. 30 and note 1 for a transcription of the passage from the typikon; see also Petit, "Typikon," p. 69) is rejected by Deissmann (*Serai*, pp. 50–51).

[68] Anderson, "Two Centers," pp. 32, 82; Anderson, "Seraglio," p. 86; Anderson, "James the Monk," p. 84; Lowden, *Octs.*, pp. 25–26.

[69] See Millet, "Octateuque," p. 72; Lazarev, *Storia*, p. 252 n. 47; Weyl Carr, *Byz. Illum.*, p. 46; Lowden, *Octs.*, pp. 25–26; and esp. Anderson, "Two Centers," pp. 29–35; Anderson, "Seraglio," pp. 89–92; Anderson, "James the Monk," p. 83.

[70] Cf. Anderson, "Seraglio," pp. 90–91, figs. 12, 13.

[71] Anderson ("Seraglio," pp. 86ff.) has given the most exhaustive examination of the hands in Ser. and their ability. N. Kluge, who provided the stylistic analysis in Uspenskii's book, noted that the painter who drew all the miniatures was weak in technique and produced badly proportioned figures resembling caricatures, poorly drawn feet and hands, naively drawn limbs, etc. (Uspenskii, pp. 101–4); according to Alpatov ("Rapport," p. 306), the miniatures in Ser. were not done by one of the best artists of the Komnenian court; according to Lazarev (*Storia*, p. 252 n. 47), the miniatures are clearly not the work of a first-rate artist.

[72] The exceptional quality of the miniatures attributable to his hand is striking, especially in the sequence illustrating Exodus and Leviticus on

fols. 246 to 285 (see figs. 779, 783, 787, 791, 795, 800, 804, 830, 841). A collaborator, not the Kokkinobaphos Master himself, must be held responsible for the more rigid figures drawn in repetitive postures—as in the Theophany at Sinai (fig. 739) or Stoning the Blasphemer (fig. 875). For a different hypothesis on the procedure of producing the miniatures in Ser., see Dufrenne, "Oct. du Sérail," pp. 247–53; and I. Ševčenko, "The Illuminators of the Menologium of Basil II," *DOP* 16 (1962), p. 271 n. 89.

[73] Compare, for instance, the armed men led by Moses to conquer Sihon (fig. 972) with Joshua leading his soldiers in God Promises Joshua the Capture of Ai (fig. 1220). Typical examples of this mediocre painter's work are the miniatures on the folios in the middle of the Book of Joshua. The hand of the Kokkinobaphos Master is still recognizable on fol. 477v (fig. 1168) in the group of the Israelites laying down the twelve stones; but the collaborator replaced him in the ensuing folios—from Joshua Piles Twelve Stones at Gilgal, on fol. 478v (fig. 1174), to the Israelites Defeat Kings, on fol. 494v (fig. 1308)—and, probably, in other miniatures in this section of the manuscript as well.

[74] Compare, for instance, figs. 1175 and 1176, 1221 and 1222, and 1309 and 1310.

[75] Bees, "Handschriften von Smyrna," p. 444.

[76] D. C. Hesseling, *Miniatures de l'Octateuque grec de Smyrne: Manuscrit de l'École Évangélique de Smyrne* (Leiden, 1909).

[77] Papadopoulos-Kerameus, Κατάλογος, p. 4.

[78] Hesseling, p. i.

[79] Strzygowski, *Sm.*, p. 113.

[80] Uspenskii, p. 52.

[81] Rahlfs, *Verzeichnis*, p. 293.

[82] Strzygowski, *Sm.*, p. 113.

were written in red cinnabar ink. The titles of chapters and of the miniatures were in red.[83] According to Strzygowski,[84] the folios, as a rule, had 43 lines and the writing area was 27 × 16 cm. In the only two existing photographs of whole folios, which were published by Uspenskii,[85] we can count 70 and 74 lines of catena text, respectively. The manuscript was written in a twelfth-century Greek minuscule, with accents and breathing marks added. Strzygowski[86] specifies that all the miniatures had a red frame; that their measurements varied from 18 × 20 cm at the beginning of the codex, to 6 × 10 cm, 3.5 × 11 cm, and 5.5 × 9.5 cm; and that they had a neutral background, save for a few at the beginning in which the backgrounds were colored. No information has survived about the gatherings; we know, from Hesseling, only that the sequence of the quaternions was the original.[87] From Papadopoulos-Kerameus we learn that the first folio of Genesis with the catena was missing.[88]

When Papadopoulos-Kerameus studied the manuscript, it contained only a fragment of the Letter of Aristeas on fol. 1r. On fol. 2r, the picture cycle began with an image of the Creator and, below that, a list of the eight titles of the books in the Octateuch and the first verse of Genesis. Genesis and catena on Genesis were written on fols. 3r–64r; Exodus and catena on Exodus, fols. 64r–115v; Leviticus and catena on Leviticus, fols. 116r–144v; Numbers and catena on Numbers, fols. 145r–184v; Deuteronomy and catena on Deuteronomy, fols. 184v–219v; Joshua and catena on Joshua, fols. 219v–238r; Judges and catena on Judges, fols. 238v–258r; Ruth and catena on Ruth, fols. 258r–260r.[89] From the description of Papadopoulos-Kerameus,[90] we may assume that on fol. 260r there followed Joseppus Christianus, *Libellus memorialis in Vetus et Novum Testamentum*, chapter 122: "On the Translations of the Scriptures from Hebrew into Greek";[91] on fol. 261r, Joseppus Christianus, *Libellus memorialis in Vetus et Novum Testamentum*, chapter 124: "On the Seven

Exiles of the Hebrews";[92] and on fol. 261v, the *epilogus:* "On the Ten Names of God."[93]

Whereas Hesseling published 334 miniatures of the codex, Strzygowski counted 395 miniatures;[94] Uspenskii,[95] who was aware of this divergence in counting, and Rahlfs both counted 380.[96] We cannot be sure if the photographs reproduced by Hesseling are the complete set of miniatures then surviving in the codex. For instance, in the story of Joshua, Hesseling does not reproduce four miniatures which in the other codices illustrate verses 10 to 27 of chapter 10 (see figs. 1268–1287); but Uspenskii reports that the first of the four, namely the Defeat of the Amorites, was "very weakly depicted" on fol. 229r.[97] However, we must notice that Uspenskii affirms that a number of miniatures in Sm. are missing, but they do exist in Hesseling's plates.[98]

A few miniatures in the cycle are missing in Hesseling's volume: one between fols. 125v and 128r,[99] four between 228v and 229r,[100] four between 238v and 239r,[101] and one between 244v and 245r.[102] Yet, Vat. 747 and Sm. had approximately the same total number of folios and the same size writing. Consequently, from Vat. 747 we can assume that there were also lacunae in the text in Sm.: one folio was missing between 125v and 128r, one between 228v and 229r (this is the folio which, according to Uspenskii, contained the miniature with the Defeat of the Amorites), one between 238v and 239r, and one between 244v and 245r.[103] The most extended lacuna in the cycle of Sm. is found between Judges 11 and 19.[104] From Vat. 747 we can again assume that no folio with the text of the Samson story was missing in Sm.;[105] furthermore, none of the scholars who surveyed the codex before its destruction noticed blank spaces for unexecuted miniatures.[106] From the sequence of the miniatures, we can deduce that fols. 226 and 227 were in reverse order.[107]

A later inscription on fol. 261v[108] records that the codex was presented to the church of St. Nikon on 3 October 1259;[109] the

[83] Hesseling, p. i.

[84] Strzygowski, *Sm.*, p. 113.

[85] Uspenskii, pl. 6, reproducing fols. 4r and 5r; cf. Lowden, *Octs.*, p. 17 n. 36 and appendix 2, p. 130.

[86] Strzygowski, *Sm.*, p. 113.

[87] Hesseling, p. i.

[88] Papadopoulos-Kerameus, Κατάλογος, p. 4, n. 1 of col. 2.

[89] Hesseling, p. ii.

[90] Papadopoulos-Kerameus, Κατάλογος p. 4.

[91] PG 106, cols. 125–26, n. 45. See note 15 above.

[92] PG 106, col. 128; Karo and Lietzmann, *Catalogus*, p. 10, *epilogus* no. 2.

[93] Karo and Lietzmann, *Catalogus*, p. 10, *epilogus* no. 4.

[94] Strzygowski, *Sm.*, p. 113.

[95] Uspenskii, p. 52.

[96] Rahlfs, *Verzeichnis*, p. 293.

[97] Uspenskii, p. 167.

[98] E.g., the miniatures on fols. 10r and 10v (nos. 61 and 65: Hesseling, figs. 13, 14; Uspenskii, p. 113), the two miniatures on fol. 240v (nos. 1416 and 1420: Hesseling, figs. 316, 317; Uspenskii, p. 175), and the first miniature on fol. 248v (no. 1464: Hesseling, fig. 327; Uspenskii, p. 177).

[99] Uspenskii (p. 151) confirms that the miniature is not present in Sm.

[100] As previously noticed, Uspenskii (p. 167) affirms that the first one existed, although very weakly depicted, in Sm.; no mention is made of the other miniatures.

[101] Uspenskii (p. 175) reports that "four miniatures exist in the Vatopedi codex which are missing in Smyrna," and adds that "these miniatures illustrate the final verses of the Book of Joshua (24:25–33)."

[102] Uspenskii (p. 176) reports that "the miniature on fol. 418v in Vatopedi, which illustrates Judges 6:38, is not present."

[103] Cf. Lowden, *Octs.*, pp. 16–17, 127.

[104] Vat. 747 illustrates this section of the text with 21 miniatures, Vat. 746 with 19, Vtp. with 17, and Ser. has 14 blank spaces for unexecuted miniatures.

[105] Lowden, *Octs.*, pp. 59–60.

[106] In his description of the pictures of Ser., in particular, Uspenskii as a rule accounts for every space the scribe left for the painter which remained blank (e.g., fols. 71r, 78v, 79vff.; Uspenskii, pp. 129, 130, 131); in most cases, he substitutes descriptions of the corresponding pictures in Sm. for the unexecuted pictures in Ser.; and when they are also missing in Sm., he expressly notes their absence in this codex and turns to consider Vtp. (e.g., Vtp., fol. 282r; ibid., p. 151). For the folios with Judges 11 to 19, however, Uspenskii does not report any missing or unexecuted miniatures in Sm. (ibid., p. 177).

[107] Cf. Strzygowski, *Sm.*, p. 117; Lowden, *Octs.*, pp. 62–63.

[108] Papadopoulos-Kerameus, Κατάλογος, p. 4; Strzygowski, *Sm.*, p. 113; Hesseling, pp. ii–iii; Uspenskii, p. 52 (reporting that it is found on fol. 262). These scholars give slight variants in their transcriptions.

[109] According to Lowden, this is the famous cult center devoted to the saint in Sparta ("Image of God," pp. 21–22; *Octs.*, p. 20).

inscription also contained the fragmentary name "Ἰωάννης ὁ Πα[. . .]."[110] In his account of a voyage undertaken in 1737–42, the English traveler Richard Pococke reported that "the Greek Metropolitan [of Smyrna] has a very fine manuscript of the Pentateuch, supposed to have been wrote about the year eight hundred, with a large comment on it; it is on parchment exceedingly well written, and adorned with several paintings, which are well executed for those times."[111] A few years later, Nikephoros, in his volumes of the catena on the Octateuch and Kings, noted that the manuscript still belonged to the metropolitan of Smyrna.[112] In his nineteenth-century catalogue of the Evangelical School library, Papadopoulos-Kerameus relates that the manuscript came from the church of St. Photeina, the Greek cathedral of Smyrna.[113]

Sm. and Vat. 746 present various stylistic problems similar to those in Ser.[114] The initial miniatures of both manuscripts are in the twelfth-century style, but not specifically in the style of the Kokkinobaphos Master.[115] The Kokkinobaphos Master's style is introduced only with the Joseph cycle; it is not the hand of the master himself, but of artists working in his style.[116] A miniature painted by the Kokkinobaphos Master in Ser.[117] corresponds with the miniatures these illuminators depicted in Sm. and Vat. 746. As a rule, the painter of Sm. is more gifted than the painter of Vat. 746, and the ties of Vat. 746 to the style of the Kokkinobaphos Master are considerably weaker than those of Sm.

As we have seen, Ser. contains a sequence of naively drawn miniatures in the Book of Joshua, from Joshua Piles Twelve Stones in Gilgal (fig. 1174) to the Israelites Defeat Kings (fig. 1308); this same sequence is composed of comparably unsatisfactory miniatures in Sm. and Vat. 746.[118]

Different hands worked on the illumination of the two codices with various degrees of ability.[119] A number of miniatures whose general design can be attributed to the Kokkinobaphos Master are nevertheless disappointing because the anatomy of the figures is poorly drawn or because the colors are ineptly applied.[120] Sm. and Vat. 746 must have been produced in the same years as Ser., i.e., the second quarter of the twelfth century.[121]

5. ROME, BIBLIOTECA APOSTOLICA VATICANA,
CODEX VATICANUS GRAECUS 746

The Octateuch Vat. gr. 746 (*olim* 478) (text figs. 58–60)[122] is a two-volume codex of 508 numbered parchment folios (volume 1 containing folios 1–251, volume 2 containing folios 252–508), and four unnumbered sheets of paper with no watermarks, one added to the beginning, one to the end of each volume.

The brown leather bindings of the two volumes (measuring 42 × 33 cm) are identical to that of Vat. 747. At the top of the spine, "Vat. 746 P. I" and "Vat. 746 P. II" are inscribed on the two respective volumes. The coats of arms of Pope Pius IX and of the prefect of the Vatican Library, Jean Baptiste Pitra, are also inscribed on the upper part of the spines.[123] On the inside cover of each volume a label repeats the identification number "Vat. gr. 746."

The parchment is very undulated, with many holes, seams, and stains caused by dampness. On almost every page the lower corners have been restored with paper. On a few folios (127, 167, 168, 195, 285, 286, 328, 348) strips of parchment have been cut off, normally below the last horizontal line of the ruling pattern.

The thirteen folios at the beginning of volume 1—which contain the Letter of Aristeas, *Theodoretus ad Hypatium*, a passage from Gregory of Nyssa's *In Hexaemeron*, and the first folio of Genesis, with chapter 1:1 and a portion of the corresponding catena—are a later addition, presumably copied from codex gr. 128 in the Bibliothèque Nationale in Paris sometime between the thirteenth and the fifteenth century.[124] On fol. 13r, the last of the

[110] Papadopoulos-Kerameus, Κατάλογος, p. 4; Lowden, *Octs.*, p. 20.

[111] R. Pococke, *A Description of the East, and Some Other Countries*, vol. 2 (London, 1745), p. 38.

[112] Σειρά, ed. Nikephoros, vol. 1, col. 5.

[113] Papadopoulos-Kerameus, Κατάλογος, p. 4. According to Rahlfs (*Verzeichnis*, p. 294), however, the manuscript was already in the Evangelical School at the beginning of the eighteenth century.

[114] Cf. Anderson, "Seraglio," pp. 94–95; Lowden, *Octs.*, pp. 17–18, 28.

[115] For instance, in God Orders Noah to Build the Ark (figs. 129, 130, text fig. 54), the miniatures illustrating the childhood of Isaac (figs. 289, 290, 292, 293, 295, 296, text fig. 55), and Covenant after the Flood (figs. 149, 150), the distinctive traits of the Kokkinobaphos Master's work are absent, nor do they appear in the corresponding miniatures in Ser. (figs. 128, 148).

[116] Anderson, "Seraglio," pp. 95, 101, and passim.

[117] See the sequence of miniatures from the story of Joseph (figs. 488–490, 516–519, 533–535, 557–559) and from Exodus and Leviticus (figs. 779, 780, 783–785, 787–789, 791–793, 800–802, 804–806, 830–833, 844–847).

[118] See figs. 1174–1310. Moreover, in both Sm. and Vat. 746 (figs. 1169, 1170), the Laying Down of the Twelve Stones has the particular traits of the style of the Kokkinobaphos Master, who was active in the corresponding miniature in Ser.

[119] In Vat. 746, Moses Descends from Sinai (fig. 806) and Joshua Proclaimed Moses' Successor (fig. 1021) were painted by a skillful artist, a close follower of the Kokkinobaphos Master, if not the master himself: figures and drapery are precisely drawn, while color and highlights are finely applied on both landscape and figures. In contrast, in Moses Addresses Joshua (fig. 725) or in Jacob's Descendants (fig. 547), the composition and drawing were apparently done by the same skillful hand, but the coloring is less effective.

[120] In Vat. 746, see the facial features in Balaam and the Angel (fig. 989), the colors in both Stoning Enchanters and Men or Women with a Divining Spirit (fig. 868) and the Theophany on Sinai (fig. 741); note the rendering of limbs in the Plague of Water Changed into Blood (fig. 647).

[121] Cf. Lowden, *Octs.*, pp. 17–18, 28.

[122] Devreesse, *Vat. Cod. Manuscripti*, p. 261.

[123] Ibid., p. 262.

[124] P. Wendland, *Aristeae ad Philocratem Epistula* (Leipzig, 1900), pp. xii–xiii; "Letter," ed. Thackeray, pp. 506–7 (fifteenth century); Rahlfs, *Verzeichnis*, p. 254 (fourteenth century); Devreesse, *Vat. Cod. Manuscripti*, pp. 261–62 (fourteenth century); *Lettre*, ed. Pelletier, p. 9 (fifteenth century); *Catenae Graecae*, vol. 2, *Collectio Coisliniana*, ed. Petit, pp. lxxxiv and xciii (fourteenth century); Lowden, *Octs.*, p. 26 (thirteenth or fourteenth century).

added folios, we find the original headpiece of Genesis (text fig. 58). Fol. 337, containing Numbers 14:36–15:20, is also a later restoration attributable to the same period. The added folios are made of a different, much whiter parchment; only the frames of the writing area are traced.

The added folios measure 40 × 27.5 cm; the original folios have slightly different measurements, 39 × 30 cm. The size of the writing area is approximately 30 × 22.5 cm (added folios) and 31 × 23 cm. The text is arranged in one column and is written in dark sepia ink; initial letters, titles, the names of authors in the catena, and chapter numbers are in carmine. Different ruling patterns are used, varying from 44 to 62 lines.[125] The added folios at the beginning have 21 to 43 written lines: the text of the Septuagint has 29 to 43 written lines, and the catena 44 to 61. On the added folios each line usually has 52 to 66 letters; the Septuagint text has 34 to 49 letters per line; and the catena 55 to 61. In the three texts each letter is 0.4 to 1 cm, 0.3 to 0.8 cm, and 0.2 to 0.5 cm high, respectively. On the added folios the margins between the writing area and the edges of the parchment are approximately 4 cm at the top, 5 cm at the bottom, 3 cm on the outside, and 3 cm on the inside; on the original folios the margins are respectively 3.5, 4.5, 4.5, and 3.5 cm.

The manuscript was written in a "scholarly hand" in a twelfth-century Greek minuscule, with accents and breathing marks added.[126] Three scribes were probably engaged in writing this Octateuch.[127]

Word endings, conjunctions, and articles are often abbreviated; the *nomina sacra* are always abbreviated and indicated by a superscribed line. Initial letters, in carmine, are larger and are placed in the margin outside the writing area. They have no ornamentation. The title of each book is in carmine uncials.

The Octateuch Vat. gr. 746 contains the Letter of Aristeas, fols. 1r–12r; Theodoret of Cyrrhus, *Theodoretus ad Hypatium (In loca difficilia scripturae sacrae quaestiones selectae, praefatio)*, fol. 12r;[128] an excerpt from Gregory of Nyssa's *In Hexaemeron*, fol. 12v;[129] Genesis and catena on Genesis, fols. 13r–150v; Exodus and catena on Exodus, fols. 151r–260v; Leviticus and catena on Leviticus, fols. 260v–310v; Numbers and catena on Numbers, fols. 310v–374v; Deuteronomy and catena on Deuteronomy, fols. 374v–438v; Joshua and catena on Joshua, fols. 438v–468r; Judges and catena on Judges, fols. 468r–502v; Ruth and catena on Ruth, fols. 503r–508v (the text breaks off at Ruth 4:15). The text of the Septuagint is normally arranged on the left side of the page from fols. 14 to 219; in the rest of the codex, the Septuagint usually occupies the inner part of each page.

Vat. gr. 746 has the following lacunae: Letter of Aristeas 1–3:15 (the added folios at the beginning start with the second part of 3:15), Genesis 1:18–25 (a folio is missing between fols. 24 and 25), Leviticus 11:44–13:1 (a folio is missing between fols. 278 and 279), Leviticus 13:27–38 (a folio is missing between fols. 280 and 281), and Ruth 4:15 to the end of the book (corresponding to the lost final part of the codex).

The manuscript has 363 miniatures. The folios are numbered in Arabic in the upper right-hand corner. The quires are also regularly numbered in the bottom margin of the first and last folios; trimming of the second volume caused this numbering to be partly cut off. In the added folios 1–13, initial letters, titles, and the names of authors of the catena were not written in red, and the folios are now missing.

On fol. 150v the total number of *stichoi* in Genesis is recorded (that is, 4308); furthermore, on the same folio, the final verses of Genesis are arranged in the form of a cross. The total number of *stichoi* is also given for Exodus (4400, fol. 260v) and Leviticus (2700, fol. 310v). Various folios have geometric headpieces; the final verses of Numbers (fol. 374r), Joshua (fol. 468r), and Judges (fol. 502v) are also arranged in the form of a cross. On fol. 508v, a later, untrained hand noted that the codex had 505 folios.

On fol. 12v, below the prologue by Gregory of Nyssa, a St. George on horseback is drawn in very faded black ink. To the side, the name of the saint and traces of words in Greek can be seen.

The manuscript is composed of 4 added sheets of paper, 1 bifolio, 1 binion, 5 ternions, and 60 quaternions. The gatherings are arranged as follows:

Volume 1: fols. 1–6 (ternion); 7–8 (bifolio); 9–13 (incomplete ternion), 14–21 (quaternion); 22–27 (ternion); 28–35 (quaternion); 36–43 (quaternion); 44–51 (quaternion); 52–59 (quaternion); 60–67 (quaternion); 68–75 (quaternion); 76–83 (quaternion); 84–91 (quaternion); 92–99 (quaternion); 100–107 (quaternion); 108–115 (quaternion); 116–123 (quaternion); 124–131 (quaternion); 132–139 (quaternion); 140–147 (quaternion); 148–155 (quaternion); 156–163 (quaternion); 164–171 (quaternion); 172–179 (quaternion); 180–182 (incomplete binion); 183–187 (incomplete ternion); 188–195 (quaternion); 196–203 (quaternion); 204–211 (quaternion); 212–219 (quaternion); 220–227 (quaternion); 228–235 (quaternion); 236–243 (quaternion); 244–251 (quaternion).

Volume 2: fols. 251–259 (quaternion); 260–267 (quaternion); 268–275 (quaternion); 276–281 (incomplete quaternion); 282–289 (quaternion); 290–297 (quaternion); 298–305 (quaternion); 306–313 (quaternion); 314–321 (quaternion); 322–329 (quaternion); 330–336 (incomplete quaternion); 337–340 (incomplete ternion); 341–348 (quaternion); 349–356 (quaternion); 357–364 (quaternion); 365–372 (quaternion); 373–380 (quaternion); 381–388 (quaternion); 389–396 (quaternion); 397–404 (quaternion); 405–412 (quaternion); 413–420 (quaternion); 421–428 (quaternion); 429–436 (quaternion); 437–444

[125] Cf. Lowden, *Octs.*, appendix 2, p. 131.

[126] Devreesse, *Vat. Cod. Manuscripti*, p. 261; *Catenae Graecae*, vol. 2, *Collectio Coisliniana*, ed. Petit, p. xciii; Anderson, "Seraglio," pp. 95–96. However, Thackeray ("Letter," p. 506) and Rahlfs (*Verzeichnis*, p. 254) suggest a date in the eleventh or twelfth century.

[127] Cf. Lowden, "Vtp. Oct.," p. 119; *Octs.*, pp. 27–28, 42. Anderson assumes instead that two scribes were employed ("Seraglio," pp. 95–96).

[128] PG 80, col. 76.

[129] PG 44, cols. 69–72.

(quaternion); 445–452 (quaternion); 453–460 (quaternion); 461–468 (quaternion); 469–476 (quaternion); 477–488 (quaternion); 489–492 (quaternion); 493–500 (quaternion); 501–508 (quaternion).

Since 1481, the manuscript has been listed, together with Vat. gr. 747, in the inventory of the Vatican Library.[130] For the style and date of the manuscript, see the discussion of Sm. above.

6. MOUNT ATHOS, VATOPEDI MONASTERY, CODEX 602

The manuscript is preserved in the library of the Vatopedi Monastery on Mount Athos[131] and is marked 602 (*olim* 515).[132] It is a one-volume codex, containing the catena on the Octateuch from Leviticus to Ruth. The first volume with the catena on Genesis and Exodus is lost.[133] Vtp. has 469 numbered parchment folios and 7 added paper folios, 4 at the beginning and 3 at the end of the codex.[134] The paper folios have no numbering; fols. i, ii, and vii are made of coarse paper instead of the smooth paper used for fols. iii, iv, v, and vi. Fols. i and vii have watermarks with the initials AG. Two additional paper folios, glued to the front and back covers, have different watermarks, the first with a crowned coat of arms and the second with three six-pointed stars.[135] Fol. iir is marked 5:A, upside down, in pencil. On fol. iiir, the number 602 is written in blue ink.

The volume has a modern, blue leather binding (size: 36 × 22 cm), somewhat damaged at the corners, and engraved with a gold pattern along the edges and the corners. In the center of the cover is a gold rinceau; on the spine, engraved in gold, there are also other decorations, the title ΠΑΛΑΙΑ ΔΙΑΘΗΚΗ, and a label which reads: ΧΕΙΡΟΓΡΑΦΟΝ I. ΜΟΝΗ ΒΑΤΟΠΕΔΙΟΥ—ἀριθ. 602.

The parchment is fairly well preserved, except for a few tears and some restoration work consisting of strips of coarse paper, especially on a few of the folios at the beginning and end of the volume. The ornamental headings on fols. 93r, 224r, 336r, and 457v have been cut off. The first folios have been heavily trimmed.

The folios measure 34 to 34.5 × 21 to 24 cm. The size of the writing area is approximately 22.5 × 15.5 cm. The text is written in dark sepia ink.

The text is arranged in one column. The ruling pattern has 42 lines up to fol. 17; thereafter, 24 to 28 lines.[136] The Septuagint text and the catena have approximately 31 and 42 written lines, respectively, up to fol. 17; thereafter, approximately 26 and 42 lines. Normally, each line of the Septuagint text has 30 to 35 letters, and each line of the catena 40 to 55 letters. In the Septuagint text each letter measures 0.2 to 0.5 cm or 0.3 to 0.8 cm, depending on the scribe; in the catena, 0.1 to 0.5 cm.

The margins between the writing area and the edges of the parchment are approximately 5 cm at the top (4 cm on the first folios), 7.5 cm at the bottom (7 cm on the first folios), 6 cm on the outside (3.5 cm on the first folios), and 3 cm on the inside (2.5 cm on the first folios).

Two scribes wrote the volume. One was responsible for most of the text: he was replaced by an assistant only from fol. 273r to fol. 332v.[137] The script is a Greek minuscule with accents and breathing marks added, which imitates the eleventh-century *perlschrift* and can be assigned to the thirteenth century.[138] The script is large and roundish. Word endings, conjunctions, and articles are often abbreviated; the *nomina sacra* are always abbreviated and indicated by a superscribed line. Initial letters, in gold ink, are larger and located inside the text or in the margin outside the writing area. They are 1.0 to 1.5 cm high in the Septuagint, and approximately 0.7 cm high in the catena.

Four folios, once containing portions of the text, are missing: between fols. 9 and 10 (Lev 3:14–4:15), 60 and 61 (Lev 19:36–20:9),[139] 317 and 318 (Deut 31:25–32:5), and 434 and 435 (Judg 12:4–13:6). Numbers 14:36–15:20 is also missing: there are blank spaces on fols. 143v and 144v. Lowden attributes the hiatus to a lacuna in the model.[140] In fact, in Vat. 746, the text missing in

[130] Devreesse, *Fonds grec*, pp. 82, 122, 178, and passim.

[131] A record of the manuscript in the monastery has existed since Sevastianov's expedition of 1859–60. Cf. V. Langlois, *Le Mont Athos et ses monastères* (Paris, 1867), pp. 99–103: "Inventaire sommaire des principaux manuscrits grecs du Mont Athos par M. de Séwastianoff," which lists as no. 1 a Bible of 910 pages containing Leviticus to Ruth, with 160 vignettes and miniatures; Kondakov, *Histoire*, vol. 2, p. 83 and n. 1; Lowden, "Vtp. Sources," p. 42.

[132] The number 515 is still in the catalogue of S. Eustratiades and Arcadios (*Catalogue of the Greek Manuscripts in the Library of the Monastery of Vatopedi on Mt. Athos* [Cambridge, Mass., 1924], p. 118).

[133] By the time of Langlois's 1867 description (*Mont Athos* [as in note 131], p. 99), the first volume of the codex was already missing. The folios now bound in the Vatopedi manuscript have probably always formed the second volume of the original Octateuch (cf. Lowden, "Vtp. Oct.," p. 119 n. 22, rejecting the different position of Uspenskii, p. 55). See also Lowden, *Octs.*, p. 30.

[134] Eustratiades and Arcadios counted 471 folios, *Catalogue* [as in note 132], p. 118.

[135] Fols. 3r, 4r, and 5r bear the ink stamp of the Vatopedi Library, with the inscription "ΕΦΡΑΓΙΣ ΤΗΣ ΒΑΤΟΠΕΔΙΝΗΣ ΒΙΒΛΙΟΘΗΚΗΣ 1879" around the border and a representation of the Annunciation in the center.

[136] Uspenskii, p. 54; Lowden, *Octs.*, p. 30 and appendix 2, p. 130. From fol. 18 on, at least two different types of ruling patterns are drawn on the parchment (see, e.g., fols. 220r and 234r).

[137] Cf. Lowden, "Vtp. Oct.," p. 118; and *Octs.*, p. 31.

[138] The script of the manuscript has been examined by Lowden, "Vtp. Oct.," pp. 119–20; and *Octs.*, p. 31. Cf. also Prato, "Scritture arcaizzanti," pp. 151–93, esp. 172–73, pl. IIa.

[139] At the bottom of fol. 60v, a note in pencil indicates that one folio is missing.

[140] "Vtp. Oct.," p. 116.

Vtp. is found on fol. 337r, which is a later replacement of the original fol. 337. It is therefore safe to assume that Vat. 746 was indeed the model used by the Vtp. scribe, who, noticing that a folio was missing in his model and evidently having no other source of Numbers 14–15 to copy, left a blank space on his parchment. Further evidence in support of this view emerges when the texts of the two manuscripts are compared, and a direct dependence can thus be definitely established.[141]

Vtp. contains Leviticus and catena on Leviticus, fols. 3r–92v; Numbers and catena on Numbers, fols. 93r–222v; catena on Deuteronomy, fols. 223r–336r; Deuteronomy, fols. 224r–335v; Joshua and catena on Joshua, fols. 336r–399r; Judges and catena on Judges, fols. 399v–457v; catena on Ruth, fols. 457v–467r; Ruth, fols. 458r–467r; Joseppus Christianus, *Libellus memorialis in Vetus et Novum Testamentum*, chapter 122: "On the Translations of the Scriptures from Hebrew into Greek," fols. 467v–468r;[142] Joseppus Christianus, *Libellus memorialis in Vetus et Novum Testamentum*, chapter 124: "On the Seven Exiles of the Hebrews," fols. 468r–468v;[143] *epilogus:* "On the Obscurity of the Scriptures," fol. 468v;[144] *epilogus:* "On the Ten Names of God," fol. 468v.[145]

The volume has 160 miniatures and two illuminated headpieces with carpetlike designs, one preserved at the head of Leviticus (fol. 3r, text fig. 61) and the other at the head of the *epilogi*. The headpieces of Numbers (fol. 93r), Deuteronomy (fol. 224r), Joshua (fol. 336r), and Ruth (fol. 457v) have been cut off. At the head of Judges (fol. 399v), no illuminated band was planned. Furthermore, the initial letters and the titles of Numbers, Deuteronomy, Joshua, and Ruth are in gold or decorated with blue rinceaux.

Portions of miniatures have been cut out on fols. 47v and 171r.[146] The manuscript has Arabic numbering in the top margin (from fol. 235 on it has been corrected). The gatherings are also numbered in Greek letters.[147]

On fol. 468v there is a note saying that the volume contains 151 miniatures.[148] Fol. 469r has a drawing of a female head and a few badly preserved later prayers mentioning Abraham and Ieroslabos, son of Michael of the family of Asans. A date is preserved in the note, but it cannot be read.[149]

The manuscript is composed of 7 added sheets of paper, 1 final bifolio, 1 binion, 3 ternions, 54 quaternions, and 2 quinions. The gatherings are arranged as follows:

fols. i–iv (cart. add.); 3–9 (incomplete quaternion; a leaf is missing after fol. 9; there is a break in the text between

Lev 3:14 and Lev 4:15); 10–17 (quaternion); 18–25 (quaternion); 26–33 (quaternion); 34–41 (quaternion); 42–49 (quaternion); 50–57 (quaternion); 58–64 (incomplete quaternion; two leaves are missing between 60 and 61; there is only one break in the text between Lev 19:36 and Lev 20:9); 65–72 (quaternion); 73–80 (quaternion); 81–88 (quaternion); 89–96 (quaternion); 97–104 (quaternion); 105–112 (quaternion); 113–120 (quaternion); 121–128 (quaternion); 129–136 (quaternion); 137–142 (ternion); 143–147 (incomplete ternion; a leaf is missing between 143 and 144, but there is no break in the text); 148–155 (quaternion); 156–161 (ternion); 162–168 (incomplete quaternion; a leaf is missing between 166 and 167, but there is no break in the text); 169–176 (quaternion); 177–184 (quaternion); 185–192 (quaternion); 193–200 (quaternion); 201–208 (quaternion); 209–216 (quaternion); 217–225 (quaternion); 226–232 (quaternion); 233–240 (quaternion); 241–248 (quaternion); 249–256 (quaternion); 257–264 (quaternion); 265–272 (quaternion); 273–280 (quaternion); 281–288 (quaternion); 289–297 (incomplete quinion; a leaf is missing between 289 and 290, but there is no break in the text); 298–305 (quaternion); 306–313 (quaternion); 314–320 (incomplete quaternion; a leaf is missing between 317 and 318; there is a break in the text between Deut 31:25 and Deut 32:5); 321–328 (quaternion); 329–332 (binion); 333–340 (quaternion); 341–348 (incomplete quaternion; a leaf is missing between 343 and 344, another between 346 and 347, but there is no break in the text); 349–356 (quaternion); 357–364 (quaternion); 365–372 (incomplete quinion; a leaf is missing between 367 and 368, another between 370 and 371, but there is no break in the text); 373–380 (quaternion); 381–388 (quaternion); 389–396 (quaternion); 397–404 (quaternion); 405–412 (quaternion); 413–420 (quaternion); 421–428 (quaternion); 429–435 (incomplete quaternion; a leaf is missing between 434 and 435; there is a break in the text between Judg 12:4 and Judg 13:6); 436–443 (quaternion); 444–451 (quaternion); 452–459 (quaternion); 460–467 (quaternion); 468–469 (bifolio); v–vii (cart. add.).

The archaistic elements in both the writing and the style of the miniatures in Vtp. previously led scholars to attribute the manuscript to the tenth or early eleventh century.[150] This date has now been rejected and a later, thirteenth-century date[151]

[141] Lowden demonstrates that in Vat. 746 the quire containing fols. 268–275 was misbound at the time Vtp. was copied; this led to an error in the arrangement of the text of Leviticus in the copy ("Vtp. Oct.," pp. 117–18; and *Octs.*, pp. 38ff.).

[142] PG 106, cols. 125–26, n. 45. See note 15 above.

[143] PG 106, col. 128; Karo and Lietzmann, *Catalogus*, p. 10, *epilogus* no. 2.

[144] Karo and Lietzmann, *Catalogus*, p. 10, *epilogus* no. 3.

[145] Ibid., *epilogus* no. 4.

[146] Not noted in Eustratiades' and Arcadios's catalogue of 1924 (*Catalogue* [as in note 132], p. 118).

[147] Gatherings 36 to 41 have a second numbering, from 1 to 7, added. The binion 329–332 has lost its original numbering, μβ. Cf. Lowden, "Vtp. Oct.," p. 118.

[148] τουτο το παλαιον εχη ηστωριας ρμα. Cf. Huber, p. 183.

[149] Uspenskii ("Asenevichi," pp. 14–16, reproduction in pl. I) calculated a date around the middle of the fourteenth century; Huber (p. 182) indicated 1313 as the most probable date. In a different reading of the notes, Lowden rejected both previous assumptions and considered it impossible to determine a precise date for the prayers ("Vtp. Oct.," p. 115 n. 9; *Octs.*, p. 32). On the Asans, see Trapp, "Genealogie der Asanen," pp. 163–77, esp. pp. 164–65.

[150] See Kondakov, *Histoire*, p. 83; H. Brockhaus, *Die Kunst in den Athos-Klöstern* (Leipzig, 1891), p. 69; De Wald, "Fragment," p. 150.

[151] Uspenskii, p. 57, followed by Millet, "Octateuque," pp. 74–75, and Alpatov, "Rapport," pp. 318–19 (middle of the century); Weitzmann, "Constantinop. Book Ill.," pp. 208–9 (repr. in Weitzmann, *Studies*, pp. 327–28); Buchthal, *Latin Kingdom*, p. 69; Buchthal, *Historia Troiana*, p. 26; Θησαυροί, p. 254.

(probably in the last decades of the century)[152] convincingly proposed. The Vtp. painter apparently worked alone in his task of illuminating the codex. Many of the miniatures he executed are minutely imitative of Vat. 746 and even resemble those of the Kokkinobaphos Master. The Vtp. painter uncritically followed Vat. 746 even in its shortcomings of drawing and composition. The roughly sketched physiognomies of the soldiers in Five Kings Put to Death (fig. 1282) and of the figures in Israelites Defeat Enemies (fig. 1292) reproduce those found in Vat. 746 (figs. 1281, 1291); while the anatomically unconvincing poses of the stoners in the Stoning of the Five Kings (fig. 1287) and the graceless, badly proportioned renderings of the limbs and whole figures of soldiers in the Slaying of the Men of Ai and Ai Set on Fire (fig. 1237) are taken from Vat. 746 (figs. 1286, 1236). The miniatures of the Book of Joshua are quite naively drawn, as they are in Vat. 746.

The influence of a style more classical than that of Vat. 746, which has its roots in the style of the Macedonian period, is evident in the monumental representations of Moses (figs. 935, 1058, 1101, 1111) and Boaz (fig. 1552),[153] which replace the more rigid corresponding figures in Vat. 746. For the cycle of the Book of Joshua the Vtp. painter used the Vatican Rotulus as a second source in addition to Vat. 746;[154] he copied the Rotulus in a somewhat indiscriminate manner, reproducing in his own miniatures the meaningless divisions created accidentally in the miniatures of the Rotulus when they were truncated and erroneously placed on separate folios.[155]

In other miniatures, the Vtp. painter attempted to improve the miniatures of Vat. 746. In Stoning Enchanters and Men or Women with a Divining Spirit (fig. 869) and Stoning the Adulterers (fig. 1093) the Vtp. painter is a more accurate colorist and draftsman than the Vat. 746 painter (cf. figs. 868, 1092). The building depicted behind the sitting Joshua in Caleb Addresses Joshua (fig. 1316) and the throne in Joshua Sends Spies to Ai (fig. 1203) are creations of the Vtp. painter and reflect the elaborate constructions typical of the Palaiologan period. In the Vtp. figures, affected stances, monumentality, vigorous movements, inflated drapery with manneristic zigzag folds—for instance, in the priests carrying the Ark of the Covenant (fig. 1164),[156] Balaam and the angel (fig. 990),[157] Moses and the followers of Korah (fig. 935),[158] the angelic Moses addressing the leprous Miriam (fig. 917), and Jephthah welcomed by his daughter (fig. 1481)— are stylistic elements common to a group of luxurious Palaiologan manuscripts, the so-called Palaiologina Group, dating from the last two decades of the thirteenth century.[159] Moses and Jephthah in Vtp. (figs. 917, 1481) correspond to the evangelists on fols. 122v, 206v, and 342v of the Gospels cod. plut. 6.28 in the Laurentian Library in Florence, from A.D. 1285 (text fig. 62),[160] to the apostles (especially Luke, James, and Jude on fols. 3v and 4v) in the Praxapostolos in the Vatican Library, cod. Vat. gr. 1208, from the end of the century (text fig. 63),[161] and to single figures in the Vatican Psalter, cod. Palat. gr. 381 (e.g., Christ giving the Law to Moses on fol. 169v).[162]

[152] Lazarev, *Storia*, p. 283; Lowden, *Octs.*, p. 31.

[153] Millet, "Octateuque," p. 74.

[154] Reference to Macedonian works can be seen in a number of the most prominent products of the thirteenth century (cf. Weitzmann, "Constantinop. Book Ill.," p. 334; Buchthal, *Historia Troiana*, p. 26; Lazarev, *Storia*, p. 283; Buchthal and Belting, *Patronage*, pp. 17ff.). A similar case of dependence on a luxurious codex from the Macedonian period is that of the thirteenth-century Vatican Psalter cod. Palat. gr. 381, which reproduced the miniatures of its renowned model, the Paris Psalter (Paris, Bibl. Nat., cod. gr. 139); cf. K. Weitzmann, "Eine Pariser-Psalter-Kopie des 13. Jahrhunderts auf dem Sinai," *JÖBG* 6 (1957), pp. 125–43; H. Belting, "Zum Palatina-Psalter des 13. Jahrhunderts," in *Festschrift für Otto Demus zum 70. Geburtstag* (*JÖB* 21 [1972]), pp. 17–38.

[155] See chap. 3, section 12, and the description of the miniatures of the Book of Joshua in chap. 1.

[156] Cf. Demus, "Kariye Djami," p. 158.

[157] Cf. Millet, "Octateuque," pp. 74–75; Lowden, *Octs.*, pp. 48–49.

[158] Cf. Weitzmann, "Constantinop. Book Ill.," p. 327.

[159] Buchthal and Belting, *Patronage*, pp. 17ff.; Lowden, *Octs.*, p. 32.

[160] Cf. Belting, *Illuminierte Buch*, pp. 65–68, fig. 38; Buchthal and Belting, *Patronage*, pp. 7, 18–20, pls. 2–4.

[161] Buchthal and Belting, *Patronage*, pp. 13–14, 59–66, pls. A, B, 38–40.

[162] Belting, "Palatina-Psalter" (as in note 154), figs. 1, 3, 4, 6, 8; *Miniature della Bibbia cod. Vat. Regin. Greco 1 e del Salterio cod. Vat. Palat. Greco 381* (Milan, 1905).

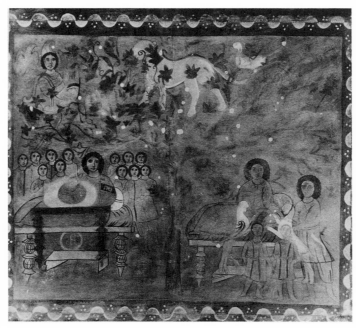

1. Dura Europos, synagogue. Jacob Blesses Ephraim and Manasseh (copy by Herbert J. Gute) (photo: Yale University Art Gallery, Dura-Europus Archive)

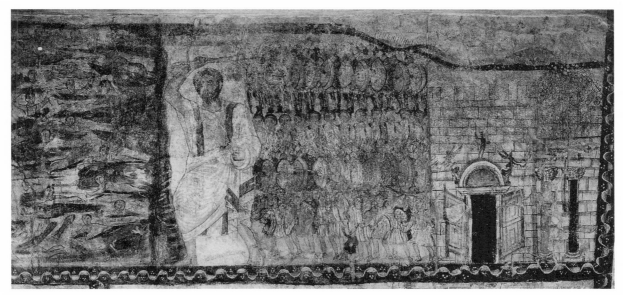

2. Dura Europos, synagogue. Crossing of the Red Sea (photo: Yale University Art Gallery, Dura-Europus Archive)

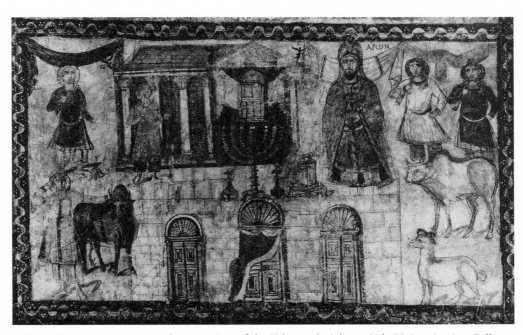

3. Dura Europos, synagogue. Consecration of the Tabernacle (photo: Yale University Art Gallery, Dura-Europus Archive)

4. The Art Museum, Princeton University, marble relief from the martyrion in Seleukeia (Antioch). Joseph in Prison (photo: The Art Museum, Princeton University)

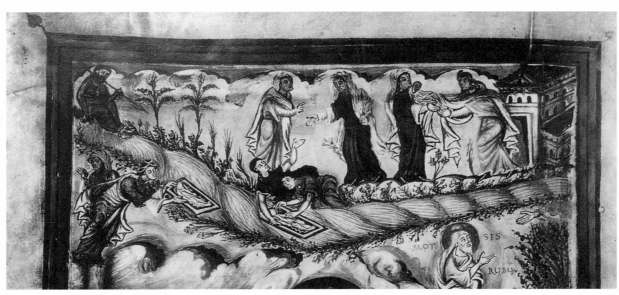

5. Rome, San Paolo fuori le mura, Bible, fol. 20v. Exodus frontispiece; detail: Rescue of Moses

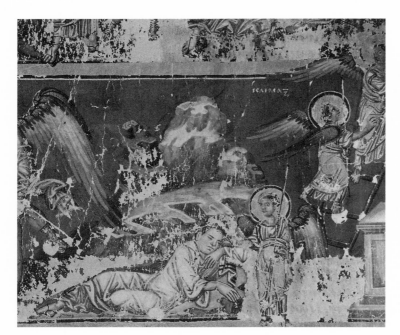

6. Paris, Bibliothèque Nationale, cod. gr. 510, Gregory of Nazianzos, *Homilies*, fol. 174v; detail: Jacob's Dream

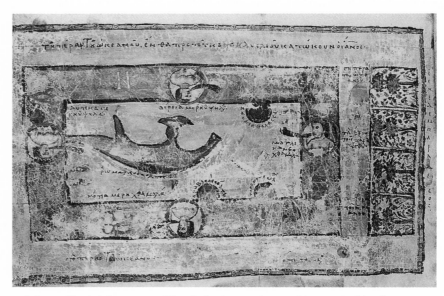

7. Mount Sinai, Monastery of St. Catherine, cod. 1186, Kosmas Indikopleustes, *Christian Topography*, fol. 66v. The World and Paradise

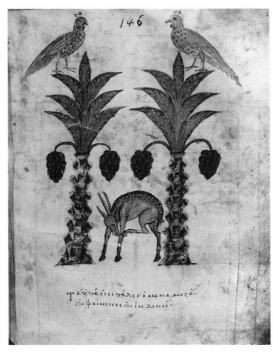

8. Paris, Bibliothèque Nationale, cod. gr. 923, John of Damascus, *Sacra Parallela*, fol. 247v. Great Whales

9. Mount Sinai, Monastery of St. Catherine, cod. 1186, Kosmas Indikopleustes, *Christian Topography*, fol. 146r. Gazelle and Palm Trees

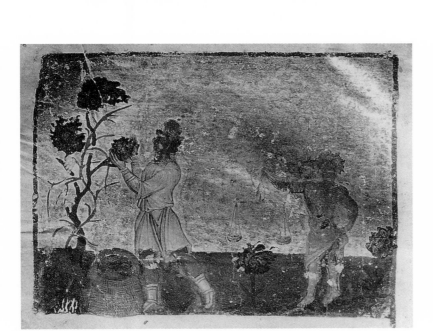

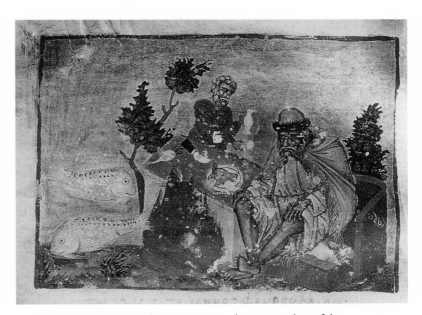

10. Mount Athos, Vatopedi Monastery, cod. 1199, typikon, fol. 44v. September

12. Mount Athos, Vatopedi Monastery, cod. 1199, typikon, fol. 134v. February

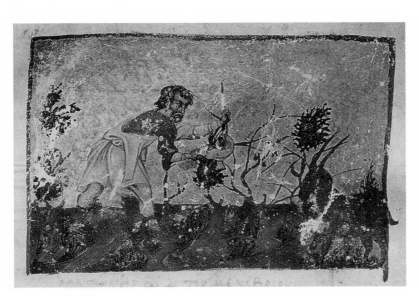

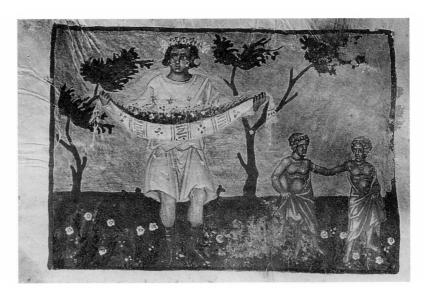

11. Mount Athos, Vatopedi Monastery, cod. 1199, typikon, fol. 89v. December

13. Mount Athos, Vatopedi Monastery, cod. 1199, typikon, fol. 177v. May

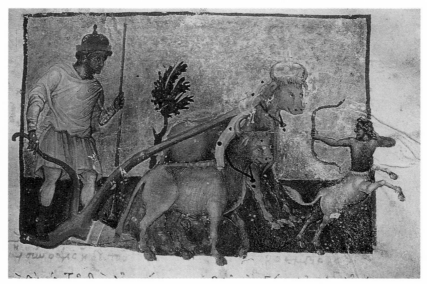

14. Mount Athos, Vatopedi Monastery, cod. 1199, typikon, fol. 76r. November

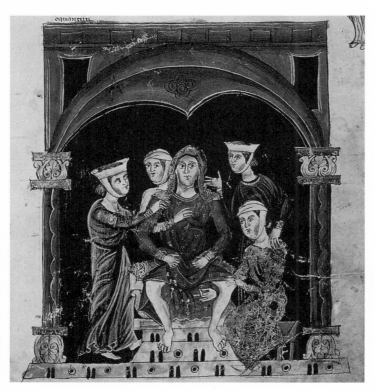

15. Vienna, Nationalbibliothek, cod. 93, medical treatise, fol. 102r. Delivery

17. Venice, Biblioteca Marciana, cod. gr. 479, pseudo-Oppian, *Cynegetica*, fol. 4r. Hunting scene

16. Rome, Biblioteca Apostolica Vaticana, Treasury, gold glass. Carpentry

18. Venice, Biblioteca Marciana, cod. gr. 479, pseudo-Oppian, *Cynegetica*, fol. 22r. Bucolic scene

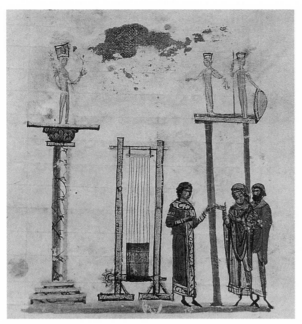

19. Jerusalem, Greek Patriarchal Library, cod. Taphou 14, commentary of pseudo-Nonnus on Gregory of Nazianzos, *Homilies*, fol. 100r. Priestess of Athena

21. Florence, Museo archeologico, Etruscan urn, inv. 5747/73. Telephos and Orestes

20. London, Egypt Exploration Society, pap. 2331, from Oxyrhynchos. Herakles and the Nemean Lion

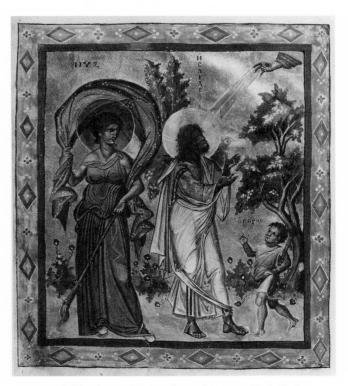

22. Paris, Bibliothèque Nationale, cod. gr. 139, Paris Psalter, fol. 419v. The Egyptians Drown

23. Paris, Bibliothèque Nationale, cod. gr. 139, Paris Psalter, fol. 435v. Prayer of Isaiah

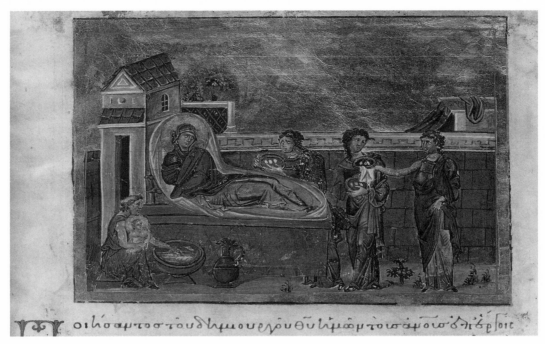

24. Rome, Biblioteca Apostolica Vaticana, cod. gr. 1613, Menologion of Basil II, page 22. Birth of the Virgin

25. Poreč (Parenzo), basilica, north apse mosaic. Christ Crowning Sts. Kosmas and Damianos

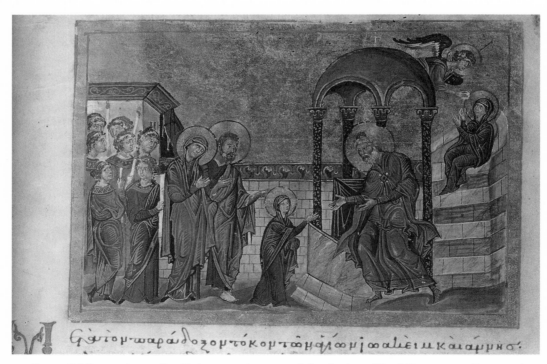

26. Rome, Biblioteca Apostolica Vaticana, cod. gr. 1613, Menologion of Basil II, page 198. Presentation of the Virgin in the Temple

27a. Paris, Bibliothèque Nationale, cod. gr. 70, Gospel Book, fol. 1v

27b. Paris, Bibliothèque Nationale, cod. gr. 70, Gospel Book, fol. 27v

27c. Paris, Bibliothèque Nationale, cod. gr. 70, Gospel Book, fol. 180v

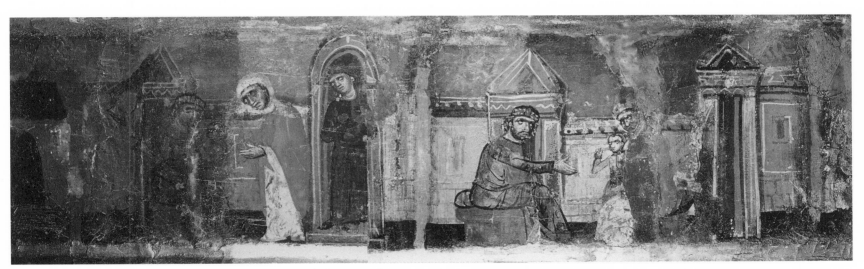

28. Mount Sinai, Monastery of St. Catherine, icon. Moses Receives the Law; detail: Pharaoh and the Child Moses

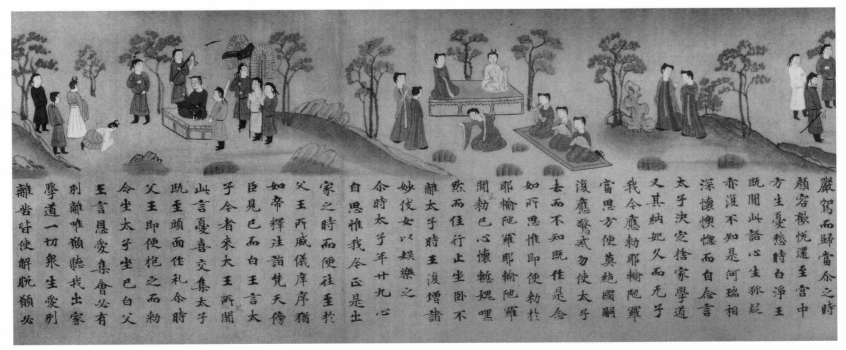

29. Nara, National Museum, papyrus scroll with illustrations from the Inga-Kyō Sutra. The Prince's Renunciation of the World

30. Mount Sinai, Monastery of St. Catherine, icon. Annunciation

31. Istanbul, St. Savior in Chora (Kariye Camii), outer narthex, mosaic. Baptism of Christ

32. Istanbul, St. Savior in Chora (Kariye Camii), inner narthex, mosaic. First Steps of the Virgin

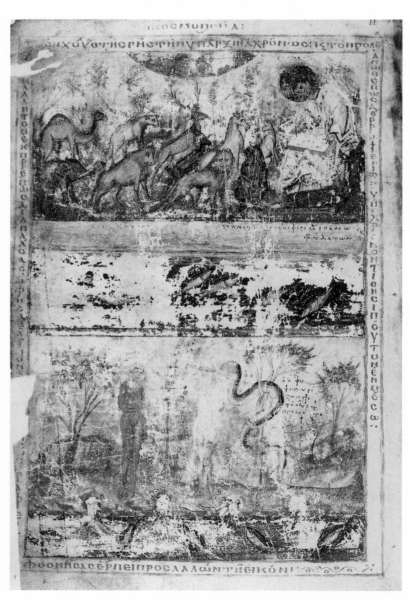

33. Rome, Biblioteca Apostolica Vaticana, cod. Reg. gr. 1, Bible of Leo Sakellarios, fol. IIr. Creation of the Birds and the Marine Creatures

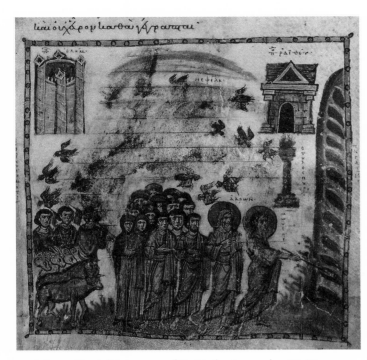

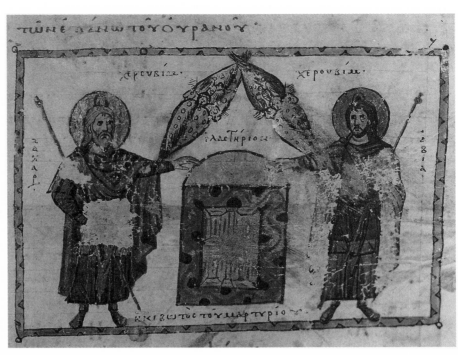

34. Mount Sinai, Monastery of St. Catherine, cod. 1186, Kosmas Indikopleustes, *Christian Topography*, fol. 74r. Scenes from Exodus and Numbers

35. Mount Sinai, Monastery of St. Catherine, cod. 1186, Kosmas Indikopleustes, *Christian Topography*, fol. 82r. Ark of the Covenant

36. Mount Sinai, Monastery of St. Catherine, cod. 1186, Kosmas Indikopleustes, *Christian Topography*, fol. 81r. Shewbread Table and Menorah

37. Mount Sinai, Monastery of St. Catherine, cod. 1186, Kosmas Indikopleustes, *Christian Topography*, fol. 82v. Tabernacle and Its Court

38. Mount Sinai, Monastery of St. Catherine, cod. 1186, Kosmas Indikopleustes, *Christian Topography*, fol. 79r. Coverings of the Tabernacle

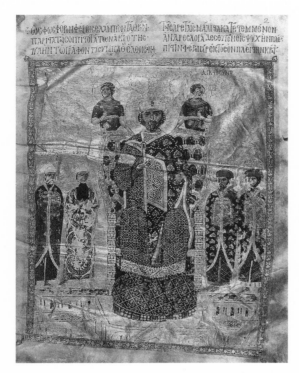

39. Paris, Bibliothèque Nationale, cod. Coislin 79, John Chrysostom, *Homilies*, fol. 2r. Michael VII Doukas and Dignitaries

40. Dura Europos, synagogue. Rescue of Moses

41. Dura Europos, synagogue. Moses and the Burning Bush

42. Dura Europos, synagogue, Torah niche. Tabernacle, Liturgical Objects, and Sacrifice of Isaac (photo: Yale University Art Gallery, Dura-Europus Archive)

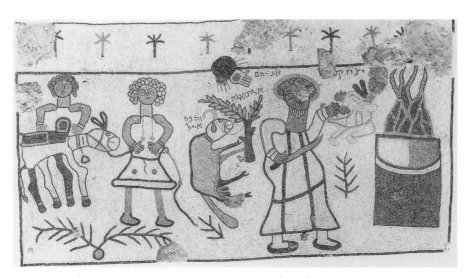

43. Beth Alpha, synagogue, mosaic pavement. Sacrifice of Isaac

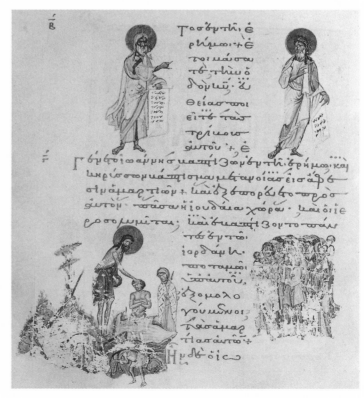

44. Paris, Bibliothèque Nationale, cod. gr. 64, Gospels, fol. 64v. Prophets, John Baptizing

† ΑΡΙΣΤΕΑΣ ΦΙΛΟΚΡΑΤΕΙ †

45. Rome, Biblioteca Apostolica Vaticana, cod. gr. 747, Octateuch, fol. 1r. Headpiece of the Letter of Aristeas

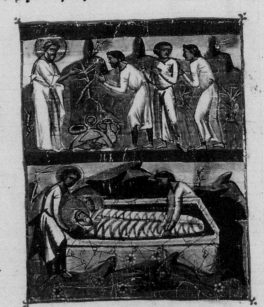

46. Rome, Biblioteca Apostolica Vaticana, cod. gr. 747, Octateuch, fol. 46v

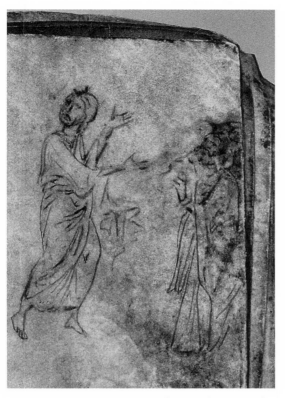

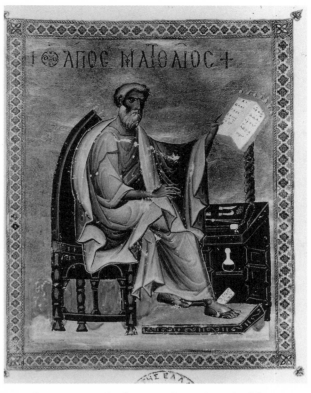

47. Mount Sinai, Monastery of St. Catherine, cod. 48, Psalter, fol. 39r. Christ Confronts Adversaries

48. Athens, National Library, cod. 57, Gospels, fol. 15v. Matthew

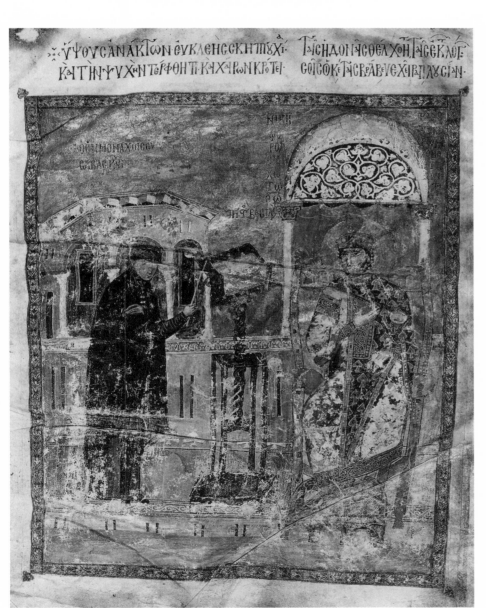

50. Istanbul, Topkapı Sarayı Library, cod. G. I. 8, Octateuch, before restoration (after Uspenskii)

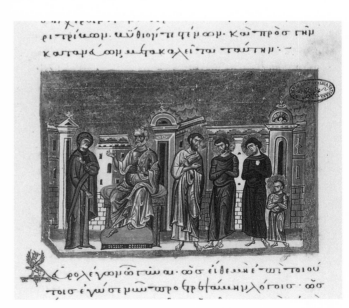

51. Rome, Biblioteca Apostolica Vaticana, cod. Vat. gr. 1162, James of Kokkinobaphos, *Homilies on the Virgin*, fol. 170r. Joseph Interrogates the Virgin about Her Pregnancy

49. Paris, Bibliothèque Nationale, cod. Coislin 79, John Chrysostom, *Homilies*, fol. 1r. The Monk Sabas Approaches the Emperor Michael VII Doukas

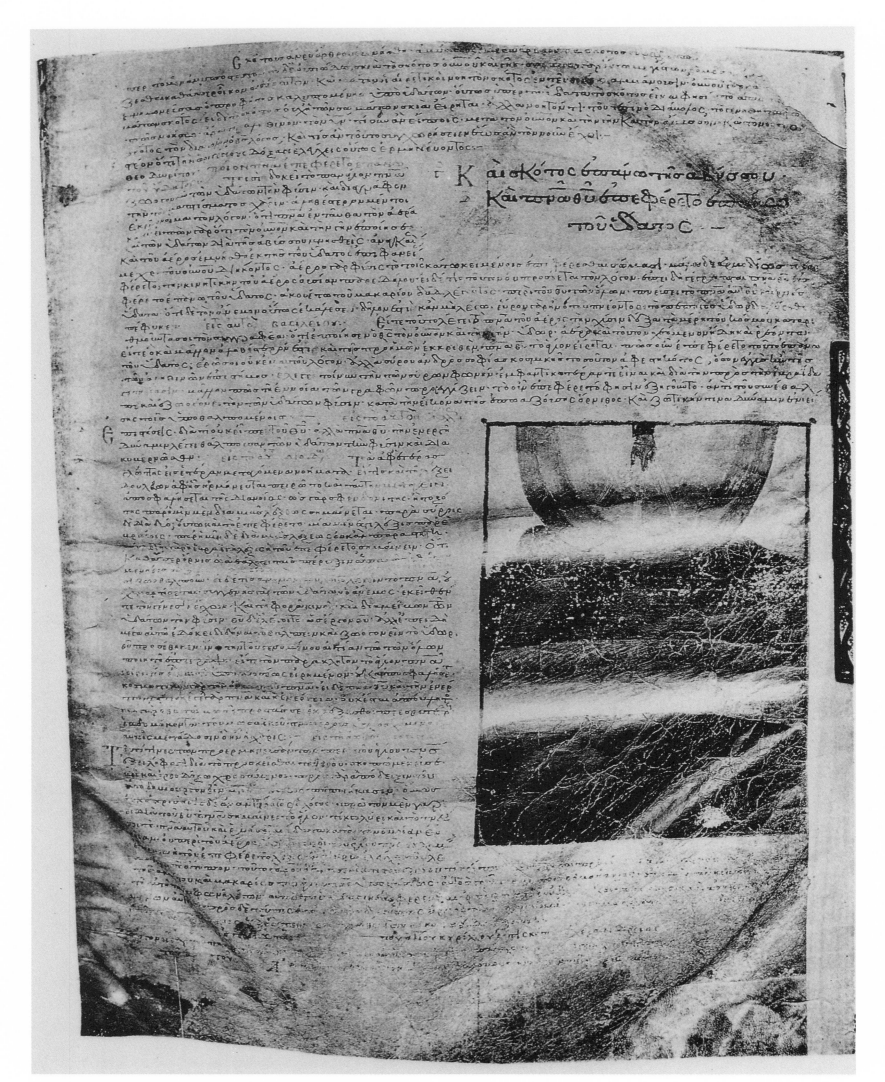

52. Smyrna, Evangelical School Library, cod. A.1, Octateuch, fol. 4r (after Uspenskii)

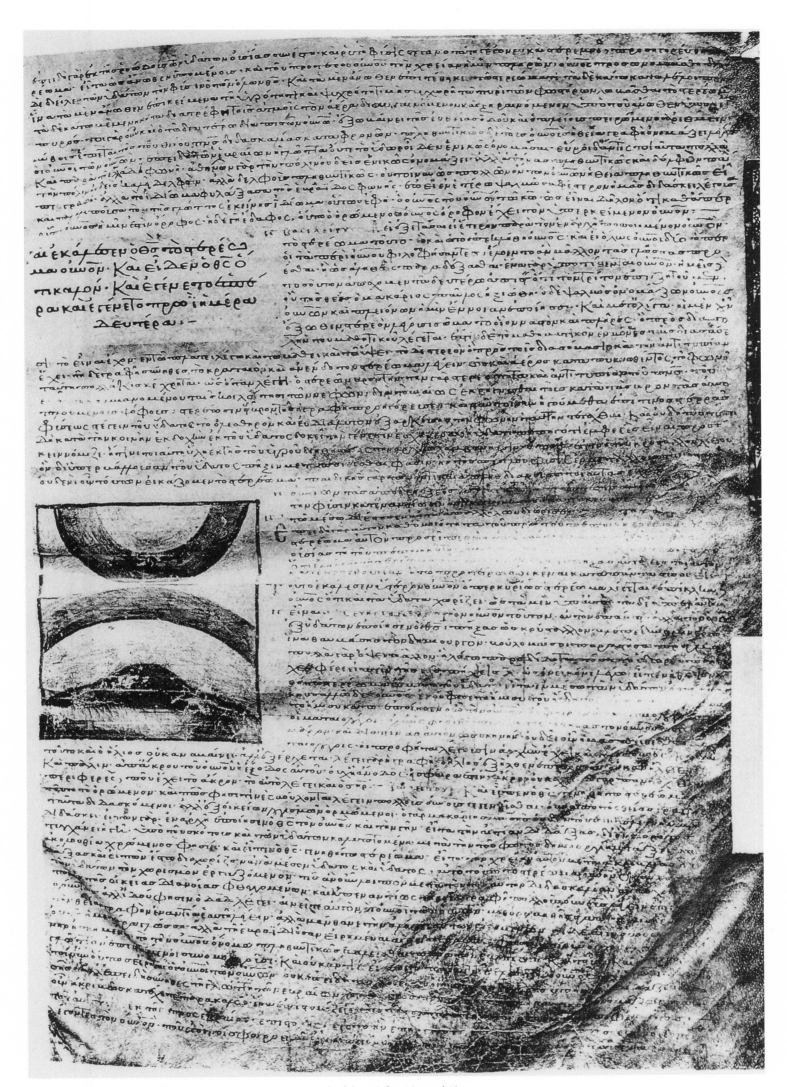

53. Smyrna, Evangelical School Library, cod. A.1, Octateuch, fol. 5r (after Uspenskii)

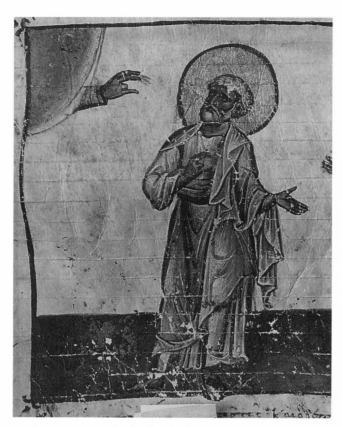

54. Smyrna, Evangelical School Library, cod. A.1, Octateuch, fol. 19v. God Orders Noah to Build the Ark; detail: Noah (photo: Buberl)

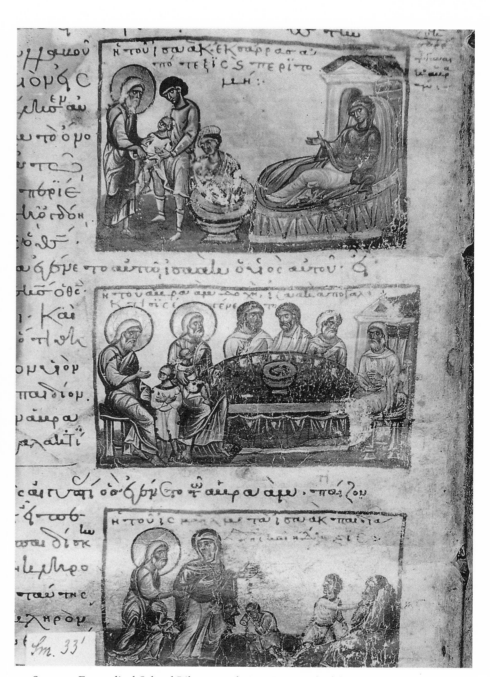

55. Smyrna, Evangelical School Library, cod. A.1, Octateuch, fol. 33v. Birth of Isaac; Circumcision of Isaac; Isaac's First Steps; Feast for Isaac; Sarah Sees Ishmael Sporting with Isaac (photo: Buberl)

56. Smyrna, Evangelical School Library, cod. A.1, Octateuch, fol. 85r. Aaron Preserves Manna; detail: Moses (photo: Buberl)

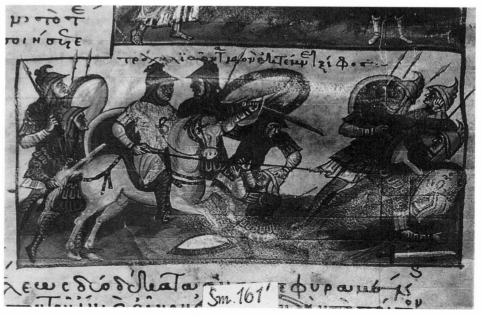

57. Smyrna, Evangelical School Library, cod. A.1, Octateuch, fol. 161v. Amalekites and Canaanites Smite the Israelites (photo: Buberl)

The page contains extensive Greek minuscule manuscript text that is a Byzantine commentary/catena on Genesis.  However, this is highly cursive Byzantine Greek handwriting that is extremely difficult to read accurately.  much is illegible.





58. Rome, Biblioteca Apostolica Vaticana, cod. gr. 746, Octateuch, fol. 13r. Headpiece of Genesis

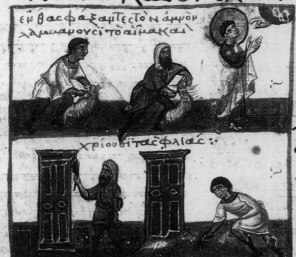

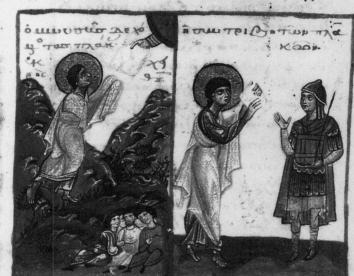

61. Mount Athos, Vatopedi Monastery, cod. 602, Octateuch, fol. 3r. Headpiece of Leviticus

62. Florence, Biblioteca Medicea Laurenziana, cod. plut. 6.28, Gospels, fol. 122v. Mark

63. Rome, Biblioteca Apostolica Vaticana, cod. Vat. gr. 1208, Praxapostolos, fol. 3v. Luke and James

BIBLIOGRAPHY WITH SHORT TITLES

OF FREQUENTLY CITED WORKS

A. PERIODICALS, SERIES, AND ENCYCLOPEDIAS

ActaIRNorv	Acta ad Archaeologiam et Artium Historiam Pertinentia, Institutum Romanum Norvegiae
AJA	American Journal of Archaeology
AnnPisa	Annali della Scuola Normale Superiore di Pisa, Classe di Lettere e Filosofia
ArtB	The Art Bulletin
BNJ	Byzantinisch-neugriechische Jahrbücher
Byz	Byzantion
ByzF	Byzantinische Forschungen
BZ	Byzantinische Zeitschrift
CahArch	Cahiers archéologiques
CahCM	Cahiers de civilisation médiévale, Xᵉ-XIIᵉ siècles
CCSG	Corpus Christianorum, Series Graeca
CFHB	Corpus Fontium Historiae Byzantinae
Comm	Commentari
CorsiRav	Corsi di Cultura sull'Arte Ravennate e Bizantina
CSCO	Corpus Scriptorum Christianorum Orientalium
	Arm: Scriptores Armeniaci
	Syri: Scriptores Syri
Δελτ.Χριστ. Ἀρχ.ʹΕτ.	Δελτίον τῆς Χριστιανικῆς Ἀρχαιολογικῆς Ἑταιρείας
DOP	Dumbarton Oaks Papers
ʹΕπ.ʹΕτ. Βυζ.Σπ.	Ἐπετηρὶς Ἑταιρείας Βυζαντινῶν Σπουδῶν
ErIs	Eretz-Israel
ErJb	Eranos-Jahrbuch
FelRav	Felix Ravenna
FrSt	Frühmittelalterliche Studien
GBA	Gazette des beaux-arts
GRBS	Greek, Roman, and Byzantine Studies
IRAIK	Izvestiia Russkago Arkheologicheskago Instituta v Konstantinopolie / Bulletin de l'Institut archéologique russe à Constantinople
JA	Jewish Art
JBAA	Journal of the British Archaeological Association
JbAChr	Jahrbuch für Antike und Christentum
JbBerlMus	Jahrbuch der Berliner Museen
JbKSWien	Jahrbuch der kunsthistorischen Sammlungen in Wien
JbKw	Jahrbuch für Kunstwissenschaft (from 1932, Zeitschrift für Kunstgeschichte)
JJA	Journal of Jewish Art
JJS	Journal of Jewish Studies
JÖB	Jahrbuch der Österreichischen Byzantinistik
JÖBG	Jahrbuch der Österreichischen Byzantinischen Gesellschaft
JQR	Jewish Quarterly Review
JSJ	Journal for the Study of Judaism
JThS	Journal of Theological Studies
JWalt	Journal of the Walters Art Gallery
JWarb	Journal of the Warburg and Courtauld Institutes
Kairos	Kairos: Zeitschrift für Religionswissenschaft und Theologie
LCI	Lexikon der christlichen Ikonographie. Ed. E. Kirschbaum et al. 8 vols. Rome, Freiburg, Basel, and Vienna: Herder, 1968–76.
LCL	Loeb Classical Library
LIMC	Lexicon Iconographicum Mythologiae Classicae. Zurich and Munich: Artemis, 1974– .
MarbJB	Marburger Jahrbuch für Kunstwissenschaft
MedRin	Medioevo e Rinascimento
MEFRM	Mélanges de l'École français de Rome, Moyen Age, Temps Modernes
Min	Miniatura
MonPiot	Monuments Piot
MünchJb	Münchner Jahrbuch der bildenden Kunst
Mus	Le Muséon
NBACr	Nuovo Bullettino di Archeologia Cristiana
OCA	Orientalia Christiana Analecta
OCP	Orientalia Christiana Periodica
ODB	The Oxford Dictionary of Byzantium. Ed. Alexander Kazhdan et al. New York and Oxford: Oxford University Press, 1991.
OLP	Orientalia Lovaniensia Periodica
OTS	Oudtestamentische Studien
PG	Patrologiae Cursus Completus, Series Graeca. Ed. Jacques-Paul Migne. 161 vols. Paris: Migne, 1857–66.
PL	Patrologiae Cursus Completus, Series Latina. Ed. Jacques-Paul Migne. 221 vols. Paris: Migne, 1844–55.
PO	Patrologia Orientalis. Ed. R. Graffin. Paris: Firmin-Didot, 1947–66; Turnhout: Brepols, 1968– .
ProcBrAc	Proceedings of the British Academy
PS	Patrologia Syriaca. Ed. R. Graffin. 3 vols. Paris: Firmin-Didot, 1894–1926.
RA	Revue archéologique
RAC	Reallexikon für Antike und Christentum. Stuttgart: Hiersemann, 1950– .
RACr	Rivista di Archeologia Cristiana
RBibl	Revue biblique
RBK	Reallexikon zur byzantinischen Kunst. Ed. Klaus Wessel and Marcell Restle. Vols. 1–5. Stuttgart: Hiersemann, 1966–95.
REArm	Revue des études arméniennes
REB	Revue des études byzantines
REG	Revue des études grecques
REJ	Revue des études juives
RepKunstw	Repertorium für Kunstwissenschaft

ROC	*Revue de l'Orient chrétien*
RQ	*Römische Quartalschrift für christliche Altertums-kunde und Kirchengeschichte*
RSBN	*Rivista di Studi Bizantini e Neoellenici*
SC	Sources Chrétiennes
Settimane	*Settimane di Studio del Centro Italiano di Studi sul l'Alto Medioevo*
ST	Studi e Testi
StM	*Studi Medievali*
StP	*Studia Patristica*

TDNT	*Theological Dictionary of the New Testament.* Ed. Gerhard Kittel, trans. and ed. Geoffrey W. Bromiley. 10 vols. Grand Rapids, Mich.: Eerdmans, 1964–76.
ThLz	*Theologische Literaturzeitung*
VChr	*Vigiliae Christianae*
VizVrem	*Vizantiiskii Vremennik*
ZAW	*Zeitschrift für die alttestamentliche Wissenschaft*
ZKunstg	*Zeitschrift für Kunstgeschichte*
ZKunstw	*Zeitschrift für Kunstwissenschaft*
ZSlPh	*Zeitschrift für Slavische Philologie*

B. WORKS ON THE BIBLE AND ANCIENT LITERATURE:
ANCIENT VERSIONS OF THE OLD TESTAMENT, CATENAE,
PATRISTICS, PSEUDEPIGRAPHA, RABBINICS, AND OTHER WRITINGS

Anecdota, ed. Vasil'ev *Anecdota Graeco-Byzantina.* Ed. Afanasii Vasil'ev. Vol. 1. Uchenyia Zapiski Imperatorskago Moskov-skago Universiteta, Otdiel Istoriko-filologicheskii 11. Moscow: Typis Universitatis Caesareae, 1893.

Aphrahat the Syrian. *La version arménienne des oeuvres d'Aphraate le Syrien.* Ed. Guy Lafontaine. 3 vols. in 6. CSCO 382, 383, 405, 406, 423, 424/Arm. 7–12. Louvain: Secretariat du Corpus SCO, 1977–80.

The Apocrypha and Pseudepigrapha of the Old Testament in English. Vol. 2, *Pseudepigrapha.* Ed. Robert Henry Charles. Oxford: Clarendon Press, 1913.

Babylonian Talmud Babylonian Talmud: Seder Nashim, Translated into English. Vol. 3, *Sotah.* Ed. Isidore Epstein. London: Soncino Press, 1936.

Barhebraeus' Scholia Barhebraeus' Scholia on the Old Testament. Pt. 1, *Genesis–2 Samuel.* Ed. Martin Sprengling and William C. Graham. Chicago: University of Chicago Press, 1931.

Basile de Césarée, Homélies sur l'Hexaéméron. Ed. Stanislas Giet. SC 26. Paris: Éditions du Cerf, 1949.

Basile de Césarée, Sur l'origine de l'homme (Hom. X et XI de l'Hexaéméron). Ed. Alexis Smets and Michel Van Esbroeck. SC 160. Paris: Éditions du Cerf, 1970.

La Bible: Écrits intertestamentaires. Ed. André Dupont-Sommer and Marc Philonenko. Tours: Gallimard, 1987.

Book of the Bee The Book of the Bee: The Syriac Text Edited from the Manuscripts in London, Oxford, and Munich. Ed. Ernest A. Wallis Budge. Oxford: Clarendon Press, 1886.

The Book of the Cave of Treasures: A History of the Patriarchs and the Kings, Their Successors, from the Creation to the Crucifixion of Christ, Translated from the Syriac Text of the British Museum Ms. Add. 25875. Ed. Ernest A. Wallis Budge. London: Religious Tract Society, 1927.

The Book of Yashar. Ed. Mordecai Manuel Noah. New York, 1840. Reprint, New York: Hermon Press, 1972.

Brock, "Anonymous Syriac Homily" Brock, Sebastian P. "An Anonymous Syriac Homily on Abraham (Gen. 22)." *OLP* 12 (1981), pp. 225–60.

Brock, "Syriac Life of Abel" Brock, Sebastian P. "A Syriac Life of Abel." *Mus* 87 (1974), pp. 467–92.

Brock, "Two Syriac Homilies" Brock, Sebastian P. "Two Syriac Verse Homilies on the Binding of Isaac." *Mus* 99 (1986), pp. 61–129.

Brock, Sebastian P., and Simon Hopkins. "A Verse Homily on Abraham and Sarah in Egypt: Syriac Original with Early Arabic Translation." *Mus* 105 (1992), pp. 87–146.

Los Capítulos de Rabbí Eliezer: Pirqê Rabbî 'Eli'ezer. Versión crítica sobre la edición de David Luria, Varsovia 1852. Ed. Miguel Pérez Fernández. Valencia: Institución S. Jerónimo para la Investigación Bíblica, 1984.

Catenae Graecae Catenae Graecae in Genesim et in Exodum. Vol. 1, *Catena Sinaitica.* Vol. 2, *Collectio Coisliniana in Genesim.* Ed. Françoise Petit. CCSG 2 and 15. Turnhout and Leuven: Brepols and University Press, 1977 and 1986.

La Caverne des Trésors: Les deux recensions syriaques. Ed. Su-Min Ri. 2 vols. CSCO 486, 487/Syri 207, 208. Louvain: Peeters, 1987.

Das christliche Adambuch des Morgenlandes. Ed. August Dillmann. Jahrbuch der biblischen Wissenschaften, 5. Göttingen, 1853.

The Chronicles of Jerahmeel; or, The Hebrew Bible Historiale, Being a Collection of Apocryphal and Pseudepigraphical Books Dealing with the History of the World from Creation to the Death of Judas Maccabeus. Ed. Moses Gaster. London: Royal Artistic Society, 1899. Reprint, New York: Ktav, 1971.

Chronique de Michel le Syrien, Patriarche Jacobite d'Antioche (1166–1199). Ed. Jean Baptiste Chabot. 2 vols. Paris: Leroux, 1900 and 1910.

Il Combattimento di Adamo. Ed. Antonio Battista and Bellarmino Bagatti. Studium Biblicum Franciscanum, Collectio Minor 29. Jerusalem: Franciscan Printing Press, 1982.

Commentaire d'Iso'dad de Merv sur l'Ancien Testament. Vol. 1, *Genèse.* Ed. Ceslaus van den Eynde. CSCO 156/Syri 75. Louvain: Durbecq, 1955.

Devreesse, Robert. *Les ancien commentateurs grecs de l'Octateuque et des Rois (fragments tirés des chaînes).* ST 201. Vatican City: Biblioteca Apostolica Vaticana, 1959.

Dictionnaire des apocryphes, ou collection de tous les livres apocryphes relatifs à l'Ancien et au Nouveau Testament. Ed. Jacques-Paul

Migne. 2 vols. Paris: Migne, 1856 and 1858. Reprint, Turnhout: Brepols, 1989.

Didyme l'Aveugle, Sur la Genèse. Vol. 1. Ed. Pierre Nautin and Louis Doutreleau. SC 233. Paris: Éditions du Cerf, 1976.

Dionysii Orbis Descriptio, Geographi Graeci Minores. Vol. 2. Ed. Karl Müller. Paris: Didot, 1861.

Diyarbakir 22 Le commentaire sur Genèse–Exode 9,32 du manuscrit (olim) Diyarbakir 22. Ed. Lucas van Rompay. 2 vols. CSCO 483, 484/Syri 205, 206. Louvain: Peeters, 1986.

The Early Syrian Fathers on Genesis from a Syriac Ms. on the Pentateuch in the Mingana Collection. Ed. Abraham Levene. London: Taylor's Foreign Press, 1951.

Eldad ha-Dani. Ed. Abraham Epstein. Pressburg: Avraham Alkala'i, 1891.

Ephraem. *In Genesim et in Exodum commentarii.* Ed. Raymond Tonneau. 2 vols. CSCO 152, 153/Syri 71, 72. Louvain: Durbecq, 1955.

Ephraem Syri, Opera Omnia. Vol. 1. Venice, 1756.

Ephrem. *Hymns on Paradise.* Ed. Sebastian P. Brock. Crestwood, N.Y.: St. Vladimir's Seminary Press, 1990.

Éphrem de Nisibe, Hymnes sur le Paradis. Ed. René Lavenant and François Graffin. SC 137. Paris: Éditions du Cerf, 1968.

Epigrammatum Anthologia Palatina. Ed. Friedrich Dübner. Vol. 1. Paris: Didot, 1864.

"The Ethiopic History of Joseph." Ed. E. Isaac. *Journal for the Study of the Pseudepigrapha* 6 (1990), pp. 3–125.

Eusebius. *Praeparatio Evangelica.* Ed. Edwin Hamilton Gifford. 4 vols. Oxford: Typographeo Academico, 1903; reprint 1978.

Evangelia Apocrypha. Ed. Konstantin von Tischendorf. 2d ed. Leipzig: Mendelssohn, 1876.

Exodus Rabbah Midrash Rabbah. Ed. Harry Freedman and Maurice Simon. 3d ed. Vol. 3, *Exodus.* Ed. S. M. Lehrman. London and New York: Soncino Press, 1983.

The Fragment-Targums of the Pentateuch According to Their Extant Sources. Ed. Michael L. Klein. Analecta Biblica 76. 2 vols. Rome: Pontificio Istituto Biblico, 1980.

Genesis Rabbah Midrash Rabbah. Ed. Harry Freedman and Maurice Simon. 3d ed. Vols. 1 and 2, *Genesis.* Ed. Harry Freedman. London: Soncino Press, 1983.

Genesis Rabbah: The Judaic Commentary to the Book of Genesis. A New American Translation. Ed. Jacob Neusner. Atlanta: Scholars Press for Brown Judaic Studies, 1985.

Germanus of Constantinople. *On the Divine Liturgy.* Ed. Paul Meyendorff. Crestwood, N.Y.: St. Vladimir's Seminary Press, 1984.

Ginzberg, *Legends Ginzberg, Louis. *The Legends of the Jews.* 7 vols. Philadelphia: Jewish Publication Society of America, 1907–37.

Jansma, "Early Syrian Fathers" Jansma, Taeke. "Investigations into Early Syrian Fathers on Genesis: An Approach to the Exegesis of the Nestorian Church and to the Comparison of Nestorian and Jewish Exegesis." *OTS* 12 (1958), pp. 69–181.

John Chrysostom. *Discourses against Judaizing Christians.* Ed. Paul W. Harkins. Fathers of the Church, 68. Washington, D.C.: Catholic University of America Press, 1979.

————. *Homilies on Genesis 1–17.* Ed. Robert C. Hill. Fathers of the Church, 74. Washington, D.C.: Catholic University of America Press, 1985.

————. *Homilies on Genesis 18–45.* Ed. Robert C. Hill. Fathers of the Church, 82. Washington, D.C.: Catholic University of America Press, 1990.

————. *Homily on Saint Babylas, against Julian and the Pagans (De Sancto Babyla contra Julianum et Gentiles).* Ed. Marna M. Morgan and Samuel N. C. Lieu. In *The Emperor Julian: Panegyric and Polemic. Claudius Mamertinus, John Chrysostom, Ephrem the Syrian.* Ed. Samuel N. C. Lieu. 2d ed., pp. 39–86. Liverpool: Liverpool University Press, 1989.

————. *Sur la vaine gloire et l'éducation des enfants.* Ed. Anne-Marie Malingrey. SC 188. Paris: Éditions du Cerf, 1972.

John Damascene. *Barlaam and Joasaph.* Ed. George Ratcliffe Woodward and Harold Mattingly. LCL 34. Cambridge, Mass., and London: Harvard University Press and Heinemann, 1983.

Josephus in Nine Volumes. Vols. 4 and 5, *Jewish Antiquities, Books I–VIII.* Ed. Henry St. John Thackeray and Ralph Marcus. LCL 242 and 281. Cambridge, Mass., and London: Harvard University Press and Heinemann, 1978.

Kahle, Paul E. *The Cairo Geniza.* 2d ed. Oxford: Blackwell, 1959.

Karo and Lietzmann, *Catalogus Karo, Georg, and Lietzmann, Hans. *Catenarum Graecarum Catalogus.* Berlin, 1902.

Kronholm, *Motifs from Genesis Kronholm, Tryggve. *Motifs from Genesis 1–11 in the Genuine Hymns of Ephrem the Syrian, with Particular Reference to the Influence of Jewish Exegetical Tradition.* Lund: Gleerup, 1978.

Légendes juives apocryphes sur la vie de Moïse: La chronique de Moïse, l'ascension de Moïse, la mort de Moïse. Ed. Meyer Abraham. Paris: Geuthner, 1925.

"Letter," ed. Thackeray Thackeray, H. St. J. "The Letter of Aristeas." Appendix to Henry Barclay Swete, *An Introduction to the Old Testament in Greek.* Cambridge: Cambridge University Press, 1914. Reprint, ed. Richard Rusden Ottley. Peabody, Mass.: Hendrickson, 1989, pp. 531–606.

Lettre Lettre d'Aristée à Philocrate. Ed. André Pelletier. SC 89. Paris: Éditions du Cerf, 1962.

Leviticus Rabbah Midrash Rabbah. Ed. Harry Freedman and Maurice Simon. 3d ed. Vol. 4, *Leviticus.* Ed. Jacob Israelstam and Judah J. Slotki. London and New York: Soncino Press, 1983.

Livre du combat d'Adam. Ed. and trans. Gustave Brunet. In *Dictionnaire des apocryphes,* ed. Jacques-Paul Migne. Vol. 1, cols. 297–388.

Mekilta de-Rabbi Ishmael. Ed. and trans. Jacob Z. Lauterbach. 3 vols. Philadelphia: Jewish Publication Society of America, 1976.

Memar Marqah: The Teaching of Marqah. Ed. John D. MacDonald. Berlin: Töpelmann, 1963.

Midrash Rabbah. See *Exodus Rabbah, Genesis Rabbah, Leviticus Rabbah, Numbers Rabbah.*

The Mishnah: A New Translation. Trans. Jacob Neusner. New Haven: Yale University Press, 1988.

Neophyti 1: Targum Palestinense Ms. de la Biblioteca Vaticana. Edición príncipe, introducción y versión castellana. Ed. Alejandro

Díez Macho. Vol. 1, *Génesis*. Vol. 2, *Éxodo*. French translation by Roger Le Déaut. English translation by Martin McNamara and Michael Maher. Madrid and Barcelona: Consejo Superior de Investigaciones Científicas, 1968 and 1970.

Numbers Rabbah Midrash Rabbah. Ed. Harry Freedman and Maurice Simon. 3d ed. Vols. 5 and 6, *Numbers*. Ed. Judah J. Slotki. London and New York: Soncino Press, 1983.

OTP The Old Testament Pseudepigrapha. Ed. James H. Charlesworth. 2 vols. Garden City, N.Y.: Doubleday, 1983 and 1985.

Papyrus Bodmer V Papyrus Bodmer V: Nativité de Marie. Ed. Michel Testuz. Cologny-Geneva: Bibliothèque Bodmer, 1958.

Philo. Ed. Francis Henry Colson and George Herbert Whitaker. 12 vols. LCL. Cambridge, Mass., and London: Harvard University Press and Heinemann, 1929.

Philo, *Questions and Answers on Genesis*. Ed. Ralph Marcus. LCL 380. Philo, Supplement 1. Cambridge, Mass., and London: Harvard University Press and Heinemann, 1953.

Photios, *Bibliothèque*. Ed. René Henry. 8 vols. Paris: Belles Lettres, 1959–77.

Pirkê de Rabbi Eliezer. Ed. Gerald Friedlander. 4th ed. New York: Sepher-Hermon Press, 1981.

Pitra, Jean Baptiste. *Analecta Sacra Spicilegio Solesmensi Parata*. 8 vols. Paris: A. Jouby et Roger, 1876–91. Reprint, Farnborough, Hants.: Gregg, 1966–67.

Rahlfs, *Verzeichnis Rahlfs, Alfred. *Verzeichnis der griechischen Handschriften des Alten Testaments*. Berlin: Weidmann, 1914.

Richard, Marcel. "Un fragment inédit de S. Hippolyte sur Genèse 4:23." In *Hippolyte, Opera Minora*. Vol. 1, pp. 394–400. Turnhout and Leuven: Brepols, 1976.

Romanos le Mélode, Hymnes. Ed. José Grosdidier de Matons. 5 vols. SC 99, 110, 114, 128, 283. Paris: Éditions du Cerf, 1964–67.

Σειρά Σειρὰ ἑνὸς καὶ πεντήκοντα ὑπομνηματιστῶν εἰς τὴν Ὀκτάτευχον καὶ τὰ τῶν Βασιλειῶν. Ed. Nikephoros Ieromonachos tou Theotokou. 2 vols. Leipzig: Breitkopf, 1772 and 1773.

Targum Genèse, ed. Le Déaut *Targum du Pentateuque*. Vol. 1, *Genèse*. Ed. Roger Le Déaut. SC 245. Paris: Éditions du Cerf, 1978.

Targum Exode et Lévitique, ed. Le Déaut *Targum du Pentateuque*. Vol. 2, *Exode et Lévitique*. Ed. Roger Le Déaut. SC 256. Paris: Éditions du Cerf, 1979.

Targum Nombres, ed. Le Déaut *Targum du Pentateuque*. Vol. 3,

Nombres. Ed. Roger Le Déaut. SC 261. Paris: Éditions du Cerf, 1979.

The Targum of the Five Megillot: Ruth, Ecclesiastes, Canticles, Lamentations, Esther. Codex Vaticani Urbinati 1. Ed. Etan Levine. Jerusalem: Makor, 1977.

Targum Onkelos to Exodus. Ed. Israel Drazin. New York: Ktav, 1989.

Targum Onkelos to Genesis. Ed. Moses Aberbach and Bernard Grossfeld. Denver and New York: Center for Judaic Studies, University of Denver, and Ktav, 1982.

Targum Onqelos to Exodus. Ed. Bernard Grossfeld. Edinburgh: T. and T. Clark, 1988.

Targum Onqelos to Genesis. Ed. Bernard Grossfeld. Edinburgh: T. and T. Clark, 1988.

Targum Onqelos to Numbers. Ed. Bernard Grossfeld. Edinburgh: T. and T. Clark, 1988.

Theodore Bar Koni. *Livre des Scolies (recension de Séert)*. Vol. 1, *Mimrè I–V*. Ed. Robert Hespel and René Draguet. CSCO 431/Syri 187. Leuven: Peeters, 1981.

Theodoreti Cyrensis Quaestiones in Octateuchum. Ed. Natalio Fernández Marcos and Angel Sáenz-Badillos. Textos y estudios "Cardenal Cisneros" 17. Madrid: Poliglota Matritense, 1979.

Theodori Mopsuesteni Fragmenta Syriaca e Codicibus Musei Britannici Nitriacis. Ed. Eduard Sachau. Leipzig: Engelmann, 1869.

Theophilus of Antioch. *Ad Autolycum*. Ed. Robert M. Grant. Oxford: Clarendon Press, 1970.

Tonneau, R. M. "Théodore de Mopsueste: Interprétation (du livre) de la Genèse (Vat. Syr. 120, ff. I–IV)." *Mus* 66 (1953), pp. 45–64.

The Tosefta Translated from the Hebrew, Third Division: Nashim (The Order of Women). Ed. Jacob Neusner. New York: Ktav, 1979.

The Uncanonical Writings of the Old Testament Found in the Armenian MSS. of the Library of St. Lazarus. Ed. Jacques Issaverdens. 2d ed. Venice: Armenian Monastery of St. Lazarus, 1934.

Van Rompay, Lucas. "A Hitherto Unknown Nestorian Commentary on Genesis and Exodus 1–9,32 in the Syriac Manuscript (olim) Dijarbekr 22." *OLP* 5 (1974), pp. 53–78.

Vermes, *Scripture and Tradition Vermes, Geza. *Scripture and Tradition in Judaism: Haggadic Studies*. 2d ed. Leiden: Brill, 1973.

C. WORKS ON THE OCTATEUCHS AND THE JOSHUA ROTULUS

Age of Spirituality Age of Spirituality: Late Antique and Early Christian Art, Third to Seventh Century. Ed. Kurt Weitzmann. Exh. cat., New York, The Metropolitan Museum of Art, November 1977–February 1978. New York: The Metropolitan Museum of Art and Princeton University Press, 1979.

Τὸ Ἅγιου Ὄρος. Athens: Constantinidos, 1903.

Ainalov, *Hellenistic Origins Ainalov, Dimitri V. *The Hellenistic Origins of Byzantine Art*, ed. Cyril Mango. New Brunswick,

N.J.: Rutgers University Press, 1961. English translation of "Ellinisticheskie osnovy vizantiiskogo iskusstva." *Zapiski Imperatorskago Russkago Arkheologicheskago Obshchestva*, n.s., 12, *Trudy Otdeleniia arkheologii drevne-klassicheskoi, vizantiiskoi i zapadno-evropeiskoi* 5 (1900–1901).

Åkerström-Hougen, *Calendar Åkerström-Hougen, Gunilla. *The Calendar and Hunting Mosaics of the Villa of the Falconer in Argos: A Study in Early Byzantine Iconography*. Acta Insti-

tuti Atheniensis Regni Sueciae, Series in 4°, 23/Skrifter Utgivna av Svenska Institutet i Athen 4°, 23. Stockholm, 1974.

Alexandre, *Commencement* Alexandre, Monique. *Le commencement du livre: Genèse I–IV: La version grecque de la Septante et sa réception*. Christianisme antique, 3. Paris: Beauchesne, 1988.

Al-Hamdani, "Sources" Al-Hamdani, Betty. "The Iconographical Sources for the Genesis Frescoes Once Found in S. Paolo f.l.m." In *Atti del IX Congresso internazionale di archeologia cristiana* (Rome, September 1975). Vol. 2, *Comunicazioni su scoperte inedite*, pp. 11–35. Vatican City: Pontificio Istituto di Archeologia Cristiana, 1978.

Aliprantis, *Moses* Aliprantis, Theologos C. *Moses auf dem Berge Sinai: Die Ikonographie der Berufung des Moses und des Empfangs der Gesetzestafeln*. Munich: Tuduv-Verlagsgesellschaft, 1986.

Alpatov, "Rapport" Alpatov, Mikhail V. "Rapport sur un voyage à Constantinople." *REG* 26 (1926), pp. 301–22.

Alpatov, "Trinité" Alpatov, Mikhail V. "La 'Trinité' dans l'art byzantin et l'icône de Roublev." *Échos d'Orient* 26 (1927), pp. 150–86.

Alpatov, "Zametki" Alpatov, Mikhail V. "Zametki o Pamiatnikax Vizantiiskoi zhivopisi." *VizVrem* 44 (1893), pp. 135–57.

Ameisenowa, Zofja. "The Tree of Life in Jewish Iconography." *JWarb* 2 (1938–39), pp. 326–45.

Anderson, "James the Monk" Anderson, Jeffrey C. "The Illustrated Sermons of James the Monk: Their Dates, Order, and Place in the History of Byzantine Art." *Viator* 22 (1991), pp. 69–120.

Anderson, *New York Lectionary* Anderson, Jeffrey C. *The New York Cruciform Lectionary*. University Park: Pennsylvania State University Press, 1992.

Anderson, "Seraglio" Anderson, Jeffrey C. "The Seraglio Octateuch and the Kokkinobaphos Master." *DOP* 36 (1982), pp. 83–114.

Anderson, "Theodore Psalter" Anderson, Jeffrey C. "On the Nature of the Theodore Psalter." *ArtB* 70 (1988), pp. 550–68.

Anderson, "Twelfth-Century Instance" Anderson, Jeffrey C. "A Twelfth-Century Instance of Reused Parchment: Christ Church College, Wake Gr. 32." *Scriptorium* 44 (1990), pp. 207–16.

Anderson, "Two Centers" Anderson, Jeffrey C. "An Examination of Two Twelfth-Century Centers of Byzantine Manuscript Production." Ph.D. diss., Princeton University, 1975.

Artelt, *Dialogdarstellung* Artelt, Walter. *Die Quellen der mittelalterlichen Dialogdarstellung*. Berlin: Ebering, 1934.

Avery, "Alexandrian Style" Avery, Myrtilla. "The Alexandrian Style at Santa Maria Antiqua, Rome." *ArtB* 7 (1924–25), pp. 131–49.

Avner, "Septuagint Illustrations" Avner, Tamar. "Septuagint Illustrations of the Book of Judges in Manuscripts of the Court School of Saint Louis." *ByzF* 13 (1988), pp. 297–317.

Avner, "Unknown Genesis Scene" Avner, Tamar. "An Unknown Genesis Scene in a Byzantine Manuscript and Its Connections with the Octateuchs and the Aelfric Hexateuch." In

Sixth Annual Byzantine Studies Conference, Abstracts of Papers (Oberlin, Ohio, 24–26 October 1980), pp. 21–22.

Babić, "Fresques" Babić, Gordana. "Les fresques de Sušica en Macédonie et l'iconographie originale de leurs images de la vie de la Vierge." *CahArch* 12 (1962), pp. 303–39.

Bagatti, "Sacrificio di Abramo" Bagatti, Bellarmino. "La posizione dell'ariete nell'iconografia del sacrificio di Abramo." *Liber Annuus* 34 (1984), pp. 283–98.

Bagatti, "Tentazione" Bagatti, Bellarmino. "L'iconografia della tentazione di Adamo ed Eva." *Liber Annuus* 31 (1981), pp. 217–30.

Bakirtzis, Τσουκαλολάγηνα Bakirtzis, Charalambos. Βυζαντινά τσουκαλολάγηνα: Συμβολή στη μελετή ονομασίων, σχήματων και χρήσεων. Athens: Archaiologikon Poron, 1989.

Bandini, Angelo M. *Catalogus Codicum Manuscriptorum Bibliothecae Mediceae Laurentianae*. 3 vols. Florence: Typis Caesareis, 1764–1770. Reprint, Leipzig: Zentral-Antiquariat, 1961.

———. *Dei Princìpi e Progressi della Real Biblioteca Mediceo Laurenziana (Ms. Laur. Acquisti e Doni 142)*. Ed. Rosario Pintaudi, Mario Tesi, and Anna Rita Fantoni. Florence: Gonnelli, 1990.

Barb, "Cain's Murder-Weapon" Barb, A. A. "Cain's Murder-Weapon and Samson's Jawbone of an Ass." *JWarb* 35 (1972), pp. 386–89.

Batiffol, Pierre. *La Vaticane de Paul III à Paul V d'après des documents nouveaux*. Paris: Leroux, 1890.

Bauer, Adolf, and Josef Strzygowski. *Eine alexandrinische Weltchronik: Text und Miniaturen eines griechischen Papyrus der Sammlung W. Goleniscev*. Denkschriften der Kaiserlichen Akademie der Wissenschaften in Wien, philologisch-historische Klasse, 51. Vienna: Carl Gerold's Sohn, 1905.

Bayet, Charles. *Recherches pour servir à l'histoire de la peinture et de la sculpture chrétiennes en Orient*. Paris: Thorin, 1879.

Beckwith, *Veroli Casket* Beckwith, John. *The Veroli Casket, Victoria and Albert Museum*. London: Her Majesty's Stationery Office, 1962.

Bees, "Handschriften von Smyrna" Bees, Nikos A. "Die Handschriften von Smyrna." *BNJ* 3 (1922), p. 444.

Bees, Nikos A. "Kunstgeschichtliche Untersuchungen über die Eulalios-Frage und den Mosaikschmuck der Apostelkirche zu Konstantinopel." *RepKunstw* 39 (1916), pp. 97–117, 231–51; and 40 (1917), pp. 59–77.

Beissel, *Vatican. Miniaturen* Beissel, Stephan. *Vaticanische Miniaturen: Quellen zur Geschichte der Miniaturmalerei/ Miniatures choisies de la Bibliothèque du Vatican: Documents pour une histoire de la miniature*. Freiburg im Bresgau: Herder'sche Verlagshandlung, 1893.

Belting, *Beneventan. Buchmalerei* Belting, Hans. *Studien zur beneventanischen Buchmalerei*. Forschungen zur Kunstgeschichte und christlichen Archäologie. Vol. 7. Wiesbaden, 1968.

Belting, "Byz. Art" Belting, Hans. "Byzantine Art among Greeks and Latins in Southern Italy." *DOP* 28 (1974), pp. 1–29.

Belting, *Illuminierte Buch* Belting, Hans. *Das illuminierte Buch in der spätbyzantinischen Gesellschaft*. Abhandlungen der Heidelberger Akademie der Wissenschaften, philosophisch-historische Klasse. Heidelberg: Winter, 1970.

Belting, Hans. "Kunst oder Objekt-Stil? Fragen zur Funktion der Kunst in der Makedonischen Renaissance." In *Byzanz und der Westen: Studien zur Kunst der europäischen Mittelalter*, ed. Irmgard Hutter, pp. 65–83. Österreichische Akademie der Wissenschaften, philosophisch-historische Klasse, Sb. 432, Vienna, 1984.

———. "Problemi vecchi e nuovi sull'arte della cosiddetta 'Rinascenza Macedone' a Bisanzio." *CorsiRav* 29 (aprile 1982), pp. 31–57. Ravenna: Edizioni del Girasole, 1982.

Belting and Cavallo, *Bibel des Niketas* Belting, Hans and Guglielmo Cavallo. *Die Bibel des Niketas: Ein Werk der höfischen Buchkunst in Byzanz und sein antikes Vorbild*. Wiesbaden: Reichert, 1979.

Benson and Tselos, "Utrecht Ps." Benson, Gertrude R., and Dimitri T. Tselos. "New Light on the Origin of the Utrecht Psalter." *ArtB* 13 (1931), pp. 13–79.

Bergman, *Salerno* Bergman, Robert P. *The Salerno Ivories: Ars Sacra from Medieval Amalfi*. Cambridge, Mass.: Harvard University Press, 1980.

Bernabò, "Adamo" Bernabò, Massimo. "Adamo, gli animali, le sue vesti e la sfida di Satana: Un complesso rapporto testo-immagine nella illustrazione bizantina dei Settanta." *Min* 2 (1989), pp. 11–33.

Bernabò, "Agar e Ismaele" Bernabò, Massimo. "Agar e Ismaele: Varianti non conosciute di Genesi 16 e 21 nella illustrazione bizantina dei Settanta." *OCP* 61 (1995), pp. 215–22.

Bernabò, "Cacciata" Bernabò, Massimo. "La cacciata dal Paradiso e il lavoro dei progenitori in alcune miniature medievali." In *La miniatura italiana in età romanica e gotica: Atti del I Congresso di storia della miniatura italiana* (Cortona, 26–28 May 1978), ed. Grazia Vailati Schoenburg Waldenburg, pp. 269–81. Florence: Olschki, 1979.

Bernabò, "Caverna" Bernabò, Massimo. "Miniatura bizantina e letteratura siriaca: La ricostruzione di un ciclo di miniature con una storia figurativa vicina alla 'Caverna dei Tesori.'" *StM*, ser. 3, 34 (1993), pp. 717–37.

Bernabò, "Esegesi patristica" Bernabò, Massimo. "L'impatto della esegesi patristica sulla illustrazione del Vecchio Testamento a Bisanzio." In *Codice miniato*, pp. 49–65.

Bernabò, "Fonti testuali" Bernabò, Massimo. "Considerazioni sulle fonti testuali di alcune miniature della *Genesi* negli *Ottateuchi* bizantini." *AnnPisa*, ser. 3, 8 (1978), pp. 467–87.

Bernabò, Massimo. "The Illustrated Byzantine Octateuchs as a Source for the Imagery of Early Christian Syria." In *Nineteenth Annual Byzantine Studies Conference, Abstracts of Papers* (Princeton, 4–7 November 1993), pp. 95–96.

Bernabò, "Introduzione" Bernabò, Massimo. "Introduzione al testo." In *Scritti di Kurt Weitzmann*. Vol. 1, *Illustrations in Roll and Codex: A Study of the Origin and Method of Text Illustration/Le illustrazioni nei rotoli e nei codici: Studio della origine e del metodo della illustrazione dei testi*, ed. Massimo Bernabò. Florence: CUSL, 1983.

Bernabò, "Laur. plut. 5.38" Bernabò, Massimo. "Considerazioni sul manoscritto laurenziano plut. 5.38 e sulle miniature della *Genesi* degli *Ottateuchi* bizantini." *AnnPisa*, ser. 3, 8 (1978), pp. 135–57.

Bernabò, "Mecenatismo" Bernabò, Massimo. "Mecenatismo imperiale e traduzione dei Settanta: L'illustrazione della *Lettera di Aristea* a Bisanzio." *Min* 3–4 (1990–91), pp. 11–20.

Bernabò, Massimo. "Le miniature degli Ottateuchi bizantini: Edizioni illustrate delle Scritture e immaginario cristiano." Ph.D. diss., Philosophisch-Historischen Fakultät, Universität Basel, 1996.

———. "Nota iconografica sulle scene del Vecchio Testamento nelle croci lignee post-bizantine di Sant'Oreste e di Firenze." *JÖB* 47 (1997), pp. 257–72.

———. "Pseudepigrapha and Medieval Illustrated Manuscripts of the Septuagint: Prolegomenous Reflections." *Journal for the Study of Pseudepigrapha* 14 (1996), pp. 85–90.

Bernabò, "Septuagint" "Searching for Lost Sources of the Illustration of the Septuagint." In *Byzantine East, Latin West*, pp. 329–34.

Bernabò, "Studio" Bernabò, Massimo. "Lo studio dell'illustrazione dei manoscritti greci del Vecchio Testamento ca. 1820–1990." *MedRin* 9, n.s., 6 (1995), pp. 261–99.

Bernabò, Massimo. "Sulla composizione e l'iconografia del ciclo del Vecchio Testamento a Santa Maria di Anglona." In *Santa Maria di Anglona*, pp. 121–23.

Bernabò, "Teodoreto" Bernabò, Massimo. "La fortuna figurativa di Teodoreto di Ciro." *MedRin* 7, n.s., 4 (1993), pp. 69–80.

Bernabò, "Tradizioni siriache" Bernabò, Massimo. "Tradizioni siriache nelle miniature degli Ottateuchi bizantini." In *The Christian East, Its Institutions and Its Thought: A Critical Reflection. Papers of the International Scholarly Congress for the Seventy-Fifth Anniversary of the Pontifical Oriental Institute* (Rome, 30 May–5 June 1993), ed. Robert F. Taft, pp. 299–311. OCA, 251. Rome: Pontificio Istituto Orientale, 1996.

Bernabò, "Tre studi" Bernabò, Massimo. "Tre studi recenti sulla miniatura bizantina." *Min* 3–6 (1993–96), pp. 99–110.

Berstl, *Raumproblem* Berstl, Hans. *Das Raumproblem in der altchristlichen Malerei*. Forschungen zum Formgeschichte der Kunst aller Zeiten und Völker, 4. Bonn and Leipzig: Schroder, 1920.

Bible Moralisée: Faksimile-Ausgabe in Originalformat des Codex Vindobonensis 2554 der Österreichischen Nationalbibliothek. Ed. Reiner Haussherr. Graz: Akademische Druck, 1973.

Biblioteca Medicea Laurenziana, Firenze: Mostra di Legature (secoli XV–XX). Florence, 1978.

La Biblioteca Medicea-Laurenziana nel secolo della sua apertura al pubblico (11 giugno 1571): Catalogo della mostra. Florence: Olschki, 1971.

Bignami-Odier, Jeanne. *La Bibliothèque Vaticane de Sixte IV à Pie XI: Recherches sur l'histoire des collections de manuscrits*. ST 272. Vatican City: Biblioteca Apostolica Vaticana, 1973.

Björnberg-Pardo, *Simson* Björnberg-Pardo, Birgitta. *Simson i fornkristen och byzantinsk konst*, pp. 81–267. Stockholm: Institutet för Kristen Ikonografi, 1982.

Blass, Friedrich. "Die griechischen und lateinischen Handschriften im Alten Serail zu Konstantinopel." *Hermes* 23 (1888), pp. 219–33, 622–25. Reprint, Vaduz: Kraus, 1964.

Blum, "Cryptic Creation Cycle" Blum, Pamela Z. "The Cryptic Creation Cycle in Ms. Junius XI." *Gesta* 14 (1975), pp. 211–26.

Bognetti et al., *Castelseprio* Bognetti, Gian Piero, Gino Chierici, and Alberto De Capitani d'Arzago. *Santa Maria di Castelseprio.* Milan: Treccani, 1948.

Bond and Thompson, *Facsimiles* Bond, E. A., and E. M. Thompson. *The Palaeographical Society, Facsimiles of Manuscripts and Inscriptions.* Vol. 1. London, 1873.

Braude, "Cokkel" Braude, Pearl F. " 'Cokkel in Oure Clene Corn:' Some Implications of Cain's Sacrifice." *Gesta* 7 (1968), pp. 15–28.

Bréhier, "Icônes" Bréhier, Louis. "Les icônes dans l'histoire de l'art: Byzance et la Russie." In *L'art byzantin chez les Slaves: L'ancienne Russie, les Slaves catholiques. Deuxième recueil dédié à la mémoire de Théodore Uspenskij*, ed. Gabriel Millet. Vol. 1, pp. 150–73. Paris: Geuthner, 1932.

Brenk, *S. Maria Magg.* Brenk, Beat. *Die frühchristlichen Mosaiken in S. Maria Maggiore zu Rom.* Wiesbaden: Steiner, 1975.

Breymann, *Adam und Eva* Breymann, Arnold. *Adam und Eva in der Kunst des christlichen Altertums.* Wolfenbüttel: Zwissler, 1893.

Brock, "Clothing Metaphors" Brock, Sebastian P. "Clothing Metaphors as a Means of Theological Expression in Syriac Christianity." In *Typus, Symbol, Allegorie bei den östlichen Vätern und ihren Parallelen im Mittelalter*, ed. Margot Schmidt, pp. 11–38. Regensburg: Pustet, 1982.

Brockhaus, Heinrich. *Die Kunst in den Athos-Klöstern.* Leipzig: Brockhaus, 1891. 2d ed., 1924.

Broderick, "Garments" Broderick, Herbert R. "A Note on the Garments of Paradise." *Byz* 55 (1985), pp. 250–54.

Broderick, Herbert R. "The Iconographic and Compositional Sources of the Drawings in Oxford, Bodleian Library, Ms. Junius 11." Ph.D. diss., Columbia University, 1978.

Broderick, "Sarajevo Haggadah" Broderick, Herbert R. "Observations on the Creation Cycle of the Sarajevo Haggadah." *ZKunstg* 47 (1984), pp. 320–32.

Brubaker, "Gregory of Naz." Brubaker, Leslie. "The Illustrated Copy of the 'Homilies' of Gregory of Nazianzus in Paris (Bibliothèque Nationale, cod. gr. 510)." Ph.D. diss., The Johns Hopkins University, 1983.

Brubaker, "Life Imitates Art" Brubaker, Leslie. "Life Imitates Art: Writings on Byzantine Art History, 1991–1992." *BMGS* 17 (1993), pp. 173–223.

Brubaker, "Reconsideration" Brubaker, Leslie. "The Twelfth-Century Octateuchs: A Reconsideration." In *XVᵉ Congrès international d'études byzantines* (Athens, 5–11 September 1976), *Résumé des communications*, vol. 3, *Art et archéologie* (unpaged). Athens, 1979.

Brubaker, "Tabernacle" Brubaker, Leslie. "The Tabernacle Miniatures of the Byzantine Octateuchs." In *Actes du XVᵉ Congrès international d'études byzantines* (Athens, 5–11 September 1976). Vol. 2, *Art et archéologie: Communications*, pp. 73–92. Athens, 1981.

Buberl, *Byz. Hss.* Buberl, Paul. *Die byzantinischen Handschriften, 1: Der Wiener Dioskurides und die Wiener Genesis.* Beschreibendes Verzeichnis der illuminierten Handschriften in Österreich. Vol. 8, pt. 4. 2 vols. Leipzig: Hiersemann, 1937 and 1938.

Buberl, "Problem" Buberl, Paul. "Das Problem der Wiener Genesis." *JbKSWien*, n.s., 10 (1936), pp. 9–58.

Bucher, *Pamplona Bibles* Bucher, Françoise. *The Pamplona Bibles.* 2 vols. New Haven: Yale University Press, 1970.

Buchthal, *Byz. Gospel Book* Buchthal, Hugo. *An Illuminated Byzantine Gospel Book of about 1100 A.D.* Special Bulletin of the National Gallery of Victoria, Centenary Year, 1961. Reprint in *Art of the Mediterranean World, A.D. 100 to A.D. 1400.* Washington, D.C.: Decatur House, 1983.

Buchthal, "Gandhara Sculpture" Buchthal, Hugo. "The Western Aspects of Gandhara Sculpture." *ProcBrAc* 31 (1945), pp. 151–76.

Buchthal, Hugo. "A Greek New Testament Manuscript in the Escorial Library." In *Byzanz und der Westen: Studien zur Kunst des Europäischen Mittelalters*, ed. Irmgard Hutter, pp. 85–98. Vienna: Österreichische Akademie der Wissenschaften, 1984.

Buchthal, *Historia Troiana* Buchthal, Hugo. *Historia Troiana: Studies in the History of Mediaeval Secular Illustration.* London: Warburg Institute, University of London, 1971.

Buchthal, *Latin Kingdom* Buchthal, Hugo. *Miniature Painting in the Latin Kingdom of Jerusalem.* Oxford: Clarendon Press, 1957.

Buchthal, *Par. Gr. 139* Buchthal, Hugo. *Codex Parisinus Graecus 139.* Dissertation der Hamburgischen Universität, Hamburg, 1933.

Buchthal, *Paris Ps.* Buchthal, Hugo. *The Miniatures of the Paris Psalter: A Study in Middle Byzantine Painting.* London: Warburg Institute, 1938.

Buchthal and Belting, *Patronage* Buchthal, Hugo, and Hans Belting. *Patronage in Thirteenth-Century Constantinople: An Atelier of Late Byzantine Book Illumination and Calligraphy.* Washington, D.C.: Dumbarton Oaks, 1978.

Büchsel, "Schöpfungsmosaiken" Büchsel, Martin. "Die Schöpfungsmosaiken von San Marco: Die Ikonographie der Erschaffung des Menschen in der frühchristlichen Kunst." *Städel Jahrbuch*, n.s., 13 (1991), pp. 29–80.

Büttner, Franz. *Adam und Eva in der bildenden Kunst bis Michel Angelo.* Leipzig: Wolf, 1887.

Buonocore, Marco. *Bibliografia dei fondi manoscritti della Biblioteca Vaticana (1968–1980).* Vatican City: Biblioteca Apostolica Vaticana, 1986.

Buschhausen, "Archemosaiks" Buschhausen, Helmut. "Die Deutung des Archemosaiks in der Justinianischen Kirche von Mopsuestia." *JÖB* 21 (1972), pp. 57–71.

Buschhausen, "Via Latina" Buschhausen, Helmut. "Die Katakombe an der Via Latina." *JÖB* 29 (1980), pp. 293–301.

Byzantine Art, an European Art: Ninth Exhibition Held under the Auspices of the Council of Europe, Athens, 1964. Athens: Office of the Prime Minister, 1964.

Byvanck, "Psautier de Paris" Byvanck, A. W. "Le problème du Psautier de Paris." *Nederlands Kunsthistorisch Jaarboek* 6 (1955), pp. 31–56.

Byzantine East, Latin West *Byzantine East, Latin West: Art-Historical Studies in Honor of Kurt Weitzmann*, ed. Doula Mouriki et al. Princeton: Department of Art and Archaeology, Princeton University, 1995.

Byzantium at Princeton *Byzantium at Princeton: Byzantine Art and Archaeology at Princeton University*. Ed. Slobodan Ćurčić and Archer St. Clair. Exh. cat., Princeton, 1 August–26 October 1986. Princeton: Department of Art and Archaeology, Princeton University, 1986.

Cahn, "Josephus" Cahn, Walter. "An Illustrated Josephus from the Meuse Region in Merton College, Oxford." *ZKunstg* 29 (1966), pp. 295–310.

Cahn, "Souvigny Bible" Cahn, Walter. "The Souvigny Bible: A Study in Romanesque Manuscript Illumination." Ph.D. diss., New York University, 1967.

Canart, Paul, and Vittorio Peri. *Sussidi bibliografici per i manoscritti greci della Biblioteca Vaticana*. ST 261. Vatican City: Biblioteca Apostolica Vaticana, 1970.

Canfora, Luciano. "Il destino dei testi." In *Lo spazio letterario della Grecia antica*, ed. Giuseppe Cambiano, Luciano Canfora, and Diego Lanza. Vol. 2, *La ricezione e l'attualizzazione del testo*, pp. 1–264. Rome: Salerno Editrice, 1995.

Canfora, *Viaggio di Aristea* Canfora, Luciano. *Il viaggio di Aristea*. Rome and Bari: Laterza, 1996.

Canivet, "Mosaïque d'Adam" Canivet, Maria-Teresa, and Pierre Canivet. "La mosaïque d'Adam dans l'église syrienne de Hūarte (Vᵉ s.)." *CahArch* 24 (1975), pp. 49–70.

Catalogo della mostra di manoscritti e documenti disposta dalla Biblioteca Apostolica Vaticana e dall'Archivio Segreto in occasione del V Congresso internazionale di studi bizantini (Rome, 20–26 September 1936). Vatican City, 1936.

Cecchelli, *Cattedra* Cecchelli, Carlo. *La cattedra di Massimiano ed altri avorii romano-orientali*. Rome: Libreria dello Stato, 1936–44.

Cecchelli, Carlo. "The Iconography of the Laurentian Syriac Gospels." In *The Rabbula Gospels: Facsimile Edition of the Miniatures of the Syriac Manuscript Plut. I.56 in the Medicean-Laurentian Library*, ed. Carlo Cecchelli, Giuseppe Furlani, and Mario Salmi, pp. 23–82. Olten and Lausanne: Urs Graf-Verlag, 1959.

Cecchelli, *S. Maria Magg.* Cecchelli, Carlo. *I mosaici della Basilica di Santa Maria Maggiore*. Turin: ILTE, 1956.

Ceresa, Massimo. *Bibliografia dei fondi manoscritti della Biblioteca Vaticana (1981–1985)*. ST 342. Vatican City: Biblioteca Apostolica Vaticana, 1991.

Chapman, "Jacob Blessing" Chapman, Gretel. "Jacob Blessing the Sons of Joseph: A Mosan Enamel in the Walters Art Gallery." *JWalt* 38 (1980), pp. 34–59.

Chasson, "Tuscan Bible" Chasson, Robert T. "The Earliest Illustrated Tuscan Bible (Edili 125/126)." Ph.D. diss., University of California, Berkeley, 1979.

Clemen, *Monumentalmalerei* Clemen, Paul. *Die romanische Monumentalmalerei in den Rheinlanden*. Düsseldorf: Schwann, 1916.

Cockerell, *Illustrations* Cockerell, Sidney C., Montague R. James, and Charles J. Ffoulkes. *A Book of Old Testament Illustrations of the Middle of the Thirteenth Century Sent by Cardinal Bernard Maciejowski to Shah Abbas the Great, King of Persia, Now in the Pierpont Morgan Library at New York*. Cambridge: Roxburghe Club, 1927.

Codice miniato *Il codice miniato: Rapporti tra codice, testo e figurazione. Atti del III Congresso di storia della miniatura* (Cortona, 20–23 October 1988), ed. Melania Ceccanti and Maria Cristina Castelli. Florence: Olschki, 1992.

Connor, "Joshua Fresco" Connor, Carolyn L. "The Joshua Fresco at Hosios Loukas." In *Tenth Annual Byzantine Studies Conference, Abstracts of Papers* (Cincinnati, 1–4 November 1984), pp. 57–59.

Corrie, "Conradin Bible" Corrie, Rebecca Wells. "The Conradin Bible, Ms. 152, The Walters Art Gallery: Manuscript Illumination in a Thirteenth-Century Italian Atelier." Ph.D. diss., Harvard University, 1986.

Crooy, *Émaux* Crooy, Fernand. *Les émaux carolingiens de la châsse de Saint Marc à Huy-sur-Meuse*. Paris and Brussels: Éditions Marion, 1948.

Crown, "Winchester Ps." Crown, Carol U. "The Winchester Psalter: Iconographic Sources and Themes of the Virgin Mary, Kingship and Law." Ph.D. diss., Washington University, 1976.

Cutler, "Aristocratic Ps." Cutler, Anthony. "The Aristocratic Psalter: The State of Research." In *XVᵉ Congrès international d'études byzantines* (Athens, 5–11 September 1976), *Rapports et co-rapports*, vol. 3, *Art et archéologie*, pp. 229–58. Athens, 1981.

Cutler, "Joshua Roll" Cutler, Anthony. "Joshua Roll." *ODB*, vol. 2, pp. 1075–76.

Cutler, "Marginal Ps." Cutler, Anthony. "The Marginal Psalter in the Walters Art Gallery: A Reconsideration." *JWalt* 35 (1977), pp. 36–61.

Cutler, "Spencer Ps." Cutler, Anthony. "The Spencer Psalter: A Thirteenth-Century Byzantine Manuscript in the New York Public Library." *CahArch* 23 (1974), pp. 129–50.

Cutler, *Transfigurations* Cutler, Anthony. *Transfigurations: Studies in the Dynamics of Byzantine Iconography*. Abington, Penn.: Pennsylvania State University Press, 1975.

Cutler and Weyl Carr, "Ps. Benaki" Cutler, Anthony, and Annemarie Weyl Carr. "The Psalter Benaki 24,3: An Unpublished Illuminated Manuscript from the Family 2400." *REB* 34 (1976), pp. 281–324.

Dalton, *Byzantine Art* Dalton, Ormond M. *Byzantine Art and Archaeology*. Oxford: Clarendon Press, 1911.

Dalton, *East Christian Art* Dalton, Ormond M. *East Christian Art*. Oxford: Clarendon Press, 1925.

D'Alverny, Marie-Thérèse. "Les Anges et les jours." *CahArch* 9 (1957), pp. 271–300.

D'Ansse De Villoison, M. "Notices des manuscrits grecs et latins qui, de la Bibliothèque des anciens empereurs grecs et de celle du Sérail de Constantinople, sont passés dans la Bibliothèque Impériale" In *Notices et extraits des manuscrits de la Bibliothèque Imperiale et autres bibliothèques*, Paris: Imprimerie Impériale, 1810. Vol. 8, pt. 2, pp. 1–32.

De Angelis, "Simbologia" De Angelis, Maria Antonietta. "Simbologia ed estetica del sangue nei codici Palatinus Graecus 431b, Vaticanus Graecus 747 e Vaticanus Graecus 746." In

Atti della settimana Sangue e antropologia nella letteratura cristiana (Rome, 29 November–4 December 1982), ed. Francesco Vattioni, vol. 3, pp. 1519–39. Centro Studi Sanguis Christi, 3. Rome: Edizioni Pia Unione Preziosissimo Sangue, 1983.

Deckers, "Lot-Sarkophag" Deckers, Johannes G. "Zum 'Lot-Sarkophag' von S. Sebastiano in Rom." *RQ* 70 (1975), pp. 121–48.

Deckers, *S. Maria Magg.* Deckers, Johannes G. *Der alttestamentliche Zyklus von S. Maria Maggiore in Rom: Studien zur Bildgeschichte.* Bonn: Habelt, 1976.

De Grüneisen, "Cielo" De Grüneisen, Wladimir. "Il cielo nella concezione religiosa e artistica dell'Alto Medioevo: Studi iconografici comparativi sulle pitture medievali romane." *Archivio della Reale Società Romana di Storia Patria* 29 (1906), pp. 443–525.

De Grüneisen, *Ste. Marie Ant.* De Grüneisen, Wladimir. *Sainte Marie Antique.* Rome: Bretschneider, 1911.

Deissmann, *Serai* Deissmann, Gustav Adolf. *Forschungen und Funde im Serai, mit einem Verzeichnis der nichtislamischen Handschriften im Topkapu Serai zu Istanbul.* Berlin and Leipzig: Walter de Gruyter, 1933.

De' Maffei, "Eva" De' Maffei, Fernanda. "Eva e il serpente, ovverossia la problematica della derivazione, o non, delle miniature vetero-testamentarie cristiane da presunti prototipi ebraici." *RSBN*, n.s., 17–19 (1980–82), pp. 13–35.

De' Maffei, "Sant'Angelo in Formis II" De' Maffei, Fernanda. "Sant'Angelo in Formis, II: La dicotomia tra le scene dell'Antico Testamento e l'originario ceppo bizantino." *Comm* 28 (1977), pp. 26–57, 195–235.

De' Maffei, "Unigenito" De' Maffei, Fernanda. "L'Unigenito consustanziale al Padre nel programma trinitario dei perduti mosaici del bema della Dormizione di Nicea e il Cristo trasfigurato del Sinai." *Storia dell'arte* 45 (1982), pp. 91–116, 185–200.

Demus, "Kariye Djami" Demus, Otto. "The Style of the Kariye Djami and Its Place in the Development of Palaeologan Art." In Underwood, *Kariye Djami.* Vol. 4, *Studies in the Art of the Kariye Djami and Its Intellectual Background*, pp. 107–60.

Demus, *Mosaics of S. Marco* Demus, Otto. *The Mosaics of San Marco in Venice.* Vol. 2, *The Thirteenth Century.* Chicago and London: University of Chicago Press, 1984.

Demus, Otto. *Die Mosaiken von San Marco in Venedig, 1100–1300.* Baden bei Wien: Rohrer, 1935.

Demus, *Norman Sicily* Demus, Otto. *The Mosaics of Norman Sicily.* London: Routledge and Kegan Paul, 1949.

De Palol, "Broderie catalane" De Palol, P. "Une broderie catalane d'époque romane: La Genèse de Gérone." *CahArch* 8 (1956), pp. 175–214.

Der Nersessian, *Aght'amar* Der Nersessian, Sirarpie. *Aght'amar: Church of the Holy Cross.* Cambridge, Mass.: Harvard University Press, 1965.

Der Nersessian, *Barl. et Joas.* Der Nersessian, Sirarpie. *L'illustration du Roman de Barlaam et Joasaph.* Paris: De Boccard, 1937.

Der Nersessian, *Londres Add. 19.352* Der Nersessian, Sirarpie. *L'illustration des Psautiers grecs du Moyen Age.* Vol. 2, *Londres, Add. 19.352.* Bibliothèque des Cahiers Archéologiques, 5. Paris: Klincksieck, 1970.

Der Nersessian, "Parekklesion" Der Nersessian, Sirarpie. "Program and Iconography of the Frescoes of the Parekklesion." In Underwood, *Kariye Djami.* Vol. 4, *Studies in the Art of the Kariye Djami and Its Intellectual Background*, pp. 303–49.

Devreesse, *Fonds grec* Devreesse, Robert. *Le fonds grec de la Bibliothèque Vaticane des origines à Paul V.* ST 244. Vatican City: Biblioteca Apostolica Vaticana, 1965.

Devreesse, *Vat. Cod. Manuscripti* Devreesse, Robert. *Bibliothecae Apostolicae Vaticanae Codices Manuscripti Recensiti Iussu Pii XII Pontificis Maximi, Praeside Johanne Mercati. Codices Vaticani Graeci.* Vol. 3, *Codices 604–866.* Rome: Biblioteca Vaticana, 1950.

De Wald, "Fragment" De Wald, Ernest T. "A Fragment of a Tenth-Century Byzantine Psalter in the Vatican Library." In *Medieval Studies in Memory of A. Kingsley Porter*, ed. Wilhelm R. W. Koehler. Vol. 1, pp. 139–50. Cambridge, Mass.: Harvard University Press, 1939.

De Wald, *Vat. Gr. 1927* De Wald, Ernest T. *Vaticanus Graecus 1927.* The Illustrations in the Manuscripts of the Septuagint. Vol. 3, Psalms and Odes, pt. 1. Princeton: Princeton University Press, 1941.

Di Domenico Di Domenico, Adriana. Review of *Il codice miniato: Rapporti tra testo, codice e figurazione. Atti del III Congresso di storia della miniatura italiana. Min* 3–6 (1993–96), pp. 140–53.

Diehl, *Art chrétien primitif* Diehl, Charles. *L'art chrétien primitif et l'art byzantin.* Paris and Brussels: Van Oest, 1928.

Diehl, *Manuel* Diehl, Charles. *Manuel d'art byzantine.* 2 vols. Paris: Picard, 1910. 2d ed., 1926.

Diehl, Charles. "Mosaïques byzantines à Nicée." *BZ* 1 (1892), pp. 74–85.

Diehl, *Peinture byz.* Diehl, Charles. *La peinture byzantine.* Histoire de l'art byzantin publiée sous la direction de M. Charles Diehl. Paris: Van Oest, 1933.

Dinkler-von Schubert, Erika. "Nomen ipsum crucis absit (Cicero, Pro Rabirio, 5,16): Zur Abschaffung der Kreuzigungsstrafe in der Spätantike." *JbAChr* 35 (1992), pp. 135–46. Reprint, *Gymnasium* 102 (1995), pp. 225–41.

Dinkler-von Schubert, *Schrein* Dinkler-von Schubert, Erika. *Der Schrein der Hl. Elisabeth zu Marburg: Studien zur Schrein-Ikonographie.* Marburg an der Lahn: Verlag des Kunstgeschichtlichen Seminars der Universität, 1964.

Diringer, *Illuminated Book* Diringer, David. *The Illuminated Book: Its History and Production.* London: Faber and Faber, 1958.

Djurić, "Novi Isys Navin" Djurić, Vojislav J. "Novi Isys Navin." *Zograf* 14 (1983), pp. 5–16.

Dobbert, Eduard. Review of N. V. Pokrovskii, *Ocherki pamiatnikov pravoslavnoi ikonografii i iskusstva* (St. Petersburg, 1894). *BZ* 5 (1896), pp. 587–600.

Dobbert, "Triumph" Dobbert, Eduard. "Der Triumph der Todes im Camposanto zu Pisa." *RepKunstw* 4 (1881), pp. 1–45.

Dobbert, Eduard. "Zur Geschichte der frühmittelalterlichen Miniaturmalerei." *RepKunstw* 5 (1882), pp. 288–302.

Dodwell, "Originalité" Dodwell, C. R. "L'originalité iconographique de plusieurs illustrations anglo-saxonnes de l'Ancien Testament." *CahCM* 14 (1971), pp. 319–28.

Dohrn, *Tyche.* Dohrn, Tobias. *Die Tyche von Antiochia.* Berlin: Mann, 1960.

Dufrenne, "Illustration 'historique'" Dufrenne, Suzy. "Une illustration 'historique,' inconnue, du Psautier du Mont-Athos, Pantocrator No. 61." *CahArch* 15 (1965), pp. 83–95.

Dufrenne, "Oct. du Sérail" Dufrenne, Suzy. "Note sur le mode de travail des miniaturistes byzantins d'après un des cahiers de l'Octateuque du Sérail." In *Études de civilisation médiévale (IXᵉ–XIIᵉ siècles): Mélanges offerts à Edmond-René Labande,* pp. 247–53. Poitiers: C.E.S.C.M., 1975.

Dufrenne, *Psautier d'Utrecht* Dufrenne, Suzy. *Les illustrations du Psautier d'Utrecht: Sources et apport carolingien.* Strasbourg: Ophrys, 1978.

Du Mesnil du Buisson, *Doura-Europos* Du Mesnil du Buisson, Robert. *Les peintures de la synagogue de Doura-Europos, 245–256 après J.-C.* Rome: Pontificio Istituto Biblico, 1939.

Dynes, Wayne R. "The Illuminations of the Stavelot Bible (British Museum, Add. Mss. 28106–28107)." Ph.D. diss., New York University, 1969.

Ebersolt, *Min. byz.* Ebersolt, Jean. *La miniature byzantine.* Paris and Brussels: Van Oest, 1926.

Eggenberger, "Vergilius Romanus" Eggenberger, Chr. "Die Miniaturen des Vergilius Romanus, Codex Vat. Lat. 3867." *BZ* 70 (1977), pp. 58–90.

Ehrensperger-Katz, "Villes fortifiées" Ehrensperger-Katz, Ingrid. "Les représentations des villes fortifiées dans l'art paléochrétienne et leurs dérivées byzantines." *CahArch* 19 (1969), pp. 1–27.

"Eldad and Medad" "Eldad and Medad." In *Encyclopedia Judaica,* vol. 6, col. 575. Jerusalem: Keter, 1972.

Eller and Wolf, *Mosaiken* Eller, Karl, and Dieter Wolf. *Mosaiken, Fresken, Miniaturen: Das Kultbild in der Ostkirche.* Munich: Bruckmann, 1967.

Engemann, "'Corna' Gestus" Engemann, Josef. "Der 'Corna' Gestus: Ein antiker und frühchristlicher Abwehr- und Spottgestus." In *Pietas: Festschrift für Bernard Kötting,* ed. Ernst Dassmann and K. Suso Frank. *JbAChr,* Ergänzungsband 8, pp. 483–98. Münster: Aschendorffsche Verlagsbuchhandlung, 1980.

Esche, *Adam und Eva* Esche, Sigrid. *Adam und Eva: Sündenfall und Erlösung.* Düsseldorf: Schwann, 1957.

Eschweiler et al., "Inhalt" Eschweiler, Jakob, Bonifatius Fischer, Herman Josef Frede, and Florentine Mütherich. "Der Inhalt der Bilder." In *Stuttgarter Bilderpsalter,* vol. 2, pp. 55–150.

Ettlinger, *Sistine Chapel* Ettlinger, Leopold D. *The Sistine Chapel before Michelangelo: Religious Imagery and Papal Primacy.* Oxford: Clarendon Press, 1965.

Eustratiades, Sophronios and Arcadios. *Catalogue of the Greek Manuscripts in the Library of the Monastery of Vatopedi on Mt. Athos.* Harvard Theological Studies, 11. Cambridge, Mass.: Harvard University Press, 1924.

Fabbri, "Months at Lentini" Fabbri, Nancy Rash. "The Iconography of the Months at Lentini." *JWarb* 42 (1979), pp. 230–33.

Ferrua, *Catacombe sconosciute* Ferrua, Antonio. *Catacombe sconosciute: Una pinacoteca del IV secolo sotto la Via Latina.* Florence: Nardini, 1990.

Fiaccadori, "Costantino" Fiaccadori, Gianfranco. "Costantino ritrovato." *FelRav* 133–134 (1987), pp. 121–36.

Fiaccadori, "Prototipi" Fiaccadori, Gianfranco. "Prototipi miniati dell'Ottateuco etiopico." *Bollettino del Museo Bodoniano di Parma* 8 (1994), pp. 69–102.

Fiaccadori, "Regno di 'Aksum" Fiaccadori, Gianfranco. "Bisanzio e il Regno di 'Aksum: Sul manoscritto Martini etiop. 5 della Biblioteca Forteguerriana di Pistoia." In *Quaecumque recepit Apollo: Scritti in onore di Angelo Ciavarella (Bollettino del Museo Bodoniano di Parma* 7 [1993]), ed. Andrea Gatti, pp. 161–99.

Fink, *Bildfrömmigkeit* Fink, Josef. *Bildfrömmigkeit und Bekenntnis: Das Alte Testament, Herakles und die Herrlichkeit Christi an der Via Latina in Rom.* Cologne and Vienna: Böhlau, 1978.

Franchi de' Cavalieri, "Furca" Franchi de' Cavalieri, Pio. "Della furca e della sua sostituzione alla croce nel diritto penale romano." *NBACr* 13 (1907), pp. 63–114. Reprint, *Scritti agiografici,* vol. 2, pp. 141–79. ST 222. Vatican City: Biblioteca Apostolica Vaticana, 1962.

Friedman, "Angelic Creation" Friedman, Mira. "The Angelic Creation of Man." *CahArch* 39 (1991), pp. 79–94.

Friedman, "Vienna Genesis" Friedman, Mira. "More on the Vienna Genesis." *Byz* 59 (1989), pp. 64–77.

Friedman, Mira. "On the Sources of the Vienna Genesis." *CahArch* 38 (1989), pp. 5–17.

Furlan, *Codici Greci* Furlan, Italo. *Codici greci illustrati della Biblioteca Marciana.* Vol. 5. Padua: Università di Padova, 1988.

Gaehde, "Octateuch" Gaehde, Joachim E. "Carolingian Interpretations of an Early Christian Picture Cycle to the Octateuch in the Bible of San Paolo fuori le Mura in Rome." *FrSt* 8 (1974), pp. 351–84.

Gaehde, Joachim E. "The Painters of the Carolingian Bible Manuscript of San Paolo fuori le mura in Rome." Ph.D. diss., New York University, 1963.

Gaehde, "Turonian Sources" Gaehde, Joachim E. "The Turonian Sources of the Bible of San Paolo fuori le Mura in Rome." *FrSt* 5 (1971), pp. 359–400.

Galavaris, *Gregory Naz.* Galavaris, George. *The Illustrations of the Liturgical Homilies of Gregory Nazianzenus.* Studies in Manuscript Illumination, 6. Princeton: Princeton University Press, 1969.

Galavaris, "Ζωγραφική" Galavaris, George. "Ἡ ζωγραφική των χειρογράφων στον δέκατο αιώνα." In Κωνσταντίνος Ζ′ ο Πορφυρογέννητος και η εποχή του: Β′ Διεθνής Βυζαντινολογική Συνάντηση (Delphi, 22–26 July 1987), pp. 333–75. Athens, 1989.

Gandolfo, Francesco. "Gli affreschi del Battistero di Parma." In *Medio Oriente,* pp. 193–201.

Garidis, "Représentation" Garidis, Miltos. "La représentation des 'nations' dans la peinture post-byzantine." *Byz* 39 (1969), pp. 86–103.

Garrison, "Creation and Fall" Garrison, Edward B. "Note on the Iconography of Creation and of the Fall of Man in Eleventh- and Twelfth-Century Rome." In *Studies in the History of Medieval Italian Painting*, vol. 4, pp. 201–10. Florence: L'Impronta, 1961.

Garrucci, *Storia* Garrucci, Raffaele. *Storia della arte cristiana nei primi otto secoli della Chiesa.* Vol. 3, *Pitture non cimiteriali.* Prato: Guasti-Giachetti, 1876.

Gaselee, Stephen. *The Greek Manuscripts in the Old Seraglio at Constantinople.* Cambridge: University Press, 1916.

Gasiorowski, *Malarstwo Minjaturowe* Gasiorowski, Stanisłav J. *Malarstwo Minjaturowe Grecko-Rzymskie.* Cracow: Wydane z Zasiłku Warunkowo-Zwrotnego, 1928.

Gauthier-Walter, "Cycle de Joseph" Gauthier-Walter, Marie-Dominique. "Sources iconographiques du cycle de Joseph à la cathédrale de Poitiers." *CahCM* 34 (1991), pp. 141–58.

Gauthier-Walter, "Joseph" Gauthier-Walter, Marie-Dominique. "Joseph, figure idéale du Roi?" *CahArch* 38 (1990), pp. 25–36.

Gebhardt, *Ashburnham Pentateuch* Gebhardt, Oskar von. *The Miniatures of the Ashburnham Pentateuch.* London: Asher, 1883.

Gerland, E. Review of F. Uspenskii, *Konstantinopolskii Seral'skii kodeks Vos'mikniziia (L'Octateuque de la Bibliothèque du Sérail à Constantinople)* (Sofia, 1907). *Berliner philologische Wochenschrift* 29 (1909), cols. 209–14.

Gerstinger, *Griech. Buchmalerei* Gerstinger, Hans. *Die griechische Buchmalerei.* Vienna: Österreichischen Staatsdruckerei, 1926.

Gerstinger, *Wiener Gen.* Gerstinger, Hans. *Die Wiener Genesis.* Vienna: Filser, 1931.

Glory of Byzantium *The Glory of Byzantium: Art and Culture of the Middle Byzantine Era, A.D. 843–1261.* Ed. Helen C. Evans and William D. Wixom. Exh. cat., New York, The Metropolitan Museum of Art, 11 March–6 July 1997. New York: The Metropolitan Museum of Art, 1997.

Goldschmidt and Weitzmann, *Elfenbeinskulpturen* Goldschmidt, Adolf, and Kurt Weitzmann. *Die byzantinischen Elfenbeinskulpturen des X.–XIII. Jahrhunderts.* Vol. 1, *Kästen.* Vol. 2, *Reliefs.* Berlin: Cassirer, 1930 and 1934. Reprint, Berlin: Deutscher Verein für Kunstwissenschaft, 1978.

Goodenough, "Christian and Jewish Art" Goodenough, Erwin R. "Early Christian and Jewish Art." *JQR* 33 (1942–43), pp. 403–18. Reprint in *No Graven Images*, pp. 185–99.

Goodenough, *Symbols* Goodenough, Erwin R. *Jewish Symbols in the Greco-Roman Period.* Vol. 1, *The Archaeological Evidence from Palestine.* Vols. 9–11, *Symbolism in the Dura Synagogue.* Princeton: Princeton University Press, 1953 and 1964.

Grabar, "Ciel" Grabar, André, "L'iconographie du ciel dans l'art chrétien de l'Antiquité et du haut Moyen Age." *CahArch* 30 (1982), pp. 5–24.

Grabar, André. "Les cycles d'images byzantins tirés de l'histoire biblique et leur symbolisme princier." *Starinar* 20 (1969), pp. 133–37.

Graeven, Hans. "Adamo ed Eva nei cofanetti d'avorio bizantini." *L'Arte* 2 (1899), pp. 297–315.

Graeven, "Antike Vorlagen" Graeven, Hans. "Antike Vorlagen byzantinischer Elfenbeinreliefs." *Jahrbuch der königlichen preussischen Kunstsammlungen* 18 (1897), pp. 3–23.

Graeven, "Rotulo" Graeven, Hans. "Il Rotulo di Giosué." *L'Arte* 1 (1898), pp. 221–30. Review in *BZ* 8 (1898), p. 249.

Graeven, "Typen" Graeven, Hans. "Typen der Wiener Genesis auf byzantinischen Elfenbeinreliefs." *Jahrbuch der kunsthistorischen Sammlungen des Allerhöchsten Kaiserhauses* 21 (1900), pp. 91–111.

Grape-Albers, *Welt des Arztes* Grape-Albers, Heide. *Spätantike Bilder aus der Welt des Arztes: Medizinische Bilderhandschriften der Spätantike und ihre mittelalterliche Überlieferung.* Wiesbaden: Pressler, 1977.

Green, "Marginal Drawings" Green, Rosalie. "Marginal Drawings in an Ottonian Manuscript." In *Gatherings in Honor of Dorothy E. Miner*, ed. Ursula E. McCracken, Lilian M. C. Randall, and Richard H. Randall Jr., pp. 129–38. Baltimore: The Walters Art Gallery, 1974.

Greenspoon, "Septuagint" Greenspoon, Leonard J. "Mission to Alexandria: Truth and Legend about the Creation of the Septuagint. The First Bible Translation." *Bible Review*, August 1989, pp. 34–41.

Grivot and Zarnecki, *Gislebertus* Grivot, Denis, and George Zarnecki. *Gislebertus, Sculptor of Autun.* London and New York: Orion Press, 1961. Reprint, New York: Hacker, 1985.

Gualdi, "Marin Sanudo" Gualdi, Fausta. "Marin Sanudo illustrato." *Comm* 20 (1969), pp. 162–93.

Gutmann, Joseph. " 'Abraham in the Fire of the Chaldeans': A Jewish Legend in Jewish, Christian and Islamic Art." *FrSt* 7 (1973), pp. 342–52.

Gutmann, "Ashburnham Pent." Gutmann, Joseph. "The Jewish Origin of the Ashburnham Pentateuch Miniatures." *JQR* 44 (1953), pp. 55–72. Reprint in *No Graven Images*, pp. 329–46.

Gutmann, Joseph. "Cain's Burial of Abel: A Jewish Legendary Motif in Christian and Islamic Art." *ErIs* 16 (1982), pp. 92–98.

Gutmann, "Dura Influence" Gutmann, Joseph. "The Dura Europos Synagogue Paintings and Their Influence on Later Christian and Jewish Art." *Artibus et historiae* 17 (1988), pp. 25–29.

Gutmann, Joseph. "The Haggadic Motif in Jewish Iconography." *ErIs* 6 (1960), pp. 16–22.

Gutmann, "Ill. Jew. Ms." Gutmann, Joseph. "The Illustrated Jewish Manuscript in Antiquity: The Present State of the Question." *Gesta* 5 (1966), pp. 39–44. Reprint in *No Graven Images*, pp. 232–48.

Gutmann, *Images* Gutmann, Joseph. *Images of the Jewish Past: An Introduction to Medieval Hebrew Miniatures.* New York: Society of Jewish Bibliophiles, 1965.

Gutmann, "Isaac: Variations" Gutmann, Joseph. "The Sacrifice of Isaac: Variations on a Theme in Early Jewish and Christian Art." In Θίασος τῶν Μούσων: *Studien zu Antike und Christentum. Festschrift für Josef Fink zum 70. Geburtstag*, ed. Dieter Ahrens, pp. 115–22. Cologne and Vienna: Böhlau, 1984.

Gutmann, "Josephus" Gutmann, Joseph. "Josephus' Jewish Antiquities in Twelfth-Century Art: Renovatio or Creatio?" *ZKunstg* 48 (1985), pp. 434–41.

Gutmann, "Med. Jew. Image" Gutmann, Joseph. "Medieval Jewish Image: Controversies, Contributions, Conceptions." In *Aspects of Jewish Culture in the Middle Ages: Papers of the Eighth Annual Conference of the Center for Medieval and Early Renaissance Studies* (Binghamton, New York, 3–5 May 1974), ed. Paul E. Szarmach, pp. 121–34. Albany: State University of New York, 1979.

Gutmann, "Noah's Raven" Gutmann, Joseph. "Noah's Raven in Early Christian and Byzantine Art." *CahArch* 26 (1977), pp. 63–71.

Gutmann, "Passover Haggadah" Gutmann, Joseph. "The Illuminated Medieval Passover Haggadah: Investigations and Research Problems." *Studies in Bibliography and Booklore* 7 (1965), pp. 3–25.

Gutmann, Joseph. "Prolegomenon." In *No Graven Images*, pp. xi–lxiii.

———. Review of K. Weitzmann and H. L. Kessler, *The Frescoes of the Dura Synagogue and Christian Art* (Washington, D.C., 1990). *Speculum* 67 (1992), pp. 502–504.

———. "The Sacrifice of Isaac in Medieval Jewish Art." *Artibus et historiae* 16 (1987), pp. 67–89.

Gutmann, "Testing" Gutmann, Joseph. "The Testing of Moses: A Comparative Study in Christian, Muslim and Jewish Art." *Bulletin of the Asia Institute*, n.s., 2 (1988), pp. 107–17.

Hachlili, *Ancient Jewish Art* R. Hachlili. *Ancient Jewish Art and Archaeology in the Land of Israel*. Leiden and New York, Brill: 1988.

Hänsel, "Miniaturmalerei" Hänsel, Ingrid. "Die Miniaturmalerei einer Paduaner Schule im Ducento." *JÖBG* 2 (1952), pp. 105–48.

Hahn, "Creation" Hahn, Cynthia. "The Creation of the Cosmos: Genesis Illustration in the Octateuchs." *CahArch* 28 (1979), pp. 29–40.

Hamann-Mac Lean, "Vizantiiskii Stil" Hamann-Mac Lean, Richard. " 'Vizantiiskii Stil' v Masterskoi Nikolaia Verdenskogo." In *Vizantiia, I Uzhnye Slaviane i Drevniaia Rus': Zapadnaia Evropa, Iskusstvo i Kul'tura, Sbornik Statei v Chest' V. N. Lazareva*, pp. 396–414. Moscow: Nauka, 1973.

Hanfmann, George M. A. "The Continuity of Classical Art: Culture, Myth, and Faith." In *Age of Spirituality: A Symposium*, ed. Kurt Weitzmann, pp. 75–99. New York: The Metropolitan Museum of Art and Princeton University Press, 1980.

Hanfmann, *Season Sarcophagus* Hanfmann, George M. A. *The Season Sarcophagus in Dumbarton Oaks*. Cambridge, Mass.: Harvard University Press, 1951.

Hartel and Wickhoff, *Wiener Gen.* Hartel, Wilhelm August Ritter von, and Franz Wickhoff. *Die Wiener Genesis*. Prague, Vienna, and Leipzig: Tempsky, 1895. Reprint, Graz: Akademische Druck, 1970.

Haussherr, "Bible moralisée" Haussherr, Reiner. "Über die Auswahl des Bibeltextes in der Bible moralisée." *ZKunstg* 51 (1988), pp. 126–46.

Haussig, *History* Haussig, Hans-Wilhelm. *A History of Byzantine Civilization*. New York: Praeger, 1971.

Havice, "Hamilton Ps." Havice, Christine. "The Hamilton Psalter in Berlin, Kupferstichkabinett 78.A.9." Ph.D. diss., Pennsylvania State University, 1978.

Havice, "Marginal Miniatures" Havice, Christine. "The Marginal Miniatures in the Hamilton Psalter (Kupferstichkabinett 78.A.9)." *JbBerlMus* 26 (1984), pp. 79–142.

Heimann, "Bury St. Edmunds Ps." Heimann, Adelheid. "The Illustrations from the Bury St. Edmunds Psalter and Their Prototypes: Notes on the Iconography of Some Anglo-Saxon Drawings." *JWarb* 29 (1966), pp. 39–59.

Heimann, "Moses-Darstellungen" Heimann, Adelheid. "Moses-Darstellungen." In *Kunst als Bedeutungsträger: Gedenkschrift für Günter Bandmann*, ed. Werner Busch, Reiner Haussherr, and Eduard Trier, pp. 1–17. Berlin: Mann, 1978.

Heimann, review of Mellinkoff Heimann, Adelheid. Review of R. Mellinkoff, *The Horned Moses in Medieval Art and Thought* (Berkeley, Los Angeles, and London, 1970). *ZKunstg* 37 (1974), pp. 284–88.

Heimann, "Six Days" Heimann, Adelheid. "The Six Days of Creation in a Twelfth-Century Manuscript." *JWarb* 1 (1937–38), pp. 269–75.

Heimann, "Utrecht Psalter" Heimann, Adelheid. "The Last Copy of the Utrecht Psalter." In *The Year 1200: A Symposium*, pp. 313–38. New York: The Metropolitan Museum of Art, 1975.

Hempel, "Traditionen" Hempel, Heinz-Ludwig. "Jüdische Traditionen in frühmittelalterlichen Miniaturen." In *Beiträge zur Kunstgeschichte und Archäologie des Frühmittelalters: Akten zum VII. internationalen Kongress für Frühmittelalterforschung* (Vienna, 21–28 September 1958), ed. Hermann Fillitz, pp. 53–65. Graz: Böhlaus, 1962. Reprint in *No Graven Images*, pp. 347–61.

Hempel, "Zum Problem" Hempel, Heinz Ludwig. "Zum Problem der Anfänge der AT-Illustration." *ZAW* 69 (1957), pp. 103–31; and *ZAW* 73 (1961), pp. 299–302. Reprint in *No Graven Images*, pp. 81–113.

Henderson, George. "Cain's Jaw-Bone." *JWarb* 24 (1961), pp. 108–14. Reprint in Henderson, *Studies*.

Henderson, "Influences" Henderson, George. "Late-Antique Influences in Some English Mediaeval Illustrations of Genesis." *JWarb* 25 (1962), pp. 172–98. Reprint in Henderson, *Studies*.

Henderson, "Joshua Cycle" Henderson, George. "The Joshua Cycle in B. M. Cotton Ms. Claudius B. IV." *JBAA* 31 (1968), pp. 38–59. Reprint in Henderson, *Studies*.

Henderson, George. "The Program of Illustrations in Bodleian Ms. Junius XI." In *Studies in Memory of David Talbot Rice*, ed. Giles Robertson and George Henderson, pp. 113–45. Edinburgh: Edinburgh University Press, 1975.

Henderson, "Sources" Henderson, George. "The Sources of the Genesis Cycle at Saint-Savin-sur-Gartempe." *JBAA* 26 (1963), pp. 11–26. Reprint in Henderson, *Studies*.

Henderson, *Studies* Henderson, George. *Studies in English Bible Illustration*. Vol. 1. London: Pindar Press, 1985.

Hesseling Hesseling, Dirk Christian. *Miniatures de l'Octateuque grec de Smyrne: Manuscrit de l'École Évangélique de Smyrne*. Leiden: Sijthoff, 1909.

Hieber, *Miniaturen* Hieber, Hermann. *Die Miniaturen des frühen Mittelalters*. Munich: Piper, 1921.

Hildburgh, W. L. "On Palm-Tree Crosses." *Archaeologia*, ser. 2, 81 (1931), pp. 49–61.

Hovingh, "Fumée du sacrifice" Hovingh, P. F. "La fumée du sacrifice de Caïn et d'Abel et l'*Alethia* de Claudius Marius Victorius." *VChr* 10 (1956), pp. 43–48.

Huber Huber, Paul. *Bild und Botschaft: Byzantinische Miniaturen zum Alten und Neuen Testament*. Zurich: Atlantis, 1973.

Hueck, *Kuppelmosaiken* Hueck, Irene. *Das Programm der Kuppelmosaiken im Florentiner Baptisterium*. Mondorf/Rhein: Krupinski, 1962.

Hutter, "Bild der Frau" Hutter, Irmgard. "Das Bild der Frau in der byzantinischen Kunst." In Βυζάντιος: *Festschrift für Herbert Hunger zum 70. Geburtstag*, ed. Wolfram Hörandner, Johannes Koder, Otto Kresten, and Erich Trapp, pp. 163–70. Vienna: Becvar, 1984.

Hutter, "Übermalungen" Hutter, Irmgard. "Paläologische Übermalungen im Oktateuch Vaticanus graecus 747." In *Festschrift für Otto Demus zum 60. Geburtstag*, ed. Herbert Hunger and Marcell Restle (*JÖB* 21 [1972]), pp. 139–48.

Hyslop, "Reliquary" Hyslop, F. E. Jr. "A Byzantine Reliquary of the True Cross from the Sancta Sanctorum." *ArtB* 16 (1934), pp. 333–40.

Iacobini, "Albero della vita" Iacobini, Antonio. "L'albero della vita nell'immaginario medievale: Bisanzio e l'Occidente." In *L'architettura medievale in Sicilia: La cattedrale di Palermo*, ed. Angiola Maria Romanini and Antonio Caldei, pp. 241–90. Rome: Istituto della Enciclopedia Italiana, 1994.

Iacobini, Antonio. "La 'Lettera di Aristea': Un prologo illustrato al ciclo degli Ottateuchi mediobizantini." In *Eighteenth International Congress of Byzantine Studies* (Moscow, 8–15 August 1991), *Summaries of Communications*, pp. 453–54. Moscow: 1991.

Iacobini, "Lettera" Iacobini, Antonio. "La 'Lettera di Aristea': Un prologo illustrato al ciclo degli Ottateuchi mediobizantini." *Arte Medievale*, ser. 2, 7 (1993), pp. 79–95.

Image du noir Devisse, Jean. *L'image du noir dans l'art occidental*. Vol. 2, *Des premiers siècles chrétiens aux "Grandes Découvertes,"* pt. 1, *De la menace démoniaque à l'incarnation de la sainteté*. Fribourg: Office du Livre, 1979. Engl. ed., *The Image of the Black in Western Art*. New York: Morrow, 1979.

Ippel, A. "Die Josuarolle: Bestand, Gestalt und Zeit." *Bonner Jahrbücher des Rheinischen Landesmuseum* 158 (1958), pp. 126–69.

Isigonis, Ant. M. "Δύο ἱστορημένα χειρόγραφα." Νέα Ἑστία 11 (1932), pp. 458–60.

Jacobs, Emil. *Untersuchungen zur Geschichte der Bibliothek im Serai zu Konstantinopel*. Heidelberg: Winter, 1919.

Jenkins and Kitzinger, "Cross" Jenkins, Romilly J. H., and Ernst Kitzinger. "A Cross of the Patriarch Michael Cerularius, with an Art-Historical Comment." *DOP* 21 (1967), pp. 233–49.

Jeremias, *S. Sabina* Jeremias, Gisela. *Die Holztür der Basilika S. Sabina in Rom*. Tübingen: Wasmuth, 1980.

The Jewish Encyclopedia. New York and London: Funk and Wagnalls, 1901–1906.

Johnstone, "Pallio" Johnstone, Pauline. "The Byzantine 'Pallio' in the Palazzo Bianco at Genoa." *GBA* 87 (1976), pp. 99–107.

Jolivet-Lévy, Catherine. "L'image du pouvoir dans l'art byzantin à l'époque de la dynastie macédonienne (867–1056)." *Byz* 57 (1987), pp. 441–70.

J.-R. *Josua-Rolle: Vollständige Faksimile-Ausgabe im Originalformat des Codex Vaticanus Palatinus Graecus 431 der Biblioteca Apostolica Vaticana: Kommentar*, ed. Otto Mazal. Graz: Akademische Druck- u. Verlagsanstalt, 1983.

Kádár, Zoltan. "Le problème du style dans les illustrations du manuscrit hippocratique de la Bibl. Nat. de Paris (Gr. 2244)." In *Actes du XIVᵉ Congrès international des études byzantines* (Bucharest, 6–12 September 1971), vol. 2, pp. 459–61. Bucharest: Academiei Republicii Socialiste România, 1975.

Kaiser-Minn, *Erschaffung des Menschen* Kaiser-Minn, Helga. *Die Erschaffung des Menschen auf den spätantiken Monumenten des 3. und 4. Jahrhunderts. JbAChr*, Ergänzungsband 6. Münster: Aschendorffsche Verlagsbuchhandlung, 1981.

Kariye Djami, see Underwood.

Katzenellenbogen, "Vézelay" Katzenellenbogen, Adolf. "The Central Tympanum at Vézelay: Its Encyclopedic Meaning and Its Relation to the First Crusade." *ArtB* 26 (1944), pp. 141–51.

Kauffman, "Bury Bible" Kauffmann, C. M. "The Bury Bible (Cambridge, Corpus Christi College, Ms. 2)." *JWarb* 29 (1966), pp. 60–81.

Keck, "Iconography of Joshua" Keck, Andrew S. "Observations on the Iconography of Joshua." *ArtB* 32 (1950), pp. 267–74.

Kelly, "Metamorphoses" Kelly, Henry A. "The Metamorphoses of the Serpent during the Middle Ages and Renaissance." *Viator* 2 (1971), pp. 301–28.

Kenfield, "Alexandrian Samson" Kenfield, John F., III. "An Alexandrian Samson: Observations on the New Catacomb on the Via Latina." *RACr* 51 (1975), pp. 179–92.

Kessler, Herbert L. "I cicli biblici a Santa Maria di Anglona." In *Santa Maria di Anglona*, pp. 61–71.

Kessler, "Hic Homo Formatur" Kessler, Herbert L. "Hic Homo Formatur: The Genesis Frontispieces of the Carolingian Bibles." *ArtB* 53 (1971), pp. 143–60.

Kessler, "Ivory Plaque" Kessler, Herbert L. "An Eleventh-Century Ivory Plaque from South Italy and the Cassinese Revival." *JbBerlMus* 8 (1966), pp. 67–95.

Kessler, "Pentateuch" Kessler, Herbert L. "Traces of an Early Illustrated Pentateuch." *JJA* 8 (1981), pp. 20–27.

Kessler, "Prophetic Portraits" Kessler, Herbert L. "Prophetic Portraits in the Dura Synagogue." *JbAChr* 30 (1987), pp. 149–55.

Kessler, "Temple Veil" Kessler, Herbert L. "Through the Temple Veil: The Holy Image in Judaism and Christianity." *Kairos*, n.s., 32–33 (1990–91), pp. 53–77.

Kessler, *Tours* Kessler, Herbert L. *The Illustrated Bibles from Tours*. Studies in Manuscript Illumination, 7. Princeton: Princeton University Press, 1977.

Kirigin, *Mano divina* Kirigin, Martin. *La mano divina nell'iconografia cristiana*. Vatican City: Pontificio Istituto di Archeologia Cristiana, 1976.

Kitzinger, "Hellenistic Heritage" Kitzinger, Ernst. "The Hellenistic Heritage in Byzantine Art." *DOP* 17 (1963), pp. 95–115.

Kitzinger, "Hellenistic Heritage Reconsidered" Kitzinger, Ernst. "The Hellenistic Heritage in Byzantine Art Reconsidered." *JÖB* 31 (1981), pp. 657–75.

Kitzinger, *Monreale* Kitzinger, Ernst. *I mosaici di Monreale.* Palermo: Flaccovio, 1960.

Kitzinger, "Nikopolis" Kitzinger, Ernst. "Studies in Late Antique and Early Christian Floor Mosaics, 1: Mosaics at Nikopolis." *DOP* 6 (1951), pp. 83–122.

Kitzinger, "Role" Kitzinger, Ernst. "The Role of Miniature Painting in Mural Decoration." In Kurt Weitzmann, William C. Loerke, Ernst Kitzinger, and Hugo Buchthal, *The Place of Book Illumination in Byzantine Art*, pp. 99–142. Princeton: The Art Museum, Princeton University, 1975.

Kitzinger, "Samson Floor" Kitzinger, Ernst. "Observations on the Samson Floor at Mopsuestia." *DOP* 27 (1973), pp. 133–44.

Kitzinger, "Story of Joseph" Kitzinger, Ernst. "The Story of Joseph on a Coptic Tapestry." *JWarb* 1 (1937–38), pp. 266–68.

Kömstedt, *Vormittelalterl. Malerei* Kömstedt, Rudolf. *Vormittelalterliche Malerei: Die künstlerischen Probleme der Monumental- und Buchmalerei in der frühchristlichen und frühbyzantinischen Epoche.* Augsburg: Filser, 1929.

Koenen, "Kindermord" Koenen, Ulrike. "Genesis 19,4/11 und 22,3/13 und der bethlehemitische Kindermord auf dem 'Lotsarkophag' von S. Sebastiano in Rom." *JbAChr* 29 (1986), pp. 118–45.

Kötzsche-Breitenbruch, *Via Latina* Kötzsche-Breitenbruch, Lieselotte. *Die neue Katacombe an der Via Latina in Rom: Untersuchungen zur Ikonographie der alttestamentlichen Wandmalereien. JbAChr*, Ergänzungsband 4. Münster: Aschendorffsche Verlagsbuchhandlung, 1976.

Köves, *Formation* Köves, Tibor. *La formation de l'ancien art chrétien.* Paris: Vrin, 1927.

Kollwitz, "Josuazyklus" Kollwitz, Johannes. "Der Josuazyklus von S. Maria Maggiore." *RQ* 61 (1966), pp. 105–10.

Kondakov, *Histoire* Kondakov, Nikodim P. *Histoire de l'art byzantin considéré principalement dans les miniatures.* 2 vols. Trans. K. Travinskii. Paris: Librairie de l'art, 1886 and 1891. Reprint, New York: Burt Franklin, 1970.

Kondakov, *Istoriia* Kondakov, Nikodim P. *Istoriia vizantiiskogo iskusstva i ikonografiia po miniatiuram' grecheskikh rukopisei.* Zapiski Imperatorskogo Novorossiiskogo Universiteta 21. Odessa: Ul'rikha i Shul'tse, 1876.

Kondakov, *Pamiatniki* Kondakov, Nikodim P. *Pamiatniki kristianskogo iskusstva na Afone.* St. Petersburg: Akademii Nauk, 1902.

Kondakov, *Tablits* Kondakov, Nikodim P. *Istoriia vizantiiskogo iskusstva i ikonografiia po miniatiuram' grecheskikh rukopisei N. Kondakova: XIV tablits risunkov (Planches pour servir à l'histoire de l'art byzantin et de l'iconographie d'après les miniatures des manuscrits grecs).* Odessa: Ul'rikha i Shul'tse, 1877.

Konowitz, "Program" Konowitz, Ellen. "The Program of the Carrand Diptych." *ArtB* 66 (1984), pp. 484–88.

Korol, *Cimitile* Korol, Dieter. *Die frühchristlichen Wandmalereien aus den Grabbauten in Cimitile/Nola. JbAChr*, Ergänzungsband 13. Münster: Aschendorffsche Verlagsbuchhandlung, 1987.

Koshi, *Genesisminiaturen* Koshi, Koichi. *Die Genesisminiaturen in der Wiener "Histoire Universelle" (Cod. 2576).* Vienna: Holzhausen, 1973.

Koukoules, "Χορός" Koukoules, Phaidon I. "Ὁ χορὸς παρὰ Βυζαντινοῖς." Ἐπ.Ἑτ.Βυζ.Σπ. 14 (1938), pp. 217–57.

Koukoules, Phaidon I. "Τὰ κατὰ τὴν γέννησιν καὶ κατὰ τὴν βάπτισιν ἔθιμα τῶν Βυζαντινῶν." Ἐπ.Ἑτ.Βυζ.Σπ. 14 (1938), pp. 87–146.

Koukoules, "Συμβολή" Koukoules, Phaidon I. "Συμβολὴ εἰς τὸ περὶ τοῦ γάμου παρὰ τοῖς βυζαντινοῖς κεφάλαιον." Ἐπ.Ἑτ.Βυζ.Σπ. 2 (1925), pp. 3–41.

Koukoules, *Vie et civilisation* Koukoules, Phaidon I. *Vie et civilisation byzantines* (Βυζαντινῶν βίος καί πολιτισμός). 5 vols. Athens: Collection de l'Institut Français d'Athènes, 1948–52.

Kraeling, *Synagogue* Kraeling, Carl H. *The Excavations at Dura-Europos, Final Report.* Vol. 8, pt. 1, *The Synagogue.* New Haven: Yale University Press, 1956. Augmented edition, New York: Ktav, 1979.

Krautheimer-Hess, "Porta dei Mesi" Krautheimer-Hess, Trude. "The Original Porta dei Mesi at Ferrara and the Art of Niccolò." *ArtB* 26 (1944), pp. 152–74.

Kresten, "Hinrichtung" Kresten, Otto. "Die Hinrichtung des Königs von Gai (Jos. 8,29)." *Anzeiger der philosophisch-historischen Klasse der Österreichischen Akademie der Wissenschaften* 126 (1989), pp. 113–29.

Kresten, "Oktateuch-Probleme" Kresten, Otto. "Oktateuch-Probleme: Bemerkungen zu einer Neuerscheinung." *BZ* 84–85 (1990–91), pp. 501–11.

Kretschmar, "Beitrag" Kretschmar, Georg. "Ein Beitrag zur Frage nach dem Verhältnis zwischen jüdischer und christlicher Kunst in der Antike." In *Abraham unser Vater: Festschrift für Otto Michel*, pp. 259–319. Leiden: Brill, 1963. Reprint in *No Graven Images*, pp. 156–84.

Krücke, "Ikonographie" Krücke, Adolf. "Zwei Beiträge zur Ikonographie des frühen Mittelalters: 1. Eine neue Szene aus dem Bilderzyklus des Lebens Jesu. 2. Über einige angebliche Darstellungen Gott-Vaters im frühen Mittelalter." *MarbJB* 10 (1937), pp. 1–36.

Krücke, *Nimbus* Krücke, Adolf. *Der Nimbus und verwandte Attribute in der frühchristlichen Kunst.* Strassburg: Heitz, 1905.

Krücke, "Protestantismus" Krücke, Adolf. "Der Protestantismus und die bildliche Darstellung Gottes." *ZKunstw* 13 (1959), pp. 59–90.

Krumbacher, Karl. Review of F. Uspenskii, "Ἡ βιβλιοθήκη τοῦ ἐν Κωνσταντινουπόλει Σεραγίου καὶ ἡ ἐν αὐτῇ εἰκονογραφημένη Ὀκτάτευχος." Παναθήναια 5 (30 April 1905). *BZ* 14 (1905), p. 671.

Kühnel, *Jerusalem* Kühnel, Bianca. *From the Earthly to the Heavenly Jerusalem: Representations of the Holy City in Christian Art of the First Millennium. RQ* 42, Supplementheft. Rome: Herder, 1987.

Kühnel, "Temple and Tabernacle" Kühnel, Bianca. "Jewish Symbolism of the Temple and the Tabernacle and Christian Symbolism of the Holy Sepulchre and the Heavenly Tabernacle: A Study of Their Relationship in Late Antique and Early Medieval Art and Thought." *JA* 12–13 (1986–87), pp. 146–67.

Künstle, *Ikonographie* Künstle, Karl. *Ikonographie der christlichen Kunst*, vol. 1. Freiburg im Breisgau: Herder, 1928.

Labarte, *Histoire* Labarte, Jules. *Histoire des arts industriels au Moyen Age et à l'époque de la Renaissance*, vol. 3. Paris: Morel, 1864.

Lafontaine-Dosogne, *Iconographie de l'enfance* Lafontaine-Dosogne, Jacqueline. *Iconographie de l'enfance de la Vierge dans l'empire byzantin et en occident.* 2 vols. Académie Royale de Belgique, Classe des Beaux-Arts, Mémoires, ser. 2, vol. 11.3. Brussels: Académie Royale de Belgique, 1964 and 1965.

Lafontaine-Dosogne, Jacqueline. "Iconography of the Cycle of the Life of the Virgin." In Underwood, *Kariye Djami.* Vol. 4, *Studies in the Art of the Kariye Djami and Its Intellectual Background*, pp. 161–94.

Laiou, "Role of Women" Laiou, Angeliki E. "The Role of Women in Byzantine Society." In *XVI. Internationaler Byzantinisten-Kongress, Akten*, vol. 1, pt. 1 (*JÖB* 31, pt. 1 [1981]), pp. 233–60.

Lambakis, "Ἀνακοινώσεις" Lambakis, G. "Ἀνακοινώσεις ἐν τῷ Ἀθήνησι Συγκροτήθεντι Αʹ Διέθνει Ἀρχαιολογικῷ Συνεδρίῳ." Δελτ.Χριστ.Ἀρχ. Ἐτ 7 (1906), pp. 29–62.

Langlois, Victor. *Le Mont Athos et ses monastères.* Paris: Didot, 1867.

Lassus, "Création" Lassus, Jean. "La création du monde dans les Octateuques byzantins du douzième siècle." *MonPiot* 62 (1979), pp. 85–148.

Lassus, *Early Christian World* Lassus, Jean. *The Early Christian and Byzantine World.* New York: McGraw-Hill, 1967.

Lassus, *Livre des Rois* Lassus, Jean. *L'illustration byzantine du Livre des Rois: Vaticanus graecus 333.* Bibliothèque des Cahiers Archéologiques, 9. Paris: Klincksieck, 1973.

Lassus, "Miniatures byz." Lassus, Jean. "Les miniatures byzantines du Livre des Rois d'après un manuscrit de la Bibliothèque Vaticane." *Mélanges d'archéologie et d'histoire* 45 (1928), pp. 38–74.

Lassus, "Quelques représentations" Lassus, Jean. "Quelques représentations du 'Passage de la Mer Rouge' dans l'art chrétien d'Orient et d'Occident." *Mélanges d'archéologie et d'histoire* 46 (1929), pp. 159–81.

Lauxtermann, *Byzantine Epigram* Lauxtermann, Marc Diederick. *The Byzantine Epigram in the Ninth and Tenth Centuries: A Generic Study of Epigrams and Some Other Forms of Poetry*, Akademisch Proefschrift, Byzantijns Nieuwgrieks Seminarium, Rijksuniversiteit Amsterdam, 1994.

Lazarev, Viktor N. "Gli affreschi di Castelseprio: Critica alla teoria di Weitzmann sulla 'Rinascenza macedone.'" *Sibrium* 3 (1957), pp. 85–102.

Lazarev, *Istoriia* Lazarev, Viktor N. *Istoriia vizantiiskoi zhivopisi.* 2 vols. Moscow: Iskusstvo, 1947 and 1948. 2d ed., 1986.

Lazarev, *Storia* Lazarev, Viktor N. *Storia della pittura bizantina.* Turin: Einaudi, 1967.

Lazarev, *Vizantiiskoe* Lazarev, Viktor N. *Vizantiiskoe i drevnerusskoe iskusstvo: Stat'i i materialy.* Moscow: Nauka, 1978.

Leanza, Sandro. "Problemi di ecdotica catenaria." In *Metodologie della ricerca sulla tarda antichità: Atti del I Convegno dell'Associazione di studi tardoantichi* (Naples, 16–18 October 1987), ed. Antonio Garzya, pp. 247–66. Naples: D'Auria, 1989.

Lefebvre de Noëttes, "Système" Richard Lefebvre des Noëttes. "Le système d'attelage du cheval et du boeuf à Byzance et les conséquences de son emploi." In *Mélanges Charles Diehl.* Vol. 1, *Histoire*, pp. 183–90. Paris: Leroux, 1930.

Levi D'Ancona, "Libro di Ruth" Levi D'Ancona, Mirella. "Figurazioni del Libro di Ruth nella Bibbia." In *Codice miniato*, pp. 3–18.

Levin, "Some Jewish Sources" Levin, Michael D. "Some Jewish Sources for the Vienna Genesis." *ArtB* 54 (1972), pp. 241–44.

Libro della Bibbia *Il Libro della Bibbia: Esposizione di manoscritti e di edizioni a stampa della Biblioteca Apostolica Vaticana dal secolo III al secolo XVI.* Rome: Biblioteca Apostolica Vaticana, 1972.

Lietzmann, "Datierung" Lietzmann, Hans. "Zur Datierung der Josuarolle." In *Mittelalterliche Handschriften: Festschrift Hermann Degering*, pp. 181–85. Leipzig: Hiersemann, 1926.

Likhachev, *Ikonopisi* Likhachev, Nikolai P. *Istoricheskoe znachenie italo-grecheskoi ikonopisi: Izobrazheniia Bogomateri v proizvedeniiakh italo-grecheskikh ikonopistsev.* St. Petersburg: Aleksandrova, 1911.

Livesey and Rouse, "Nimrod" Livesey, Steven J., and Richard H. Rouse. "Nimrod the Astronomer." *Traditio* 37 (1981), pp. 203–66.

Ljubinković, "Sopoćani" Ljubinković, Radivoje. "Sur le symbolism de l'histoire de Joseph du narthex de Sopoćani." In *L'art byzantin du XIIIᵉ siècle: Symposium de Sopoćani, 1965*, ed. Vojislav Djurić, pp. 207–37. Belgrade: Faculté de philosophie, Department de l'Histoire de l'Art, 1967.

Lowden, "Image of God" Lowden, John. "The Image of God as Creator." In *Sixteenth Annual Byzantine Studies Conference, Abstracts of Papers* (Baltimore, 26–28 October 1990), pp. 21–22.

Lowden, "Octateuch" Lowden, John. "Octateuch." *ODB*, vol. 3, pp. 1510–11.

Lowden, *Octs.* Lowden, John. *The Octateuchs: A Study in Byzantine Manuscript Illustration.* University Park: Pennsylvania State University Press, 1992.

Lowden, "Production" Lowden, John. "The Production of the Vatopedi Octateuch." In *XVI. Internationaler Byzantinisten-Kongress, Akten*, vol. 2, pt. 4 (*JÖB* 32, no. 4 [1982]), pp. 197–201.

Lowden, *Prophet Books* Lowden, John. *Illuminated Prophet Books: A Study of Byzantine Manuscripts of the Major and Minor Prophets.* University Park: Pennsylvania State University Press, 1988.

Lowden, review of *Cotton Gen.* Lowden, John. Review of K. Weitzmann and H. L. Kessler, *The Cotton Genesis: British Library Codex Cotton Otho B. VI* (Princeton, 1986). *ArtB* 70 (1988), pp. 346–47.

Lowden, "Vtp. Oct." Lowden, John. "The Production of the Vatopedi Octateuch." *DOP* 36 (1982), pp. 115–26.

Lowden, "Vtp. Sources" Lowden, John. "The Vatopedi Octateuch and Its Sources." Ph.D. diss., University of London, Courtauld Institute of Arts, 1980.

Lowden, John. "The Vatopedi Octateuch and Its Sources." In *Sixth Annual Byzantine Studies Conference, Abstracts of Papers* (Oberlin, Ohio, 24–26 October 1980), pp. 22–23.

Lowrie, *Art* Lowrie, Walter. *Art in the Early Church.* New York: Pantheon Books, 1947.

Lowrie, *Monuments* Lowrie, Walter. *Monuments of the Early Church.* New York: Macmillan, 1901.

Lugt, "Man and Angel" Lugt, Fritz. "Man and Angel." *GBA* 25 (1944), pp. 265–82.

Luoghi memoria scritta *I luoghi della memoria scritta: Manoscritti, incunaboli, libri a stampa di Biblioteche Statali Italiane*, ed. Guglielmo Cavallo. Rome: Istituto Poligrafico e Zecca dello Stato, 1994.

Magdalino, Paul. "The Bath of Leo the Wise and the 'Macedonian Renaissance' Revisited: Topography, Iconography, Ceremonial, Ideology." *DOP* 42 (1988), pp. 97–118.

Maguire, "Depiction of Sorrow" Maguire, Henry. "The Depiction of Sorrow in Middle Byzantine Art." *DOP* 31 (1977), pp. 125–74.

Maguire, *Earth and Ocean* Maguire, Henry. *Earth and Ocean: The Terrestrial World in Early Byzantine Art.* University Park: Pennsylvania State University Press, 1987.

Mango, "Antique Statuary" Mango, Cyril. "Antique Statuary and the Byzantine Beholder." *DOP* 17 (1963), pp. 53–75.

Mango, Cyril. "The Date of Cod. Vat. Regin. Gr. 1 and the 'Macedonian Renaissance.'" *ActaIRNorv* 4 (1969), pp. 121–26.

Mango, "Storia dell'arte" Mango, Cyril. "Storia dell'arte." In *La civiltà bizantina dal IX all'XI secolo* (II Corso di Studi, Centro di Studi Bizantini, Università degli Studi di Bari, 1977), pp. 241–323. Bari and Rome: "L'Erma" di Bretschneider, 1978.

Marini Clarelli, M. V. "I giorni della creazione nel 'Genesi Cotton.'" *OCP* 50 (1984), pp. 65–93.

Martin, *Heavenly Ladder* Martin, John R. *The Illustration of the Heavenly Ladder of John Climacus.* Studies in Manuscript Illumination, 5. Princeton: Princeton University Press, 1954.

Mathews, "Alt'amar" Mathews, Thomas F. "The Genesis Frescoes of Alt'amar." *REArm*, n.s., 16 (1982), pp. 247–57.

Mathews, *Early Churches* Mathews, Thomas F. *The Early Churches of Constantinople: Architecture and Liturgy.* University Park: Pennsylvania State University Press, 1971.

Mathews, "Leo Sacellarios" Mathews, Thomas F. "The Epigrams of Leo Sacellarios and an Exegetical Approach to the Miniatures of Vat. Reg. Gr. 1." *OCP* 43 (1977), pp. 94–134.

Mathews, "Philo Judaeus" Mathews, Jane Timken. "Reflections of Philo Judaeus in the Septuagint Illustrations of the Joseph Story." *Byzantine Studies/Études byzantines* 7 (1980), pp. 35–56.

Medio Oriente *Il Medio Oriente e l'Occidente nell'arte del XIII secolo: Atti del XXIV Congresso internazionale di storia dell'arte* (Bologna, 1979), ed. Hans Belting. Bologna: CLUEB, 1982.

Mellinkoff, *Horned Moses* Mellinkoff, Ruth. *The Horned Moses in Medieval Art and Thought.* Berkeley, Los Angeles, and London: University of California Press, 1970.

Mellinkoff, "Round-topped Tablets" Mellinkoff, Ruth. "The Round-topped Tablets of the Law: Sacred Symbol and Emblem of Evil." *JJA* 1 (1974), pp. 28–43.

Menhardt Menhardt, Hermann. "Die Bilder der Millstätter Genesis und ihre Verwandten." In *Festschrift für Rudolf Egger: Beiträge zur älteren europäischen Kulturgeschichte*, ed. Gotbert Moro, vol. 3, pp. 248–371. Klagenfurt: Verlag des Geschichtsvereines für Kärnten, 1954.

Menologio *Il Menologio di Basilio II (cod. vat. gr. 1613).* Turin: Bocca, 1907.

Mentré, *Création* Mentré, Mireille. *Création et Apocalypse: Histoire d'un regard humain sur le divin.* Paris: O.E.I.L., 1984.

Messerer, "Antike und Byzanz" Messerer, Wilhelm. "Antike und Byzanz in der ottonischen Bildkunst." In *La cultura antica nell'Occidente latino dal VII all'XI secolo. Settimane* 22 (Spoleto, 1974), vol. 2, pp. 837–64. Spoleto: presso la sede del Centro, 1979.

Michel, *Histoire* Michel, André. *Histoire de l'art depuis les premiers temps chrétiens jusqu'à nos jours.* Vol. 1, *Des débuts de l'art chrétien à la fin de la période romane.* Paris: Colin, 1905.

Millet, "Introduction" Millet, Gabriel. "Introduction." In Du Mesnil du Buisson, *Doura-Europos*, pp. vii–xxiv.

Millet, "Octateuque" Millet, Gabriel. "L'Octateuque byzantin d'après une publication de l'Institut russe à Constantinople." *RA*, ser. 4, 16 (1910), pp. 71–80.

Millet, Gabriel. *Recherches sur l'iconographie de l'Évangile au XIV*^e^*, XV*^e^ *et XVI*^e^ *siècles.* 2d ed. Paris: De Boccard, 1960.

Miniature *Miniature della Bibbia cod. Vat. Regin. Greco 1 e del Salterio cod. Vat. Palat. Greco 381.* Milan: Hoepli, 1905.

Mönchsland Athos *Mönchsland Athos*, ed. Franz Dölger. Munich: Bruckmann, 1943.

Morey, "Byzantine Renaissance" Morey, Charles R. "The 'Byzantine Renaissance.'" *Speculum* 14 (1939), pp. 139–59.

Morey, "Castelseprio" Morey, Charles R. "Castelseprio and the Byzantine 'Renaissance.'" *ArtB* 34 (1952), pp. 173–201.

Morey, *Early Christian Art* Morey, Charles R. *Early Christian Art: An Outline of the Evolution of Style and Iconography in Sculpture and Painting from Antiquity to the Eighth Century.* Princeton: Princeton University Press, 1942.

Morey, *Mediaeval Art* Morey, Charles R. *Mediaeval Art.* New York: Norton, 1942.

Morey, "Notes" Morey, Charles R. "Notes on East Christian Miniatures: Cotton Genesis, Gospel of Etschmiadzin, Vienna Genesis, Paris Psalter, Bible of Leo, Vatican Psalter, Joshua Roll, Petropolitanus XXI, Paris gr. 510, Menologion of Basil II." *ArtB* 11 (1929), pp. 5–103.

Morey, "Sources" Morey, Charles R. "The Sources of Mediaeval Style." *ArtB* 7 (1924–25), pp. 35–50.

Mouriki, "Moses Cycle" Mouriki, Doula. "A Moses Cycle on a Sinai Icon of the Early Thirteenth Century." In *Byzantine East, Latin West*, pp. 531–46.

Mouriki-Charalambous, "Cosmas" Mouriki-Charalambous, Doula. "The Octateuch Miniatures of the Byzantine Manuscripts of Cosmas Indicopleustes." Ph.D. diss., Princeton University, 1970.

Muñoz, "Rotulo" Muñoz, Antonio. "Alcune osservazioni intorno al Rotulo di Giosuè e agli Ottateuchi illustrati." *Byz* 1 (1924), pp. 475–83.

Muñoz, Antonio. "Nella Biblioteca del Serraglio a Costantinopoli." *Nuova antologia* 130 (1907), pp. 314–20.

———. "Tre codici miniati della Biblioteca del Serraglio a Costantinopoli." *Studi Bizantini*, ser. 2, 5 (1924), pp. 199–205.

Muratova, "Adam" Muratova, Xenia. " 'Adam donne leurs noms aux animaux': L'iconographie de la scène dans l'art du Moyen Age. Les manuscrits des bestiaires enluminés du XIIe et XIIIe siècles." *StM* 18 (1977), pp. 367–94.

Muratova, "Iconografia" Muratova, Xenia. "L'iconografia medievale e l' 'ambiente' storico." *Storia dell'Arte* 28 (1976), pp. 173–79.

Muratova, Xenia. "Su alcune particolarità iconografiche del ciclo veterotestamentario della chiesa di Santa Maria di Anglona." In *Santa Maria di Anglona*, pp. 125–34.

Mütherich, "Darstellungen" Mütherich, Florentine. "Geographische und etnographische Darstellungen in der Buchmalerei des frühen Mittelalters." In *Popoli e paesi nella cultura altomedievale. Settimane* 29 (Spoleto, 1981), vol. 2, pp. 709–43. Spoleto: presso la sede del Centro, 1983.

Mütherich, "Psalterillustration" Mütherich, Florentine. "Die Stellung der Bilder in der frühmittelalterlichen Psalterillustration." In *Stuttgarter Bilderpsalter*, vol. 2, pp. 151–222.

Narkiss, *Golden Haggadah* Narkiss, Bezalel. *The Golden Haggadah.* London: Eugramma, 1970.

Narkiss, "Main Plane" Narkiss, Bezalel. "The 'Main Plane' as a Compositional Element in the Style of the Macedonian Renaissance and Its Origins." *DOP* 41 (1987), pp. 425–41.

Narkiss, "Pharaoh" Narkiss, Bezalel. "Pharaoh is Dead and Living at the Gates of Hell." *JJA* 10 (1984), pp. 6–13.

Neuss, *Apokalypse* Neuss, Wilhelm. *Die Apokalypse des Heiligen Johannes in der altspanischen und altchristlichen Bibelillustration: Das Problem der Beatus-Handschriften.* 2 vols. Münster: Aschendorffsche Verlagsbuchhandlung, 1931.

Neuss, *Katalan. Bibelill.* Neuss, Wilhelm. *Die katalanische Bibelillustration um die Wende des ersten Jahrtausends und die altspanische Buchmalerei.* Bonn and Leipzig: Schroeder, 1922.

Neuss, *Kunst d. Alten Christen* Neuss, Wilhelm. *Die Kunst der alten Christen.* Augsburg: Filser, 1926.

Nikolasch, "Ikonographie des Widders" Nikolasch, Franz. "Zur Ikonographie des Widders von Gen. 22." *VChr* 23 (1969), pp. 197–223.

No Graven Images *No Graven Images: Studies in Art and the Hebrew Bible,* ed. Joseph Gutmann. New York: Ktav, 1971.

Nordström, *Castilian Bible* Nordström, Carl-Otto. *The Duke of Alba's Castilian Bible: A Study of the Rabbinical Features of the Miniatures.* Uppsala: Almqvist and Wiksell, 1967.

Nordström, "Elementi ebraici" Nordström, Carl-Otto. "Elementi ebraici nell'arte cristiana." In *Gli Ebrei nell'Alto Medioevo. Settimane* 26 (Spoleto, 1978), vol. 2, pp. 967–80. Spoleto: presso la sede del Centro, 1980.

Nordström, "Jewish Legends" Nordström, Carl-Otto. "Some Jewish Legends in Byzantine Art." *Byz* 25–27 (1955–57), pp. 487–508.

Nordström, "Rabbin. Einflüsse" Nordström, Carl-Otto. "Rabbinische Einflüsse auf einige Miniaturen des serbischen Psalters in München." In *Akten des XI. Internationalen Byzantinisten Kongresses* (Munich, 1958), ed. Hans-Georg Beck, pp. 416–21. Munich: Beck'sche, 1960.

Nordström, "Rabbinica" Nordström, Carl-Otto. "Rabbinica in frühchristlichen und byzantinischen Illustrationen zum 4. Buch Mose." *Figura*, n.s., 1 (1959), pp. 24–47.

Nordström, Carl-Otto. "Rabbinic Features in Byzantine and Catalan Art." *CahArch* 15 (1965), pp. 179–205.

Nordström, "Späte Judentum" Nordström, Carl-Otto. "Das späte Judentum und die Anfänge der christlichen Kunst." In *Problems in Early Christian Art.* Vol. 1, *Symposium,* Nationalmuseum, Stockholm, 20 November 1968 (*Orthodox Documentation* 3/2 [1969]), pp. 1–10.

Nordström, "Temple" Nordström, Carl-Otto. "The Temple Miniatures in the Peter Comestor Manuscript at Madrid." *Horae Soederblomianae* 6 (1954), pp. 54–81. Reprint in *No Graven Images*, pp. 39–74.

Nordström, "Water Miracles" Nordström, Carl-Otto. "The Water Miracles of Moses in Jewish Legend and Byzantine Art." *Orientalia Suecana* 7 (1958), pp. 78–109. Reprint in *No Graven Images*, pp. 277–308.

Okunev, "Lesnovo" Okunev, N. L. "Lesnovo." In *L'art byzantin chez les Slaves: Les Balkanes. Première recueil dédié à la mémoire de Théodore Uspenskij,* ed. Gabriel Millet, pp. 222–63. Paris: Geuthner, 1930.

Old English Hexateuch *The Old English Illustrated Hexateuch: British Museum Cotton Claudius B. IV.* Ed. Charles R. Dodwell and Peter Clemoes. Copenhagen: Rosenkilde-Bagger, 1974.

Oltrogge, *Histoire ancienne* Oltrogge, Doris. *Die Illustrationzyklen zur "Histoire ancienne jusqu'à César" (1250–1400).* Frankfurt am Main and New York: Lang, 1989.

"Otchet o deiatel'nosti Russkago Arkheologicheskago Instituta v Konstantinopolie v 1897-m godu." *IRAIK* 3 (1898), pp. 195–230.

Pace, Valentino. "Il ciclo di affreschi di Santa Maria di Anglona: Una testimonianza italomeridionale della pittura bizantina intorno al 1200." In *Santa Maria di Anglona*, pp. 103–10.

Pächt, "Ephraimill." Pächt, Otto. "Ephraimillustration, Haggadah und Wiener Genesis." In *Festschrift Karl M. Swoboda zum 28. Januar 1959*, pp. 213–21. Vienna and Wiesbaden: Rohrer, 1959. Reprint in *No Graven Images*, pp. 249–60.

Pächt, "Life of Joseph" Pächt, Jeanne, and Otto Pächt. "An Unknown Cycle of Illustrations of the Life of Joseph." *CahArch* 7 (1954), pp. 35–50.

Papadopoulos-Kerameus, Κατάλογος Papadopoulos-Kerameus, Athanasios. Κατάλογος τῶν χειρογράφων τῆς ἐν Σμύρνῃ Βιβλιοθήκης τῆς Εὐαγγελικῆς Σχολῆς. Smyrna: Typos, 1877.

Pérat, *Archéologie chrétienne* Pérat, André. *L'archéologie chrétienne.* Paris: Quantin, 1892.

Pérat, André. Review of N. Kondakov, *Histoire de l'art byzantin considéré principalement dans les miniatures,* vol. 1 (Paris, 1886). *GBA* 38 (1888), pp. 249–54.

Perler, "Théophanies" Perler, Othmar. "Les théophanies dans les mosaïques de Sainte-Marie-Majeure à Rome." *RACr* 50 (1974), pp. 275–93.

Perria, Lidia. "La scrittura degli Ottateuchi tra tradizione e innovazione." In *Bisanzio e l'Occidente: Arte, archeologia, storia. Studi in onore di Fernanda de' Maffei*, pp. 207–29. Rome: Viella, 1996.

Pijoán, *Summa artis* Pijoán, José. *Summa artis: Historia general del arte.* Vol. 7, *Arte cristiano primitivo, arte bizantino hasta el saqueo de Constantinopla por los Cruzados el año 1204.* 2d ed. Madrid: Espasa-Calpe, 1947.

Piper, "Bilderkreis" Piper, Ferdinand. "Der älteste christliche Bilderkreis: Aufgefunden in einer griechischen Bibelhandschrift der Vaticanischen Bibliothek." *Deutsche Zeitschrift für christliche Wissenschaft und christliches Leben* 7 (1856), pp. 149–51, 184–89.

Piper, "Denkmäler" Piper, Ferdinand. "Verschollene und theologischen aufgefundene Denkmäler und Handschriften." *Theologischen Studien und Kritiken* 34 (1861), pp. 459–503.

Piper, *Mythologie* Piper, Ferdinand. *Mythologie und Symbolik der christlichen Kunst.* 2 vols. Weimar: Landes-industrie, 1847 and 1851.

Pittura e pittori Pittura e pittori nell'antichità. Rome: Istituto della Enciclopedia Italiana, 1968.

Pococke, Richard. *A Description of the East, and Some Other Countries.* 2 vols. London: Bowyer, 1743 and 1745.

Popovich, "Personifications" Popovich, Ljubica D. "Personifications in Paleologan Painting, 1261–1453." Ph.D. diss., Bryn Mawr College, 1963.

Posner and Ta-Shema, *Hebrew Book* Posner, Raphael, and Israel Ta-Shema. *The Hebrew Book: An Historical Survey.* Jerusalem: Keter, 1975.

Prato, "Scritture arcaizzanti" Prato, Giancarlo. "Scritture librarie arcaizzanti della prima età dei Paleologi e loro modelli." *Scrittura e Civiltà* 3 (1979), pp. 151–93.

Prigent, *Judaïsme* Prigent, Pierre. *Le Judaïsme et l'image.* Tübingen: Mohr, 1990.

Quinto centenario Quinto centenario della Biblioteca Apostolica Vaticana, 1475–1975, Catalogo della mostra. Rome: Biblioteca Apostolica Vaticana, 1975.

Réau, *Miniature* Réau, Louis. *La miniature.* Melun: D'Argences, 1946.

Redin, *Koz'my Indikoplova* Redin, Egor K. *Khristianskaia Topografiia Koz'my Indikoplova po grecheskim i russkim spiskam.* Moscow: Lissnera-Sobko, 1916.

Repp, "Riesen" Repp, Friedrich. "Zur Darstellung der Riesen in den Oktateuchhandschriften aus dem Serail und aus Smyrna." *JÖBG* 4 (1955), pp. 151–55.

Revel, "Textes rabbin." Revel, Elisabeth. "Contribution des textes rabbiniques à l'étude de la Genèse de Vienne." *Byz* 42 (1972), pp. 115–30.

Revel-Neher, *Arche* Revel-Neher, Elisabeth. *Le signe de la rencontre: L'arche d'alliance dans l'art juif et chrétien du second au dixième siècle.* Paris: Association des amis des études archéologiques du monde byzantino-slave et du christianisme oriental, 1984.

Revel-Neher, "Christian Topography" Revel-Neher, Elisabeth. "Some Remarks on the Iconographical Sources of the Christian Topography of Cosmas Indicopleustes." *Kairos*, n.s., 32–33 (1990–91), pp. 78–97.

Revel-Neher, Elisabeth. "Du Codex Amiatinus et ses rapports avec les plans du tabernacle dans l'art juif et dans l'art byzantin." *JJA* 9 (1982), pp. 6–17.

Revel-Neher, "*Cohen gadol*" Revel-Neher, Elisabeth. "Problèms d'iconographie judéo-chrétienne: Le thème de la coiffure du *cohen gadol* dans l'art byzantin." *JJA* 1 (1974), pp. 50–65.

Revel-Neher, "Hypothetical Models" Revel-Neher, Elisabeth. "On the Hypothetical Models of the Byzantine Iconography of the Ark of the Covenant." In *Byzantine East, Latin West*, pp. 405–14.

Revel-Neher, "Iconographie" Revel-Neher, Elisabeth. "L'iconographie judéo-chrétienne en milieu byzantin, une source de connaissance pour l'histoire du monde juif à l'époque préchrétienne et talmudique." In *Mélanges André Neher*, pp. 308–16. Paris: Maisonneuve, 1975.

Revel-Neher, *Image of the Jew* Revel-Neher, Elisabeth. *The Image of the Jew in Byzantine Art.* Oxford: Pergamon, 1992.

RG Il Rotulo di Giosué [ed. Pio Franchi de' Cavalieri]. Milan: Hoepli, 1905.

Rice, *Beginnings* Rice, David T. *The Beginnings of Christian Art.* London: Hodder, 1957.

Rice, *Byzantines* Rice, David T. *The Byzantines.* London: Thames and Hudson, 1962.

Rice, *Byz. Art* Rice, David T. *Byzantine Art.* Harmondsworth: Penguin Books, 1968.

Richter and Taylor, *Golden Age* Richter, Jean Paul, and A. Cameron Taylor. *The Golden Age of Classic Christian Art.* London: Duckworth, 1904.

Rickert, *Ashburnham Pent.* Rickert, Franz. *Studien zum Ashburnham Pentateuch: Paris, Bibl. Nat., lat. 2334.* Bonn: Rheinische Friedrich-Wilhelms-Universität, 1986.

Riddle, "Triumph" Riddle, Margaret. "Illustration of the 'Triumph' of Joseph the Patriarch." In *Byzantine Papers: Proceedings of the First Australian Byzantine Studies Conference* (Canberra, 17–19 May 1978), ed. Elizabeth Jeffreys, Michael Jeffreys, and Ann Moffatt, pp. 69–81. Canberra: Humanities Research Centre, Australian University, 1981.

Robb, *Art* Robb, David M. *The Art of the Illuminated Manuscript.* South Brunswick and New York: Barnes, 1973.

Roma, *S. Maria di Anglona* Roma, Giuseppe. *Santa Maria di Anglona: Struttura architettonica e decorazione pittorica.* Cosenza: Effesette, 1989.

Rosenthal, *Vergilius Romanus* Rosenthal, Erwin. *The Illuminations of the Vergilius Romanus.* Zurich: Urs, 1972.

Roth, "Jewish Antecedents" Roth, Cecil. "Jewish Antecedents of Christian Art." *JWarb* 16 (1953), pp. 24–44.

St. Clair, "Narrative and Exegesis" St. Clair, Archer. "Narrative and Exegesis in the Exodus Illustrations of the San Paolo Bible: Aspects of Byzantine Influence." In *Byzantine East, Latin West*, pp. 193–202.

Santa Maria di Anglona Santa Maria di Anglona: Atti del Convegno internazionale di studio promosso dall'Università degli Studi della Basilicata in occasione del decennale della sua istituzione (Potenza and Anglona, 13–15 June 1991), ed. Cosimo

Damiano Fonseca and Valentino Pace. Galatina: Congedo, 1996.

Schade, "Adam und Eva" Schade, Herbert. "Adam und Eva." *LCI*, vol. 1, cols. 42–70.

Schade, *Paradies* Schade, Herbert. *Das Paradies und die Imago Dei: Probleme der Kunstwissenschaft*. Vol. 2, *Wandlungen des Paradisischen und Utopischen: Studien zum Bild eines Ideals*. Berlin: Walter De Gruyter, 1966.

Schade, "Tiere" Schade, Herbert. "Die Tiere in der mittelalterlichen Kunst: Untersuchungen zur Symbolik von zwei Elfenbeinreliefs." *Studium generale* 20 (1967), pp. 220–35.

Schapiro, "Place" Schapiro, Meyer. "The Place of the Joshua Roll in Byzantine History." *GBA* 35 (1949), pp. 161–76. Reprint in M. Schapiro, *Late Antique, Early Christian and Mediaeval Art: Selected Papers*, pp. 49–66. New York: Braziller, 1979.

Schapiro, Meyer. Review of Morey, *Early Christian Art* (Princeton, 1942). *Review of Religion* 8 (1944), pp. 165–86.

Schapiro, *Words* Schapiro, Meyer. *Words and Pictures: On the Literal and the Symbolic in the Illustration of a Text*. The Hague: Mouton, 1973.

Scheiber, Alexander. "Samson Uprooting a Tree." *JQR* 50 (1959), pp. 176–80; and 52 (1961), pp. 35–40. Reprint in *No Graven Images*, pp. 416–26.

Schlumberger, *Épopée byz.* Schlumberger, Gustave. *L'épopée byzantine à la fin du dixième siècle*. Vol. 3, *Les Porphyrogénètes, Zoe et Théodora (1025–1057)*. Paris: Hachette, 1905. Reprint, Aalen: Scientia Verlag, 1969.

Schmidt, *Sechstagewerkes* Schmidt, Christel. *Die Darstellungen des Sechstagewerkes von ihren Anfängen bis zum Ende des 15. Jahrhunderts*. Hildesheim: Lax, 1938.

Schmitt, Theodor. Review of Fedor Uspenskii, *Konstantinopolskii Seral'skii kodeks Vos'mikniziia (L'Octateuque de la Bibliothèque du Sérail à Constantinople)* (Sofia, 1907). *BZ* 17 (1908), pp. 641–43.

Schubert, "Auffindung" Schubert, Ursula. "Die Auffindung des Mosesknaben im Nil durch die Pharaonentochter sowie die Darstellung der vierten Plage in den beiden Pamplona-Bibeln im Licht der jüdischen Ikonographie." *Aachner Kunstblätter* 60 (1994), pp. 285–92.

Schubert, "Egyptian Bondage" Schubert, Ursula. "Egyptian Bondage and Exodus in the Ashburnham Pentateuch." *JJA* 5 (1978), pp. 29–44.

Schubert, "Errettung des Moses" Schubert, Kurt, and Ursula Schubert. "Die Errettung des Moses aus dem Wasser des Nils in der Kunst des spätantiken Judentums und das Weiterwirken dieses Motivs in der frühchristlichen und jüdisch-mittelalterlichen Kunst." In *Studien zum Pentateuch: Walter Kornfeld zum 60. Geburtstag*, ed. Georg Braulik, pp. 57–68. Vienna, Freiburg, and Basel: Herder, 1977.

Schubert, *Jüd. Buchkunst* Schubert, Ursula, and Kurt Schubert. *Jüdische Buchkunst*. Graz: Akademische Druck, 1983.

Schubert, *Spätantikes Judentum* Schubert, Ursula. *Spätantikes Judentum und frühchristliche Kunst*. Vienna: Inkomm, 1974.

Schultze, *Archäologie* Schultze, Victor. *Archäologie der altchristlichen Kunst*. Munich: Beck'sche, 1895.

Schultze, *Itala-Miniaturen* Schultze, Victor. *Die Quedlinburger Itala-Miniaturen der Königlichen Bibliothek in Berlin*. Munich: Beck'sche, 1898.

Schwab, "Isaak-Opfer" Schwab, Ute. "Zum Verständnis des Isaak-Opfers in literalischer und bildlicher Darstellung des Mittelalters." *FrSt* 15 (1981), pp. 435–94.

Schweinfurth, *Byzantin. Form* Schweinfurth, Philipp. *Die byzantinische Form: Ihr Wesen und ihr Wirkung*. Berlin: Kupferberg, 1943.

Sed-Rajna, "Haggadah" Sed-Rajna, Gabrielle. "Haggadah and Aggadah: Reconsidering the Origins of the Biblical Illustrations in Medieval Hebrew Manuscripts." In *Byzantine East, Latin West*, pp. 415–28.

Sed-Rajna, *Hebraic Bible* Sed-Rajna, Gabrielle. *The Hebraic Bible in Medieval Illuminated Manuscripts*. New York: Steimatzky, 1987.

Seroux d'Agincourt, *Histoire* Seroux d'Agincourt, Jean Baptiste Louis Georges. *Histoire de l'art par les monuments, depuis sa décadence au IV^e siècle jusqu'à son renouvellement au XVI^e*. Vol. 3, *Peinture: Table des planches*. Vol. 5, *Planches: Peinture, première partie*. Paris: Treuttel et Würtz, 1823.

Ševčenko, Ihor. "The Illuminators of the Menologium of Basil II." *DOP* 16 (1962), pp. 243–76.

Sherman, "Ripoll Bible" Sherman, Randi E. "Observations on the Genesis Iconography of the Ripoll Bible." *Rutgers Art Review* 2 (1981), pp. 1–12.

Simon, "Nonnos" Simon, Erika. "Nonnos und das Elfenbeinkästchen aus Veroli." *Jahrbuch des deutschen archäologischen Instituts* 79 (1964), pp. 279–336.

Smith, "Iconography" Smith, Alison M. "The Iconography of the Sacrifice of Isaac in Early Christian Art." *AJA* 26 (1922), pp. 159–73.

Sorensen, "Creation" Sorensen, Howard J. "Creation Account." In *New Catholic Encyclopedia*, vol. 4, pp. 423–27. New York: McGraw-Hill, 1967.

Soteriou, Εἰκόνες Soteriou, Georgios A., and Maria G. Soteriou. Εἰκόνες τῆς Μονῆς Σινᾶ. 2 vols. Athens: Institut français, 1956 and 1958.

Spain, "Relics Ivory" Spain, Suzanne. "The Translation of Relics Ivory, Trier." *DOP* 31 (1978), pp. 279–304.

Spatharakis, *Corpus* Spatharakis, Iohannis. *Corpus of Dated Illuminated Greek Manuscripts to the Year 1453*. 2 vols. Leiden: Brill, 1981.

Spatharakis, *Portrait* Spatharakis, Iohannis. *The Portrait in Byzantine Illuminated Manuscripts*. Byzantina Neerlandica 6. Leiden: Brill, 1976.

Spatharakis, "Psalter Dionysiou" Spatharakis, Iohannis. "The Date of the Illustrations of the Psalter Dionysiou 65." Δελτ.Χριστ.Ἀρχ.Ἑτ., ser. 4, no. 8 (1975–76), pp. 173–77.

Speck, "Quelle" Speck, Paul. "Eine Quelle zum Tod an der Furca." *JÖB* 42 (1992), pp. 83–85.

Speck, "Tod an der Furca" Speck, Paul. "Der Tod an der Furca." *JÖB* 40 (1990), pp. 349–50.

Stahl, "Morgan M. 638" Stahl, Harvey. "The Iconographic Sources of the Old Testament Miniatures, Pierpont Morgan Library M. 638." Ph.D. diss., New York University, 1974.

Stahl, "Old Test. Ill." Stahl, Harvey. "Old Testament Illustration during the Reign of St. Louis: The Morgan Picture Book and the New Biblical Cycles." In *Medio Oriente*, pp. 79–93.

Stechow, "Jacob" Stechow, Wolfgang. "Jacob Blessing the Sons of Joseph: From Early Christian Times to Rembrandt." *GBA* 23 (1943), pp. 193–208. Reprint in *No Graven Images*, pp. 261–76.

Ştefănescu, *Iconographie* Ştefănescu, Ioan D. *Iconographie de la Bible: Images bibliques commentées*. Paris: Geuthner, 1938.

Ştefănescu, Ioan D. *L'illustration des liturgies dans l'art de Byzance et de l'Orient*. Brussels: Université Libre de Bruxelles, Institut de Philologie et d'Histoire Orientales, 1936.

Stemberger, "Patriarchenbilder" Stemberger, Günter. "Die Patriarchenbilder der Katakombe in der Via Latina im Lichte der jüdischen Tradition." *Kairos*, n.s., 16 (1974), pp. 19–78.

Stern, *Calendrier* Stern, Henri. *Le Calendrier de 354: Étude sur son texte et sur ses illustrations*. Paris: Imprimerie Nationale, 1953.

Stern, "Layrac" Stern, Henri. "Une mosaïque du pavement romane de Layrac (Lot-et-Garonne)." *CahArch* 20 (1970), pp. 81–98.

Stern, "Poésies" Stern, Henri. "Poésies et représentations carolingiennes et byzantines des mois." *RA*, ser. 6, no. 45 (1955), pp. 141–86.

Stern, "Quelques problèmes" Stern, Henri. "Quelques problèmes d'iconographie paléochrétienne et juive." *CahArch* 12 (1962), pp. 99–113.

Stern, "Sainte-Constance" Stern, Henri. "Les mosaïques de l'église de Sainte-Constance à Rome." *DOP* 12 (1958), pp. 159–218.

Stevenson, Henricus. *Codices Manuscripti Palatini Graeci Bibliothecae Vaticanae*. Rome: ex Typographeo Vaticano, 1885.

Stichel, "Ausserkanon. Elemente" Stichel, Rainer. "Ausserkanonische Elemente in byzantinischen Illustrationen des Alten Testaments." *RQ* 69 (1974), pp. 159–81.

Stichel, "Bemerkungen" Stichel, Rainer. "Bemerkungen zur Predigt des Manuel/Maximos Holobolos auf das Fest der Verkündigung Mariens." *ZSlPh* 45 (1986), pp. 379–433.

Stichel, "Illustration" Stichel, Rainer. "Gab es eine Illustration der jüdischen Heiligen Schrift in der Antike?" In *Tesserae: Festschrift für Josef Engemann*. *JbAChr* Ergänzungsband 18 (1991), pp. 93–111.

Stichel, Rainer. "Die Inschriften des Samson-Mosaiks in Mopsuestia und ihre Beziehung zum biblischen Text." *BZ* 71 (1978), pp. 50–61.

Stichel, "Jüdische Tradition" Stichel, Rainer, "Jüdische Tradition in christlicher Liturgie: Zur Geschichte des Semantrons." *CahArch* 21 (1971), pp. 213–28.

Stichel, *Namen Noes* Stichel, Rainer. *Die Namen Noes, seines Bruders und seiner Frau: Ein Beitrag zum Nachleben jüdischer Überlieferung in der ausserkanonischen und gnostischen Literatur und in Denkmälern der Kunst*. Abhandlungen der Akademie der Wissenschaft in Göttingen, philologisch-historische Klasse, ser. 3, no. 122. Göttingen, 1979.

Stornajolo, *Topografia Cristiana* Stornajolo, Cosimo. *Le miniature della Topografia Cristiana di Cosma Indicopleuste: Codice Vaticano Greco 699*. Milan: Hoepli, 1908.

Strzygowski, "Monatscyclen" Strzygowski, Josef. "Die Monatscyclen der byzantinischen Kunst." *RepKunstw* 11 (1888), pp. 23–46.

Strzygowski, Josef. Review of L. De Gregori, "Arte bizantina." *Rivista d'Italia* 10 (1907), pt. 1, pp. 332–45. *BZ* 16 (1907), pp. 739–40.

Strzygowski, *Serb. Ps.* Strzygowski, Josef. *Die Miniaturen des serbischen Psalters der Königl. Hof- und Staatsbibliothek in München*. Denkschriften der Kaiserlichen Akademie der Wissenschaften in Wien, philosophisch-historische Klasse, vol. 52, no. 2. Vienna: Hölder, 1906.

Strzygowski, *Sm.* Strzygowski, Josef. *Der Bilderkreis des griechischen Physiologus des Kosmas Indikopleustes und Oktateuch nach Handschriften der Bibliothek zu Smyrna. Byzantinisches Archiv*, vol. 2, pp. 1–126. Leipzig: Teubner, 1899.

Strzygowski, "Trapezunt. Bilderhandschrift" Strzygowski, Josef. "Eine trapezuntische Bilderhandschrift vom Jahre 1346." *RepKunstw* 13 (1890), pp. 241–63.

Studies in Early Christianity *Studies in Early Christianity: A Collection of Scholarly Essays*, ed. Everett Ferguson, David M. Scholer, and Paul Corby Finney. Vol. 18, *Art, Archaeology, and Architecture of Early Christianity*, ed. Paul Corby Finney. New York and London: Garland, 1993.

Stuhlfauth, Georg. "A Greek Psalter with Byzantine Miniatures." *ArtB* 15 (1933), pp. 311–26.

Stuttgarter Bilderpsalter *Der Stuttgarter Bilderpsalter: Bibl. Fol. 23 Württembergische Landesbibliothek, Stuttgart*. Ed. W. Hoffmann, B. Bischoff, et al. 2 vols. Stuttgart: Schreiber, 1968.

Taylor, "Prophetic Scenes" Taylor, Michael D. "The Prophetic Scenes in the Tree of Jesse at Orvieto." *ArtB* 54 (1972), pp. 403–17.

Testini, Pasquale. "Il simbolismo degli animali nell'arte figurativa paleocristiana." In *L'uomo di fronte al mondo animale nell'Alto Medioevo. Settimane* 31 (Spoleto, 1985), vol. 2, pp. 1107–68. Spoleto: presso la sede del Centro, 1986.

Θησαυροί Οἱ Θησαυροὶ τοῦ Ἁγίου Ὄρους. Vol. 1, Εἰκονογραφημένα χειρόγραφα, pt. 4, Μ. Βατοπεδίου, Μ. Ζωγράφου, Μ. Σταυρονικήτα, Μ. Ξενοφῶντος. Ed. P. K. Christou, S. N. Kadas, and A. Kalamartze-Katsaros. Athens: Ekdotike, 1991.

Thierry, "Alt'amar" Thierry, Nicole. "Le cycle de la création et de la faute d'Adam à Alt'amar." *REArm*, n.s., 17 (1983), pp. 289–329.

Tikkanen, *Farbengebung* Tikkanen, Johan Jakob. *Studien über die Farbengebung in der mittelalterlichen Buchmalerei*. Commentationes Humanorum Litterarum, V, 1. Helsingfors: Societas Scientiarum Fennica, 1933.

Tikkanen, "Genesi" Tikkanen, Johan Jakob. "Le rappresentazioni della Genesi in S. Marco a Venezia e loro relazione con la Bibbia Cottoniana." *Archivio storico dell'arte* 1 (1888), pp. 212–23, 257–67, 348–63.

Tikkanen, *Genesismosaiken* Tikkanen, Johan Jakob. *Die Genesismosaiken von S. Marco in Venedig und ihr Verhältnis zu den Miniaturen der Cottonbibel nebst einer Untersuchung über den Ursprung der mittelalterlichen Genesisdarstellung besonders in der byzantinischen und italienischen Kunst*. Acta Societatis

Scientiarum Fennicae, 17. Helsingfors: Druckerei der Finnischen Litteratur-Gesellschaft, 1889.

Toesca, "Cimeli biz." Toesca, Pietro. "Cimeli bizantini." *L'Arte* 9 (1906), pp. 35–44.

Toubert, "Bréviaire d'Oderisius" Toubert, Hélène. "Le bréviaire d'Oderisius (Paris, Bibliothèque Mazarine, ms. 364) et les influences byzantines au Mont-Cassin." *MEFRM* 83 (1971), pp. 187–261.

Trapp, "Genealogie der Asanen" Trapp, Erich. "Beiträge zur Genealogie der Asanen in Byzanz." *JÖB* 25 (1976), pp. 163–77.

Trnek, "Vier Elemente" Trnek, Renate. "Die Darstellung der Vier Elemente in Cod. 12600 der Österreichischen Nationalbibliothek in Wien: Ein Beitrag zum Problem der Antikenrezeption in der 'Kunst um 1200.'" *JbKSWien* 75, n.s., 39 (1979), pp. 8–56.

Troje, AΔAM *und* ZΩH Troje, Louise. AΔAM *und* ZΩH: *Eine Szene der altchristlichen Kunst in ihrem religionsgeschichtlichen Zusammenhange.* Sitzungsberichte der Heidelberger Akademie der Wissenschaft, philosophisch-historische Klasse, pp. 1–107. Heidelberg: Winter, 1916.

Tselos, "Joshua Roll" Tselos, Dimitri. "The Joshua Roll: Original or Copy?" *ArtB* 32 (1950), pp. 275–90.

Tsuji, "Chaire" Tsuji, Sahoko. "La Chaire de Maximien, la Genèse de Cotton et les mosaïques de Saint-Marc à Venise: A propos du cycle de Joseph." In *Synthronon: Art et archéologie de la fin de l'Antiquité et du Moyen Age*, pp. 43–51. Bibliothèque des Cahiers Archéologiques, 2. Paris: Klincksieck, 1968.

Tsuji, "Essai d'identification" Tsuji, Sahoko. "Un essai d'identification des sujets des miniatures fragmentaires de la Genèse de Cotton: Histoire de Juda et de Tamar." In *Actes du XXIIᵉ Congrès international d'histoire de l'art* (Budapest, 1969), pp. 139–45. Budapest: Akadémiai Kiadó, 1972.

Tsuji, Sahoko. "Nouvelles observations sur les miniatures de la Genèse de Cotton." Résumé in *VIIIᵉ Congrès international d'archéologie paléochrétienne* (Barcelona, 1969), pp. 587–88. Rome: Pontificio Istituto di Archeologia Cristiana, 1972.

Tsuji, "Nouvelles observations" Tsuji, Sahoko. "Nouvelles observations sur les miniatures fragmentaires de la Genèse de Cotton: Cycles de Lot, d'Abraham et de Jacob." *CahArch* 20 (1970), pp. 28–46.

Tsuji, "Passage" Tsuji, Sahoko. "'Le passage de la Mer Rouge': Étude iconographique d'un des panneaux sculptés des portes de Sainte-Sabine à Rome." *Orient* 8 (1972), pp. 53–79.

Ulrich, *Kain und Abel* Ulrich, Anna. *Kain und Abel in der Kunst: Untersuchungen zur Ikonographie und Auslegungsgeschichte.* Bamberg: Urlaub, 1981.

Underwood, "Fountain of Life" Underwood, Paul A. "The Fountain of Life in Manuscripts of the Gospels." *DOP* 5 (1950), pp. 41–138.

Underwood, *Kariye Djami* *The Kariye Djami.* Ed. Paul A. Underwood. 4 vols. London: Routledge and Kegan Paul, 1967–75.

Uspenskii Uspenskii, Fedor. *Konstantinopolskii Seral'skii kodeks Vos'mikniziia (L'Octateuque de la Bibliothèque du Sérail à Constantinople)* (*IRAIK* 12 [1907]). Sofia: Imprimerie de l'état, 1907. *Al'bom*, Munich: Kun, 1907.

Uspenskii, "Asenevichi" Uspenskii, Fedor. "Bulgarskie Asenevichi na vizantiiskoi sluzhbe v XIII–XIV vv." *IRAIK* 13 (1908), pp. 1–16.

Uspenskii, Fedor. "Ἡ βιβλιοθήκη τοῦ ἐν Κωνσταντινουπόλει Σεραγίου καὶ ἡ ἐν αὐτῇ εἰκονογραφημένη Ὀκτάτευχος." Παναθήναια 5 (30 April 1905), pp. 52–53.

Uspenskii, "Lettre" Uspenskii, Fedor. "La Lettre d'Aristée à Philocrate sur la traduction des 'Septante' et la paraphrase byzantine du XIIᵉ siècle." In *Actes du XIVᵉ Congrès international des orientalistes* (Algiers, 1905), vol. 1, sect. 6, pp. 19–23. Paris: Leroux, 1906.

Uvarov, *Album* Uvarov, Aleksiei S. *Vizantiiskii Al'bom (Album byzantin).* Moscow: Liessner and Romahn, 1890.

Van Woerden, I. Speyart. "The Iconography of the Sacrifice of Abraham." *VChr* 15 (1961), pp. 214–55.

Velmans, Tania. "Le dessin à Byzance." *MonPiot* 59 (1974), pp. 137–70.

———. Review of J. Lowden, *The Octateuchs: A Study in Byzantine Manuscript Illustration* (University Park, 1992). *CahArch* 41 (1993), pp. 182–83.

Venturi, *Storia* Venturi, Adolfo. *Storia dell'arte italiana.* Vol. 1, *Dai primordi dell'arte cristiana al tempo di Giustiniano.* Vol. 2, *Dall'arte barbarica alla romanica.* Milan: Hoepli, 1901 and 1902. Reprint, Nendeln, Lichtenstein: Kraus, 1967.

Vikan, "Edible Icons" Vikan, Gary. "Ruminations on Edible Icons: Originals and Copies in the Art of Byzantium." In *Retaining the Original: Multiple Originals, Copies, and Reproductions.* National Gallery of Art, Studies in the History of Art, 20, pp. 47–59. Washington, D.C., 1989.

Vikan, "Joseph Iconography" Vikan, Gary. "Joseph Iconography on Coptic Textiles." *Gesta* 18 (1979), pp. 99–108. Reprint in *Studies in Early Christianity*, pp. 353–62.

Vikan, "Life of Joseph" Vikan, Gary. "Illustrated Manuscripts of Pseudo-Ephraem's 'Life of Joseph' and the 'Romance of Joseph and Aseneth.'" Ph.D. diss., Princeton University, 1976.

Vikan, "Pictorial Recensions" Vikan, Gary. "Pictorial Recensions: Beyond Byzantium and the Bible." *Studia Artium Orientalis et Occidentalis* 2 (1985), pp. 1–9.

Vileisis, "S. Maria Ant." Vileisis, Birute A. "The Genesis Cycle of Santa Maria Antiqua." Ph.D. diss., Princeton University, 1979.

Voicu, Sever J., and Serenella D'Alisera. *I.Ma.G.E.S.: Index in Manuscriptorum Graecorum Edita Specimina.* Rome: Borla, 1981.

Volbach and Lafontaine-Dosogne, *Byzanz* Volbach, Wolfgang F., and Jacqueline Lafontaine-Dosogne. *Byzanz und der christliche Osten.* Berlin: Propyläen, 1968.

Voss, Hella. *Studien zur illustrierten Millstätter Genesis.* Münchener Texte und Untersuchungen zur deutschen Literatur des Mittelalters, 4. Munich: Beck, 1962.

Voss, *Millstätter Gen.* Voss, Hella. *Studien zur illustrierten Millstätter Genesis und Physiologus Handschrift.* Graz, 1962.

Vzdornov, "Illustraciia" Vzdornov, Gerold I. "Illustraciia k Chronike Georgiia Amartola." *VizVrem* 30 (1969), pp. 205–25.

Walter, "Dextrarum Junctio" Walter, Christopher. "The Dextrarum Junctio of Leptis Magna in Relationship to the

Iconography of Marriage." *Antiquités africaines* 14 (1979), pp. 271–83.

Walter, "Three Notes" Walter, Christopher. "Three Notes on the Iconography of Dionysius the Areopagite." *REB* 48 (1990), pp. 255–74.

Weber, *Symbolik* Weber, Walter. *Symbolik in der abendländischen und byzantinischen Kunst.* Vol. 1, *Von Sinn und Gestalt der Aureole.* Vol. 2, *Anmerkungen und Bildnachweise, Literaturverzeichnis, Bibliographie, Personen- und Sachregister.* Basel: Zbinden, 1981 and 1982.

Webster, *Labors* Webster, James C. *The Labors of the Months.* Princeton Monographs in Art and Archaeology, 21. Princeton: Princeton University Press, 1938.

Weigand Weigand, Edmund. Review of A. Goldschmidt and K. Weitzmann, *Die byzantinischen Elfenbeinskulpturen des X.–XIII. Jahrhunderts*, vol. 1, *Kästen* (Berlin, 1934). *BZ* 32 (1932), pp. 376–81.

Weitzmann, *Ancient Book Ill.* Weitzmann, Kurt. *Ancient Book Illumination.* Martin Classical Lectures, 16. Cambridge, Mass.: Harvard University Press, 1959.

Weitzmann, *Bibliotheken des Athos* Weitzmann, Kurt. *Aus den Bibliotheken des Athos: Illustrierte Handschriften aus mittel- und spätbyzantinischer Zeit.* Hamburg: Wittig, 1963.

Weitzmann, *Byzantin. Buchmalerei* Weitzmann, Kurt. *Die byzantinische Buchmalerei des 9. und 10. Jahrhunderts.* Berlin: Mann, 1935. Reprint, with vol. 2, *Addenda und Appendix*, Österreichische Akademie der Wissenschaften, philosophisch-historische Klasse, Denkschriften 243. Vienna: Österreichische Akademie der Wissenschaften, 1996.

Weitzmann, *Castelseprio* Weitzmann, Kurt. *The Fresco Cycle of S. Maria di Castelseprio.* Princeton Monographs in Art and Archaeology, 26. Princeton: Princeton University Press, 1951.

Weitzmann, "Character" Weitzmann, Kurt. "The Character and Intellectual Origins of the Macedonian Renaissance." In Weitzmann, *Studies*, pp. 176–223. English translation of *Geistige Grundlagen und Wesen der Makedonischen Renaissance.* Arbeitsgemeinschaft für Forschung des Landes Nordrhein-Westfalen 107. Cologne and Opladen: Westdeutscher Verlag, 1963.

Weitzmann, "Chronicles" Weitzmann, Kurt. "Illustration for the Chronicles of Sozomenos, Theodoret and Malalas." *Byz* 16 (1942–43), pp. 87–134. Reprint in Weitzmann, *Illumination and Ivories.*

Weitzmann, *Classical Heritage* Weitzmann, Kurt. *Classical Heritage in Byzantine and Near Eastern Art.* London: Variorum Reprints, 1981.

Weitzmann, "Classical in Byz. Art" Weitzmann, Kurt. "The Classical in Byzantine Art as a Mode of Individual Expression." In *Byzantine Art, an European Art, Ninth Exhibition Held under the Auspices of the Council of Europe: Lectures*, pp. 149–77. Athens: Office of the Prime Minister, 1966. Reprint in Weitzmann, *Studies*, pp. 151–75.

Weitzmann, "Classical Mode" Weitzmann, Kurt. "The Classical Mode in the Period of the Macedonian Emperors: Continuity or Revival?" In *The "Past" in Medieval and Modern Greek Culture*, ed. Speros Vryonis Jr., pp. 71–85. Byzantina

kai Metabyzantina, vol. 1. Malibu, Calif.: Undena, 1978. Reprint in Weitzmann, *Classical Heritage.*

Weitzmann, "Constantinop. Book Ill." Weitzmann, Kurt. "Constantinopolitan Book Illumination in the Period of the Latin Conquest." In Weitzmann, *Studies*, pp. 314–34. Reprint with annotations of *GBA* 86 (1944), pp. 193–214.

Weitzmann, "Constantinop. Lectionary" Weitzmann, Kurt. "The Constantinopolitan Lectionary Morgan 639." In *Studies in Art and Literature for Belle da Costa Green*, ed. Dorothy Miner, pp. 358–73. Princeton: Princeton University Press, 1954. Reprint in Weitzmann, *Psalters and Gospels.*

Weitzmann, "Cotton Gen. Fragments" Weitzmann, Kurt. "Observations on the Cotton Genesis Fragments." In *Late Classical and Mediaeval Studies in Honor of Albert Mathias Friend, Jr.*, ed. Kurt Weitzmann, pp. 112–31. Princeton: Princeton University Press, 1955. Reprint in Weitzmann, *Illumination and Ivories.*

Weitzmann, "Crusader Icons" Weitzmann, Kurt. "Thirteenth-Century Crusader Icons on Mount Sinai." *ArtB* 45 (1963), pp. 179–203. Reprint in Weitzmann, *Sinai Studies*, pp. 291–315.

Weitzmann, *Dura* Weitzmann, Kurt. "Part I." In Weitzmann and Kessler, *Frescoes*, pp. 1–150.

Weitzmann, "Genesis Mosaics" Weitzmann, Kurt. "The Genesis Mosaics of San Marco and the Cotton Genesis Miniatures." In Demus, *Mosaics of S. Marco*, vol. 2, pp. 105–42, 253–58.

Weitzmann, *Greek Mythology* Weitzmann, Kurt. *Greek Mythology in Byzantine Art.* Studies in Manuscript Illumination, 4. Princeton: Princeton University Press, 1951. 2d ed., 1984.

Weitzmann, *Ill. Mss. at St. Catherine's Monastery* Weitzmann, Kurt. *Illustrated Manuscripts at St. Catherine's Monastery on Mount Sinai.* Collegeville, Minn.: St. John's University Press, 1973.

Weitzmann, *Illumination and Ivories* Weitzmann, Kurt. *Byzantine Book Illumination and Ivories.* London: Variorum Reprints, 1980.

Weitzmann, "Jephthah Panel" Weitzmann, Kurt. "The Jephthah Panel in the Bema of the Church of St. Catherine's Monastery on Mount Sinai." *DOP* 18 (1964), pp. 341–52. Reprint in Weitzmann, *Sinai Studies*, pp. 63–80, with annotations on pp. 424–25.

Weitzmann, "Jewish Sources" Weitzmann, Kurt. "The Question of the Influence of Jewish Pictorial Sources on Old Testament Illustration." In Weitzmann, *Studies*, pp. 76–95. Reprint in *No Graven Images*, pp. 309–328. English translation of "Zur Frage des Einflusses jüdischer Bilderquellen auf die Illustration des Alten Testamentes." In *Mullus: Festschrift Theodor Klauser.* JbAChr, Ergänzungsband 1 (1964), pp. 401–15.

Weitzmann, *JR* Weitzmann, Kurt. *The Joshua Roll: A Work of the Macedonian Renaissance.* Studies in Manuscript Illumination, 3. Princeton: Princeton University Press, 1948.

Weitzmann, "Martyrion" Weitzmann, Kurt. "The Iconography of the Reliefs from the Martyrion." In *Antioch-on-the-Orontes.* Vol. 3, *The Excavations of 1937–1939*, ed. Richard Stillwell, pp. 135–49. Princeton: Princeton University Press, 1941.

Weitzmann, "Mythological Representations" Weitzmann, Kurt. "The Survival of Mythological Representations in Early Christian and Byzantine Art and Their Impact on Christian Iconography." *DOP* 14 (1960), pp. 43–68. Reprint in Weitzmann, *Classical Heritage.*

Weitzmann, "Narration" Weitzmann, Kurt. "Narration in Ancient Art: Early Christendom." *AJA* 61 (1957), pp. 83–91. Reprint in *Studies in Early Christianity*, pp. 405–13.

Weitzmann, "Oct. Ser." Weitzmann, Kurt. "The Octateuch of the Seraglio and the History of Its Picture Recension." In *X. Milletlerarasi Bizans Tetkikleri Kongresi Tebligleri/Actes du Xe Congrès international d'études byzantines* (Istanbul, 15–21 November 1955), pp. 183–86. Istanbul: Comité d'Organization du Xe Congrès international d'études byzantines, 1957.

Weitzmann, "Ode Pictures" Weitzmann, Kurt. "The Ode Pictures of the Aristocratic Psalter Recension." *DOP* 30 (1976), pp. 67–84. Reprint in Weitzmann, *Psalters and Gospels.*

Weitzmann, "Pariser Psalter" Weitzmann, Kurt. "Der Pariser Psalter Ms. Grec. 139 und die mittelbyzantinische Renaissance." *JbKw* 6 (1929), pp. 178–94. Reprint in Weitzmann, *Psalters and Gospels.*

Weitzmann, *Psalters and Gospels* Weitzmann, Kurt. *Byzantine Liturgical Psalters and Gospels.* London: Variorum Reprints, 1980.

Weitzmann, "Ps. Vatopedi" Weitzmann, Kurt. "The Psalter Vatopedi 761: Its Place in the Aristocratic Psalter Recension." *JWalt* 10 (1947), pp. 21–51. Reprint in Weitzmann, *Psalters and Gospels.*

Weitzmann, *RaC* Weitzmann, Kurt. *Illustrations in Roll and Codex: A Study of the Origin and Method of Text Illustration.* Studies in Manuscript Illumination, 2. Princeton: Princeton University Press, 1947. 2d ed. with addenda, 1970.

Weitzmann, Kurt. *Sailing with Byzantium from Europe to America: The Memoirs of an Art Historian.* Munich: Editio Maris, 1994.

Weitzmann, "Samson and Delilah" Weitzmann, Kurt. "Samson and Delilah on a Draughtsman." *Record of the Art Museum, Princeton University* 7 (1948), no. 2, pp. 5–9.

Weitzmann, "Selection" Weitzmann, Kurt. "The Selection of Texts for Cyclic Illustrations in Byzantine Manuscripts." In *Byzantine Books and Bookmen: A Dumbarton Oaks Colloquium, 1971*, pp. 69–109. Washington, D.C.: Dumbarton Oaks, 1975. Reprint in Weitzmann, *Illumination and Ivories.*

Weitzmann, "Septuagint" Weitzmann, Kurt. "The Illustration of the Septuagint." In Weitzmann, *Studies*, pp. 45–75. Reprint in *No Graven Images*, pp. 201–31. English translation of "Die Illustration der Septuaginta." *MünchJb* 3–4 (1952–53), pp. 96–120.

Weitzmann, *Sinai Studies* Weitzmann, Kurt. *Studies in the Arts at Sinai.* Princeton: Princeton University Press, 1982.

Weitzmann, *SP* Weitzmann, Kurt. *The Miniatures of the Sacra Parallela: Parisinus Graecus 923.* Studies in Manuscript Illumination, 8. Princeton: Princeton University Press, 1979.

Weitzmann, "St. Nicholas Triptych" Weitzmann, Kurt. "Fragments of an Early St. Nicholas Triptych on Mount Sinai." In Τιμητικὸς Γ. Σωτηρίου (Δελτ. Χριστ. Ἀρχ. Ἑτ., ser. 4, no. 4 [1964]), pp. 1–23. Reprint in Weitzmann, *Sinai Studies*, pp. 211–44, with annotations on pp. 430–31.

Weitzmann, *Studies* Weitzmann, Kurt. *Studies in Classical and Byzantine Manuscript Illumination.* Ed. Herbert L. Kessler. Chicago and London: University of Chicago Press, 1971.

Weitzmann, Kurt, "The Study of Byzantine Book Illumination: Past, Present, Future." In Kurt Weitzmann, William C. Loerke, Ernst Kitzinger, and Hugo Buchthal, *The Place of Book Illumination in Byzantine Art*, pp. 1–60. Princeton: The Art Museum, Princeton University, 1975. Reprint in Weitzmann, *Illumination and Ivories.*

Weitzmann and Galavaris, *Sinai Greek Mss.* Weitzmann, Kurt, and George Galavaris. *The Monastery of Saint Catherine at Mount Sinai: The Illuminated Greek Manuscripts.* Vol. 1, *From the Ninth to the Twelfth Century.* Princeton: Princeton University Press, 1990.

Weitzmann and Kessler, *Cotton Gen.* Weitzmann, Kurt, and Herbert L. Kessler. *The Cotton Genesis: British Library Codex Cotton Otho B. VI.* Illustrations in the Manuscripts of the Septuagint. Vol. 1, Genesis. Princeton: Princeton University Press, 1986.

Weitzmann and Kessler, *Frescoes* Weitzmann, Kurt, and Herbert L. Kessler. *The Frescoes of the Dura Synagogue and Christian Art.* Dumbarton Oaks Studies, 28. Washington, D.C.: Dumbarton Oaks, 1990.

Weitzmann and Ševčenko, "Moses Cross" Weitzmann, Kurt, and Ihor Ševčenko. "The Moses Cross at Sinai." *DOP* 17 (1963), pp. 385–98.

Werckmeister, "Pain and Death" Werckmeister, O. K. "Pain and Death in the Beatus of Saint-Sever." *StM* 14 (1973), pp. 565–626.

Wessel, "Abraham" Wessel, Klaus. "Abraham." *RBK*, vol. 1, cols. 11–22.

Wessel, "Adam und Eva" Wessel, Klaus. "Adam und Eva." *RBK*, vol. 1, cols. 40–54.

Wessel, "Durchzug" Wessel, Klaus. "Durchzug durch das Rote Meer." *RBK*, vol. 2, cols. 1–9.

Wessel, "Kain und Abel" Wessel, Klaus. "Kain und Abel." *RBK*, vol. 3, cols. 717–22.

Weyl Carr, *Byz. Illum.* Weyl Carr, Annemarie. *Byzantine Illumination 1150–1250: The Study of a Provincial Tradition.* Chicago: University of Chicago Press, 1987.

Weyl Carr, "Gospel Frontispieces" Weyl Carr, Annemarie. "Gospel Frontispieces from the Comnenian Period." *Gesta* 21 (1982), pp. 3–20.

Weyl Carr, Annemarie. Review of Kathleen Corrigan, *Visual Polemics in Ninth-Century Byzantine Psalters* (New York, 1992); and John Lowden, *The Octateuchs: A Study in Byzantine Manuscript Illumination* (University Park, 1992). *ArtB* 76 (1994), pp. 165–69.

Wickhoff, *Roman Art* Wickhoff, Franz. *Roman Art.* London and New York, 1900.

"Wiener Gen.: Resumé" "Die Wiener Genesis: Resumé der Diskussion." In *Beiträge zur Kunstgeschichte und Archäologie des Frühmittelalters: Akten zum VII. Internationalen Kongress für Frühmittelalterforschung* (Vienna, 21–28 September 1958), ed. Hermann Fillitz, pp. 44–52. Graz: Böhlaus, 1962.

Williams, "Castilian Tradition" Williams, John W. "A Castilian Tradition of Bible Illustration: The Romanesque Bible from San Millán." *JWarb* 28 (1965), pp. 66–85.

Williams, "León Bible" Williams, John W. "The Illustrations of the León Bible of the Year 960: An Iconographical Analysis." Ph.D. diss., University of Michigan, 1962.

Willoughby, Harold R. "Codex 2400 and Its Miniatures." *ArtB* 15 (1933), pp. 3–74.

Willoughby, *McCormick Apocalypse* Willoughby, Harold R. et al. *The Elizabeth Day McCormick Apocalypse.* 2 vols. Chicago: University of Chicago Press, 1940.

Wilpert, *Mosaiken und Malereien* Wilpert, Joseph. *Die römischen Mosaiken und Malereien der kirchlichen Bauten vom IV. bis XIII. Jahrhundert.* 4 vols. Freiburg im Breisgau: Herdersche Verlagshandlung, 1916.

Winckelmann, *Versuch einer Allegorie* Winckelmann, Johann. *Versuch einer Allegorie, Besonders für die Kunst.* Dresden: Walterischen Hof, 1766. Reprint, New York and London: Garland, 1976.

Winogradski, W. von. "Miniatiur'i Vatikanskoi bibleiskoi rukopisi." *Sbornik Obscestva drevnerusskogo iskusstva* (1873), pp. 137–50.

Wodtke, "Dura" Wodtke, Gitta. "Malereien der Synagoge in Dura und ihre Parallelen in der christlichen Kunst." *Zeitschrift für die Neutestamentliche Wissenschaft* 34 (1935), pp. 51–62.

Wörmann, *Geschichte* Wörmann, Karl. *Geschichte der Kunst aller Zeiten und Völker.* 6 vols. Leipzig and Vienna: Bibliographisches Institut, 1915–22.

Wolska, Wanda. *La Topographie Chrétienne de Cosmas Indicopleustès: Théologie et science au VI^e siècle.* Paris: Presses Universitaires de France, 1962.

Wolska-Conus, *Cosmas* Wolska-Conus, Wanda. *Cosmas Indicopleustès: Topographie Chrétienne.* 3 vols. SC 141, 159, and 197. Paris: Éditions du Cerf, 1968–73.

Wolska-Conus, "Géographie" Wolska-Conus, Wanda. "Géographie." *RAC* vol. 10, cols. 187–89.

Wolska-Conus, "Topographie Chrétienne" Wolska-Conus, Wanda. "La 'Topographie Chrétienne' de Cosmas Indicopleustès: Hypothèses sur quelques thèmes de son illustration." *REB* 48 (1990), pp. 155–91.

Woltmann, Alfred. "Die Malerei des Mittelalters." In Woltmann, Alfred, and Karl Wörmann. *Geschichte der Malerei*, vol. 1, pp. 191–483. Leipzig: Seemann, 1879.

Woodruff, "Physiologus of Bern" Woodruff, Helen. "The Physiologus of Bern: A Survival of Alexandrian Style in a Ninth Century Manuscript." *ArtB* 12 (1930), pp. 226–53.

Woodruff, "Prudentius" Woodruff, Helen. "The Illustrated Manuscripts of Prudentius." *Art Studies* 7 (1929), pp. 33–79.

Wulff, *Altchr. und Byz. Kunst* Wulff, Oskar. *Altchristliche und byzantinische Kunst.* Vol. 1, *Die altchristliche Kunst von ihren Anfängen bis zur Mitte des ersten Jahrtausends.* Vol. 2, *Die byzantinische Kunst.* Berlin-Neubabelsberg: Akademische Verlagsgesellschaft Athenaion, 1914 and 1918.

Wulff, *Byzant. Kunst* Wulff, Oskar. *Die byzantinische Kunst von der ersten Blüte bis zu ihrem Ausgang: Handbuch der Kunstwissenschaft.* Ed. Fritz Berger and Albert E. Brinckmann. Potsdam: Akademische Verlagsgesellschaft Athenaion, 1924.

Xyngopoulos, "Ἀνάγλυφον" Xyngopoulos, Andreas. "Τὸ ἀνάγλυφον τῆς ἐπισκοπῆς Βόλου." Ἐπ.Ἑτ.Βυζ.Σπ. 2 (1925), pp. 107–21.

Xyngopoulos, "Βυζ. παράστασις μηνός" Xyngopoulos, Andreas. "Βυζαντινὴ παράστασις μηνός." Ἐπ.Ἑτ.Βυζ.Σπ. 1 (1924), pp. 180–88.

Zirpolo, "Ivory Caskets" Zirpolo, Lilian H. "Three Rosette Ivory Caskets with Scenes from the Lives of Adam and Eve." *Rutgers Art Review* 14 (1994), pp. 6–28.